The Oxford Companion to the

Photograph

The Oxford Companion to the

Photograph

Edited by Robin Lenman

OXFORD

UNIVERSITY PRESS

OXFORD

UNIVERSITY PRESS

Great Clarendon Street, Oxford OX2 6DP

Oxford University Press is a department of the University of Oxford.
It furthers the University's objective of excellence in research, scholarship,
and education by publishing worldwide in

Oxford New York

Auckland Cape Town Dar es Salaam Hong Kong Karachi Kuala Lumpur
Madrid Melbourne Mexico City Nairobi New Delhi Shanghai Taipei Toronto

With offices in

Argentina Austria Brazil Chile Czech Republic France Greece
Guatemala Hungary Italy Japan South Korea Poland Portugal
Singapore Switzerland Thailand Turkey Ukraine Vietnam

Published in the United States
by Oxford University Press Inc., New York

© Oxford University Press 2005

Database right Oxford University Press (maker)

British Library Cataloguing in Publication Data

Data available

Library of Congress Cataloging in Publication Data
ISBN 0-19-866271-8
ISBN 978-0-19-866271-6

2
Typeset by Graphicraft Limited, Hong Kong
Printed and bound by Constant Printing Limited

Advisory Editors

Sylvie Aubenas
Bibliothèque Nationale de France

Quentin Bajac
Musée National d'Art Moderne, Paris

Jane Carmichael
National Museums of Scotland

Elizabeth Edwards
University of the Arts, London

John Falconer
The British Library

Mark Haworth-Booth
University of the Arts, London, and Victoria & Albert Museum

Michael Hiley
De Montfort University, Leicester

Madeleine Hill Vedel
Arles, France

William J. Mitchell
Massachusetts Institute of Technology

Amanda Nevill
British Film Institute

Jeffrey Richards
University of Lancaster

Dr Pam Roberts
formerly Royal Photographic Society, Bath

Dr Naomi Rosenblum
New York

Graham Saxby
formerly Wolverhampton University

Larry Schaaf
formerly University of Oxford

Dr Joan Schwartz
Queen's University, Kingston, Ontario

Sara Stevenson
National Galleries of Scotland and National Photography Centre, Edinburgh

Michael Ware
University of Manchester

Contents

Introduction and Acknowledgements

It is important at the outset to explain briefly the thinking behind the book's layout and overall balance. Photography, both silver based and digital, involves complex technology based on a large body of difficult science; although it is also true that clever design has often masked this complexity and made many sophisticated imaging devices astonishingly easy to use. This *Companion* contains numerous technical entries, ranging from glossary items of 50–100 words from *Adobe Photoshop* to *zone plate* to much more substantial articles on topics ranging from *camera* and *lens development* to *astronomical*, *medical*, and *three-dimensional photography*, and theoretical subjects such as *Fourier optics* and the *optical transfer function*. There are also entries on the techniques of picture making, and the reader interested in *composition*, the use of *filters*, or how to photograph bolts of *lightning* or plates of *food* will find information on these and many similar topics. However, it was not our aim either to create a technical compendium to rival *The Focal Encyclopaedia of Photography* or *The Manual of Photography*, or to duplicate the countless photographic guides available. The technical entries have therefore been made as short and accessible as possible, while offering plentiful suggestions for further reading.

An important reason for limiting the technical content of the book lay in the development of the medium itself. When the project was conceived, shortly before the Millennium, digital photography was already firmly established. The Hubble Space Telescope, in effect a digital camera attached to a radio transmitter, had been in orbit for nearly a decade. Photojournalists were increasingly using digital equipment, and in 2000 Canon was to launch its last professional-level 35 mm single-lens reflex camera. However, purists continued to resist; images from amateur digital cameras were still markedly inferior to silver-based ones; and high-end digital cameras cost thousands of pounds or dollars. But five years later events have moved on dramatically. Digital imaging has conquered nearly all branches of professional photography, and consumer-orientated cameras costing £500 or less are capable of creating technically superb images. Moreover, these can be printed by high-street minilabs, or by connecting the camera directly to a digital printer without the need for a computer. The use of relatively simple software—increasingly in camera or in printer—makes it possible to produce exhibition-quality prints indistinguishable from silver-based ones. Moreover, completely new products have entered the market place, notably the camera-equipped mobile phone or 'personal digital assistant', capable by 2005 of taking good-quality pictures and sending them to almost anywhere in the world. In the background are important industrial changes: the discontinuation of many long-established cameras, and cutbacks in production of traditional materials; mergers or research sharing between some of the largest manufacturers; and increasing integration of the photographic, electronics, computer, and telecommunications industries.

In its relatively short history, of course, photography has already experienced revolutionary changes, starting with the earliest improvements to the *daguerreotype* and *calotype* processes in the 1840s, the introduction of the *wet-plate process* in the 1850s, then of *dry plates* from the 1870s, the *half-tone photomechanical reproduction process* and the *roll-film* camera in the 1880s, the 35 mm camera in the 1920s and 35 mm colour film in the 1930s and 1940s, Polaroid *instant photography* in the late 1940s and 1950s, and wave after wave of *automation* in the last third of the 20th century. Yet the speed of the digital revolution took nearly all professional commentators by surprise, and its potential scope and impact on other technologies make prophecies about future trends problematic. Most of the digital products available when work began on the main text of this book are now obsolete if not forgotten. We have therefore limited ourselves to outlining the principles and early history of *digital imaging* and *printing*, while including a more general article on the history of *photographic innovation*.

Several things set this *Companion* apart from most other reference books. One is the many national and regional entries it contains, including some on parts of the world, such as *Africa*, *Oceania*, and *Scandinavia*, that rarely feature in histories or encyclopedias of photography. We also aimed to give due coverage to one of the world's oldest and most fascinating photographic cultures, *Japan*, which is strongly represented in both the geographical and biographical categories. And we were fortunate to secure the collaboration of Régine Thiriez, one of the world's few experts on photography in *China* and *South-East Asia*, both areas where the medium is certain to develop rapidly in the near future. In the geographical category, however, as in the book generally, it proved much easier to draw up wish-lists than to find contributors. In the case of *Russia*, for example, a country with a rich photographic history and a mass of archives, it was impossible, and the entry eventually had to be written by the Editor. Other parts of the map remain, unfortunately, blank, or only part of their photographic

history could be covered. We hope that these gaps may be filled in future editions, for which the present one provides a template.

Another distinctive feature of the book is its strong emphasis on photography as a social practice. By the year 2000 there were few households in the developed world without at least one camera, and billions of images were being created around the world, not only by private individuals but by scientists, doctors, detectives, immigration officials, and private and official agencies of all kinds. Linked to this mass of picture making was a huge manufacturing and research industry, large economic sectors such as *tourism, advertising, fashion,* and the news media, and a photographic infrastructure including *societies, professional organizations, journals, training establishments, museums,* dealers, publishers, and charitable foundations. All of these aspects are touched upon in the book, and many of them receive detailed individual coverage.

The photographic act has also often had strong emotive, political, and even magical implications, involving questions of power, identity and kinship, the creation of myths, the shaping (or masking) of memories, and the invasion of private or sacred spaces. Today these are areas of intensive research, but also of controversy, particularly where they impinge on the European and American legacies of imperialism. There are entries on *colonial, missionary,* and *tourist photography,* the experience of *native peoples,* and photography's links with *Christianity, magic,* and *death.* In industrialized countries too, photography has aroused strong passions, and continues to do so at the beginning of the 21st century. Obscenity, privacy, the creation of stereotypes, and the ownership of images have been perennial subjects of debate, although technological and social change have shifted their emphases. Articles on *ethics,* the *Internet, law, paparazzi,* and *pornography,* and on *celebrity, erotic, nude,* and *child photography* outline the issues. This last area particularly, and related questions about photography in public places, which exercised the British photographic press in the autumn of 2004, is likely to fuel debates about civil rights, privacy, and freedom of expression for years to come.

Since the 19th century, and again often controversially, the camera has played an increasing role in politics and conflict. Thus there are entries on *propaganda,* the *Civil Rights movement* in the USA, 'struggle photography' in South Africa, and *war*—from the first murky daguerreotypes of the Mexican–American conflict of 1846–8 to today's full-colour, instantly transmitted images from Iraq and Palestine. Further material will be found in articles on *aerial* and *military photography* and *photojournalism,* and on more detailed topics such as the *My Lai massacre,* the *Wehrmacht atrocities exhibition,* and others.

From an early stage in its history, finally, photography was recognized by many practitioners, commentators, and collectors as a means of artistic expression. Although the concept of 'art photography' was first systematically propagated by the pictorialists around the turn of the 20th century, it had been anticipated decades earlier: in the writings of critics such as Francis Wey, for example, the

reception of work by masters like Roger Fenton and Gustave Le Gray, and legislative measures like the British Fine Arts Copyright Act of 1862. The rest is history, and many of the book's entries explore it, both through the biographical entries and in articles on groups and movements throughout the world. But space is also given to one of the late 20th century's most significant developments, namely the ever closer integration of photography and the other (or 'fine') arts, in terms of training, exhibitions, museum collections, prizes, and the market. The price levels of work by living photographers like Nan Goldin, Andreas Gursky, and Cindy Sherman, the award of the Turner Prize to Wolfgang Tillmans in 2002, and the organization by London's flagship contemporary art museum, Tate Modern, of its first exclusively photographic exhibition, *Cruel and Tender,* the following year, make this point decisively. Entries on *contemporary art and photography* and related topics reflect it.

Another development which made this book seem particularly timely was the growing mass of recent photographic scholarship, a substantial selection of which is cited throughout the book and listed in the Bibliography. Photographic history has also blossomed in higher education, and the former trickle of dissertations on photographic subjects has become a flood. Scholarly editions of major documentary collections, such as the Niépce and Talbot correspondence (the latter available on the Internet) are proliferating, and significant bodies of art, technical, and vernacular photographs are being archived, conserved, and often made available in digital form. For creators of reference books, of course, all this is both encouraging and frustrating. The few weeks between the completion of the main text and the end of copy-editing, for example, saw the appearance of several important books: Charlotte Cotton's *The Photograph as Contemporary Art,* for example; the first volume of a major work by Martin Parr and Gerry Badger on photographic publishing, *The Photobook: A History*; and a collection of essays on a 'dark' period of Russian photographic history, *Beyond Memory: Soviet Nonconformist Photography and Photo-Related Works of Art,* edited by Diane Neumaier; not to mention new monographs on Fenton and Stieglitz. More will certainly appear during the months of typesetting.

A major editorial issue concerned the number and size of biographical entries. The claim by the editors of Larousse's *Dictionnaire de la photo* (1996) that 20,000 entries would not have sufficed to cover every notable living photographer indicates the magnitude of the problem. After considering various alternatives, from no biographies at all to a sample of 50–100 'greats', we decided that the least unsatisfactory and most interesting solution would be a maximum of 1,000 biographical entries, including a substantial minority of non-photographers who had significantly influenced photographic culture. Entry size would be limited to *c.*100–*c.*500 words—the latter even for giants such as Cartier-Bresson, Stieglitz, and Talbot. This enabled us to offer an unusual variety of names. *P,* for example, includes not only such iconic figures as Gordon *Parks* and Irving *Penn,* but the expatriate Greek amateur Mary *Paraskeva,*

the early American photographer Henry Greenwood *Peabody*, the Hungarian lens designer Josef *Petzval*, the contemporary Portuguese photographer Mariano *Piçarra*, the Canadian Inuit photographer and print maker Peter *Pitseolak*, the aerial photographer Antoine *Poidebard*, SJ, the aristocratic amateur Count Giuseppe *Primoli*, the Russian colour pioneer Sergei *Prokudin-Gorskii*, the Czech physiologist and photographic researcher Jan Evangelista *Purkinje*, and numerous others. On the other hand, and much to our regret, we have had to leave out many other important figures, who would certainly have been included in a larger book. But many of them appear in the larger articles, and can be located in the index.

The book has been rigorously edited, when time and circumstances permitted in consultation with contributors. The goal throughout has been to create a harmonious and accessible text with a minimum of inconsistencies and overlaps between entries. Where mistakes have crept in, we hope they will be notified to the publisher so that future editions can be amended. Firm cutting of over-length contributions has enabled us to bring the main text in substantially below our original limit of half a million words. This has created space for a systematic contents list, a substantial bibliography and chronology, a selection of websites, and an index, all of which are intended to make the book as usable and companionable as possible.

In the tradition of large reference books, this has been an arduous project. It was first mooted in the early autumn of 1999 and the main text was completed, on St Agnes, Isles of Scilly, on 20 September 2004. In the intervening period many hundreds of letters and e-mails were exchanged, I travelled extensively in the UK and Europe to meet advisers, attend conferences, and recruit contributors, and hundreds of thousands of words of text were read, revised, and written. In all that time, despite the strains involved, a move from London to Cornwall, and some health problems, I only resigned once, and managed to bring the book to completion not too many months beyond the original deadline. This would have been impossible without the help and support of many people.

First, I owe an incalculable debt to the extremely professional and well-organized team at Oxford University Press; working with them was both a privilege and fun. Michael Cox charmed me into taking on the project in the first place, and gave invaluable help and encouragement in shaping the original proposal and piloting it through the commissioning process. At the other end, Joanna Harris combined great efficiency in coordinating the complex details of the final editing stage with sensitivity and kindness towards an increasingly exhausted Editor. Jackie and Edwin Pritchard completed the copy-editing process with amazing speed and accuracy and were a pleasure to work with; I am sorry that our association was so brief. Carrie Gough handled the final stages of picture management, and some important diplomatic tasks, with charm, good humour, and thoroughness. Wendy Tuckey played an indispensable role from beginning to end as our administrator, managing an ever-growing mass of accounting and list keeping and saving me from many

blunders during the commissioning process. Her contribution was all the more remarkable in that, for part of the time, it coincided with distressing events in her own life. We could not have managed without her. Nick Clarke, as designer, had joined the project at an early stage, and I am hugely indebted to him for the creativity, enthusiasm, and judgement he brought to it. The look of the book, which was vitally important to all of us, owes a great deal to him. Finally, Pam Coote was responsible editor, and my principal contact at the Press, for most of the book's gestation period. In the conventional few words it is not easy to express either my gratitude and appreciation for her contribution, or my admiration for her professionalism, problem-solving ability, level-headedness, and kindness when (occasionally) things were difficult. Working with her was an experience I would not have missed.

In the autumn of 2002 the scale of the editing task, combined with an earlier diagnosed illness, made it impossible for me to continue without additional help. At this point, the Press and I were extremely lucky to secure the services of a former Warwick graduate student, Lisa Lavender, who was able to combine the tasks of personal and editorial assistant with the demands of a young family. Her efficiency, initiative, and seemingly endless reserves of energy and good cheer soon became indispensable. Our collaboration was a pleasure from beginning to end, and I doubt whether I could have finished the book without her. My heartfelt thanks also to Lisa's husband Richard and children Georgia and Max for their friendship, and for tolerating a growing mound of paper, and telephone calls at inconvenient times.

It is perhaps invidious to single out individual members of our advisory panel, since nearly all of them provided valuable assistance over long or short periods. But my particular thanks are due to Jane Carmichael, formerly Keeper of Photographs at the Imperial War Museum, for providing sensible advice and a list of invaluable contacts at the beginning, as did John Falconer, Michael Hiley, Amanda Nevill, Pam Roberts, Naomi Rosenblum, Joan Schwartz, Sara Stevenson, and Mike Ware. I had enjoyable discussions in Oxford with Elizabeth Edwards, and am grateful for her ideas, encouragement, and contacts, especially in the social science field. Thanks also to Sylvie Aubenas and Mark Haworth-Booth for their kindness, support, and fine contributions. Jeffrey Richards tirelessly read reams of contributions and backed my resolve to keep jargon and obfuscation out of the book. Madeleine Hill played an indispensable role coordinating our small team of Japanese contributors and, from her base in Arles, acting as intermediary between Oxford and Japan. Graham Saxby, finally, who joined the team at a later stage, wrote many of the technical articles; but his friendship, advice, and practical help at awkward moments were also of inestimable value.

Not a few of our contributors not only ended up, like the Editor, writing far more entries than they had originally bargained for, but provided support well beyond the call of duty. Foremost among them were Heather Angel, Patrizia di Bello, Colin Ford, Wendy Grossman, Roger Hicks, Paul Hill, Jens Jaeger, Hope Kingsley, Robert Pols,

Molly Rogers, Roger Taylor, Régine Thiriez, Tim Troy, John Ward, and Kelley Wilder. We also owe a considerable debt to Jocelyne Dudding and Hulleah Tsinhnahjinnie, who stepped in at the last moment to save our important entry on *native peoples and photography*.

I am grateful to my colleagues in the History Department at Warwick University for their long-standing help, encouragement, stimulation, and friendship, and in relation to this project especially to Jean Noonan, Ros Lucas, Maxine Berg, Hilary Marland, and Maria Luddy. A talented former student, Veronica Rossini, helped with translations from Portuguese. I am also indebted to the University itself for the facilities—above all, an office—I enjoyed there during three years of semi-retirement between 2001 and 2004. The British Library in London, the Bodleian Library in Oxford, and the Morrab Library in Penzance provided research and working facilities over a long period. The staff of Penzance's excellent public library gave friendly and unstinting help in using their computing facilities.

Choosing and obtaining the pictures for a book of this size and scope proved to be a mammoth task in its own right. Drawing up a list of famous and beautiful images was easy and enjoyable; locating and obtaining them, and unravelling the complexities of ownership and copyright, was quite another matter. I am therefore extremely grateful to our picture researcher, Helen Nash, for the capabilities she brought to the task: skill at assembling spreadsheets and husbanding our modest budget, shrewdness and persistence in obtaining affordable deals, and patience in tracking down copyright holders and conducting complicated and often fruitless correspondence; in spite of the stresses involved, our planning sessions were a lot of fun.

Our thanks also go to many people for providing us with pictures. First and foremost, Her Majesty the Queen graciously allowed us to use some fine images from the Royal Archives, where Frances Dimond handled our requests with speed and efficiency. We are grateful to the Royal Photographic Society for the use of items from their collection, now held at the National Museum of Photography, Film, and Television in Bradford, and to the museum for items from its own holdings. David Thompson at the Science and Society Photographic Library in London was extremely helpful and a pleasure to work with. Ebrahim Alkazi, the owner of the wonderful Alkazi Collection of Indian and East Asian photographs, generously allowed us free use of a selection of his pictures; I am also most grateful to the two London-based curators of the Alkazi Collection: Sophie Gordon, for her invaluable advice and excellent contributions, and Stéphanie Roy for a memorable afternoon choosing pictures for the book. Michael Pritchard of Christie's, London, kindly gave us free use of a number of important images. Thanks also to Sylvie Aubenas at the Bibliothèque Nationale de France; Jan Ruhrmund and her colleagues at the photographic archive of the Morrab Library, and Nick Sharp of Penlee House Gallery and Museum, both in Penzance, and Brian Stevens, curator of the outstanding Comely Collection of St Ives photographs.

Many other people have helped. Clare Evans provided useful comments about *disability and photography*. David Allison offered advice and contacts at a critical stage of the project. A number of close friends have given encouragement, hospitality, and intellectual companionship over many years; David Harding, Christopher Silver, and Jim Obelkevich also specifically in relation to this project. I owe Maureen and Malcolm Dales both a number of very pleasant evenings and fascinating and indispensable advice on *wedding photography*.

Finally, my late maternal grandfather, Arthur Tomlinson, the family's first keen photographer, bequeathed a sumptuous Richard *Taxiphote* and collection of historic stereographs that provided a magical peepshow for his grandchildren. My late friend Eva Heilmann introduced me to the pleasure of using fine German cameras on many enjoyable tours of Bavaria. Sophie Wallace, my daughter and first photographic subject, has given unstinting encouragement throughout this project, as has her husband Gordon Wallace. My wife Anita Ballin has borne the main brunt of it, enduring years of absent-mindedness, disrupted holidays, and the invasion of our living space with ever-growing numbers of books and ancient cameras, yet without ever withholding her love and support. Her advice and practical help have also been, to use a Cornish expression, as good as gold. To all five of them this book is dedicated.

ROBIN LENMAN
Penzance, June 2005

Thematic Table of Contents

The following systematic contents list, in conjunction with the index and the book's cross-referencing system, is intended to assist the reader interested in pursuing particular themes. Mainly for reasons of space, biographical entries have been omitted, although entries on photographic companies are included. In a minority of cases, entries have been listed in more than one category.

Editors and Contributors

General Editor

Robin Lenman worked as Lecturer and then Senior Lecturer in the Department of History at Warwick University from 1971 to 2004. He was educated at Merton College and St Antony's College, Oxford, and Marburg University, Germany. His publications include: *Die Kunst, die Macht und das Geld. Zur Kulturgeschichte des kaiserlichen Deutschlands, 1871–1918* (1994), *Artists and Society in Germany, 1850–1914* (1997), and numerous articles and essays on 19th- and 20th-century German cultural history, and on photography and tourism. (RL)

Advisory Editors

Sylvie Aubenas, Chief Curator for 19th-century photographs, Département des estampes et de la photographie, Bibliothèque Nationale de France. (SA)

Quentin Bajac, Curator, Photography department, Musée national d'art moderne, Paris. Former curator at the Musée d'Orsay, and organizer of many shows on early, modern, and contemporary photography. (QB)

Jane Carmichael, Director of Collections, National Museums of Scotland. Formerly Director of Collections at the Imperial War Museum, London, and manager of the Photograph Archive at the Museum.

Elizabeth Edwards, Senior Research Fellow at the University of the Arts, London. Previously Curator of Photographs and Lecturer in Visual Anthropology, Pitt Rivers Museum, University of Oxford. She has written extensively on the relations between anthropology, photography, and history. (EE)

John Falconer, Jerwood Curator of Photography, The British Library. (JF)

Mark Haworth-Booth, Visiting Professor of Photography, University of the Arts, London, and Honorary Research Fellow, Victoria & Albert Museum, London. His books include *Things: A Spectrum of Photography 1850–2001* (2005). (MH-B)

Michael Hiley, Lecturer, Department of Media and Cultural Production, De Montfort University, Leicester. He is a specialist in the history of photography and in cultural heritage informatics.

Madeleine Hill Vedel, Independent scholar, Arles, France. Contributor to the Japanese sections, she has a degree in East Asian studies from Princeton University, and has spent many years working on Japanese photography. (MHV)

William J. Mitchell, Head of the Program in Media Arts and Sciences, Professor of Architecture and Media Arts and Sciences, and Alexander W. Dreyfoos, Jr. Professor at the Media Lab, MIT. Formerly Dean of the School of Architecture and Planning at MIT.

Amanda Nevill, Director of the British Film Institute, and formerly Director of the National Museum of Photography, Film, & Television, Bradford. (ANe)

Jeffrey Richards, Professor of Cultural History, University of Lancaster. He writes and broadcasts regularly on cinema theatre, and music.

Dr Pam Roberts, Former Curator of Photographs, Royal Photographic Society, Bath.

Dr Naomi Rosenblum, Independent scholar and author of *A World History of Photography*, and *A History of Women Photographers*, Long Island City, NY. (NR)

Graham Saxby, HonFRPS, was Senior Lecturer in Optics and Holography, Wolverhampton University, after a career in photography with the RAF. He now works as a freelance editor. (GS)

Larry J. Schaaf, Independent photographic historian, Baltimore, Maryland. Formerly Slade Professor of Fine Art, University of Oxford. (LJS)

Dr Joan Schwartz, Queen's National Scholar/Associate Professor, Department of Art, Queen's University, Kingston, Ontario. Formerly Chief of Photography Acquisition and Research, National Archives of Canada, Ottawa. (JMS)

Sara F. Stevenson, Chief Curator, Scottish National Photography Collection, National Galleries of Scotland, and Director of the National Photography Centre, Edinburgh. (SS)

Michael Ware, Honorary Fellow in Chemistry, University of Manchester. Exhibiting photographer, author, and research consultant in the history and science of early photographic processes. Inventor of New Chrysotype (gold printing). (MJW)

List of Contributors with Affiliations (in A–Z order by surname)

Heather Angel Wildlife photographer, who manages her own photographic library, Natural Visions, Surrey, UK (HA)

Felicity Ashbee London (FA)

Robert Ashby Independent photographer and writer, Ross-on-Wye, UK (RA)

Sylvie Aubenas Advisory Editor

Quentin Bajac Advisory Editor

Inga Lára Baldvinsdóttir Head of Photographic and Print Collections, National Museum, Iceland (ILB)

M. Susan Barger Consultant, Santa Fe, New Mexico (MSB)

Ed Bartholomew Collections Manager, National Railway Museum, York, UK (EB)

Jens Baumgarten Postdoctorate Student, University of Campinas, Brazil, and University of Hamburg, Germany (JB)

Tom Beck Chief Curator, University of Maryland, Baltimore County, Maryland (TB)

Heike Behrend Professor, Institute of African Studies, University of Cologne, Germany (HB)

Patrizia di Bello Lecturer, Birkbeck College, University of London (PDB)

Jean-Christophe Blaser Curator, Musée de L'Elysée, Lausanne, Switzerland (JCB)

Simon Braithwaite Cataloguer and Archivist, Second World War Experience Centre, National Museum of Film, Photography and Television, Bradford, UK (SB)

Marta Braun Professor, School of Image Arts, Ryerson University, Toronto, Canada (MB)

David Bruce Helensburgh, Scotland (DB)

William Buchanan Photographic historian, Scotland (WB)

Clément Chéroux Photographic historian, Paris, and Visiting Research Fellow, University of Princeton (CC)

Philip Clark English Department, McLean High School, Arlington, VA (PC)

Raymond P. Clark Chief Executive, Society of Environmental Engineers, UK (RPC)

Susie Clark Freelance photographic conservator (SC)

Brenda L. Croft Photographer and Senior Curator, Aboriginal and Torres Strait Islander Art, National Gallery of Australia (BLC)

Richard Davies Archivist, Leeds Russian Archive, University of Leeds, UK (RD)

Siobhan Davis RPS Curatorial Assistant, National Museum of Photography, Film and Television, Bradford, UK (SD)

Janneke van Dijk Curator, Historical and Contemporary Visual Culture, Royal Tropical Institute Museum, Amsterdam (JvD)

Jocelyne Dudding Senior Curatorial Assistant, Pitt Rivers Museum, University of Oxford (JD)

Elizabeth Edwards Advisory Editor

John Falconer Advisory Editor

Jane Fletcher Royal Photographic Society, Curator, National Museum of Photography, Film and Television, Bradford, UK (JLF)

Colin Ford CBE Photographic historian and Founding Head, National Museum of Photography, Film and Television, Bradford, UK (CF)

Antonello Frongia Faculty of Arts and Design, IUAV, Italy (AF)

Sabeena Gadihoke Associate Professor, AJK Mass Communication Research Centre, Jamia University, New Delhi, India (SG)

Julia Galandi-Pascual Assistant Curator, Kunstraum Alexander Buerkle, Freiburg, Germany (JG-P)

Sophie C. Gordon Associate Curator, Alkazi Collection of Photography, New York (SCG)

Malcolm Graham Head of Oxfordshire Studies, Oxfordshire Country Council (MG)

Ron Graham Scientific author, Dorset, UK (RG)

Sarah Greenough Curator of Photographs, National Gallery of Art, Washington DC (SGr)

Wendy A. Grossman Independent scholar, Guest Lecturer, University of Maryland, George Washington University (WAG)

Sudeshna Guha Research Associate, Museum of Archaeology and Anthropology, University of Cambridge (SGu)

Anthony Hamber Independent scholar, UK (AJH)

Peter Hamilton Photographer, writer, and Lecturer in Sociology, the Open University, UK (PH)

Erin Haney Postdoctoral Fellow, National Museum of African Art, Smithsonian Institution, Washington DC (EH)

Colin Harding Curator of Photographic Technology, National Museum of Photography, Film and Television, Bradford, UK (CWH)

Douglas Harper Professor and Chair of Sociology, Duquesne University Pittsburgh (DHa)

Clare Harris Lecturer-Curator, Pitt Rivers Museum, University of Oxford (CHa)

David Harris Assistant Professor, Ryerson University, Toronto, Canada (DH)

Antje Havemann Freelance Writer, Aachen, Germany (AHa)

Mark Haworth-Booth Advisory Editor

Patricia Hayes Associate Professor, History Department, University of the Western Cape, South Africa (PHa)

Roger W. Hicks FRSA Photographer and author, Moncontour, France (RWH)

Paul Hill MBE Photographer and Course Leader, MA in Photography, De Montfort University, Leicester, UK (PHi)

Madeleine Hill Vedel Advisory Editor

Osamu Hiraki Photo-critic, Visiting Professor, Waseda University, Japan (OH)

Camara Dia Holloway Assistant Professor, University of Southern California, LA (CDH)

Amanda Hopkinson Director, British Centre for Literary Translation, University of East Anglia, Norwich, UK (AH)

Kathleen Howe Director, Museum of Art, and Professor, Art History, Pomona College, Claremont, California (KSH)

Chris Howes Proprietor, Wild Places Photography, Abergavenny, Wales (CH)

Jens Jaeger University of Cologne, Germany (JJ)

John V. Jezierski Professor of History, Saginaw State University, Michigan (JVJ)

Patricia Johnston Professor of Art History, Salem State College, Massachusetts (PJ)

Steven F. Joseph Independent scholar, Brussels (SFJ)

Louise Kavanagh Assistant Librarian, Trinity College Dublin (LK)

Nancy B. Keeler Independent photohistorian, Massachusetts (NK)

Hope Kingsley Photographic historian, London (HWK)

Gerardo F. Kurtz Madrid, Spain (GFK)

Nick Lambert Research Fellow, Birkbeck College, University of London (NL)

Andrea Lange London (AL)

David Langman Director, New Zealand Centre for Photography; Managing Editor, *New Zealand Journal of Photography* (DJL)

Lisa Ann Lavender Kenilworth, UK (LAL)

Andrew Lawson Garden photographer, Oxford (ALa)

Cheryl Leibold Archivist, Pennsylvania Academy of the Fine Arts (CL)

Mark Little Senior Lecturer in Visual Culture, University of Northumbria, UK (ML)

Jan-Erik Lundström Director, Bildmuseet, Umeå University, Sweden (J-EL)

Elizabeth Anne McCauley David H. McAlpin Professor of the History of Photography and Modern Art, Princeton University (EAM)

Colleen McDannell Professor of History, Sterling M. McMurrin Professor of Religious Studies, University of Utah (CMcD)

Ray McKenzie Senior Lecturer, The Glasgow School of Art, Scotland (RMcK)

Angela Magalhães Independent researcher and curator, and former Curator at the Photography Gallery, National Foundation of Art, Rio de Janeiro, Brazil (AM)

Penny Martin Editor-in-Chief, SHOWstudio, www.showstudio.com (PM)

Rosy Martin Author, London (RM)

David Matthews Associate Dean and Programme Leader BA (HONS) Photography, University College, Falmouth, Cornwall, UK (DM)

Nancy Micklewright Program Officer, The Getty Grant Program, J. Paul Getty Trust, Los Angeles, CA (NM)

Kevin Moore Henry Luce Foundation Research Associate, Department of American Art, Fogg Art Museum, Harvard University (KM)

Catherine Moriarty Curator, Design Archives, University of Brighton, UK (CM)

A. D. Morrison-Low Acting Keeper, Department of Science and Technology, National Museums of Scotland (ADM-L)

Sarah Mumford Head of Learning Development, National Museum of Photography, Film and Television, Bradford, UK (SM)

Alison Nordström Curator of Photographs, George Eastman House, Rochester, NY (AN)

David Odo Postdoctoral Fellow, Reischauer Institute of Japanese Studies, Harvard University (DO)

Donncha O'Muirithe Sub-Editor (News), *The Irish Times*, Dublin (DO'M)

Amanda Nevill Advisory Editor

Nadja Fonseca Peregrino Independent researcher and curator, formerly Curator, Photography Foundation, National Gallery of Art, Brazil (NFP)

Sarah Pink Senior Lecturer, Department of Social Sciences, Loughborough University, UK (SP)

Roslyn Poignant Honorary Research Fellow, University College London (RPo)

Robert Pols Freelance writer, Norfolk, UK (RP)

Megan Price DPhil Student, School of Archaeology, University of Oxford (MPr)

Michael Pritchard Director and Camera Specialist, Christie's, London (MP)

Max Quanchi Senior Lecturer, School of Humanities, Queensland University of Technology (AMQ)

Jane M. Rabb Instructor, The New School, New York City, and the Lesley Seminars (JMR)

Note to the Reader

Alphabetic arrangement. Entries are arranged alphabetically letter by letter in the order of their headwords, although please note that 'Mc' and 'St' are treated as if spelled 'Mac' and 'Saint'. In order to avoid an unhelpfully long series of entries that begin with the word 'photograph', most such entries are recorded under the next significant word (e.g. photographic picture libraries appear under 'picture libraries, photographic').

Abbreviations are indicated on their first appearance in a particular entry (e.g. Royal Photographic Society (RPS)). The Museum of Modern Art, New York, appears as MoMA, New York.

Measurements are usually given first in metric units, with an approximate imperial equivalent in parentheses, except in the case of universally familiar formats such as 35 mm or 4 × 5 in.

Cross references. An asterisk (*) in front of a word signals a cross reference to a relevant entry. Any reasonable form of the referenced headword is marked in the text (e.g. *'daguerrotypist' refers to 'daguerrotype' and *'archaeological purposes' to 'archaeology and photography'). Cross references are indicated the first time they appear in an entry only. 'See' and 'see also' followed by a headword in small capitals are used to draw attention to relevant entries that have not been specifically mentioned in the text.

Contributor signatures are given as initials at the end of each entry. A key to these is printed on p. xvii, and brief biographies of the editors and contributors on pp. xviii–xx.

The **Thematic Table of Contents** on pp. xiii–xvi provides a topical method of approaching the entries in the Companion. Biographical entries have not been included, mainly for reasons of space.

Bibliographies. Brief bibliographies of further reading have been appended to many longer entries, and there is a general bibliography at the end of the book. This is supplemented by a list of websites.

Reader's comments. Every effort has been made to ensure that the information in this Companion is accurate and up to date. However, if you come across mistakes or inconsistencies in the text, or if you would like to comment on any of the entries, please write to:

The Editor, *The Oxford Companion to the Photograph*
c/o The Reference Department
Academic Division
Oxford University Press
Great Clarendon Street
Oxford
OX2 6DP
UK

Abbe, Ernst (1840–1905), German scientist and industrialist who became professor of physics and mathematics at Jena University, then in 1866 research director (and in 1875 a partner) of the *Zeiss Optical Works. He perfected the design of the Zeiss microscope, made considerable advances in the correction of *lens aberrations, and persuaded the Schott glass company to produce new optical glasses that enabled Paul *Rudolph to design the first anastigmat lens. Abbe used his considerable wealth for philanthropic purposes, establishing excellent industrial relations and employee benefits at the Zeiss works, of which he became owner after Carl Zeiss's death in 1888. In 1896 he transferred ownership to a foundation, the Carl-Zeiss-Stiftung.　GS

　　Abbe, E., *Gesammelte Schriften* (2 vols., 1904–6).

Abbe, James (1883–1973), American photographer, born in Alfred, Maine. He developed a precocious talent for photography and, still in his teens, became a photo-reporter in Newport News, Virginia, then Washington, DC. Moving to New York in 1917, he was soon sought after in the theatre world as a portraitist, publishing in *Vogue, Vanity Fair, Saturday Evening Post*, and other popular magazines. He was also active in the still vibrant New York film industry, photographing Charlie Chaplin, Mary Pickford, Rudolph Valentino, and many others. In 1923 Abbe moved to Europe and for ten years shuttled between the London and Parisian theatre and film scenes. Ever curious and adaptable, he took up *photojournalism and documented political turmoil from Mexico to the USSR, his pictures appearing in papers such as *Vu and the *Berliner illustrierte Zeitung*. He returned to the USA in 1936 after photographing the Spanish Civil War, eventually becoming a radio broadcaster. Years after his death and almost forgotten, Abbe received a major retrospective show at the National Portrait Gallery, London (1995).　TT

　　James Abbe, Photographer (2000).

Abbott, Berenice (1898–1991), American photographer, whose work falls into three phases: portraiture, documentary, and scientific. Born in Ohio, she moved to New York, then studied sculpture in Paris and Berlin. In 1923 she returned to Paris as assistant to *Man Ray, and three years later opened her own portrait studio, attracting literary and artistic figures as sitters. She purchased the work of Eugène *Atget after his death and in 1968 sold it to MoMA in New York. When Abbott returned to New York in 1929, she and her companion, the art critic and historian Elizabeth McCausland, began to document architecture and street scenes in the city. This large-format documentation (supported 1935–9 by the federally funded Works Progress Administration) was exhibited at the Museum of the City of New York in 1937 and published as *Changing New York* (1939). Abbott taught photography and served on the Advisory Committee of the Photo League (see DOCUMENTARY PHOTOGRAPHY). Her acclaimed manual, *A Guide to Better Photography*, appeared in 1941. In the 1950s her interest in improving science education led her to conduct experiments and refine the camera equipment herself. However, she had little success with publishers. In 1968 she settled in Maine.　NR

　　O'Neal, H., *Berenice Abbott: American Photographer* (1982).

Abdullah Frères (active 1870–1890s), three brothers who ran a commercial studio in Constantinople with branches in Cairo and Alexandria. In 1862, named official photographers to the court of Sultans Abdul Aziz and Abdul Hamid II, they were commissioned to document the Ottoman Empire. They also sold numerous views of Egypt and the Middle East to tourists. In 1899 they sold their business and archive to *Sébah & Jollier (or Joaillier), which led subsequently to confusion of production from the two studios, since later prints from Abdullah Frères negatives are embossed with the Sébah & Jollier blind stamp.　KSH

aberrations. See LENS ABERRATIONS.

Abney, Sir William de Wiveleslie (1843–1920), influential British photographic scientist whose early interest in photography was encouraged by the army while he was a junior officer in the *Royal Engineers. Following service in India, Abney became an instructor in chemistry and photography at the School of Military Engineering, Chatham, a post that allowed him to undertake photographic research and devise a new *photolithographic printing process. He left Chatham in 1877 to become a civil servant in the Department of Science and Art, where he soon became a major figure in British photography.

　　Abney undertook significant research on the chemistry of the newly introduced gelatin halide emulsions and was responsible for the introduction of hydroquinone as a developing agent. His introduction of silver gelatin citrochloride emulsions led to the mass marketing of printing-out paper (*POP). He was a prolific author, writing for both specialist practitioners and amateurs. It was Abney who was largely instrumental in establishing a photographic collection at the

South Kensington Museum, later to become the Science Museum Collection and form the basis of the National Museum of Photography, Bradford. JPW

Obituary, *Proceedings of the Royal Society* (Series A), 99 (1921).

aboriginal peoples. See ANTHROPOLOGY; COLONIALISM AND PHOTOGRAPHY; MISSIONARIES AND PHOTOGRAPHY; NATIVE PEOPLES, PHOTOGRAPHY AND.

abstract and experimental photography, a very diverse category of images made using an assortment of techniques, and with equally varied intentions, but which have in common the avoidance of symbolic representation. Abstract photography rejects the idea that something identifiable must be depicted, preferring instead to take the image itself and the process of image making as its object. To achieve this, an abstract photograph may emphasize the internal structures of the image, visualize the invisible, or manifest pure visibility; contemporary photographers have also presented their work as wholly new objects that make no reference to anything outside their own existence, further emphasizing the self-referential nature of the image.

The creation of abstract images has often been undertaken as a form of visual research in order to understand better the principles and significance of images. Strictly speaking, abstract photography is defined by the techniques employed and the resulting effects, not necessarily the photographer's intention. Early examples include Henry *Talbot's *contact prints of plants made in the 1830s, and Étienne-Jules *Marey's late 19th-century chronophotographs. As a self-conscious form of image making, however, abstract photography emerged in the early 20th century, as did abstract art generally, in response to *pictorialism and the decades-long privileging of photography's documentary aspect; a growing interest in the *occult also played a role. Alvin Langdon *Coburn is generally considered to be the father of abstract photography, having first used the term in his 1916 essay 'The Future of Pictorial Photography', in which he suggests exhibiting work that emphasizes the form and structure underlying the image, rather than reference to anything outside the image. This exhibition never took place, but Coburn went on to make his *Vortographs, exemplars of the new art form. (The first publicly exhibited abstract photographs were Erwin Quedenfeldt's (1869–1948) *Symmetrical Patterns from Natural Forms*, shown at the 1914 Werkbund Exhibition in Cologne.) In 1918 Christian *Schad developed the *photogram, which he called the Schadograph, a form of cameraless photography that lends itself to diverse creative intentions. A number of artists seized upon the photogram as a useful and expressive technique, including *Man Ray, El *Lissitzky, Franz *Roh, and Lázsló *Moholy-Nagy. Other experimental techniques that gained prominence in the first half of the 20th century include *solarization, multiple exposure, *cliché-verre*, *photomontage, and *brûlage*. *Surrealism, Constructivism, and other art movements embraced these methods, and helped to promote abstract photography as an art form in its own right. By 1930 abstract photography was recognized as an international style, and one particularly redolent of *modernism and the search for a new reality.

In the second half of the 20th century new theoretical approaches and technological developments increased the possibilities of abstract image making. After 1945 experimental photography flourished in West Germany, where radical new imagery suggested that a new order and understanding of society and the self was possible. In the 1950s Otto *Steinert led the *fotoform group in exploring the creative potential of abstract imagery under the label Subjective Photography. Through exhibitions, publications, and teaching, Steinert influenced a whole generation with his idea of obtaining from an object the image of its essential being. The 1960s saw a very different approach to abstraction in the attempt to wed the innovations and methodologies of science and technology to creative work, resulting in the early use of computers to produce works of art. The concept of Generative Photography, developed by the photographer and art historian Gottfried Jäger (b. 1937), arose from this movement, and includes the luminograms of Kilian Breier (b. 1931), for which light rays are directed on to light-sensitive paper, and Pierre *Cordier's chemigrams, a process in which substances are made to affect the texture of the photographic emulsion, reducing the role played by light to that of catalyst. *Digital technology has further added to the possibilities of abstraction, while other inventions such as magnetic resonance imaging and the scanning electron microscope have permitted an invisible world to be made visible.

Abstract photography, however, is not restricted to the play of light and chemicals in the darkroom or the creation and manipulation of images with computers, but throughout its history has equally found expression through *straight photography. Images by Paul *Strand, Alfred *Stieglitz, Albert *Renger-Patzsch, and Harry *Callahan, among many others, employ unusual framing and viewpoints to dissociate the identity of the objects photographed from the resulting image. These methods have not been supplanted by more technical means of creating images, whether in the darkroom or at the computer, but have recurred throughout the history of abstract and experimental photography and persist today. The repertoire of abstraction has grown such that older techniques may be revived to create new effects: Talbot's contact prints, for example, found new expression in Schad's photograms, and again in the early 21st-century work of Wolfgang Tillmans (b. 1968). Techniques may also be combined for new effects. In place of a history of successive technologies, what has characterized the development of abstract and experimental photography is an increasing sophistication in the theoretical underpinnings that artists cite as the source or meaning of their imagery. Basic definitions and concepts are now routinely challenged, including those of 'picture' and 'photography', as the image-making process turns further inward to explore its own significance. MR

Rotzler, W., *Photographie als künstlerisches Experiment: Von Fox Talbot zu Moholy-Nagy* (1974).

Jäger, G. (ed.), *The Art of Abstract Photography* (2002).

achromat. See LENSES, DEVELOPMENT OF.

Acland, Angie (1849–1930), English photographer. A Fellow of the *Royal Photographic Society and Society of Arts, Angelina Acland—'Angie' to her family, 'Miss Acland' professionally—was photographed by Charles *Dodgson and informally tutored by *Ruskin, with whom she had a lifelong friendship. She lived at the family home in Broad Street, Oxford, into which Ruskin moved after his divorce at the invitation of her father, Sir Henry Wentworth Acland. Her first portraits, in the early 1890s, include perhaps her most famous, of Ruskin and Sir Henry. Acland's work consisted of landscapes and portraits, in colour and black-and-white.　　　KEW

Hudson, G., 'Ruskin and the Aclands', *Sphæra*, 11 (2000).

Actinograph. Ferdinand Hurter (1844–98) and Vero Driffield (1848–1915) were granted British patent number 5545 on 14 April 1888 for a slide-rule exposure calculator. The device was sold as the Actinograph, initially by themselves and later by Marion & Company of London. It was the first calculator to be based on careful scientific observation, and thirteen different models for different latitudes were manufactured. Hurter and Driffield were the first to establish methods of sensitometric measurement that allowed the development of *dry plates with a standardized measurement of their sensitivity, and the development of instruments to measure photographic *exposure.　　　MP

Adams, Ansel (1902–84), American photographer, best known for his landscapes of the *American West, although his legacy also includes portraits and documentary work, and writings on photographic technique.

Born in San Francisco, Adams took his first photographs on visiting Yosemite in 1916, aged 14; he later set up a studio there, and photographed extensively in the Sierra Nevada. In the 1920s his photographs were included in exhibitions mounted by the conservationist Sierra Club. His first major solo show was at the Smithsonian Institution, Washington, DC, in 1931. The first of many books (including eventually his journals, letters, and memoirs) appeared in 1930: *Taos Pueblo*, a study of a New Mexico Indian community produced with the writer Mary Austin.

Adams's landscapes stemmed both from his fascination with the natural environment, and from his conception of it as a space of spiritual redemption. In the face of intensifying exploitation, indeed desecration, of the West in the 20th century, his images reflected a commitment to conservation. He photographed at different times and seasons, exploring the effects of changing patterns and intensities of light. The resulting pictures are remarkable in terms of composition, tonal contrast, registration of detail, and printing quality.

Adams initially trained as a pianist, a discipline echoed in his emphasis on tone, rhythm, and technical proficiency, and explicitly invoked in his famous analogies between the negative and the musical score, and between the print and interpretation through performance. His contribution to photographic method stemmed from his insistence on visualization and control of the photographic process from framing and exposure to printing. His technical publications included *The Complete Photographer* (1942) and a five-volume series (1948–56) on *Camera and Lens*, *The Negative*, *The Print*, *Natural Light Photography*, and *Artificial Light Photography*. He devised the *Zone System for determining exposure and emphasized the relationship between the quality of the negative and the potential for producing a fine print. He worked almost exclusively in monochrome, though later experimenting with colour.

Adams was a founding member of the anti-*pictorialist *f.64 Group dedicated to 'pure' photography. His aesthetic preferences changed over time, his later prints offering markedly more tonal contrast than earlier examples. In the 2002 retrospective his celebrated *Moonrise over Hernandez* (1941) was shown in three different versions, increasingly dramatic in tone. In considering provenance, not only subject matter and style but also the date of a particular print is significant.

Although Adams remains a towering figure in the history of American photography, with prices to match, his visionary interpretation of the Western landscape was eventually challenged by younger photographers associated with the 1975 *New Topographics* exhibition, who concentrated on the impact of human activity on the land.　　　LW

Adams, A., *Ansel Adams: An Autobiography* (1985).
Spaulding, J., *Ansel Adams and the American Landscape* (1995).
Ansel Adams at 100 (2002).
Hammond, A., *Ansel Adams: Divine Performance* (2002).

Adams, Eddie (1934–2004), American photographer. Although his career embraced advertising, fashion, editorial, and entertainment photography, he is best known as a photojournalist. He joined the US Marine Corps as a combat photographer and—both as such and as a civilian—covered thirteen wars. On 1 February 1968 he photographed General Nguyen Ngoc Loan executing a Vietcong prisoner in a Saigon street, an image that won him the Pulitzer Prize (1969) and was credited with helping to galvanize anti-war feeling in America. In 1988 Adams founded an annual event: 'Barnstorm: The Eddie Adams Photojournalism Workshop'.　　　LAL

Adams, Robert (b. 1937), American photographer. Adams was born in New Jersey but grew up in Colorado and studied at the University of Redlands in California. After finishing his Ph.D. in English at the University of Southern California in 1965, he returned to Colorado College to teach, write, and photograph. He was one of the ten photographers included in the seminal exhibition *New Topographics: Photographs of a Man-Altered Landscape* in 1975 at the International Museum of Photography, George Eastman House. Subsequently he documented the impact of the human presence on primarily urban landscapes in lengthy compilations of characteristically dispassionate, non-judgemental images of everything from tract housing to supermarket aisles. His many books include *The New West: Landscapes along the Colorado Front Range* (1974), *Los Angeles Spring* (1986), and

What We Bought: Scenes from the New World (1995). As with most of the *New Topographics* photographers, and those who have continued in a comparable vein (Richard *Misrach, Mark Klett, and others), Adams's photographs seldom include people. Rather, they suggest that what humans have wrought constitutes our species' most tellingly enigmatic portrait. TT

Phillips, S., *Crossing the Frontier: Photographs of the Developing West, 1849 to the Present* (1996).

Adamson, John (1809–70), Scottish surgeon and photographer, the eldest of ten children of Rachel Melville and Alexander Adamson, farmer at Burnside near St Andrews. Educated in St Andrews and Edinburgh, he became a licentiate of the Royal College of Surgeons of Edinburgh in 1829. In 1835, after gaining practical experience abroad, Adamson returned to practise medicine in St Andrews. This left him time to do a little chemistry teaching in the local school between 1837 and 1840; he subsequently took classes for the terminally ill chemistry professor. He also became acquainted with the internationally renowned scientist Sir David *Brewster, principal since 1838 of one of the university colleges. Brewster's correspondence with Henry *Talbot allowed a group of enthusiasts in St Andrews to master the new science of negative-positive photography. One of its leading exponents, Adamson taught his younger brother Robert. After the latter left for Edinburgh in 1843, Adamson continued with photography, although as his medical practice prospered he spent less time with this. Having been (by repute) a competent *daguerreotypist, he became proficient with the wet-*collodion process, although strictly an amateur. ADM-L

Morrison-Low, A. D., 'Brewster, Talbot and the Adamsons: The Arrival of Photography in St Andrews', *History of Photography*, 25 (2001).

Adamson, Robert. See HILL, DAVID OCTAVIUS, AND ADAMSON, ROBERT.

Adobe Photoshop, launched by Adobe Systems in 1990, updated several times, and still the most widely used software application for processing *digital images. The professional package is expensive and complex, taking about nine months to master completely. However, a reduced version introduced in 2001, Adobe Elements, offered a selection of features to the advanced amateur. Photoshop's principal image manipulation procedures are: contrast and brightness control, colour balance and correction and the use of filter algorithms to provide image blur, despeckle, sharpening, *unsharp masking, and dust and scratch removal. With practice, the toolbox allows for the elimination of parts of the image, and the paintbrush and pipette to fill in. RG

Evening, M., *Adobe Photoshop CS for Photographers* (2004).

Advanced Photographic System (APS). In 1992 Eastman Kodak announced a joint research project with Canon, Fuji, Minolta, and Nikon to develop a sophisticated new reduced-format system;

increasing research and development costs compelled manufacturers to work together on any major innovation to maximize future sales.

The first APS cameras and films were announced on 1 February 1996. APS was based around a 24 mm film format producing 30×17 mm ($1^{1}/_{4} \times {}^{5}/_{8}$ in) negatives (56 per cent of the area of a 35 mm negative) and Information Exchange (IX) technology that recorded picture-taking information on a magnetic strip alongside each frame and communicated this data between the user, camera, film, and photofinishing equipment. New film technologies were introduced to minimize the effect of a smaller negative size. Three formats were available—classic, HDTV, and panoramic—and the film remained stored in the cassette to limit handling. The smaller cassette allowed smaller cameras to be made.

The system was an attempt to revitalize the amateur photographic market through sales of new cameras and film. It was the first new film format to be introduced following the failure of the *disc format of 1982. A number of innovative and stylish cameras such as the Canon Ixus and Minolta Vectis were produced, but the results never quite stood comparison with 35 mm. In 2001 Minolta announced it was scaling down development of APS cameras in favour of *digital technologies. Kodak ceased making APS cameras in 2004. APS is likely to be seen as a limited success overshadowed by the unexpectedly rapid rise of digital photography. MP

advertising of photographic products. In the mid-1880s, even before he had introduced his revolutionary *Kodak camera, George *Eastman told J. Walter Thompson, founder of the famous advertising agency, that 'a picture of a pretty girl sells more than a tree or a house'. With his innate business sense, Eastman had realized what other manufacturers were slower to grasp: advertising would be absolutely crucial if the fledgling market for amateur photography were to flourish. Traditionally, photographic goods had only been advertised in specialist publications, aimed at a limited audience. Cameras such as the Kodak required a radically different approach, reflecting the knowledge, needs, and desires of a broad middle-class market. Rather than details of lens apertures and shutter speeds, what was needed were strong visual images combined with memorable slogans. Eastman took a personal interest in this aspect of the business, coming up with the classic line *'You press the button, we do the rest.' Advertisements were placed in magazines such as *Punch* and the *Illustrated London News* and leading illustrators such as Frederic Remington and Fred Pegram were commissioned to produce the artwork. When photographs replaced drawings, photographers such as Edward *Steichen were employed by Kodak to create their adverts.

Crucially, manufacturers soon realized that they were not selling just cameras and film but dreams, hopes, and, most importantly, memories, and that the best way to reach the customer was to appeal directly to their aspirations and emotions. Two 'hot buttons' pressed by advertisers over many years have been the idea of the 'Kodak Moment' as cement for the family group, and the notion of individual

creativity in an impersonal world. The importance attached to advertising is indicated by the fact that in 1892, when total sales were less than £50,000, Kodak in Britain spent nearly £5,000 on advertising. Today, the UK photographic market is worth over £1 billion annually and manufacturers invest *c.* £30 million trying to persuade consumers to spend more or to buy their product in preference to another.

Since the 1960s, advertising has become much more precise. Extensive market research has identified specific target markets based on age, gender, and income and the best way to reach them. Manufacturers and retailers of more expensive equipment tend to rely on specialist magazines whilst cheaper cameras and film and processing services, which have a broader customer base, are sold using advertising's 'blunt instruments'—newspapers, television, and billboard posters. However, many of the techniques used by advertisers have remained unchanged over the decades. The cult of celebrity, for example, has always been a powerful weapon in the advertiser's armoury. At the beginning of the 20th century, Kodak Ltd. used the work of prominent photographers such as Frank Meadow *Sutcliffe in their adverts to promote the idea of 'What you can do with a Kodak'. David *Bailey's 1977 television commercial for Olympus cameras, with its punchline 'Who do you think you are—David Bailey?' was hailed as a classic. Over a quarter of a century later, Bailey was brought back to appear in a new series of adverts, this time for Olympus digital cameras—*plus ça change.* CWH

Kenyon, D., *Inside Amateur Photography* (1992).

West, N. M., *Kodak and the Lens of Nostalgia* (2000).

advertising photography

There can be little argument that in modern capitalist societies the camera has proved to be an absolutely indispensable tool for the makers of consumer goods, for those involved with public relations and those who sell ideas and services. Camera images have been able to make invented 'realities' seem not at all fraudulent and have permitted viewers to suspend disbelief while remaining aware that the scene has been contrived. (Naomi Rosenblum, *A World History of Photography*, 1989)

During the 19th century, photography was used only rarely to advertise products or businesses. Some photographic advertisements appeared on trade cards or, by the 1890s, as small informative *half-tones in catalogues or periodicals. At the beginning of the 20th century, articles devoted to advertising photography began to appear in photographic journals. Early advisers set the tone for the rest of the century. They recommended that photographic illustrations feature human-interest subjects in a clearly understandable image, but interpreted in a personally expressive style. But the industry was slow to adopt this perspective.

At first, because they did not see the interpretative qualities of photographs, ad men used photographs exclusively with ad campaigns that employed the directive 'reason why' strategy, which lectured consumers on the benefits of the product. When early 20th-century advertising psychologists, particularly Walter Dill Scott, demonstrated that consumers were open to suggestion, they provided support for a new suggestive advertising strategy (often called 'atmosphere advertising'). Art directors typically employed drawn and painted illustrations with this new suggestive 'atmosphere advertising'. However, as the atmosphere strategy became dominant around the First World War, some advertisers began to recognize the usefulness of the subjectivity of the soft-focus, fine-art style of *pictorialist photography. Lejaren à *Hiller was the pioneer. His style of photographic illustration for fiction in women's magazines advanced the integration of pictorialist aesthetics into advertising. Soft focus, dramatic lighting, heavy retouching, combination printing, and complex stage sets were the perfect visual expressions of the suggestive strategy.

Good-quality photographic half-tones became available around 1890, but photographs were used only intermittently in advertising imagery until the 1920s. There were some highlights, such as Hiller's work, and the 'sensation' caused in 1897 by a 'combination photograph' (photomontage) that invented a scene of President McKinley and Queen Victoria drinking tea (still recalled three decades later in Frank Presbrey's 1929 *History and Development of Advertising*). But advertising photography came into its own only in the 1920s, as the advertising industry grew because of the vibrant economy and the national distribution of goods. In 1920 fewer than 15 per cent of illustrated advertisements in mass-circulated magazines employed photographs; by 1930, almost 80 per cent did.

The advertising industry professionalized rapidly after the First World War. The industry that had started as space jobbers in the 19th century added specialists such as copywriters, art directors, psychologists, and account executives to agency staffs. The new art directors established professional organizations almost immediately. The New York Art Directors Club, founded in 1920, soon sponsored exhibitions, awards, and publications, setting a pattern for similar clubs internationally.

The tremendous market for advertising photography provided opportunities for photographers of different aesthetic tendencies. Modernist advertising photography, in particular, blossomed as a fitting symbol for the self-conscious modernity of the times. The Clarence H. White School of Photography led in training commercial photographers to employ the new vision. *White had been a successful pictorialist photographer associated with Alfred *Stieglitz's *Photo-Secession. He began to teach photography in 1907 and in 1914 opened his own school, with a curriculum that emphasized design principles and encouraged work in the applied arts. White based the philosophy of his school—the 'fusion of beauty and utility'—on that of his colleague at Columbia Teachers College, Arthur Wesley Dow, who advocated a democratic ideal of art appreciation and urged the application of fine-art principles to industrial and commercial design. Some of White's students, including Anton *Bruehl, Margaret *Bourke-White, Paul *Outerbridge, Ralph *Steiner, and Margaret Watkins (1884–1969), became New York's top commercial

photographers. They practised a modernist style based on close-up views, spare geometric compositions, oblique vantage points, tonal contrast, and sharpened focus that dominated advertising photography for the next two decades.

In 1923 Edward *Steichen landed two commercial photography contracts—to produce fashion and celebrity portrait photography for Condé Nast Publications, and advertising photographs for the J. Walter Thompson advertising agency. Like Hiller and White, Steichen had been a Pictorialist art photographer who turned to commerce. Easily the dominant and most highly paid commercial photographer in 1920s New York, Steichen counted as his clients makers of beauty products, packaged foods, cars, jewellery, soaps, and so on. For nearly twenty years he worked closely with his art directors, often suggesting photographic interpretations of marketing directions. Steichen's work convinced art directors to look beyond conventional uses of photography (pictorialism for romance and suggestion; straight photography for information and reason-why). He developed a persuasive straight-photography style that projected ideals, aspirations, and obvious fantasies, but made them seem attainable.

New York's modernism was no doubt influenced by European innovations. The utopian perspectives and stylistic radicalism of Dutch De Stijl, Russian Constructivism, and German *Bauhaus and *New Objectivity aesthetics all had great influence on American graphic design and advertising photography. The European modernists saw closer connections between fine and applied photography; they desired to provide good design for all classes of people; and they viewed modern photography as a way to effect social change. Though European movements were forged in the 1910s and 1920s, their modernist aesthetics had greatest impact on the commercial world after the 1931 New York *Foreign Advertising Photography* exhibition, which showed 200 works from eight European countries. Modernist advertising photography paralleled the modernist impulse in 1930s industrial design, seen most notably in the streamlined styles of the 'Machine Age'.

The 1930s were also characterized by a divergent second trend in advertising photography towards pictures of 'real life'. The economic crisis of the Depression triggered talk of the need for 'sincerity' and 'realism' in advertising imagery, but in fact led to overly dramatic vignettes accompanied by hyperbolic headlines. The decade also saw technological progress in colour photography. Though printers had been able to register three or four colours by *c*.1900, it had been extremely challenging for photographers to provide the necessary separation negatives for the individual printing plates. Nicholas *Muray in 1931, and Anton Bruehl and Fernand Bourges (*fl.* 1930s–1950s) in 1932, were able to provide colour advertising through complex and expensive processes. When commercial materials came on the market (particularly Kodachrome in 1935), photographers could make negatives, prints, and transparencies with sufficient ease to allow colour's widespread use in advertising photography.

After the Second World War, there was a tremendous growth in the amount of money allocated for advertising; consequently, its institutional structure grew, with new agencies and publications. The glamour and elegance that often characterized pre-war images of women were supplanted by depictions of conventional gender roles and middle-class family life. Although veterans like Victor *Keppler continued to flourish for a while, new faces and styles began to dominate advertising photography; Onofrio Paccione, Bert *Stern, and Henry Wolf began their careers.

Perhaps the two best-known commercial photographers of the post-war period are Irving *Penn and Richard *Avedon, both of whom, like Steichen, made a name in both fashion and advertising photography. Both men began their careers in the 1940s and continued into the 21st century. Both continued an exploration of photographic modernism yet developed highly personal styles. Penn's work is characterized by a pictorial spareness. Seamless backdrop paper or minimal environments replaced 1930s baroque stage sets. Many commentators have noted how the calm elegance of his images tended to objectify the models, turning them into objects like those that populate his product studies and still lifes. In some ways, Avedon's work was more influential for what followed. In their sense of motion and improbable contexts (such as a Cape Canaveral rocket launch, street theatre, and the circus) his pictures exhibited a heightened modernity signalling that the world was about to change radically. His later work simplified backgrounds, isolated figures, and scrutinized features. As with Steichen and Penn, Avedon's personal and commercial work overlapped significantly.

Commercial photography in the 1960s was perhaps less stylistically unified than in other decades. It ranged from William *Klein (of *Harper's Bazaar*), who set mannequin-like models against bold contrasting patterns in the architecture and built environment; to James Moore (also of *Harper's*), who brought a street-photography aesthetic to fashion photography; to Jeanloup *Sieff, who specialized in a more natural appearance of casual outdoor life and family affection; and Diane *Arbus, whose art and commercial work played with awkward strangeness. The Japanese photographer *Hiro, however, may best express the advertising spirit of the age in his intense colour, elegant formal geometry, and subtle balance. Advertising in the 1960s saw a greater emphasis on internationalism, more space for an overlap of personal and commercial styles, and greater collaboration with art directors. The industry could not ignore changes in social values, and newer representations of gender roles and racial relations took their place alongside traditional ones.

A new trend in 1970s and 1980s advertising photography echoed the soft romanticism of the early 20th century, particularly in the work of Deborah Turbeville (b. 1938) and Sarah *Moon. Their ethereal style often revealed frank contemporary attitudes towards sexuality. In the 1980s and 1990s, Herb *Ritts produced dramatic narrative images for Donna Karan, Calvin Klein, and Giorgio Armani. Like his predecessors, he developed a distinctive personal style across his fashion, celebrity portrait, and advertising work.

Advertising around the turn of the 21st century provoked new content-based controversies. Where mid-20th-century advertising photography was often criticized for promoting overly traditional visions of life or unrealistic material aspirations, criticism of today's advertising has targeted images that glamorize drug use, tobacco, anorexic bodies, or other unhealthy lifestyles. For example, the clothing manufacturer Benetton, during its association (1984–2000) with Oliviero *Toscani, had used AIDS victims, prisoners, and refugees in its advertisements. Were these images made to stir social concern, or simply to shock? The magazine *Adbusters*, founded in 1989, is devoted to such critiques of the advertising industry.

Commercial photography has long had a significant (though often unacknowledged) place in the history of photography. The advertising industry turned to photography when it discovered the photograph's power to convey the joys and benefits of consumerism. Advertising agencies, clients, and magazine editors eagerly sought work by Steichen, Penn, Avedon, and others because they recognized their modernism and distinctive personal visions as effective selling tools. Photography remains the dominant advertising medium; and recent scholarly study of advertising photography has helped develop a more complex understanding of the diversity within modernist photography. PJ

Dyer, G., *Advertising as Communication* (1982).

Sobieszek, R. A., *The Art of Persuasion: A History of Advertising Photography* (1988).

Harrison, M., *Appearances: Fashion Photography since 1945* (1991).

Bogart, M. H., *Artists, Advertising, and the Borders of Art* (1995).

Yochelson, B., *Pictorialism into Modernism: The Clarence H. White School of Photography* (1996).

Johnston, P., *Real Fantasies: Edward Steichen's Advertising Photography* (1997).

Brown, E., 'Rationalizing Consumption: Lejaren à Hiller and the Origins of American Advertising Photography', *Enterprise and Society*, 1 (Dec. 2000).

Salvemini, L. P., *Benetton-Toscani: storia di un avventura 1984–2000* (2002).

aerial photography. Aerial photography is a hybrid of two separate technologies, aviation and photography. A variety of combinations have been used, which have proved useful to a wide range of fields, scientific, military, and artistic. Aerial views generally adhere to one of two types: the direct vertical, producing a rational, linear representation useful in cartography, and the oblique horizontal, resulting in a more descriptive, pictorial image. Although aerial photography usually implies air-to-ground views, it can also include air-to-air images of aircraft, cloud formations, and other meteorological phenomena.

At the time of photography's invention, there already existed a tradition of aerial landscape representation: the bird's-eye view, common in 17th-century France. Probably based on views from towers or hills, further enhanced by manipulations of the artist, bird's-eye views incorporated both cartographic data and picturesque detail. With the announcement of the *daguerreotype process in Paris in 1839, aerial photography was immediately proposed. A lithograph

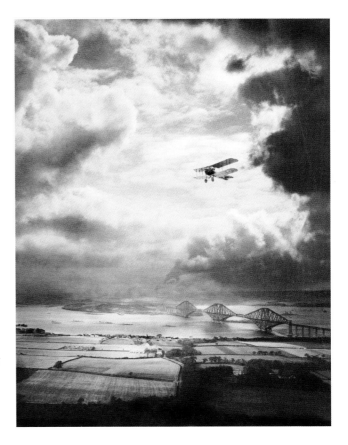

Alfred G. Buckham
Aerial view of the Forth Bridge, c.1920

from that year by Maurisset entitled *Daguerréotypomanie* lampooned the hype over the new invention, placing photography in the air via the hot-air balloon, an invention of the Montgolfier brothers from 1784. The heavy equipment and long exposure times required by the daguerreotype, however, made photography unpracticable from the unstable platform of the balloon. Not until 1858, the year *Nadar loaded the faster *wet-plate process aboard a balloon, was an aerial photograph achieved—a view of the countryside around Bièvre, France, that has not survived. The first extant aerial photograph was made in the USA two years later by James Wallace Black (1825–96), who also paired wet plate and balloon to realize a series of photographs of Boston. Nadar succeeded in making the first aerials of Paris in 1868 from a balloon tethered near the Arc de Triomphe. A wood-engraved version of the photograph appeared in *Le Petit Figaro*, with boulevard names given so that viewers could identify the scene.

Advances in both photography and aviation encouraged other combinations. The invention in 1869 of the electrically released shutter allowed airborne cameras to be operated from the ground. Kites, or kite-trains, soon became a common platform. This was the method used by George Lawrence (d. 1938) in a series of views of the San Francisco earthquake in 1906. The *dry-plate process, in general use by the mid-1880s, made photographing from balloons more feasible, as the film speed was faster and the process less cumbersome. Photographers thus ventured higher, liberated by lighter, less complicated procedures. Cecil Shadbolt (1859–92) photographed London from 610 m (2,000 ft) in 1883; Gaston Tissandier (1843–99), author of *La Photographie en ballon* (1885), took high-altitude aerials of Paris in 1885. Light, flexible *roll-film, introduced by Kodak in the late 1880s, was sent up via rockets and, oddly enough, pigeons; these methods were patented in Germany during the first decade of the 20th century. It was aeroplanes, however, invented in 1903, that revolutionized aerial photography. These provided a more stable platform and were easier to navigate into position. A Pathé cameraman took the first photograph from an aeroplane (actually a still from a cinematograph film strip) in 1908 as Wilbur Wright's passenger in a flight over Le Mans, France. The results were published in *La Vie au grand air*, the French sports illustrated.

The 20th century witnessed a dramatic expansion of aerial photography, for *military, *aerial-survey, and *archaeological purposes. Aerial *infrared and colour images have assisted studies of geology and plant ecology by identifying differences in moisture content and vegetation. Zoologists have been able to monitor wildlife populations and migrations through aerial observation. Aerial imagery is perhaps most useful in urban planning and land management, providing specialists with information on population density, travel patterns, toxicity of sites, and other land-use factors.

In the visual arts, aerial photography has been engaged for a variety of expressive purposes. As early as 1911, Karl *Struss began photographing New York from atop recently constructed skyscrapers, as did Alvin Langdon *Coburn, whose 1913 book *New York from its Pinnacles* proposed an aesthetic of modernism through its dramatic use of vertiginous views and optical distortions. In Russia, where a search for a language of modernism was under way by the late 1910s, artists such as Alexander *Rodchenko took up the aerial view as a symbol of the political and cultural transformations envisioned by communism. Similarly, German *Bauhaus artists recognized the potential of the vertical view for revolutionizing vision through the deconstruction of space, a process linked to progressive values of the period. The tradition of the extreme angle proposed by aerial photography found new potential in America in the abstract photographs of Alfred *Stieglitz, whose *Equivalents* series—cloud abstractions made during the 1920s—shifted the meaning of photographic abstraction from larger social and political causes to the expression of individual identity.

Since the explosion of the photography market during the 1970s, aerial photographs made for military or other purposes have often been reassigned to an art context. Such has been the case with Edward Steichen's photographs taken during the Second World War. This duality between aesthetics and utility is consciously exploited by contemporary practitioners, notably Yann Arthus-Bertrand, William *Garnett, Emmet *Gowin, Patricia Macdonald (see attached feature), and Alex MacLean, who, to varying degrees, work to create aesthetic imagery out of raw topographical data in order to pose questions related to perception, the environment, and human industry. KM

⊃ See also Conceptual Landscapes *opposite*.

St Joseph, J. K. S. (ed.), *The Uses of Air Photography: Nature and Man in a New Perspective* (1966).

Newhall, B., *Airborne Camera: The World from the Air and Outer Space* (1969).

Martin, R. (ed.), *The View from Above: 125 Years of Aerial Photography* (1983).

Baker, S., 'George Lawrence: A Giant in Kite Aerial Photography', *Kitelines*, 11 (1994).

Corner, J., and MacLean, A. S., *Taking Measures across the American Landscape* (1996).

Arthus-Bertrand, Y., Brown, L., et al., *The Earth from the Air* (2nd edn. 2002).

'Photography and Flight', *History of Photography*, 28 (2004).

aerial survey

Historical background

The first person to take an aerial photograph was *Nadar, who used the *wet-plate process from a captive balloon, in 1858. The first recorded still photographs to be taken from an aeroplane were not made until 1909. During the First World War, many developments took place with air cameras and mapping, but the maps were crude and it was not until 1924 that the first aerial survey took place. Using 12.7 × 10.2 cm (5 × 4 in) plates, a DH9A of RAF 84 Squadron made a survey at the request of the Anglo-Persian Oil Company of its Abadan refinery. At about this time the British Air Survey Company (f. 1923), from 1929 a subsidiary of Fairey Aviation, made important surveys in the Middle and Far East. In the same period, assisted by the French air force, the aerial archaeologist Antoine *Poidebard was making aerial surveys of Roman remains in the Syrian desert.

(*continued on p. 10*)

Conceptual Landscapes The Aerial Photographs of Patricia Macdonald

Patricia Macdonald (b. 1945) is one of a small number of artist-photographers (including Robert Petschow (1888–1945), William *Garnett, Emmet *Gowin, Georg Gerster (b. 1928), Terry Evans, Marilyn Bridges (b. 1948), and Alex MacLean) who use aerial photography as both an expressive and an exploratory medium. Macdonald's dramatic and perceptive images, made in environments across Europe and North Africa, cross boundaries of context and purpose between art, science, and environmental interpretation/politics. In addition to her artistic training and experience, she holds a doctorate in biological science; and she has worked with environmental issues in the museum sector and for government agencies and non-governmental organizations.

Her subject matter includes the palimpsests of land surfaces and the constant changes of water and the atmosphere: light, shadows, clouds, rainbows. Many images relate to the physical processes of the natural world: from 'change of state' (solid/liquid/gas), erosion, inundation, desiccation, to human interactions with the environment, and to associated metaphors. Many works are multi-layered explorations of complex environmental and cultural-landscape issues such as the loss of biodiversity due to incremental ecological degradation.

Many of the pieces engage in dialogue with literary or philosophical texts. The book and exhibition *Once in Europa* (1999), a collaboration with the writer John Berger, explored the effects of industrialization on a traditional rural community and environment in the French Alps. Other examples of such dialogue are large-scale, composite works. A seven-part exploration of desiccation, *The Mirages* (1992–5), addresses the statement 'to remain dissolved is both the obligation, and the privilege, of all substances that are destined . . . to change' in Primo Levi's essay 'Carbon' in *The Periodic Table*. A ten-part columnar piece, *The Sonnets to Orpheus* (1995), relates to Rainer Maria Rilke's eponymous poem cycle, in which the Orpheus myth is seen as a cycle of 'boundary crossings' and interrelationships rather than a linear narrative of transformation. It may be read as both an ecological and a psychological history: a 'descent' past systems of enclosure and intensive agriculture to post-industrial wasteland, followed by a 'rise' towards a new beginning.

Such large (wall-sized) composite pieces—'emergent landscapes' —create environments in their own right in the spaces where they are shown: environments which explore different perceptions of reality, as well as sampled 'traces' from the original environment(s) where the component aerial images were made. An example is the 24-part *Burnt Moorland: Grouse Shooting, Perthshire, Scotland* (1998–9) from the series *The Play Grounds*. This work links physical evidence of a landscape of attempted human environmental control (the heavily burnt moorland of a grouse moor), as well as a simulated experience of circling flight over such a place (such as might be experienced by the hunted birds), with a comparison between symbolic representations of two contrasting world-views ('paradigms'). On the one hand, the basic structure of the piece, as well as the burnt marks on the moorland surface, represents the rigid, controlling, rectilinear grid of ('old-paradigm') rationalist, modernist thought. On the other, emerging from behind this grid, the linking forms within the individual images trace the complex, non-linear, circling, feedback loops of a 'strange attractor'. The graphical forms of such diagrams have become the 'signature' of a more recently formulated world-view, or 'new (ecological/organicist) paradigm'.

Burnt Moorland encapsulates most of the key features of Macdonald's later aerial work: the ambiguity and tension between the recognizable and the (semi-abstract) 'unfamiliar' provided by the near-vertical aerial overview, enhanced by the aesthetic strategies employed in the arrangement of the composite piece; the almost physically experienced combination of joy and terror contained in these traces of the earth's dynamic surface environment and the human interactions with it; and the intellectual concepts which interest her scientifically, philosophically, and artistically.

Patricia Macdonald's aerial work is made in collaboration with Angus Macdonald, the professor of architectural studies at Edinburgh University, as pilot and operations manager of the small light aircraft used. They share interests in environmental politics, cultural landscapes as environmental 'texts', and conceptual landscapes, perception, and visuality. They are sole or joint authors of numerous publications, including eight books spanning art and environmental interpretation contexts: *Shadow of Heaven* (1989); *Above Edinburgh* (1989); *Order & Chaos* (1990); *Granite & Green* (1992); *The Highlands and Islands of Scotland* (1992); *Views of Gaia* (1992); *Once in Europa* (1999); *Air Works* (2001). RL

Cooper, T. J., 'The Marks of Someone Travelling: Overviews and Insights: Considerations of Patricia Macdonald's Aerial Art', *Portfolio*, 3 (1989).
Dorrian, M., 'The Middle Distance: On the Photography of Patricia Macdonald', *Katalog*, 11 (1999).
Lawson, J., 'Patricia Macdonald: Emergent Landscapes', *Portfolio*, 31 (2000).

Aerial survey subsumes two major areas, aviation and *photogrammetry. The chief difference between *aerial photography and aerial survey is that whereas the former can include obliques and photographic reconnaissance, aerial survey is a very precise operation involving photogrammetry.

Photogrammetry

Photogrammetry involves measuring x, y, and z of a terrain from an image, as required for the production of planimetric and topographic maps. Mapping cameras usually require to be calibrated every two years and before a mapping contract can be signed. Vertical photography is used for topographic mapping. But although the layman assumes that the vertical photograph is the same as its map counterpart, the map differs from the vertical photograph in a number of important ways. Not least of these is the *geodetic accuracy* of the map when compared to the photograph. A photograph is a perspective view, in contrast to the strictly orthogonal view of a map. The survey camera is of a very large format, 23 cm ($9\frac{1}{10}$ in) square, and weighs upwards of 100 kg (220 lb). The two major manufacturers are *Zeiss with the RMK A series plus the latest RMK-TOP, and Leica with the Wild RC-30. The camera is operated from its own mounting and sophisticated navigation sight, and is expensive (c. £150,000–400,000).

Camera calibration is usually done by the manufacturer and consists of finding the *exact* focal length of the lens (f) to two decimal places, now known as *the principal distance* or p.d., and at least four *fiducial marks* calibrated to an accuracy of 5um or better, from which *the principal point* can be found by intersection. The calibration certificate will also include information concerning tangential as well as radial distortions of the lens.

Today, *softcopy* (or digital) *photogrammetry* is the route to a faster and more economic solution to map-making. The film with its 60 per cent forward overlap of images, once processed and dried, is scanned into a computer at a scan pixel size of about 15 µm. The Zeiss PHODIS SC photogrammetric scanning system, for example, has a basic scanner integrated with an image-processing system using the same computer platform. Positive or negative representations, full colour, and all data such as tilts and scale, aerotriangulation, and fiducial coordinates allow for the generation of digital terrain models (DTMs) and orthophotos. In the 21st century there has been growing interest in the Zeiss/Intergraph Digital Modular Camera (DMC) and the Leica-Helava Airborne Digital Sensor (ADS 40). These cameras do not use film, therefore eliminating the need for scanning, and feed directly to the computer; their cost is upwards of c. £1 million.

Survey photography is a highly disciplined procedure. Flying straight and level means that the aircraft should be well trimmed and on course. The effects of drift (due to wind) must be noted, and the camera on its drift mount compensated accordingly. The aircraft's ground speed must be accurately known. These requirements are easily satisfied with the Global Positioning System (GPS) used by modern survey operators.

Weather is the greatest problem. Survey photography requires clear air, not only cloud-free but *clear* air free of haze and pollution. On average there are only fifteen days per year of such conditions in northern Europe. At 2,400 m (8,000 ft) and above, haze can obscure fine ground detail, and the mission will therefore be wasted.

Satellite imagery

Images from satellites such as LANDSAT have been available since 1973. The various types of satellite use scanners as their sensors and these are either multi spectral scanners (MSS), or thematic mappers (TM). The sensors send their images down for subsequent processing and today deliver very good quality. They are not, however, of air camera standard, and are mainly used for geological, meteorological, and earth resources interpretation. Although satellite images can be used for making maps, they are not as accurate as air camera maps, but are good enough for *military usage at 1 : 25,000 scale, and for large-area mapping of deserts etc. Satellites are invaluable for the mapping of inaccessible terrain or, by the use of radar, through total cloud coverage. RG

Graham, R. W., and Read, R. E., *Manual of Aerial Photography* (1986).
Warner, W. S., Graham, R. W., and Read, R. E., *Small Format Aerial Photography* (1996).
Etacci, C., *Introduction to the Physics and Technology of Aerial Reconnaissance and Survey* (1997).
Collier, P., 'The Impact on Topographic Mapping of Developments in Land and Air Survey: 1900–1939', *Cartography and Geographic Information Science*, 29 (2002).

Afong (A Fong, Ah Fong, Lai Afong), Hong Kong Chinese studio whose founder apparently started in the profession c.1859, leaving his son to continue c.1890. The firm continued into the third generation, until 1941. As with most Chinese studios, the man behind the commercial name is elusive. However, his business activities are clear, because from the mid-1860s he was advertising heavily in the local foreign-language press. Aiming, like his fellow countrymen, at the most profitable part of the business, he endeavoured to take photography out of Westerners' hands, undercutting their prices while offering similar products. Afong is one of the few Chinese photographers who did views; his Hong Kong series compare with *Floyd's or *Thomson's in subject matter (if not quality). While Afong the man seems to have owned the studio, how much of a photographer he himself was is unclear, since he employed Western assistants/managers, as well as Chinese staff. Ultimately, as in all Chinese ports, he and his colleagues in Hong Kong remained masters of the game. RT

Afrapix Collective. See 'STRUGGLE PHOTOGRAPHY'.

Africa

Introduction

It is almost impossible to talk about a unified history of photography in Africa, as there have been so many cultural responses to the medium,

and so many national and regional styles. Early 21st-century photographic practices there are amongst the most complex and vibrant imaging cultures in the world, embracing intersections between the global and the local. Many draw on long traditions of depicting the human body in sculptural and graphic forms.

The history of photography in Africa begins with the *colonial introduction of the medium. Much photography was integrally linked to *exploration and the development of colonial infrastructures. Imaging also drew on established ideas about Africa. Some were related to concepts of race and culture: in North Africa, for example, to a long *Orientalist tradition; whereas in parts of sub-Saharan Africa an ethnographic tradition often became absorbed into general colonial practice. Photographs by colonial photographers circulated widely, and photographs of Africa could be bought in London, Paris, or New York. However, by the late 19th century many African photographers were developing their own businesses, providing images for both local and colonial clients. From this tradition has emerged the wealth of African photography: *studio and *documentary work, *photojournalism and arts practice, and an associated photographic culture including archives of the post-colonial African nation-states, festivals like the Rencontres de la Photographie Africaine (since 1994), and publications. EE

Anthology of African and Indian Ocean Photography (Eng. edn. 1999).
Deutsch, J. G., Probst, P., and Schmidt, H. (eds.), African Modernities (2002).

West Africa

Photography arrived in the form of Western itinerant daguerreotypists working the main coastal cities, and colonial photographers accompanying expeditions. Circumstantial evidence suggests that the *daguerreotype had reached Freetown by 1845; the earliest surviving examples prove its presence by the mid-1850s. From the late 1860s to the 1880s, permanent studios run by African photographers were established in several coastal cities: St-Louis, Conacry, Freetown, Monrovia, Abidjan, Accra, Lomé, and Lagos, with entrepreneurs like the *Lutterodt family operating in several locations. While colonial photographers served political and administrative purposes, these studios met private and local needs.

West African studio photography expanded rapidly in the late 19th century, challenged only by the *postcard as the dominant photographic genre. Inland cities such as Bamako got their first permanent establishments. Pioneers included Alex Agbaglo Acolatse (1880–1975) in Lomé, Meïssa Gaye in St-Louis, and Alphonso Lisk-Carew in Freetown. While often trained by Europeans, and initially passing on European studio traditions, African portrait photographers eventually developed distinctive styles, pursuing modernity in their own way. Local artists, for example, contributed painted studio backgrounds depicting local city scenes. West African dyed cloth or woven mats also become popular as props or backdrops. Studio portraiture in 20th-century West Africa increasingly manifested African forms of self-expression and ways of seeing.

The period immediately after the Second World War, with independence approaching, was a golden age for studio photography. Often teachers, or ex-soldiers of the colonial armies, this generation of practitioners included influential, visually sophisticated, and eventually celebrated figures such as Seydou *Keïta in Bamako, Mali, Mama Casset (1908–92) in Dakar, Senegal, and Cornélius Yao Augustt Azaglo (b. 1924) in Korhogo, Côte d'Ivoire. Many, like Keïta, worked exclusively in the studio; others, like Augustt Azaglo, travelled from village to village equipped only with a camera and a simple backdrop. West African studio photography is a collaborative enterprise: sitters define who they are or want to be; the photographer colludes; the studio is a space of desire and fantasy. Another Bamako professional, Malick *Sidibé, also took his camera outside the studio to record the exuberant leisure activities of Malian youth in the early days of independence. The work of these and other photographers countered the products of the once-dominant 'ethnographic gaze'. Yet their photographs seem sui generis, performing and producing identities rather than reacting against alien, imposed ones. But, as amateur photography spread in the 1970s, black-and-white studio photography declined, revived only partially by the arrival of colour.

Today's West African scene is vibrant. With his detailed and extravagant screens, increasingly sought after by collectors, Philip Kwame Apagya (b. 1958), working in Accra, Ghana, has reinvented colour studio work. The infinitely variable self is the subject of Samuel Fosso's (b. 1962; Bangui, Central African Republic) playfully obsessive after-hours studio self-portraits. Other current photographic projects, often hosted by art institutions, include the DOF-group, and Akinbode Akinbyi's photographic engagement with the vast megalopolis of Lagos, Nigeria, treated as a system rather than a space for particular events. Dorris Haron Kasco (b. 1966; Côte d'Ivoire) also chronicles urban culture, in edgy photographs of the urban other: the street child, the fool, the outcast living in his or her unique and isolated universe. J-EL

Viditz-Ward, V., 'Photography in Sierra Leone, 1850–1918', Africa, 57 (1987).
David, P., Alex A. Acolatse (1880–1975): hommage à l'un des premiers photographes togolais (1993).
Foadey, G. E., Pivin, J.-L., and Medoune Seye, B., Mama Casset et les précurseurs de la photographie au Sénégal (1994).
Nimis, E., Photographes de Bamako de 1935 à nos jours (1998).
Wendl, T., 'Entangled Traditions: Photography and the History of Media in Southern Ghana', Res, 39 (2001).

East Africa

The region's first photographers came from both India and Europe c.1870. In Zanzibar, A. C. Gomez from Goa started the first studio in 1868, building on an established practice in India. Many more studios opened c.1890, in Zanzibar, Dar es Salaam, and Mombasa. William D. Young, who also worked as official photographer for the Ugandan railways, documenting the construction of the Mombasa–Kampala line, founded the famous Dempster Studio in Mombasa (with a branch in Nairobi in 1905).

**Afunaduula Sadula,
Kampala, Uganda**

Photocollage, c.2000

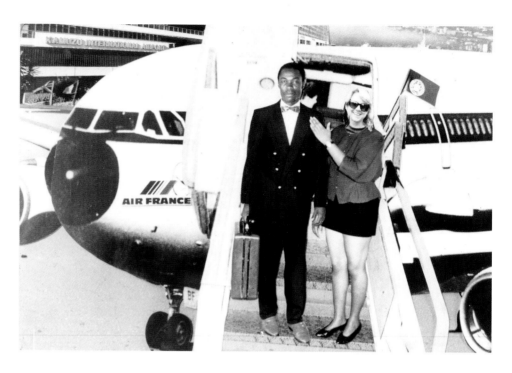

Western travellers and explorers also photographed in East Africa. Joseph Thomson (1858–95), for example, used the camera not only to record and classify Africans but also, fusing photography and local magic, as 'medicine', a 'soul-stealing machine', and a 'magic gun'. Such behaviour provoked considerable indigenous resistance to being photographed. Despite initial opposition, however, photography was widely accepted in coastal towns by c.1900, in the urban hinterland by the 1920s, and in rural areas by the 1950s–1960s.

As elsewhere, photography was integrated into a range of practices. Colonial administrations used it for control (e.g. in the production of identity cards). Colonial newspapers increasingly incorporated *photojournalism. Photographers like Omar Said Bakor (1932–93; Bakor Studio) at Lamu, Kenya, recorded the history of the town in the 1960s and did documentary work on subjects such as mental illness. However, photography's major role was as a 'theatre of self', enabling Africans to experience themselves as 'modern'; indeed, it helped to define a specifically African modernity.

Connecting with existing local visual traditions such as ornamental woodcarving, architectural plasterwork, textiles, and calligraphy, photography developed a variety of specific local histories. The Bakor Studio, for example, used montage to express patrilineal hierarchies, or reworked complex Swahili rhetoric, visualizing proverbs and sayings in photocollages. It also merged the ornamental tradition of Islamic art with photographic portraits in a way that subordinated the portrait to Islamic codes. Furthermore, photography drew on pre-existing ways of encoding cultural meaning. In portraits, clothing and textiles, especially the rectangular printed *kanga*, printed patterns and proverbs, provided subtexts that turned photographs into 'silent talkers'. Photography was also shaped, reshaped, and transformed through hybrid alliances with other media such as painting, cinema, and television. In Kenya, N. V. Parekh (Parekh Studio) from the late 1940s created so-called 'film-style photography' in which romance was staged according to Hollywood and Bombay film ideals. Likewise, in the Bakor Studio, people were montaged into televisions and radios, literally implanting photography into other media.

From the 1940s to the 1980s, most photographic portraits were produced in studios. However, as manually processed black-and-white photography gave way to quasi-industrial colour, the studios lost their monopolies. But instead of large-scale amateur photography developing, as in Europe, there emerged *itinerant photographers with neither formal training nor studios to meet people's photographic needs. They usually worked in small groups, photographing African tourists and migrant workers. Often agents of the colour labs, they competed with the few remaining studios, in the process creating a flourishing popular art form. Some, like the Likoni Ferry Photographers, Mombasa, established their own distinctive style in the 1990s, building small squatter-like portable studios without electricity or running water. Here they combined paintings, tapestry, paperware, flowers, and sofas to create foreign and global fantasy scenarios for their clients.

East African photographs have many social functions. Portraits were integrated into the cult of the dead, rites of passage, and certain traditions of healing and harming. For instance, pictures are taken of the dying or recently deceased. In central Kenya, framed photographs are placed on the closed coffin, replacing the view of the actual corpse. Along the Kenyan coast, continuing the fusion of photography and magic, Islamic healers use photographic portraits for divination, to diagnose sickness, and to identify those harming their clients.

Photographic portraits are also widely incorporated in practices of love magic. In Mombasa and Lamu, the act of photographing itself became part of comprehensive rituals of self-presentation such as weddings. Photographs are also used in gift exchange, and circulate widely, especially at Christmas, when migrant workers send pictures home. Photographs hung on sitting-room walls or stored (uncaptioned) in albums display individual reputation and status. They are also used to construct biographies that are constantly reworked—when, for example, women tear ex-husbands from albums—and thus constitute a flexible repository that constantly reflects the network of changing relations. Thus, while photography was integrated into pre-existing traditions, it also occupied new spaces, shaping memories, identities, and subjectivities in new ways. HB

Behrend, H., 'Feeling Global: The Likoni Ferry Photographers in Mombasa, Kenya', *African Arts*, 33 (2000).

Behrend, H., ' "To Make Strange Things Possible": The Photomontages of the Bakor Photo Studio in Lamu, Kenya', in R. Beck and F. Wittmann (eds.), *Close up: Contextualizing African Media* (2003).

Southern Africa

Photography reached southern Africa originally via the Indian Ocean, later than other colonial outposts like Australia and India. Jules Léger from Mauritius opened the first studio in Port Elizabeth in 1846. Though some experimentation took place, the dominant photographic modes soon became commercial *daguerreotype portraiture and *cartes de visite* for European colonial consumption.

Photography was soon harnessed to exploration and science in the southern African hinterlands. James Chapman's stereoscopic images of Victoria Falls in 1862 were barely more successful than those attempted on Livingstone's Zambezi expedition of 1858, but his Damaraland work appeared at the 1867 Paris exhibition. Photography was at this stage in the hands of those seeking knowledge of the African. Governor Sir George Grey encouraged photography along with philological and ethnographic research, and such African portraits as made their way into his collection (which later formed the basis of the South African National Library's photographic archive) were usually taken in the aftermath of conquest and colonial annexation. In the case of both the German anthropologist Gustav Fritsch's (1838–1927) splendid portraits of Xhosa leaders, and the famous Bleek-Lloyd photograph collection of indigenous San, this context is not always apparent.

From the late 19th century onwards, black urban elites also had many studio portraits taken but, in the wake of segregation and apartheid's forced removals, relatively few of them survive as collections. Better publicized by the 1930s were the remarkable studies of Kimberley-based Alfred Duggan-Cronin (c.1874–1954). He used migrant workers at the diamond mines as his original subjects, and focused on ethnic types and material culture, couched in a preservationist discourse that was highly aestheticized, at times even dramatized. Later he followed subjects back to their home areas, where he photographed important historical landscapes in both South Africa and neighbouring territories.

*Pictorialist and modernist work generated numerous salons from the early 20th century, but photographs of 'natives' usually stuck to preservationist conventions, with subjects decked out in traditional dress. This constituted the bulk of Constance Stuart Larabee's (1914–2000) exhibitions, though she also executed numerous commissions to document social change and economic development. Leon Levson's (1883–?) work is now held up as the first serious documentary photography of working and urban life for Africans, but he too moved between commercial and personal projects. The launching of the magazine *Drum in 1950 opened a new era in the photographic documentation of urban life for the majority of South Africans. The spate of photographers who helped to fashion the new urban sensibility included Alf Kumalo (b. 1930), Bob Gosani (1834–72), and Peter *Magubane. Ernest Cole (1940–90) later produced a searing documentary statement on black conditions in his *House of Bondage* (1967).

After *Drum*'s heyday, few magazines supported serious photographic work. *Leadership* was an exception, with David *Goldblatt its long-serving main photographer. Goldblatt acted as mentor to the new generation of progressive photographers appearing in the 1980s, by which time *Staffrider*, *Learn and Teach*, and *Full Frame* provided a forum for documentary work. Since the transition to democracy in 1994 new outlets have appeared, ranging from the Centre for South African Photography with its emphasis on 'art' photography to the more documentary- and politics-orientated South African History Online founded by Omar Badsha (b. 1945). The South African National Gallery in Cape Town has published, collected, and exhibited much photographic work. The Johannesburg Biennale in 1995 and 1997 was crucial for many photographic artists, while others have been represented at Documenta in Kassel, Germany, the Venice Biennale, and numerous international exhibitions of South African art and photography. Important also are new art schools and private galleries such as Stevenson in Cape Town and Goodman in Johannesburg. In 1998–9, Cape Town hosted an ambitious exhibition/festival of all-African photography, *Eye of Africa. PHA

See also 'STRUGGLE PHOTOGRAPHY'.

⮷ See also African Studio Photography *overleaf*.

Bull, M., and Denfield, J., *Secure the Shadow: The Story of Cape Photography from its Beginnings to the End of 1870* (1970).

Lundstrom, J.-E. (ed.), *Democracy's Images: Photography and Visual Art after Apartheid* (1998).

African-American photography to c.1960. Early African-American photographers were quite numerous. Jules Lion (1810–66), a black French émigré artist, began making *daguerreotype portraits in New Orleans in 1840. Before emigrating to Liberia in 1854, the black abolitionist Augustus Washington (1820–?) sporadically operated a studio in Hartford, Connecticut. In 1851, James Presley Ball (1825–1905) with his brother Thomas and brother-in-law Alexander S. Thomas owned a 'daguerrean gallery' in Cincinnati, Ohio, which

(continued on p. 17)

African Studio Photography

Commercial studios were established in Cairo and, at the other end of the continent, in Cape Colony as early as the 1840s, to exploit both European demand for exotic scenes and the portrait requirements of local people. In the 1850s and 1860s others appeared in Sierra Leone, the Gold Coast (now Ghana), Angola, and Zanzibar. N. Walwin *Holm opened his business in Accra in 1883 and later became the first Africa-based member of the *Royal Photographic Society. While some West African studios were owned by Africans from the beginning, in East and southern Africa they were founded by Europeans and Indians, the latter in East Africa introducing photographic conventions from the subcontinent that continue to influence photographic styles. In these studios, Africans worked mainly in subordinate positions, but by the 1960s were starting their own businesses and developing local African modes of representation.

The invention of the *dry-plate process in 1871, and later the *postcard boom, considerably increased the number of studios. By c.1900 they existed in nearly all major African cities, and photography became a distinct profession with its own ethics and rules of apprenticeship. Studios became part of the cosmopolitan urban milieu and contributed strongly to the creation of an African modernity. As a space removed from the everyday, they allowed photographers and customers to play with various identities and, as in spirit-possession cults and masquerades, to change them. Portraiture, as a new technology of the self, became the dominant photographic mode. Most early studios in Africa followed 19th-century portrait conventions which, in Walter *Benjamin's words, 'oscillat[ed] between execution and representation, torture and throne room'. They offered formulaic pictures that enabled members of African elites—chiefs, teachers, clerks, priests—to display themselves as Westerners, appropriating Western commodities, clothes, and poses to distance themselves from traditions stigmatized as 'primitive' and 'backward' by colonial society. Thus the colonial discourses that had invented hierarchical tribal and ethnic labels were subtly shifted towards stressing differences in degrees of modernity. Especially in West Africa, however, an alternative mode emerged which, by emphasizing a return to African traditions, had implicitly challenged Western cultural dominance.

The advent of electricity in the 1940s, and thus of artifical studio lighting, ushered in a golden age of black-and-white studio photography. Photographs increasingly became part of daily life, taken not only for official purposes (identity documents) but to capture special moments, ceremonies, feasts, and rites of passage, and more mundane events like the acquisition of a new hairstyle, dress, or boyfriend. In this period photographers such as Seydou *Keïta and Malick *Sidibé (both Mali), Samuel Fosso (b. 1962; Central African Republic), Mama Casset (1908–92; Senegal), Francis K. Honny (b. 1914; Ghana), Omar Said Bakor (1932–93) and N. V. Parekh (b. 1923; both Kenya), and many others, localized the global media and created their own unique styles.

Anon. studio photographer, Mombasa, Kenya

Portrait, c.1920s

Omar Said Bakor, Lamu, Kenya

Patrilineal Genealogy, c.1970

Locally produced textiles or paintings were used as backgrounds, showing popular excursion spots, monuments, and tourist sites. Both modern African cityscapes and images of idyllic village life were represented.

Techniques for stage-managing and manipulating the photographic image became important. Concepts of *realism, in Europe derived from a painted portrait tradition, were markedly different in Africa, where they were linked to other conventions in textiles, sculpture, and proverbs. For instance, textiles worn by customers, with well-known patterns referring to sayings or commemorating certain events, functioned as integral subtexts within photographs. Sometimes specific hairstyles, especially of women, contributed a silent commentary and engaged the viewer (or recipient) in a dialogue. In both East and West African studios, codified gestures emerged alluding to particular sayings and proverbs. Social relations were also expressed photographically. Groups of people—families, friends, couples—dressed in the same clothes to affirm their unity. Pregnant women were excluded, being seen as too vulnerable. Mutual avoidance by son- and mother-in-law might be visually replicated by their appearance in separate pictures.

The retouching (see FINISHING) of negatives also followed local aesthetic and cultural imperatives, for instance making faces round and shiny, whitening the eyes, or, as in Ghana, enhancing necks with folds of fat, evidence of wealth and beauty. *Photomontage was used (in Omar Said Bakor's words) to 'make strange things possible', placing customers in bottles, on the moon, in radios or TVs, or confronting sitters with their doubles. In Uganda from the 1990s, young photographers began to employ photocollage techniques to recycle images from calendars, magazines, and posters and combine them with customer portraits. These collages transformed sitters into VIPs, at airports, in luxury hotels, beside the Pope or the Ugandan president, in settings of constructed global cosmopolitanism.

Even after snapshot photography became widespread in Africa, studio photographers did not aim to capture individual idiosyncrasies, but rather the idealized 'social' person. Studios offered illusion and wish-fulfilment that transcended any imported 'culture of realism'. The technical revolution of the 1980s, which brought colour photography and its industrial infrastructure to Africa, precipitated a crisis. Many studios closed, and those that survived focused on tasks like the making of passport photos, the reproduction or colouring of old photos, and video production. Somewhat ironically, while African photographers, in contrast to Indian and Western ones, had not seen themselves as artists, the discovery of African studio photography by Western anthropologists and art historians in a sense 'created' photographer-artists who, like Keïta, Sidibé, and Philip Kwame Apagya (b. 1958), started to sign their photographs. Since the mid-1990s, through growing numbers of exhibitions abroad and strengthening market interest, African studio photography in general has increasingly become part of the international art photography scene. HB

Sprague, S., 'Yoruba Photography: How I See the Yoruba See Themselves', *African Arts*, 12 (1978).

Houlberg, M., 'Feed your Eyes: Nigerian and Haitian Studio Photography', *Photographic Insight*, 1 (1988).

Behrend, H., and Wendl, T., *Snap Me One! Studiofotografen in Afrika* (1998).

Behrend, H., and Werner, J.-F. (eds.), 'Photography and Modernity in Africa', *Visual Anthropology*, 14 (2001).

Wendl, T., 'Entangled Traditions: Photography and the History of Media in Southern Ghana', *Res*, 39 (2001).

Gordon Parks

American Gothic: Mrs Ella Watson, Washington, DC, 1942

claimed to be the largest in the West. James and his sons later operated a studio in Helena, Montana, 1888–1901. Finally, and among the most important, there were the *Goodridge brothers, originally of York, Pennsylvania. Yet African-American contributions to the origins and development of photography have been slow to achieve scholarly recognition; neither Robert Taft's *Photography and the American Scene 1839–1889* (1938), nor Beaumont *Newhall's *History of Photography* (1982) mentions African-American photographers.

Neglect of the pioneering work of black photographers changed late in the 20th century because of several factors: the successes of such African-American professionals as James *Van Der Zee, whose photographs were featured in the controversial Metropolitan Museum of Art exhibition *Harlem on my Mind* in 1969; and Gordon *Parks, who began his career as a documentary photographer under Roy *Stryker at the Farm Security Administration in 1941; the founding of *Black Photographers Annual* in 1973 (four volumes appeared during the 1970s); and the growth of special collections libraries dedicated to the African-American past. Deborah Willis-Thomas, first at the New York Public Library's Schomberg Center for Research in Black Culture, later as curator at the Smithsonian Institution's Anacostia Museum, spearheaded efforts to identify African-American photographers. Her *Black Photographers, 1840–1940: An Illustrated Bio-bibliography* (1985), and the Smithsonian Institution exhibition *Reflections in Black: A History of Black Photographers 1840 to the Present* (2000), led to identification by scholars searching local city directories and historical society collections of hundreds of black photographers; sadly, for many of those traced, no known images survive.

African-American photographers before 1900 worked as amateurs, and as owners or operators of commercial (usually portrait) studios. They adopted new techniques as they appeared, including all the standard 19th-century variants: daguerreotypes, *ambrotypes, *tintypes, *stereographs. Daguerrean artists were often mobile; even such successful entrepreneurs as James Ball advertised for (mostly white) sitters in a number of different cities. Some ran studios for white owners, including John Roy Lynch in Natchez, Mississippi, who became a member of the US House of Representatives during Reconstruction. Gifted black amateurs whose early work has survived include Hamilton Sutton Smith (1857–1924), who photographed friends and family, East Coast tourist sites, and his Boston and Washington communities. African-American women also practised the art, usually as unacknowledged assistants to their husbands.

Wherever an African-American middle-class community developed, black photographers' studios not only met the demand for portraiture but also reflected the emergence of a vibrant parallel society, documenting ordinary events and people. Many worked in isolation, but by the early 20th century, Chicago, New York City, Houston, Washington, DC, and Tuskegee, Alabama, emerged as centres where black photographers knew and could influence each other's work. During his 50 years as official photographer for Washington's Howard University, Addison Scurlock (1916–64) developed a national reputation and trained a generation of black photographers. At Tuskegee, Arthur P. Bedou (1886–1966), Cornelius Marion Battey (1873–?), and Prentice Herman Polk (1898–?) photographed faculty, staff, and the surrounding rural population. Perhaps best known is Van Der Zee, who for more than 50 years before his 1968 retirement operated a series of studios, and documented the *'Harlem Renaissance'.

Before 1940 African-American photographers did not ordinarily use their cameras to document social problems. Rather than focusing on black identity, most mimicked white middle-class cultural patterns. However, beginning with Parks's *American Gothic* image of the Washington, DC, cleaner Mrs Ella Watson standing with two mops in front of the American flag (1942), African-American photographers became more aggressively open in challenging the systems of segregation and discrimination that many black Americans faced. The work of photographers such as Roy *DeCarava, Richard Clive Saunders (b. 1910), and Moneta Sleet (1926–96) played an important role in the evolution of *documentary photography in the second half of the 20th century, which also witnessed an explosion of distinctively African-American work. CBS

See also CIVIL RIGHTS MOVEMENT, AMERICAN.

Coar, V., *A Century of Black Photographers: 1840–1960* (1983).
Snyder, R. E., 'In the Hood: African American Photography', *Southern Quarterly*, 36 (1998).
Willis, D., *Reflections in Black: A History of Black Photographers, 1840 to the Present* (2000).

against-the-light photography. The mental images conjured up by this technique are striking and disparate: everything from pastoral landscapes reminiscent of Turner to Nazi *propaganda photographs of storm troopers. Some are characterized by delicate transillumination (especially of leaves or hair); others, by dramatic contrasts of light and shade.

The terms *against the light*, *contre-jour*, and indeed *back lit* are, however, somewhat misleading, implying as they do a picture taken with the light directly behind the subject. The majority of successful contre-jour pictures are more side lit than back lit, with the *key light at more than 90 degrees from the camera–subject axis; typically, at around 120 to 170 degrees, so that the light strikes the subject more or less glancingly, and is reflected towards the camera.

Equally unexpectedly, the actual contrasts of light and shade are often quite modest: otherwise, the picture becomes a silhouette or semi-silhouette. The brightness range of the principal subject may well be as little as two stops (4 : 1) and seldom exceeds three or at most four stops (8 : 1 or 16 : 1). The widespread adoption (and automation) of fill-flash, illuminating areas in shadow, has made it possible to shoot against the light in circumstances that would formerly have been difficult or impossible; but, equally, fill-flash is all too often overdone, leaving the principal subject as a cardboard cut-out against its background.

Most (though far from all) successful against-the-light pictures throw the background more or less into shadow, again in the interests

Lawrence Monahan

Sand Drifts, 1938

of avoiding silhouettes. Strong shadows and 'hand of God' lighting (beams shown up by mist or dust) can be enormously effective, but probably account for a relatively small proportion of all successful contre-jour shots. Surprisingly often, the overall contrast range of the lighting is fairly small, whether the subject is a misty morning or sunset or a studio portrait: in the latter case, it is all too easy to burn out highlights in which there should be texture and detail.

A final technical point which is not immediately obvious is that many of the best contre-jour pictures of yore were taken with lenses that had, by modern standards, very high *flare levels. This was obviously the case in the days before coating, but even into the 1960s many fast lenses still exhibited plenty of veiling flare. Trying to replicate the contre-jour effects of the past, using ultra-contrasty modern lenses, can therefore be impossible. A cheap zoom, or an elderly prime lens, may prove more successful; or, for more control, Tiffen's Ultra Contrast screens (which despite their name reduce contrast, rather than increasing it) are widely used in Hollywood for contrast control in contre-jour lighting. Although deep lens shades were always recommended in the past for contre-jour photography, and although they still remain very useful for most such shots, there may be times when it is best to remove the shade in the interests of reducing contrast. RWH

agencies, photographic, organizations that sell photographers' work to the periodical press and other clients, and/or negotiate commissioned assignments for their members. Although their relations with photographers have often been difficult, agencies, like art dealers, have brought a degree of order and stability to an ever larger and more complex market place.

Historically, agencies have taken various forms, and been surrounded by much myth. Details of their practices are often hard to establish. Roughly speaking, however, they can be divided between those which employ photographers, and those run by photographers on a cooperative basis (*Magnum Photos, founded in 1947, being the most famous), in which members choose their assignments and, crucially, own the copyright of their work. Agencies can also be divided—though the boundaries are often blurred—between those dealing with up-to-the-minute news photographs (*press agencies, agences de presse*), and those concentrating on human-interest and other subjects with longer-term appeal, and supplying book publishers as well as periodicals (*picture agencies, agences d'illustration*). Modern examples of the former include *Gamma (f. 1967), and of the latter, *Rapho, founded in 1933 and relaunched in 1946. A third category, increasingly common since the mid-20th century, has specialized in a particular field: the Nautical Photo Agency, for example, or the Gérard Vandystadt sports agency.

It might be argued that the operations of Mathew *Brady, who employed up to twenty photographers in the early years of the American Civil War (1861–5), were akin to those of an agent. However, as direct reproduction of photographs in the press was still impossible, and most 'Brady' pictures were distributed as

*stereographs or individual prints, his role—like that of many 19th-century view photographers—was essentially that of a publisher. It was not until the rise of the mass illustrated press, and the large-scale adoption of *half-tone illustration *c.*1900, that agencies in their modern form proliferated. One of the earliest was that of *Bulla in St Petersburg, which supplied newspapers in both Russia and Western Europe with news and feature material, including pictures of the Russo-Japanese War (1904–5) and the 1905 Revolution. Although Karl Bulla's two sons also joined the business, the *Foto Bulla* by-line clearly covered the work of many other photographers, a practice that long remained standard among agencies.

Although Viktor Bulla produced many photographs of the 1917 revolutions in Petrograd (St Petersburg), wartime conditions and the shrinkage of the Russian illustrated press limited their circulation. The political upheavals in Berlin in 1918–19, however, were recorded by photographers working for at least ten agencies, and distributed via the German capital's *c.*150 newspaper offices throughout Central Europe. In the 1920s agencies continued to multiply in Germany and elsewhere. Although most were either politically neutral or (broadly) 'bourgeois' in character, some left-wing organizations like the German Communist Party's Unionbild agency, which distributed Soviet and 'proletarian' images, also appeared. One important European agency of the inter-war period was the Berlin-based *Dephot (f. 1928), which employed *Umbo, Felix *Man, and, briefly, Robert *Capa. Another was the Parisian Alliance Photo, founded in 1934 by Maria Eisner (1909–91), which developed an international distribution network, and a stable of photographers that included Capa, Henri *Cartier-Bresson, David (Chim) *Seymour, and Pierre *Verger. One of Alliance's American contacts was the *Black Star agency, founded in 1936 in New York by three Berlin émigrés. It flourished partly because of its connections with European photographers and publishers, partly because of the close ties it formed with *Life* magazine. It paid its core of regular photographers a monthly salary regardless of whether they worked (Alliance paid a monthly advance), feeding them ideas hammered out at a weekly partners' meeting and selling the results to editors.

Another important inter-war development was the growing interest of the big news agencies in photographs. In 1927 Associated Press (AP) inaugurated its News Photo Service, then on 1 January 1935 the AP Wirephoto network, which transmitted images to the agency's subscribers over telephone lines, albeit with complex and cumbersome equipment. Within months, AP's competitors were offering similar services using simpler methods. Other companies, including Agence France Presse and *Reuters, followed suit after the Second World War.

The founding of Magnum in 1947 was a long-heralded response by photographers to the problems of working with conventional agencies. The biggest of these concerned attribution, since many photographers had to work anonymously; freedom to choose assignments; remuneration and security of employment; copyright ownership; and control over work submitted, since images, once sold,

were often recaptioned and/or cropped in ways unacceptable to the photographer. Magnum's cooperative structure, the retention of copyright by its members, and their ability to pursue their own projects, addressed these issues, although it could not insulate itself entirely from the media changes of the next 60 years. Magnum's size, with offices in Paris, London, New York, and Tokyo, and nearly 80 photographers in its three membership categories, also created tensions, resulting in the departure of some leading figures (for example, James *Nachtwey, who formed a new agency, *VII).

The second half of the 20th century brought other developments. The rise of television and the financial problems of the classic news magazines in the 1950s and 1960s encouraged the growth of flexibly organized Paris-based agencies, strategically placed to cover events in Europe, Africa, and the Middle East, that could provide news photographs more quickly and cheaply than magazines' own staff photographers. In conjunction with improved *transmission of photographs, they were also well placed to meet transatlantic press deadlines. The reputation of French photojournalism was enhanced by coverage of the Algerian War (1955–62) by photographers working for agencies such as Reporters Associés (1955) and Dalmas (1956). The 1960s and 1970s saw the emergence of important new agencies, including Gamma, which adopted a number of features pioneered by Magnum, such as profit sharing and protection of photographers' copyright; the breakaway Sygma in 1973; and a third important newcomer, Sipa. Particularly Gamma and Sygma became giants in the hot news field, helping to maintain Paris's pre-eminence through the 1980s. (Another group, Viva, founded in 1972 and dedicated to social-issue reportage, struggled to survive.)

In the early 21st century the global media market place is volatile, and likely to remain so. Notwithstanding the emergence of new small agencies like VII, an important trend has been towards mergers and cross-media gigantism. American agencies like Contact Press Images (f. 1976) consolidated their position, and new large organizations entered the arena, most notably *Getty Images and Corbis, both initially as picture archives but soon in the business of commissioning images through their own contracted photographers. Some medium-sized organizations joined larger combines: Rapho, for example, allied itself with the magazine-publishing group Hachette Filipacchi (Elle, *Paris Match) in 2000. Driving these changes was the advantage to media conglomerates of extending control over a range of products: not only photographs, but film and TV output and graphic images, all increasingly in digitized form. A central issue in the early 21st century, despite the proliferation of cooperatives and professional organizations, is the bargaining power and operational freedom of photographers on this chessboard of outsize players. DM/RL

Fulton, M. (ed.), Eyes of Time: Photojournalism in America (1988).

Hoffman, B. (ed.), Exploiting Images and Image Collections in the New Media: Goldmine or Legal Minefield? (1999).

Amar, P.-J., Le Photojournalisme (2000).

Aguado, Olympe (1827–94), aristocratic amateur photographer of Spanish origin, resident in France. Le Comte Aguado was a founding member of the *Société Héliographique and later of the *Société Française de Photographie. Taught by Gustave *Le Gray, he was the prototype of the wealthy, committed enthusiast. He specialized in topographical and genre subjects, using the *calotype, *albumen, and *collodion processes, and played an active role in promoting photography in France. KEW

Olympe Aguado (1827–1894), photographe (1997).

airgraph, mail microphotographed by a system devised by Kodak in the Second World War for air transport between troops overseas (initially in the Middle East) and home. The addressee eventually received a re-enlarged print. Between 1941 and July 1945 c.350 million letters were sent by this method, doubtless contributing significantly to forces' morale. RL

AIZ. See ARBEITER ILLUSTRIERTE ZEITUNG.

Albert, Joseph (1825–86), German photographer, publisher, and inventor who established himself in Munich in the 1850s in the fields of portraiture and—particularly lucrative in a major art and tourism centre—art reproduction. Royal patronage by the Wittelsbachs decisively assisted him, with commissions both for informal family pictures and official portraits, the latter including life-size enlargements made by *solar cameras. After Ludwig II's accession in 1864, royal assignments became ever greater and technically more demanding. In addition to portraiture, and reproductive work of all kinds, Albert had to photograph interiors in the palace of Versailles in connection with Ludwig's castle-building programme, and to record the buildings under construction. He also ran a sumptuous portrait studio and an art-publishing business, reproduced military maps during the Franco-Prussian War, and, in Munich and Bayreuth, contributed to the iconography of early Wagnerian opera. He developed a version of the *collotype process using glass plates (*Albertotypie* or *Lichtdruck*) and worked on colour photography, from 1879 in partnership with *Ducos Du Hauron. Albert's son Eugen (1856–1929) succeeded independently, and did significant research, in photo reproduction and publishing. RL

Ranke, W., Joseph Albert: Hofphotograph der bayerischen Könige (1977).

Albin-Guillot, Laure (née Meffredi; 1879–1962), French photographer who became interested in photography soon after her marriage in 1897 to the physician/scientist Dr Albin Guillot. At first, her husband's circle of friends, which included architects, writers, and politicians, provided her with portrait subjects. During the 1920s and 1930s she was engaged by the design precepts of the *New Vision, and produced more sharply focused close-ups of objects for clients like Bon Marché and Renault. At the same time, she continued to create soft-focus *pictorialist nudes that appeared in artistic photography journals and as illustrations in volumes of poetry.

Many of her images were exhibited during the 1920s and reproduced in *Arts et métiers graphiques*.

At a time when many photographers were indifferent to the quality of prints intended for reproduction, Albin-Guillot sought to invest hers with artistry and individuality. Engrossed by her husband's lifelong research in micrography, in 1931, in collaboration with Pierre Fresson, she published in his memory a volume of 24 photomicrographs of crystals, exquisitely printed on various coloured and metallic papers. Later, she and Fresson also collaborated on similar works, which were used as decoration on the liner *Normandie*. NR

Micrographie décorative: Laure Albin-Guillot (1931).

albumen print. Introduced by Louis *Blanquart-Évrard in 1850, this silver chloride printing-out paper is coated with salted egg white and sensitized with silver nitrate. Albumen prints present a fine, warm-brown hued image on a thin paper base, although toning with gold chloride gives an aubergine-black image colour and prevents deterioration from residual sulphur compounds in the egg-white coating. Albumenized paper was manufactured from 1855, and sold ready sensitized after 1872. It was superseded by gelatin and *collodion papers by about 1890, although its use persisted until the late 1920s. It was revived by the Chicago Albumen Company in the 1980s. HWK

albums (from the Latin *albus*, white) were used before the invention of photography to collect prints, drawings, music, and poems. More personal collections, often kept by women, mingled these with contributions from friends, printed ephemera, and cut-paper work. By the beginning of the 19th century, albums were essential drawing-room accessories, used as a focus for social interaction as much as for solitary contemplation. In the 1840s photographic prints were added to this tradition. Amateur and professional photographers regularly made and exchanged albums as gifts (Julia Margaret *Cameron), as samplers of their work (Charles *Dodgson), or as limited editions for sale (*Hill and Adamson). Early *photographically illustrated publications, like Henry *Talbot's *The Pencil of Nature* (1844–6), or Anna *Atkins's *Photographs of British Algae* (1843–53), were made by pasting photographs on to the pages.

Carte de visite albums were the first produced especially for photographs. Their double-layered pages were pre-cut with window mounts, with slots through which the *cartes* were inserted. Very popular in the 1860s and 1870s, these albums mixed family portraits with those of celebrities. Designed to be displayed to visitors, they showcased the networking skills of the women of the house in keeping up social connections, and in obtaining desirable celebrity photographs. Closed, albums were decorative objects, in their tooled leather and gilt covers complete with gold clasps. Open, they could entertain visitors while the hostess was otherwise engaged, or be accompanied by a verbal commentary, varied to suit the person being addressed. More accomplished women made mixed-media albums, creating collages using cut-up photographs and watercolour or ink drawings, combining professional with amateur photographs. Often, these women's albums—for example, those of Lady *Filmer—imaginatively interpreted definitions of femininity as a socially constructed role.

By the late 19th century, album manufacture had become a considerable industry, with Germany dominating the market; in 1880 there were 48 specialist firms in Berlin alone, exporting about one-third of their output to North America. Materials ranged from leather and mother-of-pearl to cheap substitutes like *celluloid, with prices to match. In the 1890s a craze for novelties spawned all kinds of decorative embellishments, even integral clocks and music boxes. As gelatin emulsions, easy-to-use cameras, and processing services made photographs cheaper and more plentiful, *carte de visite*- and cabinet-format albums were replaced by more informal volumes with coloured, thin pages. (But albums with window mounts continued to be used, especially by committed amateurs doing their own printing, as gelatin papers were difficult to paste down without professional facilities.) Loose-leaf binders and black pages became popular after the First World War. In the 1950s postcard-sized slip-in albums made from transparent plastic pockets became popular to collect colour *snapshots.

The expansion of amateur photography during the 20th century diversified the content of albums, as photographs became more intimate and varied in style and subject matter: fully organized visual diaries like the *'baby book'; albums concentrating on one particular event like a *wedding or a holiday abroad (but then sometimes including *postcards, brochures, menus, and other items as well as photographs); casual albums compiled in the order in which photographs came back from processing. Categorization, however, is difficult, as photographs taken for personal uses are too often unconcerned with either following or breaking conventions, and can at the same time infinitely personalize the most staid poses and themes. Whether as a highly crafted collection, as a convenient container to store and view images, or—stretching the definition—reduced to a box of prints, the photographic album has become the main medium through which photographs are used to explore, construct, and confirm identity. Acts of self-reflection, such as looking at and collecting images of personal relevance, have become an indispensable feature of a modern sensibility. Viewing, sharing, and passing around albums has become an established ritual of familial gatherings, and a crucial aspect of the construction and maintenance of personal and cultural memories.

The metaphor of the album as a site for the construction, as much as the representation, of identity, was seized upon by artists in the 20th century, while album making has been abandoned by most professional photographers in favour of illustrated magazines, photography books, and limited-edition portfolios. The Viennese poet Peter Altenberg (1859–1919) made albums which, by combining his highly visual poems with snapshots and postcards, were an integral part of the construction of his persona as a modern *flâneur*,

Anon., Italian

Venice, late 19th century. Albumen print

regenerating culture by taking on feminine genres and mass-produced images. A number of contemporary artists use and subvert the album, extending its range to include images of sickness and moments of abjection (Richard *Billingham), and by representing unconventional 'families' based on bonds that are not familial in the traditional sense (Nan *Goldin). In *Beyond the Family Album* (1979), Jo *Spence rearranged her own family album, rereading it through the insights given by social history, feminism, and psychoanalysis. She reworked individual images from the past to bring out and make visible the conflicts, frustrations, and unhappiness that had been glossed over by the codes of photography, and by her mother's editing and captioning. Spence argued that the album's denials—of work, separation, illness, and daily drudgery—can be seen less as a glossing-over of realities than as evidence of frustrated maternal desires and feminine aspirations. In *Sans souci* (1991), a work using images found in Nazi family albums, Christian *Boltanski reconsidered the cultural and historical function of photographic portraits and albums. German soldiers, photographed off duty, relaxing at home and with their families, appear only as affectionate fathers, lovers, and husbands. The family-album mode of narrative effectively, despite the uniforms, masks the fact that they are also instruments of Nazism. Their familial world is constructed as separate from the ideological and historical one. Boltanski shows how photographs convey not reality but a set of cultural codes, in this case those associated with the idealization of family life as a locus of enduring affections and benevolent feelings.

It is too early to assess the impact of *digital photography on the album. On the one hand, digital techniques are dematerializing the album into infinite collections to be viewed on the computer or television screen and perhaps the *Internet, where a growing number of family albums and personal or institutional collections can be inspected. On the other, the ease with which photographs can be printed digitally on a variety of surfaces and objects has facilitated a renewed emphasis on the photograph as a physical object to be touched and handled with casual but emotionally poignant intimacy. PDB

See also FAMILY HISTORY, PHOTOGRAPHY AND; PHOTOTHERAPY; POSING FOR THE CAMERA.

Maas, E., 'Das Fotoalbum 1858–1918', in *Das Fotoalbum 1858–1918: Eine Dokumentation zur Kultur- und Sozialgeschichte* (1975).

Hirsch, M. (ed.), *The Familial Gaze* (1999).

Batchen, G., 'Vernacular Photographies', in *Each Wild Idea* (2001).

Lensing, L., and Barker, A. (eds.), *Peter Altenberg: Semmering 1912* (2002).

Noble, A., and Hughes, A. (eds.), *Phototextualities: Intersections of Photography and Narrative* (2003).

aliasing. See DIGITAL IMAGING.

Alinari, Giuseppe (1836–92), **Leopoldo** (1832–65), and **Romualdo** (1830–91), Florentine photographers and publishers. Leopoldo learned lithography and *daguerreotypy from Giuseppe Bardi in the late 1840s, and he and Bardi opened a studio in 1852. By 1854 Leopoldo had bought out Bardi and his brothers had joined the enterprise, renamed Fratelli Alinari. In 1863 it moved from the Oltrarno district to imposing premises at Via nazionale 8. In addition to portraits (including Garibaldi and Victor Emanuel II) it produced celebrated views of Florence and Tuscany; genre and street scenes; and an expanding series of Italian landscapes, presented by the fervently patriotic brothers as a tribute to the new nation. Alinari's archive eventually comprised *c.*70,000 images. Another speciality was the reproduction of works of art in Italian, German, French, and Greek galleries.

Leopoldo's son Vittorio (1856/9?–1932) took over in the early 1890s, eventually opening branches in Rome and Naples. Vittorio had wide cultural interests, running a literary salon at his villa in Fiesole and patronizing the Macchiaioli painters. His photographic magnum opus, *Il paesaggio italico nella Divina Comedia*, comprising all the landscapes mentioned by Dante, finally appeared in 1921. The previous year, however, he had sold out to the Istituto di Edizioni Artistiche (IDEA). The firm continues today as a publishing house and picture archive. KEW

Quintavalle, A. C., *Gli Alinari* (2003).

Allen, James (1907–77), African-American photographer, who ran a studio in Harlem between the wars patronized by members of the New Negro Arts Movement, including W. E. B. DuBois, Alain Locke, Paul Robeson, and Langston Hughes. Allen was also employed by the Harmon Foundation to produce artist portraits and installation shots of its annual exhibitions of African-American art. He was one of the few black photographers to be recognized as an artist. His work was frequently exhibited, and reproduced in periodicals such as *Opportunity*, *The Crisis*, and *The Messenger*. CDH

Holloway, C. D., *Portraiture and the Harlem Renaissance: The Photographs of James L. Allen* (1999).

Allen, Sydney. See HARTMANN, SADAKICHI.

Alpert, Max (1899–1980), Russian photojournalist. After an apprenticeship in Odessa, Alpert served and photographed with the Red Army 1919–24, then settled in Moscow and worked for the magazine *Rabochaya Gazeta*, then *Pravda*. He covered both news events and the gigantic industrialization projects of the early Stalin period, sometimes in regions as remote as Uzbekistan. His pioneering reportages conveyed both the antlike collectivism of vast, barely mechanized construction sites and individual endeavour. In 1931, with Arkadi *Shaikhet and Sergei Tules, he created the photo-essay *A *Day in the Life of a Moscow Worker*. He worked as a photo-reporter for the TASS agency during the Second World War, and for other agencies after 1945. RL

Morozov, S., and Lloyd, V. (eds.), *Soviet Photography 1917–1940: The New Photojournalism* (1984).

alternative (non-silver) photographic processes.
The silver gelatin 'monoculture' has dominated photographic printing for nearly a century, but with each market-driven improvement the range of monochrome printing papers has become narrower. In the 1970s several artist-photographers began a rebellion against this hegemony by rediscovering some of the forgotten 19th-century processes which had lost the struggle for commercial viability. These 'alternative' printing materials generally require the hand coating of paper with solutions of light-sensitive chemicals. The aim is to broaden the spectrum of artistic photographic practice, ranging from the immaculately crafted platinum print with its exquisite 'engraving black' tones, on the one hand, to the painterly and sometimes flamboyantly coloured pigment images of *gum bichromate, on the other. Alternative practitioners can select their materials and exercise manipulative control to a degree impossible with silver gelatin; or they can simply surrender, with wilful primitivism, to the serendipitous accidents of ill-defined photochemistry. Both holistic approaches can claim the satisfaction of being 'true to one's materials'.

The wider movement known as 'alternative photography' also encompasses the revival of early camera processes (all silver halide based) such as the *ambrotype, *calotype, *daguerreotype, *pinhole, *tintype, and wet-*collodion process, and the accompanying silver-printing processes such as *salted paper and *albumen. This account, however, is confined to the 'non-silver' methods of making the positive print, which may be subdivided into three main areas of practice, according to whether their photochemistry requires salts of iron, or chromium, or purely organic substances. Aesthetic and practical considerations tend to cut across these subdivisions, and the permanence of the image substance is an important re-emerging issue for archives and the fine-art *market, where the photographic print is viewed as art object *sui generis*.

Compared with silver gelatin printing, the conspicuous drawback of alternative processes is their low sensitivity to light—about a million times less than that of silver bromide enlarging papers. Projection printing on alternative materials is impossible with the technology commonly available, so contact printing is the only way to achieve a sufficient throughput of light; the final image can therefore only be the same size as the negative. This disadvantage was largely responsible for the early commercial demise of alternative processes such as *platinotype, in the face of a growing market for miniature cameras and bromide enlarging papers.

The light source employed must be intense, usually with some ultraviolet content: the technologists tend to opt for mercury lamps, but the mystics prefer to sun-print in the time-honoured fashion— especially if they enjoy a good climate. One compensation for the insensitivity is that a darkroom with safe lighting is not required. Another, less obvious benefit is that these imaging systems are in principle capable of extremely high resolution; for instance, modern technology has rediscovered dichromated gelatin as an ideal material for recording holograms.

With low-sensitivity processes the easiest options are lensless: to make *photograms of botanical specimens, fabrics, *clichés-verre*, or even the human form. If prints are to be made from camera negatives, the modus operandi must entail either a large-format camera, or enlarged internegatives, made in the darkroom or— increasingly—by computer technology. Although many kinds of substrate can be coated with alternative sensitizers, the usual choice is a fine-art paper selected from those intended for watercolourists, etchers, and printmakers, with regard to tint, surface texture, weight, and sizing; a few papermakers have recently introduced products especially suited for alternative photographic processes. To discover that paper can be a beautiful material may be a pleasant surprise for viewers inured to the bland surface gloss or mechanical stipple of the commercial silver gelatin photograph.

The class of alternative processes depending upon the photo-reduction of iron(III) was invented by Sir John *Herschel in 1842. 'Ferric' salts of iron(III) with the 'vegetable acids'— especially citric, tartaric, or oxalic acids—are sensitive to light, becoming reduced to 'ferrous' salts of iron(II) on exposure to the ultraviolet. Permanent images may be derived by further reaction of the product in three general ways. First, the iron(II) can reduce noble metal salts to the finely divided metal: platinum, palladium, and gold, giving rise to the platinotype, palladiotype, and chrysotype (or aurotype) processes; these are archivally permanent. Silver images can also be made by this indirect means; the processes called argentotype, argyrotype, brownprint, kallitype, sepiaprint, and vandyke, despite the variety of names, are all similar in principle, and have inferior prospects of permanence. Second, the iron(II) photoproduct may be reacted with potassium ferricyanide to give the powerful pigment Prussian blue (ferric ferrocyanide). Called *cyanotypes, these blue images endure well, provided they are protected from alkali and excessive light. The third possibility is to couple the residual iron(III) with gallic or tannic acid, making iron-gall ink, the chief writing substance since the Middle Ages. Important once for photocopying, these ferrogallate, positive-working processes are no longer used.

All these *iron-based processes* are characterized by unmanipulated printing procedures, although they may be variously toned. Some provide a printout image, which can be inspected as it builds up during the exposure, using a hinged-back printing frame to retain registration. The need for test strips is thus avoided. Printout processes have the added benefit of being self-masking, a property which accommodates a long density range in the negative and yet is non-critical in exposure time. Having no colloidal binder layer, the prints on plain paper are totally matte, so the viewer experiences no reflective surface glare from the illumination. The image substance is embedded in the surface fibres of the paper sheet, which may be attractively textured, and is always sympathetic to retouching or overpainting.

The so-called *pigment processes*, invented by *Poitevin in 1855, depend on the light-induced oxidation of organic matter by chromium(VI) in a soluble dichromate, which is itself reduced to chromium(III), a substance that causes hardening of a layer of water-soluble colloid, such as gelatin, gum acacia, casein, glue, or egg albumen, to render it locally insoluble where the light fell. Images are made visible by including a permanent pigment in the binder layer. Processes employing the light-hardening of dichromated colloids include gum bichromate, and the *carbon process and its variants (e.g. Artigue, Fresson). A related group of processes employ dichromate as a bleach (or oxidant) for a silver gelatin image, replacing the silver locally with hardened gelatin, which can then selectively absorb oily printers' inks, as in the *bromoil, oleobrom, *carbro, *ozotype, ozobrome, and *oil pigment processes, where the use of a silver gelatin paper enlargement provides a very convenient starting point. The appeal of these processes lies in the extensive manipulation that is possible with the hardened colloid matrix—in the first group, the image is developed controllably by physical removal of colloid-bound pigment, in the second, by the application of oil-based ink with brush or roller.

Direct photo-decomposition of certain coloured organic substances, natural or synthetic, has been employed since the earliest days of photography. In 1839 Herschel introduced his anthotype (or phytotype) process, involving the light-bleaching of dyes (anthocyanins) extracted from crushed flower petals; although such images cannot be fixed, a few of Herschel's still survive today. The photo-decomposition of unstable diazonium compounds, together with their coupling reactions to form synthetic azo-dyes, gave rise to the diazotype, Feertype, and primuline processes, which found application in photocopying. Recently, modern photopolymers have been employed as binders for pigment images, as in Perera's Heliochrome process. MJW

Crawford, W., *The Keepers of Light: A History and Working Guide to Early Photographic Processes* (1979).

Farber, R., *Historic Photographic Processes* (1998).

Barnier, J., *Coming into Focus* (2000).

James, C., *The Book of Alternative Photographic Processes* (2002).

Rexer, L., *Photography's Antiquarian Avant-Garde* (2002).

Álvarez Bravo, Lola (née Dolores Martinez Vianda; 1907–93), Mexican photographer. Orphaned very young, she was brought up by relations. In 1925 she married Manuel Álvarez *Bravo, began by helping her husband in the darkroom, and went on to share the use of their camera. (Their son Manuelito, born in 1927, also became a photographer.) Their work brought the young couple into contact with other Mexican artists, and when they separated in the mid-1930s, Lola was sufficiently established to pursue an independent career as one of Mexico's first female professional photographers. Her varied oeuvre included an extensive documentary record of everyday Mexican life, images of historical sites, and portraits of national and international figures from art and politics. Her 1944 one-woman exhibition at Mexico City's Palace of Fine Arts was the first of many showings of her images. She also worked as a gallery director and photography teacher. Failing eyesight made her abandon photography in the late 1980s, but her life's achievement was marked by a retrospective exhibition in Mexico City in 1992. RP

Sills, L., *In Real Life: Six Women Photographers* (2000).

Álvarez Bravo, Manuel (1902–2002). Popularly called 'the father of Mexican photography', he began almost by chance. Despite his background as a student of fine art, later experience as an assistant cinematographer with Eisenstein, and mentoring by Hugo *Brehme and Tina *Modotti, he always declared himself an autodidact. Nonetheless, he lectured in photography at San Carlos University from 1929, three years before he became a photographer. Always preferring to work in his home country, he was little known abroad before the 1970s. Even then, his reputation was as a 'photographer's photographer', accessible primarily to an inner circle able to penetrate his vaunted sense of 'mystery' and 'darkness'.

In fact, these characteristics were more to do with subject matter and style than with an innate vision. Álvarez Bravo captured little mystery in his images of everyday life, even including those of the great volcanoes of the Valley of Mexico. And he did not lack international connections: friendship with Modotti; an early spread in the magazine *Mexican Folkways*; and, in 1938, André Breton's choice of one of his prints for the cover of the Surrealist exhibition catalogue in Paris. By this time he had also met Paul *Strand and Henri *Cartier-Bresson, and exhibited with them and Walker *Evans at Julien *Levy's New York gallery in 1935.

Having grown up partly on the streets during the revolution, his fascination with ordinary lives appears throughout his oeuvre. An abundance of images testifies to this: from the boy sweeping with a twig besom, apparently lifted into a balletic pose, to the early shot of a girl on the staircase at his parents' tenement, *Daydreaming* (1931). Álvarez Bravo's reputation for mystery seems at variance with his naturally lit, unmanipulated, and largely unposed images. (An exception to the latter is the celebrated, Surrealism-inspired *Good Reputation Lies Sleeping* (1938–9), the portrait of a bandaged dancer.) But Mexico is a land of contrasts: Álvarez Bravo's marketeers sheltering from the heat under a tented rug; or his diners, shaded so that their heads vanish beneath a metal blind at a roadside bar; even his plantation workers, semi-invisible beneath palm fronds—all imply that the hidden is as crucial as the seen. Death is another theme. His *Posthumous Portrait*, of a mummy in the caves at Guanajuato, complements the images of dead infants dressed as angels sold by every photo shop in Mexico City. His series on the Day of the Dead post-dates the documentary study undertaken in Michoacan by Nacho Lopez (1923–86), and shows images now familiar from tourist brochures.

From the 1970s Álvarez Bravo's work was extensively exhibited in the USA and Europe, and he received numerous honours. AH

Kismaric, S., *Manuel Álvarez Bravo* (1997).

Amateur Photographer (*AP*), British weekly magazine which first appeared on 10 October 1884. Articles on equipment, chemistry, products, and techniques kept photographers apprised of advances. The magazine also served as a forum, providing answers to queries, sponsoring competitions, and publishing readers' portfolios. With the growth of *pictorialism in the 1890s, aesthetic questions became more prominent. Alfred *Horsley Hinton, editor 1893–1908, was a co-founder of the *Linked Ring, and solicited contributions from J. Craig *Annan, Robert *Demachy, Frank *Sutcliffe, and other leading art photographers. The paper merged with *Photographic News*, edited by another pictorialist, the marine photographer Francis J. Mortimer (1875–1944), in 1908. Mortimer provided further editorial continuity (1908–18 and 1925–44). Indeed, *AP*'s essential character has remained consistent despite cosmetic changes. Its challenge today is to balance the concerns of traditional photographers with coverage of *digital imaging. It is owned by IPC Media. KM

Kenyon, D., *Inside Amateur Photography* (1992).

amateur photography, history. 'Amateur' is not a term specific to photography. An amateur is someone who does something for the love of it, whether it is photography, sport, music, or horticulture. Like many other amateur movements that flourished from the mid-19th century on, amateur photography emerged from the social and economic conditions of modern capitalism. With the growing distinction between work and leisure, and the class issues centred around these activities, 'amateur' served as a vital differentiating category, embodying the virtue of economic disinterest. Amateur photographers were first and foremost what they were not: professionals, whose work was understood to be controlled by market demands. Whereas professionals bowed to client expectations, it was assumed, amateurs photographed for their own improvement and pleasure. Consequently, they have come to occupy a special place in the history of photography, being seen as innovators boldly elaborating both the technological and aesthetic aspects of the medium. (In truth, professional/amateur distinctions are not always clear cut. Amateurs have been constrained by conventions sometimes as rigid as those observed by professionals; and have frequently sought profit, just as professionals have often been innovators.)

However, there has also been the idea of the amateur as unskilled 'snapshooter' without knowledge or sophistication. This discrepancy reflects shifting attitudes towards amateurs during the late 19th and early 20th centuries, part of a larger industrial transition that included photography in its sweep. Whereas the amateur photographer of the 19th century tended to be wealthy, leisured, and cultured, and sometimes owned a *country house, the 20th-century amateur was increasingly middle or even, by the 1950s, working class. This shift may be explained by the gradual industrialization of photographic products and services, including retail developments like the growth of chain stores and mail-order companies, resulting in photography's growing accessibility, affordability, and ease of operation. Thus, within the vast realm of amateur photographic practice, photographers have, variously, contributed directly to the development, invention, and exploitation of photographic equipment and techniques; rejected commercialism altogether by emphasizing aesthetic and narrative potentialities of the medium; or benefited directly from commercial innovations.

John Branwell

John R. Branwell smoking a pipe, *c*.1900

Since the invention of photography, amateurs have constituted a distinct presence within the larger sphere of photographic practice. *Clubs were formed as early as the 1840s. In England, the Calotype Society was established in 1847. Its early members, including Hugh Welch *Diamond, Roger *Fenton, William Newton, and Frederick *Archer, were typically men of science, curious about new technologies and their applications. In France, the *Société Héliographique formed in 1851, counting among its members Baron Gros, Hippolyte *Bayard, Gustave *Le Gray, Henri *Le Secq, and the painter Eugène Delacroix. As the wet-plate process became widespread during the early 1850s, more amateurs took up photography, a trend reflected in the growth and proliferation of organizations: the Calotype Society became the Photographic Society of London in 1853 (and the *Royal Photographic Society in 1894), the Société Héliographique was replaced by the Société Française de Photographie (SFP) in 1854, and New York's first camera club appeared in 1861. While each of these groups included some professionals, amateurs dominated discussions of both experimental technologies and aesthetics.

What might be termed the Amateur Movement proper commenced in the 1880s with the advent of the *dry-plate process and the hand-held camera. These technological advances, increasingly mass produced, considerably expanded the numbers of amateur photographers. A significant consequence was that amateur groups, whose purposes were often as much social as intellectual, soon began to make distinctions among themselves. From the 1880s to the First World War, three different types of amateurs may be distinguished: *serious amateurs*, *art amateurs*, and *mass amateurs*. These groups defined themselves according to the technologies they used, the subjects and approaches they favoured, and the institutional structures—societies, publications, exhibition venues—they maintained. Remarkably, divisions occurred in parallel form across industrialized Western Europe and the USA.

Serious amateurs

Variously known as 'competent amateurs' and 'skilled amateurs', these formed many seminal associations during the 1880s and early 1890s. The evolving Photographic Society of Great Britain and the Manchester Amateur Photographic Society, the Deutsche Gesellschaft von Freunden der Photographie in Berlin, the Société d'Excursions des Amateurs Photographes and the *Stéréo-Club Français in France, and the Society of Amateur Photographers of New York in the USA, represent only a fraction of the organizations that flourished in this period. Initially at least, they maintained the goals and aspirations of the earliest clubs. Functioning as a kind of technological consortium, members shared information about new processes and equipment—stereoscopy, flash, detective cameras— but on a larger scale. Regular meetings featuring lantern-slide presentations were a common form of exchange. Moreover, a profusion of new photographic literature began to appear. Books like Josef Maria *Eder's 1886 treatise on instantaneous photography, *Die Moment-Photographie*, translated into several languages, served to define the parameters of amateur interests in addition to disseminating a rapidly expanding body of photographic knowledge. *Journals representing the interests of various specific amateur organizations proliferated, including *Amateur Photographer* (London), *Der Amateur-Photograph* (Düsseldorf), *L'Amateur-photographe* (Paris), and *American Amateur Photographer* (New York), to name but a few. Amateur journals in particular were often international in scope, and regularly featured articles describing technological breakthroughs in other countries.

Journals also published examples of amateur work, increasingly often as *photomechanical printing methods improved. A common example was the instantaneous or stop-action photograph, the curious product of faster emulsions and shutters. Images of animals, people, and objects arrested in mid-trajectory saturated journals throughout the 1890s, often prompting heated aesthetic debates—not all amateurs agreed on the aesthetic merits of instantaneity. Attitudes tended to reflect class divisions. Serious amateurs, who tended to exalt the instantaneous photograph as a manifestation of recent technological advances, were generally upper-middle-class men (women were rare among serious amateurs) employed in business and the sciences, who pursued photography as an offshoot of their professions. For some of them, photography served as an 'agreeable pastime, an intelligent occupation', as Albert *Londe, the prototypical serious amateur, noted in one of his many books on instantaneous photography. For others, photography's rapid development, both technologically and commercially, expressed perfectly the ideals of modern industrial capitalism, and many doubtless hoped to profit from patents or the manufacture of photographic products; the *Lumière brothers in France represent one such success story. Still for others, photography offered a pretext for sociability. This is reflected in the enormous numbers of amateur photographic societies, many of them regional and specialized, that flourished throughout Europe and the USA from the late 19th century onwards.

Art amateurs

By the mid-1890s a gulf began to appear between scientifically and artistically motivated amateurs. The latter were already a common photographic type, particularly in Britain. Charles *Dodgson, Julia Margaret *Cameron, Henry Peach *Robinson, and Peter Henry *Emerson (each of whom, it may be noted, dreamed of commercial success) had established the image of the art amateur as a kind of progressive aesthete, one capable of wedding modern technology to fine-art traditions. But in the 1890s, as amateur ranks swelled to record proportions, art amateurs began to distinguish themselves more pointedly from the rest. This was apparent on numerous levels. Early on, art amateurs exhibited their tonalist renditions of landscapes, portraits, and genre scenes among examples of scientific photography such as *X-rays and photomicrographs. Later, they began organizing separate shows which presented carefully selected examples of artistic photography in a more exclusively aesthetic environment.

In Vienna, the exhibition of artistic photographs mounted in 1891 by the recently formed Club der Amateur-Photographen served as a model for art photography exhibitions in other countries. (International contacts and influences were particularly important at this time.) In Hamburg, Ernst *Juhl and Kunsthalle-director Alfred *Lichtwark were instrumental in organizing a major series of *Kunstphotographie* salons between 1893 and 1903. For Lichtwark, art photography—effectively, *pictorialism—was part of a larger project to use amateur creativity to promote aesthetic education and improve national taste. Hamburg's leading art amateurs were the *Hofmeister brothers. In Britain, the *Linked Ring Brotherhood broke away from the Photographic Society of Great Britain in 1892, and inaugurated its own annual salons the following year. Similarly, the *Photo-Club de Paris formed in 1888, an offshoot of the SFP. In Russia, the Daguerre Society in Kiev played a similar role. In the USA, finally, the newly formed Camera Club of New York, with *Stieglitz as editor of its journal, *Camera Notes*, offered a provisional home to art photography until conflicts arising out of the Philadelphia Photographic Salons (1898–1901) led to the formation of the *Photo-Secession in 1902. Common to many members of these groups was their preference for complicated processes like *bromoil and *gum bichromate prints that resembled watercolours or graphic work rather than photographs.

Art amateurs, briefly at the vanguard of photographic modernism, claimed their status on the grounds of good taste. While in theory anyone capable of demonstrating sensitivity and aesthetic knowledge through photography might be included, practitioners tended to be well educated, leisured, and wealthy. In Europe, art amateurs were often men of high birth, while in the USA a more meritocratic standard applied, which allowed for the inclusion of women and even Midwesterners. In the end, art amateurs were marginalized by the socio-economic changes that took place in the first decades of the 20th century. Moreover, their achievement was eclipsed by the 'straight' approach of serious amateurs, whose unleashing of novel pictorial effects through instantaneity—dynamism, contingency, fragmentation—would be picked up as the vocabulary of *New Vision photography in the 1920s.

Mass amateurs

It was mass amateurs who eventually claimed the amateur title, becoming permanent beneficiaries of the industrial exploitation of photography. Mass amateurs were born out of the success of a single firm, the Eastman Dry Plate Film Company, which produced its first *roll-film camera in 1888. By 1900 the company had released an entire line of easy-to-use, inexpensive cameras, and established the world's first commercial processing service. The Kodak system was so user friendly that in 1900 the company released a child's camera, the *Brownie. Priced at 5 shillings ($1), it was affordable for most middle-class children; moreover, its use established picture-making habits that would carry over into adulthood. (Some young people, though, like Jacques-Henri *Lartigue and Alice *Austen, were lucky enough to be given much fancier equipment.) Women were also targeted as an important new consumer group: hence the long-running *Kodak Girl advertising campaign. But, more than just equipment and services, Kodak offered an entire culture. The name itself was a made-up word: George *Eastman, the founder of the firm, saw the letter K as 'firm and unyielding', and wanted something unique and memorable. 'Kodak' formed the root of an entire vocabulary: 'Kodakers', as the company's clients were called, could subscribe to the journal *Kodakery*, and could join Kodak clubs, which issued Kodak Fellowship badges to members so that they could recognize each other while 'kodaking' in the field. Availability and name recognition were key to the company's success, and shops emblazoned with the Kodak name sprang up around the world. Such rapid and widespread proliferation—by 1898, 1½ million cameras had been sold—gave rise to what became known internationally as the 'Kodak fiend', a photographer lacking not only technical skill and taste, but also manners (women in bathing attire were favourite subjects). Serious amateurs and art amateurs alike reacted with undisguised horror to the habits and output of their mass amateur cousins. As Stieglitz cautioned in 1907, 'Don't believe you became an artist the instant you received a gift Kodak on Xmas morning.' In truth, most mass amateurs were not interested in art, and cheerfully ignored the tips for 'successful photography' issued by manufacturers and photographic magazines. Their prime concern was to record their lives and fill *albums with personal *snapshots.

Since the success of Kodak, cameras and services have continued to develop, expanding amateur markets. The list is long: the triumph of colour film in the 1960s, the *Instamatic revolution of the 1960s and 1970s, then *disc cameras, *minilabs, APS (*Advanced Photographic System), and point-and-shoot *digital photography by the end of the century. While publications, clubs, and competitions continue to help in distinguishing amateur photography from mere snapshooting, the definition today easily embraces all non-commercial uses of photographic technologies. KM

See also PHOTOGRAPHIC INNOVATION, ECONOMIC AND SOCIAL ASPECTS OF; TECHNOLOGY AND AESTHETICS IN 19TH-CENTURY ART PHOTOGRAPHY.

⟳ See also The Rothschild Autochromes *opposite*.

Seiberling, G., *Amateurs, Photography and the Mid-Victorian Imagination* (1986).

Collins, D., *The Story of Kodak* (1990).

Sandweiss, M. (ed.), *Photography in 19th-Century America* (1991).

Gunthert, A., *La Révolution de la photographie instantanée, 1880–1900* (1996).

Kopanski, K. W., and Philipp, C. G. (eds.), *Meisterwerke russischer und deutscher Kunstphotographie um 1900: Sergei Lobovikov und die Brüder Hofmeister* (1999).

Ruby, J., *The World of Francis Cooper, Nineteenth-Century Pennsylvania Photographer* (1999).

Sternberger, P., *Between Amateur and Aesthete: The Legitimization of Photography as Art in America, 1880–1900* (2001).

(continued on p. 30)

The Rothschild Autochromes

Lionel de Rothschild (1882–1942), the author's grandfather and namesake, supposedly described himself, only half jokingly, as 'a banker by hobby but a gardener by profession'. His passion for gardening and above all for one genus, the rhododendron, led him to create the extraordinary 250-acre woodland garden at Exbury in the New Forest between the wars. It is possible that his eye for colour and placing can be seen in, and developed out of, his earlier experiments with photography; at all events, the same careful aesthetic governed his juxtaposition of plants to avoid clashes and led to his emphasis on pure colours in his hybrids. It may even be that his love of the pastel hues stemmed in part from the essential softness of the *autochrome process, though such things can never be definitively or indeed sensibly ascribed. His understanding of light certainly remained photographic: he used to time his tours so that he would come to one particular group of red rhododendrons with the sun shining through them.

Both interests can be seen in his father Leo, who created beautiful gardens at Gunnersbury outside London and at Ascott in Buckinghamshire and who, to judge from his absence from the numerous albums in the Rothschild Archive in London, was himself a keen amateur photographer. But, as with gardening, it was Lionel who showed himself the professional, proud of his achievement. He took photographs especially for his father of Japanese-style gardens near Lake Como in Italy, which the head gardener, James Hudson, used to help him design the Japanese garden at Gunnersbury in the early 1900s, and these were shown later when Hudson lectured on its genesis to the Royal Horticultural Society. In the black-and-white collection are a number of standard-sized albums with small prints, many of them holiday snaps taken later in his life cruising the Adriatic in his yacht *Rhodora*. There are also larger albums with prints of his earlier travels, especially in Spain, and two enormous bound volumes with selected photographs printed to a high standard and enlarged, one photograph to each 35.6 × 50.8 cm (14 × 20 in) page. Many of these, including views of Spain and the Riviera, are extremely fine, showing an exceptional sense of composition and tonality.

Over 700, mostly autochrome, glass plates survive, in varying shapes and sizes—equivalent to a mere 1 per cent of the Albert *Kahn collection, but a sizeable number in anybody else's terms. Among them, first and foremost, are many fine portraits, pictures of his family and friends, some carefully posed for the camera, others insouciantly

reading. Some are identifiable, like those of his father in hunting pink, or his bride Marie-Louise Beer taken on their engagement day and then on their honeymoon in 1912. Others are not: a black-haired girl in a wicker armchair, a middle-aged man with an election rosette and a newspaper. Lionel seems to have attempted only a handful of still lifes: vases of flowers, a nicely observed close-up of lilies (carefully off centre) next to a stone seat, corn drying on a wall. His successes make one wish he had done more of this sort of photograph, but he probably did not have that kind of patience—the patience to wait years for his hybrids to flower, certainly, but not the patience to nudge a bowl of fruit or a vase of flowers. There is a series of outstanding pictures of animals, taken at London Zoo. There are landscapes, generally taken on holiday in Europe—a sunlit bay on the Mediterranean, a harbour wall crowded with people—and finally a large number of pictures of gardens, some rather less successful than others, more in the nature of recording a particular aspect or interesting planting.

The bulk of the pictures are half plate, and two of Lionel's half-plate cameras survive, still in surprisingly good working order: a Marion tropical reflex and a Ross tropical field camera, all beautifully polished teak and lacquered brass in their fitted pigskin cases, with Lionel's name on the side. There is also a collection of Zeiss lenses, finely crafted tropical double dark slides, a Wynne's Infallible Exposure Meter shaped like a pocket watch, and even some Rapid Deadmatch paper. The whole outfit is redolent of the exquisite craftsmanship and luxury of a bygone era. There is one photograph of him using one of the cameras, dressed in army uniform; but most of the plates seem to have been taken in the few years before and after the First World War.

How Lionel chose to view his pictures is not known. He installed a drop-down screen when he remodelled the house, but that was probably used later, for films sent down from London for the amusement of his weekend guests. He himself turned his attention increasingly to gardening; indeed, perhaps 90 per cent of his extant private correspondence concerns matters horticultural. He took a handful of snaps and a small amount of cine footage, but of his own garden there seems to exist not a single autochrome; his interest had moved on. DLDER

Wood, J., *The Art of the Autochrome: The Birth of Color Photography* (1993).
Boulouch, N., *Les Autochromes Lumière: la couleur inventée* (1995).

Amber. See KONTTINEN, SIRKKA-LIISA.

ambrotype. In 1852 F. Scott *Archer modified his *wet-collodion process to produce a positive image on glass by backing the pale grey-beige image of the collodion negative with black varnish, enamel, cloth, or paper. Such collodion positives were often called ambrotypes, a trade name derived from J. Ambrose Cutting, who in 1854 patented a cemented cover glass and promoted the process. Like *daguerreotypes, ambrotypes were unique images, typically small portraits presented in hinged, padded cases. However, they were easier and less expensive to produce, and were popular through the late 1850s, when they were supplanted by *tintypes and *cartes de visite. HWK

American Place, An. New York gallery founded by Alfred *Stieglitz in 1929 after the closing of his Intimate Gallery. It became a celebrated venue for modern art. Painters like Marsden Hartley, Arthur Dove, John Marin, and Georgia O'Keeffe were regularly shown. Surprisingly, only a few purely photographic exhibitions were held between the opening of the Intimate Gallery in 1925 and the closing of An American Place in 1946—a reflection of Stieglitz's broad interest in *modernism generally, not just photography. Other than shows of his own work, Stieglitz exhibited Paul *Strand in 1932, Ansel *Adams in 1936, and Eliot *Porter in 1938. TT

American West, photography and the. Since the mid-19th century the American West has repeatedly presented a challenge to photographers, both in capturing its physical character and in giving visual form to aesthetic and cultural concerns. Over time, their images have served not only to anchor a certain conception of the West in the national consciousness, but also to combine the reality of nature and

Andrew J. Russell
Railway construction in the Green River Valley, Wyoming, near Citadel Rock, 1868. Albumen print

the meanings attached to it in constantly new ways. Although in the 19th century the interest of early photographers in the West and its landscape was not primarily aesthetic, a characteristic manner of visual treatment eventually became established. This 'view tradition' shapes general perceptions of American landscape to this day.

John Charles Frémont, in collaboration with the professional photographer Solomon Carvalho (1815–99), brought several hundred *daguerreotypes of (later) Kansas, Colorado, and Utah back from his fifth expedition to the West in 1853–4. But it was after the Civil War (1861–5) that photography of the territories west of the Mississippi developed in a sustained way. Photographers like *Jackson, *O'Sullivan, *Muybridge, *Watkins, and *Weed accompanied government-sponsored expeditions and recorded their geographical discoveries with a view to economic development and the building of communications. To this extent, therefore, their pictures were part of the economic, political, and ideological process of colonization. They functioned both as topographical documents in the reports of the US Geological Survey (see attached feature) expeditions and, especially in the hands of the railway companies, as publicity for emerging tourist destinations. The popularity and spread of the images, and the professionalization of landscape photography, was closely linked to the *wet-plate process and other technical advances. By c.1890, for example, millions of stereoscopic views of western landscapes, and of newly established coastal cities like San Francisco, were in circulation. Photography, precisely in its character as a new medium, contributed decisively to the identity formation of the still youthful nation. Watkins's sublime and monumental photographs of Yosemite Valley, and Jackson's of *Yellowstone, with their suggestion of a virgin paradise, not only influenced the specific protective legislation of 1864 and 1872, but helped to form the western myth that remains a cornerstone of American identity. They also fitted the nationalistic and theological discourse, already established in relation to painting, about the landscape's elemental significance for the nation. For the photographs of virgin land in the West seemed to mirror the 'manifest destiny' that privileged America in the evolutionary narrative of democracy and civilization.

In the first half of the 20th century this romantically and pantheistically inflected conception of the western landscape was taken further by the photographs of Ansel *Adams, only to be superseded in the 1970s by the new visual language of young photographers influenced by conceptual art. In Adams's photographs, the geographical and temporal specificity of the West was abstracted into visual metaphor and a vision of nature that could be mystically experienced. Another key figure was Laura *Gilpin, who not only made breathtaking landscapes of the south-west, but whose work responded (like that of some earlier photographers, e.g. Hillers) to its human and cultural geography. Especially notable were her studies of the Navajo people at Red Rock, Arizona, in the 1930s and 1950s.

From 1970 photographers showed increasing interest in changes in the landscape. In particular, and mostly in the form of small-format image series, the alterations caused by conflict between man and nature were registered: deforestation, pollution, and the appearance of highways, tract houses, and industry. Given the 'real' West's urbanization and suburbanization, the 'mythical' West could no longer function as a symbolic counterpoise to civilization. The *New Topographics group (e.g. Robert *Adams, *Baltz, *Shore) consciously averted their gaze from the West's still untouched—because legally protected—landscapes, in order to document, as objectively as possible, the ecological problems and general denaturization of the landcape produced by human activity. More explicitly and rigorously historically motivated was the Rephotographic Survey Project of 1977–9, which compared the landscapes as captured by Jackson, O'Sullivan, and their colleagues with the modern reality. JG-P

➲ See also American West, 1867–1879 *overleaf.*

Jussim, E., and Lindquist-Cock, E., *Landscape as Photograph* (1985).
Perpetual Mirage: Photographic Narratives of the Desert West (1996).
Sandweiss, M. A., *Print the Legend: Photography and the American West* (2002).

anaglyph. See STEREOSCOPIC PHOTOGRAPHY; THREE-DIMENSIONAL PHOTOGRAPHY.

'Analytical Photography'. See GALTON, SIR FRANCIS.

anamorphic lens systems. An anamorphic image is an image that has been distorted by a geometric transformation. In photography it is usually one that has been squeezed horizontally so that a panoramic field of view can fit into a 35 mm cine format, and can be expanded optically to reconstitute a normal image for widescreen presentation. The images are rectified by projecting them through a similar optical system in reverse. Anamorphic lens attachments such as the Isco Widerama can be used for both cine and still photography. GS

anarchists. See POLICE AND FORENSIC PHOTOGRAPHY.

anastigmat. See LENSES, DEVELOPMENT OF.

ancient monuments and photography. Almost from the moment photography was invented, the world's ancient monuments became a favourite subject; just two months after the Institut de France made public the details of Daguerre's invention, Pierre-Gustave Joly de Lotbinière was on the Acropolis making photographs. There were practical reasons for the popularity of monuments as subject matter: unlike humans the Sphinx easily held still for the twenty minutes it took to make a picture. Their popularity among both photographers and collectors, however, had other reasons as well, including the development of tourism, which made early *travel photography logistically possible, and the era's fascination with ancient history; a widespread colonial attitude towards other cultures also influenced what was photographed and how. For those who purchased the photographs, in addition to proving that such wonders actually existed, images of ancient monuments offered a link with the past in the midst

(continued on p. 33)

American West, 1867–1879 Photography and the US Geological and Geographical Surveys

When armchair travellers of the late 19th century imagined the American West, their vision was profoundly influenced by the work of nineteen photographers, painters, and draughtsmen who travelled on four US Geological and Geographical Surveys of the Western Territories. Long regarded as 'merely' documentary, these rich, complex images advanced national agendas in scientific, political, and aesthetic arenas.

The photographers included William Bell (1830–1910), Jack *Hillers, William Henry *Jackson, Timothy *O'Sullivan, and Carleton E. *Watkins. They were generally perceived as technicians rather than artists, and were salaried team members from the outset, unlike the painters, who often came as guests and travelled at their own expense. Photography, a mechanical medium, modern and perceived as objective, was employed to enhance the visual record made by scientific topographers. Led by the scientists Ferdinand Hayden, Clarence King, John Wesley Powell, and the engineer George Wheeler, the earliest survey began in the summer of 1867, and ended with the creation of the US Geological Survey as a branch of the Department of Interior in 1879. Until this time, the surveys were funded by annual appropriations from the US Congress to the War Department and the Department of Interior.

Though the scientific projects of the surveys ranged from ornithology to botany, their mission was to gather topographical and geological information in enormous tracts from present-day Nebraska to California. Much of this territory had been acquired in the Mexican–American War of 1848, but was uncharted due to its vastness and the pre-Civil War view that the dry and barren terrain was largely uninhabitable. However, the pro-business administration of President Ulysses S. Grant (in office 1869–77) that promoted mining, railway construction, land investment, and resolution of the 'Indian problem' generated new energy in these areas.

Among the photographic subjects are stark, oddly shaped rocks and buttes in sublime parade; open vistas of seemingly unpopulated land behind survey team members placed in the foreground to establish scale; or lone inhabitants, Native American or Hispanic, whose presence subversively suggests a distant echo of the past reverberating in the Anglo-dominated present. These contemplative subjects in isolated locales appear alongside more populated scenes and fertile (i.e. commercially viable) settings, including camps, towns, mines, mineral deposits, waters, forests, and portraits of survey leaders and teams. All functioned as the 'publicity stills' of the surveys.

Pressured to obtain annual reappropriations from Congress, survey leaders distributed photographs to politicians and generated dynamic stories with illustrations to float their research in the public eye. Photographers made rough prints in the field, then sent several shipments each summer of glass-plate negatives to a photographer in the Treasury Department in Washington, DC. A number was

John K. Hillers

The photographer in the field, c.1870s. Albumen half-stereograph

scratched on the negative, and proof prints were made for immediate distribution. Some photographers were free to sell their images commercially and keep the profit, while others had to return a percentage of sales to their survey leader.

*Stereographs were the most popular commercial form of American photography in the 1870s. Survey subjects carried the imprints of photographic firms including E. & H. T. *Anthony, Bradley & Rulofson, J. F. Jarvis, J. J. Reilly, and Carleton E. Watkins. In 1874 and 1875 the federal government issued two catalogues listing over 2,000 negatives by Jackson that could be ordered at cost in three different size prints, including stereographs.

Photographs were also reproduced as wood-engraved or lithographic illustrations in official survey reports and popular illustrated magazines. The first was published in 1869 in *Harper's New Monthly Magazine*, 'Photographs from the High Rockies', accompanied by thirteen wood-engravings after O'Sullivan photographs. In 1874, survey director Powell was commissioned by *Scribner's Monthly* to complete the three-part series 'The Cañons of the Colorado', generously funded and with rights granted to Powell for the engraved illustrations. When the government published Powell's survey report in 1875 it featured the *Scribner's*-funded engravings after drawings by Thomas Moran and photographs by Hillers.

The survey photographers Jackson and O'Sullivan sent work to the Vienna International Exhibition of 1873. Jackson stayed out of the field in the summer 1875 season to organize the display of survey photographs for the 1876 Philadelphia International Centennial Exposition. One of the most impressive aspects of this installation in the Department of Interior exhibition at the US Government Building was a 'window-wall' on the west side of the building, made of photographic positives of landscape subjects from the Hayden and Powell surveys printed on panes of glass.

The late 20th-century American photographers Mark Klett, Ellen Manchester, Joann Verburg, Rick Dingus, and Gordon Bushaw travelled to the original sites of numerous 19th-century survey photographs in the 'Rephotographic Survey Project' (1977–9). The team made an enormous contribution to the technical and analytical record of the photographic processes employed by the early photographers, which were largely undocumented. Noting extreme camera angles, deliberate attention to time of day and shadow placement, and unusual posing of figures to demonstrate scale, Klett et al. demonstrated that the survey photographers, imbued with a sense of drama and the aesthetic of the sublime, captured scientific content subjectively rather than objectively.

In fact, while photographic historians have sometimes argued for readings of survey landscape subjects parallel to the geological and cosmological theories promoted by the survey directors, the validity of their arguments varies with the author's understanding of the history of science. As historians of science debate and revise the received view of 19th-century scientific theories and their proponents, such interpretations are compelling but warrant readers' caution. Aesthetic language, pictorially evocative, abounds in the survey reports, magazine articles, photographic journals, and photographers' writings of this period. Photographers, striving to be seen as artists, consulted with survey painters, and survey leaders promoted the artistic merit of photographic imagery with the oft-repeated term 'picturesque'. DRI

Klett, M., et al., *Second View* (1984).

Hales, P. B., *William Henry Jackson and the Transformation of the American Landscape* (1988).

Rindge, D., introd. to L. Schmeckebier, *Catalogue and Index of the Publications of the Hayden, King, Powell, and Wheeler Surveys* (1904; repr. 2000).

of rapid and sometimes destructive social and technological change, symbolizing stability and endurance, and in some cases confirming religious belief. At the same time the photographs helped to shape understanding of the cultures that produced the monuments, and even permitted a piece of that culture to be possessed; locations like Egypt came to be defined by their ruins and archaeological sites as the monuments were repeatedly photographed, forever trapping the country and its people in the past for the delectation of Europeans. Many photographers recorded monuments for commercial reasons, but others were scientifically motivated. In the 1840s the antiquarian and traveller Eugène Piot (1812–91) devised an elaborate scheme to document the world's ancient sites and works of art. Though he hoped to make money by publishing engravings made from the photographs, his project was also intended to be a comprehensive survey of historic monuments, the first such project attempted. In June 1851 Piot published *L'Italie monumentale*, and there the project ended in financial disaster, perhaps because Piot's reproductions looked too much like lithographs, a distinctly old-fashioned medium

by that time. Subsequent projects were better organized and more successful, including Maxime *Du Camp's 1851 excursion to the Middle East, and the French government's *Mission Héliographique, which sought to record the appearance of historic structures as the prelude to preserving them.

Well before the end of the 19th century, vast numbers of ancient monuments had been photographed (often in stereographic form), from Jerusalem to the ruins of Angkor. Other, more remote sites had to await further exploration in the 20th century, and technological innovations such as *aerial and *underwater photography. MR

See also ARCHAEOLOGY AND PHOTOGRAPHY; POIDEBARD, ANTOINE.

Andreyev, Leonid (1871–1919), Russian writer, painter, and amateur photographer. After working as a journalist he became a successful author of stories and plays and, for a while, a friend of Maxim Gorky; he also entered radical politics. Having earlier taken black-and-white *stereoscopic photographs, he became a devotee and master of the Lumière *autochrome process from *c.*1908.

His *c.*400 surviving plates include handsome self-portraits and pictures of his second wife Anna, nude and clothed, his children, literary friends, and landscapes around his house at Vammelsuu near St Petersburg, and abroad. In the most successful ones, flowers, foliage, skin tones, and the play of light and shadow are rendered with extraordinary delicacy. Andreyev opposed the Bolshevik seizure of power in 1917–18 and died in Finland; *c.*300 of his autochromes are held by Leeds University. RD/RL

Davies, R., *Leonid Andreyev: Photographs by a Russian Writer* (1989).

Angkor. See INDO-CHINA.

angle of view. This term is often confused with *angle of field* and *field of view*. The angle of view is the (diagonal) angle subtended by the scene captured in the photograph. This establishes the disc of best definition required for the lens. The angle of field is the angle subtended at the lens rear nodal point by the diagonal of the format itself. In a rectilinear image this is the same as the angle of view, but not for anamorphic images such as those produced by *fisheye lenses. 'Field of view' simply describes the area covered in a scene. For example, although the angle of view of a fisheye lens is 180 degrees, its angle of field may be as low as 90 degrees. The field of view may be described as 'horizon to horizon'. For a standard (prime) lens the angle of field is typically 50–55 degrees, the same as the angle of view, and the field of view is roughly the same as that of the eye in a normal viewing of a scene or a picture. GS

Anglo-French photographic links, mid-19th century.
In spite of a politically imposed context of nationalistic rivalry that overshadowed the invention of photography, information always flowed freely between France and England, stimulating the technical and artistic growth of the medium. Scientists, already linked professionally through their prestigious national academies, were the first to contribute to this interchange. Jean-Baptiste Biot of the French Academy of Science reported to *Talbot on developments in France. The English astronomer and photographic pioneer Sir John *Herschel visited France to study *Daguerre's invention first hand, and sent news and opinions gathered there to Talbot.

During the early 1840s, commercial ventures were another context for international exchange. *Daguerreotype practitioners were quickly at work in London. These included Antoine *Claudet, a French expatriate who was an active member of photographic circles in both countries through the 1860s, and an important contact for French photographers visiting London. Talbot himself formed a business partnership with a French entrepreneur, the marquis de Bassano, to exploit the *calotype method in France. Although unsuccessful, the business brought paper-negative photography to France, and was a reference for photographic print manufacture in England and France. By 1851 *Blanquart-Évrard of Lille had created a successful print works for paper photographs. Over the next four years he commissioned negatives from French and British photographers alike, and commercialized prints and albums through dealers on both sides of the Channel.

Ultimately, amateurs were the most important links between the two countries. Travelling to the Continent, British calotypists like Calvert *Jones met and shared information with their French counterparts in Paris, and in travel destinations like Rome, Egypt, and the Near East. Roger *Fenton, a devoted Francophile who had, like many of the first great French photographers, studied painting in the atelier of Paul Delaroche, was another crucial intermediary. Fenton used the first French photographic society, the *Société Héliographique, as a model for the Photographic Society of London, founded in 1853. The photographic societies were an ideal environment for a sophisticated and learned international membership to exchange ideas. (Gustave *Le Gray's remarkable seascape *The Brig* was shown at the Photographic Society on 6 November 1856.) Their journals, such as La *Lumière*, the *Bulletin de la Société Française de Photographie*, and the *Journal of the Photographic Society*, were sources of both information and debate. All techniques of photography—old and new, British and French—were now readily accessible, and amateurs often used several methods concurrently.

The important international exhibitions of the 1850s, such as England's *Great Exhibition (1851) and France's Exposition Universelle (1855), unlike earlier industrial exhibitions, were showcases for photographic imagery as well as equipment. The best photographers of the period exhibited their work. Critics wrote passionately about photography as a new pictorial art, and discerned specifically English or French sensibilities in the images. By mid-century, then, the medium of photography had become truly international, leaving the expression of national character to the art of photography. NK

Keeler, N., 'Souvenirs of the Invention of Photography on Paper', in *Photography: Discovery and Invention* (1990).
Keeler, N., 'Inventors and Entrepreneurs', *History of Photography*, 26 (2002).

animals. See PETS; WILDLIFE PHOTOGRAPHY; ZOO PHOTOGRAPHY.

Annan, James Craig (1864–1946), Scottish photographer, son of Thomas, and at the turn of the 19th century an international figure in photography's battle for recognition as an art in its own right. His work was exhibited in Europe and the USA and widely reproduced in photographic journals. In 1894 he was elected to the *Linked Ring. His article on the hand camera in *Amateur Photographer* of March 1896 was republished in France and Belgium and quoted by *Stieglitz in the 1897 *American Annual of Photography*.

Annan specialized in the reproduction of works of art in the Glasgow family firm, T. & R. Annan, using the *photogravure process he had learned from Karl Klič (Klietsch). He manipulated his own images on the photogravure plate before they were printed. The figures in his tiny *Beach at Zandvoort* (1892) almost resemble notes of music along a slanting line. He caught the slight movement of a white horse below *Stirling Castle* (1906), and the glance of *The Etching Printer:*

Thomas Annan

Close nr. 101 High St., Glasgow, 1868–71. Albumen print

William Strang (1902) assessing his etching plate. His portrait of C. R. Mackintosh has become the icon for the architect and designer. *Anne Macbeth* (*c.*1908) appears in full Glasgow style, her collar heavily embroidered with hearts and roses. About 1890 Annan made photogravures of *Hill and Adamson calotypes, and by lending these to exhibitions and supplying prints to *Camera Work* he helped in the rediscovery of these early masterpieces. WB

Buchanan, W., *The Art of the Photographer J. Craig Annan* (1992).

Buchanan, W., *J. Craig Annan: Selected Texts and Bibliography* (1994).

Annan, Thomas (1830–87), Scottish photographer, active in Glasgow. Trained in engraving and lithography, Annan became a photographer in 1855. A friend of D. O. *Hill, he was responsible for photographing, with a camera specially constructed by *Dallmeyer, Hill's huge painting *Signing the Deed of Demission*, then having it reproduced in 1866 by Swan's *carbon process, the first major use of this new permanent process. When another, *photogravure, was discovered he took his son James to Vienna to learn it from the inventor, Karl Klič (Klietsch). The firm, T. & R. Annan, gained a high reputation for its reproduction of works of art.

The city of Glasgow commissioned Annan to record two huge civic undertakings. The first was the task of bringing clean water 56 km (35 miles) into the city, which he captured in *Photographic Views of Loch Katrine* (1889). The second was the demolition of disease-ridden slums. Annan produced a set of stark, powerful images which occasionally include slum dwellers. Those in *Close, Nr. 118 High Street* look us in the eye. Four editions, each entitled *Old Closes & Streets*, or similar, were published: *albumen (1871); carbon (1877); and two photogravure versions (1900).

Annan was a fine portraitist. The missionary and explorer David Livingstone is photographed in the restrained manner of Hill and Adamson. Annan's landscapes of the 1860s, including *Aberfoyle* and *The Last Stooks of Harvest*, were acclaimed at exhibitions. WB

Stevenson, S., *Thomas Annan 1829–1887* (1990).

McKenzie, R., 'Thomas Annan and the Scottish Landscape', *History of Photography*, 16 (1992).

anonymous photography might well be seen simply as work whose authorship has not yet been identified by curators or photohistorians. This definition, which covers large numbers of images—some, like the *daguerreotypes of *Cromer's Amateur, of outstanding quality—in public and private collections, is not incorrect; but it is incomplete.

Anonymous pictures—which should not simply be confused with amateur *snapshots—are an essential part of the vast corpus of images studied by photographic historians. They remind us that one of photography's specific features is that it is practised by run-of-the-mill professionals, scientists, experimenters, and amateur enthusiasts; on a vast scale, therefore, by practically anyone, and for extremely varied reasons. Photographic history's evolution over the past two decades has led to these images being recognized as significant, even if nothing

is known about who made them or in what circumstances. Publishers and museums now treat them on an equal footing with work by recognized artists. Arguably, indeed, anonymity is so fundamental to the nature of photography that samples should be presented in relation to practically every subject.

The most striking examples of the aesthetic of anonymous photography are amateur snaps, made en masse since the end of the 19th century, and whose richness and originality have been demonstrated by various books and exhibitions. In the collector Thomas Walther's words, 'These photographs remind us that the camera can be an extension of genius in the hand of any one of us.' SA

Fenoyl, P. de, and Laurent, J., *Chefs d'œuvre des photographes anonymes au XIX. siècle* (1982).

Heilbrun, F., Néagu, P., and Marbot, B., *L'Invention d'un regard* (1989).

Nickel, D. R., *Snapshots: The Photography of Everyday Life, 1888 to the Present* (1998).

Other Pictures: Anonymous Photographs from the Thomas Walther Collection, introd. M. Fineman (2000).

Anschütz, Ottomar (1846–1907), German photographer and inventor. The son of a decorative painter, Anschütz learned photography from Franz *Hanfstaengl and others in Munich before returning to Lissa in Poznań (today Lescnow, Poland) in 1868 to establish a studio. In 1882 he developed a practical *focal-plane shutter, often taking long series of pictures that recorded a complete activity in a manner usually identified with the 35 mm photographers of the mid-20th century. Memorable pictures of storks established his European reputation, and from 1885 he made multiple-plate *chronophotographs of up to 24 sequential images of horses and riders, later also of other animals and gymnasts. In late 1886 he devised his first 'Schnellseher' (known also as the Electrical Tachyscope) to reproduce the movements captured by his chronophotographs, and over the next decade *c.*170 machines were made, and exhibited throughout Europe and North America. His undercapitalized exhibition business, the Electrical Wonder Co. of London, failed in 1893 and Anschütz returned to still photography, designing several influential hand cameras made and sold by C. P. Goerz & Co. of Berlin into the 1920s. He also taught photography to the family of Emperor Wilhelm II, and supported amateur photography at an extensive Berlin studio. He was the first photographer admitted to the annual Berlin Art Exhibition (1899). But his reputation was eclipsed by the coming of modernism, and by the 1920s he was barely remembered. DR

Rossell, D., *Faszination der Bewegung: Ottomar Anschütz zwischen Photographie und Kino* (2001).

Anthony, Edward (1819–88) and **Henry T.** (d. 1884), American photographic entrepreneurs. Edward graduated as a civil engineer from Columbia University in 1838, but by 1842 had learned the *daguerreotype process from Samuel *Morse and opened his first 'daguerrean studio' in New York. He used both his engineering and

Anon.

British ship's cat, c.1906. Albumen print

Anon.

Scottish family group, c.1890s. Cabinet print

photographic skills when he worked on the border survey between Maine and Canada that resulted in the Webster–Ashburn Treaty of 1842. He had retired from active daguerreotyping by 1847, and thereafter was involved exclusively with the sale of photographic apparatus, supplies, and images. In 1847 he met Henry *Talbot to explore the idea of acting as the latter's agent for the *calotype patent in America, but the deal never materialized. During the Civil War, Edward Anthony was the largest publisher of images by Mathew *Brady and other prominent photographers. The partnership he eventually formed with his elder brother Henry became the largest photographic supplier in America, offering all the materials needed to build and operate a studio. The business continued after the brothers' deaths, and in 1902 merged with its largest competitor, the Scovill Manufacturing Co., and became Ansco. RW

Marder, W. E., *Anthony: The Man, the Company, the Cameras* (1982).

anthropology has used photography as a research tool since its emergence as a discipline in the mid-19th century. Arguably the two have an intertwined history, as photography authenticated and made concrete anthropological observation within the contexts of positivist science.

Nineteenth-century 'anthropological photography' is difficult to define. The emerging discipline included investigators with interests in anatomy, philology, archaeology, history of religion, biology, and geology. The production of photography was equally eclectic. Few anthropologists made their own photographs; rather, they collected material from many different sources or commissioned photographers to take pictures for them. Photographs produced in different contexts and for many different purposes were absorbed into the discourses of anthropology. Within a theoretical framework that saw culture as biologically determined, a wide range of images could be read through

Diamond Jenness

Malitauya men touring their new canoe to display it to their neighbours, D'Entrecasteaux Island, Papua New Guinea, 1911–12

racial and evolutionary spectacles, and became 'anthropological' through reception rather than specific intention. The production of these images was closely related to *colonial photography, and many anthropological collections now hold 'ethnographic photographs' from commercial photographers such as Andrew (Samoa), the *Burton Brothers (New Zealand), Middlebrook (South Africa), Zangaki (Egypt), or *Stillfried (Japan), who were selling the same images to tourists and scientists alike.

While such practices continued until the end of the 19th century, by the 1870s there were serious efforts in Britain, France, Germany, and the USA to improve both the quality and quantity of data available to those with anthropological interests. Photography was integral to this. Two types of photographs increasingly diverged from the late 19th century on: the anthropometric; and less structured images of cultural subjects. There were marked national differences both in photography and in photography collecting within anthropology, reflecting differences both in scientific organization and research styles and in types of colonial ethos. In France, for example, anthropological photography was influenced by the physical anthropology interests of Paul Broca (1824–80) and later Paul Topinard (1830–1911). A similar situation pertained in Germany, whereas in Britain cultural anthropology became a main focus at an earlier date, and in the USA both traditions were strong.

However, the 'truth value' attributed to various forms of photography had shifted by the end of the 19th century. Valued increasingly was direct observation by trained scientists rather than serendipitous gleanings, no matter how well informed. This shift was reflected strongly in both the production and consumption of photographs within anthropology, where the authority of photographs was related to the quality of scientific observation on the part of such leading sociologists and anthropologists as Herbert Spencer (1820–1903), Franz Boas (1858–1942), Alfred Cort Haddon (1855–1940), and later Bronislaw Malinowski (1884–1942). Although there were, again, national differences in the precise way this manifested itself, the overall trend is similar. Rather than just collecting discrete images, anthropologists sought coherent series to establish an anthropological narrative reflecting their fieldwork research interests.

In the production of ethnographic data, photography has conventionally been used as an inventory or survey tool. In many cases, especially in the 19th and early 20th centuries, it was seen as an instrument of 'salvage ethnography': the recording of cultures believed to be dying out or undergoing irrevocable cultural change in the face of colonialism and assumed evolutionary decline. This was the impetus for photography on the Cambridge Torres Strait Expedition in 1898 and the Jesup Expedition to the Pacific (1897–1902), both of which had intensely visual agendas.

Yet a distinction must be made between incidental, quasi-ancillary use of photographs as a form of visual notation, however rich individually—for instance, E. Evans-Pritchard's (1902–73) mid-1920s pictures of witch-doctor initiation amongst the Azande—and

rigorously structured visual enquiry in which both subject matter and interpretation are conceived in terms of visual communication. Perhaps the most famous example of the latter is Margaret Mead (1901–78) and Gregory Bateson's (1904–79) 1936–8 work on socialization and child development in Bali. They produced over 25,000 35 mm photographs as well as 6,700 m (22,000 ft) of cinematograph film. The idea of unmediated, scientifically motivated photography within structured anthropological enquiry was crucial: in Bateson's words, 'We treated our cameras in the field as recording instruments, not as devices for illustrating our thesis.'

Influenced by the documentary movement, the use and study of photography in anthropology has, since the Second World War, been developed into the sub-discipline of visual anthropology by practitioners such as John Collier and Jay Ruby. Thinking about photography in relation to anthropology has become increasingly complex and theoretical. Although many visual anthropologists prefer working with film, there continues to be strong interest in still photography. This may focus on its use as a research tool with which to explore specifically anthropological questions about, for example, gender, ritual processes, or ethnicity; or to elicit information. Or it may take the form of critical study of the social and cultural processes involved in photographic production and representation themselves; either in the past (e.g. the analysis of 19th-century racial imagery), or as a contemporary practice in different parts of the world (e.g. what is specifically Ghanaian about modern photography in Ghana?). Although photography is now a global phenomenon, photographers' social role and the meanings and uses assigned to the photographic image vary from culture to culture. So do understandings of concepts such as 'realism'. Further research may both extend empirical knowledge in these areas and underscore the limitations of classical (Western) theoretical approaches to the medium.

If photography as a form of investigation has been partially eclipsed by film, and somewhat undermined by theoretical misgivings, it has in recent decades found a new relevance in anthropology. On the one hand, the exploration of photography has become integral to the understanding of anthropology's own history. On the other, it has made substantial contributions to debates on the role of anthropology in the modern world, and to the politics of representation in a decentred, multi-vocal modern practice, in which the disciplinary objectivity assumed by previous generations has been called in question. In these contexts anthropologists have become interested in forms of cultural description created outside the discipline but in a spirit of visual enquiry. Anthropologists have written about documentary photographers as diverse as Martin *Parr, Sebastião *Salgado, and Susan *Meiselas. Similarly, anthropologists have become interested in the photographic work of contemporary Aboriginal or First Nation photographers and artists. In the early 21st century, the work of artists such as Greg Semu (Samoa), Tracey *Moffatt (Australia), Hulleah Tsinhahjinnie, Shelley Niro (USA), or Edward Poitras (Canada) often radically confronts the categories

of race and culture which anthropology had helped to construct
in the past. EE

Banta, M., and Hinsley, C., *From Site to Sight: Anthropology, Photography and the Power of Images* (1986).

Collier, J., and Collier, M., *Visual Anthropology: Photography as a Research Method* (rev. edn. 1986).

Edwards, E. (ed.), *Anthropology and Photography 1860–1920* (1992).

Edwards, E. (ed.), 'Anthropology and Colonial Endeavour', *History of Photography*, 21 (1997).

Sullivan, G., *Margaret Mead, Gregory Bateson and Highland Bali: Fieldwork Photographs of Bayung Gedé, 1936–1939* (1999).

Edwards, E., *Raw Histories: Photographs Anthropology and Museums* (2001).

Peterson, N., and Pinney, C. (eds.), *Photography's Other Histories* (2003).

Aperture (and Aperture, Inc.). The idea for a new journal of
contemporary photography was first broached at the Aspen
Photographers' Conference in the Hotel Jerome in 1951. Ansel
*Adams, Melton Ferris, Dorothea *Lange, Ernest Louie, Barbara
*Morgan, Nancy and Beaumont *Newhall, Dody Warren, and Minor
*White saw the idea to fruition, with White chosen as editor. The first
issue appeared in 1952. Differences of opinion over the aesthetic and
ideological direction of the journal arose, however, and many of the
initial backers eventually withdrew. But White carried on with the
support of Shirley Burden, a wealthy Californian businesswoman.

For much of its history *Aperture* was a reflection of White's
philosophical and strongly spiritual ideas. Through it the idea of
'reading' photographs was conceived by Henry Holmes Smith,
White, and others. Later, paralleling the emergence of Abstract
Expressionism and the San Francisco Beat movement, and influenced
by Zen, Taoism, and other philosophies, White articulated his idea
of photography as a 'way' to spiritual enlightenment.

Aperture was revived by Michael Hoffman following White's
departure in 1964. Under Hoffman's leadership, Aperture
Foundation, Inc. expanded to become a publisher of books
as well as the magazine. TT

Photography Past Forward: Aperture at 50 (2002).

aperture control. Its purpose is to regulate the amount of light
reaching the focal plane, to control the depth of field of the lens, or to
utilize the best characteristics of a lens, which are usually at less than
maximum aperture. Various methods have been used. The first was to
place a simple washer in front of the lens. These 'pill box' lenses were
superseded in 1858 by John Waterhouse's idea of inserting metal strips
with a cut-out hole into the lens barrel. Waterhouse stops were adopted
by manufacturers from the 1860s. Wheel stops, where a rotating,
perforated disc was mounted in front of the lens, were popular from
the 1850s to 1880s. The iris diaphragm, used for photography as early
as 1840 but not widely taken up until 1886, had by 1914 overtaken
all other forms of control. (But many simple amateur cameras had
either no aperture control or a simple sliding strip-stop with two
cut-out apertures.) Various aperture scales were used by different
manufacturers, but the f-number—the ratio of the focal length to the
diameter of entrance pupil—found favour from the early 1880s, with
the standard international sequence of f/2, f/2.8, f/4, f/5.6, f/8, f/11,
f/16, f/22, f/32 being adopted in the UK from 1949. Lens makers have
sought to produce lenses of ever-wider aperture, and Canon made the
world's widest aperture lens, of f/0.95, in 1961. However, few standard
production lenses exceed f/1.8.

In practical terms, an increase or decrease of exposure by 'one stop'
represents respectively a doubling or halving of the exposure; 'two
stops' is a quadrupling or quartering; and so on. The actual stops
decreased in area in steps of one-half, and so their diameter decreased
in a ratio of $\sqrt{2} : 1$, hence the f-number series f/4, f/5.6, f/8, f/11, etc.,
each representing a halving of the light passing through the aperture.
In terms of aperture, then, 'one stop down' is the difference between,
say, f/8 and f/11; in terms of exposure duration, between, say, 1/125 s
and 1/250 s; in terms of film speed, between, say, ISO 400 and ISO 200;
and in terms of filter factors, between, say, ×2 and ×4. MP/GS

aplanat, lens corrected to minimize chromatic and spherical
aberrations even at a wide aperture. Hugo Adolph von Steinheil
(1832–93) is credited with having introduced the first one in 1866. RL

Arabian Peninsula. See MIDDLE EAST.

Arago, François (1786–1853), leading French physicist and
republican deputy, and a key figure in the public launch of the
*daguerreotype. Having met *Daguerre in 1838, it was he who first
introduced the discovery at the Academy of Sciences on 7 January 1839
and, in accordance with his political convictions, skilfully arranged
that the French government should acquire the process and make it
available to the world. In the 1840s he continued to promote the
technique at the Academy. QB

McCauley, A., 'François Arago and the Politics of the French Invention of Photography', in D. P. Younger (ed.), *Multiple Views: Logan Grant Essays on Photography* (1991).

Araki, Nobuyoshi (b. 1940), Japanese photographer and
multimedia artist, born and resident in Tokyo. A prolific producer of
photo books (over 100), by the close of the 20th century Araki had
become Japan's most famous photographer. He began his personal
work during off hours from his job at the advertising agency Dentsu.
In 1964 he received the Taiyo Prize (founded that year) for the series
Satchin and his Brother Mabo. The year 1971 saw the appearance of
his privately published *Sentimental Journey*, an intimate record of
his marriage to and honeymoon with his wife Yoko (who died in 1990).
He went freelance in 1972, and throughout the 1970s self-published
numerous xeroxed photo albums. He is best known for his nudes and
explicit sexual images, often involving bondage. Shown by major
museums, these works have stimulated debate and sometimes brought
clashes with the authorities in Japan and abroad. But his oeuvre also
comprises flower studies, landscapes, and portraits. 'Erotos', a word
invented by Araki combining *eros* (love) and *thanatos* (death), defines

Nobuyoshi Araki

From *Sentimental Journey*, 1971

the major theme in his work. In Japan, he is commonly called 'Ararchy' (Araki/anarchy), a term also coined by himself. Declaring that every photograph is intimate, a kind of 'I-photograph', he also makes 'false series', putting false dates on photo prints which disrupt our definitions of reality and fiction. MHV

 Araki by Araki: The Photographer's Personal Selection (2003).

Arbeiter-Fotograf, Der, monthly journal of the Association of German Worker-Photographers (Vereinigung der Arbeiterfotografen Deutschlands), founded in Erfurt in 1926 and affiliated to the German Communist Party (KPD). The association's aim was to promote photographic activity among workers and create a source of 'proletarian' images—independent of bourgeois agencies—for the *Arbeiter illustrierte Zeitung* and other KPD papers. The journal, produced in Berlin and distributed to the association's *c*.2,000 members, disseminated technical information and organized exhibitions and competitions. It closed down after the Nazi seizure of power in January 1933. RL

Arbeiter illustrierte Zeitung (*Workers' Illustrated Newspaper* (*AIZ*); 1925–33), German illustrated weekly (from 1926) founded by the communist propagandist Willi Münzenberg (1889–1940) and affiliated to the German Communist Party. With a circulation of *c*.250,000 (1927) and a layout comparable to that of the bourgeois illustrated press, it was German-speaking Europe's leading far-left paper. It published numerous *photomontages by John *Heartfield and, in September 1931, the Soviet photo-essay *A *Day in the Life of a Moscow Worker*. It closed on 5 March 1933 following the Nazi seizure of power, but reappeared in Prague and Paris as the *Volksillustrierte*. RL

 Gruber, H., 'Willi Münzenberg's German Communist Propaganda Empire', *Journal of Modern History*, 38 (1966).

Arbus, Diane (1923–71), American photographer, born in New York. Her father, a wealthy department-store owner, provided her and her brother, the poet Howard Nemerov, with a comfortable if insular upbringing. She married young and, following the Second World War,

with her husband Allan Arbus ran a successful photography business, specializing in portraiture and fashion. By the late 1950s she was working independently and had become known for her magazine work. She studied with Lisette *Model for a time, but also rode with *Weegee through the city's seamy nights. Recognized by John *Szarkowski as a unique talent, Arbus was included in a show of new acquisitions at the Museum of Modern Art in 1965 and appeared at MoMA again in 1967 in the influential *New Documents exhibition. Her notoriety, as a photographer of odd, vulnerable, and marginal people, grew. Arbus herself was increasingly troubled, and committed suicide in 1971. The following year she was included in the Venice Biennale, the first photographer so honoured.

In many respects Arbus embodies the major elements of much that was happening in photography in the mid-20th century. She was a photojournalist; but, introspective to a fault, was also photographing herself while ostensibly photographing others. Her most bizarre subjects at first sight often provoke a sequential reaction: gawking, followed by an attempt to come to terms with what one has just done. Perhaps more than any other photographer, Arbus has prompted us to deal with our natural inclination to want to stare—without giving it up.

Some who knew Arbus in New York as her celebrity grew saw her compulsive aggressiveness as essentially that of a *paparazzo. But Walker *Evans, more kindly, said of her: 'Her distinction is in her eye, which is often an eye for the grotesque and gamey; an eye cultivated just for this to show you fear in a handful of dust.' TT

Arbus, D., and Marvin, I. (eds.), *Diane Arbus, Magazine Work* (1984).
Bosworth, P., *Diane Arbus: A Biography* (1984).
Hulick, D. H. (ed.), 'Diane Arbus', *History of Photography*, 19 (1995).

Arbuthnot, Malcolm (1874–1967), British *pictorialist photographer, and painter, who combined both interests by using *gum and oil pigment processes. He joined the *Linked Ring in 1907 and produced increasingly controversial anti-naturalistic, almost abstract gum prints. He was the only photographer to sign Wyndham Lewis's Vorticist manifesto *Blast* in 1914. He marketed pigment paper, managed Kodak's Liverpool branch in 1912, and established a portrait studio in New Bond Street, London, in 1914. He moved to France in 1926, but settled finally in Jersey. JT

Harker, M. F., *The Linked Ring: The Secession Movement in Photography in Britain, 1892–1910* (1979).

Archaeological Survey of India (ASI), governmental organization, established in 1870, dedicated to the preservation and conservation of the archaeological antiquities of *India. Its first director, Major-General Alexander Cunningham, encouraged the use of photography as a tool for recording and preserving. Significant work was produced by Cunningham's assistant J. D. Beglar (1845–1907), but Cunningham also purchased work by commercial studios and amateur photographers such as Robert *Gill. Some photographs were specially commissioned, following lists of significant sites drawn up by the Scottish architectural historian James Fergusson. Cunningham's successor, James Burgess, also regarded photography as an integral part of the ASI's work, issuing progress reports illustrated with photographs in the 1870s. During the 19th century, the photographs acquired by the ASI were collected at the India Museum in London. Today this substantial collection survives in the British Library. The collection also incorporates work by earlier photographers such as Linnaeus *Tripe. The early 20th century saw a shift away from picturesque views of antiquities towards a more scientific documentation of the archaeological process under director John Marshall. These photographs are also preserved in the British Library. The photographic archive of the post-1948 ASI is held in New Delhi. SCG

See also ARCHAEOLOGY AND PHOTOGRAPHY.

archaeology and photography. Photography radically changed earlier pictorial conventions by offering reliable representations of observed phenomena, and its ability to 'surpass the works of the most accomplished painters, in fidelity of details and true reproduction of the local atmosphere' was noted as early as 1839 by François *Arago. It was adopted by observational sciences such as archaeology on the assumption that the optical, mechanical, and chemical features associated with it were largely independent and free of the selective discrimination of the human eye and hand. The camera has been systematically used as a recording device within the discipline, although the observed archaeological reality which it supposedly captures was a creation of disciplinary requirements and has always involved conscious manipulations of photographic technique.

During the 19th century, investigations of the past were strongly tied to antiquarian fascination with Old World civilizations and Western colonial interests. Ancient ruins and art objects were among the first images to be photographed after the technology became available. They were widely circulated by commercial and amateur photographers, and, in an age of imperialism, catered to growing popular interest in other cultures and early civilizations. *Daguerreotypes of Egyptian monuments (e.g. the harem gate of Mehmet Ali in Alexandria) created in 1840 by Horace Vernet and Frédéric Goupil-Fesquet mark the beginning of a remarkable chapter in the production of architectural records through photography. The concerns of colonial governments (mainly European) stimulated scholarship and research on colonized people and their histories, and led to various projects to document the subjugated world. An early example of photography's systematic use to record a colonized terrain is from the Indian subcontinent where, from 1855, the East India Company initiated a project of photographing major historical monuments in the western and southern regions. Although this was short-lived, the rich corpus of architectural photographs taken by officers of the company was assimilated into the archives of the *Archaeological Survey of India, a bureaucratic organization formally established in 1870. These remain invaluable sources for the architectural history of the country.

Patricia Macdonald *Burnt Moorland: Grouse Shooting, Perthshire, Scotland, 1998–9,* from the series *The Play Grounds*

Patricia Macdonald From *The Sonnets to Orpheus*, 1995

Developments in photographic technology between the 1850s and 1880s made it progressively cheaper and easier to use, and permitted the large-scale replication of images. By then, photography had superseded other forms of recording practices, such as sketching, painting, and model making. Some of the earliest examples of photographs taken during archaeological excavations date from 1873–85, from the jungles of Yucatán (Mexico), by the antiquarians and mystics Augustus (1826–1908) and Alice le Plongeon (1851–1910). By scrupulously photographing their discoveries under trying conditions and publicizing their photographs, the couple had hoped to win fame and fortune, although they died in penury. Forty years later, in the 1920s, photographs of the excavations of Tutankhamun's tomb in Egypt and the Royal Cemeteries in Ur (modern Iraq) played a significant role in generating public enthusiasm and support for archaeological activities in the respective regions. The relationships forged between archaeology, *tourism, and heritage in the early 20th century were largely formalized through photography, and the *Illustrated London News* registered this interdependence consistently until the 1940s. In 1923, referring to the tourist invasion of the Valley of the Kings, it commented that 'the incessant click of the ubiquitous Kodak indeed must be a sound as familiar there as the constant creaking of the crude water wheels which abound in the locality'.

From the late 19th century, photography became central to systematic methods of excavating that were being developed to promote archaeology as an empirical science. The camera became an essential tool for recording excavation procedures and, with drawings of site maps, trench sections, and artefacts, photographs taken in the field formed an important corpus of material, accepted as depicting facts. Excavation photographs are still used for cross-referencing analyses and illustrating reports and lectures. They are treated as material objects incorporating valuable information and—although this 'commodity' role within the discipline has been largely overlooked—often circulated and exchanged as such.

Frederick Ward Putnam's (1839–1915) excavations of the Indian Mounds in the Ohio River Valley (1882–6) are an early example of archaeology's systematic engagement with photography to record all aspects of an excavation. Endorsing the maxim that 'to dig is to destroy', Putnam followed a cautious method of trenching and slicing, and ordered his helpers to undertake careful photography at every stage. The glass-plate negatives developed in the field served as sources for line engravings for Putnam's scholarly articles. They were copied on to lantern slides that he used for teaching and fund-raising both locally in Ohio and in the Boston area.

Photography was systematically drawn into archaeological excavations through the pioneering work of Lieutenant-General Augustus Pitt Rivers (1827–1900), who used the camera extensively between 1880 and 1895 to document his *Excavations in Cranborne Chase*. In fifteen years, Pitt Rivers transformed the hobby of barrow digging into a rigorous scientific pursuit. His lavishly produced reports, recording his excavations at Woodcuts and Rotherley, Woodyates, Wor Barrow, Bokerley Dyke, and Wandsdyke, included not only detailed contour maps, drawings, and lithographs of mounds and unearthed artefacts, but also photographs of the actual spadework, and of every object and skeleton *in situ*. The total of 317 photographic plates included in the four volumes were aimed at conveying the precision, and emphasizing the merits, of his scientific techniques.

Pitt Rivers understood that visual evidence was crucial for attesting his claims of obtaining high standards of accuracy in his excavations. He and Putnam were both able to show how photography could produce a document of systematic fieldwork, and to achieve this end they consciously experimented with the technology. Rules for archaeological photography that were subsequently formulated in the early 20th century stemmed from their work. These demonstrate how conditions on the ground were manipulated to provide a clear view of the excavated surface and finds, and were formulated after exhaustive experiments with the photographic apparatus.

Flinders Petrie (1881–1946), the renowned excavator in Egypt and Palestine, was one of the first professional archaeologists to discuss at length correct procedures for archaeological photography. He allocated an entire chapter to the subject in his seminal manual on archaeological practice, *Methods and Aims of Archaeology* (1904), providing guidelines for the preparation of objects for photography, lighting, choice and direction of cameras, shutter speed, and procedures for the development of glass-plate negatives. Twenty years later, Mortimer Wheeler (1890–1976) established standards for archaeological photography, through his excavations of Roman forts and towns in Wales and England (1922–38), that are still followed today. With the camera, Wheeler produced strong, clearly defined images of excavations directing the viewer's eye to aspects of fieldwork he wanted them to see. The excavation report on Maiden Castle, Dorset, is a classic example (1943). Wheeler also introduced many new types of excavation image. Photographs of pottery yards, removal of artefacts from their find spots, and payment of wages to labourers became common from his time.

In the early 20th century, the use of *aerial photography revolutionized field observations and initiated the study of settlement archaeology. Although the possibility of taking photographs from a non-captive balloon was conceived between 1880 and 1887, the first successful such aerial photograph was taken in 1906 of Stonehenge, from a military balloon, by Lieutenant P. H. Sharpe. In 1913 Henry Wellcome developed Sharpe's methods and successfully created large box kites with specially devised automatically controlled cameras for photographing the archaeological sites and his own excavations in the Upper Nile region of the Anglo-Egyptian Sudan. The impetus given by the First World War to aerial photography led to rapid developments in the principles of aerial archaeology. One of the pioneers, the French Jesuit Antoine *Poidebard, in 1925–32 used aerial observation to trace ancient caravan routes leading to Roman frontier defences in the Syrian deserts. In 1936 he also discovered many new forts and roads, and an ancient harbour beneath the sea at Tyre (Lebanon); its partial excavation with the help of divers was one of the first successful investigations of an underwater site.

Throughout the 20th century, photographic technology has been variously used in archaeological investigations. Stereoscopic photography and *photogrammetry have permitted greater accuracy in the reading of inscriptions. The photomicrographic technique, scanning electronic microscopy (SEM), has allowed detailed artefact analyses providing, for example, information on their manufacturing techniques and constituent materials. Sophisticated methods of photoanalysis have made photography all the more crucial to modern archaeological research and interpretation.

Like field notes of site excavations, archaeologists have extensively used their photographic archives for reference. Nineteenth- and early 20th-century photographs of ancient sites and ruins have been widely used for conservation projects, as these photographs sometimes recorded features that have since been lost, destroyed, or altered. One example of the value of early photographs for later archaeological work is from Copan (Honduras), where pictures taken during the exploration of the classic Mayan sites in 1891–3 were the only reliable sources available to the archaeologists of the Carnegie Institute for rebuilding the 2,500-glyph-block stairway in 1931.

Archaeological photographs reveal clearly, and at times more extensively than written texts, the complex trajectories of the discipline's development. The increasingly precise depiction of excavation techniques permitted by photography is one example of how 19th-century antiquarian pursuits were transformed into a field science of archaeology. In the process, norms of pictorial depiction were heavily borrowed from the natural sciences, and the profound impact of photographic technology on the discipline is clearly visible. It has offered a distinct visual identity for archaeology's unique investigating techniques by allowing the production of visually coherent excavation accounts. Through photography, archaeologists have been able to create lasting testimony to the value of their methodology. SGU

Banta, M., and Hinsley, C. M., *From Site to Sight: Anthropology, Photography and the Power of Imagery* (1986).

Molyneaux, B. L. (ed.), *The Cultural Life of Images: Visual Representation in Archaeology* (1997).

Poole, D., *Vision, Race and Modernity: A Visual Economy of the Andean Image World* (1997).

Edwards, E., 'Material Beings: Objecthood and Ethnographic Photographs', *Visual Studies*, 17 (2002).

Archer, Frederick Scott (1813–57), English photographer and inventor. Born the second son of a butcher, the man generally credited with the invention of the *wet-plate process began his creative life as a silversmith's apprentice and later became a sculptor. Gustave *Le Gray, R. J. Bingham, and Archer all had the idea of coating glass-plate negatives with a layer of *collodion at about the same time. Of the three, Archer was the first to publish practical directions for the process, in *The Chemist* in March 1851. His method was to mix collodion with potassium iodide, coat it on a glass plate, and sensitize it with a solution of silver nitrate. When exposed still wet it had a light sensitivity some twenty times that of *daguerreotype or *calotype materials, and with the advantage of being on clear glass. The improvement was to have a revolutionary impact on the practice of photography, not only for its improved sensitivity and practicability, but because the free and widespread use of collodion led directly to several patent lawsuits that ended, in 1854, Henry *Talbot's claims against professional photographers employing paper processes. The collodion process was deemed to differ from the calotype, and, as Archer had not patented the process, it was available to all who could buy chemicals and a manual. In 1852 Archer opened a photographic business at 105 Great Russell Street, Bloomsbury, where he photographed and invented until his death. He died very poor, and a subscription was taken up for his wife Fannie and their surviving children. GS/KEW

Archer, F. Scott, *Manual of the Collodion Photographic Process* (1852).

architectural photography can be broadly considered to encompass views of the exteriors and interiors of domestic, commercial, religious, institutional, and engineering structures, as well as records of the evolution of towns and cities. Its aim may be to create either visual documents or expressive images for artistic, publicity, or *propaganda purposes. Depending on format, carefully calculated *camera movements and/or the use of special lenses are required, especially to control *perspective.

Although architectural photographs have been made continuously since 1839, the specialized history of architectural photography is of relatively recent date. If the principal conditions for establishing such a history were access to large bodies of original and published work, and a theoretical framework within which to organize material and to situate representative and seminal bodies of work, then these conditions did not exist before the early 1980s.

The first publication to define and describe a significant portion of this history was Richard Pare's *Photography and Architecture, 1839–1939* (1982). This was followed in 1987 by Robinson and Herschman's *Architecture Transformed*, the first survey of the entire period. By the mid-1990s, the field had both broadened and deepened through the publication of previously unknown bodies of work, the incorporation of alternative methodologies, and easier access to institutional collections. Architectural photography was no longer seen as comprising a single, monolithic history but rather a number of separate practices and interrelated histories. In common with other applications of the medium, architectural photography is now understood as a form of cultural representation, which not only provides useful records of the appearance of buildings and cities over time but also insight into why these images were made and how they were used.

The *daguerreotype and *calotype in the 1840s had limited commercial potential. In their architectural uses, daguerreotypes were largely confined to wealthy amateurs, such as Alexander J. Ellis's 1840–1 collection of views of Rome and other Italian cities, or Joseph-Philibert Girault de Prangey's 1842–4 Mediterranean views. Both bodies of work long remained unknown. For publications, daguerreotype plates had to be redrawn and published as prints, as seen in N. M. P. Lerebours's *Excursions daguerriennes* (1840–4). Henry *Talbot's calotypes were

characterized by an overall softness that, coupled with restrictive patents in the 1840s and a tendency to fade, limited the success of such publishing ventures as Talbot's own *Sun Pictures in Scotland* (1845) or *Hill and Adamson's *A Series of Calotype Views of St Andrews* (1846). Modifications to Talbot's process in the late 1840s and 1850s permitted a number of architectural photographers active in France (Gustave *Le Gray, Henri *Le Secq, and Charles *Nègre), the Middle East (Maxime *Du Camp, Auguste *Salzmann, and Félix *Teynard), and India (Linnaeus *Tripe) to work on an impressive scale. However, the difficulty and cost of printing such work again restricted the size and distribution of publications to a tiny market.

In the early 1850s, the introduction of *wet-collodion glass-plate negatives and *albumen prints advanced architectural photography and allowed it to compete with other print media and begin reaching a wider audience. The grainless negative, varying in size from *stereographs to *mammoth plates, when contact printed on to albumen paper, produced photographs with astonishingly sharp detail from the shadows through to the highlights. These prints had an impersonal glossy surface that reinforced the authority of the camera.

By the 1860s, commercial architectural photographers had begun to emerge in many large urban centres, as businessmen who could address the specialized needs of architects, artisans, sculptors, illustrators, entrepreneurs, government officials, amateur historians; and, later in the century, art historians and set designers in need of visual documentation and source material. Such photographers and firms as Charles *Marville, Édouard *Baldus, Louis-Émile Durandelle (1839–1917), and, later, Eugène *Atget in Paris, Pieter Oosterhuis in Amsterdam, Joseph *Albert in Munich, Georg Koppmann & Co. in Hamburg, Bedford Lemire & Co. in London, and Thomas *Annan in Glasgow, carried out a variety of private, corporate, royal, and governmental commissions as well as speculative ventures. These included documenting the construction, renovation, and, occasionally, demolition of domestic, civic, and engineering structures as well as the recording of urban areas designated for redevelopment. In their photography of buildings, they adhered to a limited set of conventions in the form of axial, perspective, and detailed views of the principal façades and interior spaces. These provided information complementary to the traditional set of orthographic projections found in architectural draughting (plans, elevations, and sections). During the same period, and spurred by the forces of industrialism, military expansion, colonialism, and middle-class travel, semi-itinerant photographers such as G. W. *Wilson in Britain, Francis *Frith and Félix *Bonfils in the Middle East, Samuel *Bourne in India, and John *Thomson in China produced topographical, architectural, and ethnographic views. Their work was marketed in a variety of formats and sizes, catering to the varied interests of archaeologists, the military, colonial officials, and tourists. However, until the end of the 19th century, the role of photography in disseminating architectural information was restricted to a relatively small number of views. These were either in the form of original photographs mounted on board or pasted into albums and publications, or images transposed into graphic form for reproduction in books or journals.

With the introduction of commercially produced gelatin *dry plates in the early 1880s, refinements in the design of view cameras and lenses and the development of *half-tone relief printing in the 1890s, the practice of architectural photography was revolutionized. With the perfection of half-tone printing, it became possible for the first time simultaneously to reproduce black-and-white photographs, line drawings, and text, and to envision and produce commercially viable photographically illustrated publications. By the 1930s, photography had become the principal conveyor of architectural information and culture.

These technological innovations allowed professional journals, such as *The Architectural Review* in Great Britain, *L'Architecture d'aujourd'hui* in France, *Domus* in Italy, and *Architectural Record* in the USA, as well as other illustrated publications, to rely increasingly upon suites of commissioned photographs to describe contemporary buildings through sequences of exterior and interior views. Frank Yerbury and the firm of Dell & Wainwright in England, Karl Hugo Schmölz (1917–86), Albert *Renger-Patzsch and Werner Mantz (1901–83) in Germany, and F. S. Lincoln, Julius Shulman (b. 1910), Ezra Stoller (1939–89), and the firm of Hedrich-Blessing in the USA all specialized in this area of commercial architectural photography. Architects quickly realized the potential of high-quality photographs in publicizing projects and advancing their careers, and often worked closely with photographers in selecting and even specifying particular views. This tradition represents a highly circumscribed interpretation of buildings: rather than emphasizing how commercial or domestic spaces normally function, the photographs present an 'architectural' idea, one in which light is used to articulate form and space, and where use is symbolized by the presence of a few carefully placed objects on the pristine surfaces of tables and counters. This type of photography has continued to the present, stimulated by the post-1945 building boom and growth of interior design magazines in the 1950s and 1960s; by the pervasive use of colour photography beginning in the 1970s and 1980s, as seen in the work of Peter Aaron, Richard Bryant, Wolfgang Hoyt, and Steve Rosenthal; and by the advent of *digital technologies in the 1980s and 1990s. While it is still too early fully to assess the long-term repercussions of digital applications, they have already facilitated technical complexities, such as extending the photographer's control of colour, contrast, retouching, and preparation of the image for commercial printing, and have encouraged the increased dissemination of collections through scanning and online-searchable databases.

Parallel to this commercial tradition in the 20th century, and at times defined in opposition to it, was the work of a number of independent photographers for whom architecture provided either a private subject, such as Frederick *Evans's 1898–1911 images of medieval cathedrals, or one that illuminated society as a whole. Paul *Strand's seminal photograph *Wall Street* (1916) symbolized the crushing conditions inherent in capitalism and big-city life. By the 1930s, photographers began thinking in terms of how large bodies of work could cumulatively provide a more complex description of urban forms than was possible

with single images: Berenice *Abbott's ambitious project *Changing New York* (1935–8) and Walker *Evans's landmark publication *American Photographs* (1938) are two instances of this development. At the same time, earlier bodies of work, most notably Atget's photographs of the architecture of Old Paris, were reinterpreted and championed as forerunners of 'modernist' photography.

Beginning in the 1970s, with the development of an art market, the growth of museum, corporate, and private collections, and the proliferation of university courses, photographers have gradually been able to establish careers through a combination of commercial work, teaching, grants, and exhibitions that has allowed them to concentrate on independent projects. Many of these address often unnoticed and seemingly marginal aspects of cities. In North America, for example, Robert *Adams and Lewis *Baltz have investigated the fragile presence of nature in western American cities, Lee *Friedlander the visual cacophony of contemporary urban spaces, Lynne Cohen (b. 1944) the often sinister interiors of scientific laboratories and classrooms, and, more recently, Margaret Morton and Anthony Hernandez (b. 1947) the transitory architecture of the homeless. In Europe, Bernd and Hilla *Becher, since the late 1950s, have produced an extended document of the remains of 19th- and early 20th-century industrial forms, while Gabriele Basilico (b. 1944) has examined the morphology of European cities. Thomas *Struth has assembled typological views of cities throughout the world. While much of this work has been produced in an 'art' context, the traditional use of the camera to describe the world allows this photography to align itself with earlier bodies of commercial and government-sponsored work, and to yield a cumulative cultural record of individual buildings and urban spaces from 1839 to the present. DH

Pare, R., et al., *Photography and Architecture, 1839–1939* (1982).
Robinson, C., and Herschman, J., *Architecture Transformed: A History of the Photography of Buildings from 1839 to the Present* (1987).
Saunders, W. S., *Modern Architecture: Photographs by Ezra Stoller* (1990).
Elwall, R., *Photography Takes Command: The Camera and British Architecture 1890–1939* (1994).
Naegele, D. (ed.), 'Photography and Architecture', *History of Photography*, 22 (1998).
Shulman, J., *Photographing Architecture and Interiors*, introd. R. Neutra (1962; 2000).

Arctic and Antarctic. See EXPLORATION PHOTOGRAPHY.

Argentina. Like other Latin American countries, Argentina attracted numerous foreigners in the early decades of photography. With a few exceptions, activity in this large, overwhelmingly rural, and relatively underpopulated country remained concentrated in the capital, Buenos Aires, whose development was richly documented by the camera. Two pioneering *daguerreotypists were the Americans Charles Fredricks and John Armstrong Bennett, both of whom at various times also ran businesses abroad. The arrival of the *wet-plate process in the 1850s stimulated the market, especially for views, and by the mid-1860s, when the Italian-born Benito Panunzi (1819–94), a

former assistant of Felice *Beato, established himself in Buenos Aires, there were *c*.65 photographers in the city. Panunzi specialized not only in urban views but in landscapes and *gaucho* genre scenes in the surrounding province, although much of the work once attributed to him seems to have been done by another foreigner, the Frenchman Esteban *Gonnet.

In the year of Gonnet's death, 1868, the Argentinian Christiano Junior (*fl*. 1868–78) founded a studio that soon attracted the capital's elite, while Junior also produced important albums of city views. The business was bought in 1878 by another major figure, Alejandro S. Witcomb (d. 1905), who became celebrated for his portraits of Buenos Aires society from presidents, generals, and top officials down to ordinary middle-class citizens and their children. Witcomb also followed his predecessor's example by creating a dense record of the city's architecture and social and economic life. Benefiting from a long period of national prosperity, the firm lasted until 1939, leaving *c*.1 million negatives now preserved in the Argentinian National Archives.

An important early 20th-century photographer, unusual in that he made his reputation in a small town, Esperanza in the province of Santa Fe, was Fernando Paillet (1880–1967). Like many of his compatriots he combined a portrait practice with extensive documentary work, in this case recording the development of new industries and the settlement of successive waves of immigrants in the region.

Thanks to its particularly strong cultural links with Europe, Argentina benefited from the exodus of talent from Germany between the wars. In 1931 Annemarie Heinrich (b. 1912) from Darmstadt founded one of the first Buenos Aires studios to be run by a woman, and earned an international reputation for her superbly lit and composed portraits of stage and screen stars and other celebrities. The former *Bauhaus student Grete *Stern also began as a portraitist, but later distinguished herself with neo-Surrealist fantasies and ethnographic work in Argentina's northern provinces.

Despite long-term economic problems and many political and economic crises in the second half of the 20th century—reflected in the sometimes desolate work of photographers like Eduardo Gil (b. 1948) and Juan Travnik (b. 1950)—Argentina has developed a mature photographic culture, with the proliferation of galleries, museum collections, and degree-level photography courses. In 1973 two former pupils of Annemarie Heinrich, Sara Facio (b. 1932) and Alicia d'Amico (b. 1933) created the photographic publishing house La *Azotea. The Consejo Argentina de Fotografía was founded in 1979 with the aim of promoting photography in both its contemporary and historical aspects; one of its first initiatives was to organize a Paillet centenary exhibition in 1980. AH/RL

Annemarie Heinrich (1985).
Facio, S., and d'Amico, A., *Fotografía argentina, 1860–1985* (1985).
Gomez, J., *La fotografía en la Argentina, 1840–1889* (1986).
Facio, S., *La fotografía en Argentina* (1995).
Watriss, W., and Zamora, L. P. (eds.), *Image and Memory: Photography from Latin America, 1866–1994* (1998).

argentotype. See ALTERNATIVE (NON-SILVER) PHOTOGRAPHIC PROCESSES.

Arles Festival (Rencontres Internationales de la Photographie), an annual event conceived by the photographer Lucien *Clergue, the museum curator Jean-Maurice Rouquette (both of Arles), and the writer and television producer Michel *Tournier. In its inaugural year, 1970, it embraced the international photographic world with an Edward *Weston exhibition at the Musée Réattu. By 1971 it was attracting figures such as Jacques-Henri *Lartigue, Jeanloup *Sieff, Bruce Davidson, Jerry *Uelsmann and *Hiro. In 2003 over 30 official exhibitions were scheduled, including work from all over the world. Held in early July, the festival includes evening slide projections in the Roman theatre, week-long workshops with leading photographers—who have included Nicholas *Nixon, Sebastião *Salgado, Shoji *Ueda, and Édouard *Boubat—and debates, café portfolio reviews, book prizes, and the chance to meet photography's international celebrities. MHV

Armstrong-Jones, Antony. See SNOWDON, EARL OF.

Arnold, Eve (b. 1913), American photographer, whose only formal training was a six-week course with Alexey *Brodovitch at the New School for Social Research in New York. But her natural genius soon resulted in published photo-essays on everything from Harlem fashion shows and migrant workers to the Republican National Convention, Senator Joe McCarthy, and Malcolm X. She became the first female American member of *Magnum in 1951 and eventually settled in London. She used both colour and black-and-white, and her many books include *The Unretouched Woman* (1976), *In China* (1980), and works on Marilyn Monroe and Mikhail Baryshnikov. TT

Arnold, E., *Eve Arnold, in Retrospect* (1995).

artefacts. See FAULTS IN NEGATIVES, TRANSPARENCIES, AND PRINTS.

Artigue process. See ALTERNATIVE (NON-SILVER) PHOTOGRAPHIC PROCESSES.

art works, photography of. See WORKS OF ART, PHOTOGRAPHY OF.

ASA. See SENSITOMETRY AND FILM SPEED.

Associated Press. See AGENCIES, PHOTOGRAPHIC; TRANSMISSION OF PHOTOGRAPHS.

Association of International Photography Art Dealers (AIPAD). See MARKET FOR PHOTOGRAPHS.

astronomical and space photography. The application of photography to astronomy began in the 1840s. It would in time see the methods and goals of the science transformed by the photographic plate's ability to accumulate light over extended periods, and so reveal information on objects invisible to observers employing the naked eye at even the largest telescopes. The incorporation of photographic techniques into astronomical practice, however, was a lengthy process. It was marked by a series of successes as well as some spectacular flops, and an often subtle interplay of technical, scientific, social, economic, and cultural factors.

The decade of the 1840s witnessed a number of firsts, including *daguerreotypes of the sun, the solar spectrum, and the *moon. At the end of the decade, William C. (1789–1859) and George P. Bond (1826–65), based at Harvard and employing a large refracting telescope, collaborated with commercial photographers to obtain still better-quality lunar images.

There were further experiments during the 1850s, but the only protracted efforts came from the Bonds (who particularly investigated the photographic images of stars), and Warren de la Rue (1815–89), a successful British businessman with a wide range of scientific and technical interests. In 1851 he saw daguerreotypes of the moon by the Bonds on show at London's *Great Exhibition. A major problem that pioneering astronomical photographers faced was that refracting telescopes (which form their images by means of lenses) were corrected for visual (yellow-green) light, whereas early photographic plates were most sensitive in the blue region of the spectrum. Hence the focus for the eye was not the same as for a photographic plate. Reflecting telescopes, however, did not suffer this problem as they use a mirror to bring all colours of light to a common focus. In the 1850s de la Rue, armed with a reflector and the newly developed *wet-collodion process, photographed the moon. He also acquired a telescope drive that let him accurately track objects as they shifted across the sky, a key requirement for successful astronomical photographs as the earth's daily rotation causes an object to move 15 degrees per hour (as a rough measure of comparison, the apparent diameter of the moon is about half a degree). De la Rue was also responsible for the first result of astronomical significance to be achieved by photography when he compared his plates of the 1860 eclipse of the sun with other photographs taken a few hundred miles away. Through this comparison, he established that the prominences detected at earlier eclipses were real phenomena and not optical effects, and belong to the sun, not the moon.

During the 1860s, perhaps the two most significant researchers in addition to de la Rue were the Americans Lewis M. Rutherfurd (1816–92)—who fashioned the first refracting telescope designed specifically for photography in the USA—and Henry Draper (1837–82). By 1872, Draper had photographed dark absorption lines in the spectrum of the star Vega, which yielded information on the star's chemical composition. From the 1870s, the amateurs Sir William Huggins (1824–1910) and his wife Margaret (1848–1915), already an experienced photographer before she turned to astronomy, also obtained photographs of stellar spectra.

The 1874 transit of Venus (i.e. the passage of the planet across he face of the sun as viewed from the earth) was an event long

John Adams Whipple

The moon, 1851. Daguerreotype

anticipated and planned for by astronomers in many nations, as accurately timed observations of such a transit provide a means to determine the 'solar parallax', the value of which would provide a fundamental constant known as the astronomical unit. Photographic techniques were central to the arrangements of many expeditions. The results, however, were disappointing. When astronomers examined their plates under even low magnifications they found it extremely difficult to identify the exact position of the edge of either the sun or of Venus because of the blurring of image edges due to light scatter within the emulsion. Hence when a conference was convened in Paris to plan for the observations to be made at the next transit in 1882, the delegates from fourteen nations recommended that photographic techniques should not be employed.

Despite this failure, some astronomers reckoned that exciting possibilities were opening up, with the new dry plates beginning to supersede the slow, coarse-grained wet-collodion plates that allowed only relatively short exposures. The investigations of W. de W. *Abney, a prominent British photographer, were especially important. Drawn to astronomical photography when he became involved in the plans for the 1874 transit of Venus, Abney had much improved the albumen dry-plate process in preparation for the British observations.

Increased sensitivity and superior photographic materials were not the only factors in the growing acceptance of photography as a research technology in the 1880s. Important too was the fact that by this time more individuals trained in physics were entering astronomy, and their chief interests were in the physical composition of the sun and

Isaac Roberts

Photograph of nebula 31M
Andromedae, 1888. Exposure
240 minutes. Gelatin silver print

stars, not the positions of these objects in the sky. For such researchers, often known as astrophysicists, photography was a crucial aid. Also, impressive photographs of a range of astronomical objects were secured during the 1880s which demonstrated that photographs could reveal far more detail than could the human eye. Especially influential in this respect were the photographs of nebulae and star clusters taken by a number of amateurs, most notably the British sanitary engineer A. A. Common. At first, defects in his telescope's drive mechanism led to poor images. But he improved the drive and also devised a special plate holder that could be moved during exposures to help compensate for any remaining irregularities.

The great majority of the early pioneers of astronomical photography were amateurs. Free of institutional demands and usually backed by substantial amounts of their own money, men such as Common had been able to experiment, take risks, and strike out in new directions. But as photographic techniques improved, and as some professionals showed what could be done with their aid, so photography became more widely accepted even in professional circles. Here Sir David Gill (1843–1914) played a key role. In 1882, he had photographed a comet, and in so doing registered images of background stars that persuaded him of their enormous potential for positional astronomy. Gill, director of the Royal Observatory at the Cape of Good Hope, now resolved to produce a photographic catalogue of the stars visible in the southern hemisphere. This project became known as the 'Cape Photographic Durchmusterung' (CPD; Cape Photographic Review), the end product of which

49

comprised over 450,000 stars. The CPD was produced in collaboration with Jacobus C. Kapteyn (1851–1922) of the University of Groningen, who established a special laboratory to measure and reduce the plates exposed at the Cape.

A less successful large-scale photographic mapping project was the Carte du Ciel, the aim of which was to construct a photographic chart of the entire sky. Established by the international Astrographic Congress of 1887 in Paris, the project involved the collaboration of many observatories. It proved to be overly ambitious and was not completed until 1964.

Even so, the Carte signalled the further acceptance of photographic methods. The use of photographic images of stars for detailed and accurate information on stellar positions and brightnesses, however, still posed severe difficulties. While Frank Schlesinger (1871–1943) at Yale proved particularly adept at solving those problems to do with determining a star's yearly shifts in position as the earth revolved around the sun (information which could be exploited to measure the distance of the star), photographic photometry proved even more vexing. Measuring the brightness of a star image required astronomers to take into account a range of systematic errors in their instruments and photographic plates, as well as deciding upon standardized procedures. Tackling these issues and producing consensus among the international astronomical community took some decades.

Around the turn of the century, James Keeler (1857–1900) at the Lick Observatory in California (using Common's former 91.5 cm (36 in) telescope) and Max Wolf (1863–1932) at Heidelberg underlined how effective large reflectors and photography could be in revealing new information on the heavens. The leading exponent of this sort of astronomy in the 1900s, however, was the American George. W. Ritchey (1864–1945). His first major success was in designing and fashioning at the Yerkes Observatory of the University of Chicago a very fine 61 cm (24 in) reflector for astronomical photography. Through careful attention to all aspects of its design, Ritchey ensured the telescope was capable of exposures of several hours. When the Mount Wilson Solar Observatory was founded in California in 1904, Ritchey joined the staff, and played a critical role in the construction of a 152.4 cm (60 in) reflector (1908) and a 254 cm (100 in) reflector (1919), the latter easily the most powerful telescope in the world at the time. In so doing, he and his colleagues had made the big reflecting telescope designed for photography into an essential tool for astrophysical research, and major research observatories aspired to own such an instrument.

In the 1920s and 1930s there were particular efforts to improve photographic plates so that they could capture more of the light falling upon them. In these researches, C. E. K. *Mees of Eastman Kodak played a major part. Some investigators would also seek to increase the sensitivity of emulsions by various techniques, including 'hypersensitization' and the superposition of individual plates. A new sort of photographic telescope, the Schmidt telescope, also came into use c.1930 to photograph large areas of the sky.

Before the Second World War the idea of telescopes in space seemed totally impractical. The crude state of existing rocket technology implied that, at best, such instruments lay decades in the future. But the war transformed this situation. The incentive to build weapons quickened the development of rocket technology, with the largest advances being made by German engineers and scientists with their V-2 rockets. Large numbers of captured V-2 components were transported to the USA after the war, where completed rockets were soon being used for research. An early scientific success came in 1946 when the US Naval Research Laboratory flew a spectrograph in a V-2. When the exposed photographic film was recovered after the flight it showed that the further the rocket travelled through the earth's ozone layer, the more of the sun's ultraviolet spectrum was recorded. Such rocket flights, however, were very limited, and enabled observations to be made for only a matter of minutes before the instruments arched back into the atmosphere under the pull of gravity. Satellites, however, offered the prospect of making observations for far longer periods, and the advent of satellite astronomy came close on the heels of the launch of the first man-made satellite, *Sputnik I*, in 1957. By this time astronomers were also seeking to intensify the light entering their telescopes via various electronic devices, or to replace the photographic plate with another sort of light detector. Experiments with television cameras for these purposes began in the 1950s, for example. The effort to replace photographic plates was further heightened by the development of astronomy from space. Astronomers much preferred to avoid relying on astronauts to exchange plates from orbiting telescopes and so were attracted by automated space observatories equipped with electronic detectors.

During the 1960s, American and Soviet space missions also gave a huge boost to studies of the solar system, most spectacularly with the flights of spacecraft to the moon, planetary fly-bys, and the landing of spacecraft on other worlds. The photographs taken by the Apollo astronauts on their journeys in the late 1960s and early 1970s were significant scientifically as well as in evoking wider popular responses. Images of the earth from space were also often credited with having heightened environmental concern for the planet.

The first craft to soft-land on another planet was the Soviet *Venera 7* on Venus in 1970. A later version, *Venera 13*, soft-landed on Venus in 1982 and returned a colour picture. In mid-1975 the USA launched two craft to Mars, *Viking 1* and *Viking 2*. Each was a kind of double spacecraft. Both carried a 'lander' and an 'orbiter', the lander (which carried a television camera) to touch down on the Martian surface, and the orbiter (which carried a telescope and vidicon tube) to orbit the planet and return data, including images of the surface. Both the orbiters and landers returned thousands of images, and these would play an important part in changing ideas about the planet.

As spectacular and scientifically fruitful in their own way as the images from *Viking* were those secured by the flights of NASA's two *Voyager* spacecraft—both of which carried vidicons—to the outer solar system. Both craft were launched in 1977 and reached Jupiter in 1979. Jupiter's moon Io, for example, exhibited a remarkable array of light

and dark patches against a vivid orange background, as well as faint plumes that were rapidly interpreted as evidence of volcanic activity. Such pictures stirred enormous public interest.

During the 1970s charge-coupled devices (CCDs) began to become the leading light detector for astronomy and to displace photographic plates from various (although not all) applications. The main camera for the Hubble Space Telescope (HST), an orbiting observatory planned since the 1970s and launched in 1990, carried CCDs, and the many remarkable images they have secured have been the main means by which the public has become aware of the telescope's activities, as well as providing the principal body of its scientific results. CCDs were also incorporated in the camera for the *Galileo* mission to Jupiter, one of the most important planetary spacecraft of the late 1990s and early 2000s. A further milestone was reached early in 2004, when two NASA landers began to transmit high-quality pictures of the surface of Mars from digital stereoscopic cameras.
RWS

Norman, D., 'The Development of Astronomical Photography', *Osiris*, 5 (1935).
Vaucouleurs, G. de, *Astronomical Photography: From the Daguerreotype to the Electron Camera* (1961).
Warner, D., 'Lewis M. Rutherfurd: Pioneer Astronomical Photographer and Spectroscopist', *Technology and Culture*, 12 (1971).
Lankford, J., 'The Impact of Photography on Astronomy', in O. Gingerich (ed.), *Astrophysics and Twentieth-Century Astronomy to 1950: Part A* (1984).
Darius, J., *Beyond Vision: One Hundred Historic Scientific Photographs* (1984).
Osterbrock, D., *The Pauper and the Prince: Ritchey, Hale, and Big American Telescopes* (1993).
Dans le champ des étoiles: les photographes et le ciel, 1850–2000 (2000).

Atget, Eugène (1857–1927), French photographer. Despite the increasing importance now accorded his work, Atget remains a shadowy figure. Orphaned at the age of 4, he was brought up by an uncle. After a brief career as a sailor, he took up acting without great success before finally establishing himself in Paris, first as a painter, then as a photographer from *c*.1890, using a technique which hardly varied. He advertised his 'documents for artists' from 1892, and in 1898 began to make his famous views of Paris, which he sold to antiquarians, collectors, and museums. Some of his work was distributed as postcards. In 1899 he settled in Montparnasse, where he spent the rest of his life and died in poverty.

Atget was known to many painters (Derain, Matisse, Braque, and Picasso bought pictures from him), which may explain his discovery by the Surrealists as a 'naive genius', akin to *le douanier* Rousseau, in the 1920s. Otherwise it is possible his work would have disappeared with him, for the deceptively simple documentary pictures he made of the sights and people of late 19th- and early 20th-century Paris were not greatly different from those made by several contemporaries and were considered little more than functional illustrations by most buyers. Yet *Man Ray (a neighbour), André Breton and Pierre *Mac Orlan saw something new in these robust and direct photographs, made on 18 × 24 cm (7 × 9½ in) glass plates using a wooden bellows camera with a simple rapid rectilinear lens, or a wide-angle recognizable by the vignetting apparent at the edges of some of the plates. They perceived in his 'artless' images a hidden world of the unconscious beneath the surface of the city.

Atget's modus operandi was the creation of picture series on, for example, various aspects of Paris: its streets and shops, historic monuments and statues, interiors, parks and flowers, street trades and vehicles; even some nudes. The simplicity and limitations of his technique, which led him to photograph in the early morning when there were few passers-by, were also the source of its visual power, bestowing an empty and surreal charm on his cityscapes.

The albumen and bromide contact prints Atget sold to museums, galleries, collectors, and painters still turn up in unexpected places. His *petit-métiers* (street trades) series were also distributed as *postcards. In 1926 he met the American Berenice *Abbott (then associated with Man Ray), to whom we owe the only known portrait of him. She conserved many of his negatives after his death, and initially helped to keep his reputation alive, especially in the USA. Abbott sold her collection to MoMA in New York, although the majority of Atget's *c*.8,000 negatives remain in France, most in the custody of the state.

Immediately after his death, modernist photographers began to discern a precursor of the *'New Vision' in the objectivity of his work, and it thus was increasingly valued as art rather than as 'mere' documentation. This process began in 1930 with the publication of *Atget: photographe de Paris*, introduced by Mac Orlan, the then most insightful French writer on photography. The irony is that Atget himself never regarded his work as 'art'.
PH

Hambourg, M. M., and Szarkowski, J., *The Work of Atget* (4 vols., 1981–5).
Nesbit, M., *Atget's Seven Albums* (1992).
Lemagny, J.-C., et al., *Atget le pionnier* (2000).

Atkins, Anna (née Children; 1799–1871), English botanist and pioneer of the *photogram and photographic publishing. Daughter of the prominent scientist John George Children, Atkins was encouraged by him in her scientific interests. She was a competent watercolourist and published at least one lithograph. By 1823 her draughtsmanship and observational skills were refined enough for her to produce 200 illustrations for her father's translation of Lamarck's *Genera of Shells*. Botany was her particular love, especially the collection and study of seaweeds. Her father chaired the February 1839 Royal Society meeting at which Henry *Talbot first revealed the manipulatory secrets of *photogenic drawing. Father and daughter soon got a camera and took up the new art of photography, but Atkins's biggest contribution to it involved neither a camera nor her father. She conceived the idea of publishing a photographic record of her algae, making photograms by contact printing the dried specimens on sheets of sensitized paper. Her choice of Sir John *Herschel's *cyanotype process was brilliant. Iron based, inexpensive, and permanent, its characteristic blue colour proved ideal as a background for the 'flowers of the sea'. Starting in October 1843 (the year before Talbot's *Pencil of Nature*), Atkins privately published *Photographs of British Algae: Cyanotype Impressions*.

Eugène Atget

L'Homme armé, rue des Archives, 1901

52

When this part-book was completed in September 1853, it contained more than 400 photographic plates, each a hand-sensitized cyanotype negative. Atkins continued to make cyanotype photograms, increasingly as an art form employing varied natural objects. LJS

Schaaf, L. J., *Sun Gardens: Victorian Photograms by Anna Atkins* (1985).

Atlas. An ongoing assemblage of photographs made by the German painter Gerhard Richter (b. 1932) since the 1960s and exhibited since 1972. Some of the images, made by Richter himself or merely accumulated, have been used in paintings and other works. Others, ranging in subject matter from Holocaust scenes and mugshots of the Baader–Meinhof terrorist group to snaps and magazine photos, constitute a kind of random archive of Richter's times. RL

Friedel, H., and Wilmes, U. (eds.), *Gerhard Richter: Atlas der Photos, Collagen und Skizzen* (1997).

auctions. See MARKET FOR PHOTOGRAPHS.

Auerbach, Ellen (née Rosenberg; b. 1906), German-born American photographer. In 1929, after training as a sculptor, she learned photography with Walter *Peterhans in Berlin. With Grete *Stern she took over Peterhans's studio after he joined the *Bauhaus, producing portraits and advertising work under the name ringl + pit. She emigrated in 1933, and in 1937, after marrying the stage designer Walter Auerbach, settled in the USA. She did commercial work, including travel assignments, and taught photography. In 1965 she took up educational *phototherapy. Auerbach has both exemplified and helped to shape photography's aesthetic development since the 1920s by the radical modernity of her commissioned and private work, her zest for experimentation, and interest in everyday subjects. UR

Auerbach, E., *Berlin–Tel Aviv–London–New York* (1998).

aurotype. See ALTERNATIVE (NON-SILVER) PHOTOGRAPHIC PROCESSES.

Austen, Alice (1866–1952), American amateur photographer, of Staten Island, New York. She started photography at an early age and soon excelled at it, using both glass plates and film to record the 'larky' activities of her leisured family and friends and technically challenging subjects like tennis, bicycling, and motor racing. She rejected the sentimentality and self-conscious aestheticism common among amateurs and in the 1890s made a series of documentary street scenes of immigrant-dominated lower Manhattan. Equally interesting were her meticulous photographs of the Hoffman Island quarantine station in the approaches to New York and, over decades, of ships passing through the Narrows. She lost her fortune in 1929; but her last months were brightened by the rediscovery and publication of many of her early photographs. About half her *c.*8,000 images survive. RL

Novotny, A., *Alice's World: The Life and Photography of an American Original—Alice Austen 1866–1952* (1976).

Australia. That Australia is the world's driest continent has influenced the nature of its earliest photography. Its first recorded photograph was a *daguerreotype of Sydney taken in 1841 by a certain Captain Lucas. The earliest surviving is a portrait taken in 1845. Until the advent of dry-plate technology, photography was confined to sites with available water. Thus large collections of wet-plate photographs of inland places, such as those preserved at the Benedictine Community of New Norcia in Western Australia, and of the Hill End goldfields in Victoria, are rare. Ironically, however, the world's largest surviving wet-plate negative, measuring 160 × 91.4 cm (63 × 36 in) and taken by Charles Bayliss (1850–97) in 1875, shows Sydney.

From its earliest appearance, Australian photography revealed the development of the colonies and both reflected and helped to shape ideas related to nation building. To Australian viewers, early colonial photography between the 1850s and the 1870s (A. H. Stone (1801–73), Captain Sweet (1825–86), H. B. Merlin (1830–73)) documented civic development as a sign of progress towards a European-style civilization, with the concomitant displacement of Indigenous peoples; but also betrayed a sense of alienation from Europe. Europeans probably perceived the images as primitive and unfamiliar. But as modernization advanced and Australians used the medium with increasing confidence, the unfamiliar was represented by means of more familiar artistic codes.

Photographs of Indigenous peoples are an integral part of the image of a modernizing Australia. They were taken by travelling photographers (Charles Walter (d. 1907), Charles Kerry (1858–1928), J. W. *Lindt, and *Ryko), anthropologists (Baldwin Spencer (1860–1929) and A. C. Haddon (1855–1940)), churchmen (Francis Russell Nixon, bishop of Tasmania (1803–79)), policemen (Paul Foelsche (1831–1914)), and many unidentified photographers. Photographers shifted from documenting the perceived 'primitive' state of Aboriginal people (Thomas Dick (d. 1927)), or their life at early mission stations such as Coranderrk, to omitting them altogether, as in much official photography from the early 20th century onwards. The reappearance of photographs of Aboriginal people on missions reflected official removal and assimilation policies. Aboriginal people also commissioned professional portraits, which were probably used to demonstrate their ability to assimilate into the broader community, and assembled collections of photographs to preserve their own memories. Recent work by Indigenous photographers (see NATIVE PEOPLES, PHOTOGRAPHY AND) provides a range of responses to these historical iconographic traditions. Certain individual images, such as the historic land-rights photograph *Prime Minister Gough Whitlam Pours Soil into the Hand of Traditional Gurindji Landowner Vincent Lingiarni, Northern Territory* (1975) by the Indigenous photojournalist Mervyn Bishop (b. 1945), have achieved iconic status.

Land is an important theme in Australian photography and reveals relationships between 'the bush', rural and urban development, and nation building. Geological surveys documented physical features of landscape from a scientific perspective. Many of the photographers

are anonymous, though the Victoria and Queensland government geologist Richard Daintree (1832–78) was unusual in documenting human experience together with the physical landscape in north Queensland. Surveys revealing rural land-use patterns, once used to advertise the economic potential of the land, are now used as markers for documenting land degradation.

In 1903–4 panoramic landscapes from a balloon were taken by the American adventurer Melvyn Vaniman. Extensive scaled *aerial photography was used for mineral exploration; an important series was the 1934 Western Mining Survey that included work by Axel *Poignant and Stuart Gore (1905–84). Later aerial work was done by the Dutch immigrant photographer Richard Woldendorp (b. 1927).

The sale of items showing picturesque landscapes prefaced, inspired, and documented the rise of national parks, and stimulated *tourism. Photographs by J. W. Beattie (1859–1930) appeared on an 1899 Tasmanian postage-stamp series, one of the world's first pictorial issues. The use of photographs in the journal *Walkabout* played a significant role in building a romantic image of the 'outback' for the Australian National Travel Association from 1934. In the 1970s, immigrant photographers Olegas Truchanas (1923–72) and Peter Dombrovskis (1945–96) represented the idea of pristine wilderness, and their photographs have been heavily used by the Tasmanian Wilderness Society. While Truchanas's photograph of Lake Pedder failed to save it from being dammed in 1972, Dombrovskis's

Peter Dombrovskis

Rock Island Bend, Franklin River, Tasmania, before 1983

photograph of Island Bend on the Franklin River influenced the course of the 1983 federal election.

Australia has been a visual nation, creating images of itself to promote immigration, investment, and tourism. Australian official photography can be understood in the context of British imperial relationships, and the confluence of photography with the *half-tone process. Federal collections of official photographs were purchased from each state, and commissioned from commercial photographers. Successful photographs reproduced well and were used repeatedly to depict the unfamiliar Australian landscape within an English aesthetic. Strategies used to shape ideas about Australia included international exhibitions and fairs, lantern-slide shows, and distribution of photographic prints and *postcards. While some collections, such as that of Australia House, London, no longer survive, others, for example that of the Australian Overseas Information Bureau, are preserved in the National Archives of Australia.

Commercial photography rarely presents a critical image of relationships on cultural or industrial frontiers. Commercial photographs of developing industries, including gold mining (Antoine Fauchery (d. c.1870) and J. J. Dwyer (1869–1928)), pearling (E. L. Mitchell (1876–1959)), timber and agriculture (Nicholas Caire (1837–1918)), depict a rural idyll, rather than danger, death, or evidence of interracial tensions and violence. Masculine heroism, combined with an industrial aesthetic, is exemplified by the photography of Wolfgang Sievers (b. 1913). The rise of modernist architecture was documented by Sievers, Mark Strizic (b. 1928), and Max Dupain (1911–92). Newspapers employed photographers including Fred Flood (1881–1965) and Sam Hood (1872–1953), and they now influence how Australia has been seen historically. Commercial, fashion, and portrait photographers included Athol Shmith (1914–90); and Susan Watkins (b. 1912), whose work reveals modernist influences derived from her time in Dorothy Wilding's London studio.

Parallel with photography's commercial and propaganda functions, stylistic traditions of *pictorialism developed. Iconic photographs from this genre include *Bridge Pattern* (c.1934) by Harold Cazneaux (1878–1953), *Tea Cup Ballet* (c.1935) by Olive Cotton (1911–2003), *Sunbaker* (1937) by Max Dupain, and *European Migrants Arriving in Sydney* (1966) by David Moore (1927–2003). There has been a tradition of photographic societies in Australia, including the Sydney Camera Circle, Adelaide Camera Club, and the Western Australian Van Raalte Club. Early photographic journals included *Australasian Photo-Review* and *Harringtons*. A more formal structure for photography was created in 1973 with the Australian Centre for Photography, Sydney, co-founded by David Moore, which provided space for the study and exhibition of photographs.

Australian photographers have made their mark internationally on expeditions, voyages, and in wartime. Frank *Hurley accompanied several Antarctic expeditions and created his iconic image of the ice-bound *Endurance* in 1915. J. W. Lindt accompanied the 1883 Australian expedition to annex south-eastern New Guinea. The writer and *marine photographer Alan Villiers (1903–82) recorded the

last days of sail. Hurley used composite photographs to represent the First World War (*Morning after the first Battle of Passchendaele, 12.10.1917*) and was also an official photographer in the Second World War with Damien Parer (1912–44). Neil Davis (d. 1985) was the best-known official Australian photographer in Vietnam, and David Dare Parker (b. 1958) was Australia's official war photographer in 2003 in Iraq. JS

See also NATIVE PEOPLES AND PHOTOGRAPHY.

Cato, J., *The Story of the Camera in Australia* (1977).

Newton, G., *Silver and Grey: Fifty Years of Australian Photography 1900–1950* (1980).

Davies, A., and Stanbury, P., *The Mechanical Eye in Australia: Photography 1841–1900* (1985).

Galimany, D. (ed.), 'Australian Photography', *History of Photography*, 23 (1999).

Austria. The country's principal contributions to the history of photography were made in the 19th and early 20th centuries, after which, for a long time, it became something of a backwater. The Viennese physicist and mathematician Andreas von Ettingshausen attended the session of the French Academy of Sciences on 19 August 1839 at which *Daguerre's process was explained. Afterwards he received personal instruction from Daguerre, took a *daguerreotype outfit with him back to Vienna and made sample pictures which were presented to the emperor. He and other enthusiasts belonged to the Fürstenhofrunde, effectively Austria's first photographic society, founded by the painter Karl Schuh. (Later Schuh's Fürstenhof studio became a photo-studio run by Franz and Thomas Streczek, early pioneers of *stereoscopic photography.) Members of the Circle made important improvements to Daguerre's process. In particular, Josef *Petzval's f/3.6 'portrait lens', subsequently manufactured by *Voigtländer, reduced daguerreotype exposures from about fifteen minutes to a few seconds in conjunction with faster plates devised by Franz Kratochwilla and others.

Despite these refinements, however, daguerreotype portraiture did not flourish, because of economic depression in the 1840s, and because aristocratic clients still favoured paintings. It was not until the arrival of the *wet-plate process and the *carte de visite* that portraiture boomed, led by entrepreneurs such as Ludwig Angerer (1827–79) and Emil Rabending (1823–86); between 1859 and 1865 the total number of studios in Vienna surged from 38 to 161. Meanwhile the Imperial Printing Office, which had opened a photographic department under Paul Pretsch (1808–73) in 1850, had begun producing large-format architectural and landscape *calotypes, some of which were shown at the *Great Exhibition in London in 1851. Later Pretsch adopted the wet-plate process for its ability to record finer detail in smaller formats, and between 1857 and 1863 the Office executed an official commission to record Vienna's fortifications prior to their demolition to make way for the city's new boulevard, the Ringstrasse. The year 1861 saw the founding of the Vienna Photographische Gesellschaft, which in 1864 organized Central Europe's first exhibition devoted

exclusively to photography; *c*.400 cameras and other items and *c*.1,100 photographs were shown, including work by *Baldus, *Nègre, *Poitevin, and *Watkins. The *Photographische Korrespondenz* was founded the same year.

Over the next three-quarters of a century, Austrian citizens produced many more innovations. In the field of *photomechanical reproduction, early work by Joseph Berres (1796–1844) and Pretsch was followed by the Czech Karl Klič (or Klietsch)(1841–1926), who in 1879 perfected the *photogravure process. Theodor *Scheimpflug, in addition to formulating the famous rule relating to *camera movements, pioneered advances in aerial *photogrammetry and ophthalmic photography. Karl Schinzel (1886–1951) worked on colour processes, and Josef Rheden (d. 1946) on astrophotography. But by far the largest contribution, in a range of fields from sensitometry to instantaneous photography, was by the chemist Josef Maria *Eder, who also wrote an authoritative technical history of the medium. Eder also campaigned for an independent research and teaching establishment, which finally opened as the Graphische Lehr- und Versuchsanstalt (Graphic Art Institute) in 1889. Headed by Eder until 1923, and later associated with the *pictorialist Rudolf *Koppitz, it became, with the Bavarian State Photography School and the Berlin *Lette-Verein, one of Europe's leading schools.

The emergence of Austrian pictorialism was preceded by the spread of amateur photography and the foundation, in 1887, of the Vienna Amateur Photographers' Club (later the Vienna Camera Club). At its centre was an informal group, the *'Vienna Trifolium', consisting of Hugo *Henneberg, Heinrich *Kühn, and Hans Watzek (1848–1903). Over a period of about six years, ending with Watzek's death, they criss-crossed Europe making superb coloured *gum prints and cultivating links with fellow pictorialists in London, Glasgow, Hamburg, and New York. Some of their work appeared in the Vienna Secession's journal *Ver Sacrum*. Under Koppitz's leadership, pictorialism in Austria continued to flourish well into the post-war period.

From the late 19th century there was a boom in Austrian photographic publishing, further boosted by the *postcard industry from the 1890s. Its subject matter was predictable: landscapes, rural genre, and views of cities like Vienna and Salzburg. In 1887 Vienna's newly founded Museum of Municipal History commissioned the architectural photographer August Stauda (1861–1928) to record historic buildings threatened by redevelopment. Of outstanding interest too were documentary images of poverty and slums in the city, many of them made using magnesium flash, by the amateur Hermann Drawe and the journalist Emil Kläger in 1904. At the opposite extreme were the sophisticated society portraits and Wiener Werkstatt costume studies taken by Dora Kallmus and Arthur Benda at the Atelier d'*Ora (f. 1907).

Between the foundation of the First Austrian Republic in 1918 and the country's absorption into Greater Germany in 1938, photography stagnated. Economic troubles and a reduced market led to the closure of many studios. Styles remained conservative, especially by comparison with developments further north, and it was significant that most of Hungary's large and talented band of photographic émigrés settled in Munich, Berlin, or Paris rather than Vienna. Bright spots, however, were the whimsical nude and glamour photography of the *Manassé Studio, much of it related to Austria's small but lively film industry; the exploits of the sports photographer Lothar *Rübelt; and the historical work of Heinrich *Schwarz, notably the exhibition of *Hill and Adamson calotypes he organized at Vienna's Belvedere Gallery in 1929.

Not much changed after 1945. Indeed, for several decades Vienna was reputed to be one of Europe's culturally most conservative capitals. But from the 1980s Austria began to acquire the elements of a modern photographic infrastructure, with salons, galleries, and a growing number of degree-level courses in both the capital and elsewhere. Vienna today is home to leading journals such as *Eikon*, *Camera Austria*, and *Fotogeschichte*, and is the international headquarters both of the *Lomography Movement (founded by two Viennese students in the early 1990s) and, since 2002, of the European Society for the History of Photography. A landmark event was the reopening in 2003, after a long period of renovation, of the Albertina Gallery, with an exhibition that showcased the fine collection of photographs housed there since the 19th century. Other major collections exist at the Army Museum and Vienna Municipal Museum. RL

Starl, T. (ed.), *Geschichte der Fotografie in Österreich* (2 vols., 1983–5).
'Fotografie in Österreich im 19. Jahrhundert', *Fotogeschichte*, 81, 83 (2001, 2002).
Faber, M., and Schröder, K. A. (eds.), *Das Auge und der Apparat: Eine Geschichte der Fotografie aus den Sammlungen der Albertina* (2003).

autochrome. Early photographic colour transparency on glass made by the first fully practical means of producing colour photographs. The *Lumière brothers in France announced a new colour process in 1904 and began marketing autochrome plates in 1907. These were prepared by randomly scattering a mixture of potato starch grains dyed in the three primary colours on to a glass plate, which was then coated with a standard black-and-white emulsion. When loaded into a camera and exposed, the mosaic of tiny colour filters effectively produced three colour separations on a single plate. After processing, a photographic image in rich natural colours could be seen. The process required fairly long exposures and the final images were dense and needed bright illumination for easy viewing. However, it was comparatively simple to practise and became the most popular of the early colour processes, finding favour with amateurs and professionals in Europe and America. JPW

Wood, J., *The Art of the Autochrome: The Birth of Color Photography* (1993).

autofocusing. See AUTOMATION OF CAMERA FUNCTIONS.

Autograph, the Association of Black Photographers, was founded in 1988 as a non-profit agency to encourage and assist black photographers in Britain. Its primary role is to exhibit and publish work by a diverse range of contemporary artists and help them to enter

the mainstream photographic market. Autograph has been awarded funding with International Visual Arts for facilities to include galleries and research, screening, and projection facilities. LAL

autographic camera. In 1913–14 the American Henry J. Gaisman patented inventions that allowed text to be inscribed on *roll-film while in the camera. Carbon-paper-like tissue between film and backing paper was made transparent when the latter was 'written on' with a stylus through a flap in the camera back, exposing the text on the film. George *Eastman bought the inventions, and the first Autographic Kodak, the 3A, was launched in June 1914. Many other models were subsequently produced, either new designs or adapted existing ones, like the Vest Pocket Autographic Kodak (1915). RL

Coe, B., *Cameras: From Daguerreotypes to Instant Pictures* (1978).

automation of camera functions. From 1839 to the present, cameras have been continually modified in order to simplify the means by which the photographer can capture images correctly exposed and focused on the sensitized medium. Many of these refinements have been aimed primarily at amateurs and the emerging mass market, others at both amateurs and professionals.

Film loading and transport
Medium-format roll-film and 35 mm cassettes were frequently difficult to load correctly. Some cameras ceased to operate if the film was not passing through the focal plane, but most simply carried on, leaving the malfunction to be discovered at the processing stage. The introduction of the 126 drop-in cartridge in the Kodak Instamatic 100 (1963) was a successful attempt to ensure correct loading every time. The Pocket Instamatic 110 cartridge of 1972 used a 16 mm film in a similar cartridge, and *disc film (1982) also provided trouble-free loading. Efforts were also made to automate the setting of the film speed in the camera. The DX system was introduced in 1983, with metal patches on the outside of the 35 mm cassette encoding this and other information that could be used by the camera. The *Advanced Photographic System (APS), launched in 1996, took this a step further, with shooting information being recorded from the camera and stored on the film in the cassette to be used in later photofinishing.

The automatic advancing of film, and the rewinding of 35 mm into its cassette, has been accomplished by clockwork or electric motors, mainly since the 1930s. Most modern compact and single-lens reflex (SLR) cameras have battery-powered rewinding mechanisms.

Exposure
In the early 20th century some cameras incorporated so-called extinction meters: variable-density filters that could be adjusted (until the scene became invisible) to give a brightness reading. The photoelectric *exposure meter introduced in 1928 was much more precise, and linking it directly to the camera's aperture or shutter-speed controls was first done with the very advanced and expensive Kodak Super Six-20 camera of 1938; it was fully automatic for speeds from 1/25 to 1/200 s. After 1945, many cameras incorporated photoelectric or CdS (cadmium sulphide) meters with 'match-needle' or similar systems requiring the manual setting of either aperture or shutter. Automated compact and reflex cameras became increasingly common from the mid-1970s. The Canon A-1 of 1978 introduced multi-mode automatic exposure control to the SLR. The central processing units of modern cameras are programmed with data for huge numbers of possible shooting situations so that automatically correct exposure—if desired—is practically assured.

Focusing
Early focusing methods involved either visual estimation or the use of a rangefinder, eventually coupled to the lens. Autofocusing systems have been available since 1972. Ultrasonic distance detection was used in the Polaroid SX-70 Deluxe (1972), with the advantage of being usable in the dark. Infrared measurement was used in the Konica C35A (1977), and contrast measurement and other systems also came into use. All involve adjustment of the lens elements by servo-mechanisms governed by information from the camera's sensors. By the turn of the 21st century, high-end cameras could focus almost instantaneously, even in low light, and acquire and follow rapidly moving subjects.

Flash
The introduction of the microchip and electronics has enabled automatic *flash provision to be linked into the exposure circuitry so that the flash will fire without user intervention under a wide range of pre-programmed conditions. The Olympus *OM-2 (1974) incorporated a system of *through-the-lens (TTL) flash control that measured light actually reflected off the film plane during exposure; comparable systems are now widespread, working with either built-in or off-camera flashguns.

Much camera automation has depended on the development of electronics, miniaturized motors, and small, reliable, and long-lasting batteries. As each of these areas has evolved, the benefits have appeared in cameras. The Konica FS-1 of 1978, for example, was the first SLR with internal miniaturization. It had two motors, one for film transport and one for driving the shutter, diaphragm, and mirror mechanisms at each exposure. It was powered by four AA batteries moulded into the handgrip. Many of these features were adopted by other manufacturers.

Most of these innovations were initially decried by traditionalists concerned that automation would breed sloppiness, and that the photographer's creative freedom might be undermined. Professionals were cautious about their equipment's ever greater complexity and battery dependence. The rise of the super-automated camera constructed to a large extent from synthetic materials no doubt partly explains the growth of a market for *classic (manual, mechanical, and wood- or metal-built) models. However, technological advances have enabled photographers—including the elderly and disabled—to capture many pictures that would earlier have been impossible, and consistently to achieve images of fabulous technical quality.

Most of the innovations described above have been seamlessly incorporated into the new generation of *digital cameras.　MP

Time-Life Editors, *Photography Year* (1973–82).

Coe, B., *Cameras: From Daguerreotypes to Instant Pictures* (1978).

Goldberg, N., *Camera Technology: The Dark Side of the Lens* (1992).

autoradiography. The phenomenon was discovered accidentally by Henri Becquerel (1852–1908) in 1896, when he left a specimen of potassium uranyl sulphate in contact with a photographic plate. Its modern applications are mainly in medicine. For example, the iodine distribution in the thyroid gland can be mapped by injecting radioiodine and making an autoradiogram of a biopsy, or the phosphorus distribution in a leaf can be ascertained by growing it in a cultural medium containing radiophosphorus. In both cases the specimen is left for an appropriate time on a sheet of X-ray film.　GS

autotype. See ALTERNATIVE (NON-SILVER) PHOTOGRAPHIC PROCESSES.

available-light photography. Strictly, available-light photography refers to all photography without additional, artificial light. In practice, it is normally taken to mean photography in poor light. The easy solution to lack of light is on-camera *flash, but this often destroys the very atmosphere that the picture seeks to capture: better to have shallow depth of field, graininess, and even a little camera shake than the harsh, glaring light of the flash. In a smoky room, the atmosphere literally has its revenge as it bounces the flash back towards the camera.

The practice of available-light photography has been transformed over the years by the availability of ever-faster emulsions, especially in monochrome. The speed of lenses has increased rather less, though the availability and affordability of very fast lenses has become much greater. In the late 1920s, for example, the fastest lenses for 35 mm were f/1.5 Meyer Plasmats, and the photojournalist Erich *Salomon was still using f/1.8 Ernostars on plate cameras. But the fastest films that were available were, by modern standards, extremely slow: perhaps ISO 6 to 25, although the earliest forerunners of the International Standards Organization (ISO) standard had not been established at this time.

As a result, shutter speeds of 1/10 s and even 1/5 s were commonplace: even where there is no evidence of camera shake in early pictures, there is sometimes evidence of subject movement. But if the camera is supported so that shake is not a problem, exposures of 1/2 s and longer are surprisingly often successful with relaxed subjects, even if they make no special effort to keep still, and indeed if they are unaware that they are being photographed. Many early exponents of 'candid' available-light photography with 35 mm cameras were skilled at finding and utilizing impromptu *camera supports such as walls, pub tables, motor-car roofs, and more. If nothing suitable was available, the classic (and well-founded) advice was to shoot while exhaling gently, preferably leaning against a wall, or with the elbows braced on a table.

Well into the 1950s, many photographers still used slow lenses, principally because of cost: Nikon's 50/1.1 (1955) was about eight times the price of the 50/3.5 and three times the price of an f/2. And although films were much faster than before the war, 400 ASA was the fastest normally encountered; in colour, 'High Speed' Ektachrome (at 160 ASA) appeared in 1956/7 and was the fastest available, while 40 ASA was fast for a print film.

Today, with lenses of f/2 and faster readily affordable and films that deliver superb results at EI 3200 and beyond, available-light photography is almost too easy. Certainly it is no longer enough merely to capture an image in next to no light: it must also stand as a photograph in its own right. There is, however, a certain look about pictures taken with fast lenses and (relatively) slow film that is not easy to replicate with faster films and slower lenses. It may therefore be a good idea to eschew the conventional wisdom of using the shortest shutter speed feasible in a given situation: rather, the available-light photographer may well create a more interesting and memorable effect by using the longest shutter speed that is feasible. Some photographers carry this to extremes, deliberately using marked camera shake as part of their low-light technique. But, perhaps because of expectations based upon great available-light images of the past, a picture that is right on the edge of camera shake, wide open, and grainy, can have more impact than one that is technically superior.　RWH

Avedon, Richard (1923–2004), American photographer who appeared, with Irving *Penn, as the most prominent of the younger generation of *fashion photographers emerging during the late 1940s. Rejecting the sculptural formalism and dramatic lighting of his European predecessors, notably Horst P. *Horst and George *Hoyningen-Huene, he presented fashion photography as theatre. Models leaped and emoted, often out of doors, generating an aesthetic of spontaneity and light sexual candour that became the look of the post-war era.

Avedon first studied philosophy at Columbia University, New York (1941–2). In 1944, following two years in the merchant marine, during which he took identity photographs of servicemen, he enrolled in Alexey *Brodovitch's Design Laboratory at the New School for Social Research, New York. Avedon began working for Brodovitch at *Harper's Bazaar at the age of 22, and was a fashion photographer there from 1945 to 1965. During the 1950s he also contributed to *Life, Look, and Graphis, and became staff editor for Theatre Arts in 1952. In 1965, he left Harper's to work under Diana Vreeland and Alexander *Liberman at *Vogue. By this time he had shifted from outdoor settings to the studio, developing a signature white-backdrop style. This approach, at once stark and highly polished, he adapted to portraiture of both celebrities and ordinary people, reasoning that 'a white background permits people to become symbolic of themselves'.

Avedon's penchant for blending fashion and *documentary modes is especially evident in the numerous books and exhibitions of his work, over whose design he maintained a remarkable degree of

Lionel de Rothschild The photographer's fiancée, Marie-Louise Beer, 1912

Alan Weintraub Sheats Goldstein House, Beverly Hills, California (architect John Lautner), 1998

control. *Observations* (1959), designed by Brodovitch with an essay by Truman Capote, comprises dynamic portraits of celebrities such as Marion Anderson interrupted by seemingly anomalous images of street life in Italy. The book's large format announced a distinctive bold style that Avedon has maintained throughout his career. *Nothing Personal* (1964), with an essay by James Baldwin, combines celebrity portraits with images of prisoners and the mentally ill. In the early 1970s, Avedon produced a series of portraits of his dying father; these were exhibited at MoMA, New York, in 1974. In 1976 he photographed American businessmen and political leaders for the magazine *Rolling Stone*. His most controversial project, *In the American West*, a typological study of labourers and drifters in the tradition of August *Sander and Diane *Arbus, was unveiled in 1985.

Avedon's career was celebrated in the 1957 film *Funny Face*, which starred Fred Astaire as a charismatic fashion photographer. More traditional recognition came in the form of an exhibition at the Smithsonian Institution, Washington, DC, in 1962; a survey of Avedon's fashion photography organized by the Metropolitan Museum of Art, New York, in 1978; and *Evidence*, a major retrospective of Avedon's work exhibited at the Whitney Museum of American Art, New York, in 1994. Avedon's *An Autobiography* (1993) is his own most personal statement. KM

Avedon: Portraits, text by H. Rosenberg (1976).
Evidence, 1944–1994: Richard Avedon, texts by J. Livingston and A. Gopnik (1994).

Azotea, La ('the winnowing ground'), the first women's photography publishing house in Argentina. Established in 1973 by three photographers—Sara Facio (b. 1932), Alicia D'Amico (b. 1933), and Maria Cristina *Orive—it published not only their work and that of other women, but also that of important contemporary (and frequently censored) authors such as Miguel Ángel Asturias, Bioy Casares, Cabrera Infante, Alejo Carpentier, Julio Cortazar, Octavio Paz, Juan Rulfo, Ernesto Sabato, and Vargas Llosa. AH

Babbitt, Platt D. (1822–72), American photographer, best known for his views of Niagara Falls. In early 1853, Babbitt began making *daguerreotypes of the Falls from a pavilion in front of Point View (now known as Prospect Point) on the American side. His monopoly of this viewpoint gave him almost complete control over this lucrative tourist destination. According to legend, he would wait until a crowd had gathered at the edge of the Falls, photograph the group, and then attempt to sell the picture when it returned past his pavilion. However, his daguerreotypes are usually well composed and not 'snapped'. Little is known of his life. RCW

Bannon, A., and McElroy, C. R., *The Taking of Niagara* (1982).

baby book (or progress book), bound record of a child's development combining photographs with written entries on height, weight, teething, illnesses, and other life events. It was either a dedicated *album of the kind still available today or a book laid out in journal form, often including specimen height/weight charts and other information. The latter were commonly produced, with suitable advertisements, by baby-food and photographic companies and were popular from before the First World War until at least the 1950s. RL

Pilley, J. J., *The Progress Book: An Illustrated Register of Development from Birth till Coming of Age and After* (rev. edn. 1913).

From John Langford Holt's baby book, 1916–

back and front projection is used in daylight displays of colour
*transparencies and films. Instead of the image being thrown on a
white screen, it is projected on a translucent screen from behind and is
viewed by transmission. The viewing angle is limited but the image is
bright enough for daylight viewing. A more important use is in motion
pictures where actors are to be seen with backgrounds such as Niagara
Falls or a cattle stampede. Back projection set-ups take up a great deal
of room, and a more common procedure nowadays is front projection.
The background is projected on to a retroreflective screen behind the
actors. The proportion of light reflected by the actors themselves is
swamped by the stage lighting. Both forms of background projection
have been largely overtaken by computer-controlled combination
techniques. GS

backdrops, studio. More popular in Europe than the USA, the
studio backdrop was probably introduced to Britain by Antoine
*Claudet in the early 1840s. But it was in the 1860s that pictorial
cloth hangings became popular as a way of providing subjects with
the kind of grand or dignified background that was traditional for
painted portraits. Interior scenes could suggest the stateliness of home
in which such a distinguished sitter might be found, while views of the
natural world beyond might hint at the status conferred by possession
of ancestral acres. But though the aim of creating an imposing setting
survived, taste and style changed over the decades: the pictured
locations grew less domestic and the painted scenery more romantic.
Early examples tended to add a back wall to a scene already suggested
by drapes and studio furniture. Book-lined studies were popular, but
so was the classical look with columns, porticoes, and balustrades.
(Three-dimensional versions of these items might be fitted with castors
for greater mobility and made adjustable for clients of different sizes.)
By the end of the 1860s, glimpses of garden or countryside were
commonly to be had through arches or windows, and backdrops of
the 1870s frequently presented a completely outdoor environment.
At this early stage of the studio's excursion into the simulated open
air, settings tended to suggest gardens or tended grounds. There were
painted trees, shrubs, and pools, but nature was fairly well tamed.
As the 1870s gave way to the 1880s, however, rustic settings began to
acquire a wilder and more atmospheric character. There was often an
impressionistic quality about the presentation of foliage, and a ruined
folly might be seen on the skyline, with a dramatic sky behind it.
Coastal and nautical scenes also made an appearance. Indoor settings
had not completely disappeared but, by this time, they might be more
Victorian than classical, depicting wood-panelled rooms with bays,
window seats, and leaded glass.

Backdrops, furniture, and other props were commercially produced,
with specialist firms such as Engelmann & Schneider in Dresden
issuing detailed catalogues of their wares. (Germany's photographic
industry had a strong position in the market not only for cameras but
for studio fittings and *albums, whose design was also influenced by
technical change and fashion.) Bespoke cloths could be provided, and
a prosperous studio would have a selection of scenes, some of them

James Shivas, Peterhead
Scottish studio portrait, c.1890s. Cabinet print

improbable. Seaside settings, for example, complete with lobster pots and papier-mâché rocks, were sometimes offered in studios that were far from the coast. The backdrops would be rolled up and stored, sometimes on racks from which they could be taken, unfurled, and hung, and sometimes one behind the other overhead, waiting to be pulled down like blinds. Constant unrolling and rolling could take its toll on the cloth, so creases and damaged edges are sometimes visible in the finished photograph. This was not always sufficient reason to put the backcloth into retirement, since a degree of willingly suspended disbelief was clearly attainable. Were it not, pictured instances of sylvan glade meeting studio skirting board or flooring would presumably be less common.

The 1890s' taste for head-and-shoulders vignettes left little room for scenery, and neutral backgrounds came back into favour. Pictorial backdrops never died out completely, and their debased descendant, the more-or-less comic seaside setting, survived for many years; but after the First World War it was the plain or textured background that was more characteristic of studio portraits. Even in the 21st century, however, a variety of commercial products can be seen at photographic *trade fairs. In parts of India and Africa, painted backdrops and a range of props and accessories continue to signal the portrait studio (as it had been everywhere in the 19th century) as a site of fantasy and make-believe. RP

See also DATING OLD PHOTOGRAPHS.

Das Photoalbum 1858–1918. Eine Dokumentation zur Kultur- und Sozialgeschichte (1975).

Linkman, A., *The Victorians: Photographic Portraits* (1993).

Pinney, C., *Camera Indica: The Social Life of Indian Photographs* (1997).

Bäckström, Helmer (1891–1964), Swedish amateur photographer, photographic historian, and collector. A Ph.D. in physics in 1928 gave him employment as a secondary school teacher. As secretary, then chairman, of Fotografiska Föreningen (the Photographic Society), editor of its magazine *Nordisk Tidskrift för Fotografi* (*NTfF*), and professor of photography at Stockholm's Royal College of Technology, he was at the centre of photographic culture. The 97 articles he published in *NTfF* between 1919 and 1944, most of them on the 19th century, laid the foundations of historical research on photography in Sweden. From 1920 he assembled an extensive collection of photographs, equipment, and literature, which was acquired by the state in 1965 and in 1971 incorporated in the new department of photography at Stockholm's Moderna Museet. As a photographer, Bäckström remained a lifelong *pictorialist. J-EL

Bailey, David (b. 1938), English photographer, brought up in east London. Childhood painting gave him respite from the academic underachievement caused by undetected dyslexia and irregular wartime schooling. Later, cinema was an important influence, offering intimations of glamour (mostly American), fame, and sophistication. In the late 1950s he admired *Cartier-Bresson's photographs of women in the Himalayas.

After national service, Bailey assisted the fashion photographer John *French, went freelance in 1960, and, aged 22, began working for *Vogue. Using a 35 mm single-lens reflex enabled him to shoot outdoors with a 'from-the-hip' immediacy in keeping with the volatile atmosphere of the time. Spontaneity of gesture and the incorporation of random elements brought a filmic quality to his photographs that reflected his enthusiasm for French New Wave cinema. His portraits form an extended document of the iconic personalities of the later 20th century. With his stark, direct, high-contrast style he became the incisive interpreter of an era, while himself personifying the 'photographer as iconic sixties type' recreated in Michelangelo Antonioni's film *Blowup* (1967). His first publication, *David Bailey's Box of Pin-ups* (1965; literally a picture box rather than a book), contained portraits of pop stars, art directors, actors, models, and photographers. Later titles included *Trouble and Strife* (1980), *If We Shadows* (1992), *The Lady is a Tramp* (1995), *David Bailey's Rock and Roll Heroes* (1997), and *Chasing Rainbows* (2001). He has also directed documentary films and television commercials. ANE

Harrison, M., *David Bailey, Birth of the Cool: 1957–1969* (2000).

Baldus, Édouard Denis (1813–89), French photographer. Initially a painter, but discovering his *métier* as a photographer of architectural views, Baldus also contributed to the technical development of the medium. He left his native Westphalia for Paris in 1838, but may already have worked successfully as a portrait painter in the USA; his first 25 years are a mystery.

Baldus showed his paintings at salons between 1841 and 1852, and had taken up photography by 1848. In 1851 he had joined the *Société Héliographique, and worked for the *Mission Héliographique in Burgundy, the Dauphiné, and the South of France, using the special *waxed-paper negatives that he had patented. Mostly large scale, and sometimes printed from more than one negative, his pictures demonstrate his desire to create images of a commanding architectural presence, a constant feature of his work.

Following this success, Baldus successfully sought a subscription from the Interior Ministry for a series on *Les Villes de France photographiées*, and began to demonstrate his consummate skill at representing architectural form. His pictures of Paris monuments like the Louvre combine the subtle play of light across the building with stunning clarity of detail. Photographs made in central and southern France underlined his growing mastery of the medium.

In 1855 Baron James de Rothschild commissioned Baldus to create a huge album of views, bound in red leather, as a gift to celebrate the opening of the Boulogne–Paris railway by Queen Victoria. It is one of the masterpieces of early photography. Further state commissions followed, including in 1856 a series on the disastrous Rhône floods at Lyon, Avignon, and Tarascon. The Louvre's reconstruction between 1855 and 1858 was extensively documented by Baldus, and may constitute the apogee of his career. Two thousand negatives recorded the vast project 'stone by stone', as the critic Lacan wrote. Coverage

Édouard Denis Baldus

Enghien, 1855. Albumen print

of other railway and civil engineering projects followed, but by the mid-1860s Baldus had begun to devote himself to publishing photographic reproductions of art and architecture by the *heliogravure process he had invented. The business flourished initially, but failed in 1887. PH

 Daniel, M., *The Photographs of Édouard Baldus* (1994).

ballet. See PERFORMING ARTS, PHOTOGRAPHY AND.

balloons. See AERIAL PHOTOGRAPHY.

Balogh, Rudolf (1879–1944), Hungarian photojournalist and art photographer, trained in Vienna, who joined the *Vasárnap Újság* (*Sunday Journal*) in 1902. He exhibited regularly, from 1911 edited *A Fény* (*The Light*), and in 1914 founded *Fotómûvészet* (*Art Photography*). During the First World War he was a prolific war photographer on the Eastern Front, afterwards returning to photojournalism in Budapest. An extremely influential figure, Balogh was celebrated for his urban nocturnes, rural landscapes, and genre scenes; his late work reveals strong modernist influences. Most of his surviving photographs are in the Hungarian Museum of Photography. RL

 Photographies hongroises: des romantismes aux avant-gardes (2001).

Baltermants, Dmitri (1912–90), Russian photojournalist. The son of an army officer, Baltermants taught himself photography while studying mathematics at Moscow University and began taking professional assignments in 1936. During the Second World War he worked for *Izvestia* and other journals. One of many powerful images was *Attack* (1941), a dramatically blurred low-angle shot of soldiers leaping across a trench. Another, his most famous, was *Grief* (*Identifying the Dead*; 1942), taken near Kerch in the Crimea and enhanced in the darkroom with a lowering sky that makes the scene of massacre and sorrow still more harrowing. After the war he joined the popular weekly *Ogonyok*, eventually becoming picture editor. His photograph of grieving factory workers around a radio, *The Announcement of Stalin's Death* (1953), was a classic of *Socialist Realism. Later, Baltermants worked for the Kremlin, accompanying Nikita Khrushchev to China and Leonid Brezhnev to Cuba and the USA. RL

Dmitri Baltermants

Tchaikovsky, Germany, 1945

Baltz, Lewis (b. 1945), American photographer, born and educated in southern California, which provided the subjects for his early photographic series. The most notable of these were *The Tract Houses* (1969–71) and *The New Industrial Parks near Irvine, California* (published 1975). His black-and-white images, taken with a Leica on a tripod, framed the banal houses and factories with elegant exactitude, like the precise formulations of a philosopher. They seemed to show us the corporate mind. Later series concerned building projects in *Maryland* (1976), *Nevada* (1977), and *Park City* (in Utah, 1980), followed by the modern inner-city wastelands of *San Quentin Point* (1986) and *Candlestick Point* (1988). The underlying subject was landscape-as-real-estate: Baltz used construction sites to deconstruct society. He became one of the most influential members of 'the *New Topographics', a movement of global reach. 'By 1990', Baltz has said, 'it seemed to me that the world had in a sense already ended . . . it had withdrawn itself from our apprehension.' He moved to Paris, where— during the 1990s—he made large-scale installation works in colour with soundtracks: *Ronde de nuit*, *Docile Bodies*, and *The Politics of Bacteria*. These works addressed the strangely blurred interaction of humans and machines, taking in computers, high-tech hospitals, and ever-present surveillance. Baltz's early works suggested a dandy of despair. His recent installations take us deeply into ambiguous cyberworlds with a similar menace and exhilaration. He remains a restless, radical presence. MH-B

Baltz, L., *Rule without Exception* (1990).
Butler, C. H., *Ronde de nuit* (1998).

Bantzer, Carl (1857–1941), German painter of rural scenes inspired by the area around Willingshausen in his native Hesse. Influenced by the followers of Jules Bastien-Lepage, including probably Alexis *Muenier, he used numerous photographic studies in composing large, complex canvases like *Communion in a Hessian Church* (1892), and the more dynamic *Schwalm Dance* (1898). However, reflecting ambivalent contemporary attitudes towards the camera as an artist's tool, his published writings made no mention of it. Today the photographs, in the Hessian State Archive, Marburg, offer intriguing glimpses of a traditional society on the threshold of modernity. RL

Carl Bantzer: Synthetischer Realismus (1977).

Barnack, Oskar (1879–1936), German instrument maker who became head of the microscope department of Ernst *Leitz in Wetzlar soon after joining the company in 1911. After initial research on the construction of small cameras, Barnack began work on two prototypes of the Leitz Camera (*Leica) in 1913, used by himself and Leitz. The Leica I was launched commercially in 1925. Barnack remained head of Leica's construction office until his death and developed many refinements of both cameras and lenses. RS

Eggert, J., 'Deutsche Pioniere der Photographie', *Camera*, 30 (1951), No. 11.

Barnard, George (1819–1902), American photographer, known for his Civil War images. After establishing a *daguerreotype studio in Oswego, New York (1846), Barnard moved to Syracuse (1853), where he took up the *wet-plate process. In 1859 he joined Edward Anthony's New York business to take stereoscopic pictures. One of a group of war photographers organized by Mathew *Brady, he accompanied Sherman's invasion of Georgia and the Carolinas in 1864–5; 61 albumen prints were published in 1866 as *Photographic Views of Sherman's Campaign* (repr. 1977). After the war he ran studios in a series of locations and worked briefly with George *Eastman. RP

Barnardo, Dr Thomas. See MIGRATION, PHOTOGRAPHY AND.

Barthes, Roland (1915–80), French writer, critic, and literary theorist, best known for his pioneering work on cultural studies. *Camera Lucida: Reflections on Photography* (1980) is his only book dedicated entirely to photography. He elaborates the concept of the *punctum* to focus on the personal and emotional experience of the photograph as physically connected to its subject. This emphasis is related to his earlier essay 'The Death of the Author' (in *Image Music Text*, 1977), which criticizes the myth of authorial intention as the source of a work's meaning, to emphasize instead the role of the reader. *Camera Lucida* is stylistically and conceptually related to his other late works, *The Pleasures of the Text* (1973), *Roland Barthes by Roland Barthes* (1975), and *A Lover's Discourse* (1977), in their fragmented and personalized style, and in blurring distinctions between criticism and poetic, semi-fictional texts. His influence on *theories of photographic meaning had been crucial since the publication of his essay collection *Mythologies* (1957), one of the most significant attempts to bring the methodology of *semiotics to bear on popular culture, including its uses of photography. Barthes analyses and criticizes bourgeois culture without denying its pleasures. Myth, he argues, is a mode of speech which successfully hides the ideological nature of representation by making it appear entirely natural and self-evident. The main target of his criticism is bourgeois culture's denial of the opacity of representation, its insistence on the possibility of *realism. PDB

Rabaté, J. M. (ed.), *Writing the Image after Barthes* (1997).

Barton, Emma (1872–1938), English photographer, member of the *Royal Photographic Society and Birmingham Photographic Society, and respected *pictorialist. She received various awards and exhibited in Europe and the USA. Starting in 1893, Barton photographed her family and friends in her home and garden, working mainly in *gum bichromate, platinum, chlorobromide, *carbon, and, from 1910, *autochrome. By 1904 she had shifted from child studies and religious themes to old-master-style portraits. Kodak used her images for advertising in the 1920s. AL

James, P., Sidey, T., and Taylor, J. (eds.), *Sunlight and Shadow: The Photographs of Emma Barton 1872–1938* (1995).

Basilico, Gabriele (b. 1944), Italian photographer who studied architecture in Milan and photographed Italy's social scene in the 1970s before turning to the post-industrial urban landscape. From

Ritratti di fabbriche (1982), the *DATAR project (1984–5), and series on Beirut, Berlin, and Milan in the 1990s, Basilico has pursued a coherent, *Atget-like endeavour: a cumulative investigation of the relationship between individual buildings and their urban context, in a style distinguished by a revealing vantage point, rigorous composition, and low-key printing. AF

Basilico, G., and Boeri, S., *Italy: Cross-Sections of a Country* (1998).
Bonami, M., *Gabriele Basilico* (2001).

bas-relief is a sculptural technique from ancient Greece. Sculptures on walls were carved in low relief with the foremost parts flat. The relief was picked out by shadows. Photographic 'bas-relief' images are made by sandwiching a negative and a positive transparency slightly out of register and printing the combination (Fig. 1a and b). GS

Batho, John (b. 1939), American photographer. A trained archivist and book conservator, Batho began photographing in the 1960s. His colour work has been likened to Mark Rothko's non-objective

Fig. 1a

Fig. 1b

painting in its visual and philosophical depth. Equally powerful, Batho's colour images of actual places—like Monet's gardens at Giverny—are influenced by Impressionism. His later work includes prints using the Fresson *carbon process and digitized ink-jet impressions on vellum. He has taught at the University of Paris VIII and the École Nationale des Beaux-Arts in Dijon, France. TT

Batho, J., and Cheva, F., *John Batho: A Retrospective* (2002).

Battaglia, Letizia (b. 1935), Italian photojournalist, born and mainly brought up in Palermo, Sicily. Married at 16, she took up photojournalism after her divorce in 1971. In 1974, after a period in Milan during which she met her long-time partner Franco Zecchin (b. 1953), she returned to Sicily to work on the communist newspaper *L'ora*, remaining with it—though never a party member—almost until its closure in 1990. In these years, dominated by ever bloodier, drug-fuelled conflict between crime syndicates, and between *mafiosi* and the state, Battaglia created *c.*600,000 images. They form a searing record of the violence, sorrow, and despair that had become everyday reality in the Sicilian capital. With courage and tenacity, Battaglia and Zecchin used the camera as a weapon against endemic corruption, and the civil disintegration and infrastructural decay it caused. Battaglia also became involved in women's and environmental issues, and from 1985 to 1997 held a Green seat on the city council. For a time she ran a publishing house, Edizioni della Battaglia, and co-founded a monthly journal for women, *Mezzocielo*. RL

Harris, M., et al., *Letizia Battaglia: Passion, Justice, Freedom. Photographs of Sicily* (1999).

Bauhaus, photography and the. The Bauhaus was created in 1919 by the unification of two older academies in Weimar, and in its founding manifesto Walter Gropius (1883–1969) demanded the unification of all the arts under the primacy of architecture. The teaching of photography went through three main phases until the Bauhaus's dissolution in 1933.

The period until 1923 was dominated by the arts-and-crafts ethos of individual craftsmanship. Photography featured in the preliminary courses developed by Johannes *Itten and his assistant Georg Muche, but primarily, although some formal experimentation took place, as a reproductive medium. Some early Bauhaus students, like *Umbo, became photographers, but there is no significant link between this phase of the Bauhaus's history and the development of avant-garde photography. When László *Moholy-Nagy joined the faculty in 1923, the emphasis on mass production and industrial design increased, with the sale of Bauhaus work providing a source of income. Lucia *Moholy's advertising photographs successfully contributed to this, and she also recorded the school's new buildings and workshops when it moved to Dessau in 1926. Moholy-Nagy incorporated photography in his compulsory preliminary courses, so that for the first time all students received some photographic training; and some were influenced by his experimental work. Although, as yet, no free-standing photography class existed, the images produced at this time (e.g. the work of Irene

Letizia Battaglia

Magistrate Roberto Scarpinato with escort, Palermo, 1998

Bayer-Hecht (1898–1991), Florence *Henri, Erich Consemueller, and others) are among the best in the Bauhaus's history. After the departure of Moholy-Nagy and his wife in 1928, Joost Schmidt taught advertising and gave some introductory classes in photography. Then in 1929 he appointed Walter *Peterhans as the first (and only) teacher of a photography class at the Bauhaus. Although his own work was strongly influenced by *Neue Sachlichkeit, Peterhans designed a course in technique and materials that did not privilege any particular style, and from which graphic designers like Irene and Herbert Schuermann or Kurt Kranz benefited as much as photojournalists like Irena Bluehova (1904–91) or Moshe Raviv-Vorobeichic.

However, by comparison with schools like the Folkwang Institute in Essen under Max Burchartz (1887–1961), the Stuttgart School of Graphic Arts under Ernst Schneidler, and Hans *Finsler's school at Burg Giebichenstein, which offered the only curriculum in 'modern photography' worthy of the name, the Bauhaus was of secondary importance. Notwithstanding the many experiments in photography and photomontage that took place there, and the oeuvre of László

Moholy-Nagy, as a school it was less influential in this field than in industrial design, art theory, and basic pedagogics. RS

Fiedler, J. (ed.), *Photography at the Bauhaus* (1990).
Bauhaus-Archiv Berlin, *Fotografie am Bauhaus* (1990).

Bayard, Hippolyte (1801–87), French photographer and inventor, in 1839, of direct-positive photography, a process that produced a unique positive image on paper. The method rivalled the contemporaneous inventions of the *daguerreotype and *photogenic drawing. Bayard was well connected in the art world of his time. His invention was acclaimed by the Academy of Fine Arts, which saw the advantages of a process on paper for artistic practice. However, he never received support from the Academy of Sciences or the French government. His famous *Self-Portrait as a Suicide* (1840) satirized his plight as neglected inventor.

Bayard practised all photographic procedures with skill, but essentially converted to negative-positive photography (the *calotype) by 1845. During the 1840s, he was a technical and aesthetic pioneer,

defining photography's possibilities as both a documentary and an expressive medium. Paris, then undergoing phenomenal growth, was one of his preferred subjects, and his photographs express a positive view of change and progress that seems inspired by a Saint-Simonist philosophy. Staged photographs, portraiture, and still life were other favoured genres. In an extensive garden series of this period, his many self-portraits comprise a vision of himself as creator of the garden, and can be understood as a metaphor for his role in the invention of photography.

Always at the forefront of technical innovation, Bayard developed a method for the mass production of positive prints before *Blanquart-Évrard, but lacked the entrepreneurial vision to implement his ideas. He was one of the first to work with glass negatives, using the albumen-on-glass procedure by 1847, at a time when others in France were only just beginning to use paper negatives. Bayard was an unsurpassed master of this difficult technique, and used it well into the 1850s.

In 1851 he was one of five photographers chosen for the *Mission Héliographique, a government project of primary importance for photography in France. He also became a specialist in photographic reproduction of works of art, and contributed many such images to the publications of Blanquart-Évrard. Bayard was a founding member of both the *Société Héliographique (1851) and the *Société Française de Photographie (1854), now the largest repository of his work. The photographer's craft was a fundamental interest of these societies, and his personality and technical gifts coincided perfectly with this concern. Within the societies he was an effective administrator and a respected, generous colleague. Many accomplished photographers considered him their master. He also contributed to the journal La *Lumière. Bayard participated as well in the commercial current of photography that developed after 1851 with the perfection of the collodion-on-glass technique, operating a *carte de visite studio 1860–6 in partnership with the illustrator Bertall. He received the Légion d'honneur in 1864, belated recognition of this original figure who was a notable presence during the first quarter-century of photography in France.　　NK

Gautrand, J.-C., and Frizot, M., *Hippolyte Bayard: naissance de l'image photographique* (1987).

Keeler, N., 'Hippolyte Bayard aux origines de la photographie et de la ville moderne', *La Recherche photographique*, 2 (1987).

Bayer, Herbert (1900–85), Austrian-born American painter, typographer, designer, and photographer. After initial training as an architect, Bayer studied at the Weimar *Bauhaus with Johannes *Itten, Wassily Kandinsky, and Oskar Schlemmer, then headed the workshop for printing and advertising (1925–8) after the school's move to Dessau. In Berlin over the following decade, before he emigrated to the USA in 1938, he had a varied career in advertising and exhibition design in Berlin, and in 1928–30 was art director for the German edition of *Vogue. He also turned increasingly to photography as his preferred medium, producing *photomontages and modernistic, sometimes abstract images influenced by *Surrealism. In New York

he designed several exhibitions for MoMA, then moved to Colorado in 1946, where his creative versatility remained undiminished.　　LAL

Cohen, A. A., *Herbert Bayer: The Complete Work* (1984).

Beals, Jessie Tarbox (1870–1942), American photographer who initially opened a summer studio in Williamsburg, Massachusetts, where she was a schoolteacher. Hired briefly as staff photographer for the *Buffalo Inquirer* and *Buffalo Courier*; with her husband Alfred Beals, who operated the darkroom, she became an itinerant photographer (1900–2). Chosen as an official photographer of the Louisiana Purchase Exposition in St Louis, Missouri, in 1904, she turned to freelance *photojournalism, opening a studio in New York. An aggressive businesswoman, she photographed presidents and movie stars.　　CBS

Alland A., Sr., *Jessie Tarbox Beals: First Woman News Photographer* (1978).

Beato, Felice (1834–*c*.1907), Anglo-Greek photographer, born in Corfu. He spent his early career working with his brother-in-law James *Robertson in Constantinople and Malta. In the late summer of 1855 he went to record the aftermath of the Crimean War and the following year visited Jerusalem with his brother Antonio, also a photographer, and Robertson. In February 1858 he arrived in Calcutta to document the Great Rebellion of 1857 and, although he missed the fighting, produced powerful photographs of the battle sites, often described as early examples of *photojournalism. Beato left India in February 1860 and accompanied British troops to China to photograph the Second Opium War. In 1863 he moved to Japan, opening a studio in Yokohama to concentrate on landscape and portraits. Disaster struck on 26 October 1866 when fire destroyed his negatives, but Beato survived this loss, and gradually became known as one of Yokohama's more colourful characters. From Japan, he accompanied the US expedition to Korea in May 1871 and on his return continued to operate a successful studio until 1877, when he sold his entire stock to the photographer Raimund von *Stillfried. Following unsuccessful financial speculation, he accompanied Wolseley's Sudan expedition in 1885, although no photographs appear to have survived. After briefly visiting London, Beato arrived in *Burma in 1887. He established studios in Rangoon and Mandalay, also operating as a furniture and curio dealer. He probably died in Burma.　　SCG

Harris, D., *Of Battle and Beauty: Felice Beato's Photographs of China* (1999).

Beaton, Cecil (1904–80), British portrait photographer and theatrical designer. Born in Hampstead, London, Beaton owned his first camera at the age of 11. His earliest portraits, set against home-made backdrops, were of his sisters Nancy and Baba. He was educated at Harrow and Cambridge, but did not graduate. His subsequent career made him one of those rare photographers whose name is well known to the general public. He succeeded initially as a society portraitist who could maximize the allure of debutantes. But the encouragement of the Sitwell family gave him access to the world of the arts, and a 1927 portrait of Edith Sitwell was one of his

earliest published pictures. A visit to New York at the end of the 1920s led to photographic contracts for *Vogue and, subsequently, *Vanity Fair* and *Harper's Bazaar*. Beaton's work focused on the cultural icons (both social and artistic) of his day, providing a record of its famous, beautiful, fashionable, and eccentric figures. His appetite for travel enabled him to build up a body of work that had international significance. Hollywood stars captured by his camera included Gary Cooper, Marlene Dietrich, Greta Garbo, and Katherine Hepburn, while painters ranged from Salvador Dalí to Francis Bacon. His portraits spanned parts of six decades and reflected successive generations of the new and avant-garde, from Stravinsky, Cocteau, and Picasso to *Warhol and Jagger. In the 1930s he was commissioned to take a series of pictures of Queen Elizabeth, and this proved to be a prelude to further royal photographs and the eventual status of official family portraitist. During the Second World War, in a phase of his career far removed from its usual glamorous milieu, he documented air-raid damage in London and served as a war photographer in Africa and Asia.

Beaton's abilities extended beyond photography. He was a writer and illustrator (with a talent for caricature), and won recognition as a costume and stage designer. Published collections of his photographs included *The Book of Beauty* (1930), *Cecil Beaton's Scrapbook* (1937), *Cecil Beaton's New York* (1938), and *Persona Grata* (1953), in which text to accompany the portraits was supplied by the theatre critic Kenneth Tynan. He also wrote a historical study, *British Photographers* (1944), an early autobiography (*Photobiography*, 1951), and published a series of extracts from his diaries. (The unexpurgated versions that appeared posthumously were considerably more caustic.) His set and costume designs for plays, ballet, and opera were in demand on both sides of the Atlantic, and he served as costume and production designer for a number of films, winning Academy Awards for his work on *Gigi* (1958) and *My Fair Lady* (1964). In 1968 a retrospective of his work was mounted by London's National Portrait Gallery, and in 1972 he was knighted. A cerebral haemorrhage in 1974 resulted in frailty and partial paralysis, but in his last years Beaton taught himself to write and use a camera with his left hand. RP

Vickers, H., *Cecil Beaton: The Authorised Biography* (1985).

Becher, Bernd (b. 1931) and **Hilla** (née Wobeser; b. 1934), German photographers and teachers. Bernd studied painting and typography, Hilla photography. They began working together in 1959 (and married in 1961), embarking on a visual taxonomy of functional architecture in the post-industrial regions of western Germany, the Netherlands, and eventually the USA. The structures—silos, gasometers, winding-towers, and the like—are photographed in an absolutely objective and uniform manner, like laboratory specimens or pieces of sculpture, with perspectival distortions and variations of light and scale reduced to the minimum. People are absent; and the serial nature of the work is emphasized by hanging the pictures in close symmetrical rows. The Bechers were represented at West Germany's prestigious contemporary art venue, the Kassel Dokumenta, in 1972,

and their work has been widely exhibited and collected ever since, achieving high prices. Although it may appear to some oppressively passionless and repetitive, its influence on a whole generation of artist-photographers in Germany and internationally, via exhibitions, publications, and Bernd's teaching (1976–2000) at the Düsseldorf Academy, has been immense. It featured prominently at the landmark *Cruel and Tender* exhibition in London and Cologne in 2003. The following year the Bechers received the Hasselblad Foundation International Award. RL

Becher, B., and Becher, H., *Basic Forms of Industrial Buildings* (2005).

Bedford, Francis (1816–94), British landscape photographer. Trained as a lithographer, Bedford became involved with photography at his father's architectural practice in the early 1850s. Probably as a result of seeing some of his architectural illustrations, Queen Victoria commissioned him in 1854 to photograph objects in the royal collection at Marlborough House and, three years later, views of Prince Albert's native town of Coburg, as a gift for him. In the following year, Bedford took similar views in Gotha. In 1862, he travelled with the prince of Wales on a tour of the Holy Land, photographing many previously unrecorded historical sites. On Bedford's return to London, 172 of the pictures he took in the Middle East were published in 21 parts. During the 1860s and 1870s, Bedford travelled all over Britain, with large-format cameras and portable *wet-plate equipment. He published hundreds of prints of his carefully composed and technically unrivalled views, as *cartes de visite*, single prints, stereoscopic pairs, and book illustrations. Throughout much of this period, Bedford was active in the London (later *Royal) Photographic Society, and was twice its vice-president. CF

Haworth-Booth, M. (ed.), *The Golden Age of British Photography* (1984).

Before Photography exhibition, at MoMA, New York, in 1981, curated by Peter Galassi. It addressed the prehistory of photography's invention, concentrating on changing structures of visual perception, the rise of the landscape sketch in oils *c.*1800, and the attendant growth of interest in realistic detail. Galassi wrote: 'The landscape sketches . . . present a new and fundamentally modern pictorial syntax of immediate, synoptic perceptions and discontinuous, unexpected forms. It is the syntax of an art devoted to the singular and contingent rather than the universal and stable. It is also the syntax of photography.' The exhibition also paid tribute to the pioneering earlier work in this field of the Austrian-American art historian Heinrich *Schwarz. RL

Galassi, P., *Before Photography: Painting and the Invention of Photography* (1981).

Beken of Cowes, Isle of Wight, third-generation English family firm of *marine, especially yachting photographers. Pharmacist Frank Beken recorded the expanding sporting, commercial, and naval activity in the Solent in the 1890s and 1900s. Using custom-designed large-plate cameras, and in conditions demanding nerve and skill,

Francis Bedford

Baptistry of Canterbury cathedral, 1857. Albumen print

Beken of Cowes

Bluenose, 1935

he captured classic images of Emperor Wilhelm II's *Meteor*, King Edward VII's *Britannia*, and other great yachts in full sail. His son Keith and grandson Kenneth entered the modern era of powerboating and corporate-sponsored global racing. Beken's archive contains over 75,000 historic negatives. RL

 Beken, K., *The Beken File* (1980).

Belgium. 'Perhaps the Brussels sun is a less enthusiastic draughtsman than the Paris sun, but at least he draws.' One viewer's reaction to the earliest *daguerreotypes taken on Belgian soil in 1839 alludes directly to the international nature of photography and the cultural dependency of local production. In fact, the nascent Belgian state, created as an afterthought in the post-Napoleonic political settlement a mere nine years previously, could only thrive on the basis of open borders and free movement of goods and ideas. Belgium's position at the crossroads of Protestant north and Catholic south, the meeting point of Germanic and Latin cultures, informed the development of photography as of other art forms.

 Jean Jobard (1792–1861), lithographer, inventor, and tireless campaigner for intellectual property rights, was a Frenchman resident in Brussels when he purchased a prototype camera from Isidore Niépce, with which he realized the first photograph in Belgium on 16 September 1839. Many of the first generation of daguerreotypists who followed in his wake learned their profession abroad. Billing, an Englishman who had obtained a daguerreotype patent from Richard Beard, opened the first portrait studio in Brussels in March 1842. Alphonse Plumier (1819–77), son of a Liège distiller, opened a studio in his home town in 1843, following apprenticeship in Paris. Outside the cities (Brussels, Antwerp, Ghent, Liège) which supported permanent daguerreotype studios by the mid-1840s, itinerants from neighbouring countries criss-crossed Belgium, typically setting up makeshift studios in hotel courtyards.

The pattern of technology transfer continued into the era of paper photography. Guillaume Claine (1811–69) was initiated into the *wet-plate process by Abel *Niépce de Saint-Victor, using it to produce the first significant body of architectural photographs in Belgium in 1851–2, sponsored by the Interior Ministry and the Brussels municipality. Diffusion of knowledge and technique was promoted by the researcher Désiré van Monckhoven (1834–82) from Ghent, whose Traité général de photographie (1856), regularly updated, became the most successful handbook in the French-speaking world and reached eight editions by 1889.

Political upheaval in France enriched the photographic life of the Belgian capital. The jovial French judge Chevalier L. P. T. Dubois de Nehaut (1799–1872), unwilling participant in the 1848 Revolution, preferred the life of rentier and amateur photographer in Brussels, pioneering *photojournalism with subjects like King Leopold I's silver jubilee celebrations in 1856. Gilbert Radoux (1820–?), architect and political refugee, founded Belgium's first photographic printing establishment. Their work was shown at the earliest major photography exhibition in Brussels in 1856, alongside prints by their colleagues in the *Société Française de Photographie, a group which remained a natural focus for Belgian aspirations until the Association Belge de Photographie (ABP) was founded in 1874.

Photography's economic breakthrough derived here as elsewhere in Europe from the huge and instantaneous popularity of the *carte de visite in 1860. The caricaturist and showman Louis Ghémar (1819–73), who had learned photography in Edinburgh, exploited this marketing phenomenon with portrait series of royalty and local worthies. As Belgium industrialized, studios proliferated. The local market for architectural photography, on the other hand, remained stubbornly small, as Edmond *Fierlants discovered to his cost.

One leading-edge industrial application, relating to the printing press, adapted foreign technology. William Toovey (1821–?), an English lithographer working in Brussels, refined the Dutchman E. I. Asser's photolithographic process in 1863, of strategic use for military cartography; while the versatile Joseph Maes (1838–1908) 'reinvented' Joseph *Albert's *collotype process, which he exploited widely throughout the 1870s and 1880s. Towards the century's end, colonization of the Congo was documented in optimistic reports illustrated with relief *half-tones in news weeklies such as Le Patriote illustré.

With its presiding spirit of internationalism, *pictorialism quickly gained ground in Belgium, influenced both by the proselytizing of the *Linked Ring, which counted Alexandre Drains (1855–1925) amongst its members, and by adherents of the *Photo-Club de Paris, where Édouard Hannon (1853–1931) regularly exhibited. The ABP remained a broad church, organizing pictorialist salons from 1896 onwards and countering the threat posed by the small secessionist movement L'Effort, active 1901–5 around the interior designer Léon Sneyers (1877–1949). Also typical of pictorialism was the work of Gustave Marissiaux (1872–1929), whose evocative images of mine workers and their families in the Liège region, first exhibited in 1905, express a social concern previously absent from Belgian photography.

Following the cultural caesura of the First World War, a conservative tendency represented by Léonard *Misonne was offset by the bold modernist work of Pierre *Dubreuil, originally influenced by Cubist and Futurist models. The irruption of *Surrealism constituted Belgian photography's most distinctive contribution in the inter-war years. Experimenters of cosmopolitan background, notably the sculptors and graphic artists Raoul *Ubac and Sasha Stone (1895–1940), vied with home-grown practitioners of several art forms such as E. L. T. Mesens (1903–71) and Marcel Lefrancq (1916–74).

The protean figure of Willy Kessels (1898–1974) came to prominence at the Exposition Internationale de la Photographie, organized by Mesens in Brussels in 1932, which marked the definitive breakthrough of the avant-garde in Belgian photography. As customs and old structures fractured (including the ABP) during the German occupation, Kessels collaborated while other photographers fell silent. Inevitably pre-war exuberance gave way to the reticence of the 1950s, exemplified by the tellingly composed artists' portraits created by Charles Leirens (1888–1963) for the Education Ministry. Rebelling against the weight of figurative tradition, Kessels's late work veered towards abstract *photograms and overprinting, while Pierre *Cordier perfected the chemigram technique in 1963, using light-sensitive materials to create patterns evoking the forms of nature, and earning a permanent place in the Brussels metro.

Historical awareness of Belgium's photographic heritage gradually developed hand in hand with the federalization of cultural activity. Two photography museums opened in the 1980s: Antwerp serves the Dutch-speaking north, Charleroi the French-speaking south, and each serves as a forum for contemporary creation. SFJ

Vercheval, G. (ed.), Pour une histoire de la photographie en Belgique (1993).

Joseph, S. F., Schwilden, T., and Claes, M.-C., Directory of Photographers in Belgium 1839–1905 (1997).

Bellmer, Hans (1902–75), German artist and photographer. He remains among the lesser-known Surrealists due to the sexually explicit nature of his work. Living in Berlin as the Nazi Party rose to power, he successfully kept his photography secret from the authorities, after earlier trouble over a series of Dada-influenced gouaches. Bellmer nevertheless found a receptive audience in France, where the Surrealists included his images in their publications, and later emigrated there. His most celebrated photographs, produced in 1935–8, depict a life-sized adolescent girl-doll of his own making. For each picture Bellmer reassembled the doll in a perverse combination of body parts and posed it in carefully lit and composed environments to create images that suggest narratives of violence and seduction, but are ultimately ambiguous. Bellmer's graphic work was still more sexually explicit, and his later imagery pornographic. His depiction of the female body, typically in pieces and apparently the subject of violence, has earned him the reputation of a misogynist, but the work is nonetheless a significant contribution to Surrealist art. MR

Taylor, S., Hans Bellmer: The Anatomy of Anxiety (2000).

Bellocq, E. J. See STORYVILLE PORTRAITS.

bellows. Cloth, leather, and synthetic pleated bellows have all been used to provide a light-tight connection between the camera lens and sensitized material, and remain integral to modern view camera design. Cloth bags were used in the 1840s and 1850s. Bellows did not come into general use until 1851, on a camera designed and patented by Lewis's of New York. They were used to provide lens extension. Fowke's patented design for a folding bellows camera of 1856 and Kinnear's 1857 design established the standard configuration until the early 20th century, with integral bellows allowing compactness and portability. MP

Benecke, Ernest (1828–84), Anglo-German photographer, son of a banking family with financial interests in Egypt, who made over 150 *calotypes during his travels in the Mediterranean and Middle East 1850–2. His photographic output is unique both in the number of photographs of people of the region, and in its early date. It includes some of the earliest photographs of the peoples of Egypt and Palestine and encompasses a range of classes and occupations—Nubian children, slave women, Bedouins, musicians, and beggars, as well as named sitters. Benecke inscribed the date, subject, and location in the negative of most of his images, thus providing a remarkable log of his journey and photographic interests. Five albums were published by the pioneering photographic printer *Blanquart-Évrard—*Album photographique* (1851–2), *Études photographiques* (1853), and *Variétés photographiques* (1853)—but the balance of his work exists as unique prints. KSH

Benedicto, Nair (b. 1940), Brazilian photojournalist and documentary photographer, notable particularly for her studies of the indigenous peoples of the Brazilian interior, especially the Pará region; and for wider-ranging work on women and children in Latin America. She co-founded the F4 photo collective in 1979, and established the Imagen agency in 1991. LAL

As melhores fotos de Nair Benedicto (1988).

Benjamin, Walter (1892–1940), German cultural critic. Born in Berlin, the son of a Jewish art dealer, he committed suicide on the Franco-Spanish border while fleeing the Nazis, still little known outside Marxist circles. He had never obtained a university post, nor published many books, but translations and essays on wide-ranging topics from history to book collecting, Paris to Naples, Baudelaire to Marxism. However, he is now established as one of the 20th century's most original thinkers, controversial in many respects but influential for his critical exploration of the nature of modernity and modern culture, contributing to postmodernism. While in Paris working on his unfinished *Arcades Project* (1999), a study of the 19th century, he met and was photographed by Gisèle *Freund, whose writings on photography are quoted in the *Arcades* and perhaps influenced his 'Short History of Photography' (1931; in *One Way Street and Other Writings*, 1979)—for example, his disdain for *cartes de visite*. He also seems to prefigure *Barthes's writings on the *punctum* by speaking of 'the inconspicuous spot', 'the tiny spark of contingency, of the Here and Now, with which reality has seared the subject'. His celebrated essay on 'The Work of Art in the Age of Mechanical Reproduction' (1936; in *Illuminations*, 1970) is most relevant to *contemporary art and *theories of photographic meaning. Benjamin explores the effects on art of its reproducibility through photographs, claiming that the original work's aura of authenticity withers as it comes closer to a mass audience. This loss is both mourned and welcomed: new forms develop, such as photography and film, which do not rely on there being one original but many, circulating in a variety of contexts and receiving meaning from all of them. Also, a certain reciprocity develops: works of art become, or become seen as, designed to be reproduced, and reproduction becomes part of the work itself. PDB

Arendt, H., 'Walter Benjamin, 1892–1940', in W. Benjamin, *Illuminations* (1970).

Benton, Stephen (1941–2003), American physicist. He studied electrical engineering and applied physics at the Massachusetts Institute of Technology (MIT) and at Harvard University, where he developed the principle of the rainbow hologram, a white-light viewable hologram that can be reproduced by a mechanical process. This forms the basis of the embossed hologram, a device universally used as a security image and for decorative purposes.

After a period with the Polaroid Corporation, Benton joined the MIT Center for Advanced Visual Studies in 1977, and in 1982 became a founding member of the Media Laboratory and head of the Spatial Imaging Group. After greatly improving the technique for making holographic stereograms, the team went on to develop real-time holographic video. Benton was also responsible for rescuing the historic collection of the foundering Museum of Holography in New York, now housed at MIT. GS

See also HOLOGRAPHY.

Beny, Roloff (Wilfred Roy; 1924–84), Canadian photographer, painter, printmaker, and book designer, born in Medicine Hat, Alberta. Having achieved moderate success as a painter during the 1940s and early 1950s, Beny turned to photography and became known for his lavish illustrated books. After his first major exhibition, at London's Institute of Contemporary Art (1956), he published *The Thrones of Earth and Heaven* (1958), and subsequently established an international reputation for his photographs of Greek, Roman, and Italian Renaissance art, architecture, and sculpture, of archaeological ruins from Burma to Yugoslavia, and of temples and sacred objects of the Islamic, Hindu, and Buddhist faiths. He also left a rich visual record of Iran and the imperial family, an inventory of Rome's churches, and portraits of leading European cultural figures. Beny's archive of manuscripts and *c.*200,000 photographic items is now in the National Archives of Canada. JMS

Crites, M., *Visual Journeys* (1994).

Berggren, Guillaume (1835–1920), Swedish photographer who started work as an apprentice carpenter in 1850. He left Sweden in 1855, learned photography in Berlin, and settled in Constantinople in 1866, opening a studio in the Grande Rue de la Pera in the early 1870s. Berggren combined studio work—portraits of travellers and dignitaries, with the option of posing in Turkish attire—with the sale of prints offering a range of Ottoman motifs. He photographed the street scenes and architecture of Constantinople, including all its mosques, and the landscapes, ruins, and major religious sites of the Bosporus region. He also recorded developments and events such as the construction of the Anatolian railway, and the inauguration of the Orient Express in 1883. In the 1890s he made a remarkable series of documentary portraits of Constantinople's working people: bakers, street sellers, harbour workers, and prostitutes. J-EL

Berliner illustrirte Zeitung (*BIZ*), founded in 1891 by Heppner & Co. and sold to Ullstein in 1894. It was originally illustrated with engravings, then photographs. Under Kurt Korff as editor-in-chief (1905–33) the *BIZ* became very influential as a showcase for a new brand of *photojournalism embedded in modern page layouts. Between 1924 and 1933 it was the leading German illustrated weekly in terms of circulation (1930: 1,844,130), number of pages, and advertising. It became the *Berliner illustrierte Zeitung* in 1941, and last appeared on 29 April 1945. AL

Ferber, C., *Berliner illustrierte Zeitung: Zeitbild, Chronik, Moritat für jedermann* (1982).

Berlin Olympic Games, 1936. The summer Olympics that opened in Berlin on 1 August 1936 were Nazi Germany's greatest *propaganda set piece and a major photographic event. An accompanying exhibition, *Deutschland*, featured elaborate *photomontages and had a modernistic catalogue designed by the former *Bauhaus student Herbert *Bayer. Photojournalistic coverage of the games was meticulously organized—possibly with future wartime needs in mind—by Propaganda Ministry officials. The 125 accredited photographers (except for the Austrian Lothar *Rübelt, all Germans) could cover either the actual games or related events, not both. They wore uniforms and numbered armbands, and were assigned rigid time-slots. Motorcyclists and Hitler Youth runners rushed exposed film from the stadium into the city. Amateurs were also exhorted to use their cameras at the games, but heavy-handed policing, mixed weather, and technical challenges made worthwhile pictures hard to obtain. Leni *Riefenstahl, in addition to directing her celebrated Olympic film, published a volume of still photographs, *Schönheit im olympischen Kampf* (1937; republished in 1988; and, as *Olympia*, in 2002). RS

Wolff, P., *Was ich bei den olympischen Spielen 1936 sah* (1936).
Rürup, R. (ed.), *1936. Die olympischen Spiele und der Nationalsozialismus: Eine Dokumentation* (1996).

Berlin Wall. See GERMANY (FEATURE).

Bernhard, Ruth (b. 1905), German-American photographer, born in Berlin and celebrated for luminous female nudes and subtle still lifes. Bernhard did not turn to photography until she migrated to New York in 1927. After working as a darkroom assistant to Ralph *Steiner at the *Delineator* magazine she became a freelance commercial photographer and began photographing friends of her father, the graphic artist and typographer Lucian Bernhard. However, she always credited a chance meeting with Edward *Weston on a Santa Monica beach in 1935 for impelling her into photography as an art form, and they maintained a lifelong correspondence. She moved to study with Weston in Carmel, then opened her own studio in Hollywood, where she flourished as a *celebrity portraitist. But it was after her relocation to San Francisco in 1953 that Bernhard produced much of her most famous work. Hailed by Ansel *Adams as 'the greatest photographer of the nude', she manipulated light and shadow to create sensuous images of women; also studies of shells, dolls, and other commonplace objects. LAL

Bernhard, R., and Mitchell, M. K., *Ruth Bernhard: The Body Eternal* (1994).
Bernhard, R., and Mitchell, M. K., *Ruth Bernhard: Between Art and Life* (2000).

Berry, Ian (b. 1934), English photographer who emigrated in 1952 to South Africa, where he worked for leading newspapers and the magazine *Drum*. His photographs of the 1960 Sharpeville massacre attracted international attention, as did his subsequent work in the Congo. He moved to Paris in 1962, joined *Magnum Photos in 1963, and later returned to England. The social changes that had occurred during his absence inspired his book *The English* (1978). His work is grounded in the belief that the photograph is a quick, simple, and effective means of communication to a wide spectrum of people of all classes and origins in a way that words cannot be. His seminal work on South Africa and apartheid seems to confirm this. RSA

Campbell, B. (ed.), *World Photography* (1981).

Berssenbrugge, Henri (1873–1959), Dutch photographer. Born in Rotterdam, he studied painting at the Akademie van Beeldende Kunste (1892–96), but was self-taught in photography, setting up his first, shared, studio in 1907 in Rotterdam, then working in The Hague (1917–39). Both studios attracted the cultural elite of musicians, politicians, writers, and artists. As a portraitist, Berssenbrugge cultivated an unposed look, avoiding artistic backgrounds and eschewing retouching; although he also experimented with a variety of printing techniques, such as *gum and oil printing, for his *pictorialist compositions, including a method he called 'Fototechnick'. However, his favourite subjects were street photographs and ordinary people. Beginning with farmers and gypsies in Brabant, he continued in Rotterdam when he opened his studio, moved on to other Dutch and Belgian villages, and to Paris, Milan, and London. Always seeking a natural, if slightly romanticized, view of everyday life, he sought his subjects in their own environment, whether urban alleyway or country village.

Berssenbrugge was close to the De Stijl movement and interested enough in modernist ideas and *Neue Sachlichkeit to be asked to submit work for the 1929 *Film und Foto* exhibition in Stuttgart. RA

Bertillon, Alphonse (1853–1914), French photographer who worked for the Paris police from 1879 to 1914 and pioneered the use of full-face and profile portraits for identification purposes. He was trained in physical anthropology, and many of his ideas were forged in 19th-century debates about degeneration and the 'criminal type' to which Francis *Galton and Cesare Lombroso (1836–1909) also contributed.

Until Bertillon, despite initiatives in several countries (usually involving commercial or commercial-type pictures), no police or judicial service had a systematic method for using photographs as part of their records. Initially Bertillon was less interested in photography than he was in anthropometry. He recognized that the main problems in identification of criminals lay not in making good photographic likenesses, but in being able to classify or compare them. *Bertillonage*, as it came to be known, offered from 1883 a simple card-based system complemented by a systematic photographic technique of strict uniformity which could be practised throughout the judicial system. The card listed a range of physical characteristics including cranial measurements, ear, lip, and nose shape, iris colour, and, from 1892, fingerprints, to supplement exact one-seventh scale photographs. This system went much further than previous ones in solving problems of ageing, disguise, and data retrieval. A related procedure was applied to crime scenes, which Bertillon evolved from the *photometric methods developed in the 1890s for military surveying and mapping. Though Bertillon's card system was widely used, and his handbook, *La Photographie judiciaire* (1890), became a classic, his personal reputation suffered from foolhardy involvement as a handwriting 'expert' in the Dreyfus Affair (1894–1906). After Zola's famous 'J'accuse' article of 1895, his questionable judgement became a *cause célèbre*. PH

Rhodes, H. T. F., *Alphonse Bertillon: Father of Scientific Detection* (1956).

Hamilton, P., and Hargreaves, R., *The Beautiful and the Damned: The Creation of Identity in Nineteenth-Century Photography* (2001).

between-the-lens shutter. First introduced in the mid-1880s as removable shutters that fitted into a slot in the lens barrel, between-the-lens shutters were increasingly fitted to cameras from the early 1900s as demand for a range of shutter speeds grew. Sometimes lens and shutter were made and sold as a unit, sometimes the lens elements were fitted around the shutter to order. Some shutters also acted as the aperture opening to a pre-set diameter. The heyday of the between-the-lens shutter was from the 1920s to the 1960s before the widespread adoption of reflex cameras with *focal-plane shutters, and cameras with interchangeable lenses. It survives in certain medium-format cameras. MP

Biermann, Aenne (née Sternfeld; 1898–1933), German photographer and major exponent of the 'new photography' of the 1920s. Her wealthy commercial background enabled her to engage intensively with contemporary aesthetic debates. After marriage, and the birth of two children, she focused initially on her domestic surroundings, though friendship with Rudolf Hundt encouraged her to explore the medium's wider possibilities. She described her early family and travel pictures as 'vagrant photography'; yet the images of her children and their milieu are imbued with the visual language of the *New Vision and *New Objectivity: tight cropping, and a feel for the structure of materials and the tactility of surfaces. Detailed studies of plants, minerals, and everyday objects, with metaphorical undertones, also reflect the prevailing 1920s aesthetic. Biermann participated in many exhibitions, including *Film und Foto* in Stuttgart in 1929. In 1930 Franz *Roh published a monograph about her. UR

Aenne Biermann: Fotografien 1925–33 (1987).

Billingham, Richard (b. 1970), British photographer who began making photographs of his family—mother, father, and younger brother—as studies for paintings while still a student at Sunderland University. The photographs show lives troubled by drugs, violence, and neglect, yet tempered with affection. His work appeared in the *Who's Looking at the Family* exhibition at the Barbican Gallery, London, in 1994, and drew worldwide attention as part of *Sensation: Young British Artists in the Saatchi Collection* in 1998. Billingham subsequently focused on the suburban landscape surrounding his home. NRO

Billingham, R., *Ray's a Laugh* (1996/2000).

Bing, Ilse (1899–1998), German photojournalist, who worked for the *Frankfurter Illustrierte* in 1929, then moved to Paris, where she worked for *Vu* and *Arts et métiers graphiques*, champions of the *New Vision. She was known in avant-garde circles as the queen of the Leica, which features prominently in her 1931 self-portrait. She was included in *Photography 1839–1937*, curated by Beaumont *Newhall at MoMA, New York. She settled in America in 1941, but gave up professional work in 1959, partly because she felt that—especially by comparison with earlier decades—the increasing professionalization of photography was tending to marginalize women. She published *Words as Vision* (1974) and *Numbers in Images* (1976), and in 1976 exhibited at the Witkin Gallery, New York, and in a group show at MoMA, prompting renewed interest in her work. PDB

Barret, N., *Ilse Bing: Three Decades of Photography* (1985).

Biow, Hermann (1804–50), artist, lithographer, and one of the first German *daguerreotypists. In 1841 he opened a studio in Altona, then Hamburg. In 1842 he shared a studio with Carl Ferdinand *Stelzner. Biow is best known for his images of the ruins left by the 1842 Hamburg fire. In 1847–8, in Berlin and Frankfurt am Main, he also made photographic portraits of King Friedrich Wilhelm IV of Prussia and members of the German National Assembly which were subsequently lithographed. JJ

Kaufhold, E., 'Hermann Biow (1804–1850) und Carl Ferdinand Stelzner (1805–1894) in Hamburg', in B. Dewitz and R. Matz (eds.), *Silber und Salz: Zur Frühzeit der Photographie im deutschen Sprachraum, 1839–60* (1989).

birds. See WILDLIFE PHOTOGRAPHY.

Bischof, Werner (1916–54), Swiss photographer, initially influenced by his father, an ambitious amateur. Training under Hans *Finsler at the Zurich Design School gave him mastery of practical, impeccably staged object and product photography, and he opened a 'Foto-Grafik' studio in Zurich. In 1942 he joined the staff of the journal *Du, working initially in fashion. In 1945 he took up *photojournalism, travelling through Europe to document the effects of war and publishing in international magazines. In 1948 he joined *Magnum, and in 1951 co-founded the Council of Swiss Photographers. That year he made his international breakthrough with the photo-essay *Hunger in India* for *Life. Bischof's approach was humanistic, documenting war, hunger, and misery in an aesthetically detached way. Particularly his images of children transcend suffering by their compositional poise and precision. His last years were spent travelling in Asia, the USA, and South America. He died in a road accident in the Andes.　　UR

Werner Bischof: Leben und Werk 1916–1954 (1990).

Bisson brothers, Auguste Rosalie (1826–1900) and **Louis Auguste** (1814–76), French photographers, known for their portraits, architectural work, art reproductions, and *mountain photographs. Both brothers operated separately before going into partnership in 1852. In the 1840s Louis worked with his father, a former civil servant, as a *daguerreotypist, and significantly improved the process. Later, however, both brothers took up *wet-plate photography. As partners they occupied a succession of lavish Parisian studios, and in 1856 moved into the same building on the Boulevard des Capucines as Gustave *Le Gray. Despite allying themselves with the industrialist Daniel Dollfus-Ausset, they overreached themselves financially and went bankrupt in 1863; their association ended in 1864.

Dollfus-Ausset, however, had a passionate interest in mountains, and between 1855 and 1862 funded a series of photographic expeditions to the Alps, during which Auguste Bisson took *panoramic and other images. On 24 July 1861 and 13 May 1862 he braved severe difficulties—including the freezing of the *collodion on his plates—to capture views from the summit of Mont Blanc. The results were spectacular, although their commercial success failed to clear the brothers' debts.　　RL

Die Brüder Bisson: Aufstieg und Fall eines Fotografenunternehmens im 19. Jahrhundert (1999).

bit, byte. 'Bit' is a contraction of 'binary digit'. In the binary system there are only two digits, 0 and 1, so that 2 in the denary (base 10) system is represented by 10, 3 by 11, 4 by 100, 5 by 101, and so on. In electronics, a bit can be represented by a switch that is either off (0) or on (1). Eight bits represent 2^8 (256) different numbers (a byte). A kilobyte (kb) is 1,024 bytes, a megabyte (Mb) is 1,024 kb, and a gigabyte (Gb) is 1,024 Mb. The full file size of a *digitally recorded scene is roughly three bytes per pixel, so that a 3-million pixel CCD array uses $c.9$ Mb of storage space, and a 10-million one $c.30$ Mb. However, this number can be greatly reduced by one of the various forms of *compression.　　GS

Saxby, G., *The Science of Imaging: An Introduction* (2002).

BIZ. See BERLINER ILLUSTRIRTE ZEITUNG.

Black Star, American *agency founded in 1936 by three refugees from the Berlin publishing industry, Kurt Safranski, Ernest Mayer, and Kurt Kornfeld. It established a close relationship with the newly founded *Life magazine, offering editors access to European *photojournalism, and émigré photographers work and contacts in the USA. It survived the late 20th-century crisis of photojournalism, partly by pursuing corporate work, and continues to flourish. Photographers associated with it have included W. Eugene *Smith, Roman *Vishniac, Kosti *Ruohamaa, Flip Schulke (b. 1930), Rune *Hassner, and James *Nachtwey.　　RL

Neubauer, H., *Black Star: 60 Years of Photojournalism* (1997).

Blakemore, John (b. 1936), English photographer. He discovered the camera during national service in Tripoli in 1955. Wartime childhood experiences and the *Family of Man* exhibition inspired him initially on his return home to photograph the people of Coventry and its post-war reconstruction. He began teaching in the late 1970s, and became a major figure in what was then seen as a 'British obsession with photography'. His images—then and now in black-and-white—of landscape and still-life subjects, from which he makes prints superb in detail, texture, and tonal richness, are widely collected. His books include *Inscape* (1991) and *Stilled Gaze* (1994).　　RSA

Blakemore, J., *John Blakemore's Black and White Photograhy Workshop* (2005).

Blanquart-Évrard, Louis Désiré (1802–72), French printer and editor of photographic albums and books. He presented a paper-negative process nearly identical to *Talbot's *calotype process before the French Academy of Sciences, which accepted its originality and published it in its official journal in 1847. A workable paper process was thus made available in France. A skilled chemist and bold entrepreneur, he was the first successfully to apply industrial methods to photographic printmaking. His technique of chemical development of positive prints replaced slow printing out by sunlight, making mass production possible. From 1851 to 1855 he operated a photographic printing establishment near Lille where he produced *salted-paper prints of lasting quality.

Blanquart-Évrard printed the photographs for several important books on archaeology. He also produced and edited 24 albums of photographs using $c.550$ negatives made by the most accomplished photographers of the day. Subjects included art, architecture, topography, and genre scenes. Total production of this pioneering venture was $c.100,000$ prints. His overall goals were artistic. His luxurious presentation emphasized the parallels between photography and traditional fine-art printmaking. He was also the author of several books on the history and art of photography.　　NK

Jammes, I., *Blanquart-Évrard et les origines de l'édition photographique française* (1981).

Blossfeldt, Karl (1865–1932), German photographer. With August *Sander and Albert *Renger-Patzsch, Blossfeldt is today the best-known exponent of German *Neue Sachlichkeit, although his work was not discovered by the avant-garde until nearly the end of his life. In 1881–4 he served an apprenticeship in a sculpture foundry; then until 1889 trained at the Berlin Design Museum's school, and subsequently taught there until 1930. Around 1890 he began systematically tabulating plant forms, which were used as exhibits and pattern models in his classes. The form of Blossfeldt's images is always the same: cropped and treated ferns, buds, and seedpods arranged flat on pieces of card and photographed several times larger than life.

The modernistic import of Blossfeldt's photographs was mainly the discovery of the Berlin dealer Karl Nierendorf, who exhibited his pictures for the first time in 1926 and published them in the book *Urformen der Kunst* (*Archetypes of Art*) in 1928. The photographs spoke to the minimalist taste of the 1920s, seeming in an exemplary way to reveal the tectonic structures of natural forms, and to suggest aesthetic parallels between plant forms and elements of architecture and industrial design. Thus Blossfeldt became, as it were, an 'avant-gardist despite himself'. His personal aesthetic ideas, by contrast, were rooted in the 19th century. UR

Blossfeldt, K., *Urformen der Kunst: Wundergarten der Natur* (1994).

***Blücher*, SMS, sinking of**. The encounter of British and German battlecruiser squadrons in the North Sea near the Dogger Bank on 24 January 1915 was one of the First World War's few major naval engagements. The German heavy cruiser *Blücher* was badly damaged early in the battle and capsized at 12.10 p.m., when about 300 men could be seen scrambling to escape. The photograph of this scene, taken from a British warship (probably HMS *Arethusa*) approaching to rescue survivors, appeared afterwards in the *Illustrated London News* and many other papers.

Photographs of naval battles were rare in this period. Cameras were banned from the German fleet for security reasons, and the Royal Navy was suspicious of official photography at sea. Although many naval personnel had cameras, smoke, vibration, and the long ranges at which actions were usually fought made it hard to obtain worthwhile

Anon.

SMS *Blücher* capsizes at the Battle of the Dogger Bank, 24 January 1915

pictures. This dramatic image doubtless boosted British morale after repeated German bombardments of English coastal towns. However, its spectacular quality masks the *Blücher*'s relative insignificance, the disappointing outcome of the battle, and, like most early *war photographs, the horror of the event: 792 sailors killed by gunfire, drowned, or scalded to death in the ship's boiler rooms. RL

Carmichael, J., *First World War Photographers* (1989).

blueprint. See CYANOTYPE.

Blumenfeld, Erwin (1897–1969), Berlin-born American photographer. Unquestionably one of the most successful *fashion photographers of the first half of the 20th century, Blumenfeld was talented in many areas, including drawing, painting, writing, and constructing Dadaistic collages. His posthumously published autobiography, *Eye to I: The Autobiography of a Photographer* (1976; English edn. 1999), presents him as a Bosch-like observer of the world wittily decrying the absurdities of nationalism and war and the pomposity of the bourgeoisie.

After apprenticeship to a Berlin garment manufacturer, and service in the medical corps during the First World War, he spent the 1920s in Amsterdam managing a leather-goods shop. His first photography show as an amateur was held in that city in 1934. Moving to Paris in 1936, Blumenfeld continued experimenting with *nude photography and portraiture, using unusual and surrealistic combinations of lighting and exposure. During the Second World War he was interned by the French, escaped, and went with his family to New York. Hundreds of his photographs were subsequently published in magazines, including covers for *Look*, *Life*, *Vogue*, and *Harper's Bazaar*. His last years were spent writing his autobiography. TT

Ewing, W. A., *Blumenfeld: A Fetish for Beauty* (1996).

blur. See MOVEMENT, PHOTOGRAPHY OF.

Boccioni, Umberto (1882–1916), painter, sculptor, and principal theoretician of Italy's avant-garde art movement, *Futurism. Boccioni formally joined the Futurists after a meeting with Filippo Marinetti in 1910; his ideas on 'plastic dynamism' subsequently established him as the group's foremost theoretician. Like other Futurists, he was concerned with both the expression of emotion and the representation of time. His interest in photography extended to the experimental work of *Muybridge, *Marey, and the *Bragaglia brothers. Later, however, Boccioni decided that painting and sculpture were the best means for conveying dynamism, and denounced all photography as antithetical to Futurist concerns. He particularly rejected the photodynamism of the Bragaglias and engineered their excommunication from the group. MR

Bohm, Dorothy (b. 1924), German-born British street and art photographer. Bohm began her career in Manchester, opening her own portrait studio at the age of 21. Taking up street photography in the 1960s, she made many striking black-and-white pictures of London and other European cities. Bohm turned to colour in the late 1970s, at the suggestion of André *Kertész, at first using Polaroid cameras and films in a style similar to his. Her use of colour made her work progressively more abstract. She has published nine books of photography, and helped to found two London galleries, the Photographers' Gallery and Focus. CF

Boiffard, Jacques-André (1902–61), French avant-garde photographer, who began as *Man Ray's assistant (1924–9) and contributed to various journals in the orbit of *Surrealism, including *L'Œuf dur* and *Documents*. He illustrated André Breton's novel *Nadja* (1928) with photographs of Paris, but also produced nudes and distorted close-ups of parts of the body. Later he photographed a number of film productions, including Marcel Carné's *Les Enfants du paradis* (1945). In his thirties he resumed his earlier medical training, and spent his later years working as a radiologist. RL

Ades, D., Krauss, R., and Livingstone, J. (eds.), *Explosante-fixe: photographie et Surrealisme* (1985).

Boltanski, Christian (b. 1944), French photographer and object artist. He left school at 12 and in the late 1950s began producing religious paintings, later expanding his practice to artist's books, mail art, films, and performances. He is best known for apparently makeshift but elaborately theatrical installations combining small cut-out sculptures, projections, fairy lights, and found photographs from archives. Many are presented as memento mori, referring to commemorative plaques in churches and mausoleums. The *Holocaust is an underlying theme (*Lessons of Darkness*, 1986), although Boltanski downplays family history—his father was Jewish—and cites wider ideas of faith, memory, and loss. HWK

Semin, D., et al., *Christian Boltanski* (1997).

Bonfils, Félix (1831–85), and **Cabanis, Marie Lydie** (1837–1918), French commercial photographers who founded one of the most prolific and wide-ranging photographic enterprises in the Middle East, which they operated with their son Adrien (1861–1928) from La Maison Bonfils in Beirut. Founded in 1867, the business embraced views, photographs of native 'types', and a thriving portrait practice. The first catalogue, issued in 1871, listed an astounding 15,000 prints from almost 600 negatives made of the principal sites in Egypt, Palestine, Syria, and Greece, as well as a stock of 9,000 stereo views. The Bonfils were equally adept at marketing; their pictures were available in Cairo, Alexandria, Paris, London, Beirut, and Alès, France. Félix and an unknown number of assistants travelled throughout the region to compile the extensive catalogue while his wife ran the Beirut studio. After Félix's death in 1885, the studio continued under the direction of Marie and Adrien until 1918. La Maison Bonfils won photographic prizes in 1871, 1883, and at the 1889 Exposition Universelle in Paris. It published numerous albums in different formats: *Architecture antique* (1871), *Catalogue des vues*

Pierre Bonnard

Marthe in the garden, 1900–1

photographiques de l'Orient (1876), and *Souvenirs de l'Orient* (1877–8). KSH

 Carney, E. S. G., *The Image of the East: Nineteenth-Century Near Eastern Photographs by Bonfils from the Collections of the Harvard Semitic Museum* (1982).

Bonnard, Pierre (1867–1947), French painter. Like *Vuillard, also a painter of colourful, riotously decorative canvases in the *intimiste* style, Bonnard began photographing during the 1890s. Exploiting the ease of the Kodak, he favoured themes common to his paintings: domestic interiors, family scenes, table settings, and bathers. Distortions caused by the Kodak's simple lens suggest a formal relation to Bonnard's distinctive handling of space in his paintings. Photography, like Japanese prints and Art Nouveau, confirmed new approaches to the representation of space. KM

 Heilbrun, F., and Néagu, P., *Pierre Bonnard: Photographs and Paintings*, trans. D. Cullinane (1988).

Böttger, Georg (1821–1901), Bavarian lithographer and engraver turned photographer who settled in Munich in 1852 and established a successful mixed business. He taught photography, sold equipment, and in 1865 launched an early *collodion dry plate. His catalogue of views, architectural images (notably Ludwig II's castles), and art reproductions expanded in step with Bavaria's tourist industry. Böttger's outstanding photographic achievement was a 360-degree, eleven-segment panorama of Munich taken in 1858 from the tower of St Peter's church. RL

 Gebhardt, H., *Königlich Bayerische Photographie 1838–1918* (1978).

Boubat, Édouard (1923–99), French photographer. The poet Jacques Prévert called him a 'peace photographer', for Boubat was the incarnation of the French humanist, member of a movement without ideology or militants whose urge to capture the simple beauty of everyday life distinguishes their work. His first image, of a tiny girl wearing an outfit of fallen leaves in the Luxembourg gardens, was made

in 1946 and became a classic. A photoengraver by trade until 1950, his personal work, especially that featuring his muse Lella, indicated unusual talent.

Working under the inspired editorship of Bertie Gilou for the innovative magazine *Réalités* 1950–75, Boubat flourished as a globe-trotting photojournalist, but for a magazine that concerned itself more with science, industry, and economic development than with war or conflict. The role suited his temperament, for it allowed him to make small groups of images around a loosely defined subject, rather than detailed picture stories. His dictum was 'To photograph is to express gratitude.' His work dealt with simple domestic and personal events, or work, trade, and industry. His 'personal' photography produced a charming body of images, where the nude, children, cats, and his own family figure extensively. PH

Boubat, É., *La Vie est belle* (1999).

Boubat, É., *Le Guérisseur du temps*, ed. B. Boubat (2004).

boudoir photography. See MAKEOVER PHOTOGRAPHY.

Bourdieu, Pierre (1930–2002), French sociologist and philosopher. His main contribution to the study of photography is his book *Un art moyen: essais sur les usages sociaux de la photographie* (1965; *Photography: A Middlebrow Art*, trans. S. Whiteside, 1996)—a study of photographic culture amongst the French working and middle classes, both urban and rural. Written in collaboration with a team of sociologists, it comprises essays critically summarizing field studies amongst clients of professional photographers for *wedding pictures and commemorative *portraits; casual snappers; committed *amateurs and camera club members; art photographers and photographic artists; and, finally, professional photographers themselves. The book argues that photographic taste is shaped by, and subordinated to, the social functions of photographs as a means of constructing and celebrating familial and group identity, and of visualizing individual social success, however differently this might be defined by the different groups. This study is related to Bourdieu's larger project of investigating how cultural taste functions as a tool to legitimize class distinction, in a society in which knowledge operates as a means of production, as cultural—rather than financial—capital. PDB

Bourdieu, P., *Distinction: A Social Critique of the Judgement of Taste* (1979; trans. R. Nice, 1984).

Bourdin, Guy (1928–91), ultra-stylish French *fashion photographer who profoundly changed perceptions of the genre. Early Polaroid views and shots of inanimate objects anticipated his later professional interests. Strongly influenced by his friend *Man Ray, in 1954 Bourdin began photographing for French *Vogue*, with which he remained closely associated. Audaciously rejecting the 'product shot', he constructed intense narratives around elaborate tableaux or exotic locations, his groundbreaking images evoking a highly sexualized, often dangerous subtext. Themes of sexual violence, gender power relationships, and fetishism were emphasized by the glossy veneer of virtuoso lighting—a reference also to the artificiality of the medium itself. Recognizing his skill at balancing extreme content with surreal composition, saturated colour, and seductive surface detail, *Vogue* gave Bourdin a rare freedom to pursue his personal obsessions, which he also extended into provocative adverts for his primary commercial client, the shoe manufacturer Charles Jourdan. Bourdin took his reflexive exploration of photography a step further by filming his photographic sessions, and left a small motion-picture archive in addition to his stills. His most successful period, the 1970s, coincided with the rise of the second-wave feminist movement, which identified fashion photography as a key target. Bourdin's imagery, like Helmut *Newton's, has provoked ongoing critical discussions concerning the representation of femininity. PM

Cotton, C., and Verthime, S., *Guy Bourdin* (2003).

Bourke-White, Margaret (1904–71), early leader in the American *documentary photographic tradition. She was born in New York, attended Columbia University's Clarence White School of Photography, and first made her mark in her twenties as an industrial photographer in Cleveland, Ohio. Henry Luce hired her as a staff photographer for his new magazine *Fortune* in 1929, and in 1936 rehired her as one of the first staff photographers for *Life, for which she took the first cover photo, a view of the massive Fort Peck Dam. Although remaining freelance, she stayed with *Life* for most of her career, leaving in 1969 because of Parkinson's disease. As a *Life* staffer, she was a pioneer of the *photo-essay. A leading *photojournalist, one of only a few female war photographers, and the first woman attached to an army unit, she covered both the Second World War and Korea. As a seasoned press photographer, she was with General Patton at the liberation of Buchenwald, and her photographs of the released prisoners are among her most haunting. She photographed Gandhi's campaign for independence in India in the late 1940s, and racial and labour struggles in apartheid South Africa in 1949–50. She was married briefly (1939–42) to the novelist Erskine Caldwell, and they collaborated on several books, most notably *You Have Seen their Faces* (1937). CBS

Bourke-White, M., *Portrait of Myself* (1963).

Goldberg, V., *Margaret Bourke-White: A Biography* (1986).

Bourne, Samuel (1834–1912), English photographer, whose early career was spent as a banker in Nottingham. Bourne photographed in Nottinghamshire, the Lake District, Wales, and Scotland before he sailed to India, arriving in Calcutta in January 1863. He set up a studio in Simla with a Mr Howard. He was later joined by Charles Shepherd, establishing the firm of *Bourne & Shepherd. Bourne remained in India for almost eight years, concentrating on landscape and architectural views. He made three expeditions into the lower Himalayas in 1863, 1864, and 1866, in 1866 reaching a height of 5,673 m (18,600 ft). All three expeditions are described at length in the *British Journal of Photography*. In all, he produced *c.*2,000 glass

Charles Shepherd

Afridi tribesmen, Afghanistan, *c*.1865.
Albumen print

negatives during this period. Bourne left India in November 1870, handing control of a flourishing business with studios in Simla, Calcutta, Bombay, and Delhi to Shepherd and, later, Colin Murray. Back in Nottingham he ran a lucrative cotton-doubling business, continuing to photograph and paint in his spare time. Bourne's work is outstanding not only for his technical mastery of the *wet-plate process, but also for faultless artistic vision and understanding of picturesque landscape composition. His work is often presented as part of a 19th-century *colonial discourse. SCG

> Sampson, G., 'The Success of Samuel Bourne in India', *History of Photography*, 16 (1992).

Bourne & Shepherd, the most successful commercial firm in 19th- and early 20th-century India, established in Simla in 1863 by Samuel *Bourne as 'Howard, Bourne & Shepherd', and becoming 'Bourne & Shepherd' by 1865. It opened further studios in Calcutta (1867–present) and Bombay (1870–*c*.1902). Following Bourne's departure in 1870, much of the new photographic work was undertaken by Colin Murray (1840–84), although during the 1870s Charles Shepherd continued to photograph and at least sixteen Europeans are listed as assistants. Between 1870 and 1911 the firm sent photographers to *Ceylon (Sri Lanka), *Burma, *Nepal and Singapore, as well as extending its coverage of India. The firm still survives in Calcutta today, although in a much reduced form. SCG

Boutan, Louis (1859–1934), French zoologist and pioneer *underwater photographer. His experiments, which identified most of the major problems of underwater picture making, were done in the 1890s at the Arago Marine Laboratory at Banyuls-sur-Mer, on France's Mediterranean coast. In this pre-aqualung era he was hampered by a full diving suit with airlines and metal helmet, and his pressure-resistant cameras looked like strongboxes. Boutan's earliest, rather blurred pictures were made with a modified *detective camera using 9×12 cm ($3^1/_2 \times 4^3/_4$ in) plates. Focusing was difficult, and exposures lasted up to 30 minutes. (Matters were complicated by the lack of underwater timing devices.) A second camera, built by the laboratory's technician Joseph David, was designed to be completely flooded, using specially varnished Lumière plates, but was also unsatisfactory. More successful was another custom-built apparatus, watertight and incorporating a magazine of six 18×24 cm ($7 \times 9^1/_2$ in) plates, supported on a metal frame. In September 1898, despite its massive size and weight—on land, three men were needed to lift it—Boutan took acceptable pictures of himself, David, and various underwater objects at depths of *c*.3 m (10 ft). A year later, finally, a remotely activated exposure of a plaque fixed in front of the lens and inscribed *photographie sous-marine* was made 50 m (164 ft) down, lit by battery-powered underwater arc lights. However, the unnerving experience of handling the heavy and unwieldy gear in the open sea demonstrated that little more could be achieved with existing resources.

Bourne & Shepherd

Maharaja Holkar of Indore, mid-1870s. Albumen print

Boutan spent the years 1904–8 in Indo-China, and in the First World War designed naval diving equipment. He described his underwater experiments, and life at Banyuls, in a lucid, agreeably written treatise, *La Photographie sous-marine et les progrès de la photographie* (1900). RL

bracketing. With inbuilt meters, exposures are based on an average subject. But with, say, a snow scene or a shady glade, it may be necessary to make exposures one or more stops up or down to obtain a correctly exposed result. Some advanced cameras include bracketing in their exposure programmes. GS

Brady, Mathew (*c*.1823–1896), American *documentary photographer widely associated with Civil War photography. Samuel * Morse was one of several early *daguerreotypists who taught him, and Brady had set up as a 'daguerrean artist' in New York by 1844. Hampered by failing eyesight, he rarely took photographs himself, but his Broadway studio and gallery attracted prominent citizens, from whose portraits he published a volume of engravings, *The Gallery of Illustrious Americans*, in 1850. His first 'National Portrait Gallery', established with Alexander *Gardner in 1849 in Washington, DC, failed, but a second attempt in 1856 thrived as he sold wet-collodion portraits of members of Congress, the President, and other notables. When the Civil War broke out in 1861, he borrowed to outfit travelling photographic wagons and hire photographers to produce battlefield images. In addition to Gardner, Timothy *O'Sullivan and George *Barnard were among those he employed. He also purchased other photographers' negatives to sell in his studio, and published *Brady's Photographic Views of the War*, *Brady's Album Catalogue*, and *Incidents of the War*, often without crediting the individual photographers. By the war's end, with the managerial assistance of his brother-in-law Samuel Handy, he had accumulated over 7,000 negative views. Unable to sell prints to a war-weary public, he went bankrupt; in 1875 Congress voted him $25,000 for his collection, which now forms the core of the 'Brady–Handy Collection' of Civil War photographs at the Library of Congress. He died penniless. CBS

Panzer, M., *Mathew Brady and the Image of History* (1997).

Bragaglia, Anton Giulio (1890–1960) and **Arturo** (1893–1962), Italian Futurists and pioneers of 'photodynamism'. As young men the two brothers shared an interest in photography and film, frequenting the Cines film studios where their father was general manager. Each, however, pursued different aspects of photography, Anton Giulio the theoretical, Arturo the technical. The brothers were practically inseparable, and this division of labour between theory and practice, though both took pictures, suited them perfectly. In 1911 they began the research that would lead them to photodynamism, initially a meeting of Futurist principles with the *chronophotography of Étienne-Jules *Marey. While Arturo perfected the technique, his brother promoted photodynamism through lectures and exhibitions.

In 1912, under the patronage of Filippo Tommaso Marinetti, they were accepted into the Italian Futurist group, though Umberto Boccioni would see them out a year later. Their 1913 manifesto *Fotodinamismo futurista* also distanced them from Marey's sequential technique in favour of using long exposures (*The Cellist*, 1913). Subsequently the brothers continued their work, producing *photomontages and 'spiritualist photography' in addition to photodynamism; the First World War, however, ended their collaboration. Anton Giulio later produced films and avant-garde theatre, while Arturo continued working as a professional photographer, and eventually became director of Cinecittà's photographic department. MR

Anton Giulio Bragaglia: fotodinamismo futurista (1970).

Brancusi, Constantin (1876–1957), Romanian sculptor whose near-abstract work, influenced by Cubism and African art, combines organic and geometrical forms. Brancusi's disappointment with most photographs of his sculptures led him to buy a camera and install a darkroom in his Paris studio so that he could take his own. Photography became a part of his working process, as it allowed him to determine how each sculpture should be seen, and therefore how it should be formed. On his death he left numerous negatives and prints to the French state. MR

Brancusi Photographs (1981).

Brandt, Bill (1904–83), the most admired British photographer of the 20th century. He was also, and remains, one of the most mysterious. He liked it to be thought that he had been born in south London but he was actually born in Hamburg, the son of an English father and German mother. The Brandts were international merchants and bankers. Bill Brandt chose a quite different career. His imagination was formed by a cosmopolitan background, including his native Germany (which he came to hate), a crucial period of two and a half years' treatment for tuberculosis in Switzerland in the mid-1920s, training in a Vienna portrait studio in 1928, followed by three months studying with *Man Ray in Paris—in the heyday of *Surrealism—in 1929. It was in England, where Brandt settled in 1931, that his varied apprenticeship came to fruition. His first book, *The English at Home* (1936), made full use of the upstairs/downstairs lives in the country houses and London mansions of his banker uncles. Brandt presented a series of piercingly vivid photographs but also powerful juxtapositions from plate to plate. The newly invented flash bulb had become available in 1931 and Brandt—a warm admirer of *Brassaï—made good use of it in this and his next book, *A Night in London* (1938). Once more he explored all levels of society. In 1937, his concern aroused by the Jarrow Crusade (1936), Brandt photographed in the north of England, creating such stark classics as *Coal Searcher Going Home, Heworth, Tyneside*. Brandt was entranced by the blacked-out London of the 'Phoney War' period, which he captured in a series of long exposures. For the Ministry of Information he photographed the Underground stations, turned into ad hoc bomb shelters during the Blitz of 1940. He was constantly at work during the war, photographing all manner of subjects for leading

Bill Brandt

Drinks in a Surrey garden, *c.*1938

magazines such as *Lilliput* and *Picture Post*. This period is summed up in his *Camera in London* (1948), which also contains his longest—if brief—writing on photography. Among his major subjects during the 1940s were portraiture and landscape. *Literary Britain* (1951) paired landscapes with the words of the writers associated with them. In 1945 Brandt acquired a Kodak police camera with a wide-angle lens and began another project—the prolonged photographic study which was eventually published as *Perspective of Nudes* (1961). He wanted, he said, to see like a mouse, a fish, or a fly. With this camera, and later a Hasselblad with a Superwide lens, Brandt reinvented the nude. He summed up his great career with the book *Shadow of Light* in 1966, followed in 1969 by a retrospective at MoMA, New York. It was shown at the Hayward Gallery, London, and other British centres and changed the climate of opinion about photography as an art.　　MH-B

Haworth-Booth, M., and Mellor, D., *Bill Brandt: Behind the Camera* (1986).
Jay, B., and Warburton, N., *The Photography of Bill Brandt* (1990).

Brassaï (Gyula Halasz; 1899–1984), French photographer. Born in Transylvania, Hungary (now Romania), he moved to France in 1924 to work as an artist. He had received formal training in Budapest and in Berlin, where he met *Moholy-Nagy, Kandinsky, and Kokoschka, but was drawn to the lyricism and decay of Paris, the city whose image he would amplify through his photographs.

Soon after arriving, he adopted the name Brassaï, after Brasso, the village of his birth. In 1926 he met his countryman André *Kertész who, already working as a photojournalist, introduced Brassaï to photography, and in 1929 Brassaï began contributing images to the French illustrated *Vu*, which also published photographs by Kertész, *Man Ray, and others. In 1932 Brassaï was commissioned to photograph Picasso's sculptures for the first issue of *Minotaure*, the *Surrealist journal. This marked the beginning of a lifelong friendship, resulting in several photographic books, notably *Les Sculptures de Picasso* (1948) and *Conversations avec Picasso* (1964). Brassaï continued to photograph for *Minotaure* until the magazine's collapse in 1939. His cryptic handling of the female nude, and a series of photographs of discarded bus tickets and other refuse, entitled *Sculptures involontaires*, earned Brassaï the status of an honorary Surrealist. He had also supplied André Breton with street views of Paris for his experimental novel *Nadja* (1928). Brassaï's association with Surrealism has greatly coloured his reputation as a photographer. His series of night photographs *Paris de nuit* (1933), which depict an underworld of prostitutes, homosexuals, and vagrants, are often considered a representation of the social subconscious.

Brassaï won early recognition as an art photographer, participating in the show *Modern European Photographers* at Julian *Levy's gallery, New York, in 1932. His first one-man exhibition was held at the Arts et Métiers Graphiques, Paris, in 1933, and travelled to the Batsford Gallery, London, the same year. This success paralleled a steady output of commercial work. Throughout the 1930s, Brassaï worked for *Verve*, *Labyrinth*, *Lilliput*, *Coronet*, *Life*, and other magazines. Prevented from working during the German occupation, Brassaï turned to

drawing. In 1945, at the end of the war, an exhibition of his drawings appeared in Paris (published as *Trente dessins* in 1946). Also that year, with Robert *Doisneau, Édouard *Boubat, Willy *Ronis, and other humanistic photographers, he helped to re-form the agency *Rapho, signalling his return to photography.

Brassaï's greatest legacy as a photographer, however, stems from a series of monographs on various aspects of Parisian life: *Paris de nuit*; *Voluptés de Paris* (1934); *Camera in Paris* (1949); *Graffiti* (1960); and *Le Paris secret des années 30* (1976). While other photographers had published similar works during the 1930s, notably Kertész (*Paris vu par André Kertész*, 1934), Brassaï's output demonstrates the broadest insight into the city, earning him a second pseudonym, 'the eye of Paris', coined by Henry Miller in 1933.　　KM

Brassaï, *Letters to my Parents* (1997).
Tucker, A. W., *Brassaï: The Eye of Paris* (1999).
Sayag, A., and Lionel-Marie, A. (eds.), *Brassaï: The Monograph* (2000).

Braun, Adolphe (1812–77), French photographic entrepreneur, mainly active in Mulhouse, Alsace. After success as a textile and porcelain designer, Braun took up photography in the early 1850s, probably encouraged by the textile manufacturer and photography enthusiast Daniel Dollfus-Ausset. He made his debut in 1854 with an acclaimed album of *c*.300 *wet-plate flower photographs, then turned to commercial view photography in various formats (including stereoscopic and panoramic). By the late 1860s, the firm had a catalogue of *c*.6,000 Swiss, German, French, and other views, corresponding to the main tourist routes. (They also included *mountain scenes, mainly from Haute-Savoie.) In 1871 Braun photographed the ravages of the Franco-Prussian War, and scored a political *succès de scandale*, after the German annexation of Alsace and Lorraine, with a photograph of two girls in the costumes of the lost provinces.

In 1866 Braun had branched out into art reproduction, using the *carbon process acquired from the Englishman Joseph Wilson Swan. Using a fully industrialized plant, the firm was soon offering numerous high-quality prints from major galleries; in 1883, six years after Braun's death, it signed a 30-year exclusive contract with the Louvre, making reproduction its principal business.　　RL

Bergstein, M., and O'Brien, M. B. (eds.), *Image and Enterprise: The Photographs of Adolphe Braun* (2000).

Bravo, Lola Álvarez. See ÁLVAREZ BRAVO, LOLA.

Bravo, Manuel Álvarez. See ÁLVAREZ BRAVO, MANUEL.

Brazil. In 1833, Hercules *Florence invented a cameraless photographic process in rural São Paulo, but was unable or unwilling to exploit it. Seven years later, in 1840, the Abbé Louis Compte, visiting South America aboard a French vessel, made the first *daguerreotypes in Rio de Janeiro, thus officially introducing photography to Brazil. Fascinated, Emperor Pedro II (1831–89) acquired a camera and

Brassaï

Self-portrait photographing the Parisian night on the Boulevard Saint-Jacques with his 6 × 9 cm Voigtländer, 1931–2

became a major force in photography's development. He patronized the leading Brazilian photographer of the 19th and early 20th centuries, Marc *Ferrez, and was responsible for the preservation of a large part of Brazil's early photographic heritage, principally portraits and landscapes, in the Biblioteca Nacional in Rio. During the first century and more of the medium's history, hundreds of foreign photographers arrived, making important contributions in the ethnographic, documentary, and advertising fields (Pierre *Verger, Marcel Gautherot, Jean Manzon, Hildegard Rosenthal, and Hans Günther Flieg).

The spread of *clubs and societies stimulated the debates about photography as an art that produced *pictorialism (1910s–1930s) and the formal experiments linked to the Fotocine Clube Bandeirantes in Rio in the 1940s and 1950s that led ultimately to the emergence of modern photography in Brazil (Geraldo de Barros, Ademar Manarini, and Thomas Farkas).

The illustrated press promoted photography as an authorial medium with a specifically visual language. In the 1940s the magazine O cruzeiro introduced a modern editorial concept incorporating photography as a key element of communication. Essays on indigenous peoples (Jean Manzon and José Medeiros (1921–90)) sometimes brought to light tribes that were previously unknown. In the 1950s the illustrated journal Manchete also recorded a multifaceted country in a period of rapid development. The review Realidade (1966–76) served as a point of reference, publishing the work of foreign photographers (Cláudia Andujar (b. 1931), Maureen Bissiliat, George Love, and David Zingg), embodying a North American and European visual style and giving the photographer a role in the editorial and production process. In the 1980s a significant feature of Brazilian photojournalism was the independent photographic agency, e.g. Camera Tres founded by the photographer Walter Firmo (b. 1957) in 1973. These offered a way to the achievement of greater authorial rights, especially for photographers committed to more searching investigation of topical issues: abandoned children, the dividing up of indigenous lands, violence in the big cities, and the growth of religious sects in the country.

Compared with the 1960s and 1970s, characterized by military dictatorship, the 1980s and 1990s were a period of transition from censorship and isolation from international artistic trends back to freedom of expression. Photography became accepted as an art form, and a new generation of photographers explored fresh visual strategies that moved away from older concepts of 'pure' photography towards installations, self-portraiture, and the use of new supports and media. Photographers such as Miguel Rio Branco (b. 1946), Mario Cravo Neto (b. 1947), Pedro Karp Vasquez (b. 1954), and Cassio Vasconcelos (b. 1965) are notable for both their cosmopolitan training and contacts and their interest in a wide range of media, including film, sculpture, painting, and video as well as conventional photography.

Photography also increasingly entered the ambit of state and private galleries, and its value as art increased. Prestigious collectors such as Gilberto Chateaubriand, Thomas Cohn, and Joaquim Paiva entered the market, concentrating on both unique items and limited editions. Furthermore, the expansion of photographic publishing brought pictures to new sections of the public. The gallery and museum curator, charged with choosing and organizing exhibitions of historical and art photography, became a key figure.

The field of photographic criticism is quite varied. Specialist photography journals like Iris and Fotóptica, and newspapers such as Globo, Folha, and Estado de São Paulo publish articles by Paulo Herkenhoff, Moracy de Oliveira, Luis Humberto, and Stefania Bril. More analytical and historically based studies of Brazilian photography have been undertaken by scholars such as Gilberto Ferrez, Boris Kossoy, Pedro Karp Vasquez, Ricardo Mendes, Rubens Fernandes Jr., Arlindo Machado, Angela Magalhães, and Nadja Fonsêca Peregrino. Research grants are dispensed by the Fundação Vitae, and the Institutos Culturais Moreira Salles and Itaú fund the publication of books, the creation of databanks of historical and contemporary photography, and the acquisition of photographic works. This last function is also performed by the Rio de Janeiro Museum of Modern Art and the São Paulo Museum of Art (White Martins and Pirelli photographic collections).

Most photographic courses and schools are concentrated in Rio de Janeiro and São Paulo. Since the end of the 20th century photography has also been studied increasingly in the contexts of history and anthropology, and found a place in faculties of fine art and communication studies. Contacts between photographers take place via exhibitions, lectures, and workshops. Major examples are the International Month of Photography (Núcleo de Amigos da Fotografia/NAFOTO—Centre for the Friends of Photography) in São Paulo and the International Photography Biennale in Curitiba, which link Brazil unequivocally to the international photography scene. AM/NFP

Kossoy, B., Origens e expansão de fotografia no Brasil (1980).
Billeter, E., Fotografie Lateinamerika von 1860 bis heute (1981).
Vasquez, P., Brazilian Photography in the Nineteenth Century (1988).
Costa, H., and Rodrigues, R., A fotografia moderna no Brasil (1995).
Watriss, W., and Zamora, L. P. (eds.), Image and Memory: Photography from Latin America, 1866–1994 (1998).

Brehme, Hugo (1882–1954), German-born landscape and architectural photographer, active in Mexico. Stylistically a *pictorialist, Brehme migrated to Central America to exploit the international market in travel photography, and moved to Mexico in 1905. His main interest was the country's natural beauty and architectural heritage, and figures appear in his photographs mainly to indicate scale and perspective. Many of his pictures were published as *postcards, which today are highly prized. LAL

Breitner, Georg Hendrik (1857–1923), Dutch painter, influenced by Impressionism, who also took many photographs, especially of Amsterdam's streets and canals. Some of these were intended as studies for Breitner's cityscapes, and surviving prints are squared off in pencil to make details more easily transferable to the canvas. However, other pictures seem to have been taken for their own sake, and now seem

precociously modernistic in their attempts to capture ordinary people and the bustle of street life. A collection of them is in the Rijksmuseum, Amsterdam. RL

Breslauer, Marianne (1909–2001), German photographer, who trained (1927–9) at the Berlin *Lette-Verein, then in *Man Ray's Paris studio, where she met Paul Citroen, Werner Rohde, and other photographers. In 1930 she joined the Ullstein Photo-Atelier in Berlin, and subsequently published travel reportages and other work. In 1936 she emigrated to Holland, married the art dealer Walter Feilchenfeldt, and abandoned photography for art dealing. She moved to Switzerland in 1939. Her photographic work, done in only a decade, is strongly marked by the new movements of the 1920s and was rediscovered in the 1980s. UR

Marianne Breslauer: Photographien 1927–1937 (1989).

Brewster, David (1781–1868), Scottish physicist, born in Jedburgh and educated there and at Edinburgh University, after which he took a job as a tutor. Although trained for the Church, he was unable to preach—or indeed, to teach—because of a nervous reaction to public speaking. Instead, to fund his scientific work, he took to scientific journalism, and in the meantime laid practical foundations for much of the optical work undertaken during the 19th century. Because he never fully accepted the wave theory of light and because he outlived most of his scientific contemporaries, Brewster ultimately found his experimental work marginalized. Many of his achievements were attributed to others.

Brewster was involved in photography from its very beginnings: he stayed with *Talbot in 1836, and although Talbot did not publish his findings until 1839, Brewster was sent examples of his work from an early stage. Brewster's correspondence with Talbot meant that St Andrews was the first place outside England that the *calotype was practised; and it was on Brewster's advice that Talbot did not patent his invention outside England. However, although Brewster collected photographic prints and wrote fairly extensively on the subject, he apparently lacked the time to practise the new photographic art much himself. He introduced the artist D. O. *Hill to the calotypist Robert Adamson in 1843. In 1849 Brewster announced a successful lenticular stereoscope for viewing stereo-*daguerreotypes, a version of which was presented to Queen Victoria in 1851. ADM-L

Morrison-Low, A. D., and Christie, J. R. R. (eds.), '*Martyr of Science': Sir David Brewster 1781–1868* (1984).
Morrison-Low, A. D., 'Sir David Brewster and Photography', *Review of Scottish Culture*, 4 (1988).

Brigman, Anne (née Nott; 1869–1950), American photographer. Often known as Annie, Brigman was a dynamic central figure of the Californian *pictorialist movement. A member and eventually Fellow of the *Photo-Secession, she published her idealized images of the figure in nature in two books, *Songs of a Pagan* and *Wild Flute Songs*. They were exhibited at *Gallery 291 and printed in *Camera Work*.

Brigman concentrated on a woman's portrayal of the female body and its relationship to landscape, often employing heavy retouching or scratching her negatives. KEW

Brigman, A., *A Poetic Vision*, introd. S. Ehrens (1995).

Brihat, Denis (b. 1928), Paris-born nature and experimental photographer, resident in Bonnieux, Provence. After award-winning work as a photojournalist in India in 1955–6, Brihat settled permanently in the South of France, photographing the plant life around his rural home. He has experimented with various toning techniques in order to obtain colour prints from black-and-white negatives. Though tedious to make and difficult to reproduce, they are capable of strikingly subtle and delicate effects, as in *Coupe de kiwi* (1990). LAL

British Institute of Professional Photographers (BIPP). See PROFESSIONAL ORGANIZATIONS, PHOTOGRAPHERS'.

British Journal of Photography (*BJP*). British periodical launched in 1854 as the *Liverpool Photographic Journal*, becoming the *Liverpool and Manchester Photographic Journal* (1857–8) and the *Photographic Journal* (1859), before adopting the title *British Journal of Photography* from 1860. It became a weekly from 1 January 1865, a frequency it continues today. The *BJP* has held a leading position for most of its history, and its news and articles, under a succession of able editors, have recorded the development of technical and, to a lesser extent, aesthetic trends from *wet-plate to *digital imaging. MP

Brodovitch, Alexey (1898–1971), Russian-born designer, art director, photographer, and teacher, mostly resident in the USA. The son of affluent parents, Brodovitch emigrated in 1920 to Paris, where he worked as a scene painter for Diaghilev's Ballets Russes, cultivated the avant-garde, and established himself as a graphic designer. In September 1930 he took over a design class at the Pennsylvania Museum's School of Industrial Art, and succeeded both in introducing students to European modernism and in attracting important advertising commissions. In 1934 he was hired by Carmel Snow, the new editor of *Harper's Bazaar*, as art director of the magazine. Between them, over nearly a quarter of a century (Brodovitch left in 1958, Snow in 1959), they transformed the formerly staid journal into a showpiece of modernistic design and youth-orientated advertising. Brodovitch visited France annually until the war and nurtured his avant-garde contacts, presenting American readers and advertisers with as much modernism as they could take, but without its leftist politics. Cocteau, Chagall, Dalí, and Dufy were among the artists he enlisted. Photographers included *Man Ray, *Brassaï, George *Hoyningen-Huene, André *Kertész, and Erwin *Blumenfeld; later, Lisette *Model, Richard *Avedon, Henri *Cartier-Bresson, and Robert *Frank. Aiming constantly to amaze the reader, Brodovitch used cropping, bleeding, selective enlargement, and dynamic arrangement on the page to create a strong visual rhythm throughout the magazine.

In Brodovitch's Design Laboratory, students were pressed into relentless innovation. Photographers who attended, more or less profitably, in Philadelphia in the 1930s and New York from 1941, included *Arbus, Avedon, Frank, *Hiro, Art Kane, Hans Namuth, Irving *Penn, and many others. Brodovitch's reputation as a photographer rests on 104 dance images published in *Ballet* in 1945. Shot without flash with a 35 mm Contax, they used blur, flare, and grain to powerful expressive effect that was heightened in the darkroom and on the page: a daring display of rule breaking at a time when American photography was dominated by documentary subject matter and stylistic precisionism. Other books he designed included Kertész's *Day of Paris* (1945) and *Observations* by Avedon and Truman Capote (1959). Brodovitch's fortunes declined after he left *Harper's*, and he spent his final years in France. RL

Grundberg, A., *Brodovitch* (1989).

Purcell, K. W., *Alexey Brodovitch* (2002).

bromoil is a pigment process devised by C. Welbourne Piper and E. J. Wall and revealed in 1907. It has appealed both to makers of first-class prints, and also to the most saccharine *pictorialists; it was known by its detractors as 'muck spreading'. It enjoyed a considerable revival in the late 20th century, though its heyday was the 1920s and 1930s.

A bromoil 'matrix' is made by treating a conventional bromide print with a dichromate bleach. This removes the halide image but hardens the emulsion in proportion to the density of the silver image. A greasy ink is then applied to the damp matrix, usually with a special brush made of bear hair, cut on a slope: purists recoil from the use of a roller. A dabbing or 'hopping' motion adds ink, while a brushing motion removes it: considerable control is possible. The softer the gelatin, i.e. the more water it contains, the less ink it accepts, on the simple principle that oil and water do not mix.

Some modern papers are more suitable for bromoil than others, though, contrary to widespread belief, some variable-contrast papers and some supercoated papers may be used. The ideal bromide print (before bleaching) is slightly lacking in contrast, but of greater than usual density.

The life of a bromoil print is limited principally by decay of the gelatin or the support. For bromoil transfers, the image is printed laterally reversed, inked up, then transferred to plain paper with the aid of an etching press or similar: this is one of the most archivally permanent forms of print. RWH

Broom, Christina (1863–1939), British photographer who began selling her views of London in 1903, and by 1904, assisted by her daughter Winifred, was photographing a wide range of events: state funerals, boat-race crews, the effects of the First World War on the home front, the Life Guards regiment, and the first female police. Best known are her photographs of suffragettes at demonstrations and in prison. Her images show an interest in capturing individual identities, even when effaced by uniforms, or subsumed under collective activities. Her photographs are in the Museum of London,

the Imperial War Museum, London, and the Harry Ransom Center at Austin, Texas. PDB

Atkinson, D., *Mrs Broom's Suffragette Photographs* (1990).

Inselmann, A. (ed.), *A Second Look* (1993).

Brownie. See KODAK BROWNIE.

brownprint. See ALTERNATIVE (NON-SILVER) PHOTOGRAPHIC PROCESSES.

Bruehl, Anton (1900–82), Australian-born American photographer. After studying engineering in Melbourne, Bruehl settled in New York in 1919. In 1923 he studied photography with Clarence H. *White. By 1926 he had launched a successful advertising career based on a sophisticated modernist style, characterized by geometric composition, oblique vantage points, close-ups, and a full tonal range. With his brother Martin Bruehl he opened a New York studio in 1927. Condé Nast Publications paired him with the technician Fernand Bourges and, from 1932, they produced 195 colour images of the highest quality then available. Bruehl designed the image, which Bourges took with the 'one-shot' camera he had made: during the exposure, light passed through three thin acetate sheets with emulsions of different colour sensitivities. Condé Nast technicians then turned the composite transparency into a copper engraving for printing. Bruehl developed a reputation for elaborate staging and complex studio lighting. In addition to his advertising work, his editorial work appeared in *Vogue, Vanity Fair, House and Garden*, and other magazines until he closed his New York studio in 1966. Bruehl also pursued art photography, publishing the portfolios *Mexico* in 1933 and *Tropic Patterns* in 1970. PJ

Bruehl, A., and Bourges, F., *Color Sells* (1935).

Yochelson, B., *Anton Bruehl* (1998).

brûlage. Manipulatory technique, perfected by the Surrealist photographers Raoul *Ubac and David Hare (1917–92), by which the negative is heated intensely, causing a deformation in the emulsion. The print created from these negatives showed patterns generated by the deformations rather than by the photographic apparatus used. The formation of photographic images purely by chance and the elements, unmediated by conventional photography, was one manifestation of the Surrealist approach to photography in the 1920s. *Brûlage* was used alongside such techniques as the *photogram and *solarization. KEW

Warehime, M., *Brassaï: Images of Culture and the Surrealist Observer* (1996).

Bubley, Esther (1921–98), American *documentary photographer gifted in putting her subjects at ease, noted for fine images of ordinary people, especially children. Beginning as a photofinisher and darkroom technician, she came into her own under the direction of Roy *Stryker, for whom she worked in the Office of War Information (1942–3), *Standard Oil of New Jersey (1943–50), and Pittsburgh Photographic

Library (1950–1) projects. A New York-based *photojournalist, her images appeared regularly in magazines like *Life and Ladies' Home Journal. CBS

Yochelson, B., Schmid, T. A., *Esther Bubley On Assignment* (2005).

Bulla, Karl (1855–1930), **Alexander** (1881–1943), and **Viktor** (1883–?), Russian photographers of German or Swiss extraction. Although biographical details are sparse, it seems that Karl, the father, opened a portrait studio in St Petersburg in 1875, but after ten years moved into *photojournalism, based at 110 Nevsky Prospect. He worked for the St Petersburg press and foreign papers such as *Die Woche*, the *Berliner illustrirte Zeitung*, and *L'*Illustration*, and founded an important early *agency (with the by-line 'Foto Bulla'). Over a long career he covered the capital's growth into a major industrial and business centre, military and naval activity and shipbuilding, theatrical life and personalities, floods and fires—he was official photographer of the St Petersburg fire brigades—and political events ranging from revolutionary bomb attacks to the 1905 Revolution. He periodically published albums entitled *Chronicle of St Petersburg Life*. In 1916 or 1917 he settled in Estonia.

Karl's sons studied in Germany before becoming photographers themselves. Alexander specialized in portraiture, then photojournalism, doing his most important work during the First World War and the 1920s. He was arrested in 1930 and sent to the notorious *White Sea Canal project. Viktor, also a photojournalist, sometimes worked with his father, for example on a visit to Tolstoy at Yasnaya Polyana in July 1908 to mark the writer's 80th birthday, resulting in nearly 90 pictures. But by then he was an established figure, having photographed the Russo-Japanese War (1904–5) for the magazine *Niva*, and subsequently founded a documentary film company, Apollo; he became one of Russia's first newsreel cameramen. His major achievement in both media was his coverage of the events of 1917, from the fall of the tsarist regime to the Bolshevik seizure of power, then the Civil War. He took celebrated portraits of Lenin in 1920 and 1921 and (with Alexander) participated in the exhibition *Ten Years of Soviet Photography* shown in Moscow and Leningrad in 1928. Yet he too was arrested in 1937, and died either in 1938 or during the Second World War.

The largest Bulla collection, of nearly 100,000 negatives, is in the State Central Archive of Film and Photographic Documentary, St Petersburg. RL

Barchatova, Y. V., et al., *A Portrait of Tsarist Russia: Unknown Photographs from the Soviet Archives*, trans. M. Robinson (1990).

bullfighting photography. Photographs of the Spanish bullfight emerged from a well-established artistic tradition, including portraits of famous bullfighters, depictions of the performance itself, and portrayals of women as 'beautiful spectators'. Whilst in early bullfight photography technological limitations made performance photography impossible, the key visual moments and subjects, which originated in 19th-century paintings of the bullfight, appear consistently from the mid-19th-century advent of bullfight photography to the present. Contemporary bullfighting photography is primarily journalistic and most often in black-and-white. It follows an established brief to photograph key stages of the performance (including the entrance into the arena, any dramatic moments or outstanding cape passes, and, most importantly, the kill) and the triumphant performer. It is a photographic tradition firmly embedded in bullfighting culture and practised by photographers who are committed bullfight fans themselves. Indeed, some would argue that an indispensable condition for being a good taurine photographer is to have been a bullfighter, or at least to be a practical aficionado, as were the photographers Paco Cano and Pepe Cerdá. A bullfight photographer should have the knowledge that will allow him (or her) to anticipate the performance in the way a bullfighter would. Although bullfight photographers rise to national fame through the publication of their work in newspapers, magazines, and bullfighting publications such as *Aplausos* and *6Tauros6*, they are usually regionally based, like the Córdoban Ladis family. Bullfight photographs are displayed publicly in specialist museums and mainstream galleries and, more privately and in almost shrinelike style, alongside other bullfighting paraphernalia in bullfighting bars and clubs and in the homes of aficionados. For these fans such personal uses of images are an important way of mapping out their social landscapes. SP

Clementson, C., *La imagen de la fiesta* (1993).
Córdoba, J. L. de, 'Saludo', in *Ladis 25 años de fotografía taurina: los califas 1965–1990* (1991).
Pink, S., 'Visual Histories of Success', in E. Edwards (ed.), *History of Photography* (1997).
Pink, S., *Women and Bullfighting: Gender, Sex and the Consumption of Tradition* (1997).

Bullock, Wynn (1902–75), American photographer. A deeply philosophical person, Bullock surpassed one of his mentors, Edward *Weston, in the use of *solarization and other complex printing processes to explore a lifelong fascination with reality and existence. After starting as a singer in musical revues in New York and Europe he studied photography in Los Angeles with Edward Kaminski. He was strongly influenced by the work of the semanticist Alfred Korzybski, particularly the latter's exploration of time and space. Bullock's wife Edna, herself a photographer, occasionally modelled for his celebrated nude studies. TT

Bullock, W., *The Enchanted Landscape: Photographs 1940–1975* (1993).

Buna Beach, Three American Soldiers Ambushed on, February 1943. Taken by *Life photographer George Strock (1911–77) after a landing in New Guinea, the picture shows a wrecked landing craft and three dead soldiers, the foreground figure already attacked by maggots. Censorship prevented its publication until 20 September. Although the men were not identifiable, they were the first undraped and uncoffined dead Americans to appear in *Life during the Second World War, and the pictures breached an important taboo. The same

month, dozens of other gruesome casualty photographs were released, following fears on the part of the US Office of War Information and President Roosevelt that Americans were becoming complacent about the war. Both Strock's picture and some of these were subsequently used to promote war bond sales, apparently to good effect. RL

Roeder, G. H., Jr., *The Censored War: American Visual Experience during World War Two* (1993).

Burgin, Victor (b. 1941), British photographer, teacher, and theorist. He began teaching at the London Polytechnic in 1973, moved to the USA in 1980, and became professor of art history at the University of California at Santa Cruz in 1989. In the 1970s and 1980s he was regarded as one of the main links between avant-garde art and photography, and his work was widely exhibited. A 1974 poster image incorporating the 'copy' text 'What does possession mean to you? 7 per cent of our population own 84 per cent of our wealth' was described as 'one of the classic proto-postmodern appropriations of popular imagery'. He has claimed that his conceptual, Marxist, and structuralist theories make the 'categorical distinction between art and photography ill-founded and irrelevant'. RSA

Burgin, V. (ed.), *Thinking Photography* (1982).

Burma, early photography in. In contrast to *India, where evidence of photographic activity is apparent from soon after its European announcement in 1839, the medium appears to have been slow to penetrate the reclusive Burmese Empire. The earliest surviving images appear to coincide with increasing European embroilment with the country, in the form of a small series of photographs taken by John *McCosh during the Second Anglo-Burmese War (1852–4), a conflict that placed Lower Burma under British control. Similarly associated with British interests is the more substantial series of 120 large-format views (mainly of architectural subjects) taken by Linnaeus *Tripe during the diplomatic mission sent to the Burmese court at Ava in 1855. While an apparently abortive attempt to establish an amateur photographic society in Moulmein was made in the same year, the lack of any substantial European market in Upper Burma severely restricted the growth of commercial photography in subsequent decades. Early studios such as that of Jackson & Bentley were trading in Rangoon by 1865, and Philip Adolphe Klier, perhaps the longest surviving and among the most prolific photographers of the country, had opened a studio in Moulmein by 1871. A significant proportion of early photographic activity before the 1880s, however, was characterized by the practice of Indian commercial photographers such as *Bourne & Shepherd, who made photographic tours of the country without committing themselves to permanent studios. In fact, the development of photography continued to be closely associated with British colonial expansion: the absorption of the whole of Burma into Britain's Indian Empire after the campaign of 1885–6 led to an influx of European administrators, military personnel, and private traders which in turn stimulated a hitherto sluggish photograph market. The demands of tourism were also becoming a measurable factor by the 1890s, and

this decade saw a significant increase in the numbers of commercial studios. Perhaps the most distinguished of these was that of the veteran war photographer Felice *Beato, who had arrived in Mandalay *c*.1887 and was to spend the final years of his career in the new dependency, trading as both a photographer and a manufacturer of tourist goods and furniture. The rising demand for photographs from both residents and visitors is clearly evidenced by the large quantities of surviving work from firms like Klier (whose business survived until the First World War), while the Ceylon firm of *Skeen & Co. clearly felt by the late 1880s that the opening up of the country justified the establishment of a Burmese branch, which operated from 1887 as the partnership of Watts and Skeen. While several Indian photographers (most notably D. A. Ahuja) also established themselves in Burma towards the end of the 19th century, the work of indigenous Burmese photographers remains relatively scarce in this period.

The intimate connection between photography and the introduction of colonial rule to Burma is further emphasized in the work of some significant amateur photographers: Willoughby Wallace *Hooper's most celebrated work, later published, records the progress of the 1885–6 military campaign which saw the overthrow of the Burmese monarchy, while another military officer, Arthur George Edward Newland, recorded the subsequent pacification operations in photographs that were published in *The Image of War* (1894). The colonial administrator Sir James George Scott ('Scott of the Shan Hills') also produced an impressive photographic documentation of tribal life during his career as Resident in the Northern and Southern Shan States between 1890 and 1910. JF

Burri, René (b. 1933), Swiss photographer and film-maker, who studied at the Zurich Design School under Hans *Finsler. He went freelance in 1955, travelled widely, became a full member of *Magnum in 1959, and contributed to *Life*, *Du*, and other leading magazines. He is best known for 'soft' reportage of political conflicts and social issues worldwide, and for landscapes and portraits, including disarmingly appealing images of Che Guevara taken in Havana in 1963. In the 1970s he began working in colour, and experimented with collages. In 1984 the Zurich Kunsthaus produced a large Burri retrospective and book, *One World*. RL

Burrows, Larry (1926–71), British photojournalist. Born a London Cockney and described (by Beaumont *Newhall) as 'a tall, gaunt-boned Abraham Lincoln of a man', Burrows joined the *Daily Express* as a messenger boy, moved to the Keystone Agency as a darkroom assistant, then to *Life* magazine as a printer. His earliest published images were from art galleries and museums around the world.

Burrows's capacity to match his images with witty text brought him success across a wide range of publications, including *Time*, *Life*, *Quick*, *Stern*, and *Paris-Match*, and with such unlikely subjects as the novelist C. P. Snow in a four-poster bed. From 1961 to 1971 he worked out of Hong Kong for *Life*, a handy placement when the Vietnam War erupted. He accompanied the US forces, showing the whole panoply

of combat from helicopter flights to parachute drops, the gore of battle and the evacuation of the wounded. *Life* advertised a cover story with 'In Color: Ugly War in Vietnam'. But his colour was all shades of mud, khaki, and olive, splashed with scarlet. Burrows remarked: 'I can't afford the luxury of thinking about what could happen to me.' He died, camera in hand, when his helicopter was shot down at Langvie, South Vietnam. AH

Larry Burrows: Compassionate Photographer (1972).

Burton Brothers was a thriving photographic business in Dunedin, New Zealand. Walter (1836–80) specialized in studio portraiture and Alfred (1834–1914) in landscape and 'ethnographic' photography. After Walter's death Alfred continued under the Burton Brothers name until 1898, and made two major series. *Camera in the Coral Islands* (1884) comprised 230 photographs from Samoa, Tonga, and Fiji—bland scenes and poses typical of the transient photographer. *The Maori at Home* (1885) followed, *c.*200 photographs of the Maori peoples of the Wanganui River 'King Country', who named Alfred *tangata-whaka-ahua*—'The man who captured likenesses'. Also available singly, these commercially successful series are found in many contemporary travellers' albums and ethnographic collections. Sold through agents and catalogues, the Burtons' photographs remained in circulation as prints and postcards well into the 20th century. EE

Faber, P., et al., *Fotografie van de Burton Brothers in Nieuwe Zeeland 1866–1898* (1987).

Butler, Samuel (1835–1902), author of the satirical utopia *Erewhon* (1870) and the semi-autobiographical novel *The Way of All Flesh* (1903), but also a major British photographer active 1880–1900. His subjects were street life, 'portraits' of characters from literature, continental travels, Italian art, especially of the Sacro Monte pilgrimage sites of the north, and classical sites in Asia Minor, Greece, and especially Sicily. But such descriptions mask the wit, originality, and imaginative reach of his photographic invention.

Photography offered Butler escape from an oppressive family background. His first known picture dates from 1866, but his energies were focused by his travels in connection with the book *Alps and Sanctuaries* (1881), illustrated with his own drawings and etchings, and the extensive photography carried out for his art-historical work *Ex Voto* (1889), a pioneering study of the Sacro Monte and the Renaissance artist Gaudenzio Ferrari. His vivid sense of the relationship between the hyperreal life-size New Testament sculptural groups and the local communities which had furnished models for them informs his representations of contemporary Italian life. His photographs of the 1890s relate to books on the theme of *The Authoress of the Odyssey* (1897), challenging the view that the classics were handbooks for young gentlemen destined to rule the Empire. Just as his novel became an important element in the anti-Victorian early modernist movement, so his suggestion that 'Homer' was a woman living in Sicily began the ironic deflation that culminated in James Joyce's *Ulysses*. His Sicilian photographs invoke a heroic legend in a modern down-at-heel setting. The new medium brought freedom through its improvisatory speed (especially with the introduction of the Kodak), natural comedy, democratic levelling; in short, it helped to banish hypocrisy and pretension. ES

Shaffer, E., *Erewhons of the Eye: Samuel Butler as Painter, Photographer and Art Critic* (1988).

Byron, Joseph (1847–1923) and **Percy** (1878–1959), owners of the Byron Company. Born in Nottingham into a family of photographers, Joseph Byron moved to New York in 1888, where he gained a reputation as a stage photographer. Theatre publicity and celebrity portraiture sustained the studio until 1917, when Joseph's son Percy inaugurated the company's second era, specializing in ship photography. Less personal and more efficient, the studio continued to thrive until 1942, when it was dissolved. AF

Simmons, P., and Doctorow, E. L., *Gotham Comes of Age: New York through the Lens of the Byron Company, 1892–1942* (1999).

cabinet print, format introduced in 1866 as the craze for the *carte de visite* was slackening; although it was not until the 1890s that cabinet prints outnumbered *cartes*. The size of the print (predominantly *albumen, sometimes *carbon) was usually *c.*102 × 140 mm (4 × 5¹/₂ in), and was pasted on to a piece of card *c.*114 × 165 mm (4¹/₂ × 6¹/₂ in). As with the *carte*, the studio's name often appeared on the bottom front edge of the card, or on the back, sometimes with a negative number. The style of text and design often gives clues for *dating. The format rapidly became internationally accepted, albums were produced to fit it, and countless millions of images were created, mostly portraits. It continued into the 1900s. RL

Pols, R., *Dating Old Photographs* (2nd edn. 1995).

Caffin, Charles Henry (1854–1918). Although not himself an artist, Caffin, an English-born and -educated thespian and writer, wrote extensively about art and, specifically, about art and photography. His *Photography as a Fine Art* (1901) was one of the earliest treatises on the subject. He moved to New York in 1897, worked as a critic for *Harper's Weekly* among other publications, and became closely associated with Alfred *Stieglitz and his circle. His influential journalistic writing and numerous books continued to elucidate the art world and *modernism for the remainder of his life. TT

Cahun, Claude (Lucy Schwob; 1894–1954), French photographer, born into an intellectual Jewish family, and active as a writer and in Surrealist groups. Her photographic work was rediscovered after exhibitions in London (1994) and Paris (1995). It featured prominently in *Surrealism: Desire Unbound* at the Tate Gallery, London, in 2001, and Cahun is now famous for self-portraits in which she appears transformed by make-up, costumes, and *mise-en-scène*. Her images militate against notions of the photographic portrait as a mirror of the self, playing instead with stereotypes and masks which foreground the constructed nature of identity. Her work also engages with the complexities of same-sex desire, racial identity, and political engagement. She published *Aveux non avenus* (1930), a collection of texts and *photomontages, in collaboration with her lover Suzanne Malherbe. She moved to Jersey in 1939 and was active in the Resistance. Some of her work is in the Jersey Heritage Trust. PDB

Rice, S. (ed.), *Inverted Odysseys: Claude Cahun, Maya Deren, Cindy Sherman* (1999).

calendar photography. Calendars are produced either directly for sale or for distribution by businesses. While run-of-the-mill types may be assembled from stock shots, prestige calendars produced by big companies are often expensively created by top photographers, and may become collectors' items.

An illustrated calendar is normally examined when it is first received, and then gets next to no attention for the rest of the year, except perhaps when the month changes. It is, however, a piece of visual furniture. This combination of ubiquity and indifference defines calendar photography: it must be easy on the eye, preferably pandering to the owner's preconceptions and preferences. This is as true of landscapes, abstracts, still lifes, and themes (e.g. 'Britain's Pubs' or 'America's National Parks') as of the traditional motor-trade 'girlie' calendar.

It is easiest to analyse successful calendar photography by looking at unsuccessful examples, which will exhibit one or more of the following faults:

- *Lack of theme*, or strained theme. Unless the pictures 'hang together' in some way, the calendar will fail.
- *Excess of subtlety*. The user rarely wants to expend much brainpower in discerning the theme or subject.
- *Poor technical quality*. Traditional calendar photographers shot transparency film, initially with 13 × 18 cm (5 × 7 in) cameras; then 9 × 12 cm (4 × 5 in); then roll-film. Only the best 35 mm work can begin to compete with larger formats. Few portable digital cameras deliver enough quality.
- *Lack of attention to detail*, e.g. debris or an unsightly sign in a landscape, or a model with skin blemishes. Such faults can often be retouched, but it is usually quicker, easier, and cheaper to avoid them at the taking stage.

A classic has been the calendar produced by the tyre manufacturer Pirelli since 1963. Shooting it has been a big undertaking, involving not only an art director, photographer, assistants, and models but a sizeable support team, as well as a considerable public-relations effort. The photographers have included Brian *Duffy (1965), Peter *Knapp (1966), Sarah *Moon (1972), Uwe Ommer (1984), Norman *Parkinson (1985), Bert *Stern (1986), and Terence *Donovan (1987). RWH

Lichfield, P., and North, R., *Creating the Unipart Calendar* (1983).
Pye, M., *The Pirelli Calendar Album: The First Twenty-Five Years* (1988).

Callahan, Harry (1912–99), American photographer, born and raised in Detroit. He dropped out of Michigan State University after three semesters. With his lifelong friend Todd Webb he joined the Detroit Photo Guild in 1940 and through that organization met and studied with Ansel *Adams. He began teaching at the Chicago Institute of Design in 1946 under *Moholy-Nagy. Never interested in the commercial world, Callahan went on to teach at the Rhode Island School of Design in 1961, received various grants over the years, and travelled widely in Europe, Mexico, and South America. Perhaps best known for his serene nude portraits of his wife Eleanor, Callahan actually experimented heavily over the course of his career: quiescent, Zenlike landscapes, building façades, collages, and multiple exposures. He switched to colour almost exclusively in 1976. Striving always for simplicity of composition, Callahan's images often impart a profound calmness. Ever self-effacing, he commented in 1983, 'Because I love photography so much I was a successful teacher, although I never knew what or how to teach. It's the same with my photography. I just don't know why I take the pictures I do.' TT

Greenough, S., *Harry Callahan* (1996).

Calle, Sophie (b. 1953), French photographer and conceptual artist, resident in Paris. Her documentary approach, which evokes a detective-style investigation, fuses fiction and reality. Her works incorporate performative and voyeuristic elements, as in the project *The Hotel* (1981), where she worked as a temporary chambermaid in Venice secretly documenting the belongings of those whose rooms she cleaned. Collaboration with the American writer Paul Auster resulted in the projects *Gotham Handbook* and *Double Game* (published 1998). KR

Calle, S., *The Detachment/Die Entfernung: A Berlin Travel Guide* (1999).

Callier effect. This is an increase in contrast in a black-and-white negative image projected by a condenser enlarger as compared with the image produced by diffuse illumination. Because of the scattering of transmitted light by the developed silver grains, less light reaches the lens aperture from the darker parts of the negative than from the clearer parts. The effect is strongest in the shadow regions, so condenser and diffuser enlargers tend to give different shadow quality. In most amateur enlargers with condensers the Callier factor amounts to about half a contrast grade. GS

calotype, term (from the Greek *kalos*, and *typos*, image; sometimes called the Talbotype) coined by Henry *Talbot in 1840 to describe his process for producing a developed-out paper *negative. Its details were described in Talbot's notebooks of September 1840, and in the patent (Nr. 8842, for 'Obtaining pictures or representations of objects') registered on 8 February 1841. In the process's original form, paper prepared with silver iodide was washed before use with an 'exciting liquid' of silver nitrate, gallic acid, and acetic acid, then exposed in the camera. The resulting *latent image was then 'brought out' (i.e. developed) with a further gallo-nitrate solution, and fixed. Compared with exposure times of half an hour or more with the earlier

Revd George W. Bridges

St Nicolo's convent and chapel, Mount Etna, Sicily, 1846. Calotype

*photogenic drawing process, exposures were reduced initially to *c*.30 seconds in bright sunlight, and four to five minutes in open shade; even in dull conditions, usable pictures could be obtained.

In 1847, the process was adapted by L. *Blanquart-Évrard as a developed-out positive printing paper. RL

Crawford, W., *The Keepers of Light. A History and Working Guide to Early Photographic Processes* (1979).

Buckland, G., *Fox Talbot and the Invention of Photography* (1980).

Calotype Club. See AMATEUR PHOTOGRAPHY, HISTORY; CLUBS AND SOCIETIES, PHOTOGRAPHIC.

calotype process, dissemination and practice. *Talbot's discovery, almost by accident, of the *calotype process in September 1840 transformed his art. Most importantly, the dramatic reduction in exposure times meant that he could now photograph living subjects, and as early as 10 October 1840 he made a successful and moving 30-second portrait of his wife Constance. Details of the process were revealed in the patent of 8 February 1841 (strictly speaking, the name referred only to the negative; prints continued to be made by the *photogenic drawing method), to the Royal Society in June, and in scientific and popular journals. However, further refinements to the process in England would continue to revolve around Talbot and his circle.

Although Talbot hoped that calotype portrait studios would prove profitable his first licensee, the miniature painter Henry Collen, struggled to master the process. He required long exposure times, even after acquiring a special large-aperture lens from London's premier lens maker, Andrew Ross. Perhaps Collen was not a particularly competent technician, for Talbot himself produced some charming private portraits of his family, including several of his children. The masterly calotype portraits of *Hill and Adamson were produced after much experimentation following lengthy correspondence between Talbot and his scientific friend in Scotland, Sir David *Brewster.

Nicolaas *Henneman and the chemist Thomas Malone, working on Talbot's behalf at the Reading printing establishment, acquired useful experience that led to some refinements to early practice. Talbot had often waxed negatives after processing, but although this offered greater negative transparency, it was found that it sometimes led to a not always desirable increase in contrast of the print and rather cold grey tones. The aim was to produce uniform prints of a rich mulberry colour. Nitric acid, 'hypo', and hot irons were all tried as toners, although there were worries about the long-term effects of these actions. Yet consistent quality remained a problem and was always dependent on impurity-free chemicals and the vagaries of the weather.

The calotype process was most popular with amateurs. Many did not bother to apply for a licence and the materials were cheap—good-quality writing paper and a limited range of common chemicals. Compared with the *daguerreotype process, it was portable and convenient for travellers. It also enjoyed the advantage of being a negative-positive process, allowing numerous copies to be made.

There were problems of course. The unpredictable nature of the early process required an experimental bucket-chemistry approach beyond the skills of many potential practitioners. It was not surprising, therefore, that several of the early English amateurs were relatives or friends of Talbot and constantly sought his advice. Talbot's associate, Calvert *Jones, wrote regularly while calotyping in the Mediterranean, on one occasion complaining that even in the 'energetic' sunlight of Malta, he required a three-minute exposure.

The calotype process only became popular in France after 1847 when *Blanquart-Évrard found that, by omitting gallic acid from Talbot's sensitizing solution and using it solely as a developing agent, he required shorter exposures and obtained clearer images. He was able to mass-produce prints in a standard range of hues and with a consistency of quality that had eluded Talbot. Gustave *Le Gray's 'dry' *waxed-negative technique of 1851 involved waxing negatives before they were sensitized and exposed, rather than after, as was Talbot's practice. This technique further shortened exposure times and allowed negative paper to be pre-prepared and kept for many weeks, a boon to travelling photographers. Calotype photography was never popular in America. Talbot sold calotype rights to the *Langenheim brothers, operators of a successful daguerreotype studio in Philadelphia, but photographs on paper did not impress the American public and the venture was a financial disaster. During the 1850s the process was generally supplanted by *glass-plate photography; although for a while it continued to be used quite widely in warmer climates where *collodion dries rapidly. Today, calotype revival workshops are not uncommon in museums and photographic schools in Britain and France, although they tend to concentrate on printmaking from modern negatives. JPW

Arnold, H. J. P., *William Henry Fox Talbot* (1977).

Brettell, R., Flukinger, R., Keeler, N., and Kilgor, S., *Paper and Light: The Calotype Process in France and Britain 1839–1870* (1984).

Schaaf, L. J., *The Photographic Art of William Henry Fox Talbot* (2000).

Calotype Society. See AMATEUR PHOTOGRAPHY, HISTORY; CLUBS AND SOCIETIES, PHOTOGRAPHIC; EDUCATION AND TRAINING, PHOTOGRAPHIC.

camera development

Prehistory

*Pre-photographic imaging devices have a long history. The portable camera obscura, in a form that a photographer would recognize, was available in numerous versions (some incorporating a mirror to reflect the image) by the end of the 18th century, and used by artists and tourists to produce an outline of a scene or object on translucent paper. The simple box design influenced the first camera makers, while the principle of mirror viewing was taken up again from the 1860s.

The principal photographic pioneers all initially used the box camera obscura as a starting point for their chemical experiments: Thomas *Wedgwood *c*.1801, Nicéphore *Niépce in 1816, and Henry

*Talbot c.1835. But although all three were able to form images they found that excessive exposure times were required, and Niépce and Talbot began to produce cameras specifically for chemical photography. Niépce constructed cameras in the shape of simple wooden boxes designed so that a smaller box moved within a larger one. Talbot reduced the size of his cameras, having reasoned that a small image produced by a lens of large aperture and short focal length would require less exposure. He used or had made a number of boxes measuring only 75 mm cubed (3 in cubed) to which he fitted a lens, and which could hold a sheet of sensitized paper. By 1839 he was having cameras made with removable paper holders.

The early period: 1839–1860

At its most basic, the photographic camera had two principal requirements, to support a lens and to hold the sensitized material, and these have governed designs to the present day. The box-form camera was the most obvious and simplest solution. The announcement in 1839 of the *daguerreotype process in France and Talbot's process in England resulted in the commercial manufacture of cameras for photography. The first was designed for *Daguerre and manufactured by Alphonse Giroux in Paris from 1839. It was of sliding-box design with the larger front box holding the lens, and the smaller one at the rear moving for focusing purposes and incorporating a focusing screen and a fixture for a plate holder. This design, with minor modifications, was widespread until at least the 1870s. It took 16.5 × 21.6 cm (6$\frac{1}{2}$ × 8$\frac{1}{2}$ in) plates, which became the standard 'whole-plate' size. Giroux's camera was described in Daguerre's *Historique et description* (1839) and shown in British patent no. 8194 of 14 August 1839.

During the early 1840s other firms began to produce cameras. Many were manufacturers of scientific or, frequently, optical instruments, such as Charles *Chevalier in France, Andrew Ross in Britain, and *Voigtländer in Germany. In general, cameras followed the same basic pattern of either a fixed or sliding box-form design with lens and plate holders. Each firm introduced its own particular features. Chevalier's 1840 camera was a single-box design, but was hinged so that once the lens panel and viewing screen or plate holder were removed the main box would collapse to one-third of its extended size. It was sold as a portable or travelling camera. In Germany, *Steinheil's camera of 1839 was tubular, making circular pictures, and Voigtländer's camera of 1841 was conical, constructed of brass and mounted on a brass stand.

In the USA, individuals began to manufacture cameras based on Daguerre's original design. John Plumbe, c.1842, designed a scaled-down version of it that was probably made by a local instrument maker. Alexander S. Wolcott patented his own design for a daguerreotype camera on 8 May 1840; instead of a lens, it used a large concave mirror set at the back of the camera to produce an image on a small centrally mounted plate. (Wolcott's patent was taken up by Daguerre's British licensee Richard Beard and patented on 13 June 1840 (no. 8546), and Beard used the camera in his studios from 1841.) In the later 1840s, the classic American style of daguerrean camera,

a single-box design with a chamfered front end, appeared. In 1851 the Lewis type was patented (US no. 8513, 11 Nov. 1851) by W. and W. H. Lewis of New Windsor, New York, featuring a bellows between the lens board and the camera's rear section. It was the first commercially produced bellows camera in the United States.

Designs in continental Europe and the USA remained relatively fixed. In Britain, after a slow start, new ones quickly appeared that were widely adopted, and acknowledged as being of the highest quality. British cameras were generally made of polished mahogany with lacquered-brass fittings, whereas in Europe walnut was the preferred wood and metalwork was generally only lightly lacquered or left plain. As elsewhere, Talbot's *calotype process had limited take-up commercially and it was initially the daguerreotype that proved more successful; hence most cameras were designed for this as the principal application, although many were advertised as being interchangeable between the daguerreotype, paper, and, later, glass processes. The London optician Ross was commissioned to make cameras for Talbot both while he was experimenting and after the announcement of his process, and sold box-form cameras commercially.

Patent restrictions on photography initially limited the development of the camera in Britain, but by the later 1840s these were increasingly ignored, and the introduction of Scott *Archer's *wet-plate process in 1851 cleared the field. By this time British cameras had started to show refinements beyond the basic box form. An 1845 description of a camera advertised by the London instrument maker George Knight listed several novel features, including focusing scales, a built-in lens hood, and internal baffles to minimize interior reflections; another of Knight's products offered a revolving plate holder allowing 'portrait' and 'landscape' compositions, a rising front for the lens board, and a swing and tilt plate holder for correcting perspective.

From this period, and increasingly during the 1850s, camera manufacture moved from being an adjunct of scientific instrument making to a specialized trade in its own right, and improved designs were introduced. There was a range of seven standard sizes, from 6 × 5 cm (2$\frac{1}{2}$ × 2 in) to whole plate and larger. The basic sliding-box design was reversed in 1861 by F. R. Window, who put the small box at the front of the camera and added a rack and pinion for focusing. The larger rear box was fixed to the camera baseboard. The design remained popular for studio cameras for the rest of the century.

From the early 1850s the box-form design was increasingly supplemented by folding and collapsible cameras. Bland & Long, Thomas Ottewill, *Negretti & Zambra, and others began offering hinged collapsible cameras in a variety of plate sizes. The introduction of bellows allowed cameras to become smaller, lighter, and more portable. Richard Willat had shown a camera which used a black cloth between the lens board and rear standard at the 1851 *Great Exhibition, and many other designs employed bags or pleated or unpleated cloth. Captain Francis Fowke's patent of 31 May 1856 described a bellows camera which was made for the British government by Ottewill, and in 1857 the Scottish photographer C. G. H. Kinnear designed a form of bellows camera that was quickly adopted by many

manufacturers and evolved into the standard form of 'hand and stand' camera. It featured a tapering bellows which allowed it to close more tightly than Fowke's or the American Lewis design.

The years through to the 1870s and the widespread adoption of *dry plates and, later, *roll-film saw the gradual refinement of the Kinnear style of bellows camera and the decline of its sliding- and solid-box precursors. Cameras were supplied for a variety of plate sizes, or for special purposes such as *stereoscopic or *panoramic photography, and there were ingenious accessories such as repeating backs for *carte de visite or non-standard formats.

1870s–1920

This period saw increasing demand for cameras from amateur photographers as new processes, and innovations such as roll-film from the late 1880s, made photography simpler and cheaper. While the professional and studio camera did not develop significantly in its basic design, products for the serious amateur and the snapshooter changed dramatically.

More sensitive dry plates allowed cameras to become smaller, and the increasing use of metal in camera construction and the rationalization of manufacturing, especially from the 1880s, enabled them to be produced more cheaply. For the serious amateur (and some professionals) the quarter-plate (8.3 × 10.8 cm; 3^1/$_4$ × 4^1/$_4$ in) format became the standard as better emulsions appeared and enlarging became commonplace. Hand cameras taking single plates or magazines holding up to twelve were popular from the 1880s until the early 1900s. The 1899 Sanderson hand camera, made by Houghton, became popular with both amateurs and professionals and, with modifications, remained on sale until 1939. Smaller mahogany-and-brass *field cameras of an improved Kinnear pattern were mass produced in Britain, by Lancaster mainly using outworkers and prefabrication techniques, and by Thornton-Pickard and others in factories with powered machines instead of the craft methods of earlier years.

For the snapshooter interested simply in 'pressing the button', the *Kodak camera of 1888 offered to eliminate the chores of processing and printing altogether. Other American and European manufacturers quickly started to produce small box cameras taking roll-film, and folding bellows cameras offering a little more control. The 1900 *Kodak Brownie brought the cost of a camera down to 5 shillings ($1).

During the 1880s and 1890s the use of lightweight metal alloys and improved manufacturing techniques allowed a range of miniature and disguised cameras to be produced. Most were little better than novelties but some, like Houghton's Ticka (1904) and Ensignette (1909), the former taking a drop-in roll-film cartridge, proved very popular and produced good negatives that could stand enlargement to at least *postcard size. Another enormously successful and widely imitated small camera of this period was the Vest Pocket Kodak, taking a picture 41 × 64 mm (1^2/$_3$ × 2^1/$_2$ in); 2 million were sold during its lifespan (1912–26).

Attempts had been made to produce a single-lens reflex (SLR) camera since the 1860s, but the Anschütz camera (1889) and Kershaw

patent of 1905 gave an impetus to the design that was widely adopted and remained popular to 1939. Also very influential and durable was Folmer & Schwing's 1898 Graflex. Finally, the early 20th century saw the appearance of three-colour cameras capable of producing printing plates for colour reproduction.

The First World War limited camera development, and most European manufacturers did not introduce new designs while raw materials and manpower were limited. However, some specialized cameras were introduced, most notably for aerial and reconnaissance work, by both sides in the conflict. The end of the war and resumption of trade inaugurated a new era of camera development, with Germany taking over Britain's dominant role.

1920–1945

The 1920s saw a general trend of consolidation amongst camera and photographic manufacturers. In the USA the two principal firms of Eastman Kodak and Ansco continued taking over companies with allied interests. In Germany, the Zeiss Ikon combine was established in 1926 through the merger of four long-established and independent companies. In Britain, Amalgamated Photographic Manufacturers Ltd. was established in 1921, bringing together six significant companies with interests in sensitized materials, photographic equipment, and accessories; the merger of Houghtons and Butcher, which had started with the sharing of some manufacturing capacity in 1915, was completed in 1926.

The general economic climate meant that these larger groupings continued with slightly updated pre-war lines for much of the 1920s. For snapshooters, this meant simple box and folding roll-film cameras; for the serious amateur, better-quality folding roll-film cameras and quarter-plate hand and reflex cameras; and for professionals, field cameras, bellows studio cameras, and reflex and press-type cameras. But competition, the efforts of independent camera makers, especially in Germany, and the introduction of new manufacturing materials eventually created an impetus for distinctive new products. The significant use of plastics from 1929 encouraged both aesthetic and technical innovation. The work of Walter Dorwin *Teague for Eastman Kodak, for example, demonstrated the influence of art deco on styling—but also the importance of cost cutting, gimmicks, and marketing as the world economy contracted.

Of more significance at the higher end of the market was the introduction by Ernst Leitz of the *Leica camera in 1925. Though not the first 35 mm camera, it was the first to have any real commercial success, thanks to new more sensitive and finer-grained film emulsions, a new lens design, and the provision of a range of lenses and accessories designed for everything from stereoscopy to macro and copy work. Zeiss Ikon's Contax (1932) was a response to the Leica's success and offered a comparable back-up system. More generally, while the American and British industries were increasingly looking to produce cheaper cameras, the German one was able to produce precision-made cameras at reasonable prices in 35 mm, roll-film, and plate or cut-film formats. Franke and Heidecke's twin-lens reflex

(TLR) camera, the *Rolleiflex, launched in 1928, was the first of a very successful range that competed well into the 1960s.

Miniaturization was a continual theme during the inter-war years, made possible by new films and lens designs. The success of 35 mm, so-called 'miniature' cameras reflected the fact that whereas formerly the larger paper-backed roll-films or plates had been considered the minimum needed to produce good-quality photographs, this was no longer true. By the 1930s, in fact, *sub-miniature cameras taking films smaller than 35 mm were also arriving. Many were novelties, such as the range of coloured bakelite cameras produced by the Coronet Camera Co. in Britain. But some, like the Ensign Midget or the German Minifex of 1932, which took 16 mm roll-film, were capable amateur cameras producing good results. Walter *Zapp's Latvian-made Minox (1938) took 8×11 mm ($^3/_{10} \times ^2/_5$ in) negatives on 9.5 mm film in a drop-in cartridge.

The Second World War again limited non-military innovation; a few cameras were developed for espionage purposes, but most effort went into producing specialized aerial reconnaissance and instrument-recording equipment.

1945–1970

After 1945 the British camera industry enjoyed a brief resurgence, protected by import controls and duties. A quality British 35 mm camera, the Reid, a copy of the Leica, was introduced, and the Wrayflex, Periflex, various models of Ensign, and cheap box and folding cameras from Coronet and Kodak Ltd. appeared. However, once import restrictions were lifted, further consolidation within the industry only delayed its inevitable decline, and by 1968 most British camera manufacture had ceased.

The German industry continued to provide well-engineered cameras from firms such as Voigtländer, Zeiss Ikon, Wirgin, and Agfa, although by the 1960s their products were looking overpriced and technically outdated by comparison with the Japanese. Voigtländer and Zeiss Ikon merged in 1970. With the exception of some ranges of cheaper cameras, and luxury products such as the Leica, Rollei, or Swedish Hasselblad that supplied a niche market, mass manufacturing had ceased in Western Europe by the early 1970s. A similar pattern was repeated in the USA, where early post-war expansion had largely ended by the mid-1950s.

Exceptions to this pattern were the USSR; the German Democratic Republic, where the VEB-Pentacon combine was formed in 1964 from Ihagee and other Dresden firms; and China. In these countries, protected by subsidies and import controls, a variety of cameras were produced, often copies of Western products, for home use and export. But although the Russian Zenith and Kiev, Chinese Seagull, and, especially, East German Praktica achieved a respectable following abroad, their quality and styling never matched Western-made products.

It was Japan which from the 1950s came to dominate camera manufacturing. Before the war, the Japanese camera industry had been negligible, with firms such as Sakura and Canon offering a limited range of products and with no mass production comparable to Europe.

Most cameras were imported, principally from Germany. From 1946 photographic manufacturing was seen as a way of employing skills developed through munitions production. The first post-war cameras were often copies of German ones: the Nikon I of 1948 was largely a Contax derivative, and other firms produced extensive ranges of Leica copies. But during the 1950s investment in research and development began to yield results and the copies were gradually replaced by Japanese designs that were innovative, attractive, and affordable. The formation of the *Japanese Camera Inspection Institute (JCII) in 1954 to inspect all exported cameras was vital in maintaining consumer confidence at a time when many Japanese products had a reputation for poor construction and reliability. The introduction of the *Nikon F SLR in 1959, Pentax Spotmatic (1957), Canonflex (1959), and Topcon (1958), and associated lenses and accessories, was crucial in establishing the 35 mm SLR camera as the key professional outdoor and amateur camera. These and other Japanese manufacturers launched a range of models with new features with which the German industry could not compete.

The introduction of new amateur formats, the cartridge-loading 126 (1963) and 110 (1972) *Kodak Instamatic series, allowed the traditional box camera to be reborn smaller and with new features such as automatic exposure control and built-in flash. The *disc format (1982) and *Advanced Photographic System (APS; 1996) extended this further with a range of new features associated with the film. The disc format was unsuccessful and APS saw its initial success tempered by a return to 35 mm; it was soon supplanted by *digital technology. Polaroid *instant photography, launched in 1948, declined rapidly as digital cameras stole many of its advantages.

High-end professional studio cameras introduced after 1946, such as the monorail Sinar, Linhof, and Cambo, dominated studio work and remain largely unchanged, although today they are more likely to sport digital backs rather than cut-film *dark slides.

Since 1970

The major change to camera design since the early 1970s has been the introduction of electronics. Simple electric circuits had been added to cameras from the late 1930s with, for example, the Kodak Super Six-20 (1938) featuring automatic exposure control. During the 1950s and 1960s they were still largely restricted to linking built-in exposure meters to aperture or speed controls. But Polaroid's SX-70 camera of 1974 was an automatic, motorized SLR producing instant colour prints. Solid-state electronics, coupled with developments in the miniaturization of electric motors and battery technology, offered an opportunity for the rapid introduction of *automation in cameras. Konica's C35AF of 1977 was the first point-and-shoot camera with autofocus and exposure.

SLR cameras also began to incorporate new technology. Canon's AE-1 (1976) was the first, and by the late 1970s several manufacturers had introduced multi-mode cameras offering a selection of electronically controlled exposure modes, including full automation. Minolta introduced their XD-7 (XD-11 in the USA) in 1977 with both

Emma Barton *Old Familiar Flowers*, 1919. Autochrome

NASA official Multiple image of the Martian surface and Viking lander, 1976

aperture- and shutter-priority exposure, and in 1978 the Canon A1 featured five exposure modes plus manual override. Other makers, including Nikon with the FE, Olympus with the *OM2N and Fujica with the AX-5, introduced similar electronically controlled cameras; but the Canon A1 was recognized as the first of a new type of camera.

The first US patent for an electronic photographic product was granted on 27 June 1972, and for a filmless electronic camera in 1977; Kodak produced the world's first operational CCD still-image camera in 1975. But it was in the 1980s that the serious development of filmless cameras began. The Sony Mavica still-video camera was unveiled in 1981 but not sold commercially, and Canon's RC-701 of July 1984 became the first commercially sold still-video camera. In 1983 seventeen leading companies agreed a single standard for magnetic disks to avoid the problems over non-standard formats that had dogged the development of video and personal computers. This was confirmed by 46 countries in 1986. Kodak, seeing its film market threatened, launched a still-video floppy-disk system for industry in 1985 and the consumer-orientated Photo CD in 1990. They introduced a professional digital camera based on a Nikon F3 body in 1992. In 1996, a key year, Canon, Nikon, and Olympus all introduced their first digital cameras resembling conventional point-and-shoot models, and from then it was simply a question of improving user-friendliness and output quality, and reducing prices. By 2003, sales of digital cameras had overtaken film cameras in the USA, photo labs were offering a full range of digital print services, and digital cameras were available for less than £30 ($50); the first disposable models were also being promoted. The same year, Canon's 300D digital SLR, with lens, broke the £1,000 barrier. MP

Jenkins, R., *Image and Enterprise: Technology and the American Photographic Industry, 1839 to 1925* (1975).

Smith, R. C., *Antique Cameras* (1975).

Coe, B., *Cameras: From Daguerreotype to Instant Pictures* (1978).

Janda, J., *Camera Obscuras: Photographic Cameras 1840–1940* (1982).

White, R., *Discovering Old Cameras* (2nd edn. 1984).

Lewis, G., *The History of the Japanese Camera* (1991).

Goldberg, N. (ed.), *Camera Technology: The Dark Side of the Lens* (1992).

White, R., *Discovering Cameras 1945–1965* (1995).

Tarrant, J., *Digital Camera Techniques* (2003).

cameraless images. See KIRLIAN PHOTOGRAPHY; PHOTOGRAM.

camera lucida. See PRE-PHOTOGRAPHIC IMAGING DEVICES.

camera movements (or adjustments). A term often applied to the working of large-format cameras, but equally applicable to any device capable of adjusting the geometry of the lens and focal planes so as to alter perspective and image shape. Some 'shift' lenses and adaptors are available to provide movements for small (35 mm) and medium-format cameras. Main applications are in *architectural or studio table-top (e.g. *pack shot or product) photography.

The fundamental principles were set out in a patent by the Austrian Theodor *Scheimpflug in 1904. But the history of perspectival controls pre-dates photography, for Renaissance drawing instruments and18th-century portable camera obscuras were capable of some adjustment.

Photographers required this facility as soon as—in the 1840s—it was realized that the 'natural' view of the human eye/brain did not correspond to what the camera 'saw'. Pictures of a tall building show converging verticals if the camera is tilted up or down to include its top or base, and although this is exactly what we see, it may be perceived as a distortion. If the focal plane can be tilted relative to the lens, or the lens displaced relative to the focal plane, such distortions may be minimized or 'corrected'.

Lens (or optical) axis and film plane are normally kept perpendicular to each other. Movements on a camera allow photographers to tilt or swing these two components to create different effects—sometimes to exaggerate the convergence of parallel lines to suggest depth, sometimes to be able to place the camera to avoid an obstacle, and sometimes to ensure that the image is sharply focused from near to far.

Since the lens produces a circular image, shifts and tilts permit the photographer to place the rectangle of film (or CCD) at a point within (or even partly outside) this circle. In a fixed-lens camera, the circle needs only to be large enough to provide an image acceptably sharp to the corners of the image area, but on a camera with movements, special wide-field lenses (e.g. plasmat designs such as the Schneider Symmar) are necessary. The history of camera movements is directly linked to that of the optical innovations that produced lenses with ever-greater covering power. PH

Adams, A., *The Camera* (1980).

'camera never lies, the'. See COTTINGLEY FAIRIES; FRAUD AND FORGERY, PHOTOGRAPHIC; PROPAGANDA; STAGED PHOTOGRAPHY.

camera obscura. See PRE-PHOTOGRAPHIC IMAGING DEVICES.

camera phone, mobile telephone incorporating a *digital camera. Worldwide sales were predicted to reach 150 million in 2004, and 656 million in 2008. Although relatively basic by comparison with 'real' cameras, their huge market potential creates strong incentives for research into important photography-related fields such as liquid-based lenses, battery technology, digital storage media, and the transfer of images to computers, printers, and other devices. They also encourage people to take pictures. RL

cameras for special applications. The modern 35 mm SLR is the nearest that there has ever been to a 'universal' camera. Even such arcane applications as endoscopy can be tackled with appropriate accessories. But a camera that is usable for a particular application is not the same as the optimum camera for that application; in reportage, for example, many believe that the rangefinder camera is more suitable than the SLR. The further back one looks, the more one finds special application cameras.

Aerial cameras normally use very wide rolls of film, up to 24 cm (9¹⁄₂ in), though 70 mm perforated film is also used. The lenses are

normally specially computed and fixed at infinity. Some early 20th-century cameras were designed to function automatically when launched on rockets or suspended from kites.

'Big Bertha' *press* cameras were usually 9 × 12 cm or 4 × 5 in and were fitted with huge long-focus lenses. The most common focal length was 40 inches or 1,000 mm, roughly equivalent to less than a 300 mm lens on a 35 mm camera today. During the Second World War, Leitz built a 2,000 mm f/4 lens for photographing English radar installations on the other side of the Channel.

Endoscopic cameras, including those for surgical use, normally employ miniaturized video cameras feeding information back electronically. There are many other specialized cameras for *medical use, such as the fundus camera for photographing the retina of the eye.

Extreme wide-angle cameras are never reflexes, because it is much easier to build an extreme wide-angle lens if there is no need to accommodate the hinged reflex mirror. The maximum angle of coverage (for a circular image, corresponding to the diagonal of a rectangular or square negative) is close to 120 degrees.

Microscope cameras use beamsplitters and leaf shutters to obviate the vibration that would be associated with reflex mirrors and focal-plane shutters.

Military cameras have mostly been civilian products, sometimes lightly modified, though some (such as the Combat Graphic 70 mm) have found few buyers outside the military. Secret services have often used *sub-miniature* cameras.

Panoramic cameras may be of three kinds, wide angle, swing lens, and moving film. The first is merely a long, thin format: the widest practicable angle of horizontal coverage is somewhat under 100 degrees. The second has a curved film path: the lens swings about its optical axis, exposing the film through a moving slit. These typically cover 120 to 140 degrees. The third (and most complex) rotates the entire camera, while moving the film past the film gate (again, a slit) at a speed carefully matched to the speed of rotation of the camera. Panoramas of 360 degrees (and indeed more, insofar as that means anything, via multiple rotations) are feasible.

Underwater cameras such as the Nikonos have generally been less popular than underwater housings for more conventional cameras: the 1950s Rolleimarin for Rollei twin-lens reflexes is justly famous among early models.

Very-large-format cameras—e.g. the *Mammoth—were widely used until the mid-20th century for photographing large groups or for recording major technical achievements or historical events; today, an enlargement from 20.3 × 25.4 cm (8 × 10 in) or less is more than enough. RWH

Ray, S. J. (ed.), *Scientific Photography and Applied Imaging* (1999).

camera supports, devices to prevent or limit camera movement during exposure. One such, described in October 1839, was attributed to Baron Armand Pierre de Séguier (1803–76). Supports have remained essential accessories ever since, although smaller cameras

and more sensitive photographic materials permitting faster shutter speeds have made their use less necessary.

From the 1840s studio stands were employed by all professional photographers. They were usually wheeled wooden frames or tables on which the camera was mounted, allowing it to be moved easily in the studio while remaining steady during exposure. By the 1880s elaborate stands were available with side tables for *dark slides, accessories, and studio props. Adjustments by rack and pinion, screw, or pulley mechanisms allowed vertical, lateral, and angular adjustment of the camera table to either obviate or supplement the need for *camera movements.

Widely used by outdoor photographers from the later 1840s was the tripod, with adjustable wooden legs allowing it to be raised or lowered; folding models for easier portability were introduced from the 1870s. Since the 1880s portable (hand) cameras have usually incorporated a tripod mounting socket, with simple box cameras the principal exception. With the introduction of metal from the early 1900s, tripods became lighter, and collapsible. From the 1920s ball-and-socket heads permitted a greater range of adjustments. Specialized heads for stereoscopic and panoramic photography, and table tripods, were also introduced. Monopods, gun-stocks, chains, and clamps fitted with mounting screws have been designed to give additional support for cameras, while beanbags provide an alternative method where a tripod is not practical. MP

Camera Work, published between 1903 and 1917 by Alfred *Stieglitz, and perhaps the most important arts magazine of the early 20th century. In its 50 issues essayists and artists pronounced on the rapidly evolving world of art and photography. The work of key new artists from both sides of the Atlantic, John Marin, Cézanne, Matisse, Picasso, Rodin, Marius De Zayas, and others, was represented. In fact, artists such as Matisse appeared in *Camera Work* several years before the celebrated Armory Show of 1913.

Stieglitz, founder of the Little Galleries of the *Photo-Secession (1905–8) and its successor, *Gallery 291 (1908–17), saw the need for a journal that would celebrate photography as a fine art; indeed, an art that, as with painting, sculpture, and music, would inevitably evolve with time. He had founded or edited several earlier journals, *American Amateur Photographer* and *Camera Notes*, but in each of these he had encountered resistance to his ideas.

Camera Work became a forum for lively criticism and debate about not only photography but the arts in general. R. Child Bayley, Robert *Demachy, Frederick *Evans, Sadakichi *Hartmann, George Bernard *Shaw, and Edward *Steichen were among the many who contributed opinion pieces; Gertrude Stein's first writing appeared in the journal. The images presented in *Camera Work* were meticulously printed, making it unique in the world of periodicals. Detailed descriptions of the techniques used to produce them were also included.

It is significant that the last issue of the journal (49/50, June 1917) introduced the radical work of Paul *Strand. TT

Green, J., *Camera Work: A Critical Anthology* (1973).

Camerawork (No. 1, 1975–No. 32, 1985), British magazine published by Camerawork gallery and darkrooms, Bethnal Green, London (previously the Half Moon Photography Workshop). *Camerawork* provided a forum for debates about photography as a social practice in the context of questions of representation and power, and sought to educate and empower through demystifying photographic processes. The critical focus was wide ranging, encompassing histories of radical practices such as *photomontage; the politics of documentary; analysis of stereotyping in advertising; debates on photography within the community; innovative discussions deconstructing the family album; and articles on educational uses of photography. LW

Cameron, Julia Margaret (1815–79), British portrait and genre photographer. She was born in Calcutta, where at the age of 23 she married Charles Cameron, a senior British administrator, twenty years her senior. In 1845, the couple returned to England with their children, and became involved in London's artistic and cultural life.

In 1860 the family moved to Freshwater, Isle of Wight, where their neighbour was Alfred Tennyson, the Poet Laureate. Cameron had already shown some interest in photography (there is evidence that she experimented with taking and printing pictures in the early 1860s). In late 1863 her daughter and son-in-law gave her a camera, hoping it would occupy her while her husband was in Ceylon, where he owned coffee plantations. Making a studio and darkroom from some outbuildings, she took—on 29 January 1864—the portrait of a 9-year-old girl, Annie Philpot, which she dubbed 'My first success'. Cameron instantly began to take compelling portraits (many, especially those of intellectual and artistic men of the day, in extreme close-up), as well as illustrations of biblical scenes and literature. Among her famous male sitters were Robert Browning, Thomas Carlyle, Charles Darwin, Sir John *Herschel, Henry Longfellow, Tennyson, Anthony Trollope, and G. F. Watts. Using at first a 28 × 23 cm (11 × 9 in) and, later, a 38 × 30.5 cm (15 × 12 in) camera, she made almost life-sized images of these famous heads, usually against a totally dark background, their bodies draped in dark cloth. Carefully controlled lighting from one side made the results still more powerful and revealing.

Cameron's photographs of women are less dramatic. Though she photographed some female celebrities—Marianne North and Marie Spartali (painters), Thackeray's daughter Anne (herself a successful author), and the poet Christina Rossetti—most of her female models were family and friends, selected for their Pre-Raphaelite beauty. Two of her favourites were maids—Mary Hillier (frequently seen as the Madonna) and Mary Ryan, an Irish beggar girl whom Cameron had employed at least partly, it seems, because of her beauty; both began posing as teenagers. With them and other female models, Cameron pulled her camera back from its extreme close-up position, uncovered the windows in her studio, or went outdoors to create softer and prettier studies.

Though Cameron made illustrations of literary, classical, and biblical stories throughout her career, this element of her work came to a peak in the 1870s, when she created, at Tennyson's suggestion, a series of illustrations for his *Idylls of the King*. These were published, probably largely at Cameron's expense, in two large-format volumes, in 1874 and 1875. Soon after, she and her husband left England for Ceylon. Though she took some photographs there, her career was almost over. Her dying word was 'Beauty'. CF

Cox, J., and Ford, C., *Julia Margaret Cameron: The Complete Photographs* (2003).

Ford, C., *Julia Margaret Cameron, 19th-Century Photographer of Genius* (2003).

Olsen, V., *From Life: Julia Margaret Cameron & Victorian Photography* (2003).

Canada. News of *Daguerre's and *Talbot's inventions arrived in the spring of 1839. The first known Canadian daguerreotypists were amateurs and *itinerants, but by the summer of 1841 commercial studios had opened in major centres. Over the next decades, photographers in garrison towns and colonial capitals supplied British military men and government administrators with souvenirs of their tours of duty. Immigrants, fortune seekers, and genteel travellers took photographs, and purchased others to send home from commercial photographers who operated in the larger towns and cities. Smaller centres and outlying districts were served by travelling photographers who announced their arrival in the press and set up shop in the local hotel.

As the *daguerreotype process gave way to *wet-plate photography, the medium's role in the recording and shaping of Canadian history changed. Increasingly part of the rituals of public and private life, the professional photographer captured ceremonial occasions, commemorative events, and celebratory gatherings as individual and group portraits were adopted as a way to mark rites of passage, record historic meetings, symbolize social cohesion, and express corporate pride. Landscape photographs collected in albums, and *stereoscopic views issued in series and viewed through a hand-held device, were a source of both education and entertainment.

Beginning in the late 1850s, photography was used to document the construction of such monumental public buildings and engineering projects as University College (Toronto), the Victoria Bridge (Montreal), and the Parliament Buildings (Ottawa). In the same period, Humphrey Lloyd *Hime, Charles Horetzky (1838–1900), Benjamin Baltzly (1835–83), and the men of the *Royal Engineers struggled with heat and dust, overturned carts and capsized canoes, bulky equipment and messy chemicals, to produce a remarkable record of people and place in conjunction with the boundary, geological, and railway surveys in the Canadian West.

Especially in the more remote outposts of Canadian society, photography throughout the 19th century was largely a male pursuit. However, some women established businesses, while others worked as camera operators, darkroom assistants, and retouchers, for example in the Montreal studio of William *Notman. When 'Mrs Fletcher' arrived

Julia Margaret Cameron

Iago, Study from an Italian, 1867. Albumen print

in Quebec City from Nova Scotia in 1841, she announced herself as a 'Professor and Teacher of the Photographic Art' and encouraged women to take up photography as a means of securing independence in an 'honourable, interesting and agreeable' profession. Other women professionals included Hannah *Maynard (Victoria), Élise L'Heureux-Livernois (1827–96; Quebec City), Alvira Lockwood (1845–1923; Ottawa), and Rosetta Carr (1845–1907; Winnipeg).

Although primarily practised by professionals at first, photography was a topic of popular interest, scholarly discussion, and amateur experimentation, with information exchanged through professional associations, academic communities, and social circles, in particular the Art Association of Montreal and the Canadian Institute in Toronto. A particularly active pocket of early amateur photography was the *Hudson's Bay Company post at Moose Factory, where a group of employees produced a record of aboriginal and company life around Hudson and James Bays during the 1860s and 1870s. Francis Claudet (1837–1906), son of the noted London daguerreotypist Antoine *Claudet and manager of the government assay office and mint at New Westminster (1860–73), was typical of the amateurs who practised photography while on a colonial posting.

The advent of the *dry plate in the 1870s freed photographers from carrying portable darkrooms and opened up new applications, particularly for exploration and travel. During his extensive travels for the Geological Survey of Canada in the West after 1876, George Mercer Dawson (1849–1901) used dry-plate photography as an integral part of his fieldwork. Other advances towards the close of the century profoundly changed the way photographs were taken and viewed. Shortly after George *Eastman launched his first *Kodak in 1888, the amateur Robert Reford set out across Canada by train carrying the hand-held 'box' camera loaded with a 100-exposure roll of *celluloid film. Also appearing for the first time in 1888, *The Dominion Illustrated* (Montreal) heralded the modern era of photomechanically reproduced illustrations. The *half-tone process, pioneered by William Augustus Leggo (1830–1915) and George Desbarats (1838–93) in the *Canadian Illustrated News* as early as 1869, finally allowed photographs to be reproduced cheaply and accurately in text-compatible form. This new form of pictorial illustration, first in black-and-white and later in colour, added veracity and immediacy to published images, and was enlisted to nurture a new sense of Canadian nationhood. The strong tradition of *photojournalism, which began with photographs of the aftermath of the Desjardins Canal rail disaster of March 1857, continued in the work of staff photographers supplying images to major newspaper and wire service *agencies throughout the 20th century.

Interest in amateur and 'art' photography was nurtured, during the late 19th and early 20th centuries, by camera clubs and salon competitions, and a number of Canadian photographers, most notably Sidney *Carter and John Vanderpant (1884–1939), achieved international reputations for their *pictorialist work. The Canadian International Salon of Photographic Art, organized by the National Gallery of Canada between 1934 and 1941, and the wartime work of the National Film Board founded by John Grierson (1898–1972) in 1941, both validated and fostered interest in fine art and *documentary photography respectively. In the years that followed, the increasing interplay of photography, film, and television nurtured a growing awareness of the power of visual communications which assumed new intellectual proportions with Marshall McLuhan's identification of medium and message.

The last decades of the 20th century witnessed a rise in interest both in the history of photography and in photography as a fine art, with the publication of Ralph Greenhill's *Early Photography in Canada* (1965), the establishment of the photography collection at the National Gallery of Canada (1967), and the creation at the National Archives of Canada of the Historical Photographs Section (1964) and the National Photography Collection as a separate division (1975). The Canadian Museum of Contemporary Photography, created in January 1985 as an affiliate of the National Gallery of Canada, traces its origins to the Second World War and the work of the Still Photography Division of the National Film Board. The Photographs Collection of the Canadian Centre for Architecture was begun in 1974, the same year that the Photographic Historical Society of Canada with its publication, *Photographic Canadiana*, was founded in Toronto.

Technical, art, commercial, and critical periodicals which have fostered popular and scientific interest in photography since the short-lived *Canadian Journal of Photography* (1864) include *Photo Life* (Vancouver/Toronto), *Photo sélections* (Montreal), *Photo communiqué* (Toronto), *OVO* (Montreal), *Blackflash* (The Photographers Gallery, Saskatoon), and *The BC Photographer*. This literature serves a diverse audience of photographers, collectors, curators, and critics, and supports the study and criticism of photography now taught at a number of colleges and universities across Canada. Mois de la Photo, Montreal's major international biennale, and Contact, Toronto's annual photography festival, promote the medium and articulate current trends.

Significant contributions to the history of photography have been made by Canadians. Pierre Gustave Gaspard Joly de Lotbinière (1798–1865), a Swiss-born French-Canadian seigneur, was the first to photograph the Parthenon in Athens, and his daguerreotypes of Egypt, Nubia, and Syria were published as engravings in France. William Augustus Leggo invented a photo-lithographic process and patented a number of improvements to the photo-electrotyping process during the late 1860s and early 1870s. Édouard Deville (1849–1924), Surveyor-General of Canada, perfected the first practical method of photographic surveying, wrote one of the first English-language texts on the subject, and transformed *photogrammetry with his use of a survey camera and stereoscopic plotting instrument for mapping in the Rockies and along the Alaska–British Columbia boundary between 1886 and 1923.

Modern Canada developed in the photographic era. From the Union of the Canadas onwards, photography grew from a curiosity to a commonplace, with photographers—amateur and professional, government and commercial—producing an extensive record of

people, places, and events. More importantly, these images played a role in shaping individual and collective notions of landscape and identity, history and memory, nationhood and empire, helping to make British North America seem a smaller, more familiar place. JMS

See also NATIVE PEOPLES AND PHOTOGRAPHY.

Greenhill, R., and Birrell, A., *Canadian Photography, 1839–1920* (1979).

Koltun, L. (ed.), *Private Realms of Light: Amateur Photography in Canada, 1839–1940* (1984).

Borcoman, J., *Magicians of Light: Photographs from the Collection of the National Gallery of Canada* (1993).

Schwartz, J. M. (ed.), 'Canadian Photography', *History of Photography*, 20 (1996).

Cousineau-Levine, P., *Faking Death: Canadian Art Photography and the Canadian Imagination* (2003).

Caneva, Giacomo (1813–65), Italian artist and photographer, born in Padua. After training as a draughtsman and view painter, Caneva settled in Rome in 1838 and subsequently took up photography, in 1845 describing himself in the Caffé Greco's artist register as a 'painter-photographer'. He became a master of the improved *calotype and waxed-paper processes, producing views of Rome and its surroundings, photographs of works in the Vatican Museum, genre scenes, and painterly allegories (e.g. *Caritas Romana*, 1850–2). He sold some of his pictures via his friend, the photographer Tommaso Cuccioni (*c.*1790–1864). In 1855 he published a practical treatise on photography and in 1859, according to Piero Becchetti, participated in an expedition to India and China. RL

Becchetti, P., *Giacomo Caneva e la scuola fotografica romana* (1989).

Capa, Cornell (Kornell Friedman; b. 1918), Hungarian-born American photographer and advocate of concerned *photojournalism. He founded The Fund for Concerned Photography and mounted its first exhibition in 1967. It celebrated the photojournalistic work of Cornell's brother Robert and five others and led to the opening of the *International Center of Photography in 1974. Capa has travelled widely as a *Magnum photographer, and his many books include: *Israel: The Reality* (1959); *Farewell to Eden* (1964; text by Matthew Huxley); and *Margin of Life: Population and Poverty in the Americas* (1974; text by J. Mayone Stycos). TT

Whelan, R., *Cornell Capa: Photographs* (1992).

Capa, Robert (André Friedmann; 1913–54), Hungarian-born American photojournalist. One of the most charismatic figures of 20th-century photography, he also made several of its *iconic images, and was a key figure in the founding of the *Magnum agency. Alienated by the reactionary Horthy regime, he left Hungary for Germany in 1930 to study political science. Short of money, he found work as a darkroom technician at Simon Guttmann's *Dephot agency, a leading supplier of photographs to the German illustrated magazines. Friedmann learned from Guttmann many of the emergent techniques of *photojournalism, especially its business side, and the importance of the picture story. These were put to good use after the rise of Nazism led Friedmann to

move to Paris, where he and his girlfriend Gerda *Taro gradually made a name for themselves as photojournalists and picture agents. He used the name Capa to get a higher rate for the work sold by him and Taro to the press, supposedly for pictures made by a rich American photographer, then assumed it permanently once his 'brand name' had found a market. Sent by *Vu to the Spanish Civil War in 1936, he captured the conflict's most celebrated image, *The *Falling Soldier* (1936). In 1938 he covered the Sino-Japanese War in China.

Capa's early attempts to found a cooperative photo agency (with Willy *Ronis) were thwarted by war in 1939. But he was able to work for the leading American magazines, in North Africa, Sicily, and mainland Italy, and his reputation as 'The Greatest War-Photographer in the World', conferred by *Picture Post* in 1938, was ultimately confirmed by his pictures of D-Day (1944), although most of them were accidentally destroyed during processing. In 1948–50 he worked in Israel.

Although Capa's romantic life and early death made him famous beyond the narrow confines of photography, he left a body of work that revealed him as a perceptive humanist photographer and inspired innovator in the field of photojournalism. In 1947 he persuaded a small group of friends made in France during the 1930s (*Cartier-Bresson, 'Chim' *Seymour, Maria Eisner), and during the war (George *Rodger, William Vandivert), to join him in forming a new agency that would share and control the work of its members: Magnum (named after the champagne bottle). Through his knowledge of the business and his gambling skills, he kept the fledgling agency alive and solvent until he stepped on a landmine while covering the war in Indo-China. PH

Kershaw, A., *Blood and Champagne: The Life and Times of Robert Capa* (2002).

Beaumont-Maillet, L. (ed.), *Capa connu et inconnu* (2004).

Caponigro, Paul (b. 1932), American photographer who became a classical pianist before studying photography in San Francisco, and with Minor *White at the Rochester Institute of Technology. His subtly toned, evocative black-and-white images of brooding landscapes, stone chapels, and ruins in Europe, and the prehistoric megaliths of Britain and Ireland, are in the *straight-photography tradition of White and Edward *Weston. His cloud pictures are as powerful as *Stieglitz's 'equivalents'. TT

Caponigro, P., *Meditations in Light* (1996).

caption (formerly cutline), one or more sentences of text intended to elucidate a published photograph. Basic information about a picture's content supplied by the photographer or *agency will usually be tailored by the editor to a publication's viewpoint or house style. In newspapers the caption is usually positioned directly beneath the image (which may have a *heading* above it); in magazines or other publications it may be elsewhere on the same page, or opposite, or superimposed on the picture itself.

Phrases such as 'the camera never lies' or 'a picture is worth a thousand words' give a misleading idea of the relationship between text and image. The meaning of a photograph is rarely self-evident, and an editor can never precisely anticipate the viewer's degree of

sophistication or background knowledge, or sense of humour or irony. The recaptioning of news photographs by satirical papers like *Private Eye* is a constant reminder of how meaning can be subverted. Ideally, a caption should identify key figures shown in a picture and, in Harold Evans's words, indicate the 'what-why-where-when' of the event shown. Thus a caption accompanying an image of distraught villagers might read: 'Peasants at Camporeale beg for bread from the relief columns after the Sicilian earthquake that killed 300 in their beds and led at least another 80,000 to flee the area in search of safety.' But occasionally an image may be so lyrical, moving, or horrific that it can be allowed to 'speak for itself', above all in circumstances likely to be wholly familiar to the viewer: for example, crowds watching the funeral of Diana, princess of Wales, or the collapse of the *World Trade Center. AH/RL

Evans, H., *Pictures on a Page: Photo-Journalism, Graphics and Picture Editing* (1978).

Scott, C., *The Spoken Image: Photography and Language* (1999).

carbon process (or carbon transfer process or autotype). Invented by *Poitevin in 1855, this was the most important colloid-hardening printing process, used until the 1980s. Pigmented gelatin layers on paper, manufactured by the Autotype Company in many colours besides carbon black, were sensitized with dichromate solution. Contact printing under negatives insolubilized the gelatin in proportion to the penetrating light. The hardened layer was transferred to a second sheet of paper, then washed with water to develop a positive image in the chosen pigment; a double transfer could rectify the reversed handedness. Permanent ('UltraStable') three-colour printing processes were realized commercially. Variants included the Artigue and Fresson processes. MJW

Nadeau, L., *Modern Carbon Printing* (1986).

carbro. An improved version of the ozobrome process patented by Thomas Manly (d. 1932) in 1905. Manly's process produced a *carbon print from a bromide print. Pigmented gelatin paper (carbon tissue) was sensitized with bromide and ferricyanide compounds, contacted with a silver bromide print to harden the gelatin, and developed as a carbon print. Ozobrome had a number of advantages over traditional carbon printing: it required neither an enlarged negative nor daylight printing, the final image was not reversed, and the bromide print could be redeveloped and reused. Ready-made materials were produced by the Autotype Company and licensed to Kodak in the USA. The 'carbro' process—a conflation of 'carbon' and 'bromide'—was launched by Autotype in 1919. A silver halide print was bleached with a dichromate solution in contact with the pigmented gelatin paper, producing a result similar to that of the original carbon process without exposure to light.

A colour process called Trichrome Carbro used prints from red, green, and blue separation negatives to make gelatins in cyan, magenta, and yellow pigment, which were stripped and assembled in register on a final transfer paper base. It was a difficult process, and was superseded by *dye transfer.

A particularly attractive property of carbro (and carbon) prints was the variation in surface texture from matt highlights to glossy shadows (unfortunately lost in reproduction). In high-contrast prints the darker areas actually appear in low relief. GS/HWK

See also OZOTYPE.

Carjat, Étienne (1828–1906), French portrait photographer of literary and artistic celebrities (Baudelaire, Corot, Courbet, Hugo, Zola, et al.), although also well known for his caricatures and writings. His career resembled *Nadar's, and his portraits were equally sought after. Editor of *Le Boulevard* 1862–3, he also belonged to the *Société Française de Photographie and owned Carjat & Cie which, 1861–71, supplied photographic materials as well as prints from his studio. He was active until 1876. KEW

Heftler, S., *Étienne Carjat* (1982).

Caron, Gilles (1939–70), prolific and legendary French photojournalist, who joined the *Gamma agency soon after it was founded in 1967. In the next three years, in the words of a colleague, he covered conflicts 'absolutely everywhere', including the Six Day War, Biafra, Prague, and Ireland. Especially memorable were his images of students and riot police in Paris in May 1968. In April 1970, by now a hero and role model for the post-Capa generation of war photographers, he disappeared near Phnom Penh, Cambodia. He was commemorated by his friend Raymond *Depardon in *Gilles Caron, grand reporter* (1978). RL

Carrick, William (1827–78), Scottish photographer active in Russia. Brought to Russia as an infant, Carrick was educated in St Petersburg and studied art in Rome, where he discovered photography. He opened a studio in St Petersburg in 1859 and specialized in the portrayal of Russia's humbler citizens—he had little time for the rich and powerful—and is now best known for his numerous studies of workers and peasants. Initially these were made in the studio, but as Carrick's skill increased he was able to capture convincingly natural images of his subjects at work in the fields. In all this he was assisted by the technician John MacGregor, whom he persuaded to leave Edinburgh to join him. FA

Ashbee, F., and Lawson, J., *William Carrick 1827–1878* (1987).

Carroll, Lewis. See DODGSON, CHARLES L.

carte de visite, photographic print format roughly the size of a French visiting card (6 × 9 cm; $2^1/_3 × 3^1/_2$ in), traditionally imprinted with the name of its bearer. First patented by the Parisian photographer André *Disdéri in November 1854, the *carte* format was undoubtedly inspired by stereoscopic photographs taken with twin-lensed cameras from *c*.1850. (Disdéri's *carte* camera incorporated four lenses and an ingenious sliding plate holder.) While the purpose of *stereoscopic images was to simulate depth when viewed in a specially designed stereoscope, Disdéri's motivation was purely economic: in the time it

105

William Carrick

Boatmen on the Volga, 1875

took to produce one full-plate wet-collodion negative and one large contact-printed positive, one could expose, develop, and print many (ten as described in the 1854 patent, but eight in surviving uncut sheets) small photographs that could be mounted on thin cards.

Although there is no evidence that Disdéri envisioned a stylistic change in the resultant portraits, in effect the use of faster lenses with shorter focal lengths allowed greater flexibility in posing and encouraged full-length rather than bust views. As documented in an article in La *Lumière on 28 October 1854 that may have prompted Disdéri's patent registration, the wealthy amateurs Édouard Delessert and Count Olympe *Aguado had already begun experimenting with visiting-card-sized portraits that showed figures tipping their hats, holding their gloves, and dressed appropriately to the visit being made. Such fashionable people, concerned about their public self-presentation in the grand new spaces of Haussmann's Paris, became the first clients for the tiny portraits by c.1857. Members of Napoleon III's court and boulevard actresses flocked to Disdéri's and other studios to preen themselves before the camera in their evening crinolines, morning dresses, or various degrees of déshabillé.

The craze for cartes de visite and the special albums manufactured to hold them spread from Europe to the rest of the world between the late 1850s and the 1870s, with the format considered outmoded in Paris by c.1867. As carte cameras were acquired by provincial operators, prices dropped to one franc per dozen, permitting truly working-class consumption. Carte formats were also used for *tintypes, which could be inserted in the same albums as images mounted on card, or safely sent through the post.

Although the format was used for landscape and topographical views, and occasionally for scenes of contemporary events, it remained predominantly a portrait medium. Marking a shift from the scrutiny of the face to the reading of the entire body, cartes gave sitters the freedom to reveal multiple identities before the lens, and anticipated the *snapshot in expanding the repertoire of poses in which people were displayed. They were also exploited in *celebrity series which flooded the market with hundreds of thousands of portraits of Queen Victoria, Napoleon III, or Abraham Lincoln. By placing heads of state on the same page as members of ordinary families, the carte album evoked, if it did not quite effect, a social levelling consistent with the professed political goals of liberal nation-states. EAM

Darrah, W., Cartes de Visite in Nineteenth-Century Photography (1981).
McCauley, E. A., A. A. E. Disdéri and the Carte de Visite Photograph (1985).
Wichard, R. and C., Victorian Cartes de Visite (1999).
Hamilton, P., and Hargreaves, R., The Beautiful and the Damned: The Creation of Identity in Nineteenth-Century Photography (2001).

carte du ciel. See ASTRONOMICAL AND SPACE PHOTOGRAPHY.

Carter, Sidney (1880–1956), Canadian photographer, elected to the *Photo-Secession in 1904. This inspired him to establish a national *pictorialist group, the Studio Club, with Harold Mortimer-Lamb (1872–1970) and fellow Secessionist Percy Hodgins. Carter worked in banking until 1906, when he moved from Toronto to Montreal, starting a portrait studio with Mortimer-Lamb. In 1907 he organized Canada's first major exhibition of pictorial photography at Montreal's

Disdéri & Cie

Napoleon III and Empress Eugénie, c.1865. *Carte de visite* (approx. twice actual size)

Art Association. He worked sporadically as an art and antiques dealer, and maintained a photography studio from 1917 until 1930, producing society and *celebrity portraits in a haunting Symbolist style. HWK

Koltun, L. (ed.), *Private Realms of Light: Amateur Photography in Canada, 1839–1940* (1984).

Cartier-Bresson, Henri (1908–2004), French photojournalist. The son of a wealthy textile dealer, Cartier-Bresson rebelled against his bourgeois upbringing, immersing himself in the ideas of the avant-garde, particularly *Surrealism, during the 1920s. In 1927 he began to study painting with André Lhote, the chief academician of Cubism. Then in 1930 he travelled alone to Africa, further distancing himself from the *idées reçues* of Western civilization. After recovering from blackwater fever, he returned to Paris and exchanged genteel easel painting for photographic reportage. By 1932 he had replaced his cumbersome box camera with a 35 mm *Leica, the instrument that would define his identity as a photographer.

Cartier-Bresson's early work, done in France, Italy, Spain, Morocco, and Mexico in 1932–4, betrays his earlier artistic interests. To the hunger for raw experience that led him to travel incessantly he wedded a love of the instant, and principles derived from Cubism and Surrealism—spatial play between two and three dimensions, and a search for the psychologically revealing detail. This is most evident in his choice of subject matter: lives of the marginal and the dispossessed inhabiting the insalubrious neighbourhoods of Old World cities. The results evade reductive labels such as 'social documentary'. Cartier-Bresson developed a uniquely lyrical, humanitarian, documentary style known commonly as 'reportage'.

In Mexico, then a hub of the international avant-garde, Cartier-Bresson exhibited with Manuel *Álvarez Bravo at the Palacio de Bellas Artes in March 1935. He then travelled to New York, where his photographs were shown at Julien *Levy's gallery with work by Bravo and Walker *Evans. (As a photographer, Cartier-Bresson never warmed to the USA.) But he also learned the rudiments of film direction under Paul *Strand; and after his return to France in 1936 he began a three-year period as a production assistant with Jean Renoir.

In 1937 Cartier-Bresson began working as a staff photographer for *Ce soir*, the communist daily that also employed Robert *Capa and David ('Chim') *Seymour. Periodically they all submitted photographs to Maria Eisner, who ran the agency Alliance Photo; this group would found its own agency, *Magnum, in 1947. When war broke out in 1939 Cartier-Bresson enlisted, was captured, and eventually escaped to Paris. Meanwhile, believing him to be dead, MoMA in New York began organizing a 'posthumous' exhibition of his work. It finally opened in 1947, the year Cartier-Bresson embarked on a three-year trip to the Far East.

Numerous volumes of Cartier-Bresson's photographs have been published, notably *D'une Chine à l'autre* (1954), *Les Européens* (1955), *Moscou* (1955), *Flagrants Délits* (1968), *Vive la France* (1970), and *The Face of Asia* (1972). Central to his reputation, however, is *The Decisive Moment* (*Images à la sauvette*), published in 1952. Here the photographer

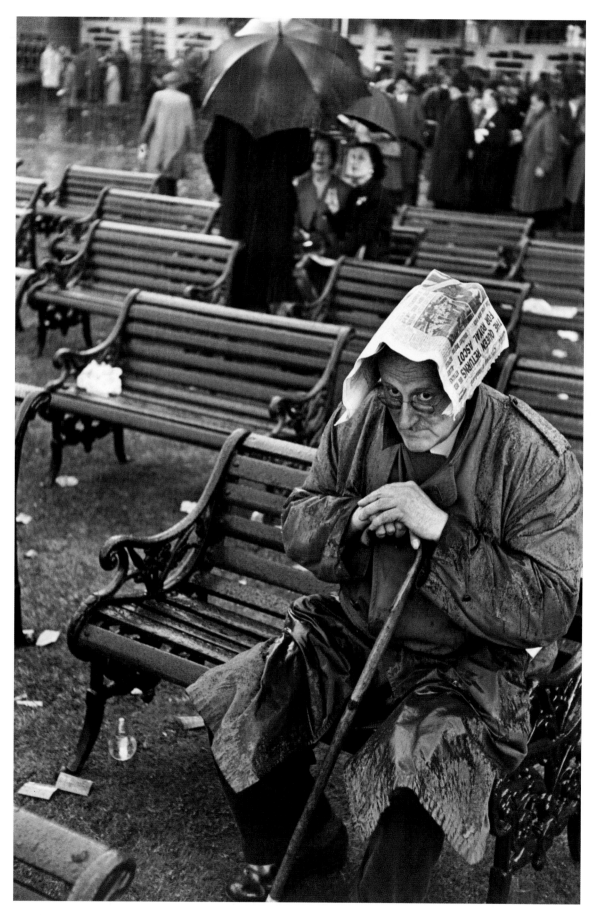

Henri Cartier-Bresson

Ascot, England, 1953

defined his widely influential approach, arguing that photography is essentially 'the recognition of a rhythm in the world of real things'.

From 1970, the year of a major exhibition of his work at the Grand Palais, Paris, Cartier-Bresson finally turned his back on professional photography in favour of drawing. In 2003 his 95th birthday was marked by the opening of a Fondation Cartier-Bresson in Montparnasse, Paris, and numerous festivities. KM

See also DECISIVE MOMENT.

Bonnefoy, Y., *Henri Cartier-Bresson: Photographer*, trans. R. Stammelmann (1980).

Galassi, P., *Henri Cartier-Bresson: The Early Work* (1987).

Arbaïzar, P., et al., *Henri Cartier-Bresson: The Man, the Image and the World: A Retrospective* (2003).

cartography and photography. Since its invention, photography has been linked to cartography in practical, technological, and theoretical ways. Even before the details of the *daguerreotype process were announced, François *Arago, addressing the French Chamber of Deputies on 6 July 1839, alluded to 'certain ideas, for the rapid method of investigation, which the topographer could borrow from the photographic process'. Various applications to mapping followed as landscape, oblique, and *aerial photography were used to inventorize and map natural and man-made features on the earth's surface.

One of the earliest uses of photography in map-making was in data gathering, from both the ground and the air. Pioneering efforts involved carrying cameras and portable darkrooms to the top of hills and tall buildings, and experimenting with kites and balloons to produce landscape views. True aerial photography was first attempted from balloons: by *Nadar in 1858, in order to obtain a photographic bird's-eye view from which he planned to produce a detailed topographical map; and in October 1860 by James Wallace Black (1825–96), who photographed Boston 'as the eagle and the wild goose see it' (Oliver Wendell *Holmes).

Phototopography or *photogrammetry was begun by the French military engineer Aimé Laussedat (1819–1907), who developed the first plane-table photogrammetrical devices and methods. However, the application of photography to surveying was subsequently refined by Édouard Deville, Surveyor-General for Canada, who invented a stereoscopic plotting instrument and perfected the first practical method of analogue photogrammetry which came to dominate the production of topographical maps. It was used in the late 19th century to survey vast tracts of difficult terrain in the Rocky Mountains of western Canada and to settle the dispute over the Alaska–British Columbia Boundary.

Another early application of photography was for the reproduction of *military maps and plans. Incorporated into the training programme at the *Royal Engineers' (RE) establishment at Chatham, England, photography was cited in 1860 by head instructor Captain Henry Schaw for its utility for 'copying plans and maps, either on the same scale, or reduced, or enlarged'. Photography was employed to reduce map images for use in compilation from large-scale (more detailed) to small-scale (less detailed) maps; to create 'guide' images on wood blocks or metal plates for use by engravers; and to support a variety of increasingly sophisticated scribing techniques.

Photography was also used to supplement map-making on boundary, geological, and railway surveys, especially in the American and Canadian West. The official reports and popular narratives which resulted from such surveys included photographic and cartographic evidence to support government and corporate agendas. In March 1874 Captain Samuel Anderson, RE, chief astronomer on the boundary survey of the 49th Parallel across the great plains of North America, wrote to his mother, 'Great people I find never read a long report but they will look over maps & pictures, and this will tell them everything if they examine the maps & the photographs carefully.' In Portugal, Joseph James Forrester (Baron de Forrester) used photography to complement his efforts to map and improve navigation on the River Douro through the wine-producing districts near Oporto. And in Australia, Richard Daintree, a geologist trained in photography, produced views that were subsequently engraved, keyed to their field location, and reproduced on the maps of the Geological Survey of Victoria in the 1860s.

These early established uses of photography for map production continue; however, since the mid-20th century, electronic imaging (involving satellites and remote sensing) has increasingly replaced film-based photography in cartographic production and reproduction. Equally, the use of photography to expedite map reproduction and distribution, and to facilitate map preservation and access in libraries and archives, has evolved from chemistry-based processes to photomechanical techniques to digital means.

Late 20th-century scholarly interest in vision and visual representation resulted in parallel critiques of the photograph and the map as accurate and objective records. Both types of visual representation were employed as tools of imperial expansion and nation building, and are now being subjected to postcolonial and contextual analyses to reveal their impact on society, history, and notions of place. JMS

Newhall, B., *Airborne Camera: The World from the Air and Outer Space* (1969).

Buisseret, D., and Baruth, C., 'Aerial Imagery', in D. Buisseret (ed.), *From Sea Charts to Satellite Images: Interpreting North American History through Maps* (1990).

Cook, K. S., 'The Historical Role of Photomechanical Techniques in Map Production', *Cartography and Geographic Information Science*, 29 (2002).

Casasola, Agust´n-V´ctor (1874–1938), Mexican photographer, active initially as a portraitist and photo-reporter in Mexico City, and in 1911 founding president of Mexico's first press photographers' association. But decisively important was the 1910 outbreak of the Mexican Revolution, of which the historically minded Casasola became a key chronicler. The agency he started in 1913—which also employed his sons Gustavo and Ismael—supplied pictures to newspapers in Mexico and North America, and he himself, using a large-format plate camera, created thousands of images ranging from battles and political events to everyday scenes on streets, railway stations, and

in the countryside. He also photographed the revolutionary leader Emiliano Zapata dead and alive. A selection of these pictures appeared in *Album histórico gráfico* (1921), and in later publications by Casasola's sons. After the revolution ended, *c.*1920, he did documentary work at various prisons and mental institutions. An extensive Casasola archive is held at the Hidalgo National Institute of Anthropology and History (INAH) at Pachuca, Mexico. RL

> *Mexico: The Revolution and Beyond. Photographs by Agustín-Víctor Casasola 1900–1940*, introd. P. Hamill (2003).

Castiglione, Virginia, Countess de (née Oldoini; 1837–99). Born into an aristocratic Florentine family, she married, aged 16, Count Francesco Verasis de Castiglione. Sent to Paris in 1855 by her cousin Count Cavour, the Piedmontese Prime Minister, to encourage Napoleon III to promote Italian unity, she achieved notoriety by having an affair with him. In 1856 she began an extraordinary creative partnership with Pierre-Louis Pierson of the photographic studio Mayer & Pierson, and together, until 1898, they created over 400 photographs of the countess. She contributed costumes, poses, ideas, and, above all, her sense of herself, and Pierson made the images. The resulting tableaux, often captioned and hand coloured by Castiglione, were either inspired by sources like contemporary operas, or re-enacted scenes from her own life.

Castiglione was an innovator, visualizing herself as muse, seductress, or deity. The photographs, for which she functioned as director and heroine, demonstrate a precocious grasp of images, disguises, role-play, and poses as expressions of the self. J-EL

> Apraxine, P. (ed.), *La Divine Comtesse: Photographs of the Countess de Castiglione* (2000).

catadioptric (or 'mirror') **lenses** are a combination of reflective and transmissive elements. They are a form of telephoto objective in which the prime focusing elements are spherical mirrors, the refractive elements being employed chiefly to correct aberrations (Fig. 1). Catadioptric objectives are small and light compared with traditional long-focus lenses, but cannot be stopped down, and instead use neutral-density filters. GS

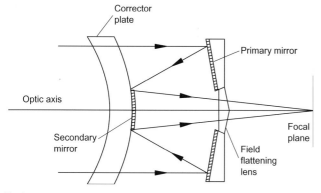

Fig. 1

cats. See PETS.

caves. See UNDERGROUND PHOTOGRAPHY.

celebrity photography. The idea of using photography to disseminate images of famous men and women is as old as the medium itself. From the rise of the *daguerreotype in the 1840s, astute photographers moved into this market, even if, as a non-reproducible unique image, the process had serious drawbacks. In the USA, however, the earliest large East Coast studios soon devised an appropriate strategy. Edward *Anthony of New York created a 'Daguerrian Gallery' of Washington notables in the 1840s. Mathew *Brady's 1850 *Gallery of Illustrious Americans* was a serial publication of lithographed portraits with biographical texts. Paper photography moved in the same direction: in Scotland, David O. *Hill and Robert Adamson created an impressive portrait gallery of figures from Scottish ecclesiastical, artistic, and intellectual circles in the first half of the 1840s. At the beginning of the 1850s a celebrity like Victor Hugo was able to reckon future sales of his portrait as a significant financial resource.

The rise of *wet-plate photography and the advent of the *carte de visite* gave renewed impetus to an already flourishing trade. The 'portrait mania' lampooned by humorists from the late 1850s had two aspects: having one's own portrait made, and collecting portraits of other people. Whether bought or exchanged, the pictures were usually collected in purpose-designed *albums in which friends and relations rubbed shoulders with contemporary celebrities: monarchs, statesmen, actors, and artists. In the 1860s Empress Elizabeth of Austria was one of several royal personages to share the craze, collecting hundreds of celebrity portraits and instructing Austrian diplomats to find images of beautiful women.

From the mid-1850s onwards most of the large portrait studios entered the celebrity picture business. Every photographer had his speciality: *Nadar, Parisian bohemians and the republican opposition; *Disdéri, society and the *demi-monde*; Camille *Silvy and Antoine *Claudet, the British aristocracy and court; the American Napoleon *Sarony, from 1866, the theatre world. Celebrity portraits became a vital part of studio publicity, displayed on interior walls and in showcases outside. In England it was not until 1860, when Queen Victoria and Prince Albert endorsed the fashion by allowing the sale of royal portraits, that the new *carte* format really took off; between 1861 and 1867, *c.*300–400 million were sold there every year. For, if the man in the street might buy a few dozen copies of his own image, a celebrity's could sell in tens or even hundreds of thousands. In December 1861, when Prince Albert died, 70,000 portraits of him changed hands in a week. In 1867 the English photographer Downey claimed to have sold 300,000 pictures of the popular princess of Wales. The numbers of such portraits registered under the *Fine Art Copyright Act of 1862 underline the profitability of the trade. While an ordinary portrait cost a few shillings, that of a celebrity could fetch pounds.

The 'contemporary gallery' concept also boomed in the 1850s. In Munich, Alois *Löcherer and Franz *Hanfstaengl published albums of eminent contemporaries, from royalty to artists and scholars. In Paris, from 1853, Théophile Sylvestre issued an *Histoire des artistes vivants* comprising photographs accompanied by biographical notes. In 1860 Disdéri launched his *Galerie des contemporains*: for 2 francs a week, subscribers received a *carte de visite* of a celebrity plus a mini-biography; by 1862 more than 120 had appeared, most of those surviving being of actors and actresses. In St Petersburg, meanwhile, Sergei *Levitsky and André *Denier produced, respectively, albums of famous writers (1857) and of the Russian ruling elite (1865–6).

As competition intensified, each studio was obliged, funds permitting, to attract celebrities and, if possible, obtain exclusive rights to them. From the 1860s onwards, famous people often insisted on payment. Charles Dickens, for example, touring the USA in 1867, refused to sit for Jeremiah Gurney without a fee. The news caused a sensation among artists, who henceforth often demanded to share the proceeds of their portrait sales. The actress Sarah Bernhardt declared that one of the main reasons for her trip to New York in 1880 was to have herself photographed by Sarony. For the first sitting, he paid her $1,500. Sarony soon became one of Bernhardt's principal photographers, and issued numerous portraits of her. She became one of the first great actresses to pay close attention to the dissemination of her photographic image, anticipating by decades the creation of the Garbo and Dietrich 'myths'.

The advent of the *dry-plate process did not fundamentally change these practices. Indeed, new formats (e.g. the *postcard) and *photomechanical printing processes accelerated their development. The increasing flexibility and portability of cameras also made it easier to go outside the studio. Henceforth, as in the turn-of-the-century series 'Our Contemporaries at Home' by the French firm of Dornac & Cie, eminent people could be photographed with greater immediacy in their own surroundings, whether offices, studios, laboratories, or homes. At the same time, *pictorialism brought a resurgence of the artist-portrait, notable examples being the work of *Coburn, *Steichen, and Frank *Eugene, specializing in European Symbolists.

From the early 20th century onwards, assisted by the spread of the *half-tone process, the main vehicle of the photographic image was the periodical: weekly, monthly, black-and-white, then, gradually from the 1930s, in colour. It became a true mass medium and the principal transmission channel for portraits of celebrities who, since the rise of the cinema, had become stars. The inter-war period saw the proliferation of large-circulation popular papers whose front pages were largely taken up with celebrity scandals and human-interest stories. The creation of magazines specializing in social events, fashion, and entertainment—*Vogue, Vanity Fair, *Harper's Bazaar*—also influenced portraiture, and photographers such as Steichen, *Beaton, and *Hoyningen-Huene became celebrated for a highly staged and artificial style with affinities both to the 19th-century portrait studio and contemporary film-making, especially in *Hollywood. In France, the Studio *Harcourt practised a technique of carefully lit studio

portraiture that transformed every sitter into a film star. In the USA, the same screen-influenced formula distinguished the work of men like Alfred Cheney Johnston (1885–1971), official photographer of the Ziegfeld Follies (and a pioneering user of colour), whose portraits, including those of many silent-era stars, presented the subject in a highly artificial and often erotically charged manner. As such portraitists also worked in *fashion and *advertising, they tended to be concerned as much with publicity as psychology.

In a different mode, in contrast to this elaborately controlled aesthetic, *photojournalism offered a freer kind of image. One of its chief exponents in this period was Erich *Salomon, who, using a small-format camera, captured more or less unawares a group of portraits of inter-war personalities remarkable for their intimacy; over 150 of them appeared in *Berühmte Zeitgenossen in unbewachten Augenblicken* (*Famous Contemporaries in Unguarded Moments*; 1931). After 1945 the race for fame, and efforts to push back the boundaries of privacy, intensified. A key development was the rise of the *paparazzo*: sleazy younger brother of the great photo-reporter (with whom, however, he shared the cult of the *'decisive moment'), who fed on plundered images that broke the conventional accord between celebrity and photographer. Technical advances—flash, fast film, long lenses—spawned a genre of smash-and-grab photography that fed both the yellow and mainstream press. This tempted some celebrities to vary the game: in the 1960s, for example, Sophia Loren and arch-*paparazzo* Tazio Secchiaroli (1925–98) actually staged 'stolen' pictures.

From the 1960s, following the example of the press and radio, television seized on celebrities and their pictures. Artists, headed by Andy *Warhol, recycled images of figures like John F. Kennedy, Marilyn Monroe, and Elvis Presley in works that acknowledged the potency both of photography and of these modern icons. At the same time, following Warhol's dictum that everyone had the right to fifteen minutes of fame, the concept of celebrity widened. Proof of this in the USA was a 1970s creation like *People* magazine, based on the principle of placing stars and ordinary people—'real folks caught up in the day's biggest news'—side by side. (However, the ultimate vehicle of 'fame for everyone' would be the *Internet, the webcam, and the 'live' website.) Also from the 1970s, following the example of a few great post-war portraitists such as Arnold *Newman, Irving *Penn, and Richard *Avedon, some photographers, including Annie *Leibovitz and Herb *Ritts, set out to make star and celebrity portraiture the heart of their business, and adopted a range of approaches, from glamour to simplicity and directness. On another tack, finally, artists like Cindy *Sherman and Yasumasa *Morimura appropriated the visual stereotypes of glamour and stardom in order to deconstruct and subvert them.

At the turn of the 21st century, photography remains central to celebrity culture. Photographers like the Peruvian-born Mario Testino (b. 1954), image maker by appointment to the rich and beautiful, are themselves celebrities. Legitimate, more or less controllable pictures are profitable for all concerned. In July 1999, for example,

CELLULOID

OK magazine paid the British footballer David Beckham and the singer Victoria Adams £1 million for their wedding photographs, and quadrupled its sales. But at the same time technology and mass demand have made the capture of illicit and intrusive celebrity pictures feasible and rewarding as never before. Despite events such as the death of Diana, princess of Wales (1997), and, partly as a consequence, a widespread 'privacy backlash', the incentive to obtain them by whatever means remains strong. The balance of advantage between photographer and celebrity continues to swing. QB

See also ETHICS AND PHOTOGRAPHY; LAW AND PHOTOGRAPHY.

Mormorio, D., *Tazio Secchiaroli, Greatest of the Paparazzi*, trans. A. Bonfante-Warren (1999).
Hamilton, P., and Hargreaves, R., *The Beautiful and the Damned: The Creation of Identity in Nineteenth-Century Photography* (2001).
Celebrity: The Photographs of Terry O'Neill, introd. A. A. Gill (2003).
Kinmonth, P., *Mario Testino: Portraits* (2003).

celluloid. One of the earliest plastics materials, 'celluloid' was the trade name for cellulose nitrate, using camphor as a plasticizer. After its introduction in the 1860s it supplanted paper as the base for *roll-film from 1888 on. Celluloid was light and flexible, and photographic emulsions adhered to it more strongly than to glass. However, in storage celluloid films became discoloured and brittle, and were dangerously flammable (celluloid burns fiercely even under water), so after *c.*1940 it was gradually replaced as a film base by cellulose acetate (later triacetate). The non-tearing, dimensionally stable polyester material developed in the 1950s for *aerial survey films has now become the universal film base. MP

censorship. See DOSSIER BB3; EROTIC PHOTOGRAPHY; LAW AND PHOTOGRAPHY; PORNOGRAPHY.

Ceylon (Sri Lanka) **1839–1900**. The first named daguerreotypist in Ceylon appears to have been S. J. Barrow, active in Colombo and Kandy 1844–9; however, the oldest surviving views of the island are probably the series of *salt prints made by the German artist turned photographer Frederick Fiebig, who visited the island, probably en route from India to England, *c.*1852. Commercial studios became well established only from the early 1860s, coinciding with the opening up of the island's interior to economic development and a consequent increase in its European population. In the last quarter of the 19th century, as road and rail networks developed, Sri Lanka also became a popular tourist destination, creating an additional photographic market. The most enduring work produced in the island over the next four decades was the exhaustive documentation of the island's agricultural resources, topographical beauties, and archaeological heritage by photographers such as *Skeen & Co., Charles Scowen, and Joseph *Lawton. Mention should also be made of Julia Margaret *Cameron, who lived in the island from 1875 until her death in 1879 and produced portraits of Sinhalese and Tamil women, as well as her only known landscape work. JF

Chadwick, Helen (1953–96), British artist who worked with sculpture, performance, and installation. She used photography to record traces of her physical self, and to create sculptural arrangements from perishable materials, in works exploring the changeable nature of organic matter, the role of memory in shaping bodies, and the capacity of objects and materials to evoke sensual meanings. In *Ego Geometria Sum* (1982–4) photographs of her body are boxed in by the wooden sculptures on to which they are printed. In *Of Mutability* (1986, Victoria & Albert Museum), blue photocopies from her body, and animal and vegetable foodstuff, create a complex installation inspired by rococo interiors. PDB

Sladen, M. (ed.), *Helen Chadwick* (2004).

Chambi, Martin (1891–1973), Peruvian photographer, and the first indigenous photographer in the Americas to attract international attention. Born into a poor, rural Quechua-speaking community, he was an unlikely candidate to do so. Aged 14, apparently due to a chance encounter with a British photographer assisting the Santo Domingo Mining Company, he became obsessed with the medium. Within two years, after panning for gold grains to pay his bus fare, he became apprenticed to the studio of Max T. Vargas in the southern city of Arequipa.

It took another dozen years for him to establish his own studio at Sicuani, and to visit Machu Picchu for the first time, accompanying an archaeological excavation. Fascinated by the ancient, and largely unacknowledged, culture of the indigenous peoples of Peru, he embarked on a lifelong project to document the architecture, markets, celebrations, ceremonies, communities, and individuals of the Andes. Concurrently, from 1920, he operated a successful portrait studio in the former Inca capital, Cuzco. It also functioned as a gallery: on one side of the door hung his majestic landscapes of snow-capped mountains and volcanic lakes and, on the other, portraits of local people in their vivid hand-woven clothes and blankets in a rich variety of regional styles.

The 1920s saw the rise of the *indigenista* movement in universities and cultural centres. Chambi was held up as a prime example of a revindication of venerable traditions overrun since the Hispanic invasion. He became active in the movement, publishing and exhibiting in its cause. He maintained his voluminous photographic output until the devastating earthquake of 1950. After that, he laid aside the plate camera that gave his work its characteristic format and formality, and shot only intermittently and on film. The destruction of his beloved Cuzco was, he believed, the end of his inspiration. AH

Chambi, M., *Cuzco, capital arqueológico de Suramérica* (1934).
Martin Chambi (2001).

characteristic curve. Often called the H & D curve after its progenitors Ferdinand Hurter (1844–98) and Vero Charles Driffield (1848–1915), this shows the relationship between exposure and photographic density. As the latter is a logarithmic quantity, it is plotted against the logarithm of the exposure. Much of the curve is

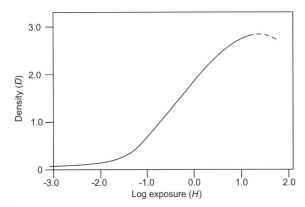

Fig. 1

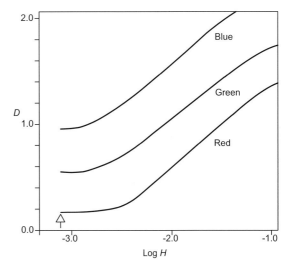

Fig. 2

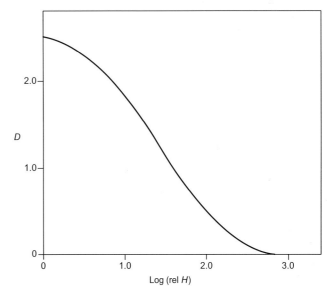

Fig. 3

approximately linear, and it determines the exposure needed to produce an image with a satisfactory range of tones. A typical characteristic curve is shown in Fig. 1. A great deal of information is available from this curve:

- *Emulsion speed.* The exposure required to produce the minimum useful density is at the point 0.1 density units above the zero-exposure density level, called the *base-plus-fog level.* This is used to establish the ISO speed index.
- *Inherent contrast.* This is the ratio of subject contrast to negative contrast, and is the slope of the line joining two standard points on the curve representing an average exposure range. The steepness of the curve increases with increasing development time.
- *Spectral sensitivity.* By exposing the emulsion to different wavelengths a set of characteristic curves will show the variation of sensitivity and inherent contrast with wavelength. In practice the emulsion is positioned under a density wedge and exposed to a calibrated spectrum.
- *Latitude.* This shows the extent to which exposure error is tolerable. The lower limit is the toe of the curve; below the 0.1 density point the shadow detail disappears. The upper point is determined by graininess, which increases with density.
- *Processing variations.* A comparison of characteristic curves shows the effect of different developers on emulsion speed and contrast. More important, families of curves made for different development times and temperatures are used to produce time/temperature charts for developing to required contrasts.

A colour negative has three characteristic curves, for red, green, and blue respectively. These are measured with a densitometer fitted with colour filters (Fig. 2). Colour transparencies are measured in the same way. In this case the characteristic curve slopes the opposite way (Fig. 3).

Characteristic curves for print materials have a slope that varies very little with development time. The slope needs to be matched to the

density range of the negative; hence the need for various grades of paper (or a variable-grade paper). As development proceeds the curve moves to the left, indicating the latitude in exposure (Fig. 4).

There are more immediately practical conclusions to be drawn from the characteristic curve. For example, if it has a very steep slope, the emulsion is high contrast, suitable chiefly for copies of black-and-white drawings. A long 'toe' and a more gentle slope indicate an emulsion with good exposure latitude that will also allow push processing. In transparency material the density range between toe and shoulder indicates the maximum recordable subject contrast. GS

See also DENSITOMETRY; SENSITOMETRY AND FILM SPEED.

Saxby, G., *The Science of Imaging: An Introduction* (2002).

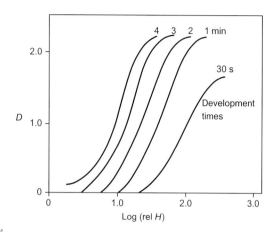

Fig. 4

charge-coupled device (CCD). See DIGITAL IMAGING.

Chargesheimer (Karl Heinz Hargesheimer; 1924–71), German photographer and avant-garde artist, born in and strongly associated with Cologne. A significant but rather mysterious figure, he learned photography at the Cologne Technical School in 1942–4, and in Munich, and avoided conscription by disabling a lung. He made his name with books on post-war Cologne and Germany, including *Cologne intime* (1957) and *Unter Krahnenbäumen* (1958), and worked in photojournalism, portraiture (Konrad Adenauer, 1954), industrial, and advertising photography, and in the 1960s in the theatre as both designer and director. But he also experimented with cameraless and mixed-media images and kinetic sculptures, including, from 1968, so-called 'meditation mills'. His archive is in the Ludwig Museum, Cologne. RL

Misselbeck, R. (ed.), *Chargesheimer: Photographien 1949–1970* (1983).

Charnay, Claude-Joseph-Désiré (1828–1915), French explorer and photographer. An amateur archaeologist, Charnay moved to America in his youth and, inspired by the explorations of John Lloyd Stephens, went to photograph ancient ruins at Mitla, Palenque Izamal, Chichén Itzá, and Uxmal in the Yucatán. The resulting portfolio, *Cités et ruines américaines* (1862) contained 49 *wet-plate photographs, taken with great difficulty in the hot climate. He later travelled extensively in South America, Indonesia, and Australia, producing both archaeological and ethnographic photographs. He returned to the Yucatán in 1880–2 and published *Anciennes Villes du Nouveau Monde* (1885), illustrated with wood engravings from his photographs. Charnay is strongly represented at the Canadian Architectural Centre in Montreal. LAL

Davis, K. F., *Désiré Charnay: Expeditionary Photographer* (1981).

chemigram. See ABSTRACT AND EXPERIMENTAL PHOTOGRAPHY; CHROMOSKEDASIC PRINT; CORDIER, PIERRE.

Chevalier, Charles Louis (1804–59), French optical specialist who joined his father Vincent in the manufacturing of optical and scientific instruments in Paris. He informed *Daguerre of *Niépce's work and was instrumental in bringing them together. Chevalier made experimental cameras and lenses for Daguerre and the Giroux *daguerreotype camera of 1839 was sold with a Chevalier meniscus achromatic lens of f/14 aperture. His combination lens was sold from 1841 to 1859 and was adaptable for landscape or portraiture by changing lens elements. Chevalier produced the first collapsible camera in 1840 and the company advertised photographic chemicals and apparatus from this time. MP

Child, Thomas (1841–98), British photographer, employed from 1870 to 1889 in Beijing as a gas engineer for the Imperial Maritime Customs. His portfolio *Views of Peking and its Vicinity* is a series of signed and dated full-plate images; he numbered and captioned 208 of them. Most originate between 1875 and 1880, long before Beijing had begun to change. The set was sold commercially and soon became, in China and abroad, 'the' visual reference on the old imperial capital. The images found their way into private albums and publications well into the 20th century and inspired generations of photographers. Probably because of prevalent anti-Westernism, Child generally disregarded local life: his work made Beijing appear primarily as a repository of traditional monumental architecture. RT

Thiriez, R., *Barbarian Lens* (1994).

child photography. Certain themes seemed natural to photography from its inception. At the time, high mortality in an industrial society beset by financial slumps and endemic disease meant that people lived with death; and the photographing of children readily became an emotional necessity. The urge to trace children through photography is at its most desperate in *post-mortem photography. This need to keep memory as something tangible or visible may be seen in the deeply poignant picture by August *Sander in 1911, *My Wife in Joy and Sorrow*, in which she holds her twins in christening robes, one alive and one clearly dead and physically withdrawing.

Photography notably encouraged the visual presentation of children as individuals. In 19th-century photographic studios, they were presented as the focus of their parents' pride and affection. But even in their best clothes and on their stilted best behaviour, children achieved a difference. The strange culture of *backdrops and studio properties that flourished in the mid-Victorian period transplanted sitters into unreal, grand, or picturesque settings, bringing the outdoors indoors—often starting a wood at the edge of a carpet—and was promoted by the visually innocent photographer; for whom the possession of such items as a classical balustrade assured his clients of dignity and distinction. The miniature clarity of the *albumen print imparted a doll's-house surrealism to adults, perched on wooden stiles or posed in painted libraries, but accepting the bizarre in the name of fashion. Willing children could effect the necessary transformation through their own curious interest. The particular adult concentration

Fritz Ballin
Gerda Ballin in party costume, Munich, *c.*1922

on the child, found in the 19th-century studio, was exemplified in later practice by Marcus Adams (1875–1959), who took tens of thousands of child portraits in his children's studio in London from 1926—including the young members of the royal family. But while 19th-century photographers planted the child into an adult world, Adams constructed a nursery. His camera sat on the toy shelf; his pictures are of children responding to the distractions of 'a trick banana, cuddly toys, lumps of glass and mechanical gadgets'.

Two notable 19th-century photographers took an immensely affectionate interest in their subjects, but approached them from radically different directions. Charles *Dodgson's photographs have a textual counterpart in his writing for children. He wrote as an adult who listened to children, experiencing the pleasures of common sense at war with logic, mixed with an opposite, irrational dream world. His sitters were encouraged to play, to break the mould of adult pride in good behaviour by lolling, to remove the constrictions and ugliness of modern clothes by posing in nightgowns, in fancy dress, or naked. Julia Margaret *Cameron's intense, even monumental vision of infancy derived from a passionate combination of her experience of motherhood and an enthusiasm for the religious painting of the Renaissance. She accepted the challenge of fine art to express an ideal of infancy and innocence through actual children.

The social presence of children, playing or working in the street, was initially one of photography's greatest hazards. Children tend to regard any event as entertainment and this, coupled with the inconvenient resemblance of the camera to the itinerant's peepshow, meant a constant clustering of interest in front of a photographer. Paul *Martin, working in London in the 1890s, who wanted to take children with a degree of naturalness in the street, ironically (in his memoir, *Victorian Snapshots*) praised the 'facile' hand camera thus: 'It is impossible to describe the thrill which taking the first snap without being noticed gave one, and the relief at not being followed about by urchins, who just as one is going to take a photograph, stand right in front shouting, "Take me, guv'nor!"' This problem is now a global one. Sebastiao *Salgado, taking photographs for his book *Migrations* (2000), managed to clear the way to his real subject through swarms of children by saying: 'I'm going to sit here. If you want me to take a picture of you, line up and I'll take a picture of you. Then you go away and play.' This formality unexpectedly generated a second expressive work, *The Children: Refugees and Migrants* (2000).

The formal engagement with street children was both social and picturesque in its drive. D. O. *Hill and Robert Adamson's Newhaven pictures show the children of an admirable society. John *Thomson's *The Street Life of London* (1876–7), focuses on the character and problems of individuals, like *The Independent Shoe Black* (1877). Such social questioning, designed to effect reform, is exemplified in the later 19th century by Jacob *Riis's journalistic work in the New York slums. Finding that words did not achieve their end, he used the shock of photography and achieved reform. In 1904, the National Child Labor Committee hired Lewis *Hine to make an often covert photographic demonstration of the exploitation of children, throughout the USA.

Sirkka-Liisa Konttinen

Cullercoats, Northumberland, 1978

The director of the committee later referred to Hine as the first to offer 'emotional' rather than intellectual recognition of social problems. The sense of deprived children as both innocent victims and symbols of hope for the future runs as a natural thread through 20th-century documentary photography—in, for example, Bert *Hardy's series on the Glasgow Gorbals for *Picture Post* (1958).

By the late 20th century, street life had almost died out in Western culture—killed by traffic and other dangers. Roger *Mayne's street photographs, principally taken in Southam Street in London in the 1950s, show a life formed by the streets themselves: 'the lack of all logic that gives effects beyond the imagination of a town planner.' His response, like Hine's, was emotional or intuitive; he became involved: 'an artist is a kind of person who is deeply interested in people, and the forces that work in our society. This implies a humanist art, but not necessarily an interest in "politics".'

While the camera was an expensive tool, it rarely fell into the hands of children. Jacques-Henri *Lartigue was a privileged child in a rich and inventive family. He offered us a new expectation of photography, seen from the child's perspective. The unthreatening character of a child 'playing' with the camera revealed and encouraged the playful loopiness of the adult world around him. Such child use of the camera is increasingly regarded as empowering children to present and explain themselves and their society. Wendy Ewald (b. 1951) circles around the problems and the charms of education and creativity by working with children. Part of her concern is for unreality (in adult terms), an invitation to children to stage or act out their dreams and fantasies for the camera. In *Secret Games* she writes: 'To ask the children themselves to participate in exploring their world is to acknowledge that it is *their* experience, and that rather than being made to "mind their place," children might be helped to find ways of illuminating and sharing their inner lives.'

In the 20th century, the gaze itself has become a guilty act, and child photography a potential crime. Where the Victorians saw the attractions of innocence, we see through a Freudian consciousness of adult guilt. Debate on the concerns raised by the exploitation of children has crystallized around the photography of Sally *Mann. She,

like Cameron, has confused our modern critical sense by introducing a studied formality to the act of photography, using a plate camera and making reference to earlier works. She is a mother and worked with her own children, which gave her intimate access and also the authority to direct or encourage. She made a consciously public art from close personal experience. In mixing her sense of beauty with a reading of the darker and more confused side of childhood experience, she offered a troubling vision to the public world she was addressing. ss

Life Library of Photography: Photographing Children (1971).
George, A. R., Heyman, A., and Hoffman, E. (eds.), Flesh & Blood: Photographers' Images of their Own Families (1992).
Goldberg, V., Lewis Hine: Children at Work (1999).
Ewald, W., Secret Games: Collaborative Works with Children, 1969–1999 (2000).
Brown, M. R. (ed.), Picturing Children: Constructions of Childhood between Rousseau and Freud (2002).

Children as Photographers project. See EDUCATION, PHOTOGRAPHY IN.

Chim. See SEYMOUR, DAVID 'CHIM'.

China. Photography in China experienced three distinct developments. In the mid-19th century, the conservative Chinese empire had no desire to be disturbed and did not welcome Westerners and their inventions. The 1842 war with Britain and the subsequent campaigns (and Chinese defeats) of 1857 and 1860 forced it to open several ports to foreign trade, but photography, which had reached Chinese shores at the same time as (or even aboard) gunboats, long remained a foreign medium with a limited reach. The situation changed radically in the early 20th century, when social changes and the advent of the Republic in 1911 led to the development of a fully Chinese style. It changed again in 1949 with Communism, which used photography as a major *propaganda tool.

The 19th century
Until 1900, photography was practised only in the few 'treaty ports' open to foreign trade along the coast and the Yangtze River. The first treaty ports were Canton, Amoy (Xiamen), Fuzhou (Foochow), Ningbo (Ningpo), and Shanghai, Hong Kong being under direct British control. In 1860 Beijing was opened to foreign diplomatic residence, and additional ports were added to the original list as time went on. Deep prejudice against both cameras and foreigners ensured that early photographers rarely ventured outside the ports. Consequently, their work reflects only the places and people depicted, not late imperial China at large.

Most early photographers were visitors for whom, 150 years later, no significant traces or pictures have been found. They were either amateur or itinerant commercial practitioners. Photographers reached China shortly after 1839; the earliest reports of activities are dated 1842; the oldest identified *daguerreotypes (by Jules Itier, a Frenchman), 1844–5. The first newspaper advertisement by a travelling

daguerreotypist (a Mr West) goes back to March 1845, in Hong Kong. Permanent studios started operating in the late 1850s in Shanghai (Legrand, in 1857) and in Hong Kong (Weed and Howards, in 1860), ports which would remain China's two major photographic centres. Photography never attained comparable significance in other ports: Canton had started well but soon lost ground to Hong Kong; Fuzhou, the important tea-export centre, already supported several studios by the 1860s but then fell behind Shanghai, while Ningbo mostly attracted amateurs. A different pattern characterized the second generation of treaty ports opened after 1858, where photography was started by the Chinese and Westerners never predominated, if they were even present. Examples include the major cities of Hankou (Hankow in Hubei, now Wuhan), Nanjing (Nanking), or Tianjin (Tientsin). In Beijing, the first studio opened only in 1892 (Fengtai, a Chinese business).

Christian missions, which originated from the 16th century, were revived when the Nanking Treaty of 1842 again allowed missionaries into the country. Catholic and Protestant churches alike eagerly seized the opportunity for fieldwork, while photography became a propaganda instrument used to stimulate Western public support. Because Chinese missionaries insisted on going anywhere they wanted, irrespective of treaty port restrictions, early images often cover areas of China not otherwise photographed at the time. However, early production includes only those mission stations with trained photographers, and able to afford the expense. In south China, the Missions Étrangères de Paris photographed churches and other religious buildings, schools, orphanages, staff, and flock. Protestants added a further dimension with medical facilities and Chinese helpers such as the 'bible women' whose task was to make contact with the female population. At home, the pictures were used in religious periodicals or books, or even in general-interest publications. They were also—especially portraits of missionaries—sold directly to the public. From c.1900, *postcards were issued on a vast scale, reaching all classes of Western society.

Early wet-plate commercial work includes two sets of stereoscopic views by P. Rossier (itinerant, 1858 in Canton) and Louis Legrand (Shanghai, 1857–9), who heads a long cosmopolitan list of resident photographers in Shanghai: French, British, American, German, and Japanese. On the Chinese side, many photographers were Cantonese. Most studios remained active for a relatively short time, although some survived for decades. They included, in Shanghai, William *Saunders (1862–87), L. F. Fisler (1871–84), or *Kung Tai (Gongtai, 1860s–1890s); Thomas *Child, semi-amateur in Beijing (1871–89); F. Schoenke (Fuzhou, 1861–75), or St J. H. Edwards (Amoy, 1870s–1890s). In Hong Kong, the *Afong studio was reputedly active over three generations, from 1859 to c.1941, while Pun Lun (1860s–1880s) had 'branches' in Hong Kong, Fuzhou, Saigon, and Singapore.

In short, by the early 1870s the Chinese already dominated the field. From the start, several Chinese studios targeted the Western market and advertised vigorously in the foreign-language local press and directories. Chinese dominance in Shanghai became very plain when

Laiwah Studio, Shanghai

The Laiwah Studio in Shanghai, *c.*1900

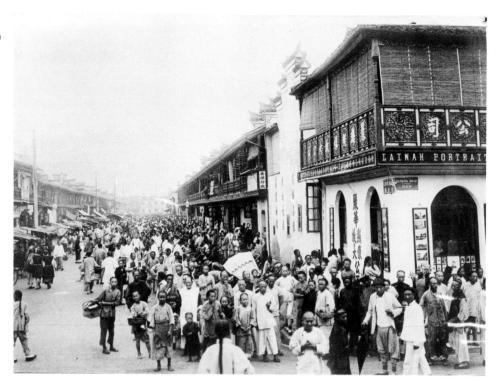

upmarket studios such as Kung Tai in the 1870s and Sze Yuen Ming in the 1890s started advertising in English, while in Hong Kong few foreigners withstood the competition for long. Their heyday was in the late 1860s–early 1870s, when Hong Kong saw W. P. *Floyd (1867–74) compete with *Thomson (1868–72), E. Riisfeldt (1872–3), H. Everitt (1874–7), and numerous Chinese, while Saunders in Shanghai held his own against the Dinmore brothers (*c.*1865–9), *Weed, Fisler, and Kung Tai.

While the commercial studios operating in the pre-1900 treaty ports can certainly be numbered in the hundreds, their identification has barely started. In fact, the history of photography in China is poorly researched by comparison with other, similar cultures, especially as regards the 19th century. Many photographs were taken to the West, where, however, they remain scattered, unindexed, and unidentified. Inside China, successive upheavals, from the 1900 Boxer Rebellion to the Cultural Revolution, caused enormous loss and destruction. The scarcity of sources such as newspapers or commercial registration papers makes it difficult to draw up precise chronologies. In addition, few photos are signed, or, if they are, it may be by copyists. Chinese names are misleading, as they normally refer only to the studio as a business, and were often retained when it changed hands. Who managed a shop is generally unclear, and the photographer's identity is a mystery even for portrait studios.

Moreover, 19th-century photography in China was, essentially, a Western medium of expression. Even when, as was often the case, it was practised by Chinese, it recorded China as Westerners saw or wanted to see it, whether the subject was genre, topography, or events. For example, although the Chinese in general were fascinated by the photographic portrait, the original format owed much to Western-generated photographic traditions; a real 'Chinese' portrait style emerged only with the advent of the Republic in 1911, when educated Chinese had become actively interested. Pre-1900 amateur photography was almost exclusively Western, because the kind of scientifically minded people who practised it in the West simply did not exist in 19th-century China. Commercial photographers, whether Western or Chinese, were small shopkeepers without much education or status, who all produced the same standard commercial images.

Broadly, 19th-century photography embraced three principal fields: *portraiture*, *topography* (architecture and landscape), and 'typical' *everyday scenes*. From the outset, Chinese studios left the last two to Westerners, apparently because only foreigners could satisfy Western taste.

Topography was important in presenting the ports and their evolution; however, as already noted, the camera did not routinely venture inland until much later. In Hong Kong, Thomson, Floyd, and Afong created sets of views, while Saunders photographed Shanghai and H. C. Cammidge (1860s–1874) its waterways, Edwards of Amoy recorded Formosa (Taiwan) and Child inventoried Beijing's monumental architecture. Views privileged the signs of Western presence, and Chinese monuments, while Chinese dwellings hardly appear. In addition to working locally, photographers travelled to other Chinese ports and even to Japan to enlarge their portfolios,

Quianguang Studio, Quingdao

Family portrait, c.1930

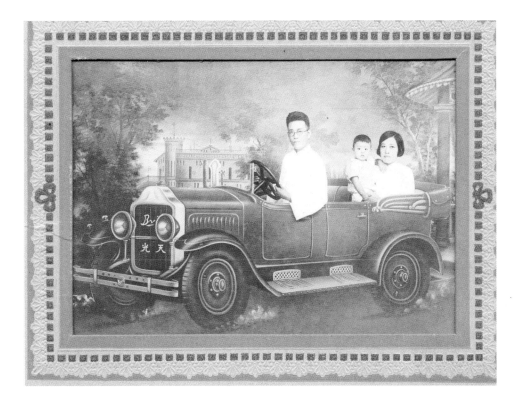

made agreements to represent competitors or amateurs, and generally tried to offer their customers as wide a range of images as possible.

Everyday scenes followed in the steps of an older tradition, that of 'export painting' for the foreign market. The activities shown were exclusively public ones, preferably—like weddings, funerals, or the ubiquitous barber—with a counterpart in the West. They belong to the universal genre of the 'exotic'. But they are also unique records of a forgotten way of life. The most prolific and influential scene specialist was Saunders of Shanghai in the 1860s. Carefully staged, agreeable, and informative, his scenes were extensively copied and pirated. They also inspired later Chinese photographers, who in the 1890s sometimes gave them a negative slant reflecting China's contemporary image in the West.

In China even more than elsewhere, and certainly in quantitative terms, the centrepiece of photography was *portraiture*. The emergence of a bourgeoisie in Hong Kong and Shanghai, in a new Western-influenced atmosphere in which wealth took precedence over learning, was crucial. It created a new market of people free from the constraints of traditional Chinese society's rigid hierarchy. Courtesans were an important part of this in Shanghai and, after 1900, Tianjin.

There were two ways to make a portrait, one for Chinese sitters and another for Western (or Japanese) ones, and the photographer's cultural background appears irrelevant. The corpus was surprisingly coherent: just as there was a vocabulary for Western portraits, an enduring Chinese equivalent emerged on the Chinese coast in the early 1860s. It stressed the sitter's social status through specific Chinese forms of representation (full face, displaying assets such as rich clothing, small feet, long nails, or Manchu archer ring for men), and blended them seamlessly with pre-established photographic traditions.

Both Chinese and Western studios catered to all comers, the Chinese ones being cheaper and therefore attractive to foreign sailors or less wealthy residents, while the Western ones were more prestigious for everyone. A few artists stand out, such as, in Hong Kong, Milton H. *Miller in the early 1860s and Thomson (1868), or the early Chinese studios in Shanghai of Su Sanxing or Kung Tai, or Sze Yuen Ming *c.*1900, which did a brisk trade in portraits of local high-ranking courtesans, which it sold as photographic cards and, later, postcards. This genre served both markets, the Chinese one as celebrity photography and the foreign one as anonymous exotic beauties.

The Republic (1911–1949)

Around the turn of the century, new conditions emerged which changed Chinese photography's character. In the late 1890s smaller, portable cameras arrived. Then, after 1900, foreigners were allowed to travel inland. Yet the crucial, unstoppable change was born of the growing number of Western-educated young Chinese for whom photography and personal cameras were part of everyday life. The medium in fact became an important tool of ongoing modernization.

As amateur photography was evolving from scratch, every style of photograph could be found. However, the persistence of scholarly

traditions created special problems with landscape, the all-important subject of countless paintings down the centuries. Efforts were made to duplicate the dreamy quality of classical painting, in particular the convention of framing a scene with paths leading into the image. But the camera could only show things as they were rather than as the traditionally schooled mind saw them. (Landscape remains only a minor genre in Chinese photography.)

Portraiture developed a character both distinctively 'Chinese' and modern. Props highlighted the approach of a new era, and studio styles acknowledged a new Chinese cultural identity. Photojournalists actively recorded the New China, with views of universities, railways, and modern social and domestic life. Newspapers' illustrated supplements were filled with images of stage and movie stars, and new fashions. But change was uneven. While Shanghai, as usual, was in the vanguard of cultural change, elsewhere the only noticeable alteration might be—at most—the appearance of telegraph poles. In some places, change was documented photographically over decades: in Yunnan, for example, where, from Auguste *François at the turn of the century, a succession of French consuls were talented photographers.

As China changed, some knowledgeable and sympathetic foreigners recorded disappearing customs. Beijing, which remained in many ways old fashioned, was a favourite subject for the likes of Sidney D. Gamble or Hedda Hammer Morrison. These 'foreign' images are now an invaluable source on early 20th-century China. In particular, they show both the old and the new, and indicate how quickly changes occurred locally, from the disappearance of men's pigtails and women's bound feet to modern crowds and changing cityscapes.

Communism

The outbreak of war with Japan in 1937 inaugurated another period of brutal change, reflected in portraits of warlords and news photographs of bombing, refugees, and executions. Other kinds of photography fell victim to the need to survive. After the 1949 communist takeover, photographic diversity faded and propaganda needs became paramount. Themes included the Long March and the dedication of the People's Liberation Army. Myriad bicycles on posters and in news photographs testified to prosperity. Old age was secure, and youth was China's vanguard and future. Snapshots from the 1970s show the vast expanse of Tiananmen Square, carved out of old Beijing; clean, healthy workers in the new factory or agricultural commune; kindergarten toddlers eager to learn for Mao; barefoot doctors; people performing their gymnastics in any convenient space; cultural minorities secure in their identities, yet fully part of China. During the Cultural Revolution (1966–76), such subjects were overshadowed by the little red book, the Red Guards and their mass demonstrations and public shaming sessions, and the revolutionary Peking Opera. But, throughout, a single vision was spread, that of Mao's successful revolution. To a significant extent, this message was propagated by Western visitors and photojournalists—an echo of the 19th-century situation in which China's image in the outside world was formed and disseminated by foreigners. Much more still needs to be known and written about

Chinese photographic practice under Mao. The work of *Li Zhensheng in the north-eastern province of Heilongjiang in the 1960s and 1970s, smuggled abroad when he left China, so far remains exceptional in size and importance. In the meantime, the growth of urban affluence, consumerism, and a degree of cultural pluralism in the post-Maoist period has been accompanied by a predictable upsurge of camera ownership and photographic activity. RT

Worswick, C., *Imperial China: Photographs 1850–1912* (1978).

Chen, S., and Hu, Z., *Zhongguo sheying shi* (*History of Photography in China 1840–1937*; 1987).

Spence, J., and Jenner, W. J. F., *China: A Photo-History, 1937–1987* (1988).

Thiriez, R., *Barbarian Lens: Western Photographers and the Emperor of China's European Palaces, 1860–1925* (1994).

Thiriez, R., 'Photography and Portraiture in Nineteenth-Century China', *East Asian History*, 17/18 (1999).

Lai, E. K., 'A History of the Daguerreotype in Hong Kong 1839–1880', *The Daguerreian Annual 2000* (2000).

Van Tugl, G., et al., *The Chinese: Photography and Video in China* (2004).

China Magazine (1868–9), a photographically illustrated journal started in Hong Kong in April 1868 by C. Langson Davies, to familiarize foreign residents with images and literature of China. The small photographic prints, reduced from larger plates, focused on scenes of daily life or architecture in the Hong Kong and Canton area, with detailed captions. John *Thomson was in charge of photography for some time, contributing local views, and also ones of *Indo-China, including Angkor. The journal folded in 1869. Copies are now extremely rare; the Peabody Essex Museum in Salem, Massachusetts, has an incomplete run. RT

Chinese Folklore Photographic Association, one of China's largest photographic associations, with over 22,000 members (2002). It was founded in 1994 by Shen Che, who felt that the culture of China's more than 50 ethnic groups needed to be recorded before much of it disappeared. He also believed that such a record, by increasing knowledge, would promote international understanding and unity. In 1998 he set up a biennial 'World-Wide Contest' judged by an international panel of judges to further that goal. It receives support from UNESCO, and in 2002 attracted entries from 1,619 photographers from 55 countries. RSA

Chit, Francis (Khun Sunthornsathitsalak; 1830–91), Thai Christian court photographer of King Rama IV (or Mongkut, reg. 1851–68) and possibly his successor, Rama V (1868–1910). His Bangkok studio, started in 1863, was later taken over by his son under the same name. Chit's large panoramas of Bangkok form a unique record of the capital's architecture and its changes over time. Modern research indicates that he was the author of some images claimed and published by, among others, John *Thomson and Wilhelm Burger. RT

See also INDO-CHINA.

Pongrapeeporn, Pipat, *Panorama of Bangkok in the Reign of King Rama IV* (2001).

Christenberry, William (b. 1936), American photographer. Raised in Hale County, Alabama, Christenberry continues to explore his native land. He has done so, however, not through portraiture of its inhabitants—there are remarkably few images of people—but by photographing its old farm buildings, warehouses, and storefronts. He has also made detailed models of these buildings and exhibited them together with found objects such as road signs. As an art student in Alabama, Christenberry studied painting and drawing. He was and continues to be influenced by the Surrealists, particularly Duchamp and *Magritte. In New York as a young man he befriended Walker *Evans, whose photographs had reinforced his own sense of humanity and place. Through an installation called the Klan Room, an elaborate assemblage of drawings, signs, and small dolls in Ku Klux Klan costumes, Christenberry also plumbed the dark side of human nature. In many senses a collagist, he describes his work as an attempt 'to integrate photography and paintings and drawings and sculpture and stories . . . into a totality that expresses my life, where I'm from, and what I care about and react to'. TT

Stack, T. W., *Christenberry Reconstruction: The Art of William Christenberry* (1996).

Christianity and photography. From its beginnings, photography has been used in a variety of ways connected to Christian beliefs and practices. Several categories of image can be identified, namely:

- photographs that have attempted to reconstruct events in the history of Christianity since biblical times;
- images purporting to show, or demonstrate the authenticity of, supernatural happenings or phenomena connected with Christian beliefs (e.g. about miracles, or the immortality of the soul);
- pictures that record significant persons, sites (e.g. shrines), rites, or performances (such as the Oberammergau Passion Play).

Each or any of these types of image, but especially the second and third, may become devotional objects, or adjuncts to devotion, in their own right.

In the second half of the 19th century, photographers created *staged religious tableaux following the tradition already established in the fine arts, and parallel to trends in contemporary painting. In 1851, for example, Gabriel Harrison exhibited two photographs (now lost) on biblical topics at the *Great Exhibition in London. In 1857 O. G. *Rejlander showed the laboriously posed and constructed composite moral allegory *Two Ways of Life* at the Manchester Art Treasures Exhibition, and in 1859 caused an even greater stir with *The Head of John the Baptist*. Julia Margaret *Cameron's photographs of the 1860s frequently included biblical and allegorical topics, with relatives and servants posed as the Virgin Mary, angels, and the Holy Family, suggesting the close alignment, for Victorian women, of piety and domesticity. The years 1898–9 saw the creation and exhibition, to a mixed reception, of F. Holland *Day's large series of photographic re-creations of Christ's life, death, and resurrection, with Day as

Christ. By the turn of the 20th century, scenes from the Oberammergau Passion Play were circulating very widely. As photographic practices and aesthetic values changed, however, and Christianity mattered less to the cultural elites of Western Europe and North America, fewer art photographs were produced on religious topics. For many contemporary artists, nevertheless, there is an indistinct boundary between the aesthetic and the spiritual. The Catholic-educated Andres *Serrano, for example, has claimed that *Piss Christ* (1987) speaks to his religious concerns. Religious tableaux have re-emerged in the postmodern practice of Bettina *Rheims (*INRI: Serge Bramly & Bettina Rheims*, 1999), and in Pierre et Gilles's portraits of the saints in the style of popular prayer cards (1987–91).

The Turin Shroud offers a classic example of photography's involvement in debates about miraculous happenings. This partly fire-damaged linen cloth, probably of late medieval origin and present in Turin since 1578, is believed by many to be the actual 'clean linen cloth' in which Christ's body was wrapped after the Crucifixion. Like other similar relics it bears the faint impress of a human form. In May 1898, during one of the Shroud's infrequent exhibitions in Turin Cathedral, the Piedmontese amateur photographer Secondo Pia (1855–1941) was commissioned to photograph it. The resulting pictures caused a sensation, not least because the negatives seemed to show a positive image of the face, while the cloth itself and the prints showed a negative one. Various theories were offered to explain this, adding to the debates about the Shroud c.1900. It was rephotographed, by Giuseppe Enrie, in 1931, and subjected to further imaging and dating procedures in the 1970s and 1980s; however, controversy still rages.

Beginning in the early 1970s, following a reported appearance of the Virgin Mary to a woman called Veronica Lueken ('the Seer of Bayside') at Bayside, Queens, NY, in June 1970, images of figures, mysterious shapes, and bursts of light were captured by visitors to the site, and hailed by believers as 'miracle photos'. Subsequently, photographers were urged to use Polaroid cameras to counter accusations of fraud. Similar phenomena were recorded in Conyers, Georgia, from 1987. Although the Catholic authorities did not support their validity in either case, the photographs, which were widely circulated on the *Internet, were accepted by many as physical manifestations of the divine.

While photographing the miraculous may be unusual, many Christians use photographs to shape memories of religious occasions. Snapshots are taken of baptisms, christenings, first communions, ordinations, weddings, and funerals, and in some societies may eventually be used as ex-votos. Other religious events, from Lourdes pilgrimages to Catholic summer camps, are also routinely accompanied by photography. While clergy may decry flashing cameras in church or at shrines, photographs are indispensable markers of social and religious rites of passage. They may also acquire significance in other ways. Between 1894 and 1897, for example, Céline Martin took 'family' photographs of her sister Thérèse and life in their Carmelite convent in Lisieux, France. After Thérèse's canonization in 1923, these images served as the basis for representations of the 'Little Flower'. Likewise

photographs of St Bernadette of Lourdes and Pius IX were transformed into holy cards and pious prints, sold for use in private devotions. The sacrality of such pictures, far from being diminished by duplication, was enhanced by iconographic massing.

For Protestants, the photograph's usefulness in conveying the 'reality' of biblical life has been an important adjunct to religious teaching. In the 19th century photographs of the Holy Land were produced as stereographs, book illustrations, and lantern slides. Individuals like James Graham (*fl.* 1850s) and organizations such as the *Palestine Exploration Fund systematically recorded Old and New Testament sites. Sunday schools and missions used photographs to teach, uplift, and entertain, the precise usage of images reflecting both denominational difference and local custom. For example, while some Protestant groups declined to place images in their sanctuaries, they employed photographs extensively in education.

Religious people, places, and rituals have also attracted documentarists. The American Farm Security Administration photographers of the 1930s, for example, and others since then, explored religious practices in their wider cultural context. Christian life and personalities became the subject of feature stories in magazines like *Life* and *Look*. Photographers continue to explore Christian experience. Cristina *García-Rodero has documented religious life in post-Franco Spain (1990), Laura Wilson (b. 1939) the lives of Hutterites in Montana (2000). In *Riders for God: The Story of a Christian Motorcycle Gang* (2000), Rich Remberg (b. 1965) has recorded the activities of an unusual group of Pentecostalists in Indiana. From the perspective of both the outsider who documents the behaviour of others and the insider who uses photographs to connect with the sacred, photography remains critical to the complex worlds of Christianity. CMCD

See also MISSIONARIES AND PHOTOGRAPHY; OCCULTISM AND PHOTOGRAPHY; VERGER, PIERRE.

Wilson, I., *The Turin Shroud: The Burial Cloth of Jesus?* (1978).

Kirkpatrick, D., 'Religious Photography in the Victorian Age', *Michigan Quarterly Review*, 22 (1983).

Wojcik, D., ' "Polaroids from Heaven": Photography, Folk Religion, and the Miraculous Image Tradition at a Marian Apparition Site', *Journal of American Folklore*, 109 (1996).

Boschiero, G. (ed.), *Secondo Pia, fotografo della Sindone* (1998).

Perez, N. N., *Revelation: Representations of Christ in Photographs* (2003).

chromogenic development. See PHOTOGRAPHIC PROCESSES, BLACK-AND-WHITE.

chromoskedasic print, a spectacular colour print or 'painting' produced by applying colourless processing chemicals in a controlled way to black-and-white photographic paper. No pigments or dyes are involved, the colour coming solely from different wavelengths of light scattered from the minute particles of silver in the paper. The term chromoskedasic is derived from Greek and simply means 'coloured by light scattering'. Dominic Lam announced the process as a new discovery in 1980, but it appears to be identical to the abstract cameraless process discovered in 1956 by the Belgian photographer Pierre *Cordier, who called his pictures *chimigrammes* (or chemigrams). JPW

chronophotography. Coined by the French physiologist Étienne-Jules *Marey in the 1880s to describe his photographs of *movement that often included a timing clock in the frame so that he could make accurate physiological analyses of movements, the term was later applied to many types of sequential images. Scientists began making single-plate chronophotographs, where a sequence of multiple overlapping images was recorded on a single plate, in the late 1850s when Bernhard Feddersen measured the duration of an electric spark. Multiple-plate chronophotography, where separate phases of movement were recorded on a series of individual photographic plates, at first by using a battery of separate cameras, was introduced by Eadweard *Muybridge for his celebrated project of photographing Governor Stanford's racehorses in 1878. At the cutting edge of photographic technology in the later 19th century, new developments were widely discussed in the photographic press and initiated many non-scientific experiments, since the phases of movement captured by chronophotographic methods could be reproduced as an illusion of natural movement in a stroboscopic viewer like a zoetrope or phenakistoscope. Before 1898 many early moving-picture cameras and projectors were patented and discussed under the rubric of new chronophotographic apparatus.

The four main figures of chronophotography, Muybridge, Marey, Ottomar *Anschütz, and Georges *Demeny, for each of whom the claim 'inventor of the cinema' has been advanced, had widely divergent careers and attitudes towards their serial images. Although his extraordinary accomplishment in making sequences of twelve *wet-plate images of Stanford's horses in various gaits was hailed in photographic journals worldwide after June 1878, Muybridge reinforced his reputation by lecturing on his work as early as a month later. He toured Europe in 1881–2, America in 1882–3, Europe again in 1889–92, and built an attraction at the Columbian Exposition in Chicago in 1893. In his lectures, Muybridge projected drawings carefully modelled on the phases of movement revealed by his series photographs on a device called the zoopraxiscope—a 'magic lantern run mad' according to the *Illustrated London News*—but his only photographic disc for the apparatus used posed individual images of the skeleton of a horse galloping. Both Muybridge's startling work and his relentless promotion of it inspired others to take up his expensive photographic methods.

Marey, who published extensively on aspects of movement, flight, and exercise, began using photographic methods for his research in 1882, at first fixing overlapping phases on a single plate and by 1888 using 1 metre (3 ft) strips of unperforated *celluloid with separate, irregularly placed images. An unsurpassed analyst of human, animal, and bird locomotion, he had little interest in reproducing movement, although he sometimes fitted a photograph series into a zoetrope to check its reliability by reconstituting the original movement. Demeny,

(*previous page*) **David Malin** Star trails around the celestial pole, 1979

Richard Bryant Vitra Museum, Weil am Rhein, Germany (architect Frank O. Gehry), 1990

his assistant from 1882 to 1894, made major contributions to Marey's photographic experiments and envisioned wider applications of the stroboscopic reproduction of movement, particularly in devising a disc-based viewer called the Phonoscope in 1892 that served as either a peepshow or a simple projector. After they split up in 1894, Demeny established his own laboratory, where he improved Marey's camera, developed pioneering projection apparatus, and made short films. Anschütz, who started taking series of chronophotographs in 1885, produced a disc-based viewer the following year he called the 'Schnellseher', which used his photographs to reproduce natural movement as a public entertainment. Over the next decade, nine successive models were exhibited in Europe and North America, but an overambitious business plan ultimately collapsed just before Thomas Edison's *Kinetoscope peepshow machine reached the public.

Whether directly or indirectly, each of these four major chronophotographers made important conceptual, technical, and practical contributions to the establishment of moving pictures in the mid-1890s, and the work of each was well known, sometimes in great detail, by moving-picture inventors and pioneers like Edison, the *Lumière brothers, Max Skladanowsky, Léon Gaumont, George William de Bedts, and others. At the same time, chronophotographic methods were used by other figures for a variety of purposes. Ernst Kohlrausch in Hanover used series photographs from 1890 in the training of gymnasts, ultimately building two cameras and two projectors for both the analysis and reconstitution of athletic movements. From 1882 Albert *Londe in Paris applied his nine-image apparatus and a later twelve-image camera to analysing involuntary movements of epileptic patients and the muscular movements of a tightrope walker and a blacksmith. Colonel Hippolyte Sébert, an occasional collaborator of Londe, applied chronophotography to the study of ballistics after 1889. Victor von Reitzner in Vienna produced chronophotographic apparatus for open-air photography of natural subjects in 1891 whose unusual technology was directly taken over by the French moving-picture pioneer de Bedts in Paris in early 1896. In Philadelphia, the Realist painter Thomas *Eakins made photographic studies for his large-scale canvases from 1884 with a Marey-style camera. A number of independent inventors were inspired by chronophotographic work to seek improved means of reproducing movement, including Augustin le Prince and Wordsworth Donisthorpe in Britain; Gray and Otway Latham, C. Francis Jenkins, Thomas Armat, and Herman Casler in the USA; and Henri Joly in France. After 1896 chronophotography disappeared as a separate photographic technique and its analytic methods were quickly subsumed into specialist, often high-speed, moving-picture work by scientists like Marey's successor in Paris, Lucien Bull, or the American efficiency experts Frank Gilbreath and F. W. Taylor. DR

Darius, J., *Beyond Vision* (1984).

Poivert, M., et al., *La Révolution de la photographie instantanée, 1880–1900* (1996).

Braun, M., 'The Expanded Present: Photographing Movement', in A. Thomas (ed.), *Beauty of Another Order: Photography in Science* (1997).

chrysotype. See ALTERNATIVE (NON-SILVER) PHOTOGRAPHIC PROCESSES.

cinema and photography. The two are linked in many respects. First, they share technological principles: film is materially composed of strips of chemically produced photographic images which, projected at speed, create the illusion of continuous movement. The methods used by *Marey and *Muybridge to photograph motion, and photographic peepshows like the *Mutoscope, were precursors of the cinema. Early experiments in movies were conducted by photographic equipment manufacturers such as the *Lumière brothers. The rules of exposure are similar, and some cinematographers (e.g. Karl Struss, James Wong Howe) started their careers as still photographers; Larry *Clark, Lucien *Clergue, Robert *Frank, Gordon *Parks, Jakob *Tuggener, and other photographers have also been committed film-makers. Technological links persist: the principles of digital video correspond with those of digital photography. Affinities of usage also obtain, not only in commercial production and post-production, but also in the use by artists of digital video (simultaneously replacing the still camera, video, and, previously, Super-8 film) for low-budget or experimental projects. Second, various institutional interconnections have developed. For example, still photography is used for purposes such as location research, continuity work, casting, and marketing publicity, which usually encompasses star portraiture (a flourishing sub-industry in *Hollywood and other movie capitals, with links to *advertising and *fashion photography) as well as production stills. Third, film and photography share a formal aesthetic founded on conventions inherited from Renaissance painting; although film also articulates narrative modes drawn from theatre and literature. Both were characterized by an association of black-and-white imagery with 'the real', and colour, popularized in the 1930s, with fantasy (advertising or film musicals); from the late 1970s, this switched as colour became naturalized within documentary, and monochrome increasingly came to signify memory and nostalgia.

Ontological questions about the similarities and differences in the import and effects of still and moving pictures date from the inception of movies and continue to be raised. Writing in the 1930s, Walter *Benjamin used the term 'optical unconscious' in relation to photography's ability to reveal that which the human eye might not otherwise see, allowing detailed observation of actuality. Henri *Cartier-Bresson famously characterized the *'decisive moment' at which content and compositional form come together. In similar vein, the post-war French critic André Bazin (1919–58) stressed the recording of reality as the photographic essence of cinema. For him, the authenticity of a film rested in minimal intervention by the director, whose responsibility lay in recognizing the significance of an event and letting the camera roll. Bazin's emphasis upon the camera as, in effect, a neutral window on the world was criticized for ignoring not only the effects of selection, setting-up, framing, and editing, but also the ideological attitudes and assumptions which influence the director's judgement in representing the social world. Hence photography, film,

and video are all implicated in general debates about the politics of media representation. As the iconoclastic French film-maker Jean-Luc Godard (b. 1930) remarked, if photography is truth then cinema is truth 24 times a second.

For others, the photographic transcends the naturalistic. The idea of the 'photogenic', that which is rendered more striking or dynamic through photography, was central both to art photography at the end of the 19th century, and to experiments in cinema, explicitly so to French 'impressionist' film-makers of the 1930s such as Germaine Dulac (1882–1942), Louis Delluc (1890–1924), and Jean Epstein (1897–1953). The emphasis was on poetic effects, allusions, and resonances. The symbolic was also central to work by the *Surrealists. Links between photography and film were evident in other art and design movements of the 1920s. Both the *Bauhaus and Soviet Constructivism were concerned with the relation between form and function, wherein angle of vision, subject matter, and new ways of seeing were stressed. The juxtaposition of images, in *photomontage and film editing, came to be understood as crucial to the creation of meaning.

Some critics have been interested in exploring differences in effect between the two media. For instance, Peter Wollen has likened film to fire and photography to ice, the former flickering through predetermined sequence and time (hence 'movies' or 'flicks'), the latter cryogenically preserving a moment for contemplation in unlimited time. In conventional narrative cinema, photographs often figure as a plot or storytelling device. For example, a close-up of a photograph might indicate an absent character, or relate to people or events diegetically in the past, often heralding flashbacks. In Edgar Reitz's eleven-part television drama *Heimat* (1984), photographs taken by one character, presented at the start of each episode, function as a linking device in a long and complex narrative extending over several decades. But photographs may figure more centrally, and in more complex ways. In Antonioni's *Blowup* (1966) a trendy young photographer enlarges a photograph taken in a London park to find he has inadvertently recorded an encounter between two people, which captures his curiosity; the narrative becomes a quest to discover what had occurred. The film interrogates notions of photographic evidence, suggesting ambiguities and uncertainties and undermining realism, but the photograph holds a moment to which the protagonist repeatedly returns. A different kind of example is Godard's *Les Carabiniers* (1963), in which two young soldiers represent their experience of travel through a suitcase of postcards (memories) collected and retained. The sequence uses the postcard as metaphor for travel, but also parodies promises of booty as the baggage brought back to their wives turns out to contain only images. More formal considerations may be central: for instance, freeze-frame may be used for emphasis and to allow the eye of the spectator, temporarily released from the narrative trajectory, to roam, contemplate, or investigate the stilled image. The American avant-garde film-maker Maya Deren (1908–61) effectively used this technique as a form of punctuation within her film *Ritual in Transfigured Time* (1946). Perhaps the best-known example of the still sequence *as* movie is Chris *Marker's poetic time-travel fantasy *La Jetée* (1963).

Aside from one image—moving in both senses of the word—the film is entirely composed of stills; voice-over propels the narrative.

The still image, finally, has been widely used in documentary film, most notably historical productions for television. A classic example, set in a period before motion pictures, but rich in photography, was Ken Burns's nine-part epic *The American Civil War* (1990), which incorporated thousands of historic photographs gleaned from museums and historical societies across the USA. Somewhat different, in that photographs were central to the narrative, was Daniusz Jablonski's *Fotoamator* (1998), which juxtaposed the memories of a survivor of the Łódź Ghetto with colour transparencies of it taken by a Nazi administrator, Walter Genewein. In both cases, the use made of the photographs was powerful and illuminating. As with actuality film footage, however, such practice raises questions about authenticity and the proper handling of sources. In the quest for visual continuity, or to arouse emotion, camera movements, cropping, commentary, and music—in short, the whole cinematic apparatus—may evoke responses in the viewer, and suggest intentions, alien to the makers of the original images. LW

Kobal, J., *The Art of the Great Hollywood Portrait Photographers* (1980).
Magnum Cinema: Photographs from 50 Years of Movie-Making, introd. A. Bergala (1995).
Monaco, J., *How to Read a Film: The Art, Technology, Language, History and Theory of Film and Media* (3rd edn. 2000).

circle of confusion. See DEPTH OF FIELD.

circuses and fairgrounds. Like many painters, photographers have long been drawn to the transient world of travelling entertainers. Between the mid-19th century and the Second World War, circuses and fairgrounds represented a kind of no man's land between archaic rural culture and the modern world of the city. The picturesque living conditions of the performers, their physique, skills, and vulnerability on trapezes or tightropes, or confronting fierce animals, gave them a powerful appeal. *Atget, *Brassaï, Robert *Capa, *Doisneau, *Mark, *Model, *Rodchenko, and Edwin *Smith were among the numerous photographers who responded. August *Sander included circus people in his taxonomy of contemporary society, along with gypsies, poachers, and itinerant bear-keepers. In the 1900s Heinrich *Zille had photographed fairgrounds on the outskirts of imperial Berlin, unsentimentally recording sideshows and carousels, beer-tents and caravans, and the public of maidservants, urban *flâneurs*, and children bunking off school. More romantic was Marcel Bovis (1904–97), who returned repeatedly to the subject over decades, recording caravans parked idyllically in fields at Argenteuil (1931), the annual Parisian entertainments of Bastille Day and the *Fête du trône*, and established circuses like Medrano and the *cirque d'hiver* with their famous clowns and equestrian troupes. His pictures illustrated his friend Pierre *Mac Orlan's circus poems, *Fêtes foraines* (1990). RL

Ranke, W., *Heinrich Zille. Photographien: Berlin 1890–1910* (1975).
Bauret, G., *Marcel Bovis: promenades parisiennes* (1996).

Civil Rights movement, American. The plight of African-Americans in the South had been recorded by photographers before the Second World War. But 'civil rights photography'—concentrated photojournalistic coverage of the struggle for the right to vote, fair employment, and equal opportunities—was a post-1945 phenomenon, and climaxed in the years between the Supreme Court's ruling in *Brown v. Board of Education* in May 1954 and the assassination of Martin Luther King in April 1968. It coincided with classic *photojournalism's final efflorescence and the rise of the new 'super-medium', television. In this period photography had three principal domestic outlets: mainstream newspapers; magazines such as *Time*, *Life*, and *Look*; and black journals like *Ebony* (f. 1945), *Jet*, *Flash*, and *Our World*. Through the big *agencies, however, the most dramatic pictures reached an international public, and for much of the period probably had greater impact abroad than TV coverage.

A milestone in the visual history of the Civil Rights movement was the case of Emmett Till, a 14-year-old black youth from Chicago who was murdered by white racists while visiting relatives in Mississippi in August 1955. A close-up image of his horribly disfigured face was repeatedly published by *Jet* the following month and shocked the black community, although it never appeared in the white press and was not shown on television until 1988. Over the following decade growing numbers of black and white photographers covered events such as the bus boycott in Montgomery, Alabama, the enforcement of school integration in Little Rock, Arkansas, the riots in Birmingham, Alabama, and the August 1963 march on Washington, DC. Among the most prominent were Bruce *Davidson, Roy *DeCarava, Benedict Fernandez (b. 1936), Leonard *Freed, R. C. Hickman (b. 1922), Bill Hudson (who took the celebrated *To the Attack* (*Birmingham Protest*) photo on 3 May 1963), Danny *Lyon, Charles Moore (b. 1931), Gordon *Parks, Moneta Sleet ((1926–96), who won the Pulitzer Prize for his picture of Coretta King at her husband's funeral), and Ernest Withers (b. 1922). Flip Schulke (b. 1930), a white freelancer who worked for *Jet* and *Ebony* (an arrangement that helped to offset police harassment of black photographers), covered the entire movement and became a friend of King.

As in the case of South African *struggle photography, it is impossible to gauge the precise effect of such images. In the mid-1950s, the mainstream media's interest in the South had been slow to ignite. However, the publication of Hudson's *To the Attack* in the *New York Times* on 4 May 1963, and subsequently around the world, shocked President Kennedy, the political establishment, and public opinion at home and abroad; comparisons increasingly began to be made with South Africa. In August, 250,000 people demonstrated in Washington, and the Civil Rights Act became law in July 1964. Other factors, of course, contributed to these developments. But by the early 1960s photojournalism was undoubtedly boosting support for King's Southern Christian Leadership Conference and allied movements. Moreover, both the campaigners and their more level-headed opponents realized that confrontations in places like Birmingham would generate powerful and emotive images. Although

photographers might be harassed and beaten up, their work, once public interest had been aroused, could not be suppressed. Pictures captured the ugliness of segregation and suggested the inevitability of change. In longer perspective, finally, civil rights photography encouraged later generations of photojournalists—men like James *Nachtwey, for instance—to believe that the graphic depiction of injustice might, eventually, end it. DW

Fulton, M. (ed.), *Eyes of Time: Photojournalism in America* (1988).
Kasher, S., *The Civil Rights Movement: A Photographic History* (1996).
Davidson, B., and Lewis, J., *Bruce Davidson: Time of Change—Civil Rights Photographs 1961–1965* (2002).

Clark, Larry (b. 1943), American photographer and film-maker. Born and raised in Tulsa, Oklahoma, he studied photography with the intention of starting a portrait business. However, he moved into new terrain, and his first book, *Tulsa* (1971), reflected his growing interest in teenage angst. After service in Vietnam he continued his photographic work with young people, which culminated in his second book, *Teenage Lust* (1983). Clark's personal life was tumultuous, and addiction to drugs and alcohol eventually led to a felony conviction and prison. Recovering, Clark picked up on his long-standing interest in the potential of cinematography. His first feature-length film, *Kids*, appeared in 1995. It documents a group of young New York City skateboarders. An outlaw road film, *Another Day in Paradise*, followed in 1998; *Bully*, a grim portrayal of teens and murder in suburban Florida, in 2001; and *Ken Park*, another skater film set in the San Joaquin Valley of California, in 2002. While many have seen Clark's work as exploitative and voyeuristic, he himself has claimed that he is simply portraying teen existence as it is and that others are in denial: 'At least my films are showing you what's going on, making people think a bit, and stirring up some controversy.' Clark joins a long line of photographers who have photographed young people in their milieu, including Nan *Goldin, Lauren Greenfield, and Nobuyoshi *Araki. TT

Wiener Secession (ed.), *Larry Clark* (1996).

classic cameras. Although there are a number of books on collecting or using classic cameras, from Harry Gross's pioneering *Antique and Classic Cameras* (1965) to Paul-Henry van Hasbroeck's *150 Classic Cameras, from 1839 to the Present* (1989), the term 'classic' has seldom been consistently or precisely defined. For some authors, the word simply means historic or landmark cameras such as the first *Kodak camera of 1888, the first *Brownie of 1900, the Polaroid of 1948, or the *Instamatic of 1963. Others have used it to include cameras incorporating a new feature, such as the Kodak Super Six-20 of 1938 with automatic exposure control. Others again have nominated cameras like the Ensign Selfix of 1948 for no apparent reason other than that they exist and are readily available, or that the writer owns one. Since the mid-1980s, however, in the context of a rapidly growing collector's market, and influenced—via authorities such as Ivor Matanle—by parallels in the vintage car world, the

definition has been increasingly refined. Today most collectors would accept that a classic camera is

1. *mechanical* and relatively complex, incorporating optical innovation, craftsmanship, and precision engineering in its design;
2. *made between the mid-1920s and early 1970s*, when the camera moved away from the traditional vintage plate or box-form design, but before the widespread advent of plastics and electronics;
3. *usable*, employing a roll-film or plate size that is still obtainable. Although companies exist that will make obsolete formats to order, 'usable' in practice means 35 mm, 120 roll-film, 127 roll-film, 620 roll-film, and 4 × 5 and 9 × 12 in sheet film. It excludes *sub-miniature and very-large-format cameras.

These criteria remain fluid, but include the majority of cameras from Zeiss Ikon (1926–75) such as the Contax, Contaflex, Super Ikonta range, and Contarex; Leitz/Leica (1925 to the present), but excluding reflexes; and inter-war German manufacturers such as Ihagee, Franke & Heidecke, Berning & Co., and Linhof. Many purists would exclude Japanese cameras, but it is reasonable to include the better-quality post-war products, including those from Nippon Kogaku (Nikon), Canon, Asahi Optical Co. (Pentax), and Tokyo Kogaku (Topcon) amongst others. There are a number of marques from other countries, or selected cameras from particular manufacturers, that meet the criteria: Hasselblad from Sweden, the Eastman Kodak Co. Ektra from the USA, the British Reid and selected Ensign models, the French Foca, and the Swiss Alpa and Tessina cameras all qualify as classic cameras.

The rise of interest in collecting, especially since the mid-1980s, has been partly driven by a move amongst photographers away from the fully automatic, plastic, and electronic cameras that began arriving from the mid-1970s. Classic cameras remain a feasible means of producing high-quality photographs, especially from the medium-format models, and restore control to the photographer. In addition, most have optics with particular characteristics that make them better for certain types of photography. An older lens that is slightly soft in focus or not colour corrected can be preferable to a modern state-of-the-art equivalent.

The above definition leaves a large number of cameras from the 1840s to the present that are collectible. Pre-1925 cameras are increasingly being termed 'vintage' and in general are simpler and more traditional in their construction. They include brass and mahogany *field and tailboard cameras mainly from 19th- and early 20th-century Britain and France. Hand and *detective cameras from the late 19th century also come into this category. There are cameras from all periods that are collected for their design or aesthetic appeal, such as the Kodak Bantam Special, designed by Walter Dorwin *Teague, or the Brownie 44A, styled by Kenneth Grange. Others are favoured by particular collectors by reason of their marque, film or plate format, material of manufacture (even plastic), or type

(e.g. stereoscopic or disguised). There remain certain landmark or historic cameras collectible because they were innovative in their construction, such as the first all-plastic camera, the 1929 Rajar No. 6, or because they incorporated a new feature, such as the roll-film Luzo of 1889 or the 1963 Instamatic 100 using a drop-in cartridge. Some cameras fit into more than one of these categories.

The size and value of the historic camera market has grown dramatically since the first regular specialist auctions in the early 1970s. In 1977 the world auction record price for a camera was £21,000, but it had reached £39,600 by 1993 and £157,750 by 2001 (all set at Christie's). In 1985 Christie's London camera auctions yielded *c.* £200,000; by the early 1990s the annual figure was almost £2 million. Nevertheless, since the majority of classic and collectible cameras were originally mass produced for an amateur market, the field remains an affordable one. MP

Permutt, C., *Collecting Old Cameras* (1976).

Matanle, I., *Collecting and Using Classic Cameras* (1986).

McKeown, J. M. and J. C., *Price Guide to Antique and Classic Cameras 2001–2* (2001).

Hicks, R., and Schultz, F., *Rangefinder: Equipment, History, Techniques* (2003).

Claude glass. See PRE-PHOTOGRAPHIC IMAGING DEVICES.

Claudet, Antoine François Jean (1797–1867), French photographer and scientist, active in England. He became an influential London portrait photographer at his Adelaide Gallery studio, licensed by the inventors to practise both the *daguerreotype and the *calotype. Claudet's earliest significant technical contribution, in 1841, was in greatly increasing the sensitivity of the daguerreotype plate, thus reducing exposure times and making the process much more suitable for portraiture. In 1851 he moved to Regent Street, where he also began using the *wet-plate process. Claudet published prolifically on photography, vision, and the photographic representation of sculpture. He was also one of the foremost early practitioners of *stereoscopic photography, inventing a folding stereoscope and other devices. Many of Claudet's impressive photographs survive, but his collection of historical photographic incunabula was destroyed by fire after his death. KEW

Pickering, B. M., *A. Claudet F.R.S.: A Memoir* (1896).

Clement, Krass (b. 1946), self-taught Danish photographer who worked initially in France. Since his first book, *Byen Bag Regnen* (*The City behind the Rain*, 1978), a portrait, both chilling and moving, of a city and its people, his prolific output has emphasized the *photo-essay or visual poem: thematically structured sequences of images, usually without commentary. His work is close to the street and the *decisive moment, melancholic, voyeuristic, nocturnal, and confrontational. He teaches at the Danish Film School and the legendary photoschool Fata Morgana, and in 1985 co-founded the influential picture agency Billedhuset. J-EL

Clergue, Lucien (b. 1934), French photographer and film-maker, born and resident in Arles. He discovered photography during a harrowing adolescence, his early nudes being a kind of therapy. Later, he related the opulent female forms sparkling in sea foam published in *Corps mémorables* (1957) to the experience of washing his emaciated, dying mother, and photographing dead animals floating in the Rhône. He subsequently photographed nudes in the Camargue, Death Valley, California, and in cities on both sides of the Atlantic. Other photographic and film subjects included *bullfighting, the Camargue landscape, and his friend Picasso (*Picasso, De Guernica aux Mousquetaires*, 1969). He began using colour in 1971 and Polaroids in 1981. He co-founded and for 25 years directed the *Arles Festival. RL

 Lucien Clergue: grands nus (1999).

cliché-verre, a hybrid technique, on the border between photography and printmaking. The image is drawn with a burin or other pointed instrument on a glass plate coated with an opaque layer of *collodion and placed on a black surface. Each stroke removes a strip of collodion, and the drawing appears in black where the glass is exposed. When the drawing is finished, the print is made on salted paper as in normal photography. The result is a drawing reproducible by photographic means. The procedure was perfected *c*.1853 by the French photographer Eugène Cuvelier (1837–1900), and used by painters of the Arras and Barbizon schools (including Cuvelier's friend Camille Corot; Daubigny, Rousseau, and Millet) between 1853 and 1874. Variants of the process were used in the 20th century by the young Paul Klee, *Man Ray, and György *Kepes. SA

 Glassman, E., and Symmes, F., *Cliché-verre: Hand-Drawn, Light-Printed. A Survey of the Medium from 1839 to the Present* (1980).

Clifford, Charles (1819/20–1863), English photographer who made most of his photographs in Spain after settling permanently in Madrid in 1852. He was official photographer to Queen Isabella II, but spent much of his time travelling and making *calotype and *collodion negatives of ancient architectural sites. His unusual treatment of architectural spaces has made him one of the most famous 19th-century photographers in Spain. He belonged to both the *Sociéte Française de Photographie and the Architectural Photographic Association. KEW

 Charles Clifford: fotografo en la corte de Isabel II (1996).

Close, Chuck (b. 1940), American photographer and painter. As a youngster, Close struggled with learning disorders. His genius as a portraitist emerged when he discovered that he could analyse Polaroid photographs of people by breaking them into tiny grid patterns. Often spending more than a year on each image, he slowly replicated (initially in black-and-white, then in colour) each small square in an enlarged format on enormous canvases. His paintings range from uncannily photorealistic to softly pointillistic faces. A paralytic illness in 1988 forced him to paint from a wheelchair, his brush strapped to his wrist. TT

 Store, R., et al., *Chuck Close* (1998).

Jean-Baptiste Camille Corot

Souvenir du bas Bréhaut, 1858. *Cliché-verre*, probably printed by Paul Desavary, 1911–13

clouds. Dramatic clouds occur with suspicious frequency in some kinds of black-and-white photography: certainly, rather more frequently than they appear in real life. They are achieved in a number of ways.

The earliest was simply to draw them in. With 'ordinary' (blue-sensitive-only) plates, this was often the only option: a blue sky, with clouds, registered as a featureless white, even when exposures were not so long that clouds blurred from movement.

Later, with *orthochromatic or better still panchromatic plates, 'sky' filters darkened the blue sky while having little or no effect on the white clouds. Yellow filters were generally counselled as being most 'natural'; many photographers (including Ansel *Adams) employed orange filtration to great effect; and even red filters do not necessarily look as extreme as their detractors maintain.

The difficulty has always been in getting the right sky over the right subject. Many photographers solved (and still solve) this by keeping a library of sky negatives, shot whenever the conditions were right, and using these to make *combination prints, as early masters like Gustave *Le Gray had done. The best look entirely natural; in the worst, the light on the subject is incompatible with the sky. Whether the sky 'belongs' to the subject or is added via combination printing, it is quite common to print heavily in order to intensify the drama of the sky. Another common trick in exhibition prints is local bleaching of the lighter areas of the sky, typically using Farmer's reducer (also known as 'liquid sunshine') to add still further drama.

In colour, although heavy printing is an option with negatives, two other options are feasible with both slide and negative films. One is the use of a polarizing filter, which intensifies blue skies, especially at right angles to the sun–camera axis, and the other is the graduated neutral-density (ND) filter, which reduces the exposure given to the sky. Serious professional graduated ND filters cause no colour shift (cheap amateur versions often shift towards green); are available in a range of densities, from barely perceptible (0.10, 1/3 stop) to strong (as much as 0.90, three stops); and are made with two or three rates of gradation from clear to tinted, from very abrupt to a longer transition. They can be set only by inspection, whether on a reflex or by direct ground-glass viewing. RWH

Curry, M., *Flug und Wolken* (1933).

clubs and societies, photographic. Today the novice amateur photographer can seek guidance from innumerable manuals and magazines, and move forward by easy stages. But in the early decades of photography beginners had a much harder time. The best way to avoid initial difficulties (the excessive choice of processes, and the problems of making them work) was to get advice from seasoned practitioners. The phrase *vae solis*—woe to the solitary—seems custom made for the early amateur. So the first clubs appeared quite soon after photography itself.

The first societies
The world's first photographic society was probably the Edinburgh Calotype Club, founded in 1843. Four years later in London, a number of amateurs formed the Calotype Society. In France, too, amateurs first banded together around photography on paper. In 1851 the *Société Héliographique was founded. Probably because they were too informal, however, these associations soon disappeared. The Calotype Society was replaced in 1850 by the Photographic Exchange Club, then in 1853 by the London Photographic Society, which eventually (1894) became the *Royal Photographic Society (RPS). In 1854 some members of the short-lived Société Héliographique formed the *Société Française de Photographie (SFP). (The first American amateur group, the American Photographic Society, appeared in 1858.) Both it and its London counterpart were solidly structured on the lines of scientific academies and learned societies, with regular formal meetings at an established venue, a bulletin, and an archive. In principle, these bodies advanced the progress of photography via that of their members. The latter often belonged to other learned societies as well, were in many cases artists and scientists, and generally came from the affluent elite. The clubs provided sociability and the chance to exchange news, technical information, and pictures, often in opulent surroundings: thus the Club der Amateur-Photographen in Vienna (f. 1887) occupied premises furnished by Nathaniel von Rothschild, with a games room, billiard room, and all the amenities of a top-rank English club.

Modern clubs
At the end of the 19th century, with the spread of the *dry-plate process and the simplification of photographic techniques and equipment, the number of amateurs grew considerably. But instead of boosting the membership of existing societies, this produced a proliferation of new ones. In France, the years 1850–70 were characterized by the hegemony of the SFP. From the 1880s on, the number of groups grew continually. The year 1887 saw the creation of the Société d'Excursions des Amateurs de Photographies, and 1888 that of the *Photo-Club de Paris. In 1892 there were 38 photographic societies in France, a figure rising to 50 in 1900 and c.100 by 1906. In England, the number rose even more steeply, from 40 in 1885 to 131 in 1890 and over 250 by 1895. (In the German Empire in 1899, 120 groups were listed, although c.25 of these were organizations for professionals and their employees.) This expansion can be explained partly by a general craze for clubs at the end of the 19th century. But it also reflects a desire on the part of a new generation of amateur photographers for a different setting for photography-related sociability: not so much a learned society as a convivial meeting place, with a clubbier atmosphere. Amateurs also wanted to distance themselves from the *professional organizations of an increasingly commercialized medium. The Society of Amateur Photographers of New York, for example, founded in 1884, emphasized its exclusive dedication to amateurs, 'unhampered by trade interests, . . . governed by men who did not sell goods or practice photographs as a trade'. Diversification, too, was the order of the day, with each new group representing a different variant of photographic activity: for example, the Photo-Vélo-Club de Paris organized photographic cycling trips,

the Photo-Postal-Club Français ran exchanges of prints by mail, the *Stéréo-Club Français was dedicated to *three-dimensional photography, and so on. (In 1890s London, a Society of Night Photographers appeared, with an annual Night-Hawks' dinner.) Photography also played a significant part in many societies whose nominal purpose was non-photographic: for example, the Société des Excursionnistes Marseillais—'les buveurs d'air'—founded in 1897, whose members saw the camera as a serious adjunct to hiking, matchmaking, and leisurely meals; 17,000 of their images survive in the Marseille archives.

Whatever their individual peculiarities, the activities of modern clubs were generally much the same, including the organization of competitions, outings, and projection sessions, the demonstration of new techniques, the mounting of exhibitions, and the publication of newsletters. Though the atmosphere might be less academic, there was no fundamental departure from past practices. Still central was the promotion of exchange and interaction between amateurs and the idea of pooling knowledge and talent. This golden age of photographic societies lasted for a good part of the 20th century, both in the West and elsewhere: in Japan, for example, clubs multiplied from the 1900s. It was only in the 1970s and, especially, 1980s, with the growth of individualism both in photography and more generally, that amateurs began to desert the photo clubs, whose numbers, at least in the West, went into steady decline.

The role of associations

At its creation in 1851, the Société Héliographique defined itself as 'purely artistic and scientific'. It was mainly in these two areas that associations made their most effective contribution to photography's expansion and progress. As far as science in general was concerned, societies pressed for the application of photography to medicine, astronomy, cartography, etc. In the narrower field of photographic science (optics, chemistry), they encouraged the development of new processes, partly by organizing regular technical competitions. At the end of the 19th century it was societies—increasingly coordinated in leagues and networks—that campaigned for the codification of practices and the standardization of materials (for example, the format and sensitivity of plates). And, in defending the interests of their members, most of whom were amateurs, they also helped to defend photographic quality, which was often threatened by commercial logic. In the 1980s, for example, it was photographic societies that, by lobbying the industry, prevented baryta-coated *papers being wholly replaced by resin-coated (RC) types.

The associations' non- or anti-commercial stance also favoured the emergence of art photography, and they bred the first artistic movement in the medium's history: *pictorialism. Although, previously, certain photographers had been regarded as artists, and many photographs had had undeniable aesthetic qualities, there had been no fully coherent movement, with its own artists, theorists, critics, journals, debates, and public. It was the society network—from the

*Linked Ring and the *Photo-Secession to the Daguerre Society in Kiev—that created the preconditions and institutional structure for this kind of collective dynamic.

Finally, the societies' achievement was not only scientific and artistic, but historical. For, by first forming collections and archives, then helping to rediscover early images, and finally promoting the study of the medium's practices and discourses, they contributed crucially to the formation of a discipline: the history of photography. CC

See also AMATEUR PHOTOGRAPHY, HISTORY.

Taft, R., *Photography and the American Scene: A Social History, 1839–1889* (1938).

Seiberling, G., *Amateurs, Photography and the Mid-Victorian Imagination* (1986).

Greenough, S., ' "Of Charming Glens, Graceful Glades, and Frowning Cliffs": The Economic Incentives, Social Inducements, and Aesthetic Issues of American Pictorial Photography, 1880–1902', in M. Sandweiss (ed.), *Photography in 19th-Century America* (1991).

Sternberger, P. S., *Between Amateur & Aesthete: The Legitimization of Photography as Art in America, 1880–1900* (2001).

CMOS sensor. See DIGITAL IMAGING.

Coburn, Alvin Langdon (1882–1966), Boston-born British photographer. A young member of the *Photo-Secession group in 1902, Coburn became a key figure in the development of American *pictorialism. He travelled widely, living for periods of time in England, and knew and photographed many of its leading personalities, and writers like George Bernard *Shaw. Coburn was aware of trends in European art and experimented, for example, with *'vortographic' prints, using the ideas of the English-spawned variant of Cubism, Vorticism. An extraordinary technician as well as artist, Coburn created photographic images using gravure, *gum, and *platinum printing techniques, as well as *autochrome. With Clarence *White and Gertrude *Käsebier, he was a founder in 1915 of the group Pictorial Photographers of America. He eventually settled in Wales and became a Freemason, and effectively gave up photography for a period of nearly 30 years between the 1920s and 1950s. Always a deeply spiritual figure, he explained this with the comment 'Photography teaches its devotees how to look intelligently and appreciatively at the world, but religious mysticism introduces the soul to God.' TT

Weaver, W., *Alvin Langdon Coburn, Symbolist Photographer: Beyond the Craft* (1986).

Collard, Hippolyte Auguste (*fl*. 1840–87), French commercial photographer. Known mainly for his topographical and documentary photographs in and around Paris, Collard exhibited at the 1855 Paris *Exposition Universelle, winning several awards for his photographs on paper. In addition to selling genre scenes, he photographed works of art, city views, and newsworthy sights like the street barricades of the *Paris Commune. He also sold photographic materials through his Paris-based company Collard & Cie. KEW

Alvin Langdon Coburn

The Haunted House, 1904

collodion. A viscous, volatile mixture of gun cotton (nitrocellulose, made from cotton wool soaked in nitric acid) damped down with butinol and dissolved in ether with added alcohol. In 1851, F. Scott *Archer described a collodion binder for silver iodide on glass for the production of *wet-plate negatives and, in 1852, collodion positives (*ambrotypes). From 1853, collodion positives were made on metal plates as *tintypes. In the early 1890s, collodion was adapted for silver chloride *printing-out paper, manufactured *c.*1910–*c.*1940. Cellulose nitrate, a substance closely related to collodion, provided the first film support, as 'nitrate' *roll-film (J. Carbutt, 1884), from 1889 until the 1950s, when it was replaced by the much less dangerously flammable cellulose acetate. HWK

collotype, a planographic *photomechanical process and variant of *photolithography, based on work by *Poitevin in the 1850s, Joubert in 1860 (as 'phototype'), and *Albert (as 'Albertype') in 1868. A glass plate is coated with dichromated gelatin: exposure to daylight through a photographic negative selectively hardens the gelatin, while subsequent drying produces *reticulations, resulting in tiny fissures that hold the ink and reproduce tonal gradation as a very fine irregular structure of wavy lines. Collotype was widely used for good-quality reproduction until the improvement of *half-tone printing in the 1890s, and persists today for some limited-edition prints. HWK

colonialism and photography have had a close and, from a modern perspective, troubled relationship. The development of mass-circulation photography and the heyday of colonial expansion were contemporary with one another. Photography was integral to those processes, being used to map and control, creating positivist knowledge of both peoples and places. Photographs were part of the vast flow of information on which the colonial project depended. Often colonialism and photography operated in mutually sustaining ways, the latter creating images of vacant space for settlement, 'primitive' lives to be civilized, and racial categories to be ordered.

There are many strands to colonial photography, embracing *exploration, *anthropological investigation, *missionary activity, big game hunting, and the recording of infrastructural projects such as the building of hospitals, roads, and railways, the management of plantations, and the control of disease and criminality. While individual images in collections from different empires may vary, the narrative of orderly plantations or mines, with a compliant and healthy labour force and a supporting infrastructure of hospitals, 'native' schools, and churches, is constant. To a degree this is also true of private colonial albums, containing snapshots of gardens, servants, sports, local friends, official duties, and exotic pets. These are now important documents of cross-cultural relations in the colonies, giving an insight into power relations and hierarchies at a local level, as experienced by people.

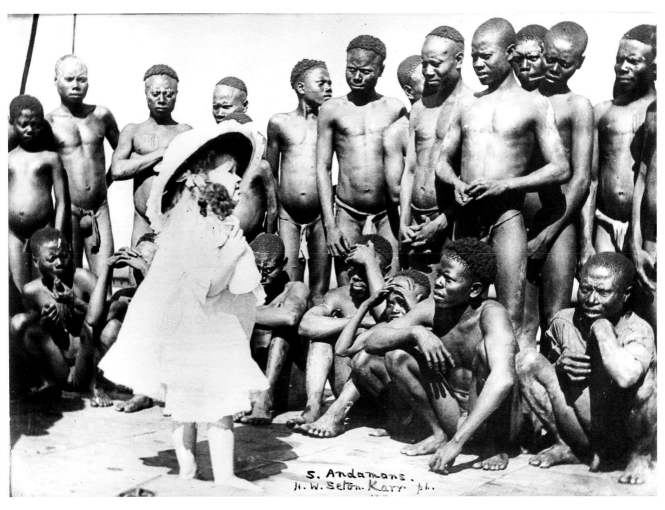

H. W. Seton-Karr

Mary Deane, daughter of the British Census Officer, aboard a government steamer with a group of Onges, Little Andaman, 1911

Exploration and mapping integral to the annexation of territory, e.g. the 'scramble for Africa', was carried out not only by cartographers but also by photographers. Earlier, David Livingstone's famous incursions in the Zambezi region in 1859 had been depicted by John Kirke through maps, sketches, and photographs, the latter suggesting an impenetrable 'darkest Africa'. Military campaigns were also photographed, for instance the British expedition to Benin in 1897, and operations along the frontiers of India. Such photographs were often disseminated as engravings in journals such as the *Illustrated London News* and later as half-tones in papers like the French *L'*Illustration*. Political events were also photographically recorded, such as the handsome volume of 35 tipped-in albumen prints by Augustine Dyer of the New South Wales Government Printer's Office, published to mark the annexation of New Guinea in 1884.

Colonial landscapes were absorbed into a Western aesthetic, and peoples into photographic styles which, if not precisely anthropological,

were inflected with categories of race and culture. J. W. *Lindt's photographs of Australian Aboriginal peoples and the landscape photographs of Samuel *Bourne (India) and John *Thomson (China) are typical of these processes. They made the colonial simultaneously familiar and contained whilst remaining exotic.

Governments were particularly interested in the recording of infrastructure. In 1869, for example, the Colonial Office in London circulated all British colonies with a view to having albums made showing all the principal buildings of each colony. An album in the French Foreign Ministry chronicles the development of communications in Tunisia, from demonstrations of new letterboxes (carefully staged for the camera) to views of telegraph offices. At the same time the geographical societies of the colonial powers increasingly used photography in the process of recording topographical features, flora, fauna, and visible mineral resources. Missionary organizations recorded their activities, often using the photographs to create

lantern-slide sets for fund-raising and informational purposes. Both kinds of images, the official and the semi-private, played a major role in education about the colonies and the economic and moral advantages to be gained through colonial endeavour. Many featured in the popular colonial exhibitions held in the late 19th and early 20th centuries, and were used to illustrate colonial literature aimed at both adults and children. In Britain, at a more formal level, the Colonial Office Visual Instruction Committee developed an empire-wide scheme of illustrated textbooks and slide shows to inspire colonial sentiments at home and to teach colonial subjects about the 'motherland'.

The photography of colonialism not only reflects the problems, injustices, and assumptions of the colonial enterprise, but was an integral part of it. From the late 20th century it attracted extensive critiques, which also revealed some of the alternative histories recorded in colonial photographs. EE

⊃ See also Dutch Colonial Presentation Photographs *opposite*.

Ryan, J., *Picturing Empire* (1997).
Fournié, P., and Gervereau, L. (eds.), *Regards sur le monde: trésors photographiques du Quai d'Orsay 1860–1914* (2000).
Hight, E., and Sampson, G. (eds.), *Colonialist Photography* (2002).
Landau, P., and Kaspin, D. (eds.), *Images and Empire* (2003).

colour reproduction principles

Additive colour synthesis

All present-day colour photography is based on the three-colour principle, originally proposed by Thomas Young (1773–1829) in 1801 to explain the perception of colour by the human eye. He suggested that the retina of the eye contained three types of colour receptor, sensitive respectively to red, green, and blue, and that the range of colours perceived depended on differential stimulation of the three types. He showed that any colour could be simulated by mixing red, green, and blue lights in various proportions. This *additive synthesis* is still the basis of colour television and *digital colour cameras. If three photographs are taken using a red, a green, and a blue filter, they will together have recorded the entire spectrum in three sections. If positive transparencies are made from these 'separation negatives', and projected in register using similar filters, the image on the screen will appear in natural colours. Some types of projection television receiver operate in this way, with separate tubes for red, green, and blue. In conventional receiver screens the colour images are interlaced in a dot pattern too small to be resolved at normal viewing distance. So, for example, what appears to be yellow is made up entirely of red and green dots, and what appears white or neutral grey is made up of all three dots in equal intensities. Digital colour cameras also record the colours in a matrix, though some types of colour receptor record only two colours plus white, computing the third colour by electronic subtraction.

At some time there have been additive colour films on the market in which a panchromatic emulsion was exposed behind a grid of red, green, and blue lines (the best known was Dufaycolor); these films were reversal processed to a positive for projected viewing. They were inherently somewhat dark, as even the brightest highlights transmitted only 33 per cent of the light. The only additive material available today is Polachrome slide film.

Subtractive colour synthesis

The subtractive principle was first proposed by *Ducos Du Hauron in 1869. Instead of adding coloured lights it operates by removing colours from white light. For example, in the additive process yellow is formed by adding red and green, cyan by adding green and blue, and magenta by adding red and blue. In the subtractive process yellow is made by removing blue from white light (a yellow filter transmits red and green but not blue; for this reason it is often called 'minus blue'); similarly, cyan is formed by removing red, and magenta by removing green. Using magenta and yellow together removes both green and blue, leaving red, and the other pairs leave green and blue respectively. Using all three filters in various densities gives desaturated colours such as brown and slate grey.

In the basic subtractive process the original separation negatives are made in the same way as in the additive process, but the subsequent positives are made in cyan, magenta, and yellow dyes, and then superposed in register. When the combination is projected, the cyan image controls the red, the magenta the green, and the yellow the blue, so again the image appears in natural colours. In the earliest processes, e.g. *carbro, the superposition was achieved either by stripping and reassembling the emulsions on one base or, as with *dye transfer, by transferring the dye images in register by imbibition.

Transparency (diapositive) materials

The Kodachrome process was the first 'tripack' process. The three emulsions were coated on top of one another, recording respectively the red, green, and blue components of the scene. The processing method, still extant, is complicated, involving three separate redevelopment stages to produce the three dye images followed by removal of the silver; but the popularity of the process, and the permanence of the colours, have kept it alive. All other materials designed to produce positive *transparencies have the dye couplers incorporated into the emulsion layers. (A dye coupler is an initially colourless substance that combines with developer exhaustion products to form an insoluble dye, and thus forms a colour image wherever developed silver is present.) The initial development process does not involve the dye couplers and produces a black-and-white negative image. A second developer contains a fogging agent and couples to form cyan, magenta, and yellow images in the three emulsion layers; the silver is then removed in a bleach-fix bath. Prints can be made from transparencies by a similar process, the emulsions being coated on a white paper or plastics base. An alternative method uses a dye-bleach system: the dyes are already present in the material, and are selectively bleached by the coloured image. The Polaroid colour processes use a form of dye diffusion: the dyes are inhibited by the negative developing solution released into the emulsion after exposure, and the unaffected dyes diffuse into the transfer material (in one of the two processes) or emerge through an opaque titanium oxide substrate (in the other).

(*continued on p. 134*)

Dutch Colonial Presentation Photographs

On the eve of the Second World War the Netherlands still possessed a worldwide empire. By far its most important component, politically and economically, was the Dutch East Indies: a huge territory comprising thousands of islands, approximately 52 times as big as the Netherlands, stretching over a length of 5,000 km (3,100 miles), and home to more than 300 ethnic groups. In 1945 it became the Republic of Indonesia.

After the bankruptcy of the Dutch East India Company in 1800, state control over the region had intensified, a process that continued throughout the 19th century, resulting in a considerable increase in the numbers of white settlers, officials, and troops. This process coincided with the establishment and spread of photography. However, the medium's role in colonial history, in both the Netherlands itself and the East Indies, has only been studied since the 1990s. Collections still exist, but for a long time the museums and other institutions that house them had no desire to be associated with the colonial past. In Indonesia especially, eyes were on the future. Hence the photographs often ended up in storerooms or attics. By the turn of the 21st century, however, they were being re-evaluated in both places.

Interestingly, many 19th-century photographers who worked in the Dutch East Indies were not of Dutch descent. One of the first, Schaefer, was German. In 1840 he was commissioned by the Dutch government to photograph landscapes and monuments, particularly the temple complex of Borobudur in central Java, the first and, since then, undoubtedly the most photographed monument in Indonesia. The arrival of two English photographers, *Woodbury and Page, promoted the development of a photographic tradition. In 1858 they opened a studio in Batavia (Jakarta) and, although Woodbury returned to England in the early 1860s, the studio continued to exist until c.1910. They travelled extensively throughout the Dutch East Indies taking photographs of local chiefs and dignitaries, as well as highly marketable pictures of landscapes and indigenous peoples; in their studio they also photographed staged scenes from daily life.

One of the first Indonesian photographers was named Cephas, who was active from c.1885, principally at the court of the Javanese sultans in Yogyakarta. He was one of the first to be permitted to photograph ceremonial court life from inside. In addition he was commissioned by the archaeological service to photograph the many Hindu Javanese monuments in central Java, which were attracting increasing scholarly and touristic interest by the end of the 19th century.

By this time it was customary for commercial photographers—as in other parts of the world, from Italy to California—to assemble groups of 'representative' subjects in albums or portfolios, either pre-selected or chosen by the customer. These productions are notable for their high technical and aesthetic quality and their emphasis on 'unspoiled' landscapes and scenes devoid of obvious European influence. The indigenous population with its traditional crafts, rituals, and customs was depicted in as timeless and romantic a manner as possible. Such images, which appear in many collections, were eventually also issued as *postcards.

Many of the Dutch settlers who arrived in the early 20th century, and who enjoyed a standard of living comparable to that in the Netherlands, also created albums. These illustrate colonial existence at micro-level. Often bound in batik or ikat, they show colonists living their everyday lives, their social activities, opulence, and extended families. Eventually they might be shared with friends and relations at home, showing off their owners' success and usefulness in a prosperous, progressively run colonial society.

Most colonists stayed in the East Indies for a few dozen years. The departure of an employee of a private company or a government department was often the occasion for a commemorative album with an underlying theme: the changes that had taken place during the employee's tenure, or the latter's achievements. Albums that take this approach reflect the 'improving' colonial policy inaugurated in the 1910s that focused on bettering the living conditions of the indigenous population. An album marking the retirement of an architect, for example, would show the municipal facilities constructed under his direction. A doctor's album would illustrate medical progress, and a civil engineer's his efforts to expand the railway network.

Finally, albums were sometimes intended to convey status, like those made for 'national' occasions. In 1923, for example, the sultan of Yogyakarta organized a spectacular dance performance to mark the 25th anniversary of Queen Wilhelmina's accession. A photographer was commissioned to record the event. This richly illustrated photographic report in a gold-tooled volume was presented by the local ruler to his queen in the distant Netherlands, and symbolizes the colony's ties to the motherland. Whether photo albums were ever sent in the opposite direction, from the motherland to colonial princes, remains to be investigated. JVD

Groeneveld, A. (ed.), *Toekang Potret: 100 jaar fotografie in Nederlands Indië 1839–1939* (1989).

Groeneveld, A. (ed.), *Fotografie in Suriname 1839–1939* (1991).

Wachlin, S., *Woodbury & Page, Photographers in Java* (1994).

Knaap, G., *Cephas, Yogyakarta: Photography in the Service of the Sultan* (1999).

Colour negative-positive process

In this process the colour film is developed directly to a colour negative. Lightnesses are reversed as in a monochrome negative, and hues are also reversed, red appearing as cyan, magenta as green, and so on. Printing is on similar material, coated on a paper base. The process allows correction in the negative of some of the colour errors inherent in prints from transparencies owing to inadequacies of the dyes. Thus the unwanted blue absorption of the magenta dye is countered by a layer of yellow that is destroyed wherever magenta is formed, and the red absorption of the cyan dye is countered by a red dye destroyed where cyan is formed. This accounts for the orange background colour of the negative.

Digital printers

Digital printers use the same dyes or pigments as commercial *half-tone processes. As the three dyes do not give a good neutral grey when used together, a grey printer is included, and is called up whenever all three dyes would otherwise be used. GS

See also INSTANT PHOTOGRAPHY; PHOTOGRAPHIC PROCESSES, COLOUR.

Farbe im Photo: Die Geschichte der Farbphotographie von 1861 bis 1981 (1981).
Hunt, R. W. G., *The Reproduction of Colour* (5th edn. 1995).
Saxby, G., *The Science of Imaging: An Introduction* (2002).

colour supplements, newspaper. Pioneered by the *New York Times*, magazine supplements were introduced to Britain by the *Sunday Times* in 1962. By the late 1960s, under the overall leadership of Harry Evans, the *Sunday Times Magazine* had become synonymous with stylish photography, and willing to spend lavishly in pursuit of stories from the Beatles to the Six Day War.

Colour supplements filled the gap left by defunct papers such as *Weekly Illustrated* and **Picture Post*. They also exploited the post-1950s availability of colour film that could be 'fixed' far better than that used earlier. Finally, and crucially, the 1960s saw the advent of 'New British' photography. Don *McCullin, Terry O'Neill, David *Bailey, and Antony Armstrong-Jones (Lord *Snowdon)—although much of their work continued to be in black-and-white—and others were breaking down barriers between documentary, fashion, and news imagery. McCullin's portrait of gang members on a north London bombsite, published in the *Observer* in 1959, had already typified it.

The *Sunday Times Magazine* proved immensely popular and belied the assumption that television was everything. Soon every Sunday paper fell in line, and even the tabloids launched mass-market versions of the new magazine journalism. AH

Evans, H., *Good Times, Bad Times* (3rd edn. 1983).

colour temperature is a way of describing the colour of an incandescent light source. The power distribution in its spectrum is related to its absolute temperature in kelvins (0 K is −273.15 °C). A halogen lamp has a colour temperature of 3,400 K, close to its actual temperature; unobscured midday sunlight is around 5,500 K. Some sources such as flashtubes, and fluorescent lamps that resemble

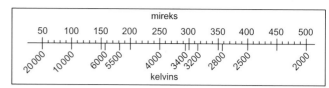

Fig. 1

incandescent sources, are given a *correlated colour temperature*. Colour films are usually balanced for daylight at 5,500 K, but professional films are available balanced for tungsten illumination at 3,400 K.

*Filters for changing colour temperature are specified by their *mirek shift*. 'Mirek' (formerly *mired*) stands for *mi*cro *re*ciprocal *k*elvins (kelvin was formerly 'degree Kelvin'). It is 10^6 divided by the colour temperature. For example, a bluish filter converting tungsten light at 3,200 K (312 mireks) to daylight at 5,500 K (182 mireks) has a mirek shift of $182 − 312 = −130$ mireks. Fig. 1 shows the relationship between colour temperature and mirek value. The colour temperature of sunlight varies throughout the day, becoming as low as 2,000 K near sunrise and sunset, and giving sunlit scenes a pronounced orange cast; the blue colour of the sky is intensified, turning shadows from bluish grey to a deep blue-violet. GS

coma. See LENS ABERRATIONS.

combination printing. See COMPOSITE PHOTOGRAPHS.

composite photographs

Multiple exposure

The straightforward 'double' or 'trick' exposure has long been a stock in trade of photographers, whether they want to create the illusion of a ghost; of a man playing chess with himself; of 'seeing through' a box to show the contents; or simply of merging disparate elements. There are two basic techniques.

The first uses a black background, which does not record at all on the film; the classic material is black velvet, which records at least three stops darker than a mid-tone; or, today, electrostatically coated black flock paper. Whatever is shot against such a background has equal 'weight' in the picture. Thus, for example, a man may be photographed pulling on a rope, with one side of the picture blanked out by a 'matte' in front of the camera lens; the other end of the rope is held by an assistant. The second exposure shows the same man, pulling on the same rope, in the opposite direction, with the other side of the picture blanked out. The main difficulty lies in matching up the rope in the middle. The same technique is used for a man playing chess with himself, or indeed, for two views of the same ballerina in different poses—or for that matter, of a bride and groom superimposed on an overall scene, or apparently imprisoned in a brandy glass. Much the same effect may be obtained by making two separate exposures, both against black backgrounds, and printing the negatives sequentially or together on one sheet of paper.

The second technique makes two exposures of the whole scene, with and without the 'ghost' element. Thus, for example, a camera case might be photographed closed (to show the outside of the case) and open (to show the equipment inside). With a simple 'ghost'—an insubstantial, semi-transparent person—it will normally suffice to photograph the same scene twice, each time for half the optimum exposure, once without the person and once with. With a more complex image, such as the camera case, a degree of masking with black felt or black flock may be necessary. Again, similar effects may be obtained by making a double exposure at the negative stage or at the printing stage, by printing two negatives either successively or together.

Combination printing

This more complex procedure may be employed at the shooting stage but is much more commonly applied at the printing stage. Elements from two or more completely different scenes are combined to create an image which has never had an objective existence. The simplest example is the 'printed in' sky, where a landscape (or any other shot) with a 'bald' sky is printed sequentially with a negative of a cloudscape; masking ensures that only the appropriate part of the paper is exposed. This was the technique used by Gustave *Le Gray in his classic seascapes of the 1850s. However, the undisputed master of complex combination printing was O. G. *Rejlander, whose *The Two Ways of Life* (1857) was made from more than 30 negatives, printed sequentially on the same piece of paper. Modern art photographers such as Jerry *Uelsmann and Andreas *Gursky have used combination printing to create disconcertingly surreal and haunting images. And, in addition to *photomontage, it has been deployed by propagandists to alter records of key events and/or to eliminate disgraced leaders (Leon Trotsky, Alexander Dubček) from group photographs.

The trickery of composite image making was described in great detail in two classic manuals, Marcel Natkin's *Fascinating Fakes in Photography* (1939) and Edwin *Smith's *All the Photo-Tricks* (1940). Today, *digital printing techniques are much easier. RWH

composition. Good composition is easier to recognize than to define. In photography, it may best be defined as the art of selection. First, the photographer selects subject matter, viewpoint, and focal length. This allows him to arrange the chosen picture elements in a pleasing group; to emphasize what is important; and to minimize what is not wanted. Further selection (or emphasis) may be effected by choice of weather conditions; time of day; time of year; focus; filtration; and even materials (high or low contrast or colour saturation).

After shooting, contrast and colour saturation may again be varied, and parts of the image may be selectively lightened or darkened in printing. Beyond this, there are physical cut-and-paste, cropping, airbrush work, and electronic retouching.

To a great photographer, composition is almost instinctive, but those without great natural talent can improve immensely through practice and study. The once-hallowed 'Rules of Composition', described below, are worthless if followed blindly but nevertheless provide a useful means of analysis; can be a fall-back position when all else fails; and are an orthodoxy against which to rebel. The principal 'Rules' are as follows:

- *Focal point*. Every picture should have a natural first resting point for the eye. This is often the principal subject but may equally be (for example) a wheelbarrow in a garden, where the garden is the real subject.
- *Rule of thirds*. Mentally divide the picture into equal thirds, both vertically and horizontally, with two lines in each direction. The 'focal point' of the picture (see above) should be on the intersection of one pair of lines ('on the thirds').
- *Format or orientation*. 'Portrait' (vertical) formats convey loftiness, aspiration, height, the ineffable. 'Landscape' (horizontal) formats convey peace, stability, the long enduring.
- *Line*. Dominant vertical lines within a picture carry the same freight as 'portrait' formats; dominant horizontal lines, the same as 'landscape'. Diagonal lines, as in many *propaganda and *advertising images, add dynamism and energy. Curved lines are supposedly easier on the eye than straight: hence the famous 'S-curve' of the early 20th-century *pictorialists.
- *Tonal mass*. The principal tonal masses in a photograph (whether light against dark, or dark against light) should hang together in coherent shapes, rather than being dotted at random across the picture.
- *Accent*. Small areas or 'accents' of very light or very dark tone can 'lift' a photograph which might otherwise look flat, dull, or muddy.
- *Balance*. Where the tonal masses are all to one side of the picture, it will look unbalanced. A small counterbalancing tonal mass, towards the other side, normally improves the composition.
- *Pattern or compositional shape*. The human eye (or rather, brain) tends to group together the main elements of the picture. This is as true of broad tonal masses as of the faces in a group portrait. Each pattern—line, circle, oval, spiral, square, rectangle, triangle—has its own emotional connotations. The triangle is especially interesting, as it may rest on its base (a 'stable' composition) or on its tip ('unstable'). The avoidance of pattern may be as important as its use, if irrelevant picture elements are not to be given undue prominence.
- *Leading the eye*. A road, a river, a furrow, a garden path: anything can be used to 'lead the eye', which will follow the line to its end—where there should be a point of interest, preferably 'on the thirds' as described above.
- *Concentration of interest*. Something large normally attracts more attention than something small; something sharp, more attention than something soft or out of focus; something bright against a dark background, or dark against a bright background, more attention than something against a background of similar tone.

- *Tonality*. Harsh tonality creates one effect (and emphasizes broad tonal masses against detail), while subtle tonality, with a long, almost liquid transition from light to dark, creates quite a different impression.
- *Colour*. Harmonious colours are tranquil; contrasting colours, whether complementary or merely dissonant, may either attract attention or add energy (or both), depending on how they are used. Furthermore, 'natural' colours (those occurring in nature, or those that look to the eye like a normal scene) are more tranquil and attract less attention than 'unnatural' colours, such as fluorescent hues or colours that are far more saturated than they appear in real life.

Study of the work of any one great photographer will reveal that all the above generalizations are dangerous. But, equally, study of the work of numerous photographers, great or not, will reveal that pictures which obey the 'Rules' and guidelines above are more often successful than pictures which do not. RWH

Feininger, A., *A Manual of Advanced Photography* (rev. edn. 1970).

compression, a *digital process that allows data to be stored or transmitted using a reduced number of *bits. It can be lossless or 'lossy'. The simplest type of lossless compression stores only the data that change from one pixel to the next. Thus a scene of uniform tone and colour takes up less memory than than a complex scene containing a wealth of detail. A more sophisticated system, LZW, also encodes any patterns repeated within the image, and is incorporated in the TIFF (Tagged Image File Format) and GIF formats. The popular compression routine JPEG is a lossy system that separates luminance and chrominance (as does a television signal) and applies lossy compression, the amount determined by the user, to the chrominance signal. The amount of data loss tolerable depends on the desired final use of the image. GS

See also INTERNET.

Tarrant, J., *Digital Camera Techniques* (2003).

Conceptual art. See CONTEMPORARY ART AND PHOTOGRAPHY.

Coney Island. A middle-class beach resort in the 19th century, and in the 20th a sprawl of commercialized entertainment easily accessible from New York City, Coney Island became one of *documentary photography's classic locations. In 1940 *Weegee snapped a girl preening for his camera as lifeguards tried to revive her drowned boyfriend. Lisette *Model did her first *Harper's* assignment there in 1941. Sid *Grossman photographed it in the late 1940s, *Frank in the 1950s (rough sleepers on foggy, deserted beaches), then Bruce *Davidson and Diane *Arbus, drawn by its phantasmagoric mixture of exuberance, tackiness, eroticism, and melancholy. Later generations of New York-based photographers and photography students continued to find it irresistible. RL

Livingston, J., *The New York School: Photographs 1936–1963* (1992).

conservation and restoration of photographic prints. Photographic conservation is the care and repair of original photographic material, enabling it to survive for as long as is practically possible. It includes work on individual photographs and also general care for groups of photographs. Restoration, by contrast, is an individual treatment which aims to return the photograph to its former appearance. It is therefore more subjective than conservation as it involves a significant degree of educated guesswork, particularly, for example, where there is a large missing area to be retouched. It may also involve practices which result in a short-term aesthetic change but a more rapid rate of subsequent deterioration.

Photographic conservation can be considered to have begun almost with the beginning of photography. Early photographers were concerned about the fading of their photographs and the *London Photographic Society set up a 'Fading Committee' which reported in 1855. The recommendations mostly concerned improving the practices used for making the photographs so that they would last longer, rather than improving their aftercare. Interest in developing longer-lasting processes has continued and was particularly prominent in the late 19th century with the wider use, for example, of the *carbon process. In the last few decades of the 20th century the modern field of photographic conservation evolved.

Conservation problems can be broadly divided into three groups, physical, chemical, and biological. Types of *physical* damage are tears, creases, and holes. *Chemical* damage includes problems such as fading, colour change, and tarnishing. *Biological* damage usually results from insects, mould, or rodents. All these types of damage result from a poor environment for keeping photographs.

Modern practitioners of photographic conservation would generally treat physical damage with repair techniques, such as the use of splints of conservation material to mend tears. Chemical damage is often difficult to treat and problems such as fading usually cannot be reversed. In this instance the best that can be achieved is often to improve the environment so that further deterioration is avoided. Biological damage takes many forms, such as holes or discoloration. Sometimes physical repairs will be necessary and at other times chemical treatments may be used.

The general care of photographs is an important part of photographic conservation. The type of environment and the way in which photographs are used can greatly affect their durability. Environmental effects which can dramatically alter the life of the photograph include temperature, relative humidity, light levels, and pollutants. Sometimes addressing these issues requires large-scale solutions, such as air-conditioning for collections. Sometimes a small-scale change in practice is all that is needed, such as not keeping photographs in a freshly painted room, or removing them from direct sunlight. The types of enclosures used for keeping photographs are also important. Damage is often the result of poor housing at the level of sleeves, boxes, cupboards, or shelving. Examples of poor enclosures are brittle brown envelopes or yellowing polyvinyl chloride (PVC) plastic sleeves. Photographs are often very sensitive to a poor storage

Harry Penhaul

Herbert Riddington and his dog
*c.*1950s, before and after restoration

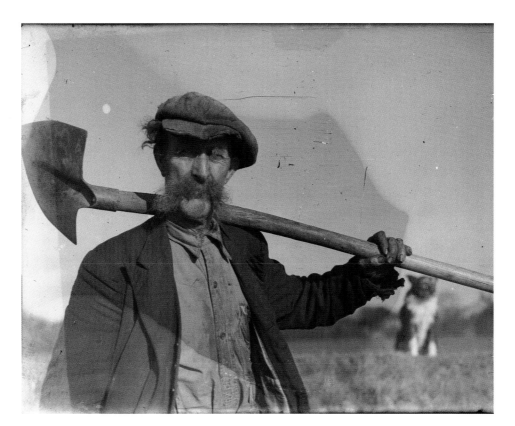

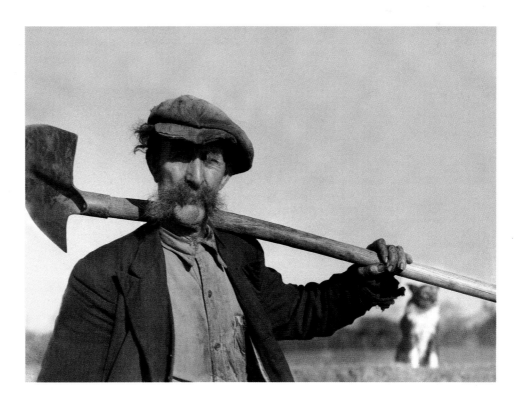

environment and require particularly pure storage materials, free of specific impurities such as acids and sulphur compounds. They also need to be handled and displayed with care to avoid damage. Mounts and frames of poor quality or condition can also cause deterioration. Interest still continues in the development of longer-lasting processes, particularly with the introduction of *digital technology, including digitally created prints and digitally stored information. Manufacturers and the conservation community have begun a dialogue which should result in more stable products.

Restoration has consisted of several elements from the outset. Initially, in the 19th century, it was mostly limited to physical repair and the retouching of missing image areas. However, with conventional black-and-white silver processes, restoration has grown to encompass chemical treatments. These are usually designed to remove tarnish or strengthen the image and are often based on repeating elements of the photographic process. These techniques have mostly been carried out with silver developed-out images, both negative and positive. Problems may arise as the treatments are usually applied to the whole photograph and are frequently difficult to control. Effects may appear such as dark patches in previously light areas. For these reasons, restoration techniques should be applied with caution. Currently many firms offer digital restoration services. These may provide the photograph owner with an aesthetically pleasing result, although digital prints will vary in their longevity. The owner should be aware of the sensitivity of the original photograph to the heat and light present during digitization. Knowledge of the way the photograph will be handled is also helpful, as damage has sometimes occurred during the procedure. SC

Keefe, L. E., and Inch, D., *The Life of a Photograph: Archival Processing, Matting, Framing, Storage* (1990).

contact print. A print made by exposing sensitized material that is directly in contact with a negative. Henry *Talbot described the practice in his 1839–40 notebooks using simple wooden printing frames, a technique that became the standard method of printmaking in the 19th century until bromide developing papers and practicable enlargers were introduced in the 1890s. Some contact printing continues to the present day using silver chloride or slow chlorobromide papers (for many years known as gaslight papers), primarily to maximize the qualities of a *negative. Printing frames and lightboxes are favoured for single prints and machines for commercial multiple copies. JPW

contact sheet. At one time all photographic prints were in contact with the original glass negative. However the 'contact sheet' has become a recognized convention of modern photography, closely associated with use of the 35 mm camera (and to a lesser extent medium formats such as 6 × 6 cm; 2^1/$_4$ × 2^1/$_4$ in). The 24 × 36 mm format typically provides somewhere between 20 and 40 negatives from a single roll of film in normal use. Cutting the reel of developed film into strips of 4–7 frames, and printing these by contact with a single sheet of photographic paper, allows all of the pictures from a given roll to be viewed on one page. A variant of the technique is to make an enlarged 'contact' sheet by placing the negative strips in a large-format enlarger, so that all can be seen on one very large sheet of photographic paper. Today, even image-processing software such as *Adobe Photoshop typically contains the option to make a 'contact sheet' from a group of images, though this term is completely misleading in a digital context.

Contact sheets emerged in the 1930s, when the *Leica and its imitators were first being used by editorial and commercial photographers, as a quick method of editing the large number of pictures that could be made with a 35 mm camera. It subsequently developed into a vital part of the photojournalistic process, as well as of amateur practice. It allowed the photographer or editor to choose from the sequence of images, and to see how an event had occurred, as well as its aftermath. It also gave an idea of how a photographer had worked on a visual idea, so that the contact sheet could be seen as almost an artist's notebook. When entry to the *Magnum agency was still largely controlled by Henri *Cartier-Bresson in the 1950s and 1960s, aspirants would have to show him their contact prints, rather than enlargements, for approval. PH

Contacts: les plus grands photographes dévoilent les secrets de leurs images (2 DVDs, 2000).

contemporary art and photography. *Pop art in the 1960s elevated mass-media images to the status of prime material, but artists still transferred photographs on to canvas. It was Conceptual art, a major force by the 1970s, that swept away traditional fine-art hierarchies based on the status of certain media—namely painting and sculpture—as intrinsically 'finer' than others. (There were other symptoms of a changing climate: for example the posthumous exhibition of Diane *Arbus's work at the 1972 Venice Biennale, the first photographs to be shown there.) Following the ideas of Marcel *Duchamp, artists and critics began to argue that the artist's role was no longer to produce objects but visual concepts, realized and communicated via the most appropriate materials, regardless of their status. Ideas, processes, and experience were to be paramount, rather than the final product. Inspired by the counter-culture and political activism of the 1960s and 1970s, artists worked against the commodification of art, evident since the 1960s art-price boom, by producing works that were ephemeral, geographically inaccessible, or highly theoretical. In the process, photographs became one of the most accessible objects on the gallery wall, easy to sell and collect. Robert Smithson's (1938–73) *Spiral Jetty* (1970; now destroyed), an unstable earthwork in the Great Salt Lake, Utah, was accessible mainly through the films and photographs he made of it. Gilbert and George's (Gilbert Proersch, b. 1943; George Passmore, b. 1942) *Living Sculptures* (1969), performance pieces enacted in or outside the gallery, survive mainly as photos and video footage, and early in their work they blurred distinctions between the performance, its record, and their real-life personas (*A Portrait of the Artist as Young Men*, 1972).

Ana Mendieta (1948–85) used her own body to create various *Silueta Works* in the 1970s, temporary silhouettes on the ground made from ephemeral materials such as snow, sand, flowers, or stones; the colour photographs she produced were intended as souvenirs of an essentially private ritual. Eleanor Antin's (b. 1935) performances and temporary installation works, such as *100 Boots Turn the Corner* (1972), one of a series based on siting 100 boots in various public places, were staged primarily for the camera. Many artists began to use photography not as a medium per se, but as part of their interest in *semiotics, their engagement with mass culture, and their preoccupation with hybrid practices and lens-based images. In *Women and Work: A Document of the Division of Labour in Industry 1973–75* by Margaret Harrison, Kay Hunt, and Mary Kelly, photographs function as documents that give women workers an individual visual identity. If the final piece looks beautiful, it is not because of the aesthetic quality of the individual images, but because of the care and visual rigour with which the whole piece—images, texts, numerical information, etc.—is composed, framed, and presented.

By the 1980s, in a politically and culturally more conservative international climate, the art world was returning to more object-based practices, but in the meantime a new generation of artists, curators, and collectors had been brought up to consider photography as one medium amongst many from which art could be made. A variety of practices acknowledging the contingency of cultural codes, including photographic ones, developed away from traditional values of art photography such as craft and self-expression. Artists, photographers, and critics focused on how the endless production, reproduction, and circulation of images had rendered trivial the notion of originality which had hitherto underpinned the artist's privileged status and photography's exclusion from the fine arts. In works such as *Untitled (After Karl Blossfeldt: 2)* (1990), Sherrie Levine's (b. 1947) rephotographed reproductions, rather than original prints, of well-known images by famous photographers (she had begun in the 1980s with Edward *Weston and Walker *Evans) questioned their status as 'original' works and, incidentally, underlined the fact that the medium's recognized 'masters' were largely male. Richard Prince (b. 1949) found his sources in magazines, rephotographing images by changing the crop, focus, or colour, and recomposing them in new series, such as *Girlfriend* (1993), which isolated and made visible the devices used in advertising and magazines to arouse desire. Cindy *Sherman, too, subverted images from popular culture in her photographic re-enactments of clichés of femininity.

One of the concerns of conceptual art was the idea of identity, including gender and racial identity, as culturally determined and socially constructed rather than essential, and artists such as Carrie-Mae Weems (b. 1953)—*Burnt Orange Girl (Colored People)* (1989–90)—and Yinka Shonibare (b. 1962)—*Diary of a Victorian Dandy* (1998)—continue to use the camera as a political tool. The commercial and critical success of many of these practitioners, who define themselves as artists rather than photographers, and do not necessarily work exclusively in one medium, problematizes established museological

categories of distinct painting and photography collections. Photography's assimilation into art has been brought about by the redefinition of art away from medium-specificity. Diverse and hybrid practices are taken up by artists according to the visual and conceptual concerns of their current projects, recognizing the camera as the main source of the world of images we live in today. The Mexican Gabriel Orozco (b. 1962) uses photography to record the unintentional presence of sculpture, or its potential, in everyday life. He often fabricates makeshift scenes and impromptu arrangements, using temporary material and everyday locations. In *Gatos y sandías* (*Cats and Watermelons*, 1992), pictures on tins of cat-food echo the green striated patterns of the watermelons on which he has arranged them. A moment of gleeful pleasure, of art inspired by supermarket shelves, whose display logic Orozco at once mimics and disrupts, is brilliantly re-evoked by a photograph which also makes visible the globalization of even the humblest foodstuff.

Wolfgang Tillmans (b. 1968) began his career photographing the London club scene and creating spreads for the magazine *i-D*. He achieved international fame for his informal photographs of friends, part street fashion, part record of the fleeting, ever-changing look of contemporary life. When he won the Tate Gallery's Turner Prize in 2000, reviewers pointed out that he was the first fashion photographer to do so. But the boundaries between artistic and commercial imagery have long been blurred, as magazines commission established artists to shoot fashion features, and fashion photographs are sold in galleries. In new museums such as London's Tate Modern, fashion photographs may be exhibited in the same section as canonical paintings of the nude.
PDB

See also PAINTING AND PHOTOGRAPHY.

Ianus, E. (ed.), *Veronica's Revenge* (1998).
Walther, I. F. (ed.), *Art of the 20th Century* (2000).
Marien, M. W., *Photography: A Cultural History* (2002).
Campany, D. (ed.), *Art and Photography* (2003).

contrast is one of many things in photography that is easier to recognize than to define. One scene may have tremendous extremes of brightness, yet not seem particularly contrasty because there are no sudden juxtapositions of light and dark. Another may have quite a low overall brightness range, yet seem very contrasty because of dramatic juxtapositions of light and dark.

In the transition to the final print, the scene with the long brightness range and low apparent contrast may benefit from rather more print contrast than the one with the short brightness range and high apparent contrast. The aesthetic side of contrast is something that can only be developed by practice, but the technical side is susceptible of rather easier control.

The path between subject contrast and print contrast is long and sometimes tortuous, incorporating as it does *lens contrast*, *film contrast* (including development technique), *enlarger contrast*, and *paper contrast* (including again development). Increases or decreases in contrast at any of these stages, relative to a largely illusory or at best

statistical 'average', may require compensatory adjustments in the opposite direction; whether in order to bring the final print closer to the photographer's vision or simply to compensate for mishap.

Generally, a contrasty *lens* allows subtler gradations of tone in a contrasty scene, because of lack of veiling *flare; but sometimes the contrast-flattening effect of an older lens can create a mood that is actually more attractive.

Film contrast (much influenced by development) may be increased to suit a flat subject or reduced to suit one with a long brightness range: 50 per cent extra and 15 per cent reduction are good starting points. Film that has been exposed through a modern, contrasty lens will need less development (and, usually, more exposure) than one that has been exposed through an old, uncoated lens, in order to maintain the same negative *density range with a given subject, though the tonality will not be the same. With the flary lens, the shadows will be 'filled' to some extent by flare, increasing effective film speed and lowering shadow contrast.

Enlarger contrast depends both on the light source and on the enlarger lens, but assuming an equally contrasty lens in both cases, a condenser enlarger will give more contrast than a diffuser enlarger. The old rule of thumb was that the condenser enlarger printed about a stop harder than the diffuser, i.e. that it required paper one grade softer or negatives developed to a lower contrast in order to print on the same grade.

Finally, *paper contrast* may be expressed simply, or with some precision. Put simply, if a print is flat and grey looking, it will usually benefit from being reprinted on a harder paper grade; but if there are pure blacks or pure whites (or worse, both) where there should be subtle greys with texture and detail, it will usually benefit from being reprinted on a softer grade. For more precision, to replace the old subjective terms of 'soft', 'medium', and 'hard' (or 'vigorous'), the most useful measure is the ISO(R) of the paper. This is the log exposure range required to give a full range from black to white, to two places of decimals, with the decimal point removed. Thus, a Grade 5 paper might have an ISO(R) of around 40 (0.40, $1^1/_3$ stops) while Grade 00 may be ISO(R) 160 (1.60, $5^1/_3$ stops). ISO(R) figures give a means of comparing different manufacturers' grades: 'Grade 2' is likely to be anywhere in the range of 90 to 100, for example. RWH

See also OPTICAL TRANSFER FUNCTION.

Hicks, R., and Schulz, F., *The Black and White Handbook: The Ultimate Guide to Monochrome Techniques* (1997).

Cooper, Thomas Joshua (b. 1946), American photographer whose fastidiously crafted monochrome images equate the grandeur and lyricism of the natural world with spiritual revelation. Born in San Francisco, he moved to England in 1972 to teach at Trent Polytechnic, Nottingham. In 1982, after a short period as a freelance, he became the founding head of the department of fine art photography at Glasgow School of Art. Using a late 19th-century 20 × 25 cm (8 × 10 in) *field camera, he makes connected bodies of landscape work in which metaphysical concerns take precedence over topographical meaning. His approach is distinguished by his preference for presenting works in triptych or multiple-image format, with the different modes of his engagement with the landscape identified by the use of titles such as 'Guardian', 'Indication Piece' or 'Premonitional Work'. In addition to his extensive practice as an exhibiting artist, he has produced a number of artist's books, including *Between Dark and Dark* (1985), *Dreaming the Gokstadt* (1988), and *Simply Counting Waves* (1994). With Paul *Hill he published *Dialogue with Photography* (1979), a collection of interviews with 21 master photographers. RMCK

copyright. See FINE ART COPYRIGHT ACT; LAW AND PHOTOGRAPHY.

Cordier, Pierre (b. 1933), Belgian experimental photographer who studied briefly with Otto *Steinert in 1958. Two years earlier, however, Cordier had invented the chemigram, a technique of abstract image making in which the texture of the photographic emulsion is affected by various substances, rendering light simply another ingredient in the process, rather than the determining factor. The technique combines the physicality of painting with the chemistry of photography, calling into question the chemigram's status as a photograph. It has become a widely used method of experimental photography. MR

Cordier, P., *Chimigrammes* (1988).

Cornelius, Peter (1913–70), German photojournalist and colour photographer. In 1949, after war service and captivity, he resumed an interrupted career in his native Kiel, specializing in reportage, landscape, and sailing photography. From 1956 he became one of the first post-war German photographers to experiment systematically with colour film as a medium of both artistic expression and reportage. With six other photographers, including Walter Boje (1905–92), Erwin Fieger (b. 1928), and Heinz *Hajek-Halke, Cornelius participated in the exhibition *Magie der Farbe* (*Magic of Colour*) at Photokina in 1960 (pub. 1961), which demonstrated the creative possibilities of colour as it was poised to conquer the mass market. He published *Farbiges Paris* in 1961, and numerous articles on colour photography. UR

Cosindas, Marie (b. 1925), American photographer. She trained as a painter, but changed to photography in the 1960s. Tackling black-and-white first, she studied with Ansel *Adams before becoming interested in colour. In 1962 Edwin *Land asked her to test his new Polacolor film, and from then on she produced memorable portraits and still lifes with the saturated colours it provided. With William Clift, Walter Chappell, Minor *White, and Paul *Caponigro, Cosindas belonged to the Association of *Heliographers, New York. KEW

Marie Cosindas: Color Photographs (1978).

Cottingley Fairies. In July 1917 two young girls, Elsie Wright and her cousin Frances Griffiths, photographed fairies beside a stream near Elsie's house in Cottingley, near Bradford, Yorkshire. What started as a practical joke was to become the world's most famous and long-running photographic hoax.

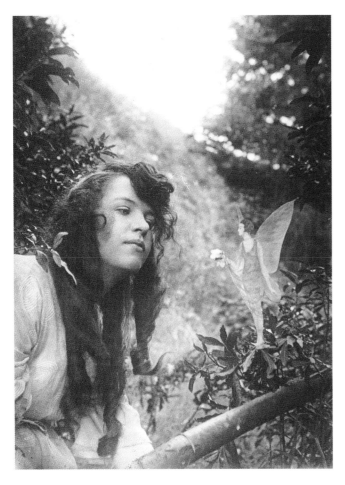

Elsie Wright and Frances Griffiths

Fairy Offering Flowers to Iris, 1920

Elsie had borrowed her father's camera and the following day, when he printed the resulting negatives, he was amazed to see fairies. Two months later, the girls borrowed the camera again. This time, Frances photographed Elsie apparently playing with a gnome. Here the whole affair would probably have ended, had not the photographs, in 1920, come to the attention of Edward Gardner, a prominent researcher into the paranormal. (Probably because of the trauma of the First World War, interest in the supernatural was at a peak.) They were subsequently seen by Sir Arthur Conan Doyle, who arranged for cameras to be given to Elsie and Frances so that they could take more fairy pictures. The girls produced three more photographs which were reproduced in *The Strand* magazine and in a book by Conan Doyle, *The Coming of the Fairies* (1922). The story spread rapidly and the girls became the focus of media attention, much of it unwanted.

Over the years, the 'Cottingley Fairies' continued to capture the public imagination, and it was not until 1983 that Elsie and Frances finally admitted that the photographs were fakes and that the 'fairies' had simply been cardboard cut-outs. The hoax, however, had been skilfully done, and perhaps succeeded at least partly because of the assumption that girls were incapable of such ingenuity. CWH

See also OCCULTISM AND PHOTOGRAPHY.

Cooper, J., *The Case of the Cottingley Fairies* (1990).

country house photography

Whenever our aristocratic amateur goes by rail or road to visit his other aristocratic friends, his Calotype chest forms, as a matter of course, a part of his luggage. He reaches Whatdyecallit Castle a full hour before dinner; the Calotype chest is opened,—the camera mounted,—the three spidery legs produced to their full length; and, by the time that the first bell has rung, our amateur has secured a very good Garden-front and North-wing. *This gives him favour in the eyes of them that sit at meat.* (Cuthbert Bede, *Photographic Pleasures*, 1855)

Country houses played a major part in the medium's early history. Nicéphore *Niépce at Saint-Loup de Varennes, Henry *Talbot at *Lacock Abbey, Wiltshire, John Dillwyn *Llewelyn at Penllergare, South Wales, Clementina *Hawarden at Dundrum, Co. Tipperary, and Julia Margaret *Cameron at Freshwater, Isle of Wight, did much or all of their most important work on country estates. As Bede's comments indicate, photography very soon became part of house party culture. Country houses offered practically everything that the early photographer needed: picturesque surroundings, models, darkroom and storage space, and manpower for shifting cameras, plates, and water. The golden age of country house photography coincided with the swansong of country house life, ending finally in 1939.

Only a fraction of the country house photographs made in this period survive. Countless collections have been destroyed or lost or, probably, moulder in attics. Tens of thousands of photographs must have been taken on Russia's rural estates during tsarism's last decades; but revolution, civil war, and emigration did away with them. (Exceptions include photographs of the imperial family at their

Anon.

Garden party, Morton Hall, Norfolk,
June 1887. Albumen print

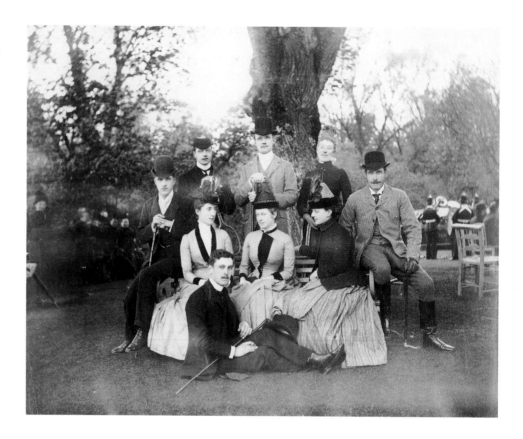

country retreats; and the work of the Greek expatriate Mary *Paraskeva at Baranovka in the Crimea.) Much more survives from peaceful Britain in the 19th and early 20th centuries, and rediscovered collections continue to arrive in salerooms and record offices. One of exceptional quality, auctioned in 2000–1, was created by William, 2nd earl of Craven (d. 1866), at the family home at Ashdown, Berkshire, in the 1850s and early 1860s. Many British photographers were women: in the 1850s and 1860s alone, for example, Lady Lucy Bridgeman of Weston Hall, Shropshire; the sisters Lady Augusta Mostyn and Lady Caroline Nevill; and Lady Fanny Jocelyn, stepdaughter of Lord Palmerston and a frequent photographer of social and political gatherings at his mansion at Broadlands, Hampshire. In *Ireland, Francis Edmund Currey, the absentee duke of Devonshire's steward at Lismore Castle, Co. Waterford, took *calotypes in the 1840s and *wet-plate pictures in the 1850s. Edward and Louisa Tenison made calotypes of their home at Kilronan Castle, Co. Roscommon, and other Irish seats. Over 3,000 glass negatives survive from the Clonbrock family, whose photographic tradition began with the marriage of an enthusiastic amateur, Lady Augusta Crofton, to Luke Dillon, later 4th Baron Clonbrock, in 1866. Soon afterwards they built a fully equipped 'Photograph House' in the grounds of their house near Ballinaske, Co. Galway. Another outstanding figure was Mary, countess of Rosse, of Birr Castle, Co. Offaly, the wife of a leading amateur astronomer. She took up photography in 1853 while

expecting her last child, installed a 'camera room' in the castle, and mastered both the *waxed-paper and wet-plate processes. Her few surviving views and portraits are of striking quality. In France, finally, the rich amateur Henry Bevan is notable for the pictures he took in the 1860s and 1870s of the house of his uncle, the banker Horace Mallet, and other relatives living in considerable splendour at Louveciennes outside Paris.

As already indicated, the country house offered practically every kind of subject favoured by the 19th-century amateur, from everyday objects—Talbot's *Breakfast Table* of 1840, for instance—to still lifes of armour and antique bric-à-brac, farms and outhouses, servants and estate employees at work, children playing or demurely posed, and guests playing croquet or, as technology improved, more energetic games like tennis and cricket. (Much early *sports photography was done at country houses.) Dogs and horses, outsize salmon and trout, and piles of slaughtered game were also recorded. *Photographic amusements—distorted mirror images, spooky double exposures, and the like—also became a staple of country house entertainment.

The definition of country house photography can be stretched in several directions. First, by 1900 many suburban business and professional families were enjoying and photographing elements of a country house lifestyle, from amateur theatricals to motoring. Classic examples include the *Lartigues at Courbevoie near Paris, the *Austens on Staten Island, New York, and the Atkinsons at Huby, Yorkshire,

whose rescued photographs were published by Colin Gordon in *A Richer Dust: Echoes from an Edwardian Album* (1978). Secondly, not all the photography that took place at country houses was done by amateurs. Between 1859 and 1862, for example, the *Schneider family of daguerreotypists toured the estates of eastern Germany and Russia photographing houses, parks, groups of servants, dogs, and whatever else their patrons would pay for. In 19th-century Britain, professionals were called in to photograph important occasions like coming-out balls, weddings, and royal visits; also corpses before burial. George Washington *Wilson might be summoned to record a royal engagement at Balmoral, or a visit by Gladstone to the earl of Aberdeen at Haddo House. In the 1870s Henry *Taunt of Oxford functioned as official photographer at Disraeli's political house parties at Hughenden in Buckinghamshire. Thirdly, and as cameras became handier, country house photography as a record of upper-class life extended beyond the park gates, to grouse moors, regattas, race meetings, and exclusive vacation spots in Switzerland or on the Riviera. The albums compiled between 1904 and 1909 by Prince Otto zu Sayn-Wittgenstein-Berleburg (1842–1911), for example, one of Europe's most cosmopolitan grandees, chronicle not only picnics at home in Bavaria but travels and social occasions across the Continent. By 1914, however, the activities of the rich and famous at, for example, the events of the 'English season' were also the target of professional photojournalists (e.g. Horace *Nicholls) working for a picture-hungry mass press.

After the First World War, except in Russia, country house life continued, although often less opulently. Social life became less formal and more mixed, with entertainers like Charlie Chaplin and Noël Coward rubbing shoulders with royalty at events like the house parties hosted by the British millionaire Sir Philip Sassoon. By the 1920s and 1930s practically every potential guest (and doubtless many servants) had at least a *Kodak, and amateur cine-cameras were also proliferating. Not to be forgotten, finally, were the activities of England's cultural elite. The painter Vanessa Bell, sister of the novelist Virginia Woolf (and great-niece of Julia Margaret Cameron), photographed life at her Sussex farmhouse, Charleston, as did other members of the Bloomsbury–Charleston circle, including Woolf herself, Vita Sackville-West, and the painter Dora Carrington. At Garsington Manor outside Oxford, Lady Ottoline Morrell used expensive German equipment to record her own, overlapping coterie between 1915 and 1928. RL

Heilbrunn, C. G. (ed.), *Lady Ottoline's Album* (1976).
Bell, Q., and Garnett, A., *Vanessa Bell's Family Album* (1981).
Seiberling, G., *Amateurs, Photography and the Mid-Victorian Imagination* (1986).
Sykes, C. S., *Country House Camera* (1987).
Davison, D. H., *Impressions of a Countess: The Photographs of Mary, Countess of Rosse 1813–1885* (1989).

Crane, Arnold (b. 1932). American photographer, best known for his informal portraits and nudes. His freelance work in the 1950s reflected his interest in documenting the diversity of everyday life.

After a decade of legal training and practice he returned to photography in the late 1960s and embarked on a lengthy project to portray eminent photographers. The series, including Ansel *Adams, Bill *Brandt, and *Man Ray, appeared as *The Other Side of the Camera* in 1995. He also took many close-ups of the female nude, in 1992 describing this work as 'textural-visceral landscapes of the human female form'. LAL

Crickmay, Anthony John (b. 1937), British theatre and portrait photographer. Crickmay has been a versatile photographer since he entered the profession in 1961, and his stage, fashion, editorial work, and portraiture has appeared in many British and overseas publications. He has photographed Queen Elizabeth II and her mother (on the latter's 90th birthday), and spent a year documenting the British Prime Minister, Tony Blair, and his family. But he is best known as a dance photographer, working for many ballet companies and publishing eight books between 1976 and 1990. In 1991 he had an exhibition at the Theatre Museum, London. CF

'criminal type'. See BERTILLON, ALPHONSE; GALTON, SIR FRANCIS; POLICE AND FORENSIC PHOTOGRAPHY.

criticism of photography, written evaluation of the medium, and of the work of individual photographers. From 1839 onwards, photography's critics tried to grasp the significance of the new phenomenon using existing categories and values. Initially this meant comparing it to established ways of making images, namely painting and drawing. Within this context, judgements varied: the French poet and art critic Charles Baudelaire (1821–67), discussing photographs exhibited at the Salon of 1859, thought it a punishment wrought by a vengeful God against an insensitive people; Lady Elizabeth *Eastlake, writing in more restrained tones in the *Quarterly Review* in 1857, found photography limited as a creative medium in its own right, but potentially of great value to artists in making accurate depictions. Later, the terms of the discussion changed dramatically. By the 1920s art critics were thinking and writing about photography as an independent medium, for readers who shared that understanding. Others used specifically photographic aesthetic values in the construction of a photographic history. Nonetheless, the prevailing critical values concerning photography have long been and still commonly are generated, written, and read within a discourse of visual art.

However, those critics able to step back from the assessment of photography's status as art and consider it as a technology with broad implications for all forms of communication have necessarily been the ones to develop a critical position with regard to photography as a whole. Tellingly, perhaps, a disproportionate number of them approached photography from the study of language and literature. The American physician and writer Oliver Wendell *Holmes proposed, in 'The Stereoscope and the Stereograph' (1859), an image of photography as a kind of 'currency', supporting a potentially infinite

exchangeability in surfaces or 'skins' of objects, landscapes, events, and people. The literary critic Walter *Benjamin, writing in Germany and France as the Nazis rose to power in the 1930s, envisioned photography in terms of a politics of culture, a means of undermining such categories as 'genius', 'originality', and 'mystery' that have historically made high culture the exclusive province of the middle class.

Throughout his study of how we make meaning from what we see, *Camera Lucida* (1981), the French post-structuralist critic Roland *Barthes was concerned with the diverse and intimate forms of photographic meaning. He was among the first to devote serious critical attention to *advertising photographs, proposing a mechanism through which such images persuade their audiences. Acknowledging her admiration for Benjamin and Barthes, Susan *Sontag represented her own convictions about photography's enormous and continuous effect on all of us in her 1977 book *On Photography*. She continued to write about how photographs function both to represent and to obscure events on an intimate and a global political scale.

Sontag's book was read in the 1970s against the background of a sharp rise in interest in photographic collecting, both private—as reflected in escalating prices for classic images—and public, as many art museums, particularly in the USA, established departments of photography. In the context of widening public interest, journals such as *Afterimage* in America and *Ten-8* in Britain offered outlets for critical discussions of photography and lens-based imagery. Photographic history and theory also began to be taught at universities, giving further stimulus (and material support) for photography criticism. Academia also supplied critical tools for examining photography's relationship to language, such as Jacques Lacan's (1901–81) psychoanalytical theories and Michel Foucault's (1926–84) discourse analysis. The art historian and critic Rosalind Krauss's writing was particularly influential in showing how photographic images are understood within historically specific discourses. Her work further underscored photography's status as the *trace*, or physical mark, of a past event.

Contemporary criticism of photography is often embedded in a broader discussion of the impact of *digital technologies. Some suggest that the ease and speed of making, manipulating, sending, and reproducing photographs in digital form has substantially undermined the medium's status as a trace, and so begun to erode the identity of photographic criticism as a distinct and coherent discourse. NRO

Krauss, R. E., 'Photography's Discursive Spaces', in *The Originality of the Avant-Garde and Other Modernist Myths* (1985).

Trachtenberg, A. (ed.), *Classic Essays in Photography* (1980).

Jussim, E., *The Eternal Moment: Essays on the Photographic Image* (1989).

Amelunxen, H. v., et al. (eds.), *Photography after Photography: Memory and Representation in the Digital Age* (1996).

Barrett, T., *Criticizing Photographs: An Introduction to Understanding Images* (2nd edn. 1996).

Malcolm, J., *Diana & Nikon: Essays on Photography* (2nd edn. 1997).

Pieroni, A., *Leggere la fotografia: osservazione e analisi delle immagini fotografiche* (2003).

Cromer, Gabriel (1873–1934), French photographer and photographic collector. He joined the *Société Française de Photographie in 1912 and organized part of its major historical exhibition in 1925; in 1927 he became its librarian. As a collector he acquired *c*.700 *daguerreotypes, many rare items of equipment, and a huge photographic library. Part of the collection was bought in 1939 by Eastman Kodak and shipped to America just after the outbreak of war. The rest was acquired some years later. The whole collection is held by the *International Museum of Photography at George Eastman House. RL

Buerger, J. E., *French Daguerreotypes* (1989).

Cromer's Amateur, an accomplished French *daguerreotypist, probably a wealthy amateur, *c*.100 examples of whose work were collected by Gabriel *Cromer. The Amateur was active in the 1840s and 1850s, producing outstanding portraits and self-portraits, street scenes, pictures of his children, and still lifes and interiors clearly influenced by 17th-century French and Dutch painting. Some images were copied by rephotographing. Especially poignant is a picture of a street organ-grinder, sharply focused but with ghostly images of children in motion around him. The daguerreotypes are held at the *International Museum of Photography at George Eastman House. RL

Buerger, J. E., *French Daguerreotypes* (1989).

Cross-Channel Photographic Project (Mission photographique Transmanche), an ongoing programme, launched in the early 1980s by the Centre Régional Photographique Nord-Pas de Calais, to fund portfolios freely inspired by the Channel Tunnel. Participating photographers, from many countries, have included Lewis *Baltz, Marilyn Bridges (*Vue d'oiseau*, 1996), Bernard *Plossu, and Josef *Koudelka. Martin *Parr's 1989 essay *One Day Trip* explored the experiences of British cross-Channel shoppers; other projects have focused on Tunnel-related portraits, construction sites, and landscapes. RL

Devin, P., 'La Mission Photographique Transmanche', in *160 ans de photographie en Nord-Pas de Calais* (2001).

Cruel and Tender: The Real in the Twentieth-Century Photograph exhibition, held at Tate Modern, London, and the Ludwig Museum, Cologne, in 2003. A large-scale show of *documentary-realist photographs featuring substantial selections of work by Walker *Evans, August *Sander, Albert *Renger-Patzsch, and a range of late 20th-century photographers including Bernd and Hiller *Becher, Philip-Lorca *diCorcia, William *Eggleston, Andreas *Gursky, Boris *Mikhailov, and Fazal *Sheikh. It was Tate Modern's first exhibition dedicated wholly to photography. The title referred to Lincoln Kirstein's characterization of Walker Evans's work in the 1930s: 'Tender cruelty'. RL

cruise-ship photography. Modern cruise-ship passengers, especially males, sport a formidable array of imaging devices, and

photography is as crucial to the cruise experience as eating and sightseeing (which it often records); a ten-day trip aboard a large liner will generate thousands of pictures. The professional's function is partly to supply batteries, memory cards, *minilab facilities, and so on; but partly to exploit the opportunities for 'special occasion' photography that arise (e.g. birthdays and anniversaries) or are built into the schedule (embarcation, the captain's cocktail party, 'crossing the Line', arrival at exotic locations, stipulated formal meals). As, for example, with *wedding and *makeover photography, the professional thrives on the gulf between amateur equipment and amateur skills. Large vessels may offer a purpose-built studio; otherwise, lights and a range of fantasy backdrops can be temporarily rigged in a bar or saloon. A proportion of the pictures may be recycled as publicity material. RL

Graves, J., *Waterline: Images from the Golden Age of Cruising* (2004).

Crystal Palace. See GREAT EXHIBITION.

CT scan. See MEDICAL PHOTOGRAPHY.

C-type print, a generic term currently used to identify the most popular means of producing colour prints and enlargements derived from negatives. It was originally used to describe negative material printed on Kodak Ektacolor and Kodacolor Type C papers developed in the 1940s and 1950s. Both were three-colour papers incorporating chemical couplers, which promoted the formation of dyes sufficiently stable to produce good colour prints from contemporary Ektacolor and Kodacolor negatives. Similar modern colour papers with enhanced dye stability are now widely available and commonly used for exhibition prints and in high streets and *minilabs. JPW

Cuba. Cuba's photographic history parallels the world's. The first Havana views, by Pedro Tellez de Giron, date from March 1840. In the next decade, international itinerants like G. W. Halsy, R. W. Hoit, and Antonio Rezzonico produced conventional portraits. A Spaniard, José Gómez de la Carrera (c.1840–1908) established a Havana business in 1865, photographing primarily for newspapers. The work of another, Elias Ibañez, who photographed the Ten Years War (1868–78), was published in *Album de La Paz* (1878). By the 1880s, as tourism increased, so did souvenir views and images of picturesque agricultural workers by Gómez de la Carrera and others. In 1898 the wreck of the USS *Maine* was widely represented in popular stereograph sets. Cuban photojournalists Lopez Quintana and Mariana Gonzáles Blanco photographed sharpshooters drilling and the aftermath of battle. In the USA, magic-lantern slides and motion pictures brought the first images of Cuba to many. *Our Islands and their People*, published in New York in 1899, was an outsize two-volume set of lavish chromolithographs from photographs by Walter B. Townsend and others.

Important collections of early Cuban photographs originated from the Cuba Company, active in sugar, tobacco, and railways from 1894 to 1960, and the *Detroit Publishing Company, including work from 1900 by William Henry *Jackson. Other Americans working in Cuba at this time included Sumner Matteson (1867–1920), who travelled throughout the island for *Leslie's* in 1904, recording sponge fishing, banana packing, and the faces of the inhabitants. These tropes continued into the early 20th century, with fashionable studios like that of Joaquín Blez (1886–1974) recording the artistic and elegant, while journalists like Moisés Hernández (1877–1939) documented factories and schools. In 1933, Walker *Evans produced some notable Havana street scenes and portraits of dockworkers. In the 1940s and 1950s Constantino Arias (1920–91) photographed Havana nightlife juxtaposed with the increasing struggle against the Batista regime. At this time Cuba was also a centre for the production and sale of pornographic photographs for tourist consumption. In 1953 Alberto *Korda opened a studio for fashion photography and reportage; Oswaldo Salas (1914–92) was in New York photographing celebrities.

Fidel Castro's victory in 1959 transformed Korda's hagiographical portrait of Che Guevara into an emblem of revolution. Salas and his son Roberto (b. 1940) returned to Cuba to work for the newspaper *Revolución*. A new impulse to celebrate the working class encouraged Tito Álvarez (b. 1916) to produce the environmental portrait series *People of my Suburb* (*Gente de mi barrio*; 1985). In the 1980s many Cuban photographers rejected both *Socialist Realism and American photographic modernism to embrace more conceptual and symbolic expressions. The gallery and archive Fototeca de Havana, founded in 1978 by 'Marucha' (María Eugenia Haya, 1944–91), 'Gory' (Rogelio Lopez Marin, b. 1953), Rigoberto Romero (1940–91), and others, promoted Cuban art photography internationally. Notable work by younger photographers includes Symbolist studies of maternity and traditional religion by Marta María Perez (b. 1959), architectural installations by Carlo Garacoia (b. 1967) and performance-influenced images by Reñe Peña (b. 1957) and Juan Carlos Alom (b. 1964). AN

Burgos, M. D., Leyva, M. D., and Salinas, P., *Cuba: 100 años de fotografía 1898–1998* (1998).

Wride, T. B., and Vivre, C., *Shifting Tides: Cuban Photography after the Revolution* (2001).

Cuban Missile Crisis. See MILITARY PHOTOGRAPHY.

Cultural Revolution. See CHINA.

Cunningham, Imogen (1883–1976), American photographer, born in Portland, Oregon. She took up photography in 1901, inspired by the pictorialist Gertrude *Käsebier. Having moved to Seattle, she studied chemistry at the University of Washington, assisted in the studio of Edward *Curtis, then continued her studies in Dresden, Germany. Returning to Seattle in 1910, she opened a studio, specializing in soft-focus portraits and allegorical woodland scenes; several, of her future husband artist Roi Partridge in the nude, shocked contemporaries. Following marriage in 1915, motherhood, and moves

to San Francisco and then Oakland, Cunningham discovered a new direction photographing botanical subjects. In the1920s her style became more sharply focused and consequently more appealing as magazine illustration. Contact with Edward *Weston, whom she considered a mentor, led to her inclusion in the prestigious *Film und Foto exhibition in Stuttgart (1929). Throughout the 1930s she participated in the West Coast artistic and commercial photography scene and was a founding member of *Group f.64 in 1931. In 1970 she received a Guggenheim Foundation Fellowship to print from early negatives. During her lifetime she published two books of her work; After Ninety, a selection of her last pictures, appeared in 1979. NR

Rule, A. (ed.), Imogen Cunningham: Selected Texts and Bibliography (1992).

curatorship

Mark Haworth-Booth, Victoria & Albert Museum (V&A), London
This essay is written from the point of view of a museum curator with responsibilities for photography as an art medium. It is necessarily coloured by 25 years spent looking after the national collection of the art of photography at Britain's national museum of art and design.

Curators serve the practitioners in their field, but they also serve the public at large. In this way, curators are like publishers. They must look both ways, be sympathetic in two directions, be loyal to the artist but also to the visitor. A curator will often be required to perform as an editor, aspiring to refine an exhibition or book to the benefit of artist and audience. Installing exhibitions is itself a minor art form.

Curators must also serve the past and the future as well as the present. And they must attempt to be fair to all comers and not succumb to prejudice or *parti pris*. They may wish to lead public taste but can only do so by selecting those artists who seem to bear the creative flame. Curators cannot simultaneously work in the public domain and collect privately, or work as artists: these roles could be fatal to the requirement that the curator aspires, like an independent critic, to objectivity, impartiality, and, in the end, justice. If that seems overweening, let us temper it by recalling that the mission statements of most museums usually include the word 'enjoyment' as well as 'understanding'.

Curators of photography need a practical working knowledge of the medium. Most have photographed with some seriousness and learned how to print. Failing direct experience of cameras and darkrooms, curators need regular access to knowledgeable professional photographers, such as the staff of the V&A's photographic studio. They also need a good grounding in the histories of art and of photography, two separate but slowly converging disciplines. They need to see as much historical and contemporary photography as possible. Curators' judgements are necessarily subjective, but their subjectivity must be based on the broadest acquaintance with what has been and is being produced. They need to know who originated ideas or styles and who has copied them, which is the great print, which the work print. They must visit the great collections in Europe and the USA, but also meet their colleagues both from other museums and

from universities and art colleges, networking as globally as possible. A photography collection needs a library containing not only the standard histories and monographs but also the major periodicals, such as *History of Photography*. These should be augmented by information files on photographers and topics which will—if fed over the years—become a unique and valuable resource.

A collection needs a conservator, or access to one, in order to plan storage and procedures for showing the collection safely in the museum's study rooms and exhibition galleries, as well as dealing with any damage and advising on loans to and from other institutions. In order to deliver the artist to the audience, the curator will work with colleagues of all kinds, including accountants, archivists, auctioneers, designers, documentation experts, donors, educators, fund-raisers, gallerists, interns, journalists, librarians, lighting consultants, marketing and press officers, printers, publishers, registrars, security staff, sponsors, technicians, and trustees. Sometimes, in cases where there is a conflict of interest, the curator will need to refer to the Museums Association's *Code of Ethics for Museums*. However, although always part of a team, it is the curator who champions the medium, with the role of driving forward the programme of acquisition, preservation, information provision, and public access. Curators must be sensitive to change and be willing to make up for the limits of their own expertise by bringing in specialist consultants.

The point of the job is to share the intense visual experiences available from photography. Such experiences are the reason why people become curators in the first place. To share those experiences with as broad a public as possible—primarily in exhibition galleries and study rooms, but also in slide lectures, books, television programmes, and websites—this is the great satisfaction curatorship can bring. Those intense experiences, residing in the photographs, will happily outlast us. MH-B

Fern, A., 'Remarks toward an Ideal Museum of Photography', in V. D. Coke (ed.), *One Hundred Years of Photographic History: Essays in Honor of Beaumont Newhall* (1975).
Haworth-Booth, M., *Photography: An Independent Art. Photographs from the Victoria and Albert Museum 1839–1996* (1997).

Elizabeth Edwards, Pitt Rivers Museum, Oxford
Curatorship of 'functional' collections or archives of photographs shares many of its concerns with curatorship of art collections. Although premised on different assumptions about 'value' or 'importance', all are concerned with issues of access, preservation, research, and public service, among others. 'Functional' collections are those that developed initially as image banks, assembled not for their aesthetic interest but for their informational content, although these categories are far from mutually exclusive.

Such collections can be found in almost every discipline, e.g. anthropology (the National Anthropological Archives, Smithsonian Institution, Washington, DC), medicine (the Wellcome Institute, London), archaeology and ancient monuments (the *Palestine

Exploration Fund, London), exploration (the *Royal Geographical Society, London), engineering, government, regional studies, religious missions, or war (the Imperial War Museum, London). While many such collections still fulfil their original informational roles, they have increasingly been recognized as important cultural artefacts in their own right. The images that comprise them have historical and documentary value in and of themselves, whether the subject matter be water management in the Netherlands or boundary surveys between India and Burma. In addition, the shape of collections—the way in which photographs were acquired, arranged, filed, captioned, and catalogued—provides evidence of the intellectual history or development of a discipline and its use of images. Curators must develop strategies that allow multiple approaches, although in doing so a balance may need to be struck between the preservation of historical photographic documents and the requirements of a picture library.

As the function, meaning, and value of such collections has changed over time, museums have sometimes adopted approaches from art photography curatorship, with its focus on the unique historical object. This shift can create tensions, as the conservation, access, storage, and ethical needs of the collections may be at variance with the institutional structures in which they have developed. Moreover, unlike even major 'art' collections, which number perhaps a few thousand or tens of thousands of images, it is not unusual for functional collections (e.g. the Imperial War Museum) to be many times larger. And here, the emphasis is not solely on the single image, as it might be in the case of an art photographer's *vintage print, but on the narratives established by series or whole collections. Furthermore, the 'functional' aspects of photographs are often manifested through different uses and formats. So it is not unusual for collections to hold a photograph in a number of formats: for instance, negative, contact print, enlargement, cropped publication print. Curators must have specialist knowledge of both their discipline and the history of photography in order to establish informed priorities in managing and presenting these large, complex, multi-layered collections.

Access to such collections is usually through the subject matter of the photograph, the photographer, or the photograph as a physical object, often being of secondary interest. Again, curators require specialist knowledge to manage large data systems organized in this way. Increasingly, functional collections are being digitized. This has advantages for access to and dissemination of photographs in collections, but creates tensions as resources are focused on making content-orientated digital copies rather than preserving the original object with its associated information, such as inscriptions on the mount. Finally, access itself is not always unproblematic. Many functional collections hold images of a sensitive nature which are not necessarily appropriate for general access, whether of war wounds, atrocities, or secret aboriginal religious ceremonies. Curators have to make difficult and informed ethical decisions about the use and treatment of such images, balanced against a commitment to make collections available.

Curators, therefore, like their colleagues in fine art, establish international networks to discuss common concerns, do research on collections, and interpret those collections in exhibitions and publications. There are various specialist groups across the world (e.g. in Britain the Religious Archives Group) interested in the potential and problems of photograph collections within their discipline, and the curatorial standards applying to them. There is also increasing interest amongst historians in the production, consumption, and institutional practices relating to collections. New ways of thinking about functional photographs, beyond the content of the image, demonstrate the interconnectedness of photographic practices and the increasingly blurred boundaries between curatorial practices in different kinds of institutions caring for photographs. EE

⊃ See also John Szarkowski *overleaf.*

Schwartz, J., 'We Make our Tools and our Tools Make Us', *Archivaria*, 40 (1995).

Tartaglia, D., and Zannier, I., *La fotografia in archivio* (2000).

Edwards, E., *Raw Histories: Photographs, Anthropology and Museums* (2001).

Curtis, Edward Sherriff (1868–1952), American photographer, famous for his monumental and seminal work *The North American Indian.* Containing *c.*2,200 photographs, it was published as twenty volumes of photogravures with text, in portfolios and bound volumes between 1907 and 1930. Drawn from over 40,000 negatives, it covered the appearance, lives, and customs of Native Americans, from the Inuit of the north to the Zuni of the south. The inspiration was the desire to record cultures perceived as dying out, epitomized by Curtis's celebrated *The Vanishing Race—Navaho* (1904). This elegiac feeling was accentuated by the aesthetic values of *pictorialism, the romantic construction of Curtis's images, and their superb print quality. Some gravures are printed on tissue-like paper, so that light reflects back from the mount through the image.

After serving an apprenticeship in St Paul, Minnesota, Curtis started his own business in Seattle in the late 1880s. By 1895 he had begun photographing Native American peoples. His great project, however, did not start until 1901 when, following a trip to Blackfoot Nation, Montana, he began to develop the necessary photographic skills and concepts. The project was supported by President Theodore Roosevelt, who wrote an introduction to the first volume, and from 1906 the bibliophile J. P. Morgan contributed financially. However, Curtis himself bore much of the cost, ruining both his finances and his health. Fewer than 300 of the 500 copies of the work were sold.

Curtis's representations of Native Americans remain controversial. His ethnographic romanticism, manifested through staging and re-enactment, and the removal of traces of the modern within images, has been seen as problematical both in documentary terms and ethically. His images' power is such that they have come to stand for Native American cultures and convey a spurious 'authenticity'. However, this does not detract from his sympathetic and masterly

(*continued on p. 149*)

John Szarkowski

John Szarkowski has a formidable and well-earned reputation. He was born (in 1925) and educated in Ashland, Wisconsin, taking a degree from the University of Wisconsin, where he majored in art history, in 1948. He began photographing as a boy and considered himself a photographer from the time he decided, at about 16, that he was not a clarinet player. He helped out at a portrait studio while at college, and worked 1948–51 as a staff photographer at the Walker Art Center, Minneapolis, where he held his first solo show. His early photographs suggest strong interests in Edward *Weston and Walker *Evans. He was indeed absorbed at college by Evans's *American Photographs* (1938) and by *Fifty Photographs by Edward Weston* (c.1947). He was also fascinated by the *Kindergarten Chats* of the architect Louis Sullivan, originally published in 1901–2 and reissued in 1947. Szarkowski moved on to the Albright Art School in Buffalo, New York, as an instructor in photography, history of art, and design in 1951. He set himself the task of photographing Sullivan's 1894–5 Guaranty (now Prudential) Building in the city. His portfolio of fifteen photographs of the building was the basis of his successful application to the Guggenheim Fellowship for funds to make the photographs for his first book, *The Idea of Louis Sullivan* (1956). This was a new kind of *architectural photography, one that paid exact attention not only to the 'art-facts' of the buildings, but also their 'life-facts'—meaning what their users had felt about them, or built around them. In Szarkowski's hands, architectural photography became a powerful critical medium, not only a descriptive one. His vigorous and vivid prose style also arrived in his first book. The Guaranty Building 'was old and dirty and largely lost among its newer, larger neighbours. Like a diamond in a pile of broken glass, it stopped few passersby.' Szarkowski's second book, *The Face of Minnesota* (1958), developed his writing and his photography, which demonstrated his skill in many branches of the art including action photography and colour. Already in 1952 his work had been acquired by MoMA, New York, and in 1961 he received a second Guggenheim Fellowship—to photograph the Quetico Wilderness Area—and held a solo exhibition at the Art Institute of Chicago. He seems, now, to have been the obvious choice to succeed Edward *Steichen as director of the department of photography at the museum. He took the department and photographic studies as a whole to new heights over the next decades. While doing so—the better to serve the medium at large—Szarkowski gave up his own practice as a photographer. Szarkowski's extraordinary roster of exhibitions while at MoMA (many of which toured nationally and internationally) began with his rediscovery of Jacques-Henri *Lartigue (Lartigue's first exhibition) in 1963, followed by *The Photographer and the American Landscape* the same year. *The Photographer's Eye* (1964) concerned the fundamental formal issues facing photographers, while *André Kertész* (1964) offered the first critical appraisal of a major master. The same year saw the opening of the Edward Steichen Galleries and Study Center, where many photographers, historians, critics, and fans have begun and continued to learn about the medium. Photography was not considered, except by very few aficionados and institutions, a collectable medium at this period. Exhibitions celebrated *Dorothea Lange* (1966), *Brassaï* (1968), *Cartier-Bresson* (1968), *Bill Brandt* (1969), *E. J. Bellocq* (1970), and *Walker Evans* (1971). As well as assembling a modernist canon, Szarkowski was alert to the lively talents of his own generation. *New Documents* (1967) introduced Diane *Arbus, Lee *Friedlander, and Garry *Winogrand. The early death of Arbus in 1971 prompted the immensely moving memorial exhibition of her work at MoMA in 1972. *Looking at Photographs* (1973), accompanied by an often-reprinted book, showed a new audience how to acquaint themselves with individual photographs and the traditions to which they belong. *New Japanese Photography* (1974) introduced major new talents—including *Domon, *Fukase, *Hosoe, *Moriyama, and *Tomatsu—to a Western audience for the first time. *Photographs by William Eggleston* (1976) was accompanied by *William Eggleston's Guide*, the first monograph on a colour photographer published by any art museum. Other shows surveyed science photography (*Once Invisible*, 1967), news photographs (*From the Picture Press*, 1973), and American photography of the 1960s and 1970s—*Mirrors and Windows* (1978). An even more monumental effort was to come. In the 1980s Szarkowski and Maria Morris Hambourg brought out a four-volume study, *The Work of Atget*, which set a new standard for the high fidelity of the reproductions and for scholarship. The books are based on Berenice Abbott's Atget collection, which was surely Szarkowski's major coup in terms of acquisitions for MoMA. Many other photographers, from many countries and traditions, have benefited from acquisition, display, and publication during Szarkowski's tenure. He concluded his career there with a spectacular survey, *Photography until Now* (1990), which gave a new reading of photographic history based on technological innovation. After retirement from the Modern in 1991, Szarkowski resumed his career as photographer, publishing *Mr Bristol's Barn* (1997). This study of a barn on Szarkowski's property in upstate New York has intriguing stylistic connections with the late work of Alfred *Stieglitz, which Szarkowski discussed in *Alfred Stieglitz at Lake George* (1996). In recent years Szarkowski has regularly taken his 4×5 in camera on trips with like-minded friends and colleagues, photographing in such locations as Texas, Nebraska, and Upper Michigan. His early and recent photographs have been exhibited by PaceMacGill Gallery, New York. Szarkowski's passion for the medium, his judicious eye, elegance as an exhibition maker, subtlety as a photographer, and eloquence as a writer—all these have had an incalculable influence on the understanding of photography. One could say that he found the medium brick and left it marble, except that he has shown us that photography has been extraordinary material all along.

MH-B

Haworth-Booth, M., 'The Idea of John Szarkowski', *Art on Paper* (Jan.–Feb. 2001).

vision of a Native past. Significantly, despite acknowledging the problems, many Native American people today view his images positively, for he is seen as respecting Native American cultures and portraying their forebears as beautiful and strong. EE

Gidley, M., *Edward S. Curtis and the North American Indian, Incorporated* (1998).

cutline. See CAPTION.

cyanotype (or blueprint, ferroprussiate process, Pellet print). Sir John *Herschel named his Prussian blue photographic printing process 'cyanotype' in 1842. It was used most notably by Anna *Atkins, for sun-printing botanical photograms. Following Herschel's death, *Marion & Co. launched it commercially as 'Ferroprussiate' paper (1872), which became the main photocopying process of the growing reprographic industry. Pellet's version (1877) was positive working. The blue colour was pictorially 'unacceptable' for many photographers, but used for proofing. Since 1990, cyanotype has attracted *'alternative process' artists, and become popular for children's workshops, owing to its cheapness, simplicity, safety, and applicability to many surfaces. MJW

Ware, M., *Cyanotype* (1999).

Czechoslovakia/Czech Republic. The *daguerreotype soon arrived in the country that now constitutes the Czech Republic, but which then formed part of the Habsburg Empire, and in general the progress of the medium there paralleled that in other European countries. *Pictorialism reached Czech photography through the Czech Club of Amateur Photographers (CKFA), formed in 1889 in Prague, with its monthly magazine *Fotografický obzor* (*Photographic Horizon*). From 1900 Voytech Preissig, also a painter, photographed modern still lifes, and another painter, Josef Váchal, took self-portraits that bridged art and photography. František *Drtikol and his rival, Vladimír Bufka, produced studio portraits and pictorialist images for salons.

After the First World War, artistic ferment and the climate of political independence in the new Czechoslovakian Republic allowed photography to become central to the development of *modernism. Photographers were influenced by Drahomír Růžička (1870–1960), a Czech émigré visitor from the USA and student of Clarence *White, who introduced specialized printing techniques and *Stieglitz's ideas on pure pictorialism. Jaroslav *Rössler, Josef *Sudek, Jaromir *Funke, Adolf Schneeberger, and Jan Lauschmann adopted the modernist approach, and in 1924 Sudek, Tibor Honty (1907–68), and Funke founded the Czech Photographic Society, leaving the CKFA. Two important Czech photojournalists of the period were Premysl Koblic (1892–1955) and Karel Hajek (1900–78).

Karel Teige (1900–51) and the leftist and anti-bourgeois Devetsil artist group were another major influence. Teige's manifesto for Poetism, published as *Foto-Kino-Film* in 1922, stimulated a wide range of photographic experimentation. Although this paralleled

*Moholy-Nagy and the *Bauhaus in Germany, Czech photographic development was distinct and eclectic, synthesizing its own responses to modernism and Constructivism. The 1930 *New Czech Photography* exhibition included modern photography in relation to architectural, scientific, technical, and documentary issues. Many periodicals published modernist photography in the 1930s, and groups such as 'Fotolinie', 'f5', and its offshoots 'f3' and 'f4', encouraged experimentation, while Lubomír Linhart's book *Social Photography* (1934), which posited a dichotomy between bourgeois (static) and socialist (dynamic) realism, addressed the political dimension. With its interplay of artistic ideas amongst overlapping groups, Czechoslovakia is considered to have produced the richest body of *Surrealist photography in the inter-war years, reflected in photography's inclusion in the 1935 Czech Surrealist art exhibition, and SVU Mánes (Mánes Union of Fine Arts) starting a photography section in 1936. Key Surrealist photographers were Jindřich Štyrský (1899–1942), František Vobecký (1902–91), Eugen Wiškovský (1888–1964; an important theoretician), and Vilém Reichman (1908–91). The Prague-born philosopher Vilém Flusser, author of the important *Für eine Philosophie der Fotografie* (1983), emigrated in 1940 but acknowledged the influence of Prague's artistic atmosphere between the wars. The period culminated in the *100 Years of Czech Photography* exhibition (1939) which, however, emphasized technical rather than artistic achievements. Avant-garde activity continued for some time after the establishment of the Nazi Protectorate of Bohemia and Moravia in early 1939, but by 1942 bans, deportations, forced labour, and general repression were affecting photography as much as other branches of culture. The euphoria and freedom that followed the liberation of the country in 1945 were stifled again all too soon after the Communist takeover in 1948.

One of the 19th-century pioneers of *photomechanical reproduction had been the Czech painter and printer Karel Klič (or Klietsch) (1841–1926), the inventor of both the *photogravure and rotogravure processes. High-quality photogravure printing was used in three of the four Czech books considered seminal in 20th-century photography: Štyrský and Jindrich Heisler's *Na Jehlách techto dńi* (*On the Needles of These Days*; 1945); Zdenek Tmej's (b. 1920) *Abeceda Duševniho Prázdna* (*Alphabet of Spiritual Emptiness*; 1945), a documentary record of forced labour in Breslau in 1941–3; and *Josef Sudek Fotografie* (1956). Karel Plicka's *Praha ve fotografii*, first published in gravure in 1940, remained in print for over 50 years.

After 1948, photographers such as Sudek and Jan *Saudek worked alone, unrecognized, for many years. *Fotograficky obzor* was relaunched and modernized, with contributions by Wiškovský, Josef Ehm (1909–89), and Funke. By the 1960s cautious *documentary work became possible, encouraged by the 1958 publication of a *Cartier-Bresson monograph by Anna Farova, a photohistorian and, later, curator at the Prague Museum of Applied Arts, where she founded the photography collection. The 1968 'Prague Spring' was famously recorded by *Koudelka (who then went into exile), but otherwise documentary concentrated on marginalized communities and the human condition in general, rather than challenging the officially

dominant *Socialist Realism. Examples included Koudelka's gypsy communities, Markéta Luskačová's Christian pilgrims, and Štecha's work with sociologists on an old people's home.

In the 1980s photographers adopted more subjective approaches. Subtly critical projects were attempted, such as Jaroslav Barta's record of motorway openings, Jiží Hanke's views from the window of his apartment, and Jozef Sedlák's recording of military recruitment interviews. Vladimír Birgus, an influential teacher, writer, and photographer at FAMU (Film and Television Faculty) Academy, Prague, where the country's only major photography course until the 1990s was taught, wrote his essay 'No Crucial Moment', considered seminal for the development of contemporary Czech photography.

After the so-called Velvet Revolution, powerfully documented by Pavel Štecha, the new independence created an explosion of photography. Strong documentary work was created by Pavel Dias, Jindřich Štreit, and Štecha, and by returning Czech-born émigrés—Koudelka's *Black Triangle* and *Rokytnik* by Jitka Hanzlová. Other key photographers and teachers since 1990 have been the Slovakian-born Miro *Švolík (staged photography), Pavel Baňka and Dušan Slivka (landscape minimalism), Evžen Sobek (Ecce Homo series), Ivan Pinkava (classically referenced portraiture), and Tono Stano (the human body).

Many new photography courses started in the 1990s, and the Prague House of Photography, an exhibition and event centre, was launched in 1990. In 2004 the Galerie Rudolfinum, Prague, held the exhibition *Czech Photography 1840–1950*, curated by Jaroslav Andel. RA

See also SLOVAKIA SINCE 1990.

Birgus, V. (ed.), *Czech Photographic Avant-Garde, 1918–1948* (2002).

Dada. See PHOTOMONTAGE; HEARTFIELD, JOHN.

Daguerre, Louis Jacques Mandé (1787–1851), French artist
and inventor of the *daguerreotype, born at Cormeilles-en-Parisis.
Showing an early aptitude as an artist, he was apprenticed in 1800 to
an architect, and *c.*1803 became a pupil of Degotti, the noted scene
painter for the Paris Opera. In 1807 he began working under Pierre
Prévost on panorama paintings. These enormous canvases were highly
realistic depictions of cities and historical scenes. Their manner of
display, in rotundas lit from above, added to their illusion of reality and
may have inspired Daguerre and Charles Bouton, another of Prévost's
assistants, to launch their own venture, the diorama. Combining the
scale of the panorama with the diaphanorama, another invention that
used paintings on paper, oiled for translucency, and alternately lit from
either side to create subtle changes in the views, Daguerre and Bouton
created a wholly novel form of highly realistic public entertainment.
It opened in Paris in 1822 and was so successful that another was built
in London.

 Daguerre is best remembered for the photographic process that
bears his name. Although he was credited in many early texts with the
single-handed *invention of photography, current scholarship
indicates that Daguerre received more than his share of credit. He
worked in partnership with Joseph Nicéphore *Niépce from 1829 until
Niépce's untimely death in 1833, and much of the preliminary work
leading to a photographic process can be credited to Niépce and this
partnership. Daguerre's greatest contribution to photographic science
was his discovery of the *latent image, without which a commercially
viable process would not have been possible. This discovery was for
many years linked primarily to Henry *Talbot's *calotype process, but
was pre-dated by the daguerreotype. His experiments finished by late
1837, Daguerre tried in 1838 to sell the process by public subscription.
This having failed, he approached François *Arago, director of the
Paris Observatory, perpetual secretary of the Academy of Sciences, and
also a member of the Chamber of Deputies. Arago, impressed with
Daguerre's discovery, brought an article before the Chamber arguing
that, as this great discovery for science and the arts could not be
patented, the French government should honour Daguerre and
purchase from him the secrets of the process and give them free to the
world. A preliminary announcement of the discovery was made on
7 January 1839. In July 1839 the government awarded Daguerre an
annuity of 6,000 francs for life and to Isidore Niépce (1805–68), son

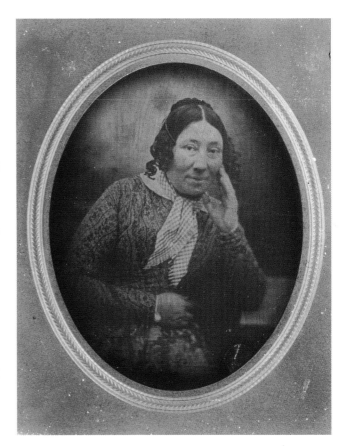

L. J. M. Daguerre
Portrait of Mme Louise Georgina Daguerre, *c.*1845. Daguerreotype

of Daguerre's late partner, 4,000 francs annually. Full details of the process were revealed on 19 August 1839. On the 14th, however, without the knowledge of the French government, Daguerre had patented the process in England, somewhat hampering the adoption of the daguerreotype there.

About fifteen daguerreotypes made by Daguerre in 1839 survive, including still lifes of statuettes, shells, and fossils, and some fine views of Paris. He announced new developments in the process in 1840 and 1841, but details never materialized. By late 1840 improvements by others in Europe and America brought it to the stage at which it is best known.

Daguerre died at his home in Bry-sur-Marne the same year that Frederick Scott *Archer introduced his *wet-plate process, which within less than a decade had superseded the daguerreotype. RCW

Gernsheim, H. and A., *L. J. M. Daguerre: The History of the Diorama and the Daguerreotype* (1968).

Wilder, K., 'Ingenuity Wonder and Profit: Language and the Invention of Photography' (Oxford D.Phil. dissertation, 2003).

Bajac, Q., and Font-Réaulx, D. de (eds.), *Le Daguerréotype français: un objet photographique* (2003).

daguerreotype. Unique positive photograph presenting a fine grey mercury-silver amalgam image on polished silver. The process derives from J. N. *Niépce's early 1830s experiments with iodine fumes to sensitize a silver-plated copper plate. Niépce's partner L. *Daguerre later discovered mercury vapour developer and salt fixer, announcing the process in 1839. In 1840, J. F. Goddard (1795–1866) increased photosensitivity by adding bromine, while H. Fizeau (1819–96) improved image density and permanence with gold chloride toning. Daguerreotypes were typically made as small portraits presented in hinged, padded, and glassed cases, and were popular until the mid-1850s, when they were supplanted by *ambrotypes. HWK

Barger, S., and White, W. B., *The Daguerreotype: Nineteenth-Century Technology and Modern Science* (1991).

daguerreotype process, dissemination and practice.
After the press announcement, in January 1839, of *Daguerre's process, would-be photographers rushed to make their own images. But they were quickly chastened. As the English daguerreotypist John Werge recalled, the process was 'extremely delicate and difficult, slow and tedious to manipulate, and too insensitive to be applied to portraiture'. Although more details were published in scientific and popular journals, it quickly became apparent that while a skilful operator could produce images of astonishing quality, there were severe limitations to Daguerre's process.

At the outset, such limitations did not deter those intrepid travellers prepared to encumber themselves with daguerreotype equipment. Daguerreotype expeditions were a problematic exercise involving the transport of bulky camera, chemicals, and apparatus, sometimes over vast distances. On arrival, photography in the open air often meant battles with the elements or insects while struggling with complicated chemical manipulations. But despite these tribulations, hundreds of

foreign views were produced. For the first time, people were able to see the world as it seemed really to be, rather than through the eyes of the artist.

However, most early daguerreotypists were frustrated by the long exposures required, which limited them to static subjects. The great prize was to find a means of reducing exposure times to the point where portrait photography was practicable. Solutions came from several sources, with American experimenters at the forefront. Alexander S. Wolcott opened the world's first photographic portrait studio in New York in March 1840. Wolcott's success was based on an ingeniously designed camera, in which a concave mirror replaced the more usual lens. This unusual optical system limited the plate size, and the images produced were by later standards of indifferent quality, but the American public was enthralled by them. Improvements then came thick and fast. In London during 1840, John Goddard found that bromine vapour dramatically increased the sensitivity of the plates and Antoine *Claudet found that mixtures of chlorine and iodine vapours had a similar effect. The 'fast' lens developed by Josef *Petzval in Austria was also a significant improvement. In France, Hippolyte Fizeau (1819–96) found that the fragile surface of a daguerreotype image could be toughened and toned by gold chloride.

Richard Beard (1802–85), who had bought a licence from Daguerre's agent, opened Europe's first daguerreotype portrait studio in London's Regent Street in March 1841. Other operators rapidly followed Beard's lead. Fortunes were made as cities and towns throughout Europe and America opened their own daguerreotype studios. By 1850, such establishments were operating as far away as India and Hong Kong. City studios were typically lavishly furnished and became fashionable haunts of the upper and wealthy middle classes. In rural areas, commercial practitioners tended to operate on a more modest scale. Some saw daguerreotype portraiture as a lucrative sideline to a more traditional trade and the quality of images produced was often poor. Werge claimed that the first portrait he saw of himself revealed 'a scowling looking individual with a limp collar, and rather dirty looking face'. There were also *itinerant operators who travelled from village to village but frequently produced little more than blackened or blank plates. This failed to dampen enthusiasm, and quality improved as the better operators became established. The American public had a special affection for the daguerreotype and American daguerreotypes shown at the 1851 Great Exhibition were judged to be the finest in the world.

The success of the daguerreotype was brief, however. By 1855, the process was being ousted from popular favour by the new wet-*collodion process. Daguerreotype photography was a technological dead end—not least, of course, because its product was a unique image—but its commercial exploitation through the portrait studio introduced the new art of photography to the world.

Daguerreotypy was continued by a trickle of practitioners from the late 19th century into the 20th. But a strong revival took place from the 1970s onwards, embracing both picture making and research into the history and chemistry of the process. With some exceptions in

other countries (for example, Patrick Bailly-Maitre-Grand in France, Michael Breton in Belgium, and Sadahiro Koizumi in Japan), activity centred in America. In 1977, Thomas Nelson published an important handbook, *A Practical Introduction to the Art of Daguerrotypy in the 20th Century*. In 1988, a new, American-based Daguerrian Society was founded. The following year, the 150th anniversary of the 1839 announcement, two American specialists, Grant Romer and Irving Pobboravsky, were commissioned by the Musée Carnavalet, Paris, to daguerreotype Parisian landmarks for a major commemorative exhibition. Researchers from the *International Museum of Photography at George Eastman House demonstrated the process at workshops at the sesquicentennial celebration held in France in 2002. JPW

Werge, J., *The Evolution of Photography* (1890).

Gernsheim, H. and A., *The History of Photography* (1969).

Romer, G. B., 'The Daguerreotype in America and England after 1860', *History of Photography*, 1 (July 1977).

Buerger, J. E., *French Daguerreotypes* (1989).

Verhulst, J., 'The Contemporary Daguerreotype', in J. Wood (ed.), *America and the Daguerreotype* (1991).

Bajac, Q., Planchon-de Font-Réaulx, D., and Daniel, M., *Le Daguerreotype français: un objet photographique* (2003).

Dahl-Wolfe, Louise (1895–1989), American *fashion photographer, who made her reputation at *Harper's Bazaar* from 1936 to 1958. In 1928, after studying painting at the San Francisco Institute of Art, then interior decoration in New York, she married the Tennessee artist Meyer (Mike) Wolfe. They settled in New York in 1933 and Dahl-Wolfe soon became a successful commercial photographer, working for periodicals and major retailers. At *Harper's Bazaar* she collaborated with Carmel Snow, Diana Vreeland, and Alexey *Brodovitch. In her 22 years there, she developed a casual but elegant style that the magazine termed 'The New American Look', in which more natural, active women replaced staged glamour. Dahl-Wolfe adopted Kodachrome in 1937 and became celebrated for her creative, subtle colour harmonies. In all, she published 86 covers, 600 colour images, and innumerable black-and-white photographs in *Harper's*. The Dahl-Wolfe Archive at the Center for Creative Photography, Tucson, Arizona, includes 16,100 negatives, and other materials. PJ

Dahl-Wolfe, L., *A Photographer's Scrapbook* (1984).

Louise Dahl-Wolfe: A Retrospective, introd. D. T. Globus (2000).

Dallmeyer, John Henry (1830–83), German-born lens designer who emigrated to England in 1851 and eventually joined Andrew Ross (1798–1859), one of the leading lens and optical instrument makers in the country. He married Ross's daughter and later inherited some of Ross's fortune; in 1860 he established his own firm in London.

Dallmeyer devised many improvements to photographic lenses, including portrait lenses, his triple achromatic lens (1862), wide-angle rectilinear lens, patent portrait lens, and—his most important invention—the rapid rectilinear or aplanat lens (1866). This lens became the standard design for nearly 60 years before being superseded by the even more highly corrected anastigmat of Paul *Rudolph in

1890. The firm produced a wide range of optics and also marketed cameras and other equipment. On Dallmeyer's death his son Thomas (1859–1906) took over and produced further significant optical advances. (He was also president of the *Royal Photographic Society 1900–3.) The company expanded into making cinematographic lenses and television lenses in the 1950s and continues to make specialized optical equipment today. MP

dance. See PERFORMING ARTS AND PHOTOGRAPHY.

Dancer, John Benjamin (1812–87), English photographer and inventor, who inherited his father's Liverpool instrument-making business aged 23. Dancer became a pioneer of photographic lantern slides. In 1837 he introduced the use of limelight as the source of illumination for magic lanterns, and later modified their optical arrangement, improving the quality of projected images. In 1840 he demonstrated the *daguerreotype process at the Liverpool Mechanics' Institution, and exhibited a magnified image of a flea. In Manchester from 1841, he continued experimenting with photomicrography and *microphotography and, following the introduction of the *wet-plate process, perfected his method, exciting much enthusiasm from both the public and scientists. In 1853 he developed a twin-lens stereoscopic camera with the lenses set at what scientists considered the normal interocular distance of 6.35 cm (2½ in). This innovation simplified the production of *stereographs. As Dancer's eyesight deteriorated in the 1870s, two of his daughters took over the business of producing photomicrographs, before selling all the negatives to Richard Suter in 1896. SD

darkroom, history and equipment. At its simplest, the early photographic darkroom was a darkened room where silvered copper plates or paper could be sensitized and processed and, later, where light-sensitive printing processes could be undertaken in darkness or subdued light. Not all photographic processes required a room; much of the *daguerreotype process, for example, could be carried out using sensitizing, iodizing, and fuming boxes in daylight. Until the early 1850s a purpose-built room was not strictly necessary, although professionals and photographers working from a fixed base would often have a permanent darkroom for convenience. The term 'darkroom' dates from *c*.1841.

The daguerreotype, early paper processes, and, especially, the later *collodion processes required a space near the camera where images could be developed and fixed. Some materials lost sensitivity once the exposure had been made or chemicals had been allowed to dry, and a darkroom or temporary dark-tent or developing box allowed processing to be done immediately after exposure. The *wet-plate process, which dominated photography from the 1850s to the 1870s, made a darkroom essential for professionals and desirable for amateurs although, as the exploits of photographers like Roger *Fenton, George Washington *Wilson, and Samuel *Bourne demonstrate, a temporary substitute like a cart or tent was adequate in the field.

The spread of commercially produced *dry plates from the 1870s obviated the need for a darkroom near the camera, although a means of loading the plates into holders or magazines was still required. The exposed plates could later be taken to the darkroom for processing. This, combined with the growing practice of enlarging from *negatives, and the standardization of negative processing from the late 1860s, shifted the emphasis in the darkroom from the making of the negative to the production of finished prints. Although some specialized work (for example, outsize enlargements) might be put out to commercial printing establishments, darkrooms became essential for professional studios and remained so, certainly for black-and-white photography, until the 1980s. By the end of the 20th century, economic and technical change had altered this situation, with studios increasingly outsourcing conventional colour work, or switching to darkroom-free *digital imaging.

The rise of the serious amateur between the 1880s and the mid-1930s had implications for the darkroom. Eastman's famous slogan *'You press the button, we do the rest' suggested that it was no longer necessary for amateurs. However, *roll-film's affordability and ease of use encouraged many enthusiasts to set up simple home facilities. More standardized, less demanding processing techniques and printing *papers enabled amateurs to achieve respectable results. Those sufficiently dedicated could either make a temporary darkroom in a bathroom or broom cupboard, convert an attic or spare room, or build a permanent structure in the garden. From the 1890s a range of products were sold to help the amateur convert existing rooms and operate on a small scale.

For those without their own spaces, many camera clubs offered darkrooms for members' use. From the 1890s to the 1930s chemists, photographic retailers, and even professional photographers would often have a darkroom for the use of amateur photographers, sometimes just for changing plates but in some cases with a full range of 'wet' facilities, an enlarger, and a supply of materials for purchase. Around the turn of the century many hotels also advertised the availability of darkrooms for guests. The rise of commercial photofinishing, especially for colour photography from the 1960s onwards, began to limit the need for amateur darkrooms, most of which only ever produced black-and-white prints. Digital photography, however, may be giving a new lease of life to the darkroom, in the new sense of a space for making images by means of scanners, computers, and printers.

Equipment
Manufacturers quickly recognized the demand for processing equipment. Some cameras from the 1840s to the 1900s were sold with a range of trays, chemicals, flasks, measuring cylinders, and printing frames, plus full instructions. More usually, the photographer bought what he needed for the plate size he worked with. The basic requirement was for a dark room. Blackout material was available, or a complete room or shed could be erected out of doors for photographic use. Portable dark-tents of various designs,

wheelbarrows, or wagons were available for travelling photographers. Until the 1850s, candlelight usually sufficed to illuminate most darkroom work. With more sensitive processes, darkness or some form of *safelight for producing a negative was increasingly necessary. Special lamps were made, or filters could be fixed to windows. By 1900 plate and film processing, with few exceptions, had to be done in complete darkness in an open tray or tank, or in a special daylight tank that was loaded in darkness and then filled with chemicals in daylight. Trays made of glass, china, gutta-percha, or, in the 20th century, plastic were made. Photographic measuring cylinders, stirring rods, and other tools and gadgets, some of questionable utility, were marketed especially from the 1890s to the 1920s.

As the emphasis of darkroom work changed from simply processing plates or film to printing, specialized equipment was produced. Contact frames and solar enlargers were operated in conjunction with the darkroom, using sunlight to expose sensitized paper. Photographic enlargers, both horizontal and vertical, were widely introduced from the 1870s and used artificial light to make the positive print or lantern slide. By 1910 timers, washers and dryers, squeegees, clips to hang prints, and thousands of other accessories were offered by manufacturers to assist in making a positive image from a negative in the darkroom, and finishing, mounting, and framing it. Apart from the materials used to manufacture it, the basic range of equipment did not change significantly during the 20th century. Finally, in addition to darkroom hardware, chemicals for use with different films, plates, paper, and processes; papers in a range of sizes, surface finishes, and weights; sensitized glass for lantern slides and *opalotypes; and other sensitized materials, were all marketed.

From the 1850s onwards, attempts were made to eliminate the darkroom, or reduce the need for it. Multiple plate holders allowed plates to be transported, magazine backs carried several plates, and dry processes, roll-film, cartridges, and cassettes allowed increasing numbers of exposures to be made without the need to reload in the dark. One of the objectives of Polaroid *instant photography was to make the darkroom obsolete. Digital media now require no special tools other than a power supply, cables, a computer, and printer. However, the production of fine silver-based exhibition prints, and a resurgence of interest in older and *alternative processes, will ensure that the darkroom remains essential for a select minority of photographers for the foreseeable future. MP

Life Library of Photography: The Print (1970).
Lewis, E. (ed.), *Darkroom* (1977).
Ostroff, E., 'Anatomy of Photographic Darkrooms', in *Pioneers of Photography: Their Achievements in Science and Technology* (1987).

dark slide, device that holds a sensitized glass plate or sheet of cut film, designed originally to transport *daguerreotype or *wet-collodion plates, or paper, sensitized in the darkroom to the camera. In the camera a sheath would be removed for exposure, and afterwards replaced and the slide returned to the darkroom. With dry processes, dark slides became the main means of transporting plates and, later,

cut film, before processing. Early slides were made of wood and held one plate. Double dark slides (DDS) were introduced from the 1850s with a metal septum to separate the two plates. This became the standard form, with later models from the 1880s sometimes having metal sheaths. From the 1970s plastic was used for both slide and sheath. Single metal slides (SMS) were popular for plates up to 9 × 12 cm (4 × 5 in) from *c.*1900 to the 1930s. MP

DATAR (Délégation à l'Aménagement du Territoire et à l'Action Régionale) **project**, officially funded scheme to photograph the natural and built environment of France, devised by the photographer François Hers and the planner Bernard Latarget. It was executed in the mid-1980s by 36 photographers, one of them Robert *Doisneau, who chose the residential districts around Paris, including some that had featured in his *Banlieue de Paris* (1949). This time, he evoked a sombre picture of once vibrant neighbourhoods dehumanized by high-rise buildings and impersonal planning. The other photographers included Lewis *Baltz and Gabriele *Basilico. RL

Paysages photographiés en France des années quatre-vingt (1989).

Dater, Judy (b. 1941), American feminist and photographer. After studying art, she met Imogen *Cunningham, became an admirer, and wrote *Imogen Cunningham: A Portrait* (1979). Dater's photograph

of Cunningham and a young nude model, Twinka, published in her *Women and Other Visions* (1975), was inspired by Thomas Hart Benton's painting *Persephone*, and challenged the traditional relationship of male artist and female model. Dater's series of self-portraits, made at the time her marriage was ending, also explore the nature of gender. She received a Guggenheim Award in 1979, and published two further books of her work: *Body and Soul* (1988) and *Cycles* (1994). CF

dating old photographs. Recognition of process or format gives the first indication of a photograph's date. Sometimes the possible time-span is very broad: *cartes de visite*, for example, were produced for over 40 years. But *daguerreotypes can generally be assigned to the 1840s or 1850s, and most *ambrotypes were made in the third quarter of the 19th century.

Where, as with *cartes de visite* and *cabinet prints, the picture has been pasted onto card, the mount may prove informative. Mounts from the 1860s tended to be very simple, with squared corners and perhaps a small trade plate on the back to identify photographer and studio. From the 1870s corners were generally rounded, while designs grew more ornate, often filling the whole of the reverse. Mounts of the 1880s tended towards visual complexity. Lists of awards, exhibitions, and famous patrons, in a bewildering variety of fonts, might be mixed

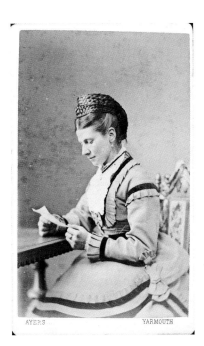

Carte de visite, T. Ayers, Yarmouth

The mount's rounded corners, the camera's relative closeness to the sitter, and the elaborate hair and costume are all characteristic of the 1870s. Several different kinds of ornamentation coincide to mark the neckline.

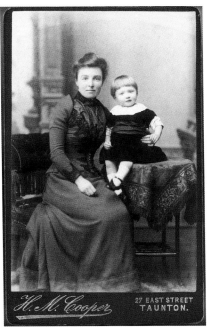

Cabinet print, H. M. Cooper, Taunton

Dark green mount and plain skirt indicate the 1890s, while 'kick-up' shoulders place the picture early in the decade. More of the studio setting is seen than in many photographs of the time.

Carte de visite, J. Stokes, Ipswich

Thin square-cut card, full-length shot, and voluminous skirt all speak of the 1860s. Glimpses of an ear and a painted outdoor world suggest the second half of the decade.

Carte de visite, Williams & Williams, Newport

A date in the late 1880s or early 1890s seems likely for this pictorial mount. (The cameo on the front, with its glimpse of peaked sleeve, supports the later option.)

Carte de visite, John Hinley, Wisbech

The busy mount design features swirls, flowers, several fonts, a turtle, and a mournful James Watt. The medal was awarded in 1880, and Hinley was not listed in trade directories after 1888.

Cabinet print, C. Mouth (W. Damry, directeur), Lille

The children's clothes (more matelot than sailor) and boy's hair may seem unfamiliar to the British eye, but the rugged texture of the French studio rock suggests the 1880s. Pencilled on the back is 'Juin 1884'.

with geometrical designs, vegetable swirls, and Japanese motifs. As the 1890s approached, a self-conscious artistic quality was often in evidence, with fully pictorial backs. Even the quality of the material changed over the decades, from the thin white card of the 1860s to the stout, dark-coloured board of the 1890s.

The appearance on mounts of the photographer's name and address can also help with dating. Family businesses went into a second generation, partnerships were formed and dissolved, and premises were changed. So the comparison of mount information with the entries in trade directories can sometimes suggest a likely period of years.

Towards the end of the century, a new sobriety came into mount design. The cardboard was generally of pale colours and designs were simple, but an effect of understated richness was achieved by textured surfaces, gold or silver printing, and bevelled edges. This taste in mounts continued through the early years of the new century, but production of *cartes* and cabinet prints went into sharp decline. Instead, the *postcard format became increasingly popular for studio portraits, and the *roll-film print became common, as families bought and used their own cameras.

The image, too, underwent change. The rather Spartan studio backgrounds of the early 1860s, with perhaps just a drape or hint of

classical architecture as context for the subject, became more imposing as backcloths came into use. At first these depicted interiors, but soon a window or an archway gave a glimpse of a painted world beyond. In the 1870s, outdoor sets became popular, with studio fences and stiles in front of sylvan backdrops. The 1880s saw a growing feeling for texture, as bark, moss, and real foliage were added to the rustic scenes. At the same time, dramatic skies, rugged ruins, and crashing waves made their romantic appearance on backcloths. Plinths and balustrades, now more rough hewn, reappeared, and, in the 1890s, a liking for the exotic might be expressed in such details as mirrors or hothouse plants.

By the 1890s, however, rather less of the studio background tended to be visible. The studio camera had gradually moved closer to the sitter, from the full-length portraits of the 1860s, through the three-quarter or half-length shots of the succeeding decades, to the head-and-shoulders images of the century's final years. Especially typical of the decade was the vignette, which dominated studio output in the 1890s. In early 20th-century portraits there was often a greater distance between subject and camera, and full-length shots were quite common around the time of the First World War.

The most useful evidence for dating, however, is often provided by costume, and especially by women's clothes. In the 1850s and for much of the 1860s, close-fitting bodices contrasted with full crinoline skirts.

The bustle made an appearance in the 1870s, with skirts bunched up and padded at the back to create a sloping line. A sense of elaboration was strong, with mixed materials and colours, built-up hairstyles, and decorative trimmings in profusion. A relative sobriety of dress was seen in the 1880s, with tight, tailored bodices and collars buttoned to the neck. The bustle made a brief return, but it was worn higher, and jutted out instead of sloping smoothly away.

The fashion focus in the 1890s was on the upper half of the body. Necklines were still high and bodies tightly encased, but sleeves went through a series of striking styles. 'Kick-up' shoulders, rising to a point, were popular at the beginning of the decade; the middle years were notable for the 'leg-of-mutton' sleeve, which ballooned out above the elbow; by the end of the century the billowing had been reduced to a mere puffing-out of material at the shoulder.

A rather heavy-busted, S-shaped look marked the early years of the new century, and this was followed by a fashion for the long and tapering hobble skirt. Blouses hung baggily over at the waist until *c.*1908, echoed the wearer's shape thereafter, and acquired V-necks from *c.*1913. Hats were wide brimmed and formidable. After the war, the 'barrel-line' or tubular skirt began to be seen, quickly followed by the boyish look (with cropped hair, low waistline, minimal bust, and head-hugging cloche hat) by which the 1920s can be recognized.

Whilst this account of dating relates primarily to British photographs, there was a degree of internationalism in the language of the 19th-century studio. Significant variations in custom across the world certainly mean that caution is necessary when dating pictures from non-British sources. But beneath the differences of local idiom, it is often possible to see fashion similarities in clothes, mounts, and studio conventions.

Photographs without people can be very difficult to date, although in family collections most pictures of places follow the popularization of roll-film in the early 1900s. Buildings, vehicles, and street furniture can sometimes provide an earliest possible date for outdoor photographs, but some local research may first be needed.　　　　　　　　RP

See also BACKDROPS, STUDIO.

Lansdell, A., *Fashion à la Carte 1860–1900* (1985).
Linkman, A., *The Expert Guide to Dating Victorian Family Photographs* (2000).
Pols, R., *Dating Old Photographs* (2nd edn. 1995).
Pols, R., *Family Photographs 1860–1945* (2002).

Davidson, Bruce (b. 1933), American photographer. Born in Chicago, Davidson studied photography at the Rochester Institute of Technology and joined *Magnum in 1958. His brilliant *East 100th Street* (1970), about the inhabitants of a particular New York neighbourhood, was the result of a two-year project, using a 4 × 5 in view camera. *New York Subway* (1986), rich in colour and brooding darkness, is a wrenching portrait of that graffiti-layered underworld and its sad, journeying people. He has consistently documented the disenfranchised, from Brooklyn gangs to the struggles of poor African-Americans.　　　　　　　　TT

Davidson, B., *Time of Change: Civil Rights Photographs 1961–1965* (2002).

Davison, George (1854–1930), British amateur photographer who joined the new Camera Club of London in 1885 and the Photographic Society in 1886. In 1889 he became a director of the Eastman Photographic Materials Company and gave up his civil service job, becoming managing director of Kodak Ltd. in 1900. Davison's upward mobility was tempered by old loyalties: his first exhibited photographs were of Lowestoft harbour, a tribute to his late father, a shipyard carpenter, and his first published letter in the photographic press proposed educational magic-lantern shows for workers. He later espoused anarchism, and his visibility on socialist marches led to his 1913 resignation from the Kodak board. Davison advocated equally progressive photography, most notably in his 1889 *pinhole photograph *An Old Farmstead* (exhibited 1890), and his 1890 paper 'Impressionism in Photography', which updated P. H. *Emerson's *naturalistic photography in the optical and philosophical idiom of modern French painting. Davison was a founding member of the *Linked Ring, and developed a liberal artistic and political community at his houses in North Wales and on the French Riviera, where he died.　　　　　　　　HWK

Coe, B., 'George Davison: Impressionist and Anarchist', in M. Weaver (ed.), *British Photography in the Nineteenth Century* (1989).

Dawid (Björn Dawidsson; b. 1949), Stockholm-based Swedish commercial photographer and artist, who studied at Christer *Strömholm's legendary Fotoskolan. His inventive probing of the medium, from questions of realism to the physical make-up of the photograph itself, stirred the art photography scene in the 1980s. Most of Dawid's photographs are created in his studio or apartment, combining a conceptualist approach with craftsmanship and technical precision. Vernacular motifs—a toolbox, wilted flowers, the shadow of the camera—yield challenging imagery. His seminal series *Rost* (1983) established something of a signature style.　　　　　　　　J-EL

Mack, M. (ed.), *Dawid: Beautiful Frames* (2001).

Day, F. (Fred) Holland (1864–1933), American publisher, philanthropist, and photographer, renowned for his photographic re-creation of the Crucifixion. On a hill outside Norwood, Massachusetts, in 1898, Day produced a re-enactment of the event in a reported 250 negatives, using himself as the model for Christ. Lauded as an artistic triumph but also attacked as sacrilegious, this series included Day's most celebrated pictures, the bust-length shots known as *The Seven Last Words*. Day's involvement in photographic politics was extensive. Disagreements with Alfred *Stieglitz resulted in his creating the 1900–1 *New School of American Photography* show without Stieglitz's participation or approval. Day's refusal to allow his work to appear in *Camera Work* hurt his posthumous reputation. For unknown reasons, he ceased active participation in exhibitions after 1902, and a 1904 fire at his studio destroyed his early negatives. Subsequently his most significant photographic projects were series of male nudes, including those of two homosexual icons, Orpheus and St Sebastian. Research on Day increased from the 1990s, and newly

Fred Holland Day

One of the Last Seven Words, 1900

addressed topics have included the roles of homoeroticism, religion, and the *occult in his photography. PC

Crump, J., *F. Holland Day: Suffering the Ideal* (1995).

Dayal, Lala Deen (also Din Diyal; 1844–1905 or 1910), Indian commercial photographer, educated as a draughtsman at Thomason Engineering College, Roorkee. According to an autobiographical note, Dayal took up photography in 1874, receiving patronage from the maharaja of Indore, as well as important British officials such as the viceroy, Lord Northbrook. During this time Dayal concentrated on architectural and landscape studies in central India. In 1884–5 he accompanied Sir Lepel Griffin on an archaeological tour, resulting in *Famous Monuments of Central India* (1886) containing 39 *collotype reproductions from his photographs.

After a short time in government employment in the Indore Public Works Department, Dayal became court photographer to Mahbub Ali Khan, 6th nizam of Hyderabad (reg. 1869–1911). The Muslim ruler of pre-1947 India's largest princely state, he had been invested with full powers in 1884, on the termination of a regency. His vast territories, extensive jewellery collection, and patronage of the arts established the nizam in many minds as the richest man in the world. In place of a court painter, he decided to appoint Dayal as the official court photographer in 1884, giving him the title 'Raja' in 1894. Dayal created a modern public image for a traditional Indian ruler, designed to be palatable to the British Raj. He was expected to document official visits from royalty and politicians from Britain, Germany, Austria, Russia, and Greece, and record a variety of military, social, and official occasions. He also travelled extensively to photograph the 'nizam's Dominions', producing architectural and topographical views for albums which were subsequently presented to the nizam's guests.

In 1886 Dayal established a studio in Secunderabad, and a *zenana (women only) studio was added in 1892. But during his time as court photographer he moved away from commercial topographical work, concentrating instead on royal portraiture and his other duties. He employed many Indian and European assistants in his studios, several later establishing their own businesses, such as Herzog and Higgins. In the late 1890s, his two sons Raja Gyan Chand and Lala Dharam Chand took over much of the work, opening a Bombay studio in 1896 which lasted until Lala Dharam's death in 1904. Following the death of the nizam, court patronage ceased, although during the 1930s the 7th nizam employed the firm on several occasions. Today Deen Dayal is considered the most significant Indian photographer of the 19th century. SCG

Dayal, L. Deen, 'A Short Account of my Photographic Career by Lala Deen Dayal (in his Own Words)', 18 July 1899 (British Library, Eur. MSS D1132).

Day in the Life of a Moscow Worker, A, a 1931 *photo-essay—known subsequently by various titles—by Max *Alpert, Arkady *Shaikhet, and Sergei Tules, under the editorial supervision of the critic Leonid Mezhericher. In over 40 published pictures, taken in

Lala Deen Dayal

Asman Jah, Prime Minister of Hyderabad, with hunting party and dead tiger, c.1890. Albumen print

five days, it purported to show how a metalworker from the Red Proletariat engineering works, Filippov, and his family 'lives, works, studies and rests'. Stylistically, it combined some dynamically angled *'New Vision' shots of people and machines with conventionally naturalistic reportage; an establishing shot of the Filippovs' Moscow neighbourhood even included a church.

The project was significant because of the propaganda value ascribed to it by Stalin's government, and because it first appeared in the German Communist paper *Arbeiter illustrierte Zeitung* (which later commissioned a Berlin equivalent, *The German Filippovs*). An exhibition of c.80 pictures toured to Berlin, Vienna, and Prague, attracting considerable attention. But *A Day* also touched on debates between supporters of incipient *Socialist Realism like Shaikhet, Alpert, and the Russian Society of Proletarian Photographers (ROPF), and avant-gardists like *Rodchenko, Boris Ignatovich

(1899–1976), and the October group. The latter's utopian collectivism and formal experimentation were confronted by an emphasis on somewhat idealized but naturalistically depicted individuals with whom ordinary people could identify. In 1934 this became the Party line.

RL

Tupitsyn, M., *The Soviet Photograph* (1996).

Deakin, John (1912–72), British photographer of the 1950s and 1960s. He started photography in 1939, and for four years in the 1950s worked for *Vogue*, not only producing more work than his contemporaries on the magazine, but photographing everything from fashion and beauty to the social scene. However, his main strength lay in portraiture: sharp, unretouched, incisive images truthful (as some said) to the point of cruelty. The pubs and clubs of Soho, London, and the friends he met there, were also his subjects, and his undoing.

Drinking led to his being sacked from *Vogue* at least twice. Eventually he produced and sold work from trips abroad. His close friend, the painter Francis Bacon, who continued to support him until his death with photographic commissions, said, 'his portraits for me are the best since Nadar and Julia Margaret Cameron'. RSA

Muir, R., *A Maverick Eye: The Street Photography of John Deakin* (2002).

death. See POST-MORTEM AND MEMORIAL PHOTOGRAPHY.

DeCarava, Roy (b. 1919), African-American photographer. He grew up in Harlem and originally aspired to be a painter, but in the mid-1940s began to explore photography. Edward *Steichen encountered his work in 1950, immediately purchased three prints for MoMA's collection, and encouraged DeCarava to apply for a Guggenheim Fellowship. Receiving the award in 1952, DeCarava devoted himself to an extended study of Harlem. His lyrical visual style departed from the documentary mode that the mass media had employed to represent the area since the Depression. In 1955, Langston Hughes persuaded his publisher to issue a book of DeCarava's Harlem photographs, entitled *The Sweet Flypaper of Life*. It was tremendously successful, though partly thanks to Hughes's accompanying fictional narrative, written at the publisher's insistence. DeCarava himself, who had always insisted on the autonomy of his work, was unhappy with this attempt to delimit the meaning of his photographs. CDH

Galassi, P., *Roy DeCarava* (1996).

decisive moment, a concept central to 20th-century photography, formulated by Henri *Cartier-Bresson in his eponymous, landmark book of 1952. (*Images à la sauvette*, the French original, appeared the same year.) Out of the chaotic, unceasing flux of the visible world, the decisive moment appears as an instant of equilibrium perceived by the photographer through the camera's viewfinder. In such an instant, compositional resolution is seen to represent the psychic dimension of underlying social and political realities. In *The Decisive Moment*, Cartier-Bresson writes: 'To me, photography is the simultaneous recognition, in a fraction of a second, of the significance of an event as well as of a precise organization of forms which give that event its proper expression.' What he was advocating was essentially stylish reportage—photography alive with social portent, seized on the fly, shrewdly observant of *beaux-arts* principles of composition. In his adherence to both social significance and formal resolution, as well as his reverence for the unmanipulated negative, Cartier-Bresson defined a photographic position squarely situated within modernist artistic practices.

A precursor of Cartier-Bresson was E. Giard, whose book *Lettres sur la photographie* (1896) proffered, like numerous others of the period, counsel on the practice of instantaneous photography. Giard's advice—to anticipate the *point mort* (dead point), or pause in the movement of an animal or mechanism—was a key strategy for early photo-reporters who came to define their profession during the late 1890s. KM

definition in a photograph is a subjective assessment of image quality and apparent sharpness based largely on the measurable factors of resolving power, acutance, and granularity.

Resolving power is a measure of the ability of the optical system (i.e. lens plus light-sensitive material) to record fine detail. It is usually stated in line pairs per millimetre. There are several types of test chart for this; one frequently used is the USAF bar chart, which has sets of three black bars on a white background, decreasing in size towards the centre of a spiral (Fig. 1a). The limit of resolution is the point at which the direction of the bars can no longer be distinguished. Both high- and low-contrast charts are used. The latter gives a lower resolving power, but is more appropriate in actual scenes. Resolving power can also be assessed from the shape and size of the *point spread function*, which is a plot of the profile of the image of a point (Fig. 1b). In *digital photography, of course, the limit of resolution of the light-sensitive surface is the pixel size.

Acutance is a measure of the sharpness of an image edge. It is defined by the *edge spread function* and measured by tracing across an image edge with a microdensitometer (a densitometer with a very small aperture), and plotting the result (Fig. 2). The acutance is the geometric mean of the slope of the edge trace divided by the overall density difference. Acutance in a photographic emulsion depends to a large extent on the nature of the developer used.

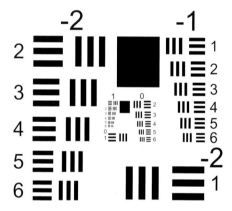

Fig. 1a

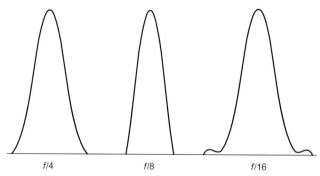

Fig. 1b

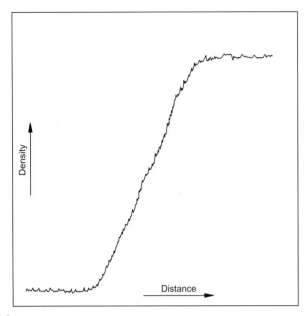

Fig. 2

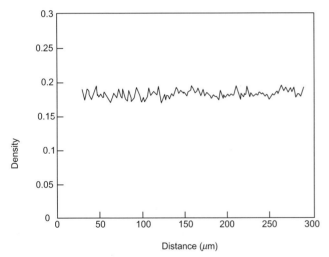

Fig. 3

Granularity is a figure related to mean *grain size. It is also measured using a microdensitometer, scanning an area of uniform density (Fig. 3). The figure is obtained from the standard deviation figure for the density fluctuations. 'Graininess' is also related to grain size, but is subjective. Its effect on definition is most noticeable in low-contrast areas of fine detail, where it may be the factor defining the visual limit of resolution. GS

See also OPTICAL TRANSFER FUNCTION.

Jacobson, R. E. (ed.), *The Manual of Photography* (9th edn. 2000).

Degas, Edgar (1834–1917), French painter and amateur photographer. Only a small and untypical fraction of Degas's photographs—*c.*60

prints made over a brief period (1895–6)—are known today. He was familiar with and used photography as early as his training years, when he made numerous copies of Italian old masters from photographs. The notebooks he kept throughout his life are filled with photographers' addresses, and he is known to have briefly frequented *Nadar at the end of the 1860s. But it was not until the mid-1890s, when amateur photography was in full swing, that he began taking pictures himself. For two years he had a veritable passion for the medium just as, at other periods, he was addicted to poetry or making monotypes.

His choice of subject was unfashionable. He favoured distinctly posed interior portraits, and cared little about the quality of prints, which he entrusted to a local photographer. He used artificial light to photograph friends such as Renoir, Verhaeren, and the Mallarmé and Halévy families, and made numerous self-portraits. These chiaroscuro images, made in the evening after dinner, have an intimate, sentimental quality at a time when the artist, ageing and nearly blind, often reflected on the death of friends and the difficulty of completing his work. Photography offered relaxation for his tired eyes and a means of examining and fixing the faces of those he loved.

There also survive fragments of a larger, lost oeuvre, some landscapes, female nudes, and dancers, more closely linked to his paintings and demonstrating his masterly sense of composition and movement. While Degas was always extremely critical of his paintings, he was proud of and amused by his photographs, though he steadfastly refused to exhibit them. SA

Terrasse, A., *Degas et la photographie* (1983).

Daniel, M., Parry, E., and Reff, T., *Edgar Degas photographe* (1999).

Delahaye, Luc (b. 1962), French photojournalist, who began in 1984, joining the Sipa agency in Paris. From the start he documented wars and conflicts. Within ten years he joined *Magnum as a nominee, becoming a full member in 1998. In 1994, he signed to the US magazine *Newsweek*.

Delahaye has won numerous awards and also attracted attention in other ways. In 1999, with the philosopher Jean Baudrillard, he published *L'Autre*, a book of black-and-white headshots Delahaye says he 'stole between '95 and '97 in the Paris Metro'; it resembles a blow-up of the little flicker books whose power resides in following an unexpected narrative invented by the viewer. Delahaye described the process as 'all a sham, a necessary lie lasting long enough to take a picture'. Two years later he photographed a dead Afghan fighter, calling the picture simply *Taliban, 2001*. Its expensive acquisition by two American museums raised some eyebrows: 'would they pay $15,000 for the image of a dead American soldier?' wondered *New York Times* photographer Chester Higgens Jr. AH

Delamotte, Philip Henry (1820–89), English photographer. A teacher of drawing and fine art at King's College, Cambridge (1855–87), Delamotte was also an influential member of the early circle of British photographers, an instructor at the Photographic Institution, London, editor of *The Sunbeam*, and a friend of John

161

Edgar Degas

Self-portrait with his housekeeper, Zoé Closier, c.1890–1900

Dillwyn *Llewelyn. In the 1850s he adopted the wet-*collodion process, using Llewelyn's Oxymel variant and publishing on the subject. Delamotte's *calotype views of the Crystal Palace were the basis of illustrations in the *Illustrated London News*. His books included *The Practice of Photography* and *Progress of the Crystal Palace at Sydenham*. KEW

Delano, Jack (1914–97), Ukrainian-born American *documentary photographer, who emigrated as a child with his parents to Philadelphia, where he studied the violin and viola. Travelling in Europe in the early 1930s while at the Pennsylvania Academy of Fine Arts, he bought a camera to record his visit. After his return, the Works Progress Administration Federal Arts Program sponsored his photographic documentation of bootleg miners extracting coal from closed Pennsylvania anthracite mines; when Paul *Strand saw Delano's resulting exhibition he introduced him to Roy *Stryker, who hired him for the Farm Security Administration (FSA) project in 1940; Delano later followed Stryker to the Office of War Information (OWI). Among his best-known FSA-OWI photographs are his 1943 documentation of the Atcheson, Topeka & Santa Fe wartime rail service between Chicago and Los Angeles. In 1946 Delano and his wife returned to Puerto Rico, where they had gone on an FSA assignment in 1941. Much of his later photography (e.g. *Puerto Rico mio*, 1990) testifies to his love for the island and its people. In addition to running Puerto Rican Educational Television he taught music and made films. CBS

Schulz, C., *A South Carolina Album* (1992).
Delano, J., *Photographic Memories* (1997).

Mike Greenslade Jubilee Pool, Penzance, Cornwall, 2003. Digital photograph

Anon. Persian officers, *c.*1840s. Hand-coloured stereo daguerreotype

de la Rue, Warren. See ASTRONOMICAL AND SPACE PHOTOGRAPHY; MOON PHOTOGRAPHY.

Delmaet, Hyacinthe César (1828–62), and **Durandelle, Louis-Émile** (1839–1917), French architectural photographers, who went into partnership in 1854 as the Second Empire's building and development boom gathered pace. After Delmaet's death his widow Clémence Jacob married Durandelle and they continued the business together until her death in 1890, after which Durandelle retired. Specializing in images of architectural and engineering construction, many of which seem precociously modernistic, they created magnificent series on, among other projects, the building and decoration of the Paris Opera (1865–72), the restoration of Mont-Saint-Michel (1874–89), the construction of the church of Sacré-Cœur (1877–90) and the Eiffel Tower (1887–9), and the extension of the Louvre (1882–4). Collections of their work are in the Bibliothèque Nationale de France, the *International Museum of Photography, and the Canadian Centre for Architecture. RL

Demachy, Robert (1859–1936), French *pictorialist photographer. Wealth allowed Demachy the freedom to pursue his artistic interests. An active photographer from *c.*1880, he built an international reputation in the 1890s, and was perhaps France's most prominent photographic artist by the beginning of the 20th century.

A founder member of the *Photo-Club de Paris, he contributed pictures to *Camera Work*, joined the *Linked Ring (1905), and won recognition from London's *Royal Photographic Society. His diverse subject matter (which included portraits, landscapes, Breton country life, and figure studies) was treated with a strong sense of the aesthetic. Not content with selecting lenses for their softness of focus, he offended purists by championing the manipulated image. Negatives were just a starting point: he retouched them, often boldly, and employed printing techniques that offered more atmosphere than sharpness. He embraced the *gum bichromate process in the mid-1890s and, from 1904, experimented with oil-based processes. The results often had a painterly quality reminiscent of Impressionism. Demachy also lectured and wrote prolifically on photographic topics. He gave up photography in 1914, but was featured alongside fellow pictorialist Émile Constant *Puyo in a Parisian retrospective exhibition in 1931. RP

Marbot, B., Poivert, M., and Royet, V., *Le Pictorialisme en France* (1992).

Demeny, Georges (1850–1917), French physiologist, physical educationalist, chronophotographer, and film pioneer. He was the long-time collaborator of Étienne-Jules *Marey from 1882 in Paris, devising many of their experiments in movement and often serving as their photographic subject. Relations between them began to decline in the early 1890s as Demeny pressed for the wider commercialization of Marey's photographic apparatus, first through the sale of Marey cameras and then through his Phonoscope of 1892, a disc-based stroboscopic viewer inspired by the success of *Anschütz's 'Schnellseher', and intended to make animated home portraits and to teach the deaf to speak. Working independently from 1894, he devised the important 'beater' movement for precisely advancing *celluloid film through a Marey-style camera, an intermittent device commonly used in early film apparatus. He also began making short films of dancers, street scenes, and the passage of a train. An 1896 system for 58 mm film was infrequently used, although a 35 mm version was marketed successfully for a while by Léon Gaumont. From early 1898 Demeny returned to physical education, organizing an international conference in 1900 and advocating new types of exercises for improving public health. DR

Mannoni, L., *Georges Demeny, pionnier du cinéma* (1997).

de Meyer, Adolphe. See MEYER, ADOLPHE GAYNE DE.

Denier, André (1820–92), Russian painter and photographer. He studied painting at St Petersburg's Academy of Arts, but opened a photographic studio on the Nevsky Prospect at about the time he graduated in 1851. It became a centre for discussions about the relationship between photography and art. Denier was an outstanding portraitist, and in 1865–6 embarked on an ambitious serial publication, *An Album of Photographic Portraits of August Personages and Well-Known Individuals in Russia*, that featured Russia's political and cultural elite. Many of his portraits were hand tinted. A keen innovator, Denier also developed a widely imitated method of printing from two negatives to create a distinctively soft effect. RL

Elliott, D. (ed.), *Photography in Russia 1840–1940* (1992).

Denisyuk, Yuri (b. 1927), Russian physicist who graduated from the Leningrad Institute of Fine Mechanics and Optics in 1954, and worked in the Vavilov State Optical Institute for more than 40 years. In 1962 he conceived the idea of recording light wavefronts by interference with a reference beam, and produced the first reflection hologram. Although slow to accept his discoveries, the authorities eventually realized their importance, and set up laboratories in all the major museums to make holograms of their treasures for travelling exhibitions. Denisyuk subsequently headed the A. F. Ioffe Physico-Chemical Institute of St Petersburg and the S. I. Vavilov State Optical Institute Laboratory. His later research included work on holograms made without a reference beam and the recording of holographic images by incoherent light. GS

Denmark. See SCANDINAVIA.

densitometry. This is the measurement of *density for the purposes of establishing the characteristics of a film or print material. Density is the logarithm of the reciprocal of the transmittance (for a print, reflectance). Transmittance is the measured transmitted light intensity divided by the incident light intensity. Its numerical value lies between 0 (totally opaque) and 1 (totally transparent). Reflectance is defined similarly, for reflected light. Both are often quoted as percentage values. A densitometer can be a simple gadget which gives a direct reading of density from a negative on a light table,

Delmaet & Durandelle

Comptoir d'Escompte, Paris, 1881. Albumen print

or as complicated as the devices used in large processing houses, which measure and automatically analyse colour negative or transparency tests, and suggest modifications to the routines or the processing solutions. Tests for emulsion characteristics are carried out using a neutral grey *step tablet*, which is a strip of film having a series of graded density steps, usually 0–3 in steps of 0.15. The reflection density of a print uses a densitometer head that has a built-in light source (oblique, to avoid specular reflections). Where accurate colour and/or tonal reproduction is essential in a final print, a calibrated *grey scale* is included in the original photograph. GS

See also SENSITOMETRY.

density, photographic. Photographic density is the common logarithm of the *opacitance* of a specific part of a negative or transparency; this is the reciprocal of its *transmittance*. There are several reasons for choosing this expression rather than transmittance itself. First, photographers tend to think of a negative in terms of darkness rather than lightness; secondly, our perceptual processes follow an approximately logarithmic response (the *Weber–Fechner law); thirdly, densities add together in a simple way, whereas opacitances and transmittances have to be multiplied together. Thus two densities of 1.0 together give a density of 2.0, whereas the corresponding transmittances of 0.1 together give a transmittance of 0.01. A density of 0 represents total transparency. Density is measured using a device called a *densitometer*.

Reflection density is the logarithm of the reciprocal of the reflectance. A reflection density of 0 is standardized on the reflectance of a freshly prepared surface of magnesium carbonate.

In a colour photograph the densities are measured three times, through red, green, and blue filters, measuring respectively the cyan, magenta, and yellow layers. GS

See also DENSITOMETRY.

Depardon, Raymond (b. 1942), French photographer and film-maker who took his earliest photographs on his parents' farm in 1954. By the time he was called up for military service he had done various photographic jobs, including moonlighting as a *paparazzo* for the Dalmas agency, and served as a war reporter in Algeria 1960–2. Back in Paris in the mid-1960s, he founded the *Gamma agency with Gilles *Caron, Hubert Henrotte, and Hugues Vassal. By 1970 he had made the first of some twenty films (*Jan Palach*). There followed editorial work for, principally, *Life and *Paris Match. In 1970 he spent a month in a Chad prison with three other European photographers. When his friend and colleague Caron disappeared in Vietnam, Depardon took a brief break from photojournalism, photographing nudes for magazines like *Lui* and *Playboy*.

In 1971 he returned to covering world events, and shared the Robert Capa Gold Medal with Chas Gerretson and David Burnett for their book *Chili* (1973) on the Pinochet coup. He also became director of Gamma, but in 1978 switched to *Magnum. Subsequently he continued travelling, publishing, and film directing. He moved

into fiction films, being selected for the Cannes Film Festival in 1985. He photographed his native Villefranche-sur-Saône for the *DATAR project, and increasingly produced books with established writers. In 2003, he brought all three disciplines together in *Un homme sans occident*, a film, stills exhibition, and book made with Louis Gardeland about the lives of desert nomads. AH

Depardon, R., Khemir, M., and Virilio, P., *The Desert* (2003).

Dephot (Deutscher Photodienst), German photo and press *agency founded in 1928 by Simon Guttmann (1890–?) and Alfred Marx. With Felix H. *Man and *Umbo joining in 1929 and Kurt Hübschmann (Hutton) in 1930, as well as Walter Bosshard, Harald Lechenperg, Robert *Capa, and Cohnitz swelling its ranks, it developed into a seedbed of modern *photojournalism. Its members' work appeared in influential illustrated papers like the *Berliner illustrirte Zeitung and *Münchener illustrierte Presse. Dephot went bankrupt in 1932, but became Degephot (Deutsche Photogemeinschaft) shortly afterwards. AL

depth of field. In a landscape photograph one expects the entire scene to be sharp, even near objects such as tree branches. In a formal portrait it is more usual for sharp focus to include only the sitter, the background being blurred. Sometimes only the sitter's facial features are in focus: photographers call this effect *zone focusing*. In all these cases an important factor is what is called *depth of field*, the distance over which the image appears sharp. It depends on the aperture and focal length of the lens and the distance focused on, and—very important— the criterion chosen for sharpness. This last is defined in terms of the acceptable diameter of the *circle* (more correctly, *disc*) *of confusion*. This is the size of the disc formed by an out-of-focus image of a point. For a pictorial photograph this is usually taken as an angular diameter of 1 milliradian, equivalent to 1 millimetre viewed from 1 metre away, though technical photography may demand a higher standard.

Depth of field is usually calculated via the *hyperfocal distance*. This is the nearest distance that gives an acceptably sharp image when the lens is focused on infinity, i.e. the film plane is at the principal focal plane of the lens. The formula for calculating the hyperfocal distance h is given by

$$h = f^2/Nc$$

where f is the focal length of the lens, N is the f-number, and c the diameter of the acceptable disc of confusion, in the same units. The nearest and furthest distances that are acceptably sharp are then given by

$$D_{near} = hu/(h + u) \text{ and } D_{far} = hu/(h - u)$$

where u is the distance the camera is focused on. The full depth of field is given by

$$D = 2hu^2/(h^2 - u^2)$$

It is clear that D is a maximum when $u = h$, i.e. the camera lens is focused on the hyperfocal distance. The depth of field is then from half the hyperfocal distance to infinity. This is the way cheap fixed-focus (so-called focus-free) cameras are constructed.

Most amateur and professional cameras (apart from studio cameras and compacts) have depth-of-field scales engraved on their lens barrels. GS

Jacobson, R. E. (ed.), *The Manual of Photography* (9th edn. 2000).

Derges, Susan (b. 1955), British photographer who explores the elemental. *Photograms exposed under artificial and ambient light register patterns of movement of particles and debris within the flow of a stream, or the tide on the shoreline. *Natural Magic* (2001) pictured moments when heat turns water in a glass jar into steam. In *The Observer and Observed* (1991), her eyes float reflected as if behind the water surface. This alchemy stands simultaneously as scientific record and poetic transformation. The formal precision of her imagery reflects an engagement with Japanese aesthetics. LW

Derges, S., *Liquid Form* (1999).

design. See INDUSTRIAL DESIGN AND PHOTOGRAPHY.

detective camera, loose term for a smallish hand-held box-form camera taking *dry plates or film. The earliest seems to have been the twin-lens reflex designed for the police by the British inventor Thomas Bolas (who coined the description) in 1881. The detective camera patented in the USA by George *Eastman and F. W. Cossitt in 1886 was a short-lived precursor of the *Kodak. Many other designs appeared over the next couple of decades, and the term remained in use, especially in France, into the 1920s.

Cameras that were concealable—and therefore more suitable for detectives—began to appear from the 1860s, but the idea was impracticable until the appearance of satisfactory dry plates in the 1870s. A craze for photographs made on the sly took hold in the 1880s, leading to ever-smaller cameras and more ingenious disguises. Cameras appeared as opera glasses, hats, books, watches, picnic hampers, ties, and canes. They sported names as suggestive as their looks, the 'Demon Detective Camera', the 'Ticka' watch camera, the 'Express Détective Nadar' (sold by Paul *Nadar), the 'Photo-Binocular', the 'Photo-revolver de Poche', and the 'Concealed Vest camera'. Not only amateurs but professionals like Paul *Martin and Paul *Strand sometimes used disguised cameras. In the 20th century specialist cameras, usually in the so-called *sub-miniature format, were produced in various countries for police or espionage work. KEW

Coe, B., *Cameras: From Daguerreotypes to Instant Pictures* (1978).

Detroit Publishing Company, founded in 1895 as the Photochrom Company by the photographer Edwin Husher with backing from the Detroit financier Rudolph Demme and Colonel H. Wild of Zurich. Demme and Wild withdrew in 1896. Husher then enlisted the financial support of William Livingstone, Detroit publishing and shipping magnate, and his sons William and Robert, who expanded operations, first as the Detroit Photographic and then as the Detroit Publishing Company. Until its collapse in 1924, the company was the most important North American source of mass-produced photographs, lantern slides, *postcards, and colour reproductions for business, tourism, and education. Success was based on the skill of staff photographers William Henry *Jackson, Lycurgus Solon Glover, and Henry Greenwood *Peabody and the exclusive American rights to the photochrom process acquired from the Photoglob Co. of Zurich. JVJ

Hughes, J., *Birth of a Century* (1994).
Stechschulte, N., *Detroit Publishing Company Postcards* (1994).

development, developer. See CALOTYPE; INVENTION OF PHOTOGRAPHY; LATENT IMAGE; PHOTOGRAPHIC PROCESSES, BLACK-AND-WHITE; INSTANT PHOTOGRAPHY.

Diamond, Hugh Welch (1808–86), English doctor and amateur photographer. He studied medicine at the Royal College of Surgeons and St Bartholomew's Hospital, London, and first practised in Soho, where he became interested in *mental illness. From 1848 to 1858, after a period at London's Bethlem Hospital ('Bedlam'), he headed the women's section of the Surrey County Asylum. Subsequently he opened a private clinic for women at Twickenham. Diamond took up photography early in his career, acquired extensive knowledge of the *calotype and other processes, and with Frederick Scott *Archer experimented with *collodion. From 1851 he began to photograph his female patients in simple poses against a plain background, and can thus be claimed to have founded the photography of mental illness. He showed the portraits at exhibitions of the Photographic Society of London (later *Royal Photographic Society) and was a key figure in amateur photography in the 1850s. He introduced various technical improvements and published articles in several journals. In 1853 he became secretary of the Photographic Society, and between 1859 and 1864 edited the *Photographic Journal*. He was also active as a landscape photographer and was interested in archaeology. JJ

Bloore, C., *Hugh Welch Diamond: Doctor, Antiquarian, Photographer* (1980).

Diana, plastic roll-film camera made by the Great Wall Plastic Co. of Kowloon, Hong Kong, between the early 1960s and the early 1970s, and sold in bulk for distribution at fairs and parties. It was also marketed under various other names. Its image quality was poor and, above all, unpredictable, and perhaps for this reason it eventually became a cult item in the USA. It featured in a famous essay on vernacular and art photography by Janet Malcolm, 'Diana and Nikon' (1976). RL

Malcolm, J., *Diana & Nikon: Essays on Photography* (2nd edn. 1997).

diapositives. See TRANSPARENCIES.

diCorcia, Philip-Lorca (b. 1953), American photographer who works with colour photographs that seem documentary, but reveal themselves as the result of complex transactions and carefully planned compositional strategies. In his street images, set in diverse locations in New York (1993), London (1995), and Havana (*Two Hours*, 1999), a beautiful mixture of available and artificial light bathes unsuspecting passers-by in glamour, giving their casual gestures and poses the poignancy of classical painting. In his series *Hollywood* (1990–2)

he photographed male prostitutes on Santa Monica Boulevard. Briefly elevated to the status of a glamorous model, each individual is placed in a scene full of narrative possibilities and subtle plays between lighting, reflections, shopfronts, and street signs. Each image is captioned with the model's (presumed) name, age, and price, like items in a catalogue, signifying the reciprocal commodification of model, artist, and viewer (as potential 'client'). Such projects made diCorcia one of contemporary art photography's most bankable stars. He participated in Tate Modern, London's first survey of documentary photography in art, *Cruel and Tender* (2003). PDB

Galassi, P., *Philip-Lorca diCorcia* (1995).

Dieulefils, Pierre (1862–1937), French photographer and *postcard publisher, based in Indo-China. He arrived in Tonkin as a soldier in 1885, in 1888 established a photographic studio in recently colonized Hanoi, and exhibited at the 1889 Paris World Fair. His major legacy is a huge series of postcards (over 5,000 items, mostly on Indo-China) published between 1902 and the 1920s. Based primarily on his studio work and travels, the collection is an essential source on the colonial development and population of Tonkin and other parts of Indo-China. RT

Vincent, T., *Pierre Dieulefils, photographe: éditeur de cartes postales d'Indochine* (1997).

Dieuzaide, Jean (1921–2003), French photographer. Much of his work was signed 'Yan'—his Resistance nickname from the Second World War—because he felt that photography might not be a respectable occupation. One of the few photographers to document the liberation of Toulouse in 1944, Dieuzaide soon became a professional photo-reporter, initially specializing in sports, then covering all the *actualité*. But he was also a faithful recorder of his native south-western France, where his first book on Gascony was published in 1946, as well as its adjoining regions, especially Catalonia, Spain, and Portugal. His pictures of French and Spanish *gitans* are romantic evocations of their life and evidence of the admiration in which they were held following the war.

Dieuzaide's work veers between a classic French humanism and a more formal style of highly graphic imagery, particularly in his architectural work and studies of natural forms in the landscape, or in his astonishing book on the sometimes quasi-erotic shapes created by cooling tar. A rigorous craftsman, his pictures are marked by the care and finesse with which they are composed and printed. So alarmed was he by the apparent demise of fibre-based printing paper in the late 1970s that he mounted a successful international campaign to persuade the manufacturers not to drop it in favour of resin-coated materials.

In 1974 he founded the gallery of the Château d'Eau in Toulouse, which rapidly became the chief photography space outside Paris, attracting work by leading photographers throughout the world. Dieuzaide was awarded the Prix Nadar (1961) and the Prix Niépce (1995). PH

Jean Dieuzaide: quarante ans de photographie (1986).

Dièz-Dührkoop, Minya (1873–1929), German portrait photographer, daughter of Rudolph *Dührkoop. In 1894 she married the Spanish photographer Luis Dièz, but was divorced in 1901. She was influenced by *pictorialism and had a decisive impact on the work of the Dührkoop studio. With her father she visited Paris and London in 1900–1 and the USA in 1904. In 1908 she joined the *Linked Ring. After setting up independently in Bremen, she took over her father's studio in 1918, and in 1919 joined the Society of German Photographers (Gesellschaft Deutscher Lichtbildner; GDL). JJ

diffraction and interference

Interference

When light beams cross they do not appear to affect one another: they continue on their way unchanged. But within the space of the overlap they do indeed interact. This interaction is called *interference*. It applies to every kind of wave train: waves in water or in a disturbed spring, sound waves, and electromagnetic waves. The interference of light beams is the basis of *holography. It can normally be seen only when the light beams are of the same wavelength and derived from a single source such as a laser. However, interference can occur with white light over very short distances (~0.02 mm), and it is the mechanism behind the colours of soap bubbles and oil films, the principle of antireflection lens coating, and the *'Newton's rings' sometimes seen in the image when using glass negative carriers in enlargers.

Interference can be constructive or destructive. Constructive interference occurs when the crests and the troughs of the two wave trains coincide (the wavefronts are *in phase*). The resultant is the sum of the two amplitudes (Fig. 1*a*). Destructive interference occurs when

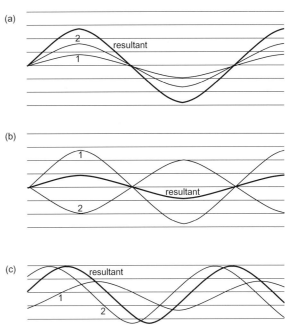

Fig. 1a, 1b, 1c

the crests of one wave train coincide with the troughs of the other (the wavefronts are *in antiphase*). The resultant is the difference between the two amplitudes (Fig. 1*b*). When the relationship is between these extremes the wavefronts are said to be *out of phase*, and the resultant waveform is the algebraic sum of the amplitudes, with a phase in between those of the two wave trains; the effect may be either constructive or destructive (Fig. 1*c*).

Thomas Young (1773–1829) was the first person to make a serious study of the subject. His double-slit experiment is an easy demonstration of interference, today using a laser pointer illuminating two slits about 0.5 mm apart, scratched on a piece of blackened film, with a white screen set up about 1 m (3 ft) away. A series of equally spaced bright spots will appear on the screen (Fig. 2*a*); these correspond with points where the optical path difference between each of the slits and the screen is a whole number of wavelengths (i.e. constructive interference).

Reflected waves from two surfaces only a very small distance apart can also interfere, as in thin films such as soap bubbles, oil films on water, and some butterfly wings. Here it is the wave trains reflected by the first and second surfaces that interfere, and there is constructive interference only when the spacing of the surfaces is an odd number of half wavelengths. Hence when white light strikes such a surface only specific wavelengths are reflected and the reflected light is thus coloured rather than white.

Diffraction

Diffraction is closely related to interference. In Christian Huyghens's (1629–95) model for the propagation of light, every point on a wavefront behaves as a source of a further wave, and the resultant wavefront is the envelope of these 'wavelets'. When a wave train passes through a narrow aperture, every point on the wavefront acts as a source of waves, and an interference pattern is set up, resulting in a central spot (the zero diffraction order) and a series of regularly spaced, much dimmer spots (first, second, etc. diffraction orders) (Fig. 2*b*). Diffraction is the main limitation on the performance of high-quality photographic lenses at small apertures, and of telescope and microscope objectives.

A *diffraction grating* is a method of generating a spectrum by interference. The grating consists of a large number of ruled opaque

Fig. 2a

Fig. 2b

lines on a transparent substrate. This produces a similar effect to Young's slits, but much more efficiently. As the angle of diffraction differs with wavelength, being greatest for red and least for violet, a spectrum is formed with red on the outside (i.e. in the opposite sense to dispersion by a prism). Diffraction gratings are widely used in spectroscopic analysis, and the most effective ones are originated holographically. GS

Heavens, O. S., and Ditchburn, R. W., *Insight into Optics* (1991).

diffractive optical elements (DOEs) owe their optical characteristics to their ability to diffract rather than refract light. They are manufactured holographically, by microlithography, or by computer-controlled electron beam etching. They have two main advantages over conventional lenses: they can be fabricated on a thin sheet (flat or curved); and a single DOE can perform many optical operations simultaneously. The main disadvantage is serious colour dispersion; but as this is in the opposite sense to refractive dispersion, a DOE can be combined with a refractive element to form an achromatic pair. Important applications of DOEs include head-up displays for aircraft, directional diffusing focusing screens for studio cameras, and bifocal contact lenses. GS

diffusion transfer process. See INSTANT PHOTOGRAPHY.

digiscoping. The combination, usually by means of special adapters, of digital cameras with spotting telescopes to obtain highly magnified digital images, e.g. of birds or other wildlife. Results vary according to the match of equipment, and vignetting and colour fringing may occur. RL

digital imaging. More than 30 years have elapsed since Bell Systems USA first announced the use of CCDs (charge-coupled devices) for a solid state camera in 1972. Essentially, a CCD is a silicon integrated circuit of the metal oxide semiconductor type with a basic structure such as that shown in Fig. 1. It comprises an oxide (SiO_2) covered silicon substrate upon which is formed an array of closely spaced electrodes.

The term 'charge coupling' refers to the method by which signal charges (which can be photoelectrons created from an image falling on the CCD array) can be transferred from under one electrode to the next. This is accomplished by taking the voltage on the second electrode also to a high level, and reducing the voltage on the first electrode, as shown in Fig. 2. By sequentially pulsing electrode voltages between high and low levels, charge signals can be transported down an array of very many electrodes with hardly any loss and very little *noise. By taking three electrodes we get one *pixel* which, typically, has the dimension of 0.009 mm or 9 micron (9 μm) square. The medium-format Kodak Pro Back (2001) had 16 million of these pixels in an area 37 mm square.

By connecting up three closely spaced MOS capacitors into storage elements, and applying a set of three-phase drive pulses ϕ_1, ϕ_2, and ϕ_3 (typically from +5 to +15 volts), charge signals can be stored under

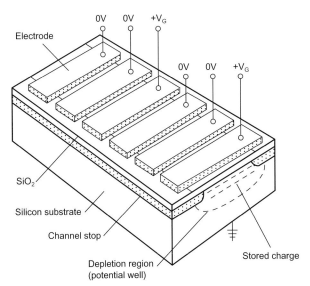

Fig. 1

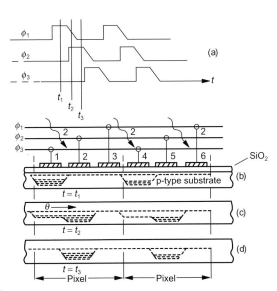

Fig. 2

every third electrode in each line of the array, as shown in Fig. 2. Under this system each storage element (or pixel if the input signal is optically generated) has every third electrode connected to the same clock voltage; consequently, three separate clock generators are required, as shown in Fig. 2a.

Full-frame transfer arrays

It would seem that current developments favour a full-frame transfer array where all the pixels are employed in the recorded image (earlier types of CCD camera used the *field-frame* array, where half the array was used for viewing). As may be seen from Fig. 3, a mechanical or electronic shutter is used to expose the pixel array to the image formed

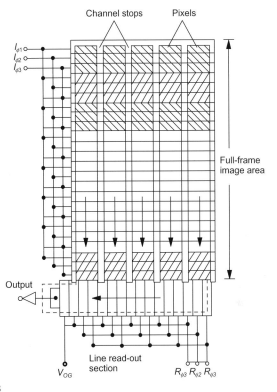

Fig. 3

by an otherwise conventional camera, the CCD array replacing the film, and a battery installed for the power source. As a three-phase system, there are three MOS capacitors to each (vertical) element, and so a square-shaped pixel is formed by appropriately spaced channel stops. When the array is illuminated by an image, photons can pass through the semi-transparent polysilicon electrodes to generate electron-hole pairs within the silicon substrate. In the example shown in Fig. 3, there is a matrix of 5 pixels shown, and the quantity of charge collected is proportional to the local radiation intensity and time allowed for collection, that is, the exposure time. The exposed pixels are then transferred directly to the shift register at the bottom of the array; from here the rest of the story takes place inside the camera, within the computer and the software.

Once a picture has been taken with a monochrome CCD imager, each image point is then clocked out, pixel by pixel, along the shift register to the output amplifier, and then to an eight-bit ($2^8 = 256$) analogue to digital converter (ADC) where each pixel-charge value (along with its x, y location) is registered in the form of a binary code. From here the image data are temporarily stored in an eight-bit buffer memory before being sent to a programmable digital signal processor (DSP) where the image is stored with other data in the dynamic random access memory (DRAM). Once the data are in the single-frame DRAM, the camera's hard disk is started and the image data transferred to it. This process takes a few seconds, depending on the number of pixels in the image.

After the image data have been stored on the camera's hard disk, smart-media, compact flash, or PCMCIA card, the digital data can then be downloaded to the computer (usually by USB or Firewire connection), where they are received by the manufacturer's image acquisition software. Finally, the image-processed data are then sent to the computer monitor's digital to analogue converter (DAC), which does the reverse job of the camera's ADC. This conversion is necessary since the monitor only accepts analogue signals (as a stream of rapidly varying voltages).

The colour image route

Colour is generally introduced by the spatial multiplex system. This is a popular system as it allows for single exposures and virtually makes the camera little different from conventional film types. The technique is to provide an individual red, green, or blue filter over each pixel, as shown by Fig. 4. Known as the Bayer colour filter array (CFA), it exemplifies the typical repeating 2×2 matrix that uses two green cells for every single red and blue cell. The reason for the $2 : 1$ ratio of green cells is to provide for improved green sensitivity and so match the human eye.

Known as the 'adjacent pixel colour interpolation technique', area array systems ensure that each pixel filter is always adjacent to the other two. If the subject had a uniform red, or blue, colour, the Bayer filter would only pass 25 per cent to the pixel array, if it were green, then 50 per cent. There would be gaps, but camera software examines the strength of the missing colours recorded by adjacent pixels, and makes a qualified evaluation of the two missing colours on a pixel by pixel basis. If, for example, the camera were to record a uniform red object, it would not be just the red-filtered pixels that created a charge signal, but all of the pixels—red, green, and blue. Were this not so, there would be open gaps in the resolution.

All the pixel filters are broadband types, allowing certain amounts of other colours through, i.e. red-green and blue-green; consequently the software algorithm has some signal information on each pixel regardless of the image colour at that point. In the example of the uniform red image, the interpolation algorithm finds little response in the green-, and even less in the blue-filtered pixels, and since the

entire matrix in the immediate area has the same response the algorithm calculates a totally red image at this point.

This method of colour interpolation degrades spatial resolution by a factor of $\sqrt{3}$ and if three pixels are approximately equal to one line pair, we can put spatial resolution of a monochrome CCD imager as:

$$r_{mono} \approx 3 \text{ px } (\mu m) \tag{1}$$

and, for a colour CCD imager,

$$r_{colour} \approx 3 \text{ px } \sqrt{3} \ (\mu m) \tag{2}$$

In terms of line pairs per millimetre this becomes:

$$R_{colour} \approx 1{,}000/(3 \text{ px } \sqrt{3}) \text{ (line pairs/mm)} \tag{3}$$

Spatial multiplex systems are not without their disadvantages, however, the main problem being that because of the averaging or resampling of the pixel intensities, artefacts can occur in the image of an object that has sharp edges or strong lines. Known as *aliasing*, such artefacts manifest themselves as stair-stepped jagged edges ('jaggies'), particularly when the display or printed resolution is too coarse to hide the effect. However, a suitable anti-aliasing technique known as *dithering* exists in *Adobe Photoshop image-processing software.

CMOS: the image of the future

CMOS image sensors are cheaper and more integrated, with much lower power consumption than CCD technology. They have considerable advantages over CCDs in that CMOS devices' structure and comparative ease of fabrication lend themselves to low-cost enhancements. The main difference between the two sensors is that while the CCD groups the output of the pixels together, through charge coupling, and then row by row presents them to the read-out section, a CMOS sensor can address each pixel individually. Problems associated with CMOS sensors include higher *noise levels and limited ISO sensitivity. However, their potential advantages are increasingly being realized through intensive research and development.

The Californian company Foveon developed an alternative sensor, the Foveon X3. Using CMOS, the X3 does without the usual Bayer CFA and so increases colour efficiency by a factor of 2 or 3. It is the first chip to capture red, green, and blue image data at every pixel site in a single exposure. To make this possible, the silicon is prepared in three layers, similar to the dye layers in colour film technology. As white light is formed by red, green, and blue, with approximate wavelengths centred on 0.4, 0.55, and 0.7 μm respectively, the different wavelengths are absorbed at different depths by the doped silicon substrates. The blue is read by the top substrate, located just 0.2 μm below the surface, the green sensors are below this at 0.6 μm, and the red even further at 2 μm. The first production cameras to incorporate the X3 sensor, the Sigma SD9 and SD10 SLRs, had a mixed reception, and the future of the technology remains uncertain.

Conclusion and outlook

The expansion of the digital market between the early 1990s and the turn of the 21st century was spectacular. In both the high-end and

Spatial multiplex system (R = red, G = green, B = blue)

G	R	G	R	G	R	G	R
B	G	B	G	B	G	B	G
G	R	G	R	G	R	G	R
B	G	B	G	B	G	B	G
G	R	G	R	G	R	G	R

(Single CCD sensor)

Fig. 4

consumer sectors it was characterized by rapidly advancing capability and falling prices; high-end innovations soon trickled down to the mass market. Camera models were superseded at an unprecedented pace: Canon's acclaimed EOS D60 professional SLR, for example, by the even better specified, and cheaper, 10D in less than twelve months. The same year, 2003, saw the launch of the 11MPx (megapixel) Canon EOS-1 DS, and of a promising new ('Four Thirds') high-end system by Olympus improving the interaction of sensor and lenses. In the medium-format field the Kodak Pro Back, housed in a Hasselblad 555ELD, found applications in studio photography, aerial survey, and remote sensing. Significantly, its price fell from £16,500 to *c.* £12,500 in about a year.

In the meantime, solutions were found for many intractable-seeming early problems, such as poor-quality LCD screens, high power consumption, high noise levels, storage limitations, and sluggish operation. The pace of innovation seems set to continue. By *c.*2010 we are likely to see up to 20MPx sensors in 35 mm-equivalent cameras, increasingly sophisticated in-camera image manipulation facilities, cableless links to computers and printers, and more extensive overlaps with other technologies (e.g. mobile communication devices). Digital will probably also conquer most of the global camera market. RG

Graham, R., *Digital Imaging* (1998).

Edwards, S. H. (ed.), 'Electronic and Digital Photography', *History of Photography*, 22 (1998).

Ang, T., *Silver Pixels: An Introduction to the Digital Darkroom* (1999).

Tarrant, J., *Digital Camera Techniques* (2003).

digital printing systems. In digital, as in all imaging processes, it is the final result that counts, and without a good printer even the finest image file cannot produce a good print.

The first electronically produced colour prints were made in 1953 when Xerox unveiled its colour xerographic prints. Electrostatic printers and plotters were introduced in the early 1980s. By the 1990s manufacturers such as Hewlett-Packard, IBM, Epson, and Kodak were in the market, each with its own system for different applications, including laser, dye-sublimation, piezo, electrostatic, thermal, and ink-jet printers.

Ink-jets
Since the 1990s, digital printing technology has advanced at the same astonishing pace as *digital imaging. By the early 2000s, good-quality prints could be produced at reasonable cost from even low-end cameras with ink-jet printers. The basic ink-jet system is sketched in Fig. 1, where it can be seen that an ink reservoir feeds each nozzle through a heated capillary tube to its critical point (400 °C+), thereby creating a tiny bubble of steam. Then when the heat is turned off, the bubble is released as a fine droplet which is squirted onto the paper with high precision. The system works on what is known as 'drop on command' technology where, as soon as the droplet is ejected, a vacuum is formed within the capillary that attracts fresh ink to replace the lost droplet. Another method is to employ a piezo electric crystal to the rear of the ink reservoir. When a drop of ink is commanded, an electric current

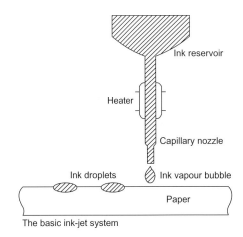

The basic ink-jet system

Fig. 1

flows through the crystal which then flexes (rather like a loudspeaker cone), to force a drop of ink through the nozzle. With conventional ink-jets the printhead will take a fraction of a second to traverse an A4 sheet of paper, and with a resolution of 720 dpi (dots per inch) this means a possible 5,760 dots across the page, with the printhead switching on and off about 11,000 cycles per second. Since the system is one of drop on command, the printhead has to respond in 0.0001 second. This is a truly awesome piece of technology, particularly since each nozzle in the printhead has a diameter approximating that of a human hair, with up to 256 nozzles per system, and a heating/cooling cycle that runs many thousand cycles per second.

There are two basic types of inks that work with ink-jet printers: pigment based and dye based. Pigment-based inks do not get absorbed into the media, but rather sit on the surface. They are very stable, even under harsh lighting conditions, and are frequently used for exhibitions and archival reproductions. Dye-based inks penetrate into the media, ensuring a smudge-proof finish with a high degree of transparency. They have a wider colour gamut than pigments, but lack the same degree of longevity. However, some manufacturers have succeeded in combining the advantages of both ink types.

Ink-jets are without a doubt the most popular form of printing, with so many advantages at an affordable price that it is difficult to see other types of printer challenging their position.

Laser printers
The laser printer is a complex device in which the printing engine is a drum with a coating that allows it to hold an electrostatic charge. The paper which is on the drum is scanned by a laser diode beam; the image medium is a toner; and as the drum rotates it picks up the toner, and heat and pressure are applied to the paper to fuse the toner onto the sheet.

Dye-sublimation printers
Sublimation is where a direct transition from solid to vapour can take place without any liquid phase being involved, and the basic principle of a dye-sublimation printer is to use a heated press to drive an image from one material into another. Some dyes and printing inks are able

to undergo sublimation, and after being driven into a material as a vapour, can solidify to form an image beneath its surface. Dye-sublimation printers require expensive ribbons and special papers, so that each print is relatively expensive compared to ink-jets. However, quality is impressive. RG

Dijkstra, Rineke (b. 1959), Dutch photographer who began as a commercial portraitist. Influenced primarily by Diane *Arbus, she developed a style of large, minimalist, almost classically formal frontal portraits, particularly used from 1992 in a series of beach portraits of teenagers. This established her reputation and led to further projects on children and young adults at points of life change or traumatic experience, capturing anxiety, vulnerability, and self-consciousness. In 1994 she photographed Portuguese matadors emerging from bullfights, and young women just after giving birth. She exhibited at the 1997 Venice Biennale. RA

 Rineke Dijkstra, Portraits (2001).

DIN. See SENSITOMETRY.

direct-positive processes. See PHOTOGRAPHIC PROCESSES, BLACK-AND-WHITE.

disability and photography. The more straightforward aspect of the subject concerns ways by which physically impaired photographers can function more effectively. Improved access to the beauty spots, heritage sites, and activities that attract photographers is one. Many simple and often inexpensive devices—adjustable viewfinders, remote shutter-release attachments, camera clamps—can facilitate actual picture making. *Digital technology has eliminated troublesome operations like film loading and will undoubtedly bring further benefits. The 'greying' of consumers in rich markets such as Japan, Europe, and North America has encouraged manufacturers to develop *image-stabilization systems and other advances calculated to appeal to the elderly, but also useful to impaired photographers of all ages. Groups like the Disabled Photographers' Society (f. 1968) in Britain, and similar organizations elsewhere, provide information, courses, and exhibition opportunities for photographers with a wide range of motor and sensory impairments.

 More contentious is the photographic representation of disability. The Disability Movement that emerged in the 1980s campaigned to replace the established ('common-sense') medical model of disability that focused on the cure or management of actual physical or mental impairment with a social one emphasizing the disempowering effects of institutional structures, language, the built environment, and social attitudes; and concentrating on the need to change society in order to achieve equal treatment. Altering the depiction of people with impairments by the mass media, especially *advertising and *photojournalism, was (and is) seen as an essential step to changing perceptions of disability. A notable text was a polemical book, accompanied by an exhibition, by the photographer David Hevey

(b. 1959), *The Creatures Time Forgot: Photography and Disability Imagery* (1992). Hevey criticized photojournalists for allegedly treating disability as an opportunity for 'grainy realism': black-and-white 35 mm photography of the kind used for famine victims, the homeless, or the unemployed. (In the background were 'canonical' figures like Garry *Winogrand and, above all, Diane *Arbus, whom he accused of 'enfreaking' the disabled and vulnerable.) He also attacked disability charities for, as he claimed, presenting impaired people as victims in need of charity rather than as citizens claiming rights, and for using stark, fear-inspiring images reminiscent of public-service warnings about drugs, drink-driving, and AIDS.

 In collaboration with London's Camerawork Gallery, which organized several exhibitions, including *A Sense of Self* (1988) and *Beyond the Barriers: Disability, Sexuality and Personal Relationships* (1990), and with commissions from trade unions, local authorities, and bodies like the Joseph Rowntree Foundation, Hevey challenged what he and the Disability Movement regarded as oppressive images. Having once worked for a specialist in annual-report portraits of top managers, he chose a similarly 'empowering' mode of studio lighting and medium-format, high-detail colour, and a viewpoint at or below the subject's eye level. Noting that 'It seemed to me important to use portrait photography to show people's impairment, . . . *without showing victims*', he rejected the high-angle monochrome image that—literally—looked down on bed- or wheelchair-bound people and presented them as a problem. Hevey's approach became a mainstream feature of the Disability Movement, and image analysis has remained part of Disability Equality Training.

 The Creatures Time Forgot included an interview with another Camerawork Gallery associate, Jo *Spence, then trying to use photography to dispel the mystification and dread surrounding cancer, and what she and other activists regarded as the disempowerment of patients, especially if they were working class and female, by 'caring professionals'. Other photographers, and organizations like the Terence Higgins Trust, have used images to demarginalize people with AIDS and other medical conditions that cause society to disable them. RL

 Cooper, R., and Cooper, R., *Eliminating Shadows: A Manual on Photography and Disability* (1990).
 Mayes, S., and Stein, L. (eds.), *Positive Lives: Responses to HIV—A Photodocumentary* (1993).

disc camera, ultra-compact camera introduced by Eastman Kodak in 1982, using a negative 8.2 × 10.6 mm: large enough for standard 10 × 15 cm (4 × 6 in) prints with a model that had a good-quality lens. But most did not and contemporary reviews merely deemed the results 'acceptable'. In the first year of production Kodak sold 8 million cameras and by 1988, when production ceased, 25 million had been sold. Consumer disappointment with prints and the perceived limited advantage of the system against 35 mm and, from 1996, APS (*Advanced Photographic System) formats slashed demand, and disc film was discontinued in 1998. MP

Disdéri, André Adolphe Eugène (1819–89), French photographer. He led a varied life in commerce, acting, and politics before patenting his trademark *carte de visite*-style photographs in 1854. Although he studied art as a young man, and listed his profession as topographical artist or painter until 1851, little is known of his ability as a draughtsman, except that he developed a compositional skill evident in his portraits, which were praised for their naturalness. He began his photographic career in 1848 or 1849 as a *daguerreotypist in Brest, birthplace of his wife Geneviève Francart (see DISDÉRI, GENEVIÈVE ÉLISABETH), but relocated to Paris in 1852. This move, perhaps prompted by debts incurred in his diorama venture with Joseph Dioss, a scene painter and student of *Daguerre, allowed him access to the famous and wealthy individuals whose portraits adorned his most popular cards. Although photographs had been used as calling cards before, notably by Ferrier in Nice, and others, Disdéri patented the method on 22 November 1854, and was the catalyst to its popularity. He achieved fame and fortune for a while, but died in relative obscurity. KEW

McCauley, E. A., *A. A. Disdéri and the Carte de Visite Portrait Photograph* (1985).

Disdéri, Geneviève Élisabeth (née Francart; *c.*1817–1878), French photographer. The daughter of a Brest businessman, she married A. A. *Disdéri in 1843, becoming his partner in the *daguerreotype business they opened in 1848 or 1849. Until her husband's departure for Paris in 1852, it is difficult to discern a significant style of her own, but during the twenty years she was the sole proprietor and photographer, she produced a body of views of Brest and the surrounding countryside. In 1872 she rejoined Disdéri in Paris, but worked from a studio of her own until her death. KEW

Disfarmer, Mike (Michael Meyer; 1884–1959), American photographer, who ran a portrait studio in his hometown of Heber Springs, Arkansas, from 1939 until his death. He photographed farmers, their families, young servicemen off to war, and many others. The pictures were apparently not intended to be anything other than what they are, small-town portraits, but they have emerged from obscurity as uncannily honest images of a type that few commercial portraitists could ever hope to achieve. This is due in part perhaps to the everyday familiarity of the photographer with his subjects within a rural community, and to a resulting mutual trust that seems reflected in the faces and posture of those photographed. Using *postcard-format ($3^1/_2 \times 5^1/_2$ in) glass plates and natural north light, Disfarmer positioned his subjects against a plain backdrop with few if any props. As with any belated discovery of a naive artistic genius, there has been much speculation concerning Disfarmer and his motives and methods. Comparisons have been attempted, understandably, with great portraitists like August *Sander, Lewis *Hine, Bill Burke, and others who have documented 'ordinary' people. TT

Scully, J., and Miller, P., *Disfarmer: The Heber Springs Portraits 1939–46* (1976).

display of photographs. See MATERIAL CULTURE AND PHOTOGRAPHY.

disposable cameras. See SINGLE-USE CAMERAS.

dithering. See DIGITAL IMAGING.

documentary photography

Introduction

In the broadest sense, all photography not intended purely as a means of artistic expression might be considered 'documentary', the photograph a visual document of an event, place, object, or person, providing evidence of a moment in time. Social or other information can be extracted from vast numbers of early photographs: for example, those assembled by Queen Victoria and Tsar Nicholas II to record aspects of their reigns; *industrial collections like the Krupp archive; Thomas *Annan's Glasgow series; *country house photography; many views (especially of towns); the *snapshots of amateurs like J.-H. *Lartigue and Alice *Austen; and so on. Even some photographs conceived by their creators as primarily expressive have been used later as documents: for example, the work of *pictorialists such as Alfred *Stieglitz (notably *The Steerage* (1907)); the *Photo-Secessionists' realistic images; or the work of Paul *Strand and others in *straight photography.

Yet the term 'documentary photography' has a more specific meaning. The *Life Library's *Documentary Photography* (1972) defined it as 'a depiction of the real world by a photographer whose intent is to communicate something of importance—to make a comment—that will be understood by the viewer'. The authors proposed three phases of its development over time: conveying visual reality (for example, the work of John *Thomson, William Henry *Jackson, or Eugène *Atget); social reality (Jacob *Riis, Lewis *Hine, and the *Farm Security Administration (FSA) photographers); and psychological reality (Robert *Frank, Lee *Friedlander, *Diane Arbus). Under this still-broad definition, much of the early photography of *exploration, *war photography, and the depiction of *folklore, social customs, or native societies (e.g. English customs by Peter Henry *Emerson and Benjamin *Stone; Native Americans by Adam Clark Vroman and Edward S. *Curtis) has been labelled 'documentary'. In the late 20th century, street photography was also included.

Perhaps as a means of differentiating it from *photojournalism, to which it is closely related, modern definitions of documentary photography have focused less on its role in recording reality than on its ability to demonstrate the need for change. Thus the Brazilian documentary photographer Sebastião *Salgado has described photography, in *Witness in our Time* (2000), as an activist's expression of ideology, 'a vector connecting the different realities of people around the world'.

The use of photography to document the need for reform began, modestly, in the mid-19th century. When Henry Mayhew began an investigation into the lives of the English labouring poor, originally

Anon.

John and Jane Moore, married for 70 years, 6 September 1894

published in the *Morning Chronicle* and subsequently as *London Labour and the London Poor* (1851), he engaged the daguerreotypist Richard Beard (1801–85) to do a series of 'character studies' of the various 'types' of the working poor, images which became the basis of the engraved illustrations in the book. Beard, a businessman rather than a photographer, had immediately grasped the potential of Daguerre's invention, and purchased the exclusive right to use the process in England, establishing 'daguerrean galleries' in London in 1841. However, the images of London labourers were only a minor part of the work of one of those galleries, and were not widely circulated or seen. And photography played only a minor role in the investigative and reforming process.

By contrast, when a later journalist-reformer, Adolphe Smith, undertook another study of the London poor in the 1870s, he collaborated directly with John Thomson in *Street Life in London* (1877–8), in which 37 case histories of various occupational 'types' were illustrated by *Woodburytype reproductions of Thomson's photographs. Compelled by his use of the *wet-plate process to pose his subjects rather than capturing them informally, Thomson, who also photographed London high society, has been criticized for sentimentalizing and misrepresenting the nature of their poverty. Nevertheless, Thomson was certainly one of the originators of social documentary photography. (In Russia, his contemporary—and fellow Scotsman—William *Carrick was not only photographing social types in the studio, but also capturing Volga boatmen at work and peasants in the fields). Another photographer who recorded lower-class Londoners, Paul *Martin, did so in a much more informal and, to our eyes, 'modern' way, by using a hand-held camera disguised as a parcel.

Finally, although his entire career as a photographer was as an employee of the US government, Jack *Hillers, chief photographer on John Wesley Powell's second survey expedition down the Colorado River in 1871–2, is also regarded as a precursor of social reform documentary photography. Subsequently employed by the US Geological Survey and the Bureau of Indian Affairs, Hillers became essentially an ethnographic photographer, winning the trust of the south-western tribes he photographed, and sympathetically recording their daily lives.

The American Progressive Era

American Progressivism (1890–1920) was marked by an optimistic belief that informed citizens could reform social evils through the democratic process. Middle-class reformers mounted multiple crusades: against disease and poverty in inner cities crowded with immigrants, exploitation of women and children in the workforce, official corruption, and alcoholism; and in favour of universal education, proper sanitation, pure food and safe drugs, and women's suffrage. In the hands of the reform pioneers Jacob Riis and Lewis Hine, the camera played a major consciousness-raising role in the passage of progressive legislation that altered cities and regulated children's employment, and transformed the understanding of photography's social and educational potential.

Riis, a Danish immigrant, worked as a labourer before becoming a police reporter in 1873 for the *New York Tribune*. Unlike Spencerian Social Darwinists, he believed that the poor were not inferior beings whose poverty resulted from inborn laziness or ineptitude, but were forced into it by their destructive surroundings. His answer to slums was model housing. He turned to photography because of his passionate commitment to reform, and his conviction that if 'there was some way of putting before the people' the terrible conditions he saw in his midnight trips with the sanitary police, people of good will would demand change. He read about German experiments with *flash photography and eventually learned to use a *dry-plate camera outfit. First in lantern-slide lectures, then in articles for the *Evening Sun*, and finally in the book *How the Other Half Lives* (1890), he forced the public to confront every detail of the squalor that his flashlit images exposed in the nocturnal city. Of the book's 43 illustrations, fifteen were *half-tone reproductions rather than line drawings based on photographs, and they helped change the patterns of journalism. Riis showed images not only of sweatshops and overcrowded lodging houses, but of the good that education could accomplish. Although later scholars have read a degree of racism into the main text of his books, his photography and captions reveal not only a superb eye for detail and composition, but a sympathetic understanding of the destructiveness of the urban environment.

Hine came to the reform crusade against child labour already trained in photography and sociology. Though he had worked in a factory, his middle-class, educated background was more typical of Progressivism. His photographic career lasted nearly four decades, and moved social documentary photography in significant new directions. He pioneered the approach of making photographs broadly available through posters and publications. (As with Riis, the impact of his efforts was vastly increased by the spread of half-tone reproduction technology.) His earliest reform photographs, of immigrants arriving at Ellis Island, were in the tradition of Riis. Although there is no evidence that the two knew each other, both worked for the reform journal *Charities and Commons*. Using initially a 12.7×17.8 cm (5×7 in) view camera, Hine during his career witnessed significant technical and artistic changes. He was associated with the Photo League and, although rejected by Roy *Stryker at the FSA, worked in the Depression for the Works Progress Administration.

Hales, P. B., *Silver Cities: The Photography of American Urbanization, 1839–1915* (1984).

Trachtenberg, A., *Reading American Photographs: Images as History. Mathew Brady to Walker Evans* (1989).

FSA and OWI

Nearly180,000 photographs produced 1935–43 under the direction of Roy Stryker, first in the FSA, and later in the Office of War Information (OWI), represent the first major body of photographic images specifically labelled 'documentary photography'. Many who use the photographs forget that the FSA—originally called the Resettlement Administration (RA)—began not as a photographic project, but as a

larger New Deal agency created in 1935 to help solve the economic crisis of the rural poor during the Depression. The RA's first director, Rexford Tugwell, hired Stryker in 1935 to create a 'Historical Section' to provide photographs for use as promotional illustrations of the FSA's work. Tugwell resigned when the agency's controversial experimental policies led to Congressional outrage, and its less radical mission, including the Historical Section, was transferred to the Department of Agriculture and renamed in 1937. War, and the shrinking of the FSA budget, led Stryker to move the section again in 1941 to OWI. When internal divisions there over propaganda policy threatened the massive Historical Section photographic files with dispersal, Stryker arranged for their transfer to the Library of Congress, where the images (both negatives and file prints) are now held.

During its lifetime, the Historical Section employed 44 photographers; a majority of photographs in the file are the work of fifteen men and women. The agency's work took place in two locations: at its Washington, DC headquarters, where Stryker directed operations, including a darkroom and the growing file of photographs; and in the field in the (then) 48 states and Puerto Rico. Headquarters supplied photographers with cameras, film, and flashbulbs. Stryker often gave them detailed general instructions (known as 'shooting scripts'), and sent them out to document the work of FSA local agents and the broader economic realities of farms, ranches, and rural rehabilitation projects. Most sent exposed film back to headquarters to be developed and later provided captions to proofs returned to them in the field. Initially, images of the people and landscapes affected by the intense rural poverty predominated in the file, bringing the human cost of the Depression into sharp focus. After 1937 the photographers included more images of the community life of rural small towns, and a few urban centres. From 1940, as Stryker first subcontracted the section's photographic services to wartime agencies, then worked within OWI, hundreds of images also documented the nation's industrial production and home front activities. As the file at headquarters grew, so too did its use and reputation. FSA images were freely available, and appeared widely in newspapers and magazines, in government pamphlets, in posters promoting agency accomplishments, and even in a giant photographic mural in Grand Central Station in New York.

As a teacher at Columbia University, Stryker had valued photography for its power to persuade and educate. The first photographers he hired, Walker *Evans, Carl *Mydans, and Ben *Shahn, taught him to understand the importance of visual integrity and artistic quality in documentary images. His photographic staff were among the finest of their generation. Dorothea *Lange created memorable images of migrant labourers in the *American West. Arthur *Rothstein, whose first job in 1935 was to set up the Historical Section's darkroom, became one of its most productive photographers. Stryker hired, and his experienced staff helped train, a whole generation of new recruits: John *Vachon, Russell *Lee, Marion Post *Wolcott, Jack *Delano, John Collier Jr., Gordon *Parks, and Esther *Bubley were among those who began distinguished careers under the FSA/OWI.

The influence of the FSA/OWI photographers on modern photography is almost incalculable. Walker Evans's exhibition of his FSA images at MoMA, New York, in 1938 helped define 'documentary photography' as an art form. The creation, and preservation in the file, of a series of images forming a coherent narrative served as precedent and inspiration for the development of the *photo-essay by *Life and Look magazines. FSA/OWI photographers worked with and demonstrated the value of new technologies: several used 35 mm 'miniature' cameras effectively to capture spontaneous action and intimate portraits, sometimes unbeknown to the subjects. OWI photographers were among the first government photographers to use 35 mm colour transparency film on a large scale. The concentration on real people who retained dignity in the face of immense hardship, combined with instinctive recognition of the importance of a distinctively photographic aesthetic, inspired imitators throughout the world. Rediscovered in the 1960s and 1970s, the FSA/OWI photographs were initially criticized as 'propaganda' for their alleged distortion and manipulation, but later achieved iconic status as a unique photographic and historical legacy.

Hurley, F. J., *Portrait of a Decade* (1972).
O'Neal, H., *A Vision Shared* (1976).
Stott, W., *Documentary Expression and Thirties America* (1973; 1986).
Fleischhauer, C., and Brannan, B., *Documenting America, 1935–1943* (1988).
Curtis, J., *Mind's Eye, Mind's Truth: FSA Photography Reconsidered* (1989).
McEuen, M. A., *Seeing America: Women Photographers between the Wars* (2000).

The Photo League

Between 1936 and 1951, the Photo League emerged as the leading US organization championing the development of documentary photography. Defending photography both as an expressive medium and an agent for social change, it originated in the earlier Film and Photo League after the film-makers moved out of the group's shared headquarters in New York. A membership organization of amateurs and professionals, the league also functioned as a cooperative, giving independent professionals a base from which to run their businesses. It provided members' darkroom space, mounted photographic exhibitions, offered elementary and advanced classes in photography, and gave photographers an outlet for news and ideas through its newsletter, *Photo Notes*. The league, through its founders Sol Libsohn and Sid *Grossman, was instrumental in preserving the photographic oeuvre of Lewis Hine. Members of the 'Documentary Production Group' completed important projects on New York street life in the Lower East Side and Harlem 1936–42. Documentary photography by league members Walter *Rosenblum, Paul Strand, and Harold Corsini appeared regularly in *Fortune*, *Look*, *US Camera*, and *Good Photography*. After the Second World War the league began a fund-raising effort to make its headquarters a 'Center of American Photography'. However, in December 1947 the FBI and the US Attorney-General blacklisted the league as a communist front organization, basing charges in part on Grossman's 1940 documentation of labour union activities. Though the charges were unsubstantiated, Cold War fears led to a drop in

membership, loss of tuition income, and inability to get its exhibitions reviewed in the mainstream press. Unable to pay its rent, the league disbanded in the summer of 1951.

The league's most important contribution to documentary photography was probably its dual roles of teaching new photographers and then providing a centre where those committed to documentary photography could connect with each other, to meet, exchange ideas, and view each other's work. In the late 1930s, when few photographic exhibition *galleries existed and *museum collecting of photographs was in its infancy, the league held regular exhibitions featuring the work of both established photographers and newcomers. Students in its classes could see the work of Eugene Atget, Lewis Hine, Paul Strand, and Edward *Weston. The league was the first to exhibit *Weegee's work. At its monthly meetings, speakers included Henri *Cartier-Bresson, Strand, Stryker, Margaret *Bourke-White, and Berenice *Abbott. The photographic historians Beaumont and Nancy *Newhall were members, as were Elizabeth McCausland and W. Eugene *Smith. In Walter Rosenblum's words, at the league 'interesting people, deeply involved with photography, were happy to help young photographers understand in greater depth the meaning of photography as a fine art'. CBS

Light, K., *Witness in our Time: Working Lives of Documentary Photographers* (2000).
Tucker, A., *This Was the Photo League* (2001).

Mass-Observation in Britain

The Mass-Observation (M-O) research organization in Britain was, like the FSA, much larger than the documentary photographic work for which it is also known. It was founded in January 1937 by three young left-wing intellectuals, Charles Madge, Tom Harrison, and the Surrealist photographer and film-maker Humphrey Jennings (1907–50), who had been dismayed, during the crisis of Edward VIII's abdication, by the population's continuing affection for the monarchy. Madge declared that to understand ordinary working-class people, intellectuals needed to study them by 'mass observation'; and the three determined to create an organization that would change society by using anthropological observation techniques to probe the character of the British, and especially of the northern working class. Active until the early 1950s, M-O undertook an almost quixotic range of projects, resulting in the publication of 25 books between 1937 and 1950. In addition to paid investigators who observed people in public settings (pubs, meetings, leisure and sport activities) thousands of volunteers were recruited to keep diaries and respond to monthly thematic questionnaires. Though central direction lagged during the war years, many of these diarists continued faithfully, creating a rich legacy of wartime observations. Best known, perhaps, was the study of industrial 'Worktown' (Bolton, Lancashire) and its inhabitants' annual seaside holiday at Blackpool, an intensive project between 1937 and 1940 that continued sporadically through the war years. The voluminous Mass-Observation Archive was donated to Sussex University in 1970.

Photography was from the beginning an important observation technique for M-O, and the best known of its photographers, Jennings and Humphrey *Spender, were strongly influenced by the example of the FSA. Spender took more than 800 candid photographs as part of the 'Worktown' study, using a hidden 35 mm camera in the belief that 'truth would be revealed only when people were not aware of being photographed'. Jennings, too, photographed the grimy environment of Bolton before abandoning M-O to concentrate on documentary film-making. Later, photography continued to be an important part of Mass-Observation work; in the village of Luccombe in Somerset, for example, John *Hinde used colour photography as part of a 1944 M-O study coordinated with the Ministry of Information to export the image of an idealized English rural community. CBS

Cross, G., *Worktown at Blackpool: Mass Observation and Popular Leisure in the 1930s* (1990).
Sarsby, J., ' "Exmoor Village" Revisited; Mass Observation's "Anthropology of Ourselves" [and] . . . Wartime Colour Photography', *Rural History* (1998).

French humanist documentary

French 'humanism' lies at the heart of 20th-century photojournalism. It was a dominant form of documentary and editorial photography from the late 1920s until the 1970s, though its impact is still felt in the 21st century. It influenced the style and content of all the great illustrated magazines of the 1930s, 1940s, and 1950s, in Europe and America. Many of the leading names of 20th-century photography were associated at various points in the life of the movement (although that is perhaps a tendentious term for such a loose grouping of like-minded individuals): *Kertész and *Brassaï, Marcel Bovis (1904–97), *Boubat, Pierre Boucher (b. 1908), Robert *Capa, Jean-Philippe Charbonnier (b. 1921), *Dieuzaide, *Doisneau, François Kollar (1904–79), Janine Niépce (b. c.1920), *Riboud, *Ronis, Roger Schall (1904–95), *Seymour, Sabine Weiss (b. 1924), and many others (including younger photographers like Martine *Franck). The leading photo *agencies *Rapho and *Magnum were formed to distribute the work of such photographers, and played a key role in the development of humanism as a global photographic paradigm. Steichen's *Family of Man* exhibition (1955) used many images drawn from the corpus, or heavily influenced by it.

Its subject matter was concisely defined by perhaps its best-known exponent, Henri Cartier-Bresson, when he told a journalist in 1951 that the most important subject for him and his colleagues was 'mankind; man and his life, so brief, so frail, so threatened'. In this sense, humanism has an ethically combative edge, aiming to celebrate and defend a humanity everywhere challenged by totalitarian power—particularly in the period 1936–68, with the Second World War and the subsequent period of reconstruction of special importance. A French magazine article of 1955 refers to a type of photography that takes as its subject 'the human being and the mark that he leaves on nature and on things'.

French humanism is deeply rooted in social themes, particularly those which came to prominence in 1939–45, and the occupation and liberation of France. After 1944, humanist photography helped

to reconstruct what it was to be French. In this, the role of the photographer providing illustrative images to the press may not seem of critical importance, but it played a part in the evolution of new representations of Frenchness which can be seen as having a primarily solidaristic role. They cluster around certain themes, the majority of which contain a central core of social and cultural referents having to do with community and solidarity, and with the sense of happiness or contentment which derives from human association.

Visually, French humanism was greatly influenced by the poetic realism of Hungarian photographers like Kertész, who worked in Paris between 1925 and 1934, and Brassaï, whose *Paris de nuit* (1934) was almost a textbook for the movement. The work of émigré photographers trained in German photojournalism of the 1920s, such as Germaine *Krull, and the impact of the *modernism of *Rodchenko and *Moholy-Nagy also played a part in inspiring a *nouvelle vision* in which the small hand-held camera—the new *Leica and *Rolleiflex in particular—freed the photographer from reliance on the studio. The street and the lives of ordinary people became the working place and the subject matter of preference, for pictures made by freelance photographers who sold their work to the illustrated press—*Vu, Match, Regards*, and others pre-1940, *Point de Vue*, *Paris Match*, and *Réalités* after the war. But perhaps more significant than the visual style of the work was the general support felt by this generation of photographers (most born between *c.*1905 and the early 1920s) for the political values of the Popular Front of the mid-1930s. Some belonged to the Communist Party or its cultural front organizations; all believed in the need to transform France to make it both more egalitarian and better able to withstand the menace of fascism.

After the miseries of defeat and occupation, the period of Fourth Republic reconstruction to 1958 witnessed the heyday of French humanist photography, revealing both its moral purpose and its distinctive subject matter. It is inclusive and universalistic, stressing equality and the primacy of the fundamental institutions of liberal society, and in particular their solidaristic connotations. *Surrealism's fascination with the unconscious aspects of everyday existence is a clear influence on French humanism—but not its *raison d'être*. It celebrates the ordinary, the everyday, the unremarked. It has a dozen or so recurrent themes, including the street, childhood, love, the family, the home, work, popular celebrations, and cultural personalities. While stressing the importance of simple, unretouched, realist representations, it also places particular value on their 'poetic' construction, a 'poetic realism' made for the printed page rather than the gallery wall. Indeed, one of the best-selling illustrated books of the post-war era, *Paris des rêves* (1950), combined humanist photographs by *'Izis' with handwritten poetry by leading French writers, from André Breton to Louise de Vilmorin. Key books such as Robert Doisneau's *Banlieue de Paris* (1949), Cartier-Bresson's *Images à la sauvette* (*The Decisive Moment*, 1952), Ronis's *Belleville-Ménilmontant* (1954), showed this work to its best advantage, but also demonstrate how the photographers were linked to central cultural figures of the day: painters such as Matisse, Picasso, or Bracque, and writers like Blaise Cendrars and Pierre *Mac Orlan.

Although the movement gradually lost steam from 1968, many of the photographers continued working, some into their nineties. Their work remains popular, and though sometimes mistakenly criticized as sentimental or nostalgic, it remains of great historical importance, picturing a world where values such as the primacy of human feelings and the sense of community still commanded widespread support.

PH

Thézy, M. de, *La Photographie humaniste, 1930–1960: histoire d'un mouvement en France* (1992).

Since the 1950s

Beginning in the 1950s, but increasingly after 1970, documentary photography became many things to many audiences. Charlotte Cotton, curator of the exhibition *Stepping in and Stepping out: Contemporary Documentary Photography* at London's Victoria & Albert Museum (2002), pointed to the 'range of emotional forces—political, humanist and aesthetic—which drive [contemporary] documentary photography'. An even larger London show the following year, Tate Modern's *Cruel and Tender*, illustrated both its contemporary and historical diversity. Simply counting relatively conventional social documentary work in Europe and the USA since the 1970s yields a huge range of subjects, from teenage sex and drug abuse (Larry *Clark), old age (Martine Franck), and domestic violence (Donna *Ferrato) to post-industrial desolation (Chris *Killip, Sirkka-Liisa *Konttinen), female sex-workers (Susan *Meiselas), the British seaside (Martin *Parr, Tony *Ray-Jones), and the French fishing industry (Jean Gaumy (b. 1948)).

The tradition of reporting unsettling social realities founded by Riis and Hine, and continued by the FSA/OWI, was already central to the growing (and to some commentators separate) field of photojournalism. In Europe, the Magnum agency became a major international distributor of documentary photography of political events. Outside Europe and North America, independent documentary photographers like Sebastião Salgado continued to use their cameras to protest against inhumane conditions. Documentary practice is now worldwide, its images disseminated through disparate outlets and media: galleries, books, magazines, newspapers and the *Internet. Like Paul Strand before 1939, many documentary photographers since 1945, such as René *Burri and Larry Clark, have also made films.

Although the earliest social documentary reform photographers had explicitly rejected the designation of their work as 'art', much late 20th-century documentary photography attracted this label. Building on the 'straight' approach of the Photo League, but in some cases moving towards the exploration of personal rather than societal problems and shortcomings, psychological rather than social reality, the makers of this kind of work captured the alienation and isolation of modern life, often more as distanced observers than as passionate advocates. Beginning with Robert Frank's *The Americans* (1958), carried further by the gritty realism of Garry *Winogrand, Lee Friedlander, and Mary Ellen *Mark, or the detachment of Diane Arbus,

Antoine Claudet Family group, *c.*1845. Tinted daguerreotype

Anna Atkins Cyanotype of British ferns, 1853

this strand of documentary practice offered ironic commentaries on American complacency.

Though it also appeared in magazines, such work was more likely to be viewed in photographic galleries and book-length monographs than in photo-essays. This important shift was illustrated by W. Eugene Smith, whose pictures appeared periodically in *Life* until the 1960s, but who published his outsize essay on Pittsburgh in *Photography Annual* (1959), and the final version of *Minamata* as a book (1975). The change was driven partly by the decline or disappearance of the great illustrated magazines, but partly also (and encouraged by the rise of an art photography *market from the 1960s) by the perception of the photographer-as-artist. Organizations like the Guggenheim and Hasselblad foundations often supplied sponsorship. The appearance of new exhibition venues in cities like San Francisco, New York, London, and Paris, and the creation of dedicated publishing houses such as Ralph *Gibson's Lustrum Press, *Aperture, and Picture Project provided important outlets.

At the same time as documentary photography turned inward, and some of its practitioners defined themselves, or were defined, primarily as artists, there was a democratization of documentary photography, an adaptation of its potential to the documenting of local communities, 'empowered' through being given a means to create and capture their identity through their own or a professional's photographs. Modelled on the FSA/OWI concept of a 'file' of photographs that document the reality of a specific time and place, but relying on local funding, this kind of documentary photography often has a celebratory character rather than one of irony or critical outrage. Enterprises such as the California Council for the Humanities Documentary Project, or the 'Milleni-Brum' project of the Birmingham Central Library, England, to document under-represented ethnic groups, re-emphasize its earliest meaning of simply making a record. In the USA on a national scale, the FSA model survived in the 1970s Project DOCUMERICA funded by the Environmental Protection Agency to document the condition of the environment. CBS

Light, K., *Witness in our Time: Working Lives of Documentary Photographers* (2000).

dodging and burning. See PRINTING AND ENLARGING, BLACK-AND-WHITE/COLOUR.

Dodgson, Charles L. (1832–98), English author and amateur photographer, better known to the wider world by his pseudonym Lewis Carroll, and for his two *Alice* books, whose fame has tended to overshadow both Dodgson's academic career as a mathematician and his extensive body of photographic work.

When Dodgson entered Christ Church, Oxford, as an undergraduate in 1851, photography was emerging into the vibrant second phase of its development. Photographic societies proliferated and legions of amateurs took to the countryside in search of picturesque subjects. In common with these photographers Dodgson saw photography

Charles L. Dodgson (Lewis Carroll)
Leila Campbell, 19 July 1879. Albumen print

as a means of artistic expression but, unlike them, he preferred to concentrate on *portraiture, with studies of children predominating. Between 1856 and 1880 he made c.3,000 photographs, all by the *wet-plate process that was his preferred medium. His mastery of exposure and of the complex chemistry of the process was typical of everything he attempted. Nothing was left to chance and errors were discarded as failures. For most of this period his prints were made by commercial establishments in London and Oxford and he only began printing again when he moved to the portrait studio that he had built above his rooms at Christ Church.

Popular myth has Dodgson as hesitant in speech and shy in company, but the evidence of his photographs suggests he had a wide social circle of relatives, friends, and celebrity acquaintances with whom he enjoyed a special rapport. The stiff formalities of prevailing photographic conventions are supplanted by a more relaxed and informal approach that draws upon Dodgson's complete understanding of compositional values and lighting. When photographing children he brings his camera down to their level where its presence becomes less commanding, and one can readily picture him kneeling to tell some wonderful nonsensical story to put his sitter at ease before making the exposure. It was a talent that few adults possessed and is indicative of Dodgson's belief that children were a gift from God whose presence gave meaning to his life as reverend gentleman, academic, children's author, and photographer. RTA

Taylor, R., and Wakeling, E., *Lewis Carroll: Photographer* (2002).

dogs. See PETS.

Doisneau, Robert (1912–94), French photographer. Born in Gentilly on the southern edge of Paris in 1912, Doisneau became a leading exponent of French humanist photography. He never moved away from the Parisian *banlieue* (suburbs), and famously turned down an invitation to join *Magnum in 1947 because it would have meant considerable travel outside France, and more particularly Paris. He had also recently joined the *Rapho agency and felt loyalty to its owner, Raymond Grosset.

The most Parisian of the humanists, Doisneau's work can be seen as a visual social history of the city, its people and culture, from the 1930s to the 1980s. He spent much of his life on projects that cover the life of its streets, the people and places that gave the city and its suburbs their identity. His pictures of lovers, children, and families are widely reproduced. Although widely known for a series of anecdotal, narrative pictures in which he used models to recreate a situation he had observed earlier—*Un regard oblique, Le Baiser de l'Hôtel de Ville*—his extraordinarily rich body of work was mainly produced 'sur le vif', plucked by chance from the stream of everyday life.

Many of his most famous photographs were self-commissions, the outcome of a long wait on a street corner, or a lengthy promenade through a series of locations which might prove productive. Doisneau preferred to describe himself as a *pêcheur d'images* (a 'fisher' of pictures) rather than to use the term commonly used for reportage photographers—*chasseur d'images* (picture hunter). The difference is significant. In order to make 'my' pictures, Doisneau said, 'I had to "get wet", to immerse myself in the life of the people whom I was photographing'. Such an approach yielded the most comprehensive and multifaceted self-portrait of his social class, the *classe populaire*, a self-portrait which also shows the photographer as a person woven into the fabric of his times.

Trained as an engraver, Doisneau took up photography in 1930–1 as the new technology of the small camera was emerging. With his precious *Rolleiflex he fished the suburbs for images which expressed his rebelliousness towards authority and convention. A period as industrial and commercial photographer at Renault (1934–9) helped to define his political and social values, which were sorely tried during the Occupation, when he scratched a living as a photographer and forger for the Resistance. Typically, his pictures of the liberation of Paris emphasize its human, popular character.

The years 1945–60 were Doisneau's heyday. He produced books that are iconic works of French humanism, worked regularly as a photojournalist, notably for *Vogue and *Life, and enjoyed rich and creative friendships with writers, musicians, and artists. In the 1960s and 1970s he had to turn increasingly to industrial and commercial work, but continued his own almost obsessive documentation of social change in Paris. Rediscovered in the 1980s as the author of iconic images of the 1950s, but also as a gifted raconteur and writer, he had a final period of intense activity, especially as a portraitist, a role for which he possessed true genius. PH

Hamilton, P., *Robert Doisneau: A Photographer's Life* (1995).

Domon, Ken (1909–90), Japanese photojournalist. Joining Nihon Kobo publishers in 1935 as staff photographer for *Nippon*, a magazine devoted to disseminating Japanese culture, he adopted a German-influenced style encouraged by the editor-in-chief, Yonosuke Natori. Domon's photographs are strong, even rigid, face to face with his human or architectural subject, aiming for truthfulness and clarity. In 1939 he resigned over a conflict with Natori. The year 1941 saw him photographing Bunraku puppet theatre. After the war he concentrated on the lower end of society, Japan's beggars, shoeshine boys, and marginal people. He judged amateur competitions for the magazine *Camera* intermittently from 1950 to 1955, and for other magazines for several more years. Through the competitions and his teaching he propagated photographic realism and encouraged amateur photographers to pursue the straight, unstaged image. His charisma and style influenced many. Amongst his books are *Muroji Temple* (1954); and *Hiroshima* (1958), focusing on the victims of the atomic bomb thirteen years later. *Children of the Chikuho Coal Miners* (1960), printed cheaply on pulp paper, sold over 100,000 copies. Though partly paralysed by a stroke, he continued to photograph with a large-format camera from his wheelchair. The series *Koji Junnrei* (*Temple Pilgrimages*) and subsequent books of strong and reverent photographs of temples and Buddhist statues in Kyoto and Nara testify to his perseverance. MHV

Donovan, Terence (1936–96), British photographer. Born in Stepney, London, he was one of a trio—the others were David *Bailey and Brian *Duffy—who burst on the world of fashion and advertising during the 'swinging sixties'. Donovan's innovative use of the medium, coupled with a discerning eye and an understanding of the age, made him much in demand by magazine editors and advertising agencies. In the studio his technical expertise and feel for the quality of light and the moment led him, in his later years, to work on advertising films—first as lighting cameraman, then as director. In an interview he said: 'All you can ask from human life is to get up in the morning, do the best you can, go to bed at night, and be as fair and uncruel as possible.' RSA

d'Ora, Madame (Dora Kallmus; 1881–1963), Austrian portrait photographer. Kallmus studied photography at Vienna's Graphische Lehr- und Versuchsanstalt, but only men were admitted to the laboratories. To obtain practical training and a trade licence, her father funded an apprenticeship at the Berlin portrait studio of Nicola *Perscheid, and in 1907 Kallmus set up her own Vienna studio with Perscheid's assistant Arthur Benda. Benda took the photographs in a manner influenced by Perscheid's *pictorialism; Kallmus was the stylist and manager, bringing in sitters through her family's upper-middle-class Jewish connections. Clients included the Austro-Hungarian aristocracy, dancers, actors, and members of the Wiener Werkstätte, whose clothing designs were shot as early *fashion photographs. In 1925, Kallmus opened a studio in Paris, publishing celebrity and fashion images in magazines such as *Femina* and *Die Dame*. The German occupation forced her to abandon her studio and retreat to the French provinces. She returned to Paris after the war, but photographed sporadically, largely forsaking glamour for photographs of refugees, her ageing contemporaries, and a surreal series on abattoirs. After a 1958 Paris retrospective and a serious street accident, she spent her last years at the Austrian country house she had reclaimed from the Nazis. HWK

Faber, M., *Madame d'Ora: Porträts aus Kunst und Gesellschaft, 1907–1957* (1981).

Dossier BB3, Paris police file on pornographic photography, running to 303 manuscript pages and covering the years 1855–68. Although many 19th-century police forces monitored the pornography industry, relatively few documents survive, and other Paris material was destroyed in the *Paris Commune of 1871. *Dossier* BB3 is exceptionally copious and informative, containing not only *c.*100 pasted-in samples of confiscated photographs but arrest reports, and details of photographers, colourists, peddlers, male and female models and their procurers, and the sentences they received. Many of those included were reputable view or portrait photographers; one was choirmaster of a Paris church. There is no record of purchasers or collectors, as possession was not illegal. But the file affords a fascinating glimpse into aspects of the French photographic and sex industries at a time of heightened public concern. RL

See also EROTIC PHOTOGRAPHY; PORNOGRAPHY.

Pellerin, D., 'Dossier BB3 and the Erotic Image in the Second Empire', in F. Reynaud, C. Tambrun, and K. Timby (eds.), *Paris in 3D: From Stereoscopy to Virtual Reality 1850–2000* (2000).

Driffield, Vero. See CHARACTERISTIC CURVE; NATURALISTIC PHOTOGRAPHY.

Drtikol, František (1883–1961), Czech photographer, painter, and mystic who studied photography at Munich's Lehr- und Versuchsanstalt für Photographie 1901–3. In 1910, after military service, and jobs in various Munich studios, he opened a studio in Prague in partnership with Augustin Skarda. Here he made acclaimed portraits of leading writers and artists, a series on early aviators, and Art Nouveau *pictorialist rhythmic studies, sold through the Artel Cooperative. The studio was also used for the development of Drtikol's best-known work, his experimental nudes, which achieved a transition from Jugendstil to modernist, *Bauhaus aesthetics, by using strong lighting contrasts with graphic, geometrically shaped sets and props. They were published as *Žena ve Svetle* (1930), now recognized as one of the classic books of photographic nudes.

Drtikol abruptly gave up the studio and photography in 1935 to study painting, meditation, and Oriental philosophy. Astonishingly, although he was probably the first Czech photographer to achieve world renown, there was no solo exhibition of his work in his lifetime. However, it was brought to light again in an exhibition organized by Anna Fárová in Prague in 1972. RA

Fárová, A., *František Drtikol: Photograph des Art Deco*, introd. M. Heiting (1993).
František Drtikol: fotograf, malir, mystik (1998).

Drum magazine (1950–85) portrayed an emergent, vibrant, black urban life in South Africa from the early 1950s. The German photographer Jürgen Schadeberg (b. 1931) joined the editorial team in 1951. Starting with Bob Gosani (1934–72), a pattern developed where darkroom assistants turned into professional photographers. None had formal training like Schadeberg, but on the job they produced images that in J. R. A. Bailey's editorial view were 'unusual and excellent', deeply expressive of the political limbo and social excitements of the time. The distinguished crop of black photographers coming through *Drum* in the 1950s and 1960s included Ernest Cole (1940–90), Alf Kumalo (b. 1930), Peter *Magubane, Victor Xashimba, Gopal Naransamy, and G. R. Naidoo. PHA

Schadeberg, J., *Images from the Black 50s* (1996).

dry-plate process. The first practicable dry-plate process was devised by Richard Leach *Maddox. Details published in 1871 described how an emulsion of silver bromide in gelatin, coated on to a glass plate and dried, remained light sensitive for a prolonged period. Although plates based on Maddox's formula were sold in London by John Burgess in 1873, it was only after improvements by Richard

František Drtikol

The Black Cloth, 1927

Kennett in 1874 and Charles Bennett in 1878 that fully satisfactory dry plates were manufactured and mass marketed. The new plates were widely adopted and within a few years dry emulsions had completely revolutionized photographic practice. More convenient to use and with greater sensitivity than wet- *collodion plates, shorter exposures led to the introduction of hand cameras; dry emulsions made roll-film possible. Modern sensitized materials continue to be based on gelatin silver halide emulsions. JPW

Du, Swiss cultural magazine, founded in 1941 by Arnold Kübler, former picture editor of the *Zürcher illustrierte*. Appearing monthly, it became famous for the exceptional quality of its photographic reproductions. Photographers associated with it have included Werner *Bischof, René *Burri, and Marc *Riboud. RL

Düben, C. (*fl*. 1850s–1860s), peripatetic commercial *daguerreotypist. Already active in Mexico in 1850 and San Francisco in 1852, he then crossed the Pacific. His advertisements in local newspapers show that he visited Shanghai, Hong Kong, Manila, Singapore, and Batavia (Jakarta) between 1852 and 1854, and was in Batavia in 1857. Although local markets were presumably too small to support permanent establishments, they were clearly profitable for visitors. Düben moved from one port to another, imitated by his fellow daguerreotypists Herman Husband (in Peru in 1847,

Honolulu in 1852) and L. Saurman, with whom he worked in Shanghai in 1852. RT

Dubreuil, Pierre (1872–1944), French photographer. He had independent means, and photographed as a serious amateur from 1891. He began as a *pictorialist: elected to the *Linked Ring in 1903, he practised *oil printing from 1904. Dubreuil's enduring importance is as an early modernist, whose novel compositional strategies—and perceived eccentricities—derived from Cubism, *Futurism, and Belgian *Surrealism. He exhibited widely and became president of the Association Belge de Photographie in 1932. Sickness and poverty led him to sell his archives to Gevaert in 1943; they were lost when the factory was bombed. HWK

Pierre Dubreuil: photographies 1896–1935 (1987).

Du Camp, Maxime (1822–94), French writer who, with his close friend Gustave Flaubert, made a classic journey to the Middle East lasting from the autumn of 1849 to the spring of 1851. The odyssey that took them from Egypt to Turkey via Palestine and Syria is well documented in their letters and subsequent writings. Apart from its literary significance, it represents the earliest attempt to create a survey of antiquities using the paper-negative process. Before leaving, Du Camp had learned the *calotype technique from Gustave *Le Gray. This was fashionable among the French intellectual and artistic elite at the end of the 1840s, and the ambitious young man hoped to raise the expedition's profile by proposing to make a photographic survey of major monuments for the Académie des Inscriptions et Belles Lettres. This official mission explains the markedly documentary character of his architectural vision. He made 220 paper negatives, mostly in *Egypt, which constituted his entire photographic oeuvre. One hundred and twenty-five prints were made, and in 1852 issued in albums by the Lille publisher *Blanquart-Évrard. They were preceded by an introduction by Du Camp, assisted by the Egyptologist Émile Prisse d'Avesnes. All 200 copies sold immediately, notwithstanding their high price. Du Camp, noticed by Napoleon III, received the Légion d'honneur. The albums were acquired by major public and private libraries, and by artists such as Eugène Fromentin, Gustave Moreau, and Auguste Bartholdi. SA

Aubenas, S., and Lacarrière, J., *Voyage en Orient* (1999).

Duchamp, Marcel (1887–1968), French artist and leading figure of the early 20th-century avant-garde. An interest in optics informed much of his work, with *chronophotography, X-rays, and other techniques for visualizing the invisible a particular concern. His ready-mades, common objects elevated to the status of art by virtue of their selection, have a conceptual affinity with photography; some scholars argue that photographs of the ready-mades, by which they are largely known, are themselves ready-mades. Significantly, these are reproduced as works by Duchamp, not as belonging to the oeuvre of the photographer. MR

Clair, J., *Duchamp et la photographie* (1977).

Duchenne de Boulogne, Guillaume (1806–75), French doctor and photographer. A noted neurologist associated with the Salpêtrière hospital in Paris, he wrote one of the most striking works of early 'scientific' photography. The way in which scientific photographs of the face and the body were made until the 1880s seems indistinguishable from that for 'artistic' or 'social' purposes. This is particularly clear in his *Mécanisme de la physionomie humaine*, published in 1862 with prints from Duchenne's negatives. It is a comprehensive and influential study of the muscles of the face, and their relationship with the expression of emotion (Darwin had a copy, and used it as a source for his *Expression of the Emotions in Man and the Animals*, 1872).

Duchenne produced photographs of his experimental methods for activating individual muscles by using small electric shocks on patients, images which are directly linked to a scientific text. His images, however, are far from neutral scientific records, and indeed Duchenne had taken some instruction in portraiture from *Nadar's brother Adrien Tournachon (1825–1903). They are visually striking, lit in a manner akin to that of contemporary art portraiture, and presented as exemplars for those practising the 'plastic arts'. Duchenne also offers an 'étude critique' of certain classical busts, for which photographs are also provided. In certain editions of the work a *partie esthétique* was added, which comprised photographs of a woman acting out emotional and erotic scenes—representing 'terrestrial' as opposed to 'celestial' love, and various expressions which represent the role of Lady Macbeth in certain critical scenes of Shakespeare's play. As this example suggests, Duchenne saw art and science as two sides of the same coin, and his strong religious faith doubtless sustained him in this view. As a result he produced some of the most famous portraits of 19th-century photography. PH

Mathon, C. (ed.), *Duchenne de Boulogne* (1999).
Hamilton, P., and Hargreaves, R., *The Beautiful and the Damned: The Creation of Identity in Nineteenth-Century Photography* (2001).

Ducos Du Hauron, Louis (1837–1920), French inventor and photographer, born into a middle-class family and privately educated. In 1859 he laid out principles for colour photography, and in 1868–9 produced a series of papers foreshadowing almost every colour process since exploited. He sensitized *collodion plates to green and red, designed a combined colour camera/projector, and made the first colour prints. His single commercial venture collapsed in a factory fire, and his subsequent life, dogged by ill luck, was eked out only by a meagre government pension and help from friends. The colour technologist D. A. Spencer wrote of him: 'Rarely has any inventor shown such imaginative foresight, or received so little encouragement.' GS

Coote, J. H., *The Illustrated History of Colour Photography* (1993).

Duffy, Brian (b. 1934), English photographer, and with Terence *Donovan and David *Bailey a key figure of the 'swinging sixties'

Maxime Du Camp

Colossus at Abu Simbel, Nubia, 1850. Salted-paper print

Guillaume Duchenne de Boulogne

Portrait of a hunchback boy, *c.*1855–7. Coated salt print

photographic, advertising, and fashion scene. By the mid-1970s, however, Duffy had become more interested in film production, and was instrumental in bringing the satirical musical *Oh What a Lovely War!* to the screen. He eventually gave up photography to return to painting, and is reputed to have destroyed his 1960s photographic work. RSA

Dufty Brothers, Francis H. (dates unknown) and **Alfred** (d. 1924). They had a substantial photographic business in Fiji in the 1870s and 1880s. Originally from England, Francis Dufty opened his studio in June 1871, on Beach Street, the most prestigious address in Levuka. It attracted many distinguished clients, both colonial and Fijian, including the governor, Sir Arthur Hamilton Gordon, Baron von Hügel, and the Fijian leader Cakobau. Duftys are best known for their portraits of Fijians, who often posed with elaborate barkcloths, clubs, and ornaments. These latter were, themselves, sometimes sold on to European collectors. Francis was closely involved in local politics and a leading figure in Fijian colonial society. His and Alfred's images, both portraits and local views, are found in many travel and nautical albums as well as in anthropological collections. They moved to Suva in the mid-1880s. Alfred left Fiji in 1887 and Francis in 1892, after which he ran a studio in Melbourne, Australia, with limited success. Two other Duftys, Walter and Edward (who specialized in landscape), had a successful studio in Nouméa, New Caledonia, with which Alfred became involved in the late 1870s. There is evidence that they all sold each other's prints through their respective studios, further enhancing the circulation of their images. EE

d'Ozouville, B., 'F. H. Dufty in Fiji 1871–1892: The Social Role of a Colonial Photographer', *History of Photography*, 21 (1997).

d'Ozouville, B., 'Reading Photographs in Colonial History: A Case Study from Fiji 1872', *Pacific Studies*, 20 (1997).

Dührkoop, Rudolph (1848–1918), German *pictorialist portrait photographer, born and mainly active in Hamburg. Originally a railway employee, Dührkoop took up photography in the 1880s, and from 1882 attended lectures by the Hamburg Kunsthalle director Alfred *Lichtwark. He opened his first studio in 1883 and made his name when he began giving his portraits a more modern look by photographing clients at home or in the open air. He first exhibited in 1899, at the 6th Salon of the Hamburg Society for the Encouragement of Amateur Photography. Dührkoop subsequently spent time in Berlin, Paris, and London, and in 1904 visited the USA, where he met Gertrude *Käsebier. In 1905 he published the collection *Hamburg Men and Women at the Beginning of the 20th Century*. In 1908 he became a member of the *Royal Photographic Society, and in 1909 opened a second studio, in Berlin. He remained one of Germany's most sought-after portraitists. His daughter, Minya *Dièz-Dührkoop, eventually took over his studio. JJ

Kaufhold, E., *Bilder des Übergangs: Zur Mediengeschichte von Fotografie und Malerei in Deutschland um 1900* (1986).

Duncan, David Douglas (b. 1916), American war photographer who covered the South Pacific during the Second World War as a second lieutenant in the US Marine Corps. Duncan's sympathetic portrayal of men and women at war earned him a staff position with *Life, for which he covered Palestine, the Korean War, and the Egyptian military coup of 1952. Duncan later undertook a variety of projects as a freelance photographer, including a collaboration with Picasso, but returned to combat photography, covering Vietnam for *Life* and ABC News. In 1972 he became the first photographer to have a one-man show at the Whitney Museum, New York. MR

Duncan, D. D., *Photo Nomad* (2003).

Durandelle, Louis-Émile. See DELMAET, HYACINTHE CÉSAR, AND DURANDELLE, LOUIS-ÉMILE.

dusk. See TWILIGHT.

dye couplers. See COLOUR REPRODUCTION PRINCIPLES; PHOTOGRAPHIC PROCESSES, COLOUR.

dye transfer. This process, originally known by the unattractive name of 'wash-off relief', was introduced by Eastman Kodak in the 1930s as an alternative to tricolour *carbro. It also began with separation negatives made using red, green, and blue filters. From these, positive transparencies of the size required for the finished print were made on special 'matrix' film having a thick, soft, yellow-dyed emulsion. These were exposed through the back and processed in a hardening developer followed by a bleach-fix and a wash in hot water to remove the layer of undeveloped emulsion, leaving an image with density represented by thickness. (Later, removal of unexposed gelatin was achieved chemically.) The matrices were then immersed in dye solutions, the red, green, and blue records respectively in cyan, magenta, and yellow dyes. After a quick rinse in conditioner solution the matrices were squeegeed in turn on to mordanted paper (i.e. paper specially prepared to receive and fix dyes) using pin registration. The process was less messy and unreliable than carbro. The dye-transfer process became a standard method for making two-colour anaglyphs for *stereoscopic viewing, using red and cyan images for right and left eyes. Dye-transfer prints are still valued for their brilliance and permanence, and for the fact that they can be made on any kind of paper, for example artists' Whatman paper. GS

Coote, J. H., *The Illustrated History of Colour Photography* (1993).

Eakins, Thomas (1844–1916), American painter, and an avid and innovative photographer who produced *c.* 700 images, from relatively mundane studies for paintings to quasi-scientific teaching tools for his drawing and painting classes. He also explored an incipient *pictorialism in dozens of aesthetically resonant figure subjects and nudes. In fact, Eakins was one of the first American photographers to explore the nude, in anatomy and motion studies and artistic studies of the human form. The latter often reflected a latent sexuality, which, along with his reliance on nude models in teaching, precipitated the scandals that plagued his life. CL

Danly, S., and Leibold, C., *Eakins and the Photograph* (1994).

early photographic processes, identification of. There are four stages in identifying photographs. A general inspection by reflected light notes the support materials, image colour, and signs of damage or deterioration. In silver prints, the latter includes yellowing and fading, usually termed 'sulphiding', and the presence of a silver sheen on the shadow areas, often called 'mirroring'. A raking light will highlight surface finish, and can reveal a relief image. A magnifying glass of between 4× and 10× will establish whether there is a grain structure to the image, and 30× will show the image structure of continuous-tone photographs. Finally, the subject matter and date of production will suggest certain processes, which were used for specific applications and within a particular time-frame.

The *daguerreotype* was the earliest direct photograph on metal; the process produces a pale grey matt image on a highly polished, silver-plated copper base. The image is monochrome, sometimes with hand tinting, and reads as a positive, although when viewed obliquely, the image appears to reverse itself. The plate may be tarnished around the edges and can show abrasion marks. A beige-grey image on a thin metal plate is characteristic of a *tintype, a silver *collodion photograph on black or dark brown varnished or enamelled tinplate. There may be mirroring of the silver, and the metal can show rust and surface blistering. Silver collodion coatings could be transferred onto leather or ivory, but the process was most commonly used for photographs on glass as negatives or positives (*ambrotypes). Tintypes and ambrotypes may look like daguerreotypes: they may be presented in similar cases, and their pale, matt highlights and mid-tones resemble the mercury-silver amalgam of daguerreotype images. However, while the daguerreotype appears to change from positive to negative depending on the viewing angle, a collodion positive will look the same from any angle. Furthermore, it will not exhibit the daguerreotype's highly reflective silver in the shadows, which instead show the metal or glass support, backed with black varnish, enamel, paper, or cloth. Some photographs on glass were made with an albumen silver coating: usually termed *hyalotypes*, they display a pale brown image colour, and can show yellowing and fading. These processes were superseded by gelatin silver bromide, as *dry plates and, later, film. Silver bromide is developed out, producing a grey-black image colour, although positive plates (lantern slides and *opalotypes) may be toned or tinted. Such photographs can show mirroring, although some opalotypes were also made as carbon transfers (see below under pigment prints), a process also used for photographs on enamel and ceramic (see PHOTOCERAMIC PROCESSES).

Photographs on paper can be negative or positive images. If the former, they are likely to be *calotypes or *waxed-paper negatives, both exhibiting the neutral brown-black image colour typical of a developed-out silver process. The superficial differences between positive prints may be subtle, so the first task is to establish whether the print is a direct photograph or a photomechanical reproduction. A photomechanical print will be made as ink on plain paper and will usually show a grain structure, discernible under low magnification. This will signal the process: a random structure like dust suggests *photogravure, a pattern of fissures distinguishes *collotype, a regular pattern of dots characterizes *half-tone printing, and a mechanically ruled white grid indicates screened gravure. An embossed line image may be produced by photoengraving, while *photolithography shows no embossing. The *Woodburytype process is a hybrid, producing continuous-tone images in pigmented gelatin from an intaglio printing plate. Woodburytypes can resemble *carbon prints in structure and colour, but the relief is more distinct, and some embossing may be seen.

The earliest direct photographic print process was *salted paper. *Salt prints* are matt, being made on plain paper, and show the warm brown colour of a printed-out silver chloride image. They could be gold toned for a colder, purple-brown hue and improved stability: untoned prints may be yellowed and faded. *Albumen paper carries the silver sensitizer in a coating of egg white, which gives the print surface a satiny shine. Untoned *albumen prints* have a warm brown colour, but were often gold toned, producing a more stable image whose hue extended from cold brown to purple-black. Albumen prints can display yellowed highlights, produced by sulphur compounds in

the egg white, and silver mirroring in the shadows. *Gelatin silver papers* comprise printed-out or developed-out silver chloride, silver bromide, or a combination of the two. Like printing-out collodion papers, they show a range of image colours from warm brown to purple or grey-black, and a variety of surface finishes from high gloss to dull matt. Most show a pigmented gelatin 'baryta' substrate layer between the paper base and photosensitive coating, which gives bright, opaque highlights and a uniformly smooth finish visible under magnification. Deterioration can produce sulphiding and mirroring. The *platinum process* used iron and platinum salts to give fine, low-contrast matt prints in grey-black or cold brown on plain paper. The iron salts may produce occasional brown stains, but platinum does not show the sulphiding and mirroring seen in silver prints. It can be confused with platinum-toned silver bromide, although the latter will have a coated surface and often a baryta layer. *Cyanotype* used iron salts for a blue image on plain paper. Cyanotypes have a matt finish and do not show sulphiding and mirroring, distinguishing them from blue-toned silver bromide prints.

Carbon and *carbro* prints are the most common pigment process. They are made of pigmented gelatin, which shows under magnification as a substantial layer, sometimes with a visible difference between the thicker, glossier shadows and thinner, more matt highlights. Carbon prints are usually a mid-brown or grey-black hue, although other colours were introduced in the early 1900s. Non-transfer pigment variants include *gum bichromate*, and the *Artigue* and *Fresson* processes, whose characteristics include a relatively high-contrast image and dense pigment layer. Hybrids such as oil prints and *bromoil* were inked on a selectively hardened gelatin surface, and exhibit an ink layer on the gelatin coating, although transfer versions show only an inked image on a plain paper base. HWK

Crawford, W., *The Keepers of Light: A History and Working Guide to Early Photographic Processes* (1979).

Coe, B., and Haworth-Booth, M., *A Guide to Early Photographic Processes* (1983).

Reilly, J. M., *Care and Identification of 19th-Century Photographic Prints* (1986).

Eastlake, Lady Elizabeth (née Rigby; 1809–93), English writer, who encountered photography in the early 1840s, when she was photographed by *Hill and Adamson. She published various books and essays on the arts before writing the important 'Photography' (*Quarterly Review*, 1857). In this she anticipated major themes in photographic *criticism: the aesthetic superiority of pre-*carte de visite portraiture; the importance of amateur photography; the power of photography as a form of communication; and the significance of its liberation of painting from representational tasks. Her husband, the painter Sir Charles Eastlake (1793–1865), became the first president of the London Photographic Society (later *Royal Photographic Society). PDB

Eastlake, E., 'Photography', in B. Newhall (ed.), *Photography: Essays and Images* (1980).

Eastman, George (1854–1932), American industrialist and photographic innovator. Eastman, born in Waterville, New York, probably inherited his acute business sense from his father, who founded the Eastman Commercial College in 1842. Within a few years of the latter's death, George—still a young teenager—left school and began working his way up through bookkeeping jobs in small businesses and banks in Rochester where the family had moved. He took up photography at the age of 23. Confronted with the laborious complexity of the silver nitrate and wet-plate process, he began a search for simplifying remedies, the intensity of which came to govern his life. Sometimes accused of patent infringement and creating monopolies by buying out innovative competitors, Eastman nonetheless became noted for his fair treatment of employees and, later, his educational philanthropy. Sometimes overlooked was his close association with Thomas Edison and the development of effective motion-picture film. Eastman's greatest legacy, however, rests with his development—in stages—of a simple camera. Beginning in 1888 with the first of several *Kodak models, followed by celluloid *roll-film in 1889, and finally with the first *Brownie in 1900, photography became increasingly accessible to the masses. TT

Brayer, E., *George Eastman: A Biography* (1996).

eclipses. See SOLAR ECLIPSES.

Economy of Signs, An, exhibition of modern Indian photography at the Photographers' Gallery, London, in 1990. The participants were Sheba Chhachhi: feminist portraiture; Ashim Ghosh (b. 1962): *sadhu* asceticism; Karan Kapoor (b. 1962): elderly Anglo-Indians; Amita Prasher (b. 1961): craftswomen in Rajasthan; Ram Rahman (b. 1955): life and politics in Delhi; Sanjeev Saith (b. 1958): scenes in Sikkim and Kashmir; Ketaki *Sheth: Mumbai (Bombay) scenes; and Sooni *Taraporevala: the Parsi community. RL

Gupta, S. (ed.), *An Economy of Signs* (1990).

Eder, Josef Maria (1855–1944), Austrian chemist and photohistorian. Eder grew up in Krems and in the 1870s studied science in Vienna, from 1875 concentrating on photo-chemistry and photography. He eventually held two Viennese professorships, including (from 1892) that of photography at the Polytechnic. Between 1889 and 1923 he was director of the Graphic Art Institute. Eder made a virtually unparalleled contribution to photography's development in the late 19th and early 20th centuries. During his professional life he produced 650 publications, including a four-volume *Ausführliches Handbuch der Photographie* (*Comprehensive Handbook of Photography*), which he edited from 1881, and the historiographically still important two-volume *History of Photography* (last German edition 1932; English trans. 1945). He had a high reputation both in Austria and abroad and received many honours, including the Légion d'honneur in 1901. His papers are held at the Weinstadtmuseum Krems. JJ

Dworschak, F., and Krumpel, O., *Dr. Josef Maria Eder: Sein Leben und Werk; zum 100. Geburtstag* (1955).

Edgerton, Harold (1903–90), American photographic innovator. Developer of the electronic flash and stroboscope, Edgerton made high-speed stop-action pictures that collapsed the intellectual boundary between entertainment and science. Perfected in 1932 at Massachusetts Institute of Technology (MIT), where he was professor of electrical engineering, Edgerton's stroboscope could emit 60 10-microsecond flashes of light per second and be recharged in less than 1 microsecond. It allowed very rapid events to be observed and, with the addition of a camera, captured on film. Edgerton's techniques arrested flying bullets, drops of liquid, and the flight of insects. He also duplicated the chronophotographic experiments of *Marey, the *Schlieren experiments of *Mach, and the hydrodynamic experiments of Worthington. During the Second World War, Edgerton designed stroboscopic lamps for night reconnaissance missions, and from the 1950s devised lights and sonar equipment for Jacques Cousteau's deep-sea explorations. Edgerton's 1939 book *Flash!* and his popular film *Quicker 'n a Wink* were the earliest examples of his talent for popularizing science and promoting his work; his photographs were widely sold, exhibited in museums, and published in magazines. These pictures of things the eye could never see, taken from the everyday world of the commonplace, aroused a sense of wonder. Their sharp detail and simple formal composition, and the wry humour of bullets exploding bananas or apples, added to their appeal. At once familiar and uncanny, they confirm our belief that reality is, ultimately, defined by what can be photographed. MB

Jussim, E., and Kayafas, G., *Stopping Time: The Photographs of Harold Edgerton* (1987).

education, photography in. The importance of children acquiring visual literacy in an image-saturated world was acknowledged in the UNESCO Declaration on Media Education in 1982. The issue has been addressed in various ways in different countries. In the English educational system, photography as a practice, and the study of photographic images, had evolved historically within different disciplines: the former under the aegis of art, the latter within English and media education. Not until the late 20th century were efforts made to incorporate both approaches jointly in the school curriculum.

As part of the 1970s initiative to increase access to the arts, the Arts Council funded a number of education posts in photography centres and galleries, enabling them to establish formal links with Local Education Authorities (LEAs), teachers, and schools. Two in particular, Mount Pleasant Photography Workshop in Southampton and Blackfriars Photography Project in London, demonstrated that children gained a great deal from being able to use photography as a means of expression. In the 1980s and 1990s the Arts Council initiated a process of research and development for photography in education by collaborating directly with LEAs. Over five years, six advisory teacher posts were established to create coherent models of classroom practice and In-Service Education and Training (INSET). These advisory teachers developed ways of working with photography in the classroom, and the majority of the projects undertaken by pupils working with them were documented in a publication for primary teachers, *Picture my World: Photography in Primary Education* by K. Walton (1995).

The previous year, the Photography in Education Working Party had produced a book entitled *Creating Vision: Photography in the National Curriculum*, which offered an approach to photography that combined both its theoretical and practical aspects with media education. It was the first attempt to present a theoretical overview of the subject's educational potential and to map out a curriculum for photography. In 1998 the Qualifications Curriculum Authority (QCA) convened a group to look at photography within the art National Curriculum as well as within the General Certificate of School Education (GCSE) and Advanced-Level Art examination syllabuses. This body argued that photography should be treated as both a practical and a theoretical subject, and that study of the medium should include both aspects in order to be fully effective. (The same year, however, an investigation published by Sarah Mumford pointed to the practical problems involved in undertaking darkroom work in schools.)

Also in 1998, in order to find out more about children's relationship to photography at different ages, Kodak sponsored a European research project entitled *Children as Photographers*; British participants were the National Museum of Photography, Film, and Television (NMPFT), Bradford, and the University of Birmingham. Cameras were supplied to 180 French, Spanish, Polish, Swedish, and British children in the 7, 11, and 15 age groups, and the 4,300 resulting pictures analysed in an attempt to discover patterns of picture taking, and children's responses to photographs at different ages. (While 7-year-olds were preoccupied with subject matter, 15-year-olds revealed critical awareness of the formal properties of pictures.)

The advent of *digital photography has facilitated practical photographic work in schools, while the importance of visual literacy for young people has been increasingly recognized. The English National Curriculum of 2001 formally requires pupils aged 11–14 to study media and the moving image, after preliminary study of still pictures; the ways in which codes and conventions function to represent ideas, beliefs, and values in works of art, craft, and design are a significant aspect of this. Photography also plays a role in enhancing other areas of the curriculum, most notably geography and history. Museums such as the NMPFT produce photographically based supporting materials in print, on CD-ROM and online. Their approach, also evident in educational materials created for particular exhibitions, promotes the study of images in context, typically asking questions such as 'Who took this photograph and why? Where was the photographer when the picture was taken? How are the people/places/objects in the photograph made to look? How do you account for this?' The objective throughout is to promote critical analysis and counter the assumption that 'the camera never lies'. SM/RL

Brown, L. K., *Taking Advantage of Media: A Manual for Parents and Teachers* (1986).
Isherwood, S., and Stanley, N., *Creating Vision: Photography and the National Curriculum* (1994).
Mumford, S., *A Case Study of Media Education in a Pyramid of Schools* (1998).

education and training, photographic. In England the first photographic processes and materials were available only to those who had paid a licence fee to inventors and patent holders to use them. In London, Richard Beard and Antoine *Claudet bought the rights to the *daguerreotype process, thus keeping instruction and training, such as it was, in their own hands. (In France and other countries there was a free-for-all.) A similar situation pertained to the *calotype, although as far as amateurs were concerned, more in theory than in practice, and groups like the Calotype Society (1847) formed to share and disseminate knowledge of the process. Propagating the 'art and science of photography' was a principal purpose of the Photographic Society of London (1853); in the words of its secretary, Roger *Fenton, 'Such a Society will be the reservoir to which will flow, and from which will be beneficially distributed, all the springs of knowledge at present wasting unproductively.' Similar bodies appeared in other cities. This network of organizations, and the qualifications awarded by the *Royal (from 1894) Photographic Society, became a significant channel of photographic education. Particularly during the *pictorialist era, both in Britain and abroad, societies played a vital role in mediating the complex skills identified with 'art photography'. Even today, *clubs and societies, especially those endowed with facilities like darkrooms, continue to pass on photographic technique and experience.

Polytechnic institutions, and military organizations like the *Royal Engineers, also provided training in the 19th century. So too, for their employees, did many of the increasing number of commercial studios. Especially in Britain, apprenticeship remained the dominant form of professional training until after the Second World War, although the foundation of the City and Guilds of London Institute in 1880 and the Professional Photographers' Association in 1901 opened the way for today's system of formal qualifications that can be studied for at colleges of further and higher education across the country. Elsewhere, patterns of training have varied considerably. In the USA, before the late 20th-century burgeoning of university-based courses, a significant role was played by private schools, which in New York alone included the establishment founded by Clarence *White in 1914, which trained many major photographers of the inter-war period; the classes run by the Photo League; and the Famous Photographers distance-learning school. In Central Europe, although apprenticeship became firmly established, there was pressure from professional organizations, as photographic practice diversified and the numbers employed increased, for the creation of photographic courses at technical colleges and other institutions, and the foundation of publicly funded photographic schools. The first of these in Germany was the Lehr- und Versuchsanstalt für Photographie in Munich (later the Munich Photo School), a joint venture between the South German Photographers' Association, the city of Munich, and the Bavarian state. It opened for men only in 1900, and admitted women from 1905. Other institutions offering photographic training before 1914 included the Berlin *Lette-Verein, the Graphische Lehr- und Versuchsanstalt in Vienna and the Akademie für Graphische Künste und Buchgewerbe in Leipzig, which in 1913 offered a chair to the German-American painter-turned-pictorialist-photographer Frank *Eugene. After the First World War photography established itself at the Folkwang School in Essen, the Dessau *Bauhaus (from 1929), the Stuttgart and Zurich Design Schools, and *Moholy-Nagy's New Bauhaus (1937–8) and its successors in Chicago.

Viewed in retrospect, these developments foreshadowed the late 20th-century phenomenon of the photographer as fine artist (complete with dealer and market valuation), or the fine artist as photographer (often in conjunction with other media or art forms, such as installations or body art). Its concomitant was photography's increasing integration into degree-level or postgraduate fine-art, journalism, and design courses at universities, *Kunsthochschulen*, or art academies. This is reflected in the backgrounds of many leading figures on the *contemporary (art) scene. Thomas Demand and Andreas *Gursky, for example, are graduates respectively of the Munich and Düsseldorf academies, Rineke *Dijkstra of the Gerrit Rietveld Academy, Amsterdam, Philip-Lorca *diCorcia of the School of the Museum of Fine Arts in Boston, and Jeff *Wall of the University of British Columbia and the London Courtauld Institute. Interesting though this development is, however, its implications should not be overstated: in the future some vocationally trained (and even self-taught) photographers will doubtless continue to achieve recognition as artists, while many art-school graduates will eventually earn their living in commercial photography or teaching.　　RSA/RL

See also SOCIETY FOR PHOTOGRAPHIC EDUCATION.

Zakia, R., Malone, R., and NeJame, F., 'Photographic Education', in L. Stroebel and R. Zakia (eds.), *The Focal Encyclopedia of Photography* (3rd edn., 1993).

Yochelson, B., *Pictorialism into Modernism: The Clarence H. White School of Photography* (1996).

Pohlmann, U., and Scheutle, R. (eds.), *Lehrjahre, Lichtjahre: Die Münchner Fotoschule 1900–2000* (2000).

Siegel, E., and Travis, D. (eds.), *Taken by Design: Photographs from the Institute of Design, 1931–1971* (2002).

Eggleston, William (b. 1939), American photographer. Raised in Memphis, Tennessee, he studied photography at Vanderbilt University, Mississippi, but had worked self-taught since getting his first camera at 18. From 1965 he experimented with colour, using it exclusively from 1967. Influenced by *Cartier-Bresson, whose book *The Decisive Moment* (1952) made an early and lasting impression on him, he belonged, like *Winogrand and *Arbus, to the generation that succeeded Walker *Evans. Eggleston presents his work mostly in small format, using the vibrant *dye-transfer process.

He achieved a breakthrough with his first one-man show, *William Eggleston's Guide*, at MoMA, New York, in 1976. Since then, notwithstanding some early criticisms of his work as trivial or vulgar, he has been regarded as a pioneer of artistic colour photography.

He worked initially on his home ground, the Deep South, photographing what appear to be typically American scenes: nondescript interior and exterior spaces, in which ceiling fans,

an open refrigerator, garage entrances, or a street intersection acquire a kind of *iconic resonance. From the 1980s he has documented his regular journeys through Europe, Africa, and Asia in lengthy photo series. He captures his subject matter as if by chance, in a snapshot-like manner, adopting a 'democratic' approach that does not privilege particular types of scene or object. JG-P

Chandés, H., *William Eggleston* (2002).

Egypt. See MIDDLE EAST, EARLY PHOTOGRAPHY IN THE.

Eisenstaedt, Alfred (1898–1995), German-born American photographer. 'No man stands taller in the ranks of photojournalists than does Alfred Eisenstaedt at 5 ft 4 in.' So said Kenneth Poli of the photographer of the stars, the powerful, and the powerless. Three typical 1930s 'Eisie' images might be of Marlene Dietrich in *The Blue Angel* (1930); of Nazi Propaganda Minister Joseph Goebbels glowering at the photographer (1933); and of the bare feet of an Abyssinian soldier during the Italian invasion (1935). Educated in Berlin, Eisenstaedt brought his considerable intellect to bear on what was still widely regarded as a humble occupation. He was an early user of 'miniature' cameras—first the *Ermanox, then the *Leica—an advocate of natural light, even for portraits, and of the picture essay.

He emigrated to the USA in 1935, and was naturalized in 1943. From *Weltspiegel* and *Berliner illustrirte*, he was now working for a very different sort of picture magazine, *Vogue*, *Harper's Bazaar*, and *Town and Country*. He was one of only four original staffers on *Life* in 1936, winning numerous prizes thereafter. He also worked frequently in Britain, producing books on subjects from tennis at Wimbledon (1972) to the city of Aberdeen (1984). AH

Eisenstaedt, A., *Witness to our Time* (1966).

Ektachrome. See PHOTOGRAPHIC PROCESSES, COLOUR; TRANSPARENCIES.

electromagnetic spectrum. James Clerk *Maxwell's model for the electromagnetic nature of light did not at first consider extension to other forms of energy propagation; but before long Heinrich Hertz had discovered radio waves and showed that they obeyed similar laws: soon afterwards Wilhelm *Röntgen discovered *X-rays. The electromagnetic spectrum had expanded from less than one octave to a range of frequencies extending from a few kilohertz to some 100 exahertz (10^{18} Hz), the shortest wavelength gamma radiation.

In Maxwell's model all the radiation is characterized by a very high-frequency alternating electric field linked to a magnetic field at right angles to it (Fig. 1). Maxwell derived a figure for the speed of light using only electric and magnetic constants, and subsequent measurements by Fizeau and others showed his calculations to be correct. Later work by de Broglie and Planck showed that the photon (the fundamental particle of light energy) was not alone in being associated with a wavelength: all fundamental particles, such as electrons and protons were, also had corresponding wavelengths.

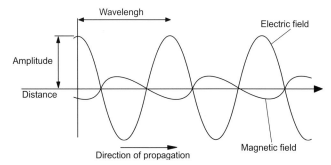

Fig. 1

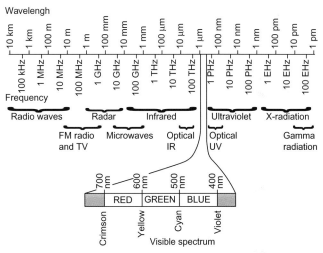

Fig. 2

For the photographer, the most important part of the electromagnetic spectrum is the visible region, and to a lesser extent its near neighbours the optical *infrared and *ultraviolet. The visible spectrum can be broadly separated into three regions defined by wavelength: blue (400–500 nanometres), green (500–600 nm), and red (600–700 nm). Human vision reaches a little beyond these limits, but only by a small amount. The optical infrared region extends roughly from 750 to 1,500 nm; special lens materials can produce optical images up to about 1,500 nm, but above this scanning devices are required. The optical ultraviolet region is roughly 250–360 nm, using lenses of special material. Radiation of less than 100 nm wavelength will still affect silver halides, but passes straight through lenses without refraction, and can only be used for *shadowgraphs: it is, of course, useful in diagnostic radiography. Fig. 2 summarizes the various regions of the electromagnetic spectrum. GS

electro-optical shutters. Mechanical shutters are effective down to around 0.2 ms. Shorter exposures need to be controlled by devices without moving parts. The two most important of these are the Kerr and Pockels cells.

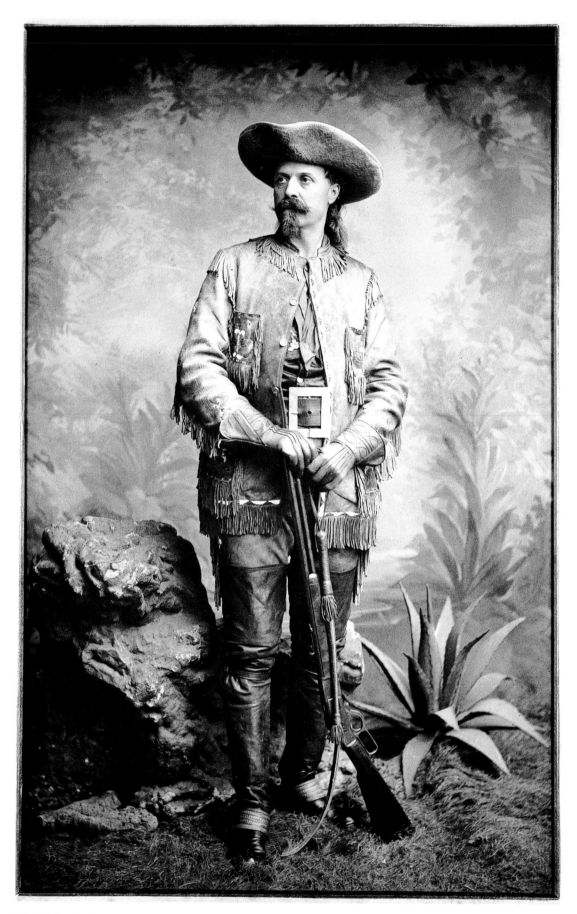

Elliott & Fry, London

Colonel Cody (Buffalo Bill), 1892. Platinum print

The *Kerr cell* is an optical cell filled with an optically active liquid such as nitrobenzene. When a strong electrical field is applied, a beam of linearly polarized light passing through it has its plane of polarization rotated by up to 90 degrees. If the cell is positioned between two crossed polarizing filters, this property can be used to operate the cell as a shutter. The *Pockels cell* operates in much the same way. It uses a crystal of a material such as potassium dihydrogen phosphate (KDP). A Pockels cell requires an electrical field of only a few kilovolts to achieve a 90-degree rotation, and can give nanosecond exposures.

Both types of shutter find uses in ultra-high-speed photography, and the Pockels cell is an important component of the pulse lasers used in industrial *holography and holographic portraiture. GS

Wilson, J., and Hawkes, J. F. B., *Lasers: Principles and Applications* (2001).

Eleta, Sandra (b. 1942), Panamanian photographer, who studied art at Finch College, New York, social science at the New York School of Social Research, and photography at the *International Center of Photography. Her most famous piece of reportage, *Portobelo* (1985), published by La *Azotea with an introduction by Maria Cristina *Orive, documents the religious, domestic, and working life of a small Afro-Caribbean fishing community. Later she moved increasingly into film, video, and teaching, dividing her time between Portobelo, Panama City, New York, and Madrid. AH

Hopkinson, A. (ed.), *Desires and Disguises* (1992).

Elliott & Fry (1863–1963), English commercial studio. Established by Joseph Elliott and Clarence Fry, the business long outlived its founders. It flourished in London's Baker Street, taking (and publishing) pictures of Victorian England's social, artistic, and political luminaries. In 1880 its impressive premises included three studios and four negative storage rooms, supported by a separate printing works at Barnet. Most of the early negatives were destroyed during the Second World War, and the business was incorporated with Bassano & Vandyck in 1963. The surviving negatives are held by the National Portrait Gallery. RP

Hillier, B., *Victorian Studio Photographs* (1975).

Elsken, Ed van der (1925–90), Dutch photographer, born in Amsterdam. His interest in photography was aroused by *Weegee's *Naked City* (1945). He moved to Paris in 1950, where he photographed the bohemian scene—bars, artists, drop-outs, and drug dealers in the Odéon district, often at night. Edward *Steichen included eighteen of these images in the 1953 New York exhibition *Post War European Photography*, and on Steichen's advice the work became a *noir* narrative, centred on Vali Meyers, an Australian girl drug addict. Published as *Love on the Left Bank* (1954), it was atmospheric, cinematic, autobiographical, becoming his most famous work.

Returning to Amsterdam in 1954, he worked as a freelance photographer and film-maker, emphasizing his personal interests and domestic life. He published seventeen books, integrating his graphic and photographic style, especially *Jazz* (1959) and *Sweet Life* (1966), following a trip round the world with his family. Travel to Africa,

Hong Kong, and Japan for magazine work produced more books. Van der Elsken's unconventional ideas clearly constrained the development of his career. The film *Bye* (1990) movingly documents his decline and death from cancer. His last words on film confirmed his approach: 'Show the world who you are.' RA

Emerson, Peter Henry (1856–1936), British photographer and theorist, born in Cuba and raised in Delaware and England. He read medicine and natural science at Cambridge, and took up photography in 1882. He lectured and wrote on art photography from 1885, codifying his theories in *Naturalistic Photography for Students of the Art* (1889). Emerson's work showed the influence of naturalism in art, encouraged by the painter Thomas Goodall, his collaborator on an album of *platinotypes, *Life and Landscape on the Norfolk Broads* (1887). Subsequent monographs, illustrated in *photogravure, included *Pictures of East Anglian Life* (1888), *Wild Life on a Tidal Water* (1890), and *Marsh Leaves* (1895). His last publication was a revised edition of *Naturalistic Photography* (1899), amended to disclaim photography's artistic pretensions, and expressed in typically intemperate language. His prickly relations with photographers like George *Davison kept Emerson out of new associations like the *Linked Ring Brotherhood. Instead, he remained loyal to the *Royal Photographic Society, which honoured him with his last exhibition, a retrospective, in 1900. In 1933, he recorded that he had written a 'true history' of artistic photography, but the manuscript is lost. HWK

See also NATURALISTIC PHOTOGRAPHY.

Newhall, N., *P. H. Emerson: The Fight for Photography as a Fine Art* (1975).

England, William (*c*.1824–1896), British photographer, who began his photographic career in the 1840s as manager of a London *daguerreotype portrait studio. He joined the London Stereoscopic Company in 1854, taking thousands of stereoscopic views all over the world. His views of the Niagara Falls, his Paris street views shown at the 1862 International Exhibition, and his Alpine views were greatly admired by contemporaries. He established a family printing and processing business in Notting Hill, London, in the 1860s. His most notable technical innovation was a slitted drop shutter, usually regarded as the precursor of the modern *focal-plane shutter. JPW

England and Wales

To 1920

The years 1839 to 1920 have often been called the formative years of photography. Bound by no single unifying vision but rather a multitude of uses, photographic commerce, art, and technology developed in many different directions. From the beginning, photographers in England and Wales were involved in all aspects of this development.

In the first decade of photography after January 1839, there was a great impetus to invention and experimentation, driven to a large extent by the inventor of photogenic drawing, Henry *Talbot. Having sent out more than 800 photographs and written numerous papers

by the close of 1839, he was the most prolific photographer and writer on photography. Consequently, his circle of family and friends, concentrated in London and at Penllergare, near Swansea, were among the best-informed and most active early amateurs. This circle, among them the *Llewellyns, Nicolaas *Henneman, Sir John *Herschel, George Bridges (1788–1868), and Calvert *Jones, played a crucial role in the development of photography on paper. While Henneman and Henry Collen were notable exceptions, these amateurs were of a similar class and financial independence, and photographed in a strictly private sphere, 'untainted' as they saw it, by commerce.

The practice of the *daguerreotype was different, being confined largely to cities and commercial portraiture. It was first demonstrated in September 1839 by M. de Saint-Croix (or Sainte-Croix) in his lodgings in London and later at the Adelaide Gallery. Shortly after, and with the sanction of the patent holder Miles Berry, John Thomas Cooper Jr. (1790–1854) demonstrated the process at the Polytechnic Institution. These two locations became intimately connected with early photography in London. In 1841, studios were opened by Richard Beard (1802–85), who purchased the patent rights from Berry, and Antoine *Claudet, who gained permission directly from Daguerre. Despite the presence of these and other portrait studios in Cardiff, Bath, Plymouth, Bristol, Liverpool, and other cities, commercial photography strained under the restrictive patents covering the calotype and daguerreotype. Although photography was added to the curriculum of King's College London and taught to *Royal Engineers at Woolwich and members of various polytechnic institutions, no practitioner could set up in business or sell photographs without permission from either Talbot or Beard. Photography in the 1840s remained a largely genteel and scientific pursuit.

What was needed to create a larger market was a patent-free, fast, and economical process, and a large public forum for its dissemination. All this arrived in the 1850s, transforming and democratizing photography. Frederick Scott *Archer's invention of the *wet-plate process was crucial to this change. His publication of the unpatented process led directly to the relinquishment of Talbot's patents in 1854, and bypassed Beard's daguerreotype patent by offering a practical alternative for portrait studios. Moreover, Archer's process made it possible to print thousands of photographic positives from a single negative. This last development provided the backbone for the *stereoscopic and *carte de visite industries.

It is unlikely, however, that the advent of the wet-plate process alone could have raised public awareness of photography so quickly without the *Great Exhibition of 1851, which introduced some of the newest processes and most important international photographers to over 6 million visitors, including Queen Victoria and Prince Albert, whose enthusiasm for photography further boosted its appeal. Two years later, when the Photographic Society of London (later the *Royal Photographic Society (RPS)) was formed, photography gained a regular 'establishment' capable of maintaining the momentum. Photographers from many societies were stimulated to exhibit work, and interaction between amateurs and professionals grew.

The impact of stereoscopy in England and Wales should not be underestimated. While carrying a whiff of the aristocratic Grand Tour, it was available to armchair travellers of all incomes. Equipment and publishing companies like the London Stereoscopic Company and *Negretti & Zambra sprang up to meet the growing demand, and photographers like Roger *Fenton, Claudet, and Lady Clementina *Hawarden produced stereo images. Stereoscopy in various forms would remain a significant branch of popular photography for many decades. Meanwhile, the *Illustrated London News, founded in 1842, became an important user of photographs, whether of engineering wonders like the Crystal Palace or Brunel's Great Eastern, or of topical events. However, until the *half-tone process became available much later in the century, the pictures had first to be converted into wood engravings, with the paper's in-house artists often adding their own modifications to liven up the image.

In the 1850s, photography rapidly entered the spheres of illustration, art, education, science, entertainment, and (albeit indirectly) news. Although the standard histories of photography emphasize the artistic achievements of photographers like Julia Margaret *Cameron, Lady Hawarden, Benjamin Brecknell *Turner, Charles *Dodgson and Fenton, photographs conceived as art were increasingly outnumbered by a flood of portraits and views intended for a mass public. Portraiture became a considerable industry, with businesses ranging from Camille *Silvy's sumptuous establishment overlooking Hyde Park to backstreet operators using touts to drum up trade and offering pornography on the side. In addition, a small army of *itinerants worked villages, race meetings, fairs, and seaside resorts well into the 20th century. Commercial view photography, also using the wet-plate process, got into its stride in the 1860s, with firms like *Frith, *Bedford, *Wilson, and *Valentine photographing landscapes throughout the British Isles and marketing them on an industrial scale as railways and tourism expanded.

*Scientific and *documentary photography also developed in the second half of the century. Dr Hugh Welch *Diamond, a leading amateur, used the wet-plate process to photograph his female mental patients in the 1850s. In 1857 the Architectural Photographic Association set its members to recording British buildings, anticipating the much more ambitious project of the *National Photographic Record Association. Photographs of the *moon, by Warren de la Rue, William Crookes, and others were studied at astronomical gatherings. John *Thomson and Adolphe Smith's part-work Street Life in London, published between February 1877 and January 1878, was a photographic and journalistic account of the poor of London, and a pioneering example of social documentary work.

A national debate about photography's status was sparked by the commissioners for the 1862 International Exhibition, who consigned photographic images to the wider 'Machinery' rather than 'Fine Arts' section. (However, the 1862 *Fine Art Copyright Act offered them protection as creative works.) As early as 1854, the Polytechnic exhibition at Falmouth had grouped photographs under the title of 'Art' rather than 'Mechanical Inventions' where they had previously

resided, but the prevailing attitude held that photography was not the equal of other graphic arts. The *British Journal of Photography* took up this cause, establishing itself as one of the most durable forums of photographic discussion and debate. In its pages, *Ruskin's aesthetics were discussed and the seeds of the first large-scale movement in art photography were planted.

The end of the 19th century and beginning of the 20th witnessed the arrival of two new inventions, colour and the *Kodak. The foundations for colour photography had been laid by James Clerk *Maxwell in 1861, when he successfully demonstrated the basis of three-colour photography, but colour photography did not become practicable until after 1907, when the *Lumière brothers' *autochrome process entered the market; even then, it remained the preserve of wealthy amateurs. The launch of the Kodak in 1888 was another matter, however, and tens of thousands of small *roll-film cameras had been sold in England by 1914, creating big opportunities for business. A. H. Harman, for example, had founded his company in Ilford, Essex, in 1879. Although still small in 1888, it would acquire Thomas Illingworth & Co. in 1912 and become Ilford Ltd., one of Kodak's great rivals. With firms like Thornton-Pickard and Houghton Sanderson, it formed part of a substantial British industry.

While these technological changes were taking place, the first clearly defined and self-conscious movement in art photography was emerging. In 1892, a small group of dedicated photographers formed the *Linked Ring Brotherhood, calling for greater recognition of art photography and espousing the *pictorialist aesthetic. The movement to entrench photography firmly in the fine arts, begun in the 1860s, gained momentum, driven forward by influential photographers including Henry Peach *Robinson, Henry Hay Cameron (1856–1911), George *Davison, and Alvin Langdon *Coburn. The Linked Ring played an important role in international art photography, maintaining close ties with continental and American groups like the Vienna Camera Club and the *Photo-Secession. Although there had been debates within the photographic community before this point, for example over *naturalism, and although it only lasted until 1910, the Linked Ring marked an important stage in photography's convergence with the fine arts.

In the couple of decades before 1914 the wider photographic scene in England and Wales was diverse and vibrant. On the fringes of art photography, Paul *Martin experimented with *night pictures and covert snapshots of street scenes and people relaxing on the beach. Edwardian London boasted two of Europe's leading portraitists, E. O. *Hoppé and Adolphe de *Meyer, and there was a network of prosperous middling studios across the country, their interests represented by organizations like the Professional Photographers' Association (1901). *Beken of Cowes was one of many successful firms of marine photographers. With the adoption of the half-tone process and high-speed rotary presses, *photojournalism came of age. In 1904, the London *Daily Mirror* became the world's first daily newspaper to be illustrated entirely with photographs. Freelances such as Horace *Nicholls supported a comfortable lifestyle with coverage

of the English sporting and social scene. Political campaigners like the suffragettes learned that tipping off photographers was a good means of gaining publicity for their demonstrations. Outside the ranks of professionals, thousands of people owned cameras, from rich enthusiasts like Lionel de Rothschild and the Yorkshire industrialist Alfred Atkinson (1864–1945) to ordinary middle-class amateurs who belonged to clubs, read journals like *Amateur Photographer*, and perhaps attended photographic conventions. Some took their cameras to war in South Africa; many more did so in the far larger conflict of 1914–18. KEW

Hiley, M., *Seeing through Photographs* (1983).
Haworth-Booth, Mark (ed.), *The Golden Age of British Photography, 1839–1900* (1984).
Seiberling, G., and Bloore, C., *Amateurs, Photography, and the Mid-Victorian Imagination* (1986).
Weaver, M. (ed.), *British Photography in the Nineteenth Century* (1989).
Cox, J., 'From Swansea to the Menai Straits: Towards a History of Photography in Wales c.1840–1860' (M.Phil thesis, University of Wales, 1990).
Cox, J., 'Photography in South Wales 1840–60: "This Beautiful Art"', *History of Photography*, 15 (1991).
Heathcote, B. and P., *A Faithful Likeness: The First Photographic Portrait Studios in the British Isles 1841 to 1855* (2002).

1920–1945

After the flurry of excitement surrounding Coburn's *Vortograph exhibition at the London Camera Club in 1917, the inter-war years seem relatively unexciting. Pictorialism remained the dominant 'art photography' style, governing the conventions of the 'good photograph' at the RPS, the photo-club salons, annuals like *Photograms of the Year*, and amateur magazines. The eminent pictorialist F. J. Mortimer (1875–1944), who had edited *Amateur Photographer* from 1908 to 1918, returned in 1925–44, and also edited *Photograms of the Year* and other influential publications. On the other hand, Cecil *Beaton and Madame *Yevonde were among Europe's most outstanding portraitists, and in Cambridge and Oxford, after starting in Swanage, Helen *Muspratt and Lettice Ramsey built a reputation with their portraits of the intellectual elite. (Hoppé, meanwhile, had turned successfully to landscape and *industrial photography.) Although not widespread, the influence of continental modernism was perceptible by the 1930s, and affected some individuals who were not primarily photographers: the painters Paul Nash and Roland Penrose, for example, and the film-maker Humphrey Jennings. Bill *Brandt, who had lived in Paris and made friends with *Brassaï and other key figures, published *The English at Home* in 1936. Humphrey *Spender, influenced by German *Neue Sachlichkeit, joined the *documentary Mass-Observation movement in 1937. Meanwhile, English photography was benefiting from the influx of refugees from Nazism. Walter *Nurnberg from Berlin began in advertising, but later became a leading industrial photographer. Photojournalism attracted Kurt Hutton (Kurt Hübschmann; 1893–1960) and Felix *Man and, from Hungary via Munich, Stefan

*Lorant, who successively edited *Weekly Illustrated*, *Lilliput*, and *Picture Post*. Another Hungarian, Andor *Kraszna-Krausz, founded the Focal Press in 1938.

The Second World War produced much outstanding photojournalism (Brandt, Man, and many others), but also lesser-known work like the book illustrations of John *Hinde, who had done important pre-war research on colour photography. But perhaps the most memorable single body of work was by Beaton, who juggled private practice with official war photography in London, North Africa, and the Far East. Despite materials shortages and government restrictions, amateur activity continued. In the 1941 edition of *Photograms of the Year*, Mortimer described photography as the 'Art of peace and modern progress, something that could not be denied'. Via the RPS, the London Salon and various publications, Mortimer worked hard to encourage it, even publishing lists of unrestricted subjects for the camera, and showcased annual selections of work in *Photograms*. In 1945 the latter listed 361 photographic clubs and societies in England and Wales. There were also 60 postal camera clubs and six photographic federations.

Since 1945

The end of the war brought renewed freedom to photograph anything and everything, although materials shortages and import controls persisted. However, the editors of the 1947–8 edition of *Photography Today* argued that such obstacles (and earlier restrictions) might even be beneficial. They added, 'Reality has come to monochrome photography; and it has come to stay. Neither the falsehoods of mediocre advertising photography, nor the shameless flattery of commercial portraiture, nor the diehards of oldtime pictorialism, can dislodge it.' Cities were at last being photographed as 'living organisms' and not as postcard images; the photojournalistic interpretations of everyday life and concerns, as seen in *Picture Post*, *Illustrated*, and *Life*, were exemplary, 'fairly burning into the brain of the reader'. Photography, as the *Photography Today* editors saw it, 'has at last burst the ties of petty representationalism and made its first steps towards creative freedom'.

There was much wishful thinking in this. Club conservatives continued to dismiss livelier, more socially relevant subject matter as 'snapshots of everyday life', technically inept and not worth exhibiting; as before, the emphasis was on technical and craft expertise rather than imagination. Outside the clubs, apart from Brandt's 1940s and 1950s nudes, documentary work by Nigel *Henderson, and photojournalism by Bert *Hardy, Jane Bown, and Grace *Robertson, not much happened in photography or English culture generally in the first post-war decade. But the pace quickened from the mid-1950s, with the efforts of the Dutch-born Hugo van *Wadenoyen to revitalize the club scene, the formation of the Combined Societies Association, and the arrival of the *Family of Man* exhibition and a landmark *Cartier-Bresson show (1958). In the background were events at the Royal Court Theatre and the Institute of Contemporary Arts, the Free Cinema documentary movement, and the rise of New Wave cinema.

Although *Picture Post* folded in 1957 the gap, until the arrival of the 1960s *colour supplements, was filled by magazines like *Queen* and newspapers like *The Observer*, which discovered both Roger *Mayne and Don *McCullin before the decade was out. Other major figures at various stages of their development in the mid- and late 1950s were John *Deakin, John Bulmer, David *Hurn, and Anthony Armstrong-Jones (later Lord *Snowdon).

Although, like music, cinema, and theatre, the photography of the 'swinging sixties' had its roots in the 1950s, it became much trendier and more visible in this decade, with magazines and—from 1962—colour supplements its principal vehicles. Fashion photography, formerly represented by old masters like Beaton, John *French, and Norman *Parkinson, was galvanized by the youthful working-class triumvirate of David *Bailey, Brian *Duffy, and Terence *Donovan who, working mainly in black-and-white, mingled fashion and documentary styles, the gritty and the cool. In his film *Blowup* (1966), Michelangelo Antonioni forever fixed the image of the brash young photographer-about-town with his Rolls-Royce and apparently limitless supply of (also) sexually available models (the photographs in the film were by McCullin). Meanwhile, Snowdon and Patrick (Lord) *Lichfield bridged the gap between the new classless celebrity culture and England's entrenched traditional elite, including the royal family, to which they lent a new glamour. In the background, building up gradually through the decade and communicated by television, was political ferment and, especially, the Vietnam War, which attracted a new generation of photojournalists working for the colour supplements and other magazines: Larry *Burrows, Philip *Jones Griffiths, McCullin, and Tim Page.

Between the late 1960s and the early 1980s there was notable documentary work, often by photographers based in, or mainly interested in, Wales, Yorkshire, or the north-east rather than London. They included Ian *Berry (*The English*, 1978), Tony *Ray-Jones (*A Day Off: An English Journal*, 1974), Raymond *Moore, Chris *Killip, and Martin *Parr; Sirkka-Liisa *Konttinen, who settled in Newcastle upon Tyne at the end of the 1960s, created the study of an English working-class community that resulted in *Byker* (1983). Important landscape photographers of this period included Paul *Hill and Fay *Godwin, whose *Remains of Elmet* appeared in 1979.

In the last quarter of the 20th century, the photographic scene became increasingly multifaceted. Groups like the *Hackney Flashers and the Half Moon Photography Workshop articulated feminist concerns. The Camerawork Gallery was one of several venues that worked with the *Disability Movement from the 1980s. *Autograph, the Association of Black Photographers, appeared in 1988, and community photographic schemes, like the turn-of-the-century 'Milleni-Brum' project in Birmingham, proliferated from the 1990s, especially in multi-ethnic towns and cities.

At the same time, various indicators demonstrated photography's increasingly central role in mainstream culture. Opportunities for photographic *education and training were one. In 1945, training was limited mainly to clubs, apprenticeship, and vocational courses,

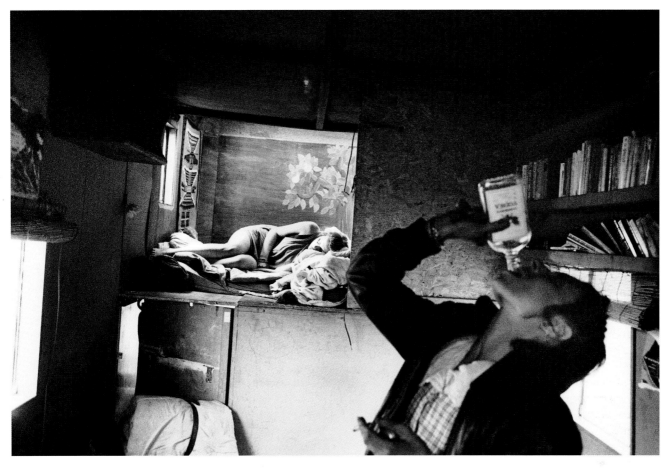

Donovan Wylie

Continuing from the Night Before, Brighton, 1996

with national service offering additional possibilities (important, for example, in the careers of McCullin and Bailey). By the 1960s, however, photography courses were appearing in schools, and in art and design colleges, and in the 1980s photography secured a niche in the National Curriculum. The Royal College of Art inaugurated a photography course in 1968, and degree-level study became possible at a widening range of institutions, from Falmouth College to the major polytechnics (later universities). *Museums also increasingly opened their doors to photography. Mark *Haworth-Booth's appointment as curator of photographs at the Victoria & Albert Museum in 1970 renewed the V&A's historic link with the medium and inaugurated its development into one of England's largest repositories of classic photography. Institutions such as the National Portrait Gallery (which had mounted a major Beaton retrospective in 1968), the Imperial War Museum, and the National Maritime Museum showed increasing interest in exhibiting photographs and making their own large collections available; a National Museum of Photography, Film, and Television was opened in Bradford in 1983. Photography's convergence with fine

art, in England as in other countries, was reflected in the exhibiting policies of major galleries. A large exhibition marking photography's 150th anniversary was held at London's oldest art venue, the Royal Academy, in 1989, and institutions such as the Hayward and the Barbican followed the same path; another milestone was Tate Modern's huge *Cruel and Tender* documentary show in 2003. The pattern was replicated, on a smaller scale, at Oxford's Museum of Modern Art and city and university galleries across the country. Early dedicated *galleries of photography such as the Photographers' Gallery (1971) in London and the ffotogallery in Cardiff were widely imitated. Finally, media interest in photography intensified. By the early 21st century, the British photographic press was larger and more varied than that of most other European countries. Photographic book publishing boomed from the 1960s, with art publishers such as Thames & Hudson increasingly interested in producing photographic monographs. Television, far from threatening still photography, became an important vehicle for it, from early survey series created by photographer-teachers such as Bryn Campbell to documentaries

on photographers from Brandt to Mario Testino in prestige arts programmes like the *South Bank Show*. RSA/RL

Badger, G., and Benton-Harris, J., *Through the Looking-Glass: Photographic Art in Britain 1945–1989* (1989).

Haworth-Booth, M., *Photography: An Independent Art. Photographs from the Victoria and Albert Museum 1839–1996* (1997).

Harrison, M., *Young Meteors: British Photojournalism 1957–1965* (1998).

Harrison, M., *David Bailey, Birth of the Cool: 1957–1969* (2000).

enlarging. See PRINTING AND ENLARGING, BLACK-AND-WHITE/COLOUR.

Ennadre, Touhami (b. 1953). Moroccan-born French photographer, who emigrated to France with his family in 1961. There, at his mother's instigation, he took his first photographs, family portraits. Ennadre gained recognition early in his career, winning the Prix de la Critique at the *Arles Festival in 1976. His mature work is stark and dramatic: objects or figures emerge from a pitch-black ground, visually isolated and thus devoid of cultural reference, yet highly suggestive. By excluding superfluous narrative elements, Ennadre concentrates on the surface detail and innate expressiveness of his subject matter, creating a sense of intimacy for the spectator. The result is both iconic and mysterious. Following the 2001 attacks in New York, Ennadre created a series of acclaimed images that make no obvious reference to the event, but subtly convey the experiences and emotions arising from it. He lives and works in Paris. MR

Ennadre, T., *Black Light* (1996).

epidiascope. *Diascope* is another name for a *transparency projector. *Episcope* is the corresponding name for an opaque projector, which images the light reflected from a document or small object on to a screen. An *epidiascope* combines both functions. Because of its optical inefficiency an episcope needs a powerful light source and a wide-aperture lens. As the type of illumination is inappropriate for transparencies, some epidiascopes have a lever mechanism to realign the light source for slide *projection. Epidiascopes are cumbersome devices, and are being largely supplanted by scanning systems linked to projectors of LCD arrays. GS

equidensity film, a photographic material containing both a negative and a direct positive emulsion, and designed to produce a line drawing effect from a continuous-tone original. The result depends on a good deal of trial and error with variations in exposure and colour filtration. Agfa's version of the material, *contour film*, was eventually discontinued owing to the ease of achieving similar results using *digital techniques. GS

Equivalents. See LANDSCAPE PHOTOGRAPHY; STIEGLITZ, ALFRED.

Erfurth, Hugo (1874–1948), German photographer. After attending the Dresden Commercial School, Erfurth served a photographic apprenticeship (1892–6), then took over a leading Dresden studio. During the next two decades he prospered commercially, exhibited widely, and garnered many awards. Before 1914 he may also have taught at the Leipzig Academy of Graphic Arts and Book Design. In 1919 he co-founded the Society of German Photographers (Gesellschaft Deutscher Lichtbildner; GDL). Although he did significant work in industrial, theatrical, and especially dance photography (and experimented with *photograms and *photomontage) his main claim to fame was as one of 20th-century Germany's leading portraitists. In addition to royalty, aristocrats, and politicians—including Konrad Adenauer in 1927—his subjects belonged mainly to the cultural elite, including artists, designers, writers, and stage personalities. He was a close friend of the painter Otto Dix, and they portrayed each other many times. Stylistically, he developed from a Jugendstil-inflected decorative *pictorialism in the 1900s to a cleaner, psychologically sharper, sometimes almost clinical approach after the First World War. In 1934 he moved to Cologne, where his studio and archive were bombed in 1943. JJ

Dewitz, B. v., and Schuller-Procopovici, K. (eds.), *Hugo Erfurth, 1874–1948: Photograph zwischen Tradition und Moderne* (1992).

Ermanox, name given to a range of German cameras made between 1924 and 1931. Launched in July 1924 by Ernemann AG of Dresden as the Ernox camera, it made exposures on 4.5 × 6 cm (1⁴/₅ × 2¹/₃ in) glass plates with initially an f/2.0 and later an f/1.8 Ernostar lens and a cloth *focal-plane shutter. It had the widest-aperture lens of any miniature camera at the time and was advertised as being suitable for night and interior photography without flash. It was therefore also ideal for the candid photography favoured by contemporary illustrated magazines in Germany and elsewhere. Its most celebrated exponent was Erich *Salomon, who from 1928 used it for famously 'indiscreet' shots of statesmen at international conferences. Another notable user, from 1929, was Felix H. *Man.

A new collapsible model with bellows was introduced in 1925. Ernemann became part of the Zeiss Ikon combine in 1926 and the camera continued to be made until c.1931 in a variety of plate sizes up to 13 × 18 cm (5 × 7 in), each with the f/1.8 lens. A reflex version was made between 1927 and 1929. The Ermanox was eventually overtaken in popularity by 35 mm cameras, notably the *Leica (for which a f/1.9 lens was available by 1932) and Contax (1932–), which were smaller and used the more practical *roll-film. MP

erotic photography is particularly difficult to define and delimit. Occupying a fluid position between the academic nude and *pornography, definitions of it have varied from period to period, influenced by shifting sensibilities and moral standards, and by authors' more or less overt or conscious intentions. Arguably any nude photograph, simply by virtue of its realism, was capable of appearing erotic to 19th-century viewers, so that even the most coldly academic studies were banned from display in photographers' windows. The exhibition in 1857 of *Rejlander's rather chaste composition *The Two Ways of Life* shocked the public because the right-hand portion of the picture presented, with the most moral

intent, nude women in lascivious poses. Nudes were officially excluded from photographic exhibitions until the last years of the 19th century, when soft focus and the artistic ethos of the *pictorialists finally gave them the right to appear in public.

In the 19th century, the history of erotic photography is inextricably linked to the history of its repression by vice squads, which dealt out more or less equal punishment to erotic ('licentious') and pornographic ('obscene') nudes, without distinguishing clearly between them. In Paris, the world capital of these products, convictions, fines, and even prison sentences rained down on photographers, vendors, and models from the 1850s onwards, although without destroying the prosperity of the trade.

Explicitly erotic *daguerreotypes, usually of women alone in suggestive, Ingres-esque poses, in settings limited to a few sofas, draperies, and ornaments, appeared early on, aimed at a clientele of wealthy hedonists. The launch of the *stereoscope in 1851 hugely boosted this market. Erotic subjects, first daguerreotypes, then paper prints, proliferated, the three-dimensional effect emphasizing the models' curves. Gouin, Braquehais, Moulin, Belloc, Lamy, d'Olivier, Dubosq-Soleil, and Derussy were among the major producers of this French speciality under the Second Empire (1852–70).

Initially the product was of quite high quality. Images were delicately coloured and gilded, poses were familiar from painting, and models were young and attractive. But in the last third of the 19th century the inventiveness of this essentially commercial product wore thin, and novelties appeared in the form of leporello-format folding series, booklets, or picture postcards with titles like 'Parisienne Preparing for Bed' or 'A Maidservant's Dreams', i.e. *fin de siècle* kitsch. The last exponents of the genre were the specialist magazines of the 20th century, ever more copiously illustrated with suggestive male and female nudes: nudist magazines in the 1930s, then glamour magazines after 1945, culminating in productions like *Playboy* and *Penthouse* in the 1960s.

Parallel to these commercial publications, in which artistic aims were never a priority, was more personal work. This remained rare in the 19th century, and was confined to a few connoisseurs. The controversy surrounding the small number of child nudes by Charles *Dodgson (Lewis Carroll), whom a female friend later described as having been 'in the pink of propriety', also underlines the difficulties of definition. The photographs of Pierre *Louÿs, by contrast, were far more clear cut. Also worth mentioning is the sculptor François-Rupert Carabin (1862–1932) who, c.1890, made over 600 photographic studies for female nudes to decorate his furniture. For these he made the models, many of them prostitutes, adopt poses much more suggestive than those in the finished works.

These private efforts were possible thanks to the spread of skills that permitted both picture taking and processing to take place behind closed doors. The known examples were probably only the tip of the iceberg, since family disapproval allowed only small quantities of work to survive. Especially striking were the 110 *cyanotypes created between 1890 and 1900 by the painter Charles Jeandel (1859–1942) of female models, singly or in groups, tethered, tied up, or suspended

in poses suggesting humiliation, pain, and consensual torture. In the spirit of de Sade and Sacher-Masoch, this singular body of work prefigures the experiments of André Boiffard (1903–61) in the 1930s, Hans *Bellmer in 1958 with his companion Unika Zürn, and Nobuyoshi *Araki since the 1970s.

But in the 20th century eroticism was not limited to these extreme cases. On the contrary, erotic work became part of photographers' official output, able to be exhibited and published. Clearly this development, the result of a more libertarian climate, was not limited to photography, but extended to all forms of artistic expression. Eroticism became a significant element of artistic production and, accepted as such, accompanied all photography's major developments, as well as becoming a field in its own right. It made its mark in *portraiture, for example Bettina *Rheims's images of stars, and above all *fashion photography, thanks particularly to the influence of Guy *Bourdin, Erwin *Blumenfeld, and Helmut *Newton. But as erotic photography, unlike pornography, was no longer confined to a kind of ghetto, most great 20th-century photographers tried their hand at it. In some cases it became central to their work.

It was after the First World War that erotic photography was treated as a legitimate genre by photographers whose artistic standing was no longer in any doubt. The series of portraits, nudes, and anatomical close-ups by Alfred *Stieglitz of his wife (from 1924) Georgia O'Keeffe between 1917 and 1933 have an astonishing intimacy. Particularly notable in the inter-war period was the work of *Brassaï, who created both realistic scenes of prostitutes with their clients and magnificent, sculptural female nudes. *Man Ray, Germaine *Krull, František *Drtikol, Paul *Outerbridge, Albert Rudomine, Roger Parry, and Edward *Weston dignified the genre by producing highly wrought studio nudes often—another new departure—with identifiable models.

Open-air nudity, often treated in a mediocre way by French and German nudist reviews in the 1920s and 1930s, found its ultimate exponent in Lucien *Clergue. His famous series of very sensuous female nudes photographed on the beaches of the Camargue in the 1960s and 1970s connected both with the return to nature extolled by the hippie movement and with the spreading fashion for holidays by the sea. Thanks to his printing technique, which emphasized both highlights and texture, the naked female body on the beach or in the waves became a new erotic stereotype. Much more sexually explicit, on the other hand, was the work of Ralph *Gibson in the USA and, as already noted, Araki in Japan.

Homoerotic photography, which flouted two taboos at once, first appeared in the work of Fred Holland *Day. His staged scenes featuring himself as the suffering and dying Christ heralded a genre in which, from Pierre Molinier (1900–76) to Robert *Mapplethorpe, eros and death are intimately linked in self-portraits and other works by homosexual photographers. At the same time, connoisseurs like Oscar Wilde were being offered pseudo-classical portraits of Taormina youths by Wilhelm von *Gloeden. Molinier, influenced by *Surrealism, was staging his transvestite fantasies already in the 1950s. But it was in the 1970s, with the explosion of *gay culture, that the

boldest works were created: by Bruce Weber (b. 1946) and above all Mapplethorpe, who depicted young black men with magnificent physiques in a style of impeccable, frigid classicism.

Today it is difficult to separate erotic photography as described above from the sexual imagery omnipresent in art, cinema, advertising, and photography. A subject that formerly had a distinct identity has become absorbed into many oeuvres, from those of *Witkin and *Goldin to a whole new generation of European, American, and Far Eastern photographers, and lost its autonomy and singular energy in the process. SA

'L'Érotisme', *La Recherche photographique*, 5 (1988).

Rheims, B., *Female Trouble*, introd. Catherine Deneuve (1989).

Nazarieff, S., *Early Erotic Photography* (1993).

Bramly, S., *Amateur* (1996).

Adam, H. C., *Die erotische Daguerreotypie: Eine mediengeschichtliche Bestandsaufnahme* (1998).

Aubenas, S., and Comar, P., *Obscénités: photographies interdites d'Auguste Belloc* (2001).

Smith, A. (ed.), *Exposed: The Victorian Nude* (2001).

Erwitt, Elliott (Elio Erwitz; b. 1928), American photographer. The son of Russian immigrants, Erwitt was born in Paris but lived as a boy in Milan, New York, and Hollywood. At the New School for Social Research, New York, he studied film-making. Roy *Stryker, for whom he worked on documentation shoots with *Standard Oil, recognized his considerable talent. Erwitt quickly became sought after both by editors in the advertising world and as a photojournalist. He joined *Magnum in 1953 (and became its president in 1966) and travelled and photographed widely. The Chaplinesque Erwitt is a master of what John *Szarkowski has called the 'indecisive moment', black-and-white images of people and animals, most often dogs, captured in seemingly insignificant instances in everyday settings. The subtle results are frequently, though not always, comic. Ever insistent that his work speak for itself, Erwitt never labels his photographs except with geographical location and date. This reticence belies his capable writing style, and a number of his many books contain insightful observations on the world and photography. Erwitt has noted, with some wistfulness, that he will probably be remembered only as a photographer of dogs. Anyone familiar with his work will disagree. TT

Erwitt, E., *Personal Exposures* (1988).

E-6 process. See PHOTOGRAPHIC PROCESSES, COLOUR.

espionage. See SUB-MINIATURE PHOTOGRAPHY.

ethics and photography. Ethics could be described as the *principles of best practice* that any photographer should adopt in carrying out their practice. The majority of these principles are based on common sense, goodwill, and morality rather than on laws and regulations. However, there are areas where the *law may provide a framework in which the photographer has to operate, e.g. copyright, contract law, etc.; and, in some countries, privacy legislation.

Most professional bodies that represent photographers have a *code of professional conduct* that all members agree to be bound by, and which provides a standard of ethics to which they conform when working. It usually covers matters like confidentiality, exercising due skill and care, the upholding of professional status, issues of corruption, and so on.

Although the UK does not have privacy laws, some countries do. These provide a legal framework in which the ethics of privacy reside. However, for those photographers not bound by legal constraints, it is in their interest not to misuse any photograph they have taken. Clearly *paparazzi* sail close to the wind in this regard, often acquiring images using long lenses and other devious means which can bring the profession into disrepute. The events leading to the death of Diana, princess of Wales, in Paris in September 1997 are a case in point.

Photojournalists or *war photographers are regularly confronted with ethical issues of an extreme kind. In photographing identifiable victims of conflict or disaster, for example, they may have to consider whether they would wish themselves or their families to be shown in such circumstances. Or, in another kind of situation, the photographer may have the choice of intervening to protect life instead of taking pictures. A third type of predicament arises when a photographer suspects that, for publicity or propaganda reasons, an atrocity or other criminal act may be taking place in order to be photographed. Finally, the photographer must ensure that his or her pictures show what they purport to show, without staging, restaging, or manipulation in the darkroom or by digital means. In practice, all these issues involve difficult grey areas, and implicate editors and newspaper proprietors as well as photographers.

There are codes governing the use of people in *advertisements*. In the UK these are produced by the Committee of Advertising Practice and the Advertising Standards Authority (ASA), which are also responsible for ensuring the code is applied in the public interest. Whilst the code does not have legal standing, it provides an ethical framework designed to protect both celebrities and the general public. The code requires, for example, that 'Advertisers . . . seek written permission in advance if they portray or refer to individuals or their identifiable possessions in any advertisement'; and that 'Advertisers who have not obtained prior permission from entertainers, politicians, sportsmen and others whose work gives them a high profile, should ensure that they are not portrayed in an offensive or adverse way.' Whilst the codes are especially important to the advertising industry, photographers in general should be guided by them.

Those in professional practice will be aware of the need for client *confidentiality* if an ethical framework is to be established for their work. Whether it be the portrait photographer making small talk with a client, or someone working in corporate photography where industrial secrets may be acquired, or information received as a consequence of negotiation or discussion, there is a need for all practitioners to adopt a confidential approach in their dealings with clients. Such conduct is required by professional bodies representing photographers as a condition of membership; and it is part of what

makes a photographer a professional. As is stated in the British publication *Beyond the Lens*, 'If photographers do not respect the subjects of their photographs, or treat them fairly, then it is only to be expected that clients will insist on acquiring copyright and owning control of the photographs themselves.'

Passing off, whilst quite rare, arises when a practitioner uses misrepresentation to take advantage of the reputation and work of another. An example might be where one photographer puts images of another photographer in his or her portfolio, passing them off as their own work. This is both unethical and tantamount to fraud. Photographic assistants need to be especially careful here. Having collaborated on a shoot with a photographer it may be a short step to passing off the resultant image as one's own, especially if one has done most of the work to achieve the shot. However, it is important to realize that the client is the photographer's, and that the latter was responsible both for the creative solution and the costs of the shoot.

Plagiarism is often mistaken for passing off, but is quite different. Basing an image on the work of another photographer without reworking, or using text authored by someone else without giving credit, is plagiarism. This is not fraud, it is copyright infringement and comparable to theft. Care should always be exercised when receiving a brief for new work, especially if the example provided by the client is based on the work of another photographer. It is in the photographer's interest to point out to the client the difficulties of 'copying' the ideas of another. Both the photographer's and the client's reputation may be at stake, and legal action may also ensue.

Those who commission photography, whether it be an advertising agent or a mother wanting a photograph of her baby, are always looking for someone whom they can trust to take the photographs. Trust is acquired through a professional working attitude, integrity in the approach to managing the shoot, and the business side of the commission. Of course all clients want high-quality work. They also want to be assured that if things go wrong, the photographer will not hesitate to put things right. This working relationship is paramount for the long-term success of any business, and is the basis of a photographer's reputation.

The range and variety of photographic work is such that it is hard to generalize too broadly about standards of conduct. Someone running an average high-street business is likely, most of the time, to face different ethical issues from, for example, a *paparazzo* or a photojournalist covering a civil war. However, the ASA's stipulation about the ethical requirements of advertising work could apply equally well to the work of photographers: namely, that it be legal, decent, honest, and truthful; prepared with a sense of responsibility to consumers and society; and have regard for the principles of fair competition generally accepted in business.　　　　DM

Gross, L., Katz, J. S., and Ruby, J. (eds.), *Image Ethics: The Moral Rights of Subjects in Photographs, Film, and Television* (1988).
Association of Photographers, *Beyond the Lens* (2000).
Gross, L., Katz, J. S., and Ruby, J. (eds.), *Image Ethics in the Digital Age* (2003).

Études photographiques, biannual French journal, edited by André Gunthert and published by the *Société Française de Photographie since 1997. It contains articles from an international group of established and emerging photographic historians, working on the history and theory of photography.　　　　KEW

Eugene, Frank (1865–1936), New York-born German photographer. After studying painting in Munich (1886–94) he became a leading American *pictorialist, co-founding the *Photo-Secession in 1902. Prominent as a portraitist, he extensively manipulated his negatives, treating photography essentially as a graphic medium. Although critics were appalled, his techniques, which included *hand colouring and aggressive scratching, were widely imitated. In 1907 he settled in Munich, teaching photography and making artist portraits. In 1913 he became professor of photography at the Leipzig Academy of Graphic Art and Book Design, eventually acquiring Saxon citizenship.　　　　PC

Pohlmann, U. (ed.), *Frank Eugene: The Dream of Beauty* (1995).

Evans, Henry Frederick (1853–1943), English *pictorialist photographer. A London bookseller who counted *Shaw and Beardsley among his customers and friends, Evans became interested in photography in 1880, won an award for microscopic studies of shells in 1887, and devoted himself fully to his art from 1898. At the turn of the century he joined the *Linked Ring Brotherhood and became involved in mounting its annual exhibitions (1902–5). But his role in pictorialism also extended across the Atlantic: he became the first British contributor to *Stieglitz's *Camera Work* (1903) and went on to exhibit at *Gallery 291 in New York. Specializing in platinum prints, he gained a reputation as a purist, for whom the retouching and manipulation of an image was unthinkable. Though he took some portraits (including a striking one of Beardsley) and landscapes, it was as an *architectural photographer that he became best known: French and English cathedrals were his favourite subjects, and his handling of mass, height, and depth was rich in atmosphere. After the First World War, when platinum became impossibly expensive, he gave up photography.　　　　RP

Newhall, B., *Frederick H. Evans: Photographer of the Majesty, Light and Space of the Medieval Cathedrals of England and France* (1973).

Evans, Walker (1903–75), often considered the leading American *documentary photographer of the 20th century. From a prosperous Chicago family, he attended exclusive New England schools and the Sorbonne in Paris, where he first became interested in photography. Using a small hand-held camera, he began photographing regularly as a freelancer in New York in 1928, focusing on street scenes and 19th-century houses. By 1933 he had exhibited at the John Becker Gallery with Margaret *Bourke-White and at MoMA, New York, the first of more than 30 shows dedicated to his work by 1995. In the early 1930s he lived in Greenwich Village with the painter-photographer Ben *Shahn. Thus he had an established reputation as a photographer when he became one of the first staff photographers hired by Roy *Stryker in

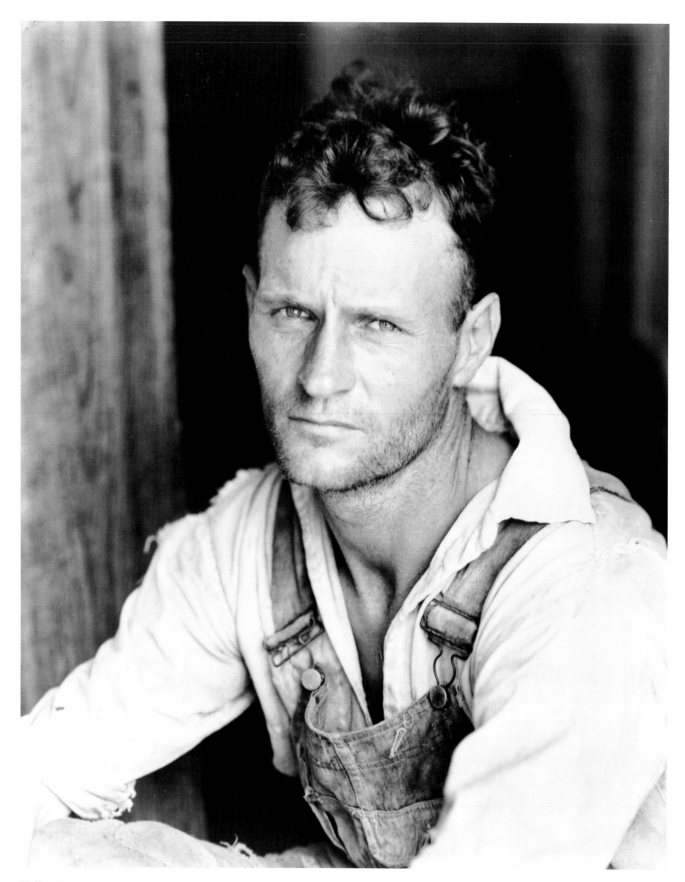

Walker Evans

Sharecropper (Floyd Burroughs), Hale County, Alabama, 1936

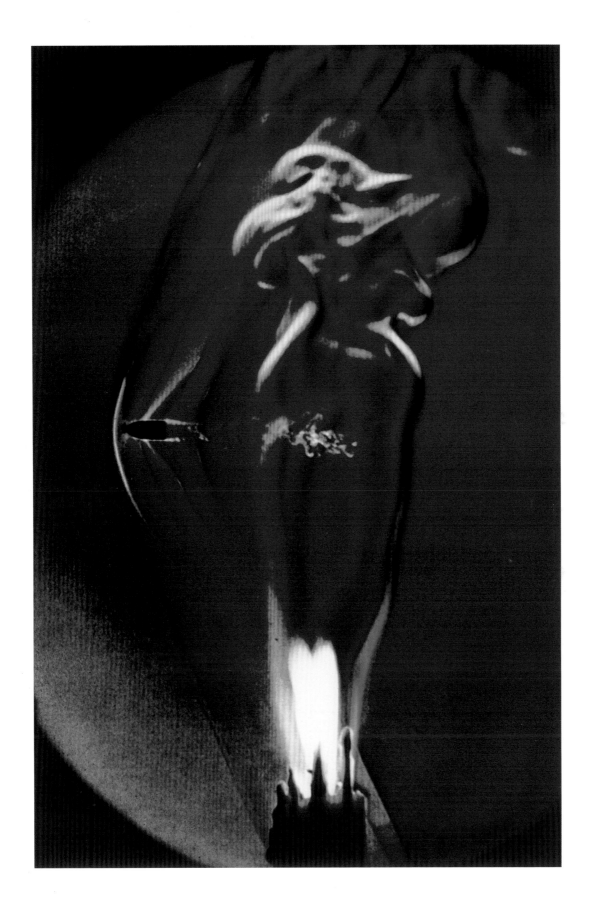

Harold Edgerton Bullet passing through a candle-flame, 1973

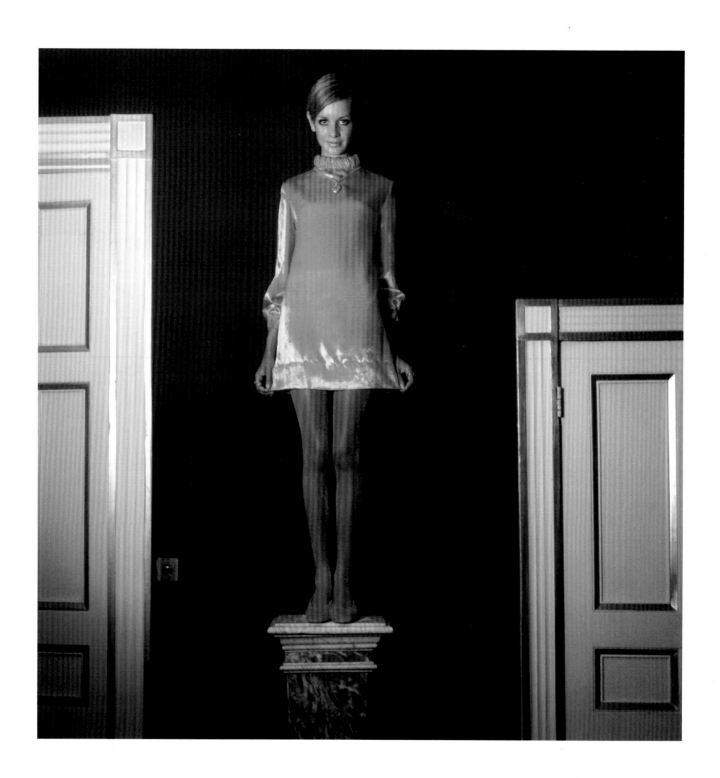

Cecil Beaton Twiggy, British *Vogue*, 1 October 1967

1935 for the 'Historical Section' of the Resettlement Administration (RA), which became in 1937 the Farm Security Administration (FSA).

Evans's early influence helped Stryker to understand and articulate the vision of 'documentary photography' that dominated the FSA files, even though Evans himself refused to accept the label of 'documentary' to describe what he regarded as photographic art using a 'documentary' style. His work with the FSA was episodic: he disliked taking directions from Stryker, and was unwilling to keep accurate records of his expenses for the bureaucracy (to the despair of the secretaries). Stryker discharged him in the autumn of 1937, ostensibly for budgetary reasons, although he rehired him briefly in 1938. Between FSA assignments, under contract with *Fortune* magazine, he took a series of photographs of Alabama sharecroppers which were never published by the magazine; these later became the basis of his best-known work in collaboration with the poet James Agee, *Let Us Now Praise Famous Men* (1941). He was associate editor and photographer for *Fortune* magazine 1945–65, when he retired from professional photography, although he continued to photograph on a freelance basis, and to teach as professor of graphic arts at Yale University (1964–75).

Evans primarily used a 20.3 × 25.4 cm (8 × 10 in) camera while working for the FSA, but occasionally worked with a 35 mm *Leica for informal shots of people, and with the Graflex Speed Graphic press camera. Best known for his direct and transparent black-and-white images (although he argued that he was actually working with shades of grey), at the end of his career he also worked with colour, and even developed an interest in the *instant colour photography possible with the Polaroid SX-70.

MoMA mounted an Evans retrospective in 1971 which established him as one of the most important American photographic artists of the 20th century. Another, comparative show in 2000 placed him in the context of 'the modern art of descriptive photography' (Peter Galassi) on both sides of the Atlantic. CBS

Szarkowski, J., *Walker Evans* (1971).
Thompson, J. L., *Walker Evans at Work* (1982).
Galassi, P., *Walker Evans & Company* (2000).

Everest, Mount. The photograph of Tenzing Norgay (1914–86) taken by Edmund Hillary (b. 1919) on Everest's summit on 29 May 1953 has become an *iconic image, exemplifying ideas of success and achievement. Although Everest was photographed from the Indian borders during the 19th century, it was not until 1921 that the first expedition to the mountain took place. Its members, including George Mallory (1886–1924), extensively photographed the mountain, its surroundings, and the local Tibetan people, and General Wheeler's accompanying photographic survey party photographed and mapped the Everest region. The British monopolized access to the mountain until 1953, and 20,000 images taken by members of various expeditions, including A. F. R. Wollaston (1875–1930), Eric Shipton (1907–77), and Alfred Gregory (b. 1913), are held at the *Royal Geographical Society.

On 3 April 1933 a team led by Colonel L. V. S. Blacker (1887–1964), in two Westland biplanes, took black-and-white and *infrared photographs, and cine-film, during the first flight over Everest. Two special Williamson Eagle cameras were used, protected by electrically heated jackets. Later RAF pictures of the mountain's flanks, made in the 1940s, provided vital clues to how it could be climbed from the south side, and were used by John Hunt's team in its successful ascent in 1953.

Contemporary photographers like David Breashears and climbers such as Doug Scott and Reinhold Messner have continued to record their experiences of Everest with the camera. Today, *digital images are taken and downloaded immediately to websites to acquaint interested parties, especially sponsors, with an expedition's every move. JW

Blacker, L. V. S., et al., *First over Everest* (1933).
Dickinson, L., *Ballooning over Everest* (1993).
Venables, S., *Everest Summit of Achievement* (2003).

execution photographs have served various purposes. Photographers and picture editors have speculated on ghoulish curiosity. Governments and occupying authorities have invoked the camera's 'unimpeachable truthfulness' to show that criminals have been punished or dissidents eliminated. Onlookers have created macabre souvenirs.

Execution images were common in the 19th century, as both paintings and popular prints. Of the former, Goya's *Third of May 1808* (1814) and Manet's *Execution of the Emperor Maximilian* (1868–9) are among the most celebrated. As soon as technology permitted, however, the camera became a natural competitor. In 1858, Felice *Beato photographed the hanging of insurgents after the suppression of the Indian Rebellion. Alexander *Gardner recorded the execution of the Lincoln conspirators in the Washington Arsenal on 7 July 1865. Two years later, the Mexico-based Frenchman François Aubert (1829–1906) took photographs relating to the execution of the French-installed, defeated Emperor Maximilian: not the shooting itself, but the site, the firing squad, and Maximilian's bullet-riddled clothing and embalmed corpse. They were marketed in France, despite efforts at censorship, by *Disdéri as *cartes de visite, and possibly influenced Manet's painting. In the aftermath of the *Paris Commune, victims of government reprisals were photographed before burial, and faked pictures of Communard atrocities by photographers like Eugène Appert (1830–91) were circulated as right-wing *propaganda. Over the next four decades, execution photographs were taken in colonial situations from the Belgian Congo to the fringes of British India; after the 1900 Boxer Rebellion in China; and during the Balkan conflicts that preceded the First World War.

Twentieth-century technology expanded the genre. The lynchings perpetrated in the American South until the 1960s were often photographed, by both commercial operators and amateurs. An eyewitness of the killing of Thomas Brooks in Fayette County,

Tennessee, in 1915 noted: 'Hundreds of kodaks clicked all morning at the scene of the lynching . . . Picture card photographers installed a portable printing press at the bridge and reaped a harvest in selling postcards showing a photograph of the lynched Negro.' Paradoxically, the abandonment of public execution elsewhere in North America, and in Europe, coincided with the rise of an illustrated tabloid press avid for gruesome images. Their circulation value was demonstrated in January 1928 when the New York *Daily News* sold *c.*1 million extra copies with an illicit photograph of the murderer Ruth Snyder in the electric chair. To obtain it, photographer Tom Howard, posing as a reporter, had strapped a specially designed single-shot plate camera to his ankle.

During the Second World War and its prelude in Korea and China, Japanese, Russian, and German forces carried out executions on a vast scale. They were often filmed or photographed for historical or propaganda purposes. But official German photographs sometimes reveal soldiers snapping hangings and shootings with their own cameras; and letters mention shouts of 'slower, slower' so that better pictures could be obtained. Although private photography of such 'unaesthetic' subjects was officially banned, many execution pictures survived. Some were captured and archived by the Russians, and re-emerged to shock visitors to the *Wehrmacht atrocities exhibition in the 1990s. The fact that they were taken at all, and often showed servicemen in relaxed mood while hostages or other non-combatants were being put to death, is a measure of the brutalizing effect both of the war and, undoubtedly, of the Nazi regime's vicious anti-Bolshevik and racist propaganda.

The wars and revolutions of the later 20th century were accompanied by countless cold-blooded killings of prisoners or civilians. Some photojournalists recorded them, others refused. Among the most celebrated images were John Sadovy's photos of Hungarian secret policemen being shot in October 1956; Eddie *Adams's of a captured Vietcong being executed in Saigon on 21 February 1968; and US army photographer Ron Haeberle's colour photographs of the *My Lai massacre a few weeks later. In Dacca in December 1971, during the Bangladesh War of Independence, prisoners were shot and bayoneted to death in front of photographers. Meanwhile, peacetime executions continued to be photographed: in China, for example, the open-air shootings of criminals and dissidents recorded by *Li Zhensheng. In the USA, although execution pictures became harder to make (though not impossible: *vide* the execution of Allan Lee Davis in Florida in 1999), interest in capital punishment remained strong, demonstrated by Lucinda Devlin's *Omega Suite* studies (1991–7) of prison death chambers; and by the reactions to Oliviero *Toscani's images of Missouri death row inmates, intended for Benetton's 2000 advertising campaign. RL

Vernichtungskrieg: Verbrechen der Wehrmacht 1941 bis 1944 (1996).
Allen, J., Als, H., Lewis, J., and Litwack, F., *Without Sanctuary: Lynching Photography in America* (2000).
Breidenbach, S. (ed.), *Lucinda Devlin: The Omega Suites* (2000/1).

exhibitions and festivals of photography

Exhibitions

Exhibitions have punctuated the narrative of photography's development, revealing new ideas and establishing movements at milestones in the medium's history. Although certain books have been seminal, exhibitions have been vital in disseminating photographic ideas, technique, and practice. Exhibitions bring artists and audiences physically together to consider the work, and are instrumental in the international exchange of ideas. Increasingly, key exhibitions are accompanied by conferences, lectures, and major publications.

Early events were generally group exhibitions, whilst later group exhibitions often confirmed a new stylistic direction, their titles becoming the name for a movement. One-man shows hardly emerged before the First World War, but some have had an importance beyond the particular photographer's career. The influence of curators like *Stieglitz, *Steichen, *Newhall, *Steinert, and *Szarkowski was vital in promoting photography to wider audiences and shaping artistic practice through their exhibitions.

Early exhibitions

Photographs were first exhibited at the *Great Exhibition of 1851 at the Crystal Palace, London, which included *daguerreotypes, *calotypes, *stereographs, and recently introduced *wet-plate photographs, totalling *c.*700 images from Britain, the USA, and continental Europe. In 1852 the first independent exhibition was held at the Society of Arts, London, with 774 photographs of all types, leading to the formation of the Photographic Society in 1853, dedicated to frequent exhibitions, the first of which was held in 1854 at the Society of British Artists.

The 1855 *Exposition Universelle in Paris included a photographic section organized by the *Société Française de Photographie, which held its own exhibitions in 1855 and 1857. By 1859 the Salon des Beaux-Arts included portrait photographs, prompting Charles Baudelaire's celebrated diatribe against photography. The first two Central European exhibitions devoted exclusively to photography were held in Vienna in 1864 and Berlin in 1865. Through to 1900, international 'universal' exhibitions including photographic technology and images were held in London, Paris, Vienna, and other cities.

Secessionist exhibitions

The first international exhibition of 'art', i.e. *pictorialist, photography was organized by the Vienna Camera Club in 1891, leading to Alfred Maskell, who exhibited in Vienna, proposing the formation of a British art photography exhibition group. In November 1893 the first annual salon of the pictorialist *Linked Ring was held, at the Dudley Gallery, Piccadilly. (The previous year, 68 photographers had contributed to a show held by the London Camera Club.) The rules stipulated that there would be no medals, selection would be by a jury of photographers, and exhibits would no longer cover the entire wall space of the gallery. Other European events of comparable importance

were the first salon of the *Photo-Club de Paris (1894), and the international exhibitions held at the Hamburg Kunsthalle between 1893 and 1903, and in Kiev in 1908.

By 1908 the Linked Ring's elitist selection process and the predominance of a limited coterie, including numerous Americans, led to the creation of a *salon des refusés* by F. J. Mortimer (1875–1944). Exhibiting at the *Amateur Photographer*'s Little Gallery, this group dominated the selection for the 1909 Linked Ring salon, precipitating the resignation of American Ring members and ultimately precipitating the end of the Ring. It was succeeded by the London Secession, led by George *Davison, which exhibited until 1911, and the much longer-lasting London Salon, led by Mortimer.

In the USA the three leading societies, of New York, Philadelphia, and Boston, had held rotating 'joint exhibitions', including European work, but Boston withdrew in 1895 and the event ceased. In 1896 Alfred Stieglitz, vice-president of the newly amalgamated Camera Club, declared, 'let's start afresh with an Annual Photographic Salon to be run upon the strictest lines'. Salons in Washington and around the country established the American pictorialist movement and in 1900 F. Holland *Day took an exhibition of the *New American School* to the *Royal Photographic Society in London, causing a sensation. It was shown in Paris in 1901, including work by Steichen, who in 1902 had one of the first ever one-man shows, at La Maison des Artistes, with paintings and photographs.

In 1902, Stieglitz arranged *An Exhibition of American Photographs arranged by the Photo-Secession* at the National Arts Club, New York, modelled on the secessionist movements in art in Europe and leading ultimately to a remarkable international exhibition of pictorial photography at the Albright Art Gallery, Buffalo, in 1910. This was the first recognition of photography as an art form in a major American art museum, leading to the gallery commencing a photography purchasing policy, with fifteen shows. However, the 1910 exhibition also marked a watershed, as Stieglitz's interest shifted elsewhere.

Modern photography: the inter-war years
The exhibition of *Coburn's *'Vortographs' at the London Camera Club in 1917, *Kertész's exhibition at the Sacre du Printemps Gallery in Paris in 1927, and the *Salon de l'Escalier show, also in Paris, in 1928 were milestones in European anti-pictorialist, avant-garde photography associated with the *Surrealist, Constructivist, and New Objectivity movements. The *Film und Foto* exhibition in Stuttgart in 1929, combined with the *Fotomontage* exhibition at the Berlin Kunstgewerbemuseum in 1931, set out the 'New Photography' manifesto.

The American reaction to pictorialism was the formation of the *'straight photography' *Group f.64 in 1932, with an exhibition at the M. H. de Young Museum in San Francisco, including *Adams, Edward *Weston, *Cunningham, and *Lange. Arising from FSA (Farm Security Administration) and other documentary work of the 1930s, the Photo League held annual exhibitions, also showing *Moholy-Nagy, *Heartfield, and others at its New York premises. Another key New York venue between 1931 and 1949 was Julien *Levy's gallery.

The first exhibition of the history of photography at MoMA, New York, *Photography 1839–1937* (1937), was organized by Beaumont Newhall. The exhibition in 1938 of Walker Evans's *American Photographs* confirmed photography's place in major American art galleries.

Post-war developments
At the 1950 Photokina, L. Fritz *Gruber arranged an exhibition of the *fotoform group. Such exhibitions continued regularly, culminating in the 1980 landmark *Imaginary Photo Museum*, curated by Newhall, *Gernsheim, and Gruber. Steinert's *Subjective Photography: An International Exhibition of Modern Photography* in Saarbrücken in 1951 showed contemporary work that was personal and expressive rather than documentary. The first major British post-war show was the Victoria & Albert Museum's (V&A) *Masterpieces of Victorian Photography 1840–1900* (1951), based on the Gernsheim Collection and commemorating the centenary of the Great Exhibition. Historically even more important were another ambitious V&A show, *From today painting is dead* (1972), and *Light from the Dark Room* (1995) and *Hill and Adamson* (2002) at the National Galleries of Scotland.

Steichen's *Family of Man* exhibition (1955), an idealistic evocation of universal human concerns, promoted photography to a wide audience (estimated at 10 million worldwide), with innovative use of display space and unframed images, and a best-selling catalogue. Conflicts and other harsh realities, largely excluded from *The Family of Man*, were addressed by the World Press Photo shows from 1955, annual selections of press images and *photo-essays.

Shifts in photography by the 1960s were reflected in Szarkowski's defining exhibition *New Documents* (1967) at MoMA, with *Arbus, *Winogrand and *Friedlander. The Diane Arbus retrospective at MoMA in 1971 was the most successful show since *The Family of Man*, the catalogue being repeatedly reprinted. (The following year Arbus became the first photographer to be included, albeit posthumously, in the Venice Biennale.) *New Topographics* at the *International Museum of Photography, Eastman House, in 1975 introduced the new photographers of the man-altered landscape, and *William Eggleston's Guide* (1976) at MoMA legitimized colour photography.

Photography's convergence with contemporary art was heralded by the 1969 exhibition at the Kunsthalle, Bern, *Live in your Head: When Attitudes Become Form*, also shown at the Institute of Contemporary Arts (ICA), London, followed by *The New Art* (Hayward Gallery, London, 1972), *Un certain art anglais* (Musee d'Art Moderne, Paris, 1979), including *Burgin, Gilbert and George, and John Hilliard (b. 1945), and *Photographie als Kunst, Kunst als Photographie* (1979) in Austria. The trend continued with *I am a Camera* (2001) at the Saatchi Gallery, London, and *Cruel and Tender* at Tate Modern, London, and the Ludwig Museum, Cologne, in 2003.

At photography's 150th anniversary in 1989, several exhibitions, *The Art of Photography* (London, Houston, Canberra); *Photography Now* (London); *Photography until Now* (New York); *Foto-Kunst* (Stuttgart) and *On the Art of Fixing a Shadow* (Chicago, Washington, Los Angeles); reviewed the medium's history as an art form.

Finally, three events which focused on hitherto neglected areas were *Fotografie Latein-Amerika* (1981) at the Kunsthaus, Zurich; *Eye of Africa 1840–1998*, a series of exhibitions held at various venues in Cape Town in 1998–9; and *India through the Lens: Photography 1840–1911* (2000) at the Sackler Gallery, Washington, DC.

Festivals

A modern phenomenon, festivals are now an important platform for photography. On one-, two-, or three-year cycles, using traditional and unconventional spaces for 25–100 exhibitions, typically for a month, they have large photographic and general audiences, and include portfolio reviews of photographers' work, seminars, talks, and opportunities for sales. Some, like Visa pour l'Image, distribute prestigious prizes. In some countries, the creation of festivals has been vital in establishing a photographic culture: Greece, for example, with its (albeit short-lived) International Month of Photography in Athens (1987–91), Photosynkyria at Thessaloniki (1989–) and Skopelos international festival (1996–).

In 1970 Lucien *Clergue and friends launched the first annual photography festival, the Rencontres Internationales de la Photographie, at *Arles, France, now a leading event in world photography. France also has Mois de la Photo, Paris (biennial), Visa pour l'Image, Perpignan (international photojournalism), and many local festivals, among the most recent Photo de la Mer at Vannes, Brittany (2003).

The annual 'exposure' festival at Hereford, England, has established an international profile since 1989. Festivals at Derby, Shoreditch, and in Scotland (fotofeis) ran during the 1990s, and in 1998 there was a Year of Photography festival in Yorkshire. In the same decade festivals started across Europe, including Naarden, Groningen (Noorderlicht), Rotterdam, Breda, Barcelona, Herten (Germany), Madrid, Braga, Plovdiv, Moscow, Odense, Rome, Milan, Hamburg, and Bratislava.

North America's leading biennial is FotoFest (Houston), since 1986; each event has a theme, with numerous exhibitions at public and commercial galleries, as well as the Meeting Place portfolio reviews attended by international photography publishers, curators, and festival directors. Photo Americas at Portland, Oregon, in alternate years to FotoFest, is similar. Commercial galleries exhibit annually in New York (AIPAD) and Los Angeles (Photo LA). In Canada, Montreal and Toronto have festivals.

So do Mexico, Argentina, Brazil, and Venezuela, and there has been a festival of African photography in Bamako, Mali, since 1994. The first Asian event was Chobi Mela, Dhaka, Bangladesh, in 2000, while the *Pingyao (China) International Festival started in 2001. In Japan, festivals of various kinds (mostly annual) have run since the mid-1980s in Tokyo, Higashikawa, Miyazaki, Nara, Okinawa, and Sagamihara. The Festival of Light has a website linking 22 international festivals in seventeen countries. RA

See also GALLERIES OF PHOTOGRAPHY.

experimental photography. See ABSTRACT AND EXPERIMENTAL PHOTOGRAPHY.

exploration photography. From studies made on David Livingstone's 1858–63 Zambezi expedition, Thomas Baines, the official artist, painted *Shibadda, or Two Channel Rapid above the Kebrabasa [Rapids]* (c.1859) in Mozambique. In the foreground stand two Europeans, one of them Baines himself, while at the bottom right-hand corner two men are discovered photographing with a large plate camera. These were Charles Livingstone (1821–73), the explorer's brother and photographer to the expedition, and the scientist and medical officer Dr John Kirk. However, practical obstacles, and Livingstone's limited ability, seem to have prevented him taking any successful pictures, and Kirk's—of trees and other static subjects—were the only ones to survive. Later, on an expedition to the Victoria Falls, Baines noted 'the difficulties in the way of a photographer' in Africa: 'the restlessness of the sitters . . . the different conditions of atmosphere and intensity of the sun—the constant dust raised either by our people or the wind—the whirlwinds upsetting the camera . . . combine to frustrate the efforts of the operator.'

Such problems meant that photography was little used outside Europe and the USA before c.1865. Nevertheless, even if the results were often meagre, the camera was regarded as a scientific tool that could capture empirical data about the unknown world, and document discoveries for the public at home.

One of the earliest sets of photographs of eastern Africa was taken on the *Royal Geographical Society's (RGS) 1860–3 East African Expedition by Colonel J. A. Grant (1827–92) who, with J. H. Speke, had been funded to find the source of the Nile. However, the only pictures taken were of the expedition's point of departure, Zanzibar. After a handful of images were made of the town and its inhabitants (including manacled slaves in the market), technical difficulties led to the camera being abandoned. Between 1860 and 1880, explorers either travelled with a professional photographer or operated the camera themselves. Désiré *Charnay, John *Thomson, J. W. *Lindt, Francis *Frith, Samuel *Bourne, and Timothy *O'Sullivan were all photographer-explorers. Thomson, who travelled throughout Asia between 1858 and 1875, advised explorers and travellers on how to use the camera, and published articles on photography in early travel guides such as *Hints to Travellers*, published by the RGS c.1893. The information provided ranged from the essential qualities required in a camera ('rigidity and strength') to advice on protecting plates and films against damp and humidity by 'boxing them in airtight containers containing chloride of calcium which had first been dried on a piece of iron over a fire'.

As photographic technology improved, so it became more widely used by *cartographers, botanists, *missionaries, geographers, *anthropologists, and *colonial officials—all in some degree explorers. William Ellis in Madagascar, Prince Roland Bonaparte (1858–1924) in Lapland, Everard im Thurn in British Guiana, Sir J. B. Thurston in Fiji and the Solomon Islands, John Claude White and Auguste *François in Tibet, Isabella Bishop (1831–1904)—a rare woman in a male-dominated field—in China, W. H. I. Shakespear (1878–1915) and later Wilfred Thesiger (1910–2003) in Arabia, were just a few of

those who used the camera to document their travels. Today their images are being re-examined as evidence of how the Victorians and their successors constructed their view of the world and of their position in it.

Of particular interest, not least because of the exceptional difficulties involved, is the record of photography in the polar regions. Although James Cook, in 1773, was the first to enter the Antarctic Circle, it was not until James Clark Ross's circumnavigation expedition of 1839–43 that man actually approached the Antarctic continent. Its doctor and naturalist, Joseph Hooker, noted that 'no instrument, however newly invented, was omitted, even down to an apparatus for daguerreotyping and talboting'. However, no pictures were actually taken. The first successful polar photographs seem to have been made by John L. Dunmore and George Critcherson in the Arctic North in 1860, and published in William Bradford's book *The Arctic Regions* in 1873.

It was not until the late 19th century that expeditions to the Antarctic began in earnest, sponsored by nation-states like Germany, the USA, and Norway interested in the continent's economic and scientific possibilities. Photographs from these and other undertakings (for example, the German expedition to observe the 1874 transit of Venus) survive in various national archives. At the same time, photography's educational and publicity value was increasingly appreciated. Sir Clements Markham, who was instrumental in organizing the 1901–4 National British Antarctic Expedition, led by Captain Robert Falcon Scott, understood photographs' fund-raising potential, and encouraged Scott to make an extensive pictorial record. Their images set the standard for future British expeditions, and began a continuing love affair between the British public and Antarctica. But it was Scott's second expedition of 1910–12 that yielded some of the greatest images. These were by Herbert *Ponting, the first official photographer on an Antarctic expedition, who made extraordinary, magical pictures despite extreme cold, darkness, and limited facilities. His work was equalled only by that of the intrepid Australian Frank *Hurley on Shackleton's 1914–16 *Endurance* expedition. In December 1911, meanwhile, the Norwegian Roald Amundsen at the South Pole (like Robert Peary at the North Pole in April 1909) had been photographed raising his national flag.

The fact that the North Polar regions were inhabited meant that Arctic photography regularly documented indigenous peoples. For example, J. E. Tenison-Woods's *stereographs taken on the voyage of the *Fox* in 1860–1 show both the landscapes and people of Iceland and Greenland. In the largest body of photographs from the 1870s, taken during the British Arctic Expedition of 1875–6, there are images of the 'Natives of Disco' as well as the obligatory bearded Englishmen. From Peary to Knut Rasmussen, from Edward *Curtis to modern photographers like Bryan (b. 1949) and Cherry (b. 1949) Alexander, the photograph of the indigenous person goes hand in hand with images of the Arctic ice. Especially in earlier photographs—as in Robert Flaherty's pioneering film documentary *Nanook of the North* (1922)—the Inuit subject is often

constructed as 'noble savage' or 'primitive' inhabiting a world outside time. JW

White, J. C., *Tibet and Lhasa* (1904).
Ponting, H., *The Great White South* (1921).
Thesiger, W., *Visions of a Nomad* (1987).
Keay, J., *The Royal Geographical Society History of World Exploration* (1991).
King, J. C. H., and Lidchi, H. (eds.), *Imaging the Arctic* (1998).
Murphy, S., *South with Endurance* (2001).

Exposition Universelle, Paris, 1855, promoted by Napoleon III in answer to London's 1851 *Great Exhibition, and the first of five world exhibitions staged in France in the late 19th century. Memorably photographed by C. Thurston Thompson (1816–68), the *Bisson brothers, and R. J. Bingham, the fair boasted over 20,000 exhibitors from 34 countries. Photography was shown separately from fine art, in Group VII with 'drawing and arts applied to industry'. Nevertheless, the medium had a strong presence, and 65 French studios alone were represented. KEW

exposure determination. Although it is not immediately apparent, the means of determining optimum exposures for reversal *transparencies (slides) exposed in camera, and for negatives, are not always identical.

The exposure required for a *transparency* is critical for two reasons. First, it is a camera original, so anything that is lost in either shadow or highlight detail is lost for ever: it cannot be recovered by dodging and burning, as it can from a generously exposed negative. Second, highlight detail determines maximum exposure: 'blown' or washed-out highlights in a transparency generally look far worse than inky black shadows. Logically, therefore, the best way to determine exposure for a transparency is by reading the brightest highlight in which texture and detail are desired. The easiest way to do this is by reading an artificial, constant highlight: and this is, in effect, what an incident light dome is.

Alternatively, a spot meter can be used to read an actual highlight, though it is important to use the highlight index, not the mid-tone index. The most widely used highlight index is probably 1 on the IRE (Institute of Radio Engineers) scale, which is $2\frac{1}{3}$ stops above the (somewhat notional) 'mid-tone index'. Most meters actually show the IRE scale ×10, so 1 is shown as 10 and 0.1 is shown as 1. The highlight index needs to be above the mid-tone index in order to ensure extra exposure as compared with a mid-tone: otherwise, a bright white in the subject would be rendered as a mid-tone grey in the slide.

All other reflected light readings require interpretation and modification, whether by the photographer or, via empirically derived exposure algorithms, by the software in a multi-sector exposure meter.

For exposing *negative* films, on the other hand, all that normally matters is adequate shadow detail. If this is present, then a fortiori the highlights will not be underexposed. The logical approach is therefore to meter the darkest areas in which shadow detail is required, preferably with a spot meter, using a shadow index. Again, the IRE

scale is widely used: 0.1 (normally shown ×10 as 1) on this scale is 2⅔ stops below the 'mid-tone index'. In this case, it needs to be below the mid-tone index in order to ensure reduced exposure as compared with a mid-tone: otherwise, a deep shadow in the subject would be recorded on the film as if it were a mid-tone grey.

If the subject brightness range between the brightest highlights in which texture is required and the darkest shadows in which texture is required is about five stops, 32 : 1, the optimum exposure for both transparencies and negatives is identical; the IRE scale reflects this, with 1 (10) being five stops above 0.1 (1).

If the brightness range is more than a stop or so greater than this, the negative will require more exposure than the transparency, in order not to lose shadow detail. If the brightness range is less, the negative may safely be given less exposure than the transparency, though most photographers would not bother, given the modest penalties for overexposure (see below).

*Through-the-lens (TTL) meters are generally designed for transparency exposure. They may therefore fail to give optimum exposures for black-and-white for the reasons described above. Spot metering of the shadows is much more reliable, or rule-of-thumb corrections may be made to incident or *matrix through-lens readings: ⅓ to ⅔ stop under 'cloudy bright' daylight, around one stop extra on bright, sunny days with deep shadows.

Three important points remain to be made. The first and most significant is that there is always room to modify exposure in the light of personal preference, or to take account of variations in subject, equipment, or technique. Many photographers establish personal exposure indices (EIs) for their favourite films: that is, film speeds that they know will give them the results they like best, whether or not they match the ISO speeds. The second is that, within reason, overexposure will have far less adverse effect on the image quality of negative films than underexposure. Contrary to popular belief, even quite drastic overexposure (as much as three stops) cannot 'blow' highlights to an unprintable featureless black in the negative (white in the print), unless the *characteristic curve of the film is an unusual shape (and some are). The third is that excessive overexposure is best avoided as it means reduced sharpness, increased grain (except with *chromogenic films), and longer printing times. All of these may be significant with 35 mm film, because of the greater degrees of enlargement required for a given print size, but they are rarely important with medium-format roll-film and they are of little or no consequence with large cut film. Overexposure also means working at a slower shutter speed or a wider aperture or both, with implications for camera shake, subject movement, and *depth of field. RWH

Langford, M. J., *Advanced Photography* (6th edn. 1998).

Hicks, R. W., and Schultz, F., *Perfect Exposure: From Theory to Practice* (1999).

exposure meters. One type measures the light falling on a scene ('incident light'); the other, the light reflected from it. The incident light meter is unaffected by the reflectivity of the subject, but relies on an 'average' subject without deep shadows. Reflected light metering

may rely on the integration of a broad-area reading, or on a spot reading of a particular tone. Both incident and integrating reflected light meters should give identical readings for an 'average' scene, which is taken to reflect about 12 or 13 per cent of the light falling upon it (and not 18 per cent as is widely believed) and to have an overall brightness range of 128 : 1, so that the brightest important highlights are 128 times as bright as (seven stops brighter than) the darkest important shadows. For a non-'average' subject, a reading of specific tones (and ideally of the whole brightness range) is the only way to ensure maximum accuracy.

Among exposure meters there are two ancient types, *actinometers* and *extinction meters*, and three modern: *artificial highlight, broad-area,* and *spot*.

Actinometers were an early form of incident light meter that relied upon the darkening of a piece of photosensitive material. The time taken to reach a specified tint, marked on the body of the meter, was the basis for exposure calculation: some meters were fitted with a chain, allowing their use as a pendulum to check the time. Their main disadvantages are sluggishness in use and a reliance on a consumable metering medium.

Extinction meters resemble a small telescope with a series of numbers or letters inside, of diminishing brightness (via filtration). The last number or letter that can be clearly read is used as the basis for calculation. The readings can be affected by the accommodation of the eye to different light levels, so they are most reliable for 'snap' readings taken in five seconds or less.

Artificial highlight meters are photo-electronic incident light meters relying on a photoresistive or photovoltaic cell, or a photodiode. The read-out may be digital or via a swinging-needle meter. As the name suggests, the exposure is keyed to an artificial highlight, a white incident light dome or plate, which may be fixed, or detachable, or designed to be slid in and out of place. This acts as a constant tone, the brightness of which depends only on the light falling upon it. Such meters are ideal for determining the exposure of transparencies and direct positives. Any corrections needed are small, and intuitive: for more texture in a light surface such as snow, exposure is reduced slightly, while for more texture in a dark surface such as a dark suit, exposure is increased slightly.

Broad-area meters measure the light reflected from the subject as a whole. Again, they are photoelectric. Most can be used equally well for incident light readings via an artificial highlight as described above. The simplest broad-area meters integrate the reading from the whole scene, treating it as a uniform grey; the most complex (in *through-lens camera meters) take numerous readings at different points and calculate the exposure via empirically derived algorithms. Broad-area meters are notoriously misled by very bright subjects such as snow scenes, or very dark ones such as black cats in coal cellars, underexposing the former and overexposing the latter. The necessary corrections to get a pleasing exposure may be as high as two or three stops for simple meters, or a stop or less with a multi-sector meter.

Spot meters are used to measure specific key tones. The most usual are shadows (for negative films) and highlights (for transparencies), though some portraitists use a skin highlight as a standard tone and other specialist applications are analogous. Trying to measure 'mid-tones' is a snare and a delusion: trying to guess what is a 'mid-tone' is difficult to the point of impossibility, and carrying an 18 per cent grey card and taking spot readings off it is unlikely to give readings that are better than (or in many cases, as good as) incident light readings. The earliest commercially successful spot meter, the SEI Photometer (1947), had no 'mid point' index, just shadow and highlight indices.

Spot meters can also be used to measure overall brightness ranges, in order to determine the need for modified development (for monochrome) or additional lighting or contrast-reducing screens (for colour). Most spot meters read a 1-degree circle and are photo-electronic, though the SEI read 0.5 degrees and was a sophisticated visual comparison photometer.

Flash meters are variants on the three modern meter types. Many have a variable 'gate' that takes account of ambient light for the duration of the shutter opening, as well as the flash exposure; others have a fixed 'gate'.

The exposure value or EV quoted on many meters since 1954 (when it was introduced as a light value or LV by Prontor with their SVS shutter) is an attempt to combine shutter speed and aperture into a single number: the original idea was that this would be taken from a separate meter and transferred to the EV ring on the shutter. EV shutters feature an interlinked shutter-speed control and aperture ring, so that increasing one automatically decreases the other, giving the same overall exposure. Thus EV 1 is 1 second at f/1.4 or 30 seconds at f/8 or any other equivalent combination, while EV 10 is 1/500 at f/1.4 or 1/30 at f/5.6 or 1 second at f/32 or any other equivalent combination. On a top-quality meter, EVs might run from −8 (8 minutes at f/1.4) to EV 24 (1/2,000 at f/90); meter readings obviously vary with film speed, so a sunny day with ISO 100 film is about EV 15, or with ISO 400 film, EV 17. RWH

See also ACTINOGRAPH; EXPOSURE DETERMINATION; MATRIX METERING.

Coe, B., *Cameras: From Daguerreotypes to Instant Pictures* (1978).
Stroebel, L., et al., *Basic Photographic Materials and Processes* (1990).

exposure value (EV) **system**. See EXPOSURE METERS.

extension tubes. Whereas a studio camera can manage an extension up to three or four times the focal length of the lens, giving image magnifications of 2 : 1 or more, most small and medium-format camera lenses will not focus nearer than about 30.5 cm (12 in) without the insertion of a spacer between the lens and the camera body, called an *extension tube*. These are usually provided in sets of three different extension sizes; when used singly or in combination they give an effectively continuous range of image magnifications up to 1 : 1 or more, depending on the focal length of the lens. They are usually fitted with pushrod systems coupling to the autofocus and diaphragm mechanisms. GS

extreme conditions, photography in. Great images rarely give the appearance of being difficult to take, or betray the effort and risk involved. But the stories behind them may be extraordinary, adding to their aura of significance and value.

Complex processes and cumbersome equipment made the achievements of 19th-century photographers particularly remarkable; *Fenton in the Crimea, for example, G. W. *Wilson in the *Scottish Highlands, the *Bisson brothers in the Alps, and Samuel *Bourne in the Himalayas created superb images in daunting environments. Tenacity, skill, the contribution of assistants, and luck all played their part.

In the 20th century, the Australian Frank *Hurley was the ultimate adventure photographer, prepared to go to any lengths to get a photograph. On Shackleton's *Endurance* Expedition of 1914–17, he constantly and literally threw himself into perilous situations. In his diary, he recounted how he would balance on ice floes to photograph the moving ship, and sometimes had to throw himself and his camera out of her path. He spent hours in the Antarctic darkness preparing to take the now famous nocturnal picture of the *Endurance* lit by magnesium flash. Later he risked his life to salvage his glass negatives from the crushed and sinking vessel. Other extreme photographic exploits include the *marine photography of Alan Villiers and Eric Newby in the 1920s and 1930s, Colonel L. V. S. Blacker's pioneering flight over *Everest in April 1933, and the work of astronauts in space and on the *moon.

Natural hazards are legion. Cold can solidify lubricants, freeze metal to skin, deplete batteries, and cause film to become brittle and break. High temperatures melt film emulsions and the cement in lens assemblies. Humidity propagates fungus; salt and sand scour glass and jam components. Although modern materials and manufacturing techniques (e.g. sealing) have reduced these problems, increasing use of electronic, battery-dependent cameras, and the ever greater demands made especially on *sports and expedition photographers have created new ones. Survival in the field requires an array of kit, from portable hairdryers to brushes, tape, and plastic bags. Extreme measures may be needed in order to keep going: in the 2003 Iraq War, for example, photographers buried their digital cameras under the sand to protect them from the desert heat. (Wilfred Thesiger, however, exploring the Empty Quarter of Arabia in the late 1940s, had kept his Leica safe in a simple goatskin bag.)

Conflict and crime create other perils. In 1866, near Fort Kearney in Montana Territory, the photographer Ridgway Glover was killed and scalped by Sioux Indians. Once technology made close-action *war photography possible, photographers became casualties. Pictures of the Pacific War (1941–5), and Robert *Capa's D-Day images, set an enduring pattern. Photographs of the intifada in Palestine, township violence in South Africa, and the destruction of the *World Trade Center in New York were made in equally life-threatening conditions. Meanwhile, *tourism was taking photographers to places where annual incomes might be lower than the value of a couple of cameras. Parts of many Western cities are

dangerous environments for photography. In such conditions, the visitor must either camouflage his equipment with paint or masking tape, or exchange it for *single-use cameras, or revert to sketchbook and diary. JW

See also EXPLORATION PHOTOGRAPHY; MOUNTAIN PHOTOGRAPHY; UNDERGROUND PHOTOGRAPHY; UNDERWATER PHOTOGRAPHY.

Hurley, F., *Argonauts of the South* (1925).
Hunt, J., *Our Everest Adventure* (1954).
Life Library of Photography: Special Problems (1972).

Eye of Africa: African Photography 1840–1998 exhibition, Cape Town, 1998–9. Covering historical and contemporary photography throughout the continent, it was the most comprehensive exhibition of African photography ever mounted. It comprised two main exhibitions at the South African National Gallery and the Castle of Good Hope, organized by the Paris-based journal *Revue noire*, and 'fringe' shows in other locations. RL

Eyre, Janieta (b. 1966), British-born photographer resident in Toronto, Canada. She studied philosophy at Toronto University, then magazine journalism at Ryerson Polytechnic University and photography at the Ontario College of Art and Design. She took up photography professionally in 1995. In her distinctive self-portraits, she frequently presents herself as a set of twins, engaging with the possibility of morphous identities and fictional doubles. Often employing fantastic and carnivalesque settings, she uses props and costumes to disrupt the fixity of image and identity. She manipulates the theatricality at play in her work by incorporating art-historical and literary references, while leaving space for the integration of fictional representations. KR

fairgrounds. See CIRCUSES AND FAIRGROUNDS.

Falling Soldier, The (*Death in Spain*). Robert *Capa's image of a Spanish Republican militiaman supposedly at the moment of death in action first appeared in the French magazine *Vu* on 23 September 1936, then in *Life* on 12 July 1937, establishing its author as a star photojournalist. Typically, however, Capa later gave vague and conflicting accounts of its creation, and in a 1975 book, *The First*

Casualty, Phillip Knightley suggested that it might have been staged. Controversy has raged ever since. In 2002 Richard Whelan forcefully defended the picture's authenticity. Drawing partly on the research of a Spanish amateur historian, Mario Brotons (d. 1997), he identified the figure as Federico Borrell Garcia from Alcoy near Alicante; the location as Cerro Muriano on the Córdoba front; and the date as 5 September 1936. According to Whelan, Capa's photograph followed a series of images of soldiers exercising to the rear of the firing line, and caught

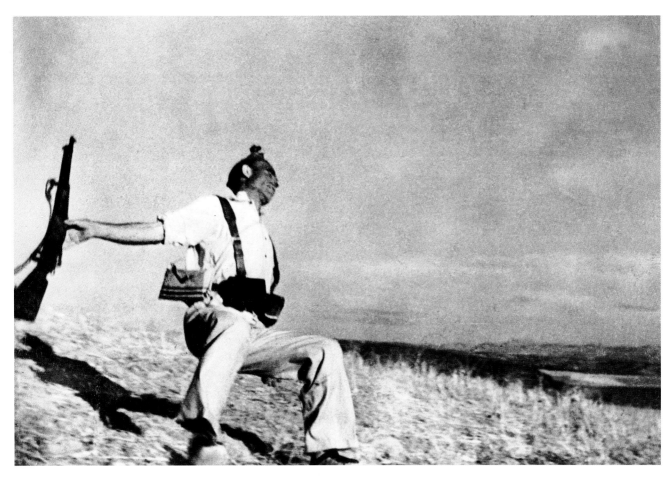

Robert Capa

The Falling Soldier (*Death in Spain*), 1936

Borrell being suddenly shot when Francoist troops worked their way behind their position in the late afternoon. His posture, with no attempt to break his fall, indicates instant death. However, Alex Kershaw challenged Brotons's research. And the identity and fate of a second soldier, photographed falling at apparently the same spot, remain, as before, mysterious. RL

Whelan, R., 'Robert Capa's *Falling Soldier*: A Detective Story', *Aperture*, 166 (2002).

Kershaw, A., *Blood and Champagne: The Life and Times of Robert Capa* (2002).

fall-off and vignetting. In all camera lenses the illuminance of the image falls off towards the periphery of the field. In a simple lens this is called cos^4 *fall-off*, as the illuminance is inversely proportional to the fourth power of the cosine of the angle of field. The effect can be reduced in two ways: by allowing a measure of barrel distortion (the fisheye effect); or by designing the lens so that the rays pass through the iris diaphragm aperture as nearly perpendicularly to it as possible.

Vignetting is the comparatively sharp cut-off of the corners of the format by the lens barrel. With modern optics this happens only when a lens is used for a format larger than it was designed for, or when an inappropriate lens hood is used. GS

family history and photography. Paraded in ranks on the mantelpiece or safely stowed away, family photographs stand in for the extended family, now dispersed. Looking at a family *album often prompts nostalgia, a dream of a return 'home' to an idealized golden past, where the sun shone and everyone smiled. In forgetting the directorial role of the photographer, recycled notions of what makes a 'good' photograph, and the technical limitations of the *Brownie or the *Instamatic, we are often inclined to give these fading fragments the status of evidence. Yet photographs present a glistening surface of meanings to reflect and project upon, and contain myriad latent narratives. They are kept because of the part they play in confirming and challenging the identity and history of their users.

Posy Simmonds

Every Picture Tells a Story, from the *Guardian,* 1982

Whilst contained within limited photographic conventions, a tension exists between the longed-for ideal and the ambivalence of lived experience.

A family album contains a micro-history of photography as a medium and a variety of genres, as interpreted by a succession of photographers both professional and amateur. In the first decades of photography's history, most likenesses were made by professionals, from studio *cartes de visite and cabinet portraits to seaside *tintypes. But from the appearance of the *roll-film *Kodak in 1888 onwards, the potential scope of family photography vastly widened, guided (in theory) by proliferating how-to-do-it manuals and industry *advertising ('Save your happy memories with a Kodak'). The number of photographs produced increased, although the themes remained much the same. Two late 20th-century developments, *instant and then *digital photography, removed third-party processing from picture making. Today, imaging companies using digital manipulation promise to 'enhance' family-album mythology by offering 'seamless, permanent, and reassuring solutions to torn and separated memories', 'cosmetic perfection', and even the opportunity to 'remove any trace of your ex-husband, ex-wife or ex-lover'.

Editorial control of family photographs—which may include selection, disposal, captioning, and arrangement—is wielded by the archivist, most often the mother, whose preferences are perhaps guided by an unconscious desire to provide evidence of her own good mothering. The conflicts and power struggles inherent in family life are repressed. Like a public-relations document or a Christmas circular, the family album (or box of CD-Rs) mediates between family members, providing a united front to the world, affirming successes, celebrations, and togetherness. It is bound within established codes of commemorative convention, so ubiquitous that they are taken for granted, even minutely reconstructed and sold back to us in advertising. But these ritually happy images may conceal harrowing realities. Michael Lesy has described the excitement and pain involved in discussing other people's family photographs: 'Sometimes I'd hear stories and see pictures that didn't hit me for two days; but once they did, I'd have a hard time answering the phone or walking into a drugstore. There were some stories that were so misshapen and horrendous that I destroyed the [interview] tapes and never even borrowed the pictures. . . . But in every case, the people told me stories; they spoke parables; they made confessions. . . . They told me the way things *really* are.'

Viewed collectively, family photographs can be seen as social documents. In Britain from the 1970s, personal snaps were used as resource materials by radical history movements concerned to write the previously hidden, 'dissonant' histories of women, the working class, and ethnic minorities. Exploring people's ordinary lives through such everyday documents provided recognition of community histories with shared cultural values. However, individual family stories may be more complex, incorporating hybridity, *migration, and cultural mixing. Individual images hold layers of different meanings and are subject to pressures from outside the frame, which are legible only if the social, cultural, and personal contexts are considered. Sometimes family picture collections are plundered, often without a critical context, merely to evoke notions of the past.

One's own family photographs hold a poignant fascination, linked to memory, forgetting, and loss. They are symbols of place and change, they remind us of the past and reconnect us to the familiar. These images may be used critically as material for interpretation in 'memory work', whilst being aware of the silences, absences, and contradictions inherent in any collection. New narratives may be explored that go beyond the mediation of the photograph to question identities and taken-for-granted memories. RM

Lesy, M., *Time Frames: The Meaning of Family Pictures* (1980).
Spence, J., and Holland, P. (eds.), *Family Snaps: The Meanings of Domestic Photography* (1991).
Kenyon, D., *Inside Amateur Photography* (1992).
Kuhn, A., *Family Secrets* (1995).

Family of Man exhibition, a collection of 503 photographs assembled by the curator of photography at MoMA, New York, Edward *Steichen, assisted by the photographer Wayne Miller and Steichen's brother-in-law, the poet Carl Sandburg. All were black-and-white except one, an outsize transparency of an H-bomb test. The exhibition opened at MoMA in January 1955 and subsequently toured widely abroad, including to Moscow in 1959, under the auspices of the US Information Agency. It was conceived, in Steichen's words, 'as a mirror of the essential oneness of mankind throughout the world'. However, although the 273 photographers represented included distinguished foreigners—among them *Boubat, *Brandt, *Álvarez Bravo, *Cartier-Bresson, *Doisneau, *Ronis, and *Sander—most were Americans, and/or members of American agencies or, especially, contributors to *Life magazine. Some critics, particularly in Europe, viewed the exhibition as Cold War propaganda and a projection of American values in thinly universalistic disguise. Certain items, such as W. Eugene *Smith's photograph of children in a wood, now seem cloying. The only nude adults depicted were non-Westerners. But not all the exhibits were upbeat or sentimental, and there were pictures of poverty and conflict, including a searing image of the 1943 Warsaw Ghetto revolt.

The exhibition was a significant event in the cultural history of the 1950s, and in American cultural diplomacy. It also marked a further stage in the museumization of photography, though paradoxically just as television was replacing the still photograph as the world's most pervasive visual medium. RL

Sandeen, E. J., *Picturing an Exhibition: 'The Family of Man' and 1950s America* (1995).

Far East (1870–9), illustrated journal launched on 30 May 1870 in Yokohama by the Australian John Reddie Black. Altogether, it published nearly 1,000 photographs of China and Japan. Each issue included six *albumen prints, either illustrating the copy or accompanied by a short informative note. Themes were mostly

Japanese until 1876, when Black moved to Shanghai and the balance reversed. Credited photographers include Moser ('our artist') in Japan, or Saunders, Fisler, *Kung Tai, *Child, and Edwards in China. Black himself certainly produced many of the anonymous images, and Japanese and Chinese artists also contributed. The journal terminated with the January 1879 issue and Black died shortly afterwards.

A complete run exists at Harvard Widener Library, full Chinese sets at the Bibliothèque Chinoise du Collège de France in Paris and the Peabody Essex Museum in Salem, Massachusetts, and a Japanese set at the British Library. RT

Farm Security Administration (FSA). See DOCUMENTARY PHOTOGRAPHY.

Farsari, Adolfo (1841–98), Italian-American photographer, mainly resident in Japan. Born in Vicenza, Farsari emigrated to the USA in 1863 and fought in the Civil War. In 1873 he moved to Japan and became an active member of the foreign mercantile community in Yokohama. In 1883 he taught himself photography, and two years later established himself in premises previously used by Felice *Beato and Baron Raimund von *Stillfried. A. Farsari & Co. was the last notable foreign-owned photographic studio in Japan during the Meiji Era (1868–1912). Farsari returned to Italy in 1890, but the studio continued until *c.*1917. SD

fashion photography

Fashion photography is an insidious profession. In art, it is what sex-appeal is to love. Artifice can be a dangerous thing; when misapplied, the results are vulgar and tawdry. Its correct use depends on instinct. It is up to the fashion photographer to create an illusion. In doing so, he is not behaving with dishonesty, but when properly invoked, the result is not merely an illusion; rather, it makes the observer see what he wishes to see. (C. Beaton and G. Buckland, *The Magic Image*, 1975)

Since its inception in the 1880s, the fashion photograph has generated criticism. Some photographers consider it too commercial, an impure application of the art form. It has sometimes been dismissed as frivolous and criticized for promoting negative stereotypes. Yet it has generated some of the most widely recognizable, provocative, and enduring imagery of our time.

The development of the *half-tone printing process enabled photographs to be printed on the same page as text without affecting image clarity even when reproduced en masse. This new technology marked the birth of the modern fashion magazine aesthetic. Initially, perhaps surprisingly, it was the *couturiers* who found photographing their garments contentious: a photograph could be a gift for plagiarists. At the other extreme, applied photography was deemed too 'real' a means of documentation, unable to idealize the female form like the drawn fashion plate.

There was an initial overlap between late 19th-century *celebrity portraiture and the fashion photograph: for example, the Parisian Reutlinger studio's *cabinet picture of Cléo de Mérode in an amazing hat, *c.*1895, and the same firm's *haute couture* photographs of a decade later. Already far more stylish, however, was the work of Adolphe de *Meyer, who reinvented the staged formality and ornate settings of 19th-century fashion illustration. A member of the *pictorialist *Linked Ring Brotherhood, he used backlighting, soft focus, props, and painted backdrops to express a baroque sensibility that was perfectly articulated in his portrait of Helen Lee Worthing (1920). In 1914 he became chief fashion photographer for *Vogue*, then in 1922 for *Harper's Bazaar*.

The models in early fashion photographs were most frequently society ladies and theatre and screen actresses rather than women working as living mannequins. After the First World War, de Meyer's visual idiom fell out of favour as a modernist aesthetic took root. The influence was pervasive, introducing a greater emphasis on sleekness and line, epitomized by art deco's streamlining effect. The advent of sportswear and dresses without foundation garments signalled more fluid and experimental poses and compositions. Associated primarily with Edward *Steichen and *Man Ray, the new style of fashion photography rejected rococo props for geometry, haughty *froideur* for character, and staid convention for avant-garde devices like *solarization and multiple exposure. Steichen's first fashion photographs—designs by Paul Poiret—had appeared in a 1911 edition of *Art et décoration*, among the first periodicals to feature fashion photography. In the late 1920s and 1930s the use of small, hand-held cameras allowed far greater compositional flexibility and work out of doors. (By this time, the major fashion magazines were shifting decisively towards photography and away from other forms of illustration.) An inspired decision by the new editor of *Harper's*, Carmel Snow, in 1933 was to hire the Hungarian sports photographer Martin *Munkácsi, who introduced a new style of dynamic outdoor sportiness that was to prove highly influential. A subsequent *Harper's* acquisition was Louise *Dahl-Wolfe, also a devotee of outdoor subjects who from 1937 began working in colour. (Later she joined *Sports Illustrated*.)

Photographers such as George *Hoyningen-Huene and Horst P. *Horst were influenced by *Surrealism. The former's early style owed much to Steichen's use of light. He began his career making backdrops for *Vogue's Paris studio in 1925, where Steichen was then working. As his style evolved, it grew to encompass architectonic symbols of Greek classicism, not unlike the canvases of the Surrealist painter Giorgio de Chirico. Carefully structured compositions were of paramount importance for the photographer. The same was true of his colleague and friend Horst, who initially trained under the modernist architect Le Corbusier. Creator of one of *Vogue's best-known photographs, *Mainbocher Corset* (1939), Horst's complex images appeared effortlessly graceful, often with a striking use of shadow. His signature style owed much to Hoyningen-Huene but was distinguished by inventive *photomontage and *trompe-l'œil* effects.

Erwin *Blumenfeld created a heretofore unseen type of visual intrigue in the fashion photograph. Techniques such as 'bleaching' and *composite printing, which he personally refined in the darkroom,

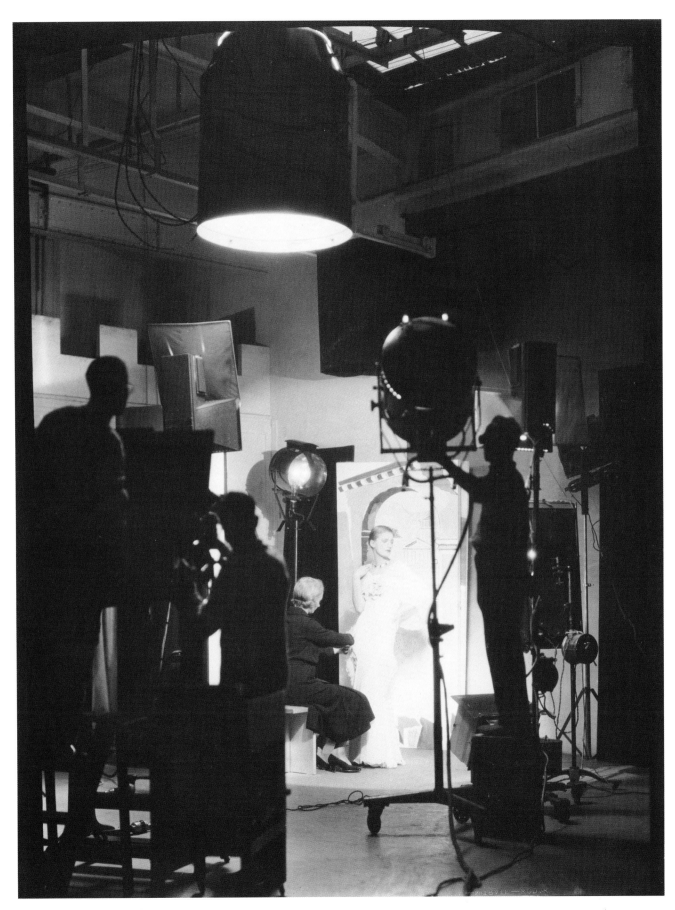

George Hoyningen-Huene

Vogue studio during a fashion shoot, late 1920s

are much copied today. Blumenfeld also broke new ground in perspective by using a wide-angle lens on the new Hasselblad camera. The ubiquity of his work in fashion magazines of the 1940s and 1950s reflected a shift in fashion's audience away from its former social exclusivity. However, although creative photography promoted high fashion through its increased visibility in magazines, it did not make the garments any more widely accessible. Instead, it generated what are now regarded as aspirational images. Blumenfeld said of the fashion photographer's role, 'we are responsible for the tastes of tomorrow. Our pictures are the essence of a page, and every page has to have its own face, its own spirit, to catch millions of eyes, as otherwise it is only a scrap of paper.' Whereas earlier in the century fashion photography's images of aristocratic and society ladies had largely circulated in the sitters' own social milieu, mid-century work increasingly aimed to create visions of luxury and exclusiveness for a mass public.

In both his portraits of royalty and high society and his fashion photography, Cecil *Beaton combined formality and fairy-tale glamour. He was first hired as a *Vogue* cartoonist in 1928. Influenced by the appeal of Hollywood films, he reinterpreted many of de Meyer's rigid stylistic hallmarks for the mid-20th century with graceful, theatrical refinement. Another British master of the elegant, luxurious image, especially when his wife Wenda Rogerson was the model, was Norman *Parkinson (like Beaton, also a successful society and royal portraitist). He often used outdoor locations, conveying pleasure and indulgence in faraway locales which epitomized the light-hearted fun and indulgence of fashion. In the 1950s elegance—even excess— revived with the end of wartime rationing and 'make-do-and-mend'. Today, photographers like Elaine Constantine pay homage to the Parkinson vision with a signature style conveying visual delight.

In the USA, Irving *Penn and Richard *Avedon were the undisputed stars of 1950s fashion photography. They produced such iconic pictures as Avedon's *Dovima in an Evening Dress by Dior with Elephants of the Cirque d'Hiver* (1959) and Penn's 1947 *Vogue* cover of the twelve most photographed models. This latter image would later influence cover layouts of magazines like *Vanity Fair* by Annie *Leibovitz, as well as signalling the beginning of the late 20th-century cult of the supermodel.

From the late 1950s, many fashion magazines broadened their editorial scope. *Queen*, for example, began publishing photojournalism and documentary work. A degree of social realism characterized the work of London's 'Terrible Three', David *Bailey, Brian *Duffy, and Terence *Donovan (all former assistants of the fashion photographer John *French), who recorded the youthful and seemingly spontaneous essence of 1960s London with visions of accessible, girl-next-door models like Jean Shrimpton, Penelope Tree, and Twiggy. But in the 1960s Avedon travelled through the American South to photograph the *Civil Rights Movement, and later documented the anti-war protests taking place across the USA. Penn was commissioned by *Vogue* in 1974 to produce a series of portraits entitled 'Worlds in a Small Room', representing various socio-economic and ethnic groups. This was a high-profile, if tokenistic, acknowledgement of global issues and the

world outside the fashion industry. It was taken further in the 1980s by Oliviero *Toscani, who used disturbing images (his own and other people's) of war and AIDS to assault the consumer and promote Benetton. Often deliberately ambiguous, these pictures played on up-to-the-minute relevance and shock value rather than timeless associations of sophistication.

Helmut *Newton's confrontational image making was defined by androgyny and sexual titillation bordering at times on the pornographic. His images were particularly contentious because they often conflated representations of female empowerment and female objectification. In some ways, Newton continued the sex and death aesthetic perfected by Guy *Bourdin in his campaigns for Charles Jourdan shoes. Though best remembered for his dark interpretations of sexuality, images frequently cropped to effectively sever the female body, Bourdin also created a portfolio of sublime and playful works such as 'Santé' (1970) during his tenure at Paris *Vogue*.

By the 1970s and 1980s, the growing interest in fitness and thus in beautifully toned bodies was increasingly exploited to sell clothing and cosmetics. Men's fashion also became an increasingly lucrative branch of the business. Bruce Weber's (b. 1946) voyeuristic, often homoerotic qualities, as seen in his Calvin Klein campaigns, were typical of the period. Herb *Ritts began his career as a celebrity photographer in the early 1970s, later specializing in nudes. Also active during this period, Deborah Turbeville (b. 1938) consciously referenced the past, inspired by the landscape of her native New England as well as by the pointillistic, soft-focus approach of early 20th-century photographers.

Today many fashion photographers, such as Mario Testino (b. 1954), are as famous as the celebrities who pose for them. The cult of the star fashion photographer began in earnest in 1966 with Antonioni's cult film *Blowup*; Avedon had already inspired *Funny Face* (1957). Steven Meisel, known for his trademark stylistic versatility, came to attention in 1992 for Madonna's book *Sex*. Nick Knight's (b. 1958) innovative *digital work explores the limits of post-production and new media, and confronts issues of racism, ageism, and size-ism in fashion image making. Corinne Day tapped into the 1990s generation of disaffected youth and music cultures in London-based magazines like *i-D*, *The Face*, and *Dazed & Confused*. By photographing so-called 'waif' models like Kate Moss, Day was applauded for rupturing the cult of unattainable beauty, but criticized for allegedly glamorizing 'heroin chic' and eating disorders. David LaChapelle (b. 1969) was first hired by Andy *Warhol to photograph for *Interview* magazine. His hyperreal and kitsch pictures of models and celebrities, in highly saturated colours, often challenge conventional notions of taste and decency. Yet his images point up the true purpose of a fashion photograph: to present an idealized, illusionistic vision that the viewer, literally, wishes to buy into. zw

Beaton, C., and Buckland, G., *The Magic Image: The Genius of Photography from 1839 to the Present Day* (1975).

Hall-Duncan, N., *The History of Fashion Photography* (1979).

Harrison, M., *Appearances* (1991).

Cotton, C., *Imperfect Beauty* (2000).

Fastenaekens, Gilbert (b. 1955), Belgian photographer noted initially for his unsettling nocturnal studies of urban and post-industrial landscapes (*Mes parents*, *nocturnes*, both 1980). In the 1980s he took part in the French *DATAR project, concentrating on industrial structures. In 1990 he embarked on an ongoing installation in his native Brussels in which the pages of ten large-format (1 × 1.30 m; 3 × 4 ft) 'books' containing different kinds of city views (clouds, building sites, green spaces, and so on) were turned at random every day to create a different visual ensemble. LAL

faults in negatives, transparencies, and prints. Every photographer has at some time produced a photograph with a technical fault. Literally hundreds of faults are possible in a process of such chemical and physical complexity, and whole books have been written about nothing else. With the automation of exposure and, to a large extent, processing, added to the manufacturers' continual quest for more robust materials, faulty images have become less frequent; but they can and do still occur. They fall into three general categories: *unsharpness*; *incorrect density and contrast*; and *artefacts*, i.e. marks, fogging, and discoloration. The lists and tables below indicate the most common faults, their causes, and (where possible) remedial action.

Unsharpness
There are three basic causes of unsharpness in a photograph:

- *Incorrect focus*. The image is blurred uniformly, with no fine detail visible. In a negative or transparency, some parts of the scene may appear sharper than others. This can happen even with autofocus systems, especially in close-ups. Use the correct *f-number (see also DEPTH OF FIELD) and focus on the most important part of the scene. With autofocus enlargers the focus should always be checked, using the fine-focus adjustment at full aperture, before the aperture is closed down.
- *Camera shake*. The image is blurred in one specific direction, so that points appear as short lines. Fine detail may be doubled. The shortest feasible exposure should be used, even if it means using full aperture, unless the camera can be held steady on a

firm base. Moving subjects can be followed by panning the camera. In printing, the enlarger should be operated with a remote switch.
- *Dirty optics*. The image is low contrast and hazy, but fine detail is present. Optical surfaces should not be touched, and a lens tissue should be kept handy.

Incorrect density and contrast
The table below assumes that the film is fresh and the processing solutions have been correctly prepared. It does not apply to transparencies or prints.

Exposure errors in transparencies can usually be compensated for, if known before processing. Underexposure of up to two stops can be remedied by extending the first development time by up to 50 per cent (push processing), overexposure of up to one stop by reducing it by up to 20 per cent. Pushing the development results in some loss of colour saturation. Small exposure errors in both monochrome and colour prints can be compensated for by adjusting the development time, within certain limits.

Artefacts
An artefact is any fault that produces a photographic image where no optical image existed. The list below does not include optical quirks such as lens *flare spots and ghost images, which can be avoided by the use of a lens hood and a careful choice of viewpoint, but there are still hundreds of possible causes of artefacts. In their diagnosis it may be prudent to follow the legendary principle of Sherlock Holmes: 'Once you have eliminated the impossible, what remains, however improbable, must be the truth.' The most common problems in negatives and transparencies are tabulated below.

Faults in prints
Almost all the faults that occur in negatives can also occur in print materials. Faults in colour prints are usually confined to colour casts due to incorrect CP filtering of the enlarger light. A colour cast in the shadows only is usually the result of underexposure of the negative; but if the negative was correctly exposed and the print shows colour casts in opposite senses in the highlights and shadows, the film was probably stale or imperfectly stored. In both cases correction is possible only by

Table 1

Exposure	Development	Shadow contrast	Highlight contrast	Average density	Rebate (fog) density
under	normal	very low	normal	low	normal
under	over	low	high	normal	high
normal	under	low	low	low	low, pinkish
normal	normal	normal	normal	normal	normal
normal	high	high	high	high	high
over	under	low	low	normal	low, pinkish
over	normal	normal	normal, grainy	high	normal

Table 2 Faults in negatives and transparencies

Fault	Cause (and remedy, if one exists)
Straight streaks, usually diagonal from corner, on every exposure (dark on negatives, light on transparencies)	Ill-fitting camera back. Examine for wear and looseness
Dark wavy lines or irregular patches, not on rebates (light on transparencies)	Light leak in camera body. Check for loose screws, pinholes in bellows
Dark splashes like exclamation marks (light on transparencies)	Developer splashed on emulsion before processing
Black or clear scuffs or tramlines	Abrasion marks made by damaged or dirty film frame (tramlines), or by over-tightening film on spool before processing (cinch marks)
Bow-and-arrow [−)] marks	Kinking the dry film before processing
Treelike markings, sometimes with small fog patches	Static electrical discharge caused by too rapid a wind, or pulling film sharply out of cassette, in cold dry weather
Small clear round spots on developed image (dark on transparencies)	Air bells clinging to emulsion surface in (first) developer. Agitate well on first immersing film in solution
Clear fingerprints (coloured on transparencies)	Emulsion touched with bare hands (not necessarily contaminated with fixer) before processing
Light splashes like exclamation marks (also transparencies)	Fixer splashed on emulsion before processing
Tiny clear specks (pinholes), dark in transparencies	Dust on emulsion surface. With lithographic film, use of incorrect developer
Ill-defined patches of different density	Uneven development. If they stretch down from perforations, insufficient agitation in the developer
Image obscured by overall grey fog, with loss of contrast (negatives)	Stray light in processing area, or too much exposure to pan safe light
*Fog that adds to overall density, including rebates (negatives)	Stale film (if rebate edges dark) or developer at too high a temperature
Surface deposit with a greenish sheen	Silver deposit caused by cross-contamination of processing solutions. Can be removed with dilute Farmer's reducer, or sometimes simply by wiping gently while in the wash
Processed film not clear, with brownish appearance from the back (negatives)	Emulsion not properly fixed. Try refixing with fresh fixer
Coloured spots on processed emulsion	Impurities in water supply, usually iron rust. Try a 1 per cent hydrochloric acid bath
Whitish deposit on emulsion	Solutions made up with hard water. May wipe off; otherwise try a 1 per cent acetic acid bath. If this does not work, deposit is sulphur from stale fixing bath. Image will deteriorate, so make a copy as soon as possible
Emulsion partly detached at edges (frilling) or in middle (blisters)	Solutions too warm. Under tropical conditions, use a prehardener
The emulsion surface looks like orange peel or crackle finish (*reticulation)	One of the solutions, or the wash water, was much too warm. When noticed, immerse film at once in 100 per cent methanol and dry rapidly with a blast of cold air before completing processing. In future, preharden and use hardening fix

Lady Mary Georgina Filmer Decorative collage, 1860s

Andrew Lawson Garden designed by Oehme & Van Sweden, Chesapeake, Maryland, c.1998–9

Table 3

Fault	Cause (and remedy, if one exists)
Low contrast, weak greenish blacks	Overexposure and curtailed development
Greyish, veiled image with yellowish rebates	Forced development of underexposed image
Purplish or bronze-coloured stains	Failure to use a stopbath, and/or prints left floating face up in fixer
Black lines and/or scuffs	Paper mechanically stressed before processing
White specks on image	Dust on negative
Grey fog with loss of detail	Stray light or incorrect safe light. Check with a coin test
Grey fog with loss of contrast	Stale paper. Add antifoggant to developer
Yellowish highlights	Exhausted developer or fixer. Try refixing in fresh bath, and in future use two fixing baths in tandem
Blisters in middle of print	Fierce water jet in washing tray. Prick blisters from back
Silvery patches on surface	Scum from washing tray. Wipe off with sponge (and clean tray!)
Emulsion missing in patches	Bacterial action from leaving prints in wash overnight. Method of prevention obvious

*digital manipulation of the image. In monochrome prints the most common faults are as shown in the table above. GS

Life Library of Photography: Special Problems (1972).

Jacobson, R. E. (ed.), The Manual of Photography (9th edn. 2000).

Feininger, Andreas (1906–99), American photographer. Feininger was perhaps the most prolific photographer and writer on photography in the 20th century. He published nearly 50 books on subjects ranging from the techniques of black-and-white and colour photography to compilations of close-up and microscopic images from nature—shells, leaves, trees—sculpture, the female nude, and the cities he had known best: Hamburg, Stockholm, Chicago, and New York. Born in Paris, the son of the painter Lyonel Feininger, he studied cabinet making at the *Bauhaus (1925–7), then architecture at the Bauschule in Weimar and Zerbst. In a subsequent period of youthful indecision he began experimenting with photography and developed the processes of *solarization, *reticulation, and *bas-relief printing. After briefly working for Le Corbusier in Paris (1932–3), Feininger relocated to Stockholm, where he flourished as a photographer for architectural firms. He moved with his family to New York in 1939 and began to contribute to *Life. After a year's service with the United States Office of War Information he became a Life staffer, and from 1943 to 1962 created hundreds of acclaimed photo-essays for the magazine. Later he became a freelance. TT

Feininger, A., The World through my Eyes (1963).

feminism. See THEORIES OF PHOTOGRAPHIC MEANING; WOMEN AND PHOTOGRAPHY.

Fenians. See POLICE AND FORENSIC PHOTOGRAPHY.

Fenton, Roger (1819–69), English, and one of the most influential and important photographers of the mid-19th century, exhibiting more widely and prolifically than any other of the period. His landscape and architectural studies were highly regarded and often referred to by critics as points of reference to which all other photographers should aspire.

Born at Crimble Hall, near Bury, Lancashire, he was the third son of John Fenton, banker, and MP for Rochdale. He attended University College London, graduating with a BA in 1840, before going on to study law intermittently for the remainder of the decade. He was called to the Bar in 1851. Despite this formal education, Fenton's real ambition was to become an artist, and using an inheritance from his grandfather he was able to train in both Paris and London, submitting three studies to the Royal Academy between 1848 and 1851. This training and experience distinguished Fenton's career as a photographer and set him apart from many of his contemporaries.

During this period photography emerged from infancy into precocious adolescence, full of hope, ambition, and ideals, with Fenton playing a crucial role in determining its character. He was able to do this in two ways: first, through his active involvement with the Photographic Society in London, of which he became honorary secretary at its formation in 1853; and, secondly, through the example of his own work that was widely exhibited throughout Britain and Europe. Unlike his contemporaries, Fenton never felt constrained to stick to one distinct photographic genre. Instead he moved freely from portraiture, narrative tableaux, documentary sequences, landscape and topographical studies, and elaborate *still-life studies made in his studio. He used large-format plates to make impressive studies of architecture, and the *stereoscopic camera for more intimate studies in the third dimension. Commercially his work occupied the top

end of the market where it was widely sold by leading printsellers, most notably by Thomas Agnew & Sons, of Manchester and London, the firm that underwrote his expedition to photograph the Crimean War in 1855. This extensive body of photographs, made in just four months, contains a number of now *iconic images, with the desolate and forbidding *Valley of the Shadow of Death* regarded as the most eloquent metaphor of warfare. Despite working in several genres, Fenton remained consistent in his love of the British landscape and the history it enfolded. Each summer he photographed in locations revered for their ruined abbeys, cathedrals, castles, romantic associations, and literary connotations. These are now considered to be among the finest architectural and topographical studies of the 19th century.

In October 1862 he announced his complete retirement from photography and had his apparatus and entire stock of over 1,000 large-format negatives auctioned. With this decisive act he closed a remarkable and influential photographic career.　　　RTA

Gernsheim, H. and A., *Roger Fenton, Photographer of the Crimean War* (1954).
Baldwin, G., Daniel, M., and Greenough, S. (eds.), *All the Mighty World: The Photographs of Roger Fenton 1852–1860* (2004).

Ferrato, Donna (b. 1949), American *documentary photographer. In 1981, while working on a project about suburban couples, she found herself suddenly confronted by domestic violence, and immersed herself in the subject for ten years. The result was *Living with the Enemy* (1991), a book and exhibition that led to the creation of a campaigning organization, Domestic Abuse Awareness. In 2002 she published a photographic series on sexuality, *Amore*.　　　RL

Ferrez, Marc (1843–1923), Brazilian photographer, born and resident in Rio de Janeiro. The son of a Frenchman, Ferrez spent his youth in Paris, but returned to Rio aged 16 and worked in the Leuzinger photographic studio (1860–5); he also received photographic instruction from the German engineer and botanist Franz Keller. After opening his own business in 1865, Ferrez created outstanding landscapes and marine photographs, eventually becoming official photographer to the Brazilian navy and enjoying the patronage of Emperor Pedro II. He also mastered *panoramic photography, creating images over a metre (3 ft) wide. In 1875 he accompanied

Donna Ferrato

Domestic violence, from *Living with the Enemy*, 1991

an American scientific expedition to southern Bahia, and took the first photographs of the Botocudo Indians. Afterwards he continued to travel widely, recording slaves on coffee plantations, indigenous peoples, railway building, mining, and the general development of Brazilian society. He won a gold medal at the 1876 Centennial Exhibition in Philadelphia, and many other awards thereafter. In the 1890s he became interested in cinematography, and in 1907 opened a cinema in Rio; his son Júlio Marc already headed the Brazilian branch of Pathé Frères. In 1912 Ferrez introduced the *autochrome process to Brazil. AM/NFP

> Ferrez, G., *Photography in Brazil, 1840–1900* (1984).

ferrotype. See TINTYPE.

festivals of photography. See EXHIBITIONS AND FESTIVALS OF PHOTOGRAPHY.

field camera, original designation of cameras using plates 12.1 × 16.5 cm (4³/₄ × 6¹/₂ in) or larger and intended for outdoor (e.g. landscape or architectural) photography. The American term is *view camera*. They generally have a range of rear and front standard *movements and *bellows to allow for displacement, and interchangeable lenses. The designation is now applied to any larger-format camera from 10.2 × 12.7 cm (4 × 5 in) and above, including what would earlier have been called hand cameras as well as monorail and drop-baseboard cameras. MP

Fierlants, Edmond (1819–69), Belgian photographer and photographic publisher. Born in Brussels into a prominent family of lawyers, Fierlants learned photography in Paris with Hippolyte *Bayard. Sole Belgian founder member of the *Société Française de Photographie in 1854, he gained a reputation as a skilful experimenter with the Taupenot *dry-plate process. The Belgian state, created as recently as 1830, was in search of a national identity, one strand of which was a cultural heritage rich in art and architecture. This heritage needed its spokesmen and popularizers, and Fierlants conceived it as his mission to undertake this task within his chosen medium. Armed with favourable reviews and the goodwill of the Belgian government, Fierlants returned to Brussels in 1858 and received successive commissions to record the historic art and architecture of Bruges (1858), Antwerp (1860), Brussels (1862–4). and Louvain (1865). Fierlants founded the Société Belge de Photographie in 1862. Granted a royal warrant in 1863, this body published a stock catalogue in 1865 numbering 1,400 items. But by now, in this niche market, publicly funded commissions had dried up. In 1867, divorced and in debt, Fierlants opened a branch studio for portraiture in Brussels. It did not prosper, Fierlants was forced to relinquish control of his company and died a ruined man. SFJ

> Joseph, S. F., and Schwilden, T., *Edmond Fierlants (1819–1869): photographies d'art et d'architecture* (1988).

fill light, 'fill-in'. See AGAINST-THE-LIGHT PHOTOGRAPHY; LIGHTING AND LIGHTING EQUIPMENT.

Filmer, Lady Mary Georgiana (née Hill; 1838–1903), English aristocrat who used photographs in the 1860s to make mixed-media collages prefiguring the irony and ambiguity of 20th-century *photomontage. The wife of Sir Edmund Filmer, she was considered a 'fast woman' in court circles because of a flirtation with the prince of Wales. In her collages, she plays with the connotations of collecting and exchanging photographs as a fashionable upper-class pursuit, associated with flirting and gossiping about possible affections. On one page from her *album, now in the Musée d'Orsay, Paris, the prince's portrait is used with other male 'heads' to decorate the canopy of an umbrella, and again to fashion its handle, turning the future king into an accessory handled with casual intimacy. On other pages, pictures of handsome members of upper-class society are grouped in arrangements which seem to play with the truth of both photographs and affections. PDB

> Di Bello, P., 'The Female Collector: Women's Photographic Albums in the 19th Century', *Living Pictures*, 1/2 (2001).

Film und Foto (*FiFo*) exhibition. Held initially in Stuttgart in May–June 1929, this was the first big manifestation of modern photography in Europe and the first major show there of modern American photography. There were minor forerunners in Germany, France, and other countries, but as a comprehensive overview *FiFo* was unsurpassed. It was organized by the *Deutscher Werkbund*, whose press officer Werner Graeff was also a promoter of the *New Vision. Room One was designed by László *Moholy-Nagy and presented an introduction to the role of modern and avant-garde photography. Next were rooms showing American and Soviet photography, the work of different schools and teachers, a historical overview, and individual photographers' stands. Notwithstanding some conservative attacks the show was greatly acclaimed, and toured from Stuttgart to Zurich, Berlin, Danzig, Vienna, and Agram in the same year; in 1931 a selection from it was shown in Tokyo and Osaka. A 1930 follow-up exhibition, *Das Lichtbild*, without Room One but with a larger historical section, toured Germany for two years. The name *Film und Foto* was used for a Nazi propaganda show in 1936. RS

> Eskildsen, U., and Horak, J.-C. (eds.), *Film und Foto der Zwanziger Jahre* (1979).

filters. Some photographers always use filters; others never do. Claims by either side to a greater purity of vision are spurious.

In monochrome, the classic 'sky' filters (yellow, orange, red, in increasing order of effect) not only darken blue skies, but alter other tonal relationships and cut through haze. Deep yellow and orange filters are often reckoned to give good tonal relationships for the majority of outdoor shots: it is instructive to go through any Ansel *Adams book and see how often he used such filters.

Other filters for monochrome are used to lighten their own colour, or darken complementary colours. For example, deep red will lighten a red rose, making it easier to hand-colour; weak red will lighten a florid complexion; green will lighten foliage and darken red brick; and so forth.

Until the advent of *orthochromatic films, 'sky' filters were all but useless, and with ortho films, the effect of even a yellow filter is greater than with panchromatic. Filter factors, the extent to which exposure must be increased to compensate for the light absorbed by the filter, vary from film to film and from subject to subject. With experience, the photographer may well halve or double the 'average' exposure correction factor.

Neutral-density (ND) filters are equally useful in both colour and monochrome, when a long exposure is desired and for whatever reason it is not practicable to reduce the aperture below a certain level. They may be described in stops; in filter factors; or in terms of log density. Thus a weak ND filter may be 1 stop, $2\times$, $D = 0.3$, while a stronger one may be three stops, $8\times$, $D = 0.9$. The importance of knowing which description is used is obvious. Cheap NDs sometimes introduce colour casts, usually green.

For shooting colour out of doors, especially *transparencies where the final picture is a camera original, the most useful filter is often a *polarizer*. As well as suppressing obvious reflections, these can darken blue skies and (by suppressing white-light reflections) increase overall colour saturation.

The other filter most often used in professional outdoor colour photography is the 'grey grad' or *graduated filter*, clear at one end, and neutral grey at the other. The density of the dark side, and the abruptness of the transition, can vary widely: some photographers carry several grey grads to achieve different effects. Coloured 'effects' grads such as the tobacco grad are all too easy to overuse.

In the studio, weak *colour-correction* (CC) filters are often employed. These are available in a wide range of (numbered) strengths, in both additive and subtractive primary colours: red, green, blue (RGB) and cyan, magenta, yellow (CMY). Thus CC05R is a weak red, CC50G a strong green, and CC20Y a middling yellow. A special case for colour correction is for daylight-balanced films under tungsten lighting (for which a blue filter is required) or for tungsten-balanced films under daylight (amber). These are often used with CC filters to get the best possible result. Balancing any film for fluorescents is difficult, but a CC30M is often a good starting point.

Most modern glass filters are dyed in the mass, so the colour goes all through the filter, but optical resin filters are often dip coated with colour (grads have to be) and a few filters, especially polarizers, are sandwiched in glass. Gelatin filters (literally of dyed gelatin) and their rather tougher acetate cousins are widely used for studio photography or for highly specialized filtration such as tri-cut colour, or infrared.

Traditionalists distinguish between filters (which change the colour of the light) and screens (which do not), such as polarizers, soft-focus attachments, and neutral density.

Any filter will slightly reduce lens resolution, but except for the very worst filters, this varies from the negligible to the imperceptible: even optical resin filters, often derided by the ignorant, are extremely unlikely to have any significant adverse effect on image quality. This can be confirmed by photographing a test chart with and without the filter, rather than relying on what 'everyone knows'. Clean gels have no perceptible effect, and the effect of glass is measurable only in the laboratory.

High-quality filters are more often coated than cheaper ones, though the importance of this can be overstated; they are likely to be mechanically stronger; and if they are in brass threaded mounts, as the best are, then there is less danger of their binding in the filter threads of lenses.

In *digital photography, filtration effects can be applied by means of image-processing software like *Adobe Photoshop, or in-camera. RWH

Life Library of Photography: Light and Film (1971).

Fine Art Copyright Act, 1862. British law extending copyright protection to photographs as well as works of art. This was done, despite arguments that photography was merely a 'mechanical process', partly to encourage foreign participation in the imminent 1862 International Exhibition. (In the event, photographs were excluded from the fine-art section.) To obtain protection, photographers had to register images at Stationers' Hall, London, and pay a fee. Over 250,000 items were registered during the Act's lifetime (1862–1912). Most were commercial pictures, including royal and celebrity portraits, views and genre scenes, advertising images, and photos of floods, shipwrecks, and other newsworthy events. Some were by amateurs, and sometimes it is unclear why they were registered at all. A fascinating selection of the pictures, held at the National Archives, London, was published by Michael Hiley in *Seeing through Photographs* (1983). RL

finishing. The whole concept of 'finishing' has changed significantly over the years. Once it referred as much to work on *negatives as to work on prints; today it is confined almost exclusively to prints.

Negatives
Negative finishing consists of three steps: *spotting*, *retouching*, and *varnishing*, not necessarily in that order.

Spotting consists of filling 'pinholes' in plates, clear areas caused for the most part by dust spots during exposure or by air bells during development; rarely, from imperfect coating. A pinhole reads as a dark spot in the print, so the aim is either to match the surrounding negative tone perfectly (resulting in no flaw in the print) or to fill it slightly darker, resulting in a light spot on the print which is much easier to conceal than a dark spot. When the flaw is a hairline, rather than a spot, by far the best way to make it disappear is to break it up into ever-shorter sections: trying to 'paint' along the line will make things worse, not better. Dark spots on a negative are easier to spot

out at the print stage, when they will be light spots. The normal media for negative spotting are either dyes or pigments, diluted to the appropriate tone. Both tend to darken as they dry.

Retouching—such as removing, or at least greatly reducing, wrinkled complexions—could be done with dyes and pigments, but pencil retouching was much more usual. Each retoucher had a personal style. Some worked in tiny circular scribbles, others with tiny ticks. In the great days of *Hollywood retouching, entire complexions were rebuilt in this way. The classic way to 'fix' pencil retouching (which was in its nature easily smudged or removed) was to hold the negative in the steam from a kettle, thereby softening the gelatine and fixing the retouching in it. This is remarkably effective.

Varnishing was done for one or more of three reasons. First, it could be used to protect retouching, but this was hazardous, as it brought the risk of disturbing the handwork: the varnish was always flowed on, rather than painted. Second, it could provide a 'tooth' for further retouching, especially on the shiny side of a glass plate: numerous formulae were published. And third, it protected the negative from the printing medium: *printing-out paper was particularly risky on a humid day, as the excess of silver nitrate could stain the negative. Modern photographers tend to use very thin clear polyester film between the negative and the paper for the same reason.

Prints

Print finishing is much the same as negative finishing, and again, the same media and techniques are used, though pencil retouching was never used much and today is hardly used at all. Pigments sit on the surface and are therefore more obtrusive, but they are also easier to use; dyes, which sink in, are invisible but make it much harder to correct mistakes. An extremely useful innovation of the 1990s was 'SpotPens', very fine-tipped fibre-tip pens charged with dyes of different intensities. Glycerine in the dyes retarded absorption, allowing corrections for a brief while before the spot became invisible. RWH

Fink, Larry (b. 1941), American photographer, who studied with Lisette *Model and at the New School for Social Research, New York. His brilliance is in his portrayal of people as they are, though some have accused him of engaging in a kind of withering satire (especially of the rich). One is continually reminded of Diane *Arbus and even *Weegee, but Fink's images are more sharply focused. *Social Graces* (1984) is an essay on people, ranging from the lives of the rural poor to bizarre balls, gallery openings, and other social events in New York. TT

Fink, L., *Boxing* (1997).

Finland. See SCANDINAVIA.

Finsler, Hans (1891–1972), German-born photographer, active in Switzerland. He studied architecture and art history before taking up photography in the 1920s. His work was dominated by contemporary *Neue Sachlichkeit. In 1932 he settled in Zurich, established a studio for advertising photography, and founded a photography class at the Design School which he headed until 1957. He taught many famous Swiss photographers, including Werner *Bischof, René *Burri, Emil Schulthess, and René Gröbli. UR

Hans Finsler: Neue Wege der Photographie (1991).

fireworks, like *lightning, require both forethought and luck to be photographed effectively. Jacques-Henri *Lartigue took impressive black-and-white firework photographs on the Promenade des Anglais, Nice, in 1911, but colour works better. A tripod or other firm support is essential, a locking cable-release and/or multi-exposure facility desirable. To capture multiple bursts, the shutter must either be kept open and the lens covered—for example, with a piece of black card—between discharges, or opened repeatedly to re-expose the frame. Manual cameras and medium-speed (ASA 100-200/DIN 21-4) film are suitable. For big sky-filling displays a wide-angle lens and high viewpoint are recommended; an expanse of water between fireworks and photographer doubles the spectacle. Long exposures can be combined with firelight and 'painting' with flash to create interesting foreground effects with spectators, children running about with sparklers, etc. RL

'first photograph, the'. See VIEW FROM THE STUDY WINDOW.

fisheye lens, a lens that has an *angle of view of not less than 180 degrees. Its name originates from the fact that a fish at the bottom of a pond looking up can see a whole hemisphere above the water, due to the refraction of light at the water–air interface. The first true fisheye lens was the Robin Hill Sky Lens of Beck, introduced in 1934 to map cloud formations. By their nature fisheye lenses, unlike rectilinear wide-angle lenses, produce an optical image that is progressively distorted towards the periphery of the field, an extreme case of barrel distortion. There are several possible geometries for this distortion: most fisheye lenses for cameras are designed to produce equidistant projection, in which the radial distance from the optical centre of the image is directly proportional to the angle of view. GS

fixation. This is the part of photographic processing that makes the image permanent. The lack of a good fixing medium hampered early photography. *Talbot, the father of silver halide photography, used a concentrated solution of common salt. *Herschel discovered that sodium thiosulphate ('hypo') formed soluble complexes with silver halides. In the early days of wet *collodion it was customary to use potassium cyanide for fixation, sometimes with unfortunate results for the photographer. Since the 1950s the use of ammonium thiosulphate has become universal, as it works quickly and is fairly easily washed out of paper fibres. GS

Flaherty, Frances Hubbard (1883–1972) and **Robert Joseph** (1884–1951), American film-makers, who contributed greatly to definitions of documentary and ethnographic film. Except for *Nanook*

of the North, made by Robert alone between 1920 and 1922, the major films, *Moana of the South Seas* (1923–5), *Man of Aran* (1932–3), *The Land* (1939–41), and *Louisiana Story* (1946–8), were made collaboratively. Both Flahertys made still photographs in conjunction with these films.

Robert's *Nanook* images are true film stills, probably made to record the film-making process. Frances was principal still photographer in Samoa and Ireland, producing extensive studies of each community. These were used during filming as screen tests, storyboards, and illustrations and, later, as aesthetically accomplished and evocative images in their own right. Following Robert's death, Frances worked to establish him as the father of documentary film and the proponent of 'non-preconceptionism', a Zenlike state she deemed essential to cinematic creativity. She lectured extensively, published *Odyssey of a Film Maker: Robert Flaherty's Story* (1960), and established the Flaherty Film Seminars. Major photographic holdings are in MoMA, New York, the National Archives of Canada, and the Robert and Frances Flaherty Study Center, Claremont, California. AN

Rotha, P., *Robert J. Flaherty* (1984).

flare. The type of flare that is formed by reflections of the lens diaphragm in the lens elements is rarely important, as it is easily seen in the viewfinder of any camera with through-lens viewing.

Much more insidious is 'veiling flare', caused by stray light bouncing about inside the lens and the camera body. Some of this is reflected out through the lens; some is absorbed by baffles and blacking; and some ends up on the film, where it 'fills' the shadows, suppressing subtle shadow detail, flattening contrast, and reducing the overall brightness range of the image. This can be at its worst on an overcast day: it is much reduced in directional lighting, provided the directional light does actually shine directly on the front of the lens. The worst thing about veiling flare is that because it is uniform over the emulsion it has a greater effect on the shadows than on the mid-tones and highlights, giving an effect resembling underexposure in the print.

The difference between the brightness range of the subject and the brightness range of the projected image is expressed as a 'flare factor'. For a modern, well-made bellows camera with a multicoated lens it can approach 1, i.e. no flare at all. But an old box camera with an uncoated lens and a poorly blacked interior may have a flare factor of 4 or more, so that (for example) a subject brightness range of 128 : 1 (seven stops) may be reduced to an image brightness range of 32 : 1 (five stops).

Flare is reduced by better coating; by the use of lens shades that are as deep as possible; by good blacking and baffling; and by the use of simple lenses with as few glass–air surfaces as possible. RWH

Ray, S. F., *Applied Photographic Optics* (3rd edn. 2002).

flash photography. From the early days of photography it was obvious that artificial light would be indispensable; freed from the vagaries of the sun, pictures could be taken where natural light was lacking or on dull days when studio work became impossible.

Naturally, it was thought that bright lights would reduce exposure times and photographers turned to chemicals. Limelight was produced by heating a ball of calcium carbonate in an oxygen flame until it became incandescent but, though L. L. B. Ibbetson, J. F. Goddard (1795–1866), and Antoine *Claudet used it in 1840, the results were poor: chalk-white faces peered from the harshly lit picture, an effect created by the proximity of the light source and the dissimilar reflectance of different parts of the scene. However, attempts using limelight and other chemical sources (such as Bengal light, a pyrotechnic compound made briefly popular by John Moule under the name of photogen in 1857) were doomed to failure, either because they did not contain the rich blue, actinic wavelengths that the *orthochromatic plates of the day required (limelight), or because of their low intensity and the copious clouds of fumes they released (Bengal light).

There was one exception: magnesium. In 1862 Edward Sonstadt began experiments to prepare the metal on a commercial basis and by 1864 magnesium wire was placed on sale, though at a colossal price—more than double that of silver. Following a demonstration in February that year Alfred Brothers (1826–1912), a member of the Manchester Literary and Philosophical Society, produced a photograph in a darkened room in only 50 seconds. The highly actinic light proved ideal for photography.

Magnesium was burned as a wire or ribbon (the larger surface area of the latter aiding combustion), either twisted into tapers or in clockwork lamps with a reflector. Lamp designs were many and varied: powdered magnesium, blown into the naked flame of a spirit lamp, produced a vivid flash, and multiple-headed lamps could fire more powder at a time, but burning was often incomplete and unpredictable. Exposures varied considerably and the air remained laden with grey, opaque fumes, making the metal unsuitable for studio use. Nevertheless, magnesium lamps gained in popularity through the 1870s and 1880s despite the expense.

Flashpowder

Producing a shorter, more predictable flash became the goal. Charles Piazzi *Smyth, experimenting in the pyramids at Giza, Egypt, in 1865, had attempted to ignite magnesium filings mixed with gunpowder. The resulting picture was poor but the principle was sound: combining magnesium with an oxygen-rich chemical would sustain combustion. In November 1865 J. Traill Taylor used such a mixture, thereby sometimes (wrongly) being credited as having invented flashpowder.

Perhaps due to the conflagration that these and other early powders produced, they were treated as no more than novelties. Then, in Germany in 1887, Adolf *Miethe and Johannes Gaedicke mixed fine magnesium powder with potassium chlorate to produce *Blitzlicht*—the first widely used flashpowder. The ability to produce 'instantaneous photographs' at night, or arrest moving objects with the relatively short-duration flash, caused great excitement, and there was an upsurge in artificial-light photography. In February 1888 a reporter for the New York *Sun*, Jacob *Riis, recorded wretched immigrants in the city slums by firing magnesium cartridges in pistol-like flashguns

(which caused great fear) or casually throwing a match into a heap of flashpowder in a frying pan, on one occasion almost burning down a hovel and setting light to his own clothes.

Flashpowder is effectively an explosive, with almost twice the power of gunpowder, and such accidents were common. Photographers generally prepared flashpowder by grinding the components in a mortar and pestle, but often forgot that they should grind them separately before mixing. There were a number of incidents; in Philadelphia three photographers died in separate accidents and the 'blinding, smoke-belching, evil-smelling' powder acquired a fearsome reputation. By the early 1900s flashpowder formulations had been refined so that flashes lasted only 10 ms, an improvement which aided portraiture, as subjects no longer closed their eyes during the exposure. However, a convenient 'smokeless' light continued to elude science, though there were many ingenious attempts, for example by burning magnesium in muslin bags.

Flashbulbs

In his experiments in *underwater photography in the 1890s, Louis *Boutan used a cumbersome magnesium lamp devised by the engineer Chauffour. Powdered magnesium, sealed in a glass jar fixed to a lead-weighted barrel to supply oxygen during burning, was ignited by means of an alcohol lamp (and, later, electrically). Paul Vierkötter used the same principle in 1925, when he ignited magnesium electronically in a glass globe. In 1929 the Vacublitz, the first true flashbulb made from aluminium foil sealed in oxygen, was produced in Germany by the Hauser Company using Johannes B. Ostermeier's patents. It was quickly followed by the Sashalite from the General Electric Company in the USA.

Traditionally, in dim light photographers removed the lens cap from a tripod-mounted camera (or, after shutters were introduced, used the 'B' setting) while the flashpowder was lit. Flashbulbs, however, weighed little, were easily fired electrically (the current heated a filament, which ignited a primer paste and burned the aluminium), were extremely powerful, and far more convenient. For safety a chemical spot changed colour if the bulb was cracked or leaking, and lacquer both prevented shattering and could be coloured to match the sensitivity of the new colour films. Mass-market cameras were soon fitted with integral flashguns or synchronizers to fire a bulb when the shutter opened. The freedom this conferred, coupled with predictable exposures, was immense and by the 1950s bulbs had virtually supplanted powder. Bulb manufacturers proliferated and produced literally hundreds of types up to the 1970s, by which time they had decreased from the size of a domestic light bulb to the diminutive AG1 series at only 3 cm (1.2 in) high. Refinements such as flashcubes (made from four AG1 bulbs), Magicubes, Flashbars, and Flip Flashes all increased amateur convenience.

Electronic flash

Electronic means of creating light eventually superseded chemicals. In June 1851 Henry *Talbot recognized that if a moving object was lit by a bright enough light for a short enough duration it would 'freeze' its motion; he reputedly pinned a page from *The Times* to a revolving plate and lit it with the discharge from a series of Leyden jars (effectively a crude capacitor): the first flash photograph (and, incidentally, the first high-speed photograph).

Experiments with discharge tubes, which produce a short-duration flash, were conducted in the 1870s and 1880s by Crova, *Anschütz, and others, as well as the Seguin brothers in the 1920s. However, Harold *Edgerton's work in high-speed photography during the 1920s and 1930s proved that when a short-duration flash was powerful enough he could—to the public's delight—arrest the motion of a speeding bullet. Edgerton's designs led to the production of Kodak's 1939 Kodatron flashlamp and, subsequently, smaller, portable flashguns which—with a flash of less than 1/10,000 s—could freeze any subject that photographers normally encountered. By the 1950s pictures of leaping dancers and icelike flowing water were common in amateur exhibitions. The miniaturization of electronic flash relied as much upon improvements in battery technology as the introduction of small, powerful capacitors. A capacitor was used to store an electric charge, which could be released to fire a flashbulb. In the case of electronic flash the dangerously high voltages involved required that the flashgun design used a low-voltage charging circuit to protect the user.

Photographic flash has moved through chemical and electronic phases, driven by a desire to shorten duration and increase intensity. Refinements lie with automatically quenching the flash when a sensor either in the flashgun or within the camera detects that enough light has reached the film ('auto' flash), and using an infrared pre-flash to set distance and aperture on automatic cameras. Disadvantages lie only with unequal lighting in subjects at dissimilar distances from the source of the principal flash and the harsh shadows produced by the generally smaller reflector, a consequence of miniaturization. CH

Martin, R. (ed.), *Floods of Light* (1982).
Howes, C., *To Photograph Darkness* (1989).
Bron, P., and Condax, P. L., *The Photographic Flash: A Concise Illustrated History* (1998).

Fleischmann, Trude (1895–1990), Austrian-born American photographer, born into a Viennese Jewish merchant family. She received her first camera aged 9, trained at the Graphische Lehr- und Versuchsanstalt (1913–16), and for a while worked as a retoucher for Madame *d'Ora. In 1920 she opened her own studio in Vienna, taking portraits of musicians, artists, writers, also dancers and actors in their stage roles. Her modernist approach, employing unusual angles and close-ups, matched the new market of illustrated magazines and secured her participation in important contemporary exhibitions. She emigrated in 1938, and between 1940 and 1969 ran a flourishing portrait and fashion studio in New York. AL

Schreiber, H., *Trude Fleischmann: Fotografien in Wien 1918–1938* (1990).

Florence, Hercules (1804–79), French-born artist and photographic pioneer, resident in Brazil. In 1825–9 he accompanied the German naturalist Georg von Langsdorff's expedition into the interior, and

produced a detailed illustrated account of its discoveries. Subsequently, after settling in rural São Paulo, he embarked on various scientific investigations and, to circumvent the lack of local printing facilities, devised a method of reproducing texts initially called *poligraphie*. In 1832–3, having learned about the properties of silver nitrate from the apothecary (and later famous botanist) Joaquim Corrêa de Mello (1816–77), he started experimenting with the camera obscura. However, although fascinated by the images it produced, he turned back to seeking a means of cameraless duplication, eventually using a glass plate coated with soot and gum arabic. After writing or drawing on it with a burin and placing it in contact with paper treated with silver or gold chloride, he printed out the image by sunlight. Crucially, he also discovered a means of fixing the result. Florence's notebooks reveal both that he had perfected this process by 1833–4, and that he called it *photographie*—several years before the term was used (albeit to describe camera processes) in Europe. In October and December 1839, after learning of *Daguerre's invention, he announced his success in the Brazilian press, but later resumed his earlier work on printing.

Florence was a modest man who has often been dismissed or ignored in the literature on the *invention of photography. In fact, his experiments were successfully replicated in the 1970s on the basis of his surviving papers. However, as Boris Kossoy has pointed out, for such a discovery to have advanced beyond the experimental stage, a favourable socio-economic climate was needed. This existed in Britain, France, and parts of the USA by the 1830s, but not in Brazil. AM/NFP/RL

Kossoy, B., *Hércules Florence 1833: a descoberta isolada da fotografia no Brasil* (1980).
Kossoy, B., 'Photography in Nineteenth-Century Latin America: The European Experience and the Exotic Experience', in W. Watriss and L. P. Zamora (eds.), *Image and Memory: Photography from Latin America 1866–1994* (1998).

Flower, Frederick (1815–89), Scottish-born wine merchant and amateur photographer, active in Oporto, Portugal. He seems to have taken up photography c.1849, although most of his surviving *calotypes were made in the years 1853–8; he apparently abandoned the medium in 1859. His work included social scenes, attractive bits of local scenery, and views of the Douro and its shipping. He moved finally to England in 1874 and died in London. RL

Frederick William Flower, um pioneiro da fotografia portuguesa (1994).

flowers. See GARDEN AND PLANT PHOTOGRAPHY.

Floyd, William Pryor (*fl* . 1860s–1870s), British (?) photographer active in Macao (1866) and Hong Kong (1867–74). He was a talented and successful portraitist, as shown by numerous *cartes de visite* of Chinese and Western subjects. His Chinese 'types' were often tinted in vivid colours. Floyd also created excellent landscapes or mementoes of events (e.g. hurricanes), assembled as portfolios in bound albums or pasted on cards with printed captions. By 1868 his list included 150 references to views of Hong Kong and Macao. However, he faced

strong competition, particularly from *Thomson and *Afong. He left in November 1874. RT

f-number. See APERTURE CONTROL.

focal length. In a hypothetical 'thin' lens (i.e. a lens that can be approximated on a ray diagram to a single plane at which refraction occurs), the focal length is the distance from the lens to the point at which a collimated beam of light entering the lens is brought to a point. In Newtonian optics this point defines the focal plane, perpendicular to the optic axis. In practice the focal length is measured from the rear nodal point, or node of emergence (see GAUSSIAN OPTICS). As the rear nodal point is the position of the equivalent thin lens, i.e. the Newtonian lens that would produce the same effect, this distance is properly called the *equivalent focal length*. GS

focal-plane shutter. This is constructed of cloth (latterly metal) blinds and set as close to the surface of the sensitized material as possible, i.e. in the focal plane. First proposed in 1862, the most influential design was produced by Ottomar *Anschütz in 1883 and patented by him in 1888. It allowed speeds up to 1/1,000 s—faster than any conventional shutter. It was used on a number of cameras made by Goerz from 1888 and widely adopted by other manufacturers of single-lens reflex (SLR) cameras from the early 1900s. It continues in an adapted form in the modern 35 mm SLR camera. MP

Focal Press. See KRASZNA-KRAUSZ, ANDOR.

focusing screen, a screen of translucent diffusing material positioned in the focal plane of a camera lens to check the accuracy of focus and depth of field. It is traditionally made of acid-etched glass, which gives a fine grain structure, but there is a trade-off between fineness of grain and image brightness towards the corners of the field. 'Directed' diffusing screens using diffraction principles, and made holographically or by electron beam etching, are becoming increasingly common. Single- and twin-lens reflex cameras usually employ Fresnel screens to brighten the peripheral image, with a central clear area including an optical focusing aid such as crossed prisms or a microprism array. Professional cameras usually allow a range of screens to be used for different kinds of work. GS

fog, a darkening of part or all of a negative (or lightening of a transparency) that is not part of the optical image. There are three main kinds: *light fog*, caused by stray light leaking into the camera (or processing area); *chemical fog*, caused by faulty processing (usually contamination of one solution by another); and *age fog*, caused by inappropriate storage (too warm, too humid, too long). All show different symptoms, and once the particular category has been identified it is usually easy to determine the cause. But the subsequent rescue of an important image may require many hours of computer time. GS

folklore. Every group bound together by common interests and purposes, whether educated or uneducated, rural or urban, possesses a body of traditions which may be called its folklore. Folklore in general develops when people come together in groups for communal activities; these may be religious, cultural, or social in character, or mark events in the natural world, or combine several functions (e.g. harvest festivals, May Day and solstice celebrations, etc.). In Britain, as industrialization and mechanization gathered pace, old agrarian traditions gradually declined as country people migrated to the towns. It was against this background of urbanization that many Victorian folklorists and photographers endeavoured to preserve what they saw as valuable remnants of the old traditions. English folklore began to emerge as a subject worthy of study and research, encouraged by the foundation of the Folklore Society in 1868, the introduction of scholarly journals such as *Folklore* (f. 1890), and academic conventions like the 1891 International Folklore Congress in London. Members of the Folklore Society included archaeologists, anthropologists, and historians.

From the 1860s, many amateur and professional photographers recorded traditional customs and events in lantern slides and photographs. Subjects included local fairs, morris dancing, beating the bounds, and illustrated legends of ancient sites. Photographs were often published in popular books and in *postcard form. Lantern slides were used to illustrate talks on various aspects of folklore to new national and civic 'scientific societies'. The Oxford photographer and lanternist Henry *Taunt, who had a deep interest in local folklore and archaeology, published photographically illustrated works on 'Merrie England' and prehistoric monuments like the Rollright Stones. Henry Underhill (1855–1920), an Oxford grocer, was an amateur folklorist who produced his own hand-coloured lantern slides and photographs for local societies. Large-scale operators like Francis *Frith acknowledged the historical and commercial value of folkloric events and objects in their catalogues of views and postcards. Today, interest in retrieving, preserving, and making accessible this form of visual culture can be measured by the many collections being made available on the *Internet by centres for local county studies and academic institutes. MPR

Brown, B. (ed.), *The England of Henry Taunt, Victorian Photographer* (1973).

Fontana, Franco (b. 1933), Italian photographer, born and resident in Modena. Fontana worked as an interior designer before taking up photography *c*.1961. His first exhibition was in Modena in 1968. In the 1970s, while working successfully in advertising, he won international

Harry Penhaul

The Grand Bard of the Gorsedd of Cornwall, Morton Nance, receives the fruits of the earth from the Lady of Cornwall, *c*.1950s

acclaim with near-abstract landscapes that transform terrain into patterns of intense colour. Later he produced equally striking nudes and cityscapes. His many books include *Modena, una città* (1970), *Terra da leggere* (1973), and *Skyline* (1978). In 1991 he presented his important collection of 20th-century photographs to the Modena Civic Gallery. RL

Franco Fontana: fotografie 1965–1987 (1987).

Fontcuberta, Joan (b. 1955), Catalan photographer, curator, writer, and publisher. Fontcuberta has worked in both advertising and photojournalism, and been associated with a number of significant groups and publications, including the Madrid-based magazine *Photovision* (f. 1981). His prominence in contemporary art photography rests on his use of the camera to create impossible creatures, scenes, and sequences of events, thus challenging its claim to represent 'the real'. Thus an early series, *Fauna*, presented hybrid variations on animals and their 'adaptations' studied by the zoologist Peter Ameisenhaufen; *Constellacions* (1993), dirt and insects on a car windscreen as a vision of the night sky; and *Sputnik* (1996–7), a wholly fictitious narrative, backed by fake documents and photographs, of a Russian space mission. Fontcuberta initiated the Barcelona Photo Festival, and in 1996 was appointed artistic director of the *Arles Festival. LAL

Joan Fontcuberta: Wundergarten der Natur (1995).

food photography is a branch not only of *advertising (product) photography, but also of *fashion photography: that is, there are fashions in the food itself, and also in the way it is photographed.

Early food photography—even into the 1960s and 1970s—tended to be formalized, symmetrical, and dull. The food was extremely highly finished, often slicked with glycerine to add a shine and shrouded in cigarette smoke blown over it to simulate steam. From the 1950s onwards, the 'lifestyle' aspect became more and more important. At first the settings were as glossy and unrealistic as the food: the most popular scenarios were the banquet, or the suburban home. In the late 1970s or early 1980s, photographers concentrated more upon the shapes and textures of the food, also on the surroundings, sometimes taking either approach to extremes. The shapes and textures school would arrange miserably few slivers of food on a huge plate, while those who favoured surroundings sometimes showed so much of an Umbrian courtyard or a stainless-steel kitchen that a lively game of hunt-the-food ensued.

To ensure natural-looking food, as few tricks as possible are used, though a few ruses remain and are essential: for example, over-filling sandwiches or wraps to the point where they can hardly be picked up and eaten. In general, better lighting and faster photography (so that the food does not go cold and congealed) have replaced all the other tricks, though beer is still salted to make it foam and olive oil may be used to add a sheen to meat. Garnishes are as important as ever, especially with heavily sauced foods such as Mexican or Indian, which can all too easily look like a pile of brown sludge.

Where the budget allows, the easiest way to photograph food is in three stages. For the first, the position of the food in the set is 'blocked in' with handfuls of crumpled tissue paper or other substitutes. For the second, the dish is cooked and set up and the final lighting decided, along with Polaroids for exposure determination. Finally, a freshly cooked plate of the same dish is set up, and photographed very quickly at its best.

Props are very important. Some can be well worn, such as knives, cutting boards, and copper saucepans or iron frying pans. Others must be brand new, or almost brand new, or they look shabby and unhygienic: plates, (most) glasses, plastic cutting boards. And then there are a few tricks such as plastic ice-cubes or spray-on mist to create the impression of a cold glass, though increasingly the latter would be done with real condensation and fresh drinks.

Although large formats dominated in the past, today 6 × 7 cm and even 35 mm deliver acceptable quality because films are so much better than they used to be. Although flash does not dry out the food like hot lights, mixed flash and hot lights can be useful for creating a sunny ambience, whether dawn or (more usually) the setting sun. RWH

forgery. See FRAUD AND FORGERY, PHOTOGRAPHIC.

formats, plate and film

Plates

Before about 1920 almost all photographic prints were contact prints. Enlargers did exist, but most print materials required a long exposure to daylight to produce an image. Although film was available, serious photographers tended to prefer plates, which were easier to retouch and could be used in contact printing frames more readily than film. Indeed, as late as 1950, plates were still in use by press photographers, because the fastest emulsion then obtainable was on plates, and because a plate could be used in an enlarger while still wet, saving precious time.

The first commercially made camera, the Giroux of 1839, took $6^1/_2 \times 8^1/_2$ in *daguerreotype plates, and when the Liverpool Dry Plate Company introduced the first widely available plates, this was the basic size adopted. It became known as *whole-plate* format. It was followed by the smaller *half-plate*, which at $4^3/_4 \times 6^1/_2$ in was somewhat broader than a halved whole plate, but approximately the same shape as a whole plate, and by the *quarter-plate*, which, at $3^1/_4 \times 4^1/_4$ in was a true quarter of the large format. Most British hand cameras took quarter-plates, but continental cameras used the metric size of 9 × 12 cm. British owners of such cameras used quarter-plate adapters in the 9 × 12 cm *dark slides.

Among professional photographers the smallest format in general use was half-plate rather than whole plate, though many worked with larger formats such as 8 × 10, 10 × 12, 12 × 15, and even 16 × 20 in or their metric equivalents. Some intrepid souls even used the huge 20 × 24 in *mammoth format, and even larger plates were manufactured for *photomechanical reproduction in process cameras. By the end of

the 19th century silver halide emulsions had improved in speed and resolution, as had enlarger optics, and small cameras were built to take sixth- and even ninth-plate sizes. There were other sizes too. For serious work such as press photography 4 × 5 in format was appropriate, being large enough for contact printing but small enough to fit in an enlarger. Contemporary fashion demanded the *postcard format ($3^1/_2 × 5^1/_2$ in). Another popular size was $2^1/_2 × 3^1/_2$ in, the continental equivalent being 6.5 × 9 cm (close enough for most plate holders to take either size). Special double-length plates were available for *stereoscopic cameras.

By 1970 production of plates had virtually ceased. Among the last to be produced commercially was Ilford's FP Special, a panchromatic emulsion designed for three-colour separations, with a gamma (see SENSITOMETRY) almost constant over the visible spectrum. Plates have continued to be produced in small quantities for special purposes such as *photogrammetry and microlithography; and for holograms in sizes up to a colossal 1 m (3 ft) square.

Film

After the introduction of *roll-film, the number of formats became reduced. To begin with, quite large roll-film formats such as postcard and even half-plate were common, but these fell out of use, and by 1945 only the 116 size ($2^1/_2 × 4^3/_4$ in) remained alongside the *Kodak Brownie models with their 120 and 620 formats ($2^1/_4 × 3^1/_4$ in, or 'six by nine' in present-day parlance). The VP (vest pocket) format ($1^1/_2 × 2^1/_4$ in) had been a short-lived challenger, as well as the equally short-lived Bantam camera, which produced $1^1/_4 × 1^3/_4$ in negatives on $1^3/_8$ in wide film.

This last film, equipped with edge perforations, became the standard 35 mm professional cine-film, with a format of around 18 × 24 mm, the exact size depending on whether or not sound was recorded on the film. The first 'miniature' camera, the *Leica, used this film with a larger format that eventually settled at 24 × 36 mm, where it has remained ever since, apart from a few variants such as the Robot with its 24 mm square format and several half-frame cameras with formats of 18 × 24 mm. A number of *sub-miniature cameras using 16 mm amateur cine-film appeared in the 1940s; but the best known of them, the Minox, used the now obsolete 9.5 mm film, with an image size of 8 × 11 mm. Formats aimed at the mass market more recently have included the cartridge-loading 126 size (28 mm square) and 110 (11 × 17 mm) disc (8.2 × 10.6 mm) and, most recently, the *Advanced Photographic System (APS) cassette, with a 17 × 30 mm format.

Among professional photographers, before the rise of *digital imaging, cut films reigned in the studio, where formats largely followed the old plate sizes, the most common being 4 × 5 in, 5 × 7 in, and 8 × 10 in. For general work the medium-format 120 and double-length 220 films were ubiquitous, with image sizes of (nominally) 4.5 × 6, 6 × 6, 6 × 7, and 6 × 9 cm and for *panoramic cameras, up to 6 × 24 cm. For reportage the 35 mm format was king for many years, but is also rapidly being overtaken by digital.

There are several standard film sizes for *aerial reconnaissance and survey cameras. The two most commonly used are $9^1/_2$ in wide for survey work, with an image size of approximately 9 in square, and 70 mm film with double perforations, used in 6 × 6 cm format for tactical reconnaissance. The Imax cine-camera also uses 70 mm film, with a format of approximately 6 × 8 cm. Other aerial cameras, now mostly obsolete, used 5 in and 9 in wide roll-film. All these films are available in lengths up to 300 ft. RWH/MP/GS

A. Adams, *The Camera* (1980).

fotoform is regarded as the most important German photographers' association of the early post-Second World War period. It was founded in the first instance, on the initiative of Wolfgang Reisewitz in 1949, as an exhibiting society. Early members included Siegfried Lauterwasser, Ludwig Windstosser, Peter *Keetman, and Toni Schneiders, but it was Otto *Steinert, the group's spokesman, who decisively shaped its programme. Heinz *Hajek-Halke and Christer Christian joined later. Fotoform's members presented their work under the programmatic label *'subjective photography', and had a formative influence on art photography in West Germany. A collective stand was taken against the old-fashioned validation methods of the professional associations. In general, fotoform harked back to the avant-garde, experimental photography of the 1920s, and developed within the orbit of non-representational art. It made its breakthrough at the first Photokina exhibition in Cologne in 1950, and by the mid-1950s was breaking up. UR

'subjektive fotografie': Der deutsche Beitrag 1948 bis 1963 (1989).

Fourier optics. The Fourier model for image formation provides a simple and elegant explanation of the limits of resolution of an optical system and of the nature of the image itself. The underlying principle is the same as that used for the analysis of sounds or electronic signals. The whole of sound reproduction theory is based on the principle that any sound, no matter how complex, is made up of sinusoidal (wave-form) components of various amplitudes, frequencies, and phases. The converse, that any sound pattern can be built up from an appropriate spectrum of sinusoids, is equally true. This is called respectively *Fourier analysis* and *Fourier synthesis*, after Joseph Fourier (1768–1830), who first worked out the mathematical principles.

The precise optical analogy is that the light beam emitted (reflected or transmitted) by any object, no matter how complex, is identical with the pattern of diffraction that would be transmitted by a spectrum of sinusoidal diffraction gratings of various transmittances, spatial frequencies, and spatial phases, and, for a two-dimensional object, orientations. Similarly, any desired light beam can be constructed by superimposing appropriate sinusoidal gratings on a plane wavefront. One small extension is necessary. Because (unlike a sonic or electrical signal) a transmittance cannot be negative, there is always a 'd.c.' component present in an optical grating, equal to half the amplitude of the grating.

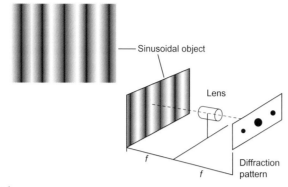

Fig. 1

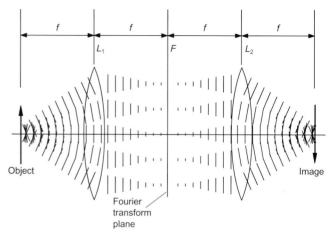

Fig. 3

Fig. 2

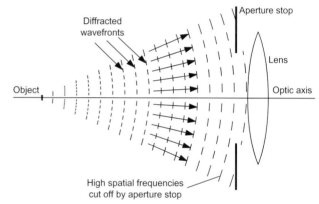

Fig. 4

The Fourier approach treats imaging as a diffraction phenomenon, and a lens as a device for performing an optical Fourier analysis (in two dimensions) of the sinusoidal functions that together create the shape of the wavefront from the object. The principle is approached by considering a simple sinusoidal grating (Fig. 1). This produces a single pair of diffracted plane wavefronts. If the grating is situated at the front focal plane of the lens, these wavefronts will converge towards the rear focal plane, forming two spots; this can be readily demonstrated using laser light. The electrical field in this plane is the Fourier transform (i.e. the spatial frequency spectrum) of the object grating, and represents—as it must—a single spatial frequency.

When the object is more complicated, the diffraction pattern at the rear focal plane is also more complicated. But it still consists of pairs of spots. Each pair indicates a specific amplitude, spatial frequency, and orientation of the originating sinusoidal grating by (respectively) their intensity, separation, and angle. Indeed, simple objects can be identified from their diffraction patterns. The letter V of (Fig. 2) shows the characteristic pattern of two rectangles at an angle to one another. One thing the visible pattern does not show is the spatial phases of the

gratings; but they are nevertheless present in the electric field.

A fundamental property of a Fourier transform is that it obeys the commutative law. This implies that if a Fourier transform is carried out on a Fourier transform, the result is just the original function. So a second lens positioned with its front focal plane in the rear focal plane of the first will produce a replica of the original object at its own rear focal plane (Fig. 3). This, of course will not be news to a photographer: it is part of traditional geometrical optics. What was not generally appreciated, and not actually seen before lasers appeared, was the presence of the diffraction pattern that proved the existence of the optical Fourier transform in the principal focal plane of the lens. (It is, of course, present even with white light, but is smeared out by dispersion and lack of coherence.)

One important outcome of the Fourier principle is that it indicates the absolute limit of resolution of a lens. Because the highest spatial frequencies in the object wavefront are diffracted to the largest angle, they may miss the lens altogether (Fig. 4). Closing the lens aperture down progressively cuts off the higher spatial frequencies, just as applying a high-frequency blocking filter removes the highest sound

Fig. 5a

Fig. 5b

frequencies from a hi-fi amplifier. The effect was first noticed in the early 1950s, when it was seen that the image of a Sayce grating (a rectangular intensity-profile grating, Fig. 5a) became markedly sinusoidal in profile at the fine-detail end as the aperture of the lens under test was closed down, indicating that the higher spatial frequencies present in the bars were not being recorded (Fig. 5b). GS

Steward, E. G., *Fourier Optics: An Introduction* (1989).
Saxby, G., *The Science of Imaging: An Introduction* (2002).

Foveon sensor. See DIGITAL IMAGING.

frame grabber, a device that takes an analogue signal from an imaging device such as a TV camera or a videotape and stores it in digital form similar to that given by a digital camera. It represents the successor to the still picture extracted from a movie sequence, or a photograph of a TV screen. GS

France

To 1920

It is clear to historians today that two great nations, France and Britain, dominated photography in the 19th and early 20th centuries: in terms of inventions, numbers of major photographers, influence on the rest of the world, and diversity of the medium's applications. The explanation for this quasi-duopoly clearly derives from the two countries' ascendancy on the world stage. Their economic prosperity

and colonial empires, and the fact that London and Paris were both cauldrons of intellectual and artistic activity, are sufficient to explain why photography, like other arts, technologies, industries, and fashionable pursuits, was particularly advanced there. However, this preliminary socio-economic observation does not explain everything: Berlin or Moscow, St Petersburg, Rome, Madrid, Rio de Janeiro, or New York, even if not playing leading roles, might nevertheless have become significant centres of activity, as they did in other fields. In photography, however, this became true only to a limited extent. Although from *pictorialism onwards the Italian, Belgian, German, Austrian, and American schools began to make major contributions, until the 1880s London and Paris were at the heart of photographic activity; *Niépce, *Daguerre, *Talbot, *Poitevin, *Brewster, *Archer, *Le Gray, *Maddox, *Ducos, Charles Cros (1842–88), Henri Becquerel (1852–1908), the *Lumière brothers, and other French and British figures were associated with the birth of photography and most of its key developments until *c*.1900.

This said, it is necessary to establish what was distinctive about 19th-century *French* photography. By its agreement with Daguerre, the French government acquired his and Niépce's invention in order to present it to 'humanity'. For a while, the spectacular announcement in Paris in August 1839 eclipsed Talbot's quiet work in the English provinces. The invention, which became the object of an immediate craze, was almost universally perceived as French. A shock wave radiated outwards from Paris, but also engulfed the city itself. The portrait studios lampooned by wits and cartoonists like Honoré Daumier became a speciality of the French capital. The *calotype, as Edmond de Valicourt vividly put it, seemed 'stifled at birth'. Its resurrection at the end of the 1840s was also strongly linked to Paris; the improvements made by the Lille publisher *Blanquart-Évrard and others, though the subject of disputes with Talbot, restored the process to centre stage, as the unique, expensive *daguerreotype was beginning to lose its appeal. The ultimate refinements of the paper-negative process by Gustave Le Gray (1849–51), inventor of the *waxed-paper process, succeeded in making the calotype completely practicable. From the late 1840s it enjoyed definite success, albeit different from that of the daguerreotype. The overwhelming majority of daguerreotypes were commercial products, studio portraits that rarely had artistic value, and other applications remained marginal. With the calotype, on the other hand, as the works of Talbot, then *Hill and Adamson, demonstrated, photography entered the domain of the intellectual and artistic elite. As Eugenia Parry Janis has shown, this was particularly marked in France. In the hands of skilled amateurs and professionals, the calotype pushed forward the frontiers of the medium. Painters such as Delacroix and Courbet made early and considerable use of it, abundantly supplied with purpose-produced work by artists like Vallou de Villeneuve and Durieu.

The development of *archaeology, and the study, restoration, and conservation of *ancient and historical monuments, also came to rely heavily on photography, to which they offered enormous scope: for

Félix Moulin, Studio

Study, 1854. Albumen print

example, the project later known as the *Mission Héliographique (1851), whose extraordinary results remain one of the jewels of early paper-negative photography in France. Notable too was Maxime Du Camp's visit to Egypt (1849–51), Eugène Piot's to Italy (1851), and Auguste Salzmann's archaeological work in Jerusalem (1854).

Having become a fashionable pursuit by the beginning of the 1850s, photography offered plenty of rewarding activity to rich amateurs. Olympe and Onésipe *Aguado, Odet de Montault, Benjamin and Édouard Delessert, Roger du Manoir, the vicomte de Vigier, and many others were trained by Le Gray, whose personality and technical virtuosity gave substance and coherence to this French calotype school. Another, allied group was centred on the Sèvres porcelain works around its director, Henri-Victor *Régnault, and the head of its decorative workshops, Louis-Rémy Robert. In the 1850s, photographic technique was discussed in France, as in England, in stately homes, town mansions, academies, museums, and learned societies. The yield was rich, varied, and often innovative, despite its frequent indebtedness to contemporary painting. Blanquart-Évrard, who between 1851 and 1855 published some of it in the form of thematic portfolios or books, helped to bring it to a wider public. The creation of the *Société Héliographique in 1851, then the *Société Française de Photographie in 1854, and numerous journals such as La *Lumière, the Bulletin de la Société Française de Photographie, Le Cosmos, and the Revue photographique, promoted debates and exchanges of ideas outside the confines of commercial practice. Into the 1870s, amateurs coexisted harmoniously with professionals, collectors with technical experts, and devotion to art with business imperatives. Personalities like *Nadar, the *Bisson brothers, and Le Gray showed that dealing in art did not necessarily kill it.

As the *wet-plate process spread like wildfire, adopted by every commercial enterprise in the years following its invention in 1851, the number of Paris studios multiplied still further. The stereo view and the *carte de visite portrait in particular boosted the number of customers, whether affluent Parisians or foreign visitors passing through. As in the first years of the daguerreotype, commercial considerations tended to get the better of artistic aspirations. At the beginning of the 1860s figures like *Nègre, *Le Secq, Nadar, and Le Gray, for various reasons, left the field.

The universal exhibitions that took place in Paris in the second half of the 19th century (1855, 1867, 1878, 1889, 1900) were also opportunities to display the richness and variety of French photography and keep abreast of developments abroad.

The wet-plate era in France produced an upsurge of spectacular works like the large editions of views and architectural pictures by firms like *Braun, Bisson, and *Delmaet & Durandelle, and artists such as *Marville and *Collard, who kept a close eye on the transformations of the urban scene, demolition, redevelopment, and major engineering projects. Official patronage was plentiful from the outset. After the Mission Héliographique, commissions to *Baldus, the Bissons, Le Gray, and Marville produced lavish albums—iconographic splendour in the service of political power. Specific to France throughout the

19th century, though varying in style from one generation to the next, were photographic studies aimed at painters: views, forest studies, animals, and more or less 'academic' nudes. Paris, the world's leading art centre, had more resident painters than anywhere else, and photographic production reflected this fact. Vallou, Quinet, Famin, d'Olivier, Marconi, Cuvelier, and many secondary figures, provided them with a wealth of source material for their pictures.

From the beginning of the 1870s, after the fall of the Second Empire, the situation changed. Some large firms, such as Reutlinger, Nadar, Braun, Marville, and Delmaet & Durandelle, continued to flourish. But the aristocratic amateurs had vanished with the empire, as well as some of the artist-photographers. Photography's main energy was flowing in new directions—for example, scientific photography, which developed considerable momentum thanks to technical progress and the emergence of new fields of scientific interest. *Marey, *Londe, Richer, Hardy, and Montméja applied the medium's new capabilities to medicine and studies of the body in motion.

*Amateurism, stimulated by rapid shutters and smaller, more user-friendly cameras, became more diverse and broadly based, to the point where it was no longer possible, as it had been 30 years before, to name its leading practitioners. However, it became feasible to classify amateurs and their pictures in sociological and iconographical terms. Their sources of inspiration, epitomized by the work of Jacques-Henri *Lartigue, were fun rather than high culture: cycling, boating, motoring, sea bathing, amusements, gags, amateur theatricals, mostly—with the exception of geniuses like Lartigue—recorded with a degree of banality that persists to this day.

In reaction against this kind of amateur practice, which seemed to distance photography from art, an international movement emerged, pictorialism, whose French variant formed around a body of amateurs, the *Photo-Club de Paris, founded in 1888. Among a host of minor talents, a few key figures soon stood out, such as *Demachy, *Puyo, *Dubreuil, and Ferdinand Coste (1861–1932). In addition to subjects common to all the pictorialist schools, especially landscapes, pastoral scenes, and Symbolist portraits, French pictorialism distinguished itself by its images of the female nude, particularly the classically inflected ones of Puyo. This French proclivity was not peculiar to photography, but also common to painting, sculpture, and the decorative arts. The pictorialist style flourished for a number of years, cultivated and replicated in the movement's numerous journals and exhibitions. But it had neither the capacity for self-renewal nor the germ of modernity; and unlike Austrian or, especially, American pictorialism, it lacked the impulse to break with the conventions of the 19th century and engage with the new world emerging in the 20th.

Thus France lost its position in the field of avant-garde photography until the 1930s. The exception, of course, was Eugène *Atget, whose work (with hindsight) successfully synthesized the literal recording of reality and the formal innovations of 'pure' photography. But Atget was an isolated figure, and did not become a force to be reckoned with until the 1930s, when his work was discovered by the avant-gardes. He had no contact with or influence on the French photographic world

of the pre-1914 period, which wore itself out with theoretical debates about the artistic status of the medium. SA

Jammes, A., and Janis, E. Parry, *The Art of French Calotype* (1983).

Brettell, R., Flukinger, R., Keeler, N., and Kilgor, S., *Paper and Light: The Calotype Process in France and Britain 1839–1870* (1984).

Buerger, J. E., *French Daguerreotypes* (1989).

Marbot, B., and Poivert, M., *Le Pictorialisme en France* (1992).

McCauley, E. A., *Industrial Madness: Commercial Photography in Paris, 1848–1871* (1994).

Aubenas, S., and Gunthert, A., *La Révolution de la photographie instantanée, 1880–1900* (1996).

Bajac, Q., 'La Photographie à Sèvres sous le Second Empire: du laboratoire au jardin', *48/14 La Revue du Musée d'Orsay*, 5 (1997).

L'Art du nu au XIXe siècle: le photographe et son modèle (1997).

Bajac, Q., and Font-Réaulx, D. de, *Le Daguerréotype français: un objet photographique* (2003).

Since 1920

French photography in the 20th century has been strongly marked by two world wars and the social and political upheavals that followed and preceded them. In a broad sense this has led to two types of responses by photographers, one highly formalist, the other more socially responsive. For some of this period, France could still be considered as the cultural centre of the world, particularly in the 1920s and 1930s, and the role of photography was both as a major contributor to modern art and the primary visual means of recording social and cultural change. Paris was important as a haven for cultural refugees from Central and Eastern Europe following the 1914–18 war and the Russian Revolution. It also attracted gifted and creative individuals from America and, to a lesser extent, Britain. The cultural melting pot had a corrosive effect on the pictorialist ethos of the pre-war French photography of Puyo, Demachy and their colleagues, which looked increasingly outmoded to a generation marked by the horror of the trenches and the advance of the machine age. Of greater interest to the avant-garde were Atget's documentary images of Paris. J.-H. Lartigue was creating a fascinating oeuvre out of his own somewhat gilded lifestyle, but this work was hardly known at the time outside his own social circle.

In the 1920s, modernist ideas from Germany and Soviet Russia—Dada, Constructivism, *Neue Sachlichkeit—were rapidly taken up by the younger generation of French artists and photographers. In 1921, André Breton declared that 'photography has dealt a fatal blow to the old forms of expression', and the new medium remained at the heart of cultural innovation until 1939. The influx of foreigners, such as Andre *Kertész, *Man Ray, Berenice *Abbott, Germaine *Krull, Gisèle *Freund, *Brassaï, Ergy Landau, Alexander *Liberman, Robert *Capa, and many others, helped to make of Paris a vibrant centre of photography, though its preeminence began shifting to New York by the end of the 1930s as the shadows of war deepened.

A major factor in the dominance of Paris in the 1920s and 1930s is the emergence and success of a new form of publishing, the mass-circulation photographically illustrated magazine. Although the magazine concept was pioneered in Germany, the appearance of *Vu

from 1927 defined a new market in France for illustrative photography, one increasingly marked by the use of small portable cameras such as the *Leica, *Rolleiflex, and Contax, the dramatic compositions pioneered by the Constructivists and the *Bauhaus photographers to record what one influential commentator of the era, Pierre *Mac Orlan, famously termed the 'social fantastic of the street'. This new photography—baptized 'la nouvelle vision'—to the extent that it presented ordinary life to a mass audience, was infused with increasingly humanistic perspectives, strongly influenced by the socialist ideas of the Popular Front. The French Communist Party was especially adept at enrolling young French photographers—such as Henri *Cartier-Bresson and Willy *Ronis—in front organizations such as the Association des Artistes et Écrivains Révolutionnaires, and used their pictures in its magazine *Regards*, and the daily paper *Le Soir*. Their work increasingly focused on social themes as political tensions increased towards the end of the 1930s.

The 1930s also witnessed the emergence of small independent picture *agencies, distributing photographs to an increasingly international market in the press and publishing industries. Alliance-Photo (founded by Pierre Boucher) and *Rapho (founded by the Hungarian Charles Rado) were two of the more successful of the many created during this era, which included Robert Capa's first essay at a forerunner of the photographers' cooperative that would later become *Magnum, which briefly (1938–9) distributed his work and that of his friend Ronis.

With only one or two galleries showing photography (notably the Pléiade bookshop in Saint-Germain-des-Près), publication was the main form in which *nouvelle vision* photographs appeared in the 1930s. Periodicals such as *Art et médecine*, *Arts et métiers graphiques*, and *Minotaure* were notable for showcasing new work. Books or serials were a key outlet for innovative work such as Brassaï's *Paris de nuit* (1933), or François Kollar's *La France travaille* (1931–4). There was almost no market for print sales, and major art galleries did not show photography. Commercial photography—fashion, advertising, portraiture—became the primary domains in which *nouvelle vision* work could be displayed. Some central figures of the era, such as André Vigneau, Laure *Albin-Guillot, Florence *Henri, Jean Moral, and Remy Duval, were instrumental in exploring new compositional styles, as well as *photograms, double exposure, collage, and *solarization in their professional work. Perhaps against such tendencies, and certainly with an eye on the American *Group f.64 movement, Emmanuel *Sougez established the Groupe du Rectangle which opted for 'photographie pure'. It reformed as the Groupe du XV after 1945, but by then was more of an occasional talking shop than a vibrant art movement.

The Second World War and the Occupation (1940–4) did not bring photography in France to an end, but led to a fundamental shift in its focus, with significant influence on the post-war period. Relatively little has been published about this sombre era. In the occupied zone, the Nazi authorities held a firm grip on the means of visual expression, while Vichy carefully controlled what appeared in the 'zone libre'. Those photographers who remained in France and were not

incarcerated either abandoned their work or were obliged to perform menial and ill-paid tasks—social portraiture, commercial and editorial photography for the heavily censored illustrated media of the period. A number took part in the Resistance from 1941, their skills of practical use in the forging of passes and documents. The liberation of Paris in August 1944 was a key moment in the emergence of a new, post-war style of photography, focused closely on the social and cultural problems faced by the Fourth Republic (1947–59). The humanist ethos was much concerned with contemporary issues of reconstruction and the need to redefine a French identity sullied by memories of war, defeat, occupation, and collaboration.

For the next two decades, French photography was marked by a fascination with a 'poetic' and often romantic style of image making, primarily in black-and-white and heavily concentrated on the way of life of ordinary French people—but with an emphasis on Paris. Made on the streets or in the bistro with available light and the ubiquitous small cameras of the day, it was in marked contrast with the 'art' photography of the USA. Most of the key works of this period were made by freelance editorial photographers, Cartier-Bresson, *Doisneau, Ronis, *Izis (Bidermanas), and Brassaï being the best-known names. Their photographs appeared in the press, but their greatest impact came about through publication in monographs, often with an introductory text by a 'literary locomotive'. The iconic works remain Doisneau's *Banlieue de Paris* (1949), Izis's *Paris des rêves* (1950), Ronis's *Belleville-Ménilmontant* (1954), Cartier-Bresson's *Images à la sauvette* (1952; better known by its English title, which defines the photographic orientation of all these photographers, *The Decisive Moment*). This approach was promoted by some key figures in the French press—Albert Plécy (editor of *Point de vue* and a keen supporter of humanist photography), Raymond Grosset of Rapho, the printer Braun, whose Mulhouse firm produced an outstanding quality of heliogravure reproduction, the advertising executive and publisher Robert Delpire, and Florence Arthaud (whose eponymous publishing house issued a number of the classic books of this genre). Many photographs by the French humanists appeared in Steichen's global blockbuster exhibition, *The *Family of Man*.

By the late 1950s claims were being made that the photographic image could be a sort of universal language, an idea given credence by a UNESCO conference in 1958. Plécy was instrumental in forming Gens d'Images, which from 1955 awarded the annual Prix Niépce to promising young photographers, including Jeanloup *Sieff, Doisneau, and Jean *Dieuzaide; and a Prix Nadar for photography books. Several photographers began to devote serious attention in their work to trends in modern art—such as *art brut* and abstraction. The 'social' programme of humanism began to show signs of exhaustion as the conflicts within French society, its growing wealth and technological progress began to erode the consensus of French cultural identity evident in the immediate post-war era. Whereas in the 1930s it had looked eastwards, French photography was now more open to transatlantic influences. The challenge to the dominance of the humanist paradigm began to appear in the form of a more personal and often elliptical or confrontational approach influenced by American photography, made by a younger generation: Robert *Frank's *The Americans* (published by Delpire in 1958) and Klein's *New York* (the Prix Nadar book of 1957), played important roles in this shift. Their approach was increasingly influential on younger reportage photographers such as Raymond *Depardon and Gilles *Caron.

The 1960s were a watershed for French photography in the era of the Vietnam War, the Prague Spring, and a gathering political crisis in the Fifth Republic. By 1968, a new generation was emerging, often highly politicized and unafraid of using photography to show all aspects of the contemporary world. The events of 1968 were hardly covered by the humanists, who left the recording of the street battles to young Turks like Caron and Bruno Barbey. The 1960s and early 1970s also saw the emergence of Paris as global centre of the photojournalism industry, and the appearance of new photo agencies such as Sipa, Sygma, and *Gamma which drew the best talent. A significant group of dedicated documentary photographers emerged and included Raymond Laboye, Guy Le Querrec, Claude-Raimond Dityvon (b. 1937), Martine *Franck, Patrick Zachmann, and Christian Louis. As in the 1920s and 1930s, Paris was once more the *ville lumière* of photography. Fashion magazines became the source of much avant-garde work, for French 'art' photography—hitherto more or less non-existent, or carried on by minor figures—was increasingly associated with *la mode*. Magazines such as *Vogue*, *Jardin de la mode*, *Elle*, *Marie-Claire* all vied to publish photography that explored the limits of the medium. Photographers such as Sieff, Helmut *Newton, Frank *Horvat, and Guy *Bourdin developed distinctive styles that were a foretaste of the obsession with the body and sexuality that marked art photography in the 1990s.

The 1970s and 1980s were a watershed in the wider cultural appreciation of photography. While the sociologist Pierre *Bourdieu could devote a book to the subject and get away with calling it 'a middlebrow art' ('un art moyen') in the 1960s, by the 1980s such an idea was laughable, for photography had moved to centre stage in French cultural policy, with the formation of a number of important institutions, and the increasing presence of the photograph in leading public and private galleries and *museums. Photography was both popular and a form of cultural distinction. Public bodies included the Centre National de la Photographie (f. 1982), with its remit to advance contemporary work, and the Patrimoine de la Photographie, which conserves important archives and donations; and a network of regional and local bodies. In addition, the history of photography—a subject largely ignored until the early 1970s—was increasingly well served and promoted by a dedicated group of curators in the Bibliothèque Nationale led by J.-C. Lemagny, and several museums (especially the Musée Carnavalet, Musée d'Orsay, and the pioneering Musée Français de la Photographie at Bièvres), and by the activities of an enlightened group of collectors, of whom the foremost were perhaps M. and Mme André *Jammes. The state belatedly realized that its archives were a treasure trove of photographic gems, and there has been significant investment since the 1990s in making this work available

in digitized form. It has also become a significant 'client' for photography, commissioning projects by leading documentary and art photographers.

The 'rise' of photography as a respected art medium since the 1970s has been inseparable from and greatly assisted by the emergence of the *market in photographic prints. The first permanent galleries began to appear in the mid-1970s. By the 1990s Paris was probably second only to New York in the number and range of specialist outlets, and the number of regular Parisian cultural events built around photography is ever growing, with a biennial Mois de la Photo and an annual largely commercial festival at the Louvre. The *Arles Festival was founded in 1970 and emulated by numerous others, including a Photo de la Mer festival launched at Vannes, Brittany, in 2003. Several important regional centres for photography have also developed over the same period, such as the Centre Régional Photographique Nord-Pas de Calais, despite their regular (and justified) complaint that Paris tends to hog both the limelight and the major part of the resources available. PH

Saint-Cyr, A. de Gouvion, Lemagny, J.-C., and Sayag, A., *Art or Nature: 20th-Century French Photography* (1988).
Phillips, C. (ed.), *Photography in the Modern Era: European Documents and Critical Writings, 1913–1940* (1989).
La Photographie: état et culture (1992).
160 ans de photographie en Nord-Pas de Calais (2001).

Franck, Martine (b. 1938), Belgian-born French photographer, brought up in the USA and England before studying art history in Madrid and Paris, then visiting the Far East. After working as a laboratory assistant at *Life* she started doing magazine reportage, and stage photography at the Théâtre du Soleil, Paris. In 1972 she co-founded the agency Viva, and in 1980 joined *Magnum. Whether her subjects have been old people (*Le Temps de vieillir*, 1980), Tibetan refugees, or the inhabitants of Tory Island, where she worked in the 1990s, Franck has remained firmly in the tradition of French humanist documentary. In 1970 she married Henri *Cartier-Bresson. RL

Franck, M., *One Day to the Next* (1998).

Martine Franck

The wedding of Pauline Doohan and Brian Gallagher, Tory Island, 1996

Franco-British photographic links, mid-19th century.
See ANGLO-FRENCH PHOTOGRAPHIC LINKS, MID-19TH CENTURY.

François, Auguste (1857–1935), French consul in south China
between 1896 and 1904, first in Longzhou (Guizhou) and Kunming
(Yunnan-fu) in Yunnan. He also undertook several exploration trips
on major rivers and in eastern *Tibet. He extensively photographed
places and people, from officials to labourers and actors. About an
hour of movie footage has also survived. In retirement, he wrote texts
elucidating his images. François's work has been an invaluable means
of documenting China's state palaces in the last decade of the empire.
His archive is held by the Association Auguste François in France. RT

Frank, Robert (b. 1924), Swiss-born American *documentary
photographer and film-maker, celebrated for the mordant images of
the USA published in his book *The Americans* (1958/9). A sensitive
child, Frank grew up in a Jewish household overshadowed by Hitler's
anti-Semitism and fears of a German attack. Rebellion against
Swiss respectability led him to an apprenticeship with a Zurich
photographer in 1941 rather than joining his father's business.
Until leaving for Paris to pursue commercial photography in 1946,
he worked for several photography and film studios. He moved to
New York in 1947, and was hired by Alexey *Brodovitch, art director
of *Harper's Bazaar*.

Frank found fashion photography lucrative but unsatisfying, and
soon grew restless. In 1948, seeking to re-evaluate his work, he
photographed in Peru and Bolivia; using a 35 mm Leica for the first
time made him feel like an artist. In 1955, finally, a Guggenheim
Fellowship enabled him to produce the personal, artful imagery
he aspired to. Travelling throughout the USA, he photographed flags,
cars, jukeboxes, televisions, politicians, and segregated buses in the
South, among other subjects. He arranged 83 photographs into a book
with four sections, each introduced by an image of the American flag.
Initially published in France, the US edition of *The Americans* appeared
in 1959 with an introduction by the 'Beat' novelist Jack Kerouac,
who praised 'The humour, the sadness, the EVERYTHING-ness and
American-ness of these photographs!' In Frank's America, cars seemed
to receive better treatment than people, and electronic devices
dominated. The pictures were denounced in the press, and still offend.
But they were attuned to a decade that produced Nabokov's *Lolita*,
Hitchcock's *Psycho*, studies of anomie and the 'lonely crowd', and the
start of the *Civil Rights movement. *The Americans* was one of the
20th century's seminal photographic publications and inspired a
whole generation of documentary and street photographers.

By 1959, Frank was concentrating mainly on film-making. With the
painter Alfred Leslie he made *Pull my Daisy* (1959), a 28-minute film
featuring Kerouac as narrator. Frank had become an integral part of
the Beat Generation counter-culture and a pioneering independent
film-maker. Subsequently he made more than 25 films and videos, all
very personal in style. He commented in *Home Improvements* (1985):
'I'm always looking outside trying to look inside.' One of his most

spellbinding films, *Cocksucker Blues* (1972), is unlikely to be publicly
released; the Rolling Stones, who had commissioned Frank to depict
their 1972 American tour, disapproved of the explicit sex and drug
scenes, so it may be shown only if Frank is present.

Photography recaptured Frank's interest in the early 1970s. He
began making composites with two or more photographs and short
commentaries penned in, on, or under the images. For example,
the statement 'Sick of goodbys' [*sic*] appeared scrawled in the 1978
diptych of the same title, a reference to his heartache at his daughter
Andrea's accidental death (1974). Many later works have been
composites incorporating texts. Frank has devised imagery that is
both extremely personal and artistically meaningful. His art and
life are inseparable. TB

Greenough, S., and Brookman, P. (eds.), *Robert Frank* (1994).
Frank, R., et al., *Robert Frank: Storylines* (2004).

fraud and forgery, photographic. Photographic fraud denotes
the criminal use or production of 'counterfeit' photographs for unjust
gain or advantage; photographic forgery the creation of photographs
that are intended to convey a misleading impression either of their
own provenance or of what they depict. Excluded are aesthetic
manipulations, e.g. selective enlargement, cropping, common since
the beginnings of the negative-positive process, and techniques like
*photomontage where the manipulations are intended to be obvious.

Unlike a drawing or painting, the photographic image is made by
light acting directly on a surface, without intervention by the maker's
hand. As a result, photographs were at first believed to be objects that,
by their very nature, represented 'the truth'; hence the popular
expression 'the camera never lies'. Although critics such as Walter
*Benjamin, Roland *Barthes, Susan *Sontag, and others have
challenged the assumption of veracity, it has died hard, at least until
*digital manipulation became widespread towards the end of the
20th century.

In fact, the perceived veracity of photographic images invites
alteration in the service of untruth. Early tampering might have been
as crude as rubbing someone's image off a *daguerreotype plate or
cutting someone out of a paper print. Methods of manipulation
became more sophisticated as the medium itself evolved. The same
methods of using multiple negatives and/or staged scenes to create
fictional scenes like Henry Peach Robinson's *Fading Away* (1858)
have been employed to produce images of supposedly real events that
either never occurred or were never photographed: Eugène Appert's
(1830–91) *Crimes of the Commune* (1871) are a classic early example.
In 20th-century totalitarian *propaganda, various techniques were
used to alter photographs of important scenes by removing or inserting
key personalities. Crucial in every case is the intention to deceive.
An image produced for another reason might become fraudulent when
used in a secondary way. For example, a manipulated photograph
showing a politician in a compromising but fictitious situation,
originally intended as a private joke, could be treated as fraudulent if
used in an election campaign as evidence of misbehaviour.

Famous photographic forgeries of the past, such as William Mumler's 'spirit photographs', the *Cottingley fairy photographs, or the 'peppered moth' evolutionary fraud might seem laughable now, given the relatively primitive techniques used. But digital technology has entirely altered the situation. In February 1982 the *National Geographic set alarm bells ringing when it used digital means to move the Pyramids closer together to fit a cover, even though the motive was purely technical. The ever-growing sophistication of image manipulation (and generation) tools since that time poses fundamental problems in relation to the veracity of the image.

The rising monetary value of art and classic photographs over the past 50 years has encouraged photographic fraud. In particular, the (usually) much higher value of *vintage prints by comparison with the rest of a photographer's oeuvre has created a strong incentive either to forge them using suitable materials or, more frequently, to pass off later prints as vintage. Other kinds of forgeries endeavour to create new images that mimic a photographer's style, technique, and subject matter. The revival of interest in historic processes and materials has made it possible to recreate such archaic products as daguerreotypes, *tintypes, and *cartes de visite; and examples made, for example, during American Civil War re-enactments have been passed off as genuine period photographs.

Proving that a particular photograph is fraudulent can be difficult and sometimes impossible. Most often authenticity is determined by a combination of approaches: visual examination, including scrutiny of costumes and other objects visible in the picture, reference to documents that may illuminate the historical context, and scientific analysis of the support and other materials. However, some skilled forgeries may escape detection altogether. MSB

See also OCCULTISM AND PHOTOGRAPHY.

Mitchell, W. J., *The Reconfigured Eye: Visual Truth in the Post-Photographic Era* (1994).

Hooper, J., *Of Moths and Men: An Evolutionary Tale* (2002).

Freed, Leonard (b. 1929), American photographer. 'The more ambiguous the photograph is, the better it is. Otherwise it would be propaganda.' This observation, made by Freed when reviewing images from his long career, succinctly indicates why his black-and-white pictures of people are so successful, capturing as they do the frequently quirky, sometimes humorous, sometimes troubling—even violent— situations in which humans find themselves. Born in Brooklyn, Freed initially wanted to be a painter. He travelled to Europe and settled in Amsterdam. He studied with Alexey *Brodovitch, joined *Magnum, and began taking on photojournalism assignments in the USA, Europe, and Israel, where he covered the Six Day War in 1967 and the Yom Kippur War in 1973. He documented New York's Hasidic community, published books on post-war German Jews, *Deutsche Juden Heute* (1965), and studies of American blacks, *Black in White America* (1968). His documentation of police in New York, *Police Work* (1980), seems almost a continuation of *Weegee's photography in the same city. Freed was one of six photographers included in *The Concerned

Photographer exhibition of 1967 conceived by Cornell *Capa and mounted by the Riverside Museum, New York. TT

Rosenkranz, S., *Leonard Freed: Photographs 1954–1990* (1991).

French, John (1907–66), often overlooked in surveys of British *fashion photography of the 1950s and 1960s in favour of his two famous one-time assistants, David *Bailey and Terence *Donovan. Yet this quintessentially English gentleman took fashion photography to a mass audience with the elegant, graphic images he published not only in fashion publications like *Harper's Bazaar, Vanity Fair,* and *The Tatler,* but also in newspapers. Recognizing Fleet Street editors' desire for contrasty pictures, but also aware of the aesthetic limitations of printing them on cheap newsprint, French saw that low-contrast, 'high-key' prints—where most of the detail was in the lighter areas— would reproduce best. To do this, he rejected popular direct tungsten lighting for softer daylight photography, bouncing light off reflector boards. Taking few of the photographs himself, French preferred to work closely with his models (including Pauline Stone and Jean Shrimpton), calmly instructing his assistants to make the exposures. In a career of nearly 10,000 sittings, French's participation in the Allied landing in Sicily during the Second World War was the only hiatus. PM

Fresnel, Augustin (1788–1827), French physicist and optical pioneer, who used a period of house arrest in 1814 to develop the mathematics of light waves, polarization, birefringence, and diffraction (one form of diffraction is named after him), and prepared the ground for *Maxwell's work on electromagnetism. Later he designed a complex prism system for collimating lighthouse beams. This system, in a smaller version, controls the beams of photographic spotlights, and underlies the optics of camera focusing screen brighteners. GS

Fresson process. See ALTERNATIVE (NON-SILVER) PHOTOGRAPHIC PROCESSES.

Freund, Gisèle (1908–2000), German-born French photojournalist. Born into a cultured German-Jewish family near Berlin, she was introduced to photography by her father, an art collector. She later studied sociology with Norbert Elias and Theodor Adorno, researching the impact of photography on portraiture, an unusual topic given that the history of photography was not yet a recognized academic discipline. In 1933 Freund actively opposed the rise of Nazism and fled Germany just ahead of the police. In Paris she continued her studies and supported herself with reportage for *Vu, *Life and other magazines. The publication of her photographs and her thesis, as *Photography and Society,* attracted the attention of Parisian intellectuals. More perhaps than her photojournalism, the portraits she made of André Malraux, Walter *Benjamin, Colette, James Joyce, Virginia Woolf, and others, nearly all in colour, are among her best known work. The outbreak of war forced Freund to flee to Argentina,

but she eventually returned to make France her home. Freund joined *Magnum at Robert *Capa's invitation, but the association ended in 1954 after she was blacklisted in America. In the mid-1980s she gave up photography to give herself more time to read.　　　MR

Gisèle Freund, Photographien und Erinnerungen (1998).

Friedlander, Lee (b. 1934), American street photographer. He was first introduced to photography aged 14, and went on to study at the Art Center in Los Angeles. He later found work photographing jazz musicians for album covers. Friedlander supported himself with freelance commercial work and teaching until the 1960s, when he turned to America's social landscape for his subject matter and the art gallery for his livelihood. Robert *Frank, Walker *Evans, and Eugène *Atget were influences, but Friedlander made the *documentary style associated with these photographers distinctly his own, packing his images with visual information that carried both social meaning and formal complexity. He particularly liked to employ reflective and semi-transparent surfaces in his photographs, thereby creating multiple layers within the frame-bound single image. He worked in series, taking a variety of subjects—including televisions, trees, letters, and himself—as themes in projects of concentrated study. His empathetic prints from E. J. Bellocq's glass-plate *Storyville negatives, which he purchased from a dealer in 1966, helped these mysterious images to celebrity.　　　MR

Slemmons, R., *Like a One-Eyed Cat: Photographs by Lee Friedlander, 1956–1987* (1989).

Friends of Photography, Carmel, California, group founded in 1967 by Ansel *Adams, Morley Baer, Beaumont and Nancy *Newhall, Brett *Weston, and others from the *Group f.64 school, with the aim of promoting creative photography and supporting its practitioners. After Adams's death in 1984, the organization moved to San Francisco where the Ansel Adams Center for Photography opened in 1989. Over its 30-year history the Friends mounted many major exhibitions, published catalogues and monographs, and organized workshops and educational programmes. As a consequence of confused goals, dwindling membership and financial difficulties, but also of photography's by now established position in the cultural mainstream, the organization closed its doors in October 2001.　　　TT

Friese Greene, William (1855–1921), English photographer and inventor of early cinematographic apparatus, although most authorities now dismiss the claim that he was the inventor of 'commercial kinematography'. During the 1880s, he worked with the lanternist J. A. R. Rudge. In 1889, with Mortimer Evans, he patented an apparatus for taking 'photographs in rapid series', which some saw as the beginnings of the cinema. In fact, *Marey and Le Prince had already anticipated his ideas, and it has been shown that his apparatus was incapable of successfully synthesizing motion. Other interests included stereoscopic cinematography, colour cinematography, and electrical printing without ink.　　　JPW

Frima, Toto (b. 1953), self-taught Dutch photographer who has worked since 1979 almost exclusively with polaroids. She became known for her nude self-portraits, often in diptych or triptych form, made with an SX-70 camera. From the mid-1980s she also used a large-format (50×60 cm; 19.7×23.6 in) camera, which required careful planning and technical assistance. In 1990 the Rheinische Landesmuseum, Bonn, mounted a large exhibition of her work. Her principal subject continues to be herself.　　　RL

Toto Frima 50×60 (1990).

Frissell, Toni (1907–88), successful American commercial photographer of the inter-war years: a remarkable achievement for a woman because of the travel and corporate demands. But Frissell was a maverick. The daughter of a New York physician, she had a privileged childhood. Through family connections she began her career as a writer for *Vogue*, where the editor, Carmel Snow, pointed her towards photography. Frissell learned it from her brother, the documentary film-maker Varick Frissell; then apprenticed to Cecil *Beaton. Her fashion images and *celebrity portraits appeared regularly in *Vogue* from 1931 to 1942, and *Harper's Bazaar* from 1941 to 1950. As her career soared she was often on assignment, leaving her two children with their nannies and her husband, Francis McNeill (Mac) Bacon III. Frissell excelled at outdoor photography, and favoured small cameras to achieve more natural, spontaneous results. She produced journalistic photographs for the Red Cross and the US Women's Auxiliary Army Corps during the Second World War, and action pictures for *Sports Illustrated* in the 1950s. The Library of Congress, Washington, DC, contains 340,000 Frissell items, including her own selection of her 1,800 best prints.　　　PJ

Toni Frissell, Photographs: 1933–1967 (1994).

Frith, Francis (1822–98), English photographer who made his photographic reputation with images from his journeys to Egypt and Palestine between 1856 and 1860. Prior to this, however, he was a successful businessman who, becoming increasingly attracted to photography, helped to found the Liverpool Photographic Society in 1853. By 1855 he had sold his grocery and printing businesses in order to devote his time to photography. On returning to Britain, he married and moved to Brightlands in Reigate. From this base he embarked on his most ambitious photographic project, the documentary coverage of Britain, which would be his lasting legacy. The photographic company he established in 1859, Francis Frith & Co., sold British views for illustration and as stereographs published by *Negretti & Zambra; it continued as a family business until 1960. The firm was one of the first suppliers of mass-market photography in Britain. In his later years, Frith distanced himself somewhat from the day-to-day running of the company, devoting much of his time to publishing books and essays on his Quaker faith and evangelical Christianity.　　　KEW

Nickel, D. R., *Francis Frith in Egypt and Palestine: A Victorian Photographer Abroad* (2004).

From today painting is dead exhibition, at the Victoria & Albert Museum, London, 16 March–14 May 1972. Arguably the most influential British photographic exhibition of the modern period, its title was derived from the remark allegedly made by the French painter Paul Delaroche on learning of *Daguerre's process. Subtitled 'The Beginnings of Photography', the show married early equipment and images in ways that inspired a new interest in photography and photographic history, and its success resulted from a happy amalgam of curatorial, design, and institutional skills. The curator was Dr David Thomas of the Science Museum, assisted by Gail Buckland of the *Royal Photographic Society. The exhibition was designed by Robin Wade and sponsored by the Arts Council. JPW

'*From today painting is dead*': The Beginnings of Photography (1972).

Fryston, Yorkshire. See HULME, JACK.

f.64. See GROUP F.64.

f-stop. See APERTURE CONTROL.

Fukase, Masahisa (b. 1934), Japanese photographer, born in Hokkaido into the family of a photo-studio owner. His first solo show, *Sky over an Oil Refinery*, was in 1960. After working for an advertising agency, Fukase went freelance in 1968, and his Tokyo-based series *Homo Ludens* (1971) was followed in 1978 by *Yoko*, about his wife and their life together. After his divorce in 1976 he had returned to Hokkaido, where he shot a series on crows in the 1970s, and later (1987) *Ravens*, a dark and haunting work. The importance of family in his work continued with *Family* (1971–90), a document of his parents' home and family members from a fixed viewpoint; and *Memories of Father* (1991), of his dying father. In 1992 Fukase was disabled by a serious accident. MHV

Ollmann, A., *The Model Wife* (1999).

Fukuhara, Shinzo (1883–1948), Japanese modernist photographer. After studying in New York and Europe he returned to Japan in 1913. Though working for the cosmetics company Shiseido under his father he devoted much time and effort to his own art photography and to developing forums for other art photographers. In 1921 he formed the group Shashin Geijutsusha (Art Photography) with Roso Fukuhara and launched a magazine of the same name. He published *Paris and the Seine* in 1922 and *Hikari to sono kaicho* (*Light and Harmony*) in 1923. A major influence on his contemporaries, he helped to found the Nihon Shashinkai (Japan Photographers' Group) in 1924. MHV

Fulhame, Elizabeth, 18th-century Scottish (?) pioneer of photographic imaging. Count Rumford greatly admired the 'ingenious and lively Mrs. Fulhame', who in 1794 published her *View to a New Art of Dying and Painting*. Encouraged by Joseph Priestley, she detailed her *c.*1780 method of photographically creating images on cloth by utilizing the salts of gold. A woman of strongly feminist views, she

disappeared from view by 1800. Although no examples of her photography have been uncovered, her processes influenced both her contemporaries and the pioneering photographic researches of Sir John *Herschel. LJS

Schaaf, L. J., 'The First Fifty Years of British Photography: 1794–1844', in M. Pritchard (ed.), *Technology and Art: The Birth and Early Years of Photography* (1990).

Fulton, Hamish (b. 1946), British conceptual artist and landscape photographer. Since the 1970s, Fulton, who describes himself as a 'walking artist', has produced photographic images and other works inspired by walking across the world, on the principle of 'no walk, no work'. In addition to photography, he uses drawings, sculpture, and wall paintings, together with texts, to encapsulate his experiences. LAL

Fulton, H., et al., *Hamish Fulton: Walking Artist* (2002).

Funke, Jaromir (1896–1945), Czech photographer, who began freelance photography in 1922 after abortive medical and legal studies. From 1931 he taught photography at the School of Arts and Crafts, Bratislava, and also studied aesthetics there, before becoming a professor at Prague's State Graphic School (1934–44).

Funke's images of chance arrangements and *objets trouvés* sought supra-reality in reality; he was central to the Czech avant-garde in the 1920s and 1930s, gaining wide international recognition. Although he described his work as photogenism or poetism rather than *Surrealism, it both informed and was influenced by *Man Ray's *photograms and French Surrealism. RA

Jaromir Funke 1896–1945: Pioneering Avant-Garde Photography (1996).

Fürstenhofrunde, Vienna. See AUSTRIA.

Fuss, Adam (b. 1961), British photographer, resident in New York. He has used the cameraless image and the *photogram, creating a photographic language of beauty and strength. Working with large-format coloured paper, but also with historic processes such as the *daguerreotype, Fuss explores and redefines our notions of what constitutes a photograph or an image. Organic materials such as flowers, plants, animals and their entrails, water, smoke, and egg yolk are combined to evoke themes of time, energy, chance, memory, and death. J-EL

Futurism and photography. The ideology of the Italian Futurists, whose manifesto was published on the front page of *Le Figaro* in 1909, celebrated technological progress and the machine age. The artists associated with the group sought material expressions of *kinesis* and *dynamis*, movement and energy, which were held up as paradigmatic values of the new modern sensibility. A frontal attack on the past and, on the level of aesthetics, a denial of movements such as *pictorialism, Futurism would seem to have found its ideal medium in photography, yet the relationship between the two was fraught with conflict. While

the photographic image was on one level the perfect marriage of art and science, its static and lifeless nature was antithetical to the Futurist concept of 'universal dynamism': rather than expressing the perpetual activity of life, photography arrested it. The Futurists therefore did not immediately accept photography as an art form, but deployed it propagandistically: members posed for their portraits, which were then circulated as *postcards and in the press in order to publicize the group; photography was also used to record its activities. For the Futurists, the fact that photography lent itself to the manipulation of reality, that an image could be constructed, only underscored the notion that the camera could not be relied upon to express universal dynamism. The *Bragaglia brothers, however, challenged this. Influenced by the ideas of the prominent Futurist Umberto Boccioni (1882–1916), the *chronophotography of Étienne-Jules *Marey, and also by Henri Bergson's theories of movement, in 1911 Anton Giulio Bragaglia began developing an aesthetics of 'photodynamism' while his brother Arturo handled the production of images. Photodynamism involved high-key lighting and long exposures to capture sudden gestures in a way that depicted movement as an indivisible reality, rather than a sequence of static poses. In 1913 they were accepted into the group and photodynamism became the first Futurist expression of photography as an art form. Yet the Bragaglias' place in the group was short-lived as Boccioni came to reject all photography as mechanical and therefore outside the realm of artistic expression. The Bragaglias were thus excommunicated from the group, though they continued their research and maintained relations with many of its members. In addition to the use of photography for purposes of propaganda and the photodynamism of the Bragaglias, the Futurists experimented with photo-performance. Working with the conception of photography as a constructed reality, the painter and sculptor Fortunato Depero (1892–1960), among others, pushed portraiture in new directions by play-acting to the camera. The result captured something of the dynamism so vital to Futurist aesthetics by presenting an explosive and emotive alternative to conventional portraiture. The coming of war in 1915, and later the rise of fascism, ultimately led to the dissolution of Italy's first avant-garde art movement, but not before the work of the Futurists had stimulated an interest in experimental uses and techniques of photography. MR

Bragaglia, A. G., *Fotodinamismo futurista* (1913).

Lista, G., *Futurism and Photography* (2001).

Gabor, Dennis (1900–79), Hungarian-British physicist and electronics engineer best known for his discovery of the principles of *holography, for which he received the Nobel Prize for Physics in 1971. Educated in Budapest and Berlin, he fled Nazi Germany for Britain in 1933, where he found employment with Thomson-Houston in Rugby as a research engineer. In 1947 he was engaged in research in electron microscopy, and conceived the idea of recording and reconstructing a wavefront as a possible method of improving image resolution by recording the electron wavefront and replaying the resultant hologram (his own coining) using visible light, obtaining enormous magnification. He made the first holograms using mercury light, but they were only partially successful, and their practical realization had to wait for the insights of other workers such as Emmett *Leith and the invention of the laser. In the meantime, other methods of image enhancement had rendered Gabor's original ideas redundant. He retained his interest in holography until his death, and was one of the first persons to sit for a holographic portrait. GS

galleries of photography. The Photographic Society (later *Royal Photographic Society) had the first dedicated gallery of photography, mooted in 1853 when the society was set up, and at its various locations in London was able to stage a series of shows, as well as its annual exhibition. A move to the Octagon in Bath in 1980 allowed more ambitious exhibitions, but this had to close in 2002.

In 1905 Alfred *Stieglitz set up the Little Galleries of the *Photo-Secession (later renamed *Gallery 291) on Fifth Avenue, New York, not just for photography, but also for painting and sculpture, with monthly exhibitions organized by Stieglitz. A startlingly original way of promoting photography by curatorial sponsorship and exhibitions on a commercial marketing basis was perhaps inevitably American. However, it moved almost completely away from photography and closed in 1917. Stieglitz subsequently reopened with photography at the Intimate Gallery (1925), and then at An *American Place (1929–46).

New York was the gallery hub, where the Julien *Levy Gallery showed photography from 1931 until 1946 alongside its modern art, and from 1954 to 1961 Helen Gee's Limelight café and gallery had some 70 exhibitions of both modern and historical photography, mainly as one-man shows. The Image Gallery also had *Weegee and *Winogrand shows in 1960. But perhaps the key development was the opening of Lee Witkin's gallery of photography in 1969. From then to the 1970s commercial galleries expanded rapidly, particularly in SoHo.

Galleries have since opened in many cities, either as commercial operations, or, particularly in the UK and USA, as part of alternative cooperative photography centres such as the *Friends of Photography (Carmel, then San Francisco), Lightwork (Syracuse), and Los Angeles and Houston Centres for Photography. Notable in the UK was the Half Moon Photography Workshop, founded in Bethnal Green, London, in 1973, with a more political agenda. Other European countries have also had such centres, such as Toulouse, Rotterdam, Athens, Graz, Tarragona, Milan, and Helsinki. In the Ginza district of Tokyo, galleries sponsored by the major Japanese camera manufacturers, and Leica, mount regular, usually weekly shows.

The first dedicated photography gallery in the UK was the Photographers' Gallery, founded by Sue Davies in London in 1971, which has been at the forefront of contemporary photography ever since. Britain has also benefited from a series of state-funded dedicated photography galleries since the 1980s—Cornerhouse (Manchester), Side (Newcastle), ffotogallery (Cardiff), Open Eye (Liverpool), Impressions (York), Site (Sheffield), and Waterside (Bristol).

There are now commercial photography galleries everywhere, each representing their stable of photographers. Generally they are unable to show large exhibitions, but one that has had great impact is the Saatchi Gallery (1985), London, showing contemporary photography since the late 1980s, and the controversial *I am a Camera* exhibition in 2001. Galleries now also form part of major dedicated photography centres and museums, such as the Museum of Photography, Film, and Television, Bradford, the Maison Européenne de la Photographie, Paris, and the *International Center of Photography, New York. RA

Gallery 291. Opened by the *Photo-Secession group in New York in 1905, the Little Galleries of the Photo-Secession became known by its Fifth Avenue address simply as '291'. Alfred *Stieglitz and F. Holland *Day were the primary founders of the Photo-Secession, but Edward *Steichen actually located the Fifth Avenue space and helped in the design and development of *Camera Work*, the gallery's celebrated journal. Other people, of many, at the founding were Clarence H. *White, Gertrude *Käsebier, and Joseph Keiley. By 1908, Stieglitz's focus was on the introduction of European modernist painting and art to the United States. *Brancusi, Cézanne, Matisse, Elie Nadelman, Picasso, Picabia, Henri Rousseau, and Toulouse-Lautrec all received shows at 291. The gallery closed in 1917 when

Stieglitz began to concentrate on his own work, particularly portraits of his wife, Georgia O'Keeffe. TT

Whelan, R., *Alfred Stieglitz: A Biography* (1995).

Galton, Sir Francis (1822–1911), English explorer and polymath, remembered today primarily as the founder of the eugenics movement; but also a scientist who used photography as a research tool.

Around 1875 Galton was asked by HM Inspector of Prisons to examine photographs of criminals to ascertain whether a distinct type of facial feature could be associated with criminality. From this project came the idea of composite portraiture. Galton experimented with stereoscopes and lantern dissolving views before discovering that successive brief exposures of three different full-face portraits on a single plate produced the 'generic' image required. He went on to apply similar techniques to families, races, and 'lunatics'. He later tried to perform the opposite task by expunging all the typical characteristics but preserving peculiarities. Termed 'Analytical Photography', this technique involved exposing a negative composite in front of a positive portrait. It was not a success. Inspired by *Muybridge's motion studies, Galton also applied his composite technique to galloping-horse photographs. He believed the results explained why artists had misrepresented animal motion for so many years. Galton's interest in personal identification led him from composite photography to fingerprints, and he published recommendations for recording them photographically. He was knighted in 1909. JPW

See also MENTAL ILLNESS, PHOTOGRAPHY AND THE STUDY OF; POLICE AND FORENSIC PHOTOGRAPHY.

Forrest, D. W., *Francis Galton* (1974).

Gamma, French photo *agency, founded in January 1967 by a group including Hubert Henrotte of *Le Figaro* and the photographer Raymond *Depardon, who, with Gilles *Caron, was to establish Gamma's reputation for buccaneering coverage of conflict in France and worldwide. In 1973 over-rapid expansion caused a split, with Depardon taking over management of Gamma and Henrotte leaving to found a rival organization, Sygma. But Gamma continued to develop into a large, heavily capitalized organization with, by *c.*2000, over 50 staff and associate photographers and *c.*1,500 stringers worldwide. Its archive held *c.*25 million images. RL

Amar, P.-J., *Le Photojournalisme* (2000).

Garcia-Rodero, Cristina (b. 1949), Spanish photojournalist who studied both photography and painting. She became interested in Spanish folk and religious culture and travelled widely to record provincial popular festivals. Later she examined similar subjects in other cultures, including religious rituals in Haiti (2001). She has also worked as a portraitist, landscape photographer, and teacher. LAL

Garcia-Rodero, C., *España oculta* (1989).

garden and plant photography. Garden photography has emerged relatively recently as a specialist genre, to satisfy a lively market in garden-related books and magazines. However, photographers of all kinds have responded to the beauty of plants and gardens since photography began. Henry *Talbot looked no further than his own house and garden at *Lacock Abbey for subjects for his experiments. His contact print of a leaf, made in 1839 and published in *The Pencil of Nature* in 1844, was one of the very first images to have been preserved by photography. Pioneering topographical photographers in the mid-19th century, such as Clausel in France and *Fenton in England, made little distinction between natural landscape and man-made features, including parks and gardens.

Some of the great masters of photography have made occasional forays into the garden to create telling images. Among them were *Stieglitz and *Steichen in the USA, but there have been few more evocative photographs of gardens than Eugène *Atget's series of Saint-Cloud and Parc de Sceaux, which formed part of his obsessive photographic study of Paris from 1890 until his death in 1927. These monochrome pictures, which show public spaces devoid of people, and which were made in overcast and often foggy conditions, have an arresting mystery, and appeal to modern sensibilities by their use of a short-focus (wide-angle) lens.

Plant forms have also been the inspiration for great photographic art. When Edward *Weston made his famous pictures of peppers around 1930, he seized upon the fruits' anthropomorphic qualities. Isolated from any horticultural context, they look like writhing human bodies. The German photographer Karl *Blossfeldt made a life's work of close-up studies of plant forms. He would take a flower, a leaf, a collection of seedcases and, laying them against flat backgrounds, would conjure them into exquisite abstract patterns and forms. The English gardener-turned-photographer Charles Jones (1866–1959), whose work has recently been rediscovered, made photographic records of his prize fruits and vegetables. Here the plain backgrounds have the effect of removing any sense of scale, so that the garden harvest appears monumental and surreal. In the late 20th century, images of plants appear almost as light relief in the otherwise confrontational homoerotic work of Robert *Mapplethorpe. Even then, his choice of callas and lilies may well have been guided by their prominent display of sexual parts.

Garden making itself is an art form, and arguably the most successful garden photographs are those that aim only to make a record. Such are the prints by the forgotten photographer Charles Latham, who made a priceless record for *Country Life* of the greatest English gardens before many of them vanished forever in the First World War. About the same time, the pioneering plant photographer Reginald Malby was lugging his teak and brass half-plate camera around the Alps to record alpine plants in their natural habitat. His book *With Camera and Rucksack in the Oberland and Valais* appeared in 1913.

Edwin *Smith's black-and-white pictures, reproduced by *photogravure in Edward Hyam's book *The English Garden* (1964), are a beacon of excellence, recording with unsurpassed artistry the modest cottage garden as well as the grandest of parks. At that time,

practical gardening books were appearing, illustrated by Ernest Crowson, J. E. Downward, and the retired schoolmaster Harry Smith. Colour reproduction was poor, however, and it took another generation of improvements in cameras, film, and printing before the flood of garden publications became possible from the 1980s onwards. A new breed of specialists arose to satisfy this demand, among them Valerie Finnis, herself a noted gardener. Garden photography became a distinct niche of the profession, alongside fashion and cookery work.

Garden photography itself tends to be unburdened by technical problems—it is largely outside work in natural light. However, the subject matter is demanding, because plants and gardens are ephemeral in their beauty, and need to be caught at the right time and in benign weather and light. The modern garden photographer is itinerant, chasing the seasons between continents. Leaders in the field, such as Marina Schinz (USA), Jerry Harpur (UK), and Marijke Heuff (Holland) have spent their working lives on the move between locations. The market place for garden photography is international and diverse. Many publications are entirely practical, but others such as *Gardens Illustrated* (launched in 1993) are inspirational and have promoted artistic photography that holds its own beside the work of Atget, Blossfeldt, and Edwin Smith. AL

Nichols, C., *Photographing Plants and Gardens* (1998).

Griffiths, M., *Gardening: A Century in Photographs* (2000).

Gardin, Gianni Berengo (b. 1930), Italian photographer. Born in Santa Margherita Ligure, he took up photography in 1954, specializing in photojournalism and documentary work. His pictures first appeared in the weekly *Il mondo*, and subsequently in numerous other publications in Italy and abroad. He also did corporate work for Fiat, Olivetti, and Alfa Romeo. In 1979 he began collaborating with the architect Renzo Piano, documenting the various stages of Piano's projects. Gardin has exhibited internationally and published *c*.150 books. MR

Gardner, Alexander (1821–82), Scottish-born American photographer. He taught himself photography *c*.1843 and reported for the Glasgow *Sentinel* before moving to Washington in 1858 to operate a gallery for Mathew *Brady. Gardner was one of several photographers who worked for Brady in the American Civil War and, with Timothy O'Sullivan, he resigned in 1863 in protest against Brady's failure to credit others, eventually opening his own studio. He made many of his surviving post-1863 views while serving as official photographer for the army of the Potomac. Especially notable is his two-volume *Gardner's Photographic Sketch Book of the War* (1866), incorporating images with lengthy captions which memorialized and made iconic key sites of Union victory and loss. After the war Gardner photographed the trial and *execution of the Lincoln conspirators; in 1867 he became official photographer for the Union Pacific Railroad, and created a significant body of *stereographic images of Great Plains Native American tribes and striking western landscapes. CBS

Garnett, William (b. 1916), American photographer. He served as a photographer with the Signal Corps in the Second World War and became noted for his aerial work, published in *Life and other magazines. He taught at the University of California, Berkeley, for many years and developed strong ties with the conservation and land-use movements, working closely, for example, with the architect Nathaniel Owings. Often shooting vertically down through a trapdoor in his small plane, Garnett creates beautifully patterned images of fields and desert landscapes. TT

Garnett, W., *William Garnett, Aerial Photographs* (1994).

gaslight paper. This chemically developed silver chloride or chlorobromide paper used the first contact-speed emulsion fast enough to be printed by gaslight. The colloquial description persisted into the 1930s, by which time electricity was the dominant artificial light source, and 'gaslight' signalled the paper's relative slowness in comparison with bromide papers. Manufactured from the early 1880s, usage was limited until the introduction of Velox paper in 1893. Most papers had gelatin emulsions, although a collodion variant was current from 1895 into the 1910s. Gaslight paper was inexpensive and easy to handle; it was popular for contact-printed photographs until the 1960s, when the supremacy of 35 mm negatives made enlarging paper imperative. HWK

Gaussian optics. The German mathematician and physicist Carl Friedrich Gauss (1777–1855) made a contribution to optics that made possible the design of modern optical objectives; his designs are still the basis of a whole family of camera *lenses. He extended Newton's laws of optics, which originally considered only 'thin' lenses (i.e. lenses that could be considered as existing in a single plane), to real lenses that could be thick or contain several components. He showed that any lens could be treated by Newtonian methods when described in terms of six *cardinal points*, namely the front and rear principal foci, principal points and nodal points, and the planes through these points. If the lens is wholly in air, the principal and nodal points coincide with one another.

Gauss began with the premiss that the actual path of the rays through the lens could be ignored: it was the path of the rays into, and out of, the lens that mattered. He then showed that the entry and exit paths of a ray could be established in terms of the principal (or nodal) planes. A ray entering the lens, and (when produced) crossing the front principal plane at a particular point, would emerge as if it had originated at the corresponding point on the rear principal plane (Fig. 1). The normal rules for geometrical optics are now followed, the space between the principal planes being ignored.

The positions of the nodal points are established using a different procedure. A ray entering the lens that emerges without change of direction, when produced forwards from the point of entry and backwards from the point of exit, intersects the optic axis at the front and rear nodal points respectively (Fig. 2).

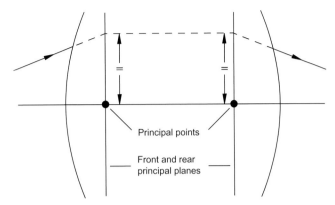

Fig. 1

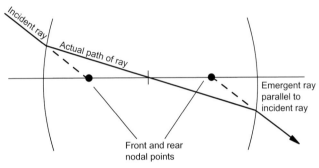

Fig. 2

Fig. 3a

Fig. 3b

The position of the rear nodal point is a critical factor, as the focal length is measured from the rear nodal point. In a conventional (prime) lens the nodal points are about one-third of the way inside the lens, though this may vary (in the Rapid Rectilinear lens of the 1860s the nodal points were actually crossed). In a *telephoto lens the rear nodal point is well in front of the lens itself, so that the physical dimensions of the lens are less than its focal length. In most *wide-angle lenses the rear nodal point is well behind the lens (a *retrofocus* configuration) to give space inside the camera for the reflex mirror (Figs. 3a and b). A *zoom lens operates by shifting the components along the optic axis to move the rear nodal point from behind the lens (short focus) to in front of it (long focus). GS

Buchler, W. K., *Gauss: A Biographical Study* (1987).
Saxby, G., *The Science of Imaging: An Introduction* (2002).

gay and lesbian photography can be conveniently defined as photography, not necessarily sexual in content, relating to or tending to promote the identity and concerns of the homosexual community. For practical reasons, and given that picture making and exchange per se have played a significant role in the community's formation, the photographers themselves have usually been homosexual or bisexual; but not necessarily.

Photographs by gay men and lesbians exhibiting homosexual themes have a long history ranging from the art mainstream to the edges of gay and lesbian private life. Private erotic pictures and heavily traded *postcards found gay male audiences during the late 19th century. While small, the number of private photographs still extant hints at a much larger original lode of homosexual images. Many of these photographs have been destroyed or hidden over the years, and only recently have any been collected and published. The first photographs taken by identifiable gay and lesbian artists include late 19th-century images by Alice *Austen, F. Holland *Day, and Wilhelm von *Gloeden. Such photographs were often couched in the language of *pictorialism or classicism, making them safer for public consumption. The early 20th century saw more photographers engaged in the active depiction of gay and lesbian life, including Germaine *Krull's staged lesbian encounters, *Brassaï's pictures of Parisian night life, and George Platt *Lynes's photographs of his friends and sexual partners.

The gay liberation movement of the 1970s set the stage for gay and lesbian photographers to make and publicize pictures with openly homosexual content, in galleries, bookshops, and periodicals such as *On our Backs*. JEB (Joan A. Biren; b. 1944) undertook a lesbian portrait project during the 1970s, and Tee A. Corinne (b. 1943; both a photographer and the chronicler of the important lesbian photography movement on the American West Coast) broke new ground with her 1982 series *Yantras of Womanlove* which used negative printing, multiple exposures, and *solarization to depict lesbians making love. Also during the 1970s, Duane *Michals's series of story photographs and Arthur *Tress's surreal fantasy photographs along the New York docks drew gay male photography to the edges of mainstream consciousness. The most celebrated late 20th-century gay or lesbian photographer was Robert *Mapplethorpe, whose portraits of black men and sadomasochistic sexual practices spurred controversy both within and outside the community. The furore surrounding the cancellation of his show *The Perfect Moment* by the Corcoran Gallery of Art in Washington, DC, in 1989 led for a while to the sidelining of

gay and lesbian photographic work by nervous museum directors, and threatened the careers of many equally worthy gay and lesbian photographers. Portrait series such as those by Catherine Opie (b. 1961) and Robert Giard were among the better-known and more important contributions of the 1990s to gay and lesbian photography. Opie's *Being and Having* (1991), which depicts lesbians wearing false moustaches and beards, plays aggressively with stereotypes of masculinity and femininity as they relate to sexuality. Giard's *Particular Voices* project, a compendium of portraits of writers, helped to commemorate 20th-century gay and lesbian culture, an important concern considering the devastation caused by AIDS and the critical neglect of much gay and lesbian literary production. These projects, among others, indicate a concern on the part of photographers to give gay and lesbian life a public face. PC

Boffin, T., and Fraser, J., *Stolen Glances: Lesbians Take Photographs* (1991).
Ellenzweig, A., *The Homoerotic Photograph* (1992).
Bright, S., and Posener, J., *Nothing But the Girl: The Blatant Lesbian Image* (1996).
Waugh, T., *Hard to Imagine* (1996).
Hammond, H., *Lesbian Art in America: A Contemporary History* (2000).

gaze, the. See THEORIES OF PHOTOGRAPHIC MEANING.

genre photography. Like genre paintings, genre photographs evolved in many directions in the second half of the 19th century, encompassing a vast array of subjects, from domestic scenes and re-creations of theatrical, literary, or fairy-tale subjects to pictures of village and small-town life. Genre images in both media usually incorporate a *staged narrative, and a sentimental, moralizing, or humorous gloss that distinguishes them from *realism or *naturalism. Sequential treatment expanded the storytelling element still further. A classic of Victorian painted genre was Augustus Egg's three-part moral melodrama *Past and Present* (1858). Four years earlier, Roger *Fenton had created a courtship sequence, *A Romance*, with the titles 'Strong flirtation of which one spectator highly disapproves', 'Popping the question', 'Sealing the covenant', and, 'The honeymoon'.

Genre painting was experiencing a revival just as photography was establishing itself in the middle decades of the 19th century. Although some early photographs taken by *Talbot and *Hill and Adamson in the 1840s seem influenced by this, the acknowledged masters of genre photography emerged later with the establishment of photographic societies and salons of 'art' photography. Photographers in the 1850s who were concerned to establish the medium's aesthetic credentials were often drawn to the genre mode, doubtless with the aim of emulating successful painters like Sir David Wilkie and William Powell Frith. Not only Fenton but Oscar *Rejlander, Henry Peach *Robinson, Julia Margaret *Cameron, and Charles *Dodgson are among those associated with genre photographs of various kinds. Their work illustrates the breadth of the term *c.* 1850–90. Rejlander went in for heavily moralizing subjects. Cameron recreated celebrated literary

Anon., Italian

Italians eating pasta, late 19th century. Albumen print

scenes. Dodgson captured children's *tableaux vivants*, and in individual studies evoked the types of child character popular in Victorian fiction. Robinson's country maids (actually middle-class girls dressed up), photographed in the environs of Leamington Spa, convey urbanizing England's increasingly idealized image of rustic life. (By contrast, *Sutcliffe's fisherfolk and *Emerson's rural workers are more naturalistically observed.) In Germany, where industrialization set in later and more rapidly than in England, both genre painting and photography, with particular emphasis on sentimentalized peasants and fishermen, retained a strong position at exhibitions and on the market. In Italy, pictures of travelling musicians (*pifferari*), water gatherers, and picturesque villagers eating spaghetti, by photographers like Michele Amodio and Filippo Belli (1836–1927), were an important part of the country's sizeable tourist photograph industry.

Quantitatively, however, the genre 'salon' photograph was insignificant compared with the industry created by genre *stereographs, often devised and marketed in sets. Production of these peaked in the 1850s and remained strong for decades, with publishers like the London Stereoscopic Company and *Underwood & Underwood marketing thousands of series and individual cards. All kinds of fictional narratives were used, from *Hamlet* to *Little Red Riding Hood* and saucy bedroom farces. (Many *erotic sets, anticipating later peepshow, film, and video mini-narratives, might also be classified as genre.) But the term genre also widened to include real-life scenes that were essentially proto-*documentary in character. By the early 20th century, classic genre was being eclipsed both by *modernism and by the rise of the unstaged, more personal *snapshot. KEW

Jones, J., *Wonders of the Stereoscope* (1976).

Dewitz, B. v., Siegert, D., and Schuller-Procopovici, K. (eds.), *Italien sehen und sterben: Photographien der Zeit des Risorgimento (1845–1970)* (1994).

Genthe, Arnold (1869–1942), German-born American photographer who received a doctorate in philology and linguistics from Jena University in 1894. As a photographer he was self-taught, and is probably best known for his pictures of Chinatown in San Francisco (1896–1906), where he opened a portrait studio in 1897, two years after arriving in America. Although his studio and equipment were destroyed in the 1906 earthquake, his prints survived and the Chinatown photographs were published in 1908. In that year he also started making *autochromes. Genthe travelled widely in South America, Japan, and Germany, photographing landscapes and architecture, and in 1910 exhibited at the International Exhibition of Pictorial Photography in Buffalo organized by Alfred *Stieglitz. Relocating to New York in 1911, he flourished as a *celebrity portraitist. He also became celebrated for his dance photographs, published in *The Book of Dance* (1916) and *Impressions of Isadora Duncan* (1929). His autobiography, *As I Remember*, appeared in 1936. It has subsequently been shown that his Chinatown photographs, mostly taken with a hidden camera, were manipulated (for example by removing superfluous figures, and signs in English) in much the same way that Edward S. *Curtis's photographs of Native Americans were

retouched to eliminate distracting elements that might undermine the supposed 'authenticity' of the image. TT

Tchen, J. K. W., *Genthe's Photographs of San Francisco's Old Chinatown* (1984).

George Eastman House. See INTERNATIONAL MUSEUM OF PHOTOGRAPHY.

Germany. The older literature tended to depict Germany—i.e. the territories eventually forming the German Empire in 1871—as one of the cradles of early photography. Probably early in 1839, in fact, the Munich scientists Franz von Kobell (1803–82) and Carl August von *Steinheil succeeded in making paper negatives of local sights, and Steinheil revealed the details of their process to the Bavarian Academy of Sciences on 13 April. However, they were not independent of events in France and England, and it was the techniques developed there that soon came to dominate photography's development in Germany.

Early history

As in other countries, it was the *daguerreotype which attracted most attention in larger German towns and the press from August 1839. Already that year, daguerreotypes were exhibited for sale, in Hamburg by the optician and instrument maker Rudolf Koppel, and in Berlin by the art dealer Louis Sachse and the optician Theodor Dörffel. Other cities such as Munich, Cologne, Dresden, and Leipzig followed almost immediately. Brochures with descriptions of Daguerre's process were circulating in Germany by the late summer of 1839. Opticians, booksellers, picture dealers, and pharmacists saw photography as a both fascinating and marketable product that could be sold at high prices—sometimes equivalent to a workman's monthly pay. When portraiture became feasible in 1841, the medium's commercial exploitation really began. Daguerreotypists travelled from town to town offering their services: for example, the Swiss-born Johann Baptist *Isenring in south Germany, or the Weninger brothers from Vienna in the north. At the same time, 1841–2, the first studios were started in Hamburg (Hermann *Biow) and Berlin (J. C. Schall). Recognized both by contemporaries and later critics were, among others, the pioneers Carl Ferdinand *Stelzner, Joseph *Albert, Franz *Hanfstaengl, and Hermann *Krone. Specialist periodicals began appearing in the mid-1850s, such as the Prague-based *Photographisches Journal* (1854–65), then the *Photographisches Archiv* (1860–97) in Elberfeld and the *Photographische Mitteilungen* founded by Hermann Wilhelm *Vogel in 1864.

The rapidly developing commercial sector was dominated by small businesses, mostly studios with one or two employees. The occupational statistics published under the empire showed 4,574 people working in photography in 1875, 6,364 in 1882, as many as 11,851 in 1895, and 19,406 in 1907. The percentage of women rose from 7.5 per cent in 1875 to 18.7 per cent in 1907. Although many did processing or finishing jobs in factory-like conditions, a growing

Hans Breuer

German soldiers leaving for China, 1900

number had important front-of-house jobs in studios or, as with the successful Elvira Studio in Munich, ran their own. The Berlin *Lette-Verein's excellent women's photography school, founded in 1890, expanded rapidly. The state-subsidized Munich Photography School, founded in 1900, opened its doors to women in 1905.

Camera and equipment manufacture became an important industry. A sizeable infrastructure developed, from which firms like *Zeiss, *Voigtländer, and Agfa emerged. Eventually the German photographic industry, concentrated especially around Berlin and Dresden, became the largest in Europe. German firms also led the field in related branches like *album manufacture and, from the turn of the century, *postcard production.

From 1839 until the early 1850s, the daguerreotype was the dominant process, but was then rapidly supplanted by the *wet-plate process,

which remained dominant into the 1870s. It was then replaced by the gelatin *dry-plate process. Although *roll-film appeared with the arrival of Kodak cameras at the end of the 1880s, it was not used by professionals until the First World War.

If portraiture was the backbone of commercial photography, it should not be forgotten that the reproduction of works of art (painting, sculpture, and prints), as well as landscape, topographical, architectural, and documentary work was also done by many firms. It is problematical to treat these branches of photography purely in aesthetic terms, or divorced from trends in the fine arts or from practice in other countries. In Germany, as elsewhere, the question of whether photography was an art was discussed. But attempts to formulate the medium's autonomous aesthetic capability in radical terms were rare before the rise of *pictorialist 'art photography'

(*Kunstfotografie*) in the late 1880s and early 1890s. In visual terms, professional photographers tended to rely on current fine-art conventions, while using the latest technical innovations, such as retouching of negatives and prints, hand colouring, the use of electric light in studios, *stereo photography, and new developing and copying techniques; also new formats as they appeared (**cartes de visite* from *c.*1860, *cabinet prints from the 1870s).

1880–1918

In the last quarter of the 19th century, as photography became increasingly widespread even among the lower middle class, and as important changes occurred in the visual arts, commercial photography came in for increasing criticism. It came mainly from middle-class amateurs, who found much to find fault with, primarily with professional portraiture, but to a degree also with view photography. They not only rejected excessive retouching, unnatural poses, and the whole studio *mise-en-scène*, but also the ubiquitous *albumen print with its hard, shiny surface. From the late 1880s, amateurs founded societies to promote their interests and propagate their ideas, partly by means of regular public exhibitions intended to influence photographic practice generally. One of the most important was the Society for the Encouragement of Amateur Photography (Gesellschaft zur Förderung der Amateurfotografie) founded (initially under a different name) in Hamburg in 1891, and supported by the director of the Kunsthalle, Alfred *Lichtwark. The issues were debated above all in newly founded journals like the *Photographische Rundschau*, the *Photographische Correspondenz*, and the *Atelier des Photographen*.

In fact, pictorialist art photography's influence on professional photography was considerable. For portraitists such as Rudolph *Dührkoop, Nicola *Perscheid, or Hugo *Erfurth, it was decisive. Their portraits seemed more atmospheric, more natural, and, to a degree, more private—at all events, their poses, lighting, and printing methods were much more varied and individual than in run-of-the-mill studio work. Some branches of landscape and architectural photography also retreated from the conventional nicely composed long shot and tourist-orientated view. Details and light effects became the centre of aesthetic interest, and—for example in the work of the *Hofmeister brothers—the toning and surface texture of the final print. Numerous exhibitions in major German cities, many with international participation, emphasized the movement's importance. By the 1900s, however, the impact of art photography and the debates surrounding it was diminishing markedly, even though the pictorialist style remained dominant. There was a shift towards a more objective or 'factual' (*sachlich*) photography, linked with Erfurth but also with August *Sander, who made preliminary pictures for the great project he was to undertake in the 1920s in the years before the First World War.

In the shadow of the debates surrounding art photography, the development of the medium in aesthetically more neutral fields such as science, technology, journalism, documentation, or the purely private sphere went on apace. At the end of the 19th century a new market for

photography emerged in the illustrated press. Although photographs by Ottomar *Anschütz had been reproduced by the autotype process in the Leipzig *Illustrirte Zeitung* as early as 1883, it was not until the late 1890s that photographs reproduced in this way appeared regularly in journals and newspapers. The largest-circulation illustrated papers were Ullstein's *Berliner illustrirte Zeitung* (1891) and Scherl's *Woche* (1899). Berlin became a centre for press photographers, and alongside existing picture *agencies, specialized photo agencies such as Zander & Labisch (1895) appeared.

The First World War led to a remarkable spread of amateur photography. Many soldiers took cameras with them and, official prohibitions notwithstanding, documented their daily lives. Not until 1916, when it established the Picture and Film Bureau (Bild- und Filmamt; BUFA), did the government make systematic use of photographs as *propaganda. However, the war's photographic legacy was much more strongly shaped by amateur pictures, mostly taken in rear areas far from the front line. JJ

Peters, U., *Stilgeschichte der Fotografie in Deutschland 1839–1900* (1979).
Baier, W., *Quellendarstellungen zur Geschichte der Fotografie* (1980).
Kaufhold, E., *Bilder des Übergangs: Zur Mediengeschichte von Fotografie und Malerei in Deutschland um 1900* (1986).
Dewitz, B. v., and Matz, R., *Silber und Salz: Zur Frühzeit der Photographie im deutschen Sprachraum 1839–1860* (1989).
Honnef, K., Sachsse, R., and Thomas, K. (eds.), *German Photography, 1870–1970: Power of a Medium* (1997).
Pohlmann, U., and Scheutle, R. (eds.), *Lehrjahre, Lichtjahre: Die Münchner Fotoschule 1900–2000* (2000).

The period 1918–45 was one of headlong technical, aesthetic, and organizational change. However, although the process was both far reaching and conspicuous, it was partly rooted in the pre-war years, and still far from complete long after 1945. There were major changes above all in modes of seeing, and in ideas about what photography was and what its tasks should be. Particularly notable between 1918 and 1945 were links between theoretical debate (Walter *Benjamin, Siegfried *Kracauer, László *Moholy-Nagy, et al.), the proliferation of aesthetic viewpoints, and the growing importance of the medium in culture, politics, and economic life. On the other hand, the enormous range and experimental vitality of artistic and journalistic photography tends to obscure the fact that less spectacular developments like changes in photographic retailing and manufacture, and the vast expansion of amateur photography, were no less characteristic of the period. Older aesthetic traditions also persisted in practically every field. Photographers like Hugo Erfurth and Franz Grainer who were already well known before the war further consolidated their success.

1918–1933

In the photographic industry the growth trend of previous decades resumed soon after the end of the war. A new professional body, the Society of German Photographers (Gesellschaft Deutscher Lichtbildner; GDL), was founded in 1919. In 1925 the numbers officially employed in photography were 15,673 (including 4,118 women, or 26.3 per cent).

In 1933 the figure was 22,032, and at the last pre-war count, in 1939, 23,435 (including 9,980 women, or 42.6 per cent). The structure of the business remained practically unchanged. Most enterprises were small, with fewer than five employees. But conditions were different on the manufacturing and chemical side, where a strong trend towards concentration developed; and Agfa, Kodak (Germany), and Zeiss-Ikon (founded in 1926) were among the biggest firms. The amateur market became increasingly important, as photography became ever more widely accessible and more workers took it up. (In 1931 workers' photography clubs had c.2,400 members.)

Technical development favoured the spread of the medium. The industry moved towards smaller, better-specified cameras, with Leitz's *Leica, available since 1925, at the peak. Film gradually replaced glass plates, and the almost simultaneous introduction of colour film by Kodak and Agfa from 1936 was of major importance.

It is virtually impossible to list all the most significant trends and personalities in photography in this period. Both photojournalism and photographically illustrated publications had received an enormous boost from the war. Existing illustrated papers were joined by new ones, and circulations rose. The *Berliner illustrirte Zeitung* reached its peak in 1929 with 1.8 million copies. New creations in the 1920s included the *Münchener illustrierte Presse*, the Nazi *Illustrierter Beobachter*, and the Communist *Arbeiter illustrierte Zeitung* (*AIZ*), as well as newspaper supplements and a wide range of magazines. New photo agencies were founded, such as *Dephot in Berlin (1928). Well-known press photographers of the 1920s and 1930s included the sports specialist Martin *Munkácsi, Erich *Salomon, Tim *Gidal, Felix H. *Man, Paul *Wolff, and *Umbo (Otto Umbehr). Though several had to emigrate after 1933, they continued to work for the press in France, England, or the USA. Only a small proportion of photojournalists had attended a photographic school: for example, the Halle-Burg Giebichstein Design School, the Folkwang School in Essen, the Stuttgart Design School, or older institutions such as the Bavarian State Photographic School. A separate photographic section—under Walter *Peterhans—was not established at the *Bauhaus until 1929. Nevertheless, there was considerable cross-fertilization between theory and practice. Thus the *photomontage developed by John *Heartfield with the Dada group became a much-used cover-page device for the *AIZ*.

Particularly significant for the aesthetics of photography were, on the one hand, the 'objective' image (*Neue Sachlichkeit—New Objectivity) and, on the other, experimental photography (Neues Sehen—New Vision), including cameraless pictures. Objectivity was exemplified by the work of Albert *Renger-Patzsch, whose industrial photographs and landscapes were highly influential. His book *The World is Beautiful* (*Die Welt ist schön*, 1929) was a major success. Karl *Blossfeldt's macrophotographs of plants emphasized form and structure by isolating the subject. Helmar *Lerski and Erna *Lendvai-Dircksen adopted a comparable approach with their portraits, which concentrated on the face. August Sander's series of full-length portraits of people of all ages and classes in their

surroundings caused a considerable stir when the first images appeared in 1929. Examples of experimental photography were the collages and *photograms of Hanna *Hoech, Moholy-Nagy, and Raoul *Hausmann.

In 1929 both the *Film und Foto* (FiFo) exhibition in Stuttgart, organized by Franz *Roh, and Werner Gräff's book *Here Comes the New Photographer!* (*Es kommt der neue Fotograf!*) offered an overview of 1920s photography in all its formal variants. The development of both artistic and applied photography (also beyond 1933) can be followed more broadly in annuals like *The German Photograph* (*Das deutsche Lichtbild*; 1927–38 and 1955–79) and *German Camera-Almanach* (*Deutscher Camera-Almanach*; 1905–41).

1933–1945

In formal and stylistic terms, there was little immediate change after the Nazi seizure of power in January 1933. But theoretical debate soon ceased, and by 1938 many leading photographers and writers had been banned from working or forced to emigrate. Only the politically and racially 'sound' could belong to the regime's principal control mechanism, the Reich Chamber of Culture (Reichskulturkammer). In other ways, too, the totalitarian impulse worked its way through the system. Formally and technically, German photojournalism maintained the standards set during the Weimar Republic, and remained as 'modern' as its counterparts in democratic countries abroad. But photo-reportage became a tool of the Propaganda Ministry, which as early as March 1933 had established an 'Illustrated-Press Department'. All press photography was subject to ministerial control, and photojournalists and picture editors lost any semblance of independence. Tactless or incorrect captions, even 'inappropriate' positioning of Hitler in relation to other Nazi leaders, could incur dire penalties. All photo agencies came under the control of the regime except for the American Associated Press, which maintained a degree of autonomy until 1941. The leading figure in German press photography between 1933 and 1945 was Heinrich *Hoffmann, whose personal relationship with Hitler since the 1920s dominated Führer- and Party-related photography; and Hoffmann's own firm was Germany's largest picture agency. The photographic press was required to propagate Nazi aesthetic principles. Photography clubs and the League of Amateur Photographers (Amateurfotografenverband, f. 1908) were politically 'coordinated'.

As in painting, a few niches of freedom survived. Herbert *List, for example, was able to pursue his surreal 'metaphysical' photography without interference. But other individuals (Paul *Wolff, Walter Hege (1893–1955), Hilmar Pabel (1910–2000)) came to terms with the regime, or were more or less forced to work for it. Some exponents of 1920s experimentalism, such as Höch, remained in Germany but were unable to exhibit or publish their work.

During the war, initially, photography was promoted in advertisements and propaganda as a bridge between servicemen and home. From 1943, however, scarcity of materials created increasing problems for private photographers. Official war

reporting was under military control, with photographers assigned to propaganda companies (PKs). These were formed in 1938 and first deployed during the occupation of the Sudetenland the same year. PK photographers were well equipped (especially by comparison with their British counterparts), often used colour film, and achieved superb results; casualties were correspondingly high. In 1940 the illustrated weekly *Signal was launched as a vehicle for propaganda abroad and many of its leading photographers continued their careers in the new generation of West German magazines that emerged after the war. JJ

Mellor, D. (ed.), *Germany: The New Photography 1927–33* (1978).
Fiedler, J., *Fotografie am Bauhaus* (1990).
Lugon, O. (ed.), *La Photographie en Allemagne: anthologie de textes 1919–39* (1997).
Sachsse, R., *Die Erziehung zum Wegsehen. Fotografie im NS-Staat* (2003).

Post-war German photography was initially dominated by 'ruin photography', which presented the devastation of German cities as a kind of blanket warning against war, while suppressing issues of responsibility. By contrast, the task of showing Nazi atrocities was fulfilled by Allied photographers (e.g. Margaret *Bourke-White, Lee *Miller, Sergei Morosov, George *Rodger). The two most celebrated 'ruin photography' publications, on Cologne (Hermann Claassen, *Gesang im Feuerofen—Song in the Furnace*, 1947) and Dresden (Richard Peter Sr., *Dresden: Eine Kamera klagt an—Dresden: A Camera's Testimony*, 1949) already showed the beginnings of reconstruction. With the start of the Cold War, the ideological confrontation between the two German states was also reflected in photography, with the two 'scenes' developing in different directions. But, while the history of West German photography is well documented, material on the East is scarce.

West Germany to 1990

In the West, the photographic industry rapidly reorganized itself, dominated by Agfa, now based in Leverkusen. Both art photography and the amateur market expanded steadily. A major stimulus was the biennial Cologne Photokina show, inaugurated in 1950: the world's largest photographic *trade fair but also, largely thanks to L. Fritz *Gruber, a photography festival of increasing cultural importance. The German Photographic Society (Deutsche Gesellschaft für Photographie; DGfP), founded in Cologne in 1951, was a photographers' organization attuned to Germany's changing economic conditions. The Society of German Photographers (Gesellschaft Deutscher Lichtbildner; GDL), in existence since 1919, had reorganized itself in the late 1940s, but did not come to terms with its past until the 1980s and 1990s, by which time it had become marginal. In 1987 it renamed itself the German Photographic Academy (DFA).

In the field of photojournalism and the press, Berlin had forfeited its leadership after the war. The Americans in particular were anxious to foster a full range of magazines in Germany. But after the 1949 currency reform, journals started by the Allies (for example *Heute*,

launched in the summer of 1945) became hard to sell, and withered over the next few years. There was increasing competition from new German magazines like the Munich *Revue*, the Cologne *Neue illustrierte*, and the Hamburg *Kristall*, which had appeared in 1946. In 1948 came *Stern, Constanze, and Quick. With these magazines, following the example of *Life, photography was the core element, claiming to be a universal medium of communication. The annual *Das deutsche Lichtbild* reappeared—also in an English-language edition—in 1954 (until 1979), its editors Wolf Strache (b. 1910) and later Otto *Steinert hoping to restore German art photography's international profile.

The art photography of the 1950s harked back to certain tendencies of the 1920s and developed in the ambit of non-representational, abstract work; *solarization, *photomontage, photograms, *negative prints, and other experimental techniques were revived. Trend setting in West Germany was the *fotoform group (f. 1949) with its programme, strongly influenced by Steinert, of *'subjective photography'. But if most 'high' 1950s art photographs were in monochrome, colour was becoming increasingly important. At first it was confined to luxuriously got-up fashion and advertising imagery. But by the late 1950s many German photographers—for example, Peter *Cornelius, Walter Boje (1905–92), Erwin Fieger (b. 1928)— were experimenting with colour's aesthetic possibilities. Above all, however, amateurs were taking to it. By the end of the 1960s, colour film usage had outstripped that of black-and-white. (Around this time amateurs were also strongly influenced by Karl Pawek's vision—in the wake of the *Family of Man exhibition—of photography as a universal language, and especially by three celebrated 'world exhibitions' he organized in 1964, 1968, and 1973.)

In the emerging art of the 1960s, photography was increasingly discovered by 'fine' artists, although a certain distance persisted between the fine-art and photography scenes. Under the banner of 'generative photography', a group that included Gottfried Jäger, Manfred Kage, and Kilian Breier presented the photographic process as an analytical, step-by-step 'generative' system—an approach that tended to result in abstract compositions, often serially organized.

The 1970s saw the rise of so-called 'authorial photography' (*Autorenphotographie*), partly conditioned by a crisis in conventional magazine photojournalism. It was a movement of independent photographers who dedicated themselves to self-selected—and in some cases very long-term—projects that deliberately eschewed any kind of commercial use.

Since the 1970s, photography in Germany, as elsewhere, has embraced a multitude of ideas and tendencies. The proliferating technical options created by new cameras, lenses, and other equipment have encouraged this. In both the amateur and commercial sectors, colour has almost completely supplanted monochrome. Since the 1980s, electronic imaging has increasingly dominated product design, advertising, and photojournalism. This has transformed the relationship between reality, simulation, and

fiction, with implications for society's collective visual memory, and for the formation of a supposedly objective public opinion. In the 1990s the truthfulness and authenticity so long naively ascribed to photography were increasingly overshadowed by individual visual worlds and subjective interpretations of reality. The process was accelerated by the spread of *digital image capture and manipulation.

East Germany

Reunification in 1990 focused renewed attention on the East German photographic scene. The German Democratic Republic (GDR) had inherited both a mature photographic culture and a sizeable portion of what was left of pre-1945 Germany's world-class photographic industry. VEB-Pentacon, for example, a combine formed in 1964 from several Dresden camera manufacturers, exported robust products like the Praktica single-lens reflex. But ultimately state subsidies were no substitute for the design sophistication and non-stop innovation achieved abroad, especially in Japan. Work in the official media (and in science and industry, with more arcane specialisms in the Stasi and military) was safe but dull, supplying official newspapers like *Neues Deutschland* with endless images of victorious athletes and optimistic-looking workers, dark-suited communist functionaries and fraternal delegations. Pollution, vandalism, infrastructural decay, escape attempts, and the Wall were taboo. At the same time, although a network of amateur clubs and journals existed, openings for art photographers were limited. By the 1980s a kind of passive opposition was expressing itself in documentation of the grimmer aspects of GDR life. Sad nudes and desolate, poisoned-looking landscapes abounded. But it is premature, given the patchy information available, to write off the history of East German photography as an inevitable dead end. In particular, the role of private photography in the GDR's totalitarian society deserves to be investigated.

Since 1990

The German photographic world at the beginning of the 21st century is multifaceted, partly because of the historically and politically conditioned federal structure of German cultural institutions. German photography is exhibited worldwide, and successful in the market place. Members of the so-called 'Düsseldorf School' are particularly highly valued. Many talents have been shaped by the teaching of Bernd and Hilla *Becher at the Düsseldorf Academy. Their best-known students include Andreas *Gursky, Candida Höfer, Axel Hütte, Thomas *Ruff, Jörg Sasse, and Thomas *Struth, who have developed in individually distinctive ways within the tradition represented by their teachers; and who, above all, use colour as an indispensable means of expression. In addition to Düsseldorf, many other colleges and academies are notable. The most important photographic collections are also widely distributed: in Hamburg, Munich, Essen, Cologne, Berlin, and Dresden.

Photographers' changing conditions of work were reflected as early as 1969 in the founding of the League of Independent Photo-Designers (Bund Freier Fotodesigner; BFF). In response to the rapid transformation of photojournalism at the end of the 20th century another body, Freelens, was formed in Hamburg in 1995. With *c.*1,400 members it is the largest German photographers' organization, and in particular endeavours to safeguard photographers' creative property rights: an increasingly important task. UR/RL

➲ See also Inner-German border photography 1952–1989 *opposite*.

Kemp, W., *Theorie der Fotografie*, iii: *1945–1980* (1983).

Honnef, K., Sachsse, R., and Thomas, K. (eds.), *German Photography, 1870–1970: Power of a Medium* (1997).

Kuehn, K. G., *Caught: The Art of Photography in the German Democratic Republic* (1997).

Domröse, U. (ed.), *Positionen künstlerischer Photographie in Deutschland seit 1945* (1998).

Amelunxen, H. v., *Theorie der Fotografie*, iv: *1980–1995* (2000).

Hartewig, K., and Lüdtke, A. (eds.), *Die DDR im Bild* (2004).

Gernsheim, Alison (née Eames; *c.*1911–1969) and **Helmut** (1913–95), British photographic historians and collectors. Helmut, born in Munich and trained at Bavaria's State Photographic School, worked freelance until he settled in Britain in 1937, becoming a British citizen in 1946. On his arrival, he began a photographic survey of historic buildings and monuments for the Warburg Institute, London. In 1938 he met Alison, and they married in 1942, beginning a highly influential scholarly collaboration. Together they wrote important monographs on Julia Margaret *Cameron (1948), Charles *Dodgson (1949), *Daguerre (1956), and Alvin Langdon *Coburn (1966). Although they also wrote separate larger works they are best known for their joint surveys *Masterpieces of Victorian Photography* (1951) and *The History of Photography* (1955). Their collection of early photographic incunabula and images, including Niépce's *View from the Study Window*, and their research notes, are preserved as the Gernsheim Collection at the Harry Ransom Humanities Research Center, University of Texas, Austin. KEW

Getty Images Inc., Seattle-based picture agency formed in 1997 after its precursor, Getty Communications, had bought the Hulton-Deutsch archive. Its aim was to make digitized stock and current images rapidly available over the *Internet. Subsequent acquisitions included Gamma Liaison, and the Image Bank from Eastman Kodak, both in 1997. In 2002 Getty took over distribution of still images captured from CNN news broadcasts. By 2003 it owned *c.*25 per cent of the 'visual content' industry, with an archive of *c.*70 million still images.

Although firms like Getty and its rival, Microsoft-owned Corbis, represent an efficient solution to the tangle of problems surrounding picture location and use, their power in the market place has caused concern, and Getty has clashed with photographers' organizations over its contracts. RL

Hoffman, B. (ed.), *Exploiting Images and Image Collections in the New Media: Goldmine or Legal Minefield?* (1999).

Inner-German Border Photography 1952–1989

The 1,393-kilometre (870-mile) border between East and West Germany developed from a guarded demarcation line after the end of the Second World War into a layered border-security system—part of the 'Iron Curtain'—using sophisticated fencing and detection equipment. It was the interface not only between two heavily armed, ideologically opposed power blocs, but between two identity concepts. The German Democratic Republic (GDR) officially described the fortified border as an 'anti-fascist protection barrier' to hinder attack from the West. Unofficially, however, it was intended to prevent East Germans leaving for the Federal Republic (FRG). To this end, the GDR erected a wire fence in 1952. Then, starting with the construction of the Berlin Wall in 1961, and completed in 1970, an integrated barrier and detection system was built along the whole border, and continually improved until the 'fall of the Wall' in 1989. Its core was an impassable rear fence with anti-personnel mines and tripwires sited eastwards of the actual demarcation line and invisible from the West.

This complex, deadly security system was minutely observed by both sides. In the GDR, the task of border control was assigned initially to the police, then from 1961 to the army. In the FRG it fell to a police organization, the Bundesgrenzschutz (BGS; Federal Border

Protection Force). Both agencies used photography intensively, for surveillance, military reconnaissance, and the documentation of incidents. In the huge photo archives assembled on both sides, even the most serene snowscape reveals its tell-tale jeep or watchtower. Of particular interest were the other side's activities and personnel; border violations, escapes, and attempted escapes; details of weapons, equipment, and vehicles; and, for the BGS, alterations to the security system itself. Everyday photographic practice reflected the different interests and priorities of East and West. GDR forces focused primarily on border violations by their own and West German citizens. (Physical traces of escape attempts were photographed, and the pictures used for training in the interpretation of footprints and other evidence.) The BGS endeavoured to document the human and legal consequences of the barrier's existence, and of orders to shoot would-be escapees. Every successful flight to the West was regarded as a defeat for the GDR guards and a success for the BGS.

Mutual surveillance often functioned as a kind of virility display. Phrases like 'photo hunt' and 'photo shoot' were used. The military confrontation between opposing powers was sublimated into aggressive observation, with the aim of testing the the other side's

Bundesgrenzschutz Official

Intelligence photographs of East German border guards, various dates

253

Bundesgrenzschutz Official

East German observers monitoring a border tour by West German politicians, Lübeck-Eichholz, 25 March 1987

```
                    A n l a g e

Objekt:3 GAK O Abschr. EICHHOLZ   UTM-Wert des Objektes: PE 1530 6795
Tag der Aufnahme:  25.03.87        UTM-Wert: eigener
Zeit:  13.30 h - 14.00 h           Standort:
Kamera und Objektiv:Jashica, 300erWetter:  trüb
Nr. des Negatives:                 Entfernung:  ca. 20 m
Filmsorte:   Copex Pan Rapid
Bilder wurden gefertigt durch:    POK Heppe, GSA Küste 1
Bilder werden archiviert bei:     GSK Küste, StB LZ
Negative werden archiviert bei:   GSA Küste 1

           Stabsfähnrich  Fähnrich
```

```
Besonderheiten (z.B. Objektbeschreibung):

 GAK am 25.03.1987 diesseits MGZ, O Lübeck-Eichholz während
  des Besuches des CDU-Fraktionsausschusses "Innen und Recht" SH.
```

-2-

alertness and monitoring every feature of a potential battlefield. The West's officially sponsored 'border tourism' was regarded as provocative by the GDR, and demonstratively recorded. Observation by the BGS, tourists, and local residents was countered by bursts of 'enemy surveillance' activity by GDR patrols. Both sides' surveillance photographs were minutely analysed, and filed with details of place, time, and the names, rank, function, and equipment of anyone depicted. Such data were assiduously collected by the BGS, as GDR personnel changed constantly for strategic reasons. Photographs were also used to confirm the identities of border guards who

escaped to the West. The GDR showed a similar interest in the BGS and its activities, and in border visits by British, American, and West German military personnel.

The East regarded unauthorized crossings of the border from the West as provocations, and the BGS had to prevent them. Its archive contains numerous photographs of deliberate frontier violations by West Germans, often resulting in the vandalization or destruction of GDR border signs. The photographing of such incidents by GDR personnel was also photographed by the BGS, who in their turn were photographed by their opposite numbers. Photographs on each side often reveal someone photographing or observing the photographer —a routine part of the 'game' along the 'inner German' border.

Distinctive 'border iconographies' developed in East and West. For East Germans, including guards, photographing frontier installations was strictly forbidden. Even official photography required specific authorization. In fact, to hamper would-be escapees, any kind of depiction of the border area was prohibited on pain of imprisonment. Therefore, while Western photographers tended to concentrate on the barrier itself, East German ones typically avoided showing it at all, or did so only surreptitiously. These divergences of practice are also apparent in private images made on both sides. GDR guards usually took pictures as souvenirs of their participation in the building of the barriers, but limited their subject matter to comrades, accommodation, and the work itself; the surrounding area and any landmarks were omitted. But pictures by BGS personnel were made both as souvenirs and to document GDR brutality: for example, the forcible evacuation of the border zone and blowing-up of houses carried out in 1961. These particular photographs, taken by a member of the Bavarian BGS, were placed in an album and used to accompany conducted tours of the border into the 1980s.

The most famous and symbolic section of the inner German border was the wall between East and West Berlin. Its construction began on 13 August 1961 in a final effort to stem the drain of manpower from the GDR to the West. This led to dramatic escape attempts, some of which ended fatally. Particularly in the Bernauerstrasse, where house fronts ran directly along the demarcation line, fugitives tried to jump across in full view of onlookers and photographers. One of the most dramatic pictures was captured as early as 15 August by the photojournalist Peter Leibing, as the GDR policeman Conrad Schumann suddenly vaulted over the barbed wire to freedom. Rapidly published worldwide, the picture became a symbol of the West's challenge to communism. In later years, pictures from Berlin—of Checkpoint Charlie, the truncated tramlines on the Potsdamer Platz, the increasingly graffiti-covered Wall itself, and, from the air, the necklace of floodlights marking the border at night—became part of the core iconography of the Cold War. Conversely, the photographs of frantic crowds dismantling the Wall in November 1989 graphically symbolized communism's collapse. AHA

Flemming, T., and Koch, H., *Die Berliner Mauer: Geschichte eines politischen Bauwerks* (2001).

Ghirri, Luigi (1943–92), influential photographer of the Italian cultural landscape. Born in Reggio Emilia and educated in Modena, Ghirri began photographing in 1970 and was influenced by contemporary American photographers, including the topographical photography of William *Eggleston. Ghirri shared with Eggleston an interest in the naturalistic use of colour, but brought a keen intellect and sense of humour to his work. His 1975 series ∞ consisted of 365 pictures of the sky shot on consecutive days. He exhibited widely in Italy and Europe in the 1970s, and more than 30 books have been published on his work. Through mentorship and by stimulating group projects he influenced a generation of Italian photographers. MR

Constantini, P., and Chiaramonte, P. and G. (eds.), *Luigi Ghirri: niente di antico sotto il sole* (1997).

ghosts. See COMPOSITE PHOTOGRAPHS; OCCULTISM AND PHOTOGRAPHY.

Giacomelli, Mario (1925–2000), self-taught, prolific, and influential Italian photographer. A typographer by trade, Giacomelli began photographing aged 30, taking as his principal subject matter the people and landscape of his native Senigallia. Influenced by Italian Neorealist cinema, he nevertheless found in his subjects something deeply personal. Giacomelli's approach to photography was essentially as an artist, yet in the 1950s and 1960s, when his influence was at its peak, photography had not yet been accepted as an art form in Italy; recognition of his achievements was therefore limited, and from necessity he continued working as a typographer. His photographic oeuvre is staggeringly varied, but his images all share a strong graphic quality and a concern with suffering and decay. Giacomelli once compared the wrinkles of an old woman with the furrows of a ploughed field; however, he did not join the two in romantic metaphor, but saw in both evidence of waste and depletion. Among his best-known works are nudes, images of the old people his mother cared for at a nursing home, and pictures of young priests, their robes black against fresh snow. MR

Crawford, A., *Mario Giacomelli* (2000).

Gibson, Ralph (b. 1939), American photographer. Born in Los Angeles, the son of a Warner Brothers employee, he learned photography as a teenage naval recruit; then studied briefly at the San Francisco Art Institute and worked as an assistant to Dorothea *Lange. He also joined the Beat scene. A period back in Los Angeles produced *The Strip* (1967), but in 1966 he moved to New York, writing later, 'New York and I were a perfect match just waiting for one another, although I knew it first.' He did little commercial work, but lived a day-for-night existence honing a style. *The Somnambulist* (1970; published by Gibson's Lustrum Press, which subsequently produced other books by himself, Robert *Frank, Larry *Clark, and others) suggests dreamlike unreality by means of surreal cropping and juxtaposition, shadows,

Ralph Gibson

The Somnambulist, 1974

reflections, and grain. It brought him fame, strengthened his commitment to the photographic book, and gave him the means to travel. Erotic images, combining a sense of intimacy with daredevil touches of incongruity and bad taste, ballasted *Days at Sea* (1974) and have remained central to his work. Now a leading New York photographer, Gibson continues to be fascinated with the details and textures of bodies and things, often working in close-up, both in colour and monochrome. He has won numerous awards and photographed in many countries, including France, Italy, Japan, and Egypt. RL

Gibson, R., *Deus ex Machina* (1999).

Gidal, Tim (Nahum Gidalevich; 1909–96), German-born Israeli photojournalist and writer. Gidal studied law, history and art history in Munich and Berlin, and started photography as a Zionist student. His first published pictures appeared in the **Münchener illustrierte Presse* in 1929. After emigrating in 1933 he lived in Switzerland (where he wrote a doctoral dissertation on photojournalism), the Middle East, and India, contributing to numerous publications. Between 1938 and 1940 he worked for **Picture Post*, and 1942–5 for the British army magazine *Parade*. After moving to the USA in 1947 he was an editorial consultant for **Life*. He later held academic posts in America and Israel. His many books include *Modern Photojournalism: Origin and Evolution 1910–1933* (1973). RL

Gidal, T., *My Life as a Photoreporter* (1984).

Gill, Robert (1804–79), British amateur photographer and military officer in India, who served in the Madras Infantry from 1824. Known as 'an excellent draughtsman' he was occupied for over a decade, from 1844, in making painted copies of the wall paintings in the cave temples of Ajanta. Most of this work was destroyed in the Crystal Palace fire of 1866, but Gill had taken up photography in the mid-1850s, and from the early 1860s until his death he produced an important archaeological record of Ajanta and other sites. Two volumes of his photographs, *The Rock-Cut Temples of India* and *One Hundred Stereoscopic Illustrations of Architecture and Natural History in India*, were published in 1864, with texts by the architectural historian James Fergusson. JF

Gilpin, Laura (1891–1979), American photographer who devoted more than 60 years to photographing the landscape and peoples of the American south-west. Born and raised in Colorado, she studied photography at the Clarence White School in New York in 1916–17, acquiring a keen sense of design and a lifelong interest in book production and platinum printing. Returning west in 1918, she established herself as a commercial photographer, but her main interest lay in the documentation of regional culture. In books on the Pueblo Indians, the Rio Grande, and the Navajos she explored the interconnections between people and their physical environment. Heir to a photographic tradition that celebrated the West as a wilderness, Gilpin instead pictured it as a historical environment that shaped, and was in turn shaped by, human activity. Her sustained interest in landscape photography set her apart from all other American women of her generation, and her record of Navajo life, compiled over a period of 35 years, remains unmatched as a record of a Native American group during a period of intense change. Gilpin's photographic and literary archives are held by the Amon Carter Museum, Fort Worth, Texas. MAS

See also AMERICAN WEST, PHOTOGRAPHY AND THE; NATIVE PEOPLES AND PHOTOGRAPHY.

Gilpin, L., *The Enduring Navaho* (1968).
Sandweiss, M. A., *Laura Gilpin: An Enduring Grace* (1986).

glamour. See CALENDAR PHOTOGRAPHY; EROTIC PHOTOGRAPHY; PLAYBOY; PORNOGRAPHY.

glass-plate formats. See FORMATS, PLATE AND FILM.

glass-plate photography, history and practice. In an 1852 review, the editor of an American publication, *Humphrey's Journal*, wrote of glass-plate photography, 'many objections might be made against its universal adoption—the nature of the material will always be an insuperable obstacle to its general use'. This was a remarkable misjudgement, particularly as its advantages compared to the materials used in contemporary processes were widely recognized. Glass was a cheaper base than the silvered copper plates used to make *daguerreotypes, and its transparency was far superior to anything possible using the paper negatives of the *calotype. Within a few years glass-negative processes were to displace completely the daguerreotype and calotype processes from mainstream photography. Glass plates became the most widely used support for negative materials for the remainder of the 19th century and continued to be important for much of the 20th. Glass plates were also to find use as the base component of several positive processes, photographic lantern slides, *stereoscopic views, some *photomechanical printing processes, and the first practicable colour processes.

The pioneers Nicéphore *Niépce and *Daguerre produced images on glass, although credit for the first true photograph on glass is usually given to Sir John *Herschel for his negative of his telescope taken in September 1839. However, Herschel's technique, which involved depositing a thin layer of silver chloride on the plate, was tedious and time consuming and never widely adopted. Producing photographs on glass was problematic. It proved difficult to find a means of binding the silver salts to a glass plate that would withstand the rigours of processing. Many substances were tried, including gelatin, milk, and starch, but the most successful proved to be *albumen obtained from the white of an egg. The first widely adopted process was announced in 1847 by a Frenchman, *Niépce de Saint-Victor. It involved coating a glass plate with egg white containing potassium iodide. After drying, the plate was washed with silver nitrate solution. A similar process patented in America in 1850 by John Whipple was improved by the *Langenheim brothers of Philadelphia and marketed as the hyalotype process. Because of near perfect transparency and fine resolution of detail, hyalotypes proved ideal for making photographic lantern slides. With slight variations, the process remained in use for the commercial

production of lantern slides into the 20th century. Albumen positives on glass were also adopted for the production of stereoscopic transparencies. Viewed by direct light in the *Brewster stereoscope, they provided a far clearer image than daguerreotype views or those on paper, which could only be viewed by reflected light.

Although popular with architectural and landscape photographers, albumen plates required exceptionally long exposure times, which disqualified them for most photographic work. The answer was Scott *Archer's *wet-plate *collodion process introduced in England in 1851. The coated and sensitized plate was exposed in the camera while still wet and developed immediately. Collodion negatives could record fine detail and required shorter exposure times than any previous process, and the wet-plate process rapidly became the standard form of photography. (What became an immensely popular variant of the process, the collodion positive or—in America—*ambrotype, was described by Archer in 1852.) However, its great limitation was the requirement for plates to be prepared on the spot and exposed and developed while still moist. A photographer working away from home was forced to transport an enormous amount of equipment with him, including portable dark-tent, chemicals, glassware, and a copious supply of water. For a short trip this baggage might be carried on the back but for longer expeditions a handcart or horse was often required. The photographic exploits of Roger *Fenton in the Crimea, George Washington *Wilson in the Scottish Highlands and Islands, and numerous photographers in the *American West vividly illustrate the difficulties involved. Many attempts were made to produce a sensitive dry plate which could be prepared in advance. For twenty years a multitude of unlikely substances were suggested as a binding agent for silver salts, including sugar, honey, ginger wine, and tea. None proved satisfactory until Richard Leach *Maddox in 1871 published details of a plate coated with gelatin containing an emulsion of silver bromide. Successful experiments to improve Maddox's plates took place in England and by the end of the decade, gelatin silver *dry plates were being factory produced. They were more sensitive than wet-collodion plates and could be stored indefinitely. With exposures of fractions of a second now possible and the removal of a major part of the previously inescapable chemistry of photography from the practice, dry gelatin silver emulsions revolutionized photography.

Some photographers objected to the new dry plates on the grounds of cost (wet-plate photographers were able to use the same glass base over and over again); but the advantages of the dry plate were overwhelming and a giant new industry was established. In 1879 Alfred Harmen opened the Britannia Works, later to become Ilford Limited, Britain's largest dry-plate manufacturing company. Plate coating was originally done by hand and four men could coat 12,000 whole plates a day. Mechanization soon took place and during the 1880s coating machines producing about 1,000 plates an hour were introduced. An American photographic amateur, George *Eastman, began manufacturing dry plates in Rochester, New York, in 1880. The Eastman Dry Plate Company, established in 1881, was the precursor of Kodak Ltd.

Ultimately, dry emulsions were to help destroy glass-plate

photography, for they made possible the introduction of flexible *roll-film, exploited brilliantly by Eastman's original *Kodak camera of 1888. Roll-film brought enormous numbers of new amateurs into photography, although the plate market was sustained by professional photographers and the serious amateur, who initially treated the new roll-film cameras with contempt. Roll-film did, however, allow a rapid series of consecutive exposures and, in an attempt to match this advantage, a variety of magazine plate cameras were introduced—like the twelve-shot Facile used by Paul *Martin in the 1890s. But these instruments, although often ingenious, tended to be heavy, clumsy, and uncertain in operation. Few survived beyond 1914.

As roll-film was improved during the first half of the 20th century, more and better cameras were designed and marketed to take advantage of the benefits offered. Yet for a time glass plates continued to be favoured by large sections of the photographic community. This was partly simple conservatism, but there were also fears that a cellulose film base could not provide the absolutely flat and rigid platform at the focal plane of a camera, so necessary for sharp images. There was also concern about the flammability and chemical instability of cellulose nitrate-based film. Many professionals, particularly press photographers, were still using glass plates until the 1950s. There was also a steady market for plates from scientific and technical photographers in such fields as spectroscopy, astronomy, radiography, graticule making, and nuclear tracking, and from the printing and graphic arts industry, where film base rigidity was essential. Demand plummeted following the successful introduction of dimensionally stable polyester film base. By 1970 most major manufacturers had closed their glass-plate production lines. JPW

Tissandier, G., A History and Handbook of Photography (1878).
Taft, R., Photography and the American Scene (1938).
Mees, C. E. K., From Dry Plates to Ektachrome Film (1961).
Gernsheim, H. and A., The History of Photography (1969).
Hercock, R. J., and Jones, G. A., Silver by the Ton (1979).

glazing, a method of achieving a high gloss on the surface of a print, traditionally involving squeegeeing the print (hardening fixed and thoroughly washed) onto spotlessly clean plate glass or ferrotype (enamelled metal) sheet, and stripping it off when dry. Possible faults included unglazed areas due to air pockets or specks of dirt, 'oyster shell' markings caused by uneven springing from the glass in hot weather, or total failure to separate. The last could be avoided by pre-bathing the washed print in a dilute solution of ox gall, an evil-smelling fluid whose odour never subsequently departed completely. This laborious method was superseded by the advent of flatbed and rotary glazers, which employed a chromium plate surface (later stainless steel) and heat, but gave a less brilliant result. Modern resin-coated glossy papers have rendered glazing processes redundant, although some older enthusiasts using fibre-based paper remain loyal to the plate-glass method. GS

Gloeden, Baron Wilhelm von (1856–1931), German photographer famous for nude studies of Sicilian peasant boys.

Naoya Hatakeyama *Underground/River*, from *Tunnel Series*, 1999

David Miller Lightning from thunderhead at Hall's Creek, Australia, 1995

During the 19th century, many northern European homosexuals visited the South, drawn by its reputation for looser social and sexual mores. Moving for health reasons to the Sicilian coastal town of Taormina in 1878, von Gloeden pursued his vision of a homosexual Arcadia to such a degree that his landscapes and pictures of peasant girls are mostly forgotten. Extensive use of props intended to evoke the ancient Mediterranean gave his pictures a publicly acceptable classical veneer while reminding homosexual viewers of the ancient Greek tolerance of *paederastia*. Sexually explicit images featuring full-frontal nudity were sold quietly to foreign tourists and made into much traded *postcards. After the baron's death in 1931, Mussolini's police destroyed 1,000 glass negatives and 2,000 prints as obscene; the rest of the archive was saved by 'Il Moro', von Gloeden's long-time assistant.

PC

See also GAY AND LESBIAN PHOTOGRAPHY.

Pohlmann, U., *Wilhelm von Gloeden: Sehnsucht nach Arkadien* (1987).

Wilhelm von Gloeden

Boy adorned with lilies, 1904

Godowsky, Leopold. See MANNES, LEOPOLD, AND GODOWSKY, LEOPOLD, JR.

Godwin, Fay (1931–2005), British photographer, who took up photography in 1969 after a career in publishing. Working at first on portraits of writers and social documentary, she became increasingly interested in landscape when the poet Ted Hughes suggested that he would write poems to illustrate her pictures, a work that produced *Remains of Elmet* (1979). Her mainly monochrome work on the British landscape soon established her as a photographer with a keen eye, but also showed her strong interest in conservation. *Land* (1985) and its accompanying exhibition confirmed her photographic reputation, and was followed by her election as president of the Ramblers' Association in 1987. Her 21st-century work moved into colour, often used *digital imagery, and looked at small-scale, local environments: beaches, nursery gardens, and their associated detritus.

Godwin's work evoked a similar resonance in Britain to that of Ansel *Adams in the USA. The reason is her interest in combining her image-making skills with environmental politics. Like Adams, Godwin developed a consummate ability to encapsulate the character and forms of landscape in images which advocate the need to conserve threatened areas and highlight the impact of man in environmental change. PH

Goldblatt, David (b. 1930), South African photographer, sometimes called 'the father of South African documentary photography'. His role as mentor to younger generations of photographers is unquestionable. But Goldblatt himself resists any straightforward 'documentary' label. Professional since 1963, and based for many years at *Leadership* magazine, Goldblatt founded the progressive Market Photography Workshop in Johannesburg in 1989. His work encompasses the impact of mining, the class and race fragilities of whiteness, the homogenization of South African towns, and the effects of Bantustan policy on African commuters (for the Carnegie Commission). His great long-term thematic project on structures and environments, and the values inscribed in them,

David Goldblatt

Going Home: 8.45 p.m., Marastad-Waterval Bus, South Africa, 1984.

surfaced with remarkable coherence and timeliness after apartheid's end with *South Africa: The Structure of Things Then* (1998). PHA

David Goldblatt, *Fifty-One Years* (2001).

Goldin, Nan (b. 1953), American photographer, known for her frank and apparently unstudied depictions of herself and her friends in intimate and often unsavoury circumstances. Her *snapshot-like aesthetic, and choice of subject matter that includes sex, drugs, domestic violence, cross-dressing, prostitution, and death, have deeply influenced the generation of photographers that followed her, in art and even fashion photography.

Growing up in suburban middle-class Massachusetts, Goldin began photography *c.*1970 with glamorous and theatrical monochrome images of her teenage friends in surroundings such as dance clubs and seedy bedrooms. She was a key figure in the latterly identified Boston School, a group of photography students at the School of the Boston Museum of Fine Arts that included Mark Morrisroe and Philip-Lorca *diCorcia. Their work is characterized by intimate and autobiographical subjects, captured with apparent casualness. By 1978, Goldin and many of her friends had moved to New York, and the downtown scene became both subject and venue for this constantly changing performance. The sequenced slide show set to pop tunes, like Goldin's best-known work, *The Ballad of Sexual Dependency*, was also a product of this group and those times.

The book version of *The Ballad* (1986) explores relationships and includes such revealing images as *Self-Portrait with Brian Having Sex*, *Nan and Brian in Bed*, and *Nan One Month after Being Battered. Cookie Mueller* (1991) commemorated a close friend who, with her husband Vittorio, died of AIDS in 1989. Images like *Self-Portrait Writing in Diary During De-Tox* (1989) document her rehabilitation after years of addiction. *The Other Side* (1993), on transvestites and transsexuals, and *A Double Life* (1994), chronicling a group of Goldin's friends over 25 years, continued her exploration of relationships in the *demi-monde. Tokyo Love* (1994), a collaborative project with Nobuyoshi *Araki, showed familiar lost subjects in a different society.

In form, Goldin's work epitomizes photography's move since the 1970s away from the perfect single image to casually composed assemblages of sequenced colour slides and multi-image installations. Its content is also seminal in its emphasis on autobiography, sexuality, and outsider culture. AN

Nan Goldin: I'll Be your Mirror (1996).

Gonnet, Esteban (1830–68), French photographer and surveyor, active in Buenos Aires, where he was probably a partner, with another Frenchman, in the Fotografía de Mayo studio in the 1860s. Gonnet was one of the earliest photographers of Buenos Aires and its rural hinterland. The fine *albumen prints published in albums entitled *Recuerdos de Buenos Aires* in 1864 capture the contrast between traditional and modern aspects of the developing city. He also recorded the life and customs of the *gauchos* of the surrounding cattle ranches. For a long time most of his work was attributed to the Italian-born photographer Benito Panunzi (1819–94). RL

Alexander, A., Buchbinder, P., and Priamo, L., *Buenos Aires: ciudad y campaña* (2003).

Goodridge brothers (**Glenalvin J.** (1829–67), **Wallace L.** (1840–1922), and **William O.** (1846–90)), African-American photographers born in York, Pennsylvania. The success of their

Goodridge Brothers

Studio Shoot, 1888–9

entrepreneur parents, Evalina and William, a mulatto descendant of Charles Carroll, enabled Glenalvin to open a *daguerreotype gallery in York in 1847. Thanks to the influence of Joseph Rinhart and Montgomery Simons, Glenalvin achieved a regional reputation for prizewinning *ambrotypes. However, an extortion scheme falsely accusing him of sexual assault resulted in his imprisonment and premature death.

By 1865, Wallace and William had re-established the studio in Saginaw, Michigan. To the end of the century it shared in the success of the area's timber economy. The brothers were an effective team. Wallace managed the studio and specialized in portraiture. William, under contract to regional railways, travelled throughout Michigan recording the lumber boom with *stereographs and larger views. In 1890 William died, only a year after the Department of Agriculture sent his lumber views to the Centennial Exhibition in Paris as part of its forestry display. Until Wallace's death in 1922, the studio remained the most important African-American establishment in photography's early history. JVJ

Jezierski, J., *Enterprising Images* (2000).

Gowin, Emmet (b. 1941), American photographer who studied at the Rhode Island School of Design. Reminiscent of his teacher Harry *Callahan's classic images of his wife Eleanor, Gowin early on focused often on his own wife Edith, in tranquil rural settings. He sometimes used a *snapshot technique, attaining a circular pinhole-like image by mounting a 10.2 × 12.7 cm (4 × 5 in) camera lens on a 20.3 × 25.4 cm (8 × 10 in) body. Later he created quietly evocative black-and-white aerial photographs of man-scarred landscapes, from the USA to Czechoslovakia. TT

Gowin, E., and Reynolds, J., *Changing the Earth* (2002).

grain is a curious blend of the quantifiable and the subjective. It may even create an impression of more sharpness than exists: a grainy enlargement from 35 mm may look sharper than a grainless enlargement from a larger format. In conventional monochrome films, actual particles of silver make up the image; in colour films (and chromogenic monochrome films) dye clouds are formed in proportion to the silver halide image that is later bleached out.

Graininess can be quantified as granularity, using a microdensitometer trace, though differing methodologies limit the usefulness of comparison between the results achieved by different researchers: the only meaningful comparisons are between films tested under the same conditions, usually by the same laboratory. Granularity figures are normally expressed as root mean square (RMS) values of the density fluctuations over the trace.

Subjectively, some kinds of grain are simply more pleasing to the eye than others: 'crisp' (clearly defined) grain usually looks better than mushy. Both quantifiable and subjective qualities may be modified by film design; developer choice; exposure (more exposure means coarser grain, except with colour and chromogenic monochrome films); duration of development (more time means more grain); and agitation (more agitation means more grain).

Although grain and sharpness are related—slower films tend in general to be finer grained and sharper than faster ones—there is a trade-off between the two at any given speed: the sharpest films are rarely the finest grained, and vice versa. A slow, fine-grain film in a speed-increasing developer will normally give finer grain than a faster, coarser-grained film in a fine-grain developer. RWH

See also DEFINITION.

Jacobsen, R. E. (ed.), *The Manual of Photography* (9th edn. 2000).

Great Eastern, SS. See SHIPBUILDING AND PHOTOGRAPHY.

Great Exhibition, London, 1 May–15 October 1851. Originally called 'The Great Exhibition of the Works of Industry of All Nations', it was housed in Joseph Paxton's revolutionary and very photogenic Crystal Palace, which was extensively photographed by British (B. B. *Turner, Robert *Howlett, et al.) and French (Jules Dubosq, Baron Gros) photographers, both at its original site in South Kensington and in 1854 when it was moved to Sydenham (Philip *Delamotte). In addition to its thousands of other exhibits, it incorporated the first large international exhibition of photography, exhibiting a range of materials and styles that most of the public had never before witnessed. (Terms like *photograph*, *positive*, and *negative* had to be explained in the catalogue.) Although most photographs were placed in Class X with musical and scientific instruments, some *calotype landscapes were shown in the Fine Arts section, and received awards. Singled out for special praise were French calotypes and American *daguerreotypes (including 48 by Mathew *Brady), which were hailed as the best on show; John Whipple's daguerreotype of the moon inspired the British businessman Warren de la Rue (1815–89) to enter the field himself. The exhibition, which was visited by over 6 million people, not only increased awareness of photography in general but publicized important innovations, most notably *Archer's revolutionary *wet-plate process. Queen Victoria's enthusiasm for Dubosq's stereo-daguerreotypes of the exhibition boosted the incipient craze for *stereoscopic images.

Another fillip to photography was the jury's decision to use it instead of lithography to illustrate its final report, which eventually included *c.*150 photographs of industrial products. Finally, the Great Exhibition's success encouraged the founding of the Photographic Society of London (later *Royal Photographic Society), which eventually came into being in January 1853. KEW/RL

Haworth-Booth, M. (ed.), *The Golden Age of British Photography, 1839–1900* (1984).

Greece. Although the first Greek photographers were active before the end of the 1840s, the medium was slow to develop, and a guide published in 1891 listed only 27 practitioners for the entire country. (Other Greeks ran photographic businesses in cities around the eastern Mediterranean, and as far away as the Crimea.) The pace quickened in the 20th century, with the spread of amateurism, the growth of an illustrated press, and coverage of the Balkan Wars by Greek

John Beasley Greene

Female statue, Abu Simbel, Egypt, 1854.
Salted-paper print

photojournalists. As in the previous century, Greece continued to be an important destination for foreign photographers keen to record its ruins and ancient monuments for private or commercial purposes; the Swiss Fred Boissonnas (1858–1946), the German Herbert *List, and the Russian George *Hoyningen-Huene were among many to seek inspiration there. But Greek photographers of the mid-century included the dance and portrait specialist *Nelly—probably the most internationally celebrated—Spiros Meletzis (b. 1906), Dimitris Harissiadis (1911–93), Kostas Balafas (b. 1920), and the modernist documentary photographer Voula Papaioannou (1898–1990). However, despite the foundation of the Greek Photographic Society (EFE) in 1952 and the organization of the First Panhellenic Exhibition of Photographic Art in Athens in 1956, the post-war photographic scene was undistinguished, with few critics or international contacts and a lack of outlets for art photography other than the country's amateur clubs. This situation, as Greek photographic historians have emphasized, persisted into the 1970s.

In the last quarter of the 20th century, however, important new developments took place, centred mainly on Thessaloniki and Athens. In the former, where the journal *Fotografia* had been founded in 1977, Greece's first international photography festival, Parallaxis '85, was held in 1985, followed by the creation of an annual event, Photosynkyria, which took place between 1989 and 1996. In the capital, the Photography Centre of Athens had been founded in 1979, followed in 1986 by a

privately funded Hellenic Centre of Photography, which the following year organized the first International Month of Photography—following the Parisian model—in Athens, an event that was repeated in 1989 and 1991. A further development, in 1996, was the inauguration of regular photographic festivals on the island of Skopelos. Meanwhile, photographic courses proliferated, international contacts became stronger, and the work of a growing number of young Greek photographers was successfully exhibited at home and abroad. Major historical shows included *Athens 1839–1900: Photographic Testimonies* (Athens, 1985), *Das Land der Griechen mit der Seele Suchen* (Cologne, 1990), and *The Invention of Landscape: Greek Landscape and Greek Photography, 1870–1995* (Thessaloniki, 1996). Continuing problems, however, have been a shortage of public funds for major projects, and photographers' difficulty in finding a market for their work. RL

Xanthakis, A., *History of Greek Photography* (1988).

Stathatos, J., *The Invention of Landscape: Greek Landscape & Greek Photography, 1870–1995* (1996).

Stathatos, J., *Image and Icon: The New Greek Photography 1975–1995* (1997).

Greene, John Beasley (1832–56), French-born American photographer who, more than other early photographers of Egyptian antiquity such as Maxime *Du Camp or Félix *Teynard, conceived of photography as a tool in archaeological exploration. On visits to Egypt (1852, 1854, 1855) and Algeria (1856), he conducted excavations and made photographs. His Egyptian negatives were carefully coded—I (Inscription), P (Paysage), or M (Monument). *Blanquart-Évrard published 94 of them as *Le Nil* (1854). His 1855 photographs of a portion of his excavation at Medinet Habu must stand as the first systematic photographic record of an excavation. He belonged to the *Société Française de Photographie and the Société Asiatique. KSH

Greenlaw, Alexander (1818–70), English amateur photographer. After joining the Indian army in 1834, Greenlaw was posted to Madras with the 46th Regiment. He took up photography in the mid-1850s, sending examples of his work to the Photographic Society of Bombay in 1855. These prints, including studies of temples and numerous portraits, received high praise in the society's journal. During 1855–6 he produced an extensive series of mammoth *waxed-paper negatives documenting the ruined Hindu city of Vijayanagara, southern India. These views, mostly architectural studies, display considerable technical and aesthetic quality. The negatives also include a number of unusual tree and plant studies. In 1859 Greenlaw was sent to Rangoon, Burma, where he produced further architectural and topographical views. After leave in England in 1863–6, he returned to India, remaining with the army until his death. Greenlaw's work has survived in negative form only; there are no known contemporary prints. Greenlaw is also known for his modification of the *calotype process, in an attempt to compensate for the fierce heat of southern India. This so-called 'Greenlaw's Process' was published in *The Photographic News* of 15 January 1869. SCG

grey card. Standard card used to assist the determination of correct exposure with a reflected-light *exposure meter. It has a reflectance of 18 per cent, corresponding to a mid-grey (Zone V in the *Zone System) and a reflection density of 0.7, halfway along the density scale for an average negative and the main calibration point for a reflection exposure meter. Like the *grey scale, it can be included in the photographed scene for assessment of tone and colour balance in the final image.

Commercial grey cards have a 90 per cent reflectance white on the reverse side, for highlight readings on meters. In poor light it is more convenient to use this side and multiply the indicated exposure by 5 ($2\frac{1}{4}$ stops). Highlight readings are also a useful approach for colour transparencies of awkward subject matter where highlight detail is important. GS

grey scale. (1) In photography, a grey scale is a card bearing a set of neutral grey patches arranged in increasing equal steps of reflection density from white to black, representing equal visual steps of grey. Its main use is to match the density scale and colour balance of a transparency or print, for which purpose it is usually included at the edge of the photographed scene, or shot separately at both ends of the film. Its inclusion in the picture area was mandatory in the making of separation negatives for *carbro or *dye-transfer prints, as both density and gamma (a measure of the relative contrast of the negative) of the three separations had to be accurately matched.

(2) In electronic imaging, the grey scale is the number of tones that can be represented in the system. For example, in a five-bit system there are 2^5 (32) levels of grey, and in an eight-bit system 2^8 (256) levels. GS

Grossman, Sid (1913–55), American photographer. Co-founder with Sol Libsohn of the Photo League, he played numerous roles throughout its existence (1936–51). He organized classes in *documentary photography, founded the Documentary Group; served on the executive board; was a reviewer, writer, and editor for the league's newsletter *Photo Notes*. He regularly defended photography as an art form, a documentary record, and a means of mass communication. His 1940 photographs of labour union activity led to FBI investigations and the blacklisting of the league as a communist front in 1947. CBS

Tucker, A., *This Was the Photo League: Compassion and the Camera from the Depression to the Cold War* (2001).

Group f.64. Founded in reaction to soft-focus *pictorialism and East Coast hegemony, Group f.64 was initially conceived by friends Preston Holder and Willard Van Dyke in Oakland, California, *c*.1931. Edward *Weston became its then best-known member, and others included in the group's 1932 exhibition at the M. H. de Young Memorial Museum in San Francisco were Ansel *Adams, Imogen *Cunningham, John Paul Edwards, Consuelo Kanaga, Alma Lavenson, Sonya Noskowiak, Henry Swift, and Brett *Weston. The controversial exhibition subsequently travelled to several venues on the West Coast

and, as with most things revolutionary, met with mostly negative reviews and raised eyebrows. The group's name came from the lens-aperture setting offering the maximum depth of field, and its 'seeing straight' manifesto read in part as follows: 'The Group will show no work at any time that does not conform to its standards of pure photography. Pure photography is defined as possessing no qualities of technic [sic], composition or idea, derivative of any other art-form. The production of the "Pictorialists", on the other hand, indicates a devotion to principles of art which are directly related to painting and the graphic arts.' TT

Heyman, T., *Seeing Straight: The f.64 Revolution in Photography* (1992).

group photographs. In the earliest studios, when a slight movement could mar a necessarily long exposure, two or more sitters increased the chances of a spoilt plate (and often incurred higher fees). As shorter exposures became possible, family groups were more often attempted, though it sometimes proved difficult to fit everyone in against the studio background. Larger groups were regarded as a particular challenge, and were occasionally created by combining on one print figures from several different negatives. But by the 1880s, faster plates allowed a proliferation of institutional, sporting, occupational, and other groups, often taken out of doors. In the ports of California and southern Australia, photographers took sailing-ship crews on the decks of their vessels. In the USA, college graduation classes became an important new branch of business. To ensure that all faces could be clearly seen (and maximum sales achieved), photographers generally sought to group the participants in rows on more than one level. Soldiers and athletes were as likely to be asked to squat on the ground as small schoolchildren, and the convention was quickly established—and has never died—that chairs in the centre of the picture should be allocated to such senior figures as officers, teachers, team captains, employers, and newlyweds. The deployment of hands and (sometimes) feet in group portraits will often reflect suggestions made by the photographer, and folded arms or hands on bare knees have both persevered as the body language of manliness. The invention of the panoramic camera, which exposed the film section by section, allowed fleet-footed 20th-century schoolboys to appear at both ends of the same institutional group. Photographers like the American Neal Slavin (b. 1941) have turned the group photograph into an art form, a microcosm of organizations, communities, or whole societies. RP

Slavin, N., *When Two or More Are Gathered Together* (1976).
Linkman, A., *The Victorians: Photographic Portraits* (1993).
Tonkonow, L., and Trachtenberg, A., *Multiple Exposure: The Group Portrait in Photography* (1995).

Gruber, L. Fritz (1908–2005), German photographer, photographic impresario, and collector. Born in Cologne, he studied humanities and worked in newspaper publishing before moving to England in 1933. He returned to Germany in 1939, and after 1945 worked as a photographer for the British occupation forces. He played a leading role in organizing the first Photokina exhibition in 1950, giving space to the *fotoform group and ensuring that the fair would become a major cultural as well as trade event. Until 1960 he was responsible for all aspects of Photokina; thereafter for its exhibitions, which included shows on colour (1960) and sequential (1972) photography, and a major conspectus, *The Imaginary Photo Museum*, in 1980, the year he retired. By this time, Photokina was the world's largest single showplace for photography. In all, Gruber edited sixteen catalogues and organized *c.*300 exhibitions. He produced many other publications, and films, and in 1951 helped to found a major professional organization, the German Society for Photography (Deutsche Gesellschaft für Photographie; DGfP). His photographic collection was bought by the Ludwig Museum in Cologne in 1977. UR

Gruber, L. F., *Glanzlichter und Schlagseiten: Photographische Erinnerungen* (1988).

Gsell, Émile (1838–79), Saigon-based commercial photographer who travelled through much of *Indo-China during the opening of the country by French officials and scientists. As an official photographer he accompanied several missions of exploration, first in 1866 with a scientific survey of Angkor (where he arrived just behind John *Thomson), then to Hue, and finally to still unpacified Tonkin. He made evocative portraits of local people in his successful Saigon studio, and of others he met on his travels. RT

Des photographes en Indochine (2001).

Guidi, Guido (b. 1941), Italian photographer, who began experimenting in the late 1960s with pseudo-documentary images that interrogated photography's objectivity. Influenced by Neorealist film and Conceptual art, in the 1970s he began investigating Italy's man-altered landscape. Working in marginal and decayed spaces with a 20.3×25.4 cm (8×10 in) camera, Guidi creates dense sequences intended as meditations on the meaning of landscape, photography, and seeing. Later he investigated the life and death of modernist architecture, with projects on Scarpa, van der Rohe, and Le Corbusier. AF

Guidi, G., *Varianti* (1995).
Guidi, G., *In Between Cities* (2004).

Güler, Ara (b. 1928), Turkish photographer. Born in Istanbul, Güler has been active as a photographer since the 1950s, when he began working as a journalist, first for the newspaper *Yeni Istanbul* and later for *Hayat* magazine. His work, which shows people firmly anchored in their environments, attracted international attention when it appeared in *Paris Match* and *Stern* in 1958, and has subsequently been distributed worldwide by *Magnum. Although based in Turkey, Güler has travelled widely, sometimes comparing himself to an explorer. Working with equal mastery in black-and-white or colour, he has exhibited in Turkey, Europe, Britain, Japan, and the USA. His photographs have been the focus of nearly 30 books in different languages. NM

Maga, İ. (ed.), *Ara Güler Saygı / Tribute to Ara Güler* (1998).

gum bichromate process. Under strong light, soluble dichromates react with gum acacia (or 'arabic'), rendering it insoluble in water. By incorporating artists' pigments in the colloidal layer, a 'painterly' *contact-printing process results. Invented by *Poitevin in 1855, and popularized as 'Photo-aquatint' by Alfred Maskell and Robert *Demachy in 1894, it usually involves several applications of layers of pigmented, dichromated gum, interspersed with reregistration under the negative, exposure, and development with water. Gum bichromate is a popular *'alternative process', inexpensive but expressive, offering great manipulative control over images in watercolour, and the possibility of three-colour printing. MJW

Scopick, D., *The Gum Bichromate Book* (1991).

Gursky, Andreas (b. 1955), German photographer, who studied at the Folkwangschule, Essen, and the Staatliche Kunstakademie, Düsseldorf, absorbing the traditions of both photojournalism and documentary photography. With several other students of Bernd and Hilla *Becher, he arrived in the late 1980s, exhibiting images of leisure spaces and landscapes. He progressed to stock exchanges, midnight raves, and endless apartment blocks, from 1992 often using *digital manipulation. The enhanced complexity of the resultant photographs of vast man-made venues made Gursky one of the most influential and bankable colour photographers of the turn of the 21st century. KEW

Galassi, P. (ed.), *Andreas Gursky* (2001).

Haas, Ernst (1921–86), Austrian-born American photographer. Even as a youth in Vienna, Haas's unique perception of the world manifested itself in transcendent images. His poignant photographs of waiting relatives of POWs returning from Russia were seen by Robert *Capa of *Magnum. Haas moved to New York, began publishing in *Life*, and travelled widely. Easily passed over now as the maker of pretty colour images, Haas, nonetheless, was an unmatched visionary in both black-and-white and colour composition. His was the first-ever exhibition of colour photography mounted by MoMA, New York, in 1962. As metaphysically eloquent as the best descriptions of Zen and Zen archery, Haas's writings on seeing and photographing are unparalleled. TT

Hess, H. E., and Langer, F., *Ernst Haas* (1992).

Hackney Flashers (1977–early 1980s). A collective of socialist and feminist documentary photographers based in Hackney, east London. It was an offshoot of the Photography Workshop, of which the pioneering documentary photographer Jo *Spence was a founding member. The group's impetus came from a desire to engage politically and socially with the community in which they lived. Groundbreaking projects such as *Women and Work* highlighted the inequalities of women's work inside and outside the home, and *Who's Holding the Baby?* challenged the ideology of motherhood. KR

Spence, J., *Putting Myself in the Picture* (1988).

Hagemeyer, Johan (1884–1962), Dutch-born American fruit farmer and photographer. In 1916 Alfred *Stieglitz introduced him to Anne *Brigman in Berkeley, California, where he opened a portrait studio. He developed a politically and artistically radical milieu that included Imogen *Cunningham, Tina *Modotti, and Edward *Weston. In 1923 Hagemeyer built a studio in Carmel, later establishing the town's first gallery. Despite crucial intellectual influence on Weston, he never joined *Group f.64: the modern compositions and subjects of his photographs retained *pictorialist soft-focus and subdued tonalities. He continued to work and exhibit, but his life was undone by illness and financial troubles. HWK

Hajek-Halke, Heinz (1898–1983), German experimental photographer, who spent his first twelve years in Argentina, later studying painting in Berlin. At the beginning of the 1920s he worked as an engraver, illustrator, designer of film posters, and picture editor.

He began to photograph in 1924, and produced experimental works in 1925, some in collaboration with the fashion photographer Yva. He took up *photojournalism and in the 1930s did both scientific assignments (biological macrophotographs) and personal abstract work and *photograms. In 1949 he co-founded the *fotoform group around Otto *Steinert, and from the 1950s onwards, with his experimental photograms, *photomontages, and 'light-graphics' (eventually in colour), became a leading exponent of a 'subjective', aesthetically autonomous medium unconcerned about the representation of objective reality. From 1955 Hajek-Halke taught graphic art and photography at the Berlin Hochschule der Bildenden Künste. UR

Hajek-Halke, H., *Lichtgrafik* (1964).

halation. The appearance of haloes around light sources recorded by the photographic image. Light strikes the emulsion; is diffused by the turbidity of the emulsion; is transmitted down to the back of the emulsion support; and is reflected back up again. It can be minimized by the use of light-absorbing anti-halation layers either on the back of the emulsion support or between the emulsion and the support. Historically, anti-halation backings were sometimes removed mechanically, by rubbing with the fingertips, but modern anti-halation layers are normally dyes that are washed out during processing. Black-and-white 35 mm films do not have an anti-halation backing: instead, the base is dyed grey. RWH

half-tone process. A *photomechanical process by which the tones of a photographic image are represented by tiny dots of variable size. Typically, the process involves photographing a subject through a cross-line screen to produce a half-tone negative, which is then used to make a printing plate. A picture printed from the plate is made up of dots proportional in size to the light passing through the negative. Although a coherent image is seen by the naked eye, inspection with a low-powered lens easily reveals the dot structure. Half-tone has a long history. Henry *Talbot demonstrated the principle of the process in 1852, but it only became a commercially viable means of reproducing photographs alongside words on the printed page after improvements in the 1880s. Half-tone was the major factor in the expansion of popular illustrated newspapers and magazines *c*.1900, leading to the enormous circulations of the present day. JPW

Verfasser, J., *The Half-Tone Process* (3rd edn. 1904).

Hallensleben, Ruth (1898–1977), German photographer. In 1930 she apprenticed herself as a landscape and portrait photographer in Elspeth Gropp's studio in Cologne. In 1934 she started her own studio there, moving to nearby Wiehl in 1943. From 1961 to 1973 she worked in Wuppertal. In addition to landscape and architectural photography, and reportage, it was her industrial work which became best known, especially after her death. Over *c.*40 years she created sober documentary images of people and objects in the most varied branches of industrial production, mostly in the Ruhr. UR

Ruth Hallensleben: Industrie und Arbeit (1990).

Halsmann, Philippe (1906–79), Latvian-born American photographer. He taught himself photography while studying electrical engineering in Dresden in the mid-1920s, and undertook assignments for Ullstein in Berlin. After moving to Paris in 1928 he became friends with *Man Ray and other avant-garde figures, and established himself with surrealistic portraits of the intellectual elite. He emigrated to the USA in 1940 and eventually became a fashion and editorial photographer for *Life*, for which he did a record 103 covers. Meanwhile he strengthened his reputation as one of the century's most original portraitists. Some of the numerous celebrities he photographed, including Richard Nixon, Marilyn *Monroe, and the duke and duchess of Windsor, agreed to jump for his camera (*Philippe Halsmann's Jump Book*, 1959). But perhaps his most memorable images were of Salvador Dalí: *Dali Atomicus* (1948), for example, in which the maestro is discovered in mid-air with water and hurtling cats (a shot that had to be repeated many times), and the slightly sinister *Dali's Skull of Nudes* (*c.*1950). Tender and understated, by comparison, was a twilit study of a nude pregnant woman sitting alone with a cat (*c.*1950). RL

Halsmann on the Creation of Photographic Ideas (1961).

Hamaya, Hiroshi (1915–99), Japanese photographer, born in Tokyo. At first he concentrated on the everyday lives of ordinary Japanese. During the war he contributed modern, dramatic photo spreads of Tokyo and its inhabitants to the magazine *Front*, known for its stylish, upbeat presentation of contemporary Japan. He soon left and moved to the northern Niigata prefecture to photograph traditional life in a harsh environment. *Yukiguni* (*Snow Country*) appeared in 1956, followed by *Ura-Nihon* (*The Under-Surface of Japan*) in 1957. He joined *Magnum in 1960, the first Japanese photographer to do so, but after photographing the US Security Treaty riots that year, he returned to landscapes. OH

Hiroshi Hamaya: 50 Years of Photography—Aspects of Nature and Aspects of Life (2 vols., 1981).

Hanaya, Kambei (Kuwata Kazuo; 1903–91), Japanese photographer. Born in Osaka, he bought a photography shop in neighbouring Ashiya in 1929, and in 1930 co-founded the amateur Ashiya Camera Club. Inspired by European art, he helped to position it as Japan's leading avant-garde photographic group. His reputation grew through his unusual expression of movement through double exposure, montage, slow shutter speeds, etc. and the publication of his photographs in the respected *Provoke* magazine. He pressed for the establishment of the Kansai Gakusei Shasin Renmei (Kansai Student League of Photography) in 1939, lending his shop as its base, and influenced amateurs throughout his life. OH

hand colouring of photographs was widely used from the beginning to offset the medium's most obvious limitations. Various techniques were devised, and *daguerreotype portraitists like Antoine *Claudet became celebrated for delicately tinted images, for which they often employed miniature painters made redundant by photography. *Erotic daguerreotypes were frequently coloured to eliminate the unappealing, corpselike grey of the plain image. Hand-coloured photographic prints, ranging from Japanese genre scenes to Italian views, were common in the later 19th century.

As late as the 1950s, the principal incentive of colouring was increased naturalism as compared with monochrome. Even after colour prints became relatively commonplace, many 'high-street' photographers continued to offer hand colouring: it was not only more archivally permanent than the colour prints of the day, but often cheaper as well, especially for large prints.

Predictably, once colour prints became more affordable (even though colours remained fugitive in the extreme), demand for hand colouring declined and the availability of materials fell so low that the very survival of the art seemed in doubt. Then, in the late 1980s and early 1990s, hand colouring enjoyed a revival which continued unabated at the time of writing. Several materials that had been in production for close to a century were suddenly in demand again, and new products were even introduced to make hand colouring easier.

Aesthetically, there were two strands to the revival. One was 'fine art', in the hands of photographers—for example, Ouka *Lele in Spain—who saw an opportunity to produce unique prints. The other was nostalgic and frankly saccharine: the photographic equivalent of the big-eyed children churned out by the 'artists' whose prey are Montmartre tourists. Advertising, as is its wont, exploited both.

Almost any print may be hand coloured, though some surfaces and papers are easier than others: glossy, resin-coated prints are the most difficult. In the early 21st century, even ink-jet materials were successfully adapted for hand colouring: Marshall's, leading manufacturers of transparent oil paints for hand colouring, introduced an ink-jet canvas for hand colouring in 2001.

Most prints for hand colouring are made lighter and less contrasty than those that are not to be coloured, and many are toned with sepia or selenium to create a warm image which can be surprisingly close to a skin tone. To get a strong colour in a dark-toned subject, it is sometimes possible to use filtration to lighten the subject at the taking stage. For example, a red rose, unfiltered, records very dark and does not take red colouring well; but strong red filtration will lighten the rose and allow it to be coloured a richer red.

The colouring media fall broadly into three groups: oils, dyes, and a residual group that includes watercolour pigments, coloured pencils, and even food-colouring dyes.

So-called 'transparent' *oils* can be applied so thinly that they are literally transparent (but still have plenty of colour density) or so thickly that the silver image is completely obscured. For transparent effects, the most usual approach, they are normally applied with a cottonwool bud, and rubbed into the emulsion with a gentle circular or orbital motion; they can be removed with an appropriate solvent, again on a cotton bud if needed. All oils require a more or less matte surface to provide a 'tooth' for the oil to stick to, but in old books there are recipes for varnishes which create such a tooth, allowing (for example) even glass lantern slides to be hand coloured. Oils dry very slowly: at least overnight for a lightly coloured print, and days or even weeks for heavy impasto. This is a mixed disadvantage, however: it gives the hand colourist more time to make revisions.

Dyes dry much faster, sinking into the emulsion instead of sitting on top of it, but this makes them trickier to use. In particular, it is very hard to get even tones in areas such as skies, because the colour cannot be 'worked' in the same way as oils: the only way to 'work' dyes is to use very dilute colours and build them up in repeated applications to get the required intensity of colour. Also, pre-wetting the area to be dyed (and only the area to be dyed), with water and a little wetting solution, makes dye control easier. Despite these difficulties an invention of the 1990s, SpotPens, allowed fairly easy dye colouring. These are dye-charged pens resembling conventional felt tips, which greatly encourages freedom in use. The great advantage of any dye system is that it allows even glossy, resin-coated prints to be hand coloured.

Coloured pencils are useful for touching in fine details, and there are some pencils specifically designed for hand colouring. Again, a 'tooth' is needed as for pigment media. Otherwise, among residual materials for colouring, the main concern is archival permanence. Some dyes adversely affect the silver image; others simply fade, often at different rates for different colours. RWH

Swan, A., '*Coloriage des épreuves*: French Methods and Materials for Coloring Daguerreotypes', in J. E. Buerger, *French Daguerreotypes* (1989).
Worobiec, T., *Toning and Hand Colouring Photographs* (2002).

H & D curve. See CHARACTERISTIC CURVE.

Hanfstaengl, Franz (1804–77), Bavarian artist, lithographer, and photographer who trained at the Munich Academy (1819–25). In 1834 he founded a lithographic firm in Munich, but in 1835 transferred it to Dresden, where he acquired a reputation for executing old-master reproductions for the Saxon government. In 1845 he returned to Munich where, probably with Alois *Löcherer, he learned photography. In 1852 he opened a studio with Moritz Lotze, specializing in portraits, and by 1853 had become court photographer. At the 1854 German Industry Exhibition in Munich he and Lotze also showed townscapes and photographs of the Munich exhibition building (*Glaspalast*) under construction. Hanfstaengl became internationally known for the

method of negative retouching he unveiled at the 1855 Paris World Exhibition. In 1861 he joined the *Societé Française de Photographie. After publishing a series of celebrity portraits entitled *Album of Contemporaries* (1860–5) he began to withdraw from the business, transferring the management of the studio to his son Edgar (1842–1910), who concentrated increasingly on art reproductions. JJ
Gebhardt, H., *Franz Hanfstaengl: Von der Lithographie zur Photographie* (1984).

Harcourt Studio. Opened in 1934 by Robert Ricci and Cosette Harcourt (Germaine Hirschfeld; 1900–76) and financed by two magazine publishers, the Lacroix brothers (one of whom was married to Harcourt), it became Paris's most elegant and sought-after portrait establishment. Portraying its subjects like classical works of sculpture, or film stars, the studio set a standard for beauty and *celebrity portraiture that was unmatched from the 1930s to the 1960s. To be photographed by Harcourt was to arrive on the artistic or theatrical scene. The studio lost its pre-eminence in the 1970s but continues today, still specializing in the glamorous black-and-white image. KEW
Baqué, D., and Denoyelle, F., *Harcourt* (1991).

hardeners. In solutions at temperatures above about 25 °C gelatin begins to absorb excessive amounts of liquid and to soften; an unhardened photographic emulsion may become reticulated or even detached from its substrate. To avoid this, most emulsions are treated with a hardening process during manufacture. Hardening solutions such as formanal (formaldehyde), in alkaline solution, crosslink the collagen molecules and limit the swelling. For high-temperature development (35° plus) a further similar prehardening bath is desirable, as well as the addition to the developer of sodium sulphate. Trivalent ions such as aluminium (Al^{3+}) also have a powerful hardening effect, and are added to most negative fixing baths in the form of potassium alum. Chrome alum is even more effective, but is used as a separate final bath, as it is unstable in acid solution. GS

Hardman, Edward Chambré (1899–1988), British photographer, active in Liverpool. He took a correspondence course in photography while on military service in India in 1917, and eventually became Liverpool's leading portraitist, retiring in 1965. He also took documentary photographs of the city, the best known of which was *Birth of the Ark Royal* (1950). The house at 59 Rodney Street that he occupied from 1948 was acquired by the National Trust, and opened to the public in 2004. Hardman left a hoard of photographic equipment, documents, and nearly 150,000 images. RL

Hardy, Bert (1913–95), English photographer, who worked his way up as an agency and army photographer to become a staffer on *Picture Post* 1941–57. He said he became a photographer 'by sheer luck', having left school at 14 and learned every other stage of photographic processing first. His skilled manipulation of natural light (he never employed flash) and feel for social conditions gave his documentation

of inter- and post-war Britain a particular edge. His lengthy sojourns in countries at war prompted debates at home on everything from the discovery of concentration camps to the treatment of POWs in South Korea. After *Picture Post* folded in 1957, he went into advertising, specializing in classical monochrome mood images.　　AH

Hardy, B., *My Life* (1985).

harems. See ORIENTALISM.

Hariharan, Parameswaram (b. 1926), Indian-born scientist, who was successively director of photographic laboratories at Hindustan Films and senior professor at the Indian Institute of Science, Bangalore, before joining the Division of Applied Physics of CSIRO in Sydney. Hariharan's main research field has been *holography and *interferometry; he is responsible for the standard theoretical works on both subjects. He was the first to make a successful hologram in colour using three lasers, and for a time collaborated with the public artist Alexander in producing large holograms and surrealistic holographic stereograms.　　GS

Harlem Renaissance, an internationally acclaimed flowering of African-American cultural production, including photography, between the wars. The rapid modernization of the African-American population during the early 20th century, the by-product of migration, urbanization, industrialization, the First World War, and a volatile racial climate, forged a national consciousness and sense of community. Efforts to make American society acknowledge the full citizenship of black Americans occurred on multiple fronts, coalescing into the so-called New Negro Movement. Socio-economic circumstances had engendered a distinctive, self-determined identity and culture, manifested not only in political activity but also at the personal level, through the carefully cultivated presentation of the body by means of attire, coiffure, cosmetics, and comportment. The figure of the 'New Negro' epitomized the modern sensibility that African-Americans claimed, and deployed to counteract the derogatory caricatures that pervaded the American imagination. Recognizing the power of photography and other new visual technologies, African-American-owned studios emerged to cater to the demand for portraiture that recorded New Negro self-fashioning. The output of photographers such as James L. *Allen, James *Van Der Zee, and Addison Scurlock (1916–64) constitutes an unprecedented visual record of peoples of African descent in America.　　CDH

Willis, D., *Reflections in Black: A History of Black Photographers, 1840 to the Present* (2000).

Harper's Bazaar, 'A Repository of Fashion, Pleasure and Instruction', was launched as an upmarket weekly on 2 November 1867 by Harper Brothers, New York, under the title *Harper's Bazar*. It featured high-quality black-and-white engravings of London and Paris fashions, altered slightly to suit American taste. *Harper's* became a monthly in 1901, and in 1913 was relaunched as *Harper's Bazaar* by William

Randolph Hearst. The first stage in the magazine's 'golden age' began with Adolphe de *Meyer's arrival from *Vogue in 1922. The second, as de Meyer's ethereal, studio-centred style was losing its appeal, was the appointment of Carmel Snow as editor (1932). She daringly hired the Hungarian-born sports photographer Martin *Munkácsi, who contributed dynamic outdoor images, and a designer of genius, Alexey *Brodovitch, as art director (1934). Under the Snow–Brodovitch regime, contributing photographers included *Blumenfeld, *Brandt, *Brassaï, *Cartier-Bresson, *Hoyningen-Huene, *Kertész, and *Man Ray; the 22-year-old Richard *Avedon joined in 1945. Snow's and Brodovitch's departure at the end of the 1950s, and Avedon's move to *Vogue in 1965, were serious blows. However, the art directors Ruth Ansel and Beatriz Feitler, responsible for the iconic April 1965 cover featuring a space-helmeted Jean Shrimpton, helped to restore its youthful vibrancy, as did work by photographers like Toni *Frissell, Louise *Dahl-Wolfe, Herman Landshoff, Bob Richardson, Jeanloup *Sieff, and Deborah Turbeville. *Harper's* enjoyed yet another reinvention in 1992 when Liz Tilberis moved from British *Vogue and opened its pages to photographers such as Cindy *Sherman and David Sims.　　ZW

Hartmann, Sadakichi (1867–1944), controversial American dramatist and progressive art critic, born in Japan and brought up in Germany. He was central to the transition from aestheticism to modernism in American art. In 1898 Alfred *Stieglitz invited him to write for *Camera Notes* and, from 1903, *Camera Work*. Hartmann supported the *Photo-Secession's emphasis on individual expression, but criticized photographers' inattention to artistic principles, and *pictorialist resistance to modern subject matter. He continued to write on photography under the pseudonym Sidney Allan, and was an important intellectual influence on Stieglitz; they remained lifelong friends.　　HWK

Hartmann, S., *The Valiant Knights of Daguerre*, ed. H. W. Lawson and G. Knox (1978).

Hassner, Rune (1928–2002), Swedish photographer, film-maker, and photohistorian. After an apprenticeship with Rolf Winquist, he went freelance in 1949, basing himself in Paris until 1957. Participating in the path-breaking exhibition Unga Fotografer in 1949, and in 1958 co-founder of the Tio Fotografer cooperative, he became a spokesman for the first post-war generation of Swedish photographers. His Paris years were devoted to *fashion, reportage for Swedish periodicals, and articles on the French photo scene. But his speciality became politically and socially conscious *photojournalism, combined with travels in India, Mexico, China, and West Africa. *The New China* (1957) was a milestone, Hassner being both author and photographer. From the early 1960s he turned increasingly to film. *Pictures for Millions*, his book on the history of photography seen through the prism of the printed and mass-reproduced image, was first a TV series. In 1982–95 he headed the first university-level photography programme at Göteborg University. In 1988 he also became director of the Hasselblad Center in Gothenburg.　　J-EL

Hatakeyama, Naoya (b. 1958), Japanese photographer. Hatakeyama's first major series, begun in the 1980s, was *Lime Hills*. It comprised colour photographs of the workings of lime quarries. The photographs were incisive descriptions of large-scale human interventions in the landscape. There seemed to have been an unusual moral and aesthetic poise behind the camera: Hatakeyama observed without obvious commentary. He showed the purposeful stripping away of hillsides, as if the event had the elegance of an orange being peeled. Man-made hillsides vied with, and became confused with, natural ones. Then came the *Blast* series, which captured flying debris caused by the explosives laid by mining engineers. He found a hideous beauty in these walls of flying rock. Alongside these works, which he continues to make, Hatakeyama is photographing another series— *Untitled*—which shows what happens to all this extracted material. The *Untitled* photographs are taken from high vantage points like the Tokyo Tower. The colour prints, each 22.5 × 46 cm (8⁴/₅ × 18¹/₁₀ in) are exhibited in grids of 48 or more images. The city seems both sprawling and homogenized, orderly and variegated, artificial and organic. Paradoxes and equipoise epitomize Hatakeyama's oeuvre. (He is also a noted architectural photographer.) *River* and *Tunnel*, two connected series from the late 1990s, were published as *Underground* in 2000. The first traces a river flowing through Shibuya, the Tokyo district where Hatakeyama lives: each view is horizontally bisected by the edge of the river's concrete bed. Above are the man-made tower blocks, below is the river, contrasted, compared, but also balanced—leaving us to question our assumptions. *Tunnel* takes us into the dark void beneath the city, where we gradually make out a strange symmetry between the structure and its dark reflection. In 2001 Hatakeyama made a series titled *Slow Glass* in Milton Keynes, England. Views of the city were seen through rain on a car windscreen, each drop acting as a tiny, inverted camera image of the scene. These deft postmodern pictures are as much about the perceiving mind behind the camera as they are about the places beyond the glass. MH-B

Berg, S. (ed.), *Naoya Hatakeyama* (2002).

Hausmann, Raoul (1886–1971), German-Austrian photographer, painter, and writer, and founding member of the Berlin Dada movement. He trained as an academic artist in his native Vienna before moving to Berlin in 1900. The German avant-garde, having been dispersed by war, reconvened in 1917 and Dada was born. Hausmann claimed to have invented the technique of *photomontage the following year while holidaying on the Baltic coast with fellow Dadaist Hannah *Hoech; George Grosz and John *Heartfield, however, also claimed this distinction. Hausmann's photomontages explored the poetic possibilities of printed texts rather than functioning as overt political messages. MR

Hawarden, Lady Clementina (née Fleeming; 1822–65), British photographer. Although she photographed for a mere eight years, exhibited only twice, and sold just a handful of prints, Lady Clementina was already recognized by contemporaries as a most influential photographer. Educated in her native Scotland, and London, she also spent nearly two years in the early 1840s in Rome, where she toured the great art collections. In 1845, back in London, she married the Hon. Cornwallis Maude. It was not until 1857, when her husband inherited the title of 4th Viscount Hawarden, that Lady Clementina made her first photographs, with a *stereo camera. These early images were sometimes views of the Hawarden estate at Dundrum, Ireland, but more often involved her growing family—eight of her ten children survived to adulthood. Although Hawarden photographed landscape and genre scenes, she is most famous for the images of her adolescent daughters, made in her London flat at 5 Princess Gardens, South Kensington. Using wet-*collodion plates of various formats, she created striking portraits of the girls using natural light and often mirrors. Her 'studies', as she called them, were exhibited in 1863 and 1864 at the Photographic Society of London, where they won praise and, in 1864, a silver medal. She became a full member of the society in 1863. Hawarden declined to sell her prints publicly, except once in 1864 for a charity fête to found a women's art school. KEW

Dodier, V., *Lady Hawarden: Studies from Life 1857–1864* (1999).

Hawes, Josiah Johnson. See SOUTHWORTH, ALBERT SANDS, AND HAWES, JOSIAH JOHNSON.

Haworth-Booth, Mark (b. 1944), a major curatorial and scholarly influence on the development of photographic culture in Britain. After reading English at Cambridge and art history at Edinburgh, he worked at Manchester City Art Gallery, before moving to the Victoria & Albert Museum (V&A), London, in 1970, retiring as senior curator of photographs in 2004. He has curated numerous exhibitions and published widely, including *Photography: An Independent Art* (1997), a study of the V&A's collection, and *Things: A Spectrum of Photography, 1850–2001* (2004).

Haworth-Booth is part of a generation that saw photography become a growing institutional concern. Amongst his many influences is the work of John *Szarkowski, as well as the long-standing passion for literature and poetry that is so evident in his writing. His legacy lies not only in the books and exhibitions he has produced, but in the many significant acquisitions made for the V&A collection. RR

hazards and difficulties of early photography. For the 19th-century practitioner, photography was fraught with personal and technical adversity. Chemicals such as mercury, ether, and ammonia filled the *darkroom with dangerous or unpleasant fumes. Constituents of sensitizers and developers were poisonous, and while India-rubber gloves offered good protection, they were inflexible, clumsy, and little used. Chromate sensitizers produced a painful, chronic skin rash, while caustic chemicals included nitric and hydrochloric acid. Sometimes the remedies were worse than the problem; potassium cyanide was used to remove silver nitrate stains from skin. *Collodion was inherently explosive, as the eponymous

and prematurely deceased founder of Mawson's plate factory found. Coating plates by candlelight or gaslight carried similar risks.

The darkroom environment was equally challenging: space was constrained, and in smaller field tents the photographer had to kneel or lie down to work. Ventilation was poor or non-existent, and lightproofing faulty. Materials quickly lost photosensitivity, so photographers had to sensitize their own plates and printing paper. Out in the open, large quantities of water had to be carried up mountains and across rugged terrain in order to obtain wet-plate views. *Albumen paper was thin and liable to tear, and glass-plate negatives were heavy and fragile. Temperature fluctuations reticulated coatings, while airborne pollutants and water impurities ruined them. *Wet collodion plates had to be exposed while still tacky for optimal sensitivity; and although preserved or 'dry' collodion plates addressed this problem, they sacrificed both sensitivity and reliability. Protracted exposures, especially for *daguerreotypes, taxed the patience of both photographer and sitter; more than one of the latter described the agony of trying to keep one's head still and eyes open, while sweat and tears streamed down one's face.

Before the advent of papers sensitive to artificial light, printing was problematic: low winter temperatures and dull light might extend a fifteen-minute exposure to a couple of days, while summer sunshine could produce excessive heat and condensation within the printing frame, leading to blotchy prints. New problems arose with the introduction of ready-sensitized plates and papers. Photographers had previously judged exposure by inspection, but the new dry-plate negatives and developing-out papers produced a *latent image to be subsequently revealed by chemical development. Exposure was estimated through a combination of mathematics and sheer luck, as manufacturers did not apply a common system of calibrating sensitivity until the 20th century. One might expose a whole box of negatives in the field, and return home to find the calculations wrong and the photographs ruined. Printing was also difficult; one journal remarked that using the new gelatin bromide papers was like wheeling a barrow backwards, blindfolded. These problems were finally solved by the introduction of standardized materials, *exposure meters, light and flexible film negatives, simple snapshot cameras, and processing labs. Yet practitioners then complained that the science, skill, and art had been removed, leaving photography a safer but duller practice. HWK

See also EXTREME CONDITIONS, PHOTOGRAPHY IN.

Brothers, A., *Photography: Its History, Processes, Apparatus and Materials* (2nd edn. 1899).

Jay, B., *Cyanide and Spirits* (1991).

Ostroff, E., 'Anatomy of Photographic Darkrooms', in E. Ostroff (ed.), *Pioneers of Photography: Their Achievements in Science and Technology* (1987).

Heartfield, John (John Helmut Herzfelde; 1891–1968), German graphic artist and writer, who trained at the Munich (1907–11) and Berlin (1912–14) design schools. During the First World War he avoided military service by feigning a nervous illness and in 1916,

in protest against anti-British propaganda, changed his name to Heartfield. In 1916–17 he co-founded the Malik Verlag and the journal *Neue Jugend*, and joined the Dada movement. Between 1919 and 1935 he published satirical journals with his brother Wieland and the artist Georg Grosz. He had joined the German Communist Party in 1918 and from 1922 worked increasingly for its publications, including the *Arbeiter illustrierte Zeitung*. Between 1930 and 1938 he created over 200 *photomontages, including famous anti-republican and anti-Nazi propaganda pieces like *The Sleeping Reichstag* (1929) and *The Meaning of the Hitler Salute* (1932). He also worked for the stage directors Erwin Piscator and Max Reinhardt. He emigrated in 1933 to Prague, then in 1938 to London. In 1950 he returned to East Berlin, where he designed political posters and worked for Brecht's Berlin Ensemble and the German Theatre. JJ

Heartfield, J., *Krieg im Frieden: Fotomontagen zur Zeit 1930–1938* (1982).

Willett, J., *Heartfield versus Hitler* (1999).

Heilborn, Emil (1900–2003), Swedish photographer and film-maker, born in St Petersburg. Initially trained as an engineer, and resident in Stockholm from 1927, he took up *industrial and *advertising photography in 1930, working for Sweden's major industries. Through commercial commissions he worked his way to a modernist, even productivist, aesthetic: the fragment, the tightly cropped view, the bold diagonal and unsettling perspective, the multiple rendering of mass-produced objects; his non-industrial images reflected the same spirit. Heilborn's photography speaks to the machine age, imbued with vitalism and focused on a dynamic future. In the 1940s he turned to film-making. J-EL

Heinecken, Robert (b. 1931), American Conceptual artist and photographer. Sometimes described as a 'photographist', Heinecken since the 1960s has appropriated and manipulated mass-media images to create witty and satirical, often controversial, works in a variety of media. Notable are the 1970s series *Cliché-Vary/Autoeroticism, -Fetishism, -Lesbianism*, and *A case study in finding an appropriate TV newswoman* (1984), in which he presented *composite images of male and female TV newscasters. LAL

Enyeart, J., *Heinecken* (1980).

Held, Heinz (1918–90), German photographer. After the Second World War Held managed a Cologne art gallery and worked as a journalist, then took up photography under the influence especially of Otto *Steinert's 'Subjective Photography'. Between 1956 and 1980, among other jobs, he worked as a photographer for Cologne's biennial *trade fair, Photokina. He also published travel books and contributed to numerous German and European magazines. Between 1960 and 1963 he ran Germany's first private photographic gallery. His photographs of people are characterized by precise observation, discreet distance, and an emphasis on the unspectacular and everyday. UR

Held, H., *Fotografien 1950–1985* (1988).

Heliographers, Association of, New York photographers' cooperative, numbering only 42 members in its prime, yet including some of the most influential American art photographers of the 1960s. Paul *Caponigro, William Clift, Carl Chiarenza (b. 1935), and Marie *Cosindas were co-founders of this group initiated by Walter Chappell. The 1 July 1963 Lever House show marked the Heliographers' first public exhibition, promoting 'camera vision' as a way of seeing and recording the world meaningfully rather than mechanically. KEW

Chappell, W., 'The Arising, Manifestation, and Eventual Eclipse of the Association of Heliographers 1960–65, New York City', *History of Photography*, 24 (2000).

heliographic processes, a term used in the late 19th century to describe photographic printing processes particularly suited to reproducing drawings, plans, engravings, and manuscripts. All are characterized by low light sensitivity, and therefore easy handling without a *darkroom, but likewise require contact printing by sunlight or electric arc. Many are capable of the high contrast appropriate for the 'line' or *'half-tone' images commonly employed in reprography, but 'heliography' can also include some *'alternative' processes used for continuous-tone pictorial photography. The most widely used were the *cyanotype ('ferroprussiate', or 'blueprint'), Pellet print, ferrogallate (ink process), sepiaprint, brownprint, aniline, and anthracotype processes. MJW

Lietze, E., *Modern Heliographic Processes* (1888).

heliogravure was initially cited by J. N. *Niépce (1829) to describe his photo-etching process (1826), which used a pewter plate coated with a bitumen resist that hardened on prolonged exposure to light. In France, the term typically described *half-tone etching processes having an aquatint grain, such as that by Niépce's cousin *Niépce de Saint-Victor (1853) on steel plates, *Talbot's *'photoglyphic engraving' on copper, and the Garnier–Dujardin etchings with aquatint rosin on copper (1867). In continental Europe, heliogravure also designated Karel Klič's *photogravure process and was later applied to rotogravure (rotary gravure). HWK

Helmholtz, Hermann (1821–94), German physiologist, physicist, and genius, one of the towering figures of 19th-century empirical science, including optics and human vision. In 1850, on the recommendation of Alexander von Humboldt, he became professor of physiology and pathology at Königsberg University, where he discovered a means of measuring the speed of nerve impulses and invented the ophthalmoscope. After holding posts in Bonn (1855) and Heidelberg (1858), and publishing his monumental *Handbook of Physiological Optics* (2 vols., 1856, 1867), he became professor of physics in Berlin (1871). There, in addition to research in many other fields, he investigated colour vision. In 1878 he became director of the Physikalische Institut, then first president (1888–94) of the new Physikalisch-Technische Reichsanstalt. JJ

Cahan, D. (ed.), *Hermann von Helmholtz and the Foundations of Nineteenth-Century Science* (1994).

Henderson, Alexander (1831–1913), British-born Canadian landscape and commercial photographer. He emigrated to Canada in 1855, settled in Montreal, and took up photography as an amateur. He became the first North American member of the Stereoscopic Exchange Club in 1859, contributed articles to the photographic press, and won medals at several international exhibitions. In 1865, he self-published his first and best-known collection, *Canadian Views and Studies by an Amateur*. The following year he opened a studio in Montreal and established a reputation for landscape work, especially winter snow scenes. During the 1870s, he photographed the construction of the Intercolonial Railway and a decade later produced promotional photography for the Canadian Pacific Railway (CPR) in western Canada. He became founding president of the Montreal Camera Club in 1889, and served as manager of the CPR Photography Department from 1892 until his retirement in 1897. Nearly all his negatives were destroyed after his death. JMS

Triggs, S. G., 'Alexander Henderson: Nineteenth-Century Landscape Photographer', *Archivaria*, 5 (1977–8).
Guay, L., 'Alexander Henderson, Photographer', *History of Photography*, 13 (1989).

Henderson, Nigel (1917–85), British photographer and teacher. Originally a student of biology, Henderson began to produce paintings and collages in the late 1930s, turning to photography only after wartime service as a pilot and subsequent studies at the Slade School of Art. Documentary photography in east London (1949–52) and involvement in the beginnings of *Pop art preceded his first major one-man show (1961). His willingness to experiment led to the creation of *photograms, the manipulation of negatives, and the painting of prints. Between 1965 and 1982 he twice served as head of photography at Norwich School of Art. RP

Henneberg, Hugo (1863–1918), Austrian *pictorialist photographer. After a scientific education he travelled widely, and met *Stieglitz in New York. He joined the *Linked Ring Brotherhood in 1894, and with Heinrich *Kühn and Hans Watzek (1848–1903) belonged to the *Vienna Trifolium. His speciality was still lifes, and landscapes that closely resembled the popular 'atmospheric paintings' of the time: lonely farmhouses at dusk, and ploughmen working under lowering skies. In 1902 he showed a selection of *gum prints with the Vienna Secession. Later he turned to graphic art. RL

Matthies-Masuren, F., *Bildmässige Photographie* (1903).

Henneman, Nicolaas (1813–98) English-based Dutch photographer. Affectionately nicknamed 'Nichole' by the *Talbot family, Henneman first became Henry Talbot's valet and later his photographic assistant. From the winter of 1843–4 until its closure in 1846, Henneman was proprietor of the photographic studio at 8 Russell Terrace, Reading, known as the 'Reading Establishment', where he printed the plates for Talbot's *The Pencil of Nature* and *Sun Pictures in Scotland*, as well as *Annals of the Artists of Spain*. After his marriage in 1846 he opened a London studio, aided by Talbot.

The 'Talbotype' or 'Sun Picture Rooms' were open by August 1847, at 122 Regent Street. A year later, Henneman was joined by Thomas Malone, with whom he worked until 1851. Henneman continued to operate until 1858, expanding the business to include a printing works at Kensal Green. He left London in 1859, working at photographers' establishments in Birmingham and Scarborough. KEW

Schaaf, L. J., 'Introduction', *The Pencil of Nature: Anniversary Facsimile* (1989).

Sterling, W., *Annals of the Artists of Spain* (1848).

Henri, Florence (1893–1982), American-born painter and photographer, mainly active in Paris. After studying painting in Germany and Paris she entered the *Bauhaus in 1927 and, influenced by László *Moholy-Nagy, turned increasingly to experimental photography. Although her painting became secondary, her portraits, still lifes, and other photographic work were strongly influenced by Cubism and Constructivism. She participated in the 1929 *Film und Foto* exhibition in Stuttgart and other important shows before opening an advertising, fashion, and portrait studio in Paris. After 1945 she returned increasingly to painting. RL

Florence Henri, Artist-Photographer of the Avant-Garde (1990).

Herschel, Sir John Frederick William (1792–1871), British photographic inventor and muse. In the dark days of 1839, when Henry *Talbot's invention of photography on paper seemed to be losing on every front to the metal plates of his rival, Louis *Daguerre, it was Herschel who sustained the English inventor's hopes and who greatly expanded the field of study. So extensive was Herschel's education, and so creative his mind, that on merely learning of the existence of the new art, he independently invented his own process in under a week. Recognizing the need to impose an intellectual discipline on its development, he suggested the name photography itself (to replace Talbot's awkward *photogenic drawing), along with the terms positive and negative to describe its productions. His formidable reputation, and the goodwill he enjoyed throughout Europe, did much to bolster his friend Talbot's cause; indeed, it may well have been critical to Talbot carrying on at all. With unlimited curiosity and a fertile imagination unhampered by any considerations of practicality, Herschel invented hundreds of photographic processes. Some presaged later practices, including the first negative on glass (1839). Some were potentially useful, such as the gold-based *chrysotype, inspired by the 18th-century work of Elizabeth *Fulhame. Some proved to be very practical, especially the 1842 iron-based *cyanotype used by his friend Anna *Atkins to produce the first photographically illustrated book, and later employed for decades in the form of the architect's blueprint. His application of hypo to fix the photographic image permanently is used to this day. Herschel was the first to photograph the spectra (extending the pre-photographic work of his father William) and was well on his way towards inventing full-colour photography when personal circumstances forced him to put his researches aside in 1843. 'My first love was light', he once told

his wife, and his extensive photographic researches were mostly designed to understand the nature of light, rather than using light to record nature. Herschel's paradoxical lack of interest in taking photographs himself is best explained by his long-standing and complete mastery of the camera lucida, the very drawing instrument whose frustrating characteristics inspired Talbot to invent photography in the first place. Herschel preferred drawing's contemplative observation to photography's *snapshot (another term he devised). But he was deeply interested in artistic photographs, including those made by his brother-in-law John Stewart, and especially in the controversial masterpieces produced by his close friend Julia Margaret *Cameron. He had sent her some of the earliest photographs he made while she was in India, and decades later she proudly exclaimed: 'you were my first teacher & to you I owe all the first experiences & insights.' Her haunting photographs of her muse late in his life are a lasting testimony to the spirit of the man. LJS

Büttman, G., *The Shadow of the Telescope: A Biography of John Herschel* (1974).

Schaaf, L. J., *Tracings of Light: Sir John Herschel & the Camera Lucida* (1989).

Schaaf, L. J., *Out of the Shadows: Herschel, Talbot & the Invention of Photography* (1992).

Heydecker, Joe (1916–97), German writer, photographer, and anti-Nazi who, as a wartime conscript, using a 35 mm Kine-Exakta, took over 1,000 private photographs of military life in west and east. But most notable were his illicit images of the Warsaw Ghetto, made in February 1941, which revealed the dreadful conditions there. Later, his wife and friends helped to conceal them. Heydecker settled in Brazil in 1960 and exhibited the Warsaw photographs for the first time in São Paulo in 1981. RL

Heydecker, J., *Das Warschauer Ghetto* (1986).

high-speed photography. See MOVEMENT, PHOTOGRAPHY OF; SCIENTIFIC PHOTOGRAPHY.

Hill, David Octavius (1802–70), Scottish painter, and **Adamson, Robert** (1821–48), Scottish photographer, whose partnership in the 1840s was an extraordinary creative collaboration. They met in May 1843, when a formal dispute within the Church of Scotland caused the withdrawal of some 450 ministers, who formed the Free Church of Scotland. Hill greatly admired the action, saw it as morally highly significant, and determined to paint it. Whilst he was engaged in sketching the meetings, he encountered Sir David *Brewster, who urged him to consider working with Adamson.

Adamson arrived in Edinburgh on 10 May. His studio was a south-facing garden at Rock House on Calton Hill, 300 m (1,000 ft) above sea level. Hill met Adamson, and they made trial *calotypes of the individual ministers and groups. They were both impressed, and entered into partnership in July. In 1843 they worked both independently and with other painters. They also employed an assistant, Miss Mann (*fl.* 1840s–1850s). In the spring of 1844 they

probably entered into a closer partnership, planning the publication of six books of calotypes on the fishing life of the Firth of Forth, Highland character and costume, the architecture of Edinburgh and Glasgow, Scottish castles and abbeys, and Scottish portraits. Perhaps for reasons of technical difficulty or cost, none was published, although Hill and Adamson did publish views of St Andrews in 1846. In 1844 they commissioned new equipment from the instrument maker Thomas Davidson (1798–1878), including a camera that could take architectural prints 43 × 32.5 cm (16 × 13 in). With this they also took radical portrait calotypes of figures like the Revd Dr Thomas Chalmers and the boys at Merchiston Castle School, and they carried it down to York for the meeting of the British Association for the Advancement of Science.

In 1845–6 Hill attempted to promote the calotypes through articles written by Dr John Brown and Elizabeth Rigby (later Lady *Eastlake). In 1845, he sent a portfolio to London where it was seen and applauded. Hill then tried to market an album of 100 calotypes as a model of the artistic use of photography. Some of these were set up and bound, but may never have been sold. In 1846 the calotypes included pictures taken at Edinburgh Castle. In mid-1846 the studio work seems to have slowed. Adamson may have fallen ill at this point and there are few calotypes datable to 1847. At the end of that year, he returned to St Andrews, and died the following January. Within three to four years, the partners took more than 3,000 calotypes, of an aesthetic and technical excellence which profoundly influenced later practice in Scotland and abroad. SS

➲ See also Hill and Adamson *overleaf.*

Schwarz, H., *David Octavius Hill: Master Photographer* (1932).
Bruce, D., *Sun Pictures: The Hill–Adamson Calotypes* (1973).
Ford, C., and Strong, R., *An Early Victorian Album: The Photographic Masterpieces of David Octavius Hill and Robert Adamson* (1974).
Stevenson, S., *The Personal Art of David Octavius Hill* (2002).
'David Octavius Hill', *History of Photography*, 27 (2003).

Hill, Paul (b. 1941), British photographer and educator who has played a central role in the development of British photography since the 1970s. His commitment to the cause of photography, which he has championed relentlessly for over 30 years, distinguishes him from many contemporaries. Apart from numerous exhibitions and publications of personal work, his belief in the future of photography found its best expression through his 'Photographer's Place' which, for twenty years, brought eminent practitioners, many of them American, before British audiences in a series of influential workshops. He was awarded an MBE in 1994, and a second edition of his seminal volume *Approaching Photography* (1982) appeared in 2004. RTA

Hill, P., *White Peak, Dark Peak* (1990).

Hiller, Lejaren à (John Hiller; 1880–1969), American illustrator and photographer. After art training at the School of the Art Institute of Chicago, Hiller started commercial illustration in 1905. Two years later, he went freelance in New York, producing pen-and-ink drawings for popular magazines. In 1913 he convinced *Cosmopolitan* magazine to illustrate fiction with his overpainted photographic tableaux. He was an overnight sensation. By developing a commercial photography style based on the art photography style of *pictorialism, Hiller introduced a sense of subjectivity and emotion to his narratives that engaged his viewers (and challenged expectations of photographic *realism). He developed a reputation as an extremely creative studio photographer, going to great lengths to construct sets or make toy stages that could be photographed, enlarged, and used as backgrounds for his models. He employed soft focus, combination printing, dramatic lighting, and heavy retouching to craft his theatrical interpretations. In 1924 he became vice-president and director of photography for the New York commercial division of *Underwood & Underwood. His subjects ranged from promoting beauty products in mass-circulation magazines to advertising hospital supplies in medical journals through his humorous and mildly erotic re-creations of *Surgery through the Ages* (1927–33). Hiller's archive is at the Visual Studies Workshop, Rochester, New York, and the *International Museum of Photography, George Eastman House. PJ

Brown, E., 'Rationalizing Consumption: Lejaren à Hiller and the Origins of American Advertising Photography', *Enterprise and Society*, 1 (2000).

Hillers, Jack (1843–1925), German-American government photographer. An immigrant from Hanover, Hillers fought for the Union in the Civil War and in May 1871 met the explorer and anthropologist John Wesley Powell (1834–1902), eventually director of two federal agencies, the Bureau of Ethnology (1879) and the US Geological Survey (1881). Powell hired him as a boatman for an expedition down the Green and Colorado rivers, but a year later appointed him the expedition's photographer. On this and many subsequent expeditions Hillers took superb wet-plate views of the Grand Canyon and other locations in the desert West and south-west; and, in 1892, of the *Yosemite Valley. Powell, increasingly interested in Native American culture, also commissioned many pictures, some straightforwardly ethnographic, others more contrived, of Native American tribes, including the Southern Paiutes (who named Hillers Myself in the Water), the Hopis, and the pueblo-dwellers of Arizona and New Mexico, most notably at Zuni. Back in Washington, DC, he made portraits of hundreds of visiting Indian delegates. Hillers's pictures were widely exhibited and published in his lifetime, and are mostly preserved in the National Archives and the Smithsonian Institution. RL

Fowler, D. D., *Myself in the Water: The Western Photographs of John K. Hillers* (1989).

Hime, Humphrey Lloyd (1833–1903), Irish-born Canadian photographer. Although only an amateur when he went to Canada in 1854 to join an engineering firm, he served as official photographer to the Assiniboine and Saskatchewan Expedition to the western interior in 1858 and, despite the limitations of the *wet-plate process, effectively captured the character of the territory in the 50 images

(*continued on p. 277*)

Hill and Adamson The Newhaven Calotypes

The Scottish fishing village of Newhaven lies a mile north of Edinburgh, on the estuary of the River Forth. In 1841 its recorded population was 2,103, including 300 fishermen. Between 1843 and 1847, the village saw a remarkable exploration in photographic art. When D. O. *Hill and Robert Adamson first entered into

partnership, Sir David *Brewster sent a letter to Henry *Talbot explaining their intentions which included the confusing phrase: 'Mr D. O. Hill, the Painter, is on the eve of entering into partnership with Mr Adamson and proposes to apply the Calotype to many other general purposes of a very popular kind, & especially to the

D. O. Hill and Robert Adamson

Elizabeth Johnstone Hall of Newhaven, 'It's no fish ye're buying, it's men's lives', 1843–6. Calotype

execution of large pictures representing difft. bodies & classes of individuals.'

Hill had first met Adamson to discuss the use of photography in assisting his painting commemorating the formation, in May 1843, of the Free Church of Scotland, and was thinking of wider applications of such natural studies for painters. Before this, he had painted in the village of Newhaven, and his earlier work expresses a concern for the immediate translation of experience which offers a parallel to photography. In 1835 he exhibited three paintings at the Royal Scottish Academy: *The Peacock Inn: Sketch at Newhaven*; *Evening: Scene on the Beach at Newhaven—Painted on the Spot*; *Sketch of an Oyster Boat Painted on Newhaven Beach*. His enthusiasm presumably derived principally from the work of the surgeon Charles Bell (1774–1842), who advised painters to observe people active in their natural setting: 'At the gaming house, on the exchange, in the streets, this study affords amusement of the highest interest and gratification.' In Edinburgh at this time there was some difficulty in studying from the figure—in practice, painters worked mostly from plaster casts rather than from life. Hill was unquestionably fascinated by the opportunity offered in photography to study single figures and to construct groups. His enthusiasm was echoed in the reaction of the marine painter Clarkson Stanfield to the Newhaven calotypes: 'They are indeed most wonderful, and I would rather have a set of them than the finest Rembrandts I ever saw.'

But the Newhaven photographs have a larger ambition. In August 1844 the partners announced the publication of six volumes of pictures on particular subjects. First on the list was *The Fishermen and Women of the Firth of Forth*. They had taken a few calotypes of the fishermen and women in 1843, but this announcement signalled a new intention—the idea of a coherent work on the subject.

Hill admired the calotype process in Adamson's hands in terms of its unevenness and imperfection: 'The rough surface and unequal texture throughout of the paper is the main cause of the calotype failing in details before the process [or 'precision'] of Daguerrotypy —& this is the very life of it. They look like the imperfect work of a man—and not the much diminished perfect work of god.' This slightly cryptic phrase defines the aesthetic of the calotype—it has a human character and can be used as a medium for fine art. It has life.

Newhaven was remarkable in the context of the 1840s. It was a small working-class community flourishing in times of distress. The periodic slumps of the Industrial Revolution, endemic disease, the potato famine, and the Highland clearances had driven the poor into the cities and generated disastrous slums. By contrast, the village was self-governing, heroic, educated, and moral. Work there was hard and hazardous. The men fished at sea from small, unprotected boats. Fanny Kemble wrote of the fishwives: 'It always seemed to me that these women had about as equal a share of the labour of life as the most zealous champion of the rights of her sex could desire.' They were remarkable for their singing voices and for their self-confidence; they were also distinctive in both their dress and their beauty. At the time of the 'Disruption' in the Church of Scotland, the Newhaven congregation were active supporters of the Free Church.

The Fishermen and Women series of calotypes focused on Newhaven with a few additional pictures taken in Portobello and St Andrews, including the extraordinary group of the Fishergate containing more than twenty women and children. Around 120 pictures were taken of men, women, children, and groups involving, in the organization and taking, a phenomenal amount of time and cooperation. The subjects must have been well aware of the purpose of the photographs and in agreement with it.

The original objective was not realized, and the series was never published as a discrete group of pictures. It includes a proportion of failed negatives which reveal the intention to explore the village's working activity: cleaning lines, selling fish, bringing in the catch, and even—a technical impossibility—the boats in the water (simulated by positioning a boat on the beach with sail set). The calotypes picture the social structure of the village: the way fathers educated sons, and fishwives supported each other. They are also concerned with subtler questions of the community's human and cultural sophistication, from the minister's bible class to people simply thinking.

There would appear to be no 19th-century parallel for such a large-scale visual exploration of a community, apart from anthropological studies overseas. The admiration it aroused implies that it was a model offered to help solve the social problems of the 1840s; which in itself answers the question raised later of voyeurism in examining the lives of the poor. The Newhaven series most closely resembles the kind of social *documentary work of the 20th century, seen especially in magazines like *Picture Post* or *Life*. It connects most interestingly, in the 20th century, with Paul *Strand's celebration of village life, including his 1954 Hebridean study *Tir A'Mhurain* (*The Land of Bent Grass*), which pays visual tribute to Hill and Adamson's work. SS

Stevenson, S., *Hill and Adamson's 'The Fishermen and Women of the Firth of Forth'* (1991).

he made. Hime left engineering for stockbroking in the 1860s, and apparently also gave up photography. LAL

Hinde, John (1916–98), Irish photographer, pioneering adept of the tri-colour *carbro process, and *postcard publisher. During the Second World War he illustrated books on British life and worked for *Illustrated* magazine. His colour photographs for Stephen Spender's tribute to Civil Defence workers, *Citizens in War—and After* (1945), made with a Devin one-shot camera, were both moving and technically superb. The Dublin-based postcard company he ran between 1956 and 1972 built its success on colour printing, tourism, and, when necessary, 'gilding the lily' to please the public. RL

Hindesight: John Hinde Photographs and Postcards by John Hinde Ltd 1935–71 (1993).

Lejaren à Hiller

*Jail Break, c.*1930

Hindenburg disaster, 6 May 1937. The German passenger airship, inbound from Europe in bad weather, caught fire when about to berth at Lakehurst, New Jersey, and crashed, killing 35 of the 97 people on board. Although this was the *Hindenburg*'s eleventh transatlantic round trip, her arrivals were spectacular enough to attract media interest, and a radio reporter, a newsreel crew, and 22 press photographers were on hand for the event. Not only newsreel footage but numerous still photographs recorded the crash, including a sequence taken by an amateur, Arthur Codfod, who, ironically, had come to collect a consignment of photographs for *Life* magazine. A professional, Gerard Sheedy, shot 35 mm colour Kodachrome transparencies. The existence since January 1935 of the Associated Press Wirephoto network permitted rapid distribution of the black-

and-white pictures, and many newspapers carried them the following day. Sheedy's images, which required special processing at Rochester, appeared in the *New York Sunday Mirror* on 23 May. RL

Goldberg, V., *The Power of Photography: How Photographs Changed our Lives* (1991).

Hine, Lewis Wickes (1874–1940), American sociologist and *documentary photographer, born in Oshkosh, Wisconsin, where he studied at the State Normal School, completed courses in drawing and sculpture, and worked in a factory before studying sociology at Chicago University in 1900. A self-taught photographer, he moved to New York in 1901, becoming an instructor in nature studies and official photographer to the Ethical Culture School. In 1905, informed

Lewis Hine

Faces of the Hopeful, Ellis Island, 1910

by his training in sociology, and with his reformist interests sharpened by his experiences at the school, he began using the camera to study social problems by recording the arrival of immigrants at Ellis Island. These images led the National Child Labor Committee (NCLC) to hire him in 1906 for its campaign to ban child labour in agriculture, the canning and textile industries, mining, and other places progressive reformers regarded as unsafe or morally unfit for children. While working for the NCLC, he completed his master's degree in sociology at Columbia University (1907). He first published his photographs with accompanying text as an essay in *Charities and Commons*, later better known as *Survey* magazine, in whose pages his passionate opposition to child labour appeared regularly. Between 1908 and 1918 the NCLC

sent Hine throughout the eastern states to document the prevalence of the problem. Using *flash photography techniques pioneered by Jacob *Riis, he documented young boys working underground in coal mines in Pennsylvania. Plant managers at southern textile mills tried to exclude him from their premises. Always he accompanied his images, intended for use in posters, pamphlets, lantern lectures, and other NCLC campaign media, with detailed captions describing working conditions, the ages of the children, and, if possible, their wages. Hine also did occasional photographic work for the American Red Cross between 1910 and 1914, and between 1918 and 1920 documented post-war conditions in the Balkans, Italy, and Greece, images which became part of *The Human Cost of War* (1920).

Hine began to receive recognition as a photographer rather than simply as a reformer in 1919, when his first one-man show was mounted. He continued to work as a photographer and photo director for *Survey* 1922–9, and for the Red Cross. Notwithstanding his standing as a reformer and photographer, his experience photographing construction of the Empire State Building, New York (1931), and the work of the Tennessee Valley Authority (1933) and Rural Electrification Administration (1934–5), Roy *Stryker did not hire him for the FSA's monumental documentary photographic effort. Instead Hine became photographic director of the National Research Project of the Works Progress Administration (WPA). Though equally fine, these images are much less widely known than his pioneering child labour photographs. CBS

Gutman, J. M., *Lewis W. Hine and the American Social Conscience* (1967).
Gutman, J. M., *Lewis W. Hine, 1874–1940* (1974).
America & Lewis Hine: Photographs 1904–1940, text by A. Trachtenberg (1977).

Hiro (Yasuhiro Wakabayashi; b. 1930), Japanese-American fashion photographer, born in China to Japanese parents who later returned to Japan. He moved to New York in 1954 and in 1956–7 assisted Richard *Avedon. The years 1958–60 brought him to Alexey *Brodovitch, whose personal assistant he became, and from whom he received both influence and encouragement. Combining simple but elegant design with sophisticated technique and striking colour, he opened his own New York studio in 1958, receiving commissions from *Harper's* and other fashion magazines. His work extends beyond fashion and advertising to personal explorations, including portraits, children, and landscapes. MHV

Avedon, R. (ed.), *Hiro Photographs* (1999).

histogram. In *digital photography, an electronic bar chart showing the distribution of tones in an image, from completely dark (on the left) to completely light (on the right). In advanced cameras it can be displayed 'live' as an *exposure aid in the viewfinder, to indicate the dynamic (tonal) range of the image being taken. RL

historiography of photography. The first histories of photography were written by its inventors, thereby establishing a tradition of privileging technological development over other aspects.

In 1839 Louis *Daguerre published his *Historique et description des procédés du Daguerréotype et du diorama*, and Henry *Talbot unveiled his version of photography's discovery, *Some Account of the Art of Photogenic Drawing*. With these publications the history of photography took shape as a debate about the identity of the medium's inventor. Well into the 20th century, photographers and chemists (the early histories were written by practitioners, for practitioners) argued for the claim of one or another individual to have first solved the problem of fixing images, and they often did so along nationalistic lines. In his 1925 *Histoire de la découverte de la photographie* (Eng. 1936), Georges Potonniée claimed unequivocally that it was Nicéphore *Niépce who deserved sole credit, and played down the role of Englishmen and Germans in photography's development. The Austrian Josef Maria *Eder countered this exclusionary claim in his *Geschichte der Photographie*, which saw four editions, the last in 1932, by situating Germans and Austrians at the heart of the medium's history: Eder declared that the true inventor was in fact a German chemist. Notwithstanding their histories' nationalistic bias, both Eder and Potonniée would influence future historians due to the thoroughness with which they covered the subject of early photographic technologies.

Around 1900, however, perspectives shifted as photographs came increasingly to be regarded as art objects. Subsequently, although the role of technological advances remained important, the history of photography came to be written as the history of an expressive medium within the history of art. This change in how photographs were viewed, both literally and conceptually, had much to do with the theoretical debates that appeared in journals like *Camera Work*, and exhibitions of work by contemporary photographers, including the 1910 exhibition of pictorial photographs that Alfred *Stieglitz organized at the Albright Gallery in Buffalo, New York. In the meantime, improvements in *photomechanical printing allowed photographs to be easily reproduced in publications, while growing interest in stylistic development increasingly demanded it. In 1929 William Shepperley was the first to take an image-orientated approached in his *History of Photography*. Two years later the Austrian art historian Heinrich *Schwarz published a monograph on David Octavius *Hill, the first study of photography from an art-historical perspective. Treating photography as an art form, however, had its problems, principally the apparent lack of an obvious linear stylistic development from photography's invention onwards. How, for instance, could the expressive nature of pictorial photography be viewed as the natural successor to the hard reportage of daguerreotypy? The answer lay in selectivity: a precursor of the photograph as an aesthetic object was found in the *calotype, while David Octavius Hill was championed as the 'father' of pictorial photography—in other words, the daguerreotype should be left to one side of any discussion on pictorial photography. This method of simplifying an otherwise complex history by organizing types of photographs into discrete categories would later become common practice. In the 1930s museums also began to accept photographs as art objects. The Paris Musée des Arts

Décoratifs held an exhibition of contemporary photography in 1936, and the Victoria & Albert Museum in London and the Metropolitan Museum in New York did likewise in 1939. (The Metropolitan had accepted 22 photographs from Stieglitz as a gift in 1928, and showed a selection the following year, but did not stage its first big exhibition until a decade later.) It was, however, Beaumont *Newhall's 1937 exhibition at MoMA, New York, that influenced how generations came to regard photography and its history. Newhall had trained as an art historian, and so treated photographs as aesthetic objects and the history of photography as the development of stylistic concerns determined by technological invention. In preparation for staging his visual survey, Newhall familiarized himself with the published histories of Eder, Potonniée, and others, and travelled to England and France. For the exhibition catalogue, *The History of Photography, from 1839 to the Present*, he wrote a 90-page text in which he somewhat arbitrarily divided the history of photography into three periods: primitive (1839–51), early (1851–1914), and contemporary (1914–37). Newhall expanded the catalogue for republication a year later, rewrote the text in 1949, and revised it again for new editions in 1964 and 1982. While accepted by many as the definitive history of photography, and used as a textbook in countless universities that now included photography in their curricula, Newhall's *History* had many shortcomings: his formalist approach ignored the content and uses of photographs in favour of aesthetic appreciation, and his history focused on French and English photography, overlooking important developments in Russia, Germany, and elsewhere. In the latter part of the 20th century historians largely rejected the idea of a single master narrative as told through a canon of 'masterpieces'—Newhall's guiding principle—and instead sought to describe photography as a complex socio-cultural phenomenon. Feminist and multicultural perspectives also became prominent. Parallel developments were taking place in art history, film studies, and other disciplines. Journals such as *History of Photography*, *Études photographiques*, and *Fotogeschichte*, and large synoptic histories like Michel Frizot's *Nouvelle Histoire de la photographie* (1994), examine what is distinctive about photography and consider the purpose or function of photographs, rather than remaining fixated on particular images and their aesthetic qualities. Recognizing that 'photography' encompasses a vast array of practices and artefacts, cultural historians deny that there is one true history of photography, and instead explore its many and concurrent histories. MR

Gasser, M., 'Histories of Photography 1839–1939', *History of Photography*, 16 (1992).
'Why historiography?', *History of Photography*, 21 (1997).
Jaeger, J., *Photographie: Bilder der Neuzeit. Einführung in die historische Bildforschung* (2000).
Peterson, N., and Pinney, C. (eds.), *Photography's Other Histories* (2003).

History of Photography, British quarterly journal, launched in January 1977. Its scope is international. Thematic issues have concentrated on aspects of photography from particular regions, periods, or disciplines. Its editors have been Heinz H. Henisch (1977–91), Mike Weaver and Ann Hammond (1991–2000), and Graham Smith (2001–). KEW

Hockney, David (b. 1937), British artist, born in Bradford, Yorkshire, and trained at the Royal College of Art. His interests have included painting, printmaking, film-making, and stage design. His creative use of photography began in 1981 when he became dissatisfied with the restrictions imposed by single-viewpoint perspective. He therefore made large collages of photographs, including Polaroids, taken from different viewpoints; work that he described as 'a critique of photography made in the medium of photography'. A selection of it was shown at the Hayward Gallery, London, in 1983. Hockney's interest in painters' use of optical devices in the past produced the book *Secret Knowledge: Rediscovering the Lost Techniques of the Old Masters* (2001). CR

Hockney's Photographs, introd. M. Haworth-Booth (1983).
Joyce, P., *Hockney on Photography* (1988).

Hoech, Hannah (1889–1978), German painter and photocollagist, who studied graphic design in Berlin before joining the Dada movement in 1918. Until 1922 she lived with Raoul *Hausmann, and they influenced each other with their mixture of collaging and writing. Between 1922 and 1927 Hoech produced a number of collage novels and a huge series of images reflecting her role as a woman in the arts. More famous for its title than its imaginative quality is her *Cut With the Kitchen Knife Dada Through the Last Weimarian Beer Belly Epoch of Germany* (1924). From 1927 to 1930 she lived in the Netherlands, exhibiting frequently. Returning to Germany in 1930, she settled in northern Berlin and began to collect the relics of Dada. Although denounced as a 'cultural bolshevik' in 1937 she survived the Nazi period in isolation and 'inner emigration'. Not until shortly before her death did she experience a revival of interest in her work. Her late paintings and photographs still await rediscovery. RS

Fotografieren hieß teilnehmen: Fotografinnen der Weimarer Republik (1994).

Hoeltzer, Ernst (1835–1911), German engineer employed by the Iranian Telegraph Department who took up photography and established a commercial studio in Isfahan. During almost 30 years' activity in *Iran (1871–98), he made over 3,000 negatives using the *collodion process. Although only a third of his total oeuvre has survived, his photographs provide an unparalleled view of life in Isfahan and throughout Iran during the period. His work differs in subject matter and orientation from that of other Western photographers, perhaps because his marriage to an Armenian woman gave him a more intimate window into the life of the inhabitants. KSH

Scarce, J., 'Isfahan in Camera: 19th-Century Persia through the Photographs of Ernest Hoeltzer', *Art and Archaeology Research Papers* (Apr. 1976).

Hoepffner, Marta (1912–2000), German photographer, early and decisively influenced by her uncle, the Dadaist Hugo Ball. In 1929

she began studying painting, printmaking, and photography at the Städel School in Frankfurt am Main. After the dismissal of her teacher Willi Baumeister by the Nazis in 1933 she left to found her own design studio. She also experimented with *negative printing, *solarization, and *photomontage. After the wartime destruction of her studio she started a photographic school in Hofheim (Taunus). From the mid-1950s she worked exclusively on cameraless photography and experimental colour work; most notably, in the 1960s, her 'variochromatic light objects'. UR

Marta Hoepffner: Fotografien und Lichtobjekte (1984).

Hoffmann, Heinrich (1885–1957), German photographer and Nazi propagandist. The son and nephew of photographers, he worked in the *Hoppé studio in London before setting up in Munich as a portraitist and photojournalist. His photograph of cheering crowds on 2 August 1914 unwittingly captured the young Adolf Hitler, a fact which would later benefit Hoffmann's career. Drifting to the far right after the First World War and revolutionary events in Bavaria, he joined the Nazi Party in 1920 and convinced an initially camera-shy Hitler of photography's political value. (The relationship was cemented by Hitler's liaison, from 1930, with Hoffmann's assistant Eva Braun.) After 1933 his virtual monopoly of Hitler photographs, as 'the man who sees the Führer for us', made him one of the Third Reich's major profiteers. His scenes of carefully constructed intimacy, presenting his master, especially in the regime's early years, as a clean-living, nature-loving man of the people, were massively disseminated. After 1945, though claiming to have been a mere chronicler of events, he was fined and imprisoned. His extensive photo archive survives. RL

Herz, R., Hoffmann und Hitler: Fotografie als Medium des Führer-Mythos (1994).

Hofmeister, Theodor Ferdinand Eduard (1868–1943) and **Oscar Ludwig Robert** (1871–1937), German amateur photographers, born and active in Hamburg. The remarkable creative partnership between Theodor, a businessman, and Oscar, a judicial official, made them leading exponents of German *pictorialism and, as members of Hamburg's Society for the Encouragement of Amateur Photography, key figures in the 'Hamburg School' of art photography at the turn of the century. Their chosen medium was the large-format *gum bichromate print; The Solitary Horseman (1903), for example, acquired by Alfred *Stieglitz and now in the Metropolitan Museum of Art, New York, measures 68.5 × 98 cm (27 × 38¹/₂ in). While each major work was jointly planned, Oscar made the exposure, and Theodor undertook the complex production of the final print. Their portraits and somewhat melancholy north German landscapes won international acclaim, and six of their pictures appeared in the July 1904 issue of *Camera Work. In the 1920s, however, their work was eclipsed by *New Vision photography, and remained forgotten until rediscovered by Fritz Kempe in the 1960s.

The Hofmeisters clearly met the demands of theorists like Alfred *Lichtwark and Ernst *Juhl for an 'artistic' photography that would go beyond the mere reproduction of reality. But their non-naturalistic colours, sometimes near-abstract simplification of forms—already, for example, in Marsh Flowers (1897)—and use of integral frames matched modern tendencies in the visual arts generally. Like the contemporary graphic revival and the rise of the large-format watercolour, their claim to wall space, salon-worthiness, and serious prices challenged the hallowed supremacy of the oil painting. RL

Kopanski, K. W., and Philipp, C. G. (eds.), Meisterwerke russischer und deutscher Kunstphotographie um 1900: Sergei Lobovikov und die Brüder Hofmeister (1999).

Hoinkis, Ewald (1897–1960), German photographer who started taking pictures aged 11 with a Reisekamera. After photographic training in the air force (1915–18), he studied painting and worked in a bank, whilst freelancing as an artist. Concentrating on photography from 1925, he exhibited at *Film und Foto, opening a studio in his native Görlitz (1929), then Berlin (1931). A modernist and friend of Georg Grosz, he became a leading portrait, fashion, and advertising photographer, and head of photography at the Meisterschule für Graphik und Buchgewerbe. Hoinkis's Berlin studio was destroyed in 1944 and he restarted his career in Munich, then Frankfurt. RA

Hollywood publicity photographs. Still photography, comprising both studio portraiture and the work of publicity-department 'stillsmen', made a significant contribution to the Hollywood film industry, especially during the heyday of the studio system from the 1920s to c.1950.

Portraiture

The pre-First World War emergence of the star system, with its attendant publicity apparatus and fan magazines (e.g. Photoplay, founded in 1912), boosted demand for glamorous images. Until c.1920 it was met by commercial operators like *Underwood & Underwood in New York (promoters of Theda Bara) and Nelson Evans and the Witzel studio in Los Angeles. Screen actors often invested heavily in promotional portraits. With the consolidation of the studio system, however, portraiture became part of an elaborate star-grooming process conducted in-house. Leading star photographers, who worked in 'portrait galleries' on the studio lot, included (over longer or shorter time-spans) Ruth Harriet Louise (1903–40), George Hurrell (1904–92), and Clarence Sinclair Bull (1895–1979) at MGM, Eugene R. Richee at Paramount, Jack Freulich (d. 1936) at Universal, and Ernest Bachrach at RKO. Freelances like Tom Kelley (b. 1914) and André de Dienes (1913–85) were hired by MGM and Selznick International as required. There was also, as the work of figures like Horst P. *Horst, George *Hoyningen-Huene, and Edward *Steichen demonstrates, a dynamic relationship between Hollywood portraiture and contemporary *fashion and *advertising photography.

McDonnell Douglas Electronics Portrait of Dennis Gabor, 1971. Virtual image transmission holographic portrait

Giles Penfound, Warrant Officer British corporal washing his feet, Iraq, 27 March 2003

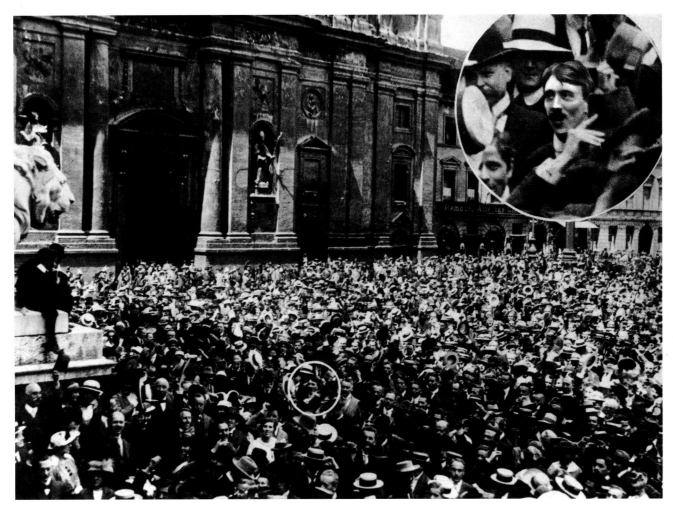

Heinrich Hoffmann

Crowds on the Munich Odeonsplatz, including Adolf Hitler (inset), celebrate the outbreak of the First World War, 2 August 1914

Although some stars hated photography and others would only work with a favoured photographer—Greta Garbo with Bull, for example, from 1929—most either revelled in the process or accepted it for the sake of their careers. Using 20.3 × 25.4 cm (8 × 10 in) studio cameras, and every artifice of lighting and make-up, Hollywood portraitists strove to create images of unearthly perfection and allure. Blemishes like Garbo's mole or the young Joan Crawford's freckles were eliminated by retouching, and the final results vetted by studio executives before release to fans, the press, and publicists. Portraiture was a serious operation, with photographers sometimes taking hundreds of pictures a day and teams of retouchers and lab technicians turning out thousands of prints. Paramount issued over 1,700 different portraits of Carole Lombard while she was under contract (1930–7). Styles shifted over time, and from studio to studio, with MGM portraits, like its films, the most elaborate and stylized, while Warner

Bros. favoured a more informal, naturalistic approach. Eroticism was curbed by censorship, and the rules of the Advertising Advisory Council (f. 1933) kept retouchers busy trimming curves and masking cleavage. Stars immortalized as much by their portraits as their films included Louise Brooks, memorably photographed by Richee in the late 1920s, but also portrayed—as flapper, vamp, and 'jazz baby'—by others including *Muray and Steichen; Garbo; and, the ultimate siren, Dietrich.

Stills

Studio stillsmen were less prominent and well paid than portraitists, and their work was more varied. Each production was assigned a photographer, who had to record publicity-related events before and after principal cinematography, make any photographs required as props (e.g. the election posters in *Citizen Kane* (1940)), and take stills

283

during every important scene. The results were used for record, continuity, and publicity purposes, and as raw material for posters. Finally, stillsmen had to take general-purpose pictures of the stars 'at home' and in society for fan magazines and the press. (Here they were competing with the less sycophantic efforts of the Hollywood press corps and magazines like *Life and Look.*)

Stillsmen usually wielded 20.3 × 25.4 cm cameras, or 10.2 × 12.7 cm (4 × 5 in) ones for action shots, 35 mm being rarely used before the Second World War. The work demanded both diplomatic and technical skills, since directors' attitudes to still photography varied considerably: whereas Cecil B. DeMille, Erich von Stroheim, and Josef von Sternberg, for example, valued and were even influenced by it, others like John Ford regarded it as a nuisance. For practical or security reasons, scenes sometimes had to be completely reorganized for stills: those for Hitchcock's *Psycho* (1960), for instance, though creepy, give an entirely misleading idea of the plot. Some stills became more famous than the film itself: Garbo's face superimposed on the Sphinx, for example, and Marilyn *Monroe's billowing-skirt publicity shot for *The Seven Year Itch* (1954).

Stills were produced in huge quantities, and many were destroyed after use. By the late 1930s, however, they were being collected, with pre-1920 examples especially sought after. They are often historically important, showing 'archaeological' details of the film-making process, or scenes or characters cut from a finished film, and facilitating the reconstruction of truncated masterpieces like Stroheim's *Greed* (1923) and *The Wedding March* (1927). Stills, rather than frame enlargements from actual footage, illustrated much of the older literature on cinema.

With the decline of 'classical' Hollywood from the late 1940s, both stars and photographers became freelances whose activities were organized by agents rather than studios. But the star-as-freelance still needed an image, and the cinema's need to compete with other entertainments made publicity and marketing even more important than before. Film-makers arranged photo opportunities for their productions, and photography on or around film sets became a significant aspect of *photojournalism, as *Magnum photographers' work demonstrates. And, while fan magazines declined, celebrity, gossip, and 'lifestyle' ones multiplied, all hungry for star pictures. Especially from the 1960s onwards, Hollywood image making merged with the broader industry of *celebrity photography. RL

See also CINEMA AND PHOTOGRAPHY.

Kobal, J., *The Art of the Great Hollywood Portrait Photographers 1925–1940* (1980).
Davis, R. L., *The Glamour Factory: Inside Hollywood's Big Studio System* (1993).
Finler, J. W., *Hollywood Movie Stills: The Golden Age* (1995).
Magnum Cinema: Photographs from 50 Years of Movie-Making, introd. A. Bergala (1995).
Hicks, R. W., and Nisperos, C., *Hollywood Portraits: Classic Shots and How to Take Them* (2001).

Holm, N. Walwin (1865–?) and **J. A. C.** (1888–?), West Africa-based British photographers, typical of countless fairly small-scale colonial operators. Holm Senior was active in Accra, Gold Coast (now Ghana), from 1883, opened a studio in Lagos (Nigeria) in 1896, and in 1897 joined the *Royal Photographic Society. His son managed the studio while Holm studied law in England, then in 1919 opened an Accra studio. Holm Senior originally created souvenir *albumen prints, and by 1900 reproduced these and private images as *postcards marketed as 'Photoholm-Lagos'. Holm Junior's studio operated in an era of expanding portraiture, and documented locally significant subjects such as emerging cityscapes, family houses, businesses, and ceremonial and political occasions. EH

Holmes, Oliver Wendell (1809–94), American physician, writer, and important early collector and promoter of photography, which he briefly practised himself in 1864–5. Convinced, eventually, of the educational value of *stereoscopic photographs, he invented a simple stereo viewer in 1859 and advocated the creation of stereo libraries. He wrote three important articles on photography in the *Atlantic Monthly* (1859, 1861, 1863), in the first of which he coined the term 'stereograph' to describe what he called 'double-eyed or twin pictures'. RL

Taft, R. M., *Photography and the American Scene: A Social History, 1839–1889* (1938; repr. 1964).

Holocaust, photography and the. The campaign to annihilate the European Jews between 1933 and 1945 took place in stages. First, Jews were identified and subjected to discrimination; then concentrated in camps and ghettoes; then massacred. At each stage the camera was present, either as witness or instrument.

Identification and Discrimination
In the 1930s photography was extensively used in the racial science textbooks that aimed to differentiate between Jewish and Aryan physical types. Hitler's seizure of power in Germany in January 1933 was followed by a succession of anti-Semitic measures: vandalization of Jewish property, boycotts, discriminatory legislation, and the widespread destruction of synagogues during the 'Night of Broken Glass' (*Kristallnacht*) of 9–10 November 1938. These actions were extensively photographed, mostly by journalists of the regime-controlled press. The victims' viewpoint was, for obvious reasons, seldom represented. However, some Jewish professional photographers, such as Abraham *Pisarek, continued to work clandestinely and record the persecution of their community. Pictures by foreigners are rare, although some undercover reportage took place, and was occasionally published. The Centre de Documentation Juive Contemporaine (CDJC) in Paris, for example, has the album of a Dutch amateur who travelled through Germany by motorcycle from Bentheim to Berlin systematically photographing anti-Semitic posters.

Erich Hartmann

Gas chamber at Majdanek, Poland, 1994

Concentration

Parallel to these discriminatory measures there developed, from 1933, a policy of incarcerating opponents of the regime, then ordinary criminals, asocial elements, homosexuals, Jehovah's Witnesses, Jews, and gypsies. Until the war, concentration camps were presented as a testing ground for new correctional methods. Far from being kept secret, they featured in the regime's propaganda. Thus between 1933 and 1938 Friedrich Bauer did several reportages on Dachau, extracts of which appeared in the Nazi press. This externally orientated iconography was matched by photographic activity inside the more important camps, each of which had a laboratory supplying its picture requirements: identity photographs, and documentation of works in progress, visits by Nazi dignitaries, and medical experiments. The outbreak of war hardly affected this, but brought external propaganda to an end. It was no longer a question of showing the 're-education' of detainees, but of concealing their participation in the war economy. The very few reportages still produced inside the camps emphasized their productive potential and were mainly intended for the Nazi hierarchy, or industrialists interested in cheap labour. However, some rare clandestine photographs were taken by prisoners themselves to bear witness or incriminate their captors: for example, by Georg Angéli at Buchenwald, Rudolf Cisar at Dachau, and Polish victims of medical experiments at Ravensbrück.

War allowed another form of concentration, namely ghettoization. Decided upon during the invasion of Poland, the formation of ghettoes began in the winter of 1939–40. They received considerable photographic coverage by propaganda-company photographers such as Cusian and Grimm in Warsaw or Hensel and Vandrey in Lublin. Many of their pictures, which, like contemporary newsreels, depicted ghetto inhabitants as dirty, diseased, and work shy, eventually appeared in mass-circulation papers like the *Berliner illustrierte Zeitung*. By contrast, the photographs of the Warsaw Ghetto taken surreptitiously by Joe *Heydecker, a propaganda-company darkroom assistant,

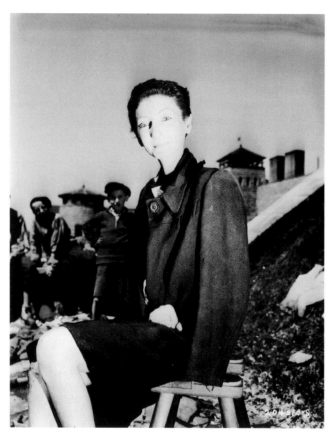

Ignatius Gallo (US Army)

The actress Livia Nador on her release from Gusen concentration camp, Austria, 12 May 1945

showed the terrible conditions there. Equally revealing and harrowing images were made by Jewish photographers like Mendel Grossman, a Łódź inmate. Different again, finally, were the Agfa colour transparencies of Łódź and its ghetto taken 1940–4 by a Nazi administrator, Walter Genewein; and the 54 triumphantly captioned photographs included in SS General Stroop's report on the destruction of the Warsaw Ghetto in 1943.

Extermination

After the invasion of Russia in June 1941, the number of Jews under German control increased enormously. The policy of concentration, no longer feasible on such a scale, gave way to one of extermination. On its eastward advance the Wehrmacht committed or tolerated many atrocities. But four special SS units (*Einsatzgruppen*) were given the task of summarily shooting communist functionaries and Jews. Despite repeated bans, many amateur photographs were taken of these *executions. Some soldiers and SS men, after committing their crimes, posed cheerfully beside the corpses. The 'final solution of the Jewish question'—systematic extermination—was launched at the January 1942 Wannsee Conference. From March, Jews throughout Occupied Europe faced deportation to death camps at Auschwitz-Birkenau, Belzec, Chelmno, Majdanek, Sobibor, and Treblinka. As the 'final solution' was secret, these deportations were rarely photographed. However, there are some clandestine images, such as those taken by Hubert Pfoch, an Austrian soldier, of a transport destined for Treblinka; and official pictures by the Würzburg police. The prohibition of photography was even stricter in the camps themselves, although there is a surviving series from Auschwitz in 1944 on a transport of Hungarian Jews. The photographs, probably taken by SS photographers, show the arrival of the trains, the selection of prisoners for work or death, and the disinfection and sorting of baggage. In fact everything is shown except actual killing. Evidently other official pictures were taken (and witnesses from both Auschwitz and Mauthausen spoke of gassings being photographed), but destroyed before the camps were liberated. The only surviving images that relate directly to extermination were taken secretly by Polish resisters at Auschwitz in the summer of 1944. They show a group of women who have been forced to undress before entering the gas chamber, and the work of the incineration squad.

The liberation of the camps

At the end of 1944 several American aerial reconnaissance missions photographed Auschwitz. In the photographs accommodation huts, rolling stock, and even gas chambers are precisely discernible. But picture interpreters were hardly interested in these details, compared with the target value of the camp's industrial plants. For the Allies, photographic coverage of the concentration- and extermination-camp system did not begin until the camps' liberation in January (Auschwitz), then April, 1945. While the Russians were uncommunicative about the horrors they found, the British and American authorities decided to give them blanket publicity. Three categories of photographers were involved: photojournalists like

Margaret *Bourke-White, Lee *Miller, and George *Rodger, *military photographers, and ordinary soldiers with their cameras. The terrible images they captured were widely disseminated by the press in the months that followed. In facilitating this, British and American planners hoped both to show civilians what they had been fighting against, and to prepare future communication strategies. For, on the threshold of the Cold War, liberation of the oppressed was already looming large as a political issue.

These photographs are unquestionably a milestone in the visual history of the 20th century. In 1945 the picture industry came face to face with the industry of death. Even if the images mostly show concentration camps, they have today become icons of the extermination of the Jews. As such, they vividly colour our perception and memory of the past. CC

⮕ See also Not Waving but Drowning *overleaf*.

Reifarth, D., and Schmidt-Linsenhoff, V., 'Die Kamera der Henker: Fotografische Selbstzeugnisse des Naziterrors in Osteuropa', *Fotogeschichte*, 3 (1983).

Loewy, H., ' "... without Masks": Jews through the Lens of "German Photography" 1933–1945', in K. Honnef, R. Sachsse, and K. Thomas (eds.), *German Photography 1870–1970: Power of a Medium* (1997).

Brink, C., *Ikonen der Vernichtung* (1998).

Zelizer, B., *Remembering to Forget: Holocaust Memory through the Camera's Eye* (1998).

Milton, S., and Markon, G. (eds.), 'Photography and the Holocaust', *History of Photography*, 23 (1999).

Chéroux, C., *Mémoire des camps* (2001).

holography owes both its conception and the name 'hologram' to a paper written by Dennis *Gabor in 1948, for which he was eventually awarded a Nobel Prize; but the first successful holograms were not made until 1961, soon after the invention of the laser. Before long, other workers such as Stephen Benton developed new techniques that extended the scope of holography.

Holography has three things in common with photography: it uses light energy; it employs a light-sensitive surface; and the result is a visible image. But there the resemblance ends. The light energy has to be the well-disciplined monochromatic beam of a laser; the light-sensitive surface needs a resolution much higher than that of a photographic film; and the final image is three dimensional.

In the making of a hologram there is no need for a lens. A hologram is the record of the shape of the wavefront reflected by the object. This contains information about the direction and distance of every point on the surface of the object relative to the light-sensitive material. Although the wavefronts are passing through this surface at the speed of light, their shape can be recorded by causing the object wavefront (or *object beam*) to interfere with an unmodulated beam (the *reference beam*) derived from the same light source as the object beam. This pattern is stationary, and can be recorded by any light-sensitive material having a resolution of 2,000 mm^{-1} or better. If the pattern is recorded permanently (e.g. on a silver halide emulsion), the original object wavefront is recreated when the record is illuminated by the original reference beam. Each point on the hologram codes the wavefront as seen from that viewpoint, resulting in full three-dimensional parallax: it is as if the object itself were being viewed through a window.

There are two basic types of hologram. In the first type the object and reference beams fall on the recording material from the same side. The interference pattern consists of bars through the thickness of the sensitive material roughly perpendicular to its surface, like the slats of a venetian blind. The image must be reconstructed ('replayed') using a laser beam or (less effectively) a quasi-monochromatic source such as a filtered mercury arc; the image is viewed from the opposite side, as in a photographic transparency. This type of hologram is called a *laser transmission hologram*. In the other type of hologram the object and reference beams fall on the recording material from opposite sides. The interference pattern consists of sheets through the thickness of the sensitive material roughly parallel to its surface, like the pages of a book. When the hologram is illuminated with white light it reflects only the wavelength that matches the spacing of these interference planes. This type of hologram is called a *white-light reflection hologram*. A transmission hologram can produce a sharper and deeper image than a reflection hologram, but the latter is easier to display, as it can be mounted on a wall, replayed from the front by an ordinary white spotlight, and viewed like a photograph.

Both types of hologram are fairly simple to make using a laser pointer with the collimating optics removed or adjusted to give a divergent beam. Fig. 1 shows a simple arrangement for a basic transmission hologram. Fig. 2 shows an arrangement for a basic reflection hologram.

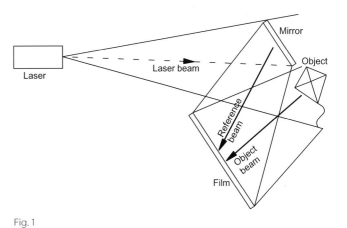

Fig. 1

Fig. 2

(*continued on p. 289*)

Not Waving but Drowning Pre-Holocaust Photographs of East European Jewry

The nearly 1,500-km (940-mile) route south from the Baltic to the Black Sea, from the Latvian capital Riga via Vilnius in Lithuania, Slonim and Kobrin in Belarus, Lvov (once Lemberg), and Cernovsty (Czernowitz) in the Ukraine, and through Romania to Radauti, Suceava, Bacau, and the port of Constanza, traverses what was once the heartland of the East European Jew. But of the dozens of former shtetls that lay along this route, there are only the faintest traces: a cemetery here, a synagogue or two there, and save for Riga, with nearly 10,000 Jews, and Lvov, with 8,000, there are few living Jews to be found at all. The Nazis murdered most of them. Many of the survivors chose not to stay to watch the communists strip the communities of their remaining assets, nationalize Jewish shops, and either demolish the synagogues or convert them into warehouses, libraries, or fire stations.

Well before the Holocaust, the world of the shtetl was fast disappearing. Massive emigration to America, as well as the big cities of Austria-Hungary and Germany, before the First World War depleted many of the smaller communities. Then came the modernization of inter-war Central and Eastern Europe as well as the Sovietization of Jewish life in the Ukraine, Belarus, and Russia.

By the turn of the century, several ethnographers—we would now call them documentary photographers—set out to capture this vanishing world. Not surprisingly, perhaps, they concentrated on the pious and the impoverished. Best known of the early chroniclers was Solomon Zainwil Rapaport (1863–1920). Born in a small town in Belarus, he lived in St Petersburg before fleeing to Paris, where he changed his name to An-Ski. Dedicated to recording and championing Yiddish culture and folklore, An-Ski wrote the play of Jewish possession, *The Dybbuk*, which is still performed today. He and several colleagues spent the years 1911–14 travelling through Volhynia and Podolia photographing and making sound recordings of Jews at home, in the market place, at work, and at prayer. The expeditions were financed by Baron Horace Guenzburg. The photographs, several hundred of which found their way to the Hebrew University and the Yiddish Institute for Jewish Culture (YIVO), are impressive, even if they reveal more interest in ethnography than in individuals.

Some twenty years younger than An-Ski was Alter Kacyzne, who sometimes collaborated with him. Like his mentor, Kacyzne was deeply involved with Yiddish culture and worked as a writer and photographer. In 1920 the American Yiddish newspaper *Forverts* asked him to document Polish Jewry, which he did with obvious love for his subjects. Kacyzne remained in Warsaw until the Nazis came, fled to Tarnopol, and was murdered in the Jewish cemetery. In 1999 YIVO, working with his daughter, published a selection of his photographs as *Polyn*, a poignant, lovingly made study divided by theme: Beginning the Day, The Market Place, At Work, At Home, and lastly On the Way, photographs of Jews leaving for the New World.

But the leading photographer of Jews in Eastern Europe was Roman *Vishniac, whose reputation is based on *A Vanished World*, published in 1983. It is an impressive work, although not without certain puzzles. In it, Vishniac states that he was driven to capture the life of the East European Jew because 'the world was about to be cast into the mad shadow of Nazism', resulting in 'the annihilation of a people who had no spokesman to record their plight'. Considering that the vast majority of the pictures in the book were taken between 1935 and 1937, before the German onslaught, that statement seems suspect. Vishniac continues: 'none of my colleagues was ready to join me', suggesting that he was unaware of An-Ski and Kacyzne. This is unlikely. Claiming to have been jailed eleven times while taking the photographs, Vishniac writes, 'I was forced to use a hidden camera.' Be that as it may, in at least half the photographs people are staring directly into the lens. But none of this detracts from the intensity of the images. The book has remained in print for over two decades because of its remarkable, heartbreaking portraits.

Yet all of the above studies share a particular failing. An-Ski, Kacyzne, and Vishniac all had to walk past, turn away from, or edit out of their pictures a great number of Jews who were neither pious nor impoverished. In the 1930s, Vishniac lived in Berlin, surrounded by 175,000 other Jews. If he really was so prescient about the Nazis' murderous intent, why go all the way to Poland? If Vishniac took pictures of secular-looking Jews motoring down the Friedrichstrasse, working at the KaDeWe department store, or as waitresses or bus conductors, they have not been published. The point is that by this time hundreds of thousands of Jews in Sofia, Vilnius, Riga, Kiev, Warsaw, Prague, Zagreb, and scores of other cities were dressing like everyone else, and were running banks or working as lawyers, doctors, accountants, or academics—or, indeed, as clerks, cleaners, tailors, or prostitutes. Yet they were destined for destruction just as surely as their bearded, sidelocked co-religionists living in picturesque ethnic squalor.

However, there are studies of this other Jewish world. The forerunner, *Image before my Eyes: A Photographic History of Jewish Life in Poland, 1864–1939* (1977), edited by Lucjan Dobroszychi and Barbara Kirschenblatt-Gimblett, pays homage to Polish Jewry in all its aspects. Both Vishniac's and Kacyzne's photographs are used throughout, as well as those of lesser- or unknown photographers. Here we find secular-looking Jews in the Austrian and Polish armies, Jews at civil weddings, in the workplace, or on the stage. And many of them are clean-shaven, besuited, middle-class, assimilated people.

Two decades later, two other remarkable books appeared. Yaffa Eliach's *There Was Once a World* (1998) does not qualify as a photography book at all. Eliach, a history professor in Brooklyn, spent seventeen years seeking out as many former Jewish residents of the

Polish town of Eishyshok as she could find, collected their pictures and their stories, and assembled them in book form. She herself was born in Eishyshok. Although the book's reproductions are poor and the text seems interminable this is an incomparable study: a chronicle of an entire Jewish town as told by those who lived in it. Nevertheless, it is in the US Holocaust Memorial Museum in Washington, DC, that Eliach's work really comes alive. Here stands a five-storey, square-sided tower with several catwalks across it. Inside, blown-up photographs from Eishyshok cover nearly every inch of wall-space. They soar above the visitor and recede below, out of sight. Here are six shirtless teenage boys showing off their muscles; two young girls stuffed into their overcoats on a snowy day; two men standing in a garden grinning impishly behind a statue of the Eiffel Tower; and portraits everywhere, of families at home, in the photographer's studio, reclining in a grassy park, standing on a ship, wearing army uniforms.

Today, not a Jew lives in Eishyshok. There is a mass grave outside the town. But in the single most emotionally compelling exhibit in Washington's Holocaust Museum, this Jewish town, its poor and its rich, its religious and its secular, stares out at us.

What the museum accomplishes so brilliantly in an exhibition, *And I Still See their Faces*, compiled by Golda Tencer and friends involved with the Shalom Foundation in Warsaw, does in a book. This organization, according to Tencer (an actress in the Warsaw Yiddish Theatre), launched appeals in Poland and Israel for everyone (non-Jews and Jews) to send in any Jewish-related photographs they might have. Many people responded. We see snapshots, group portraits, brothers and sisters in the studio, at a summer camp, a blurry snapshot of a market place, three fat women in the street, a gaggle of gnarled-looking rabbis, even images of Jews in the Nazi-era ghetto being herded onto transports to their deaths. The pictures are reproduced exactly as they were received, with torn edges, yellowed, crumbling, faded: altogether 450 photographs.

As we look at pictures from both these remarkable projects, we gain a more balanced understanding of the world that was destroyed, and of the people who met unspeakable, grotesque deaths. Watching them, frozen in the Eishyshok Tower in Washington, where they look down on millions of visitors each year, or in the pictures of Golda Tencer's tender study, we see their smiles, their hugs, their pride. And we know what they do not: they are not waving but drowning. ESE

When the sensitive material is a silver halide emulsion it can be developed and fixed in the usual way; but the image is much brighter when the developed emulsion is bleached (rehalogenated) rather than fixed, so that the interference pattern is recorded as changes of refractive index rather than of density.

There are a number of different types of hologram within the two main categories. Most of these make use of a transfer process analogous to photographic copying. The primary holographic image is used as the object for a second hologram. If a primary (or master) transmission hologram is reversed ('flipped') in the replay beam, the image becomes real rather than virtual, and can be projected onto a second light-sensitive surface, where it acts as the object beam for a second (transfer) hologram. The final image can be behind, in front of, or (most commonly) straddling the plane of the final hologram. The main varieties of hologram are:

1. *Multi-image holograms.* Several images can be seen successively by changing the viewpoint or illuminating light, or by tilting the hologram. This effect is achieved by making several exposures using different reference beam angles, or by transferring several master holograms side by side onto a single final transfer hologram.

2. *Rainbow holograms.* These are transmission holograms viewable by white light, made by transfer with the master hologram masked down to a narrow horizontal slit. This has the effect of replacing the vertical parallax of the final image with a holographically generated diffraction grating; thus the viewer sees the image through part of a projected spectrum. There are several sophisticated versions. One uses a geometry that collapses the spectrum on itself, resulting in an uncoloured image; others combine different reference angles in a multi-exposure transfer hologram that gives multicoloured and/or multiple images.

3. *Focused-image holograms.* The optical image formed by a lens is used as object beam. This principle can be used to form holographic images in a modified conventional camera. The technique can be combined with the slit principle to produce one-step rainbow holograms.

4. *Embossed holograms.* The final transfer hologram is made on photoresist, so that the interference pattern is formed in ridges and can be reproduced by mechanical hot stamping from a metal replica. This is possible only with a transmission hologram, and embossed holograms are rainbow holograms backed with a reflective layer. Many embossed images are not true holograms, but are dot matrix diffraction images produced dot by dot using two focused laser beams set at angles under computer control.

5. *Holographic stereograms.* These represent the ultimate in multi-image transfer holograms. A series of up to 100 images produced by a moving camera (or generated by a computer) is recorded as a set of adjacent narrow holograms 1–2 mm wide on a continuous length of holographic film. The whole series is then transferred holographically to give a single final image which has full horizontal parallax. This system has the advantages of not needing a laser for its origination, and of being able to produce an image of any required size. By employing multicolour rainbow geometry it is possible to replicate a series of colour transparencies in true colour. Stereograms can also be used for brief animation sequences.

6. *Holographic (or diffractive) optical elements.* A hologram of a lens or an optical mirror behaves exactly like the original lens or mirror. It is thus a holographic optical element (HOE). There are many ways

of making HOEs using laser light; and as the interference patterns are comparatively simple it is also possible to compute these and engrave them on a glass or plastics substrate under computer control to produce diffractive optical elements (DOEs). The main advantage of HOEs and DOEs is that a large number of elements can be superimposed on a single surface, an impossibility with conventional optical systems. The disadvantage is that they are highly dispersive, and can therefore be used effectively only with monochromatic light.

7. *Holographic interferograms.* If a hologram is doubly exposed, and between the two exposures the object is slightly distorted, in the resulting image the distortion is contoured by secondary (moiré) interference fringes at half-wavelength intervals. This property makes holography an important tool in the analysis of stress and vibration.

Display and art holography
Although the main applications of holography today are in security foils, information storage, and *diffractive optical systems, the technique has a healthy life in the world of fine art. Many holograms are now in public collections such as the Victoria & Albert Museum, London, and in private collections such as those of Matthias Lauk in Pulheim, Germany, and Jonathan Ross in London.

Holography was first taken up as an art medium in the late 1960s and 1970s by a few professional artists such as Margaret Benyon (b. 1940) in Britain, Paula Dawson (b. 1954) in Australia, and Harriet Casdin-Silver (b. 1925), Anaït Stevens, Ruben Nuñez (b. 1930 in Venezuela), and Rudi Berkhout (b. 1941 in the Netherlands) in the USA. Some well-known artists such as Salvador Dalí dabbled in it; others, like the British public artist Alexander (b. 1927), adopted it as an important element of their creative kit. The world's largest permanent collection of art holograms, formerly held by the now defunct Museum of Holography in New York, is now housed in a special section of the Massachusetts Institute of Technology.

Holograms offer a number of unique qualities for the artist: they can be three dimensional; they can be multi-image or animated; they can offer a range of dazzling colours that change with viewing position; they can include optical effects and illusion, including pseudoscopic (inside-out) images and real images that hang in front of the hologram; or they can be totally abstract constructions of moving light. GS

See also INTERFEROMETRY; LEITH, EMMETT; DENISYUK, YURI.

Benyon, M., 'Holography as an Art Medium', *Leonardo*, 6 (1973).
Hariharan, P., *Optical Holography: Principles, Techniques and Applications* (2nd edn. 1996).
Caulfield, H. J., *Handbook of Optical Holography* (2nd edn. 1997).
Saxby, G., *Practical Holography* (3rd edn. 2003).

Holy Land. See MIDDLE EAST, EARLY PHOTOGRAPHY IN THE.

home-mode photography. See SOCIOLOGY AND PHOTOGRAPHY.

Hooper, Willoughby Wallace (1837–1912), British military officer in *India who served in the 7th Madras Light Cavalry from 1858. In 1861 Hooper was seconded to take ethnographical photographs in the Central Provinces, and a number of these striking portraits, made with a fellow officer, George Western, were later published in *The People of India* (1868–75). Hooper again worked in collaboration with Western in the early 1870s on a series of narrative views illustrating such themes as hunting, and in 1876–8 produced a number of forceful studies of victims of the Madras Famine. As provost marshal of the Expeditionary Force which annexed Upper *Burma in 1885–6, he provoked controversy by allegedly holding up a military *execution in order to photograph the scene. His documentation of the campaign was subsequently published as *Burmah: A Series of One Hundred Photographs* (1887). JF

Hopkinson, Tom (1905–90), British journalist, whose flair for the editorial use of photographs eventually earned him a knighthood. Brought in at the foundation of *Picture Post* in 1937, he became editor in 1941. He was sacked in 1951, and in 1958 became editor of the South African magazine *Drum*, operating in semi-clandestinity under the apartheid regime. In the 1960s he established the first pan-African university journalism courses, and in the 1970s and 1980s founded and directed the Centre for Journalism Studies at Cardiff University. AH

Hoppé, Emil Otto (1878–1972), British photographer. Born in Munich and educated in Vienna, he moved to London c.1900 to work in a bank. However, success as an amateur photographer led him to open a portrait studio in 1907, and he did so well that in 1913 he took over the mansion formerly owned by the painter John Everett Millais. Consciously breaking with convention, Hoppé worked to 'thaw' his sitters by engaging them in conversation and catching them in informal poses, even smoking. Sometimes (Jakob Epstein, Henry James) he photographed them at home using natural light. By 1914 he had a long list of literary, artistic, and society celebrities to his credit. In the 1920s he turned to landscapes and modernistic urban views; travelled extensively; and in 1930 published an outstanding volume of *industrial photographs, *Deutsche Arbeit* (*Germany at Work*). RL

Pepper, T. (ed.), *Camera Portraits by E. O. Hoppé* (1978).

Horna, Kati (1912–2000), Hungarian-born Mexican photographer, who emigrated to Paris in 1933, then worked as a photojournalist for various anarchist publications during the Spanish Civil War; in 1939 she settled in Mexico. There she worked on various newspapers and magazines and associated with the Mexican and émigré avant-garde. Her more personal photography, including series such as *Fetishes* (1962) and *The Girl and the Masks* (1967), betrays Surrealist leanings. LAL

Billeter, E., *Fotografie Lateinamerika, 1860–1993* (1994).

Horsley Hinton, Alfred (1863–1908), British *pictorialist photographer, founder member of the *Linked Ring Brotherhood (1892), and editor of *Amateur Photographer* (1893–1908). Trained in art, he became a journalist, editing the *Photographic Art Journal*

(1887–91) and *Photographs of the Year* (1892). Hinton managed Ralph Robinson's studio in Guildford (1891–2) and, like Ralph's father H. P. *Robinson, advocated manipulation and combination printing (see COMPOSITE PHOTOGRAPHY) in the darkroom. However, his landscape photographs explored feeling as much as composition. He found inspiration in unpicturesque mudflats at low tide on wintry days. Most of his work was lost after his death. JT

Horsley Hinton, A., *Pictorial Photography* (1896).

Horst, Horst P. (Horst Bormann; 1906–2000), German-born American fashion photographer, one of the most important of the 1930s and 1940s. His studio images, strongly influenced by both classicism and *Surrealism, are icons of the staged fashion photograph. Born into a prosperous commercial family, he first studied architecture at the Hamburg Design School, then assisted Le Corbusier in Paris in 1930. His interest in photography was aroused by George *Hoyningen-Huene, a regular contributor to Paris *Vogue* since the mid-1920s and head of its photo-studio 1926–9. Horst became his friend, model, and assistant, began contributing to *Vogue* in 1931, and in 1935 took up Hoyningen-Huene's former post there. After shuttling for several years between Europe and New York, he found himself in the USA when war broke out, was drafted into the army, and in 1943 became a US citizen, with the name Horst P. Horst. After 1945 he continued to work for American *Vogue* and *House and Garden*, from 1961 encouraged by *Vogue* editor Diana Vreeland to capture the lifestyle of international high society. He travelled widely, and from 1958 exhibited frequently.

Horst's arrangements of light and shadow, using the minimum of props and backgrounds, give his models a statuesque quality, and convey a kind of ideally rarefied and timeless illusionism entirely different from the dynamically contemporary work of photographers like *Munkácsi. His fashion images often contain references to antique art, which he studied closely, and *Surrealism (*Hands, Hands*, 1941). Horst also created still lifes, nudes, and portraits of the artistic and social elite. UR

Horst, R. J., and Schirmer, L. (eds.), *Horst: Sixty Years of Photography* (1991).

Horvat, Frank (b. 1928), Italian-born photographer with an unfolding personal agenda. He spent the Second World War in Switzerland, where, aged 15, he took up photography. The late 1940s found him back in Italy, studying art, working in advertising and, eventually, becoming a freelance magazine photographer. After periods in France (meeting *Cartier-Bresson and *Capa), Pakistan and India (working freelance), and England (working for *Life* and *Picture Post*), he settled in Paris in 1955 and began to build a career in fashion photography. Travel nevertheless remained a feature of his life, and the ensuing years saw him active as a fashion and advertising photographer in both Europe and the USA, while a commission for the German magazine *Revue* took him around the world. Since the late 1970s, personal projects have absorbed an increasing amount of his time, and he has focused on subjects as

varied as trees, townscapes, sculpture, and Ovid's *Metamorphoses*. His versatility continues: he has experimented with *digital imaging since the late 1980s, while his visual diary *A Daily Report:1999* served (*inter alia*) as a reminder of his credentials as a documentary photographer. RP

Frank Horvat, *Frank Horvat* (1989).
Horvat, F., *Fifty One Photographs in Black and White* (1998).

Hosking, Eric (1909–91), legendary British bird photographer, whose *Barn Owl with Vole* (1948) epitomizes the quality of his achievement. Self-taught, Hosking began photographing in 1929. He pioneered the use of *flash, first with bulbs, then with early electronic units and photo-cell triggering devices. But his commitment went far beyond the technical. He believed that bird photographers should have a deep understanding and knowledge of their subjects, and concern for their welfare. Indeed, after being attacked by an owl—his favourite subject—and losing an eye, he blamed his own lack of understanding for the accident. He photographed over 2,000 species and had an archive of over 250,000 black-and-white negatives and 100,000 colour transparencies. RSA

Hosking, E., *The Art of Bird Photography* (rev. edn. 1948).
Hosking, E., and Lane, F. W., *An Eye for a Bird: The Autobiography of a Bird Photographer* (1970).

Hosoe, Eikoh (b. 1933), Japanese photographer. Trained at Tokyo Junior College of Photography (now Tokyo Polytechnic), he co-founded the group *VIVO in 1959 with Shomei *Tomatsu, Kikuji *Kawada, Ikko *Narahara, and Yasuhiro Ishimoto. Its members encouraged each other to experiment with both subject matter and print technique. With Vivo, Hosoe's style evolved towards high-contrast and graphic expression. In his first major series of nudes, *Man and Woman* (1960, pub. 1961), he created images remarkable both for the contrastiness of the prints and for their vision of human relationships. Before Vivo's demise in 1962, Hosoe produced *Barakei* (*Ordeal by Roses*), an intense photo portrait of the novelist Yukio Mishima. In his series *Kamaitachi* (1969) and *Embrace* (1971) Hosoe collaborated with Hijikata Tatsumi, the founder of *butoh* dance in Japan. An enthusiastic traveller and fluent English speaker, Hosoe often participated in the photographic workshops in Carmel, California, with Ansel *Adams, Imogen *Cunningham, and others, and at the *Arles Festival, France. From the late 1980s he promoted the study and use of platinum prints in Japan. He became a professor at Tokyo Polytechnic and helped to create the Shadai Gallery. He encouraged the establishment of photography departments in Japanese museums and in 1995 became director of the Kiyosato Museum of Photographic Arts. His recent work was published in the book *Luna Rossa* in 2000. He has won many Japanese and foreign awards. MHV

Japon des avant-gardes, 1910–1970 (1986).

Hou Bo. See XU XIAOBING.

291

Eric Hosking

Barn owl with vole, 1948

Howlett, Robert (1831–58), British photographer, celebrated for his 1857 portrait of Isambard Kingdom Brunel against the checking drum of the *The Great Eastern*, and for his photographs of the ship's construction. He also invented a portable photographic tent and published a manual, *On the Various Methods of Printing Photographic Pictures upon Paper*. Howlett made photographic studies for the painter William Powell Frith, who used them for *Derby Day* (1858), and went into partnership with Joseph Cundall *c.*1855 to form Cundall, Howlett & Co., later Cundall, Howlett & Downes, producing **cartes de visite*, views, and publications. KEW

Hoyningen-Huene, George (1900–68), Russian-born American fashion photographer. From an aristocratic background, he settled in Paris in 1920 and worked as a draughtsman in his sister's fashion company, YTER, then for **Harper's Bazaar*. He also studied painting with André Lhote and made contacts in the film industry and the avant-garde; in 1924 he worked with **Man Ray on a fashion portfolio. In 1925 he was hired as an illustrator by French **Vogue*, but moved into

photography and headed the magazine's photographic studio 1926–9. He also began a lifelong friendship with Horst Bormann (**Horst). In 1929 he joined American *Vogue*, but after breaking with Condé Nast moved to *Harper's* (1935–45). After the Second World War he abandoned fashion photography for teaching. He also made short films and collaborated with the director Georg Cukor.

Hoyningen-Huene was one of the most influential fashion photographers of his time. Like Horst and another friend, Herbert **List, with whom he visited Greece in 1937, he often used surrealistically inflected Hellenic motifs. He excelled at stylish studio compositions using shadows and elaborate lighting, but also created quintessentially modernistic open-air swimwear pictures. Overall, the taste, economy, restraint, and fine calculation of effects in his best work reveal the artist born and trained. RL

Ewing, W. A., *The Photographic Art of Hoyningen-Huene* (1986).

Hubble Space Telescope. See ASTRONOMICAL AND SPACE PHOTOGRAPHY.

Eikoh Hosoe

Kaimatachi, no. 8, 1965

Robert Howlett

Isambard Kingdom Brunel, 1857

Hudson's Bay Company. During the 1860s and 1870s, a small group of company employees in the Eastmain, Moose, and Rupert's River districts pursued photography as a pastime. Prominent among them were Bernard Rogan Ross (1827–74), a native of Londonderry who used photography to illustrate his scientific, anthropological, and geographical investigations; Charles George Horetzky (1838–1900), an accountant at Moose Factory who later served as a photographer on the Canadian Pacific Railway surveys of the Canadian West; James Laurence Cotter (1839–89), a career 'company man' whose photographs appeared as engravings in the *Illustrated London News and in annual reports of the Geological Survey of Canada; and William Bell Malloch (d. c.1885), a doctor sent to Moose Factory in 1870. Using the *wet-plate process in isolation and under trying conditions, these and other company employees, including chief trader George Simpson McTavish (1834–c.1893) created a valuable record of Company, fur-trade, Indian, and Inuit life in the area of James and Hudson bays. JMS

Birrell, A. J., 'The Early Years, 1839–1885', in L. Koltun (ed.), *Private Realms of Light: Amateur Photography in Canada, 1839–1940* (1984).

Hugo, Charles-Victor (1826–71), French photographer. He took up photography in 1852 in Jersey, where he had followed his father Victor Hugo into exile from Second Empire France. From autumn 1852 to 1855, often in collaboration with Auguste Vacquerie, one of his father's disciples, he produced an impressive body of more than 350 images: portraits of his father and his circle, his family, self-portraits, and landscapes. The author of these photographs is sometimes hard to identify—hence the attribution 'Jersey workshop'.

Far from being a mere pastime, photography was seen by Victor Hugo as a weapon against Napoleon III's regime, enabling him to project his image abroad. He also planned to publish a souvenir of the Channel Islands combining text and photographs. This intense activity ended with the expulsion of Victor Hugo from Jersey to Guernsey in October 1855. QB

Heilbrun, F., and Molinari, D. (eds.), *En collaboration avec le soleil: Victor Hugo, photographies de l'exil* (1998).

Hulme, Jack (d. 1988), British amateur photographer, born and resident in the mining village of Fryston, West Yorkshire. He took up photography as a teenager, using a camera bought from a second-hand stall and a home-made enlarger. By the early 1940s he had graduated to the *Leica which he was to use for the next 40 years. It cost him the enormous sum of £91. But, as he said later, 'I didn't drink, smoke or gamble.' All the while, he photographed constantly, creating a unique record of Fryston, its people, and their daily lives. By the 1980s he had amassed over 10,000 negatives, taken over 70 years. Pit villages had been photographed by photojournalists such as Bert *Hardy and Bill *Brandt, but Hulme's pictures were different—created from within the community and not intended to be viewed by outsiders.

In 1986 he was belatedly recognized when a touring exhibition of his photographs was organized, accompanied by a book. Poignantly,

this coincided with the closure of Fryston colliery and consequent decline of the village. Hulme, however, was not despondent. 'I don't feel sad now,' he said. 'I've had a good life in the village. I've happy memories and these photographs to look at. I don't know what made me save them all. It was just a hobby I loved, an obsession. The camera has been my life.' CWH

World Famous Round Here: The Photographs of Jack Hulme (1990).

humanist photography. See DOCUMENTARY PHOTOGRAPHY; FAMILY OF MAN.

Hungary. The news of *Daguerre's invention was announced in Hungary as early as 2 February 1839, in the publication *Hasznosm Mulatságok* (*Useful Inventions*), and a translation of Daguerre's manual appeared in the spring of 1840. That year, the Hungarian mathematician Josef *Petzval designed an anastigmatic lens with sixteen times greater luminosity than Daguerre's, dramatically shortening exposures, and his design was commercially exploited by *Voigtländer. In June 1841 the painter Jacopo Marastoni opened the first photographic studio in Pest. At the 1855 Paris Universal Exhibition Antal Simonyi won an award for an 'instant' photography process.

The period until 1900 saw the rise of commercial portraiture and the application of photography to landscape (Balázs Orbán, Károly Divald), ethnography (József Plohn), and astronomy (Jenö Gothard, Miklós Konkoly Thege). After 1890 *pictorialist 'art photography' established itself with the formation of the Circle of Friends of Photography (1894), the Budapest Photo Club (1899) and the National Association of Hungarian Amateur Photographers (1905), whose journal *A fény* (*The Light*) was edited by Mano Mai, the court photographer. Notable portraitists in the pre-1914 period included two women, Olga Máté and Ilka Réva, and József Pécsi (1889–1956), who founded and headed (1913–20) the photography department at Budapest School of Industrial Drawing. In 1930 Pécsi published a seminal book on advertising, *Photo und Publizität*.

Hungarian newspapers were being increasingly illustrated with photographs from the mid-1890s onwards. The Budapest-based János Müllner started freelance press reportage in 1904, covering female labour and other social issues in the capital. Reportage by Müllner and other photojournalists continued through the First World War and its turbulent aftermath, including, in the summer of 1919, the short-lived Socialist Republic headed by the Communist Béla Kun. During the subsequent period of reaction under Admiral Miklos Horthy, many photographers left Hungary, moving to Germany and France, then to Britain and the USA. They included *Kertész, *Moholy-Nagy, *Brassaï (Gyula Halasz), Robert *Capa (Endre Erno Friedman), Cornell *Capa, Martin *Munkácsi, Nicholas *Muray, and György *Kepes. Other influential émigrés were Stefan *Lorant and Andor *Kraszna-Krausz, and the later inventor of *holography, Dennis *Gabor.

The pictorialists who stayed behind developed a 'Hungarian' style, including Pécsi, Rudolf *Balogh, Károly Escher (1890–1966), Ernö

Vadas, and Zajky Zoltán. Balogh, regarded as the father of Hungarian photojournalism, was an artist-photographer and journalist on the progressive *Est* newspaper. He recruited Escher, who photographed political events, the arts, and social conditions for 30 years. Documentary photographers also stayed, including the press photographers Klára Langer and Kata Sugár (1910–43), and the left-wing photographers centred on *Munka* (*Work*) magazine, whose 1932 exhibition *Our Life* was closed by the police. Also notable were the teacher Iván Hevesy, his pupil/partner Kata Kálmán, whose *Tiborc Album* was an outstanding study of Hungarian village life, and Angelo (Pál Funk; 1894–1974), a successful society portraitist.

The post-1945 communist regime permitted little innovative or challenging work. The Association of Hungarian Photographers (AHP), formed in 1956, remained the leading photography organization, publishing *Photo Art* magazine. Street fighting in the 1956 Hungarian Revolution was documented by photographers, particularly Tibor Szentpétery, József Vas, Károly Kiss, Dezsō Széki, and Bojár Sándor. Ata Kandó (b. 1913) photographed refugees fleeing across the Austrian border, but although published in the West, she was unacknowledged in Hungary. In the 1960s and 1970s photographers took fine-art or traditional directions to avoid problems with the authorities and Mari *Mahr, originally a photojournalist, left for England. Others, such as Demeter Balla (b. 1931), Peter Korniss (b. 1937; a World Press Photo winner and judge), Imre Benko (Eugene Smith Award winner), and György Tóth (b. 1950) produced more challenging conceptual and documentary work into the 1980s.

The liberal atmosphere of the 1990s encouraged all types of photography and new initiatives to preserve historical material. In 1990 the Budapest Photographers' Cooperative and the AHP created the Hungarian Photographic Foundation, to establish a Museum of Hungarian Photography (HMP) in Kecskemét. Started with 75,000 items collected by the AHP since 1958, the collection has since expanded threefold. In 1998 the Foundation established the Hungarian House of Photography at the restored Mai Manó House, Budapest, for contemporary and historical events. The HMP has also organized many shows of local, historical, and émigré photographers, particularly the 1998 exhibition *Photographers Made in Hungary: Some Went Away/Some Stayed Behind*, which toured thirteen countries. RA

Ford, C., *The Hungarian Connection* (1987).
Kincses, K., *Photographers Made in Hungary: Some Went Away/Some Stayed Behind* (2000).
Biro, A., *Photographies hongroises: des romantismes aux avant-gardes* (2001).
Hungarian Photography Yesterday/Today/Tomorrow (CD-ROM, 2002).

Hunt, Robert (1807–87), English scientist. Born in Plymouth, Hunt was trained as a chemist but became interested in photography immediately following the announcements of 1839. He investigated the properties of several metallic salts for photographic purposes, suggested iron sulphate as a developing agent, explored the possibilities of colour photography, and devised several original processes and techniques. He considered becoming a professional calotypist, but

science was always his first interest and he soon abandoned the idea. Hunt was a prolific author and was most influential as a writer. He published the first substantial English-language photographic manual in 1841, a work that was to run for six editions and became one of the most sought-after handbooks of the day. His most important work was *Researches on Light*, originally published in 1844, with a considerably expanded edition appearing ten years later. He was a member of the Calotype Club, and in 1853 a founder member of the London (later *Royal) Photographic Society. JPW

Thomas, C., *Views and Likenesses* (1988).

Hurley, Frank (1885–1962), Australian travel photographer who began his career with a Sydney postcard company in 1905. Six years later he made his first journey to Antarctica with Douglas Mawson's expedition, producing work that earned him a place on Ernest Shackleton's 1914 expedition. Hurley's photographs of the *Endurance* caught in the frozen sea have come to epitomize Shackleton's ill-fated but ultimately heroic attempt to cross Antarctica. Hurley went on to be an Australian official photographer of both world wars. Always interested in the expressive possibilities of photography, Hurley created dramatic, emotive images, sometimes at the expense of documentary accuracy. MR

Alexander, C., *The Endurance* (1998).

Hurn, David (b. 1934), British photojournalist, one of a generation of post-1945 photographers intent on changing the world with a vision of how it was and could be. Inspired by the spirit of Sir Benjamin *Stone and his followers, Hurn, and Tony *Ray-Jones, saw themselves as both witnesses to and interpreters of their age. In 1977 he founded an innovative photojournalism course at Newport College of Art in Wales that reflected his philosophy of focusing on an objective reality with an individualistic, educated eye. He continued to photograph for both exhibition and publication after retiring from teaching in 1990. RSA

Harrison, M., *Young Meteors: British Photojournalism 1957–1965* (1998).

Hurter, Ferdinand. See CHARACTERISTIC CURVE; NATURALISTIC PHOTOGRAPHY.

hyperfocal distance. See DEPTH OF FIELD.

Iceland. The first Icelandic *daguerreotypist was Helgi Sigurdsson (1815–88), who learned the process while abortively studying medicine in Copenhagen. He was active from 1846, the year that the first foreign visitor photographed in Iceland. However, notwithstanding its magnificent landscape, Iceland offered few inducements to early photographers. In winter it was too cold and dark, and in summer midges stuck to *collodion plates. Materials were difficult to obtain and store. Moreover, unusually among European countries, there was practically no tradition of portraiture, and photographers in effect had to create it, once a market had formed. But in 1860 Reykjavik, the largest town, still had only 1,444 inhabitants. Its first commercial studio was opened by Sigfús Eymundsson (1837–1911) in 1867.

Urbanization boosted photographers' numbers, although not significantly until the 1890s, when 21 new recruits entered the profession. Nicolina Weywadt (1848–1921) and Anna Schiöth (1846–1921) were among several women active since the late 19th century. At first photographers trained in Denmark, but later did so at home. Although output in the first decades was mostly portraiture, from c.1875 landscapes became popular, linked to well-known tourist spots. Iceland's first photographic publication was a portfolio of twelve views, six by Eymundsson, issued by the Tourist Association in 1896. Magnús Ólafsson (1862–1937) made *panoramic landscapes, and published Iceland's first photographic handbook in 1914. By the 1930s and 1940s the importance of landscape work had increased, with exhibitions and a growing number of photographic publications, motivated partly by commercial, partly by patriotic reasons (Iceland had been granted autonomy under the Danish crown in 1918, and would become independent in 1944). Town dwellers were drawn to the wild terrain of the highlands, and a romantic view of the land characterized the imagery of both amateur photographers—increasingly numerous since the 1920s—and professionals. Occupation during the Second World War by British, then American forces galvanized the photographic market and strengthened cultural links with the USA.

The emergence of amateur photographic societies after 1950, as well as closer relations with foreign countries, further encouraged exhibiting. The influence of movements like Abstract Expressionism also made itself felt. Otherwise, however, international currents were slow to have an impact and photography only gradually achieved a significant position in Icelandic cultural life, reflecting its history as a primarily practical and commercial rather than expressive medium. ILB

Balvinsdóttir, I. L., and Hafsteinsson, S. B. (eds.), 'Photography in Iceland', *History of Photography*, 23 (1999).

iconic photographs. Like its religious precursors, a modern, secular icon not only conveys information but is instantly recognizable and is, in Vicki Goldberg's words, 'a representative image of profound significance to a nation or other large group'. In mass societies this presupposes not only clarity and strength of the image itself, but methods of industrial reproduction and distribution and a visually literate, culturally homogeneous audience. Non-photographic examples might include patriotic paintings like Emanuel Leutze's *Washington Crossing the Delaware* (1850) and graphic images such as *Your Country Needs You* (1914) or the Leigh/Gable poster for *Gone with the Wind* (1939).

Photographs become icons to the extent that their perceived message (not necessarily the one intended by the photographer) encapsulates broadly prevalent concerns and aspirations. This may happen after a lengthy time-lag: Howlett's 1857 portrait of I. K. Brunel, for example, became celebrated, as a symbol of perseverance and enterprise, as British interest in 'Victorian values' revived in the 1950s. More often, especially during the mid-20th-century heyday of *photojournalism, the process has been much more rapid. Lange's *Migrant Mother* (1936) was published almost at once and became an icon of suffering and resilience in the face of overwhelming crisis. (Its obvious religious overtones doubtless increased its impact.) Doisneau's *Kiss at the Hôtel de Ville* (1950) evidently chimed with a hunger for individual self-fulfilment after years of austerity and, for Americans perhaps especially, ideas of 'romantic Europe'. Korda's *Che Guevara* (1962) inspired rebellious 1960s youth; Leibovitz's *John Lennon and Yoko Ono* (1980) filled them with nostalgia.

War has generated a disproportionate number of iconic images. Capa's *Falling Soldier* (1936) and Omaha Beach photographs (1944) rapidly transcended the events they depicted. So did Rosenthal's *Raising of the Stars and Stripes on *Iwo Jima* (1945), incorporating as it did an already powerful symbol—'Old Glory'—and depicting the figures in a de-individualized, monumentally heroic way. Speaking of Larry Burrows's Vietnam picture of a wounded black marine reaching out to help a white fellow casualty (1966), a colleague, Wallace Terry, identified the timeless, mythic quality of the photographic icon: 'It's

almost as if Larry had captured something in biblical terms—I could see David reaching out to Jonathan in the Old Testament on those battlefields of Israel. I could see all battlefields. . . . That's what the best of photography catches.'

An image's potency might be measured both by its ubiquity—in schoolbooks, or on posters, T-shirts, or record sleeves—and by how often it is borrowed and adapted for new purposes, satirical, commercial, or propagandistic. This 'play' may change or subvert its meaning. Yet its effectiveness (sometimes registered by protests and demands for censorship) depends on the persistence of the original's core patriotic, pacifist, or other associations. RL

Goldberg, V., *The Power of Photography: How Photographs Changed our Lives* (1991).

Koetzle, H.-M., *Photo Icons: The Story behind the Pictures* (2 vols., 2002).

Illustrated London News (*ILN*), British illustrated paper, launched by Herbert Ingram on 14 May 1842, the first of three path-breaking journals—the others were the Parisian *L'*Illustration* and the Leipzig *Illustrirte Zeitung* (both 1843)—aimed at the growing mass market. The *ILN*'s first number carried a sensational artist's impression of an attempt to assassinate Queen Victoria and Prince Albert. In its early decades, pictures by photographers such as Felice *Beato, Antoine *Claudet, Joseph Cundall (1818–95), and Roger *Fenton were used as the basis for wood-engraved illustrations. The full integration of text and *half-tone photographs by rotogravure took place in 1912. (But drawn illustrations continued to coexist with photographs for many years.) The *ILN* appeared at varying intervals during its life, and ultimately as a quarterly. It closed in 1989. RL

Dewitz, B. v., and Lebeck, R., *Kiosk: Eine Geschichte der Fotoreportage* (2001).

Illustration, L', French illustrated weekly, launched in 1843. On 1 July 1848 it published wood engravings of barricades in the rue Saint-Maur-Popincourt in Paris before and after the previous week's fighting, based on *daguerreotypes specially made by a photographer called Thibault. Autochrome-based coloured pictures were appearing by 1910. On 21 May 1938 *L'Illustration* published a cover-story on Leni *Riefenstahl's film *Olympia*, with photographs by Riefenstahl. The paper became *France Illustration* in 1945 and continued until 1955. RL

Dewitz, B. v., and Lebeck, R., *Kiosk: Eine Geschichte der Fotoreportage* (2001).

Illustrierter Beobachter (*IB*; *Illustrated Review*; 1926–45), the Nazi Party's weekly magazine, launched in recognition of *photojournalism's growing importance in German cultural and political life. From 1930 it became an important vehicle for the Führer cult surrounding Hitler, and between 1933 and 1945 Hitler pictures (mostly taken by Heinrich *Hoffmann) appeared on 207 *IB* covers. It is thus an important source for the evolution of photographic Hitler propaganda; but also, given its use of *photomontage and other modern techniques, for the history of photojournalism generally. RL

Herz, R., *Hoffmann & Hitler: Fotografie als Medium des Führer-Mythos* (1994).

Illustrirte Zeitung, German illustrated weekly, founded in Leipzig by the Swiss-born publisher Johann Jakob Weber in 1843. It soon began printing wood-engraved illustrations based on photographs, such as a series on the new Altona railway station from *daguerreotypes by Carl Ferdinand *Stelzner (13 September 1845). But a major breakthrough was direct reproduction, from 1883, of photographs using Georg Meisenbach's early version of the *half-tone process, patented in 1882. On 15 March 1884 it published action photographs of military manoeuvres by Ottomar *Anschütz, and in December 1913 Antarctic pictures by Herbert *Ponting. Like its fellow pioneers, *L'*Illustration* and the *Illustrated London News*, it ultimately acquired a rather conservative image (and was known as 'the old aunt'). It ceased publication in 1944. RL

Dewitz, B. v., and Lebeck, R., *Kiosk: Eine Geschichte der Fotoreportage* (2001).

Image, quarterly journal of the *International Museum of Photography, George Eastman House, Rochester, NY. Founded in 1952 by Beaumont *Newhall, it includes articles on all aspects of the museum's varied collections. Its character has changed over the years, combining historical notices, biographies, and critical analyses that make it a resource for film and photographic scholars, especially those interested in the history of the Eastman House collection. KEW

image intensifier (amplifier) **tube**, a device for electronically amplifying images that are too weak to record directly on film or a CCD (see DIGITAL IMAGING) array. The photons forming the optical image stimulate the release of electrons at a photocathode, and these are accelerated and focused electronically to form a much brighter image on a phosphor screen, which is at a potential of 15–20 kV. This image can be optically focused onto a CCD array or film. The image can be further intensified by passing through a microchannel plate carrying a further potential of about 1 kV, or a second and even a third intensifier tube can be used in a series to give a final amplification of more than 10 million. However, this has a corresponding trade-off in image resolution. A scene illuminated by, for example, hazy starlight will appear extremely noisy and grainy. There are applications for these devices in surveillance, *military, and *astronomical photography. The cameras used are generally fitted with wide-aperture (f/1.5) *catadioptric lenses. GS

Saxby, G., *The Science of Imaging: An Introduction* (2002).

image stabilization (IS). It is difficult to keep a camera completely steady without a tripod or other support. Low light and long lenses compound the problem. TV cameras are steadied by a system of weights and dampers, or by gyroscopes. The method adopted for small cameras and binoculars is a servomechanism in which the sensor is an orthogonal pair of accelerometers coupled to a piezoelectric actuator, which moves a floating lens element that moves to compensate for any movement of the image. (Where the image motion is steady and predictable, as in aerial survey photography, the film is moved during exposure at compensating speed.) The benefits are substantial,

especially given the bulk and weight of modern automated equipment. Even early (mid-1990s) IS systems were claimed to give the equivalent extra stability of a two-stop faster shutter speed (e.g. 1/250 s instead of 1/60 s). Commercially, IS also makes it easier to market big cameras and long lenses to older or disabled consumers. GS

Indian subcontinent

1839–1900

While photography reached South Asia swiftly following the public announcement of *Daguerre's process in 1839, surviving work from the first decade of the medium's public existence remains extremely scarce. Photography certainly received an initially enthusiastic response in the subcontinent: by the close of 1839 several long descriptive articles had appeared in the Indian newspapers and by early 1840 advertisements indicate that *daguerreotype equipment was being imported into Calcutta. In March of that year Dr (later Sir) William Brooke O'Shaughnessy, an officer in the Bengal Medical Service who had previously been experimenting with *photogenic drawing, exhibited a number of successful daguerreotype views of the city which excited considerable local interest. But in common with most of the work produced in the course of the 1840s, these images, the earliest documented photographs taken in India, are now apparently lost, and with the exception of the work of transient visitors such as Alphonse Itier (in 1844) and Baron Alexis de la Grange (in 1849), no sufficient body of material survives to enable us to make a definitive assessment of this early photographic activity. The few known commercial photographers who opened studios in the 1840s do not appear to have remained in business for any substantial time and it appears likely that irregular access to reliable chemicals, lack of local expertise, and a limited market, coupled with the difficulties of introducing the public to an unfamiliar medium, played a significant role in inhibiting photography's growth during its first decade in India.

If the surviving photographic corpus of the 1840s is meagre, the following decade presents a remarkable contrast. Spearheaded by amateurs who mastered the paper-negative processes adapted to tropical conditions, the 1850s saw an outstanding flowering of photographic achievement. Much of this work was focused on the architectural heritage of the subcontinent, a reflection both of the development of *archaeology as a discipline and of the official sponsorship of the medium by the East India Company. In 1854 the company had issued a dispatch from London recommending the use of photography for the documentation of archaeological and architectural sites, and this encouragement led directly to the secondment of military officers such as Thomas Biggs (in 1855) and Linnaeus *Tripe (in 1856) to photographic duties in western India and the Madras presidency respectively. Although these official initiatives were uncoordinated and were often abruptly terminated for financial reasons, they fostered the use of the medium among civil servants and military officers and resulted in the creation of a body of work which was to form the foundations of the photographic collections of the

*Archaeological Survey of India in succeeding decades. Among a number of distinguished amateurs from the military and civil services active in the 1850s, particular mention should be made of Dr John Murray of the Indian Medical Service, who produced an astonishingly assured range of views of the Mughal capitals of Delhi, Agra, and Fatehpur Sikri, and the army officer Robert Tytler and his wife Harriet, who, after a remarkably short apprenticeship (receiving tuition from both Murray and Felice *Beato), produced over 500 large paper negative views of scenes connected with the Indian Rebellion of 1857–8 (see attached feature).

In addition to the East India Company's role in providing official backing and encouragement for photography, the establishment of amateur photographic societies also played a major role in fostering its development. The formation of societies in the three presidency capitals of Bombay (Mumbai), Calcutta, and Madras in the mid-1850s reflected a growing public interest in and familiarity with the medium, and such groups functioned as a forum for the exchange of technical expertise and discussion, defining the specifically Indian subject matter which photography was best placed to document. At the inaugural meeting of the Bombay Photographic Society in October 1854, the chairman, Captain Harry Barr, outlined a range of subjects open to the photographer, foremost among them the subcontinent's 'magnificent scenery—its temples—palaces—shrines', while the 'varied costumes, characters and physiognomies of its millions of inhabitants' were also a fitting subject for the photographer. Bombay was soon followed by the establishment of similar societies in Calcutta and Madras in 1856, and in a lecture delivered in Calcutta that year, the Revd Joseph Mullens formulated a similar if more extensive programme of activity for the Indian photographer. In addition to these topographical, archaeological, and anthropological subjects, he commended the use of the camera for the creation of a complete and systematic documentation of all areas of Indian life, including public works, medicine, criminal investigation, agricultural and industrial processes, and natural history. While celebrating photography's ability to capture the picturesque variety of India's varied population and the dramatic beauties of its landscapes, such comprehensive programmes situated the medium explicitly within a colonial context which was to stimulate the production of a good deal of work in this and the following decades. While a number of the suggested areas in which photography could function as a tool of administrative control (such as the photographing of convicts) were not followed up very vigorously, the creation of an extensive visual archive of ethnographical types was enthusiastically pursued with government backing. Perhaps the most important result was the publication, between 1868 and 1875, of the eight-volume work *The People of India*, produced under the editorship of India Office officials John Forbes Watson and John William Kaye. Containing some 500 photographic portraits of Indian racial and caste types, the work was ostensibly the result of Governor-General Lord Canning's photographic interests, and was intended to present a comprehensive scientific record of the racial variety of the subcontinent. The letterpress accompanying the portraits, however, makes it clear

Lala Deen Dayal

Interior of the Great Sas-Bahu Temple, Gwalior Fort, India, *c.*1880. Albumen print

Samuel Bourne

Raja Jey Singh's Observatory and Dasaswa Medh Ghat, Benares, India, 1865. Albumen print

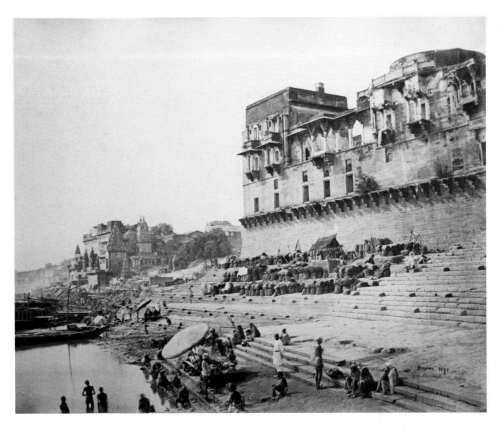

how far such purported objectivity was compromised by the circumstances of its production. Produced mainly by photographers employed in the military or administrative services of British India in the uneasy decade following the Mutiny, the work is as much a handbook for the identification of the politically trustworthy or suspect, as a contribution to scientific knowledge.

All three photographic societies maintained an active programme of exhibitions which both served to raise public awareness of photography and facilitated the rapid growth of a commercial market in the 1860s. If the rebellion of 1857–8 disrupted official programmes of archaeological documentation, it directed a new attention to India, which was satisfied to a degree by the arrival of commercial photographers such as Beato, whose documentation of the after-effects of the upheavals at Delhi, Lucknow, Kanpur, and the other principal sites of military activity, sold well in both India and Europe. While Beato's attraction to India had been narrowly focused on these events, the late 1850s and early 1860s saw a major shift towards the establishment of commercial photography. Short-lived commercial studios had appeared in Calcutta as early as 1844, while the first professional *calotypist, F. Schranzhofer, was briefly in practice in the same city in 1849. The work of Frederick Fiebig, a professional artist and lithographer in Calcutta in the 1840s who took up photography c.1848, is a precursor of the growing primacy of photography over the other graphic media, and by the end of the 1850s a number of studios had been set up in the larger Indian cities. One of the earliest studios to

remain in business over a number of years was that of James William Newland, who arrived in Calcutta in 1850, after a peripatetic existence as a daguerreotypist in South America, the Pacific, and Australia. Here he found a metropolis of sufficient size and wealth to support a permanent establishment which survived for a full decade, progressing from daguerreotype portraiture to the more adaptable wet-*collodion process. By the time Samuel *Bourne arrived in India in 1863, he was impressed not only by the healthy state of amateur photography, but also by the flourishing commercial scene, in a city whose wealth supported a growing body of professionals. Bourne's own success in India became an exemplar for the other major commercial firms who in the course of the 1860s and 1870s produced a body of work largely directed towards a European clientele, creating an image of India predicated on notions of the picturesque and the exotic which found a ready market among residents and visitors. Notwithstanding the limitations of this perspective, these two decades saw the production of work from a number of firms which is characterized by a freshness of response to the Indian scene and a technical virtuosity in representing it, but which in the closing decades of the century was to become ossified into the standardized and formulaic production of views.

As an invention of Western technology introduced to the subcontinent from abroad, photography in India was inevitably dominated by European concerns. Notwithstanding this ascendancy, Indians had been involved with the medium from its early days. Evidence of the extent of Indian participation is clearly seen in the

Louis Rousselet

Royal Natch at Jug Navas, India,
c.1865–8. Albumen print

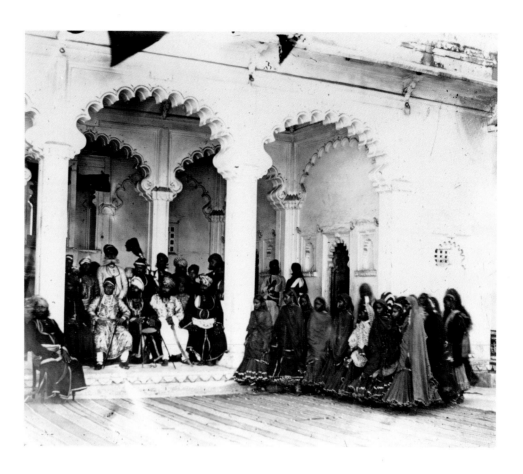

amateur societies, whose membership boasted a significant Indian component from their foundation. In Calcutta the distinguished scholar and antiquarian Rajendralal Mitra was an early society member and a practising photographer, while in Bombay Dr Bhau Dajee, founder of the Bhau Dajee Museum, was a council member from soon after the formation of the society. His brother Dr Narain Dajee was a regular contributor to the society's exhibitions and from the mid-1850s to the 1860s also practised as a commercial photographer in addition to his medical duties. Some impetus to the development of photographic skills among Indians can certainly be traced to the inclusion of photographic tuition at a number of educational establishments. Perhaps the most active of these was the school established at the Elphinstone College in Bombay in 1855, where classes consisting predominantly of Indian students were introduced to a wide range of photographic processes. Among the graduates of these classes was Hurrichund Chintamon, who thereafter established a successful studio in Bombay which survived until the 1880s. Similar initiatives were undertaken in Madras at the School of Industrial Arts, and here too the school acted as a conduit for the dissemination of photographic expertise among the Indian community. Photography was also seen as something of a fashionable pursuit among the ruling families of India. While the raja of Chamba's ownership of an expensive apparatus appeared to Bourne to be for display rather than for practical use, a

number of princes, including the maharaja of Jaipur and various members of the ruling family of Tripura, were accomplished photographers. In addition, a number of rulers, among them the maharaja of Benares (Varanasi), if they felt no inclination to practise photography personally, employed state photographers to record their families and territorial possessions. While most Indian commercial photography appears to have been directed towards an indigenous clientele, a few professionals, most notably Lala Deen *Dayal, spanned the divide between ruler and ruled to create a large and successful photographic enterprise which attracted the patronage of both British viceroys and Indian princes.

Photography had gained its first secure foothold in the Indian subcontinent through the dedication of amateurs who, whether in the course of their official duties or through enthusiasm for an artistic leisure pursuit, had created an impressive body of work by the end of the 1850s. It was on these foundations that the professional photographer built, producing a vast archive of images for a predominantly European market. For three decades, demand for such material maintained the position of the commercial photographer in what was still a demanding and difficult medium, particularly in the harsh Indian climate. As technological advances placed simplified photography within the grasp of all, the primacy of the professional was eroded. This development had been foreseen by Bourne as early as

the 1870s, when he bemoaned the abandonment of high-quality large-format prints in favour of 'small scraps fit only for the scrapbook'. Photographic manuals aimed specifically at the amateur in India had appeared as early as 1860, and intermittently thereafter, but the appearance in the mid-1890s of George Ewing's comprehensive amateur manual *A Handbook of Photography for Amateurs in India* (1895), which ran into several editions, signals the ending of an age of photographic experiment and achievement. JF

1900–1947

Early 20th-century Indian photographic history reveals both continuity and new departures. Technological developments were to have a major impact on photography as a hobby in the new century. The invention of the hand-held *Kodak box camera (1888) did away with the daunting paraphernalia associated with professional photography; heavy plate cameras gave way to *roll-film cameras, and eventually to 35 mm 'miniatures'. These advances freed photography from the confines of the studio, extended private and amateur practice, and facilitated a more democratic engagement of Indians with the medium.

As well as in the presidency towns of Calcutta, Bombay, and Madras, a number of indigenously owned portrait studios sprang up after 1920 in cities like Lahore, Muree, Rawalpindi, Dacca, Chittagong, Khulna, Peshawar, Srinagar, and the capitals of princely states like Jaipur, Jodhpur, and Hyderabad. It is difficult to identify a specific 'Indian look' in these photographs, which continued to reflect existing colonial aesthetics. Instead it is worth noting the difference in their purpose. These portraits of individuals and families were different from the universalized 'types' taken in the past by colonial photographers to classify the country ethnographically. The confluence of non-realist forms of cinema in the 1920s with other forms of popular and visual culture like theatre and chromolithography contributed to more performative and fantastical forms of photography in smaller local studios. These used stylized backdrops and props as well as traditions of hand tinting and painting over photographs.

Official photography, with its agenda of surveillance, continued to focus on landscape, the army, and architecture. Major events covered were Lord Curzon's ceremonial *durbar* in 1902–3 and King George V's Delhi *durbar* in 1911. From 1902 onwards, historic sites were excavated by the Archaeological Survey of India. Photographs were used for purposes of verification (depicting sites 'before' and 'after' restoration) as well as for sale, marking links between heritage and tourism. Ethnographic photography survived through the work of anthropologists like W. H. R. Rivers and A. R. Radcliffe-Brown, as well as in the form of phototype *postcards from 1899.

Calcutta and Bombay remained significant centres of photographic activity. Ambalal Patel and Oonwalla practised salon photography in Bombay. Shahpur N. Bhedwar became an international celebrity, winning awards in India and London. In Bengal, Maharaja Prodyot Coomar Tagore (1873–1942) was the first Indian to be elected a Fellow of the *Royal Photographic Society; Arya Kumar Chaudhuri

(1887–1935) was the first to bag its 'best award' in 1913. Sukumar Sen wrote the first Bengali article on the aesthetics of photography in 1911. An invisible pioneer of modern Indian photography was an amateur, Umrao Singh Sher-Gil (1870–1954), who took informal pictures of his family and some striking self-portraits in Lahore, Simla, Paris, and Budapest. He also took *autochromes and *stereographs.

The first advertisements for *zenana studios exclusively for women in *purdah* were seen at the turn of the century (Raja Deen Dayal's zenana studio in Secundrabad, 1896, and Sarojini Ghosh's *Mahila Art Studio* in Calcutta, 1898). Photography by women was still rare, but by the 1920s Annapurna Dutta (1894–1976) was running her own business in Calcutta. Several women practised amateur photography from the 1930s, including Manobina Roy (1919–2001), Debalina Mazumdar (b. 1919), Mira Chowdhuri (1905–94), and Indira De (1912–92) in Calcutta.

There were more Indians in the photographic societies of Bombay, Calcutta, and Madras. The 1930s saw the proliferation of exclusively Indian-run amateur societies and camera clubs (e.g. the Camera Pictorialists of Bombay, 1932; Madras Amateur Photographic Society, 1932; the United Provinces Amateur Photographic Association, 1937). The UP Amateur Photographic Association started by S. H. H. Razavi began the 'postal portfolio' movement (1940) to extend club membership all over the country.

The camera entered an era of candid photography. Local freelance photographers documented the freedom struggle (the civil disobedience movement, the salt *satyagraha*, and Gandhi's Dandi march in 1930) paving the way for news photography. There were demands for images of popular national leaders. Shambhu Shaha (1905–88) documented the streets of Calcutta from the early 1930s, while international photographers such as Margaret *Bourke-White, Henri *Cartier-Bresson, and Cecil *Beaton visited India during this time. Meanwhile, the *Illustrated Weekly of India* under Stanley Jepson was offering local Indian photographers possibilities for work. Homai Vyarwalla (b. 1913) was to become India's first female photojournalist. Her contemporary, Sunil Janah (b. 1918), became known for his striking images of the 1943 famine and Partition (1947), and for his documentation of the anthropologist Verrier Elwin's work with tribals in eastern India.

India since 1947

The pain of Partition as well as the euphoria of independence was evident in journalistic photographs of the 1940s, 1950s, and 1960s taken by photographers like Sunil Janah, N. Thiagarajan, Virendra Kumar, and Homai Vyarawalla, among others. Early freelance photographers, or those employed by agencies like the Press Information Bureau, captured images of national leaders, visits of dignitaries, and symbols of 'modern' India such as dams, ships, and atomic reactors. This optimism began to wane by the 1960s. The war with Pakistan and creation of Bangladesh (1971) led to an influx of refugees into India that was poignantly recorded by Raghu *Rai and Kishor Parekh (1930–82). Rai was to become one of India's

best-known photographers with a vast body of work spanning nearly four decades. His contemporary Raghubir *Singh settled abroad and gained international recognition in colour photography.

*Photojournalism has been one of the major impulses of 'modern' Indian photography, and most significant contemporary documentary photographers emerge from this tradition. This legacy, however, has often dictated certain stereotypical images of India and constrained formal experimentation. There are, of course, departures from this by contemporary practitioners who depict the coexistence of rural, exotic India with its urban, modern counterpart. One of the first to gain international recognition for her striking portraits of India's urban middle- and upper-class families was Dayanita Singh (b. 1961). Others representing this new generation of documentary photographers include Pablo Bartholomew (b. 1955), Sooni *Taraporevala, Ketaki Sheth, Prashant Panjiar (b. 1957), Pramod Pushkarna, Ram Rahman (b. 1955), and Achinto (b. 1959).

A striking feature of Indian contemporary photography is its diversity of genres. Commercial photography (fashion, industrial, and advertising) is represented by a wide range of photographers such as Prabhuda Dasgupta, Swapan Parekh (b. 1966), Rajesh Vora (b. 1954), Ashok Salien, Meenal Aggarwal, Farokh Chothia, Rafique Syed, Atul Kasbekar, and Sheena Sippy. Rajesh and Naresh Bedi have largely dominated *wildlife photography. Significant also is the work of installation artists such as Sheba Chhachi (b. 1958) and, later (2001), Vivan Sunderam (b. 1943), who has digitally reworked the photographs taken by his grandfather Umrao Singh Sher-Gil. Other traditions of popular photography, such as studio and street photography, amateur and domestic photography, cinema stills and *postcards, persist. SG

⮈ See also Lucknow *opposite*.

Embree, A., and Worswick, C., *The Last Empire: Photography in British India* (1976).
Thomas, G., *The History of Photography in India 1840–1980* (1981).
Ghosh, S., *Chhobi Tola* (1988).
Pinney, C., *Camera Indica* (1997).
Dehejiya, V., et al., *India through the Lens: Photography 1840–1911* (2000).
Falconer, J., *India: Pioneering Photographers 1850–1900* (2002).
Pelizzari, M. A. (ed.), *Traces of India: Photography, Architecture and the Politics of Representation 1850–1900* (2003).

Indo-China, 19th-century. Strategically placed on the commercial routes between the Indian and Chinese worlds, the Indo-Chinese peninsula attracted Western attention long before the advent of photography. Colonization was an unavoidable outcome. At the end of the 19th century, Cochinchina, Tonkin, Annam (together now Vietnam), Cambodia, and Laos formed French Indo-China, and *Burma had been claimed by Britain. Siam (Thailand) remained the only independent country in the region. Its experience of photography was also unusual.

In Siam, serious photographic activity not only started earlier than in Saigon or Hanoi, but the leading early photographer was a local man. This unique situation was thanks to King Rama IV (or Mongkut, reg. 1851–68), a scholar interested in foreign languages and sciences, including photography. Mongkut not only welcomed foreign photographers, as witness *daguerreotype portraits of him by French missionaries, or John *Thomson's photographs and writings, but employed as his photographer Khun Sunthornsathitsalak, a Thai Christian also known as Francis *Chit who opened a commercial studio in Bangkok in 1863. Possibly as early as 1857, and presumably commissioned by Mongkut, Chit recorded images of kings, royal consorts and their children, courtiers, royal dancers, religious events, court ceremonial, and architecture. His work in fact defined Siam enduringly as a land of royal pageants. As Pipat has shown, his large panoramas of Bangkok form a unique record of the capital's architecture and its changes over time. Signed prints and other evidence now suggest that Chit actually was the author of images claimed and published by various Westerners, including Thomson in 1865 and Wilhelm Burger in 1869.

In Cambodia, a French protectorate from 1863, the court was photographed by visitors, in graceful postures similar to those of Chit in Bangkok. Photography in Cambodia, however, illustrates the more general pattern of *colonial image making established in French Indo-China. It also included photographs of the Angkor ruins first described in detail by the French naturalist Henri Mouhot in 1863.

Although French missionaries had been present there for some time, the political takeover of Indo-China lasted from 1858 in Cochinchina (at the southern end of the peninsula) to the end of the century in Laos (in the centre). While the metropolitan government was lukewarm about annexation, local French pressure for it was strong, and one means to excite interest in Paris was photography. Records were created by the military, especially naval officers, and, over the whole period, by various exploratory missions. This typical colonial process of evaluating and taking possession explains the large number of photographs made for official purposes. Meanwhile, commercial photography was capturing more marketable subjects, although these also emphasized the French 'civilizing' presence in the form of official and civil architecture, military installations, and other evidence of Westernization. Also prominent were local customs, villages, peasants, and other subjects indicative of the country's wealth.

The stages of annexation influenced the evolution of photography; Saigon was the early photographic centre, Hanoi the later one. As Cochinchina's capital, Saigon was developed into a Western-type city. The first photographic studios in French Indo-China were established there, possibly by Clément Gillet (1864–67) and Charles Parant (1864). Famous visiting photographers include Thomson, en route from Singapore to Hong Kong in 1868. Émile *Gsell, the leading early Saigon professional, alternated studio work with participation in official expeditions. In 1866 he went to Cambodia with a scientific mission to photograph Angkor. His *carte de visite* sampler gives a fair idea of his production, with the Angkor temples which made his reputation effectively subsidizing studio portraits. Many of these

(*continued on p. 306*)

Lucknow Photography and the Indian Rebellion

The uprising that occurred in northern India in 1857, while brutal and bloody for both sides, had a lasting effect on British minds and was responsible for moulding the attitudes and beliefs of 'the Raj' into the 20th century. Following a rebellion by Indian soldiers against British officers at Meerut on 9 May 1857, a popular uprising swept across the Gangetic plain, involving local rulers, landowners, and peasants. The events that subsequently occurred in Lucknow, Kanpur (Cawnpore), and Delhi were to become the stuff of legends, mythologized through both text and image. Photography, already a highly sophisticated medium, was central in creating and perpetuating these tales.

The rebels took Delhi in mid-May. It was not until 14 September 1857 that the British began the recapture of the city by storming the Kashmir Gate. The first photographer to arrive was Dr John Murray, in February 1858. According to his diary, Murray produced 62 *calotypes in Delhi and 240 stereoscopic views, nearly all of which were architectural views. Charles Moravia (c.1821–1859), an engineer and highly skilled photographer, accompanied Murray on some of his excursions.

An important record was created also by Felice *Beato, who visited the city in April–May 1859. Beato systematically documented each site associated with the fighting. He was accompanied for at least part of the time by the husband and wife team Robert and Harriet Tytler. Robert Tytler (1818–72), who credited his knowledge of photography to Beato and Murray, made a moving portrait of the deposed king of Delhi, Bahadur Shah II. He was assisted in this by the professional photographer Charles Shepherd (later of *Bourne & Shepherd).

After 1860, it was the lure of Delhi's historical Islamic ruins, particularly the Qutb Minar, which drew photographers, rather than the events of 1857. Only one site achieved iconic status through repeated representation: the Kashmir Gate. Preserved carefully by the British as a memorial, the gate was photographed throughout the 19th century, and was often printed as a postcard in the early 20th century.

Photographers often overlooked Kanpur, notorious for the three massacres of Europeans that occurred in June and July 1857. Almost all the structures associated with 1857 were destroyed by advancing British troops, leaving very little to photograph. Dr Patrick Fitzgerald (1820–1910) of the Madras army, however, reached the city in November 1857 and made the only known photographs of the Bibighur—the house where almost 200 women and children were killed—before it was pulled down.

In 1862–3, a memorial was constructed to the Bibighur massacre in the shape of a large, mournful angel. It was set in a park forbidden to Indians until 1947, and was regarded by the British almost as a pilgrimage site. The angel was photographed repeatedly to fulfil the seemingly endless desire for images of the statue. As it achieved iconic status, it was reproduced and sent throughout the empire, in both photographic and postcard format.

Themes of British heroism and fortitude in the face of suffering are reflected most consciously in photographs of Lucknow. The British community was besieged in the Residency from 30 June 1857 until troops led by Colin Campbell began to evacuate the survivors between 19 and 23 November. Lucknow then remained in rebel hands until 14 March 1858 when the British army under Campbell stormed the city. Only a handful of photographs were made before this date, most notably those by Dr Fitzgerald, who is the only photographer known to have worked while under fire in January 1858 at Alambagh, a country house just outside Lucknow.

The first photographers to enter the city arrived with the relieving army. A small group of photographs in the National Army Museum, London, by Lance-Corporal Jones (*Royal Engineers) are possibly the first photographs of the recaptured city. Jones was the first of many to photograph the Residency, whose battered tower flying the Union flag quickly became the symbol of British resistance.

Felice Beato, arriving in Lucknow towards the end of March 1858, followed closely behind the relieving forces. By August that year his Lucknow views were on sale in Calcutta at a studio run by his brother Antonio. His photographs were presented in a sequence that mirrored the British advance across the city, a sequence that has been followed by nearly every guidebook to Lucknow written since. Although Beato had arrived after the fighting was over, he attempted to convey the severity of the conflict by recreating a scene of carnage in the Sikanderbagh. Here he ordered previously buried skeletons to be exhumed and scattered across the courtyard.

Between mid-1858 and the early 1860s a gradually increasing number of photographers visited Lucknow. The city was undergoing rapid change, as the British tried to rebuild Lucknow into a 'modern' colonial city, with broad avenues and spacious parks. The Indian photographer Ahmad Ali Khan, who had been photographing in Lucknow before 1857, documented some of these changes, although he now worked under an alias of 'Chota Miya' as he had fought on the side of the rebels. Oscar Mallitte (d. 1905) photographed Lord Canning's official tour of the provinces affected by the rebellion in late 1859. Other early photographers include J. C. A. Dannenberg (d. 1905) who documented the city in 1859, and the amateur photographer Donald Horne MacFarlane (1830–1904) who visited Lucknow in 1860, both concentrating on architecture.

These photographs, alongside poems, plays, and songs, occupy a complex and sometimes controversial place in the various histories of the uprising. Once accepted as an impartial record, today observers recognize that such images were created within a particular colonial context that influenced what was photographed, how, and by whom. The photographs, widely available through commercial studios in India and Britain, were an important way to remember events. The reproduction of the images as engravings in magazines such as the *Illustrated London News* widened their audience further. By recalling the price of Empire, the need to persevere and stand firm was subtly but repeatedly reinforced. SCG

show Saigon people; others, individuals from Cambodia to Tonkin, including Chinese. There are actors and bullock carts, princes and priests, and Western architecture.

Absent from Gsell's portfolio was ethnography—that is, people photographed as specimens of a race or culture—a genre which eventually became important in the photography of Indo-China. This type of work, then in its infancy, met the perceived colonial need to classify populations in order to rule them. Prime examples in Indo-China were the hill tribes of Tonkin and Laos. French scientists and photographers also recorded the border tribes of the southern Chinese province of Yunnan, probably because the region was increasingly seen as a future extension of French Indo-China.

Thirty years after Gsell, at the northern end of Indo-China in Hanoi, Pierre-Marie *Dieulefils created his own portfolio of portraits (including the now ubiquitous French officials), everyday scenes, and tribal types. In 1895 he was commissioned to travel over most of Tonkin and photograph foreign Asians for official registration purposes. He also became a successful *postcard producer, and in 1909 published a classic record of the Angkor ruins.

Chit had captured a timeless fairy kingdom; Gsell, Cochinchina at an early stage of colonization; Dieulefils, Tonkin at a more advanced stage. All three photographers showed 'Indochina' and its people, yet in different places and at different times. RT

Thomson, J., *The Antiquities of Cambodia* (1867).

Des photographes en Indochine: Tonkin, Annam, Cochinchine, Cambodge, et Laos au XIXe siècle (2001).

Pipat, Pongrapeeporn, *Panorama of Bangkok in the Reign of King Rama IV* (2001).

industrial design and photography. Mechanized manufacturing methods brought about the mass consumption of objects of diverse forms and appearances in the industrialized nations of the world. Drawn representations of goods in *advertising and mail order catalogues were an important means of promoting sales. As printing technology advanced in the first half of the 20th century, photographs replaced these images. Attempts to raise awareness of the social, economic, and cultural implications of mass manufacturing were made from various quarters—famously by William Morris and subsequently by other advocates of design reform. The values of truth to materials and of fitness of purpose were taken forward from their craft basis by the proponents of photographic modernism in the early decades of the 20th century; for, as well as aiding commerce, photography was an ideal process for promoting a machine aesthetic.

In Germany, the yearbooks produced by the Werkbund in the early years of the century utilized a photographic style that depicted the organization's products with plain backgrounds removed from context. This technique was developed during the late 1920s through the aesthetics of *New Objectivity photography, most famously by Albert *Renger-Patzsch, who photographed everyday objects in striking serial or rhythmic arrangements. The seminal exhibition *Machine Art* held at MoMA, New York, in 1934 included a catalogue with photographs that emphasized the formal coherence, precision, and surface finish of the industrially produced objects on display. These were the work of Ruth *Bernhard, daughter of the graphic designer Lucian Bernhard whose lithographic posters had presented goods to German consumers in a similarly objectified manner.

Both modern *architecture and industrial design were presented to mass audiences through photography, most significantly through publications. In Britain, the staff photographers of the *Architectural Review* from 1930, Mark Oliver Dell and H. L. Wainwright, pioneered a distinctive approach that emphasized formal values. Bird's- or worm's-eye views, dramatic lighting, and the absence of people or other indicators of scale promoted concentration on the object in isolation.

After the Second World War, state-funded design reform organizations developed this principle, building large collections of images to support educational campaigns addressed to manufacturers, retailers, and consumers. The Council of Industrial Design (COID) in Britain and the Hemmens Forskningsinstitut in Sweden were established in 1944, and the Rat für Formgebung in Germany in 1953. Photographs were exhibited and reproduced, and provided a resource for designers. The COID made available to consumers a searchable reference system of goods in current production at their London Design Centre in 1956. These collections now form substantial photographic archives that reveal much about the products made throughout the 20th century and the significance of the way they were represented.

Finally, cameras themselves are designer objects. A classic example of stylish looks inviting handling and display was the early *Leica. In the 1930s Walter Dorwin *Teague and Kodak promoted the camera as fashion accessory. After 1945 design remained a key competitive element. The 1970s produced Kodak's eye-catching Ektra 110 cameras, Canon's collaboration with the Italian 'bio-designer' Luigi Colani, and the Rollei 35 and Olympus *OM and XA series. Style still counts in the *digital era, with products like Canon's Digital Ixus (Elph) and 21st-century *camera-phones marketed both as machines and 'lifestyle statements'. CM

See also INDUSTRIAL PHOTOGRAPHY.

Rat für Formgebung, *In anderem Licht: Lichtinszenierungen in der Sachfotografie aus fünf Jahrzehnten* (1994).

Moriarty, C., 'A Back Room Service? The Council of Industrial Design Photographic Library 1945–1965', *Journal of Design History*, 13 (2000).

industrial photography can be defined as photographic practice that takes place within and/or at the behest of an industrial organization, to document production processes, products, work organization, employees, or the layout, equipment, or culture of an enterprise. The pictures may serve either internal (e.g. administrative or industrial relations) or external (e.g. *advertising or public relations) purposes. In principle there is no distinction between images made by in-house specialists or professionals hired from outside; and photographs taken by workers or clerical staff. The borderline between *documentary pictures and journalistic, advertising, and public relations ones is fluid, depending on context and usage in individual cases.

Walter Nurnberg
Worker at Air Products Ltd., Stoke-on-Trent, shot-blasting the inside of a metal pipe with a compressed-air gun, 1967

The use of photographs to depict industrial activity and products began in the 1850s and 1860s. Few firms employed their own photographers, but commissioned independent operators, or employees who could use a camera. Many well-known figures worked occasionally for industrial companies. Carleton *Watkins in the late 19th century produced many pictures for mining, shipping, and *railway companies in California. Albert *Renger-Patzsch repeatedly took on industrial work throughout his career, for example with the

Zündapp Works in Nuremberg in 1930, or Schubert & Salzer, a manufacturer of textile machinery in Ingolstadt, after 1949. Margaret *Bourke-White began her career as an advertising and industrial photographer in Cleveland, Ohio. Industrial photography cannot be tied to a particular aesthetic or function. There are innumerable links with other branches of the medium, such as *portraiture, reportage, and *architectural and advertising photography. However, it has been particularly associated with certain technical innovations (*flash, *panoramic equipment) and styles, such as the use of extreme chiaroscuro and, in general, *New Objectivity. The 1920s were characterized by especially close links between artistic and applied, including industrial, photography.

Early industrial photography centred not on the individual worker but on plant, buildings, and the workforce as a group. Working people as such—artisans, labourers, farmworkers, or fisherfolk—were, indeed, photographed from an early stage; *vide* the fishwives of Newhaven, Scotland, immortalized by *Hill and Adamson in 1843–5. However, people in industrial photography appear primarily as part of the production process, with the emphasis on their function rather than their individuality. In general, major engineering projects such as *shipbuilding, railway construction, and large-scale building were photographed earlier, more intensively, and more often than office work or the production of food or luxury goods. Well-known examples of the photographic documentation (and presentation) of major building operations are the re-erection of the Crystal Palace in south London in 1857 (P. H. Delamotte) and the reconstruction of the Louvre in 1855–7 (Édouard Denis *Baldus), every stage of which was recorded. The construction of locomotives and the building of railway lines with their tunnels and viaducts was another prominent early subject. Particularly well documented was the creation of the first US transcontinental railway, completed at *Promontory Point, Utah, in 1869, photographs of which are among the most frequently reproduced examples of classic industrial photography. Less well known but equally spectacular are Marc *Ferrez's pictures of the nearly finished Paranagua–Curityba line in Brazil (1879), and images of railway construction in British India. Other massive and comprehensively photographed communications projects included the building of the Suez and Panama Canals, and the Forth Bridge in Scotland.

A special case is mining photography, because of lighting problems *underground. Especially in coal mining, the dangers associated with artificial light meant that photography began comparatively late, at the end of the 19th century, although pictures of iron-ore extraction had already been taken in the 1860s. Another problem in mining was the complexity of the workings—the network of shafts and galleries—which could not be rendered visually. Hence individual miners were depicted much more often than other kinds of workers. In mining regions (e.g. Cornwall, England) such pictures had a certain nostalgic 'ethnographic' flavour; rather than showing a dynamic, growing industry, it was sometimes a case of creating a visual record of a centuries-old tradition.

Precise periodization of the themes of industrial photography is scarcely possible. However, certain subjects predominated at particular times. In the early phase, as the examples above indicate, overall views of works and construction sites were commoner than other subjects. Products and individual machines were also photographed early on. The Birmingham firm of Wright & Sons had its railway wagons photographed as early as 1858. Albums of product photographs were already in use as advertising material in the 19th century. Pictures of the workforce became more common from the last quarter of the century. By contrast, production processes and work routines could hardly be shown *in situ* until plates were sufficiently sensitive and lighting problems had been solved. Such obstacles also meant that for a long time work processes had to be staged, something that was impossible during normal hours. By 1900, together with pictures of events like ship launches, anniversaries, the inauguration (or demolition) of buildings and machines, and the celebration of local and national festivals, almost the whole register of modern industrial picture types was in place. In the 1920s the increased showcasing of products can be seen as a direct consequence of the professionalization of advertising. Dominant at all times, though adapted to prevailing stylistic trends, was a documentary, 'factual' visual vocabulary.

The long-term development of industrial photography at individual company level can only be followed reasonably adequately in relation to large firms. Krupp in Essen (founded 1811/12), a maker of iron and steel products, most notably artillery, is an outstanding—and outstandingly well-documented—example of a firm's systematic use of photography. The Krupps, until at least the post-First World War period, greatly valued the photographic depiction of the enterprise, for both internal and external purposes. From early on they used the camera as a means of self-presentation, both privately and for business, although the two spheres are not always easily distinguishable. The company had a photographic department from 1861, and chief works photographer from then until 1901 was a minor relative, Hugo van Werden (1836–1911). The department had multifarious tasks, producing views of the plant(s) and auxiliary buildings, pictures of production processes, portraits of blue- and white-collar employees, and records of product tests, including trials of Krupp guns and armour plate. Accident damage was also photographed, as well as the firm's increasingly elaborate welfare arrangements. (Considerations of surveillance and discipline probably played a part in this.) In important cases, the owners gave detailed instructions about what was to be photographed, and how. On 12 January 1867, for example, Alfred Krupp (1812–87) wrote to van Werden about a proposed works photograph: 'I suggest using a Sunday, as there is too much smoke, steam and commotion on a weekday, and the loss [of production] would be too great. Whether 500 or 1,000 men will be needed is up to you.' The Krupp family was also an official subject, especially when celebrities like the emperor visited. But most pictures, irrespective of subject matter, could be used for a range of purposes: as advertisements, for example, or as illustrations for the company newspaper or in presentation albums; even, in due course, as examples of the history of industrial photography. This seems characteristic of company photographs regardless of their country of origin.

Industrialists use photography, within prevailing cultural and economic limits, to project a certain image of themselves and their undertakings. The French textile manufacturers Blin & Blin, Jewish emigrants from Alsace who settled in Elbeuf, Normandy, in 1872, tried to present their factory as a model of state-of-the-art efficiency in order to legitimize themselves in their new surroundings. The Ansaldo shipyard in Genoa also endeavoured through photographs to create an aura of modernity, good organization, and patriotism.

The visual record of a firm, developing perhaps over several decades, is never unified, and often an accumulation of pictures created for particular purposes and for particular target audiences inside and outside its walls. Such diversity is emphasized by David Nye in his study of the American giant General Electric. Pictures reveal company values and priorities at a given moment, but there is seldom an autonomous long-term strategy. At the turn of the 21st century, a large corporation may use pictures to address a wide range of publics, including existing or potential consumers of its products, neighbours, environmental groups, shareholders, and its own workforce. Particular events, such as strikes or pollution disasters, may require the production of extensive visual *propaganda.

Another variant of industrial photography is workers' photography, carried out within the enterprise. In Germany in the 1920s and early 1930s a social democratic- and communist-influenced photographic movement developed which, in 1931, had *c.*2,400 members. It was stimulated by social documentary photography, and contemporary work in Russia. The *Arbeiter illustrierte Zeitung* and *Arbeiter-Fotograf* offered publication outlets. However, a distinctive 'work' style failed to emerge: partly because of workers' own self-perception, partly because of the limitations on workplace photography imposed by management.

In conclusion, industrial photography is a highly diverse phenomenon. It reflects both the technical and aesthetic currents prevalent in photography generally at a given time; and prevailing notions of photography's usefulness to industry. The pictures can be read to reveal both the messages intended by their makers, and period-specific cultural traits of particular companies and of industry per se. Today, as the case of Bernd and Hilla *Becher demonstrates, some industrial images belong to the canon of art photography.　　JJ

Nye, D. E., *Image Worlds: Corporate Identities at General Electric 1890–1930* (1985).

Matz, R., *Industriefotografie: Aus Firmenarchiven des Ruhrgebiets* (1987).

Tenfelde, K. (ed.), *Bilder von Krupp: Fotografie und Geschichte im Industriezeitalter* (1994).

Kosok, L., and Rahner, S. (eds.), *Industrie und Fotografie: Sammlungen in Hamburger Unternehmensarchiven* (1999).

Woronoff, D., *La France industrielle: gens des ateliers et des usines 1890–1950* (2003).

infrared (IR) **photography**. Silver halides are inherently sensitive to the short, high-energy wavelengths, but they can be dye sensitized to longer, lower-energy wavelengths, including infrared. IR is normally defined for photographic purposes as ranging from 700 nm to 15,000 nm.

Cryptocyanine, the first practical IR sensitizing dye, was developed in 1919. Since then, IR photography has been widely used for forensic work, in military intelligence, and in other applications where 'invisible' IR radiation gives a different picture from visible light. For example, live foliage is a strong IR reflector, while many camouflage materials are not. Visually, they are hard to distinguish; with IR, there is no difficulty.

Today, these applications are mostly handled digitally, as many forms of image sensor have a high inherent sensitivity to IR. Traditional silver halide IR films rely increasingly for their commercial survival on their pictorial potential. Classic IR effects include almost-white foliage and almost-black skies, along with pallid, corpselike skin tones; IR images are particularly favoured for *hand colouring.

There are three kinds of IR film: true IR mono, extended-red mono, and false-colour.

True IR mono films are sensitized only with a dye such as cryptocyanine. As well as the inherent blue/UV sensitivity, they are therefore sensitive only to IR: there is a 'green gap' where the film is not sensitive at all. An orange or even deep yellow filter is therefore sufficient to cut out the blue/UV light reaching the film, leaving only the IR to record. Typical sensitization extends to 800 or 900 nm. Specialist films have been sensitized to 1,100 nm and beyond, but their shelf life tends to be short, and there is little point in sensitizing much beyond 1,300 nm, as water vapour in the atmosphere absorbs longer wavelengths. Kodak's long-established High Speed Infrared is a true IR film, and many of the effects associated with it—the enormous grain and the way in which highlights seem to drip light as they might drip syrup in which they had been dipped—are widely regarded as inherent in IR films, although in fact they are specific to this one.

Extended-red films are sensitized like ordinary panchromatic films to green and visible red, but in addition are sensitized to IR. Typically, the sensitization is not as far as for a true IR film: it goes out to *c.*730–750 nm. In order to see obvious IR effects it is therefore necessary to use a very strong filter, preferably with a T_{50} (50 per cent transmission) of 710 nm or 715 nm. Although a deep red 'tri-cut' filter will cut haze dramatically, the photograph is unlikely to look very different from one taken with a fast pan film such as Ilford HP5 Plus. The great advantage of extended-red films is that they can be loaded in subdued light in the same way as any other film, whereas true IR films normally need to be loaded in complete darkness. To approach the effects that High Speed Infrared delivers, however, these already slow films must be exposed very generously indeed: a stop or two over one's best guess. The effective film speed can be 6 or below with an IR filter.

False-colour films are integral tripacks like any other colour film, but one layer is sensitized to IR. Depending on the filtration used— a medium yellow is the standard—the colour of the photographs can vary widely. Some colours can be kept 'normal' (blue skies, for example) while foliage turns red; blue jeans might turn yellow; and green paint might go blue.

Contrary to widespread belief, IR films do not record the heat of the human or any other mammalian body, nor (to the disappointment of generations of schoolboys) do they enable the photographer to see through clothing.

A surprising thing about infrared is just how far into the red the human eye can see, even though 'deep red' is typically defined as having a wavelength of 690–700 nm. Give the eye time to acclimatize, and exclude all other light, and an 'infrared' filter with T_{50} at 715 to 720 nm is transparent. A bright enough light—a flashbulb, for example—is visible at as much as 750 nm.

A problem rarely encountered but worth knowing about is that some materials that are opaque to visible light are at least partially transparent to IR. Camera bellows, plastic developing tanks, and even the tubs in which 35 mm films are stored have been known to cause problems here. Also, some 35 mm IR films are susceptible to 'light piping' down the film from the exposed leader. RWH

Paduano, J., *The Art of Infrared Photography* (4th edn. 1998).

Inha, Into Konrad (1865–1930), Finnish author, nationalist, and photographic pioneer, born in Virrat, Finland. Born Nyström, he assumed the Finnish name Inha. After studying literature and aesthetics in Helsinki and photography in Germany and Austria, he was active as journalist, traveller, historian, translator, and photographer. In 1894 he travelled to Karelia following the routes taken by Elias Lönnrot, the compiler of the *Kalevala*, the Finnish national epic. *Kalevalan laulumailta* (*From the Songlands of the Kalevala*; 1911), the resulting book with pictures and text by Inha, is a photographic epic exploring, in dramatic and heroic images, landscape and rural culture as expressions of the nation's soul. Inha's photography is always detailed and precise, and his collected oeuvre a pictorial monument to the young nation. J-EL

Inha, I. K., *Kalevalan laulumailta*, ed. P. Laaksonen (1999).

ink-jet printing. See DIGITAL PRINTING SYSTEMS.

ink processes comprise ferrogallic processes and variants using printer's ink, and were adopted for direct positive printing from the 1880s. Dichromates or ferric chloride (which converts to ferrous chloride on exposure to light) will selectively harden gelatinized paper, which is then treated with gallic or tannic acid to give a black image (*Poitevin, 1859; Colas, 1885). The Fotol process (Dorel, 1900) used a *cyanotype print to harden a gelatin base, producing a planographic surface that was inked for short-run reprographic work. This was modified for offset *photolithography (Tellekampf, 1909), incorporating dichromated rubber and glycerine on zinc plates and employed through the 1930s. HWK

Instamatic. See KODAK INSTAMATIC SERIES.

instantaneity. See AMATEUR PHOTOGRAPHY, HISTORY; DECISIVE MOMENT; TECHNOLOGY AND AESTHETICS IN 19TH-CENTURY ART PHOTOGRAPHY.

instant photography. The desire to see a finished photograph immediately, without tedious and time-consuming processing, is as old as photography itself. The earliest 'instant' process was the ferrotype or *tintype, invented in 1852 by A. A. Martin and used for well over a century afterwards, especially by *itinerant street and *seaside photographers.

Like the tintype, traditional photo booths used conventional processing, speeded up by means of high concentrations and temperatures. A *digital photo booth uses digital capture, then writes the image either to conventional silver halide paper or (less often) to some other printing medium such as dye sublimation. To a certain extent, too, some types of digital photography may be regarded as 'instant', especially those where the camera can be docked directly with a printer (normally dye sublimation) which produces a small print quickly and without further intervention.

Since 1947, however, 'instant' photography has been all but synonymous with the Polaroid Land camera, invented by Edwin *Land. This has effectively gone through two generations, the original *peel-apart* type (which survives for many applications) and the *integral* type.

The *peel-apart* variety was first demonstrated on 21 February 1947 at the American Optical Society; the first Polaroid camera, the Model 95, went on sale in a Boston department store on 26 November 1948. The technology is an ingenious combination of conventional and novel techniques. The exposure is made on a negative material, which is then brought into close contact with the positive material, with the developing agent sandwiched between the two. The developing agent is viscous, and is typically contained within a pod that bursts when the sandwich is drawn through two rollers. The really clever part is that the unused silver in the negative image diffuses across to the positive material to create the final image; the original images were sepia, but black-and-white arrived in 1950. Polacolor (1963) refines this technology, using a dye-diffusion process to create a colour image. After development, the two halves of the sandwich are peeled apart; the negative is either discarded or (with some types of black-and-white film such as Type 55 P/N, introduced in 1961) cleared with sodium sulphite, washed, and dried.

As well as the obvious applications for snapshots, identity photographs, and professional testing of exposure and lighting, the colour films in particular have attracted considerable attention for their 'fine-art' potential. (A few art photographers, such as Toto *Frima, have used Polaroids almost exclusively; many others, and the British painter David *Hockney, have had significant Polaroid phases.) The two most usual techniques are emulsion transfer and emulsion lift. In the former, the materials are separated before development is complete, and the image is rubbed down onto another support; in the latter, the image is floated off the finished print and caught on another support. Watercolour paper is popular as the support in both cases.

There have been several formats, some short-lived, some enduring; there are also giant peel-apart cameras, generally up to 508 × 610 mm (20 × 24 in), but these are rare and extremely expensive to run.

Emulsion types have also come and gone, such as Type 413 infrared (introduced 1964).

The same peel-apart technology has also been applied to transparencies, both monochrome and additive colour: Polachrome (1983) transparencies are made up of a grid of coloured lines, rather along the lines of some early colour processes. This was also the basis of the short-lived Polaroid movie process. Like all additive colour systems, the transparencies are dark as compared with additive films, and Polaroid reversal films are also particularly tender and prone to scratching. Those who use them for their (considerable) creative potential normally either duplicate them onto conventional reversal materials, or scan them, rather than entrusting them to the tender mercies of origination houses.

Because peel-apart films use a highly modified version of conventional processing, both time and temperature are important: the higher the processing temperature, the shorter the processing times. Below about 18 °C, 65 °F, processing may be so slow that it effectively never finishes.

Integral films first appeared in 1972 with the SX-70. A grey film is ejected from the camera, and develops before the user's eyes. The chemistry here is a good deal cleverer even than the peel-apart variety, with a vanishing opacifier and the 'pod' chemistry described above remaining in the image as a new stratum between other strata in the film. Development is always to completion, so time and temperature are much less important.

Again, there have been quite a few formats. The appeal of these films has generally been to amateurs; they find limited use in technical and scientific work, and there has been some creative interest in the way in which the image can be manipulated by physical pressure on the film as it is developing.

Because Polaroid cameras produce big images in camera, the cameras themselves need to be big: *depth of field is shallow, and focusing must be precise. Polaroid devised numerous ingenious solutions to the problems involved, including 'folding' the light path with mirrors; sonar autofocus; and ultra-fast materials (to allow the use of small apertures for maximum depth of field).

Most attempts to produce similar materials to Polaroid (whether peel-apart or integral) foundered either on patent violations or on the sheer ingenuity of Polaroid's scientists in coming up with ever-better materials. The only enduring rival, with a much smaller range of materials and sizes, has been Fuji. And yet, in the early 21st century, the Polaroid corporation ran into serious financial difficulties, a victim principally of *digital photography, which replaced many Polaroid applications where speed was more important than quality. RWH

Hockney's Photographs, introd. M. Haworth-Booth (1983).
Hitchcock, B., and Klochko, D. (eds.), Innovation/Imagination: Fifty Years of Polaroid Photography (1999).

intensification and reduction. As late as 1950 some print papers were available in one contrast grade only. If the density range of the negative did not fit, it would be necessary to raise or lower its contrast by *intensification* or *reduction*. Some recipes involved hazardous substances such as mercuric chloride, uranyl nitrate, or potassium cyanide. Almost all were unreliable. Two intensifiers worked well: chromium and quinone-thiosulphate. Both produced a linear increase in the slope of the *characteristic curve. The only reliable reducer, due to Howard Farmer (c.1860–1944), produced a uniform density reduction, with negligible loss of contrast. Farmer's original recipe used a 10 per cent solution of sodium thiosulphate mixed with an equal quantity of a 1 per cent solution of potassium hexacyanoferrate (III) (potassium ferricyanide). This gives variable results with modern emulsions, and keeps for only a few minutes. Modern technique uses the two solutions separately, with alternate immersions. It is still sometimes used to clean up highlights in silver prints.

Details of other obsolete after-treatments can be found in old copies of the *British Journal of Photography Almanac*. But there is nothing any after-treatment can do that cannot be bettered by modern *digital manipulation. GS

interferometry is an important tool in measurements concerned with extreme accuracy. This is because the measurement unit is the wavelength of light (which is less than 1 micrometre). It depends on the fact that two crossing light beams can (under certain conditions) produce a stationary pattern of light and dark bars (called *interference fringes*), at intervals that bear a simple relation to the wavelength used. Optical Interferometry has been a laboratory technique for over a century, but until the advent of the laser with its highly monochromatic beam it was difficult to find a light source capable of forming fringes over a distance of more than about a millimetre. Today, interferometry's main areas of application are in the measurement of displacements and distances, gas and fluid flow, temperature and pressure variation, in microscopy, spectroscopy, and the sensing of acceleration and rotation—and, of particular importance to the photographer, the control of lens fabrication to surface accuracies of fractions of a wavelength. Interference fringes occur when both beams originate from the same source (are *mutually coherent*). Where the beams cross they interact so that where wavecrests coincide they reinforce resulting in a bright fringe (constructive interference) and where crests coincide with troughs they cancel out and there is a dark fringe. A shift in the phase of one of the beams by half a wavelength results in a light fringe being replaced by a dark one and vice versa. This would indicate a change in one of the optical path lengths of about 0.25 μm (for green light).

Interferometers

In interferometric measurement, a number of different optical arrangements are employed. The two most important in imaging technologies are the *Michelson* and *Mach–Zehnder* interferometers.

Michelson interferometer. One of the earliest optical devices to use interference phenomena, it employs a partial mirror (a *beamsplitter*) to send two beams to mirrors at equal optical path distances from the source. On their return the beamsplitter acts as a *beam combiner*.

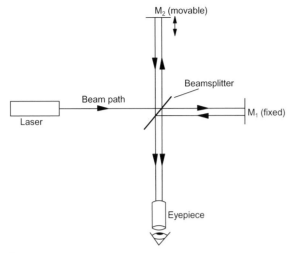

Fig. 1

The combination of the two beams produces an interference pattern that is observed through a telescope eyepiece (Fig. 1). This pattern may consist of either concentric rings or straight bars, depending on whether the mirrors are in exact alignment or (more usually) set at a very small angle. If one of the mirrors is moved slowly along the beam, the fringes will move across the field, and the exact distance moved can be measured by counting the number of fringes that move past the cross-hairs in the eyepiece. The main use of the basic instrument is to measure the coherence length of near-monochromatic light sources by measuring the optical path difference at which the fringe contrast falls to zero. An important variant is the Twyman–Green interferometer, in which an optical component to be tested (e.g. a photographic lens) is placed in one beam, and the fringes produced by the returning beams are examined for irregularities.

Mach–Zehnder interferometer. This device sends the two beams along paths forming a parallelogram, using a beamsplitter and a separate beam combiner (Fig. 2). One of the beams passes through an optical cell, often a wind tunnel work section. By examination of the interference pattern of the recombined beams it is possible to obtain data on fluid flow, shock waves, and convection currents, as changes in the density of a gas change the shape of the fringe patterns,

Fig. 2

showing the detail of the flow. Both the Michelson and Mach–Zehnder configurations are used as standard tests for assessing the stability of optical tables.

Holographic interferometry

A hologram is a record of the interference pattern generated by two mutually coherent laser beams, one unmodulated (the reference beam) and one modulated by reflection from the subject matter (the object beam). A double exposure with a small distortion or other movement introduced between the exposures results in a large *moiré pattern on the holographic image that contours the distortion with fringes at half-wavelength intervals, thus making visible (and measurable) extremely small strains.

Speckle interferometry

Laser illumination of a surface produces a grainy effect known as *laser speckle*, caused by interference between rays reflected from adjacent points on the surface. The speckle pattern is unique to the surface and the position of the illuminating source, and changes if the subject matter is moved or distorted. This is the basis of *speckle interferometry*. The subject is illuminated by laser light and the image recorded by a television camera. A second image is recorded after the subject is stressed, and this image is then subtracted electronically from the first; the result, enhanced, is displayed on a screen or recorded as a photograph. Where the speckles have changed there will be reduced contrast, and where they remain unchanged (i.e. no subject movement) there will be increased contrast. Again, the result is fringes contouring the distortion. The technique can cope with larger distortions than holography can, and has the advantage of real-time observation, but the resolution is low. Speckle interferometry is often inaccurately called 'TV holography'.

In interferometry, visual analysis allows a reading precision of about one-quarter of a wavelength, but digital analysis of the fringe pattern gives the greater precision needed for the testing of surfaces that must be accurate to a tiny fraction of a wavelength, such as astronomical telescope optics.

Although their main use is in industrial research, interferograms, in particular the holographic type, can form interesting and often beautiful patterns. A number of holographic artists have exploited the formation of attractive fringe patterns seen on holograms of vibrating objects and in portraiture using a double laser pulse to contour minute facial movements. GS

See also HOLOGRAPHY.

Jones, R., and Wykes, C., *Holographic and Speckle Interferometry* (2nd edn. 1989).

Hariharan, P., *Basics of Interferometry* (1992).

International Center of Photography (ICP). Founded in 1974 by Cornell *Capa in the historic Straight House on Fifth Avenue, New York, ICP has become one of the world's pre-eminent exhibitors and collectors of photography. Its predecessor was the International Fund for Concerned Photography. Capa was inspired by his brother Robert's

sense of the importance of a social role for photography. To that end, and in addition to an expanded exhibition space, ICP runs a school which offers photographic instruction and interpretative courses on the theory and history of photography. TT

International Museum of Photography, at George Eastman House, Rochester, New York. Formerly the residence of the industrialist and philanthropist George *Eastman, founder of Eastman Kodak, it opened in 1949 as an independent museum and educational institution. It comprises Eastman's restored colonial-revival mansion and gardens, galleries, a research centre, and cinemas. It houses a collection of over 400,000 images, and one of the largest collections of photographic technology and equipment in the world, both dating from the invention of photography to the present day. In addition to expanding these holdings and organizing exhibitions, the museum conducts important research on photographic *conservation. LAL

1000 Photo Icons. George Eastman House (1999).

Internet. The Internet has become an important medium for photographers because it enables images to be transmitted, displayed, and downloaded to computers extremely rapidly worldwide. Photography on the Internet is possible because scanners (and later *digital cameras) have been developed to capture images electronically. The first drum scanner was built for the SEAC computer at the US National Bureau of Standards in 1957 by a team led by Russell A. Kirsch (whose other major contribution was to codify the square 'pixel' as the basic unit of a digital picture).

The Internet itself grew out of the ARPANET, a network developed under the direction of Dr J. C. R. Licklider of the Advanced Research Projects Agency to link major research centres in the USA. The key to the network's flexibility was its decentralized design, involving routers sending packets of information via all possible connections. The ARPANET was commissioned by the US Department of Defense in 1969 and continued to grow throughout the 1970s. By the 1980s independent service providers and bulletin boards were continuing to multiply, and the Internet Activities Board was founded in 1983. The ARPANET ceased to exist in 1990, by which time it had been superseded by its progeny.

The Internet developed as a visual medium when the first graphical browsers became available. In 1989 Tim Berners-Lee at the Centre Européenne de Recherche Nucléaire (CERN) proposed a web browser that would display webpages consistently across all computers. With the addition of standardized display formats, the World Wide Web (WWW) came into its own from the mid-1990s. Photographs displayed on the Internet are generally shown as JPEG files (invented by the Joint Photographic Experts Group in 1990), GIF files (Graphics Interchange Format, developed by Bob Berry of Compuserve in 1987), and the non-proprietary PNG format (portable network graphics, a free alternative to GIF, developed by Thomas Boutell from 1995). The JPEG is generally used for photographs whilst the GIF is more suitable for geometric shapes and line art. All these formats involve

*compression, which means that the image's file size is reduced by simplifying its range of colours. Heavy compression results in obvious image degradation, so there is a trade-off between file size and image quality.

The Internet may be used by photographers in several ways. The most obvious is the online gallery, which can showcase one photographer's work or act as a larger repository (e.g. for *agencies or picture archives). It presents photographs in a similar way to its physical counterpart, but with the added flexibility of dynamic links and search options to assist viewers. Its layout and style influence its attractiveness to new visitors. The gallery may also be used to sell photographs directly, acting as an online shop. This is useful to freelance photographers wanting to distribute their work, which may be downloaded as secure files or physically mailed to the buyer as prints. Here, the photograph on the website is only a representation of the print, not a substitute for it. The popularity of web-based diaries and writings (weblogs or blogs) has led to collections of images posted as photo journals. Although these are generally by amateurs, the Internet has become a major outlet for online *photojournalism. The net speeds delivery of news and photographs, allowing freelancers and small groups to compete with large news agencies. This has broadened the spread of news photography, although some traditional photojournalists fear their skills are being displaced by low-resolution Internet images.

The web's interactive forums also allow the widespread discussion of photographic issues, and interactive reviews of new equipment. This benefits both traditional and digital photographers who want to raise questions or develop their skills. These forums also bring new techniques and concerns to light in a worldwide community of photographers. Other sites teach online photographic courses. The Internet also enables large and rarely seen photographic archives—and document collections like the *Talbot Correspondence—to be placed online, often as part of major academic projects. For instance, the 17 million photographs of the Bettmann archive, spanning the 20th century, are to be relocated to a mine north-east of Pittsburgh for preservation underground. Their digitized contents will be made available online with other Corbis holdings. However, the physical inaccessibility of the archive concerns some historians, even though the storage conditions will preserve its actual substance. Another problem relating to this and other large collections is the time it takes to digitize material.

Copyright is a major issue with Internet photography. As with music files, images can be downloaded from websites and used without their owners' permission. The nature of digital data makes copying extremely easy, and although various technologies, including encryption and digital watermarking, are designed to prevent illegal use of images, most can be circumvented. Additionally, older photographs can be scanned and placed in the digital domain. The resulting problems extend from straightforward breach of copyright to more complex issues such as illegal alteration of images. By 2000 this had become both easy and widespread. In 2004 a widely

published composite picture 'showed' the US presidential candidate John Kerry with Jane Fonda at an anti-Vietnam War protest. It was not only used without the original photographers' permission, but modified for political purposes and posted on websites under the false imprint of Associated Press: a veritable catalogue of infringements. Another notorious 21st-century problem is the creation of *pornography at offshore locations and its distribution via the Internet. However, notwithstanding these and other concerns, it seems certain that the Internet will continue to expand rapidly, and probable that, overall, its utility to photographers will continue to outweigh its dangers. NL

Mitchell, W. J., *The Reconfigured Eye: Visual Truth in the Post-Photographic Era* (1992).

Hoffman, B. (ed.), *Exploiting Images and Image Collections in the New Media: Goldmine or Legal Minefield?* (1999).

Andrews, P., *The Photographer's Website Manual: The Indispensable Guide to Building and Running a Website* (2003).

invention of photography. The year 1839, when the *daguerreotype and *photogenic drawing were introduced to the public, is a largely symbolic date, for it represents only the year in which the new art was revealed. Its invention had occurred in stages, incorporating many earlier developments in chemistry, physics, and the visual arts. The history of photographic invention may be loosely divided into three parts: photographic prehistory; the years 1790–1838; and the public announcement of photographic processes in 1839. Photographic prehistory, that is, events impinging on photography in the period before 1790, saw the establishment of an underlying structure of thought and technology in Western art and science enabling photography to be both desired and invented. After 1790, and especially in the first decades of the 1800s, numerous 'proto-photographers' began making deliberate experimental steps towards photographic imaging. The first published details in 1839 expanded the inventing from the private sphere of a handful of isolated individuals to the more public and accessible one of artists and scientists worldwide.

Photographic prehistory

Although the term 'prehistory' of photography is sometimes used to cover all experiments up to 1839, it is most appropriate for the earliest period of technical and thematic development. Its scientific and artistic roots date back to antiquity and evince tempting photographic hints up to the dawn of the 19th century. In this early history, two strands of investigation emerge. Advances in optical and chemical technology provided the mechanisms on which photography would rely. These mechanisms would have gone unused, however, had the public not developed an appreciation of images that purported to be more accurate, and therefore more truthful. These two strands can be found in the development of linear perspective, in the use of drawing machines, in the growing consumption of public entertainment and illustrated literature, and in the increasingly experimental investigation of the natural world.

Linear perspective came into widespread use in Italy in the 15th century. The desire for images that deceive the eye, *trompe l'œil*, encouraged the adaptation of architectural and scientific measuring instruments to *drawing machines*. These devices, one of the simplest being the camera obscura, aided artists in creating mathematically precise spatial depictions in single- or multiple-point perspective. Images made with the help of instruments like the camera obscura, and later the camera lucida, were considered more true to nature, or more real.

The camera obscura was made famous by Giovanni Battista della Porta's *Magiæ Naturalis* (1558), which was translated and reprinted countless times and reached the height of its popularity in Europe in the 17th century. In it, Porta treated the camera obscura as an instrument of entertainment, physics, and a bit of natural magic—rather as photography would be treated two centuries later. His treatise made the device more desirable, and the desire for such instruments in turn made his treatise famous. The mid-17th century was also a time when artists like Diego Velázquez (1599–1660) and Jan Vermeer (1632–75) became interested in *pre-photographic imaging devices like the camera obscura, and had increasing access to them. The use of mirrors and lenses to scrutinize nature, both for the purposes of science and for the purposes of art, became commonplace.

However, without some advance in the understanding of the physics of light and also chemistry, the images thus created were, in Henry *Talbot's famous words, nothing but 'fairy pictures, creations of a moment, and destined as rapidly to fade away'. Classical philosophers had remarked on the light emitted from living organisms like cuttlefish and fireflies, and also on decaying vegetable matter. But it was not until 1602 that a man-made phosphorus existed. Vincenzo Cascariolo accidentally created a powder of barium sulphide, by treating his so-called 'Bolognian Stone' with charcoal in a furnace. When exposed to light, the powder then emitted light. In the first instance, this accidental invention allowed for the realization that light and heat did not always act in tandem. Importantly for photography, it also introduced the notion of 'insolation'—the practice of exposing a substance to the sun's rays in order to bring about a certain effect.

Cascariolo's work encouraged many similar experiments. A century and a half later, while attempting to create Baldewin's phosphor, Johann Heinrich Schulze (1687–1744) discovered what he called 'scotophorus'. This mixture of chalk (calcium carbonate) suspended in an aqueous solution of silver nitrate, darkened when exposed to solar radiation. Schulze recognized not only that light, as opposed to heat, was responsible for the change, but that silver was essential to the process. He then proceeded to cut stencils and create images suspended in the solution. In creating these, albeit transient, images Schulze made primitive photographic experiments.

In fact the change of colour in silver compounds exposed out of doors had been noted already by Georgius Fabricius (1516–71), if not earlier. Most experiments were conducted using horn silver (luna cornea), an ore from German silver mines. This substance could also be prepared artificially by adding salt to a solution of silver nitrate.

Substances that darkened by the aid of the sun were not as sought after as those that were luminous, perhaps because of an ancient association of darkness with evil, or because there seemed to be less practical use for darkness than for light. It was not long, however, before the darkening of chlorides and nitrates of silver became a standard part of physical experiments on the solar spectrum. Carl Vilhelm Scheele (1742–86) and Jean Senebier (1742–1809) both cast the image of the solar spectrum on silver compounds, measuring the darkening effects of the various colours of light in the spectrum. They established that the violet or blue end of the spectrum was by far the more chemically active.

Not all expressions of interest in instantaneous and mechanical images were accompanied by chemical experimentation. Tiphaigne de la Roche's (1729–74) novel *Giphantie à Babylon* (1760) so convincingly described the idea of a mirror retaining perfectly the view reflected in it that it had made its way into photographic history by the 1860s. Although the best known, *Giphantie* is not the only written description of such an idea. On 12 November 1769 the German physicist Georg Christoph Lichtenberg (1742–99) recorded in his notebook a conversation with a friend regarding the practical possibilities of fixing the image of the camera obscura, and in 1791 the British writer (and theorist of the picturesque) William Gilpin (1724–1804) expressed the desire to fix the image reflected in a Claude glass. Less concrete examples of such a bent for instant, optically created images can be found in the work of Samuel Taylor Coleridge (1772–1834), who sought to describe the experience of a moment flashed on his eye. A similar idea can be found in the 'arrested transience' of the topographical and meteorological paintings of John Constable (1776–1837).

These might be seen as sophisticated manifestations of a widespread desire for images based on the direct copying of nature, or objects in nature. The tracing of shadows was eulogized in Pliny's tale of the Corinthian maid, fabled to have invented painting by tracing the outline of her lover's shadow. In the late 18th century the making of such 'skiagrams' or *'silhouettes', using instruments like the Physionotrace, became fashionable. Likewise, there were instruments for enlarging or copying drawings and even machines for copying sculptures. Demand for such devices helped prepare the market for photography, once it had been perfected.

Photographic experiments to 1838

In the late 18th century there was a significant increase in specific experiments intended to create images chemically. It was generated by two distinct desires: for faithful, inexpensive, and quick copies or representations of nature; and for an accurate visual recording device for use in science. Cross-fertilization between scientific and artistic interests and needs was common, for instance in notions of colour, in the reproduction of natural phenomena, and in the illustration of scientific texts. Some individuals, mostly working in isolation from one another, began to seek a chemical solution to the creation of wholly mechanical, and thus more true, representation. Those who

recognized and experimented with the interaction of light and chemicals, but did not make permanent images in the camera obscura, may be called proto-photographers.

Of these proto-photographers Elizabeth *Fulhame was the first to publish. Her *Essay on Combustion* (1794) contributed greatly to the understanding of the chemical precipitation of metals, a necessary condition of chemical fixing. But Fulhame has primarily been recognized as a proto-photographer by her use of silver salts to stain patterns and designs on cloth. She also suggested that the method could be applied to painting and map-making. Better known were Thomas *Wedgwood's attempts at the turn of the 19th century to 'fix the image of the camera obscura'. His friend and sometime collaborator Humphry Davy (1778–1829) discussed these experiments in the *Journal of the Royal Institution* in 1802. Wedgwood's attempts were also mentioned in William Thomas Brande's 1819 *Manual of Chemistry*, published many times in the USA and Britain. The 1836 British edition of this manual described Wedgwood's and others' experiments in detail. However, their fundamental shortcoming was failure to fix the image—i.e. to prevent further darkening by exposure to light—after it had been formed.

While some proto-photographers like Fulhame and Wedgwood attempted to make designs or images, Sir John *Herschel continued the tradition of analysing the solar spectrum. In 1831 he demonstrated the formation of a weak image of the spectrum with platinum salts, a demonstration attended by Talbot, among others. His first contribution to photography had been made in 1819, when he noticed and published the property exhibited by hyposulphites of dissolving unreduced salts of silver. This observation proved to be the basis for photographic fixer, or 'hypo'—a discovery which it took Herschel very little time to recognize in 1839.

In the early 19th century many other individuals may have experimented with solar images. The chief factors contributing to this rise in experimentation were the ready availability of the chemical knowledge, the popularity of projection-based drawing instruments like the camera obscura and camera lucida, and the growing market for inexpensive illustrations. However, it is difficult to verify exactly what experiments were conducted by whom and when. Many of the trials were intended as parlour amusements and remained unpublished, their authors recounting them only in the early months of 1839. Among suspected or confirmed proto-photographers are Mungo Ponton (1802–80; Scotland), Samuel *Morse (USA), James Miles Wattles (USA), Hercules *Florence (Brazil), Thomas Young (1773–1829; England), Andreas Friedrich Gerber (1797–1872; Switzerland), and the French physicist J. A. C. Charles (1742–1823). None of these men published or patented their processes, and little is known about most of them, but they testify to the burgeoning interest in such images. In the midst of all this photographic experimentation, those individuals who eventually made permanent solar images in the camera obscura were beginning their own attempts at the 'fixing of images'. They are considered the primary inventors of photography.

Working in complete isolation from Wedgwood and Fulhame, and also in the 1790s, Joseph Nicéphore *Niépce began the experiments that would lead him to what he called *héliographie*. His goal was less the scientific investigation of nature, or the creation of multiple designs, but rather the multiple reproduction of landscape views made in the camera obscura. Although François *Arago claimed in 1839 that J. A. C. Charles had demonstrated imaging with silver salts to the Parisian scientific public *c.*1800, Niépce's work proceeded independently of Parisian scientific circles. His early experiments from 1816 to the late 1820s were conducted for two distinct ends: the copying of engravings or other printed material, and the formation of images in the camera obscura. His determination to create a positive image, as well as his interest in engraving from the images, led him away from early attempts with silver chloride on paper towards more solid, and more reflective, surfaces of pewter, stone, glass, and silver. Although silver and pewter plates did allow the image to appear positive by reflection, his colleague, the Parisian engraver Augustin Lemaître (1797–1870), was unable to find a satisfactory method for engraving the faint images. After years of trial and experiment, Niépce succeeded in copying an engraving in 1822 and making, in 1824, a *point de vue*—a positive (but difficult to view) image made in the camera obscura. Although accounts of his earliest experiments have not survived, his letters tell us these images were created by the unique use of a thin varnish of the resinous asphalt bitumen of Judea, dissolved in oil of lavender, on bases of stone and glass. He later applied the same process to pewter. In a letter of September 1824, he declared to his brother that this stage signalled his success.

According to some accounts, it was the same year, 1824, that Louis Jacques Mandé *Daguerre borrowed a laboratory to investigate the possibility of fixing images by sunlight. Although his exact experiments are not known, Daguerre did try various substances, including phosphorus and silver compounds. His experiments had not progressed beyond what he called *dessin fumé*, a type of *cliché verre*, when, in 1826, he was informed by the Paris optician Charles *Chevalier of Niépce's work. Daguerre initiated the first contact and they met in Paris in 1827, after which Niépce travelled on to England to visit his brother Claude.

On his arrival in Kew, Niépce found his brother in a state of precarious mental, physical, and financial health, and their jointly developed internal combustion engine, the *pyréolophore*, unadvanced and unsold. Frustrated in his initial purpose, Niépce turned to promoting his photographic invention. The Royal Society was, however, in disarray and its Committee of Papers did not meet during Niépce's visit. He was unable to present a formal paper to scientists in London, and neither Herschel nor Talbot heard about or saw the results of the heliographic process. Although Niépce found an enthusiastic friend in the Royal Society member and botanical illustrator Francis Bauer, he failed to interest other scientists or artists in London. While Niépce's visit to Britain in the winter of 1827 was, by all accounts, a promotional failure, it did provide us with the earliest surviving example of a photographic plate made in a camera obscura. It also compelled Niépce to provide a public name, *héliographie*, for his process. He

returned to his estate of Gras in debt, leaving Bauer with several images, among them the now celebrated *View from the Study Window*: a direct-positive, laterally reversed image that Niépce had made the previous summer with an exposure of probably 2–3 days.

By 1829, Niépce had renewed his researches and entered into a partnership with Daguerre that was to lead directly to the invention and perfection of the *daguerreotype in the 1830s. Unfortunately, none of their images from this period has survived. Niépce's experiments with silver iodide as a light-sensitive compound were an important step forward, but he died suddenly in 1833 and was succeeded by his son Isidore (1805–68) in the partnership with Daguerre. The further specific steps leading to the highly detailed, positive *daguerreotype as it was revealed to the public in 1839 remain unknown. However, Daguerre's own crucial discovery of mercury vapour as a means of developing the *latent image, and salt as a fixer, evidently took place between 1835 and late 1837.

At *Lacock, England, Talbot was conducting his own experiments on the imaging process that was to rival Daguerre's in 1839. Talbot explained his interest in his poetic reminiscence of a failed attempt at drawing with a camera lucida on the shores of Lake Como in 1833. One of the best-known narratives of photography's genesis, it was published twice, first in February 1839 as *Some Account of the Art of Photogenic Drawing*, and again in 1844 in the first fascicle of *The Pencil of Nature*. Talbot came to his experiments relatively late, beginning his attempts at photography in the spring of 1834. But he achieved his desired result more rapidly than anyone else, attaining stabilized images almost immediately. However, within the year, he set aside his experiments in favour of more pressing concerns in optics, biblical studies, and integral calculus.

The mechanism used by Talbot was similar to Fulhame's and Wedgwood's. It was also much the same process tried by any number of proto-photographers, and Niépce in 1816. Talbot brushed writing paper with a salt solution, and then with a solution of silver nitrate, creating a light-sensitive silver chloride. Exposing this to sunlight created a visible image, without the need for further development, but this action took place very slowly. He observed very quickly that different strengths of the salt solution affected the sensitivity of the resulting chloride; more salt equalled less sensitivity. Using a strong salt solution after exposure, he stabilized (i.e. temporarily fixed) the print, which was, in the first instance, a negative. Once stabilized, it was possible to print through the negative and obtain the reverse, in this case a positive image. In his working notebooks, Talbot privately named the paper 'sciagraphic' or 'photogenic' paper; it was not until January 1839 that he chose 'photogenic drawing'.

Talbot conducted further experiments in Geneva in the autumn of 1834. Letters from his family indicate that he shared these images, but apparently only within his extended family, not with the public. It is from the summer of 1835 that his earliest camera obscura negatives survive, made in miniature, specially constructed cameras. Talbot later wrote that this was the summer of his most prolific photographic experiments before 1839. The best known of these early images is a photogenic drawing of the *Latticed Window of Lacock Abbey*, dated August 1835.

Public announcement, 1839

The photographic events of the first half of 1839 were largely dominated by the public announcements of the two inventors, Daguerre and Talbot, and two scientists, Arago and Herschel. Their papers, comments, and the larger debate about priority was recorded in minute detail in popular magazines and in the reports of the two largest scientific institutions, the *Comptes rendus* of the Académie des Sciences in Paris, and the *Transactions* of the Royal Society in London. Although these scientific reports were not widely available at the time, the subsequent history of the invention has depended heavily on them.

The timing of the public announcement of the daguerreotype appears to have been precipitated by events in 1838. The process had been improved sufficiently for Daguerre and Isidore Niépce to attempt its sale by subscription. Although this proved unsuccessful, the partners did attract the attention of the permanent secretary of the Académie des Sciences, Arago, who stated later that he understood immediately the significance of the invention for the advancement of physics, especially the study of light. It was this understanding that set him about preparing the announcement and gaining the interest of government. In 1838 Talbot had also begun to gather together his photographic results with the intention of publishing them.

The announcement of the daguerreotype was made to a meeting of the Académie des Sciences by Arago and the physicist Jean Baptiste Biot (1774–1862) on 7 January 1839. No practical details of the process were described. Talbot, unaware of the differences between his process and Daguerre's, hastened to show a number of specimens. He took examples made in 1835 to scientific friends nearby, or sent them folded up in a letter. The first public showing of Talbot's images was on 25 January 1839, at the Royal Institution's Friday evening lecture, presided over by Michael Faraday and attended by more than 300 people. That same day, Talbot sent his first letter about photography to his long-time colleague Herschel. Within five days, driven by curiosity and primed by a lifetime of experimental work, Herschel succeeded in forming an image in the camera obscura and fixing it with hyposulphite. On 31 January, the day that Talbot's first paper on photography was being read before the Royal Society, Herschel was able to display his own photographic process when Talbot came to visit.

In France, Arago and Biot were alerted to the rival process by letters from Talbot. Biot reacted by striking up a dialogue with his English colleague. Arago pressed on with his championing of Daguerre's priority. The task of convincing the French government to buy an invention from which it would not profit possibly led Arago to defend Daguerre's status as sole and independent inventor more vigorously than, as a scientist, he might otherwise have done. In the end, he achieved his aim, although his methods earned him enemies and detractors. The government paid Daguerre a pension of 6,000 francs; Isidore Niépce received 4,000. But this triumph for Arago, Daguerre, and Niépce came at a heavy price for other inventors.

The debate over priority of invention in photography had several effects. The most apparent was the writing of many histories legitimizing one inventor over another as the 'first'. More subtle, but perhaps more damaging for the history of photography, was the quiet suppression of independent advances in photographic imaging in early 1839. It was a time of widespread and fruitful experimentation. The mere suggestion of a method of imaging chemically by the action of sunlight stimulated a number of scientists and artists to experiment. Herschel, aside from making photographs using 'vegetable colours' in the search for colour photography, publicly established the name 'photography' in March, and in the same paper illustrated a scientific finding with a photograph. Mungo Ponton established the sensitivity of bichromate of potash, laying the foundations for gum printing. In Munich, probably early in 1839, the astronomer and mathematician Carl August von *Steinheil and the mineralogist Franz von Kobell (1803–82) created several 42 × 42 mm (*c.*1⅝ × 1⅝ in) paper negatives of buildings in the city; Steinheil announced the details of their process to a committee of the Bavarian Academy of Sciences on 13 April. Hippolyte *Bayard developed a direct positive process on paper, and exhibited his own photographs in June 1839. Many more individuals attempted to make images from their knowledge or suspected knowledge of the daguerreotype and photogenic drawing. In Switzerland Andreas Friedrich Gerber (1797–1872), in America John William Draper (1811–82) and probably Edward Everett Hale and Samuel Longfellow, and in Wales the *Llewelyns conducted experiments in the spring of 1839, and were able to produce results in spite of the sketchy nature of their information.

In February 1839 in England (April in the USA), Talbot had published the working methods for his photogenic drawing as well as his own and Herschel's methods of stabilizing and 'washing out'. Talbot's inventions of photogenic drawing and, in 1840, the negative-positive *calotype process provided the template on which virtually all photography would be based until the *digital age. However, the daguerreotype, with its silver surface and minute detail, became initially the favoured medium and remained so for the next decade in both Europe and, especially, the USA. On 19 August the details of the daguerreotype process were released to the public. These announcements of 1839 opened a new era of photographic discovery, innovation, and commercial use that soon escaped the confines of the West and extended across the globe. KEW

Gernsheim, H. and A., *L. J. M. Daguerre* (1956).

Buckland, G., *Fox Talbot and the Invention of Photography* (1980).

Gautrand, J.-C., *Hippolyte Bayard: naissance de l'image photographique* (1986).

Busch, B., *Belichtete Welt: Eine Wahrnehmungsgeschichte der Photographie* (1989).

Schaaf, L. J., *Out of the Shadows: Herschel, Talbot and the Invention of Photography* (1992).

Batchen, G., *Burning with Desire: The Conception of Photography* (1997).

Marignier, J.-L., *Niépce: l'invention de la photographie* (1999).

Bajac, Q., *The Invention of Photography: The First Fifty Years*, trans. R. Taylor (2002).

Iran (Persia), **early history**. The beginning of photography in Iran is associated with the court at Tehran and the patronage of Nasir al-din Shah (reg. 1848–96). The Frenchman Jules Richard is credited

with making the first *daguerreotypes at Tehran in 1844. He was later appointed to the faculty of the Tehran Polytechnic, Dar al-funin, where in 1860 Nasir al-din Shah established a school of photography. The shah was an early photography enthusiast—he practised himself—and encouraged Western practitioners to establish studios in Iran, as well as the development of an Iranian photographic practice. The extensive photographic collection from the princely courts, now held by the Axkhana Shahr Photography Museum in Tehran, consists of over 1,000 albums. Luigi Pesce, an Italian colonel who arrived in Iran in 1848, made the first images of Persepolis and Pasargadae in the 1850s using the *calotype process; his views received a citation of honour at the 1862 London Exhibition. A number of Europeans who accompanied missions to the shah's court made photographs in and around Tehran, although most are apparently lost. The first extensive body of extant work is by the Italian Luigi Montabone, 62 albumen prints made during a scientific mission to Iran in 1862.

Although French and Italian photographers are most frequently cited in histories of early photographic practice in Iran, Russian influences should not be discounted. In 1867 the Russian governor-general of the khanates of central Asian Turkestan to the north of Iran ordered an exhaustive photographic record of the land, settlements, archaeology, and peoples of the region. This project, the Turkestanskii Al'bom, eventually comprised more than 1,200 photographs in six volumes and would have served as a powerful example of photography's applications.

The initial use of photography as an adjunct to diplomatic duties or scientific missions was followed by a period in which commercial studios—operated by Iranians and Europeans—proliferated. The German engineer Ernst *Hoeltzer ran one in Isfahan for almost 30 years and accumulated over 3,000 negatives. Commercial studios doing domestic portraiture could be found in the provinces, as well as in major cities such as Tehran and Rasht. Studios at tourist destinations also sold views of monuments and landscapes, and genre studies that emphasized the exotic or picturesque aspects of Persian life. A number of travellers made their own photographs. Jane Dieulafoy, a Frenchwoman who travelled extensively in the region in the 1880s, was particularly drawn to Iranian popular life and made powerful portrait studies very different from the conventional photographs of 'native types' produced by commercial studios. The detailed descriptions she provided of her subjects and their situations provide the personal and cultural context absent from most photographic work of the period.

Scholarly travellers made, purchased, or commissioned photographs to accompany their reports and include in publications. The Gertrude Bell Photographic Archive at the University of Newcastle upon Tyne contains over 6,000 prints and negatives made or collected by Bell in the course of archaeological expeditions in the Middle East, including Persia, between 1899 and 1914. In addition, a number of art historians and archaeologists commissioned quite extensive photographic surveys, among them Franz Stolze, Jacques de Morgan, and Friedrich Sarre.

The most prominent early photographer of Iran is Antoine Sevruguin (late 1830s–1933). The son of a Russian diplomat in Tehran, he learned photography in Tbilisi from a Russian photographer. Some time in the 1870s, he returned to Iran after making a photographic survey of Azerbaijan and Kurdistan. With his brother he established a studio in Tehran and became an official photographer to the court, a position he held until his death. Over 60 years, Sevruguin created a photographic description of Iran—portraits of the nobility and emerging urban elite, landscapes and cityscapes, architectural monuments, rituals and ceremonies, trades, and the country's diverse people and tribes. He showed his photographs at international exhibitions and sold views to travellers. His photographs were the best-known representations of turn-of-the-century Iran. He assembled an archive of over 7,000 negatives, most of which have since been destroyed. KSH

Scarce, J., 'Isfahan in Camera: Nineteenth-Century Persia through the Photographs of Ernst Hoeltzer', *Art and Archaeology Research Papers* (Apr. 1976).

Stein, D., 'Early Photography in Iran', *History of Photography*, 7 (1983).

Adle, C., and Zoka, Y., 'Notes et documents sur la photographie iranienne et son histoire', *Studia Iranica*, 12 (1983).

Bohrer, F. N. (ed.), *Sevruguin and the Persian Image: Photographs of Iran, 1870–1930* (1999).

Ireland's earliest photographer was Francis Stewart Beatty, a Belfast engraver, in September 1839. Its first commercial studio opened in Dublin's Rotunda building in 1841 and was soon joined by those of a motley band of entrepreneurs in a country where the *daguerreotype did not enjoy patent protection. Leone Glukman opened a particularly successful studio in Dublin in the 1840s, and his lithographs of daguerreotypes of the Young Irelanders, including William Smith O'Brien, the leader of the 1848 Rebellion, were a great success.

Irish experimenters with the *calotype process included William Holland Furlong and Michael Packenham Edgeworth, a half-brother of the novelist Maria Edgeworth. John Shaw Smith took an extensive series of calotypes on his travels to Italy and the Middle East in the early 1850s. The Dublin Photographic Society was established in 1854, becoming the Photographic Society of Ireland in 1858.

The 'Big Houses' in the country were associated with many fine photographers in the 1850s and 1860s. Francis Edmund Currey at Lismore Castle, Co. Waterford; Lady Augusta Dillon (née Crofton) and the Hon. Luke Dillon of Clonbrock House, Co. Galway; Edward King Tenison of Kilronan Castle, Co. Roscommon; and Mary, Countess of Rosse, at Birr Castle, Co. Offaly. The albums of Hugh Annesley of Castlewellan, Co. Down, date from the mid-1850s to the late 1870s. William Despard Hemphill, a Tipperary surgeon, published *The Abbeys and Castles of Clonmel* (1860), illustrated with his mounted *stereographs.

Meanwhile, professional photographers were making their mark. James Robinson, who ran a studio in Dublin, made legal history in 1859 when his stereoscopic pair *The Death of Chatterton*, modelled after the painting of the same name by Henry Wallis, was deemed to have infringed copyright law. Commercial studios in the 1850s had begun taking an interest in topographical views. By 1857 the London

William Mervyn Lawrence

Ross Castle, Co. Killarney, Ireland, late 19th century. Albumen print

Stereoscopic Company had sent employees to capture Ireland's scenery on camera. Frederick Holland Mares, who was deeply influenced by ideas of the picturesque, created a widely known series of scenic views in the 1860s, the negatives of which were bought by William Mervyn Lawrence (1840–1932) in the 1870s. Lawrence became the leading name in Irish topographical photography, with Robert French the best known of his photographers.

Landscape has remained the dominant genre in Irish photography, appearing in many guises, from topographical views and *postcards to late 20th-century documents of the troubles in the North. Interpretations of the landscape, as fantasy, memento, nightmare, or boundary, continue to be varied.

The Lauder family, through Lauder Brothers (est. 1853), and Lafayette's, dominated the studio business in Dublin; Alfred Werner was a successful society portraitist in the 1880s and 1890s. Other firms included Edward Harding in Cork, Thomas Wynne (1838–93) in Castlebar, Co. Mayo, and A. H. Poole in Waterford. Alexander Ayton had a studio in Derry in the early 1860s and published *Sights and Scenes in Ireland* in the late 1890s, which included remarkable images of rural poverty in Donegal in the 1860s. In Belfast, E. T. Church ran a successful studio in the 1870s and 1880s. Robert Welch (1859–1936) established a studio there in 1883, and his knowledge of the scenery, antiquities, botany, and geology of Ulster is reflected in his work. Welch was official photographer of the Harland & Wolff *shipbuilding company, and in 1914 also photographed impoverished western communities for the Congested Districts Board. Other notable Ulster photographers include Francis Bigger, Alexander Hogg, and William Green.

In 1894 Professor John *Joly of Trinity College, Dublin, patented a single-shot colour process, and in 1895 exhibited transparencies at the Royal Dublin Society. However, the invention failed commercially and was rendered obsolete by the *autochrome process.

Ireland's early 20th-century cultural revival was largely driven by literature. However, both George Bernard *Shaw and J. M. Synge (1871–1909) were keen photographers, and Synge recorded life on the Aran Islands on his visits there in 1898–1902. *The Camera* in the 1920s proved to be an influential journal. Father Frank Browne, SJ, who had taken up photography in 1897, became renowned for his pictures of the *Titanic* leaving on her maiden voyage; on his death in 1960 he left over 40,000 images, now in the Jesuit Archive in Dublin.

Many surviving photographs relate to Ireland's political history. The National Library of Ireland's collection alone includes police photographs of nationalist conspirators and suspects; pictures of evicted families, including the remarkable Coolgreany Evictions Album (1887); and many images of the events and personalities of 1916–22. Political violence in Northern Ireland has inspired much documentary photography. During the emergency that began in 1969, photojournalists converged on Ulster from all over the world. Willie Doherty, Victor Sloan, and David Farrell, among others, created more avowedly artistic work. Since 1980 Brian Hughes has documented Belfast's street life and political murals. Here too, the landscape tradition persists, as evidenced by Paul Seawright's unsettling and enigmatic photographs of places where murder victims were discovered.

The *postcard industry reached its zenith in the work of John *Hinde, whose idealized and retouched images dominated the business in the 1950s and 1960s. Indeed, Hinde's images have been an enduring

Anon.

The prince of Wales and his entourage on the Giant's Causeway, Co. Antrim, Ireland, late 19th century. Albumen print

source of ironic homage, most notably in the work of Anthony Haughey. Liam Blake, Walter Pfeiffer, Tom Kelly, and Peter Zoller's romanticized landscape images have also proved popular.

Photography was only gradually accorded an honoured place in Ireland's artistic life. The Irish Gallery of Photography, founded in 1978, provided a venue in Dublin for photographers to exhibit work increasingly informed by international trends. Similarly, the Press Photographers' Association of Ireland has championed photojournalism, with the *Irish Times*, in particular, leading the way.

The history of photography on the island was relatively neglected until the work of such pioneers as Edward Chandler. There is an increasing interest in Ireland's photographic heritage in universities and colleges of higher education. Archives include that of the National Library of Ireland in Dublin, with *c.*300,000 images; the Irish Architectural

Archive; the Ulster Museum; the Ulster Folk and Transport Museum; and the Public Record Office of Northern Ireland. LK/DO'M

See also COUNTRY HOUSE PHOTOGRAPHY.

Rouse, S., *Into the Light: An Illustrated Guide to the Photographic Collections of the National Library of Ireland* (1998).

Kavanagh, L., 'Photography and Ireland: A Select Bibliography', *History of Photography*, 23 (1999).

Maguire, W. A., *A Century in Focus: Photographers and Photography in the North of Ireland* (2000).

Chandler, E., *Photography in Ireland: The Nineteenth Century* (2001).

Irie, Taikichi (1905–92), Japanese photographer born in the ancient capital, Nara. He opened a photographic shop and studio in Osaka before the Second World War. After the war, he became aware of the

traditional culture of his native city, and turned his lens towards Nara Buddhist art, a main interest throughout his life. His photographs are noted for their reverence for Buddhist discipline, whether in landscapes of the Yamato region, views of Nara, or documents of Buddhist rituals (of which he created an important historical and aesthetic record). After his death, his entire opus was donated to Nara, which established the Nara City Museum of Photography for them. OH

iron-based processes. See ALTERNATIVE (NON-SILVER) PHOTOGRAPHIC PROCESSES.

Isenring, Johann Baptist (1796–1860), pioneering Swiss photographer. Trained originally as a carpenter, Isenring subsequently studied painting and engraving at the Munich Academy. As early as 1839 he experimented with *Talbot's *calotype process, but then switched to the *daguerreotype, in November ordering a Giroux camera from Paris. In August 1840 he exhibited portraits in his native St Gall, then in Munich (October) and Augsburg (November). He achieved exposure times of *c*.6–20 seconds, and also began to colour his portraits. In 1841–2, after a period in Munich, he toured southern Germany, latterly with a transportable studio. He settled in St Gall in 1843, later earning a reputation as a graphic artist. UR

Wäspe, R., *Johann Baptist Isenring, 1996–1860: Druckgraphik* (1985).

Ishiuchi, Miyako (b. 1947), Japanese photographer whose black-and-white photographs explore themes of memory and time. She began photographing in the late 1970s amidst the run-down streets and derelict buildings of Yokosuka, the US naval base city and her hometown: *Yokosuka Story* (1977), *Apartment* (1978), and *Endless Night* (1980) resulted. She then focused on human skin and ageing. In *1.9.4.7.* (1990), she photographed the hands and legs of women born in 1947. In *1906 to the Skin* (1994), the body of *butoh* dancer Kazuo Ohno is her subject. *Chromosome XY*, her series on men's skin, appeared in 1995, followed by *Nails* (2000), on men's fingers and nails. MT

ISO. See SENSITOMETRY.

Italy. Partly because of the country's political and economic fragmentation until the completion of Unification in 1870, the emergence of a photographic culture in Italy lagged behind many other European countries. Although the announcements of 1839 caused an initial flurry of interest in the various Italian capitals, and an Italian translation of Daguerre's manual appeared in Rome in February 1840, few notable developments took place until the late 19th century. For at least two centuries, however, the Grand Tour had sustained a market for engraved and painted views of Italian monuments and landscapes, and photography arrived just as improved communications and great economic prosperity were bringing new waves of middle-class tourists to Italy from France, northern Europe, and America. Noël-Paymal Lerebours's *Excursions daguerriennes* (1840–4) included many Italian views engraved from *daguerreotypes, and doubtless influenced other productions such as the Milan-based publisher Ferdinando Artaria's *Vues d'Italie d'après le daguerreotype* (1849). In the 1840s and 1850s the artist-photographer Giacomo *Caneva marketed *calotypes of Roman monuments. But it was the advent of the *wet-plate process at the beginning of the 1850s that

Anon., Italian

View of the Tiber and St Peter's, Rome, late 19th century. Albumen print

Anon., Italian

View of Venice, late 19th century.
Albumen print

enabled view photographers like Carlo *Naya and Carlo *Ponti in Venice, and Giorgio *Sommer, Robert *Macpherson, Tommaso Cuccioni (1813–64), and James Anderson (1813–77) in Rome, to prosper. Florence, actually the capital of the new state between 1865 and 1871, was home to the country's leading photographic dynasty, the *Alinari brothers, whose ambition to record Italian landscapes, monuments, and works of art throughout the kingdom was both commercially and patriotically motivated. Another important Florentine firm was founded in 1866 by Giacomo Brogi (1822–81), and later expanded to over 80 employees by his son Carlo (1850–1925). Thanks to the efforts of all these firms, and the technical and business innovations they pioneered, Italian photographs in their tens of thousands had found their way to practically every corner of the civilized world by c.1920, including landscapes, architectural and monumental views, and *genre scenes, from travelling musicians (*pifferari*) to fisherfolk, peasant girls, and rustic taverns.

In 1889 Carlo Brogi became a co-founder and vice-president of the Società Fotografica Italiana and—further evidence of a maturing photographic culture—campaigned for improved copyright protection for photographers. Another prominent contemporary, although much of his work was done in Paris, was one of *belle époque* Italy's, and Europe's, most prolific amateurs, Count Giuseppe *Primoli.

Although most materials had to be imported, photographic activity, including the launch of several journals, increased significantly in the last two decades of the 19th century. As in other countries, there were debates about photography's acceptance as an art, and the medium

was promoted as such by various mechanisms, including an influential exhibition of artistic photography held in Florence in 1895. The First National Photographic Congress, held in Turin in 1898, further encouraged *pictorialism and was followed by another in Florence in 1899. The year 1904 saw the launch of *La photografia artistica*, a journal intended to serve as the movement's official mouthpiece; the photographers Guido Rey and Edoardo di Sambuy achieved international recognition and made contact with pictorialism's greatest champion, Alfred *Stieglitz. In other quarters, however, it was the new technical processes of photography that were being promoted rather than the work of artist-photographers: the journals *Il dilettante di fotografia* (1890) and *Il progresso fotografico* (1894) pushed scientific and pseudo-scientific developments such as *microphotography, *X-rays, spirit-photography, and Étienne-Jules *Marey's *chronophotography.

Other forms of photographic practice and ideology also surfaced, including the realist *verismo* movement. Nevertheless, pictorialism dominated the scene, at least until 1911, when the Third National Photographic Congress was held in conjunction with two exhibitions: the International Photographic Exhibition, a display of pictorialist work, and the International Competition of Scientific Photography, which included examples of Marey's chronophotography. This event signalled pictorialism's relative decline and the beginning of experimental photography in Italy, with *Futurism in the lead. As Italy's first avant-garde art movement, Futurism best embodied the search for a modern visual language, and the photodynamism of the *Bragaglia brothers in turn best embodied the visual research

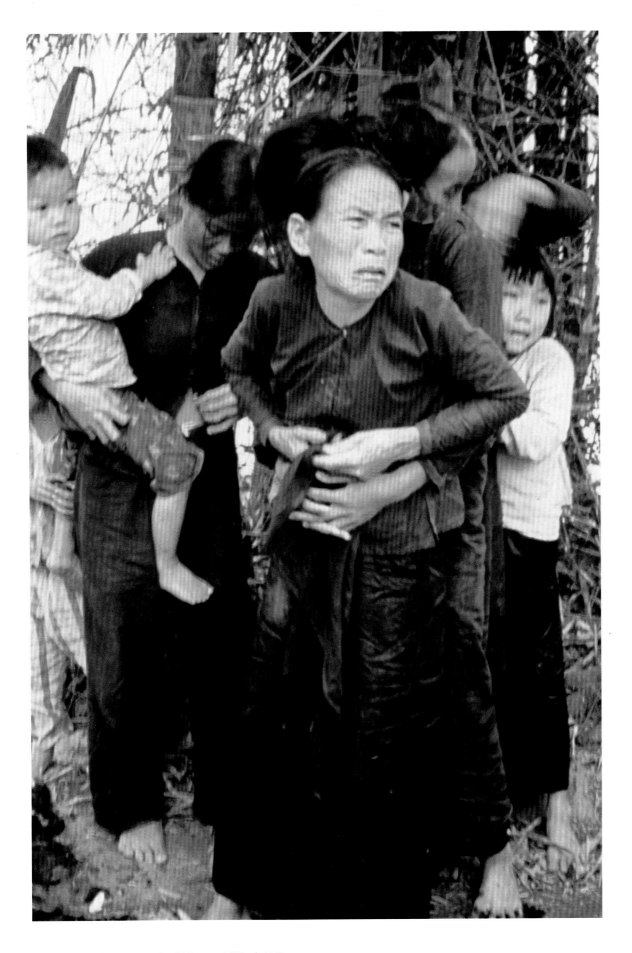

Ronald Haeberle My Lai 4, South Vietnam, 16 March 1968

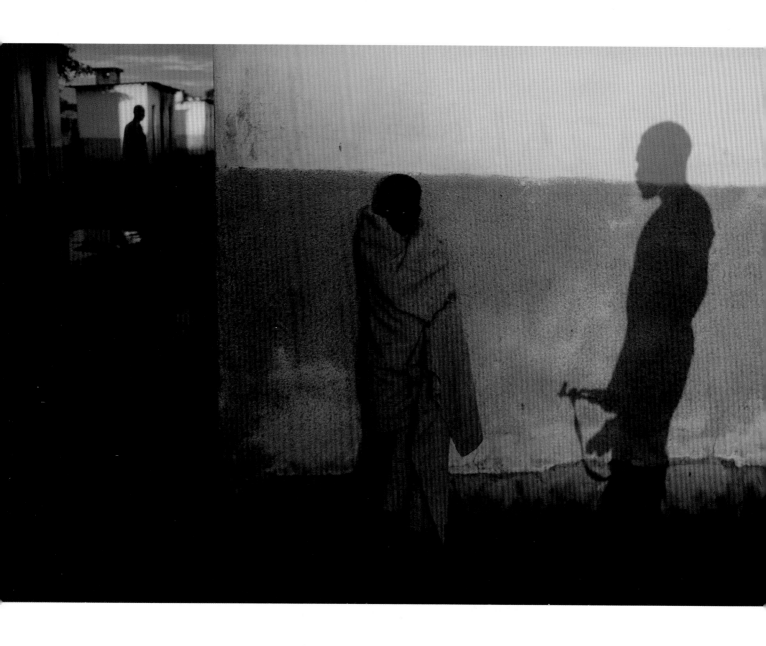

James Nachtwey Karamoja, Uganda, 1986

of the Futurists. Despite disputes within the movement concerning photography's ability to capture the sensory experience of the new century, Futurism undoubtedly contributed to the growing diversity of photographic techniques and theoretical approaches.

Photography's development during the fascist era (1922–43) was uneven and, like other branches of Italian culture, probably influenced as much by the socio-economic divide between north and south as by the dictatorship. Though less important than, for example, radio, photography was used extensively as *propaganda, under the aegis of the National Institute LUCE. Big events, like the 1932 exhibition commemorating the tenth anniversary of the March on Rome, incorporated thousands of images, and countless more filled the fascist press and boosted the regime's multifarious projects. Interestingly, the propagandists were not averse to experimental and modernist styles when it suited them, and radical designers like the Futurist photomonteur Tato (Guglielmo Sansoni; 1896–1974) did propaganda work in the 1930s. Photography, and especially photojournalism, was officially subject to censorship. However, most Italian photographers were probably unaffected by state interference. Modernist influences from abroad, especially Weimar (pre-1933) Germany, were widespread. The quintessentially avant-garde photographer and film-maker Luigi Veronesi (1908–98), who had strong links with Fernand Léger, the Delaunays, and *Moholy-Nagy, produced *photograms, rayograms, and other experimental work. *Photomontage was widely practised, not only by Tato but by Wanda *Wulz, Marcello Nizzoli, and Bruno Munari (1907–98), all of whom contributed to the remarkable efflorescence of Italian advertising in the 1930s. Important here too were the designers of the Studio Boggeri in Milan, and Attilio Rossi's modernistic graphic arts magazine *Campo grafico* (1933–9). Finally, amateurs stayed busy, the availability of materials permitting; it was possible to do documentary work, for example in poor rural communities like Marone near Brescia (Lorenzo Antonio Predali); and even some of the regime's opponents, like Eva Paola Amendola, were able to record their years of internal banishment.

After the Second World War, two major strands of photography took shape: lyrical or expressive photography and *Neorealismo*-influenced reportage; the dialogue between the two effectively replayed the old debate of whether photography should be considered an art form or an offshoot of science. (At a popular level, the *photoromance (*fotoromanzo*) flourished in the 1940s and 1950s, associated with publishers like the Del Duca brothers.) The group known as La Bussola, formed in 1947 by Giuseppe Cavalli (1904–61), Veronesi, *Giacomelli, and other photographers based in the small town of Senigallia, sought to distinguish their work from photojournalism by asserting themselves as artists. In a culture still generally hostile to the reception of photography as an art form, however, it was work influenced by the Neorealist cinema of Luchino Visconti and Roberto Rossellini that received the greatest recognition. *Neorealismo* provided a new way of seeing that suited the post-war ethos: the Italian landscape and culture were no longer viewed as a larger-than-life setting for acts of grand heroism, but instead as a mundane backdrop for more

intimate examination of human relations and experience. Both strands borrowed from American art, literature, and cinema, particularly Depression-era work such as that of the FSA photographers. Paul *Strand, who collaborated with the Italian cinematographer Cesare Zavattini on the book project *Un paese* (1955), was perhaps the single greatest influence on Italian photojournalists in this area. Yet, for lack of institutional support, most Italian photographers were producing work now considered amateurish; Mario Giacomelli, however, changed this, and also reconciled reportage with lyricism. The most revered photographer of the post-war years, Giacomelli's work combined the harshness of *Neorealismo*, with its unflinching scrutiny of the bleak post-war landscape, with a deeply felt empathy. He dominated the scene in the 1950s and 1960s together with Paolo Monti (1908–82), the two greatly influencing a subsequent generation of photographers.

Of this new generation, Luigi *Ghirri emerged as leader of an informal group that sought collective support for their practice by staging exhibitions, organizing workshops, and instigating group projects with the purpose of stimulating each other as well as the public. The 1984 'Italian Journey' project, which generated an exhibition and a book, was one such initiative organized by Ghirri. A reaction to the dry, apparently objective photojournalism of the 1970s, the project undertook an anthropological and existential examination of place by seeking traces of human experience in the landscape. The American *New Topographics* photographers, including Stephen *Shore, were an intellectual model for this approach, but the Italians gathered in rural places such as Scanno and Senigallia to find expressive interpretations of a specifically Italian reality. It was characteristic of this period that photography was approached as a critical and analytical practice. By the turn of the 21st century outside influences no longer played the central role in the development of Italian photographic culture that they had done in the medium's first century, and while still a multi-regional entity, Italy entered the new century with a strong and varied photographic culture of its own. MR

Zannier, I., *70 anni di fotografia in Italia* (1978).

Zannier, I., *Storia della fotografia italiana* (1986).

Costantini, P., and Zannier, I.,*Cultura fotografica in Italia* (1986).

Dewitz, B. v., et al., *Italien sehen und sterben: Photographien der Zeit des Risorgimento* (1994).

Pelizzari, M. A. (ed.), 'Nineteenth-Century Italy', special issue, *History of Photography*, 20 (1996).

Shanahan, P. (ed.), 'The Italian Cultural Landscape of the Modern Period', special issue, *History of Photography*, 24 (2000).

itinerant photographers today are mainly active in regions like rural India and the Andes where camera ownership is small and studios rare. But in the 19th century, itinerants, mainly portraitists, abounded in Europe and North America, initially outnumbering fixed studios.

Among the earliest travelling daguerreotypists was the Swiss Johann Baptist *Isenring, who toured southern Germany with a mobile studio in 1841–2 before eventually settling in St Gall. Also well documented are operators in the north German duchies of Schleswig and Holstein

between 1839 and the revolutions of 1848–9. Information about the *daguerreotype process had reached towns like Kiel and Lübeck by the autumn of 1839, and the first pictures were soon available there. Between 1839 and 1848, c.65 photographers (all but one exclusively daguerreotypists) were active in the duchies, including 48 itinerants, some of whom also visited Hamburg, Denmark, and Norway. Usual practice was to set up in rented premises in a market or coastal town, advertise in the press, and stay for a few days or weeks until demand flagged. Many individuals also plied additional trades, as opticians, miniaturists, or showmen of technical gadgets. An interesting case study is that of Gregor Renard (1814–85), who had trained as a silhouettist and portrait and porcelain painter before taking up daguerreotypy in 1843. Then, using whichever skill was needed, he toured Denmark and the duchies before finally opening a studio in Kiel in 1847. Two of his brothers had similar careers. Many of the surviving portraits by Renard and his contemporaries, of merchants, farmers, small-town bigwigs, and their families, are of respectable quality. The plunge in prices during the decade suggests a marked increase in production.

Itinerant photographers were also numerous in Victorian and Edwardian England, especially in country areas. Many of the pictures of harvesters, village schoolchildren, and tradespeople preserved in rural museums, or published in collections like Gordon Winter's *A Country Camera 1844–1914* (1966), were probably taken by them. According to Audrey Linkman, the first English daguerreotypist to obtain an itinerant's licence was Edward Holland, for Doncaster racecourse in 1842; but others worked unlicensed. John Werge, himself an itinerant in the 1850s, wrote, 'For many years most of the early daguerreotypists were birds of passage frequently on the wing.' While Werge usually rented rooms, the Scotsman John Beattie (who eventually settled in Bristol) and the Canadian-born Oliver Sarony (1820–79; who later established himself magnificently in Scarborough) used elaborate travelling studios. Trade was generally good, although by the decade's end all three had switched from the daguerreotype to the easier *wet-plate process.

From c.1860, as studios proliferated and increasingly monopolized the upmarket end of the business, itinerants became more marginal, part of the Victorian floating world of pedlars, tinkers, knife grinders, and travelling entertainers. (The distinction was blurred, but only slightly, by the fact that studio photographers—such as Henry *Taunt of Oxford, for example—might send assistants, or even travel themselves, to work the crowds at bank holiday venues like Boulter's Lock on the Thames.) They frequented fairgrounds, beaches, and popular leisure spots like London's Hampstead Heath, and appeared often in contemporary prints and cartoons. The product, from the late 1850s onwards, was the glass positive (*ambrotype) or, increasingly, the *tintype, using photography's first effective *instant process to make relatively crude images at rock-bottom prices. Itinerants were constantly denigrated by their studio colleagues: for using touts and dubious practices to drum up trade, for undercutting lower-end studios, for working on Sundays (when clients were plentiful, and dressed for the camera), and for passing off shoddy wares; as one critic

complained, 'these itinerants bear something like the same relation to the skilled photographer that the organ grinder has to the musician'. Still, they had become a feature of the expanding leisure scene, and remained so well into the 20th century.

The USA had hundreds or even thousands of itinerants in the 19th century who operated successively with the daguerreotype, the ambrotype—which enjoyed a brief but spectacular vogue in 1856–7—and the tintype. They criss-crossed the country on foot, or by stagecoach, riverboat, or train, the more successful working from hired railway carriages or steamboat suites. Those who travelled long distance remained perpetual outsiders, rarely or never able to establish a rapport with a particular community. However, another type of American itinerant, with no studio but a regular regional clientele, was evidently common until c. the Second World War. One such was the self-taught Otto Ping (1883–1975) who, c.1900–c.1940, served the scattered rural population of Brown County, Indiana. Clients were photographed on porches or in the open, against walls, vehicles, or crudely improvised backdrops. Subjects were mainly portraits, of individuals, couples, or groups, from children to the very old, but with some shots of farmyards, animals, and operations like sawing or stone breaking. *Post-mortem images also survive. For much of Ping's career the cost of taking, processing, and delivering a commissioned picture was about a dollar, and quality was basic. (The rarity of wedding photographs in Ping's archive, held by the Indiana Historical Society, suggests that for such occasions clients would pay more for a studio photographer's skills.) Ping travelled about by buggy or truck and had various other occupations, none of them lucrative. His ultimate abandonment of photography was probably caused by official curbs on itinerants, prompted by studio lobbying during the Depression, and increasing camera ownership among his clients.

In Britain, itinerants flourished between the wars, and a tintypist was still operating on London's Westminster Bridge in 1953. *Seaside 'smudgers', using either conventional or instant-film cameras, survived for another couple of decades, to be finally edged out by the *Instamatic revolution. RL

See also PHOTOWALLAHS; PORTRAITURE.

Chapell, G., *The Itinerant Photographer* (1936).

Steen, U., 'Die Anfänge der Photographie in Schleswig-Holstein', *Nordelbingen*, 56 (1987).

Linkman, A., *The Victorians: Photographic Portraits* (1993).

Hartley, W. D. (ed.), *Otto Ping, Photographer of Brown County, Indiana 1900–1940* (1994).

Itten, Johannes (1888–1967), Swiss painter, teacher, and prolific visual and educational theorist. Between 1908 and 1913 Itten studied art and pedagogics in Geneva and Vienna, where he subsequently ran a private art school and prepared foundation courses in art education. He later taught at the Weimar *Bauhaus (1919–23), where he founded the obligatory preparatory course. In 1926 he opened a private art school in Berlin which included a photographic class headed first by *Umbo and later by Lucia *Moholy. After leaving Germany in 1938

he became director of the Zurich Design School, remaining until 1953. Although Itten's influence on photography was indirect, most teachers in the field owe their basic curricula to his systematic approach.　RS

Itten, J., *Werke und Schriften* (1978).

Iturbide, Graciela (b. 1942), the foremost Mexican photographer of her generation. Although trained in cinematography, she spent the years 1970–2 assisting in the studio of Manuel *Álvarez Bravo. Thereafter she became freelance, combining her interests in anthropology and photography. Her first major project was on the Seri, a nomadic people of the northern desert region, whose lives she shared for months at a time. This established the pattern for much of her later work: always spending time getting to know her subjects in the round; particularly interested in the lives of women; fascinated by the

ways of life of Mexico's 7 million indigenous inhabitants. She made her reputation with in-depth reportage on topics ranging from the matriarchal culture of Juchitan to the *latina* girl gangs of Los Angeles. Rite and tradition, nature and culture, identity and modernity inform style as well as content in her images. As she herself explains: 'Photography is a way of life. I write, I draw with light my daily experiences; . . . I seek to trap life in the reality that surrounds me, without forgetting that therein lie my dreams, my symbols, my imagination.' She has also worked extensively outside Mexico, especially in the southern hemisphere.　AH

Graciela Iturbide (2001).

Iwo Jima, *Raising of the Stars and Stripes at*, 23 February 1945. Taken after four days of savage fighting for this key Pacific island, and

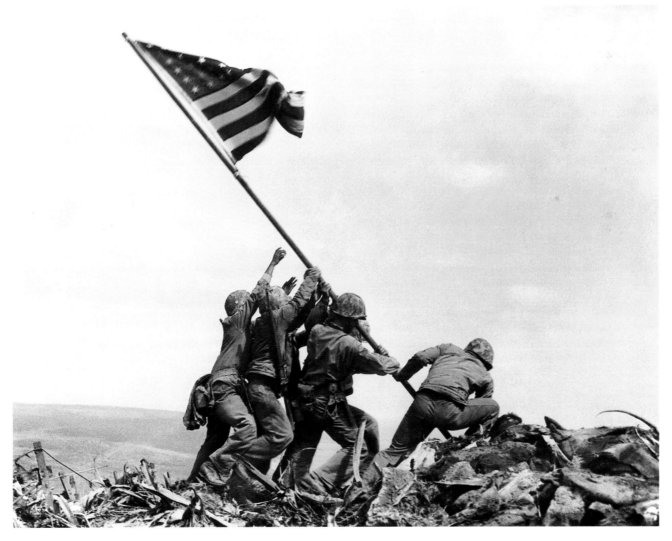

Joe Rosenthal

The Raising of the Stars and Stripes at Iwo Jima, 23 February 1945

first published by *Life, the picture by AP photographer Joe Rosenthal (b. 1911) is one of the Second World War's *iconic images. Cropped from the first of four shots, it shows five marines and a medical orderly raising a large American flag on Mount Suribachi. (The earlier raising of a smaller flag had been recorded by marine photographer Lou Lowery.) Subsequent controversy notwithstanding, it was not staged. Rosenthal stated afterwards: 'It wouldn't have been any disgrace at all to figure out a composition like that. But it just happened that I didn't. Good luck was with me, that's all—the wind rippling the flag right, the men in fine positions, and the day clear enough to bring everything into sharp focus.' The image appeared on stamps and war-loan posters, and later inspired Felix de Weldon's Marine Corps memorial at Arlington Cemetery, Virginia (1954). It has since been borrowed and parodied for many purposes, from jeans advertisements to political propaganda, and featured in late 20th-century debates on flag burning. RL

Moeller, S., *Shooting War* (1989).

Marling, K. A., and Wetenhall, J., *Iwo Jima: Monuments, Memories and the American Hero* (1991).

Izis (Israëlis Bidermanas; 1911–80), Lithuanian-born French photographer. He came to France in 1930 and started his own commercial studio to make social portraits. He spent the Occupation in the Limousin, adopting the pseudonym Izis, and at the Liberation made his name with a striking series of frontal portraits of *maquisards* (Resistance fighters). He returned to Paris to work as a freelance, and became a major contributor to the French humanist school with work that often displayed a wistfully poetic image of the city and its people. His first book, *Paris des rêves* (1950), was a considerable success: he had designed the work, and approached writers and poets to contribute a short text or poem to accompany his pictures of the city. He joined *Paris Match* in 1950, and for twenty years could choose his assignments, though he never enjoyed working for the magazine. However, his numerous books, following the same principle as his first and with texts by important writers of the era such as Jacques Prévert and Colette, found a ready audience. Particularly notable are *Le Grand Bal de printemps* (1951), *Les Charmes de Londres* (1952), *Le Cirque d'Izis* (1965), and his book on Chagall, a personal friend, in 1968. PH

Izis, *Captive Dreams: Photographs 1944–1980* (1993).

Jackson, William Henry (1843–1942), pioneering American landscape photographer. After commencing his career as a photographic retoucher and colourist in 1858, he opened his own studio in Omaha, Nebraska, with his brother in 1862, and made his first portraits of Native Americans. In 1869 he photographed railway construction work for the Union Pacific Railroad Co., then 1870–7 worked as an official photographer for the US Geological and Geographical Survey, accompanying expeditions to Arizona, Colorado, and New Mexico. This scientifically conceived work created a visual record of geographical discoveries for use in the economic and communications development of the lands west of the Mississippi. Jackson's images of the Rocky Mountains, especially of the *Yellowstone region, taken in 1871 and widely published, significantly influenced Congress's decision the following year to designate the area as the USA's first national park. His 1875 catalogue of views (not all taken by himself) made before and during his work with the Hayden Survey included more than 2,000 items.

Jackson's technically immaculate landscape photographs, taken with a large-format camera using *'mammoth' plates up to 50 × 60 cm (19^7/$_{10}$ × 23^3/$_5$ in), did much to shape the public's visualization of the West, and influenced photographers well into the 20th century, including Ansel *Adams. JG-P

Hales, P. B., *William Henry Jackson and the Transformation of the American Landscape* (1988).

Jacobi, Lotte (1896–1990), German-born American photographer. Daughter and granddaughter of German-Jewish photographers from Prussian Poland, she trained at the Munich Photographic School before joining her father's Berlin studio in 1927. She thrived in the city's booming market for photojournalism, fashion, advertising, and stage photography and frequented left-wing literary circles, and the Piscator and Reinhardt theatre companies. Portrait subjects, mostly taken outside the studio, included Albert Einstein, the communist leader Ernst Thälmann (for the 1932 presidential election), and performers like Peter Lorre, Lotte Lenya, Leni *Riefenstahl, and Grock the clown. Dance was another important speciality. In 1932–3 she photographed extensively in the USSR. Forced to emigrate in 1935, she eventually established herself in the USA in both photography and cultural politics. She influenced post-war German photography, and in later life experimented with abstract, cameraless images ('photogenics'). RL

Beckers, M., and Moortgat, E., *Lotte Jacobi: Berlin–New York* (1998).

Jammes, André and **Marie-Thérèse**, French antiquarian book dealers who began collecting photography in 1955. Over more than 25 years, concentrating on items relating to the first century of photography, they assembled the most important private collection in the field, especially regarding early French photography, the photographically illustrated book, and the history of *photomechanical processes. Acquisitions were made from book dealers in London and Paris (Goldsmith, Lambert, Maggs Brothers), from great private collectors (Braive, Gilles, Sirot), and from photographers' descendants (Charles *Nègre's workshop, *Niépce's correspondence). The Jammes brought discipline to photographic collecting and, from the early 1960s, mounted several historical exhibitions based on their collection: *A Century of Photography from Niépce to Man Ray* (1965), *French Primitive Photography* (1969), *Niépce to Atget* (1977), *From Niépce to Stieglitz* (1982), and *The Art of French Calotype* (1983). André also published extensively on early photography, including books on Nègre (1963), *Talbot (1973), and *Bayard (1975). Since the early 1980s many of their works have entered French and American public collections by donation and purchase. In October 1999 and March 2002, important parts of their collection were sold at three separate auctions in London and Paris, achieving record prices. QB

Jammes, A., *Niépce to Atget: The First Century of Photography from the Collection of André Jammes* (1977).
Sotheby's, Paris, *La Photographie I, II, III: Collection Marie-Thérèse et André Jammes* (1999, 2002).

Japan

To 1945

In the late 1840s, the first *daguerreotype camera came to Japan through a Dutch trader in Nagasaki, and was purchased by Shunojo Ueno, a dealer in European and American goods and avid student of Western science. Arriving well before the American Commodore Perry began the process of opening Japan to the West (1853), this camera was therefore available to record feudal Japan. Unfortunately, no photographs taken with it have been found. The oldest datable photographs extant in Japan were taken after Perry's second visit in February 1854 by his acting master's mate Eliphalet Brown Jr., and by the Russian photographer Lieutenant Alexander Fyodorovich Mozhaisky, who reached Japan a month after Perry. The oldest surviving photograph by a Japanese is a daguerreotype portrait of Nariakira Shimazu taken in 1857 by Shiro Ichiki, now in the Shoko Shusei Kan (Shimazu family museum) in Kagoshima.

Rihei Tomishige

View of the first and second
donjons of Kumamoto Castle from
the Utoyagura Tower, 1871.
Wet-collodion negative

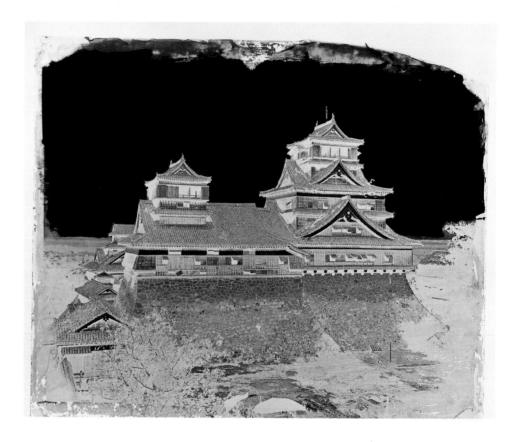

Photography caught on in the liberal, wealthy, and intellectually curious sections of society. The first to receive a daguerreotype from Shunojo Ueno, Lord Shimazu, head of the Satsuma clan, became an important early patron of photography. In 1854 Shimazu paid for the published translation of a two-volume book on photographic technique by Kohmin Kawamoto. In 1862 Ueno's son Hikoma set up the first Japanese-owned portrait studio in Nagasaki. The same year, Renjo Shimooka opened a photography studio in Yokohama. Both establishments earned most of their income photographing foreigners and making picturesque albums of typical Japanese scenes and kimono-dressed women.

The most significant Western photographers of this period were the Italian Felice *Beato, who worked primarily in the 1860s, and the Austrian Baron Raimund von *Stillfried in the 1870s and 1880s. Arriving in Japan via the Crimea and China, Beato set up a studio in Yokohama in 1863 with a painter named Charles Wirgman, and is best known for his staged scenes, using paid Japanese models, for Western tourists and landscapes. Beato published albums of his images, beautifully hand coloured with elegant Japanese covers. He also recorded the bombardment of the Shimonoseki batteries by a British-led naval squadron in 1864. After 1867–8 he photographed less, but his studio, F. Beato & Co., continued. In 1877 it was sold to Stillfried, who carried it on through the 1880s.

With the opening of Japan and the numerous foreign influences now pouring in, the over-200-year stability of the Tokugawa government began to falter in the face of pro-feudal and pro-Western factionalism. With the Meiji Revolution (1868) came *bunmei kaika* (civilization and enlightenment), a time of officially promoted modernization that encouraged the proliferation of photo studios; by 1880 there were over 150 in Tokyo alone. The state also began to make direct use of photography. In 1872 an edict was passed to put the Emperor Meiji's portrait, taken by Kuichi Uchida (1844–75), in every school. In 1871 a government-sponsored expedition to survey and develop land on the northern island of Hokkaido included photographers to record progress and help publicize it to prospective settlers. The principal photographer involved was Kenzo Tamoto (1832–1912). Amongst the many photographs taken were numerous images of the impoverished indigenous Ainu peoples in their desolate surroundings. In 1877 the first Japanese war photographs were made by an official group, including Hikoma Ueno, of the South-Western Rebellion initiated by the Satsuma samurai Takamori Saigo, who led 40,000 followers against the new government. (Another early Japanese war photographer was Rihei *Tomishige.) In 1894, on the outbreak of the Sino-Japanese War, a Japanese Army Photographic Unit was formed under Kenji Ogura, who led it again in Manchuria during the Russo-Japanese War of 1904–5. With war photography came censorship, and as photographers were attached to the army they could only document approved subjects. The Russo-Japanese photographs depict the Russian enemy, desirable expanses of empty land, the sparse

and backward native population, and Japanese victories; though occasionally also the horrors of war.

The number of amateur photographers expanded, and in 1889 *Shashin Shinpo* (*New Photography*) magazine and the Nihon Shashinkai (Japan Photography Club) appeared. *Shashin Geppo* (*Monthly Photography*) magazine followed in 1894 for art photography (essentially *pictorialism), which was increasing its following by 1900. In 1901 the Tokyo Shayukai (Tokyo Photography Group) started. Western pictorialist photographers and European Impressionist painters were sources of influence and inspiration. In 1904 the *Yutsuzu-sha* dedicated to research and art photography began, from 1907 known as the Tokyo Shashin Kenkyukai (Tokyo Photography Research Group). Yasuzo *Nojima (aka Kozo), though less enamoured of pictorialism's soft-focus techniques, was among the most successful fine-art photographers, and one of the first to work extensively with the nude. Active in the Tokyo Photo Study Group, which he joined in 1910, he was also influential through his portrait studio and gallery (1915–20). The celebrated Naniwa Photography Club was founded in Osaka by Kichinosuke Ishii and Shozaburo Kuwata in 1904. Dedicated to pictorialism until the late 1920s, it later became identified with the Shinko Shashin (New Photography) movement.

In the late 1910s, domestic manufacturing industries for paper and chemicals developed and photo supplies became cheaper and more easily obtainable, opening photography to amateurs and the middle class. More clubs formed to promote knowledge and exchange ideas. The Taisho period, coinciding with the First World War in Europe, heralded a time of economic growth and democracy. Self-expression and modern aesthetic ideas came into vogue. From 1920 smaller and handier *roll-film cameras arrived. It was in this period that the optical firms that later developed into Japan's world-famous camera makers appeared (albeit initially under different names). The oldest, Konishi Honten (later Konica) dated from 1873; but it was joined in 1917 by Nippon Kogaku (later Nikon), then Olympus (1919) and Minolta (1928); Canon, Fuji, and Ricoh followed in the 1930s.

Shinzo *Fukuhara was one of the most sophisticated pictorialist photographers in Japan. He founded the magazine *Shashin Geijitsu* (*Fine Art Photography*) in 1921, which also saw the birth of the amateur photo magazine *Camera* by Katsumi Miyake. In 1922 Hakuyo Fuchikami (1889–1960) followed with the monthly *Hakuyo*, with fine *collotype illustrations. The activity around the magazine led to the formation of Nihon Koga Geijitsu Kyokai (Japan Fine Art Photography Group), a Kobe-based association with a nationwide membership of amateur pictorialists. The journal *Geijitsu Shashin Kenkyu* (*Studies in Fine Art Photography*) also began in 1922, with first Minoru Minami, then Kenkichi Nakajima as editor.

In 1924 the *Photo Times* started for advanced amateurs. Edited by Sakae Tamura (1906–87), it introduced foreign trends, featuring photographers such as *Moholy-Nagy and *Man Ray. Sen-ichi Kimura figured prominently in it in the 1930s. The monthly *Asahi Camera*, Japan's most wide-ranging—and still extant—photo magazine, was launched in 1926, together with Fuchikami's *Nihon Shashin Bijutsu Nenkan*

(*Yearbook of Japanese Photography*). Nihonkoga Kyokai (Japanese Fine Art Group), closely affiliated with Fuchikami's Nihon Koga Geijitsu Kyokai, began in 1928, its members including Makihiko Yamamoto (1893–1985), Tamura, Yoshio Date, and Jiro Takao. In Osaka in 1930 Ueda Bizan founded the Tampei Shashin Club to promote the modernist photography influenced by German *Neue Sachlichkeit. That year the Shinko Shashin Kenkyukai (New Photography Study Group), supported by the *Photo Times*, was founded by Sen-ichi Kimura to explore new aesthetic trends, and in 1932 Iwata Nakayama (1895–1949), Yasuzo *Nojima, and Ihei *Kimura started the modernist monthly magazine *Koga* (*Light Picture*). For the first issue, Ina Nobuo wrote a symbolic text entitled 'Return to Photography', influenced by the German critic Franz *Roh. Nakayama introduced the movement to the Kansai area, where he settled in 1929, opening a studio in Ashiya, between Osaka and Kobe. There he started the Ashiya Camera Club with Kanbei *Hanaya, Juzo Matsubara, and Kichinosuke Benitani. Their output was freer than that of the Tokyo clubs, and included *photograms, *photomontages, and portraiture.

Concurrently, Yonosuke Natori (1910–62), who had studied in Germany, founded the group Nippon Kobo (Japan Workshop) in 1933, and brought together Natori and Kimura, the designers Hiroshi Hara and Nobuo Ina, and other young photographers including Ken *Domon. They began the foreign-language magazine *Nippon* featuring uplifting, patriotic imagery to promote Japanese culture overseas.

From 1935 avant-garde movements began to influence photographers nationwide. In Osaka a *Surrealism-influenced photographic style was pioneered by the Avant-Garde Zoei Shudan (Avant-Garde Image Creators), established in 1937. In Tokyo, a more intellectual view of avant-garde photography was supported by the Zen'ei Shashin Kyokai (Avant-Garde Photographic Society), founded in 1938 by the art critic Shuzo Takiguchi. The trend spread to other parts of Japan such as Nagoya, where the Nagoya Photo Avant-Garde Group started in 1939, and even to Japan's Manchurian colony, Dalien. In Tottori prefecture, on Honshu's south-western coast, the young Shoji *Ueda made Surrealist-influenced portraits of his family in the dunes, and photographed buildings and people in his seaside village.

The growth of nationalism in the 1930s brought curbs on freedom of expression, including domestic censorship. New laws limited foreign film and paper imports, banned cameras on aircraft, and in 1937 prohibited photography from a height of 100 m (330 ft) or more (20 m from 1940). Meanwhile, the government backed photographic developments with military potential, such as *infrared film, *underwater cameras, high-speed and X-ray films. While artistic expression was restricted, advertising and propaganda offered alternative creative outlets. Photographic mural montages showing inspirational nationalistic scenes—influenced by avant-garde photomontage—were installed for public viewing. In 1941 the Japanese photo world underwent reorganization. The magazines *Shashin Geppo* and *Shashin Shinpo* folded, and the number of journals fell from ten to four: *Shashin Nippon* (*Photography Japan*), *Shashin Bunka* (*Photography Culture*), *Hodo Shashin* (*Journalistic Photography*), and *Asahi Camera* (until April 1942).

329

The pre-war and wartime years were busy times for photojournalists. Nationalistic magazines like *Front*, launched in 1942 by Toho-sha, featured militaristic, dynamic layouts, with photomontage and two-tone colour. Photographers covered Japanese military operations, and captured images of events such as the Pearl Harbor attack for the domestic press. In 1945 powerful photographs were taken of the atomic destruction that ended the war, in particular those of Yoshito Matsushige in Hiroshima and Yosuke Yamahata in Nagasaki; and in 1946 images of reconstruction. But such work was mostly banned from publication and distribution by the American authorities and thus hardly seen before the Peace Treaty of 1952.

Banta, M., and Taylor, S., *A Timely Encounter: Nineteenth-Century Photographs of Japan* (1988).

Borhan, P., and Iizawa, K., *La Photographie japonaise de l'entre deux guerres: du pictorialisme au modernisme* (1990).

Kaneko, R., *Japanische Photographie, 1860–1929* (1993).

Bennett, T., *Early Japanese Images* (1996).

Since 1945

Though published on poor-quality paper and with limited print runs, many short-lived magazines, frequently referred to as *kasutori zasshi*, exploited the new-found liberty of the post-war years. More enduring publications included the *Sun Photo News* of Mainichi Publishing (1946) and, with Yonosuke Natori at the helm, *Weekly Sun News* (1947), modelled on the American *Life*. The latter was premature in a post-war economy, and Natori moved on to Iwanami Publishing in 1950 where he began the Iwanami Photo Library series of photographic pocket books on Japanese cultural history, the bombing of Hiroshima (by Shigeichi Nagano (b. 1925)), theatre, architecture, and cities. A number of 'straight photography' specialists found work here. *Asahi Camera* reappeared in 1949 after a seven-year break.

Photorealism gathered momentum under the tutelage of Ken Domon, competition judge and columnist for *Camera* magazine, where he pushed candid, straight images under the banner of 'direct connection of the camera and the motif'. Many talented amateurs and future professionals had their first images published by *Camera*.

While Japanese photojournalists were influenced by foreign colleagues visiting Japan between coverage of the Korean and Indo-China wars (*Capa arrived in April 1954, just before his death), other photographers travelled abroad. Yasuhiro Ishimoto, born (1921) in the USA but raised in Japan, studied in Chicago with Harry *Callahan and Aaron *Siskind. In 1955–6 Ihei Kimura published books on visits to Europe, and in 1958 Hiroshi *Hamaya's book on his trip to China appeared. Natori also photographed abroad and published collections of this work.

The mid- and late 1950s brought a challenge to realism from more experimental and individualistic, German-influenced *Subjective Photography; in 1956 the Japan Subjective Photography League was formed, and a large exhibition held in Tokyo. (Earlier that year, the *Family of Man* exhibition had reached Tokyo, attracting thousands of visitors.) In 1957 Ikko *Narahara, Eikoh *Hosoe, Shomei *Tomatsu, Kikuji *Kawada, and six others were shown together in an exhibition entitled *Junin no Me* (*The Eyes of Ten*), organized by the critic Tatsuo

Fukushima. In 1959 six of them created *VIVO as a photographer-managed agency of the new photography. It became extremely influential amongst younger photographers like Daido *Moriyama, who moved from Osaka to Tokyo to work with the group.

The 1950s also saw the beginning of the Japanese camera industry's rise to global dominance. The *Japanese Camera Inspection Institute (JCII) started work in 1954, and the launch of the *Nikon F in 1959, and a bevy of cameras by Pentax, Canon, and other manufacturers at the same time, heralded the ascendancy of the Japanese-made SLR (single-lens reflex). In terms of design, technological sophistication, and manufacturing efficiency, Japanese companies showed that they were second to none, and more than equal to the demands of both the high-end professional and mass-consumer markets.

The ratification of the Security Treaty between Japan and the USA in 1960 brought riots and organized protests. In October, a photographer on *Mainichi shimbun*, Yasuji Nagao, captured the dramatic assassination of the socialist leader Inejiro Asanuma by a young right-wing extremist, earning Japan's first Pulitzer Prize. Photographers who documented the violence were hindered from publishing in the domestic press, and to evade this censorship, some published small volumes of their work, including Hiroshi Hamaya's *Ikari to kanashimi no kiroku* (*A Record of Anger and Sadness*), which included a photo of the left-wing leader Michiko Kanba, beaten to death by the police. Later published by *Life*, the image led to Hamaya's membership of *Magnum.

Social documentary work continued. Shishei Kuwabara held his first solo exhibition on *Minamata disease in 1962, thirteen years before Eugene and Aileen *Smith's celebrated book. Shigeichi Nagano explored the urban street scene, and the life of the Tokyo 'salaryman' in a period of frantic economic growth. His work was cited as exemplary by Natori in his debates with Tomatsu in *Asahi Camera* in 1960; while Natori insisted on story-based reportage, Tomatsu put the case for photography as an autonomous means of expression.

In general the 1960s were a time of exploration, including bold new work from VIVO photographers (even after the agency's dissolution). Amidst the political upheavals, there were dynamic changes in film and literature as well as photography. Photographers from Hosoe to Moriyama collaborated with figures in the emerging dance scene (Hosoe) and radical avant-garde theatre (Issei Suda (b. 1940) and Moriyama). Takuma Nakahira (b. 1938), photographer and editor of *Gendai no me* (*The Modern Eye*), and in 1968 co-founder of the journal and collective *Provoke*, held new-left views and became deeply involved with student protest movements. He also strongly influenced photographers like Moriyama, who contributed to the second and third issues of *Provoke* (which promptly folded). Although short-lived, the *Provoke* experiment remained influential, representing an individualistic, aggressively anti-conventional photography of graininess, distortion, and blur, epitomized by the disturbing Moriyama images later gathered in *Stray Dog* (1999).

Another influential Tokyo figure was Shoji Yamagishi, editor of *Camera Mainichi* from 1970 until his death in 1979. He encouraged many photographers, including Moriyama, and the VIVO members

Kishin *Shinoyama, Yoshihiro Tatsuki, and Noriaki Yokosuka: photographers also committed to extreme individualism. Fluent in English, Yamagishi published major New York photographers such as Diane *Arbus, Robert *Frank, and Garry *Winogrand in his magazine and facilitated exchanges with the New York museum and gallery world. In particular, he collaborated with John *Szarkowski at MoMA on the 1974 exhibition *New Japanese Photography* which, with its catalogue, was one of Japanese photography's first large-scale manifestations on the American scene. The participants included Domon, Tomatsu, Kawada, Masahisa *Fukase, Narahara, Hosoe, Moriyama, and numerous others—but were limited by Yamagishi to those active in Tokyo. The economic background was the post-1973 recession, to which photographers reacted in various ways; some, like Issei Suda, Kazuo Kitai, and Hiromi Tsuchida, switched their attention to the countryside, where traditional ways of life were gradually being transformed.

The mid-1970s saw the creation of several galleries run by young photographers in Tokyo: Prism (Miyabi Taniguchi and Osamu Hiraki), Camp (Keizo Kitajima and Seiji Kurata), and Put (Noboru Hama et al.). The main members of the latter two were students of the small Workshop Photo School (1974–6) run by leading photographers including Tomatsu, Moriyama, Nobuyoshi *Araki, Fukase, Hosoe, and Yokosuka. The gallery movement continued to spread, both in Tokyo and elsewhere. Zeit-Foto Salon, owned by Etsuro Ishihara, opened in 1978. He did much to raise the profile of Japanese photography in Europe, and showed *Brassaï, *Doisneau, *Cartier-Bresson, and *Man Ray, among others, in Tokyo. Photo Gallery International (PGI) opened in 1979 with the show *Message from the West Coast*, featuring Ansel *Adams, Brett *Weston, and Wynn *Bullock, and continued to organize exchanges with American galleries. The short-lived Gallery Min (1986–90) excelled in lavish exhibitions and catalogues. The Seibu Museum of Art presented major shows of Arbus, *Avedon, and others. Outside Tokyo, the Dot gallery opened in Kyoto (1980), and the Picture Photo Space Gallery in Osaka (1984). The Third Gallery Aya opened in 1995, with many exhibitions of female photographers.

Museums also proliferated, starting with the Domon Museum in Yamagata (1983). The Tsukuba Museum of Photography functioned for six months during the Tsukuba Expo in 1985, and in *Paris–New York–Tokyo* showed foreign and Japanese work side by side. The Kawasaki City Museum (1988) was the first general Japanese museum with a photography department, followed by the Yokohama Museum in 1989. The 1990s added no fewer than five photography museums, including the Tokyo Metropolitan Museum of Photography, which opened fully in 1995.

The 1980s saw the rise of new photographers whose constructed and carefully thought-out work can be characterized as 'art referential'. Among them were Michiko *Kon (still lifes); Yasumasa *Morimura (elaborate self-portrait re-creations of classic Western paintings); Hiroshi *Sugimoto ('portraits' of wax-museum figures, and near-abstract seascapes and cinema screens); and Toshio *Shibata (dramatic images of dams and waterways). All earned considerable acclaim both in Japan and abroad. Meanwhile, photographers such

as Keiichi *Tahara and Jun *Shiraoka had established themselves outside Japan in the 1970s and attracted critical attention in Europe throughout the 1980s. Kenro Izu and Sugimoto later followed their example, but chose New York as their stamping ground. A new generation of 'Nature Photo' photographers, including Manabu Miyazaki, Michio Hoshino, and Mitsuaki Iwagou, also appeared in the 1980s. Although there was a long tradition in this field, these photographers sought subjects outside Japan.

In the 1990s, open competitions and festivals attracted young photographers and helped launch their careers: for example, the New Cosmos of Photography (1991–), and the Hitotsubo-Ten (1992–). They encouraged the young, often women, to express themselves through photography; laureates included Hiromix, Rika Noguchi, and Masafushi Sanai. Over the decade, traditional photo magazines gradually lost ground with the young, compared with lifestyle and fashion magazines. Talented photographers sought editorial work rather than classic photography-magazine spreads. Araki, an ultra-prolific (and controversial) photographer and book producer, became highly popular both with the general public and other photographers, and in Europe, where he had numerous shows, probably Japan's best-known photographer.

In the first decade of the 21st century, Japan has one of the world's most thriving photographic cultures, and the work of both historical and contemporary Japanese photographers has become an essential component of representative collections worldwide. In 2003 the first comprehensive survey of Japanese photographic history was organized by the Museum of Fine Arts, Houston. Given the huge variety of photographic practice in Japan over the six decades since 1945 (and not forgetting the country's countless amateurs: by the 1990s, photography was the main hobby of Japanese pensioners), the complexities of Japanese society and culture, and the coexistence of robust traditions with a vigorous appetite for modernity, the outsider should be wary of facile generalizations about trends and influences. However, three features of the Japanese photographic scene stand out: first, the tendency since 1945 for many photographers to live and work abroad, sometimes for long periods; second, the ever-increasing participation of women, often in path-breaking ways; and, third, the growing institutionalization of the medium since the 1970s–1980s, with the proliferation of galleries, museums, festivals, prizes, and university photography courses—contrasting with the more traditional system of private associations, groups, and masters which dominated Japanese photography from the late 19th century until the Second World War. MHV/MT/OH

❍ See also Constructing the Self as 'Other' *overleaf*.

Spielmann, H., *Die japanische Photographie: Geschichte, Themen, Strukturen* (1984).
Holborn, M., *Black Sun: The Eyes of Four. Roots and Innovation in Japanese Photography* (1986).
Putzar, E., *Japanese Photography 1945–1985* (1987).
Weiermair, P., and Matt, G., *Japanese Photography: Desire and Void* (1997).
Tucker, A. W., et al., *The History of Japanese Photography* (2003).

Constructing the Self as 'Other' Early Japanese Tourist Images

Images of Japan were among the most sought-after early tourist photographs, reaching the zenith of their popularity at the turn of the 20th century after having first appeared in the 1860s. They were objects prized as much for their beautifully applied hand tinting, elegant silk album covers, and elaborately decorated lacquer album boxes as for their subject matter: picturesque landscapes, kimono-clad maidens, and samurai warriors. Despite certain important similarities with other non-Western tourist images,

however, the Japanese material cannot be usefully explored using a colonial model.

Although Japan was never colonized in the strictest sense, the so-called Treaty of Peace and Amity signed at Kanagawa with the United States in 1854, and subsequent 'unequal' treaties which opened the country to the outside world, placed Japan in a semi-colonial position that restricted its national sovereignty. The photography of Japan in this early period can also be characterized

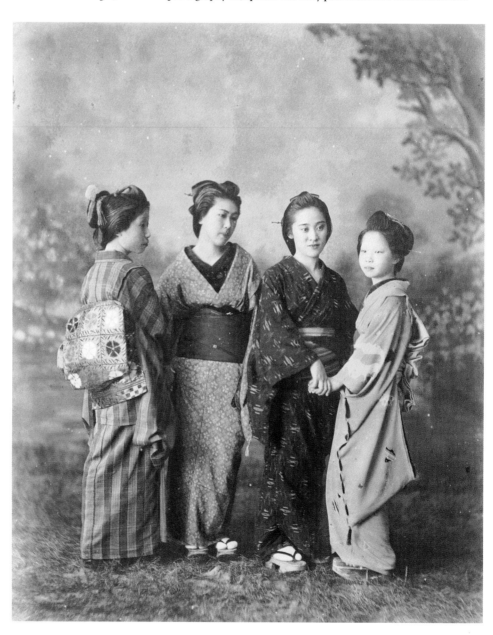

Anon.

Four Graces. Late 19th century

as 'semi-colonial', reflecting significant but not overwhelming external influence on Japanese society and cultural production. While the earliest images of Japan were indeed produced (just as in the colonial world) by foreigners, who enjoyed a privileged position as Westerners in Japan, they were not representatives of a colonial government with formal control over the population. In order to create their products, Western photographers had to negotiate with Japanese subjects without the aid of an alien power.

But, notwithstanding these important distinctions, early tourist images of Japan share certain similarities with those produced under colonial conditions. The stereotypical photographic exotica, for example, produced by and for Westerners were just as essentializing of Japanese culture as images of 'sexually compliant women' and 'primitive types' were of colonized peoples, though here expressed through bare-breasted geishas or straw-clad peasants. These early images were part of the creation of stereotypes about Japanese culture that, to some extent, persist to the present day. Importantly, however, the Japanese images mostly lacked the morally dichotomizing messages found in colonial tourist photographs. Japanese subjects were not typically portrayed as uncivilized or uncultured but rather as highly civilized—imposing samurai warriors and fine temples—if inscrutable.

By the 1860s, as Europeans and Americans began to settle in the treaty ports of Nagasaki, Yokohama, and Hakodate, there had developed an indigenous Japanese photographic market place more extensive than could be found elsewhere in Asia. Foreign professional photographers had begun arriving since the late 1850s, establishing photo studios and teaching Japanese students, who in turn created their own businesses. There were over 100 professional photographers working throughout the country by the 1870s, and by the end of the 19th century Japanese photographers had all but replaced Europeans and Americans as the principal producers of photographic images of Japan.

Government sponsorship was important in the early development of Japanese photography, but it was external demand for images of Japan that drove the successful commercialization of the domestic industry. This demand was in turn driven by external discourses about Japan, the most important of which was *Japonisme*, the Euro-American fashion for 'things Japanese'. Ideas about Japanese social and material culture suffused Western consciousness from opera to popular travel stories in the second half of the 19th century. The *Japonisme*-constructed Japan of lacquer, temples, and cherry blossoms provided the parameters within which these early tourist

images were judged. The latter sustained and created external attitudes about Japan even as they were themselves created by these attitudes. Subjects that did not conform to preconceived notions were not photographed (or at least not sold commercially), whilst images that reaffirmed stereotypical ideas were produced in great volume. As foreign-trained Japanese photographers rose to dominance, there seems to have been no disruption in the supply of stereotypical images. The late 19th-century changeover from Western to Japanese producers had virtually no effect on the nature of the images offered for sale, for tourist images were, as now, market driven. This was also due in part to the long shelf life of images, which could be reproduced and sold repeatedly over decades. But much new work was also produced in the established commercial style in order to complement existing stock.

Many of the stereotyped tourist photographs of Japan look very much like pre-modern visual representations found in *ukiyo-e*. These woodblock prints—which also inspired many Western artists—included portraits of celebrated geisha and actors, as well as famous views, for example of Mount Fuji. Many of these same subjects also formed an important part of the pre-modern and even ancient domestic tourist trail, which privileged certain prospects, temples, flora, and other objects. Prior to Western stereotyping, then, there existed a domestically generated essentialization of Japanese culture. This image was adapted to feed *Japonisme*-inspired desires for particular types of photographs of Japan. Japanese photographers actively produced and reproduced stereotypical images of Japan, presenting the Japanese self as 'other' for the international photographic market.

As photography continued to develop in Japan, individual consumers began to purchase photographic services. By the second half of the 20th century many Japanese owned a camera, photographic culture had become deeply embedded in society, and the tourist photograph of Japan became increasingly personalized. Whilst commercially produced images (mainly *postcards) with stereotypical subjects are still sold, the modern Japanese tourist photograph is most often self-produced and serves as a souvenir of personal presence: 'I was there.' This photographic evidence proves the fulfilment of the tourist's aim to visit a famous location—including some of the same places pictured in *ukiyo-e* prints and early tourist photographs—a photographic practice which has now spread across the globe as the Japanese themselves have become ubiquitous tourists. DO

Banta, M., and Taylor, S., *A Timely Encounter: Nineteenth-Century Photographs of Japan* (1988).

Japanese Camera Inspection Institute (JCII). Organization created in 1954 to inspect Japanese exports, as part of a campaign to raise the reputation of Japanese industry. Its little gold stickers on cameras and lenses soon became symbols of quality and value. The JCII also authenticates historic cameras, and runs a small camera museum in Tokyo. RL

Japan Photographers' Association (JPA). Founded in 1989 to promote photographers and photographic culture, with 533 members at the end of 2002, the JPA is open to professional and amateur photographers, critics, editors, and teachers, and organizes an annual members' exhibition, forums, seminars, workshops, and publications. MSH

Japan Professional Photographers' Society (JPS). Founded in 1950 to establish photography as a profession in its own right and ensure freedom of photographic expression, the JPS is Japan's largest society of professional photographers, with—at the end of 2002—1,760 members. Its activities include the protection of photographic rights and the promotion of exhibitions, technical research, international exchanges, and publications. MSH

Jarché, James (1890–1965), British press photographer who worked for early illustrated newspapers like the *Daily Mail*, *Daily Herald*, and *Daily Sketch*, and for the Associated Press *agency. A *Royal Photographic Society member, he retired in 1959, after almost 60 years of photographing nearly every subject available, from politics and war to theatre and London street life. KEW

Jarché, J., *People I Have Shot* (1934).

Jbz, Jacob Olie. See OLIE, JACOB.

Jodice, Mimmo (b. 1934), Italian photographer, born in Naples, and one of the first in Italy to articulate the centrality of the photographic image in contemporary culture. Active since the 1970s, also as a photography teacher at the Naples Academy, he has exhibited and published internationally. He is known especially for his haunting photographs of Naples, capturing its jarring mixture of past and present, beauty and dilapidation (*Naples: une archéologie future*, 1982);

and for documenting the Conceptual art scene in Italy. His images often explore the nature of objects not as cultural signs but as fetishes, reconstructing and reanimating a specific Neapolitan identity, marginalized and commodified by dominant Italian culture. PDB

Jodice, M., *Eden*, text by G. Celant (1998).

Johnston, Frances Benjamin (1864–1952), American photographer, one of the first successful American female professionals, and the first American woman press photographer. She studied art in Paris 1883–5 and joined the Art Students' League in Washington, DC, when she returned. After an apprenticeship to the Smithsonian Institution's director of photography, she opened her own portrait studio in Washington in 1890, becoming one of the city's premier society photographers and unofficially serving as presidential photographer to the Cleveland, Harrison, McKinley, Theodore Roosevelt, and Taft administrations. Her career had multiple dimensions. Her documentary photographs of the Washington school system and of the Hampton Institute won awards at the Paris Exposition and Third International Photographic Congress (both 1900). As an art photographer she belonged to the jury of the Philadelphia Photographic Society exhibition in 1899, and in 1904 became an associate member of the *Photo-Secession. As an architectural photographer she was frequently commissioned by wealthy families and individuals to document their homes, and in the 1930s and 1940s created a massive photographic architectural

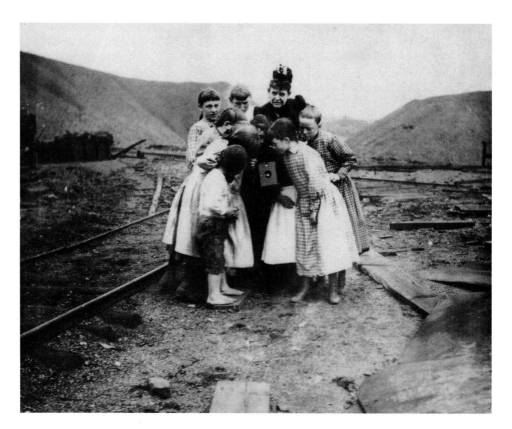

Frances Benjamin Johnston

A Kodak creates a sensation, *c*.1890s

record for the Carnegie Survey of the Architecture of the South, for which, in 1945, she was made an honorary member of the American Institute of Architects. CBS

Daniel, P., and Smock, R., *A Talent for Detail: The Photographs of Miss Frances Benjamin Johnston, 1889–1910* (1974).

Johnston, John Dudley (1868–1955), English amateur photographer, born in Liverpool, and an accomplished and widely exhibited *pictorialist. In 1907 he joined the *Linked Ring Brotherhood and the *Royal Photographic Society (RPS). He was twice RPS president (1923–5; 1929–31), editor and frequent contributor to the *Photographic Journal*, and honorary curator of the RPS collection (1924–55). SD

Johnston & Hoffmann (1880–1950s), commercial photographers in Calcutta. Established in 1880 by P. A. Johnston (d. 1891) and Theodore Julius Hoffmann (*c*.1855–1921), the firm was among the most successful studios and photographic publishers in India in the late 19th and early 20th centuries. From *c*.1890 a Darjeeling studio (managed by Hoffmann) was also maintained, as well as shorter-lived studios at Simla and Rangoon. By 1910, under the management of A. D. Long, the firm's catalogue rivalled that of *Bourne & Shepherd, comprising several thousand views of scenery, architecture, and industry, and portraits of characteristic types from India, Burma, and Sri Lanka. One of the longest-surviving studios in the subcontinent, Johnston & Hoffmann continued trading under Indian management into the early 1950s. JF

'joining of the rails'. See PROMONTORY POINT, UTAH, MEETING AT.

Jokisalo, Ulla (b. 1955), Finnish photographer, resident in Helsinki. Educated at Helsinki University of Art and Design, she juxtaposes found images from popular culture with personal photographs, often combining her images with artefacts like needlework. Core motifs—scissors, the female face, the house, fabrics—constantly recur. Her concerns are personal history, memory, loss, and the mother–daughter relationship. She has exhibited nationally and internationally, and produced several monographs. J-EL

Joly, John (1857–1933), Irish scientist and inventor. After graduating in engineering at Trinity College, Dublin, Joly worked in the college's engineering department, but his interest in earth sciences led to his becoming professor of geology and mineralogy, a post he held for 36 years. He published prolifically and invented a number of scientific instruments, including a photometer, and was the first person to employ radioactive substances in the treatment of cancer. In 1894 he patented the *réseau* method for additive colour photography, using fine ruled red, green, and blue lines on a screen exposed in contact with the emulsion. GS

Jones, Revd Calvert Richard (1802–77), Welsh clergyman, daguerreotypist, calotypist, and close associate of Henry *Talbot. His penchants for watercolouring and travel were facilitated by

close friendship with Kit Talbot, the inventor's wealthy cousin. An accomplished marine painter, Jones became one of the first British *daguerreotype artists. While intrigued with Talbot's work on the more familiar medium of paper, encouraged by Hippolyte *Bayard, he held out hope for a practical direct-positive process. Finally seduced by the rich prints in Talbot's 1844 *Pencil of Nature*, Jones turned to the *calotype with characteristic enthusiasm and mastery. Travelling with Kit Talbot in the Mediterranean, teaching photography to the Revd George Bridges in Italy, or simply reworking familiar picturesque scenes of Swansea shipping, Jones consistently produced stunning architectural, marine, genre, and cityscape photographs. He sold hundreds of his negatives to Talbot for use in photographic publishing (later leading to many of his works being attributed to Talbot). An unexpected inheritance in 1847 derailed plans for him to manage Talbot's photographic operations. With the responsibilities of new-found wealth, opportunities for photographing began to wane. He produced a few negatives in France and Belgium into the early 1850s, but these failed to improve on his exciting earlier work. Jones promoted the concept of multiple *panoramic negatives ('joiners', as he termed them) to the Photographic Society of London in 1853. LJS

Buckman, R., *The Photographic Work of Calvert Richard Jones* (1990).
Schaaf, L. J., *Sun Pictures Catalogue Five: The Reverend Calvert R. Jones* (1990).

Jones Griffiths, Philip (b. 1936), British photographer, born and educated in Wales, who studied pharmacy but turned to freelance photography in 1961. In his first overseas assignment (1962) he covered the war in Algeria for *Observer Magazine*. In Vietnam from 1968–70 for *Magnum (of which he became a full member in 1971) he covered the 'Zippo Brigade' and the Tet offensive near Saigon. The focus of his approach in Vietnam was not the American military but the experience of ordinary Vietnamese. The resulting book, *Vietnam Inc.* (1971), shocked the American public and encouraged the anti-war movement. His work as an independent *photojournalist has appeared in the *Sunday Times Magazine*, *Look*, *Life*, *McCall's*, and the *New York Times*. He also covered conflict in Israel and Northern Ireland. He became interested in documentary films in 1974 and worked as a cameraman for Granada Television. As a noted war photographer, he lectured at the Royal College of Art in London. CBS

Jones Griffiths, P., *Dark Odyssey* (1996).

Jonsson, Sune (b. 1930), Swedish photographer, writer, and film-maker, born in the northern province of Västerbotten. He studied ethnography at Stockholm University before returning home to embark on what became a lifelong documentary project. Basing himself at the provincial museum, he has produced over twenty books, including several novels, *c*.50 films, and a vast photographic archive. Västerbotten has remained the epicentre of his work, although Prague, Congo, and southern Sweden have also inspired monographs. His first book, *Byn med det blå huset* (*The Village with the Blue House*, 1958), expanded the documentary repertoire, blending crisp classical

photography with evocative short stories about a region and its people. Concerned with rural ways of life in a period of rapid change, Jonsson has focused on both individual destinies and disappearing occupations. His particular interest in agriculture has resulted in a 40-year, nationwide survey of changes in the cultivated landscape and its inhabitants. In 1993 he received the Hasselblad Prize.　　　J-EL

journalism, photographic. Early *journals concerned themselves principally with the technical side of photography, especially chemistry, and necessarily contained few if any pictures. Today, such articles tend to appear (if at all) in the specialist scientific press. A few modern journals of photographic *criticism prefer not to trouble themselves with too many actual photographs, relying mainly on text, but the growth of *photomechanical reproduction in the late 19th century led to a more visually orientated style for the less theoretically minded reader. Several magazines founded in the 1850s accommodated this shift in emphasis and are still published today. The most popular British weekly, *Amateur Photographer*, was launched in 1884 but incorporates *Photographic News*, founded in 1858. Although the important *Philadelphia Photographer* began in 1864, the main mass-market American magazines appeared much later: *Popular Photography* in 1937, *Shutterbug* in 1971, *American Photographer* (later *American Photo*) in 1978. (The French *Photo* and Italian *Fotografia reflex* began, respectively, in 1967 and 1980.) The latest development, apparent since the 1990s, has been the proliferation of consumer-orientated magazines dedicated to *digital photography.

Magazines relying purely or principally on visual content have never been as commercially successful as 'how-to' magazines telling (or purporting to tell) amateur and sometimes professional photographers how to improve their work, whether aesthetically or (more usually) technically. The principal reason for this is the influence of advertisements. Without these, the price of a typical photographic magazine would be anything from twice as high (for the most expensive magazines) to ten times higher (for mass-circulation magazines). The job of the photographic journalist, therefore, is principally to hold the advertisements apart: the editorial content of a magazine varies from about one-third to three-quarters of the publication, the rest being occupied by advertisements. Advertisers, of course, prefer articles that deal with (and therefore sell) materials and equipment. The best writers on the subject have always been enthusiasts, most of whom started as amateurs and remain so at heart; the least successful are normally journalists who have turned to photography, instead of the other way round. In the better how-to magazines, technical expertise is the basic criterion for hiring staff or freelances, with skill at actually making photographs either taken for granted or accorded a secondary role. The drawback to this approach can be a somewhat mechanical or formulaic approach which can rapidly ossify: an editor with a feeling for both current and future readership is essential, but he (more rarely she) must not concentrate on the future too much because this will alienate the often traditionalist photographer who subscribes to the magazine.

'Opinion' or 'op-ed' columnists are almost unknown in the photographic press in the USA, where there is a terror of alienating advertisers, but even in Britain few seem willing to court controversy as a means of keeping the readers interested and involved in the issues of the day. This again can lead to an overly predictable reliance on technical matters.　　　RWH

journals of photography, early. These can be divided between those acting as the official organs of photographic *societies and others that may be defined as 'independent'. Such journals were published weekly, fortnightly, and monthly since the 1850s and were complemented by almanacs and annuals.

During the 1840s knowledge of the technology and processes of photography was distributed through a number of published manuals and other existing channels such as the periodical press. A single issue of a French publication, *Le Daguerreotype, revue de la photographie*, appears to have been published in June 1847 and is cited as the only journal of photography in this decade. From the early 1850s many industrialized countries saw the publication of journals of photography. These were primarily the publication organs of newly formed photographic societies, particularly in Britain and its empire. In parallel, a number of the most commercially successful and influential journals were 'independent'. Several survive to this day.

The content of 19th-century journals included papers presented at meetings of photographic societies together with other administrative business of the societies; articles, primarily on photographic technology and processes; letters, reviews, and news. Reprinting articles from other, sometimes foreign, publications was also common. Coverage of photography's applications remained limited during the 19th century and this was reflected by the advertisements placed in journals that were dominated by equipment and materials manufacturers. Paradoxically, photographic illustration was not widely used in 19th-century photographic journals.

The first successful English-language journals were published in the USA: the *Daguerreian Journal Devoted to the Daguerreian and Photogenic Arts* (1850–2), renamed *Humphrey's Journal of the Daguerreotype and Photographic Arts* (1852–62), and the monthly *Photographic and Fine Art Journal* (1851–60), which included the innovation of pasted-in photographic prints. Subsequently, the *Philadelphia Photographer* (1864–88), edited by Edward L. Wilson, became highly influential. In 1889 it became *Wilson's Photographic Magazine*, and in 1914 merged with *Camera*.

The first successful European photographic journal, *La *Lumière* (1851–67), was founded by the *Société Héliographique, but continued independently after the latter's demise. It was followed in 1855 by the *Bulletin de la Société Française de Photographie*, and still exists today. Various other journals were published in France from the mid-1850s but ceased publication within a decade. Journals also proliferated in the German-speaking countries, albeit with a high turnover, and there were 24 by 1900. Most notable were the *Photographische Rundschau und Mitteilungen* (1864) and the more professionally orientated *Atelier des Photographen* (1894).

In Britain, the first and longest-lasting photographic journal was the *Journal of the Photographic Society of London*, which commenced publication on 3 March 1853 and, renamed *The Photographic Journal* in 1859, has appeared continuously ever since. Other titles followed in the 1850s. The *Liverpool Photographic Journal* (f. 1854) became the *Liverpool and Manchester Photographic Journal* in 1857 and the *British Journal of Photography* in 1860, still extant. Another early creation was Thomas Sutton's polemical *Photographic Notes* (1856–67). In 1858 the weekly *Photographic News* appeared, and continued until 1908 when it merged with the *Amateur Photographer* (f. 1884). The size of the market for early British journals is interesting. There was a print run of 2,000 copies of the first issue of the *Journal of the Photographic Society of London* in 1853. A year later this had risen to 4,000, though by February 1855 circulation was recorded as 2,750 copies per issue. The *Photographic News* had the highest circulation figures of any British 19th-century photographic journal, with *c.*7,000 copies per issue in 1869. The reason was perhaps partly because it was independent of any society, partly because it had the best information service.

First in Japan was the short-lived *Datsuei Yawa* (*Tales of Photography*, 1874), followed by *Shashin Zasshi* (*Photography Magazine*, 1880–1), then *Shashin Shimpo* (*Photographic News*), which was founded in 1882, relaunched in 1889 and 1896, and lasted until 1940. Under the editorship of Fukusawa Yokitsu, it acted as an important conduit for information from abroad and in the 1890s moved close to the Japan Photographic Society. *Shashin Geppo* (*Monthly Photo Journal*) started in 1894 as a promotional hand-out for the photographic firm Konishi Honten (precursor of Konica), but became an important art photography journal, also surviving until 1940. Many more titles appeared in the 20th century, with the Second World War as a major watershed.

Increasing numbers of photographic societies and the advent of *amateur and art photography from the 1880s gave further impetus to journals of photography. Some catered primarily for the social and hobbyistic aspects of the medium, and acted as important vehicles for photographic *advertising. Others, such as *Camera Work, Die Kunst in der Photographie*, and the privately circulated *Linked Ring Papers* were identified with *pictorialism and addressed a public whose concerns were more exclusively aesthetic. Secessionist art magazines such as *The Studio* and *Ver Sacrum* also opened their pages to the cream of *fin de siècle* art photography. AJH

Taft, R., *Photography and the American Scene: A Social History, 1839–1889* (1938).
Gernsheim, H., *Incunabula of British Photographic Literature 1839–1875* (1984).
Sennett, R. S., *The Nineteenth-Century Photographic Press: A Study Guide* (1987).
Tucker, A. W., et al. (eds.), *The History of Japanese Photography* (2003).

Juhl, Ernst (1850–1915), German photographic collector, patron, and critic, born and active in Hamburg. From a wealthy business family of Danish origin, Juhl devoted himself from 1896 entirely to promoting photography. Like Alfred *Lichtwark, he saw it as a means of enlivening Hamburg's rather spartan cultural scene, and believed that *pictorialism, practised by leisured amateurs, would establish it securely as a fine art. By organizing a series of international exhibitions between 1893 and 1903, playing a leading role in the secessionist Society for the Encouragement of Amateur Photography (f. 1895), and supporting the *Hofmeister brothers and other local pictorialists, he helped to establish Hamburg as a leading photographic centre *c.*1900. He was also a prolific writer and, 1896–1902, picture editor of the *Photographische Rundschau*.

Juhl's aesthetic views were distinctively modern, ranking expressiveness of form and quality of treatment above conventional hierarchies of subject matter. (The fine-art equivalent was the provocative claim that a bundle of asparagus painted by Manet was more significant than an academic history painting.) From 1909 Juhl helped to create a public photographic collection in Hamburg, Germany's first. Much of his own collection was bought by the Hamburg Museum for Art and Design in 1915. RL

Kaufhold, E., *Bilder des Übergangs: Zur Mediengeschichte von Fotografie und Malerei in Deutschland um 1900* (1986).
Kunstphotographie um 1900: Die Sammlung Ernst Juhl (1989).

Juniata County Photography Project, an ongoing study, begun in the early 1980s by Jay W. Ruby of Temple University, of photography in rural central Pennsylvania since 1839. It runs counter to the scholarly paradigm, dominant until the 1970s, that concentrated on 'important' or 'canonical' photographers and their work and analysed images in the context of art. Ruby adopted an anthropological perspective, arguing that the camera, a tool accessible to everyone, creates images often produced for reasons other than art, e.g. for purposes of investigation, record, publicity, or pleasure. This broader approach focuses on commercial and avocational photographers working in a vernacular mode, the kinds of images they produced, and the kinds of people who used them. Juniata County is viewed as a microcosm for the rest of rural America and photography. Sources for the study include local newspapers, city directories, oral tradition, and photographs found in flea markets and historical societies. LR

Ruby, J. W., *The World of Francis Cooper, Nineteenth-Century Pennsylvania Photographer* (1999).

Kahn, Albert (1860–1940), French banker and amateur photographer. After experience with a Richard *Verascope, and a world tour (1908–9), he had the idea of creating a photographic and cinematographic 'Archive of the Planet'. He spent a fortune on bulk consignments of Lumière *autochrome plates, and on hiring operators to scour the world for images. He died a ruined man. The archive, which includes *c.*72,000 autochromes and 172,000 meters of motion-picture film, is preserved in Kahn's house, now a museum, in the Paris suburb of Boulogne. RL

Kaiserpanorama, the most elaborate and long-lived of the many devices for the display of *stereoscopic pictures that flooded Europe and America during the mania for stereo views launched at the *Great Exhibition of 1851. Intended as a commercial public entertainment, the Kaiserpanorama in its classical form seated 25 people around a circular structure to view two sets of 50 transparent stereo views rotated from within by a clockwork mechanism. First suggested by David *Brewster in his 1856 book *The Stereoscope*, a working apparatus was sold by Claude-Marie Ferrier in Paris from around 1860 and became a travelling show for fairs and markets. Aloys Polanecky introduced his Ferrier 'Stereogramm-Salon-Apparat' in 1866 and exhibited it across Austria and Germany until 1899. The name Kaiserpanorama came from the show's most famous entrepreneur, August Fuhrmann, who travelled with a Kaiserpanorama in the 1880s in Breslau, Frankfurt am Main, and then Berlin. Fuhrmann organized the independent showmen scattered across Central Europe who used the apparatus, patented mechanical improvements, established a scheme for the rental and regular exchange of picture series, and produced new sets of views, in a business organization later closely replicated by motion-picture distributors. At its peak *c.*1900, his Berlin-based organization supplied *c.*250 affiliates from a stock of over 1,000 series comprising *c.*50,000 stereo images. From the beginning, the pictures for the Kaiserpanorama consisted principally of travel views of both exotic distant lands and European cultural monuments, initially provided by Ferrier and Soulier in Paris. Fuhrmann expanded the range of subjects so that about one-fifth of his offerings were of 'news' events like the San Francisco earthquake of 1906 or subjects of social or political interest like the series 'Martyrs of Science'. Later often established as a fixed exhibition in small towns, a few Kaiserpanoramas survived as local entertainments into the 1950s. DR

Kanemura, Osamu (b. 1964), Japanese photographer, born and living in Tokyo. He began photographing in 1989, the year the Showa emperor died and Japan's building and economic boom ended. He photographs the construction and demolition of Tokyo. Influenced by the 'snapshot' styles of Garry *Winogrand and his teacher Kiyoshi Suzuki, he photographs fragments of the city: streets crowded with eclectic buildings, electric cables, and bicycles. He repeatedly returns to favoured sites. His books include *Happiness is a Red before Exploding* (2000) and *I CAN TELL* (2001). MT

Blink: 100 Photographers, 10 Curators, 10 Writers (2002).

Kar, Ida (née Karamian; 1908–74), Russian-born photographer of Armenian parentage, influential in establishing post-war British recognition of photography as an art form. She lived in Alexandria in the 1920s; then Paris (1928–33), where she mixed with the avant-garde; then again Egypt, where she ran the Idabel studio in Cairo with her husband Edmond Belali and participated in two Surrealist exhibitions. In 1945, now married to the English art critic Victor Musgrave, she arrived in London. Living in Soho, she created an extensive portrait gallery of British bohemians, as well as French artists and intellectuals. In the late 1950s she contributed photo stories about life in London to the *Tatler* and the *Observer*, and portraits of visiting cultural celebrities. Kar travelled widely, and in 1964 was invited to Cuba to photograph celebrations for the revolution. Hers was the first solo photography show at the Whitechapel Art Gallery, London, in 1960, which brought critical but not financial success. She arranged another exhibition at the House of Friendship, Moscow, in 1962. She died lonely and impoverished. AL

Williams, V., *Ida Kar: Photographer 1908–1974* (1989).

Karelin, Andrei (1837–1906), Russian photographer. As a child, he was apprenticed to an icon painter; later he trained at the Imperial Academy of Arts in St Petersburg. His continuing identification with fine art appears from the title of the establishment he opened in the western city of Nizhni Novgorod in 1869, Photography and Painting Portrait Studio (it also incorporated an art school), and from a self-portrait *c.*1890 with brush, palette, and canvas. Although his main business was portraiture, he also did landscapes and genre scenes, including striking 'groups within rooms' in which figures—both popular and middle class, including his own family—posed in natural light in real interiors. His album *Nizhni Novgorod* (1870) lovingly

Lennart Nilsson Week 20: a foetus sucks its thumb, from *A Child is Born*, 1965

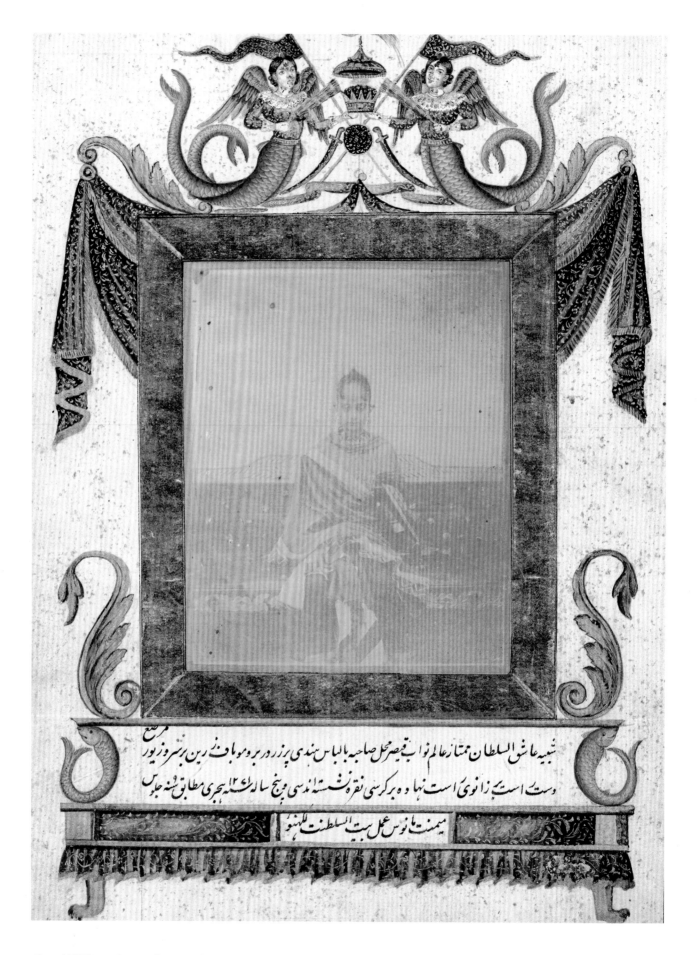

Ahmad Ali Khan Portrait of Mumtaz Alam Nauwab Waisar Mahall Sahibah of Oudh, *c.*1855. Salted paper print with manuscript additions

depicted the city's architecture and inhabitants. Karelin collected Russian art and costumes, which increasingly appeared in his pictures. He won considerable acclaim in Russia and abroad. RL

Elliott, D. (ed.), *Photography in Russia 1840–1940* (1992).

Karsh, Yousuf (1908–2002), Armenian-born Canadian portrait photographer. At the age of 16, he was sent to Quebec by his parents to work for his uncle, George Nakash, a portrait photographer. At 20, he apprenticed with John H. Garo in Boston. Karsh returned to Ottawa in 1934, where he established an international reputation for his small studio, photographing visiting politicians, scientists, and social celebrities, including Churchill, G. B. *Shaw, and Eleanor Roosevelt. Commissioned often by *Life, and a member of the *Royal Photographic Society, Karsh continued to work from his Ottawa studio until 1992. KEW

Karsh, Y., *In Search of Greatness* (1962).

Käsebier, Gertrude (1852–1934), American photographer, *pictorialist, and portraitist famous for her frequent examination of the mother-and-child theme. Käsebier studied painting at Brooklyn's Pratt Institute before seriously taking up photography. She opened a New York-based portrait studio in 1897–8. Exhibition appearances, and her role as a judge at the 1899 Philadelphia Photographic Salon, increased her reputation and made her business a resounding success. *Stieglitz devoted the initial 1903 issue of *Camera Work* to her, despite his reservations about the commercial nature of much of her work. The two strong-willed artists would later quarrel, causing Käsebier to leave Stieglitz's *Photo-Secession. *Blessed Art Thou among Women* and *The Manger* (both 1899), Käsebier's best-known early photographs, epitomized a recurring mother-and-child motif. Mothers perform a nurturing role in her photography, readying children for the world; children frequently look outward, prepared to explore. Less known, but of equal importance, are Käsebier's Native American subjects, many of them performers in Buffalo Bill's Wild West Show. Unlike George Catlin's and Karl Bodmer's frontier paintings or Edward *Weston's photographs, Käsebier's images present the Indian as individual rather than racial representative. Even photographs with generic titles like *The Red Man* refuse to engage in anthropological categorization. Käsebier's soft-focus lens sometimes creates an archetypal, romanticized Indian, but without sacrificing the subject's personality. PC

Michaels, B., *Gertrude Käsebier: The Photographer and her Photographs* (1992).

Kawada, Kikuji (b. 1933), Japanese photographer. Freelance from 1959, after four years with Shinchosa Publishing, he co-founded the *VIVO photo agency with Shomei *Tomatsu and others. His 1961 solo exhibition *Chizu* (The Map; pub. 1965) of traces left by the Second World War, in a high-contrast monochrome style, garnered critical attention; the rising-sun flag lying wet and sullied on the ground is its most *iconic image. In *The Last Cosmology* (1995) he created a cosmos of black-and-white, blending the real and imaginary. Other publications include *Castle of Ludwig II* (1979) and *The Nude* (1984). MT

Keetman, Peter (b. 1916), German photographer. Influenced by his father, a keen amateur photographer, Keetman trained at the Munich Photographic School. After graduating in 1937 he worked in the studio of Gertrud Hesse in Duisburg, then in industry. He was badly wounded in the Second World War. In 1949 he was one of the five founders of the *fotoform group. Keetman is best known for his experimental interests, emphasizing detail, abstraction, and structure and famously exemplified by his industrial reportage *A Week in the Volkswagen Works* (1953). UR

Sachsse, R., *Peter Keetman: Bewegung und Struktur* (1996).

Keighley, Alexander (1861–1947), British *pictorialist photographer and director of his family's textile firm. He took up photography in the 1880s, winning a competition in *Amateur Photographer* in 1887. From 1895 he made atmospheric *carbon prints, often dodging and double printing them. His work was exhibited and collected by societies in the USA and Europe. He was an artist, energetic advocate, and organizer, a member of the *Linked Ring Brotherhood from 1900, a Fellow of the *Royal Photographic Society from 1911, and driving force behind the formation of the Yorkshire Photographic Union, the first federation of regional societies in England. JT

Keïta, Seydou (1923–98), Malian photographer, born and active in Bamako. Trained as a cabinetmaker, he took up photography in 1949. He worked exclusively as a studio portraitist, chronicling Bamako's citizens over three decades. His skill at supplying his clients with clothes, props, poses, and backdrops produced photographs with a dense, compelling individuality. And his oeuvre, of over 200,000 photographs, depicts a founding stage in African modernization, as experienced in one thriving, expanding city. After a period photographing for the Mali government, Keïta gave up photography in 1977. His breakthrough in Europe in the early 1980s, followed by exhibitions worldwide, helped bring his work, and African photography generally, to wider critical and public attention. J-EL

Seydou Keïta (1997).

Lamuniere, M., *You Look Beautiful Like That: The Portrait Photographs of Seydou Keïta and Malick Sidibé* (2001).

Keith, Dr Thomas (1827–95), Scottish master of the paper negative. Keith's father was photographed by *Hill & Adamson; in 1844, his brother daguerreotyped the Holy Land to illustrate their father's book. From 1853, with John Forbes White, Keith created the finest early views of Scotland's architecture and landscape, exclusively with paper negatives. His photographic activities were only curtailed when his exceptional talents as a surgeon claimed all his time. It was not until 1915 that his achievements were rediscovered by Alvin Langdon *Coburn. LJS

Schaaf, L. J., *Sun Pictures Catalogue Six: Dr. Thomas Keith and John Forbes White* (1993).

Kepes, György (1906–2001), Hungarian photographer who studied at Budapest Academy of Arts, worked as a painter and film-maker, then moved to Berlin, London, and Chicago with *Moholy-Nagy. In 1938 he became head of the light and colour department at the Chicago Institute of Design, and from 1943 held many professorial positions in the USA. In 1967 he became founder director of the Center for Advanced Visual Studies at MIT, conceived to link art and technology and promote a holistic view of the world. As both painter and photographer, Kepes was fascinated by light's ability to convey form, movement, and space, expressed in collages, *photograms, and *clichés-verre. RA

Kepes, G., *Language of Vision* (1944).

Keppler, Victor (1904–87), American *advertising photographer. Born into a New York immigrant family, Keppler embraced photography early and in his teens improvised a commercial darkroom in a coal cellar. After assisting the Japanese-American photographer Robert Waida, he became independent in the booming mid-1920s, eventually working with America's largest agencies—most notably BBDO—and corporations. He made his debut with deceptively simple table-top arrangements, but later mastered studio set-ups of Hollywood-like complexity and, in the 1950s, location shoots that mimicked *photojournalism. This versatility, and a legendary flair for problem solving, made him one of advertising's most sought-after photographers, flourishing during the Depression and reaching a pinnacle of success after 1945. (During the Second World War he designed propaganda posters for the US Treasury.) A tireless innovator, Keppler enthusiastically embraced the technical and business changes that took place during his career, including the commercial use of colour, the advent of electronic flash, the corporate identity cult, and the opportunities offered by television. After leaving advertising in 1961 he headed a distance-learning establishment, the Famous Photographers School. He published a technical manual, *The Eighth Art: A Life of Color Photography* (1938), and an illuminating autobiography, *Man + Camera* (1970). RL

Kerr cell. See ELECTRO-OPTICAL SHUTTERS.

Kertész, André (1894–1985), Hungarian-born American photographer. He always said that he was 'born a photographer', but his gift for composition and for seeing the curious juxtapositions that the camera can record so well must have been acquired during his sojourn in Paris (1925–36), where he experienced *Surrealism and all the other modernisms in the heady atmosphere of Montparnasse. He encouraged (and taught) *Brassaï to take up the medium and photograph the nocturnal world. By the early 1930s, Julien *Levy was describing him as 'the prolific leader in the new documentary school of photography'. Through the publication of his pictures in the leading magazines of the day, he inspired the younger generation of French and émigré photographers with a style of photography that linked, as *Cartier-Bresson would later say, 'the eye, the hand and the heart'.

His style, and in particular the lyrical and poetic modernism that his photographs display, powerfully influenced French humanist photography, a visual perspective that became almost ubiquitous by the 1950s.

A gifted amateur before moving to Paris to find work in his chosen profession in 1925, Kertész developed a lyrical form of *New Vision modernism in his work for the emergent illustrated press. Although he worked in other formats, it was the visual freedom offered by the new *Leica 35 mm camera that best revealed his ability, although he also experimented with distortion and photographic effects. His publications on children (1933) and Paris (1934) pioneered the new genre of the photographic book. Moving to New York in 1936, he remained an editorial photographer for the rest of his career. After retirement he continued to photograph, and was 'rediscovered' towards the end of his life.

When Beaumont *Newhall was assembling his historic MoMA exhibition *Photography 1839–1937* (1937), he asked Kertész for some prints. The latter proposed his series of distorted nudes, published to great acclaim in France in 1933. Newhall, with ascetic New Englander zeal, insisted that if shown they would have to be cropped to exclude the pubic hair. Kertész reluctantly agreed, but held it against Newhall ever after: as he ruefully recalled, 'This was my welcome to America'—a country that seemed to ignore his talents. The Keystone agency, which offered him the job that took him to New York, made him do studio work, when his forte was the street, the 'circumstantial magic' of the decisive moment (practised well before *Cartier-Bresson), seized with a small camera. Much of his Paris work during the heyday of modernism, 1925–36, had been made for the leading illustrated magazines of the era such as *Vu* and *Art et médecine*. Virtually all his best work in the USA was personal—the famous series of pictures from his apartment window of Washington Square is typical—and it was not until he gave up his job in 1962, and shortly thereafter rediscovered his 'lost' Hungarian and Paris negatives of 1912–36, that his reputation revived. PH

André Kertész: Diary of Light, 1912–1985 (1987).

Kesting, Edmund (1892–1970), German artist and photographer. After training at the Dresden Academy (1915–22) he founded private art schools in Dresden (1919) and Berlin (1927), and from 1932 worked as an advertising photographer. In the 1920s he was closely involved with the artistic avant-garde, and from 1925 devoted himself intensively to experimental photography (*photograms, *photomontage). During the Third Reich he was banned from painting. In 1945–6 he produced the photomontage cycle *Dresden Dance of Death* (*Totentanz aus Dresden*). From 1946 onwards he held official teaching posts in Dresden and Berlin and, from 1956, at the School for Film and Television in Babelsberg. JJ

Galerie Döbele, Stuttgart, *Edmund Kesting zum 100. Geburtstag: Gemälde, Arbeiten auf Papier, Fotografien* (1992).

key light. See LIGHTING AND LIGHTING EQUIPMENT.

Keystone View Company, the world's largest producer and distributor of stereo views, founded in 1892 in Meadville, Pennsylvania, by Benjamin L. Singley. It purchased negative collections of other companies such as B. L. Kilburn and *Underwood & Underwood, but also manufactured stereo viewers and lantern slides. It was acquired by the Mast Development Company in 1963 and closed in 1976. Its stock of stereo prints and negatives, the Keystone-Mast Collection, the largest in the world, is at the California Museum of Photography, Riverside. The Johnson-Shaw Museum in Meadville displays original Keystone equipment and views. LR

Khaldei, Yevgeny (b. 1917), Russian photojournalist and war photographer. Originally a steelworker, Khaldei became an apprentice photographer at the TASS agency in Moscow in 1930. He worked as a front-line photographer throughout the Second World War, from the German invasion of Russia to the fall of Berlin, where he captured an *iconic photograph of a soldier hoisting a Soviet flag over the Reichstag. Afterwards he covered the Potsdam Conference and the Nuremberg Trials. He suffered anti-Semitic persecution in the 1950s, but later returned to work for TASS and *Pravda*. RL

Grosset, M., *Khaldei. Un Photoreporter en Union Soviétique* (2004).

kicker. See LIGHTING AND LIGHTING EQUIPMENT.

Killip, Chris (b. 1946), Manx-born British *documentary photographer. With Graham Smith and other northern-based photographers whose vision was untainted with academic dogmas about the nature of photography, he helped to establish the New British Photography movement of the 1970s. His first book, *Isle of Man*, appeared in 1980. He participated in a major exhibition devoted to the English north-east, *Another Country*, in 1985. His Newcastle upon Tyne collection *In Flagrante* (1988), with text by John Berger and Sylvia Grant, captured skinheads, caravan dwellers, rough sleepers, and wild children in a decaying, wind-lashed industrial landscape. RSA

Kimura, Ihei (1901–74), Japanese photojournalist and adept of the Leica camera (introduced to Japan in 1929). Born and raised in Tokyo, he is considered the photographer to have best captured the city's spirit. He discovered photography while working in Taiwan (1920–2), and in 1924 opened a studio in Nippori, Tokyo. His portrayal of Tokyo began *c*.1930. In 1932 he founded the monthly photo magazine *Koga* with Yasuzo *Nojima and Iwata Nakayama to showcase the German-influenced New Photography movement in Japan. He briefly joined Nihon Kobo publishing directed by Yonosuke Natori in 1932, leaving in 1933 to found the group Chuo Kobo with Nobuo Ina and Hiroshi Hara in 1934. During the war he worked as a photojournalist in Manchuria and as head of photography at Toho-sha, publisher of *Front* magazine. Subsequently he joined Sun News Photos, turning freelance in 1948. First chairman of the Japan Photographers' Society 1950–8, he judged contests for *Camera* magazine together with Ken *Domon in 1952. He admired the *Cartier-Bresson photographs that

he saw in 1952, and in 1954–5 worked in Paris, London, Helsinki, and Rome. He then left the urban scene and focused on the northern prefecture of Akita, in more than twenty visits in twenty years. His style became more fluid and spontaneous as he unobtrusively recorded his subjects in their daily lives and work. He also portrayed major Japanese writers. In 1975 *Asahi Camera* magazine inaugurated an annual award in his honour. MHV

kinetoscope, mechanical device that creates the illusion of movement from still images, a precursor of the modern motion-picture projector. In the late 1880s, influenced by the experiments of Eadweard *Muybridge and Étienne-Jules *Marey, the American inventor Thomas Edison (1847–1931) set out to create a visual counterpart to his phonograph machine. He was assisted by William Dickson (1860–1935), who had experience as a photographer. Patented in 1887, the prototype was both a camera and a viewer, and used *celluloid film. The kinetoscope was first demonstrated publicly in 1891. Subsequent versions were for viewing only. MR

Kingslake, Rudolf (1903–2003) and his future wife **Hilda** (née Conrady; 1902–2003), among the most brilliant students at the newly formed Technical Optics Department at Imperial College London under the professorship of Hilda's father. In 1929, the year of their marriage, Rush Rees, president of the University of Rochester, New York, invited Kingslake, by then a senior lecturer at Imperial, to become associate professor at his newly formed Institute of Optics, aware that he would also be getting Hilda's services free. In 1937 Kingslake began a 25-year career as head of lens design at Eastman Kodak; but he continued to teach at the university, and on his formal retirement returned to it. He wrote a number of important books on photographic optics, including *A History of the Photographic Lens* in 1989. His last book was *Optics in Photography* (1992). His career spanned the history of lens design from the era of slide rule, log tables, and protractor to the computer and fast *Fourier transforms. In all this work Hilda played an important part. She died, after 73 years of devoted marriage and professional collaboration, in February 2003; Rudolf outlived her by only a few days. GS

Kinsey Institute for Research in Sex, Gender, and Reproduction, Indiana University, Bloomington. Incorporated in 1947, the institute's mission is to promote interdisciplinary research on human sexuality, gender, and reproduction. It has an archive of *c*.75,000 sexually relevant photographs, begun by the celebrated field biologist Alfred C. Kinsey (1894–1956). Photography's affordability and accessibility gave it a special place in Kinsey's mid-20th-century surveys of sexual practice. This collection of images depicting the nude human body and an array of sexual poses and acts encompasses a wealth of photographic prints, negatives, slides, and more unusual formats like *stanhopes. The photographs, produced by commercial, fine-art, and amateur photographers, date from 1880 to the 1990s, but the majority are from 1940s and 1950s America. Although most

of the makers are unknown, the institute has extensive holdings of work by George Platt *Lynes and Wilhelm von *Gloeden. Other known photographers represented include André de Dienes, *Manassé, Clarence John *Laughlin, Irving *Penn, Judy *Dater, Les *Krims, and Joel-Peter *Witkin. The collection's size and diversity make it a valuable academic resource. However, access remains restricted to qualified scholars as a result of the federal obscenity case *US* v. *31 Photographs* (1957). JPY

Squiers, C., and Pearson Yamashiro, J., *Peek: Pictures from the Kinsey Institute* (2000).

Pearson Yamashiro, J., 'Sex in the Field: Photography at the Kinsey Institute' (Indiana University Ph.D. dissertation, 2002).

Kirchner, Ernst Ludwig (1880–1938). Though known primarily as a German Expressionist painter and co-founder of the group Die Brücke, throughout his career Kirchner also produced drawings, prints, sculpture, and—discovered much later—photographs. He was always exceptionally deliberate and energetic about promoting the work he admired, including his own, to the point of later writing supportive criticism under the pen name L. de Marsalle. His photographs seem to have served various purposes, including recording his bohemian life with friends and models, but they were usually used as a means of promotion. NRO

Kirchner-Museum Davos, *Katalog der Sammlung*, ii: *Fotografie* (1994).

Kirlian photography. In the early 1940s Seymon and Valentina Kirlian developed a process of recording on film corona discharges from living matter. The method of obtaining the photograph (more properly, *photogram) is to position a metal plate in contact with one side of the film, and some part of the subject's body (usually the fingers) on the other. The subject is earthed, and the plate is charged to a high potential with a Tesla coil. The film records the corona discharge from the subject resulting from the ionization of the surrounding air. Such discharges can be affected by temperature, humidity, and other environmental factors, and this has led to a large number of pseudoscientific claims about 'auras' and 'biofields'. There is evidence that the image does indeed change according to the emotional state of the subject, and this has been linked by enthusiasts to 'bioenergy', 'astral bodies', and other paranormal phenomena. However, a much more likely cause of the variation is simply changes in skin conductivity. GS

See also OCCULTISM AND PHOTOGRAPHY.

Kiss at the Hôtel de Ville, The (*Les Amants de l'Hôtel de Ville*), by Robert *Doisneau. In March 1950 Doisneau was commissioned by *Life* to do a photo-essay on springtime romance in Paris and proceeded, as occasionally before, to set up encounters using young actor-models. Although Doisneau himself regarded the assignment as 'a bit corny', it was a big success in the USA, and was republished in *Ce soir* as 'the photo-story that delighted Americans'. *The Kiss*, though arguably the liveliest of the six published pictures, had not received any special prominence in *Life*, and appeared in only one-sixth-page format. Moreover it was not until the 1970s, following the massive redevelopment of the French capital, that Doisneau and his images of 'Old Paris' became famous. When *The Kiss* was issued as a poster in the mid-1980s it became a popular *icon, reproduced on T-shirts, shower curtains, and all sorts of other objects; *c*.2.5 million postcards were also sold.

This had the unwelcome result for Doisneau that couples came forward claiming to have been the subject of the photograph, and in 1988 one of them sued for damages under the law of 17 July 1970. This suit was followed by another brought by the actress actually used, Françoise Bornet. Although both claims failed, the litigation and attendant publicity, and especially the revelation about staging, overshadowed the photographer's last years. RL

Hamilton, P., *Robert Doisneau: A Photographer's Life* (1995).

Koetzle, H.-M., *Photo Icons. The Story Behind the Pictures, 2: 1928–1991* (2002).

Klein, William (b. 1928), American artist, film-maker, and experimental photographer. Originally a painter, Klein's approach to photography was always irreverent, more to do with the possible outcomes of photographic media and processes than the creation of pictures. His intense volume of New York images, *Life is Good and Good for You in New York: Trance Witness Revels* (1957), made in an eight-month period in 1954–5, assaulted the conventions of photography best embodied in the visually pristine work of Henri *Cartier-Bresson. Klein developed a personal anti-aesthetic of blurring, distortion, and graininess that reflected his own experience of the city and gave impetus to the emerging genre of street photography. At the same time he embarked on the book project, he began shooting glamorous yet innovative pictures for *Vogue* and other publications, expanding the limits of acceptability in *fashion photography. Although well received in Europe, *Life is Good* was reviled in America as the work of a hack. Klein, however, went on to produce three more books, on Rome, Moscow, and Tokyo, and to be recognized as one of the 20th century's most influential photographers. MR

Heilpern, J., *William Klein: Photographs* (1981).

Klucis, Gustav (1895–1944), multifaceted Russian visual artist. Born in Rujiena, Latvia, he studied in Riga, Petrograd, and Moscow. Productive as a painter, graphic artist, sculptor, and photographer, he was employed on design projects for Soviet pavilions at a number of international exhibitions between the wars. He began to experiment with *photomontage after the First World War and, during the 1920s, frequently incorporated photographic images into posters designed to promote events or disseminate *propaganda. In 1932 he was commissioned to design the gigantic posters of Lenin and Stalin erected in Moscow's Sverdlov Square to mark the completion of the new Dnieper Dam. He found further opportunities to use photomontage in his illustrations for books and periodicals in the 1930s. Arrested in 1938, he died in captivity. RP

Elliott, D. (ed.), *Photography in Russia 1840–1940* (1992).

Knapp, Peter (b. 1931), Swiss photographer, art director, film-maker, and stage designer, trained at the Zurich Design School and in Paris. Active initially as a graphic artist, Knapp later became a highly versatile photographer, ranging from reportage to portraiture, fashion, and glamour; in 1966 he shot the Pirelli Calendar. From 1983 he taught an advanced class at the Paris École Supérieure d'Art Graphique (former Académie Julian), and is the principal author of an outstanding primer, *Dix ans d'enseignement: cours de photographie* (c.1998), largely illustrated by students' work. RL

Knorr, Karen (b. 1955), Puerto-Rican-born American photographer, resident in London. Her major photographic series *Belgravia*, *Gentlemen*, *Country Life*, *Connoisseurs*, and *Capital* (1979–92) depicted the English upper classes at home and in various institutional settings. Embodying a range of approaches, these works both interrogated and renewed notions of *documentary. Interweaving different kinds of text (captions, titles, quotations) with various photographic genres (portraiture, still life, reportage), and inserting fiction, irony, and humour, Knorr's work has combined a conceptual approach rich in metaphor and allegory with sensuality and visual pleasure. Later works, such as *Academies*, also examined institutions. J-EL

Knudsen, Knud (1832–1915), Norwegian photographer, active in Bergen 1864–98. Knudsen celebrated the Norwegian landscape and was the first person systematically to photograph the entire country; his archive contains over 12,000 images. He conveyed the drama of Norway's extraordinary natural heritage in grand and powerful photographs, often making skilful use of a human figure for scale. Although less numerous, his close-up studies of rock and ice are ahead of their time, anticipating the photographic vision of the 20th century. J-EL

Meyer, R. (ed.), *Den Glemte Tradisjonen* (1989).

Kodachrome. See COLOUR REPRODUCTION PRINCIPLES; PHOTOGRAPHIC PROCESSES, COLOUR; TRANSPARENCIES.

Kodak Brownie. First introduced in 1900, the humble box Brownie can justifiably claim to be *the* camera of the 20th century. For 80 years, the name was synonymous with popular photography. Generations of snapshooters used their Brownies to create a photographic record of their world and their lives. Many famous photographers, too, acknowledge that their first interest in photography can be traced back to the childhood present of a Brownie. Indeed, such was its dominance that all box cameras, whatever their manufacturer, were commonly known as 'Brownies'. It is the camera that both popularized and democratized photography. George *Eastman saw that if the cost could be reduced, many more people might take up photography. Asked by Eastman to design the least expensive, yet still effective and reliable, camera possible, his camera designer, Frank Brownell, came up with the Brownie. Originally designed to appeal to children, the camera was not named after Brownell but after the pixie-like 'Brownie' characters created by the popular children's author Palmer Cox. Eastman, always

a shrewd salesman, cleverly adopted the name and used drawings of the characters on the packaging. Brownies were not toys, however. Although cheap (just 5 shillings; $1), they were capable of producing perfectly good photographs—a fact that people soon realized. Following the success of the original model, Kodak made a range of folding and box Brownie cameras. Between 1900 and 1980, nearly 100 different models bore the famous name. CWH

Coe, B., *Kodak Cameras: The First Hundred Years* (1988).

Kodak camera, revolutionary *roll-film box camera launched by the Eastman Co. in June 1888. A simpler version of a design patented in 1886, it held a 100-shot roll of Eastman's already successful paper-backed American Film, wound on by a key. The f/9 fixed-aperture lens was incorporated into an ingenious cyclindrical shutter cocked by a string and activated by a button. The short focal length of the lens (57 mm; 2¼ in) and small diameter (64 mm; 2½ in) of the image meant that objects from a distance of 1 m (3½ ft) would be sharp. The camera was small and portable, being 165 mm (6½ in) long, 95 mm (3¾ in) high, and 83 mm (3¼ in) wide. 'Kodak' was a made-up name chosen by George *Eastman as being distinctive and pronounceable in any language.

As remarkable as the camera itself (which was not the first to be designed solely for rollable film) was the marketing and back-up concept that went with it. Eastman planned to separate picture taking from processing, 'the work that any person whomsoever can do in making a photograph, from the work that only an expert can do'. After exposure of the film, the camera could be returned to the factory and then sent back, reloaded, with a set of prints. As the immortal slogan put it, *'You press the button, we do the rest.' The original Kodak was an immediate success, and c.5,000 were sold. It was then replaced by a new version (later named the Number 1 Kodak) with a simpler, cheaper shutter. The substitution, at the end of 1889, of *celluloid for paper-backed film also simplified processing, and the many subsequent Kodak cameras were designed for it.

The cost of the Kodak itself (5 guineas; $25) and each processing cycle (2 guineas; $10) made it essentially a middle-class gadget. But its portability and ease of use made it the perfect adjunct to the bicycling, hiking, and seaside holidays that were coming within reach of ever-larger numbers of people by the end of the 19th century. RL

Coe, B., *Cameras: From Daguerreotypes to Instant Pictures* (1978).

'Kodak culture'. See AMATEUR PHOTOGRAPHY, HISTORY.

Kodak Girl. In 1910 a striking new element was introduced into Kodak advertising—the Kodak Girl wearing her characteristic striped dress. For over 60 years she would be the personification of popular photography in the public imagination, subtly symbolizing it as easy, fun, and family friendly. Created by a leading poster artist, John Hassell, the first Kodak Girl was based on a photograph taken by Cavendish Morton, using his wife as the model. Over the years, Kodak commissioned some of the best artists and illustrators of the day to

design the advertisements. As the decades passed, the girl's appearance altered, reflecting the changing fashions of the time. CWH

Harding, C., 'The Kodak Girl', *Photographica World*, 78 (1996).

Kodak Instamatic series. By the 1960s research had identified the perceived difficulty of film handling as an obstacle to the expansion of mass-market photography. In response, Eastman Kodak introduced the plastic drop-in Kodapak cartridge giving 12 or 24 28 mm (1$^1/_{10}$ in) square pictures. The format came to be known as 126. The Instamatic series was launched in February 1963 and was hugely successful, selling *c*.50 million units by 1970. From 1966 revolving flashcubes were incorporated. Other manufacturers adopted the 126 format, and many design variants appeared, from basic plastic-lensed models to sophisticated and expensive cameras like Kodak's German-made Instamatic 500 (1964). Although disparaged by 'serious' photographers, the 126 Instamatic, in conjunction with new colour negative films, gave respectable results and, true to Kodak's tradition, introduced countless newcomers to photography. In marketing terms it prepared the ground for the automated 35 mm and APS (*Advanced Photographic System) cameras of the 1980s and 1990s, which ultimately superseded it; Kodak discontinued 126 in 1999.

In 1972, however, the company had launched a *sub-miniature (110) version known as the Pocket Instamatic. A similar drop-in concept was applied, and pictures measured 13 × 19 mm ($^1/_2$ × $^3/_4$ in). The camera also sold exceptionally well, was widely imitated, and appeared in basic and advanced versions (e.g. the Canon 110ED, Minolta 110 Zoom, and Pentax Auto 110 SLR). A niche market survived into the 21st century. RL

Coe, B., *Cameras: From Daguerreotypes to Instant Pictures* (1978).

Koga, Japanese art photography magazine, published initially by Jurakusha, May 1932, then Koga-sha from January 1933 until its demise in December 1933. *Ko-ga* means *photo-graph* in Japanese. Founding photographers included Yasuzo *Nojima, Iwata Nakayama, and Ihei *Kimura; the photo critic Nobuo Ina joined with the second issue. An important figure in the Japanese New Photography movement, Ina translated Franz *Roh's essay 'Return to Photography', spreading the influence of the German New Photography movement. Both photographic and written essays (notably by Kanbei *Hanaya) were published. Photographic content included Nojima's strong, dynamically posed portraits, and Tokyo images and street shots by Kimura. MHV

Koishi, Kiyoshi (1908–57), Japanese photographer. Born in Osaka, he was a pioneer of Japanese commercial photography through his advertising studio, and an important proponent of pre-war 'new photography'. From 1928 he was active in Osaka's prestigious Naniwa Shashin Club alongside Nakaji *Yasui. He early explored alternative techniques, such as *photomontage, camera movement and *solarization to express his strong viewpoints. His exhibition *Shoka Shinkei* (*Early Summer Nerves*; 1932, pub. 1933) is exceptional for its anti-war stance and avant-garde style. Amongst other projects he collaborated with Ihei *Kimura and others on a photo-mural for the Paris Exposition Universelle, 1937. OH

Kon, Michiko (b. 1955), Japanese photographer. She took up photography after initially learning woodblock printing. Her still-lifes featuring fish skins, salmon roe, cabbage-stuffed stockings, often in the form of clothes, have been well received both in Japan and abroad. Her photographs are constructed, sharp, with deep blacks and bright

whites, and quite humorous. Her early work appeared in the 1987 monograph *Eat*, and in a second monograph, *Michiko Kon, Still Lifes*, in 1997. She has received numerous awards. MHV

Konttinen, Sirkka-Liisa (b. 1948), Finnish-born photographer and film-maker, resident in Newcastle upon Tyne, England. In 1969 she co-founded the film and photography collective Amber, dedicated to engagement with ordinary people in the north-east; Side Photographic Gallery was a later offshoot. Konttinen's first book, *Byker* (1983), documented a Newcastle community about to be rehoused, conveying in memorable black-and-white images human warmth in bleak surroundings. Other books include *Letters to Katja* (1994), and studies of the partly untouched, partly post-industrial north-eastern coastline, *Writing in the Sand* (2000) and *The Coal Coast* (2003). RL

Koppitz, Rudolf (1884–1936), Austrian *pictorialist photographer and teacher, who studied and taught at Vienna's important Graphische Lehr- und Versuchsanstalt. During the First World War he served in aerial reconnaissance. His work, much of it using the *gum bichromate process, reflects his links with modern artists such as Gustav Klimt and Egon Schiele, involvement with the 'life reform' movement (nudism, sun culture, expressive dance) popular in Central Europe from the 1900s, and agrarian romanticism. The figures in his celebrated *Movement Study* (1926; a nude and three robed dancers) and the nude self-portrait *In the Bosom of Nature* (1923), in which the half-recumbent artist is framed by tree trunks, rocks, and snowy mountains, are posed to convey a dreamlike harmony reminiscent of Symbolist painting and graphic art. In Koppitz's lifetime his work was exhibited in Europe, America, and Japan. RL

Faber, M. (ed.), *Rudolf Koppitz, 1884–1936* (1995).

Korda, Alberto (Alberto Diaz Gutierrez; 1928–2001), Cuban photographer, celebrated for his picture of the Argentinian revolutionary Ernesto 'Che' Guevara, *Il guerrillero heroico*, taken on 5 March 1960. Korda was self-taught, and worked in fashion and advertising before covering the Cuban Revolution of 1958 (with a group of photographers including Osvaldo Salas, Raul Corrales, and 'Marucha' (María Eugenia) Haya) and joining the newspaper *Revolución*. Between 1959 and 1969 he was Fidel Castro's personal photographer, a position that did not prevent his studio being expropriated in the 1968 'ofensiva revolucionaria' against private business. In the 1970s he worked as an underwater photographer for government and scientific agencies.

In 1967, the year of Guevara's death, the Italian publisher Feltrinelli distributed Korda's *Che* photograph, which became an icon of student protest around the world, reproduced on T-shirts, mugs, and posters. The photographer earned little from this, but in 2000, in London, successfully asserted his copyright when the picture was used in a vodka advertisement. His early work had had a new lease of life outside Cuba as part of a more general 'discovery' of Cuban culture in the 1990s. AH

Alberto Korda: momenti della storia (1988).

Koudelka, Josef (b. 1938), Czech photographer, born in Boskovice. Koudelka studied aeronautical engineering at Prague's Technical University. In 1962, largely self-taught, he became photographer at the Divaldo Theatre, Prague, and from 1967 devoted himself solely to photography. During the 1960s he worked extensively in marginalized eastern Slovak gypsy communities (the work later won the Prix Nadar), but in 1968 he became internationally known—initially as the anonymous 'PP'—for his pictures of the Russian invasion of Prague. After winning the Robert Capa Gold Medal in 1969, he found asylum in England in 1970 and affiliated to *Magnum in 1971. In 1975 *Gypsies* was exhibited at MoMA, New York, and published by Aperture, establishing his reputation. Although in 1987 he became a citizen of France, where he lives, he still travels widely to work on projects, doing no commercial work.

Showing everyday life and rituals, particularly of nomads and exiles, Koudelka's black-and-white imagery is more humanist and theatrical than journalistic. His later work includes panoramic studies of man's destruction, especially powerful in the book *The Black Triangle* (1994), on open-cast ore mining in the western Czech Republic. RA

Kracauer, Siegfried (1889–1966), German cultural critic who emigrated to the USA in 1933 and pioneered the genre of sociological film criticism. Kracauer was Theodor Adorno's teacher and Walter *Benjamin's close associate, and so had links with the Frankfurt School. His early work writing feuilletons for the *Frankfurter Zeitung* allowed him to cover a wide range of topics while indulging his interest in sociology and philosophy. In these essays Kracauer celebrated everyday human experience, finding in the exploration of apparently superficial spheres of existence a means to transcend the emptiness of modern living. Modernity in his view is characterized by a spiritual deficit, a separation from the absolute. Photography can transcend this lack by recording and revealing physical reality, while at the same time underscoring its superficiality; thus the photograph reveals the modern world as a metaphysical void. The study of filmic realism for which Kracauer is known was a consideration of how the surface can reveal a loss of meaning, and from this understanding lead to a 'revelation of the negative'. MR

Kracauer, S., *The Mass Ornament* (1995).

Kraszna-Krausz, Andor (1904–89), Hungarian-born writer on film and photography, and major photographic publisher. After working in Germany as a film critic, and editing the journal *Filmtechnik* (1926–36), he emigrated to England in 1937. In 1938 he founded Focal Press, using it to enlighten amateurs and demystify photographic technology. It prospered with many times reissued classics like *The All-in-One Camera Book* and *The Focal Encyclopaedia of Photography*, and monographs on Victorian photographers. Later it also embraced cinematography and television, producing many handbooks for professionals. The Kraszna-Krausz Foundation, established in 1983, encourages work in the visual media. RL

Krims, Les (b. 1943), American photographer. Educated at Cooper Union and Pratt Institute, Krims has taught for most of his career at Buffalo State College. The small artist's books he published in the 1970s, sequential parodies of sex, violence, and American domesticity, spawned both outrage and admiration. The best-known include: *The Little People of America* (1972), *The Deerslayers* (1972), *The Incredible Case of the Stack o'Wheat Murders* (1972), *Fictcryptokrimsographs* (1975), and *Idiosyncratic Pictures* (1980). Later titles include *Bark Art*; *Art Bark (for Art Park)*; *Irving's Pens*; and a series entitled *The Decline of the Left*, a critique of the exclusivity and hypocrisy inherent in art 'movements' generally. TT

Green, J., *American Photography: A Critical History 1945 to the Present* (1984).

Krone, Hermann (1827–1916), German photographer and photo-chemist. The son of a Breslau lithographer, Krone studied philosophy and science at Breslau University, but also trained as a draughtsman and lithographer. Between 1848 and 1850 he worked part time at the Breslau observatory. He also studied photography and in 1852 opened a studio in Dresden. He first became known for portraits, then also for views of the Saxon landscape. His strong interest in photo-chemistry, astrophotography, and teaching enabled him, from 1870, to lecture at the Dresden Polytechnic. In 1874 he was invited to join an expedition to the Auckland Islands in the South Pacific to photograph the transit of Venus. He joined an expedition to Russia in 1887. His papers are held in the Krone Archive at Dresden Technical University. JJ

Hesse, W. (ed.), *Hermann Krone: Historisches Lehrmuseum für Photographie. Experiment. Kunst. Massenmedium* (1998).

Krull, Germaine (1897–1985), German photographer, trained at the Bavarian State Photography School in Munich (1916–18). She published a book on the nude in 1920, but in the course of a prolific and versatile career also produced portraits, reportage, advertising, and architectural work. In 1924 she settled in Paris, where she married the film-maker Joris Ivens, contributed to numerous illustrated magazines, and mingled with the photographic avant-garde. Her book *Metall* (1927), a collection of highly modernistic industrial and engineering images, identified her with contemporary *New Vision photography. She continued in this vein during the 1930s, but also did portraits, nudes, and *photoromans* based on the works of Georges Simenon. She was also a friend of André Malraux and a supporter of various left-wing causes. In the Second World War, after a spell in Brazil, she worked with the Free French movement in Brazzaville and covered the 1944 invasion of southern France. Much of her later life, after a period as a war photographer in Indo-China, was spent in Thailand and India. RL

Sichel, K., *Germaine Krull, Photographer of Modernity* (1999).

Kühn, Heinrich (1866–1944), German photographer and scientist, born in Dresden. He studied science and medicine in Leipzig and Freiburg, and mastered *microphotography in Berlin. In Innsbruck he did cell and tissue research and interested himself in applied photo-chemistry and -physics. From 1891 he worked intensively on optics. In 1896 he joined the Vienna Camera Club and with Hugo *Henneberg and Hans Watzek (1848–1903) formed the so-called *'Vienna Trifolium'. The three of them travelled to Italy, Germany, and Holland and distributed their work as gum prints, to considerable international acclaim. Kühn specialized in portraits and landscapes. In 1904 a visit from *Stieglitz in Innsbruck led to an extensive correspondence that lasted until 1931. From 1906 he experimented with Lumière *autochromes, and in 1914–15 ran a photoschool in Innsbruck. In the 1920s he dedicated himself mainly to writing and to experiments in photographic technology. JJ

Heinrich Kühn: Photographien (1988).

Kung Tai (Gong Tai), Chinese photographic studio perhaps already active in the Shanghai foreign concessions in the 1860s; it lasted into the 1890s, although whether all along with the same proprietor is unclear. Kung Tai was one of those early treaty-port Chinese studios which, while serving foreign customers, also established itself in the fledgling business of local portraiture. It dealt with gentry, and on one occasion the photographer was invited by a high official up the Yangtze River to visit and record his family, including the women. RT

Kuwabara, Kineo (b. 1913), Japanese photographer and editor. The son of a Tokyo pawnbroker, he began photographing with his Leica in the 1930s—primarily Tokyo—before being sent to Manchuria to document Japanese colonization. After the Second World War, he worked on several amateur photographic magazines as editor-in-chief, and on *Shashin Eizo* (*Photographic Image*) as photo critic. After viewing his negatives, Nobuyoshi *Araki became the driving force behind his first one-man show, *Tokyo, 1930–40: The Lost Metropolis* (1973). A retrospective collection of his work, *Tokyo 1934–1993*, appeared in 1995. Director of the Japan Photographic Association, and former president of the Japan Photo Critics' Association (1954–65), he continues to photograph Tokyo and teach. OH

Lacock Abbey, a former Augustinian nunnery founded in 1232, was the Wiltshire home of Henry *Talbot and the site of many of his early experiments in photography. Talbot inherited it on his father's death in 1800, when he was only 5 months of age, but did not take up residence there until 1827. Many changes had been made to the abbey by this time, and the only major alteration Talbot undertook was the addition of three bow, or 'oriel' windows along the south gallery in 1828–30. The middle one became the subject of his earliest extant photographic negative, made in August 1835, which he entitled *Latticed Window.

The abbey and the adjoining village of Lacock were held by Talbot's family until 1944, when his granddaughter, Matilda Talbot, donated the abbey and village to the National Trust. The Fox Talbot Museum is located in the abbey's grounds. RCW

Buckland, G., *Fox Talbot and the Invention of Photography* (1980).

Lacock Abbey, Latticed Window. See LATTICED WINDOW, LACOCK ABBEY.

Lambe Creek, near Truro, Cornwall. In June 1937 a group of artists, including Roland Penrose, Max Ernst (escaping personal and legal difficulties in London), Lee *Miller, Paul and Nusch Eluard, *Man Ray, the Belgian poet Edouard Mesens, and the British painter Eileen Agar, spent three weeks at Penrose's brother's house at this secluded spot off the Truro River; Henry Moore and his wife visited. It was probably the largest gathering of Surrealists ever held on British soil. The time was spent in carefree creative and erotic interaction, interspersed with trips to local beauty spots and to the Heron inn at nearby Malpas. The idyll was recorded in numerous very informal photographs, mostly by Penrose and Miller, now held by the Falmouth Art Gallery. RL

Penrose, A., *The Surrealists in Cornwall* (2004).

Lambert & Co., G. R., commercial photographers in Singapore, 1867–c.1914. Founded by the German-born Gustave Richard Lambert (b. 1846), the firm was by the end of the 19th century the largest and most successful studio in South-East Asia, maintaining branches at various times in Kuala Lumpur, Bangkok, and Sumatra. It was appointed photographer to the king of Siam in 1880 and was also extensively patronized by the British colonial authorities to record political occasions and official visits. Although Lambert's personal presence in Singapore was sporadic, under the management of Alexander Koch the studio assembled the most extensive photographic documentation of the area, with a catalogue of views covering almost the entire Malay Archipelago. The firm's work forms a particularly valuable historical record of the growth and developing topography of the colonial centres of Singapore and Kuala Lumpur. Its fortunes waned in the 1910s and it closed during the First World War. JF

Lamsweerde, Inez van (b. 1963), and **Matadin, Vinoodh** (b. 1961), Dutch photographer partners who have enjoyed both critical and commercial success. They won recognition for the 1993 series *Final Fantasy*, which seamlessly conflated the bodies of children with the features of adults, and their provocative, digitally manipulated photography, with its sophisticated interplay of glamour and horror, has been exhibited and published internationally ever since. Lamsweerde and Matadin have done editorial *fashion work for *The Face*, *Visionaire*, French *Vogue*, and *Harper's Bazaar*, and advertising campaigns for Calvin Klein, Yohji Yamamoto, and Balenciaga. PM

Inez van Lamsweerde, Photographs (1999).

Land, Edwin (1909–91), American scientist, inventor, and industrialist, born in Bridgeport, Connecticut. While studying physics at Harvard in the 1920s he became interested in the *polarization of light. He developed a new polarizing material, which he called Polaroid, and in 1937 formed the Polaroid Corporation with himself as president and head of research.

Land is best known for the invention of the Polaroid *instant photographic process, in which processing chemicals are incorporated in the photographic material and processing occurs immediately after picture taking, using a special camera. Land involved the Eastman Kodak Company in the production of Polaroid type 40 film that was introduced in 1948. It was a 'peel-apart' system that gave sepia-coloured prints. The Polacolor process, which gave a full colour print in 60 seconds, was introduced in 1963 and the SX-70 system, which was integral and did not require peeling apart, was introduced in 1972. CR

McElheny, V. K., *Insisting on the Impossible: The Life of Edwin Land* (1998).

landscape photography

Beginnings

Photographing the landscape is the most enduring activity in the history of the medium. More prints of picturesque ruins and leafy glades have been made, sold, and seen than those of any other genre. From photography's hesitant beginnings in 1835, when Henry *Talbot

placed his 'mousetrap' camera in the grounds of Lacock Abbey to record a group of trees against the skyline, landscape has appealed to photographers everywhere.

The attitude of the Victorians towards the landscape underwent a gradual change during the course of the century, most notably after 1851 when the census recorded for the first time that more people were living in cities and towns than in the countryside. This shift in the demographic balance altered perceptions of both environments. Cities were increasingly regarded as dangerous places to live, for both health and social reasons, while the countryside became identified with notions of freedom, cleanliness, spiritual redemption, and an intact social order. It was the leisured and financially independent members of society, who either lived in or had ready access to the rural landscape, who took to photography when it came to their attention.

In the 1840s and well into the 1850s two processes dominated photography. The *daguerreotype was the preferred choice of commercial portraiture, whilst the *calotype appealed to amateurs working in the landscape, for whom sharpness and crisp definition were the antithesis of artistic expression. The distinction between the two methods also reflected the social class of the photographer, for daguerreotypists were regarded as being in trade and those who used the calotype belonged to polite society, where education, leisure, and shared ideals allowed amateur practice to flourish. Its members could afford the relatively high cost of cameras, lenses, and chemicals and had the time to use them. For this group, landscape in its purest and simplest form, devoid of buildings and man's apparent intervention, occupied the high spiritual ground where the play of light over natural forms evoked the presence of God. Here, the soft texture of the calotype negative and the warm tones of the *salted-paper print invited quiet contemplation. However, the preferred subject for photographers of this early period were landscapes of association. These associations drew upon antiquarian, historical, or sometimes fanciful references, and most frequently related to abbeys, cathedrals, castles, and ruins whose picturesque outlines and ivied walls evoked a distant past. Better still were landscapes with literary associations where the narrative context of popular fiction, especially that of Sir Walter Scott, provided the imaginative prism through which the photograph would be understood. By adopting this approach, photographers were following in the well-established tradition of topographic artists whose accurate delineations of Britain's landscape were a well-recognized and popular genre.

These were the photographers who founded photographic societies throughout Britain during the 1850s with the express intention of advancing understanding and appreciation of the medium through regular meetings and *exhibitions. The role of the exhibition in promoting a lingua franca for landscape photography cannot be underestimated, as this type of work predominated. As the exhibition season fell in the winter months, photographers tended to work during the early summer and autumn when the light was at its most delicate and expressive. This annual cycle of summer production and winter exhibitions was an implicit feature of landscape photography well into the 20th century. Exhibitions reigned supreme and it was not uncommon for photographers to make duplicate prints and submit them to several venues, both in Britain and abroad, in the hope of gaining wider recognition and prizes.

Landscape photographs shown during the early 1850s were most frequently made using the calotype process or one of its variants. But as the decade progressed the shift to the *wet-plate process created a new aesthetic of eloquent tonality and finely rendered detail. The transition was gradual, and best understood through the work of photographers like Roger *Fenton, Francis *Bedford, and George Washington *Wilson, whose training as artists allowed them to move seamlessly between exhibiting and commercial activity. For others the gap proved too wide and their landscape studies are dull and lifeless representations that use light as the means of exposure rather than as the lively agent of description.

Realism to pictorialism

There were strong parallels, on both sides of the English Channel, between landscape photography and painting. Gustave *Le Gray's studies of trees in the Forest of Fontainebleau matched the predilection of realist painters for 'bits' of nature—trees, hedgerows, or corners of deserted farmyards—for their own sake and removed from any historical or narrative context. The same interest in apparently commonplace detail, now reproducible in all its precision by the wet-plate process, characterized the work of Edward Fox (*fl*. 1850s–80s), Henry White (1819–1903) and others in the 1850s—and the hyper-detailed early paintings of the *Pre-Raphaelite Brotherhood. As the *Athenaeum*'s photography critic wrote in 1856, 'Exactitude is the tendency of the age.' In the 1870s and 1880s, naturalism (or *plein-airisme*) was practised by both photographers and painters (some of whom used the camera to create preliminary studies). And the neo-romantic landscapes of the *fin-de-siècle*, with their simplifying, monumentalizing treatment of peasants and the rural scene, had their exact counterparts in the work of continental *pictorialists like Hugo *Henneberg and the *Hofmeister brothers.

In the meantime, middle-class demand for landscape and topographical views seemed insatiable. It was fired initially by the appeal of the stereoscope with its three-dimensional peep into distant vistas and exotic realms. This fashion was supplanted by the marketing of loose prints (or 'view scraps') as photographic souvenirs of travel for mounting into albums. The publication of photographic views of whatever type or subject matter was directly linked to the parallel growth of *tourism, which saw increasing numbers escaping the cities and towns in search of picturesque beauty and sublime experience, armed with little more than a Murray's handbook and a pair of stout shoes. Some of the leading photographic publishers, such as Wilson, *Frith, *Valentine, and the London Stereoscopic Co. were large-scale enterprises that issued tens of thousands of prints annually. They could be bought everywhere, from printsellers, stationers, booksellers, dealers in fancy goods and tourist souvenirs, railway bookstalls, hotels, and even aboard the pleasure steamers that plied the coastal routes.

Nor was this type of operation limited to Britain, as photographers throughout Europe, most notably in France and Italy, tapped into the market. For the *Alinari brothers of Florence, and probably for many of their counterparts in other new European states, making and publishing views was not only a commercial enterprise but a patriotic one, assembling and popularizing the elements of a national topography.

View publishing underwent a number of transitions, most associated with the size and presentation of the finished print, but nevertheless it was a business that endured into the 20th century, when the market for photographic *postcards took over. Until then, countless millions of *albumen prints were published and bought to join the trappings of gentility that furnished every respectable parlour.

In the closing decades of the 19th century, photographers again began to search for photography's aesthetic, and debates about 'truth' and realism once more ran through the photographic societies. Among the leading advocates in England were George *Davison, Peter Henry *Emerson, Alvin Langdon *Coburn, and Alfred *Horsley Hinton, whose writings and exhibited work realigned photography with artistic principles. Their prints were elaborate confections that owed more to the intervention of gum, pigments, and handwork than photography itself. By the end of the century the wheel of taste and opinion had turned full circle, from the impressionistic results of paper negatives through the period of wet-collodion objectivity to pictorialism. Paradoxically, it was this group which 'rediscovered' the work of the early amateurs, appropriating many of the original processes to their own purposes and ideals. (It was significant that in Hamburg, one of the major centres of continental pictorialism, an exhibition of Julia Margaret *Cameron's work was held in 1898.) The notion of rediscovery and appropriation continued to underpin landscape photography throughout the 20th century as generation after generation redefined its relationship to the countryside. **RTA**

See also AMERICAN WEST, PHOTOGRAPHY AND THE.

Brettell, R., et al., *Paper and Light: The Calotype in France and Great Britain, 1839–1870* (1984).

Seiberling, G., *Amateurs, Photography and the Mid-Victorian Imagination* (1986).

Kaufhold, E., *Bilder des Übergangs: Zur Mediengeschichte von Fotografie und Malerei in Deutschland um 1900* (1986).

Taylor, R., *Photographs Exhibited in Britain 1839–1865* (2002).

Modernism and the landscape

The First World War was a cultural as well as a political, social, and economic watershed. The 'high' machine age had arrived, and with it a new non-deferential, democratic era that swept away traditions in favour of progress. *Modernism had a profound effect on photography, and progress transformed the landscape. Landscape photographers began to move away from painterly effects created by soft-focus lenses and manipulation of the negative or print. They sought once again to exploit the medium's ability to render fine detail, and to reveal the subtleties of tonal gradation in monochrome prints. For them, this *'straight' approach was what made photography unique. Although it had its antecedents in the topographical photography of the 19th century, it was seen as distinctively modern and in tune with the European New Objectivity movement that was to influence West Coast American photographers led by Edward *Weston, Imogen *Cunningham, and Ansel *Adams. Landscape and nature were their principal motifs and they eventually formed the *Group f.64, which produced exquisitely crafted prints that transformed the subject into a specifically photographic aesthetic experience rather than simply a record of what was in front of the camera.

However, it would be a mistake to believe that pictorialism and its legions of proponents of the pastoral idyll had been simply ousted by this modernist precisionism. Far from it: the style remained popular amongst most landscapists and dominated photographic salons and camera clubs, mainstream collections like that of the *Royal Photographic Society, and publications like *Amateur Photographer* and *Photograms of the Year* until the 1950s.

Metaphor and transcendentalism

After 1920 many landscape photographers also sought to reflect the expressive potential in details abstracted from the larger view. The metaphorical possibilities of this mode of photographic seeing were heightened by making the resultant print an object of contemplation rather than a mirror held up to nature.

A towering figure of this era was Alfred *Stieglitz, who as a gallery owner in New York played a major role in introducing modernism to the USA, and as a photographer, like his friends Paul *Strand and Edward *Steichen, discarded the manipulations of the *Photo-Secessionists. Using straightforward techniques, he photographed clouds, trees, and grasses to evoke experiences and feelings in a manner comparable to music. It was a more subjective and meditative approach to photographing the landscape, and though these so-called *Equivalents* only captured the imagination of a few photographers and museum curators at the time, Stieglitz's influence was long lasting and profound, and later passed on by Minor *White and Paul *Caponigro in particular. Their contributions can be associated with the rise of Western interest in oriental religions, philosophies, and meditation movements in the 1960s. British-based photographers influenced by this philosophical and subjective approach included Raymond *Moore, Thomas J. *Cooper, and John *Blakemore.

Ansel Adams refined the appeal of the landscape genre through his monographs and technical handbooks. But it was the combined associations, in his awesome images of the American West and other wilderness regions, of nature mysticism and conservationism that made it a mass-market commodity. Adams was one of the first photographers ultimately to be able to live from sales of his prints. By the 1970s the finely crafted landscape print had become a collectable art object and the best examples were eagerly acquired by museums, exhibited in newly created photographic galleries, and sold through established auction houses at prices that photographers could only have dreamed of a few years earlier. The Ansel Adams 'industry' played

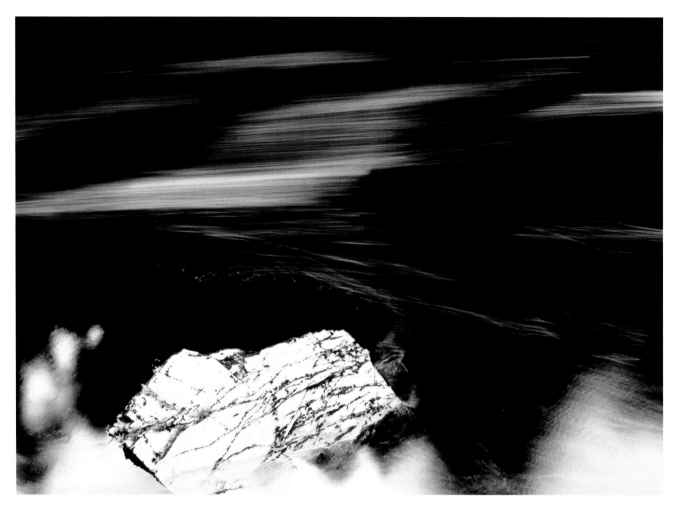

Thomas J. Cooper

Diamond Rock, the River Findhorn, Morayshire, Scotland, 1997

a major role in popularizing landscape photography and the buying of photographs for domestic as well as public display.

For some, however, there was an innate conservatism in the fully tonal 'fine'-print approach. European photographers such as Bill *Brandt, Hugo van *Wadenoyen, and Otto *Steinert preferred their landscape photographs to have more dramatic contrast between tones and a greater degree of formalism in their composition.

New Topographics

As photography's cultural prominence increased in the last quarter of the 20th century, more and more practitioners began to question the accepted parameters of the landscape genre. They did not wish to evoke the monumental, the mysterious, or the metaphoric in their photographs, preferring a less obviously expressive mode. Labelled the *'New Topographics' movement (from a 1975 exhibition at the *International Museum of Photography, George Eastman House), its advocates in the USA and Europe presented undramatic views

that tended to concentrate on content rather than form or mood. Mankind's effect on the land was more relevant to them than evocations of pastoral bliss or the wonders and mysteries of nature. Notwithstanding echoes of the survey photography of the 19th century, the photographs were more than mere records. They offered a subtle critique of insensitive building and land use that did not overtly direct the viewer to a specific point of view. The polemic was 'cool' and understated, like their tonally muted prints.

Colour

The technical advances in colour photography after the Second World War had a massive impact on landscape photography. The majority of photographers, particularly amateurs, wanted accurate, colourful representations of what they saw in nature and the countryside; 35 mm colour reversal film became universally available and the world, as mediated through sitting-room slide shows and publications like *National Geographic, became exuberantly polychromatic. Colour

printing was initially much more problematic, but the improved dye-incorporation method for films and papers eventually made colour almost as user friendly as black-and-white. The beginning of the 21st century has seen *digital technology and ink-jet printing almost eliminate the conventional colour darkroom whilst offering colourists new creative opportunities .

Art and politics

Although these advances converted many landscape photographers to colour, there were other impulses too. These had more to do with shifts in contemporary culture and politics, and the emergence of the colour photographic print as the preferred medium of the fine artist. Contemporary landscape photographers now make work largely for an art gallery audience. They also undertake well-researched thematic projects which are ideologically or geographically specific rather than producing a mélange of their 'greatest hits'. Grants and sponsorship have brought exhibitions and publications of landscape work to a wide public. The range of outlets for the dissemination of work has offered photographers engaged with environmental issues and the politics of the countryside platforms for their ideas and beliefs.

Opportunities to comment critically on the effects of industrialization, ownership and access, commodification of heritage, and even concerns relating to race, class, and gender have been taken up by photographers who live in a post-industrial, postmodern world that would have seemed unimaginable in 1920. Photographers like Robert *Adams, Keith Arnatt, John Davies, Fay *Godwin, John Kippin, Karen *Knorr, Ingrid Pollard, Richard *Misrach, and Jem *Southam, for example, reflect the diversity of ideologies and styles—from descriptive documentary forms, ironic juxtapositions, and revealing narratives to the application of culturally and politically resonant text to images— that have become the photographic currency of today. PHI

Haworth-Booth, M., *The Land: Twentieth-Century Landscape Photographs* (1975).

Di Grappa, C. (ed.), *Landscape: Theory* (1980).

Jussim, E., and Lindquist-Cock, E., *Landscape as Photograph* (1985).

Waite, C., *The Making of Landscape Photographs* (1993).

Taylor, J., *A Dream of England* (1994).

Andrews, M., *Landscape and Western Art* (1999).

Fehily, C., Newton, K., and Wells, C., *Shifting Horizons* (2000).

Hammond, A., *Ansel Adams: Divine Performance* (2002).

Lange, Dorothea (1895–1965), American *documentary photographer, who studied photography at Columbia University and worked as an assistant to Arnold *Genthe before beginning a photographic trip around the world in 1918. When she ran out of funds in San Francisco, she remained, opened a photographic studio, and during the early 1930s began photographing homeless rural people flooding into the city from the Dust Bowl exodus. Her photographs brought her to the attention of Paul Taylor, an economist at California University, who hired her to create a documentary record to accompany his report on agricultural conditions for the California State Relief Administration, and subsequently married her. When Roy *Stryker saw these images, he hired her as a staff photographer for the Farm Security Administration (FSA), for which she worked sporadically as Stryker's budget allowed 1935–9. During this period, she made many of her best-known photographs, including the image known as *Migrant Mother* (1936). She later also photographed for the San Francisco branch of the Office of War Information, 1943–5, recording the internment of Japanese-Americans and the founding of the United Nations. In 1954–5 she was a photographer for *Life* magazine, afterwards travelling extensively and producing photographic essays on Ireland, Egypt, and Asia. CBS

Meltzer, M., and Lange, D., *Dorothea Lange: A Photographer's Life* (2000).

Borhan, P., *Dorothea Lange: The Heart and Mind of a Photographer* (2002).

Langenheim, William (1807–74) and **Frederick** (1809–79), German-born American photographers, amongst the most respected daguerreotypists of the 1840s, operating studios in Philadelphia and New York. William emigrated from Brunswick in 1834, settling first in Texas, where he fought in the Texas War. In 1840 he settled in Philadelphia, only to find that his brother Frederick had arrived just previously. A German brother-in-law sent them a *Voigtländer camera and instructions on the *daguerreotype process, which they soon mastered. Voigtländer in 1845 also married into the family, and the Langenheims became his representatives in America, promoting and selling his lenses. They maintained other links with Europe and in 1845 produced eight copies of a five-plate panorama of Niagara Falls, sending examples to *Daguerre, Queen Victoria, the kings of Bavaria and Prussia, and other notables, receiving praise from all. The brothers experimented widely in photographic processes, first in 1849 with *Talbot's *calotype process, an experiment that proved financially disastrous; then with their own hyalotype process, patented in 1850, which allowed images to be produced on glass for lantern-slide projectors. RW

'W. and F. Langenheim—Photographers', *Pennsylvania Arts and Sciences*, 11 (1937).

Brey, W., 'The Langenheims of Philadelphia', *Stereo World*, 6 (1979).

lantern slides. See PROJECTION OF THE PHOTOGRAPHIC IMAGE.

Lartigue, Jacques-Henri (1894–1986), French photographer. Photography's best-known child prodigy, Lartigue caused a sensation in 1963 when MoMA, New York, unveiled a selection of his early photographs. These comprised stop-action images of aeroplanes, sporting events, and fashionable women in the Bois de Boulogne, most taken during the 1910s. Concurrently, *Life* magazine published a body of Lartigue's work, broadening his fame. Despite his controversial status as an untrained amateur, Lartigue's reputation crystallized through a series of books and exhibitions, notably *Boyhood Photographs of Jacques-Henri Lartigue: The Family Album of a Gilded Age* (1966); *Diary of a Century*, with an afterword by Richard *Avedon, in 1970; and 'Lartigue 8 × 80', his first Paris retrospective, held at the Musée des Arts Décoratifs in 1975. In 1979

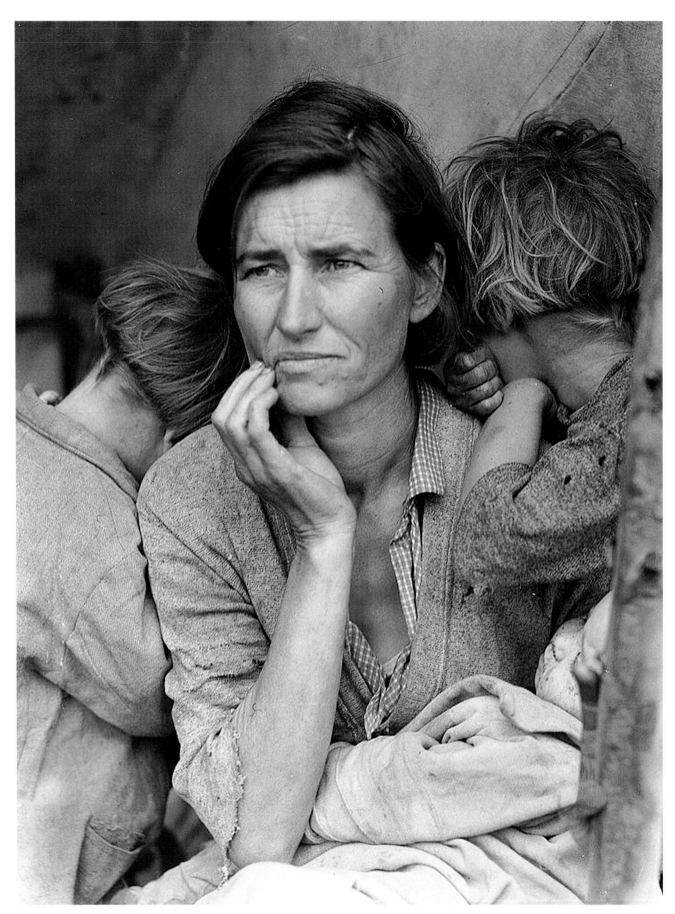

Dorothea Lange

Migrant Mother (Prairie Mother), 1936

Jacques-Henri Lartigue
Lartigue's cousin Simone Roussel
at Rouzat, 16 September 1913

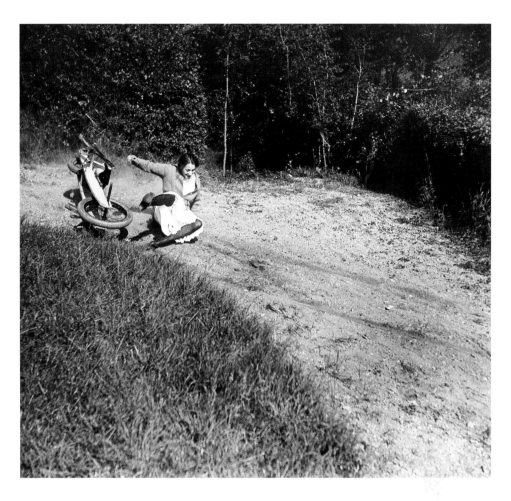

Lartigue made an enormous gift of albums, negatives, diaries, and paintings to the French state.

Lartigue's photographic production might be divided into three phases. In 1902, aged 8, he began photographing under the tutelage of his father, a successful engineer, financier, and serious amateur photographer. Lartigue's early photographs, made with a variety of cameras, depict leisure activities in Paris, and at the family's summer home in Rouzat. These photographs, often indistinguishable from those of Lartigue's father, show a range of technical and aesthetic accomplishment. Lartigue entered a second phase in 1910 when, at 16, he began emulating the work of photo-reporters. His sports and fashion photographs, taken during the 1910s, are preoccupied with the same kind of instantaneity and social wit disseminated by magazines like *La Vie au grand air*, *Je sais tout*, and *Fémina*, which Lartigue read assiduously. He had numerous photographs published during this period, the first of which, of an aeroplane over Paris, appeared as a frontispiece in *La Vie au grand air* in 1912. During the mid-1910s, Lartigue moved into a third phase, photographing as a sideline to other artistic pursuits. Starting in 1913, he began making short films with a cinematograph. In 1915 he studied painting at the Académie Julian, leading to a moderately successful art career.

Lartigue's photographs began to appear in *Point de vue*, the French illustrated weekly, during the mid-1950s, but received no critical attention. Their impact in the USA, however, where an art photography movement was blossoming, was more favourable. Full of movement and social humour, Lartigue's photographs struck American viewers as the intuitive creation of an untrained eye. John *Szarkowski, curator of the MoMA exhibition, described Lartigue as a 'true primitive', and argued that Lartigue had unwittingly discovered the essence of modern photography: to compose pictures out of the flux of life. This modernist assessment drew Lartigue into the company of other well-known hand-held camera practitioners, namely Henri *Cartier-Bresson and Garry *Winogrand. Equally important, Lartigue has been loosely classified as an amateur, a photographer without extensive training who photographed for the love of it. These views reflect the general lack of understanding of the diversity of photographic practice *c.*1900. KM

Szarkowski, J., *The Photographs of Jacques Henri Lartigue* (1963).
Rice, S., 'Remembrance of Images past', *Art in America*, 80 (1992).
d'Astier, M., Bajac, Q., and Sayag, A. (eds.), *Lartigue: l'album d'une vie, 1894–1986* (2003).
Moore, K., *Jacques-Henri Lartigue: The Invention of an Artist* (2004).

latent image, an invisible picture formed by a brief exposure to light, and which can be subsequently amplified into a full-strength image. Henry *Talbot's first process of *photogenic drawing produced a visible image directly in the camera or printing frame. Termed a printout process, this approach relied totally on solar energy to reduce the light-sensitive silver halide to the metallic silver that formed a visible image. While producing the gratification of a visible picture, the inescapable consequence was very long exposure times. In the competing early process, the *daguerreotype, a brief exposure in the camera produced a barely visible effect on the silver iodide, and fuming with mercury brought the image to full strength. It is not at all clear that *Daguerre understood the implications of this, but Talbot certainly did when in September 1840 he noticed an anomalous behaviour in one of his papers. Rapidly tracing its roots, he deduced that the addition of gallic acid allowed him to use a brief exposure to form a latent image. This invisible recording of the various intensities of light comprising the scene could then be converted into a full-strength visible image by development in a solution of gallic acid and silver nitrate. He named this new negative process the *'Calotype' (loyal friends called it the Talbotype) and wrote in the *Literary Gazette*, 'I know of few things in the range of science more surprising than the gradual appearance of the picture on the blank sheet, especially the first time the experiment is witnessed' (19 February 1841). Anyone who has entered a darkroom and developed a print in an open tray will readily understand this sense of magic. Talbot had discovered for himself 'physical development', where the liquid developer donated silver for the image, and this amplified the effect of the exposure by a factor of 100. Other approaches, curiously including light itself, can be used, but most modern developers exploit 'chemical development', where the silver available in the sensitive coating is utilized. Continuing research has improved the practical aspects of this to the point where the factor of amplification can be in the millions. But amidst the competing theories, the underlying mechanism of the latent image is nearly as much a mystery to present-day scientists as it was to Talbot. LJS

Barger, S., and White, W. B., *The Daguerreotype: Nineteenth-Century Technology and Modern Science* (1991).

Schaaf, L. J., *Out of the Shadows: Herschel, Talbot and the Invention of Photography* (1992).

latitude, exposure. For a given film, this represents the range of exposures that will produce an acceptable final image. It is usually expressed in *stop values, but sometimes as a ratio or a log-exposure range. For example, a ratio of 8 : 1 = a log-exposure range of 0.9 = 3 stops. Latitude is less for high-contrast subject matter and for slow emulsions. It is much less for colour transparencies than for colour negatives. GS

Jacobson, R. E., et al., *The Manual of Photography* (9th edn. 2000).

Latticed Window, Lacock Abbey, August 1835. In his *Pencil of Nature* (1844), Henry *Talbot observed that whatever history might think of later advances, nothing could 'admit of a comparison with the value of the first and original idea'. This iconic *photogenic drawing negative of the oriel window at Lacock Abbey, a celebration of the act of seeing and recording, is the most potent symbol we have of that first

Henry Talbot

Latticed window, Lacock Abbey, August 1835

and original idea. It was not the first camera negative that he achieved, nor is it completely alone as a survivor of the pre-1839, pre-public period. But the fusion of Talbot's lilliputian image with his own handwriting has made it a powerful and, indeed, the pre-eminent symbol of his quest to master light. The labelling was almost certainly done for the occasion of Talbot's first public exhibition of his photographs, on 25 January 1839 at the Royal Institution in London. LJS

Schaaf, L. J., *Out of the Shadows: Herschel, Talbot and the Invention of Photography* (1992).

Laughlin, Clarence John (1905–85). A New Orleans writer and poet influenced by French Symbolism and *Surrealism, Laughlin took up photography in 1934. Haunting early images of ante-bellum architecture became signature works: *Ghosts along the Mississippi* (1948) was reprinted more than twenty times. Laughlin worked as an architectural photographer, and published and exhibited widely: his fantastical montages were particularly influential in the 1960s. He lectured on American 19th-century architecture and photography, latterly at the University of Louisiana, to which he donated his photographic archives in 1970. He gave up photography in 1967 and focused on writing. HWK

law and photography. Generally speaking, the body of law specifically relating to photography in Western legal systems is small. However, as photography is an everyday pursuit, it is covered by the many and wide-ranging civil and criminal laws which govern society in general, e.g. libel, obscenity, and employment law.

The legal framework for both amateur and professional practice is the same. It is in fact the application of general law to a specific activity—photography. Photographers clearly operate within society and, in so doing, have duties and responsibilities as others do. Photographic practice is therefore mainly regulated by the general laws of the country or state in which the practice is taking place, rather than by specific laws enacted to control photographers and photographic practice.

There is an ongoing movement to harmonize some areas of law across the European Union, e.g. copyright and employment. In general, however, custom and practice need to be considered separately in each country, especially where photography is taking place in socially or politically charged circumstances. Even in the UK, where press freedom is firmly established, photographers have often collided with authorities such as the police, and the civil or criminal law has been used to restrict photographers' freedom to work unhindered, e.g. at public demonstrations or on private property.

Although there are areas of law common to many legal systems, the nuances of national law are important, and too complex to be discussed here in any detail. The following can therefore only be an introduction to a few issues of obvious relevance to photography, namely the protection of the photographer's property rights in a work (copyright); the protection of person(s) who may be the subject(s) of a work (privacy); and the more general protection of society (obscenity, child protection).

Today, *copyright* law in the UK is governed by the 1988 Copyright, Designs, and Patents Act (CDPA), relating to images made from 1988 onwards, and the 1956 Copyright, Designs, and Patents Act, for those created prior to 1988. Whilst there is similarity between the two Acts, the 1988 Act extended the rights of photographers in line with those enjoyed by other artists, such as authors, painters, and sculptors. The 1988 CDPA describes a photograph as 'a recording of light or other radiation on any medium on which an image is produced or from which an image may by any means be produced, and which is not part of a film'. The phrase 'irrespective of artistic quality' also appears in the CDPA, which is important because a copyright is maintained whatever the quality of the photograph. In addition to many general provisions, the CDPA also covers areas which are specific to photography: photographers in employment, commissioned photography, ownership of negatives, copyright protection, duration of copyright, assignment of copyright, moral rights, false attribution, rights to privacy, copyright infringement, etc.

In the USA, copyright is defined by the 1976 Copyright Act and awards a similar level of protection to 'artistic works' as in the UK. The duration of copyright of photographic or other artistic work in the USA is 70 years from the death of the creator of the work. Due to European harmonization, from 1996 all countries of the EU also have a duration of copyright of 70 years (retrospective for works made between 1989 and 1996).

Because of the excesses of some elements of the media and the unethical behaviour of a few photographers, *privacy* is an ongoing subject of debate in Britain, with high-profile cases (usually involving tabloid newspapers) fought out expensively in the courts. This is because, at present, the UK does not have specific laws preventing the taking of photographs that infringe a person's privacy. Whatever the future may hold in this regard, for example as a consequence of rulings by the European Court of Human Rights, photographers should be aware that there are other laws that may be applied to control the acquisition and use of photographic images. This could include the laws of trespass, libel, and breach of confidence. However, there is no British equivalent to American rights of privacy and publicity.

In the USA, whilst copyright is protected by federal law, privacy and publicity rights are subject to individual state law. While some states have such legislation, others do not. California has some of the strictest privacy laws in America, enacted in 1999 after lobbying by a group of privacy-conscious Hollywood actors.

Even before the debates following the role of *paparazzi* in the death of Diana, princess of Wales, in Paris in 1997, France was reputedly one of Europe's most difficult environments for photography. The law of 17 July 1970 had been framed in draconian terms to protect the individual's privacy, forbidding unauthorized photography, even for private purposes, of any person, however well known, in public or private, singly or in a group, or even of their animals or other property. Particularly since the 1990s the law has been applied so rigorously that photographers, especially photojournalists, have protested strongly at its implications. A special organization, L'Observatoire de l'image,

backed by photographers and other media professionals, now exists to monitor developments and lobby for change. Not only celebrities but many ordinary individuals have used the 1970 law to protect their privacy. The work of humanist documentary photographers such as *Cartier-Bresson, *Doisneau, and *Ronis, many of whose photographs depicted anonymous people in the street, would probably be impossible today without the risk of legal action. Indeed, both Doisneau (for the 1952 *Kiss at the Hôtel de Ville*) and Ronis (for an even older picture of a Parisian flower seller) eventually found themselves in court.

Over the years there has been a shift in what is considered to be *obscene*, in line with larger changes in culture and social mores. However, the notion of obscenity is subjective, creating perennial problems of definition for legislators, the police, and other agencies. In a global media environment, the fact that standards of tolerance vary from country to country (and often within countries) adds to the complexity. In the last resort, especially where there is a defence of artistic merit, boundaries may have to be established in court. Since the late 20th century, the publicity surrounding child abuse, combined with the spread of the *Internet, has heightened concern about indecent pictures of children. In the UK, the 1959 Obscene Publications Acts and the 1978 Protection of Children Act (extended by the 1994 Criminal Justice Act to include not only photographs but 'pseudo-photographs' produced by image manipulation software) deal with this sensitive area of image making. Today, as in the past with *nude or *erotic photographs of adults, pictures of children involve complex problems of moral and legal judgement, and troublesome issues such as the borderline between art and pornography, the status of private family photographs, and the immunity or otherwise of materials in museums or university libraries. DM

Gross, L., Katz, J. S., and Ruby, J., *Image Ethics: The Moral Rights of Subjects in Photographs, Film, and Television* (1988).
Berkeley, A., *Focal Guide to Photography and the Law* (1993).
Almasy, P., 'Le Photojournaliste et la loi', in P. Almasy et al., *Le Photojournalisme: informer en écrivant des photos* (1993).
Cassell, D., *The Photographer and the Law* (1997).
The ABCD of UK Photographic Copyright (1999).
Rozenberg, J., *Privacy and the Press* (2004).

Lawton, Joseph (d. 1872), British commercial photographer active in Sri Lanka, *c*.1866–72. Originally employed by a commercial agency in Sri Lanka, by the mid-1860s Lawton had established himself independently in Kandy. Although overshadowed by the quantity of surviving photographs by his contemporary *Skeen & Co., Lawton produced a comparably fine body of work documenting the landscape and agricultural products of the island's interior. His most important work, however, remains his extensive photographic documentation (1870–1) of the archaeological sites of Anuradhapura, Mihintale, Polonnaruwa, and Sigiriya, a project commissioned by the government Committee on Ancient Architecture and characterized by a sensitive blending of aesthetic and documentary elements. JF

Lee, Russell (1903–86), American documentary photographer. After graduating in chemical engineering in 1925 he worked in industry until 1929, when he began to attend the California School of Fine Arts, then joined an art community in Woodstock, New York. He bought his first camera in 1935. Hearing of the photographic work of the Farm Security Administration (FSA), he travelled to Washington, DC, to meet FSA director Roy *Stryker in 1936, who hired him and sent him on the road for most of the next six years. His most famous FSA photographs are of Pie Town, New Mexico; he also pioneered photographic work in the black districts of Chicago. After war service in the army he worked occasionally for Stryker for the *Standard Oil of New Jersey and Pittsburgh Photographic Library projects. He began teaching in the University of Missouri Photo Workshop in 1948, becoming its director in 1953; in 1965 he joined Texas University's Department of Fine Arts. CBS

O'Neal, H., *A Vision Shared: A Classic Portrait of America and its People, 1935–1943* (1976).
Hurley, F. J., *Russell Lee, Photographer* (1978).

Legrand, Louis (*c*.1820–?), Frenchman (Chinese name Ligelang) who opened a clockmaking and photographic business in Shanghai in August 1857. It was China's first 'permanent' photographic studio, as Hong Kong did not have one until 1860. Legrand apparently abandoned his studio in or after 1859, but continued a trading business in Shanghai. His set of 78 *stereographs of Shanghai was the earliest commercial photographic vision of the city to reach Europe. RT

'La Chine au stéréoscope', *La Lumière* (24 Mar. 1860).

Le Gray, Gustave (1820–84), major mid-19th-century French photographer. Planning originally to be a painter, he frequented the studio of Paul Delaroche, where he met Henri *Le Secq and Charles *Nègre. He evidently took up photography in Rome (1844–7). But it was after his return to Paris that he became committed to it, practising the *daguerreotype and, above all, from 1848, the *calotype, which *Blanquart-Évrard was then trying to popularize in France. He worked with Olivier Mestral and Le Secq, and attracted the attention of Léon de Laborde, a curator at the Louvre, who introduced him to official and artistic circles. In 1850–1 Le Gray pioneered two major innovations: *waxing photographic paper before sensitization, and—it seems independently of Bingham and *Archer—using *collodion on glass. These researches, published in four works 1850–4, and Le Gray's mastery of photographic technique, made him a leader of the young generation of French calotypists. In 1849 he opened a studio, where he did his own work, executed commissions, and gave lessons. His pupils included Maxime *Du Camp, Léon de Laborde, the *Aguado brothers, Adrien Tournachon, and John Beasley *Greene. In 1851 he was one of the five photographers chosen for the *Mission Héliographique, and on a three-month journey through Touraine and Aquitaine experimented with the waxed-paper technique, making over 600 negatives.

Joseph Lawton

Rambodde waterfall and rest house, Ceylon, *c*.1870. Albumen print

Le Gray distinguished himself especially by the care he took with his *salted-paper prints, using a personal technique to create an infinite variety of nuances. He co-founded the *Société Héliographique in 1851, then the *Société Française de Photographie in 1854. He did portraits, landscapes (views of Fontainebleau), architecture, and urban scenes. From 1855 he ran a large studio on the Boulevard des Capucines, supported financially by the de Briges family. This meant accepting commercial constraints that he had hitherto avoided, favouring *wet-plate photography, and attempting to reconcile the demands of art and productivity. His acclaimed seascapes, done between 1856 and 1858 on the Norman, Breton, and Mediterranean coasts, combined technical virtuosity (instantaneity, combination printing) with beauty of composition. He also made portraits of the empress (1856), a reportage on the new military camp at Châlons-sur-Marne (1857), tree studies near Fontainebleau, romantic views of Paris (1859), and numerous studio portraits (Victor Cousin, Alexandre Dumas).

In 1860, financial and personal difficulties forced him to leave Paris on a Mediterranean cruise with Dumas. He made calotypes of the aftermath of Garibaldi's capture of Palermo (June–July 1860) that

Gustave Le Gray

The Great Wave, Sète, 1857.
Albumen print

appeared as engravings in the French press. After quarrelling with
Dumas he travelled to Lebanon (views of Beirut, the ruins of Baalbek),
then Alexandria, where he executed commissions for rich travellers like
the comte de Chambord and the prince of Wales. In 1864 he settled in
Cairo, becoming drawing master of the children of Khedive Ismail
Pasha, and in state military schools. Commissions from the khedive in
1866 (camels loaded with military equipment) and 1867 (a trip up the
Nile with the khedive's sons) enabled him to create works exceptional
in their quantity, inventiveness, and subtlety. By the late 1860s Le Gray
was forgotten in France; the importance of his work, and his visionary
belief in the future of photography, did not begin to be appreciated
until the 1980s. SA

Janis, E. P., *The Photography of Gustave Le Gray* (1987).
Aubenas, S., et al., *Gustave Le Gray: 1820–1884* (2002).

Leibovitz, Annie (b. 1949), American photographer. In the early
1970s, while studying at the San Francisco Art Institute, she began
working for *Rolling Stone*, becoming chief photographer in 1973 and
winning fame with tour coverage of bands like the Rolling Stones
(1975). In 1983 she joined *Vanity Fair*, specializing in stylish,
meticulously planned celebrity portraits. A cover picture of the actress
Demi Moore, nude and pregnant (1991), was sensational. *Iconic,
however, had been her portrait of Yoko Ono and John Lennon shortly
before Lennon's murder in 1980. In 1999 she published *Women*, a

collection of 170 American female portraits, mostly of non-celebrities,
with an introduction by Susan *Sontag. RL

Annie Leibovitz: Photographs 1970–1990 (1991).

Leica I–III models. The Leica was not the first 35 mm still camera
but it was the first commercially successful one, with a basic design
still recognizable into the 1960s with the Leica IIIg (1957). The first
radical redesign took place in 1954 with the introduction of the Leica
M3 with its new body design and bayonet-fitting lenses.

The Leica benefited from a number of factors. The lenses designed
by Max Berek were of good quality, essential for use with 35 mm
negatives, then considered 'miniature'. Photographic emulsions were
increasingly sensitive, with a reduction of grain and defects that
allowed enlargements to be made with little loss of quality. Oskar
*Barnack's camera was small, portable, and well made, appealing to
photographers used to heavy, cumbersome plate and roll-film cameras.
Last but not least, the huge demand for news and lifestyle pictures by
the contemporary illustrated press put compactness and versatility
at a premium.

Ernst *Leitz's Leica I (or Model A) was introduced in 1925 with a
fixed 50 mm Anastigmat lens that was replaced by an Elmax and then
Elmar lens, which remains the standard Leitz lens today. The camera
was immediately successful, with almost 1,000 being sold in the first
year and nearly 59,000 examples made up to 1932. Interchangeable

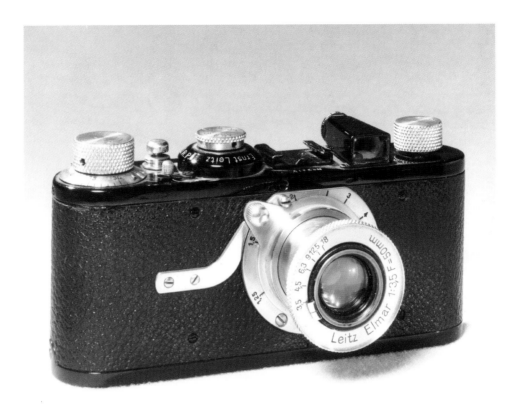

lenses were introduced with the model I(c) of 1930. The Leica II of 1932 incorporated a coupled rangefinder into the body housing for precise focusing and the Leica III of 1933 added slow shutter speeds down to one second. With the new cameras a range of accessories and lenses were also issued that added to the functionality of the camera. By the time production of the Leica III ceased in 1939 over 220,000 examples of these models had been made and the lenses ranged from the wide-angle 28 mm Hektor to the telephoto 400 mm Telyt. Alongside these were specialized viewfinders, copying attachments, stereo, and other camera bodies with further refinements.　　MP

Rogliatti, G., *Leica: The First Fifty Years* (1975).

Leica versus Contax. Between the 1930s and 1960s arguments raged between supporters of the two top 35 mm cameras—Leica and Contax. Both attained their mature form *c.*1950, but the debate began much earlier. *Leitz was the first to produce a precision 35 mm camera, designed in 1913 though only marketed in 1925; and when *Zeiss Ikon followed a few years later (the Contax was introduced in 1932, with an improved model in 1934), they needed to bypass Leitz's patents. This sometimes resulted in improvements; and in the early days the Contax lenses were certainly superior. In place of the Leica's horizontally moving fabric shutter the Contax had a vertically moving metal shutter resembling a roll-top desk cover. A sliding pair of cylindrical lenses with a high mechanical advantage replaced the comparatively crude cam-operated rangefinder mechanism of the Leica. The Contax also

introduced a removable back and reloadable cassettes that closed when the back was unlocked. But these and other devices made the Contax system more complex and difficult to repair; the shutter was particularly delicate. In contrast the Leica had to be engineered to tighter tolerances, but was easier to strip and repair; it was also lighter.

Late versions of the two cameras, the Leica IIIf (1950) and Contax IIIa, were marketed in the early 1950s, by which time their basic design had reached its limit. Zeiss turned its attention to the up-and-coming SLR format with the Contaflex, and Leitz introduced the first of the M-series rangefinder cameras. But all models of the 'classic' Leica and Contax cameras are still sought after by collectors, and many are still in daily use. The debate, however, continues.　　GS

Hicks, R., *A History of the 35 mm Still Camera* (1984).

Leith, Emmett (b. 1927), American physicist. After graduating from Wayne State University, Leith joined the research team of the University of Michigan's Radar and Optics Laboratory, where he was assistant head during the 1960s. In 1962, working with Juris Upatnieks on synthetic aperture radar, he conceived the idea of recording images by interference methods using coherent light, and succeeded in producing the first transmission *hologram. He became professor of electrical engineering at the University of Michigan and Director of the EEES Department's Electro-Optics Laboratory, where he worked on imaging through scattering media, an important area in *medical imaging.　　GS

Leitz, Ernst, Sr. (1843–1920) and **Jr.** (1871–1956), German optical manufacturers. In 1849 Carl Kellner established an optical institute in Wetzlar, Germany, for the development of lenses and microscopes. Kellner died in 1855 and his widow continued the business with twelve employees. Ernst Leitz Sr. became a partner in the company in 1865 and took over sole management in 1869, renaming the business after himself. The 10,000th microscope was produced in 1887 and the number of employees expanded to 120. Leitz was an enlightened employer whose paternalistic attitude was demonstrated by the introduction of health insurance, pension and housing schemes, and, by 1899, an eight-hour day.

Ernst Leitz Jr. became sole owner of the business in 1920, continuing the traditions established by his father. By 1924 the number of employees had risen to 1,000, and Leitz's decision to proceed with the manufacture of the *Leica camera was instrumental in strengthening the company as sales of scientific equipment were falling. During the Third Reich Leitz and his daughter, Dr Elsie Kühn-Leitz (1903–85), quietly arranged for Jewish employees to be transferred overseas and supported by the firm's branches, and endeavoured to assist forced labourers assigned to the plant. After their father's death in 1956 his sons, Ernst III, Ludwig, and Günther, took over the management of the firm. The last remaining family member retired from the board in 1986. MP

Lele, Ouka (Barbara Allende; b. 1957), Spanish photographer, painter, and poet. Born in Madrid into an artistic family, she learned photography at an early age, though she initially hoped to become a painter. In the late 1970s she joined post-Franco Madrid's turbulent cultural scene, the *movida madrileña*; but had her first photographic show, *Peluquería* (*Hair Salon*)—figures bizarrely coiffed with objects like turtles or electric razors—in Barcelona in 1979. In the 1980s she became famous for large, carefully organized monochrome photographs hand painted with watercolour and varnished. She applied this striking and sometimes disorientating technique both to everyday scenes and portraits and to elaborately staged fantasy pictures (e.g. *Dream of a Summer Night*, 1986) reminiscent of Symbolism or Surrealism. Later she created more serene images, often including her daughter Maria; and, from 1988, giant polaroids. Her work is widely represented in Iberian and French museums. RL

Ouka Lele (1997).

Lendvai-Dircksen, Erna (1883–1962), German photographer. Brought up in rural Hesse, Erna Dircksen studied painting at the Cassel Art School. After her first divorce she studied photography in Berlin and settled in 1913 in Dresden-Hellerau, where she married Erwin Lendvai, a Hungarian composer. In 1916 she opened a portrait studio in Berlin. After her second divorce she became interested in racism and embarked on a long series of rural portraits published in book form (*Das deutsche Volksgesicht*, 1930, continued from 1942 as *Das germanische Volksgesicht*). Her work attracted Nazi approval as early as 1930, and during the Third Reich she received state

commissions, including one for a book on autobahn construction workers. After 1945 she worked in northern Bavaria, from 1951 concentrating on landscape photography in colour. RS

Philipp, C. G., 'Erna Lendvai-Dircksen (1883–1962). Verschiedene Möglichkeiten, eine Fotografin zu rezipieren', *Fotogeschichte*, 3 (1983).

lens aberrations. Aberrations are imperfections in the optical image formed by a spherical lens (or optical mirror). There are five main aberrations:

1. *Chromatic aberration*. The refractive index of glass varies with wavelength. This results in different focal lengths and image magnifications for different colours.
2. *Spherical aberration*. Lenses with spherical surfaces have a shorter focal length at their periphery than at their centre.
3. *Coma*. The various circular zones of a lens produce an image of an off-axis point that is distorted radially into a comet shape known as a *coma patch*.
4. *Curvature of field*. The focal surface is not a plane but a bowl shape.
5. *Astigmatism*. Because a lens appears asymmetric to an off-axis beam, the image of a point is not a point but a short line radial from, or tangential to, the optic axis of the lens. These images are formed in different planes.
6. *Distortion*. The image magnification is greater towards the edges of the field (*pincushion distortion*) or less (*barrel distortion*) than at its centre.

These faults can be minimized by the choice of several glasses with different refractive indices, dispersions, and surface curvatures, and the judicious positioning of an aperture stop. GS

Ray, S., *Applied Photographic Optics* (3rd edn. 2002).

lenses, development of. The ability of a lens to converge light to a focus has been known for a long time. In the Archaeological Museum in Heraklion, Crete, there is a Minoan rock crystal hand lens dating back to 2000 BC. The ability of a *pinhole to form an inverted image was recognized in the Middle East as early as the second century AD. The main disadvantage of pinhole optics is that if the pinhole is made smaller in order to sharpen the image, the image illuminance falls off rapidly; also, beyond a certain point the sharpness begins to fall off due to the effects of *diffraction. Somewhere along the line some unknown person put the two ideas together and positioned a lens over the enlarged pinhole, combining the imaging power of both. The idea of a variable aperture came later, but the invention of the iris diaphragm is credited to Sir Christopher Wren, who was professor of astronomy at Oxford from 1660 to 1673. (Wren's Fire of London Monument in the City of London is in fact an astronomical telescope.)

The first experiments in photography by *Niépce, *Daguerre, *Talbot, and others used simple double convex lenses, but these suffer seriously from coma, an aberration (see LENS ABERRATIONS) that causes a serious fall-off in sharpness of the image towards the edges of

the field, necessitating a small aperture. William Wollaston's (1766–1828) *meniscus lens* of 1812, a lens convex on one side and concave on the other, with a stop in front of the concave side, gave good definition at f/11 over a field angle of around 45 degrees, and became widely adopted. This lens was used in the popular *Kodak Brownie cameras right up till the late 1930s. Single lenses of this type showed chromatic aberration (an inability to focus different colours in the same plane), resulting in camera obscura images showing coloured fringes. To minimize this effect, *Chevalier designed the first *achromat* in 1821, balancing out the colour dispersion with a weak negative lens of glass with high dispersion as a cemented doublet (a combination of two glasses). As early photographic materials were only sensitive to blue, chromatic aberration did not affect the photographic image, but as the eye is much more sensitive to yellow than to blue (which made visual focusing on a screen difficult) achromats for photography were matched for blue and yellow wavelengths.

Achromats, like simple lenses, suffer from spherical aberration, a defect caused by the outer zones of the lens having a shorter focal length than the inner zones. This causes a kind of haziness in the image that is uniform over the field: it can be suppressed by the use of a small stop. This defect was not necessarily a disadvantage. The *pictorialists of the late 19th and early 20th centuries felt a need for *'soft-focus' effects, which a measure of spherical aberration fulfilled admirably. This movement was eventually strongly opposed by a group of photographers who demanded maximum image sharpness, using very small apertures: consequently they became known as *Group f.64. It was found that spherical aberration could be minimized by a careful choice of curvatures for the various surfaces of the lenses. Such lenses were known as *aplanats*.

The first really important advance in photographic lens technology was heralded by Josef *Petzval's Portrait lens of 1841, the first objective to have been computed mathematically. It contained four single lenses, two in the form of a cemented doublet, and covered a field of some 25 degrees at an aperture of f/3.6, representing almost a thirtyfold improvement in image illuminance and reducing *daguerreotype exposures from twenty minutes or more to less than a minute. *Voigtländer, *Steinheil, and others improved the design, increasing the aperture size to f/2.4, and the lens sold in millions for more than 60 years. Indeed, it is still to be found in some cheap slide projectors.

By the mid-1850s the much faster *wet-collodion plates had become popular. At the same time there was an increasing requirement for photographic records of *architectural, *industrial, and *scientific subjects. The introduction of photographic reproduction processes in the printing industry, as well as for specialized disciplines such as *photogrammetry and *astronomy, demanded the development of an orthoscopic lens, i.e. one with correct 'drawing'. The lens aberration concerned here was curvilinear distortion, which resulted in the outer parts of the image being stretched out (pincushion distortion) or pushed inward (barrel distortion), depending on whether the stop was respectively behind or in front of the lens. In 1865 Steinheil solved the

problem by dividing the lens into two symmetrical components with the stop in the middle. Using this principle a number of *wide-angle lenses were developed, one of the more extreme being the Goerz Hypergon, which had a completely spherical profile and covered 120 degrees at f/22, employing a little bulb-operated windmill in front to reduce the light fall-off over the image area. Even more bizarre was the Sutton water-filled lens designed for a *panoramic camera with cylindrically curved plates, and equipped with a butterfly-wing aperture to control fall-off. Only a few of these were made, and surviving specimens command high prices.

In 1866 *Dallmeyer and Steinheil independently designed what became known as the *Rapid Rectilinear* lens. It consisted of two achromatic doublets facing one another, with a central stop. With the exception of astigmatism, all the aberrations were now under control. The lens covered a field of around 53 degrees at f/8, and was the standard lens in better-quality amateur cameras for many years.

The next great advance in lens design was the elimination of astigmatism, an aberration that causes the outer parts of the image to be blurred in a particularly disagreeable way, and had hitherto limited lenses to either a narrow angle or a small stop. It was not possible to correct this aberration with the five existing types of optical glass available, as attempts to reduce it only increased other aberrations. However, in 1866 *Abbe and Schott developed a new series of optical glasses incorporating barium, with a different range of values of refractive index and dispersion. This gave lens designers the flexibility to minimize astigmatism while retaining control of the other aberrations, and in 1890 Paul *Rudolph of Zeiss designed the *Protar*, the first *anastigmat*, using two doublets, one of the 'old' glasses and the other of the 'new'. In 1893 the principle was further exploited by Emil van Hoegh (1865–1912), who put the doublets together into a single cemented group and placed two of these symmetrically, one either side of the stop. This lens was the Goerz *Dagor*, covering 90 degrees at f/6.8. It had the added advantage that the front component could be removed, leaving a perfectly usable lens of twice the focal length. In England Dennis Taylor (1862–1943) simplified the format by separating the lens components to produce the 'Cooke triplet' lens with a negative element between two positive elements. He later split the central element into two, providing a symmetrical lens which, as the Cooke *Aviar*, became the standard long-focus lens for *aerial photography for some 40 years. In 1902 Rudolph added a further cemented element to the triplet design and created the immensely successful Zeiss Tessar lens with an aperture of f/4 (later f/2.8), which remained in production for more than 80 years.

By the 1950s it seemed that all aspects of lens design had been pursued to the limit. The practice of antireflection coatings for glass–air surfaces had made it possible to design much more complex lens systems, and *zoom lenses were already in the sights of designers. But two revolutions were still to come. The first was the advent of computers. Up to this point, designing a lens from scratch had meant up to six months' hard slogging with slide rule, protractor, and log tables. Now it was becoming possible to design a lens in a day or so,

and trace thousands rather than tens of ray paths. It became possible simply to specify the requirements and have the computer design the lens that would fulfil them, and even give the manufacturing tolerances for each surface, a blessing for the production system. The second was the novel concept of the *optical transfer function, which went beyond the limited parameters of resolving power and acutance to define lens performance at all spatial frequencies. This tied in with a *Fourier approach to image quality, developed at about the same time. Fabrication techniques evolved to include computer-controlled machinery using diamond tools, paving the way to aspherical lens profiles that could eliminate spherical aberration with a single surface. Later, new rare-earth glasses with very low dispersion, and techniques for making lenses from plastics, gave designers even greater freedom. GS

See also FISHEYE LENS; TELECENTRIC LENS.

Henney, K., and Dudley, B., *Handbook of Photography* (1939).
Kingslake, R., *A History of the Photographic Lens* (1989).
Ray, S. (ed.), *Photographic Lenses and Optics* (1994).
Ray, S., *The Photographic Lens* (2nd edn. 2001).

lenticular stereogram. See STEREOSCOPIC PHOTOGRAPHY; THREE-DIMENSIONAL PHOTOGRAPHY.

Leroy, Catherine (b. 1944), French war photographer, captivated as a child by the pictures in *Paris Match*. In 1966 she arrived in Vietnam with a Leica and $150 and, a diminutive but intrepid figure, photographed there for two years. She parachuted with airborne forces; was wounded; and at Hue in 1968 was captured by the North Vietnamese Army. Her pictures of the Lebanese civil war won her the Robert Capa Gold Medal in 1976. She was a contract photographer for *Time* and a member of the Sipa agency. Leroy lives in Los Angeles and sells Vietnam photographs via a website, Pièce Unique Gallery. RL

Leroy, C., and Clifton, T., *God Cried* (1983).

Lerski, Helmar (Israel Schmuklerski; 1871–1956), Swiss actor, writer, photographer, and film-maker. Raised in Zurich, he spent several years in North Africa before moving to the USA, where he became a film actor and then one of the earliest professional cinematographers. From 1915 he followed the same profession in Berlin, before turning to portraiture in 1928. His dramatically lit images of working men and women won immediate acclaim. From 1932 until 1948, with a two-year interlude before the Second World War, Lerski worked as a photographer and film producer in Palestine. In both his Berlin and his Palestine portraits he used mirrors and white surfaces to create a theatrical 'light structure' around his subjects. In 1936 he executed his best-known experiment in portraiture: more than 160 images of a street sweeper, called *The Metamorphosis of Light*. This final photographic statement was followed by a shift to documentary film. In 1948 Lerski moved back to Zurich. RS

Eskildsen, U. (ed.), *Metamorphosis through Light* (1982).

Le Secq, Henri (1818–82), French architectural photographer. The son of a politician, he studied art in the studio of Paul Delaroche in the early 1840s. Encouraged by fellow pupil Gustave *Le Gray, he turned to photography, initially as an aid to painting. But his enthusiasm for his native Paris and its buildings led him to build a reputation as an architectural photographer. In 1851 he became a founder member of the *Société Héliographique. That year, he was also invited to join the official *Mission Héliographique to create a visual record of potentially threatened historic buildings. Le Secq's brief included, in addition to a number of ecclesiastical sites in the Paris area, the cathedrals of Chartres, Strasbourg, and Rheims. His practice was to produce *salted-paper prints from *waxed-paper negatives, and his oeuvre encompassed still-life and landscape studies as well as architectural work. At the end of the 1850s, when paper negatives were being superseded by glass, he largely withdrew from photography, concentrating on his painting and antiquarian interests. RP

Mondenard, A. de, *La Mission héliographique: cinq photographes parcourent la France en 1851* (2002).

Lessing, Erich (b. 1923), Austrian photojournalist, born and resident in Vienna. He spent the years 1939–47 in Palestine, part of the time in the British army. He became an associate member of *Magnum in 1951, and specialized in political coverage in the USA and Europe, including the 1956 Hungarian Rising, for the major international news magazines. He also did some Hollywood work, for example on the production of *Moby Dick* (1956). LAL

Erich Lessing: Photographie (1994).

Lette-Verein Photographic School. The Lette Association for the Encouragement of Women's Employment was founded in Berlin in 1865 by the Prussian liberal lawyer Wilhelm Adolf Lette (1799–1868), and ran numerous training courses for women. Its photographic school opened in 1890 and from 1902, with the inauguration of lavish new premises, counted as one of the best such institutions in Central Europe. It covered a wide range of technical subjects, including X-ray photography. Men were admitted from 1910. Female pupils included Erna *Lendvai-Dircksen and Marianne *Breslauer. RL

Levitsky, Sergei (1819–98), Russian photographer. An aristocrat by birth, he initially studied law and entered the civil service. On a mission to the Caucasus in 1843, accompanied by the chemist and botanist Julius Fritzsche, he made several *daguerreotype views that won acclaim in Paris. Travelling there himself in 1844 he met *Daguerre, then moved to Rome and photographed a group of prominent Russians including Nikolai Gogol. In November 1849 he opened the Daguerreotype Institute of Sergei Levitsky in St Petersburg, soon attracting a glittering clientele. In the 1850s he adopted the *wet-plate process and started working by electric light: a boon considering St Petersburg's mere 5.5 hours of winter daylight. He began the series *Portraits of Russian Writers* in 1857. Between 1859 and 1865 he successfully took *cartes de visite* in Paris, photographing

Napoleon III and his family in 1864. Finally he returned to his thriving Russian studio, which he ran with his son Raphael.

Appointed court photographer in 1877, Levitsky lived to become the grand old man of Russian photography, active in salons and societies at home and abroad. But much of his work was done by assistants, his own best pictures having been made between the 1840s and 1860s. Particularly notable were portraits of the anarchist Mikhail Bakunin (1863) and the writer Alexander Herzen (1864). Unlike many contemporaries, he generally avoided *hand colouring and other manipulations, although an exception was a striking 1856 portrait of Tolstoy in uniform. The Levitsky studio remained in business until 1914. RL

Elliott, D. (ed.), *Photography in Russia 1840–1940* (1992).

Levitt, Helen (b. 1913), American *documentary photographer and film-maker, born in Brooklyn and active in New York from 1939. She was largely self-taught, although during the 1930s she frequented the *Photo League and was strongly influenced by Henri *Cartier-Bresson. (Among other similarities, both photographers were shy, self-effacing characters; for her black-and-white street photographs, Levitt used a Leica fitted with a prism finder to enable her to work unobserved.) During the 1940s and 1950s, her strongest work and her first exhibition, at MoMA, New York, in 1943, focused on children and New York neighbourhoods ('the nabes'). Far from appearing cute, her child subjects present themselves as assertive, even menacing territorial beings. She collaborated with James Agee in *A Way of Seeing: Photographs of New York* (1965, 1981) and with Agee and Janice Loeb on the film documentaries *The Quiet One* (1948) and *In the Street* (1952), seeking to reveal the internal dynamic of ethnic and working-class neighbourhoods. This activity won her several fellowships between the mid-1940s and the mid-1970s. In the 1980s she returned to black-and-white still photography. CBS

Westerbeck, C., and Meyerowitz, J., *Bystander: A History of Street Photography* (1994).
Weiermair, P. (ed.), *Helen Levitt* (1998).

Levy, Julien (1906–81), New York dealer and collector who played a vital role in introducing European avant-garde art, especially *Surrealism, to America. Having become interested in contemporary art at Harvard, he travelled to Paris in 1927 to experience it at first hand. There he met *Man Ray, who introduced him to the work of *Atget; and in November 1930, with Berenice *Abbott, Levy organized an Atget exhibition at the New York Weyhe Gallery where he worked on his return. In 1931 he opened his own gallery at 602, Madison Avenue with a retrospective show of American photography that embraced early *daguerreotypes and the work of figures such as *Brady, *Käsebier, Clarence *White, *Stieglitz, *Steichen, and *Strand. In 1932 he mounted a modern photography exhibition with pictures by *Bing, *Brassaï, *Kertész, *Lerski, Lee *Miller, and *Peterhans, and Man Ray's first large New York show. The following year he introduced *Cartier-Bresson to the American public. The

gallery continued, at three successive locations, until 1949. Levy's collection of *c*.2,000 photographs (including 362 by Atget) was donated to the Philadelphia Museum of Art in 2001. RL

Hambourg, M. M., 'From 291 to the Museum of Modern Art: Photography in New York, 1910–37', in *The New Vision: Photography between the Wars* (1989).
Jacobs, L., and Schaffner, I. (eds.), *Julien Levy: Portrait of an Art Gallery* (1998).

Lex-Nerlinger, Alice (1893–1975), German graphic designer and photographer. Alice Lex studied (1911–16) at the Berlin School of Arts and Crafts, where she met Hannah *Hoech and John *Heartfield. After marriage to Oscar Nerlinger she helped with the production of his photographs and animated films. In 1928 she joined the Communist Party and began successfully designing political posters. Following a short imprisonment in 1933 she went into 'inner emigration' and did not publish until 1945. For the last three decades of her life, Lex-Nerlinger was a well-known graphic designer in the GDR. RS

Fotografieren hieß teilnehmen: Fotografinnen der Weimarer Republik (1994).

Liberman, Alexander (1912–99), Ukrainian-born American designer (in the 1930s using the pseudonym 'Alexandre'), art director, artist, and photographer. He was sent to school in London in 1921 and later studied in Paris, ultimately with the painter André Lhote. After assisting the graphic designer Adolphe Cassandre (1931–2) he became art director, then also managing editor of the illustrated weekly *Vu* (1933–6), whose appearance he transformed. He reached New York in 1941, joined *Vogue*, and eventually succeeded Mehemed Fehmy Agha as art director. In 1962 he became editorial director of Condé Nast publications, remaining until he retired in 1994. Liberman strongly influenced Condé Nast's avant-garde vision and publishing strategy by showcasing modern masters such as Henri Matisse and Jackson Pollock. He also exhibited paintings and sculpture, and photographed members of the New York social and artistic scene. His memoirs appeared in 1995. ZW

Liberman, A., *The Artist in his Studio* (1960; repr. 1988).

Lichfield, Patrick (Thomas Patrick John Anson, from 1960 5th earl of Lichfield; b. 1939), British photographer. Lichfield began photography as a schoolboy at Harrow and, despite family opposition, became a professional after a brief career in the Grenadier Guards (1959–62). After starting with society weddings and child portraits he established himself on the 1960s celebrity and fashion scene, soon working regularly for the *Sunday Times*, *Queen*, and American *Vogue*. In the 1970s he took numerous royal portraits and in 1981 photographed the wedding of Prince Charles and Lady Diana Spencer. He shot the first of many Unipart calendars in 1979, and has worked with companies like Cathay Pacific, Burberry, and Olympus. Though a capable all-rounder, his supreme talent has been for glamorizing the beautiful, aristocratic, and famous. Lichfield has published extensively and is an intelligent commentator on the photographic scene. He has also invested successfully in restaurants and stage productions. RL

Lichfield, P., and Mosley, C., *Lichfield in Retrospect* (1988).

Lichtwark, Alfred (1852–1914), German art historian, writer, and director of the Hamburg Kunsthalle from 1886 to 1914. A key figure in the emerging field of museum and art education, he regarded amateur cultural pursuits, including photography, as a major positive influence on public taste. In portraiture especially, he believed that amateur photographers could break away from the unnatural and manipulated studio stereotypes imposed by commercial pressures. With his friend Ernst *Juhl, he promoted *pictorialism in Hamburg, opened the Kunsthalle to a series of photographic salons between 1893 and 1903, and published lectures on amateur photography (*Die Bedeutung der Amateur-Photographie*, 1894). Although Lichtwark's airier notions of art as an antidote to social conflict now seem dated, his belief in the value of amateur creativity in mass society continues to appeal. RL

Kempe, F., *Vor der Camera: Zur Geschichte der Photographie in Hamburg* (1976).

Life, American weekly illustrated magazine, launched by Henry Luce (1898–1967) on 23 November 1936, with a cover picture of the Fort Peck Dam in Montana by Margaret *Bourke-White. Luce had already founded *Time* (1923) and *Fortune* (1930), and created *Sports Illustrated* in 1954. After heavy initial losses *Life* began to make a profit in 1939, when its circulation was *c*.2 million; by 1960 it was 6 million. In December 1972 publication was suspended, although *Life* appeared as an annual until 1978, then monthly 1978–2000, finally expiring in May 2000.

Life was the 20th century's most famous magazine, and a model for countless others. It developed the *photo-essay to a fine art and published work by many of the world's finest photojournalists. Its 'concept' was a mixture of entertainment and improvement, informed by belief in a society based on optimism, patriotism, cooperation, and enterprise. Luce's confidence that this 'middle-American' model could be extended worldwide was expressed in his essay 'The American Century' in *Life* on 17 February 1941. Significantly, many *Life* photographers were represented in Steichen's *Family of Man* exhibition in 1955.

As Erika Doss has argued, it is probably too simple to blame *Life*'s decline simply on the rise of television, although the diversion of advertising revenue to TV weakened its finances. There was also competition from a new generation of niche magazines, and friction within the organization: many photographers, including Robert *Capa and W. Eugene *Smith, resented the often high-handed editorial treatment of their work, and the management's support for Richard Nixon in 1972 enraged employees. Most fundamental, however, was perhaps the fact that Luce's original vision of an integrated liberal society did not, or had ceased to, correspond to reality. AH/RL

LIFE: The First 50 Years, 1936–86 (1986).
Doss, E. (ed.), *Looking at LIFE Magazine* (2001).

Life Library of Photography, a multi-authored, multi-volume publication issued in American and foreign (including UK) versions by Time-Life Books Inc. First to appear was *The Camera* (1970); other topics included studio, child, and nature photography, photojournalism, special applications, and the conservation of photographs. Each volume contained a historical overview, practical information, and illustrations by outstanding, often *Life-associated photographers. A matching series of yearbooks was launched in 1973, and a revised edition of the original books appeared in the 1980s. It remains a valuable resource. RL

life model slides appeared in the mid-1870s as a combination of photographic lantern slides with the long-established tradition of the *tableau vivant*, where live models struck poses representing famous paintings or narrative scenes. Usually depicting popular stories, songs, or poems, they were issued in series of twelve, although some reached 60 images. The British slide makers Bamforth & Co. in Holmfirth, and York & Son in London, were by far the leading suppliers amongst a dozen competitors. The American Alexander Black made the most elaborate use of the technique in the 1890s in four full-length plays, including *Miss Jerry* and *A Capital Courtship*, which opened in New York and toured throughout the country. Occasionally photographed in open-air settings, most life model slides were produced on a simple stage using painted backdrops that was remarkably similar to early moving-picture sets. After 1900 production was limited to illustrating popular songs: series were typically given free to entertainers and travelling theatrical troupes by music publishers in support of the sale of sheet music, a direct publicity forerunner of the music video. DR

Crangle, R., 'Zweidimensionales Leben: Die britischen Life model-Dias', *Fotogeschichte*, 74 (1999).

Light from the Dark Room exhibition. In 1995 the National Galleries of Scotland, in collaboration with the National Museums of Scotland and three Canadian collections, mounted the 20th century's pre-eminent exhibition of Scottish photography. The venue was the Royal Scottish Academy of which David Octavius *Hill had been secretary 150 years previously. Curated by Sara Stevenson, the exhibition demonstrated the extraordinary riches of Scottish photography, contemporary as well as historical. More than 60 photographers were represented, from *Hill and Adamson and Thomas *Keith to Callum Colvin and Thomas Joshua *Cooper. DB

Stevenson, S. (ed.), *Light from the Dark Room* (1995).

lighting and lighting equipment. Photography is, by definition, 'writing with light'. Getting the right amount of light, from the right direction, at the right time, has always been a fundamental concern of photographers.

With natural light, the photographer must choose his viewpoint carefully, perhaps moving the subject (or asking the model to move), or returning at another time of day or under different weather conditions, to take the best advantage of the lighting effects. Otherwise, the photographer must supply and control the light; and controlled lighting may be divided into three parts: key, fill, and effects.

The *key* light determines the shadows, and is (as its name suggests) the 'key' to the whole lighting plot. The key may be broad or small, hard or soft, but it must be the only light that creates shadows: 'crossed

shadows' such as a double nose shadow are the token of a sloppy lighting technician. Out of doors, during the day, the key is the sun. The crudest form of artificial key light is on-camera *flash.

The *fill* determines the ratio of the shadows to the highlights. Again it may be broad and soft, or small and hard, but it must never cast a visible shadow on the principal subject. Out of doors, during the day, skylight provides the fill: a wide lighting ratio on a bright, clear, sunny day, or a very small ratio (completely 'flat' lighting with no strong shadows) on an overcast day. When so-called 'fill' flash is used, it often functions as the key, with daylight or other available light supplying the fill.

Effects lights, sometimes known by their old Hollywood name of 'kickers', have no real counterpart in nature; they are used in photography to mimic the way in which the human eye scans a subject, lingering here, skipping there, and adjusting in sensitivity to see into the shadows or to avoid being blinded by highlights. Classic examples include the hair light; the catchlight in the eyes; or lights that draw attention to (for example) jewellery or clothing.

Another useful distinction in lighting is the difference between *chiaroscuro*, the interplay of light and shade that has been the staple of European painters since Caravaggio and Joseph Wright of Derby, and *notan*, the 'flat' style familiar from Japanese woodblock prints.

Some photographers pride themselves on being able to light a portrait or a still life with a single light; others pride themselves on being able to handle numerous lights while still retaining a naturalistic effect. However, the distinction is somewhat unreal, since skill in lighting lies in being able to create the desired effect, regardless of whether it takes one lamp or a dozen.

The earliest purpose-built *studios resembled massive greenhouses, with complex systems of blinds to allow the direction of the dominant light to be controlled. North-facing windows were particularly favoured because (in the northern hemisphere) they never receive direct sunlight, only diffuse skylight: to this day, big, diffuse light sources are often known as 'northlights'.

To overcome the limitations of climate, and to extend photography beyond the hours of daylight, electric lighting became increasingly popular towards the end of the 19th century; more popular, it seems, than gas, because 'half Watt' lights (as they were often known) were much easier to move than gas. This was not just because they relied on a cable rather than a rubber hose: the mantle of a gas lamp is very fragile, and becomes more so with age. As well as incandescent lamps (first demonstrated publicly in 1840, four decades before Edison's patent), arc lights were also used; these had been demonstrated as early as 1808, but they remained tricky to use and noisy, and because of the very high UV output they could give rise to a painful condition that amounted to sunburn of the retina, an affliction known in the early days of Hollywood as 'Klieg eye' after a leading manufacturer. Another option, popular on location, was pyrotechnic lighting, via either 'flashpowder' or (only slightly less dramatically) magnesium ribbon; the latter was sometimes woven into a mat for speedier combustion. From 1929, the flashbulb (where the combustible material was sealed into an oxygen atmosphere inside a glass ampoule)

increasingly supplanted flashpowder; not until the 1960s did small, portable electronic flash provide a workable alternative, albeit with vastly smaller light output.

As long as black-and-white reigned supreme, the colour of the light was not important, and indeed, mercury vapour lamps (the modern high-efficiency version dates from 1934) were often touted in photography books before the Second World War; how much this reflects actual usage, rather than a typically photographic obsession with technology, is unclear.

When colour became important, there were three choices. First, the film could be matched to the *colour temperature of the lighting: so-called Type A and Type B films were matched to 3,200 K and 3,400 K respectively. Second, a *filter could be used to bridge the discrepancy, either over the lighting or over the camera lens. Third, the lighting could be made to match the sensitivity of daylight film, as was first done with electronic flash, and later with a variety of continuous lights: HMIs, 'daylight' flicker-free fluorescents, and integrally filtered tungsten.

The earliest successful commercial electric flash units appeared after the Second World War. Well into the 1970s, however, studio flash tended to be massive, barely transportable, and by later standards very low powered: 5,000 watt-seconds was regarded as a lot of power, and a 5 kW-s power pack and 'northlight' (big soft box) together might weigh the best part of half a tonne. Multiple 'pops' were often necessary when shooting *still lifes including, for example, cars. From the 1970s onwards, however, 'monobloc' heads became increasingly popular, incorporating both the power pack and the flash head in a single compact unit. Again, power was low in the early days—200 W-s was regarded as a lot—but by the 1990s, 1,000 W-s and more per unit was commonplace. Separate generator-head units remained in production, but were much smaller: typically 2,000 W-s packs, supplying up to three heads per pack. By the early 21st century, 10 to 20 kW-s was regarded as quite modest in a big commercial studio.

Regardless of the lighting medium, positioning is the real skill. The 'lighting stand', effectively a tripod with a very tall centre column, is the basic light support but there are also floor mounts, boom arms, and overhead railway systems. The last often incorporate complex pantographs for height adjustment.

All lighting media have their own 'look': it is very difficult, for example, to recreate the Hollywood film-star look of the 1930s and 1940s without generous amounts of 'hot' or tungsten lighting. Many lighting plots are, however, surprisingly formulaic: 'Paramount' or 'Butterfly' lighting (the latter from the shape of the nose shadow) relies on a key that is high and to one side of the camera, and a fill that is low and to the other side. Nor can lighting be considered in isolation. Again taking Hollywood portraits as an example, the use of large formats (normally 20.3 × 25.4 cm (8 × 10 in)) was very important, as was in the early years the tonal rendition of *orthochromatic (as distinct from panchromatic) film-stocks. RWH

Keppler, V., *Man + Camera* (1970).
Life Library of Photography: Light and Film (1971).
Kerr, N., *Lighting for Imaging* (1994).

lightning. On 18 June 1847 the Missouri photographer
T. M. Easterly daguerreotyped a cloud-to-cloud electrical discharge,
although only a copy of the plate survives. The earliest extant lightning
photograph was taken in 1882 by the British-born American
William N. Jennings (1860–1946), who went on to experiment
with photography of both natural and artificial electrical discharges
(and colour). In 1902 the English physicist Charles Vernon Boys
(1855–1944) invented a camera that deployed two moving lenses to
record the actual evolution of a lightning stroke. By 1926, when André
*Kertész captured a celebrated image of a great bolt forking down the
Eiffel Tower, the aesthetic possibilities of lightning were being widely
exploited. Today, in storm-prone regions like Florida or the Great
Plains, photographers make a living transforming lightning into
dramatic prints and posters.

Even simple cameras, if firmly supported and capable of long
exposures, can make effective lightning images. Scale can be indicated
by the inclusion of a silhouetted skyline. Aperture settings and choice
of lenses will be influenced by the distance and intensity of the flashes.
Adequate shelter and a distance of at least 4 km (2.5 miles) are
advisable. RL

Schonland, B. F. J., *The Flight of Thunderbolts* (1950).
Darius, J., *Beyond Vision: One Hundred Historic Scientific Photographs* (1984).
Bluestein, H. B., *Tornado Alley: Monster Storms of the Great Plains* (1999).

Lindström, Tuija (b. 1950), Finnish-born photographer, resident
in Öland, Sweden. After graduating from Konstfackskolan of
Stockholm in 1984, she quickly established a distinctive style, in
which portraiture, still-life, landscape, and figure studies provided
the basis for sculpturally tactile, emotionally and erotically charged
black-and-white images. The female body, often both vulnerable and
assertive, features prominently, as in the remarkable photographic
and filmed series of women floating in water, *Women at Bull's Pond*.
She was professor of photography at the School of Photography and
Film at Gothenburg University (1992–2002). J-EL

Lindt, John William (1845–1926), one of Australia's pre-eminent
19th-century photographers, is best known for his quietly theatrical
and melancholic studio portraits of Aboriginal people. Born in
Frankfurt am Main, Germany, he arrived in Australia c.1862 and went
into business with the photographer Conrad Wagner at Grafton,
NSW. The series *Australian Aboriginals* (1873–4) posed indigenous
people from Clarence River in meticulously constructed studio sets
of vegetation and Aboriginal artefacts. Widely disseminated, it
influenced the way in which Aboriginal people were represented.
In 1876 Lindt moved to Melbourne, setting up his own studio and
developing a successful portrait business. In 1885 he accompanied
Sir Peter Scratchley's tour of recently annexed Papua New Guinea.
There, in a field situation, Lindt's romantic vision resulted in
Picturesque New Guinea (1887), which exemplified his motto
'Truth—but Truth in a pleasant form'. EE

Jones, S., *J. W. Lindt, Master Photographer* (1985).

Link, O. Winston (1914–2001), American *railway photographer,
who turned to photography after studying civil engineering, and
through industrial assignments became a master of complex lighting
set-ups. His major railway work was done between January 1955 and
March 1960, when he took c.2,400 mostly nocturnal photographs of
the trains and personnel of the Norfolk & Western Railway which, in
the mid-1950s, was the last American company still relying solely on
steam. With the company's cooperation he traversed the 3,700-km
(2,300-mile) system, using 4 × 5 in Graphic View cameras, an assistant,
and a formidable outfit of flashbulbs and batteries. (He also made
sound recordings of the trains.) His most famous image, *Hot Shot
Eastbound at Iaeger Drive-In, West Virginia* (1956), is a monument
both to Link's virtuosity and to 1950s culture.

After Norfolk & Western's transition to diesel in 1960 ended this
saga, Link turned to other projects, such as the construction of the
Verrazzano Narrows Bridge in New York harbour. Although his steam
photographs captivated train enthusiasts, they were slow to achieve
wider recognition. But three books finally established his reputation:
Ghost Trains: Railroad Photographs of the 1950s (1983), *Steam, Steel
and Stars: America's Last Steam Railroad* (1987), and *The Last Steam
Railroad in America* (1995). RL

Linked Ring, Brotherhood of the. Founded in April 1892 by
photographers who had resigned from the Photographic Society of
Great Britain in 1891–2, it was intended to further the prosecution of
art photography in general, and *pictorialism especially. Its records
note that the first and second meetings occurred on 9 and 27 May 1892,
initiating the first 'Links', including Bernard Alfieri, Arthur Burchett,
Henry Hay Cameron, Lyonel Clark, Henry E. Davis, George *Davison,
Alfred *Horsley Hinton, Alfred Maskell, Henry Peach *Robinson,
Ralph W. Robinson, Francis Seyton Scott, Henry Van der Weyde, Tom
Bright, Francis Cobb, and W. Willis. Formed under the symbol of three
linked rings, the society quickly established itself as a powerful force in
the development of a photographic aesthetic worldwide. Influential
photographers—including women after 1900—from Britain, Europe,
and the American *Photo-Secession were admitted by invitation only.
The *Linked Ring Papers*, first published 11 February 1896, were
circulated annually to members from 1893 to 1909, promoting and
discussing the aesthetics and practice of pictorialism. A Photographic
Salon was held annually in which members' work was exhibited, and
later published in the journal *Photograms*. KEW

Harker, M., *The Linked Ring* (1979).

Lippmann, Gabriel (1845–1921), French physicist. In 1891 he
presented his *photochromie* process to the Académie des Sciences in Paris.
Instead of using dyes or pigments, it produced colour photographs
by wave interference, but although the results were impressive, they
were very difficult to achieve. Lippmann's earlier inventions included
a capillary electrometer, which would later be used in the first
electrocardiograph, and a coelostat that immobilized the image of a
star, allowing it to be photographed. In 1908 he was awarded the Nobel

Prize in Physics for his colour photographic work, which demonstrated undulatory theory. Some of his colour photographs, specially mounted for viewing at an angle, are preserved in museums, the finest collection being at the Preus Museum at Horten, Norway. KEW

Saxby, G., *The Science of Imaging: An Introduction* (2002).

Lissitzky, El (1890–1941), Russian designer, architect, and photographer. Having travelled in Europe and studied architectural engineering in Germany before the First World War, Lissitzky returned to Russia and became inspired by *Futurism and its fascination with abstraction. His first one-man exhibition was in Hanover in 1923. He designed Russian exhibitions abroad during the 1920s, drawing increasingly on the resources of the camera, as with the frieze of photographs and newspaper cuttings created for the Soviet pavilion at Cologne in 1928. Book design gave further opportunities to explore the possibilities of photography, and he used *photomontage to create striking *composite images. He often presented the work of other visual artists: a 1929 catalogue for a Japanese cinema exhibition, for example, and a 1933 collection of Parisian photographs by Ilya Ehrenburg. In 1932 Lissitzky became art editor of *USSR in Construction*—a monthly publication promoting the state's achievements—and large-scale photographic spreads became a frequent feature of his designs. Despite illness, he continued in this post until 1940, seeing his talents as necessarily aligned with the aims of the state. At his death, he was working on posters supporting the Russian war effort. RP

Tupitsyn, M. (ed.), *El Lissitzky, Beyond the Abstract Cabinet: Photography, Design, Collaboration* (1999).

List, Herbert (1903–75), German photographer. In 1923, after studying art and literature, List joined the firm of his father, a Hamburg coffee importer, and travelled extensively in Central and South America on business. Friendship with Andreas *Feininger deepened his interest in photography, which he took up professionally after emigrating in 1936. In 1937 he travelled to Greece with George *Hoyningen-Huene, and there cultivated a bold, contrasty style and a fascination with surreal juxtapositions of ruins and everyday objects. He also made experimental double exposures and heroically stylized male nudes. After the German invasion of Greece he returned to Germany and joined the army. From 1945 he lived mainly in Munich, producing independent series (for example *Memento 1945* about Munich's ruins), and photo-essays for numerous illustrated papers. In the 1950s he became one of Germany's leading portraitists. UR

Scheler, M. (ed.), *Herbert List: Die Monographie* (2000).

literature and photography. Literature welcomed photography in 1839. Notwithstanding its potentially universal appeal and infinite documentary and imaginative possibilities, photography (writing with light, etymologically) posed no threat to the older literary medium. The two interacted in an expanded aesthetic universe—warily from 1839 to 1914, amicably from 1918 to 1945, and vigorously from 1946 to the millennium.

1839–1914

Photography soon allied itself with literature. Henry *Talbot's pioneering *Sun Pictures of Scotland* (1845) showed landmarks from the celebrated works of Sir Walter Scott, and his Scottish disciples staged tableaux from Scott and Robert Burns. Authors, especially Walt Whitman and Mark Twain, exploited the self-portrait. Publishers inserted photographs in popular works like Hawthorne's *Marble Faun* (1860), and *photographically illustrated books featured settings described by canonical writers. George Washington *Wilson issued a folio of Scottish landscapes to be bound into Queen Victoria's best-selling *Leaves from the Journal of our Life in the Highlands* (1868).

Some authors, like Thomas Carlyle and Ralph Emerson, pondered photography's capabilities and implications; others—Théophile Gautier in Spain (1840), Maxime *Du Camp, accompanied by Gustave Flaubert, in Egypt (1849–50)—tested them pragmatically. Literary admirers like George Sand encouraged *Nadar's aerial and underground photography experiments in Paris. At the same time, literary realism flourished. Photography set a standard of veracity, while suggesting new ways of viewing and representing reality. Émile Zola (himself a keen photographer) emulated the camera's mirroring of society. Heinrich Heine and August *Strindberg felt complimented when their writing was called 'photographic', although critics sometimes used the term pejoratively, implying imaginative deficiency. Novelists and playwrights made various symbolic and practical uses of photography. Nathaniel Hawthorne's *House of the Seven Gables* (1851) featured a photographer as romantic hero, Henrik Ibsen's *The Wild Duck* (1884) another as an obtuse eccentric. Fictional photographs tracked the lovers' relationship in Leo Tolstoy's *Anna Karenina* (1875–7); Mathew *Brady's Civil War scenes influenced Stephen Crane's *Red Badge of Courage* (1895).

Many authors became avid photographers: not only Zola but Charles *Dodgson (Lewis Carroll), Samuel *Butler, Victor Hugo, Strindberg, Bret Harte, Pierre *Louÿs, George Bernard *Shaw, Giovanni Verga, and Leonid *Andreyev, but often so discreetly that biographers remained ignorant or dismissive. All resisted photographic illustrations of their writing. Henry James, who used Alvin Langdon *Coburn's photographs as frontispieces for his collected works, famously mingled his praise with wariness about their competitiveness in his preface to *The Golden Bowl* (1909).

Photographers seeking to elevate their own artistic status similarly remained aloof from literature. Henry Peach *Robinson and Julia Margaret *Cameron occasionally borrowed subjects from literary classics. F. Holland *Day, Coburn, and Edward *Steichen esteemed Maurice Maeterlinck, whose mysticism offered an alternative to prevailing realism. Gertrude *Käsebier and Clarence *White created scenes for magazines, but other *pictorialists, promoting photography as art, generally preferred their own visual narratives. Few embraced Sadakichi *Hartmann's idea for a 'Photographic Illustration Company' to provide a visual accompaniment to literary texts.

1918–1945

After the First World War, all the arts sought new systems and beliefs. Literature proclaimed traditional forms and content bankrupt; photography demanded recognition for aesthetic as well as documentary qualities. Faster transportation and communication multiplied interactions. Mexico City alone found D. H. Lawrence seeking Edward *Weston, Henri *Cartier-Bresson rooming with Langston Hughes, and Pablo Neruda meeting Tina *Modotti, Manuel *Álvarez Bravo, André Breton, Louis Aragon, and Octavio Paz. These encounters, especially those pertaining to *Surrealism, disseminated innovations, sometimes displayed at venues like Shakespeare & Company's bookshop in Paris.

Cross-fertilization gratified young artists like Walker *Evans, who chose photographing over writing (like André *Kertész and László *Moholy-Nagy), yet appreciated their shared qualities. Disliking pictorialist manipulations, photographers like *Man Ray and Paul *Strand valued 'straight' or 'experimental' pictures, featuring mechanical, natural, or abstract objects, not figures or landscapes. Disliking lengthy panoramas, writers like Virginia Woolf and Sherwood Anderson valued shorter, patterned structures, evoking the inner life of ordinary subjects. Regardless of medium, modernists sought whatever deepened insight.

Few inter-war artists were talented in both media, unless circumstances compelled (Vladimir Mayakovsky and Alexander *Rodchenko in post-revolutionary Russia). Fears about independence, competition, and cost still discouraged collaboration. Dadaists and Surrealists ignored André Breton's call for books illustrated solely by photographs, except in esoteric, often erotic, limited editions. *Stieglitz's circle did not even illustrate the literature they admired. But modernists proved generous publicists. Jean Cocteau first praised Man Ray's photograms; Stieglitz first published Gertrude Stein; Carl Sandburg wrote the first monograph about a living photographer (Steichen, his brother-in-law); Henry Miller's first novel immortalized *Brassaï, whose memoirs helped immortalize Miller.

Few writer-photographers persisted. Carl Van Vechten ended a successful career as an art critic and novelist to pursue photography (1932); Wright Morris commenced his nostagic 'photo-texts'. Some documented exotic assignments (Evelyn Waugh in Abyssinia, W. H. Auden in Iceland and China). By 1940 William Faulkner's intense interest in photography, especially old cameras, dwindled and Eudora Welty ceased photographing professionally when publishers recognized her fiction.

As in the previous century, authors often mined photography for content. Pictures, usually of lost parents or lovers, inspired many meditations (Rainer Maria Rilke, Constantine Cavafy, Thomas Hardy). Thomas Mann utilized X-rays in *The Magic Mountain* (1924), Vladimir Nabokov the photo horoscope in *Invitation to a Beheading* (1938). But many still disdained the medium. Calling Margaret *Bourke-White a 'poetess of the camera' was complimentary; E. M. Forster's description of Sinclair Lewis's style as 'photographic'

was derogatory. Few shared Charles *Sheeler's equation of his prints with poems by his friend William Carlos Williams.

The Depression and the Second World War made non-documentary art seem frivolous or perilous. Global crises compelled writers and photographers to collaborate in representing the latest disaster—in books, but also in *photo-essays for new illustrated magazines like *Life*. Kurt Tucholsky helped John *Heartfield assemble his anti-Nazi photomontages; Erskine Caldwell joined Bourke-White and James Agee Evans in recording America's South. Farm Security Administration photographs illustrated texts by Archibald MacLeish (1938) and Richard Wright (1941). Bertolt Brecht in exile protested against fascism and capitalism in quatrains, later published under the news photograph inspiring each (1955). Such engaged undertakings revealed that even documentaries could be framed, cropped, or airbrushed to influence response; texts ceased to emulate the camera's supposed dispassion.

1945–2000

With peace, artists gladly abandoned the grim subjects so long monopolizing attention; but the only visions most dared represent were their own. Many photographers, even former aspiring writers like Aaron *Siskind and Minor *White, turned from documentary to personal or abstract work. Authors too favoured the subjective or unconventional. Autobiography flourished in both media. Cecil *Beaton's diaries, and memoirs by Coburn, Man Ray, Gisèle *Freund, and Bourke-White helped make them as famous as writers. Even before conglomerates acquired publishing houses and photographs became valuable, dealers relished celebrity. Noted writers became the subjects of visual sequences by Rollie McKenna, Inge *Morath, and Jill Krementz, who specialized in literary portraits for book jackets and publicity, adding renown to their subjects (often their friends or spouses) and themselves.

Significant collaborations, increasingly born from commerce rather than creativity, increased—often initiated by photographers, not writers or publishers. Richard *Avedon approached Truman Capote and James Baldwin, as did Roy *DeCarava, Langston Hughes, Lucien *Clergue Cocteau, and Eikoh *Hosoe Yukio Mishima. (But Ted Hughes proposed collaboration with Fay *Godwin.) Noted writers provided prefaces for photographers' publications: Lawrence Durrell for Brassaï and Bill *Brandt; Tom Wolfe for Marie Cosindas, Bruce Chatwin for Robert *Mapplethorpe.

Young photographers often yearned to be *auteurs*, presenting their own free-standing narratives. Reinforcing their aspirations were cultural critics like Walter *Benjamin and Susan *Sontag, who challenged the traditional assumptions of all the arts and favoured the fragmentary, inconclusive, and subjective; and Roland *Barthes, whose seminal *Camera Lucida* (1980), translated by the poet Richard Howard, analysed images as well as narrative. Issues of class, genre, race, and sexual orientation became part of discourse in all the visual arts, especially photography, as they had always been of literary ones. Heated cultural debates featured photography as best reflecting

postmodernist concerns, its pictures 'texts' to be 'read' on many levels by everyone, not only elites. Photographers dared to embrace formerly taboo literature, many specially equipped. Hosoe, John Baldessari, and Elsa Dorfman considered writing careers; Robert *Adams earned a doctorate in English, Sally *Mann a master's degree in writing; Danny *Lyon and Bruce Charlesworth often combined their pictures and texts. Eugene *Smith, Duane *Michals, and Barbara Kruger (b. 1945) began writing after securing reputations as photographers. Most preferred presenting pictures in self-designed books, not museum or gallery exhibitions, which they deemed esoteric and inaccessible, and reviews unfairly influential.

Allusive photographic book titles appeared. Baldessari accompanied scenes in *Ingres and Other Parables* (1971) with an imaginative prose paragraph, but *Close-Cropped Tales* (1981) lacked words. Captions for single pictures—traditionally minimal—needed interpretation; Lyle Bongé's *Hokusai's Wave Winding up* (1980) portrayed an asphalt road. Diane *Arbus pioneered handwritten captions, sometimes with contextual material, evoking meanings usually associated with literature. Letters and words—usually road and wall signs—had long attracted *Cartier-Bresson, Alvarez Bravo, Evans, and Siskind. Now phrases, epigrams, aphorisms, associative word chains, even whole paragraphs, appeared in pictures. Most revolutionary were 'stories', with or without words. Barbara Kruger, Sherrie Levine (b. 1947), and Louise Lawler (b. 1947) signed a reproduction of an Alberto Moravia short story, used as a magazine centrefold; Levine elsewhere appropriated literary passages, sometimes unattributed. Ralph *Meatyard, drawing on repetitive content from Gertrude Stein and Flannery O'Connor, compelled viewers to interpret *The Family Album of Lucybelle Crater* (1974). Baldessari used traditional literary forms—the allegory, parable, fable, and fairy tale—to deepen conceptual photographs. Michals increasingly provided verbal guides to his philosophies, first with provocatively titled books, then with handwritten linking texts. Such practices hardly made photographs literary but provided a self-consciously innovative alliance with language and, by extension, literature.

Some writers returned the compliment, though more conventionally and sporadically. The doubly gifted tradition was continued by Wright and Thomas Merton (in their last years) and by Morris, Jonathan Williams, Allan Ginsberg, John Howard Griffin, Julio Cortazar, Bruce Chatwin, Jerzy Kosinski, Yevgeny Yevtushenko, Michael Ondaatje, and Michel *Tournier. But few illustrated their own works.

Photographers had long acknowledged literary influences—particularly of Blake, Poe, Baudelaire, Whitman, Joyce, Pound, and Williams. Now writers, especially poets, found inspiration from photographs: from books (Charles Simic, Seamus Heaney), popular magazines (Marianne Moore, Elizabeth Bishop), and newspapers (Denise Levertov, Kenneth Pitchford). Others addressed specific pictures such as Howard on Nadar's, Cocteau on Clergue's, and John Logan on Siskind's. Album pictures still stimulated meditation (Philip Larkin, Ted Hughes, Anne Sexton, Charles Wright, Howard

Nemerov, and Robert Creeley). Some poets borrowed allusive diction or fresh imagery; Adrienne Rich did both in *Snapshots of a Daughter-in-Law* (1963). Novelists continued utilizing real or imagined photographs (Nabokov, Grass, Kosinski); a few explored the lives of significant photographers (Ondaatje, Bellocq; Richard Powers, *Sander). Many feminist writers (Cynthia Ozick, Rosellen Brown) featured photographer-heroines, acknowledging the medium's open, inclusive character.

By the millennium, enduring photographs, like enduring books, were regarded as complex mirrors of society, not transparent windows. Both media faced challenges posed by digitization. Meanwhile publishers are reprinting landmark works and collaborations, while issuing collections of writers' photographs, literary picture books, and even scholarly studies of literary and photographic interactions. All recognize that photography's achievements—like literature's—are essential to understanding civilization since 1839. JMR

Rabb, J. M. (ed.), *Literature & Photography: Interactions 1840–1990* (1995).

Li Zhensheng (b. 1940), Chinese photojournalist who began working for the state-controlled *Heilongjiang Daily* in Harbin, a major industrial centre in north-eastern China, in October 1964. Between 1966 and 1976 he chronicled the traumatic events of the Cultural Revolution, photographing 'struggle meetings', parades, and the public humiliation of 'class enemies'. Subsequently he recorded the downfall of those who had seized the opportunity to amass power and wealth: the 'coal queen' Wang Shouxin, for example, shown in February 1980 on trial, having her jaw dislocated to silence her pleas, and awaiting execution in a snowy field near Harbin. In 1982 Li moved to Beijing to teach photography at the International Political Science Institute. Later, he smuggled c.30,000 carefully annotated negatives to the USA. They form a chilling and probably unique visual record of the Cultural Revolution and its aftermath in an important region. RL

Li Zhensheng, *Red-Color News Soldier* (2003).

Llewelyn, John Dillwyn (1810–82), Welsh photographer. He married a favourite cousin of Henry *Talbot, Emma Thomasina, née Talbot, in 1833, becoming one of the 'Welsh cousins' of the Talbot family just prior to Talbot's first photographic experiments. As a member of the Royal Society and Linnean Society, he experimented enthusiastically with the new art of photography at his country home in Penllergare, Glamorgan, South Wales, with his wife and later their daughter Thereza Mary. By 5 March 1839 he had already succeeded in making 'some faint drawings', as Mary Lucy Cole, his mother-in-law and Talbot's aunt, wrote to Talbot that day. Although he used *photogenic drawing and *daguerreotype processes, after 1840 he turned primarily to the *calotype, and later to *collodion. His invention of the Oxymel process produced perhaps the most successful 'moist collodion' process, by bathing the collodion plates in a commercial mixture (Oxymel) consisting of honey and vinegar, allowing it to remain moist for the day. Llewelyn is best known for his artistic landscapes of the British countryside, and for

his involvement with the early circle of British photographers, among them his lifelong friend Philip Henry Delamotte (1820–89), and his son-in-law Nevil Story-Maskelyne (1823–1911). He was also on the original council of the Photographic Society of London (later the *Royal Photographic Society). KEW

Morris, R., *John Dillwyn Llewelyn, 1810–1882: The First Photographer in Wales* (1980).

Schaaf, L. J., *Sun Pictures*, ii: *Llewelyn, Maskelyne, Talbot: A Family Circle* (1986).

Lobovikov, Sergei (1870–1941), Russian photographer. As a penniless orphan he was apprenticed to a photographer in Viatka (Kirov) where, encouraged by Andrei *Karelin, he started his own studio in 1894. His landscapes and peasant genre scenes, using the *gum-bichromate and, later, *bromoil processes, established him as a leading *pictorialist, showing at the 1900 Paris Exposition and scoring triumphs at international salons in Dresden (1909), Budapest (1910), and Hamburg (1911). His diaries vividly describe the complex, quasi-culinary darkroom procedures behind his evocative images of Russian rural life. He remained active in the 1920s, and in 1927 was given a one-man retrospective in Moscow by the Russian Photographic Society. He spent his last years as a scientific photographer in Leningrad (St Petersburg), and died there during the siege. RL

Meisterwerke russischer und deutscher Kunstphotographie um 1900: Sergei Lobovikov und die Brüder Hofmeister (1999).

local history and photography. Innumerable published volumes of old photographs, 'Memory Lane' columns in local newspapers, and the widespread digitization of photographic collections reflect the adage that 'a photograph is worth a thousand words'. Photography introduced a new source of visual information, offering for the first time an apparently objective window on the past. For history since the 1840s the West European or North American local historian has an increasing selection of images to draw on, showing the streets and buildings, the special events, and at least some aspects of the everyday lives of virtually every community, urban or rural. Such photographs are unequalled for their directness, taking the viewer back to a particular scene or incident. One image may record vital information about a particular building or business, another may provide the only known likeness of some local character, whilst a third may show the first appearance of the cinematograph at a local fair.

Millions of photographs are preserved in national, local, and private collections and, increasingly, information about these collections, and low-resolution copies of many images, are appearing on the *Internet. Eventually, extensive and comparative online picture research should be feasible. For the present, however, photographs tend to be a scattered resource and the assiduous local historian may have to undertake considerable background research before tracing even the publicly available collections. In a typical English city or county, someone looking for pictures of a particular historic building might need to visit the local studies library, record office, or museum,

and the local sites and monuments record. Local museums and history societies may have important holdings and, often, detailed local knowledge. Picture research may, however, take the keen researcher far from the locality: perhaps to a major university library; or to Aerofilms, which has *aerial photographs dating back to the 1920s; or to collections held by the National Monuments Record Centre at Swindon, the British Motor Industry Heritage Centre at Gaydon, the National Railway Museum at York, or the Imperial War Museum in London. Back in the locality, the picture archive of the local newspaper, or cuttings collections or photograph-indexing projects at the library, may yield further material.

The lives of a few places can be reconstructed with the help of large collections of pictures built up over years or decades. People and events in the Yorkshire mining village of Fryston, for example, were recorded by the working-class amateur Jack *Hulme, who took more than 10,000 pictures over *c*.70 years. A very different kind of community, the market town of Villefranche-de-Rouergue in southern France, had two rich and enthusiastic amateurs, a doctor called Dufour and a hardware merchant, Théron, who photographed it intensively between *c*.1890 and 1914. Each had a different perspective: whereas the Catholic conservative Dufour photographed church festivals, his clerical friends, and the peasants working on his estate, the liberal Théron recorded commercial life, and military, political, and cultural events associated with the Third Republic. However, both used fine equipment, and their plates can be blown up to reveal a wealth of fascinating social detail. Another French example was the village of Pontlevoy in the Loire Valley, the 'patch' of two professionals, Louis Clergeau (1877–1964) and his daughter Marcelle (1903–84). Between them they took over 10,000 photographs of the weddings, processions, harvest festivals, and other private and public events in Pontlevoy and the surrounding region between 1902 and Marcelle's retirement in 1963. Louis also recorded artisan and farm work and, between 1910 and 1912, activity at one of France's first airfields, established nearby. Not only many of his plates but most of his meticulously kept working notebooks have survived.

But although the researcher may sometimes discover a wealth of images, the hunt will often be frustrated. Bankruptcies, mergers, fires, and wartime glass salvage have led to the destruction of many important bodies of work. Many of the Oxford photographer Henry *Taunt's glass negatives became garden cloches or greenhouse panes. Most of the Bradford Belle Vue (see MIGRATION AND PHOTOGRAPHY (FEATURE)) studio's negatives ended on the local rubbish tip. But beyond these losses, it seems likely that many aspects of life since mid-Victorian times went unrecorded, in part because of the interests or motives that inspire all photographers to take pictures. View photographers, for example, photographed tourist sights rather than factories or back streets. Artistically inclined 'serious' amateurs would be likely to focus on quite different subjects from, for example, public health inspectors or photographers interested in the history of architecture or railways. (But 'unwanted' realities sometimes creep in: a queue of emigrants in a street scene by George Washington *Wilson,

Anon.

Alexander Berryman with his family and maid, Penzance, 1880

for example, or local urchins, lined up to stop them pestering the photographer, beside a row of picturesque old buildings.)

Questions also need to be asked about the photographs. Technical limitations constrained early photographers and put some subjects out of bounds for decades. Lengthy exposure times made it impossible at first to record movement, and early photographs of virtually empty streets should not be interpreted as evidence of urban decline; contemporary prints showing streets filled with carts, farmers with flocks of sheep, bill stickers, and pavement artists may be closer to reality. Even after exposure times had been reduced, photographers might continue to take pictures of streets and buildings at quiet times—for example, the early morning—in order to avoid including easily datable features (costumes, vehicles) or to focus attention on architecture rather than people and traffic. *Night shots were impossible for most of the Victorian period, and early indoor photography required studio facilities and long exposure times. To record craft work, or unusual scenes such as children undergoing school medical examinations, subjects were often moved out of doors; other forms of staging were common, and can easily be misinterpreted. Portraits can also be misleading, since working people were likely to have themselves photographed in their Sunday best; hands, complexions, and, to a degree, demeanour may offer better clues to class and occupation. Finally, although *digital photography has made it easier to doctor images, the skilled photographer was always able to alter pictures, perhaps by removing an individual from a group, or merging two processions into one. In any project involving photographic evidence, other kinds of documentation and, wherever possible, the memories of surviving people must be called in to interrogate and amplify the visual record. MG

⮑ See also West Cornwall and Scilly photography *opposite*.

Martin, G. H., and Francis, D., 'The Camera's Eye', in H. J. Dyos and M. Wolff (eds.), *The Victorian City, Images and Realities*, vol. ii (1973).

Dufour, B., *La Pierre et le seigle* (1977).

Thomas, A., *The Expanding Eye: Photography and the Nineteenth-Century Mind* (1978).

Miller, S. T., 'The Value of Photographs as Historical Evidence', *Local Historian*, 15 (1983).

Oliver, G., *Photographs and Local History* (1989).

Couderc, J.-M., *A Village in France: Louis Clergeau's Photographic Portrait of Daily Life in Pontlevoy, 1902–1936*, trans. W. Wood (1997).

Löcherer, Alois (1815–62), German photographer. In 1840, after studying chemistry and pharmacy in Munich, and establishing himself as a pharmacist there, he learned *daguerrotypy, possibly from Johann Baptist *Isenring. Soon afterwards he also mastered the *calotype process. Löcherer was important mainly as a teacher of other photographers, e.g. Franz *Hanfstaengl. But, in addition to portraits, he made a famous series of outsize calotypes of the casting, transportation, and erection of Ferdinand von Miller's huge *Bavaria* statue in Munich (1845–50). In 1852 Löcherer travelled specially to Paris to learn the wet-*collodion process. JJ

Pohlmann, U. (ed.), *Alois Löcherer: Photographien 1845–1855* (1998).

logarithms. In photography, logarithms are everywhere. When photographers talk about, for example, 'giving one-and-a-half stops more', they are using logarithms, whether they know it or not. Again, when they talk of *'density', they are talking of logarithmic values. At one time, tables of logarithms existed to simplify calculations by turning multiplications into additions. In the era of pocket calculators such tables are no longer needed (nor slide rules, which are also based on logarithms). But the concept of a logarithm remains important, especially where perceptual processes are involved. Human visual (and auditory) processes operate logarithmically (see *Weber–Fechner law).

The basic thesis underlying the logarithmic principle is that any positive number can be expressed as a power (normally of 10), and that this power (the *logarithm* of the number) has a unique relationship with the number itself.

Consider two series of numbers:

1	2	3	4	5
10	100	1,000	10,000	100,000

There is an obvious connection: the number of zeros. It is more obvious if we write 10^1, 10^2, 10^3, and so on for the lower series. The upper series is the logarithm (base 10) of the lower series. Both series can be continued indefinitely in either direction, the upper series continuing 6, 7, 8 . . . upwards and 0, −1, −2 . . . downwards, the lower continuing 1,000,000, 10,000,000, 100,000,000 . . . (or 10^6, 10^7, 10^8) upwards and 1, 0.1, 0.01 . . . (or 10^0, 10^{-1}, 10^{-2}) downwards.

Numbers between those in the upper series have logarithms too. For example, log 2 is 0.3, an important value for the photographer. An increment of 0.3 on the logarithmic scale represents a doubling on the arithmetic scale. So a logarithmic series 0.3, 0.6, 0.9 . . . represents the doubling-up series 2, 4, 8 . . . , and is used in plotting characteristic curves and (with the decimal point omitted) in ISO logarithmic speed indices.

There are logarithms to other bases too. One every photographer will be familiar with (perhaps unknowingly) is base 2. It underlies the light-value series on *exposure meters. Each increment on the scale represents a doubling of the stimulus:

No.	1	2	4	8	16	32
Log	0	1	2	3	4	5

Photographers use logs base 2 when they speak of (say) giving three stops (i.e. eight times) more exposure. To convert logs base 10 to base 2 one simply divides by 0.3, and to convert logs base 2 to base 10 one multiplies by 0.3. GS

Lomography, international vernacular-photographic movement founded by two Viennese students, Matthias Fiegl and Wolfgang Stranzinger. In the early 1990s they discovered the Lomo Kompakt Automat, a basic auto-exposure 35 mm camera made in Leningrad (St Petersburg) since 1983, and found it ideal for taking uncomposed, spontaneous *snapshots, especially in the street and in low light.

(*continued on p. 376*)

West Cornwall and Scilly Photography *c*.1880–*c*.1960

The Isles of Scilly and the westernmost tip of Cornwall, with the towns of Penzance and St Ives, and fishing villages like Sennen, Mousehole, and Newlyn, have a rich photographic heritage linked, in this period, with the development of a regional tourist industry; the establishment of artists' colonies at Newlyn and St Ives; two world wars; and the growth of amateur photography. Local photograph collections exist today at the Cornish Studies Centre in Redruth, the Penlee Gallery and Morrab Library in Penzance, and the museums at St Ives and St Mary's. For historical reasons, however, many more images are held at national institutions such as the National Maritime Museum (*c*.20,000 photographs by the *marine photographer Francis Mortimer (1875–1944)); the Imperial War Museum (Newlyn's First World War seaplane base); the Royal Archives, Windsor (royal visits to the duchy of Cornwall), and the National Archives (pictures registered under the *Fine Art Copyright Act, 1862). The photographs of Vanessa and Virginia Stephen (later, respectively, Bell and Woolf), who spent their childhood summers at St Ives, are in the Tate Gallery archives and various American collections. Cornwall's spectacular scenery attracted commercial firms like *Wilson, *Valentine, *Frith, and even Oxford-based Henry *Taunt. Gibson of Scilly holds an archive dating back to the 1870s. Other photographers whose work survives include John Charles Burrow (1850–1914) of Camborne, who pioneered *underground photography in Cornish mines *c*.1892, and the Austrian oceanographer Count Larisch-Moennich, who took dramatic storm pictures at Hell Bay, Bryher, and St Ives just before the First World War.

Although gradually, tourism offset the depression following the mid-19th-century collapse of Cornish mining, and the later decline of the fishing industry. The completion of Brunel's Tamar railway bridge in 1859 and the inauguration of the Great Western Railway's (GWR) seven-hour Cornish Riviera express from Paddington to Penzance in 1904 facilitated its growth, and GWR played a major role in marketing the beauties of the 'far West' to visitors. Over the years, tourism's structure changed considerably. Until 1914 the emphasis was on upper-middle-class families who 'took' houses for 2–3 months in the summer: at Sennen, for example, the headmaster of Cheltenham College and a bevy of senior clergy, and at St Ives the editor of the *Dictionary of National Biography*, Leslie Stephen, who bought the lease of Talland House in 1881 and holidayed there with his family and literary guests until 1895. Tourism diversified after the First World War, with the spread of paid holidays and boarding houses, and again after the Second World War, with the proliferation of chalets and caravan sites and an influx, finally, of retired 'permanent tourists'.

Photography both recorded and influenced these developments. By the late 19th century the number of commercial firms in the region had greatly increased, including Trevorrow and Studio St Ives in St Ives, Preston and Poole in Penzance, and Gibson in Penzance and

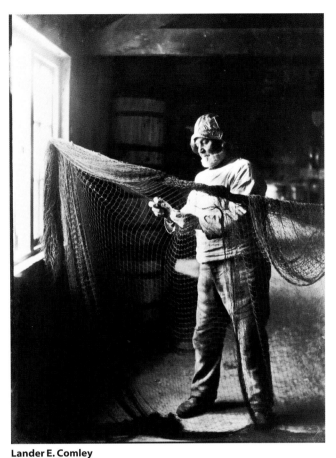

Lander E. Comley
Dandy Dick Comley mending nets, St Ives, Cornwall, 1900s

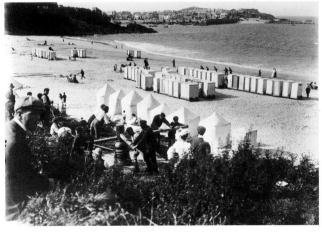

Lander E. Comley
Blowsers hauling nets full of pilchards, St Ives, Cornwall, 1900s

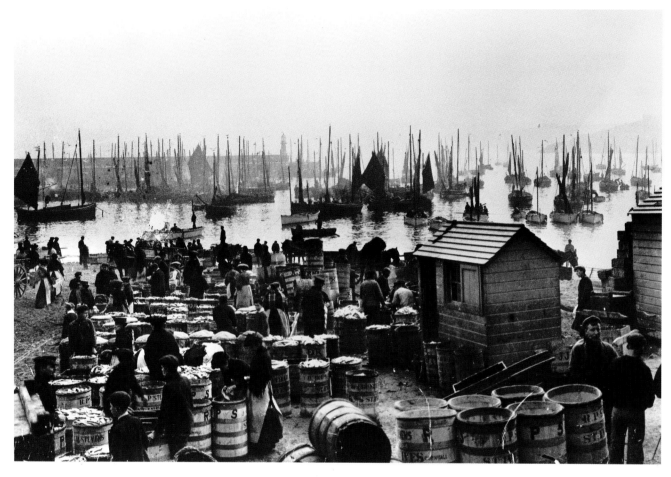

Lander E. Comley

Pilchard market at St Ives, Cornwall, 1900s

Scilly. The Gibsons began *c.*1870 and eventually established themselves on both Scilly and the mainland. Their business was portraiture, local views and genre scenes (Newlyn's legendary fishwives), and news events, especially shipwrecks. Competition was keen, between local firms for wreck pictures, and against the big national companies in the lucrative view market. As communications improved and tourism increased, firms like Wilson and Frith extended their picture-making and distribution networks nationwide, and surviving albums often contain a mixture of work by them and local operators. Both together shaped the image of Cornwall as perilous, wild, and exotic.

Both local and visiting amateurs proliferated. The former included John Branwell at Penlee House, Penzance, who recorded events in and around his mansion and park. At St Ives, Herbert Lanyon and Landor Elvin Comley produced fine views and nautical images. Their vision was clearly influenced by contemporary *pictorialism, and by notions of the 'maritime picturesque' evolving since the days of *Hill and Adamson. However, Comley's pictures especially, of the crowded harbour and fish market, and bathing tents beside net 'blowsers' on

the beaches, also document social and economic change. For the Stephens, photography was an absorbing holiday pastime. In 1892, for example, Virginia noted that her two elder half-siblings 'keep a visitor's list by photographing everyone who comes to the palatial residence [Talland House]'; views, beach games, corners of the garden, and the likenesses of servants and local characters were all assiduously recorded. Their albums anticipate the efforts of more numerous middle- and lower-middle-class visitors after the First World War.

The two art colonies emerged in the early 1880s, influenced by the contemporary *plein-airisme* of Jules Bastien-Lepage (1848–84). While the Newlyners concentrated on fishing and rural genre, often of a melodramatic kind, their St Ives colleagues preferred seascapes; but overlaps were frequent. More remains to be discovered about links between painting and photography in both places, but they were numerous. In the first place, like their French counterparts (e.g. Alexis *Muenier), the British painters probably used the camera in the production process, to create studies and economize on models. Secondly, firms like Gibson would not only have photographed

Harry Penhaul

Self-portrait, *c.*1950s

paintings before they were dispatched to Birmingham, London, or Paris, but were clearly influenced in their own genre production by the artists' work. Thirdly, painters like Percy Craft recorded artists' varied social activities, from cricket matches to charades and fishing parties. This tradition, especially at St Ives, continued into the era of Ben Nicholson and Barbara Hepworth in the 1940s and 1950s.

Notable finally was the career of the press photographer Harry Penhaul (1914–57). He used glass plates even on the most perilous assignments and, a popular figure, spent most of his time photographing local 'diary' events, and much-loved characters on their retirement. However, extreme weather or a maritime tragedy could propel his work overnight into the global media arena. RL

Williams, D., *West Cornwall Camera* (1990).

Lenman, R., 'British Photographers and Tourism in the 19th Century: Three Case-Studies', in D. Crouch and N. Lübbren (eds.), *Visual Culture and Tourism* (2003).

Dell, M., and Whybrow, M., *Virginia Woolf & Vanessa Bell: Remembering St Ives* (2004).

Subsequently they not only founded the Lomo Society International and organized exhibitions, but dissuaded the manufacturer from abandoning Lomo production and themselves took over distribution. Later, the society designed and marketed multi-lensed plastic cameras ('samplers') capable of taking several images on a 35 mm frame. But the Lomo 'philosophy'—'Shoot—don't think'—is independent of any particular equipment, film based or digital. Although Lomography's headquarters remained in Vienna, 'embassies' appeared worldwide. From 1997, however, it became a classic *Internet phenomenon, with dozens of websites and thousands of pictures exhibited online. RL

Albers, P., and Nowak, M., 'Lomography: Snapshot Photography in the Age of Digital Simulation', *History of Photography*, 23 (1999).

Londe, Albert (1858–1917), one of the leading French *medical photographers of the 19th century. From 1882 to 1903 he worked at the Salpêtrière Clinic in Paris under its director Jean-Martin Charcot, creating the photographs of female patients that served as evidence for the Salpêtrière doctors' specific theory of hysteria. In fact, however, they were wholly staged representations in which doctor, patient, and photographer all collaborated. Londe also revived the photographically illustrated journal *Iconographie de la Salpêtrière*; in 1893 developed a twelve-lens camera that could take a rapid succession of pictures; and in 1895 constructed an ultra-high-speed shutter. Also that year he introduced X-rays into French medical photography. With Paul Richer he worked on the photography of *movement. His principal publications were *La Photographie médicale: application aux sciences médicales et physiologiques* (1893) and *Traité pratique de radiographie et de radioscopie: technique et applications médicales* (1898). Londe belonged to the *Société Française de Photographie from 1879, and in 1887 co-founded the Société d'Excursions des Amateurs Photographes. JJ

Bernard, D., and Gunthert, A., *L'Instant rêvé, Albert Londe* (1993).

Long, Richard (b. 1945), English sculptor and photographer of the environment, and leading exponent of Land art. His art is based on his relationship with the landscape around him as he walks, and his first major work was *A Line Made by Walking* (1967), documented by photographs, drawings, and diagrams. Subsequent journeys, some lasting for weeks, took him all over the world. En route he uses local materials to make small temporary sculptures that survive only in his photographs. He won the Turner Prize in 1989. LAL

Long, R., *A Walk across England* (1997).

Lorant, Stefan (1901–97), Hungarian-American journalist and editor, and a founder of modern *photojournalism. Lorant left Hungary in 1919 to escape right-wing repression, one of a talented generation of émigrés that included the *Capa brothers, *Brassaï, *Gabor, *Kertész, and the film-maker Alexander Korda. After working in the Viennese film industry he moved to Germany and in 1930 became editor-in-chief of the liberal *Münchener illustrierte Presse. Forced to emigrate by the Nazis, he eventually reached London and ran a succession of

illustrated journals: *Weekly Illustrated* (formerly *Clarion*) in 1934; *Lilliput* (1937), which he sold to the press magnate Edward Hulton; and, published by Hulton, *Picture Post from October 1938. Assisted by Tom *Hopkinson, Lorant pushed circulation up to 1,350,000, while pursuing a leftish, anti-fascist, and anti-appeasement line. Though his idiosyncratic editorial style put a strain on colleagues he had a keen design sense and excelled at juxtaposing images—most famously, Neville Chamberlain and a llama—for maximum polemical effect. After the fall of France in 1940 he left for the USA, and subsequently devoted himself to the production of illustrated books. RL

Lotar, Eli (1905–69), French photographer and film-maker, of Romanian origin. He left Bucharest for Paris in 1924, hoping to make a career in film, but took up photography after meeting Germaine *Krull, with whom he created reportages for *Vu and other magazines. He participated in the 1929 *Film und Foto exhibition in Stuttgart, and became part of the *New Vision-orientated group loosely described as the 'Paris School' (*Boiffard, Krull, *Man Ray, *Tabard, and others). He published pictures of Greece in *Minotaure, documented the slaughterhouses of La Villette, and did street photography in the Paris suburbs. He also kept a toehold in the cinema, working with Buñuel on *Land without Bread* (1933) and Renoir on *Une partie de campagne* (1936). After spending most of the Second World War in Switzerland, he made a documentary film, *Aubervilliers*, with Jacques Prévert in 1946. LAL

Eli Lotar (1993).

Louÿs, Pierre (1870–1925), French writer who achieved early notoriety with his 'Sapphic' *Chansons de Bilitis* (1894) and novel *Aphrodite* (1896). But his interests, friendships, journeys, and other writings reveal a much more intriguing character. Between 1890 and 1896, before his marriage to Louise de Hérédia, he photographed intensively, mainly using a small *Kodak. He portrayed his friends Jean de Tinan, Debussy, and Mallarmé and recorded his numerous visits to North Africa. But his most personal, original, and, because of its subject matter, least-known series of pictures was created in his Paris flat: portraits of very young girls, female friends, mistresses, or models in provocative or obscene poses. Most of them are locked away in private collections. Precisely staged, strong, aesthetically pleasing, and—unusual for this kind of picture—often poetic, they are intimately linked to Louÿs's intense personal life and compulsion to record his sexual experiences. They form part of an obsessive collection that includes other, acquired photographs, notes, poems, and interminable lists of specialized vocabulary. SA

Goujon, J.-P., 'Pierre Louÿs, photographe érotique', *La Recherche photographique*, 5 (1988).

Lumière, Auguste (1862–1954) and **Louis** (1864–1948), French inventors. As well as earning lasting fame from the worldwide exhibition of their Cinématographe moving-picture system in 1895–8, the Lumière brothers made notable contributions to still photography.

Their father, Claude Antoine Lumière (1840–1911), had studied photography with *Nadar in the late 1850s and opened a portrait studio at Besançon in 1861. The firm subsequently turned to the manufacture of photographic plates and in 1882 achieved a major breakthrough when Auguste and Louis devised new mechanized production apparatus and sensitive new plates called *étiquettes bleues*; by 1900, now based in Lyon, the company was the largest of its kind in Europe. The Cinématographe was largely the work of Louis, although Auguste helped with its evolution and appeared with his family in several films. The brothers perfected their *autochrome system of colour photography in 1904 and marketed it with great success from 1907. Louis also experimented with giant-screen moving pictures (1900), a photographic panorama (1902), a multi-layered *stereoscopic portrait system (1920), and stereo films (1930s). Auguste, long interested in medicine, established a laboratory in Lyon in 1910 and spent the rest of his life researching tuberculosis and cancer.　　DR

Chardère, B., *Les Lumière* (1985).

Lumière, La. Weekly journal founded by the *Société Héliographique in 1851. Edited by Ernest Lacan, the first issue appeared 9 February 1851, and it continued through the disappearance of the Société Héliographique and the founding of the *Sociéte Française de Photographie, appearing every Saturday until 1867. It contained articles charting the development of photographic art, science, and industry in both France and Europe as a whole. Reprints of primary material relating to the *invention of photography, reports on the *Mission Héliographique, and a lively correspondence section have made this a valuable resource for the history of photography.　　KEW

Laffitte, J. (ed.), *La Lumière (1851–1860)* (1996).

Lutterodt family, a dynasty of photographers rooted in Accra (Gold Coast, now Ghana) but working itinerantly along the West African littoral from at least 1870. Born *c.*1850, Gerhardt Lutterodt, son of the notable mixed-race Dane-Accra family, was probably the first photographer-member. He toured port towns between Freetown and Duala by steamship, eventually emerging as an influential propagator of photographic technologies; he is still remembered in Accra and Lome by descendants of studios opened a century ago. Lutterodt descendants further expanded his trade: William, probably a cousin, was advertising studios in the bustling entrepôts of Cape Coast and Elmina by 1880. A nephew, Frederick (1871–1937), had opened Duala Studio in Accra by 1889; Gerhardt's son Erick (1884–1959) had established the Accra studio in the same neighbourhood by 1904, while a Fernando Po family studio ran contemporaneously. Erick and Frederick prospered with a large urban clientele, and also recorded expeditions for the British and German colonial governments travelling through the Gold Coast, Togo, and Cameroon hinterlands. Lutterodt studios in Accra, particularly, expanded and multiplied until at least 1950. Collectively, their images documented the burgeoning city landscape, political events and personages, and cultural ceremonies, and testify to an expansion of visual documentation for private and public purposes.　　EH

lynching. See EXECUTION PHOTOGRAPHS.

Lynes, George Platt (1907–55), American photographer for the New York City Ballet and glamour portraitist of artists, writers, and *Hollywood stars. His photographs often feature surrealistic sets, unconventional angles, and dramatic lighting. In his studio by night, as a sideline, he shot hundreds of male nudes. Kept mostly private during his lifetime, they were Lynes's favourite pictures and, after rediscovery in the 1970s, are today his best-known images. Ranging from documentary-style photographs to illicit sex pictures, they occasionally appeared under pseudonyms in European gay magazines. The *Kinsey Institute has a large collection of them.　　PC

Woody, J. (ed.), *George Platt Lynes: Photographs 1931–1955* (1981).

Lyon, Danny (b. 1942), American photographer, born in Brooklyn and educated at the University of Chicago. His initiation into the tumultuous world of *photojournalism came when he joined the Student Non-Violent Coordinating Committee at the height of the *Civil Rights movement in 1963. He went on to document the demolition of Lower Manhattan's architectural heritage, motorcycle gangs and stockcar drivers, the brutal existences of prisoners in Texas, and the rural poor of New Mexico and the Andes. Widely published, Lyon has also made extraordinary films, including *Llanito* (1971), *El mojado* (1973), *Los niños abandonados* (1975), and *Little Boy* (1977).　　TT

Lyon, D., *Knave of Hearts* (1999).

Lyon, Edmund David (1825–1891), British commercial photographer in India. After service in the British army, Lyon came to India as a professional photographer in 1865, basing himself at the south Indian hill station of Ootacamund in the Nilgiri Hills. A number of his views of the area were shown at the Paris International Exhibition of 1867. His most important work in India, however, is the series of *c.*400 architectural and archaeological views of western and southern India commissioned by the Bombay (Mumbai) and Madras governments in 1867–8. Lyon left India in 1869, returning to Europe via Malta, where he was again commissioned to photograph architectural subjects for the colonial authorities. Lyon's photographs were well received in England, where he exhibited and lectured extensively on Indian architecture, using his photographs as illustrative material. A large collection of his negatives and prints is held in the British Library, London.　　JF

Lyons, Nathan (b. 1930), American photographer and educationalist. A black-and-white photographer specializing in photographic essays and series, Lyons is also founder and director of the Visual Studies Workshop, Rochester, New York, and a founding member of the *Society for Photographic Education. His role in photographic education, and his stint as curator of photographs at George Eastman House, were marked by an openness to often-marginalized areas of photographic art, like artists' books, video, and *mixed media.　　KEW

McBean, Angus (1904–90), British stage photographer and *Surrealist. Born in South Wales, McBean moved to London, and a job in antiques, in 1925. In the early 1930s he made theatrical masks and properties and also worked for a while in the studio of the society portraitist Hugh Cecil. In 1936 he was commissioned by Ivor Novello to make masks and take production photographs, and within a year he was specializing in theatre work, photographing the luminaries of the day. (His record of Vivien Leigh's career would extend over 30 years.) From 1937 he created a series of Surrealist portraits in bizarre studio sets: torsos emerged from landscapes and disembodied heads floated on lily pads. Such idiosyncrasy subsequently proved out of tune with the spirit of the war years, which also marked a hiatus in his theatrical work. During the late 1940s and 1950s, having resumed theatrical photography, McBean was in constant demand at Stratford, the Old Vic, and the major opera houses. He also photographed visiting stars of stage and screen, produced his own quirky Christmas cards, and created record covers, including the Beatles' *Please Please Me* (1963). Poor health and changing markets led to his semi-retirement from the mid-1970s. RP

Woodhouse, A., *Angus McBean* (1982).

McCosh, Dr John (1805–85), Scottish doctor and amateur photographer, employed by the Indian Medical Service 1831–56. During the Second Sikh War (1848–9) he made a series of *calotype portraits and a small number of views in Lahore, including the tomb of Maharaja Ranjit Singh. He was later posted to Burma with the 5th Battery, Bengal Infantry, where he photographed scenes from the Second Anglo-Burmese War of 1852. His photographs, in the National Army Museum, London, and the Victoria & Albert Museum, London, are among the earliest surviving work from South Asia. SCG

McCosh, J., *Advice to Officers in India* (1856).

McCullin, Don (b. 1942), English photographer. Working always in grainy, black-and-white images, he has moved between social documentary, war photography, landscapes, and special overseas projects. It was his good fortune to hit the renaissance of British photography that took place in the 1960s. Born in a poor area of north London, he trained at Hammersmith School of Arts and Crafts and in the RAF during national service in Kenya. His first piece of reportage, of gang members posing in a bomb-damaged house in Finsbury Park, appeared as an *Observer* feature on 15 February 1959.

He worked as a staffer for the *Observer*, then for the *Sunday Times Magazine*, and went freelance in 1985. He became famous, and won many awards, for his coverage of conflicts in the Congo, Cyprus, Israel, Vietnam, Biafra, Cambodia, the Lebanon, and Northern Ireland; some of his images, such as those of a starving albino boy in Biafra and a shell-shocked American soldier in Vietnam, have become icons of 20th-century warfare.

McCullin has prided himself on 'de-Hollywoodizing' war, but been scarred in the process. He has reflected at length, in print and on television, on the ethics of recording suffering and death. His book on England, *The Homecoming* (1979), also shows a sombre vision of alienated, aggressive people living on the margins and in subcultures. In the 1990s a personal retreat brought him to Somerset, where he rediscovered an outer tranquillity he hoped would produce inner peace. He experimented with early photographic processes, but even his close-ups of artichoke plants remained hauntingly dark. By the turn of the 21st century he was back in Africa, working for Christian Aid on an AIDS awareness project. He explained: 'I sat in England and thought—what is the purpose of my life? . . . I thought, I don't want to sit in England looking at the beautiful landscape . . . I'm damn well going to try and make people take notice that we have far too much in the West.' Since the 1960s he has also made regular visits to India. AH

McCullin, D., *Unreasonable Behaviour: An Autobiography* (1990).

Mach, Ernst (1838–1916), Austrian physicist, mathematician, and philosopher of science. He became professor of mathematics at Graz (1864), then of physics in Prague (1867) and Vienna (1895). He made important discoveries in the physiology of human sensation, in particular visual perception, and later studied human kinaesthetic sensation. From 1873 and 1893 he discovered the laws governing shock waves caused by projectiles and in the mid-1880s used *Talbot's electronic *flash techniques to capture them photographically. GS

Cohen, R. S., and Seeger, R. J., *Ernst Mach, Physicist and Philosopher* (1970).

Machu Picchu. See PERU.

Macijauskas, Alexandras (b. 1938), Lithuanian *documentary photographer, prominent in Lithuania's principal photographers' association, the Art Photography Society. He made his name with two extensive monochrome surveys of rural life, *Market* (1969–80) and *Veterinary Clinic* (1977–84; not for the squeamish). Using a wide-angle

Ian Waldie Diana, princess of Wales, surrounded by paparazzi on the day her marriage ended, 28 August 1996

Freeman Patterson Abandoned house, Namibian Sperrgebiet, late 1990s

Angus McBean

Audrey Hepburn, 1950

lens, he comes in close and low as his subjects—who, doubtless from long familiarity, mostly ignore him—manhandle assets more solid than photography: geese, grain sacks, and gigantic pigs.　　RL

Macijauskas, A., *My Lithuania* (1991).

Mac Orlan, Pierre (Pierre Dumarchey; 1882–1970), French novelist, poet, and writer on photography. His central preoccupation, articulated in stories like *Quai des brumes* (1927; famously filmed by Marcel Carné in 1938), was the opposition between immemorial ways of life, and marginal people like itinerant entertainers, and the rationalism of the modern city. As a critic, he celebrated the monochrome photograph's ability to capture details that betrayed the mysterious, secret life of cities—what he termed the 'social fantastic'— behind their monumental and functional façades. This was best pursued in 'those popular quarters where bars loom into view out of the fog'; and especially at night: 'Photography makes use of light to study shadow. It reveals the people of the shadow. It is a solar art at the service of night.' Such sentiments explain his enthusiasm for photographers like *Brassaï and *Kertész; for *Atget, for whose first published collection of photographs he wrote an introduction (1930); and for *Ronis, whose pictures of Belleville-Ménilmontant he described as 'poems of the street'. He also had a long association with the poetic realist Marcel Bovis (1904–97), whose suburban nocturnes, with their wet cobblestones and fog-muffled lamps (e.g. *Rue Brancion*, 1931), were inspired by Mac Orlan's writings. Conversely, Bovis was the natural illustrator for his circus poems, *Fêtes foraines* (1990).　　RL

Phillips, C. (ed.), *Photography in the Modern Era: European Documents and Critical Writings, 1913–1940* (1989).

Macpherson, Robert (*c.*1815–1872), Scottish photographer, active in Rome, where he established himself *c.*1841 as a painter and art dealer. Introduced to the 'new art' of photography in 1851, he subsequently favoured Dr J. M. Taupenot's collodio-albumen process which, despite long exposures, best suited his practical and aesthetic needs.

Macpherson's self-designation as an artist-photographer is justified by his architectural and landscape studies. Through choice of viewpoint and manipulation of contrast, he exploited the interplay between light and shade to produce strong graphic images. Despite commercial constraints, his architectural photographs went beyond mere description to evoke the grandeur of imperial Rome. By 1858, with Tommaso Cuccioni (1813–64) and James Anderson (1813–77), Macpherson was one of Rome's leading photographers, and was the first to photograph the Vatican interior, recording many of its sculptures. He maintained strong links with the Photographic Society of Scotland and the Architectural Photographic Association. Unlike his successful rival Anderson, however, he failed to meet the growing demand for popular topographical views, and his business declined during the 1860s.　　SD

Dewitz, B. v., Siegert, D., Schuller-Procopovici, K., (eds.), *Italien sehen und sterben: Photographien der Zeit des Risorgimento (1845–1870)* (1994).

macrophotography. See PHOTOMACROGRAPHY.

Maddox, Richard Leach (1816–1902), English physician and amateur photographer, recognized today as the inventor of the first practicable gelatin silver halide emulsion. Maddox suffered from ill health in his early years and moved abroad. He practised medicine for a time in Constantinople, and during the 1870s in Corsica and Italy, before eventually returning to England. For most of this period he was a keen photographer, winning medals for his photomicrographs. He stayed in touch with developments through his friend John Trail Taylor, editor of the *British Journal of Photography* (*BJP*).

Maddox was concerned about the health risks of the *collodion process (which included ether and cyanide) and familiar with the numerous unsuccessful attempts that had been made to find a dry substitute for collodion to carry sensitive silver salts. In an 1871 article in the *BJP* he published details of a gelatin bromide emulsion he had devised that gave promising results. Others improved the idea, and within ten years gelatin bromide *dry plates were being mass produced and a giant new industry was established. Dry emulsions revolutionized photography, being more convenient to use and more sensitive than wet collodion plates. The shorter exposures they permitted led to the introduction of hand cameras; and they made *roll-film possible. Modern sensitized materials continue to be based on gelatin silver halide emulsions.

Like his predecessor Scott *Archer, Maddox refused to patent his discovery, and although the *Royal Photographic Society awarded him the Progress Medal, its highest honour, he died in poverty.　　GS/JPW

magazines. See CELEBRITY PHOTOGRAPHY; FASHION PHOTOGRAPHY; PHOTOJOURNALISM.

magic and superstition have surrounded photography from the beginning. Because of the way it captured the image, especially of living people, the camera was widely believed to cause death or illness or to steal the soul. Photographs were thought to have supernatural powers, or be amenable to witchcraft. There are many variants of these beliefs, which are often related to those concerning the power of the shadow, the soul, or the status of the dead. The anthropologist and folklorist J. G. Frazer included examples in his compendium *The Golden Bough* (1911–15), reporting, for instance, a Yankton Dakota man who feared that his spirit might stay with the photograph after his death instead of going to the spirit land.

While many, especially later, reports are probably travellers' tales or reactions to a photographer's intrusion, others reveal unease or even terror in the face of a new technology. In 19th-century Japan it was said that being photographed once reduced one's shadow and a second time shortened one's life. In parts of South America, photography was believed to peel the face, and in China the camera lens was thought to be made of the eye of a dead Chinese baby. The Araucanian people of Chile believed that photographs could be used

to bring bad magic upon the subject, while in parts of Papua New Guinea, photographs of people subject to witchcraft are still believed to be especially dangerous.

The camera was itself seen as a magical instrument, and there are many accounts of subjects fleeing. The photographer's disappearance under the black cloth and the inversion of the image on the focusing screen were perceived as dangerous. Even in Western Europe, the uncannily precise reproduction of God's creatures was sometimes seen as the devil's work. Significantly, the word for photography/photographer in many cultures translates as 'shadow catcher', 'soul taker', or 'face stealer'.

The magical, mysterious, and quasi-supernatural qualities of photographs reflect their perceived power in society. Instances of both benevolent and malevolent magical properties occur in film and literature, for example the deadly camera in *The Eyes of Laura Mars* (1978), and the magical photograph which speaks and moves, yet is still 'a photograph', in J. K. Rowling's *Harry Potter and the Chamber of Secrets* (1998). All point to the astonishing power sometimes attributed to photography, and the anxiety it has evoked. EE

Behrend, H., 'Photo-Magic: Photography in Practices of Healing and Harming in Kenya and Uganda', *Journal of Religion in Kenya and Uganda*, 32/33 (2003).

magic lantern. See PROJECTION OF THE PHOTOGRAPHIC IMAGE.

Magnum. Founded at meetings in Paris and New York in the spring of 1947, it was the first self-governing, cooperative photographic agency, whose members also owned the copyright to their work. Founding members were Robert *Capa, who had nourished the idea since the mid-1930s, George *Rodger, David 'Chim' *Seymour, the *Life photographer Bill Vandivert, and Henri *Cartier-Bresson. They grandly divided up the globe, with Seymour covering Europe, Cartier-Bresson India and the Far East, Rodger Africa and the Middle East, and Vandivert the USA; Capa would rove freely. Maria Eisner (1909–91), formerly of the Alliance Photo agency, and Vandivert's wife Rita would run the business side. The agency would be based in Paris, with offices in London and New York (later also Tokyo).

Founded when magazine journalism was still booming, Magnum survived several early crises, including the deaths of Capa and another early member, Werner *Bischof, in 1954, and Seymour in 1956, to become a prestigious elite organization. It is democratically organized, with a tiered system of nominees, associates, and full members (limited to 36) voted in at a geographically rotating AGM. Full members have included Eve *Arnold, Ian *Berry, Susan *Meiselas, Inge *Morath, James *Nachtwey, Martin *Parr, Gilles *Peress, Raghu *Rai, and Sebastião *Salgado. They have preserved the principle of choosing their own assignments and keeping control of their own work. The agency's picture archive has become a major media and scholarly resource. AH

Morris, J., *Get the Picture* (1998).
Miller, R., *Magnum: Fifty Years at the Front Line of History* (1998).

Magritte, René (1898–1967), Belgian Surrealist known for mysterious and witty paintings. Using a deliberately banal painting style, he sought to penetrate the boredom of everyday life to reach something fantastic. He used his camera in much the same way, making photographs that manage to shimmer mysteriously, appearing by turns extraordinarily dull and extraordinary. He frequently posed his friends and more often his wife Georgette in tableaux with the same deadpan approach as is characteristic of his paintings; other images, however, are more casual, apparently recording the doings of Magritte and his fellow Surrealists. MR

René Magritte: Photographs (1990).

Magubane, Peter (b. 1932), South African photographer. In the 1950s, before apartheid's forced removals, photography was part of a flowering of black creativity in South African cities. Against this background Magubane started his career at *Drum* magazine from modest beginnings, ultimately becoming senior photographer. This work environment also provided initial opportunities for other famous black photographers such as Ernest Cole (1940–90), Bob Gosani (1934–72), and Alf Kumalo (b. 1930). *Drum* had moved towards celebrating emergent black urban identity and culture; it also allowed room for new images of social and political existence in the 1950s and 1960s.

As political protest intensified, Magubane photographed historic events such as the Sharpeville massacre (1960) and the Treason Trial in the early 1960s, and the Women's March in Pretoria in 1965. He became the first black photographer to exhibit in South Africa, and remained there, operating under increasingly brutal conditions, during the 1970s. He was frequently arrested, harassed, and beaten by police for being in possession of a camera, and took to various forms of concealment. While never convicted of any crime, Magubane spent many days in detention, and was ultimately placed under a banning order for five years.

Magubane embraced a tough, Americanized style to represent conditions in townships during the 1960s and 1970s, in both photographs and captions. From the 1980s he photographed for *Time* magazine. His post-apartheid projects since 1994 have therefore surprised many, comprising colour photography of rural ethnic costume and ritual, mainly for the growing tourist coffee-table market. PHA

Magubane, P., *The Fruit of Fear* (1986).

Mahr, Mari (b. 1941), Chilean-born British photographer. After working as a photojournalist in Budapest in the 1960s she moved to London in 1972. Dreams, memory, history, fantasy, and magic-realist humour resonate within her enigmatic, black-and-white, multi-layered observations, generally presented as series. Everyday objects—a chair, a metronome, candles, twine, pot plants—are rendered strange through unexpected juxtapositions of scale within the picture or through shifts in angle of vision. The pictures are assembled from details, originally by means of multiple exposure,

later using *digital tools. Titles sometimes invoke particular persons or places: the Russian Futurist artist Lili Brik, for example, or a stay in Geneva, although the imagery remains open to multiple interpretations. Her work is personal, and often concerns matrilineage, most particularly in the series *Between Ourselves* (1991–2; pub. 1998), which includes homage to her daughter, mother, and grandmother. LW

Maitani, Yoshihisa (b. 1933), celebrated camera designer for Olympus Optical Co. Ltd. His work reflects the values of originality, intelligent cost cutting, and technical quality. In 1959, his first major project, the Olympus PEN half-frame camera, inexpensive but with a Tessar triplet lens, was launched to rave reviews. From 1960, as design team leader, he produced the viewfinder PEN, then in 1963 the PEN F, the first half-frame single-lens reflex camera, with a rotary shutter synchronized to all shutter speeds. Over 1.7 million PENs were made. In 1972 he designed the Olympus M1, a small full-frame 35 mm SLR, which (renamed the OM-1) launched the *OM series. It was followed by the stylish XA 'capsule' pocket cameras. MT

makeover photography. The idea of the photographer's studio as a site of fantasy and make-believe, where identities can be magically altered or multiplied, is central to much *erotic photography and to classic *Hollywood portraiture. But even the humblest clients of early small-town studios, posed in not-quite-fitting Sunday clothes before painted *backdrops, hoped to appear more alluring and dignified than in real life. The camera's mythic ability to confer sophistication and status still draws studio clients in Africa and India.

The makeover experience—intensive making-up and hairstyling followed by a portrait session—established itself in Western high-street photography from the 1980s, fitting neatly with related services like model work and *wedding photography. Clients are mainly or exclusively women, pleasing a partner or simply themselves; as one Australian studio put it, 'We specialise in the mums and the grandmums who have "done their time" and sacrificed for their family, and would now like a morning just for themselves to be totally pampered.' Celebrity culture, and the importance of self-presentation in Western societies, are key influences. (In post-Unification Germany, the transformation of East German women for the Western job market became a profitable business.) More exotic makeover modes, involving sets and costumes, are limited only by the client's willingness to pay and the studio's resources.

Makeover photography's erotic variant is *boudoir photography*. Its purpose is to create seductive images of the female client, again either for presentation to a partner or for her own satisfaction. Erotic portraiture has a long history, but its modern, shopping-mall manifestation dates from America in the early 1980s. It is both lucrative and challenging. Creating glamorous images of self-selected 'real people' is harder than working with professional models. A performance must be elicited, either on a studio 'set' or at home. Weight, height, and complexion problems must be masked by styling and lighting. Success requires tact, and an intuitive ability to realize the client's erotic self-image, with or without a partner in mind. Spontaneity must be balanced with careful preparation; private fantasies with current media fashions; sexual rapport between photographer and subject with an atmosphere of tastefulness and security. Given that flattering the client, rather than raw titillation, is the aim, mastery in these areas is hard for amateurs to match, even with sophisticated equipment. Boudoir photographers' files would offer fascinating insights into fashions in contemporary eroticism. Discretion, however, is the lifeblood of the business. RL

See also POSING FOR THE CAMERA; STAGED PHOTOGRAPHY.
Venticinque, M., *Boudoir Photography: The Fantasy Exposed* (1986).

Malin, David (b. 1941), British-born astronomical photographer who between 1975 and 2001 worked at the Anglo-Australian Observatory in Sydney. His training and previous career in chemistry enabled him to pioneer methods—including 'malinization'—of radically enhancing faint photographic images of distant galaxies and other celestial phenomena, greatly increasing the information obtainable from them. The techniques he devised for capturing colours invisible to the eye produced pictures that were both revealing and astonishingly beautiful. Malin has had a galaxy and a minor planet named after him. Among his many publications are *Colours of the Stars* (1984, with Paul Murdin) and *A View of the Universe* (1993). Since his retirement he has marketed astronomical pictures through an *Internet business, David Malin Images. RL

Malmberg, Carl Jacob (1824–95), Swedish photographer, born in southern Finland, who began working in St Petersburg in the late 1840s. Initially a daguerreotypist, he learned the negative/positive process after settling in Stockholm in the early 1850s. He took portraits, cityscapes, and views of early industrial landscapes. A technical pioneer and inventor of an early *half-tone process, Malmberg was also notable for his association with the gymnastics movement founded by Pehr Henrik Ling and, in the 1880s, for gymnastic studio photographs used as the basis for illustrative drawings. He worked finally in Skövde, southern Sweden. J-EL

Mammoth camera, a huge camera custom designed by the Chicago photographer and inventor George R. Lawrence in 1900 in order to photograph a complete train owned by the Chicago & Alton Railway. It was 6.1 m (20 ft) long when fully extended and, with its 227 kg (500 lb) plate holder, weighed 633 kg (1,400 lb). The plate itself measured 2.44 × 1.37 m (8 × 4$\frac{1}{2}$ ft). A single, 2$\frac{1}{2}$-minute exposure of the train was made, and three contact prints sent to the Exposition Universelle in Paris, where the picture won the 'Grand Prize of the World for Photographic Excellence'. RL

Baker, S., 'The Mammoth Camera of George R. Lawrence', *History of Photography*, 1 (1991).

mammoth plate, an outsize format used by some 19th-century view specialists, notably photographers of the *American West like Carleton E. *Watkins. On his 1867 journey up the Columbia River in Oregon, for example, Watkins employed 41.3 × 52.7 cm (16¹/₄ × 20³/₄ in) plates to create magnificent images such as *Cape Horn near Celilo*. On other occasions he used even larger, 45.7 × 55.9 cm (18 × 22 in), plates. Other users of the mammoth format included Mathew *Brady, William Henry *Jackson, and Eadweard *Muybridge. RL

Man, Felix (Hans Felix Sigismund Bauman; 1893–1985), German photographer who made his reputation with the early illustrated photo magazines the *Münchner* and *Berliner illustrirten*. The Nazi seizure of power obliged him to leave for England in 1934. He joined *Picture Post* at its inception, and in 1938 became its chief photographer. He remained until the paper's demise in 1951, working for the last three years as its 'colour specialist'. He travelled and photographed across the world, documenting nations at war, at work, and in repose. He was a master of non-studio portraiture, and his images of statesmen like Mussolini and Churchill brought him international fame. AH

Kaufman, C. M., *Felix H. Man: Sixty Years of Photography* (1983).

Manassé Studio, Viennese glamour studio founded by the Hungarian-born Adorján (1893–1947) and Olga (née Spolarich; 1895–1969) Wlassics in the early 1920s. It supplied images to illustrated papers and traded in film-star *postcards. Its whimsically posed, oiled, and hairless nudes, linked to contemporary cinematic and lifestyle fashions, now seem so kitschy and dated as to be rather appealing. Technical trickery showed diminutive nudes in various sexy predicaments, trapped in cigarette cases or being fished from teacups. Business boomed in the 1930s, and early in the Second World War the couple ran a studio in Berlin. After Adorján's death Olga returned to photography in Vienna, but later became a painter. RL

Faber, M., *Divas and Lovers: Photographic Fantasies from Vienna between the Wars* (1998).

Mann, Sally (b. 1951), American photographer, best known for photographs of her three children, often naked, dirty, or wounded, in poses that suggest their precocious sexuality. Her first widely recognized body of work, *At Twelve* (1988), similarly portrayed just-pubescent girls. Later work explored landscapes of the American South, especially the Blue Ridge Mountains in south-western Virginia where she was born, grew up, and lives.

Mann's black-and-white photographs are made with a large-format view camera, and thoughtfully and skilfully printed. She has also worked in platinum, Polaroid, and Cibachrome. Her images are generally large and, issued in extremely limited editions, have enjoyed great success both critically and commercially.

In the late 1980s, the widely exhibited family photographs eventually published in *Immediate Family* (1992) and *Still Time* (1994) were attacked as perverse and exploitative, or praised as innocent and beautiful, depending on the political stance of the viewer.

Mann's landscape work is strongly influenced by *pictorialism. Appearing less controlled and more flawed than the images of her children, the prints are purposely made with damaged lenses to exaggerate irregularities of focus and evoke historical photography. All her work has a literary character, and embodies nostalgia for innocence lost or under threat. She has also participated in group commission projects that reflect her values and interests, producing images of the Calakmul Biosphere in Mexico for the Nature Conservancy's *Last Great Places* exhibition (2001), and untitled images of windows made from the perspective of the dying for *Hospice: A Photographic Inquiry* (1996). AN

Mannes, Leopold (1899–1964), and **Godowsky, Leopold, Jr.** (1902–83). These two American inventors were the sons of famous musicians, and groomed for professional stardom; but they were far more interested in photographic technology, carrying out their initial researches in bathrooms and kitchens. They were recruited by the far-seeing Kenneth *Mees into the Kodak Research Laboratory and invented Kodachrome, the first tripack colour emulsion, released as cine material in 1935 and 35 mm film in 1937. Both men eventually returned to musical careers. GS

Männikkö, Esko (b. 1959), Finnish photographer, active in Oulu. Since his breakthrough at ARS 01 in Helsinki, his colour photography, in which each image has its unique recycled wooden frame, has been exhibited worldwide. Subjects include still lifes of game and fish, house exteriors, panoramic landscapes, and, above all, portraits of un- or self-employed single males from Finland's northern regions. Männikkö's concerns are identity, masculinity, Finnishness, friendship, and loneliness. His 'environmental' portraits, staged in domestic surroundings, convey a strong sense of immediacy, unpretentiousness, and dignity; eye contact and deliberate poses suggest the presence of self-contained universes. Männikkö's art, documentary at heart, seduces through somewhat obtrusive colour, image detail, and precise composition. His later portrait series, and panoramic landscapes, have ranged geographically wider, embracing Mexican immigrants in Texas, Spain's regions, and Finns of non-Finnish origin. J-EL

Man Ray (Emmanuel Radnitsky; 1890–1976), American photographer who worked in many media, and whose innovative photographs challenged boundaries between art and fashion, commercial and fine art, fact and fiction. He was a pioneer in propelling the photographic medium into an avant-garde art form. Born in Philadelphia, he spent the early years of his career in New York, where he came into contact with *Stieglitz and his circle and met Marcel *Duchamp and Francis Picabia. An inveterate experimenter and iconoclast, he was drawn to the irreverent Dada spirit, as manifested in such early New York photographs as *Man* and *Woman* (1918). These compositions demonstrate his provocative use of the medium as a conceptual rather than documentary tool. Moving

Man Ray

Noire et blanche (Kiki with African mask), 1926

to Paris in 1921, he was embraced by members of the Dada and embryonic *Surrealist movements. His experimental cameraless images, named Rayographs, were heralded as paradigmatic Dada expressions and reproduced with a preface by Tristan Tzara in *Les Champs délicieux* (1922). His camera became his entrée into diverse Parisian milieus throughout the 1920s and 1930s, placing him and his photographs at the centre of vanguard artistic activities, celebrity circles, and the fashion world. His iconic photograph *Noire et blanche*, published in Paris *Vogue* in 1926, epitomizes the artist's idiosyncratic approach to the medium. Situated at the intersection of modernist interest in *l'art nègre* with the fashion world, this image formally and psychologically juxtaposes an African mask with the head of his lover Kiki, inflecting the composition with irony and ambiguity. Such images reflect Man Ray's multifaceted engagement with photography, summed up in his own words: 'I do not photograph nature, I photograph my fantasy.' In the process, he often manipulated the medium through techniques such as *solarization and image reversals, evoking the dreamlike world of Surrealism. His characteristically enigmatic statements about photography include 'The Age of Light' (1933) and 'Photography is Not Art' (1937). After two decades of prolific artistic activity in Paris, he was forced by events in Europe to return to the USA in 1940. He spent the war years in Hollywood, where he worked prodigiously across media until his return to Paris in 1951. Although he participated in a number of exhibitions while in the USA, he felt largely misunderstood and under-appreciated in his native land. His autobiographical *Self-Portrait* (1963) is an orchestrated compilation of personal musings published during a late revival of his career. Man Ray influenced the development of photographic practices in the 20th century not only through his diverse and innovative oeuvre but also through the numerous photographers who apprenticed with him, including Berenice *Abbott, Lee *Miller, Curtis *Moffat, Jacques-André Boiffard, and Bill *Brandt. WAG

Foresta, M. (ed.), *Perpetual Motif: The Art of Man Ray* (1988).
Grossman, W., '(Con)Text and Image: Reframing Man Ray's *Noire et blanche*', in A. Hughes and A. Noble (eds.), *Phototextualities: Intersections of Photography and Narrative* (2003).
Sayag, A., and L'Écotais, E. de (eds.), *Man Ray: Photography and its Double* (1998).

Maori photography. See NATIVE PEOPLES AND PHOTOGRAPHY.

Mapplethorpe, Robert (1946–89), American photographer, born and mainly active in New York. He studied painting and sculpture, and in the late 1960s was involved with underground film-making before taking up photography, self-taught, in the 1970s. A key stimulus was access to the photography collection of the Metropolitan Museum of Art via a friend, John McKendry, its curator of prints and photographs. Though he became more widely known after the appearance of his first book, *Lady: Lisa Lyon*, a study of a female bodybuilder, Mapplethorpe already had a reputation for his artist-portraits (David Hockney, Patti Smith), flower studies, and nudes. Irrespective of subject matter, his images are characterized by flawless craftsmanship and classical poise; especially the black or white male nude is presented as a kind of mortal sculpture.

In the 1980s atmosphere of political and cultural conservatism, fuelled by moral panic about AIDS, Mapplethorpe's aggressive flouting of taboos on male nudity, and some highly explicit homoerotic images, made him a controversial figure, together with other 'transgressive' artists such as Andres *Serrano; his AIDS-related early death increased this notoriety. A wide-ranging retrospective exhibition, *Robert Mapplethorpe: The Perfect Moment* (1989), partly funded by the National Endowment of the Arts (NEA), provoked an immense furore and inflamed the 'culture wars' between liberals and the right over issues such as *pornography, freedom of expression, and NEA policy. Mapplethorpe's artistic reputation has survived, however; another major retrospective was held in Brussels in 1993, and in the decade after his death the prices of key works topped $20,000. RL

Danto, A. C., *Mapplethorpe* (1992).
Morrisroe, P., *Mapplethorpe: A Biography* (1993).

maps. See CARTOGRAPHY AND PHOTOGRAPHY.

Marey, Étienne-Jules (1830–1904), French scientist who used the camera as one of many instruments during his lifelong investigation of the human and animal physiology of *movement. Marey's methods and images were remarkably influential in the histories of photography, art, aviation, military reform, moving pictures, physical education, and scientific labour management. He was a pioneer of biophysics who devised graphing machines to trace the body's movements and added the camera to his graphic method in 1882, following *Muybridge's example. Unlike Muybridge's, however, Marey's photographic systems made sequential images on a single plate over space in real time. Marey called his method *chronophotography. With it, he analysed for the first time the mechanics of human and animal locomotion, trajectories of projectiles, geometric forms engendered by strings and wires moving around an axis, and the movements of water and air. In 1888 Marey replaced his glass plate with *roll-film, introducing one of the important technological bases of motion pictures. He was an important figure in the French scientific and photographic establishment, writing more than 300 articles and seven books. His decomposition of locomotion provided a scientific basis, in Europe, for training the body and analysing the movements of work, from which American time-and-motion studies were derived. After his death, chronophotography was integrated into the work of artists who sought ways of expressing modernity, speed, and dynamism, such as Marcel *Duchamp and the Italian Futurists. MB

Braun, M., *Picturing Time: The Work of Etienne-Jules Marey (1830–1904)* (1992).

Étienne-Jules Marey

Sword-thrust, 1895.
Chronophotograph

marine and nautical photography embraces many sorts of subjects, from aesthetically motivated seascapes to functional images of *shipbuilding, vessels of all kinds, ports, sailors, and the social, economic, military, and leisure aspects of seafaring. This variety is exemplified by the holdings of the world's great collections. The National Maritime Museum at Greenwich, London, has marine *calotypes by *Talbot, Calvert *Jones, and their circles, c.1,200 nautical photographs by *Frith & Co., 30,000 pictures from the Nautical Photo Agency, large and small collections by individual photographers (for example, 20,000 by Francis Mortimer, 30,000 by Alan Villiers); and many thousands more. The San Francisco Maritime Museum holds 200,000 images relating to the American Pacific Coast. The scope of a third major collection (c.500,000 pictures), at the Maritime Museum, Newport News, Virginia, appears from the selection of superb vernacular photographs published by John *Szarkowski in *A Maritime Album* (1997).

Although the beauty of marine subjects soon attracted photographers, the slowness of early processes confined them to static motifs: the SS *Great Britain* moored to a jetty in an 1845 calotype, the ships photographed by Calvert Jones in harbour or beached on mudflats, and the fisherfolk posed by *Hill and Adamson beside their boats and cottages at Newhaven, Scotland. But technical progress gradually reduced these limitations so that, for example, by 1851 the Le Havre photographers Warnod and Macaire could daguerreotype vessels moving in and out of port. Their commercial success perhaps encouraged the first internationally famous marine photographer, Gustave *Le Gray, to embark on his celebrated series of pictures of ships at sea and in harbour. The first, *The Brig*, which was exhibited to great acclaim in London in November 1856, was followed by others taken at Sète in the Mediterranean in 1857, and off Cherbourg in 1858. Some of them, because of exposure problems, were printed from separate negatives of sea and sky. (Other Frenchmen who made seascapes in the 1850s included *Le Secq, *Baldus, the Toulon calotypist Olivier, and Le Gray's pupil Eugène Colliau.)

Doyen of British marine photographers for much of the early 20th century was Francis J. Mortimer (1875–1944). As a young man, he spent three years on the often storm-bound Scilly Isles off Cornwall, where he recorded the huge winter seas bursting on Bryher and Annet, and ventured in pilot gigs out into the great swells around the archipelago. Mortimer's award-winning *bromoils, and many other marine pictures, appeared in the numerous publications he edited—including **Amateur Photographer*—for more than 40 years.

The proliferation, by the inter-war period, of the evocatively captioned, well-made seascape (and nautical genre scene) at exhibitions, in photographic annuals, and as *postcards prompted a predictable reaction: the 'landscape at land's edge' as pure form, sometimes with mystical undertones. Outstanding examples were the near-abstract images made at *Point Lobos and elsewhere on the California coast by Edward *Weston in the 1930s and 1940s and Minor *White in the 1940s and 1950s; and on Cape Cod by Harry *Callahan in the 1970s. At the century's end, Thomas Joshua *Cooper and Hiroshi *Sugimoto took the photographic rendition of sea and sky to a point of seemingly unsurpassable minimalism. (But others, like Fay *Godwin, depicted the coastline quite differently, with all its man-made detritus of industry, leisure, and warfare.)

A major marine subject was the commercial sailing vessel, whose swansong in the period c.1880–1939 coincided with the spread of portable, easy-to-use photographic equipment. Many seafarers, like Captain Woodgate of the clipper *Cutty Sark*, took cameras with them, and some captured spectacular images. But a towering figure was the Australian-born journalist Alan Villiers (1903–82). He gained his first photographic experience on an Antarctic whaling trip in 1923–4, using a basic camera lent by the Tasmanian newspaper he worked for. Then he scented the journalistic potential of the sailing ships that carried grain from southern Australia to Europe via Cape Horn, and in January 1928 embarked in the four-masted barque *Herzogin Cecilie*. In 1929 he repeated the exploit in the *Grace Harwar*. On both trips he took a

Gustave Le Gray

The Brig, 1856. Albumen print

Kodak 120 camera with just two exposure settings. Later, Villiers was modest about his photographs: 'If there is any excellence in [them], the credit is due to the foolproof qualities of the modern cheap camera, and not to the skill of the photographer.' Yet many were superb, depicting the privations of the voyages, the motley bands of semi-outcast men who crewed the ships, and the terror and grandeur of storms in the Southern Ocean and Atlantic. Finer still were those of another amateur, Eric Newby (b. 1919), who sailed from Queenstown, Ireland, to Australia in the *Moshulu* in 1938–9.

Villiers, who described the Cape Horn sailing ship as 'the most splendid blend of utility and sea strength and functional beauty ever achieved by European man', had a romantic agenda. By the 1920s, such vessels incorporated modern refinements—steel masts and spars, enclosed wheelhouses, and brace winches to work the sails—that enabled owners to cut manning levels to a minimum. But Villiers wanted to commemorate an older, less technological reality, and something mythic and elemental, 'the age-old fight of man against the sea'. It was a sentiment worthy of Robert *Flaherty, whose 'man against nature' documentaries *Nanook of the North* and *Man of Aran* date from the same period. For this reason (and hoping to make a film about the voyage as well as photographs) Villiers chose the 'unspoiled old-timer' *Grace Harwar* in 1929: 'She had an open wheel which would be hellish in a winter gale, and she had long, heavy hand braces. She was the best ship in the fleet from the documentary point of view.'

Very different from Villiers's early books—indeed, an exercise in industrial archaeology—was *West-Country Coasting Ketches* (1974), by a retired mariner, William Slade, and the director of the National Maritime Museum, Basil Greenhill. Its subject was a type of unglamorous, family-owned small sailing vessel that carried coal, bricks, salt, and similar cargoes between south-west England, Ireland, and sometimes France between the 18th century and 1939. The book contains an illuminating—and most un-nostalgic—memoir by the veteran ketch master Slade, specimen ship plans, and numerous copiously annotated photographs illustrating their tackle and operation. Even the most lyrical were pressed to yield maximum information. It was an object lesson in the scholarly use of camera-created images in conjunction with other evidence.

In the 19th century maritime nations supported huge fishing fleets, which in 1914 were still largely wind driven. By this time, several generations of photographers had worked in fishing villages, beginning with Hill and Adamson at Newhaven in the 1840s. Like painters, they were captivated by the beauty of boats under sail and by fisherfolk's curious costumes and archaic working methods. Fishing, and the close-knit communities it supported, carried strong moral, indeed biblical connotations at a time of rapid economic and social change. (In Britain, fishermen seem to have acquired the same kind of symbolic significance as peasants in continental Europe.) Particularly celebrated was Frank Meadow *Sutcliffe, whose everyday proximity to the Whitby fishing community enabled him to capture fine unstaged studies of the

Alexander Gibson

Victims of the *Mohegan* disaster, St Keverne churchyard, Cornwall, 1898

men and their families. He also eventually used folding Kodaks to take harbourside snaps at Newlyn, Cornwall, where both photographers and painters were creating an industry out of fishing images and, as in other places in Britain and abroad, helping to redefine whole regions for *tourism.

The great port complexes that developed in the 19th century also became centres of photographic activity. This included work by non-professionals: Alice *Austen of Staten Island, for example, who for decades recorded the traffic in and out of New York; or the tug masters Orison Beaton and Hiram Hudson of Puget Sound, who took many fine ship photographs for their employer. But nautical photography also became a major commercial activity, associated with names like Cribb, Symons, and West at Southsea and Portsmouth, Renard at Kiel, *Bulla at St Petersburg, and Geisel at Algiers; and serving a variety of markets, from admiralties, shipping lines, and specialist publications to the mass of ordinary postcard buyers. At Puget Sound, *c.*1900, Wilhelm Hester had a mixed practice, photographing shipyards and launch ceremonies, ships' crewmen on deck, and captains and their wives in their saloons. In England, Frank *Beken of Cowes was creating a successful ship-portrait business in the crowded waters of the Solent.

Beken, however, had started in the late 1880s in response to the rapid growth of yachting, and by the 1900s was immortalizing the superb vessels owned by King Edward VII, Emperor Wilhelm II, and their coterie of millionaire enthusiasts. After 1945 boating became ever more popular, from windsurfing and dinghy sailing to corporate-sponsored round-the-world racing. Yacht photography continued to develop into a highly competitive and lucrative specialism, demanding global mobility and advanced communications as well as nerve and skill. At the beginning of the 21st century, world leaders like Rick Tomlinson, Thierry Martinez, Beken, and their rivals garner rich rewards from corporate commissions, equipment and sportswear advertising, calendar and library sales, and publicity work for maritime organizations like the (British) Royal National Lifeboat Institution. Meanwhile, interest in all aspects of marine photography continues to grow, encouraged by festivals such as Photo de la Mer at Vannes in Brittany.

Equally challenging has been wreck photography. Most 19th-century practitioners who lived anywhere near the sea captured a wreck at some time or other; Sutcliffe, G. W. *Wilson, and Hester, for example, all did so. The fact that ships often stranded at inaccessible places and disintegrated rapidly put proximity and local knowledge at a premium,

Francis J. Mortimer
The Relief Boat (Isles of Scilly), 1911.
Composite print

creating a competitive advantage for small operators against national newspapers and photographic companies. Particularly interesting was the story of the Gibson family in Scilly and Penzance, which for five generations supplemented routine commercial work with daring wreck photography across the region. As the copyright files in the National Archives indicate, there was a significant market for dramatic images of stranded vessels, and for grisly pictures of bodies washed up or awaiting burial; major disasters, like the wreck of the liner *Mohegan* in 1898 with over 100 deaths, attracted the national illustrated press. But the stiffest competition for pictures came from seasoned local rivals like Hawke of Helston, Burrow of Camborne, or Harrison of Falmouth, who in some cases photographed the same scene from the same perilous vantage point. Retouching or composite printing was used to compensate for difficult conditions, or to match the painterly conventions of the genre, with Alexander Gibson (1857–1944) especially adept at dubbing in doom-laden skies or wind-lashed rigging. When the American sailing ship *Granite State* grounded at Porthcurno in 1895, a group of well-dressed Victorian onlookers, complete with telescope, was neatly added to the foreground. After 1945, the greater rarity of peacetime wrecks was offset by technical improvements in photography, the widening reach of news organizations, and, above all, the sometimes enormous consequences of individual accidents. The capsizing of the American freighter *Flying Enterprise* in December 1951, 800 km (500 miles) west of Land's End, provided a fortnight of sensational picture coverage as salvage teams struggled vainly to save her. The stranding of the tanker *Torrey Canyon* between Scilly and Cornwall in 1967 was the first of a succession of late 20th-century marine ecological disasters. Such incidents expanded the potential usage of wreck photography—by governments, insurers, and ecological groups as well as the news media—and its scope, from the casualty itself and salvage efforts to pollution and clean-up operations lasting months or years.

The marine environment is exceptionally hostile to photographers. Sand, salt water, and spray ruin unprotected equipment. Light on sand and water tricks exposure meters, wind and boat movement blur the image. Waves and surf are hazardous. Mortimer needed a special protective suit for his exploits on Scilly and helpers to drag him out of harm's way. Frank Beken, facing great yachts approaching at the speed of a train, used a rubber bulb gripped between his teeth to trigger his camera's shutter. Both he and his son also became expert boat handlers. Villiers and Newby risked their lives taking photographs on wave-swept decks or high aloft. Jean Gaumy (b. 1948), working in La Rochelle trawlers in the mid-1980s, braved cold, darkness, and brutal storms in the Atlantic. Today, waterproof camera housings, heavy-duty clothing, and helicopters have made marine photography somewhat easier and safer, though much more expensive. However, increasingly demanding sporting and industrial assignments, tighter deadlines, and the need to use complex (especially *digital), battery-dependent equipment far from base have substituted new problems for the old. RL

Villiers, A., *Last of the Wind Ships* (1934).
Bonnett, W., *A Pacific Legacy: A Century of Maritime Photography 1850–1950* (1991).
Historic Photographs at the National Maritime Museum: An Illustrated Guide (1995).
Newby, E., *Learning the Ropes: An Apprenticeship in the Last of the Windjammers* (1999).
Tomlinson, R., *Shooting H₂O* (2000).
Gaumy, J., *Men at Sea* (2001).
Plisson, P., *The Sea* (2002).

Anon.

Barque *Penang* at Millwall, July 1932

Marion & Co., major British photographic business of the late 19th and early 20th centuries. It was a branch of the Parisian stationery firm A. Marion and by the late 1850s was dealing in photographic plates, papers, albums, and mounts. In 1863 they moved to Soho Square and in 1885 opened 'the largest dry plate factory in England' in Middlesex. From the 1880s they were retailing photographic equipment and materials, many under the 'Soho' brand. Marion joined the 1921 combine Amalgamated Photographic Manufacturers Ltd., and in 1928 Apem Ltd. which became part of Ilford Ltd. in the early 1930s. MP

Mark, Mary Ellen (b. 1940), American photographer. Born in Philadelphia and educated at the University of Pennsylvania and the Annenberg School of Communications, she realized early on that photographing people was to be her life. From 1965 to 1966 she was a Fulbright Scholar in Turkey and over the years has received assignments from *Life, Ms, Paris-Match*, and other news and photography magazines. Like W. Eugene *Smith, whose work she admired, Mark has always displayed a strong independence as a social documentary photographer and is renowned for the intense concentration she brings to her projects. For *Ward 81* (1979), for example, she lived in a ward at the Oregon State Mental Hospital for months in order to develop a rapport with staff and patients. Mark's many projects have included photographic essays on drug addicts in England, homeless youth in Seattle, the lives of women in Northern Ireland, Mother Teresa's work with the dying in Calcutta, prostitutes in Bombay, and itinerant street performers throughout India, a country to which she has repeatedly returned. Her books include *Passport* (1974), *Falkland Road* (1981), *Streetwise* (1985), *Mother Teresa: Her Missions in Calcutta* (1985), and *American Odyssey, 1963–1999* (2000). TT

Fulton, M., *Mary Ellen Mark: 25 Years* (1991).

Marker, Chris (b. 1921), French photographer and film-maker, associated with French New Wave cinema. Lyricism, cinematic experimentation, and critical interrogation of notions of truth characterize his films. Notably *Sans soleil* (1982) concerns history, memory, and travel, and challenges *documentary modes. His twenty-minute science fiction narrative *La Jetée* (1962) contemplates a man who returns from the future to re-experience his own death, and is composed of photo stills linked by voice-over. In *Si j'avais quatre dromadaires* (1966), travel photographs, themselves moments frozen in time, operate as freeze frames countering the narrative flow of off-screen commentary. LW

market for photographs. There is no single market for photographs. The expansive nature of the medium is such that many independent markets coexist and occasionally overlap, but the term is mostly understood to describe the art photography market. This has been growing since the late 1960s, when Lee Witkin opened the first successful gallery devoted to photography in New York. Since then specialist galleries and private dealers have emerged; museum,

institutional, and private collections have been formed; and regular auctions and fairs, such as the annual Photography Show held in New York by the Association of International Photography Art Dealers (AIPAD) since 1980, have become established. The greatest activity has undoubtedly been in the USA, but gradual acceptance of the historical and artistic role of photography has promoted wider interest and the market can now be considered truly international in scope.

Beginnings

Photography began to be offered for sale soon after its invention in 1839. Many photographers, such as Roger *Fenton, Julia Margaret *Cameron, and Gustave *Le Gray, exhibited and marketed their work to a public of collectors. Printsellers and dealers in photographic equipment and materials often doubled as agents for the sale of photographs, and even lent works for sale to the annual salons of leading associations such as the Photographic Society of London or the *Société Française de Photographie. Photographs were sold individually, either mounted on card or, unmounted, to paste into *albums. Made-up albums containing a pre-selected range of images were also available. Early British collectors included Prince Albert, Queen Victoria, and Chauncy Hare *Townshend, whose collection formed the basis of the now extensive holdings at the Victoria & Albert (formerly South Kensington) Museum, London. As early as 1865, Cameron was able to sell 80 photographs to the same institution through her dealer, Colnaghi, although this was not a regular occurrence. At around the same time, the rising popularity of the relatively inexpensive *carte de visite* and *stereograph formats resulted in collecting activity on a considerable scale.

Slow progress

The turn of the 19th and 20th centuries saw growing interest in the promotion of photography as a fine art and, to some extent, in the history of the medium. Works by Cameron and *Hill and Adamson were rediscovered and published alongside those of contemporary photographers and artists in Alfred *Stieglitz's *Camera Work*. Meanwhile Stieglitz was exhibiting photography regularly at his *Gallery 291 in New York and occasionally succeeded in selling work. However, his sales technique and pricing policy were unorthodox and the gallery relied heavily on free labour and favours to survive. Julien *Levy's New York gallery opened in 1931, with a retrospective exhibition of American photography organized in collaboration with Stieglitz. But although Levy continued to show work by both past and contemporary photographers, commercial considerations compelled him to intersperse photography shows with more saleable paintings and sculpture. Even Helen Gee, who opened her Limelight gallery and thriving coffee bar in New York in 1954, could not generate enough sales to convince herself to persevere after 1961. Other galleries in Paris and New York showed photography, but none of these early establishments could sustain themselves by selling photographs. Nevertheless, they played an important part in raising awareness of photography, which, in turn, encouraged a few pioneering collectors and curators to devote more attention to the subject. For those few

collectors in the mid-20th century interested in early photography, the market remained informal and uncompetitive. Their most fruitful source was the flea market or the antiquarian bookshop.

Quickening pace

*Museum interest in photography developed patchily. On the initiative of Wilhelm *Weimar, the Hamburg Museum of Art & Design began buying *daguerreotypes in the 1900s, and in 1915 acquired part of the important *Juhl collection. In 1910 the Albright Art Gallery in Buffalo hosted Stieglitz's *International Exhibition of Pictorial Photography*, and bought a dozen items from it. MoMA, New York, established a photography department in 1940, but it was many years before other institutions followed suit. A few museums, such as the Victoria & Albert, had holdings of photographs dating back to the 19th century, spread over different departments, but no specific department or curatorial staff responsible for them. Only since the 1970s has there been a gradual proliferation of dedicated photography collections in museums worldwide. The Metropolitan Museum in New York, the J. Paul Getty Museum in Los Angeles, the Musée d'Orsay in Paris, the Victoria & Albert Museum in London, the National Museum of Photography, Film, & Television in Bradford, and the Scottish National Portrait Gallery in Edinburgh are among the international institutions with substantial collections of art and general photography.

This rise in museum activity has coincided over the last *c.*30 years with a rapidly expanding network of galleries and dealers specializing in photography. Europe's first photographic auction was held in Geneva in 1961; Petzold in Augsburg began in 1975, Christie's in London in 1976. Meanwhile, degree courses on the historical, cultural, and theoretical aspects of photography multiplied. These seemingly disparate developments have fused into the informal economic network that forms the modern market. It now includes the primary sale of contemporary work as well as the secondary sale of images from all periods up to and including the present.

Hesitation and doubt, scarcity and value

For better or worse, photography has become a tradeable commodity, but acceptance of this has been slow, and relative to other antique and art markets the number of people involved remains modest. A major inhibiting factor has been photography's infinite reproducibility. The introduction of the negative-positive process invented by *Talbot heralded the beginning of mass circulation of prints from one negative, and many 19th-century photographs were printed in large quantities for a mass market. However, the disrespect shown towards such early photographs over the next century or more was largely responsible for the relative scarcity of material today. Tracts of photographic history are no longer easily represented by original material because the prints have been destroyed or lost, or because surviving examples are too damaged or faded to reveal their original purpose.

The limited edition has been encouraged by galleries and dealers for contemporary photographers aiming to sell their prints, and editions commonly vary from a very few examples to 20 or 30 prints from one negative. Very occasionally, editions of over 100 are issued. Ironically, many of these limited editions result in more prints being made than was common before their introduction. For most of the 20th century, certainly until the 1970s, there was little real demand for photographs beyond their primary (e.g. *fashion, *advertising, *photojournalistic) function. Having supplied a client, photographers would move on to the next project, at most producing a few additional prints for a portfolio or for publicity or personal use. There was no proper market and few exhibitions, so little requirement for more than a few prints from any one negative.

Most publicity relating to today's photography market emanates from public sales where record prices are achieved, creating the impression that only very expensive works are changing hands. The reality is very different. The breadth of the market, with prices for single photographs ranging from a few pounds or dollars up to five- or six-figure sums, reflects the diversity of the medium and, especially, the balance between photography as document and photography as art. Collectors, whether private, corporate, or institutional, drive the market and approach acquisitions from very different intellectual and economic standpoints. Some are interested primarily in investment. Others are searching for visual records of specific social or historical events or particular people, while still others may be interested in the history of the medium itself. Categories that have become sought after, with prices to match, include family albums, early *erotic images, *Hollywood publicity stills, and *railway and *industrial photographs. There is also growing demand for photographs as works of art. The work of contemporary fine artists and art photographers (two increasingly overlapping categories) is obviously aimed at this market, and by 2000 individuals such as Philip-Lorca *diCorcia, Andreas *Gursky, Cindy *Sherman, and Jeff *Wall were all fetching very high prices. However, earlier work produced with a different primary purpose continues to be re-evaluated as 'classic photography' and assimilated into the art photography market.

Prices are based on a combination of factors, very similar to those that apply to other works of art: the reputation of the artist-photographer; the perceived importance of the particular image within his or her body of work, or within a wider historical or photographic context; rarity, provenance, and condition. Since the 1960s, the concept of the *vintage print has played an increasingly central role. So many variables inevitably result in a wide variation in price even for works by the same photographer. The most predictable prices tend to be for contemporary works bought directly from a gallery. Prices can be set for the work of a contemporary photographer, and graded according to which number a print may be from an edition; the more prints are sold, the fewer remain available and so the price increases. The secondary market thrives in part on the ability of one person to buy from another and sell for a higher price. Opinions on commercial value vary according to personal experience, and prices can be more flexible.

Conclusion

The modern market is just old enough to show signs of the natural cycle of any art market. Auctioneers, dealers, and galleries have now sourced and sold material over a period of more than 30 years. Much of this material has been acquired by collectors and leaves the market, possibly forever in the case of major institutions. Important private or corporate collections may be donated or bequeathed to museums (e.g. *Gruber, Levy) or may be sold (Anderson, *Jammes), in which case the photographs re-enter the market and the cycle begins again. The most sought-after works by the most famous names inevitably become scarcer as examples disappear into collections and this, in turn, raises the prices of similar works still available. Gradually, buyers look elsewhere for less expensive purchases and lesser-known photographers are rediscovered. The relationship between curators, collectors, and dealers is complex. At best it brings attention to work that has languished or remained hidden and contributes to our knowledge and understanding of many of the less well-documented avenues of photographic history. LS

Blodgett, R., *Photographs: A Collector's Guide* (1979).
Koetzle, M., *Das Foto: Kunst- und Sammelobjekt* (1997).
Badger, G., *Collecting Photography* (2003).

Martin, Paul (1864–1944), French photographer resident in England. The son of a small-scale manufacturer, Martin accompanied his family to England in 1872, eventually became a commercial wood engraver, and took up amateur photography in the early 1880s. In 1888 he co-founded the West Surrey Photographic Society. His outstanding achievement was a series of candid pictures made 1892–8 using a modified Facile hand camera, taking a magazine of twelve quarter plates, that could be disguised as a parcel. Martin's subjects included street scenes near his London workplace, children and courting couples, and holidaymakers relaxing at English and continental seaside resorts and pleasure spots like Hampstead Heath. Captured unobtrusively by a shy photographer, they have a freshness and immediacy lacking from the contemporary salon *pictorialism in which Martin, perhaps through lack of funds, was only a fringe participant. (Prior to exhibiting them as lantern slides, Martin blacked out the backgrounds of many of his snapshots, so that the main figures resembled cut-outs, a practice that differentiated him significantly from milieu-conscious contemporary documentarists like Lewis *Hine, Jacob *Riis, or Alice *Austen). He experimented continually, and in 1896 received the Royal Photographic Society's Gold Medal for a series of pioneering night photographs entitled *London by Gaslight*, which drew praise from Alfred *Stieglitz. Between 1899 and 1926 Martin ran a mixed photographic business. His autobiography, *Victorian Snapshots*, appeared in 1939. RL

Flukinger, R., Schaaf, L., and Meacham, S., *Paul Martin, Victorian Photographer* (1978).

Marville, Charles (1816–1878/9?), French photographer, forever associated with Baron Haussmann's transformation of Paris between 1865 and 1878, for he was the official photographer of the

Paul Martin

London by Gaslight: Leicester Square, 1896

Charles Marville

Cul-de-sac de Rohan (de la rue du Jardinet), *c.*1865–8. Albumen print

Ville de Paris from 1858 until the end of his life. Initially trained as an artist-engraver, he experienced early success during the brief vogue for illustrated storybooks of the 1830s. However, by the 1850s he had taken up photography, becoming a master of the *calotype process and acquiring the position of official photographer to the Louvre in 1851, for which he reproduced many works of art. He also took numerous pictures for *Blanquart-Évrard's photographic publications (1851–4) before becoming an architectural photographer, noted for his photographs of French and German medieval buildings.

From 1858, now using the *wet-plate process, and with a unique sense of space and form, Marville photographed Haussmann's new constructions. They include the great public gardens of Boulogne and Vincennes, the new squares, and the street furniture introduced to make the city more modern, cleaner, and safer. In 1865 he was asked to photograph the oldest streets due for demolition, a magisterial record of 425 views on *mammoth plates of 51 × 60.8 cm (20 × 24 in) for the most part that is widely seen as his masterwork.

Marville's oeuvre, completed by a series of views of the main boulevards of the city after their transformation in 1877, remains one of the great projects of 19th-century photography, not simply for the wonderful grasp of light and composition it demonstrates, but for the richness of detail that makes his pictures extraordinary documents of social history. PH

Charles Marville: Photographs of Paris at the Time of the Second Empire on Loan from the Musée Carnavalet (1981).

Masclet, Daniel (1892–1969), French portrait and landscape photographer. Masclet began as a professional cellist, but compiled an album of photographs (now lost) in the First World War and in the 1920s frequented the *Photo-Club de Paris. Through Robert *Demachy he met Baron de *Meyer, with whom he worked on *Harper's Bazaar* before moving on to *Vogue*. In 1928 he opened a studio in Paris, specializing in historicist portraits. A decisive meeting with Edward *Weston in 1933 turned him towards landscapes and a sparer, more modernist style. He produced books on the nude (1934) and landscape photography (1935), and after the Second World War published prolifically on many aspects of photography. As an exhibition curator, juror, and critic he was a major figure on the European photographic scene. LAL

Mass-Observation. See DOCUMENTARY PHOTOGRAPHY; SPENDER, HUMPHREY.

material culture and photography. The fact that photographs are not simply images but also *things* that people use in their everyday lives, collect in museums, or display in galleries is often overlooked. However, the physical nature of photographs has been central to their understanding and *social functions since the advent of the medium. There are two categories of 'thingness'. First is the material form of the photograph itself: for instance, *albumen prints or *collodion

Elizabeth Edwards

Photographs used as votive objects around the image of a saint, St Xavier del Bac, Arizona, USA, 1998

negatives. Second are the presentational forms of photographs such as stereocards, *cartes de visite, or *albums; or, indeed, the manner in which photographs are framed and displayed. These two are linked to a third, the material traces of the use of photographs, from scratching on the negative and retouching to grubby handling marks or texts written on the print. These last may radically alter the reading of an image: for example, inscriptions discovered on the backs of unexceptional snapshots of a voyage from Germany to South America, expressing a Jewish family's anguish at bereavement, dispossession, and exile; or captions in an album crossed out and overwritten, suggesting the ending of relationships.

Photographs are composite objects made of various materials, such as paper, chemical emulsions, card, glass, acetate, or cellulose nitrate. Although they have seldom been fully articulated, material considerations were integral to early processes. Henry *Talbot referred to his photographs as 'specimens', as they were for him experiments with the behaviour of chemicals on paper. The *daguerreotype was highly tactile. In its embossed Union case, it had to be manipulated in the hand so that the polished surface could reveal its image. The *ambrotype and, to a lesser degree, the *tintype required a similarly tactile response.

Material factors have affected both the aesthetic and monetary evaluation of photographs. The concept of the *vintage print, for example, comprises both 'ideal' and material elements: on the one hand, notions of authorship and authenticity; on the other, often, the use of time-specific historic materials. The *pictorialists of the late 19th and early 20th century cited the unique qualities of surface texture and pigmentation, produced by complex manipulations, in support of the photograph's claim to be fine art.

Choices about materials reveal the intentions of photographers for their work. For example, the choice of tintype over ambrotype was not just a financial decision but one about the robustness of the image as object. The choice to print on platinum- over albumen- or, later, gelatin-based papers suggests a desire for permanence; the Survey movement in Britain in the 1880s and 1890s required contributors to submit images as platinum prints 'without the polluting touch of silver' as a guarantee of longevity.

Photographs have had a wide range of formats and supports, from diminutive *cartes* to *mammoth prints, and been displayed in a rich variety of albums, frames, and mounts. In the 19th century the development of new material forms was an important motor of the photographic industry. The photographic press was full of novelty formats to lure customers—such as small 'gem'-sized photographs— and albums and mounts specifically designed for them. In the past, photographs were incorporated into all kinds of objects, such as jewellery, buttons, and boxes, or printed on ceramics. Today, they are available as jigsaws, and on mugs, mouse mats, and the ubiquitous T-shirt; even on women's handbags. Many photographic forms mimicked other classes of precious object. For instance, plates with photographs on them belong to a tradition of commemorative tableware going back at least 500 years. Similarly, many 19th-century

albums refer to medieval devotional books with heavy embossing, gilt-edged pages, and metal clasps. Indeed, as a 'core' possession of the household, the photograph album became a kind of secular bible. Even modern flip-page wallets often resemble books, with gold 'tooled' detail stamped on plastic 'leather'.

The presentational forms of photographs shape the viewer's relations with them. For instance, 19th-century photographic jewellery, including lockets containing human hair (a second trace of the subject), was worn next to the skin. The size and weight of an album determines how it will be viewed: laid out on a table or held intimately in the hands. For two people to view the latter requires close physical proximity. Decoration and materials may reflect the subject matter of the photographs, for example white-wedding albums—or modern 'wedding books'—embossed with silver bells. In the colonial period it was not uncommon for the bindings of albums to reinforce the 'exotic' reading of the photographs, e.g. albums from South-East Asia adorned with Malay metalwork, or Japanese albums with lacquered covers.

Frames concentrate attention on the image by isolating it from its surroundings and presenting it in a socially appropriate way. They can also be used to extend the meaning or value of the image, e.g. by encasing significant photographs in velvet or silver. (Inscribed and illuminated mounts, like those used for 19th-century Indian royal portraits, fulfil the same function.) Framed photographs are often grouped, as if in a domestic shrine, on a bookcase, piano, or television set, with the categories in each group—for example, *wedding or graduation pictures—reflecting their significance. Images may also be grouped *within* a frame, to create a narrative of an occasion or journey. Finally, the form in which photographs may be offered as gifts is meaningful: a framed and autographed image suggests a very different relationship between giver and recipient from a simple enprint.

Physical alteration of a photograph's surface may also carry an important cultural or emotional charge. Some interventions, like montage, may create an entirely new object, juxtaposing one image, or parts of it, with significant others. Others involve the addition of new materials such as hair or cloth. The tinting of daguerreotypes, and the extensive overpainting of photographs found in modern India and West Africa, are attempts to enhance the perceived realism of the image.

In the *digital age, the significance of the material object remains. Culturally inflected decisions are made about which images will be printed out as snaps, which as framable enlargements, and which will be discarded. Another palette of choices relates to manipulation of the original file. Such possibilities continue to underline the importance of materiality in our relationship with photographs. EE

Henisch, B. A. and H. K., *The Photographic Experience 1839–1914: Images and Attitudes* (1994).

Batchen, G., *Photography's Objects* (1997).

Edwards, E., and Hart, J. (eds.), *Photographs Objects Histories: On the Materiality of Images* (2004).

matrix metering, a system of automated *exposure determination that divides the viewed field into six or more segments, several of which may overlap. The weighted responses from the various segments are fed to a central processor, which analyses the separate luminance differences and the average luminance value, and matches the result to one of a large number of stored data for different types of subject. Matrix metering is a highly sophisticated system that became possible only with the advent of cameras incorporating onboard microprocessors. GS

Maxwell, James Clerk (1831–79), Scottish physicist of genius whose greatest contribution to physics was his electromagnetic model for the nature of light, expressed in four monumental equations based on the findings of Michael Faraday. Another outstanding achievement was the placing of the kinetic theory of gases on a sound mathematical basis. He extended the work of Young and Helmholtz on colour vision and, based on the theory of primary colours, produced the first colour photograph in 1861, making separation negatives through red, green, and blue filters and projecting the images in register through similar filters. Although the experiment was flawed (the 'red' record was actually ultraviolet, his plates being insensitive to red), it led to the development of genuine three-colour additive and subtractive colour photography. GS

Harman, P. M., *The Natural Philosophy of James Clerk Maxwell* (1908).

Mayall, John Jabez Edwin (originally Meal; 1810–1901), British *daguerreotypist who began his career in Philadelphia. With his partner, Samuel Van Loan, Mayall operated from 140 Chestnut Street in 1845–6, until his return to London, where he opened, at 433 The Strand, 'The American Daguerreotype Institution', styling himself 'Professor High-School' (or Highschool). Photographer by appointment to Queen Victoria and creator of iconic images of 19th-century Britain and British notables, Mayall ran numerous studios in London and later Brighton, where he became mayor in 1877. Several of his sons also became photographers, using the business name Mayall. KEW

Maynard, Hannah (née Hatherly; 1834–1918), Canadian portrait and landscape photographer, born in Bude, Cornwall. After emigrating with her husband, a shoemaker, she became one of British Columbia's first professional photographers, opening a studio in Victoria, Vancouver Island, in 1862. Her considerable oeuvre is a record of the peoples and landscapes of late 19th-century Canada, and of Victoria's development from a settlement into a modern city. But she also experimented extensively with *photomontage, *photosculpture, multiple exposure (see COMPOSITE PHOTOGRAPHS), and combination printing. Some of her portraits, conventional at first sight, include multiple images of herself seated, standing, and even pouring milk onto her seated self from a frame on the wall. She retired in 1912. LAL

Mayne, Roger (b. 1929). Though still an active photographer, printmaker, and draughtsman, Mayne will always be linked with England in the 1950s and early 1960s—especially with the London district of Notting Dale, described by Colin MacInnes in his novel *Absolute Beginners* (1959). Mayne studied chemistry at Oxford and while still there published his first photographs, of a student ballet production, in **Picture Post*. He was quick to acquaint himself with the works of masters like *Cartier-Bresson, *Steinert, *Strand, and *Weegee and—with Hugo van *Wadenoyen—exhibited international contemporary photographs in Britain through the Combined Societies. Through exhibitions, articles, and his own widely published work, Mayne injected a new urgency and ambition into British photography. In 1956 he held a one-man show at the Institute of Contemporary Arts and discovered one of his most inspiring subjects—Southam Street, London W10. He photographed the street and its lively inhabitants for five years. As well as street environments and the teenager phenomenon, Mayne photographed the Aldermaston anti-nuclear marches, northern factories, landscapes, family life, the British at play. Subsequent exhibitions and publications established him as one of Britain's modern masters. MH-B

Mayne, R., *Photographs* (2001).

Meatyard, Ralph Eugene (1925–72), American photographer, a Kentucky optician who took up photography in 1950. He photographed in his spare time, joining the Lexington Camera Club and participating in workshops with Henry Holmes Smith and Minor *White. White introduced Meatyard to Zen Buddhism; this influenced the symbolism of his pictures, whose intimations of mortality developed out of a 1961 heart attack and, later, cancer. Masked friends and family peopled narratives derived from eclectic reading: his last, major project, *The Family Album of Lucybelle Crater* (1970–2), was inspired by the protagonist of a Flannery O'Connor story. HWK

medical photography. As far back as 2500 BC, surgical 'operations' were depicted on the tombs of the pharaohs, so that the partnership between medicine and art can be said to be at least 4,500 years old. The teaching and study of human anatomy has always required illustration. The Flemish anatomist Andreas Vesalius (1514–64), in questioning the infallibility of Galen, elevated the science of human anatomy through direct observation of dissections of the human body. Vesalius sketched the vascular system and the skeleton, and encouraged professional artists to portray the human body. Such eminent artists as Leonardo da Vinci, Michelangelo, Raphael, and Titian joined with physicians to observe and study dissections. Vesalius eventually published his masterpiece *De Humani Corporis Fabrica* in 1543. It was both a great medical book and a landmark in the history of illustration and printing.

Illustrating the human body in health and disease thus came to be important for teaching and research, and for patient management. Anatomical painting and drawing reached great heights of technical

and observational skill. To this day some of the most detailed and accurate drawings of the peripheral vasculature and nerves are to be found in French texts dating from the second half of the 19th century.

The invention of photography

Methods of illustration changed with the invention of photography, which proved to be a turning point not only in medicine but also in scientific research and worldwide visual communication generally. At one stage *stereoscopy also became popular, although three-dimensionality is mostly of little intrinsic value for medical illustration.

The impact of photography was profound for medical illustration. The medium's strength lies in its ability to record accurately, rapidly, repeatably, and without excessive cost. It has been argued that the arrival of photography reduced the importance of more traditional medical illustration skills. However, even up to the 1970s (before the advent of reliable high-quality miniaturized camera systems), medical painting was able to be more selective and discriminatory (in terms of colour, conformation, and texture) than photography, and this was particularly so in ophthalmology and endoscopy. Nowadays we are less concerned with the method of production of a picture or image than with its fitness for its purpose.

Cinephotography has played an important part in medicine and physiology; one of the most spectacular examples of its early use was by Eadweard *Muybridge in 1901, whose rapid series of single camera exposures shed much light on the nature of human and animal locomotion. The technique was said to have been applied to the recording of the exposed heart of a dog by Reichart in 1887. This may well have been the earliest medical motion picture.

One of the pioneers of medical photography was Frederick T. D. Glendening, a staff photographer at St Bartholomew's Hospital, London, c.1892–4. He worked in the outpatients department, and his clinical photographs became important for analysis and diagnosis of disease on the surface of the body. Besides its important role in diagnosis and management, photography permitted the circulation of visual records vital to the teaching of medicine. Glendening's work is preserved in the *Royal Photographic Society's collection (housed at the National Museum for Photography, Film, and Television in Bradford, England). His work covers an extensive range of physical disorders, including curvature of the spine, clubfoot, smallpox, and the effects of alcoholism.

Specialist systems

Endoscopy. As early as the 1880s there had been much interest in recording images of the interior of the body obtained using endoscopes. Dry photographic plates, replacing the old wet-*collodion techniques, simplified endoscopic procedures. In 1884 Brainerd was able to photograph the larynx by reflected sunlight, and in 1894 Nitze produced flash photographs through a cystoscope. Nowadays, 'endophotographs', both still and moving, are of high quality. Modern endoscopes are very sophisticated instruments able to incorporate lasers and guide wires etc., to enable procedures to be carried out during an endoscopic examination.

Ophthalmology. Medical photographers often had the task of recording the external condition of the eyes and face, and ophthalmic photography can be considered as an early offshoot of mainstream medical photography. Cinephotography had a special place in the teaching of ophthalmology, to make available to a wide audience procedures that otherwise could be seen only by the surgeon. Slit lamp cameras for taking what amount to 'optical sections' of the living eye, and fundus cameras able to photograph the retina, are examples of techniques in ophthalmology that extend the normal scope of medical photography.

X-ray systems. The discovery in 1895 by *Röntgen of X-rays employed photography as the best way to retain a permanent record of X-ray images. Today, X-ray systems have become very sophisticated, with computerized tomography (CT) scans able to image sections through the body; and to store large numbers of them in such a way that the data can be called up to produce images of any desired cross-section of the part recorded. A particularly spectacular development in X-ray technology has been in cardiac angiography, the visualization of blood vessels. Real-time X-ray equipment with image enhancement enables the cardiologist to view the heart after contrast medium has been introduced into the coronary arteries to determine any blocked or seriously narrowed vessels. Cardiac catheters are also used for the insertion of stents to hold vessels open mechanically, and for the 'ballooning' of vessels to allow more blood to flow through. It is also possible mechanically to ream out vessels that have become blocked. All of this can be visualized by the surgeon (and indeed the patient) with minimal invasiveness, using CCTV, and photographed at each stage.

Outside the visible spectrum

Beyond the violet, at the short wave end of the spectrum, are *ultraviolet (UV) and X-radiation and beyond the red, at the long wave end, *infrared (IR). Medical photography was quick to exploit these wavelengths outside the area of visible light.

UV. Energetic UV radiation waves make many substances fluoresce, that is, give off visible light, usually blue or greenish yellow. UV fluorescence photography is used in dentistry to record the presence of artificial teeth and is useful in recording dermatological conditions such as psoriasis, and fungal infections of the skin, such as ringworm.

IR. Silver halide emulsions sensitive to IR wavelengths are also useful in medical photography. Most of the IR radiation is reflected from the skin surface. Of the remainder, some is scattered and some absorbed by subcutaneous vessels. Infrared photography can thus be used to determine and record peripheral vascular patterns in venous thrombosis, varicose veins, and varicose ulcers.

The development of IR technology underwent a dramatic change at the end of the 1960s when IR-sensitive military scanning systems became available for medical work. Since that time scanners and the electronic images they produce have become more reliable, and can be accurately calibrated in terms of temperature in the scene being scanned. The use of thermal imaging systems has been a great success

in industrial applications such as process control, preventive maintenance, energy conservation, etc. These scanners operate within two separate wavebands, the shorter about 2–6 microns and the longer 10–14 microns, the latter corresponding to human body temperature. The IR radiation from the human body is sufficient to produce accurate 'maps' of the skin surface temperature. In medicine and physiology thermal imaging finds application in a wide range of conditions where temperature can be related to subcutaneous blood flow, and to its neurological control. Rheumatology, dermatology, diabetic neuropathy, pain syndromes, and genetic inherited diseases are just a few of the areas where research has identified an important role for thermal imaging in clinical diagnosis and management.

Digital imaging

The effect of *digital techniques on photography and related imaging has been profound. It is no longer necessary to use film to record and store images. Equally important, digital analysis methods can enhance and manipulate images to produce more information than ever before. Whereas medical imaging has traditionally dealt with visible light, and with some UV, IR, and X-ray images, nowadays it is possible for CT and magnetic resonance imaging (MRI) scans together with ultrasound to be combined with digital visual techniques in spectacular ways. For example, CT and MRI scans can look through the human body and produce slices that are similar to the individual pages of a book. (MRI is a more complicated type of tomography that produces images of soft tissues rather than hard ones such as bone.) Perhaps one of the most notable projects is the Visible Human Dataset, a large atlas of digital images of the human body. When complete, it will consist of about 20,000 images from horizontal sections of a complete male and female cadaver. The male data set consists of axial MRI images of the head and neck taken at 4 mm intervals and longitudinal sections of the rest of the body also at 4 mm intervals. The CT data consist of axial CT scans of the entire body taken at 1 mm intervals at a resolution of 512×512 pixels, each pixel being made up of twelve bits of grey tone that can be rendered in colour. The anatomical cross-sections are also at 1 mm intervals and coincide with the CT axial images. There are 1,871 cross-sections for each mode, CT and anatomy, obtained from the male cadaver. The data set from the female cadaver will, when complete, have the same characteristics as that from the male cadaver, with one exception. The axial anatomical images will be obtained at 0.33 mm intervals instead of 1 mm intervals. This will result in over 5,000 anatomical images. The data set is expected to be about 40 gigabytes in size—a truly monumental task.

Such digital images can be deconstructed and reconstructed to give views from any angle. A further advance is that images from several imaging methods taken in the normal course of clinical investigation can be treated in the same way. They can be combined and animated to allow the observer to 'fly through' any part of the body. Flying through blood vessels can identify the size and position of obstructions and narrowed areas with great precision. Flying through the colon can identify, in great detail, polyps that require surgery, and the image

sequences can help to plan it accurately. The technique is exceptionally useful in the teaching of surgery.

Conclusion

There is now a case for medical imaging to embrace all the traditional uses of medical photography, as well as new methods such as MRI, CT, X-ray angiography, ultrasound, and *thermography, even though practitioners using these techniques are often cardiologists, radiologists, physicians, and surgeons. In some countries medical thermal imaging does have specially trained practitioners called thermographers. The distinction between photography and imaging continues to diminish now that digital imaging has developed so spectacularly. Specialist computer programmers can now claim to be medical imagers.

Imaging has been one of the great successes in medicine and physiology during the latter part of the 20th century. The pace of development and innovation continues to increase and to provide tremendous benefits in the diagnosis, management, and treatment of a huge range of diseases, and to contribute to better medical care for very many people. One of photography's most important attributes is its permanence, so that it not only provides durable pictorial records, but can be used to record longitudinal studies of progressive chronic conditions, as well as the progress of their cure.　　　RPC

⊃ See also The Discovery of X-Rays overleaf.

Barrett, H., and Swindell, W., Radiological Imaging (2 vols., 1981).
Walter, I., Biomedical Photography (1992).
Harubini, K., Electronic Videoendoscopy (1993).
Lee, H., and Wade, G. (eds.), Modern Acoustical Imaging (1995).
Dermer, R. A. (ed.), 'Medicine and Photography', History of Photography, 23 (1999).
'Versehrte Koerper—Fotografie und Medizin', Fotogeschichte, 80 (2001).

Mees, Kenneth (1882–1960), English-born chemist and physicist who began his career with the Croydon-based company Wratten & Wainwright. In 1907, with Samuel Sheppard, he published his first important paper, expanding the work on *sensitometry begun by Hurter and Driffield. In 1912 George *Eastman employed him to establish the Kodak Research Laboratory in Rochester, New York, which he directed for 43 years. His teams produced the first tripack colour materials and, later, colour negative-positive materials. In 1942 he produced the monumental Theory of the Photographic Process. In 1949 he established the *International Museum of Photography in Rochester.　　　GS

Meisel, Steven (b. 1954), American fashion photographer. Born and active in New York, Meisel graduated from Parsons School of Design and, after working briefly as a fashion illustrator, began photographing in the early 1980s. He is particularly noted for his contributions to Italian and American *Vogue. Adept at appropriating a broad range of visual sources, Meisel's reputation for diversity has brought him prestigious advertising assignments, from Prada, Dolce & Gabbana, and Versace. His collaboration with Madonna on her controversial book Sex (1992) is perhaps his best-known work.　　　PM

The Discovery of X-Rays

In the late 19th century, British and American scientists investigating the radiation produced by an electrical discharge in a tube of gas at low pressure had noticed that photographic plates placed nearby became fogged. In England, William Crookes thought the plates were faulty and sent them back to Ilford. In the USA, W. Jennings and A. Goodspeed considered the phenomenon interesting enough to make the fogged materials worth keeping, but could not explain it. Then, on 8 November 1895, the German physicist Wilhelm *Röntgen in Würzburg noted that a discharge in a tube masked with black paper to block the escape of any visible light caused a surface coated with barium platinocide to fluoresce, and deduced that the discharge had produced radiation invisible to the eye.

The next stage involved photography. Röntgen found that this unknown radiation, provisionally labelled 'X-rays', affected a photographic plate through some materials but not others. On 20 November he created a first radiographic image of the metal fittings on his laboratory door. On 22 December he took the first picture of human bones photographed through flesh: the ringed hand of his wife Bertha. Between the end of December and the beginning of January 1896 Röntgen deposited a preliminary notice with the Würzburg Society of Medical Physics, sent copies to colleagues, and informed the Berlin Physical Society. His findings caused a considerable stir in the scientific community. During January 1896 the experiments, which were not in themselves particularly complicated, were replicated by scientists elsewhere: Toussaint Barthélemy and Paul Outin in France, for example, Alan Swinton in England, and Arthur Wright in the USA.

Medical scientists immediately recognized the significance of X-rays, which seemed to realize the age-old dream of seeing inside the intact, living body. The potential applications were many, including detection of fractures and internal abnormalities, location of metal objects such as bullets, and, after injecting opaque substances, observation of the circulatory and digestive systems in action. With Röntgen's discovery, photography seemed finally to have found a clinical application. Formerly used as a means of documentation, supplementing the inadequacies of visual memory, it now became an investigative tool in its own right, more powerful than the human eye. As early as 1896, some hospitals created radiographic departments, and in Paris only a few months after the discovery Albert *Londe opened a laboratory at the Salpêtrière. Surprising, not to say fantastic, therapeutic properties were attributed to X-rays. Some doctors used them to treat skin diseases, others believed that they would soon be used against tuberculosis, or to eradicate certain bacteria. Some even thought that these rays that could make the invisible visible might be used to restore sight to the blind. By the end of the 19th century, in short, X-rays seemed to be a veritable panacea.

Wilhelm Röntgen

X-ray photograph of Frau Röntgen's hand, 1895

Outside scientific circles, they attracted an unusual degree of interest from the public at large. The press seized on them at an early stage. On 5 January 1896 the Viennese *Die Presse* announced Röntgen's discovery in a sensational article. On the 7th it was the turn of the German *Frankfurter Zeitung* and the British *Standard*, on the 8th the New York *Sun*. Readers were enthralled by the small number of accompanying images: the ringed hand, a compass, metal objects embedded in a piece of wood. One reason for this popular sensation was, of course, that the discovery seemed to promise the fulfilment of so many medical dreams. But these invisible rays, designated with the mathematical symbol for the unknown and undermining the boundaries between interior and exterior space, matched the public's taste for the fantastic, already whetted by 19th-century science fiction. Some clever operators organized X-ray sessions in fairground booths, sometimes alternating with demonstrations of that other 1895 novelty, the *Lumière brothers' cinematograph. Meanwhile, cartoonists and sketch writers let their imaginations run riot, soon inevitably with visions of machines that could show

clothed people naked. Later it was literature's turn, most notably Thomas Mann's novel *The Magic Mountain* (1924), in which the hero sees his flesh seemingly 'disintegrated, annihilated, dissolved' by the X-ray machine, and later, as a keepsake, gets a radiograph of his beloved's thorax: an unforgettable symbol of mortality and desire.

History soon acknowledged radiography's central role in the development of both medical science and physics, since it was while studying X-rays that Henri Becquerel (1852–1908) discovered radioactivity. But beyond the scientific domain, X-rays formed part of that vast reservoir of collective fantasy that was to nourish both popular culture (comics, pulp fiction, cinema) and the artistic avant-garde for much of the 20th century. CC

Kern, S., *The Culture of Time and Space, 1880–1918* (1983).
Pallardy, G. and M.-J., and Wackenheim, A., *Histoire illustrée de la radiologie* (1989).
Glasser, O., *Wilhelm Konrad Röntgen and the Early History of the Roentgen Rays* (1993).

Meiselas, Susan (b. 1948), American photojournalist and *documentary photographer. After gaining an MA in Education at Harvard she worked as photography adviser for the Community Resources Institute of the New York schools system, running workshops while also photographing freelance. Her first success came with *Carnival Strippers* (1976), a feminist take on a particular kind of women's business. (Her documentary interest in the sex industry has continued throughout her career.) She joined *Magnum in 1976, becoming a full member in 1980. Her overseas pictures first struck home with coverage of the Sandinista revolution in Nicaragua in 1978: harrowing colour images of the outgoing dictator Somoza's atrocities against civilians, with children dying before the camera. From then on, Meiselas was committed to frequent returns to Central America, where she documented the human rights struggles of the 1980s and 1990s. But a six-year project on the Kurds produced a major exhibition and book, *Kurdistan: In the Shadow of History* (1997). She has received many awards, including the Robert Capa Gold Medal (1979). AH

Magna Brava: Magnum's Women Photographers (1999).

memory and photography. Since the advent of photography the photographic image has been regarded as an *aide-mémoire*. The very act of taking a photograph signals the moment as worthy of remembering and, while objects break, landscapes change, and people die, the photograph endures, allowing it to be used to remember 'what has been'. The huge number of family portraits and snapshots that document personal history attests to the memory value placed on photographs. In *sociology, visual ethnography, and (more controversially) the work of historians like Michael Lesy, *family photographs have been used to elicit information about practices and relationships in the past.

Some 20th-century theorists, however, have disputed the photograph's role in aiding memory, claiming instead that it actually serves the process of forgetting. Roland *Barthes believed a photograph can do little more than confirm the existence of an object at some other time, in some other place, while Susan *Sontag suggested that with the passage of time a photograph loses its specificity to become a purely aesthetic object open to multiple readings. Ultimately, both Barthes and Sontag argued, because the photograph only records the surface appearance of what has been, and not the complex meanings associated with sensory experience, it cannot rightly be called a 'memory image'. The iconic properties of the more durable photograph will inevitably replace the myriad details of the experience represented in the image; in the end it is the photograph itself that is remembered. Catherine Keenan has questioned this idea, noting that photographs not only supplement memory, but can also configure it. An image that closely relates to a personal memory may come to be associated with that memory, and with time may even influence the memory's content. When the image plays a part in actually configuring the narrative of memory then the photograph is a memory image properly speaking. Sontag later conceded that certain images may deepen one's understanding of the past.

Photographers such as Jo *Spence have explored these ideas regarding personal memory in their work. In *Beyond the Family Album*, an exhibition at the Hayward Gallery, London, in 1979, Spence displayed images of herself from birth to adulthood alongside text that questioned both the way in which identity is constructed and the role photography plays in this development of 'self'. In the exhibition, she acknowledged the tendency of family photographs to omit the more disturbing experiences of life, such as illness and divorce, to present instead a selective history that enforces forgetting; yet she also

actively interrogated the photographs as memory images, allowing them to suggest memories of both what was represented and what was omitted. The photographs then took on new meaning for her as her understanding of their content and her childhood deepened. This technique of engaging with personal photographs is used by art- and *phototherapists. In later work Spence further explored these themes and techniques by role-playing in front of the camera, allowing memory to influence the production of new images. MR

Lesy, M., *Time Frames: The Meaning of Family Pictures* (1980).
Barthes, R., *Camera Lucida: Reflections on Photography* (1981).
Keenan, C., 'On the Relationship between Personal Photographs and Individual Memory', *History of Photography*, 22 (1998).
Spence, J., *Putting Myself in the Picture* (1998).

mental illness, photography and the study of. The photography of mental illness can be defined as the practice—usually in clinics or similar institutions—of depicting people whose behaviour has been deemed markedly abnormal by their contemporaries. The pictures once served to document case histories, but occasionally also as therapeutic instruments. Both in publications and by themselves they were used as illustrations and as tools of teaching and research.

As early as the end of the 18th century there was considerable interest in the precise depiction of external manifestations of mental disorder; and already before the advent of photography several illustrated works on the subject existed, for example by the doctors Jean-Étienne Esquirol in France and Alexander Morison in England. Later, photography played an important role in diagnostics and comparative research—then dominated by the so-called 'visibility paradigm': the notion of external symptoms unequivocally indicative of particular illnesses or disturbances. With the abandonment of this in the 20th century, psychiatry's interest in pictures of mental patients diminished.

So far, research indicates that photography in mental institutions, like the establishment of psychiatry as a medical specialism, took place earliest in France and Britain.

The beginnings of the practice can be dated back to the 1840s: the Frenchman Jules Baillarger was probably one of the first to make portraits of the mentally ill, in 1848. But the best-known early portraits were taken by the British doctor and amateur photographer Hugh W. *Diamond. In pose and setting, Diamond's pictures resemble standard contemporary portraiture. However, he regarded his pictures as a means not only of documentation but of therapy. In this his British colleague T. N. Brushfield, and others, followed him. In addition, Diamond's portraits of patients were shown at exhibitions—e.g. at the Photography Society in London—and used as the basis for the lithographs that illustrated the treatise on mental illnesses by the English psychiatrist John Connolly. Interest in depictions of the mentally ill persisted in 19th-century England, although no one equalled Diamond's fame. Charles Darwin used

Hugh Diamond
Female mental patient, *c*.1850s. Albumen print

Annie Leibovitz John Lennon and Yoko Ono, 1980

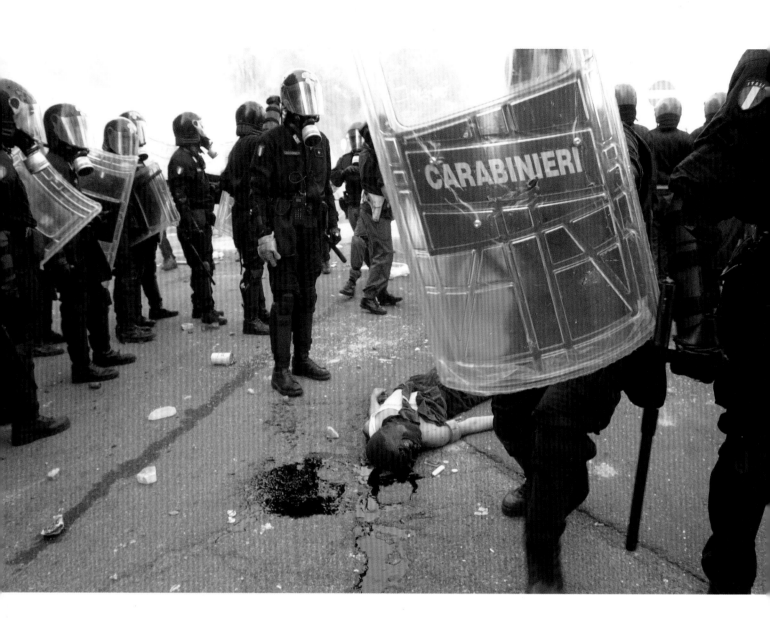

Nick Cornish Death of Carlo Giuliani, Genoa, 2001

photographs of mental patients for his book *Expression of the Emotions in Man and Animals* (1872), both for study purposes and, occasionally, to illustrate his arguments.

In France, the subject is particularly associated with the Paris Salpêtrière's celebrated psychiatric department, where Désiré Bourneville and Albert *Londe became known for their pictures of male and female 'hysterics'. However, although these images were intended to substantiate a particular view of the condition, they were hardly an objective clinical record. Rather, they should be seen as complex, staged scenarios of illness that reflected the ideas of the director, Jean-Martin Charcot (1825–93).

Even if photography of the mentally ill seems to have flourished particularly in England and France, doctors, psychiatrists, and photographers in other countries also made portraits of patients. In the USA as early as 1858 Isaac Newton Kerlin published a book on mentally ill children illustrated with original photographs. In Austria the director of the provincial asylum in Hall/Tyrol, Dr Joseph Stolz (1811–77), had probably been photographing patients since the late 1850s. The pictures were used in 1865 by the Viennese psychiatrist Max Leidesdorf (1816–89) as the basis for illustrations in his textbook on mental illness.

With changes in the basic paradigms of psychiatry (and, later, psychology), interest in portraits of mental patients declined markedly. Soon they were no longer accepted as research materials, and their scientific value for diagnosis, comparative studies, or, indeed, therapy evaporated. However, despite the visibility paradigm's abandonment in psychiatry, its role in biology, especially human and racial, remained considerable in the 20th century. Here, the search for external, physiognomical signs of intellectual and psychic deviance from a 'healthy' norm played an important and sombre role, particularly in Nazi Germany.

In the meantime, early photographs of the mentally ill, like those by Diamond and the Salpêtrière doctors have attracted increasing attention from art and cultural historians, as manifestations of a specific intellectual milieu. Meanwhile, the mentally ill themselves were attracting interest from *documentary photographers, among them Diane *Arbus, Mary Ellen *Mark, Lord *Snowdon, and Mario *Giacomelli. Alexey *Brodovitch, himself confined to a mental hospital for a while in the 1960s, recorded the experience with a miniature camera. JJ

Didi-Huberman, G., *Invention de l'hystérie: Charcot et l'iconographie photographique de la Salpêtrière* (1982).

Gilman, S. L., *Disease and Representation: Images of Illness from Madness to AIDS* (3rd edn. 1994).

Günthert, A., 'Klinik des Sehens. Albert Londe, Wegbereiter der medizinischen Fotografie', *Fotogeschichte*, 21 (2001).

Mesch, Emil Ragnar Borg (1869–1956), Swedish photographer. After apprenticeship to Edvard Lundholm, he opened his first studio in Gävle in 1891, worked for a time in Landskrona, then in 1899 settled permanently in Kiruna, inside the Arctic Circle. He was known as an adventurous and enterprising spirit, a legendary mountaineer, and, above all, a pioneer in photography. He documented the unique frontier settlement of Kiruna, the utopian character of early modernization and urbanization there, the struggling Sami culture, and, especially, the wildness of the Arctic north. Group portraits of fascinating complexity, and panoramic landscapes, are prominent in his work. J-EL

Metinides, Enrique (b. 1934), Mexican press photographer. Known as 'the Kid' ('el Niño'), he had his first front-page picture published at the age of 12. From the late 1940s until 1993 he worked for the Mexico City tabloid *La Prensa*, helping to define the genre of *nota roja* (bloody news): unsparing images of suicides, crashes, fires, stabbings, and natural disasters. As a Red Cross volunteer, he often reached the scene by ambulance. A roadside mass for a dead motorcyclist (1973), and the staring eyes of a woman smashed by a car on a hot spring day in 1979, are typical. RL

Bush, K., Chantala, F., and Kuri, J. (eds.), *Enrique Metinides* (2003).

Metzker, Ray K. (b. 1931), American photographer who studied with Harry *Callahan and Aaron *Siskind. Shunning both commercial photography and the photojournalist's detached sensibility that he had originally adopted, Metzker embraced experimental techniques without sacrificing technical skill. One such, 'Pictus Interruptus', entailed introducing an object into the frame by holding it in front of the lens, thereby disrupting the image with a blurred and abstract form. In 1985 Metzker turned to the natural landscape for his subject matter, yet continued to employ experimental techniques to personalize the imagery. MR

Turner, E. H., *Ray K. Metzker: Landscapes* (2000).

Mexico. For the first 50 years or so, photography in Mexico was mostly in the hands of foreigners. Appropriately, perhaps, it was a Frenchman, François Aubert (1829–1906), who recorded the aftermath of the French-installed Emperor Maximilian's execution in 1867. Later, German portraitists and 'ethnographers' such as Hugo Brehme (1882–1954) and Wilhelm Kahlo (father of Frida Kahlo) set up studios and documented social types. Eventually, however, some of the porters and assistants employed by Europeans found themselves the inheritors not only of materials (including fully equipped studios) after the adventurers had moved on or returned home, but of a whole tradition that they then made their own. A famous early portraitist, and the first Mexican photographer to achieve an international reputation, was Romualdo Garcia (1852–1930), who from 1887 to 1914 ran a studio in the wealthy silver-mining town of Guanajuato, where he recorded a rich procession of local and itinerant types, from aristocratic landowners to priests, businessmen, peasants, and feathered indigenous people demonstrating their acts in a circus. (Unfortunately, much of Garcia's archive was destroyed by floods in 1905.)

The revolution of 1910–20 was recorded in spectacular fashion by the father of Mexican *photojournalism, Agustín *Casasola and his sons. They bravely set up their weighty cameras to record refugees being expelled from their homes by federal forces, or prisoners of war being shot; or at city gates, almost under the horses' hooves, as rebel Zapatista soldiers rode in. Casasola even mounted a camera on the roof of a railway wagon to show troops being transported sardine-like from one end of the vast country to the other, and *soldaderas* (female camp followers) using their stoves on makeshift platforms between the carriages. Emiliano Zapata, the southern Zapotec Indian dressed in rug and sombrero, was caught breakfasting at the counter of Sandborn's in Mexico City, and the assassinated Pancho Villa sprawled amid shattered glass and bloodstains on the running board of his car.

As well as galvanizing news photography, the revolution also had a longer-term impact. Sergei Eisenstein shot parts of his revolutionary film *Que viva Mexico!* in 1930–1, and was assisted by Manuel *Álvarez Bravo, then a camera operator. It was his photograph of a young Mexican striker killed by soldiers at a demonstration (1934) that made him the *maestro* of Mexican photography. Longevity and inventiveness enabled him to mine the rich seams of his homeland for over 50 years, creating a vast oeuvre of landscapes and skyscapes, street scenes and interiors, portraits and nudes, and intimate studies of plants and *artesanias* (popular artefacts). But already in the 1930s he had an international reputation, being hailed by *Cartier-Bresson and André Breton as an exponent of Mexico's 'natural' surrealism.

Two of Álvarez Bravo's collaborators helped to put women photographers on the Mexican map. Tina *Modotti, Italian in origin and Mexican by adoption, drew her inspiration, like Álvarez Bravo, initially from film. Her vision was essentially political. To her, all life was politics: the massed straw hats of the workers assembling in a town square; their tools, with the hammer and sickle predominant; even a row of telegraph poles, spelling industry and communications. Graciela *Iturbide, 40 years younger than Álvarez Bravo, worked as his assistant in the 1960s, acquiring enough of his insistence on his own culture to meld it with her own anthropological background into a vision of her own. Her documentation of the *Seri* (the 'people of the sand dunes', nomads of the northern deserts) and of *The Women of Juchitan* (1989), a matriarchal society in south-western Oaxaca, are irreplaceable portraits of communities and their relationship with the land.

Literature has also played a role in the development of Mexican photography. Juan Rulfo (1918–86) published only two books, but was posthumously discovered to have been a major photographer. His novel *Pedro Páramo* (1955) is set in the aftermath of the *cristero* (anti-secular) rebellions, during which the eponymous protagonist dies. The photographs he took from the 1940s to the 1960s, while attempting to support his family as a tyre salesman, evoke the same atmosphere of a demi-world half lost to reality, filled with dreams and death. He used an old square-format camera and, like the great majority of Mexican photographers, shot only in black-and-white.

(As Álvarez Bravo famously observed: 'Mexico has far too much colour for me to need to add any of my own.')

The next generation coincided with the literary boom of the 1970s and 1980s, and the fashion for so-called Latin American 'magic realism'. But authors such as Elena Poniatowska, Raquel Tibol, Juan Villoro, Carlos Monsivais, Cuauhtemoc Medina, and Carlos Fuentes all produced critical writings on Mexican photography. This coincided with a boom within the medium itself: photographers such as Gerardo Suter (b. 1957), Francisco Matas, Lourdes Grobet, Maya Goded, Flor Garduño (b. 1957), Rafael Doniz, Yolanda Andrade, Enrique *Metinides, and Mariana Yampolsky (b. 1925), have all exhibited in the USA and elsewhere, and continue to build on Mexican traditions in reportage and art photography.

Finally, the rise of *digital imaging has played its part in breaking down cultural and national barriers. The photographer at the forefront of many of these experiments is the California-based Pedro Meyer (b. 1935). Future 'Mexican' developments will undoubtedly involve not only the latest technological innovations from north of the border, but also the Mexican-American culture emerging there. AH

Imagen histórica de la fotografía en México (1978).

Canales, C., *Romualdo Garcia, un fotógrafo, una ciudad, una época* (1980).

Levine, R. M., *Images of History: Nineteenth- and Early Twentieth-Century Latin American Photographs as Documents* (1989).

Billeter, E., *Fotografie Lateinamerika 1860–1993* (1994).

Mraz, J. (ed.), 'Mexican Photography', *History of Photography*, 20 (1996).

Mexico: The Revolution and Beyond. Photographs by Agustín-Víctor Casasola 1900–1940, introd. P. Hamill (2003).

Meyer, Adolphe Gayne (from 1916) **de** (Demeyer Watson; 1868–1946), portrait and fashion photographer of Franco-British origin. Little is known of his early life, although he was active in *pictorialist amateur circles in the 1890s. In 1899 marriage to Olga Caracciolo, an illegitimate daughter of Edward VII, brought him the title of a (Saxon) baron and a position in London high society, where he blossomed as a celebrity portraitist. Abandoning his earlier, rather sombre style he used shimmering concoctions of soft focus, gauzy backgrounds, and backlighting to bathe his sitters in romantic glamour; the glowing halo of hair or feathers became a particular hallmark. Outstanding in this phase of his career were images such as Vaslav Nijinsky as *Le Spectre de la rose* (1911), and portraits like that of the Marchesa Casati. (He also experimented with the *autochrome process.) His mentor since the 1890s had been Alfred *Stieglitz, who published his pictures in **Camera Work* (1908 and 1912), and exhibited them at *Gallery 291 (1907 and 1909).

De Meyer's high-pictorialist artifice, also brilliantly deployed in still lifes and flower studies, lent itself to fashion and advertising work, especially as contemporary advertising doctrine, with Hollywood on the horizon, was abandoning mere product illustration for associations of escapism and fantasy. By 1914 de Meyer was chief fashion photographer for *Vogue*; between 1922 and 1934 he held the same position at *Harper's*. By the 1930s, however, his style was passé,

superseded by the harder-edged images of photographers like
*Steichen. De Meyer's last years, in southern California, were spent
in poverty and obscurity. ZW/RL

A Singular Elegance: The Photographs of Baron Adolphe de Meyer (1994).

Meyerowitz, Joel (b. 1938), American street and landscape
photographer. After a streetwise upbringing in the Bronx, he studied
painting and medical illustration. An encounter with Robert
*Frank encouraged him to drop his job as an advertising art director
for photography. He spent 1962–5 with Garry *Winogrand working
the New York streets, especially Fifth Avenue which, he recalled,
'had the pulse of life, the most vigour, the most beautiful women, the
heaviest business action. The mix was best on Fifth.' (He described
this frantic bohemian period in the book he wrote with Colin
Westerbeck, *Bystander: A History of Street Photography* (1994).)
In the 1970s he turned increasingly to colour, becoming one of its
leading exponents in American art photography. His pace also slowed.
In 1976 he embarked on a project on Cape Cod, using a heavy view
camera and achieving haunting twilight effects with long exposures
(*Cape Light: Color Photographs*, 1978). In 1978 he was commissioned
to photograph Eero Saarinen's Gateway Arch in St Louis. However,
his career has largely been spent in New York, and after the attacks
of 11 September 2001 he received privileged access to 'Ground Zero'
during the clearing operations. RL

Westerbeck, C., *Joel Meyerowitz* (2001).

Michals, Duane (b. 1932), American photographer, born into a
steelworker's family in McKeesport, near Pittsburgh. He studied art
at the University of Denver and the Parsons School of Design in
New York and became an assistant art director for *Dance Magazine*.
Self-taught as a photographer, he has worked commercially for many
magazines, including *Look, Mademoiselle, Esquire*, and *Vogue. Michals
was strongly influenced by *Magritte and other Surrealists early in
his career and is considered one of the major innovators of the
photographic art world. Often accompanied by his alter ego, Stefan
Mihal, he has explored the use of photographic sequencing as a way of
illustrating wide-ranging metaphysical questions such as existence and
non-existence, death and rebirth, desire and rejection. He has also
produced memorable erotic work. Most of his images have been shot in
black-and-white using natural light, but he often creates settings and
situations, and manipulates exposure, prints with multiple negatives,
and paints on his images with colour. He was an early practitioner of
writing on the photographic prints themselves and also accompanies
his photos with text panels. As a portraitist, he has photographed a
considerable number of the well-known artists and actors of the 20th
century, many of them his close friends. Continually working between
appearance and reality, and understanding the power of the camera to
act as a kind of referee on that playing field, Michals has said, somewhat
whimsically, 'I am a reflection photographing other reflections within
a reflection. To photograph reality is to photograph nothing.' TT

Livingstone, M., *The Essential Duane Michals* (1997).

microphotography (or microimaging), the process of making
microscopically small photographs of large objects by optical
reduction. It became a popular means of creating photographic
jewellery and novelties (e.g. *stanhopes) in the 1860s, and a memorial
ring incorporating a microphotograph of Prince Albert was made
for Queen Victoria in 1861. The same method was used to create
composite portraits of 500 or more celebrities on a single *carte de visite*
(so-called 'mosaic cards'), for viewing with a magnifying glass.

The technology was used during the Franco-Prussian War
(1870–1) and First World War to produce tiny copies of messages to
be carried by pigeons. Initially these were made through a reversed
microscope system and read through a conventional microscope.
'Microdot' messages by espionage organizations hidden under full
stops in other, innocent, messages were encoded and read by similar
means. (Such a procedure had been suggested by Sir David *Brewster
in 1857; Japanese agents may have carried ingested micro-documents
in the Russo-Japanese War (1904–5).) An application of microimaging
in the Second World War was the *airgraph. Today, microimaging is a
standard procedure in the semiconductor industry for producing
masks for microcircuits. GS

Henisch, H. H. and B. A., *The Photographic Experience 1839–1914: Images and
Attitudes* (1994).

Middle East, early photography in the. The geographical term
is ill defined, roughly covering the eastern Mediterranean from Egypt
in the west and extending to *Iran in the east through the Arabian
Peninsula; in the 19th century, Europeans also distinguished it by
the dominant religion, Islam. Early photography in the region was
motivated initially by fascination with the monuments of antiquity,
especially Egyptian but including the ruins of Asia Minor; by the pious
reconnaissance of Palestine (the Holy Land); and by Western interest
in an exotic East subsumed under the rubric of *Orientalism.

Early explorations

Egypt was one of the earliest destinations for photographers, and
was to become one of 19th-century photography's most frequently
represented subjects. François *Arago, secretary of the French
Academy of Sciences, specifically linked the use of *Daguerre's
new process to the necessity of recording the hieroglyphic texts on
Egypt's ancient monuments, an investigation begun by the scholars
who accompanied Napoleon's army of the Nile in 1798. By October–
November 1839 the first of many photographers were in front of the
Sphinx. Frédéric Goupil-Fesquet (1817–?) had accompanied the
painter Horace Vernet to Egypt to make photographic studies to
complement the artist's sketches. Pierre Joly de Lotbinière, a Swiss
who had been in Paris during the 'daguerreotypomania' of the autumn,
was also there with daguerreotype equipment. Their photographs were
reproduced as engravings and aquatints in Noël-Paymal Lerebours's
Excursions daguerriennes (1840–4) and Hector Horeau's *Panorama
d'Égypte et de Nubie* (1841), respectively. Both went on from Egypt to
photograph in Palestine and Syria.

Maxime Du Camp

Gustave Flaubert in a Cairo garden,
1850. Salted-paper print

They were the first in a procession of photographers, initially using the two early processes, the daguerreotype and *calotype, and later the *wet-plate negative process. The motive for many of the early photographic surveys of the region was scholarly interest in the history of architecture as a record of the trajectory of civilizations. The first

extensive survey (*c.*250 plates) was completed by an antiquarian and historian of Islamic architecture, Joseph-Philibert Girault de Prangey (1804–92). In 1842–3 he travelled through Asia Minor, Syria, Egypt, Palestine, and Greece daguerreotyping architecture, sculptural details, landscapes, and, occasionally, people in the region. The plates, in many

Eric Matson

Bethlehem from the South, *c*.1934–9

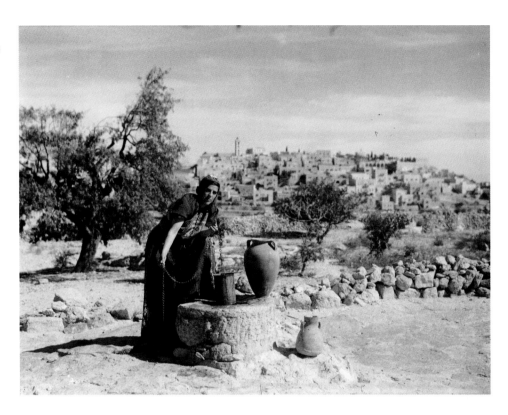

cases the earliest known photographs of sites, were made for personal, scholarly reference and were neither displayed nor reproduced. Pierre Trémaux (1818–?) worked on a similar project documenting the architectural history of Asia Minor and Africa, which was published in three parts over the course of several years (1847–62). Trémaux employed daguerreotypes, his own sketches, and, later, calotypes as the basis for the lithographic illustrations. Later fascicles of *Voyage au Soudan oriental et dans l'Afrique septentrionale exécutés en 1847 à 1854* were issued with mounted *salted-paper prints which faded and required replacement by lithographic reproductions.

The writer and romantic traveller Maxime *Du Camp accomplished an extensive series of 220 paper-negative prints on his journey up the Nile and across the Sinai in 1849–51; 125 were published in the first photographically illustrated travel book, *Égypte, Nubie, Palestine et Syrie* (1852). In rapid succession, other photographers followed suit. Félix *Teynard published 160 calotypes from his 1851–2 journey up the Nile as *Égypte et Nubie* (1854), which he described as a photographic atlas to complement the great Napoleonic project, *Description de l'Égypte*. Louis de Clercq (1836–1901) produced a six-volume survey of the architectural heritage of Syria and Palestine, *Voyage en Orient 1859–60*, for which he photographed ancient monuments, Islamic architecture, and Crusader castles.

Photography was an early adjunct to the archaeological projects that marked the exploration of the ancient lands of the Middle East by Western scholars, although it was rarely used as a systematic record of the phases of excavation until the end of the 19th century.

(Perhaps the earliest photographs of an excavation were made in 1843 in Mesopotamia, present-day Iraq.) The French consular officer Paul-Émile Botta (1805–70) had daguerreotypes (now lost) made of the excavation of what he identified as the Palace of Nineveh, but was actually the Palace of Sarhgan at Khorsabad. John Beasley *Greene, a francophone American associated with the French Egyptologist vicomte de Rougé, travelled and photographed in Egypt in 1853, 1854, and 1856. On his second visit, he excavated the second court at Medinet Habu which he systematically documented with calotypes. In 1854 Auguste *Salzmann photographed archaeological sites in and around Jerusalem. His photographs of architectural details were intended as evidence to support his patron Louis-Felicien de Saulcy's contested dating of the monuments. This early period also saw the work of other amateur calotypists—Ernest *Benecke, John Shaw Smith (1811–73), and Colonel Claudius Wheelhouse—whose photographs were not intended as adjuncts to their scholarly studies or for publication.

In 1856 Francis *Frith embarked on the first of three photographic expeditions to the Middle East and the beginning of what would be a remarkably prolific career as the publisher of travel images. He used the recently introduced wet-plate process, which yielded crisply detailed images and permitted near-perfect copy negatives necessary for the large-scale production of prints, in multiple formats: 20.3 × 25.4 cm (8 × 10 in), 38.1 × 48.3 cm (15 × 19 in) *mammoth plates, and stereos. In addition to standard topographical views, he photographed staged scenes in which European travellers strolled through ancient sites and

native types provided local colour. Frith combined an understanding of what his viewers wanted from travel photographs—a scene they could engage with imaginatively rather than an accurate but dull record of place—and a commercial genius for production, distribution, and marketing. His first book, *Egypt and Palestine Photographed and Described by Francis Frith*, issued in an edition of 2,000 in 1858, began a series of publications in multiple editions that established F. Frith & Co. of Reigate in the mass production of travel views and books. In 1860, *Egypt, Nubia, and Ethiopia*, with 100 stereo views, appeared; the same year, audiences in Manchester and Liverpool were thrilled by projected glass lantern slides of his views of Egypt and the Holy Land. On his final trip to Egypt in 1859–60, he made the first photographs of Ethiopia and the ancient kingdom of Meroë. He published two editions of the Bible illustrated with photographs from Egypt and Palestine. The four-volume Mackenzie series (1862) contained 148 *albumen prints derived from all three of his expeditions. After 1860 he devoted himself to the publication company, photographing only occasionally in Britain, and hiring 'operators' to furnish his publishing business with foreign views.

After 1860 photography in Egypt was dominated by professional commercial photographers who produced technically competent, standardized views. A number of studios catered to tourists who flooded into Egypt with the new package tours begun by Thomas Cook in 1869, the same year that distinguished Europeans such as Adolphe *Braun travelled to Egypt to cover the opening of the Suez Canal. Guidebooks directed visitors to studios where they could obtain views for inclusion in personal photographic albums. The studios of *Sébah, Antonio Beato (c.1825–1903), the Zangaki brothers (*fl.* 1870s–), Légékian (*fl.* 1860s–1890s), W. Hammerschmidt (*fl.* 1860–), Otto Schoefft (*fl.* 1870s–1890s), Henri Béchard (*fl.* 1869–late 1880s), and a branch of the Beirut studio of *Bonfils et Cie offered extensive catalogues—views of archaeological sites, antiquities in the Cairo Museum, atmospheric views of the Nile, costume studies of ethnographic types, and genre scenes frequently staged in the studio or an adjacent courtyard. Photographers established branches within the sites themselves, as for example Antonio Beato's studio in the ruins at Luxor, collapsing the distinction between the experience of a place and the acquisition of its photographic representation.

Absent from the vast majority of photographic depictions of 19th-century Egypt was any reference to a modernizing society with contemporary inhabitants. The country of the photograph was a procession of ancient sites which had been cleared and resembled exhibitions at an international exposition, quaint street scenes, and quasi-ethnographic studies of exotic types. These widely disseminated images came to define Egypt.

The Holy Land

Photographic attention to the ancient sites and landscapes of Palestine, more commonly referred to by contemporaries as the Holy Land, was motivated as much by religious sentiment as it was by secular, historical investigation. The Revd Alexander Keith cited the accepted veracity of the photograph as evidence for the literal truth of the Bible, and based the illustrations for *Evidence of the Truth of the Christian Religion* (1844) on daguerreotypes made by his son George Skene Keith. Similarly, the English clergyman George Bridges (*fl.* 1840s–1850s) published a series of calotypes made in Jerusalem in 1850 as 'illustrating the Bible'. Members of the missionary community in Jerusalem also deployed the new technique to document the reality of holy sites. James Graham (active 1853–7) began photographing in 1853 and was the most prolific of these early photographers. He in turn trained the convert Mendel John Diness (d. 1900), a Russian Jew who ran a successful portrait studio, as well as supplying standard views of the city, until he emigrated to the USA in 1860. In 1862 the prince of Wales, accompanied by an entourage which included Arthur Stanley, dean of Westminster and one of the foremost biblical scholars of the day, travelled through Egypt and the Holy Land. Francis *Bedford was commissioned to photograph the tour and published the results in four volumes as *Egypt, Sinai and Jerusalem* (1863). By the late 1860s there were a number of commercial studios offering views of sites sacred to the increasing number of Christian tourists.

But the most extensive photographic survey of Jerusalem was completed by a detachment of British *Royal Engineers and the photographer Colour Sergeant James McDonald (1822–85) in 1864–5. The survey was financed privately and charged with mapping the city and its water supply, evaluating the antiquity of monuments, and photographing. The resultant images and the archaeological discoveries furnished the impetus for the *Palestine Exploration Fund (PEF; f. 1865) to finance and conduct surveys, which included photography, in the region. McDonald and the Royal Engineers with a group of civilian scholars returned in 1868 to survey the Sinai Peninsula and identify Mount Sinai and the route taken by Moses and the Israelites from Egypt, as well as to map and record the region they traversed. The photographs accompanying the *Ordnance Survey of Jerusalem* (1864) and the *Ordnance Survey of the Peninsula of Sinai* (1869) were widely disseminated and provided a model for the integration of military and scholarly expeditions in the region. Political and religious motives continued to merge in the extensive mapping and recording of biblical lands under joint projects of the British military and the PEF, including a survey with photographs of the Wilderness of Zin accomplished by T. E. Lawrence (1888–1935) in 1913.

Commercial views

Not only in Egypt and the Holy Land but throughout the region, commercial photographers compiled stocks of images of sites of interest and constructed views of the exotic life of the East, available both to armchair travellers—through publishers and agents in Europe and the USA—and to the increasing number of tourists. Initially, the professionals produced images primarily for sale in Europe. However, as European travel increased, first in the areas closest to the Mediterranean sea routes to Palestine, Egypt, and Lebanon, and later in Mesopotamia and Arabia, a number of commercial studios

appeared in major cities. Initially their proprietors came from outside the region, primarily Europe, although Indian and Turkish operators were represented. But soon local entrepreneurs established businesses. The studios acquired negatives of principal tourist sites, either by purchase from local operators or through their own photographic expeditions, which they offered for sale throughout the region. Contemporary guidebooks advised travellers on the best sources for view photographs and listed the addresses of studios and their agents. In many cases, views from Sébah, Abdullah Frères, Bonfils, Zangaki, Légékian, Beato, and others are interchangeable, and there is compelling evidence that studios transferred negatives or made copy prints from other studios' stock images.

The introduction of *dry-plate negatives for medium-size hand cameras, and then, in 1888, the *Kodak *roll-film camera, transformed the market, as it created the opportunity for hundreds of thousands of vernacular travel photographs. Demand for large, professionally executed view photographs diminished. An increasing number of tourists, as well as commercial and official visitors to the Middle East, used the new technology to make their own photographs, which were preserved in family albums and archives. It also heralded a change in photographic publishing, as travellers relied on their own snapshot photographs to illustrate travel accounts, and publishers responded to the growing number of 'Kodakers' by producing manuals offering instruction in taking high-quality travel photographs. On the other hand, the turn of the century saw the reinstatement of the photographic tour as a medium for popular instruction. In 1905 *Underwood & Underwood marketed a set of 100 stereographs, *Egypt through the Stereoscope*, as a complete tour of Egypt and its antiquities conducted by the Chicago University Egyptologist James Breasted. Sets of stereoscopic views accompanied by an authoritative text became an accepted pedagogic tool. The standardized views presented in this and similar projects served as a counterpoint to the personal, contingent, and unmediated possibilities inherent in the snapshots made by Kodak-wielding tourists.

The Arabian Peninsula

Photography arrived late in the region, perhaps because of the difficulty of travel and prohibitions against Western visitors to the holiest sites of Islam. As elsewhere in the Middle East, photographic expeditions were driven by the twin goals of geographical knowledge and military intelligence. Beyond the views taken by travellers on their way to India as they passed through Jeddah and Aden, the vast expanse of Arabia was first photographed by Sadic Bey (Mohammed Sadic; 1832–1902), beginning in 1861 and continuing during the course of multiple surveys and assignments in the region through 1895. He made the first photographs in Mecca and Medina, the two holiest shrines of Islam, and documented the *haj* and the annual journey to bring the *mahmal*, the embroidered covering for the Kaaba, from Cairo. By the late 1870s there were at least two Indian photographers with studios in Mecca. Only after 1885 was the *haj* documented photographically by Europeans, Christian Snouk Hurgronje

(1857–1936) in 1885 and Jules Gervais-Courtellemount (1863–1931) in 1896. The northern provinces were photographed in 1908 by two British officers, General Stephen Butler and Captain Aylmer, on a joint mission for the *Royal Geographical Society and the War Office. In 1911, after travels through Jordan, Palestine, Syria, and Iraq, Gertrude Bell travelled south from Baghdad into Arabia to photograph and report on the central provinces, again on assignment from the War Office. In the 1940s, finally, another Briton, Wilfred Thesiger (1910–2003), travelling by camel with his Leica in a goatskin bag, photographed Arabia's 'Empty Quarter' and its inhabitants. KSH

Vaczek, L., and Buckland, G., *Travellers in Ancient Lands: A Portrait of the Middle East 1839–1919* (1981).

Nir, Y., *The Bible and the Image: The History of Photography in the Holy Land, 1839–1899* (1985).

Graham-Brown, S., *Images of Women: The Portrayal of Women in Photography of the Middle East 1860–1950* (1988).

Perez, N. N., *Focus East: Early Photography in the Near East 1839–1885* (1988).

Janis, E. P., *Louis de Clercq: voyage en Orient* (1989).

Carney, G., Wahrman, D., and Rosovsky, N., *Capturing the Holy Land: M. J. Diness and the Beginnings of Photography in Jerusalem* (1993).

Howe, K., *Excursions along the Nile: The Photographic Discovery of Ancient Egypt* (1993).

Howe, K., *Revealing the Holy Land: The Photographic Exploration of Palestine* (1997).

El-Hage, B., *Saudi Arabia: Caught in Time, 1861–1939* (1997).

Gregory, D., 'Emperors of the Gaze: Photographic Practices and Productions of Space in Egypt, 1839–1914', in J. Ryan and J. Schwartz (eds.), *Picturing Place: Photography and the Geographical Imagination* (2003).

Nickel, D. R., *Frances Frith in Egypt and Palestine: A Victorian Photographer Abroad* (2004).

Midorikawa, Yoichi (1915–2001) Japanese landscape photographer, born in Okayama. A dentist by trade, he began photographing as a student in Tokyo and co-founded the group Ginryu-sha with professional photographers. He gradually turned to photographing landscapes in his forties, in particular the Setonai-kai around his home town. His work stresses the beauty inherent in the conjunction of nature and human activity; for example, in the lines of light on ships' wakes in a sunset sea. MHV

Miethe, Adolf (1862–1927), German physicist, photographic inventor and writer, perhaps best known for his invention, with Johannes Gaedicke in 1887, of the first widely used flashpowder (*Blitzlicht*). But he also designed lenses and made important contributions in the fields of colour photography and printing, and the spectral sensitivity of photographic materials. At the end of the 19th century he edited several photographic journals and became a director of *Voigtländer in Brunswick. In 1899 he became professor of photochemistry and spectral analysis at the Berlin Polytechnic. He published treatises on general (1896) and landscape (1897) photography. LAL

Migrant Mother (or *Prairie Mother*), by Dorothea Lange. The last and most tightly composed of six pictures of a woman and children at a migrant pea-pickers' camp in Nipomo, California, on a wet day in early March 1936. Lange, then employed by the Resettlement Administration (RA) under Roy *Stryker, visited the camp on impulse while travelling with her husband, Paul Taylor. The family seems to have been completely destitute; indeed, the woman had just sold the tyres of her car to buy food. The photographs were taken more or less without preliminaries, although the final one was evidently arranged so that the mother's face dominates the composition. Surprisingly, Lange did not record her subject's name or history; she was subsequently identified as Florence Thompson, a 32-year-old mother of seven.

Lange knew she had the picture she wanted. 'I did not approach the tents and shelters of other stranded pea-pickers,' she wrote later. 'It was not necessary; I knew I had recorded the essence of my assignment.' Her photograph appeared immediately in the *San Francisco News*, with the result that food was sent to the camp: a more than usually tangible effect of RA photography. *Migrant Mother* rapidly achieved *iconic status, and in 1938, for aesthetic reasons (and despite Stryker's protests), Lange retouched the negative to remove the mother's left thumb from the foreground. It was exhibited at MoMA in 1941, was included in the *Family of Man* exhibition in 1955, and, between 1936 and the 1970s, was adapted as *propaganda for various causes. Florence Thompson died in 1983. In 1998 an unretouched *vintage print of Lange's photograph was acquired by the Getty Museum for $244,500. RL

Koetzle, H.-M., *Photo Icons. The Story behind the Pictures, 2: 1928–1991* (2002).

migration and photography. Portraits by the Canadian photographer William *Notman discovered in an Aberdeen bookshop, or group photographs of first-generation Asian immigrants from the Belle Vue Studio, Bradford (see attached feature), are a reminder of the multiple and complex links between photography and migration. The camera has been used to maintain emigrant ties, promote emigration opportunities, impose immigrant control, create the immigrant Other, and encourage immigrant assimilation. Photographs have documented forced migrations as well as recording migrant workers, migrant adventure, and migrant hardship. Increasingly throughout the 20th century, as photographers themselves have offered migrant perspectives, the medium has become a way to document, explain, and understand the immigrant experience.

During the 19th and early 20th centuries, a stream of humanity flowed through the ports of London and Liverpool destined for the USA and the British colonies. As improvements in transportation, imperial expansion, Old World hardships, and New World opportunities all acted to disperse friends and families, photography was presumed to have important domestic and social implications. The discovery of gold, first in California and Australia in the 1850s, in British Columbia and New Zealand in the 1860s, in South Africa in the late 1880s, and finally in the Klondike at the close of the century, set off a different wave of migrations, all thoroughly recorded by the camera.

In *The Camera and the Pencil* (1864), Marcus Aurelius *Root stressed the contribution of photographs to 'primal household affection', acknowledging that 'the exigencies of life, in most cases, necessitate the dispersion of relatives, born and reared under the same roof, towards various points of the compass, and often to remote distances'. Not only did photographs serve 'to strengthen and to perpetuate the ties of kindred, of friendship, and of general respect and regard', but the love of kindred maintained and nurtured by photographs was, he argued, 'one of the most potent preservatives of a life of purity, virtue and honor, as also one of the most active stimulants to a laudable and manly social ambition'.

In these times of unprecedented human movement, Root and others were quick to recognize the social role of the photograph as a form of 'domestic glue' maintaining the ties of kith and kin across vast distances. Their observations were echoed much later by the 20th-century British cultural historian and theorist Raymond Williams, who recognized the importance of the cheaply reproducible photographic image within 'a society characterised by wholly unprecedented mobility and change' and attributed its popularity to 'the effects of the vast dispersal of families on the generations of emigration, colonisation and urbanisation'. To this end, portraits on jewellery, *cartes de visite*, and cabinet cards kept loved ones visually close, and single and *stereoscopic views permitted the exchange of glimpses of Old and New World landscapes important to those at home and abroad. Karin Becker Ohrn's interviews with three generations of a Finnish-American family in the early 1970s vividly illustrate how personal reminiscences in conjunction with photographs served to maintain this bridge between cultures.

The great transatlantic migrations of the 19th century included not only those displaced by the early 19th-century Scottish Highland clearances and the potato famine in Ireland (1845–9), as well as those seeking gold, adventure, or land, but also aspiring merchants, tradesmen, and professionals, among them photographers and would-be photographers who brought the new medium to North America or took up photography as a lucrative new business venture. Some established studios in major cities, others pioneered photography on survey expeditions to the American and Canadian West. William Notman, Alexander *Henderson, and Alexander *Gardner were Scottish born. John Plumbe Jr. moved to the USA from Wales aged 12. William H. Bell, who accompanied the US Government Survey of 1872 led by Lieutenant George M. Wheeler, was born in Liverpool.

With the advent of the *wet-plate process, lantern slides, and photomechanical reproduction, photography was used increasingly as a tool of publicity, documentation, and surveillance by governments, steamship and railway companies, land speculators, and others to promote opportunities to prospective emigrants, to lure settlers through colonization schemes, and to attract migrant workers with the promise of employment. Between 1882 and 1905, some 18,000 children were sent to new homes in Canada and Australia from England by Dr Thomas Barnardo (1845–1905), who created a photographic department to produce a systematic, if purportedly

exaggerated, photographic record of the children upon their rescue, and after their recovery, from life on the streets. At ports of entry, where the Old World Other prepared to meet the New World gaze, individuals and family groups, passing through the immigration halls in search of a new life in the USA or Canada, were photographed by Augustus Sherman, a registry clerk and amateur photographer at Ellis Island, and by William James Topley, a professional photographer working for the Canadian government at Quebec City. Alice *Austen of Staten Island took sympathetic pictures of the immigrant districts of lower Manhattan. In 1904 and again in the 1920s, Lewis *Hine took photographs at Ellis Island, portraying the new arrivals with dignity and respect, at a time when anti-immigrant sentiment was pervasive.

As the flood of immigrants fleeing poverty, war, famine, drought, religious and political persecution increased, the *Keystone View Company, *Underwood & Underwood, H. C. White & Co., and other publishers of popular stereoscopic photographs in the early 20th century documented immigration and marketed images to schools, libraries, social service agencies, and philanthropic organizations as educational sets. And just as photographers were among the displaced and the disenfranchised, the fortune seekers and the gold-diggers of the 19th century, so they were among the wave of emigrants who fled fascism, war, and persecution in Europe during the first decades of the 20th, bringing with them different artistic traditions, political perspectives, and views on issues such as class, politics, and race, which dramatically affected American photography.

If Alfred Stieglitz's 1907 photograph *The Steerage* has come to epitomize immigration to the New World, then Dorothea Lange's 1936 *Migrant* (or *Prairie*) *Mother* has become the icon of migrant farmworkers in Depression America. The Farm Security Administration's collection, now held in the Library of Congress in Washington, DC, consists of more than 75,000 photographs showing the plight of poor farmers during the Dust Bowl years and the Great Depression.

Whether recorded in *pictorialist or *documentary style, or produced for journalistic or propagandistic reasons, images of truckloads, trainloads, and boatloads of people, whether destined for death camps, detention centres, or distant shores, bear witness to the geographical displacement of individuals and communities, their possessions, their ideas, and their dreams.

At the close of the 20th century, as notions of the 'melting pot' gave way to a heightened awareness of cultural diversity across the USA, the landmark three-part exhibition *Points of Entry* organized in 1995–6 by the Center for Creative Photography, Tucson, Arizona, the Museum of Photographic Arts, San Diego, and the *Friends of Photography, San Francisco, explored the relationship between photography and immigration to the USA, focusing on the artistic and social visions of selected European émigré photographers who helped shape a new style of photography and a startling new vision of this country between the 1930s and the 1950s; the history and breadth of immigration as addressed through social documentary photography, portraiture, genre pictures, cartoons, illustrations, and broadsheets; and exploring themes central to emerging definitions of multiculturalism.

Today, in communities around the world, photography continues to be used to elicit and document the immigrant experience as the basis for a better understanding of cultural diversity. Over six years, Sebastião *Salgado visited *c.*40 countries to produce his book *Migrations* (2000). Focusing on issues both personal and political, contemporary artists now employ photography to confront their own experiences of migration, cultural change, and adjustment. Their photographs and photography-based installations add to the many ways in which photography has been employed to record the processes of human diaspora, the pain or hope of those who left, the sadness and suffering of those left behind, and the transformations in society, culture, and place that ensued. JMS

➲ See also Bellevue Studio, Bradford *overleaf*.

Ohrn, K. B., 'The Photo-Flow of Family Life: A Family Photograph', in *Saying Cheese: Studies in Folklore and Visual Communication* (1975).
Fleischhauer, C., and Brannan, B. W. (eds.), *Documenting America, 1935–1943* (1988).
Holland, P., and Spence, J. (eds.), *Family Snaps: The Meanings of Domestic Photography* (1991).

Mikhailov, Boris (b. 1938), Ukrainian photographer. Originally an engineer, Mikhailov took up photography after the KGB's discovery of nude photos of his wife lost him his job. After 1989, though middle aged, he became the *enfant terrible* of photography in the former USSR and famous in the West; partly, perhaps, because the 'Brasilianization' shown in his photographs—extreme polarization between rich and poor—is hardly a serious possibility there. His work can be seen both as a reaction against the pre-1989 embargo on anything liable to bring the 'Soviet way of life' into disrepute, including the imperfect naked body, and as a celebration of survival against the odds. His series *Unfinished Dissertation* (1998), about everyday life in his native Kharkov, began in 1984, the pictures being stuck into the back of a friend's thesis with various texts and observations. *Case History* (1999) showed Kharkov's *bomzhes* (homeless): derelict humans urinating in the street, inebriated or sniffing glue; or, for a consideration, lifting filthy clothes to reveal inflamed genitals and scarred, emaciated bodies. The series was shown at the Saatchi Gallery, London, in 2001 and won the Citibank Private Bank Photography Prize. RL

military photography. Photography carried out for military purposes by service personnel or civilian auxiliaries. Although often treated as synonymous with *war photography, the latter has concentrated more on actual combat, and been more journalistic in character. Military photography mainly serves functional training, organizational, and technical needs of little interest to the public at large, including military geography, intelligence gathering, and weapons research. While some famous individuals—for example, Edward *Steichen and David Douglas *Duncan—have worked for the military, most military photographers have been relatively anonymous.

(*continued on p. 413*)

Belle Vue Studio, Bradford

The Belle Vue Studio was opened by Benjamin Sandford Taylor in Manningham Lane, Bradford, Yorkshire, in 1926. At the time, Manningham was a thriving area of Bradford with Manningham Lane at its hub—a lively street full of successful businesses and shops. The business did well and 'Sandford Taylor's', as many of its customers referred to it, became one of Bradford's best-known photographic studios. The building was modest. The ground floor comprised a shop, office, and, to the rear, the studio itself. The studio was a simple affair—a daylight studio with one side built entirely of glass. Even after electric lighting became widely available, the studio continued to operate using only daylight illumination until its closure in 1975. Sandford Taylor and his family lived in a flat above the shop.

The studio's popularity continued after the Second World War. Indeed, it was so successful that Sandford Taylor had to take on extra staff. In 1946 Tony Walker joined the studio as assistant photographer, together with his sister-in-law Ella Johnson who looked after the administrative side of the business. Walker had originally started in the photographic trade in the 1920s as a canvasser—going from door to door collecting photographs for copying, enlarging, and hand colouring.

During the 1950s many traditional photographic studios experienced a decline in business. More and more people owned cameras and chose to take their own pictures at a fraction of the cost of a visit to a studio. In order to survive, studios had radically to alter their working practices—photographing weddings at the church, for example, rather than posing the happy couple in the studio. As customer numbers declined, photographers needed to sell whole albums of pictures instead of single prints in order to maximize their income. Even so, many long-established studios were forced to close.

Sandford Taylor died in 1953 and the business was bought by Walker. To his immense relief, the slump in business that many other studios were experiencing was not shared by the Belle Vue, for the studio soon acquired a new, enthusiastic, and faithful clientele. Walker's ownership coincided with the beginnings of large-scale Asian immigration to Bradford, and Manningham was at the heart of this new community. It may have been geographical good fortune that attracted the first of these new customers but a number of other factors combined to make the Belle Vue Studio *the* place to have one's photograph taken. Walker and his staff gave their sitters exactly what they wanted and the word quickly spread.

Although the formal, traditional poses and props still favoured by the studio appealed to his new clientele, Walker was astute enough to quickly adopt new ideas if he thought they would satisfy his customers' needs. Many recent immigrants wanted photographs to send back to their families at home. For them, it was important that their portraits showed how successful they were in their new lives. The studio soon assembled a set of useful props as the visible trappings of

Belle Vue Studio, Bradford

Portrait, 1960s or 1970s

material success. Watches were prominently displayed on wrists. Cameras and transistor radios were visible on the studio table. Cigarettes and sunglasses symbolized Western sophistication; books represented education. Although nearly all the men worked in the local textile mills or on public transport, briefcases were carried proudly and rows of pens lined top pockets—symbols of prestigious clerical employment. All these things were concrete proof of well-paid employment and disposable income.

Walker's desire to please his new customers, extending them a warm welcome, producing the sort of portraits they wanted, and showing respect towards them and their cultural traditions, was in marked contrast to the widespread prejudice they usually experienced. At the time, many studios refused to photograph non-white people on the grounds that they would put off their regular clients.

Although he still had plenty of customers, Walker was forced to close the Belle Vue Studio in 1975 so that he could nurse his wife through a long illness. He had originally intended to reopen the studio at some stage but, following his wife's death, decided to make his retirement permanent. Thousands of glass negatives were simply taken to the local tip and dumped. Those that remained were put into shoe boxes and left in the cellar. The camera and studio equipment

were sold to an antiques dealer for a nominal sum. In 1983 Walker was approached by a photographer, Simon Fisher, who offered to buy the business. Pleased that the building would remain a photographic studio, Walker agreed a price and set about emptying the premises, including disposing of the negatives that he had overlooked during his first clear-out. A skip was hired and it was only as the negatives were being carried out that the new owner realized what they were and insisted that they should be kept.

Tony Walker died in 1990, aged 84. Plans to reopen the studio came to nothing and the building is now used as a junk shop, piled high with second-hand furniture and bric-à-brac. The rear extension that once housed the studio is dilapidated; most of the panes of glass have been broken and the roof is patched up with hardboard and polythene. However, the glass negatives have fared better. Saved from the builder's skip, 15,000 plates dating from the 1950s to the 1970s now have a safe and permanent home at the Bradford Heritage Recording Unit. A unique and priceless resource, they not only reveal the history of a photographic studio but also, more importantly, the aspirations of an entire community which made its home in Bradford in search of a better life. CWH

Smith, T., *Here To Stay: Bradford's South Asian Communities* (1994).

War has generated millions of functional photographs. Already during the American Civil War (1861–5) the camera was extensively used by General Hermann Haupt, head of the US Military Railroad Bureau, by the federal medical authorities, and the Army Medical Museum (f. 1862), and by the North's organizer-in-chief, US Quartermaster-General Montgomery Meigs. During the Russo-Japanese War (1904–5), the Japanese Army Photography Unit (f. 1894) took 4,847 photographs in Manchuria. In the world wars of the 20th century, organizations such as the US Army Signal Corps produced hundreds of thousands of images. French military photographers took *c.*90,000 pictures in Indo-China in 1944–55. In the Vietnam War (1965–75), photographers were deployed by the US army, air force, Coastguard, Marine Corps, and navy; and at the height of the conflict *c.*10,000 pictures were reportedly being created by the army alone every month. Even limited campaigns like the Falklands War (1982) were heavily photographed.

Military organizations adopt technical innovations that appear directly relevant to their aims. Photography's principal appeal lay in its unparalleled reproductive precision and ability to record detail, and armies first concerned themselves with it in the mid-19th century, usually adapting existing techniques to their own purposes.

Military geography
It was in this field that photography first established itself. Precise knowledge of the theatre of operations, achieved by accurate surveying and mapping of terrain, can be of decisive military importance. In the American Civil War photography was extensively used for surveying, map-making, and reproducing engineering plans. In the First World

War the Austrian Military-Geographical Institute alone produced some 120 million maps.

Military-geographical tasks were often assigned to army engineers. In Britain the *Royal Engineers used photography from the mid-1850s, and from 1856 taught it at their base in Chatham. The War Office's Board of Ordnance also adopted it, and under General Henry James a studio was established at Southampton charged mainly with the enlargement and reduction of maps. In 1859 James reported his achievements to a parliamentary committee, and the following year Captain Donnelly of the Royal Engineers claimed in the *Photographic Journal* that using photography could save the Survey Office *c.* £1,600 a year. In France, Colonel Aimé Laussedat (1819–1907) began to experiment with *photogrammetry and topographical photography at the end of the 1850s. In 1861 his methods were adopted by the War Ministry, which also decreed that every brigade should have an officer proficient in photography (*Disdéri trained them). The Prussian General Staff established a studio in 1868. Here too, military geography was the priority, and in 1867–8 the War Ministry commissioned photogrammetric experiments by Albrecht Meydenbauer (1834–1921), but was not convinced by the results. During the Franco-Prussian War (1870–1) a 'Field Photography Detachment' was set up under Engineer Captain Burchardi and conducted photogrammetric surveys of the fortifications of Strasbourg, Paris, and other places. However, they were completed too late to be used. Comparable work was done in Italy (Paganini, Ferero, Manzi) and Austria (von Hübl, von Orel, *Scheimpflug). In 1907 von Orel, with *Zeiss, developed the stereo-autograph, an instrument that greatly facilitated the drawing of maps from photographs.

Intelligence gathering

Photo-assisted topographical surveys are closely related to reconnaissance of hostile territory, positions, and activities, under the heading of 'photographic intelligence' (a subcategory, today, of 'imagery intelligence'). In the Crimean War (1853–6), sappers photographed enemy positions prior to mining them, and the British HMS *Hecla* conducted photographic surveys of Russia's Baltic ports. The German navy carried out coastal surveys from 1881, and in the 1880s photographic intelligence gathering on land and sea became commonplace, with installations like fortifications and naval dockyards of particular interest. Staff officers lured into compromising situations could expect to have their papers copied by increasingly sophisticated means. Military observers of foreign wars, such as the British and German officers attached to Japanese forces in the Russo-Japanese War (1904–5), also had an intelligence-gathering function.

Particularly important was *aerial reconnaissance. Experiments were done by *Nadar, Laussedat, and others in the late 1850s, and in 1862 General McClellan's troops used balloon pictures in the siege of Richmond, Virginia. But the systematic creation of aerial units did not take place until later, when, for example, balloon detachments were set up in Germany (1884) and Britain (1890). In 1907–10 the Saxon engineer officer Alfred Maul experimented with cameras mounted on rockets, gyroscopically stabilized, and recovered by parachute. The results were good enough for the system to be used by Bulgaria in its war with Turkey in 1912. But in 1911 (also against Turkey) the Italians had taken reconnaissance photographs from aeroplanes; a British observer at the French army manoeuvres of 1911 had flown with French pilots and taken excellent pictures; and the French army had used aerial photography during the second Moroccan crisis. But it was the First World War that produced the most spectacular advances. When British troops attacked at Neuve Chapelle in March 1915, it was with maps prepared—for the first time in the history of warfare—solely from photographic reconnaissance. Automated, motorized cameras, filters to penetrate haze, and dampers to reduce vibration were among the war's most important technical developments, in conjunction with longer-range, more stable aircraft. Overlap in systematically produced images created a stereoscopic effect, allowing specialists to discern trenches, ammunition stockpiles, camouflaged batteries, and other traces of enemy activity. Intelligence officers became increasingly skilled at interpreting pictures and combining them with other kinds of information.

In the inter-war years the British introduced the F24 aerial camera (1925), and used photography effectively in theatres like India's North-West Frontier. German planners, however, took a more holistic approach: 'The military organisation that has the best photographic intelligence', wrote the army commander-in-chief General Werner von Fritsch in 1938, 'will win the next war'. By 1939 Germany had plentiful reconnaissance aircraft and 5,200 ground personnel. (During the war, however, German photographic reconnaissance was hampered by poor interpretation and inadequate integration with other intelligence sources.) The Second World War brought further advances in all branches of photographic intelligence gathering.

Allied air reconnaissance units became capable of rapidly mapping contested territories with the use of automatic cameras and industrial processing; the RAF produced over 6 million images during the last year of combat alone. Periscope photography from submarines became increasingly important, with German technology (the Primarflex camera) pre-eminent. Major assaults such as the Normandy invasion (1944) were preceded by picture taking on an immense scale by Resistance agents (some using the Kodak MB spy camera), and from ships, submarines, and aircraft. Another elaborate Allied reconnaissance operation was the 1943–4 campaign to locate and identify German V-1 and V-2 missiles.

In the second half of the 20th century all major armed forces possessed the capacity to make and interpret intelligence photographs, although the most sophisticated and expensive facilities were monopolized by the superpowers. Notable was the American National Photographic Interpretation Center (NPIC), a branch of the CIA organized by Arthur C. Lundahl in the mid-1950s but not officially inaugurated until 18 January 1961. Intelligence-gathering technology developed continually. The Lockheed U-2 spy plane (1955) was capable, with its Perkin-Elmer cameras, of recording a golf ball on a putting green from 16,775 m (55,000 ft), and it was the U-2, in conjunction with low-level photography by conventional aircraft, that identified Russian missile sites during the Cuban Missile Crisis of August–October 1962. By this time the American Samos and Russian Cosmos programmes were beginning a new era of satellite-based reconnaissance—a form of intelligence gathering that, combined with *infrared, *ultraviolet, and *digital technology, continued to advance rapidly at the beginning of the 21st century. On the modern 'digital battlefield' the near-instantaneous exchange of images between satellites, aircraft, ground troops, and theatre commanders provides unprecedented quantities of data for targeting, damage assessment, and other tactical purposes.

Weapons technology

Also of considerable military importance is visual documentation of the behaviour and effects of munitions, from bullets to torpedoes, missiles, and *nuclear bombs. Initially the British army was particularly innovative. Photography was adopted by the Royal Artillery at Woolwich in 1859, and by 1866 attempts were being made to record projectiles in flight. However, precise ballistic studies had to wait until the medium was more advanced. In 1882–3 the French army also experimented at a range near Calais. But it was Ernst Mach, working in Prague in 1885–6, who made the decisive breakthrough. In Germany Ottomar *Anschütz worked regularly for the military, for example photographing projectiles at the Gruson works at Magdeburg in 1889. The effects of impact and explosions, for example on armour plate, were also photographed. Manufacturers increasingly took their own photographs, and the Krupp Archive in Essen contains many pictures of firing tests from 1875 onwards. These were used for both record and advertising purposes, establishing the armaments industry's widespread practice of enlisting still photography, film, and ultimately computer graphics to show off its products.

Other uses

Although surveying, intelligence gathering, and weapons research account for a high proportion of the military photographs taken since the 1850s, they are not exhaustive. From the Crimean War onwards, medical photography, embracing the handling of wounded personnel, surgery, hospitals, and rehabilitation programmes, was a major field. Since the Franco-Prussian War, microphotography, e.g. the Second World War *airgraph, has been extensively used to convey documents. Combat photographs, particularly in the 20th century, have been taken in vast numbers for armed-forces journals such as *Parade*, *Stars & Stripes*, and *Leatherneck* and publications by the British Ministry of Information; release to the press; and other informational/propaganda purposes. In peacetime, photography has played an important public-relations role, showing troops on peacekeeping missions or rescuing taxpayers from natural disasters, and for recruitment. Not to be forgotten, finally, are duties relating to heads of state: over 40 years, for example, the British *Royal Naval Photographic Branch took over 100,000 photographs of life aboard the royal yacht *Britannia*. JJ/RL

Kiesling, M., *Die Anwendung der Photographie zu militärischen Zwecken* (1893).

Babington Smith, C., *Evidence in Camera: The Story of Photographic Intelligence in World War 2* (1958).

Brookes, A. J., *Photo Reconnaissance* (1975).

Sekula, A., 'The Instrumental Image: Steichen at War', *Artforum*, 14 (1975).

Davis, K. F., 'A Terrible Distinctness: Photography of the Civil War Era', in M. A. Sandweiss (ed.), *Photography in Nineteenth-Century America* (1991).

Brugioni, D., *From Balloons to Blackbirds: Reconnaissance, Surveillance and Imagery Intelligence* (1993).

Miller, Lee (1907–77), American photographer. Lee Miller was the rarest of women, in that she crossed from one side of the camera to the other. First a model for fashion luminaries *Horst, *Steichen, and *Hoyningen-Huene, she remained with *Vogue* magazine as a fashion photographer. In 1925 she broke the mould and came to Paris, where she apprenticed herself to the Surrealist photographer *Man Ray, whose model and lover she also became. Later she married an Egyptian, Aziz Elouis Bey, and lived for a while in Egypt, but also travelled in Europe with the British Surrealist Roland Penrose. She brought an eye for dreamlike—or nightmarish—incongruity to the Second World War, in which, for *Vogue*, she photographed the German occupation of France, the London Blitz, and the liberation of Paris. In April 1945, when many of her colleagues put down their cameras in horror, she took some of the first professional images of German concentration camps. *Vogue* had never published work like it before or since, and she wrote much of the copy to accompany her pictures.

In 1947 she married Penrose and settled in Sussex, where much of her former entourage came to her. She rephotographed artists and writers such as Colette, Cocteau (with whom she had made a film in 1931), Ernst, Picasso, and Saul Steinberg. Life and art combined, and she became as famous for who she was as for all she achieved. AH

Livingston, J. (ed.), *Lee Miller: An Exhibition of Photographs, 1929–1964* (1964).

Miller, Milton H. (*fl*. 1860s), American photographer from San Francisco, active in Hong Kong and Canton c.1860–4. His outstanding portraits of Chinese are unmatched in Chinese photography. The Second Opium War (1858–60) marked the real start of photography in China. With Canton occupied by British and French forces and Hong Kong already a British territory, Miller could exploit two wealthy markets, the—mostly British—military, and the local gentry. While he did other types of photography, his typical large prints of Chinese and Western models testify to a unique closeness to his subjects. RT

Minamata, Japanese coastal town in Kumamoto prefecture, south-eastern Kyushu. In 1956 it was discovered that mercury and other substances discharged by the Chisso chemical works had contaminated the fishing grounds and caused widespread poisoning. Initial steps to solve the problem were inadequate, and the continuing effects of 'Minamata disease' were documented in the 1960s by the Japanese photographer Shishei Kuwabara. But much greater impact was achieved by W. Eugene *Smith, who lived in Minamata 1972–4 and recorded both the suffering of the victims and the campaign for compensation. On one occasion he was beaten up by Chisso employees. The photographs appeared in *Life* (2 June 1972), the *Sunday Times Magazine* (18 Nov. 1973), and other journals, and in a book published by Smith and his wife Aileen, *Minamata* (1975). They were also exhibited at the *International Center of Photography, New York (1975). Smith's Minamata reportage is one of the most powerful in the medium's history. His image of 15-year-old Tomoko Uemura helpless in her mother's arms has become an icon of environmentalism. RL

Maddow, B., *Let Truth be the Prejudice. W. Eugene Smith: His Life and Photographs* (1985).

minilab, automated processing machine for the rapid, darkroom-less production of consumer-quality prints. Minilabs appeared at the end of the 1970s and spread everywhere in the 1980s, manufactured by Japanese companies like Konica and Noritsu, and Western firms such as Kodak (from 1985) and Agfa. Their speed and limited training requirements made them popular with both high-street retailers and consumers, particularly tourists. Modern versions can print from *digital memory cards, a boon to the computer shy. RL

Minkkinen, Arno Rafael (b. 1945), Finnish-born American photographer. His work concerns the human body—its limits, fragility, and, especially, its relationship to nature. Always incorporating his own nude body into the landscape, Minkkinen's single-negative black-and-white self-portraits, as they are termed, record a performance. Yet the image is the aim, making precise and humorous use of photographic language (viewpoint, perspective, illusions). Minkkinen's pictures draw upon and extend Finnish landscape traditions while remaining highly personal and distinctive. Exhibiting extensively, Minkkinen is an active teacher, workshop leader, and curator. Notable publications include *Frostbite* (1978), *Waterline* (1994), and *Body Land* (1999). J-EL

Minotaure, Le (1933–9), *Surrealist journal published by Albert Skira, edited by E. Tériade (until 1937), who in turn was advised by André Breton. It was exceptionally well produced, and published photographs by *Álvarez Bravo, *Brassaï, *Bellmer, *Man Ray, *Ubac, and others. The more than 150 Brassaï images represented some of the photographer's most important 1930s work, including series on Picasso sculptures, nudes, Paris nocturnes, and graffiti. RL

Minox camera. See SUB-MINIATURE PHOTOGRAPHY; ZAPP, WALTER.

mirror lenses. See CATADIOPTRIC LENSES.

Mirrors and Windows exhibition. John *Szarkowski is perhaps the most prolific photographic historian of the 20th century. Unfazed by the growing complexity of styles and purpose in photography, particularly in the post-war years, he mounted an exhibition of 127 images in a show entitled *Mirrors and Windows: American Photography since 1960*. Originating at MoMA, New York, in 1978, it travelled for two years throughout the USA. Szarkowski articulated his thesis as follows in its accompanying volume: 'There is a fundamental dichotomy in contemporary photography between those who think of photography as a means of self-expression and those who think of it as a method of exploration'; or, roughly, those who look introspectively in mirrors to find themselves, and those who look through windows at whatever might be out there. In the first group, Szarkowski included Minor *White and much of what was published in his magazine *Aperture*; and in the second, Robert *Frank as manifest in his revolutionary book *The Americans* (1959). This is to oversimplify Szarkowski's elaborate analysis and, in fact, he steps back a little from his own initial dichotomization by suggesting a continuum, 'a single axis with two poles', between which many of the photographers and images in the show could be seen to shift. TT

Szarkowski, J., *Mirrors and Windows: American Photography since 1960* (1978).

Misonne, Léonard (1870–1943), Belgian *pictorialist photographer. Born in provincial southern Belgium into a prosperous family, Misonne studied mining engineering, but never practised it, preferring to devote himself entirely to photography from 1896 onwards. A prominent presence in the first wave of pictorialism, Misonne travelled widely and learned the *bromoil process from Émile Constant *Puyo in Paris in 1910. As a figurehead of the pictorialist movement in Belgium, he acquired a lasting reputation for landscapes, bucolic and timeless, a genre he would exploit throughout his life. Misonne's work tended to express a conservative aesthetic, although the later townscapes outgrew the underlying anecdotal sentimentality present in some of his earlier views. The images are characterized by a masterly treatment of light and atmospheric conditions, as summed up in Misonne's credo 'Le sujet n'est rien, la lumière est tout' ('The subject is nothing, light is everything'). While the subject matter remained more or less constant over half a century of activity, Misonne's chosen medium evolved towards more manipulated processes—from *carbon printing, including the Fresson process, until 1910–15, by way of bromoil until 1930–5, up to a final phase using mediobrome. SFJ

Debanterlé, R., Mélon, M.-E., and Polain, D., *Autour de Léonard Misonne* (1990).

Misrach, Richard (b. 1949), American photographer, best known for his 'nuclear landscapes' shot in the Nevada desert, and for technical experimentation in photographing plants, water, and the nocturnal environment of the *American West. Typically, pictures are large and colours slightly muted, underlining the scale and desolation of the landscape within which a presence, for instance, dead animals, or an event, such as smoke, has summoned attention. Impact emerges from tension between pictorial beauty and the destruction often implied by what is pictured. His work method is solitary; days at a time spent in a van reading, waiting for something to happen, sometimes accompanied by his wife Miriam, author of several essays on his work. He stresses pure photographic communication, and in 1979 published *A Photographic Book* which is entirely wordless. Now, captions are limited to statements of place and date. The influence of American formalism, associated with landscape photography of the West, is marked. The operatic title for his 1999 retrospective exhibition, *Desert Cantos*, emphasizes the poetics of the imagery. His recent work includes recordings of the movement of light on the Golden Gate Bridge, San Francisco, where he lives. LW

Misrach, R., *Desert Cantos 1979–1999* (1999).

missionaries and photography. Missions have used photographs in at least two ways: as a means of converting and teaching; and to raise funds and report their activities in a wider world. Mission archives, for instance those of the London Missionary Society, or the Basel Mission, are rich sources for understanding their organizations' agendas both in the field and at home.

Missionaries' exploitation of photographs continued a long tradition of using images as a means of articulating and propagating 'truths'. Many were learning photography by the 1850s, and by the late 19th century the flow of photographs generated by mission work was enormous; British missions alone had some 10,000 missionaries worldwide, almost all using the medium in some aspect of their work.

The case of William Ellis (1794–1872) of the London Missionary Society exemplifies some of the complexities involved. Ellis, a veteran of the South Seas, learned *wet-plate photography in London (possibly from Roger *Fenton) before travelling to Madagascar in 1853. His aim was both to make ethnographic and botanical pictures and to use photography (and an electric telegraph) as a kind of conjuring trick to impress the population. Significantly, Ellis's rival, the French Jesuit Marc Finaz, planned to outbid him by demonstrating the piano, hot-air balloons, and a *daguerreotype outfit that reached him in November 1855; 'I must work [with it] to gratify those people who will be useful to me,' he noted in his diary. But Ellis had already sent some *albumen prints to his contacts in the capital, Antananarivo,

Anon.

Monk from the German Trappist
Mission photographing local people,
Marianhill, Natal, South Africa, 1894.
Albumen print

MARIANNHILL, 1894.

explaining: 'Each of them was taken with the sun and light in one minute. I can teach anyone in Madagascar to take a likewise [*sic*] with the sun in a minute if you would like anyone to learn.' Both men, clearly, were using the camera to win influence in Madagascar's volatile political environment; and, like other missionaries, Ellis also used photographs to publicize his activities at home, in the process ensuring that the engraved versions used for publication were suitably adapted to his purposes.

The magic lantern was seen as a crucial piece of promotional and, indeed, social equipment; one missionary in Basutoland used lantern-slide shows as a rival attraction to 'pagan dances' in the next village. Lantern slides, perhaps the pre-eminent medium of 19th-century moral instruction, were used to inculcate the values of the mother country through informational shows, or to teach Bible stories and moral tales of sobriety, hard work, and self-improvement; the texts of hymns and psalms were also projected. Missions appealed for images, both photographic and non-photographic, that might be suitable for their activities, and sometimes exchanged them. At home, many societies created sets of slides that could be borrowed for educational use. Peripatetic preachers in Europe and North America would describe the work of their missions through lantern lectures in village halls and schools. In isolated communities these shows became an important means of forming views of the world. Some missions used carefully arranged or posed photographs to demonstrate the 'before' and 'after' of their efforts. In the 1890s, for example, the Marianhill Mission in Natal showed a pair of photographs: *Heathen Kraal*, showing dirt, nakedness, and disorder, and the positively

contrasting *Christian Kraal*. Photographs, often juxtaposed with indigenous ('savage') artefacts, were also used extensively in exhibitions of missionary work.

By the end of the 19th century, with the development of cheap *half-tone *photomechanical printing, mission publications were often extensively and directly illustrated with photographs, and many missionaries learned photography specifically with the aim of creating this kind of documentation.

Missions also produced photographs for wider purposes. For instance, Marianhill Mission's photographs were both religiously and ethnographically motivated, and were collected by museums of anthropology in the late 19th century; as were those of the London Missionary Society's Revd W. G. Lawes in New Guinea, who sold them through King's Studio in Sydney. Conversely, ostensibly scientific work, like the Austrian missionary Martin Gusinde's photographs of the remains of 'old religion' in Tierra del Fuego, sometimes reflected missionary interests. EE

See also CHINA.

Holland, L., *Indians, Missionaries and the Promised Land* (1980).
Landau, P., 'The Illumination of Christ in the Kalahari', *Representations*, 45 (1994).
Jenkins, P., 'The Earliest Generation of Missionary Photographers in West Africa', *Visual Anthropology*, 7 (1994).
Peers, S., *William Ellis. The Working of Miracles: Photography in Madagascar 1853–1865* (1995).
Bottomore, S., 'Projecting for the Lord: The Work of Wilson Carlile', *Film History*, 14 (2002).

Mission Héliographique. The first state-sponsored photographic survey of architectural monuments. In 1837 the French government founded the Commission des Monuments Historiques to inventorize France's ancient and medieval structures for the purpose of preservation and restoration. It was headed by Prosper Mérimée, who visited a different region each year between 1834 and 1853 to catalogue the monuments by historical importance and need for repair. In 1839 Isidore-Séverin-Justin Taylor suggested using *daguerreotypes to document the commission's work and aid in the restoration, but Mérimée considered the daguerrean image too cold and ugly. A decade later, however, when the *calotype came to prominence in France, Mérimée made photography an integral part of the commission. The paper process in its improved form was both precise and atmospheric, which perfectly suited the project's scientific and romantic purposes. Mérimée commissioned five photographers—Édouard-Denis *Baldus, Hippolyte *Bayard, Gustave *Le Gray, Henri *Le Secq, and O. Mestral, all of whom except Bayard (who worked with albumen on glass) used the calotype process. Each photographer was given a detailed list of monuments by region, and in the summer and autumn of 1851 they together produced more than 300 paper negatives, which were deposited the following year in the archives of the Palais Royal (Bayard's glass negatives have been lost). Their artistic approach was undoubtedly influenced by Taylor's monumental publication *Voyages pittoresques et romantiques dans l'ancienne France* (20 vols., 1820–78) and *Blanquart-Évrard's 1851 *Traité*, which included a section on how to capture a structure's beauty using the paper process. Having completed their work, the mission photographers hoped to see the photographs published and their art recognized, yet no such publication was ever produced by the commission. Mérimée's goal was to repair the decaying monuments, and the photographs were not treated as works of art but as functional aids. All five photographers, however, received later commissions on the basis of their mission work. MR

Mondenard, A. de, *La Mission Héliographique: cinq photographes parcourent le France en 1851* (2002).

Mission Photographique Trans-manche. See CROSS-CHANNEL PHOTOGRAPHIC PROJECT.

mixed-media images. Photographic prints have rarely been used on their own: in books and limited editions, early photographers juxtaposed images with text; Victorian women combined them with watercolour in their *albums; photographs were used to decorate a variety of objects from fire screens to buttons; and some commercial albums even included music boxes activated by turning the pages. The reproducibility and versatility of photographic prints has ensured that, in different cultures, photographs have been mixed with an infinite variety of other media and materials, including embroidery—as in the 'AIDS Memorial Quilt' (Names Project Foundation, 1996)—and sculpture—as in Mexican 20th-century *fotoesculturas*. Many 20th-century works of art have responded to the ubiquity and mutability of photographs, from Dada *photomontage to the mixed-media paintings of *Pop art. In contemporary culture, *digital technologies and the *Internet are creating new possibilities for blurring distinctions and mixing media. Websites and digital art routinely mix still and moving images, animation, graphics, and sounds. Computers have made it possible to print photographs on any number of objects— mugs, T-shirts, and computer mats—leading to a resurgence of the passion for objects decorated with photographs. Mixed-media works often have a highly tactile quality, mixing the photograph as a trace of the Other with the trace of the hand of the maker. Geoff Batchen argues that objects combining photographs with hand-made arrangements reciprocate photography's gift as an image which has been touched by the world. PDB

Batchen, G., 'Vernacular Photographies', in *Each Wild Idea* (2001).

Model, Lisette (Elise Stern; 1901–83), American photographer, of Italian-Austrian-French background, born in Vienna. She studied music under Arnold Schoenberg and following her father's death went to study voice in Paris. On the advice of her sister, and with instruction from Rogi André, André *Kertész's first wife, Model took up photography as a job to fall back on. Some of her first photographs were of wealthy men and women lounging in deck chairs in Nice, which she cropped closely to create a sense of confrontation; especially memorable was a menacing-looking gambler basking in the late-afternoon sun (*Promenade des Anglais*, 1934). In 1937 she married the painter Evsa Model, and the following year emigrated to New York. There she found commercial work with *Harper's Bazaar* and other journals, while also creating images for exhibition, such as her *Running Legs* series. Model taught at the New School for Social Research from 1951 until her death in 1983; Diane *Arbus was among her pupils. MR

Thomas, A., *Lisette Model* (1990).

modernism and photography. The invention of photography was part of the process of modernization of the means of production that took place during the Industrial Revolution. In the 19th century, more and more goods once made by hand, including images, became machine made. Photography is a modern form of image making, contributing to the development of modernism, for example in painting, by taking on its representational tasks.

By the beginning of the 20th century, with the diffusion of illustrated magazines and newspapers, photography was a mass-communication medium. *Photojournalism acquired authority and glamour, and document-like photographs were used in *advertising as symbols of modernity. Artists and photographers began looking at the photographs used in mass culture, to develop an aesthetic true to the intrinsic qualities of photographic materials: the accurate rendition of visible reality; framing that crops into a larger spatial and temporal context; viewpoints and perspectives generated by modern lenses and typically modern spatial organizations (for example, tall buildings); and sharp, black-and-white images. This objective, mechanized vision became art by foregrounding not its subject matter, but its formal structure as an image.

In the USA, Alfred *Stieglitz rejected the hand-crafted look of *pictorialism, in favour of a more *'straight' photography (*The Steerage*, 1907). In *Camera Work*, he championed photographers who used the *realism of the medium to create beauty from everyday life, and to make statements about the nature of photography, rather than about the world; (Paul *Strand, *Blind Woman*, 1916). Their work often abstracted reality by eliminating social or spatial context; by using viewpoints that flattened pictorial space, acknowledging the flatness of the picture plane; and by emphasizing shape and tonal rendition in highlights and shadows as much as in the actual subject matter (Edward *Weston, *Nude*, 1936).

In Europe, avant-garde artists sought to break down traditional definitions of art, and the barriers between art and design, often with the utopian aim to merge art with everyday life. They also questioned the notion of artistic identity based on the myth of the artist as a special kind of being emoting over a canvas in the isolation of a studio. Instead, they embraced technologically advanced means of production, developed *mixed-media practices, and often engaged with social and political issues. At the *Bauhaus, László *Moholy-Nagy explored the *abstract possibilities of photographic and cinematic images. In Soviet Russia, Alexander *Rodchenko's work (*Chauffeur*, 1933) advocated a new aesthetic vision that would change individual and mass consciousness. He emphasized the constructedness of images, rejecting the illusion that photographic representations could be an unproblematic mirror of reality. The use of reflective surfaces is a common modernist device to reveal how every viewpoint, artistic or ideological, is constructed rather than natural. In Italy, the *Futurists exploited blurred movement to celebrate the speed and dynamism of modern life. In Berlin and throughout Europe, Dadaist *photomontage was used to challenge the authority of mass-cultural representations.

The development of modernist photography has often involved the recategorization of documentary or otherwise functional photographs in an art context. An example is the posthumous redefinition of Eugène *Atget as a modernist photographer, first by *Surrealist magazines, then by Berenice *Abbott's exhibitions and articles. A similar process can be seen in the use of social documentary photographs in the *Family of Man exhibition.

In the post-1945 period, American modernism became dominant in the West, emphasizing specialization and purity, and downplaying the political engagement of earlier avant-garde groups: to be modern, each discipline had to refine the definition of its own competencies. Photography became art by transcending its reality-bearing function through the subjectivity that photographers, as authors of their images, managed to instil in their pictures. The writings of the art critic Clement Greenberg and the photographic historian Beaumont *Newhall, and the exhibitions mounted by MoMA, New York, emphasized formal and aesthetic qualities that defined 'masters' and 'canonical' images that transcended their historical and social context. A tradition of essential photographic values was identified for successive photographers to explore and push to further limits. This 'authorial' approach is often contrasted with the *theories of photographic meaning developed since the late 1970s. It does not follow from this, however, that modernism did not theorize about photography; rather that it did so implicitly, using a critical language of universal values which erased the traces of its own ideological construction. **PDB**

Nesbit, M., 'Photography, Art and Modernity', in J. C. Lemagny and A. Rouillé (eds.), *A History of Photography* (1987).

Varnedoe, K., *A Fine Disregard: What Makes Modern Art Modern* (1989).

Harrison C., and Wood, P. (eds.), *Art in Theory 1900–1990* (1992).

Edwards, S., 'Photography and Modernity in Nineteenth-Century France', in P. Wood (ed.), *The Challenge of the Avant-Garde* (1999).

Childs, P., *Modernism* (2000).

Modotti, Tina (1896–1942), Italian-born photographer with so profound an appeal that many have claimed her for their own. To some she was a classicist, for the manner of her still lifes; to others a modernist in the mould of her mentor Edward *Weston, for the perfection of her focus and contrast; to others a documentarist, particularly for her series on the women of Tehuantepec, so inspirational to her companion Frida Kahlo; and to yet others a Futurist, born into an Italian tradition to which she added all the surreal influences that her years living in Mexico (and association with the *Estridentista* vanguard) could bring. Undoubtedly, however, she came to regard herself primarily as a revolutionary. Regardless of her years as a young immigrant actress in early Hollywood, she dedicated her life not to stardom but often to ignominy. Nearly all her 230 photographic images were created in just seven years in Mexico between 1923 and 1930, when she was expelled and went to Moscow. Her hallmark is astonishingly forceful and carefully composed images on political themes: an extolling of the dignity of labour through close-ups of a man's hands clasping a shovel, or an assemblage of workmen's tools; direct propaganda with overhead shots of massed demonstrations, or a worker reading the communist paper *El machete*; a project on the puppeteer Lou Bunin that developed their joint concept of political metaphor. Modotti died of heart failure alone in a taxi in Mexico City. **AH**

Modotti T., and Weston, E., *Idols behind Altars* (1929).

Constantine, M., *Tina Modotti: A Fragile Life* (1975).

Lowe, S. M., *Tina Modotti and Edward Weston: The Mexico Years* (2004).

Moffat, Curtis (1887–1949), American painter-photographer who trained in New York and Paris. Moffat collaborated with *Man Ray on Rayograph abstractions. He opened a studio in London in 1925, where he became an important figure in interior design. Moffat experimented extensively with three-colour processes; two colour still lifes were included in MoMA's 1937 landmark *History of Photography exhibition. An avid collector of non-Western art, he incorporated these objects in innovative ways into his photographs. Among Moffat's most noted images are portraits of Iris Tree (his first wife), Nancy Cunard, and Lady Diana Cooper. **WAG**

Beaton, C., and Buckland, G., *The Magic Image* (1975).

Curtis Moffat

Masks, c.1920s

Moffatt, Tracey (b. 1960), Australian photographer and film-maker. Her work reflects her views on aboriginality and the misconceptions about and representations of her people in art and cinema. Her earliest photographic work was a series of black-and-white portraits of members of the Aboriginal and Islander Dance Company, *Some Lads* (1986), a subtly subversive take on the 19th-century ethnographic photograph. Using a *documentary style, Moffatt often draws on images from film and television made during her youth in the 1960s and 1970s as an adopted half-Aboriginal child in a white family. She carefully stages images to reflect familiar tableaux, but with a twist. For example, the series *Scarred for Life* (1994) seems to comprise familiar snapshots of childhood, but with disturbing captions. Thus the image of a girl washing a car has the text 'Her father's nickname for her was useless'. Later works such as *Artist*, a series of collages of Hollywood images, explored the impact of television on popular culture and everyday life. LAL

 Hentschel M., and Matt, G. (eds.), *Tracey Moffatt* (1998).

Moholy, Lucia (née Schulz; 1894–1989), Czech-British photographer, writer, and teacher. After studying in Prague she moved to Germany, worked in publishing, and in 1921, in Berlin, married László *Moholy-Nagy. It was to be—in her words—a 'symbiotic' relationship which lasted longer than the marriage. She collaborated in his early experiments with *photograms and photocollages, and gave valuable editorial help with his writings. After he joined the *Bauhaus in 1923 she became the school's first documentary photographer. Her understated, near-abstract photographs of design products, and of the Bauhaus's new buildings in Dessau (1926), were published worldwide, though largely uncredited. But she became a noted portraitist, often using disconcerting close-ups. Divorced from Moholy-Nagy in 1929, she taught photography at Johannes *Itten's private art school. In 1934 she emigrated to London, where she worked as a lecturer and portraitist and published *A Hundred Years of Photography* (1939). In 1942 she founded a microfilm reproduction service for libraries and governments, and from 1946 worked on important UNESCO archiving projects. In 1959 she moved to Switzerland to pursue a third career as an art critic. RS

 Sachsse, R., *Lucia Moholy* (1985).

Moholy-Nagy, László (1895–1946), Hungarian-born theorist and multimedia artist. He arrived in Berlin in 1919 with no formal training, but immediately became active in the arts. After his marriage with Lucia Schulz (*Moholy) he engaged both in art theory and in avant-garde painting and *photogram production. At the Weimar *Bauhaus 1923–8 he developed a curriculum in industrial design comprising material studies as well as early media elements, e.g. photography and film. He also wrote two influential books, *Malerei Fotografie Film* (1924) and *Von Material zu Architektur* (1929; trans. as *The New Vision*, 1930), and planned a third (*Vision in Motion*) which appeared posthumously in 1947. In 1928 he moved to Berlin, where he worked as an exhibition and stage designer and film-maker.

He continued to collaborate with Lucia even after their divorce. With his second wife and his daughter, he emigrated in 1934 to Amsterdam, then London—where he produced several photographic books and designed sets for the film *Things to Come* (1936)—and in 1937 to Chicago, where he founded, and tirelessly promoted, the 'New Bauhaus' (soon reorganized as the Chicago School of Design). There he worked in colour photography and acrylic sculpture, and planned numerous projects in various media that his early death left unrealized. Although Moholy's reputation attracted many talented students to Chicago, it was not until the advent of Conceptual art that the importance of his work was fully recognized. **RS**

In Focus: László Moholy-Nagy at the J. Paul Getty Museum, Los Angeles (1995).

moiré patterns are generated whenever two gratings of equal or nearly equal pitch are superposed. The size of the pattern is inversely proportional to the angular displacement and the pitch difference. Moiré patterns often appear in familiar surroundings, as when approaching a motorway bridge with railings, or when viewing brickwork through a net curtain. They have their uses, as in holographic *interferometry, but can be a nuisance when they occur in printing, as when a *half-tone illustration is copied onto another half-tone system, or in a colour half-tone when the screens are set at too small an angle to one another. In such cases the image appears overlaid by a pattern of large squares or hexagons. **GS**

Wade, N., *The Art and Science of Visual Illusions* (1982).

Monroe, Marilyn (Norma Jean Mortenson; 1926–62), American actress and glamour legend. After a troubled childhood and early first marriage, she worked as a model and Hollywood bit player before starring in a thriller, *Don't Bother to Knock*, in 1952. The discovery of nude calendar photographs of her (taken by Tom Kelley (b. 1914)) attracted huge publicity and boosted her appeal; some of them appeared in the first number of *Playboy* in November 1953. Her best films included *Gentlemen Prefer Blondes* (1953) and Billy Wilder's Prohibition-era farce *Some Like It Hot* (1959); her last was *The Misfits* (1961), written by her third husband, Arthur Miller. In retrospect, her often dysfunctional, convention-negating roles seem as subversive as those of her fellow 1950s stars James Dean and Marlon Brando.

But Monroe's supreme asset was her voluptuousness and aura of guilt-free sexuality, as bewitching in still photographs as on the big screen; Norman Mailer described her as 'a Stradivarius of sex'. Early cover appearances included *Yank* magazine (26 June 1945) and *Life* (7 Apr. 1952, by Philippe *Halsmann). A New York publicity shot for *The Seven Year Itch* (1954), catching her skirt billowing over a subway ventilator, became a 1950s icon. Though notoriously difficult with film directors, she enjoyed being photographed, whether by GIs in Korea or by top professionals. Richard *Avedon said, 'She was more comfortable in front of the camera than away from it.' Eve *Arnold, who photographed her making *The Misfits*, recalled, 'She knew she was superb at creating still photographs, and she loved doing it.' Others who photographed her included André de Dienes (1913–85), Milton

H. Greene (1922–85), who took over 4,000 pictures of her, *Beaton, *Cartier-Bresson, and *Eisenstaedt. The last was Bert *Stern in July 1962, shortly before her death. Monroe photographs were also appropriated by artists from *Warhol in the 1960s to the Chinese Dai Guangyu in the 1990s. With Dean, Elvis Presley, John Lennon, and Diana, princess of Wales, she was a global icon of the later 20th century, and perhaps the most photogenic. **RL**

Stern, B., *The Last Sitting* (1982).

Dienes, A. de, *Marilyn Mon Amour* (1986).

Dyer, R., *Heavenly Bodies: Film Stars and Society* (1986).

Moodie, Geraldine (1854–1945), Canadian photographer who documented the life of pioneers in the Canadian West. Her husband's position in the Royal Canadian Mounted Police enabled her to photograph many of Canada's changing landscapes. In 1885 John Moodie received a commission with the North West Mounted Police, and for the next 32 years Geraldine accompanied him to posts across western Canada and into the Arctic in connection with Canadian territorial claims. By 1895 she was sufficiently well known to be commissioned by the government to photograph historical sites. **LAL**

Moon, Sarah (b. 1940), British-born *fashion photographer and film-maker, resident in Paris. After studying art she worked as a model, then, from 1967, a photographer. Her carefully staged images are mysterious, nostalgic, and surreal, sepia toned or in colours muted and diffused by *grain. Some evoke fairy tales: for example, a one-eyed, dandyish old tom-cat-in-clothes being cosseted by two demure young women. Her 1972 Pirelli Calendar pictures suggested an ultra-exclusive 1930s brothel. She has made films about *Cartier-Bresson (1994), and early cinematography (*Lumière & Company*; 1995). **RL**

Sarah Moon, Coincidences (2001).

moon photography. The first successful lunar *daguerreotype was secured in 1840 by John W. Draper (1811–82), professor of chemistry at the University of the City of New York. With a twenty-minute exposure Draper recorded an image 2.54 cm (1 in) in diameter that clearly revealed light and dark patches. In the years around 1850, William C. Bond (1789–1859) and George P. Bond (1825–65) at Harvard, in collaboration with two professional photographers, John Whipple and J. W. Black, obtained better daguerreotypes of the moon with exposures of only a minute. Some of these images were displayed at the *Great Exhibition of 1851 in London, where they were seen by the British businessman Warren de la Rue (1815–89), who was encouraged to experiment with lunar photography himself. Using the new *wet-plate process, he successfully photographed the moon with 10–30 s exposures. Another pioneer was the American Lewis M. Rutherfurd (1816–92), who had given up a legal career to devote himself to photography and other scientific pursuits, and who obtained exposures (which when photographing the full moon were only 1/4 s in duration) that could be enlarged to display considerable detail.

The 1890s were notable for the 100,000 plates obtained by Maurice Loewy (1833–1907) and Pierre Puiseux (1855–1928) of the Paris Observatory for their atlas of the moon. Although other photographic atlases were published, by this time lunar studies were not at the forefront of astronomy and in the first half of the 20th century drew relatively little attention.

The advent of the space age, however, transformed this situation, and the moon became a key objective for both the American and Soviet space programmes. Photography of its surface from the earth, as well as from spacecraft that flew by, orbited, and even landed on it, produced a wealth of new information. On 7 October 1959 the Soviet *Luna 3* spacecraft photographed the far side of the moon with a dual-lens 35 mm camera. The images were automatically processed, scanned, and transmitted to earth by radio. In 1966 *Luna 9* soft-landed on the moon, carrying a camera as well as instruments to analyse the lunar soil, and confirmed that the surface consists of fragmented material rather than dust.

In the 1960s American programme several *Ranger* and *Surveyor* spacecraft journeyed to the moon. *Surveyor 1* soft-landed just months after *Luna 9* and captured more than 10,000 high-resolution images. In 1966 and 1967 NASA also launched five *Lunar Orbiters*, which took images over practically the entire lunar surface, and provided information vital for the selection of landing sites for human missions. The imaging system exploited two lenses that photographed the lunar surface simultaneously, one at high and one at medium resolution. The long- and short-focus lens provided resolutions of 1 m (3 ft) and 8 m (26 ft) respectively, and the photographic system was designed so that (as with *Luna 3*) it could develop and scan the exposed photographic film. The data were then transmitted to earth as a video signal. On 20 July 1969, when Neil Armstrong and Edwin 'Buzz' Aldrin became the first men to walk on the moon as part of the *Apollo 11* mission, Armstrong used a specially modified medium-format Hasselblad to make a historic image of Aldrin. The five later Apollo flights that took men to the surface of the moon also carried a range of still and television cameras.

In 1994 the *Clementine* spacecraft, a joint project of the US Department of Defense and NASA, spent 70 days in lunar orbit, mapped the entire lunar surface, and returned some 1.8 million images. RWS

See also ASTRONOMICAL AND SPACE PHOTOGRAPHY.

Darius, J., *Beyond Vision: One Hundred Historic Scientific Photographs* (1984).
Light, M., *Full Moon* (1999).

Moore, Raymond (1920–81), the second British photographer—after Bill *Brandt—accorded a solo show at London's Hayward Gallery (1981). While Brandt's photography seemed the equivalent of a concert grand, Moore's resembled a clavichord. Once the viewer is attuned to them, Moore's unobtrusive, exacting, graphic skills become addictive. His subject was Britain's grey light, its deserted parks, out of season resorts, dilapidated coastlines, and lonely B roads—and the way they can unexpectedly light up with epiphany or darken with melancholy. His work continues to attract new admirers. MH-B

Moore, R., *Murmurs at Every Turn* (1981).

Morath, Inge (1923–2002), Austro-American photojournalist who studied languages in Berlin and between 1945 and 1948 worked as a journalist in Vienna. In 1948 she accompanied Ernst *Haas to Paris, where she became an editorial assistant with *Magnum. In London she learned photography with Simon Guttmann. After returning to Paris, and Magnum, in 1953, she became a staff member in 1955. Over the next four years she created some of her most famous series of images, such as the dressing of a Spanish torero. In 1961 Morath moved to the USA, where she concentrated on photographing film sets, and everyday life in New York. In 1962 she married the playwright Arthur Miller, subsequently accompanying him on his literary travels through Eastern Europe and Asia. Her interest now shifted to portraiture of authors, actors, and artists, mostly in their homes. From the early 1980s she divided her life between America and Europe; her later work concentrated on living conditions in her own region of origin, south-eastern Europe. RS

Inge Morath: Life as a Photographer (2000).

Morell, Abelardo (b. 1948), Cuban-born American photographer. Brought to the USA by his family, Morell was educated at Bowdoin College and Yale. He has taken perception and camera obscura photography to a new level, projecting, for example, cityscapes onto interior walls of children's bedrooms and printing the results. Influenced in part by magic realism in Latin American literature, Morell's work has visually explored the world of child perception, the lives of paintings on museum walls, and the physicality of books, including *Alice's Adventures in Wonderland*. He teaches at the Massachusetts College of Art. TT

Morell, A., *A Book of Books* (2002).

Morgan, Barbara (née Johnson; 1900–92), American photographer who was born in Kansas, raised in southern California, and studied art at the University of California at Los Angeles (UCLA). After marriage to the photographer and writer Willard Morgan and a period teaching design and printmaking at UCLA, she became convinced that, given the necessary creativity, photographs could have the same aesthetic quality as graphic art. The Morgans moved to New York in 1930 and, after the birth of her sons, she concentrated exclusively on photography, joining the Photo League. Convinced that her work could convey the spirit of dance movement, in 1941 she produced a seminal book entitled *Martha Graham: Sixteen Dances in Photographs* in which straight photographs, double images, and light graphics were reproduced. From then on she worked with all manner of photographic manipulations as well as straight photographs to extend the expressive dimensions of the medium. She was an enthusiastic lecturer and had more than 35 solo exhibitions during her lifetime. NR

Curtis, C. L., and Agee, W. C., *Barbara Morgan: Prints, Drawings, Watercolors & Photographs* (1988).

Morimura, Yasumasa (b. 1951), Japanese contemporary artist, born and resident in Osaka. Morimura's appropriation of well-known

Western masterpieces began with self-portraits as Van Gogh. He continued this series, *Daughter of Art History* (pub. 2003), by replacing the faces of the *Mona Lisa*, Jesus, Manet's *Olympia* and, most recently, Frida Kahlo with his own features. A master of costume, painting, cosmetics, and computer manipulation, he pays homage to and refashions icons of the Western canon. Not limiting himself to painted masterpieces, he has recreated well-known photographs by Cindy *Sherman and Andy *Warhol and, in his *Actress* (1997–8) series, publicity portraits of Marilyn Monroe and Brigitte Bardot amongst others, mimicking their gestures down to the curled toes. He works not only with photography but with moving images and installations. MHV

Yasumasa Morimura, texts by R. Velazquez and P. Gonzalo (2000).

Moriyama, Daido (b. 1938), Japanese street photographer. Born in Osaka, Moriyama was early attracted to graphic design. In 1959 he began studying photography and was deeply affected by William *Klein's *New York* and Shomei *Tomatsu's *Occupation*. In 1961 he went to Tokyo to meet the members of *VIVO. Though the group was disbanding, Eikoh *Hosoe hired him as assistant, giving him access to Tomatsu and the Tokyo photo world. Moriyama's own work took off in 1964 when he met Takuma Nakahira, editor of *Gendai no Me* (*The Modern Eye*), who then published his work. *Asahi Graph*, *Asahi Journal*, and *Asahi Camera* followed. In 1968 he participated in the epoch-making photographic coterie magazine *Provoke* with Takuma Nakahira, Koji Taki, and others, to 1970. *Japan: A Photo Theatre* (1968) was the fruit of his friendship with the poet-dramatist Shuji Terayama. His personal style developed in grainy snapshot essays with undertones of stealth and voyeurism, and out-of-focus images photographed and rephotographed to magnify contrast and distort the subject. Considered to be among the most talented and influential photographers of his generation, Moriyama has nonetheless been pursued by personal demons, and the 1970s were a time of personal and creative crisis. In the 1980s he regained focus, and was awarded the 1983 Photographer of the Year Award by the Photography Society (Shashin Kyokai). He has frequently exhibited and published in Japan and abroad, from the New York Museum of Modern Art's *New Japanese Photography* show in 1974 to the 1999 retrospective mounted by the San Francisco Museum of Modern Art. MSH

Phillips, S. S., Munroe, A., and Moriyama, D. (eds.), *Daido Moriyama, Stray Dog* (1999).

Morse, Samuel F. B. (1791–1872), American artist and inventor who provided the first American eyewitness account of *Daguerre's new photographic technology. In Paris to promote his telegraph, Morse met Daguerre on 7 March 1839, and two days later wrote to his brothers, editors of the *New York Observer*, that the *daguerreotype 'is one of the most beautiful discoveries of the age . . . the exquisite minuteness of the delineation cannot be conceived'. After returning to New York, Morse, the president of the National Academy of Design, began his own experiments and gave a keynote address on

daguerreotypes at the 1840 Academy annual dinner. Assuaging the fears of artists, he predicted a 'great revolution' that would be 'in the highest degree favourable to the character of Art', aiding perspective and shading and increasing appreciation for those artists whose work was true to nature. Morse was particularly interested in the technology because, *c.*1821–3, he had attempted similar experiments 'to fix the image of the Camera Obscura', but produced only negative images that he was unable to make permanent. Few of his early daguerreotype experiments are extant, and his significance remains primarily that of a cultural transmitter and interpreter of the technology. PJ

New York Commercial Advertiser (22 Apr. 1839).
Evening Post (New York) (27 Apr. 1840).
Batchen, G., ' "Some Experiments of Mine": The Early Photographic Experiments of Samuel Morse', *History of Photography*, 15 (1991).

Mortensen, William (1897–1975), American photographer. Controversial in his own time and even now, Mortensen was born in Utah, studied briefly in New York, then moved to Hollywood to work in set design, mask making, and then as a photographer and portraitist. His celebrated differences with the *Group f.64 clique, particularly Ansel *Adams, centred on Mortensen's unwillingness to accept that a photograph was sacrosanct, not to be tampered with. Mortensen, on the contrary, utilized elaborate methods, such as abrasion tone and Metalchrome, to create images, usually figurative, sometimes fantastic. TT

Dawson, M., et al., *William Mortensen: A Revival* (1998).

motion pictures. See CHRONOPHOTOGRAPHY; CINEMA AND PHOTOGRAPHY; HOLLYWOOD PUBLICITY PHOTOGRAPHS; MUTOSCOPE.

mountain photography. By 1833, when Henry *Talbot experienced the frustration of trying to draw the Alpine horizon from the shore of Lake Como, the cultural shift that transformed mountainous regions from dreary wildernesses to monuments of the sublime was well established. Large-scale tourism, facilitated by improvements in transport and business organization, would develop rapidly over the following decades. Both changes made it inevitable that views of and from mountains would eventually become a staple of photography. In the mid-1850s Friedrich von Martens (1806?–85?) made *panoramic photographs and another photographer, Claude-Marie Ferrier, *stereoscopic views of the Alps, and others followed. Already prominent as a promoter of mountain photography, however, was the Mulhouse manufacturer and amateur glaciologist Daniel Dollfus-Ausset, who in 1849 and 1850 had brought two French *daguerreotypists, Gustave Dardel and Camille Bernabé, to photograph from the shelter he had built near the Aar glacier. He also funded the *Bisson brothers. By 1856 Auguste Bisson was taking panoramic Alpine images, using the wet *collodion process and plates 1 m (*c.*3 ft) wide. In July 1860, with 25 guides and porters to carry the equipment, he attempted unsuccessfully to scale Mont Blanc,

Daido Moriyama

Yokosuka, 1970

Auguste Bisson

Passage des Échelles, Mont Blanc, 1862. Albumen print

but succeeded the following year and in 1862, on both occasions obtaining pictures from the summit. In 1868 he made a final ascent that yielded 60–80 stereographs, including four more from the top. By this time, another of Dollfus's associates, Adolphe *Braun, had taken spectacular climbing photographs in the Haute-Savoie. In the field of scientific mountain photography, meanwhile, Aimé Civiale (*fl.* 1850s–1880s) was undertaking extensive topographical surveys in the Pyrenees and the Swiss and Austrian Alps. And across the Atlantic, Carleton E. *Watkins and Eadweard *Muybridge in the late 1860s and 1870s were risking their lives to capture spectacular mountain views at *Yosemite.

Ranging more widely between the 1880s and 1909, and often using a telephoto lens to dramatize his studies of individual mountains, the Italian photographer Vittorio Sella (1859–1943) worked not only in the Alps but in Africa, Alaska, the Caucasus, and the Himalayas, where he created a four-part panorama of *Everest. In the early 1920s, significantly, 31 of Sella's photographs were presented to the American Sierra Club, where they were seen by the young Ansel *Adams. He later wrote that they moved the viewer to 'a definitely religious awe': the same effect that his own visionary images, both views of distant ranges and pictures taken during serious climbs in the Sierra Nevada

and elsewhere, would have on generations of nature enthusiasts. Enormously widely disseminated as book illustrations, calendars, and posters, Adams's mountain photographs are the most iconic examples of the entire genre.

Other influences on Adams were two Englishmen, Arthur Gardner, who wrote *The Art and Sport of Alpine Photography* (1927), and Frank Smythe (1900–49), who took part in three Everest expeditions and wrote 27 books during his career. Smythe was not only an accomplished photographer but shared the pantheism fundamental to Adams's vision.

While Adams famously used large- or medium-format equipment, the availability of 35 mm cameras, especially the *Leica, from the mid-1920s considerably reduced the burdens that climbers had to bear and, increasingly by the Second World War, major expeditions were equipped with them. By the late 20th century, lightweight SLRs were becoming increasingly popular. Technical advances notwithstanding, however, mountain photography remains exceptionally challenging. Perched on top of Mont Blanc on 24 July 1861, Auguste Bisson could barely stop shivering long enough to make his exposures, and his team had difficulty in melting enough snow to wash the plates after development. Just over a century later,

while climbing on Baffin Island, Chris Bonington (b. 1934) found the cold incredible:

The metal of the camera was so cold that if it touched my cheek as I held it to my eye I received a cold burn. As soon as I brought the eyepiece anywhere near the warmth of my body it misted and froze over, so that I could see nothing. Worst of all, though, the film was so brittle in the cold that it snapped at the least excuse. I tried to warm the camera inside my parka, but felt the heat drain out of my already chilled body, into this lump of metal, which had a temperature of around minus thirty. (*Boundless Horizons: The Autobiography of Chris Bonington*, 2000)

JW/RL

See also EXTREME CONDITIONS, PHOTOGRAPHY IN.

Brower, D., *Summit: Vittorio Sella, Mountaineer and Photographer. The Years 1879–1909* (1999).
Washburn, B., *Mountain Photography* (1999).
Smythe, F., *Frank Smythe Omnibus* (2001).
Hammond, A., *Ansel Adams: Divine Performance* (2002).

movement, photography of. The limitations of early photographic chemistry and optics meant that there could be no movement at all in front of the camera if a clear image were to be made. Anything that moved would either blur or streak the picture; if the exposure were too long, the moving subject would disappear altogether. Scientists had long observed that any rapidly moving object seems perfectly stationary when illuminated by the explosion of an electrically generated spark (just as a flash of lightning seems to make everything within its arc stop for an instant), and had used the camera to record this phenomenon by 1850. In 1851, for example, Henry *Talbot, experimenting with a printed sheet rotating on a wheel, captured an image in which the words on the paper 'were perfectly well defined and wholly unaffected by the motion of the disc'. But outside the laboratory, *daguerreotypes and *calotypes portrayed hauntingly empty city streets that in reality were filled with pedestrians and carriages: the long exposure time had obliterated them all. The *wet-plate process that superseded these processes was also relatively slow; but photographing from a distance, reducing the negative size—a practice used by Charles *Nègre for his 1850s Parisian genre scenes— or using lenses that concentrated the light reaching the plate, did permit the first successful attempts at capturing motion. What these earliest *snapshots revealed were awkward postures quite different from anything seen by the naked eye, dictated by common sense, or represented by artists. Nonetheless, the depiction of movement in a photograph effectively fixed moments that the unaided eye could not perceive: it came to be understood as a way of suspending time, or making time eternal. One might perhaps say that, in its capacity to freeze movement, photography pictures our experience of time as an eternal 'now' which is always 'then'.

In the early 1880s the standardization and mass manufacture of gelatin *dry plates initiated a revolution in photography. The plates were extraordinarily fast (1/1,000 s was not beyond imagining) but, more important, their mass production freed the photographer from the complex and messy chemical manipulations involved in *collodion plate preparation, and photography from the confines of the studio. Soon cheap hand-held cameras designed for the dry plate appeared, and photography became a leisure enterprise available to anyone who could afford a camera and a packet of plates.

Scientific experimentation in the photography of movement created an enormous vogue for 'instantaneous photography', while at the same time its association with science raised the status of motion photography in general. Leland Stanford's commission to Eadweard *Muybridge was the first of these experiments, and though Muybridge used wet collodion, not dry plates, he published his images in 1878 just as dry plates started to become widely available. The excitement created by Muybridge's widely publicized pictures of running horses, and the extensive dissemination of *Marey's *chronophotography after 1882, meant that leaps, somersaults, and jumps frozen in mid-trajectory became a palette of effects that enlivened the photographs of both the scientifically inclined amateur and the Kodak-toting Sunday snapshooter. Free from preconceived ideas about composition or aesthetics, the unrehearsed spontaneity of these pictures was identified with the rush and exhilaration of modernity. Jacques-Henri *Lartigue, who delighted in photographing all the new symbols of mechanical progress, danger, and speed, provides us with one of the most striking examples of this trend. His joy in capturing family and friends in mid-air, fashionable ladies strolling in the Bois de Boulogne, racing cars, and swooping aeroplanes lies as much in the photograph as in the achievement of making it at all. Lartigue used the camera to discover what occurs in an instant of time. With other amateurs, he helped establish a repertoire of accident and surprise that is the foundation of both the *New Vision and *photojournalism, where the camera's capacity to capture what happens in a moment still astonishes, enthralls, or horrifies us.

About ten years after Lartigue's most famous pictures were made (and with a world war in between), Henri *Cartier-Bresson photographed movement in the form of complex, tightly structured compositions. For Cartier-Bresson, photographing movement was a way of making visible a surrealistic notion of time: not just a container in which events took place, but an ecstatic dimension of reality. In his method of working, Cartier-Bresson's eye finds a moment of order in the chaos of random movement, and simultaneously his camera—the newly marketed Leica II, with its eye-level viewfinder—records what he saw, freezing the motion that could only be perceived peripherally. The moment that Cartier-Bresson's camera captures is, however, not just any moment, but the right, the *decisive moment, a visual configuration that satisfies the aesthetic demands of the photographer. It is not what actually happens in that moment, but what it looks like, that makes the moment decisive.

In the 1950s and 1960s the expatriate American William *Klein (who also favoured blurred photographs as described below), the Swiss Robert *Frank, and, in their wake, the Americans Lee *Friedlander and Garry *Winogrand, added the photographer's own movement to that of the moving subject and often made that mix the subject of their images. Seemingly fragments stolen in passing,

their off-kilter compositions reflect both the photographer's role of capturing life on the fly, and the impossibility of the camera ever stilling the ceaseless motion just beyond the frame.

Time-lapse photography contracts the movements at the other end of the temporal spectrum: events too slow to be perceptible to the eye. Ernst *Mach seems to have been the first to propose time-lapse photography in 1888, and his son Ludwig the first to adapt it to the growth of plants, taking pictures at fixed intervals from exactly the same position at the same time of day over a period of weeks to make visible the plant's unfurling interaction with its environment.

Overlong exposures and blurs, originally seen as mistakes or aberrant effects, have become creative tools to express the aesthetics of movement, and a way of compensating for the way that photography typically pictures time in instants rather than as a continuum. Time exposures register movement in real time, the time that the shutter is left open. Aimed at the night sky, the camera can track the rotation of the stars and planets as streaks across the sky or, more prosaically, it can register the cumulative patterns of light made by the headlights of moving cars as ribbons along the road. The Japanese photographer Hiroshi *Sugimoto has made photographs inside cinemas, timing his exposure to the precise length of the film being projected. The resulting image documents the movie's passage as a radiant white rectangle, literally vanishing from the screen.

Camille *Silvy was probably the earliest artist to use blur consciously in his 1850s landscapes to enliven what was otherwise embalmed stillness, and Julia Margaret *Cameron used blur to great effect in her portraits. The 1911 photodynamic experiments of the brothers Anton Giulio and Arturo *Bragaglia posited the blur as a metaphor for modernity because it could recreate in a photograph the effects of movement on the psyche. According to Anton Giulio, who wrote a manifesto proclaiming the superiority of photodynamism as art, the trajectory made by placing an open lens before a moving subject conveyed the emotional experience of the speed and dynamism of modern life. He belonged briefly to the Italian *Futurist movement and his ideas were woven into the Futurist photography manifesto of 1930. But by this time German and Soviet avant-garde photography had made the snapshot's instantaneity central to their aesthetic: the work of *Rodchenko and *Moholy-Nagy, for example, made the Bragaglias' efforts seem archaic. Since the 1960s photographers including Dieter Appelt (b. 1935), Duane *Michals, Michael Snow (b. 1929), and Ralph Eugene *Meatyard have returned to the blur to undermine our complacency in photography's rendering of time as frozen movement, or to subvert photographic conventions of finicky exactitude. In their images, figures are rendered illegible by their movement; their fluidity emphasizes the transitory nature of the present, and makes visible the way in which photography sustains the illusion of what we call 'now'. In testimony to the larger influence of the photography of movement on contemporary culture, the blurred photograph has become a prominent trope in the work of two Germans confronting the Nazi past, the writer W. G. Sebald and the painter Gerhard Richter (b. 1932). For them, the photographic blur has become a visual metaphor for the instability of memory and, more importantly, for the photograph's ultimate failure to represent what is ineffable and inexpressible. MB

See also EDGERTON, HAROLD.

Darius, J., *Beyond Vision* (1984).
Frizot, M., *Le Temps d'un mouvement: aventures et mésaventures de l'instant photographique* (1987).
Janis, E., Kozloff, M., and Weinberg, A., *Vanishing Presence* (1989).
Poivert, M., et al., *La Révolution de la photographie instantanée, 1880–1900* (1996).
Braun, M., 'The Expanded Present: Photographing Movement', in A. Thomas (ed.), *Beauty of Another Order: Photography in Science* (1997).
Gunthert, A., 'La Rétine du savant: la fonction heuristique de la photographie', *Études photographiques*, 7 (2000).
Ullrich, W., *Die Geschichte der Unschärfe* (2002).
Moore, K., *Jacques-Henri Lartigue: The Invention of an Artist* (2004).

MRI scan. See MEDICAL PHOTOGRAPHY.

Mucha, Alphonse (1860–1939), Czech painter and graphic artist who also practised photography for nearly 50 years, from the 1880s to the 1930s. But it was only c.1892, in Paris, that he began using it in an organized way, often to make studies for his paintings and illustrations. Much of his output consists of indoor photographs of models, either nude or, in photographic tableaux, in period costumes connected with an ongoing work. However, his photographic archive, still in private hands, reveals a much wider range of subjects. QB

Ovenden, G. (ed.), *Alphonse Mucha, Photographs* (1974).

Muenier, Alexis (1863–1942), French *plein-airiste* painter who used photography extensively in preparing his pictures; *The Conversation* (1887) and *The Best Days* (1889) are particularly well documented. He made thousands of negatives on and around his estate at Coulevon, Franche-Comté, and on journeys to southern France, Corsica, and Switzerland. Though many probably related to specific works, Muenier, like his contemporary Émile Zola, evidently had a more general passion for 'reporting' the details of the visible world. RL

Weisberg, G. P., *Beyond Impressionism: The Naturalist Impulse in European Art 1860–1905* (1992).

Mulas, Ugo (1928–73), Italian photographer who worked in Milan from the mid-1950s as a stage photographer for the theatre director Giorgio Streheler, and freelance in *fashion and *industrial photography. He made many artist portraits, both in Italy, where he was official photographer at the Venice Biennale 1954–68, and in the USA, where he made sensitive images of *Duchamp, Newman, Rauschenberg, *Warhol, and others. In the 1970s he undertook an important series, *Verifiche* (1970–3), exploring the nature of the photographic medium, its materials and processes, in a work that spanned modernist self-referentiality and the rigour of Conceptual art. PDB

Keller, U., 'Ugo Mulas: *Verifications*', *Afterimage*, 7 (1980).

multiple exposure. See COMPOSITE PHOTOGRAPHS.

Munch, Edvard (1863–1944), Norwegian artist whose sombre, psychologically raw paintings and prints were a key early influence on Expressionism. He studied painting in Christiania (Oslo), and spent formative periods in Berlin and Paris. He famously remarked that 'The camera can't compete with painting as long as you can't take it with you to heaven or to hell.' Yet photography, as with many painters of his generation, played an important part in his probing of the human psyche. Initially closer to Impressionism, he evolved an intense personal aesthetic energized by emotions of love, anger, jealousy, and despair. Several of Munch's best-known images have photographic precursors, such as *Weeping Girl* (1907) or *Sin* (1902). Yet his most original photographs were self-portraits, which he made throughout his life. Examples such as the claustrophobically oppressive *Marat in the Bath* (1908), or the late close-up self-portraits of the 1930s, suggest that the camera can, after all, plumb the inferno. J-EL

Eggum, A., *Munch and Photography*, trans. B. Holm (1989).

Münchener illustrierte Presse (1923–44), founded by the liberal Munich firm of Knorr & Hirth, and one of Central Europe's most successful and innovative illustrated weeklies. Its circulation reached 280,000 in 1927. Editor from 1930 until the Nazi takeover in 1933 was the Hungarian-born Stefan *Lorant. RL

Munkácsi, Martin (Martin Marmorstein; 1896–1963), Hungarian-American photographer. Munkácsi trained as a decorative painter in 1912 and worked as a sports reporter in Budapest between 1914 and 1926. Already well known, he spent the years 1927–34 in Berlin, mainly publishing in large papers like the *Berliner illustrirte Zeitung*. He also created dynamic 'lifestyle' images of sporty modern people, like the famous, superbly timed *Fun at Breakfast Time* (c.1933). Visiting New York in 1933, he was encouraged by Carmel Snow of *Harper's Bazaar* to try his hand at fashion photography, and adopted it as a second career after emigrating to America in 1934. After 1946 he switched again, to editorial design. For two periods of his life he was the most featured and highly paid photographer in his field: 1925–35 in sport (being a celebrated early football photographer) and 1935–47 in fashion, to which he brought a lively outdoor realism with echoes of the 1920s avant-garde. He died in 1963 at a soccer game. RS

Martin Munkácsi: An Aperture Monograph (1996).

Muray, Nicholas (1892–1965), Hungarian-born American photographer who studied at the Graphic Arts School in Budapest (1904–8), then learned colour photoengraving in Berlin (1909–11). He worked initially as a colour printer in New York from 1913, then as a photoengraver for Condé Nast Publications (1916–21). He opened a portrait studio in Greenwich Village c.1920 and won fame for his celebrity images published in *Harper's Bazaar* and *Vanity Fair*. After 1930, his *fashion and *advertising photographs in the colour *carbro process were much in demand. Through the celebrity caricaturist Miguel Covarrubias, his colleague at *Vanity Fair*, he encountered the vibrant circle of Mexican artists in New York, and acquired a collection of Mexican art. His papers are in the Archives of American Art, Smithsonian Institution. PJ

Muray's Celebrity Portraits of the Twenties and Thirties: 135 Photographs, introd. M. F. Margolis (1978).

museums and photography. Museums have used photography routinely since the 1850s, when its inventorial and reproductive potential became clear. By the late 19th century many museums had photographic studios, producing a wide range of images, both recording their own collections and gathering comparative material from other institutions. By the early 21st century, institutions such as the Holocaust Memorial Museum, Washington, DC, the Imperial War Museum, London, and Imperial War Museum North, Salford, were making imaginative use of large-scale installations of mounted or projected photographs as an integral part of their displays.

Photographs, made at many points in an object's 'museum life', e.g. on acquisition or when being loaned to another institution, are used to record, classify, and investigate objects. *Infrared (IR) and X-ray photographs are also used extensively in research and conservation to reveal both the inner structure of artefacts and how they have been made. Complex and sensitive computer-based techniques such as solid-state IR imaging and reflectography are used on paintings to reveal changes, underdrawing, or later restorations. In conservation, pictures are taken before, during, and after intervention to record procedures. There is a sense that a museum object becomes the sum of its photographs.

While often seen as neutral and objective, recording styles have shifted markedly over the last 100 years, reflecting changes in interpretative approaches to objects. To a degree, photographs endow museum objects with certain meanings. For instance, they might be photographed as 'scientific specimens' with even lighting and neutral background, or with different coloured backgrounds and lighting to enhance different features of the object. Some museum photographs have been recategorized over the years. For example, Roger *Fenton's 1850s photographs of classical statuary in the British Museum, taken largely for inventory purposes, are now seen as 'art photography', as are Walker *Evans's 1935 images of African art made for MoMA, New York.

Many museums have kept photographic records of their displays which have become important historical documents for understanding the changing presentation of objects. Museum exhibition catalogues have used photographs in an increasingly sophisticated way as a form of 'take-home' exhibition. With installation or performance art, catalogue photographs remain the only record.

Since the late 20th century photographs have contributed to the corporate identity of museums. Photographs of objects, including photographs themselves, appear on countless gift items, now major revenue earners for museums, from Julia Margaret *Cameron Christmas cards to *Muybridge T-shirts. Postcards are important expressions of the identity of an institution and its holdings. These are no longer only 'scientific' in style; many objects are represented only through their

details, like products in lifestyle magazines—a segment of embroidery, the background of a painting, or close-ups bled off the edges of a card accentuating, perhaps, the exoticism of an African mask.

Apart from the procedures already described, museums seldom make systematic use of photography to record their everyday practices, processes, and hierarchies. However, there is an increasing body of work by art photographers that explores the nature of museums, their work, and their underlying ideologies, for instance that of Thomas *Struth, Karen *Knorr, and Rosamund Purcell. The Tate Gallery, London, has published a set of documentary-style photographic postcards by Nicholas Turpin presenting a witty and ironic view of the relationship between people and objects in the museum. EE

Haworth-Booth, M., and MacCauley, E. A., *The Museum and the Photograph: Collecting Photography at the Victoria & Albert Museum 1853–1900* (1998).

Borne, G., 'Public Museums, Museum Photography and the Limits of Reflexivity', *Journal of Material Culture*, 392 (1998).

Barker, E. (ed.), *Contemporary Cultures of Display* (1999).

Edwards, E., *Raw Histories* (2001).

museums of photography. The term occurred very early on, with the appearance of the first studios, and was often used by pioneering independent photographers to describe their establishments: for example, the Macaire brothers in Paris at the end of the 1840s; and Hermann *Krone in Dresden a few years later for the collection of plates he assembled to demonstrate his techniques.

At this time very few public institutions were interested in photography; the earliest collections owed their creation to private initiatives emanating from associations (e.g. the London Photographic Society, later the *Royal Photographic Society (RPS), and the *Société Française de Photographie). A precocious exception was the South Kensington (later Victoria & Albert) Museum, whose director Henry Cole from 1852 bought and commissioned photographs for both teaching and documentary purposes. It was there, too, in 1854, that the London Photographic Society, with royal patronage, organized the first photographic exhibition to be held in a museum.

But this remained an isolated example. Photography's entry into museums in the 19th century, eventually on a massive scale, was either by the back door of documentation (via libraries, and the archives of various organizations) or into science museums. It was not until the 1930s, and the delayed effects of the struggle waged by certain exponents of *pictorialism since *c*.1890, that photography modestly began to gain access to the museum as an autonomous artistic medium. In 1928 and 1933 Alfred *Stieglitz gave several hundred photographs to the Department of Prints of the New York Metropolitan Museum. (In 1910, however, the Albright Gallery in Buffalo, New York, had acquired some of the pictorialist works shown there by the Photo-Secession; and in 1915 much of the German collector Ernst *Juhl's collection had been bought by the Hamburg Museum of Art and Design.)

The inter-war period witnessed a new enthusiasm for photography, whose historical pedigree was underlined by the various celebrations and exhibitions commemorating the centenary of its invention, in both Europe and the USA. The year 1927 saw the opening of the Kodak Museum at Harrow, near London. The same year, the Musée des Arts et Métiers in Paris dedicated one of its galleries to a strictly technical survey of photography and cinematography. But the movement was particularly strong in the USA. In 1935, for example, the San Francisco Museum of Art acquired its first camera images. But it was at MoMA, New York, that the first photography department in an art museum was created. Taking place in 1940 on the initiative of Alfred Barr and Beaumont *Newhall, it was the culmination of nearly a decade of interest in the medium, and affirmed photography's importance in the visual culture generated by the Industrial Revolution. But MoMA, by virtue both of the breadth of its acquisition and exhibition policy, and of its definition of photography as both language and artistic medium, remained a brilliant exception until the 1950s.

By then, however, public and, above all, private initiatives were proliferating, the latter often from individuals involved with photography either as manufacturers, amateurs, or professional practitioners. In 1949 the Rochester, New York, house of George *Eastman, the founder of Kodak, was transformed into a museum of the history of photography and cinematography—the first such collection in the world and still one of the most important. In Essen, Germany, Otto *Steinert created a photography department at the Folkwang Museum in 1959. Thanks to the initiative of an amateur photographer and collector, André Fage, France's first photographic museum was founded at Bièvres. Interest in the history of photography and its pioneers prompted other local initiatives: in 1972, for example, the Musée *Niépce opened at Chalon-sur-Saône, organized initially around the Niépce archives housed in a museum in the town. Three years later, Henry *Talbot's home at *Lacock Abbey opened to the public.

Today, institutions dedicated to photography are both numerous and very varied in structure, approach, and size. Constructing a typology is therefore tricky. One model, that of the museum specifically dedicated to the history of photography (and sometimes also cinematography) in all its technical, artistic, sociological, and cultural aspects from its origins to the present, has found many imitators. Examples, in addition to George Eastman House, include the National Museum of Photography, Film, and Television at Bradford (1983), which today houses numerous British collections of images and equipment (including those of the Science Museum, the Kodak Museum, and the RPS); the Musée Niépce; the Belgian museums of photography at Antwerp (1966) and Charleroi (1987); the Museum of Hungarian Photography in Kecskemét (1990); and the Fotomuseum in Munich. A second category is more narrowly focused on photographic technology, often particularly cameras: for example, the Swiss Camera Museum at Vevey (1971), the camera collection of the National Museum of Technology, Prague (reorganized 1983), and the Canon Camera Museum in Tokyo. At the opposite end of the spectrum are institutions dedicated to the art and culture of photography: the Musée de l'Élysée, Lausanne, the House of Photography, Moscow, the International Center for Photography, New York, and the

Metropolitan Museum of Photography, Tokyo, all have this in common; and in Paris, although chronologically more restricted in scope, the Maison Européenne de la Photographie.

A third model, exemplified by MoMA, is that of the fine-art museum incorporating photography. Most large North American museums (the Metropolitan Museum, Art Institute of Chicago, Boston Museum of Fine Arts, National Gallery in Washington, DC, J. Paul Getty Museum, San Francisco Museum of Art, Houston Museum of Fine Arts, Amon Carter Museum, Fort Worth, etc.) had either created photographic departments by the end of the 20th century or at least become seriously active in the field. The model also caught on in Europe: for example, in Britain (the Victoria & Albert Museum, National Portrait Gallery, and National Galleries of Scotland), Paris (the Musée d'Orsay, Musée National d'Art Moderne-Centre Pompidou), Vienna (the Albertina), and the Netherlands (Rijksmuseum). Outstanding curators such as John *Szarkowski (MoMA), Weston *Naef (Getty), and Mark *Haworth-Booth (Victoria & Albert) have been important in integrating photography into the wider museum scene. Many self-contained museums of photography are now affiliated to museums of fine or contemporary art: e.g. the Agfa Photo-Historama in Cologne, linked to the Ludwig Museum; the Hague Museum of Photography built onto the Gemeentemuseum; the Fotografiske Museet in Stockholm, close to the Moderna Museet; and the Canadian Museum of Contemporary Photography affiliated to the Ottawa Gallery of Fine Art.

A fourth, less common model is that of the museum or foundation created around a particular photographer or establishment. Notable, apart from Lacock, are the *Alinari Foundation in Florence; the *Primoli Foundation in Rome; and the *Cartier-Bresson Foundation in Paris (2003). Finally, many non-photographic museums and other institutions hold extremely important photographic collections: in London alone, for example, the British Library, Imperial War Museum, National Maritime Museum, Royal Geographical Society, Wellcome Institute, and numerous others. And the development of the *Internet has brought with it the creation of 'virtual' photographic museums—e.g. the American Museum of Photography—almost as varied in size and content as their bricks-and-mortar counterparts. QB

Thomas, D. B., *The Science Museum Photography Collection* (1969).

Naef, W., *The J. Paul Getty Museum Handbook of the Photography Collection* (1995).

Boom, M., and Rooseboom, H., *A New Art: Photography in the 19th Century. The Photo Collection of the Rijksmuseum, Amsterdam* (1996).

Haworth-Booth, M., *Photography: An Independent Art. Photographs from the Victoria & Albert Museum 1839–1996* (1997).

Stevenson, S., and Forbes, D., *A Companion Guide to Photography in the National Galleries of Scotland* (2001).

Snell, S., and Tucker, P., *Life through a Lens: Photographs from the Natural History Museum 1880 to 1950* (2003).

Muspratt, Helen (1907–2001), and **Ramsey, Lettice**, best known for their portraits of Cambridge's intellectual and literary figures.

Ramsey, through her psychology studies and marriage with the mathematician Frank Plumpton Ramsey, was well connected to this circle when she and Muspratt opened their studio in 1932, expanding to Oxford in 1937. Muspratt had already established a portrait studio in Swanage in 1929, where she belonged to the artistic community and experimented with modernist techniques such as *solarization, developing an innovative style of rhythmic composition and bold framing. Muspratt also documented life in Russia (1936) and the Rhondda Valley mining communities (1937). AL

Williams, V., *The Other Observers* (1986).

Mutoscope. Devised in 1894 as a simple paper toy using photographs to show moving pictures on the flick-book principle, by late 1897 the Mutoscope had evolved into a cast-iron automat viewer for public arcades; and spawned the Victorian era's most successful film company, which used its large-format 68 mm wide images to gain lucrative contracts for exhibition in vaudeville and music-hall theatres across Europe and America. The partnership behind the American Mutoscope and Biograph Co. included the engineer Herman Casler, the entrepreneur Elias Koopman, the salesman and machinist Harry Marvin, and Edison's chief Kinetoscope investigator William Kennedy-Laurie Dickson (1860–1935), who not only contributed early mechanical advice but became one of Biograph's leading film-makers in 1896–1901. Although AM&B's Mutoscope was the most successful and long-lived of many flip-card viewers, the term became generic as numerous other companies made similar apparatus well into the 1920s, the best known being the 1896 Kinora of the *Lumière brothers, popularized by Charles Urban in Britain from 1902 as a device for home moving-picture portraits. DR

Rossell, D., 'The Biograph Large Format Technology', *Griffithiana*, 66/70 (2000).

Muybridge, Eadweard (1830–1904). Born Edward Muggeridge in Kingston upon Thames, England, Muybridge emigrated to America in 1851, returned after a stagecoach accident, reappeared in San Francisco *c*.1867, and became an outstanding landscape photographer of the West. Commissioned to photograph the racehorses of ex-governor of California Leland Stanford in 1872, he developed, in 1878, a battery-of-cameras system that produced high-speed sequential photographs showing the horse's brief suspension in the air during phases of its trot and the gallop, a much-debated issue. He sold zoetrope strips from this work, and devised a 'zoopraxiscope' to illustrate his lectures on the horse in America and Europe. Muybridge visited *Marey in Paris in 1881, then accepted an invitation from the University of Pennsylvania to photograph human and animal movement in 1884. This eleven-volume work, containing 781 plates assembled from 19,347 single images, was published by subscription in 1887 as *Animal Locomotion*: one of the most curious challenges to our faith in the camera as the guarantor of the visible. Many plates are assemblages rather than chronological sequences, and although Muybridge's stop-action photography is often claimed to be an antecedent of motion pictures, it is better understood as a treasure trove of figurative, often erotic,

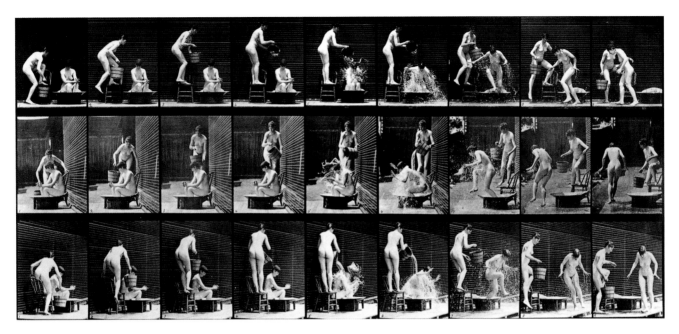

Eadweard Muybridge
Nude woman pouring water over another in a bath, from three camera angles, c.1870s. From *Animal Locomotion* (1872–85)

imagery. A pronounced eccentric, who was acquitted of the murder of his wife's lover, Muybridge returned to England in 1894, and died digging a replica of the Great Lakes in his back garden. MB

Mozley, A. V., 'Introduction', in *Muybridge's Complete Human and Animal Locomotion* (1979).

Prodger, P., *Time Stands Still: Muybridge and the Instantaneous Photography Movement* (2003).

Mydans, Carl (1907–2004), American *documentary photographer, raised in Boston, where he studied journalism and worked for the *Boston Globe* and *Boston Herald*. To expand his news stories, in 1931 he bought a Contax 35 mm camera, moved to New York, and joined *American Banker*. Roy *Stryker selected him as one of the first photographers of the Resettlement Administration (later Farm Security Administration (FSA)) in 1935, and Mydans enlightened Stryker on the potential and use of photography, particularly of the 35 mm camera. Dispatched to document the cultivation of cotton in the South, he focused his lens with compassion and insight as much on the poverty and dignity of the black and white workers as on their sometimes primitive agricultural methods. Though his influence on the FSA was considerable, Mydans's stay was brief. In 1936 he became one of the first staffers of *Life* magazine, remaining as a photographer and war correspondent for the Russo-Finnish War (1939), the Second World War (both in Europe and the Pacific (1940, 1942–5)), Korea (1950 and 1951), and Vietnam (1968). When *Life* ceased publication in 1972, he joined *Time*. CBS

O'Neal, H., *A Vision Shared* (1976).

My Lai massacre, Vietnam War atrocity documented, almost casually, by US army photographer Ronald L. Haeberle. My Lai 4 was a quiet hamlet in Quang Ngai Province, South Vietnam, an area suspected as a Vietcong stronghold. Early on 16 March 1968 a US infantry unit led by 24-year-old Lieutenant William Calley arrived there by helicopter to avenge a recent ambush. Haeberle carried a service Leica loaded with black-and-white film and a personal Nikon for taking colour transparencies, and worked with little interference from the soldiers. Within four hours, nearly 500 of the village's 700 inhabitants, mainly women, children, and old people, had been massacred. Despite efforts at a cover-up, a campaign started by a young soldier, Ronald Ridenhour, led eventually to the court martial of Calley, who was convicted of murder in 1971. Haeberle's black-and-white film (turned over to his 31st Public Information army unit, but left unused until found by investigators) became a key part of the evidence. The colour pictures (which he retained) were especially harrowing, showing groups of terrified and humiliated women about to be shot, and corpses of children and babies. First published in the Cleveland *Plain Dealer* on 20 November 1969, they were later purchased by *Life*, and probably helped to turn public opinion further against the war. But army regulations were also tightened to ensure that all film shot on operations, whether officially or not, would remain military property. CBS

See also EXECUTION PHOTOGRAPHS; MILITARY PHOTOGRAPHY; WAR PHOTOGRAPHY.

Hersh, S., *My Lai 4* (1970).

Mills, N., et al., *The Vietnam Experience: Combat Photographer* (1983).

Nachtwey, James (b. 1948), American photojournalist. Educated at Dartmouth College, Nachtwey went west to learn photojournalism in Albuquerque, New Mexico. He has stated that his intense interest in photographing the war-torn world was fostered in particular by images from Vietnam. He joined *Magnum in 1986 and published his first book, *Deeds of War*, in 1989; *Inferno* appeared in 2000. Just as Sebastião *Salgado has been criticized for his beautifully composed images of starving people, critics have raised questions about Nachtwey's visual preoccupation with the grimness of war and poverty. He has countered: 'I try to photograph with compassion, and in such a way that people can relate their own humanity to that of others. I try to make it so that it stops just short of pure horror because I think that would indeed turn people off.' Nachtwey was the subject of a powerful—though to some critics over-adulatory—2002 documentary, *War Photographer*, directed by Christian Frei. TT

James, S., 'Nachtwey: Images from the Inferno', *RPS Journal*, 140/2 (Mar. 2000).

Nadar (Gaspard Félix Tournachon; 1820–1910), French photographer, and a central figure in the extraordinary expansion of photography in the mid-19th century. An exact contemporary of Charles *Nègre and Gustave *Le Gray, this son of a Lyon printer and publisher, born in Paris and orphaned at an early age, had a poverty-stricken and chaotic youth. He cultivated Paris's literary Bohemia and its world of little satirical papers, and dabbled in medicine, literature, and caricature. It was at the beginning of the 1850s, when the invention of the *wet-plate process encouraged the rapid proliferation of studios, that Nadar—initially via his younger brother Adrien, a mediocre painter for whom he got lessons from Le Gray—became interested in photography. He began in partnership with Adrien (autumn 1854–spring 1855), and they distinguished themselves with a series of portrait studies of the mime Charles Debureau that were shown at the 1855 *Exposition Universelle; and by a commission by the doctor *Duchenne de Boulogne. However, the brothers' collaboration soon ended with a spectacular quarrel and a lawsuit.

Nadar's vast circle of contacts in the worlds of art and journalism allowed him to choose subjects from among his most talented contemporaries, who flocked to his house and studio at 113 rue Saint-Lazare. He rapidly achieved success and fame. Working alone between 1855 and 1860, he produced his most inspired and inventive work, creating richly nuanced *salted-paper prints from glass-plate negatives. Particularly memorable, among the hundreds he undertook in these years, were his portraits of Charles Baudelaire, Gustave Doré, Alexandre Dumas, Honoré Daumier, Théophile Gautier, Jean-François Millet, and Marie Laurent.

His style was spare: no decor, a neutral background, clothes that served simply to bring out the sitter's outline. He evoked painters like Holbein, Van Dyck, and Leonardo, and made skilful use of light to emphasize facial expression. His talent for relating to his subjects, most of whom were his friends, is very apparent, and they often look more natural and lifelike in his portraits than in those of other photographers.

In 1860 he left his first studio for an opulent building on the ultra-fashionable Boulevard des Capucines (where he was to remain until 1870), becoming heavily indebted as a result. His work, done by numerous assistants and then, from the 1870s, his son *Paul, became more commercial and conventional. Portraits were reduced to the *carte de visite* format and sitters, more and more of whom were actresses, were less carefully chosen.

Fascinated by scientific progress, Nadar was also a pioneer in the field of *aerial photography (1858) and photography by artificial light (1861 in the Paris catacombs, 1864–5 in the sewers). His main interest in the 1860s was aerial navigation, and he put much time and money into a balloon aptly named *Le Géant*.

After the 1870s Nadar no longer played a significant role in photography, and let his son run the business. His exceptional longevity gave him time to work up his memories and become a living legend and an oracle for early photohistorians. SA

Nadar, F., *Quand j'étais photographe* (1900).
Prinet, J., and Dilasser, A., *Nadar* (1966).
Greaves, R., *Nadar ou le paradoxe vital* (1980).
Hambourg, M. M., Heilbrun, F., and Néagu, P. (eds.), *Nadar* (1995).

Nadar, Paul (1856–1939), French photographer, son of Félix *Nadar, whose studio he inherited. Known for his inventive approach to photography, he became famous after collaborating with his father in interviewing the chemist Chevreul on his 100th birthday, 31 August 1886. Paul photographed Félix interviewing Chevreul, combining the photographs not only with transcriptions of the dialogue, but with a sound recording using Clément Ader's (1841–1925) phonophone. It was published in *Le Journal illustré* on 5 September 1886, with twelve photogravures corresponding to statements made by Chevreul.

Nadar

Portrait of Jean Journet, 1856–9.
Salted-paper print

In 1891 Nadar founded the journal *Paris-Photographe*, and in 1893 became the French representative of Eastman Kodak. KEW

Auer, M., *Paul Nadar, le premier interview photographique* (1999).

Naef, Weston J. (b. 1942), American curator of photographs, educated at Ohio State University (1964–6) and Brown University (1966–9). His highly influential career as a curator includes fifteen years in the department of prints, photographs, and illustrated books at the Metropolitan Museum of Art (1969–84). He joined the J. Paul Getty Museum in mid-1984, coincidentally with the formation of its department of photographs and the acquisition of several private collections that formed the basis for the Getty's own photographs collection. Naef has written standard works on American 19th-century landscape, the Alfred *Stieglitz Collection, and on books illustrated with mounted photographs. Apart from building what is arguably the world's finest collection of the art of photography, and playing a leading role in scholarship, Naef has pioneered new exhibition and publishing formats. He is cataloguing the 1,280 *mammoth-plate photographs of Carleton *Watkins. MH-B

Naef, W., *Photographers of Genius* (2004).

Narahara, Ikko (b. 1931), Japanese photographer. His career began during his graduate studies with a one-man show, *Human Land* (1956), about the man-made industrial island of Gunkanjima. The critical response led him to become a freelance professional. With Shomei *Tomatsu, Eikoh *Hosoe, and others he participated in the *Eyes of Ten* exhibition (1957), and co-founded the *VIVO agency in 1959. He spent 1962–5 in Paris and travelling in Europe, publishing the resulting photos in *Where Time Has Stopped* (1967). On his return to Japan, he focused on the arts of Japan (*Japanesque-Zen*, 1970). *Where Time Has Vanished* (1975) documents four years travelling the USA from his base in New York, where he was included in the MoMA exhibition *New Japanese Photography* in 1974. He photographs with a critical eye and a strong personal aesthetic, has significantly influenced younger photographers, and has received important awards. OH

 Innovations in Japanese Photography in the 1960s (1991).

National Geographic. The National Geographic Society was founded in January 1888 in Washington, DC, and its journal, entitled the *National Geographic Magazine* until 1962, first appeared in October: a drab publication, very different from the vibrant magazine it later became. In the 20th century photography, often (like Charles Martin's *underwater *autochromes, published in 1927) at the cutting edge of what was possible, was central to the magazine's appeal, and it commissioned work by many leading wildlife and scientific specialists, as well as photojournalists. Its first all-colour edition appeared in 1962. At the beginning of the 21st century it has an estimated international readership of 40 million, and the society holds an archive of over 10.5 million photographs. LAL

 Bendavid-Val, L. (ed.), *National Geographic: The Photographs* (1994).

National Photographic Record Association (NPRA) (1897–1910). This emerged from the county survey movement in the UK. The project, launched in Queen Victoria's jubilee year, was led by Sir Benjamin *Stone. The object was to record the heritage of the British Isles, although a majority of the coverage is of England. Amateur photographers, such as Geoffrey Bingley, George Scammell, and Lucy Beedman, submitted many hundreds of photographs. They were encouraged to photograph local churches, ancient buildings, archaeological monuments, and folk customs. The pictures articulate important values and assumptions. Fidelity was crucial, and the NPRA eschewed 'artistic' interventions such as the *pictorialist style (hence their preference for amateurs). Great stress was laid on the permanence of the record, and photographs were to be submitted as large-format platinum prints 'untainted by silver'. The scheme was conceived as a form of domestic 'salvage ethnography' and collective memory, 'to leave to posterity a permanent pictorial record of contemporary life, to portray for the benefit of future generations the manners and customs, the festivals and pageants, the historic buildings and places of our time'. The resulting 4,500 prints were submitted to Stone, labelled, mounted on cards, placed in custom-made boxes, county by county, and deposited in a somewhat resistant British Museum, the storehouse of national treasures. The NPRA's intentions were similar to those of 'salvage ethnography' projects on the European mainland, many of which lasted until the Second World War. EE

 Taylor, J., *A Dream of England: Landscape, Photography and the Tourist's Imagination* (1994).

native peoples and photography

Introduction

Indigenous, aboriginal, and First Nation peoples have been the focus for Western photographers since the mid-19th century. They have often been the subjects of stereotypical and appropriating discourses, used to demonstrate and legitimize *colonial and racialist policies. Photography, with its essentializing and intrusive capabilities, became both a symbol and an instrument of dispossession, literally 'stealing the shadow' by furnishing the means to remove its subjects' right and ability to determine their own history and representation.

It is for this reason that photography has become such a potent and critically important medium to many indigenous and aboriginal peoples, and its history contested. However, new research is revealing histories of indigenous imaging—documentary, family, and artistic— buried beneath Western and colonial imaging.

At the same time an energetic and critical contemporary practice has evolved in which works of photographic art address key and interrelated issues of sovereignty, identity, cultural heritage, and land rights, as well as the destructive histories of, and social problems experienced by, groups now minorities in their own land. The following contributions on *Australia, Aotearoa/*New Zealand, and North America demonstrate the range of approaches and concerns which constitute a dynamic photography too often ignored by dominant models of photographic history and practice. EE

 Peterson, N., and Pinney, C., *Photography's Other Histories* (2003).

Australia

The genesis of a public Indigenous photography in Australia is unknown, although work from many Indigenous amateurs who photographed their families and communities from the early 20th century onwards is being rediscovered. The first notable Indigenous professional photographer was Mervyn Bishop, who from the early 1960s covered important social, political, and historical events. From the early 1980s onwards, the work of individual Indigenous photographers, such as Tracey *Moffatt, Kevin Gilbert, Ricky Maynard, Michael Riley, and Brenda L. Croft, was increasingly recognized, and exhibited internationally. However, Australian Indigenous photography was first shown collectively in an arts context in a landmark exhibition in Sydney, *Aboriginal and Islander Photographers*, in 1986. Articulated through a range of styles, Indigenous photographic practice had developed both as a medium for political expression and as a response to colonial imaging and appropriation.

Michael Riley (Wiradjuri nation), for example, has produced monochrome documentary photography as well as film, video,

Mervyn Bishop

Australian Prime Minister Gough Whitlam pours soil into the hand of traditional landowner Vincent Lingiarni, Northern Territory, 1975

and conceptual work. Like other Indigenous photographers, he has endeavoured to capture the strength, grace, and resilience of Aboriginal and Torres Strait Islander peoples, in contrast to the bleak stereotypes of *photojournalism; while addressing the sacrifices of Indigenous people, the ravages of introduced disease, and anger at two centuries of dispossession and dislocation. In contrast to Riley's evocations of damaged land and damaged souls, Destiny Deacon (Erub/Ku Ku/Mer nations) draws on the influences of popular Anglo culture in an increasingly urban Indigenous existence, making satirical series, co-opting kitsch memorabilia, family members, and friends in fantastical scenarios such as *It shows no fear* (1999) and *No need looking* (1999). In a more documentary idiom, Rick Maynard's evocative black-and-white portraits of his community, *The Moonbird People* (1985), depict important continuing cultural traditions for Tasmanian Aboriginal people, while *No more than what you see* (1993) portrays the harsh life of Indigenous prisoners in South Australia's jails. Darren Siwes's (Ngalkban) portraits reveal his training as a painter. His own image is inserted into distinctive photographs of Adelaide's

urban milieux, landmarks, and cultural landscapes, resulting, as Christine Nicholls has put it, in a kind of ghostly memento mori that is simultaneously an epiphanic, contemporary Indigenous presence.

Since 2000, new photo-media artists have come to notice. Christian Thompson (Bidjara/Pitjara) is a young artist-curator, whose people are from Queensland. Based in Melbourne since 1999, he rapidly emerged as an important figure in new media art and technology. Jason Hampton's (Gurindji/Ngalarkan people) sci-fi renderings of country, Indigenous physical and cultural (ill) health were included in *conVerge: Adelaide Biennial of Australian Art* (2002). Jennifer Fraser (Bundjalaung) has curated web galleries and exhibitions as well as showing her work nationally, commenting on issues such as the Republic and DNA testing. Like Thompson, Dianne Jones (Balardung) draws on international Conceptual art, incorporating imagery beyond the stereotypes of Indigenous people and their visual culture. Jones's playful approach is evident in *Shearing the Rams* (2001), a digital reworking of a much-loved Australian icon, Tom Roberts's 1890 painting of pastoral labour and reward.

Eadweard Muybridge

Native American family, Alaska,
*c.*1868. Lantern slide

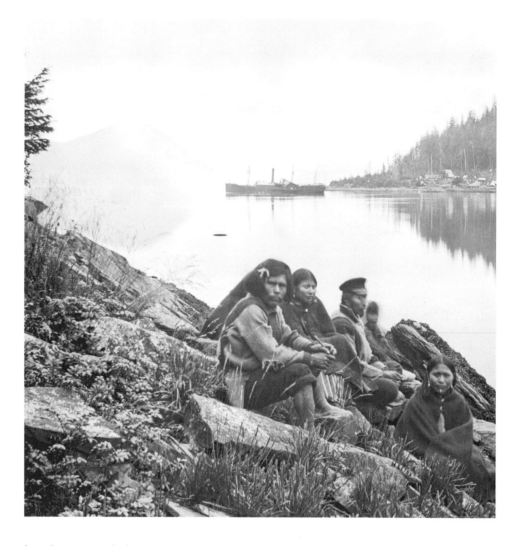

While photographers like Moffatt and Gordon Bennett, also known internationally, demand that their work be seen as contemporary, not 'Indigenous' art, others consider the duality of their work fundamental. Indigenous photographers work to overcome memories of centuries of mistreatment, and an atavistic distrust of that most abusive of colonial devices, the camera. Formerly reduced (literally) to the picture postcard, Indigenous peoples have come back into focus through the print and digital media. All are familiar with, if not fluent in, global visual and written languages, articulating this in their work, using new media technology not to replace traditional tools, but as an addition to their modern equipment of cameras and computers. As bell hooks has written, 'Such is the power of the photograph, of the image, that it can give back and take away, that it can bind.' BLC

New Zealand
Maori use of photography can be traced back to 1853 when the daughters of Dicky Barrett and Rawinia Waikaiua of Ngati Te Whiti, Caroline and Sarah, had their *daguerreotype taken by the itinerant

photographer Lawson Insey. This family study of the two girls in their matching Victorian dresses is the first known photograph of New Zealand Maori.

Initially photography focused on important personages, chiefs, and political leaders, or on those who could afford the guinea fee. While Maori images rapidly became a staple of the tourist, commercial, and scientific market, they were also quickly adapted and adopted by Maori culture as *taonga* (cultural treasures) that retained the *mana* (power, prestige) and *mauri* (life force) of the individual portrayed. Early acceptance and use of the camera by Maori was generally proportionate to the level of contact with Europeans, with a resulting large percentage of the earliest commercial studios with successful reputations for Maori portraits being established in Auckland. Amongst these were John Nicholas Crombie (*fl.* 1854–73), who photographed twelve prominent Maori chiefs who attended the Kohimarama Conference in 1860. His portrait of a defiant-looking Tomika Te Mutu, displayed at the International London Exhibition in 1862, was one of the earliest Maori photographs to be seen in Britain

and widely marketed. The Pulman Studio (*fl.* 1869–1900) also took sensitive portraits of important personages such as the Maori King Tawhiao, and the American Photographic Company (*fl.* 1872–5) made numerous images in a style reminiscent of the *American West, where the photographer had trained.

There is little documentation on these early portraits, but the ledgers of Frank Denton in Wanganui show that by the 1880s Maori were actively commissioning photographs for personal and ceremonial use. William Partington (*fl.* 1880s–1928), also of Wanganui, and Samuel Carnell (*fl.* 1873–85) of Napier, also had a significant number of Maori clients, and such photographers, who were seen to have a positive rapport with Maori communities, were engaged to record special events and social gatherings, and to copy and reproduce existing prints. This increased commissioning of photographs related to the practice of seeing the image as a spiritual bridge to absent individuals, and as a consequence led to the practice of putting photographs on the walls of meeting houses, either in addition to or as a substitute for traditional ancestral carving, and placing photographs around the coffin during *tangihangi* (funerals).

During the early 20th century there was a backlash by some Maori against the inappropriate usage and commercialization of Maori culture in photography, such as the taking and selling of unauthorized photographs of *tangihangi*, and the printing of chiefs' portraits on souvenir tea towels or biscuit tins, where they contravened *tapu* (taboo). Concurrently, other groups began to exploit the photograph for their own advantage, such as the selling of *postcards within Whakarewarewa to supplement the village's income. Individuals such as Guide Makereti used the camera for her public role of raising awareness of Maori issues and self-determination, while at the same time adapting versions of these public portraits for her personal albums. Both groups were concerned about the manner in which Maori were represented by photography, and attempts were made to restrict the unauthorized use of cultural images as early as 1893, when Queen Wi Rangitehu registered Robert S. Thompson's—her husband's—photographs of the graves of Maori warriors fallen in the Taranaki Land Wars under the Fine Art Copyright Act of 1877, to prevent their inappropriate reproduction.

From the 1900s hand-held cameras for personal use enabled Maori to take photographs of themselves by themselves for their own purposes. These pictures are now invaluable in showing the way Maori culture changed and adapted to colonial influence and the assimilation policies of the 1910s to 1950s, especially as there are few other local visual records of this time. For their own purposes, Maori also increasingly worked in collaboration with outsiders to record and preserve their culture. In 1923, for example, Apirana Ngata sponsored the government tourist photographer and Dominion Museum ethnographer James McDonald to record what was feared to be a disappearing way of life. McDonald also worked with the Maori ethnographer Te Rangi Hiroa and Elsdon Best to produce important visual and sound recordings of traditional life, including the first cinematographic films of Maori. The photojournalist Robert Hutchins

and the documentary photographer Ans Westra (b. 1936) recorded with dignity the realities of Maori life in conditions of economic and political inequality, helping to bring about re-evaluation of the government's housing policies.

The first Maori professional photographer was Ramai Hayward (b. Ramai Te Miha and aka Patricia Miller) of Ngai Tahu and Ngati Kahungunu descent, who worked in Devonport between 1938 and 1946 before embarking on an international career as a film-maker with her husband. By the 1970s, Maori professionals were increasingly focusing on Maori issues and displaying the images both within and outside Maori environments to raise awareness of cultural issues: for example, the coverage by the freelance film-maker and photographer John Miller of Ngapuhi descent of pivotal events such as the 1981 protests against the Springboks' rugby tour.

Contemporary Maori artists increasingly use the camera to explore and (re-)present their cultural identity within their Maori community, as well as investigating the Maori heritage within the wider New Zealand and international community. Artists such as Fiona Pardington, Lisa Reihana, and Ross T. Smith use the camera for individual, cultural, and political expression, appropriating anthropological, documentary, and art techniques to create an ongoing visual dialogue between artist and audience. JD

North America

The history of Native photography has had a late start, though not because of an unwillingness to embrace the latest technology. In the 19th century it was doubtless more logical to pick up the latest firearm from the battlefield than it was to salvage state-of-the-art camera equipment left by a fleeing photographer. Negotiating the violent foreign occupation of Native lands left little time to contemplate the processes of photography. While emigrant Americans were honing their photographic techniques, recording pristine landscapes for settlers, the First Nations of North America were fighting for survival and focusing their creative energies on staying alive.

By the end of the 19th century, just as people generally were picking up the camera, so too were native communities. The image in the viewfinder was familiar, of family and friends. One of the earliest Native photographers, Richard Throssel (Cree/Scottish/Crow; 1882–1933), officially photographed community members throughout the Crow territory from 1902 to 1912. The images by Jennie Ross Cobb (Aniyunwiya; 1882–1958) while at the Cherokee Seminary in Tahlequah, Oklahoma, provide evidence of both Native class structures and Native modernity. She photographed her Aniyunwiya world as she saw it, in stark contrast to the images by non-Native photographers that reinforced their own conceptions/constructions of Native America. By 1906, photography was being taught to students at the Carlisle Indian School in one of the finest and best-equipped photographic studios in the state of Pennsylvania. Twenty years later, Horace Poolaw (Kiowa; 1906–84) embarked on a professional career photographing community members and events that was to last for half a century.

It is essential today that young Native photographers have Native resources with which to work, and know that there is a difference in imaging when the photographer is from within. The present author and her colleagues have the honoured position of belonging to the first generation of exhibiting fine-art Native photographers. That honour also imposes the responsibility, through their photographic approach, of fostering the philosophical values of their communities.

National and international exhibitions of contemporary Native lens-based art flourished throughout the 1980s and 1990s, establishing the canon that exists today. The landmark exhibition *Native Nations*, held in 1998 at the Barbican Art Gallery, London, was split ideologically into two sections and distributed physically over two separate floors. The upper floor featured the familiar vintage images of North American Indians by non-Native photographers judging, capitalizing on, and scientifically documenting the 'other'. The lower floor presented not-so-familiar images by ten Native photographers. These addressed social and political issues of sovereignty, land rights, cultural affirmation, and family. This grouping only partially represented a canon that includes many other art photographers, as well as vigorous communities of Native photojournalists.

There is now an abundance of Indigenous/First Nation photographers assuming the responsibilities of imaging: composing, digitizing, developing, presenting images of family and community; evoking philosophy, politics, personal dreams and visions, and constructing visual sovereignty through photographic imagery; Native thought made visual. HJT

Poolaw, L., *War Bonnets, Tin Lizzies, and Patent Leather Pumps: Kiowa Culture in Transition, 1925–1955* (1990).
Albright, P., *Crow Indian Photographer: The Work of Richard Throssel* (1997).
Tsinhnahjinnie, H. J., 'When is a Photograph Worth a Thousand Words?', in J. Alison (ed.), *Native Nations: Journeys in American Photography* (1998).

naturalistic photography was a movement introduced by P. H. *Emerson, primarily through his book, *Naturalistic Photography for Students of the Art* (1889), a polemic against conventionalism in art and photography. Emerson insisted that each picture demanded an original approach based on the direct observation of nature. This derived from contemporary ideas of naturalism in art, discussed in texts such as Francis Bate's 'The Naturalistic School of Painting' (*The Artist*, 1886), and Thomas Goodall's 'Landscape' essay in Emerson and Goodall's *Life and Landscape on the Norfolk Broads* (1887). Like Bate, Emerson championed visual devices such as differential focus, peripheral diffusion, subdued tonal values, and the subordination of extraneous detail. These formal elements were intended to correlate a picture—whether painted or photographed—with 'natural' human vision, which Emerson validated by selectively quoting Hermann *Helmholtz's 1867 text on physiological optics. There were also similarities in subject matter—landscape and rural genre—inspired by painters such as Jules Bastien-Lepage, a prime influence on Goodall and Bate and their colleagues in the New English Art Club.

While Emerson saw himself as a lone critic of the photographic status quo, he was extending aesthetic ideas current for over 35 years: formal antecedents can be seen in work by *Hill and Adamson and Julia Margaret *Cameron, and would later influence *pictorialism. Yet Emerson recanted, in 'The Death of Naturalistic Photography' (1890). He was partly provoked by George *Davison's lecture 'Impressionism in Photography', which recast and updated—but did not credit—Emerson's ideas. Emerson had also concluded that photography could not be a fine art, citing Hurter and Driffield's sensitometric research, which demonstrated that the photographer had little control over tonal values preordained by a standard correlation between exposure and development. He referred to conversations with an artist (probably J. M. Whistler) and research in psychology, which indicated the importance of subjectivity in producing and experiencing art. If art depended on the vagaries of individual perception, it was difficult to substantiate an objective truth to nature, or a mimetic medium such as photography. HWK

Turner, P., and Wood, R., *P. H. Emerson, Photographer of Norfolk* (1974).
Kemp, W. (ed.), *Theorie der Fotografie, i: 1839–1912* (1980).

Naya, Carlo (1816–82), Italian photographer who catered to the early tourist trade. Originally a lawyer, in 1857 Naya settled in Venice and opened a photographic studio. He supplied photographs to Carlo *Ponti, and together they published albums of views, although they apparently quarrelled in 1868. In Venice Naya photographed genre scenes and works of art as well as architectural views; he also travelled to Egypt and other sites to photograph ancient monuments. Comprising over 8,000 negatives, his work continued to be printed well into the 20th century. MR

Dewitz, B. v., et al., *Italien sehen und sterben: Photographien der Zeit des Risorgimento* (1994).

negative. The formal definition of a negative, i.e. an image with all the tones of the original scene reversed, is so well known as to be virtually redundant here. But the first photographs—*daguerreotypes—were not made from negatives: they were positives: they reproduced the tones of the original in direct proportion. One might speculate that had it not been for the enthusiastic reception of Henry *Talbot's negative-positive process, photographic technology might have bypassed it and gone straight to reversal processing (not much more complicated than negative processing), leaving the concept of a negative image to a few quirky philosophers. Indeed, with the advent of scanning techniques and *digital photography, both of which produce direct positives, the photographic negative may already have had its day, apart from the work of a small band of enthusiasts continuing to work with *cyanotype and dichromated colloids. But although the idea of a direct positive is inherently simpler, there is an undoubted attraction about the negative-positive process that transcends its obvious complexity. Its adaptability may ensure its survival, especially in the case of colour negatives (in which not only the tones but also the hues are reversed). While it is true that many

professional photographers work exclusively with colour transparency material, there is no doubt that the colour negative-positive process, with its integral colour masking, can provide a truer colour rendering than can be achieved in a one-step colour process; and for the many enthusiasts who prefer to produce their colour prints in the darkroom, the process has almost unlimited flexibility. GS

Nègre, Charles (1820–80), French painter and documentary photographer. Born in Grasse, Nègre went to Paris at the age of 19. He studied painting under Ingres and Delaroche, another of whose pupils, Gustave *Le Gray, introduced him to photography. After a short period of making *daguerreotypes, he embraced the *calotype process, becoming adept at retouching negatives and printing. He used his pictures as aids to painting and developed his skills as a landscape and architectural photographer. In 1852, acting independently of the official *Mission Héliographique, Nègre embarked on his own photographic survey of his native Midi. Within a year, he had made c.200 negatives of its scenery, towns, industries, and buildings (both old and new). However, the attempted publication of a subscription series (1854) quickly foundered. Other projects included pictures on themes of labour and street life (early 1850s), an unfulfilled plan to publish engravings from his pictures of the Holy Land, and a series of images—commissioned by Napoleon III in 1860—of the Imperial Asylum at Vincennes. In 1861 he retired to the South. RP

Jammes, A., and Sobieszek, R., *French Primitive Photography* (1969).

Negretti & Zambra, London photographic firm. In 1850, the Italian-born optician Enrico (Henry) Negretti (1817–79), resident in London since 1829, took Joseph Zambra (d. 1877) into partnership. They occupied Nicolaas *Henneman's old rooms, 122 Regent Street. As official photographers to the *Great Exhibition of 1851 they published one of the first large series of stereographs; later sponsored *Frith's 1857–8 journey to Egypt and the Holy Land; and published stereos from all over the world, including *Beato's of the Opium Wars. They also sold and manufactured photographic equipment like the ornate and complicated Magic Stereoscope of 1857. Negretti took the first balloon photographs of the capital in 1863. Headed by various sons, the firm continued into the 1930s. KEW

Nelly (Elly Seraidari, née Souyoultzoylou; 1899–1998), Greek photographer. Born in Aydin, Turkey, she studied art, music, and photography in Dresden in the 1920s. She opened a studio in Athens in 1924, introducing new techniques and styles to Greek visual culture and specializing in photographing dance movement. Despite the uproar over her portrait of a nude dancer on the Parthenon in 1927, her career flourished in Greece, where she worked for the official tourism agency, and later in New York, where she and her husband, the pianist Angelos Seraidari, lived from 1940 to 1966. In 1987 her work was exhibited at the Benaki Museum in Athens. NR

Harder, M., *Nelly: Dresden—Athens—New York. From the Photographic Archive of the Benaki Museum, Athens* (2001).

Neorealismo. The photographic aspects of the cultural movement known as *Neorealismo* had a striking impact on Italian photography from the early 1940s. Part of a short-lived if highly influential reaction against fascism and the pictorial values that it had promoted, it also drew inspiration from the literary and cinematic ideas emerging in the chaos of post-war Italy. The films of Rossellini, Visconti, and Fellini are marked by this moment, as is the literature of Italo Calvino. The affinities between photography and cinema, as well as with painting, were particularly strong in this respect. It is clear that the film-makers in particular drew heavily on the visual approach and subject matter of the photographers.

Alberto Lattuada, a young cinematographer, wrote a short book in 1941 about the need to see photography as a documentary medium that could grasp reality in an instantaneous form and implied both a judgement and a selection of the facts. His work on a penal colony in Sardinia, made in 1941, conforms to these aspirations. Lattuada's work was a plea for a photography that sought to escape from fascist propaganda and ideology, to focus on presenting the reality of Italy's situation to the public. This manifesto for a new photography, informed by left-wing ideas and close in spirit to French humanism, was particularly urgent in the reconstruction period when the social and political issues that confronted Italy— land reform, industrialization, the problem of the *mezzogiorno*, were acute.

In 1948 the Venice Biennale was devoted to the *Fronte nuovo della arti*, which inspired many photographers. Because *Neorealismo* could be seen to cross the arts, to be a form of inspiration to create a new Italy from the wreckage of history, it was less of a movement than a *Zeitgeist*—the spirit of the times, as the writer Calvino acknowledged. In photography, *Neorealismo*'s main output was in the form of reportage on various social and political problems, and in particular on exploring the deprived parts of Italy that the Italian press tended to ignore. *Neorealismo* devoted considerable attention to rural poverty and to the archaic way of life of the peasants of Italy's more remote regions. Significant among them are Valentino Petrelli's (b. 1922) work on the small village of Africo, in Calabria, Mario De Biasi's (b. 1923) in the *bassi* (working-class areas) of Naples, Fulvio Roiter's (b. 1926) in the mines of Sicily and the mountains of Umbria, Franco Pinna's on rural communities in Sardinia. Their work appeared in certain important magazines of the time, *Ferrania*, *Realismo*, and *Il caffe*, where it was often presented as an indictment of social ills.

The use of stark black-and-white photography to present social and political facts is a key visual feature of *Neorealismo*, and it evolved into a formalism that marks much of Italian photography in the 1950s and 1960s, particularly present in the work of Mario *Giacomelli. At the same time, some of the *paparazzo* photography of Italy's *dolce vita* in the 1950s has clear affinities with *Neorealismo*, especially in the sense that it seeks to unmask celebrities and present them as ordinary people. PH

Zanner, I., *Neorealismo e fotografia* (1987).

Nepal. The existence of early photographs from Nepal has been speculated upon, but to date no conclusive evidence has appeared. Currently the earliest known photographs are the portraits of royalty, Nepali tribes, and landscapes by Clarence Comyn Taylor (1830–79) dating to 1863–5. Photographers working for *Bourne & Shepherd visited Nepal in the 1870s–1880s and are said to have instructed the first Nepali photographer, Dambar Shamsher (1858–1922) whose son Samar also took up photography. Shamsher passed on his knowledge to the painter Purna Man Chitrakar c.1880, who encouraged several generations of Chitrakars to become photographers, including Dirga Man Chitrakar (1877–1951). T. J. Hoffmann, of the Calcutta-based firm *Johnston & Hoffmann, visited Nepal in the 1890s and received court patronage. Members of the ruling family also visited Hoffmann's Calcutta studio on several occasions. Between the 1870s and the 1930s, hunting expeditions were keenly documented by European firms. Local studios had begun to appear by 1920, catering to a more middle-class clientele. Over the following decades, portable cameras were introduced in larger numbers and amateur photography increased, often documenting significant family events. SCG

 Onta, P., 'A Suggestive History of the First Century of Photographic Consumption in Kathmandu', *Studies in Nepali History*, 3 (1998).

Neshat, Shirin (b. 1957), Iranian-born photographer and video artist, based in New York. Because of the Iranian revolution, Neshat was away from her homeland for twelve years, visiting again for the first time in 1990. The striking transformations in Iranian society that had taken place form the basis of much of her work, which has been widely exhibited in Europe and North America. *Women of Allah*, a series of photographs depicting women, some carrying guns, wearing the *chador*, and with their faces and hands covered with finely written Persian script, drew critical attention for their examination of conflicting assumptions about the 'Islamic woman'. Her video work, for example the trilogy *Turbulent*, *Rapture*, and *Fervour*, often explores gender in traditional Islamic society. However, although frequently set in an Iranian context, Neshat's photographic and video images address social issues that transcend specific cultural boundaries. NM

 Gagnon, P., *Shirin Neshat* (2001).

Netherlands, the. Photography was introduced to the Dutch public on 1 March 1839, in an anonymous article in the *Algemeene Konst- en Letterbode*. Since that time, the Netherlands has developed a lively tradition, one that was and is representative of photographic and artistic movements throughout Europe. The history of this tradition, while thoroughly documented at home, has been largely neglected in the mainstream English, French, and German photohistories.

Typically for the 19th century, Dutch photographic activity was concentrated in the cities. Local and foreign photographers recorded the sights of Amsterdam, The Hague, Haarlem, and Rotterdam from the very earliest days of photography. In 1855, the first photographic exhibition, the *Exhibition of Photography and Heliography*, was mounted at the Amsterdam gallery Maatschappij Arti et Amicitiae. More than 40 Dutch and international photographers exhibited *daguerreotypes and photographs on paper.

One of these was Pieter Oosterhuis (1816–85), trained as a painter but already making daguerreotypes by 1853. He, and later colleagues like Julius Perger (1840–1924) and Johann Georg Hameter (1838–85), soon turned to *collodion on glass, taking stereo and topographical city views as well as portraits. *Vues de Hollande*, published by Oosterhuis in the early 1860s, is a representative example of the tradition of topographical views of cities like Scheveningen, Utrecht, and Amsterdam promoted by these photographers. Although such views were enjoyed by Dutch audiences, they were more frequently sought by collectors throughout Europe. Amsterdam and Rotterdam were common destinations for French, British, and eventually American photographers, who fostered an interchange of information on photographic techniques and philosophies with practitioners in the Netherlands.

As in other countries, Dutch photography in the second half of the 19th century was dominated by the rise of the portrait studio, the proliferation of scientific and commercial applications of the medium, and eventually the spread of *pictorialism. It was not until the turn of the 20th century that Dutch photography's status changed, and photographers organized themselves into groups and associations. Artists like Georg Hendrik *Breitner and Willem Witsen (1860–1923) practised photography but continued to consider themselves as painters, and their photographs merely as studies. This attitude was finally to change in 1908, when the Stedelijk Museum in Amsterdam mounted the first Dutch museum exhibition devoted to international and national photography. The *Tentoonstelling van Foto-kunst* included not only influential foreign photographers, but native pictorialists like Bernard Eilers (1878–1951) and Henri *Berssenbrugge. These photographers were influenced both by British writing from the 1880s but also strongly by the style and traditions of the Hague school of realist painting. Though not quite complete, the acceptance of photography into Holland's long pictorial tradition was assured.

In the 20th century, Dutch photography developed a strong social and political *documentary style fostered by the two world wars. It also formed close ties with the German avant-garde. Piet Zwart (1885–1977) joined the Ring Neuer Werbegestalter, the 'New Ring' that advocated the use of radical design in advertising, and *Moholy-Nagy helped to edit the *Internationale Revue i 10* for two years (1927–9). Modern photography by Gerrit Kiljan (*fl.* 1930s), Paul Schuitema (1897–1973), and Jan Kamman (1898–1993) as well as Piet Zwart rendered the Netherlands photographic scene as vibrant as that of any of its neighbours at this time. While the avant-garde tradition flourished, so did documentary photography, made internationally famous by the films and photographs of Ed van der *Elsken. Koen Wessing (b. 1942) and Marrie Bot (b. 1946) continue this tradition. (The history of Dutch photography during the German

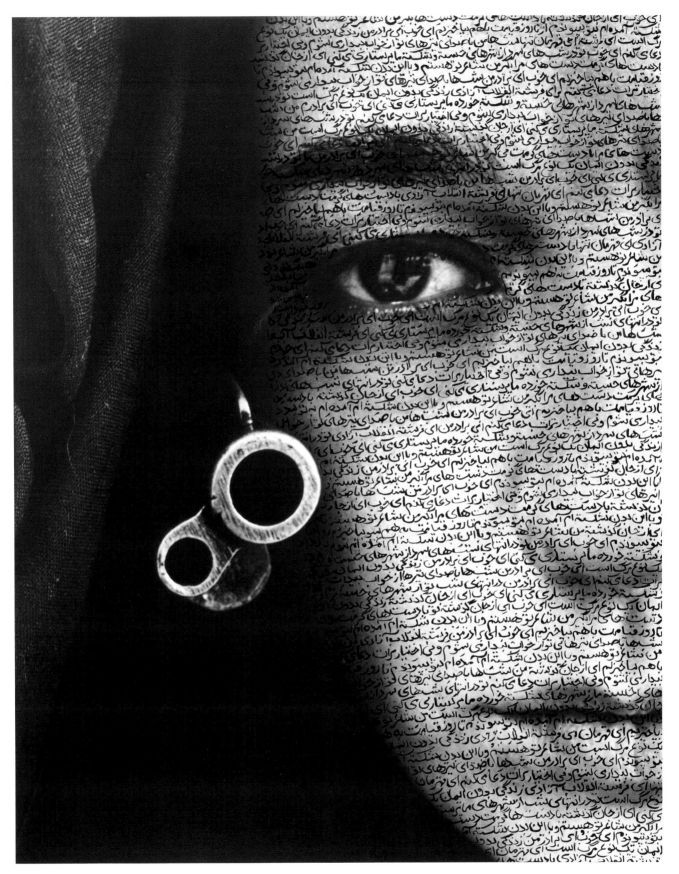

Shirin Neshat

From *Women of Allah* series, late 1990s

occupation remains to be studied in detail, but the underground images made in the period have attracted increasing interest.)

The diversity of Dutch photography and its links with international movements continue in the 21st century. Conceptual artists like Jan Dibbits (b. 1941), Ger van Elk (b. 1941), and Paul den Hollander (b. 1950) pushed conceptual photography to great lengths through the 1970s and 1980s. They have been joined by increasing numbers of internationally influential artists, Rineke *Dijkstra, Bertien van Manen (b. 1942), Hellen van Meene (b. 1972), and Ad van Denderen (b. 1943), who have formed a photographic aesthetic unique to the Netherlands.　　　　　　　　　　　　　　　　　　　KEW

Leijerzapf, I. (ed.), *Fotografie in Nederland 1839–1920* (1978).
Bool, F., and Broos, K. (eds.), *Fotografie in Nederland, 1920–1940* (1979).
Leijerzapf, I. (ed.), *Roots + Turns: 20th Century Photography in the Netherlands* (1988).
Bool, F., and Hekking, V., *Die illegale Camera 1940–1945: Nederlandse fotografie tijdens de Duitse bezetting* (1995).

Neue Sachlichkeit. In 1925, Carl Gustav Hartlaub mounted an exhibition of paintings at the Mannheim Kunsthalle with the title *Neue Sachlichkeit* (New Objectivity), and the subtitle 'German Painting since Expressionism'. These pictures by a number of post-Dada artists—among them Christian *Schad, who had executed a series of *photograms in 1918—included portraits and interiors painted in a meticulously realistic manner without drama or expressionist distortion. Both the style and the label rapidly caught on as shorthand for unemotional precisionism in representing people and things. (However, the term has also been defined more broadly as a stance of cool detachment towards society generally, hence the alternative translation 'New Sobriety'.) One of the earliest writers to apply it to a photographer was Kurt Tucholsky, in a 1927 'Letter from Paris', about Albert *Renger-Patzsch. A year or two later, practically every show of sharp and detailed photographs used the phrase, and it obviously fitted much contemporary advertising, architectural, and industrial work.

The term can be seen as practically synonymous with the American *straight photography of the late 1910s–early 1920s espoused by Paul *Strand, Charles *Sheeler, and Alfred *Stieglitz. Common to both was the reaction against *pictorialism (in Germany, *Kunstphotographie* (art photography)) and the insistence that photographs should not masquerade as graphic works or paintings. There were parallels in France, Belgium, and Czechoslovakia. Other German *neu-sachlich* photographers included Aenne *Biermann, Karl *Blossfeldt, Hein Gorny (1904–67), Adolf Lazi (1884–1955), and Willy Zielke (1902–89), architectural specialists like Arthur Koester, Werner Mantz (1901–83), Erich Meinholz, Ernst Scheel, Hugo Schmoelz (1879–1938), and Julius Soehn, and industrial photographers like Erich Angenendt (1894–1962), Ruth *Hallensleben, Erna Wagner-Hehmke, and Paul *Wolff.

Paradoxically, although in the 1920s Neue Sachlichkeit was viewed as an antidote to reactionary anti-modernism, it was exploited by the Nazis after 1933 as a form of modern-looking functionalism, sometimes labelled 'German Objectivity', that met some of the regime's *propaganda needs.　　　　　　　　　　　　　RS

Ahrens, A., 'Meinungsaustausch: Kunstphotographie und neue Sachlichkeit', *Camera*, 11 (1932–3).
Mellor, D. (ed.), *Germany: The New Photography 1927–33* (1978).
Lugon, O. (ed.), *La Photographie en Allemagne: anthologie de textes 1919–39* (1997).

New Documents exhibition. Conceived by John *Szarkowski at the Museum of Modern Art in 1967, it featured the work of Diane *Arbus, Lee *Friedlander, and Garry *Winogrand. Szarkowski said of the photographers: 'Their aim has been not to reform life but to know it, not to persuade, but to understand.' The artists' overall objective of candidly documenting people going about their everyday lives, however, may have been overwhelmed at the time by viewers' perception of the images—particularly those of Arbus—as essentially bizarre.　　　　　　　　　　　　　　　　　　　　　TT

Newhall, Beaumont (1908–93) and **Nancy** (1908–74), American curator-scholars, and two of the giants of photographic culture. The young Beaumont, with the encouragement of Alfred Barr, director of MoMA, New York, mounted the *Photography 1839–1937* exhibition in 1937, the first major retrospective show in the medium's history. It is widely acknowledged that through that exhibition the Newhalls, working closely together, established photography as a fine art in the USA. Beaumont founded the photography department at MoMA in 1940, and Nancy oversaw its continuance during the Second World War while her husband was involved with army photo-reconnaissance overseas. After the war, Beaumont became curator of photography, then director of the *International Museum of Photography, George Eastman House. Educated at Harvard and in Europe, he was a prolific writer and researcher. His most renowned work, *The History of Photography* (1937), appeared in many editions, the last in 1982. He wrote monographs on such figures as H. Frederick *Evans, Timothy H. *O'Sullivan, William Henry *Jackson, Henri *Cartier-Bresson, and Edward *Weston. Many of his books were co-authored with Nancy, who herself wrote major catalogues and monographs on Alvin Langdon *Coburn, Paul *Strand, and Peter Henry *Emerson. Beaumont Newhall's autobiography *Focus: Memoirs of a Life in Photography* (1993) is a fascinating collection of memories of the major events and artists (many his personal friends) of 20th-century photography.　　　　　　　　　　　　　TT

Newhall, B., *In Plain Sight: The Photographs of Beaumont Newhall* (1983).

Newman, Arnold (b. 1918), American photographer. Born in New York, Newman spent most of his youth in Miami and other East Coast cities. He was drawn to painting, but his impecunious family was unable to send him north to the Art Students' League where he wanted to study. Instead, he briefly attended Miami University. During the Depression, he found work in portrait photography studios in

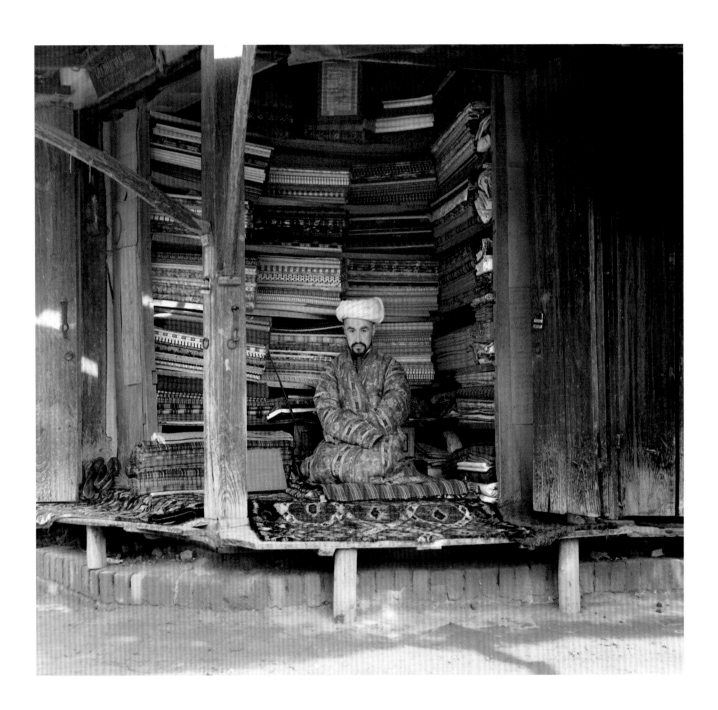

Sergei Mikhailovitch Prokudin-Gorskii Dry-goods dealer, Samarkand, c.1909–15

Agnes Richardson *Valentine Mine*, Kodak advertisement, c.1903

Unidentified artist Saucy German postcard, 1902

Philadelphia. Later, in West Palm Beach and Miami Beach, he became quite successful in that commercial field. On a visit to New York, he met Beaumont *Newhall who supported his efforts, as did Ansel *Adams and Alfred *Stieglitz. Moving to New York finally, he befriended *Man Ray, Piet Mondrian, and others in the city's art world and, still only in his twenties, began to be invited to exhibit his work. By the 1940s and later he was frequently commissioned to do portraits by major magazines, *Life, Fortune, and *Harper's Bazaar among them. Newman's style of portraiture masterfully integrates his subject within a setting reflective of that person's profession and personality. Widely travelled and honoured, Newman became a visiting professor at Cooper Union in New York in 1975. TT

New Objectivity. See NEUE SACHLICHKEIT.

news photography. See AGENCIES, PHOTOGRAPHIC; PHOTOJOURNALISM; WAR PHOTOGRAPHY.

Newton, Helmut (1920–2004), Berlin-born Australian fashion photographer whose vision of an aggressively confident and predatory form of female sexuality dominated the last third of the 20th century, when his career was at its zenith. Determined to be a photographer from his teens, Newton served an apprenticeship with the fashion and theatre photographer Yva (1900–42). His Jewish background compelled him to emigrate in 1938, first to Singapore, then Australia, where he served in the army from 1940 to 1945. Influenced by the photojournalist Erich *Salomon and iconic fashion photographers like de *Meyer, *Steichen, and *Penn, he moved to Melbourne, where his career as a freelance began. Settling in Paris in 1957, he worked for international titles such as *Jardin des modes*, *Queen*, *Playboy*, *Elle*, and *Nova*, quickly establishing his signature oeuvre with images of powerful, seemingly 'machine-made' women in aggressively sexual roles. Captured almost exclusively in settings associated with the jet-set elite, Newton's photographs spoke of an intensely personal fantasy world where women are simultaneously dominant and dominated. Inspired by the nocturnal worlds created by European modernists like *Brassaï and fascinated by the burgeoning—then principally Roman—genre of *paparazzo* photography, Newton's interest in *voyeurism extended to using night-vision telescopes and binoculars. His erotic idiom was most prominent in the 1970s in magazines like French and American *Vogue*, associated with products by such groundbreaking 20th-century designers as Yves Saint-Laurent, Ungaro, and Chanel.

Newton once remarked that he liked his fashion models to be built like truck drivers; his most appealing nudes are private images of friends and of his wife, the photographer Alice Springs (June Brown; b. 1923). He died in a car crash on Sunset Boulevard in January 2004. PM

Kelly, I. (ed.), *Nude: Theory* (1979).
Felix, Z. (ed.), *Helmut Newton: Selections from his Photographic Work* (1994).
Contacts: les plus grands photographes dévoilent les secrets de leurs images, 1 (DVD, 2000).

Newton's rings. These are the fringes seen when a pair of surfaces that are not quite optically flat are brought into contact and transilluminated. They are formed by interference between the wavefronts reflected between the two surfaces. Their shape forms a guide for lens makers, who position the lens on its pattern under mercury light, and check the rings for number and uniformity.

Newton's rings can be a nuisance when they occur in a slide mounted between glasses or in the negative stage of an enlarger. They can be avoided by using glasses given a special antireflective coating. GS

New Topographics exhibition. Conceived by William Jenkins, assistant curator of 20th-century photography at the International Museum of Photography, Eastman House, in 1975, it featured photographs of man-altered landscapes or, more accurately, lands *upon* which humans have erected houses, buildings, and other structures that attest their presence (though actual people are eerily absent). A form of *documentary photography, the images were not intended to be judgemental—though in hindsight they are extraordinarily telling about urban sprawl and other environmental issues. The photographers included were Robert *Adams, Lewis *Baltz, Bernd and Hilla *Becher, Joe Deal, Frank Gohlke, Nicholas *Nixon, John Schott, Stephen *Shore, and Henry Wessel, Jr. TT

New Vision (Neues Sehen, Neue Optik), term associated with the experimental ideas of László *Moholy-Nagy, whose book *Von Material zu Architektur* (1929), summarizing his foundation teaching at the *Bauhaus, appeared in the USA in 1932 as *The New Vision: From Material to Architecture*. However, it is sometimes used more loosely to characterize a variety of avant-garde and modern (including humanist-documentary) post-pictorialist styles in Europe and America since the 1910s. RL

Hambourg, M. M., and Phillips, C., *The New Vision: Photography between the World Wars* (1989).

New Zealand. Photographic history is contiguous with New Zealand's nationhood. In 1835 a confederation of northern Maori tribes announced a Declaration of Independence. In 1840 a bicultural nation was created by the Treaty of Waitangi. By the mid-1870s Canterbury had experienced the largest exponential growth of any new colony. These are the decades which saw the first negative, *calotypes, and the *dry plate. But New Zealand's geopolitical distance from the centres of photographic production meant that its frontier culture remained on the periphery in terms of the first early unique processes. Hence, *daguerreotypes are rare, as are calotypes. *Ambrotypes were popular from the 1850s to the 1860s, affordable to the well-off. The *wet-plate process quickly outperformed the limitations of its predecessors and was suited to the open and bushy landscape in New Zealand's bright sunlight.

New Zealand had many amateur gentleman-photographers who could afford the new medium, which in New Zealand largely supplanted painting. J. N. Crombie (*fl*. 1854–73) and W. F. Crawford

of Hawke Bay, active in the 1850s, were two such. In Canterbury A. C. Barker produced some notable interiors, and views of the burgeoning city of Christchurch and its ruling citizens. Both Crawford and Barker were politicians. Another amateur was the Anglican clergyman and teacher John Kinder (1819–1903).

Mid- to late 19th-century New Zealand was beset by political unrest, but little of this was deemed suitable for the camera. In general, early photography was too difficult and expensive a medium to be a reliable recorder of social, military, and public events. Such photographs as do exist are highly prized. Militiamen, however, flocked to studios to have their likenesses taken before going out to quell disturbances. A few photographers, like Harding or Daniel Manders Beere, ventured outdoors to capture some action or depict prisoners. Photographs were either views or landscapes, but mostly portraits. Enterprising immigrants were keen to record their new-found success in the colony and many a homestead was also proudly photographed. At the very least, *cartes de visite could be sent to relations abroad.

The advent of the *dry plate made the photographer's work much easier, with *tourist photography especially benefiting. The country had for several decades enjoyed a reputation as a South Seas paradise, and studios such as *Burton Brothers in Dunedin (eventually taken over by Muir & Moodie) faced increasing demand for souvenirs of sights like Rotorua, Lake Taupo, and the Whanganui River.

As cartes and cabinet prints gave way to *postcards, studio portraits became more affordable. *Pictorialism dominated New Zealand photography from the early 1900s to the 1950s, as photographers followed overseas models and achieved some success in international salons with technically accomplished but derivative work. The arrival of 35 mm had some impact, though mostly in encouraging street photographers. It was not until the 1960s that an awareness of European and American avant-garde photography began to be felt, largely as a result of photographic publications.

Post-pictorialist photography as an expressive medium was also stimulated by immigrants such as the Czech Frank Hofmann (1916–89) and the American-trained John Fields (b. 1938). *Documentary photographers have included John Pascoe (1908–72), Les Cleveland, and Dutch-born Ans Westra (b. 1936), who has depicted Maori life. From the 1960s, poetic realism came to the fore, with the magazine PhotoForum (f. 1970) influential through its editorial policy and some exhibitions. Of later generations, Laurence Aberhart (b. 1949) has focused on indigenous and colonial architecture, usually devoid of people. The more accessible work of Peter Peryer (b. 1941) has received greater international acclaim. The intensely personal work of Rhondda Bosworth and Janet Bayly (b. 1955) done, respectively, in black-and-white and SX-70 Polaroid, has addressed gender concerns. Prior to the advent of *digital technologies, most colour processes were vigorously explored. However, New Zealand has suffered from its geographical remoteness from the international photography scene—or scenes. There are considerable collections nationwide, but no departments of photography in major art galleries. The New Zealand Centre for Photography seeks to address this situation. DJL

See also NATIVE PEOPLES AND PHOTOGRAPHY.

Main, W., and Turner, J. B., New Zealand Photography from the 1840s to the Present/Nga Whakaahua O Aotearoa mai I 1840 ki naianei (1993).
McCredie, A., and Main, W., Photographers in Search of a Nation (4 vols., 1993–5).

Nicholls, Horace (1867–1941), English photojournalist and war photographer. After working in Chile and Johannesburg, and successfully covering the Boer War, Nicholls established himself as a freelance photojournalist in London in 1902. He specialized in the regattas, horse races, and social events of the English 'season', often using *composite printing and other manipulations to enhance his pictures' saleability. In 1917–18 he made a powerful series of photographs of female war workers for the Department of Information. Subsequently, until 1932, he worked at the new Imperial War Museum. RL

Buckland, G., The Golden Summer: The Edwardian Photographs of Horace W. Nicholls (1989).

Niépce, Joseph Nicéphore (1765–1833), French photographic inventor. He was the son of a lawyer at Chalon-sur-Saône, Burgundy, and, apart from a period in the army, spent most of his inventing life at the family estate at Gras in Saint-Loup de Varennes. Baptized Joseph, he began to use the name Nicéphore in his early twenties, while enrolled at the Oratorian college in Angers, where he learned the science and experimental methods that enabled him to work on such diverse projects as the combustion engine, dyeing, and photography. In 1807, he and his brother Claude (1763–1828) obtained a patent for their pyréolophore, a boat engine driven by internal combustion.

Niépce began his photographic experimenting no later than the spring of 1816, half a year before his search for a native lithographic stone. This suggests that his photographic experiments led him to lithography, although his son Isidore (1805–68) suggested the opposite. In search of a satisfactory positive image he employed many substances, among them bitumen of Judea, lavender oil, gum guaiacum, and vapours of iodine, on supports of paper, stone, silver, and pewter. He succeeded with an impractical but functional process in the 1820s both in copying engravings and in capturing points de vue, direct positive images made with the camera obscura. In 1827, Niépce travelled to London via Paris, visiting the engraver Augustin Lemaître (1797–1870) and Louis *Daguerre, the former already a colleague, and the latter soon to be his partner. Although Niépce attempted to interest King George IV, the Royal Academy, and the Royal Society in his héliographie, his inability to market the invention properly, internecine politics in the Royal Society, and the absence abroad of both Sir John *Herschel and Henry *Talbot at the time ensured his failure. He dejectedly returned home, leaving behind the picture known as *View from the Study Window (Point de vue du Gras à Saint-Loup de Varennes; 1827). In 1829, Niépce brought his experiments and

Horace Nicholls
Henley Regatta, 1912

chemical knowledge into a partnership with Daguerre that was, with Daguerre's recognition of the *latent image, to lead directly to the invention of the *daguerreotype. KEW

Marignier, J. L., *Niépce: l'invention de la photographie* (1999).
Bajac, Q., *The Invention of Photography*, trans. R. Taylor (2002).

Niépce de Saint-Victor, Abel (1805–70), French photographic inventor. An army lieutenant and cousin of Nicéphore *Niépce, he first experimented in 1847 with negatives made with albumen on glass, a method subsequently used by the *Langenheim brothers for their lantern slides. At his laboratory near Paris, Niépce de Saint-Victor worked on the fixation of natural photographic colour as well as the perfection of his cousin's heliographic process for *photomechanical printing. His method of photomechanical printing, called heliogravure, was published in 1856 in *Traité pratique de gravure héliographique*. In the 1850s he also published frequently in *La *Lumière*. KEW

Towler, J., *The Silver Sunbeam* (1864).

night photography. Taking pictures after dark, by moonlight or streetlighting, is a technique that many photographers have attempted. It involves a tripod-mounted camera with the shutter left open until enough light has reached the film to create a properly exposed negative. Even with today's fast films, exposures can be many minutes long, especially for pictures created by moonlight alone. (Comparable

principles apply to *digital photography, with low ISO-equivalent sensitivity recommended to limit *noise). Many problems beset the night worker, such as:

- **Reciprocity failure*. An exposure adjustment which is needed with film exposures longer than one second. The correction is exponential, i.e. the longer the duration of the original exposure, the greater the correction needed.
- **Flare*. Stray light from streetlights included within the frame can seriously degrade image quality. Strong light sources just out of the image area can also cause flare, but can be eliminated by shading the lens.
- *Casts*. Odd colour shifts caused by using colour film under mixed lighting, combined with long exposures, which in themselves can cause different colour effects. This can either be frustrating or exciting, depending on the type of image expected.
- *Movement*. Long night exposures cause moving objects to record as streaks or lines. This can be a nuisance, or can be used to good effect, for instance when photographing the movement of stars or traffic.

One photographer's problem is another's creative opportunity; there are no absolute rules. While the camera shutter stays open, foreground objects can be 'painted' with flash or torchlight, or slow-synchronized flash can be used to freeze foreground action during long exposures. Night photography requires much time and effort to

produce consistently good results. It can, however, impart theatricality and beauty to an otherwise ordinary scene, and many have been seduced by its dramatic possibilities.

Some of the earliest successful night pictures were by Paul *Martin in 1896, making 10- to 45-minute exposures along the Thames Embankment. They caused a stir, and his lantern-slide series *London by Gaslight* won a *Royal Photographic Society gold medal; subsequently a Society of Night Photographers was founded in London. Martin's pictures were admired by Alfred *Stieglitz, whose wet-street image *Night, New York* was taken in 1897, and followed by other nocturnes later. Urban night photography blossomed in the 1920s and 1930s, from Josef *Sudek in Prague to Berenice *Abbott in New York. In Paris, *Brassaï demonstrated his painstakingly acquired mastery of haunting nocturnal effects in *Paris de nuit* (1933). (He timed exposures with cigarettes: a slow-burning Boyard 'bleu' or sparkier Gauloise 'jaune' according to need.) The dimly lit suburban streets and café windows reflected on wet cobblestones of Marcel Bovis (1904–97) recall the romantic French films of the period. Meanwhile, Bill *Brandt published *A Night in London* in 1938, and continued to photograph during the eerie conditions of the wartime blackout. One of the last of the great black-and-white night photographers was O. Winston *Link, who between 1955 and 1960 produced a classic body of nocturnal steam-train images. AS

See also FIREWORKS; TWILIGHT.

Bauret, G., *Marcel Bovis: promenades parisiennes* (1996).
Tucker, A. W., *Brassaï: The Eye of Paris* (1998).
Night: Photographs of Magnum Photos (1998).
Sanderson, A., *Night Photography* (2001).

Nikon F. This did more than any other single-lens reflex (SLR) camera to enhance the reputation of the Japanese photographic industry and its products. Introduced in 1959, it quickly became a best-seller and professionals' choice. Although not the first SLR, it incorporated features that made it particularly appealing. Its superlative build quality made it attractive to professionals, notably photojournalists in combat situations; the viewfinder gave a 100 per cent view; it came with a range of accessories including a four-frame-per-second motordrive; and it was immediately available with lenses from 21 mm to 500 mm. The Nikkor lenses, especially, were recognized as being of exceptional quality.

Between 1959 and 19 May 1974, when production ended, 862,600 cameras were made. Users included such legendary names as Don *McCullin, W. Eugene *Smith, David Douglas *Duncan, Alfred *Eisenstaedt, and nearly every photographer on *Life* magazine from 1960 until its close. It was also standard equipment at *National Geographic* and United Press International (UPI). Its use in Vietnam and at most demonstrations in the 1960s confirmed its iconic status.

The Nikon F was instrumental in helping the SLR and 35 mm film gain acceptance amongst professionals, encouraged consumer acceptance of Japanese photographic equipment, and helped to start the development of 'system' SLR cameras with a range of lenses and accessories designed to work with and complement each other. Subsequent Nikon models, with the F2 from 1971, extended this concept. MP

Cooper, J. D., and Abbot, J. C., *Nikon F Nikkormat Handbook of Photography* (1968).
Matanle, I., 'Right from the Start', *Amateur Photographer*, 200/3 (26 July 2003).

Nikonos camera. See UNDERWATER PHOTOGRAPHY.

Nilsson, Lennart (b. 1922), Swedish photojournalist and celebrated *medical photographer. Working with scientists and contributing directly to the development of photographic technology, Nilsson has continually expanded the limits of imaging the human body. Few photographs are better known than his of the growing foetus, and his book *A Child Is Born* (1965), depicting life from conception to birth, has been published in over twenty countries; the 1965 *Life* issue featuring Nilsson's photographs sold out its print run of 8 million copies in four days. Nilsson's career began with magazine photography, making an international breakthrough with a picture essay on a polar-bear hunt in 1947. He was under contract to *Life* 1965–72. With human biology as his special field, Nilsson's recent achievements have included images of the biochemistry of human love, and sensational photography of the HIV virus. He has received numerous awards for both still photography and TV productions. NASA's *Voyager I* and *Voyager II* probes both carried photographs from *A Child Is Born* on their journeys into space. J-EL

Nilsson, L., *Hans livs bilder* (2002).

Nimslo camera. See THREE-DIMENSIONAL PHOTOGRAPHY.

'9/11'. See WORLD TRADE CENTER, NEW YORK, DESTRUCTION OF.

Nixon, Nicholas (b. 1947), American photographer. Born in Detroit, Nixon studied American literature at Michigan University. In 1974, the year he received an MFA from New Mexico University, he participated in the *New Topographics* exhibition at the International Museum of Photography, George Eastman House. Working almost exclusively with a 20.3 × 25.4 cm (8 × 10 in) view camera and contact prints, Nixon is known for his extraordinary photographs of ordinary people: his family—including an ongoing series of his wife Bebe and her sisters—residents of nursing homes, nudes, AIDS sufferers, and the inhabitants of small towns and city neighbourhoods. TT

Galassi, P., *Nicholas Nixon: Pictures of People* (1988).

Noir limite, French avant-garde group founded in January 1986 by Jean-Claude Bélégou (b. 1952), Florence Chevallier (b. 1955), and Yves Trémorin, and dedicated to a body-centred photography challenging the limits of what was culturally acceptable and technically possible. Its 1987 exhibition *Corps à corps* provoked a scandal and police intervention. Its last show, *Death*, was held in a former slaughterhouse in Le Havre. It dissolved itself in April 1993. RL

Nicholas Nixon

Bebe and I, 1998

noise, mottling or colour-speckle interference in *digital images, usually in shadow areas and at sensitivity equivalents of ISO 400 or higher. Noise levels are related not just to the number of pixels in a sensor but also to their configuration and architecture, and to the camera's processing algorithms. Sustained research by manufacturers has reduced noise, in high-end cameras, to a level at or below comparable *grain in film. RL

Nojima, Yasuzo (aka Kozo; 1889–1964), Japanese photographer. The son of a banker, he could afford to experiment with the new medium of photography. He belonged to the Tokyo Shashin Kenkyukai (Tokyo Photo Study Group) from 1910, opened a portrait studio in 1915, and ran a gallery from 1919 to 1920. He then opened a salon at home for exhibitions. Inspired by developments in Europe, he turned from *pictorialism to a more experimental style, working predominantly with *gum bichromate and later *bromoil prints. He posed his human subjects as carefully as he would his still lifes, in dynamic compositions with strong gazes. Co-founder, with Ihei *Kimura and Nakayama Iwata, of the photo-art magazine *Koga in 1932, he placed images from his portrait series *Woman* in every issue, shaping the journal's character. He exerted a powerful influence on young photographers of his time. MHV

non-silver processes. See ALTERNATIVE (NON-SILVER) PHOTOGRAPHIC PROCESSES.

Norway. See SCANDINAVIA.

nota roja (bloody news). See METINIDES, ENRIQUE; POST-MORTEM AND MEMORIAL PHOTOGRAPHY.

Nothhelfer, Gabriele and **Helmut** (both b. 1945), German husband-and-wife team of documentary photographers, resident in Berlin. In 1973 they embarked on a long-term project on leisure and alienation, a series of studies of consenting ordinary individuals in public places. Cumulatively, their images of sad rich people at motor shows, or middle-aged men at Catholic festivals, convey a sense of angst and emptiness in the midst of plenty. RL

Honnef, K. (ed.), *Lange Augenblicke: Gabriele und Helmut Nothhelfer* (1993).

Notman, William (1826–91), Scottish-born Canadian photographer who emigrated to Montreal in 1856 after a financial scandal terminated his textile business. A keen amateur photographer, he founded a studio which soon excelled in hand-coloured portraits, composite group photographs, staged snowscapes and hunting scenes, and views. Notman also created celebrated construction photographs of the huge Victoria Bridge across the St Lawrence, completed in 1860. By 1874 the studio employed 55 people and was producing 14,000 photographs annually. It also dominated the lucrative college graduation business north and south of the US border and, via the Centennial Photographic Company, participated profitably in the 1876 Centennial Exposition in Philadephia, pioneering a system of photo-identity passes in the process. In the 1870s and 1880s several employees, and Notman's eldest son, photographed the surveying and construction of the Canadian Pacific Railroad. New branches were founded, and by the time Notman died the family was or had been involved in *c*.26 studios, nineteen of them in the USA.

Although the firm later contracted, the core business in Montreal survived. Notman's youngest son Charles sold it to Associated Screen News in 1935, but remained involved with portraiture until his death in 1955. In 1956, *c*.400,000 Notman photographs and many of the firm's records were transferred to the McCord Museum at McGill University. RL

Dodds, G., Hall, R., and Triggs, S., *The World of William Notman: The Nineteenth Century through a Master Lens* (1993).

Nozolino, Paulo (b. 1955), Portuguese photographer and film-maker, from 1989 based in Paris. After training as a painter in Lisbon, he took up photography in 1972, then studied at the London College of Printing before embarking on a period of worldwide travel. Much of his work has focused on the traditional cultures of North Africa and the Middle East, but he has also produced urban images that seem reminiscent of Robert *Frank. LAL

Siza, M. T., and Weiermair, P. (eds.), *Livro de viagens: Portugiesische Photographie seit 1854* (1997).

nuclear explosions, photography of. Official photographs were taken of the first atomic bomb test at Alamogordo, New Mexico, on 16 July 1945, but a failed projector prevented them being used to brief the airmen detailed to attack Japan. The bombing of Hiroshima on 6 August was recorded by Sergeant George R. Caron using a hand-held K-20 aerial camera in the tail of the B-29 bomber *Enola Gay*; photography from fixed cameras was thwarted by the manoeuvring of the aircraft. The Nagasaki attack on 9 August was also photographed, and pictures were released to the press on the 11th, the day Japan surrendered. On the 17th, *Time* published eight images of the Alamogordo test. On 19 November, *Life* published a full-page colour photograph of the event.

Photography of post-war American tests was at first strictly controlled. But from 1952, detonations in Nevada became more easily accessible to the press, and photographers and editors increasingly tended to aestheticize them, constructing an 'atomic sublime' (Peter Hales) that masked the weapons' destructiveness. Black humour also crept in: a 1951 *Life* photograph captured a delicate puff of atomic cloud floating towards the phantasmagoric Las Vegas skyline. In the meantime, Harold *Edgerton's company, EG&G, was devising equipment that could capture the intense heat and light of an explosion from 7 miles' distance and at speeds of 1/100,000,000 s.

Images of atomic devastation were slower to reach the public. The Japanese press photographer Yoshito Matsushige managed to take five usable pictures of the damage in Hiroshima on 6 August 1945 but, although the negatives escaped confiscation by the Americans, they were not published in *Life* until September 1952. (Yosuke Yamahata took similar pictures in Nagasaki.) In March 1953 *Life* showed the effect of an atomic blast on houses and their (dummy) inhabitants, revealed with surreal clarity by cine-frame enlargements; and, a year later, pictures of the crew of the Japanese fishing boat *Lucky Dragon*, irradiated by fallout from the first H-bomb test on Elugelab Island. An outsize transparency of the fireball was chosen by Edward *Steichen as the only colour image in the 1955 *Family of Man* exhibition. The year 1958, finally, saw the appearance of Ken *Domon's chilling study of bomb survivors thirteen years on, *Hiroshima*. RL

Leo, V., 'The Mushroom Cloud Photograph: From Fact to Symbol', *Afterimage*, 13 (1985).

Fermi, R., et al., *Picturing the Bomb: Photographs from the Secret World of the Manhattan Project* (1995).

Hales, P. B., 'Imagining the Atomic Age: *Life* and the Atom', in E. Doss (ed.), *Looking at Life Magazine* (2001).

Light, M., *100 Suns. 1945–62* (2003).

nude photography

To 1920

It seems likely, though not absolutely certain, that the first nude photograph was taken almost immediately after the medium was born. At all events, the optician Nicolas Lerebours, a photographer and author of technical manuals, claimed to have produced them from 1841. But the daguerreotyped nudes that have survived are mostly anonymous and hard to date precisely. As with portraits, however, there was a lively trade in nudes from an early stage. The ostensible purpose of these images—known as *académies*—was to serve as studies, or life documents, for painters and sculptors. They were therefore considered not as works in their own right but as a convenient bridge between the reality of the model and the finished work of the artist, who thereby saved himself wearisome and sometimes expensive drawing sessions. Delacroix wrote in his journal that photography was 'the palpable demonstration of the delineation of nature's true form, of which we otherwise have only the most imperfect idea'; he, and other painters who were more discreet about their methods, like Gérôme or Courbet, regularly used nude photographs from the early 1850s onwards. To meet the requirements of artists, or because they had neither the time nor the freedom to develop a properly photographic aesthetic of the human body, the first photographers who specialized in this field often produced inept versions of 'fine-art' nudes, modelled on the antique sculptures used in beginners' classes, Ingres odalisques, or studio props.

The liveliest—indeed, practically the only—production centre for nude photographs *c.*1840–*c.*1880 was Paris. The centre of artistic life, and a city with more tolerant attitudes than other capitals, it had

US Defense Nuclear Agency

The Fire Ball Rising: A-bomb test, Eniwetok Atoll, Marshall Islands, 1948

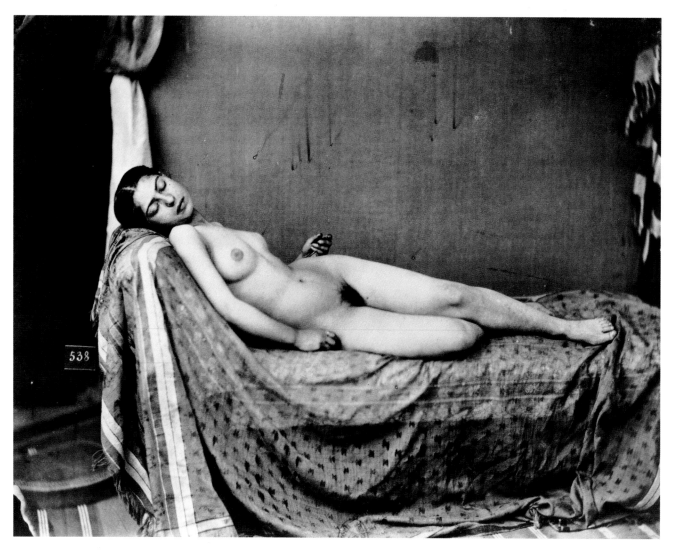

Louis-Camille D'Olivier

Nude, 1854. Salted-paper print

the photographers, models, and artists for these pictures, as well as other customers who were not necessarily interested in turning them into paintings.

From the 1850s onwards, production boomed. The painter Julien Vallou de Villeneuve (1795–1866) took up photography and created dozens of artistic *calotype nudes between 1852 and 1854, some of which were used by Courbet and Delacroix. Other artists, often also painters by training, like Louis-Camille d'Olivier (1828–after 1870) or Jacques Antoine Moulin (1802–after 1875), used charming models to create highly seductive *académies*. The question of whether these images were primarily artistic or erotic obviously raises fundamental issues about the photograph's realism in an area in which closeness to reality was a bonus for art. The ambiguity remains despite the fact that,

officially, these 'academic' studies were intended as study material for artists. Although the large preponderance of female photographic nudes compared with male ones matched that in painting, it can also be explained by demand from male collectors of nude photos. The police, who closely scrutinized the trade, banned the pictures from public display and only allowed them to be sold in the context of art training.

In fact certain photographers, such as Gaudenzio Marconi (1841–85) or Louis Igout (1837–after 1885), specifically identified themselves as suppliers of the École des Beaux-Arts, and their style, with its constant reference to classical gestures derived from painting and sculpture, and the studied simplicity of its settings, reduced the nude image's ambiguity to a minimum. Others who were well known

in different fields did occasional nudes, either (*Le Secq, *Nègre) in connection with their own paintings, or (*Nadar, *Le Gray) to meet special requests from artists.

Only a few photographers c.1850–c.1890 presented nudes as fully-fledged works in their own right. An example was the London-based Swede Oscar Gustav *Rejlander, whose ambitious, large-scale morality picture *The Two Ways of Life* used combination printing to incorporate large numbers of nude women, whose realism shocked the public when it was exhibited in 1857.

However, the emergence of *pictorialism towards the end of the 19th century created a new situation. Photography's assertive claim to be an art automatically secured the nude's entrée into the national and international salons held on both sides of the Atlantic in the 1890s and 1900s. Especially in France (Robert *Demachy, Émile Constant *Puyo) and the USA (Clarence *White, Alfred *Stieglitz, Edward *Steichen) fine examples were created which, with their indistinct backgrounds, selective treatment of detail, and often more or less veiled eroticism, resembled contemporary Symbolist (later Art Nouveau) paintings, prints, and drawings. Indeed, one of the leading exponents of the pictorialist nude, the expatriate American Frank *Eugene, used an etching needle among other manipulations to create an essentially graphic effect. Although past its peak by c.1910, pictorialism set a pattern for the 'salon nude' that was to remain a feature of mainstream exhibitions and photographic annuals into the 1950s: young and nearly always female, artfully posed and lit, without body hair, anonymous, and often with arch titles such as *Sans Souci* or *The Woodland Pool*.

From the 1870s and 1880s onwards, meanwhile, the use of nude photographs by artists had become increasingly commonplace, from Auguste Rodin, Alexandre Falguière, and Sir Lawrence Alma-Tadema to Gustave Moreau and Pablo Picasso. The list could probably be greatly extended if more photographic evidence had survived. Simpler technology also encouraged artists to take their own studio or open-air nudes: for example, painters such as Pierre *Bonnard, Edgar *Degas, André Derain, Thomas *Eakins, Ernst Ludwig *Kirchner, Edvard *Munch, Alphonse *Mucha, Franz Stuck, and José Maria Sert, illustrators like Heinrich *Zille, and sculptors such as François-Rupert Carabin and Antoine Bourdelle.

Finally, scientists also appropriated nude photography, especially those whose research was linked to the arts and to the representation of movement: e.g. Paul Richer (1849–1933), Albert *Londe, Eadweard *Muybridge, and Étienne-Jules *Marey. The physician Richer, Charcot's assistant at the Paris Salpêtrière, then from 1903 professor of artistic anatomy (on which he had published a classic textbook in 1889) at the École des Beaux-Arts, created demonstration pictures of male and female models in motion that included precise annotations of measurements and age. Richer worked closely with Londe, from 1882 the director of the Salpêtrière's photographic laboratory. Both knew the work of Muybridge and Marey. Over three decades from 1880 to 1910, these four scientists used instantaneous exposures and the systematic breaking down of movement to investigate every

aspect of the body in motion, its static poses and dynamic sequences, in the service of art.

<div style="text-align: right">SA</div>

Das Aktfoto: Ansichten vom Körper im fotographischen Zeitalter (1985).
Marbot, B., and Rouillé, A., *Le Corps et son image* (1986).
Le Corps en morceaux (1990).
The Most Beautiful of Nature's Work: Thomas Eakins's Photographic Nudes in their French and American Contexts (1994).
Pultz, J., and Mondenard, A. de, *Le Corps photographié* (1995).
Callen, A., 'The Body and Difference: Anatomy Training at the École des Beaux-Arts in Paris in the Later 19th Century', *Art History*, 20 (1997).

Since 1920

The 1920s were a time of economic, political, and social change, accelerated by the horrors of the First World War and a desire to reject the class inequality and political instability of the past. In American and European cities, affluence, consumerism, commercial mass entertainment, and the increased spending power and social freedom of women undermined traditional conventions and popularized self-consciously modern lifestyles. New illustrated newspapers and magazines, or modernized versions of existing ones, appeared, along with innovative ways of reporting political, cultural, and sporting events through the camera and the printed page. Later, especially in continental Europe, left- and right-wing totalitarian movements identified themselves with the creation of a 'New Man', and with modernistic or pseudo-modernistic utopias in which the healthy, youthful 'body beautiful', disciplined by collective sporting activity, would play an emblematic role. But in bourgeois-liberal and social democratic circles too, there were visions of a cleaner, healthier, more egalitarian society to be achieved by revolutions in urban planning and education and the construction of welfare states, sometimes underpinned by fashionable eugenic notions.

At first glance, the kind of nude photography that epitomized the period was the work of Martin *Munkácsi: sporty girls with bobbed hair doing healthy, modern things: jogging round pools, climbing into baths, or luxuriating under showers. But the variety of the genre was now much greater than before the war. Still ubiquitous was *pornography, by the 1920s largely in *postcard format, though often in traditional 'French' or fake-Orientalist guise, and available in legendary sleaze havens like Port Said and Soho. With a core clientele of soldiers, tourists, and schoolboys, and given a new lease of life by the Second World War, it flourished well into the second half of the century, until displaced by mainstream glamour magazines and ultimately video cassettes. Visible genitalia, provocative eye contact, and voluptuous poses were its hallmarks; *Atget's *Reclining Woman* (1920), of a friendly prostitute displaying herself for a long exposure, was its nearest approach to classic photography. Glamour photographs were less revealing and technically and aesthetically more polished. Specialists in Europe included the Vienna *Manassé Studio, which used starlets and cabaret artists as models and livened up its nudes with visual trickery, and in the USA experts in suggestive semi-nudity like Alfred Cheney Johnston (1893–1971); although, like Hollywood films, American glamour was increasingly censored in the 1930s.

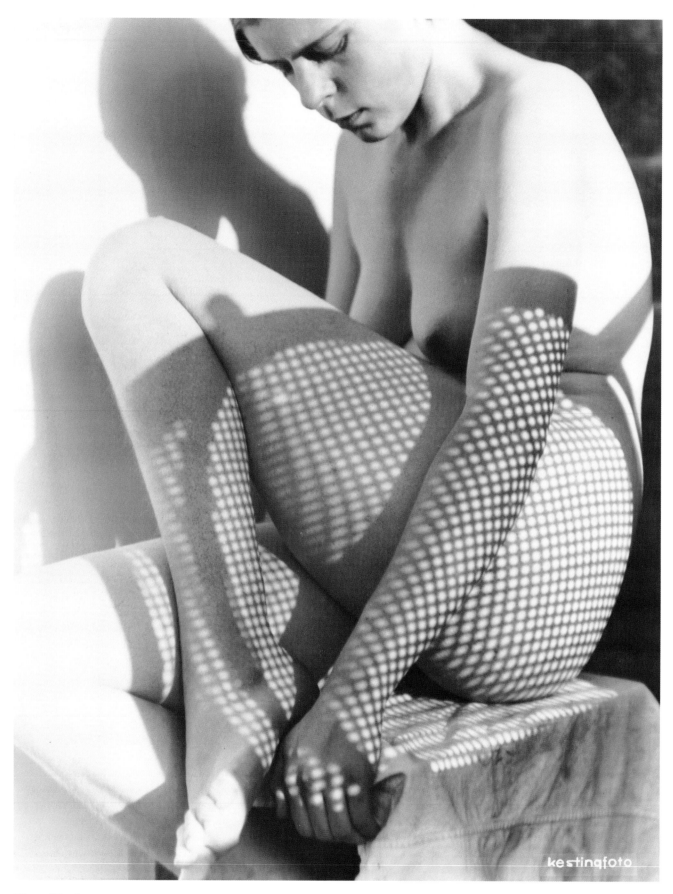

Edmund Kesting

Nude with shadows, 1931

Also widely circulated since before 1914 was 'naturist' imagery, an offshoot of the Central European *Lebensreform* movement with its sun cults and rejection of body-deforming modern clothing. The photographic nudes in naturist magazines and books like Franz Löwy's *Das schöne nackte Weib* (1921) illustrate the benefits of various diets and regimes, or different physical or ethnic types; the more stylish and dynamic prefigure the athletes and dancers of Leni *Riefenstahl.

Outside the mainstream, the avant-garde nude was characterized by formal and technical experimentation, wit, eroticism, and sometimes undertones of fetishism and sadomasochism. Techniques used to make the human body strange included *solarization and negative printing (*Man Ray, *Moholy-Nagy, *Feininger), the distorting properties of certain lenses (*Brassaï, *Kertész), and the use of shadows, mirrors, and surreal juxtapositions (*Kesting, Imogen *Cunningham, George Platt *Lynes). This work, much of it done in Paris, remained widely influential, from Bill *Brandt in England to Grete *Stern in Argentina. Another astonishingly productive concentration of nude photographers was in Prague, where Anton Trcka (1893–1940), Jaromir *Funke, František *Drtikol, Josef *Sudek, and others moved between a range of styles from late pictorialism to Surrealism and abstraction. But some of the most outstanding modern nudes of the period between the 1920s and the 1940s were created in the USA, by Alfred *Stieglitz and Edward *Weston. Stieglitz's reputation in the field rests on pictures of friends like Rebecca Salsbury-Strand at Lake George in upstate New York in the 1920s, and on a long series of probing and intimate studies of his wife Georgia O'Keeffe. Weston's derives from the nudes modelled by Tina *Modotti and other lovers in the 1920s, after he had abandoned pictorialism, and from pictures of his second wife Charis Wilson in the 1930s and 1940s. The best work of both photographers succeeds and moves through its balance of abstract, erotic, and naturalistic elements, endowing real anatomies with sculptural form.

The variety of nude photography increased still further after 1945. Between the 1940s and the 1970s, Brandt, another of the century's great nude photographers, used chiaroscuro, close-ups, and wide-angle distortion to explore the nude as abstract form. On Sussex beaches, ears like shells, hair like weed, and boulders of flesh appear as objects of contemplation, surreal and strange. The influence of Brandt's work, which itself looked back to Brassaï's and Kertész's nudes of the 1930s, remained strong, for example on Japanese photographers like Eikoh *Hosoe and Kishin *Shinoyama.

In the background the cultural context was changing again. As social mores became more liberal and censorship declined in the 1960s, there was an upsurge of nudity in the arts and mass culture of the West. Countries like Portugal and Spain, which until 1974 and 1975 had endured years of clerical-authoritarian dictatorship, underwent periods of intense cultural experimentation which, at least in cities, included discovery of the photographic nude. The same would happen after the end of the communist regimes in Eastern Europe (1989–90).

An obvious consequence was a vast expansion of commercial glamour photography, extending from tabloid newspapers and lifestyle magazines to 'top shelf' publications whose only selling point was nudity, supported by sexually explicit text. Long-standing taboos on pubic hair and genitalia disappeared, and magazines like *Playboy, which had symbolized anti-puritanism in the 1950s, looked old-fashioned by the 1970s. Amateurs also experimented, as technical manuals and sometimes clubs increasingly offered tips on shooting 'glamour'. Although by the 1990s there were signs of a new prudishness emerging, especially in relation to depictions of children, the display and marketing of nudity on an immense scale seemed to have become fundamental to Western civilization.

This had important implications for 'serious' nude photography. On the one hand, the decorous neo-pictorialist nude finally disappeared during the 1960s. On the other, male nude photography, formerly an under-the-counter product no matter how seriously done, became increasingly acceptable, at least in big-city galleries and art-publishing circles, and artists like Robert *Mapplethorpe joined the mainstream. Meanwhile, an important strand of nude photography remained strongly influenced both by Brandt and by the modernism of the inter-war period, with its emphasis on the body as pure form, either 'museumized' in isolation or discovered naturally in the open air, entwined in trees or lapped by waves. A major exponent of this was Lucien *Clergue, whose first collection of Mediterranean nudes, *Corps mémorables*, appeared as early as 1957, and who spent his subsequent career depicting the (mainly female) nude as a kind of sculptural revelation in quarries, deserts, on beaches, and in city buildings. Franco *Fontana followed in colour, creating abstract compositions with trees, pools, and magnificent torsos (*Frammenti*, 1982).

A contrasting response to the ubiquitous 'glamour nude', with its glossy, blemish-free surface and defining lack of intimacy, has been in the direction of realism and, precisely, intimacy: the nude as naked *person*. Anticipated decades before by amateurs like *Bonnard, *Andreyev, and *Lartigue, this has characterized the work of photographers like Harry *Callahan, Emmet *Gowin, and Nicholas *Nixon who—like Stieglitz and Weston—have photographed partners or spouses over years or even decades. (David *Bailey's brilliant study of Marie Helvin, *Trouble and Strife* (1980), also deserves mention, although intimacy is often blocked by visual gimmickry). Less tender and more detached, but comparable in their rejection of glamour and artifice, are Lee *Friedlander's *Nudes* (1991): young women in unkempt domestic settings, plainly lit and with skin blemishes, body hair, and genitals exposed to the camera in matter-of-fact, even casual self-revelation. Other photographers have moved further along the scale of realism in their pursuit of 'the nakedness of the human creature', confronting the viewer with bodies that are old, deformed, or hermaphroditic. Representative of this approach is the group of photographers associated with the Internet magazine *Nerve*. But still more extreme in his rejection of the idealized, commercial nude has been Boris

*Mikhailov, whose photographs of naked or semi-naked slum dwellers, alcoholics, and homeless people seem like a deliberate of parody of the Western glamour industry. RS/RL

Jay, B., *Views on Nudes* (1979).

Kelly, J. (ed.), *Nude Theory* (1979).

Clergue, L., *Nude Workshop* (1982).

Nudes, introd. S. Callahan and P. Olschewski (1995).

Richter, P.-C., *Nude Photography: Masterpieces from the Past 150 Years* (1998).

Boris Mikhailov: Case History (1999).

Field, G. (ed.), *Nerve/The New Nude* (2000).

Pohlmann, U., et al., *The Nude: Ideal and Reality. From the Invention of Photography to Today* (2004).

nuit américaine. See TWILIGHT.

Nurnberg, Walter (b. 1907), German-born British photographer. Brought up in Berlin, he originally hoped to be a musician, but gravitated towards advertising. He began studying photography in 1930 and, after emigrating in 1933, opened an advertising studio in London. His first big assignment was to advertise GPO greetings telegrams. Later he joined *Kraszna-Krausz's stable of writers at the Focal Press. Ultimately, however, he became one of post-war Britain's outstanding *industrial photographers, applying a modernistic, sometimes abstract vision to the representation of objects and processes. His book *Lighting for Photography: Means and Methods*, first published in 1940, remains a classic. RL

Ward, J., 'The Walter Nurnberg Photograph Collection at the National Museum of Photography, Film & Television, Bradford', in B. Finn (ed.), *Presenting Pictures* (2004).

Obernetter, Johann Baptist (1840–87), Bavarian photo-chemist. Born into a civil service family in Munich, he studied chemistry with Bunsen, Liebig, and Pettenkofer, and in the early 1860s worked briefly for the photographer Joseph *Albert. Practical experience convinced him that two of photography's biggest problems were the impermanence of printing processes and prodigious consumption of silver. Obernetter's achievements included the invention of silver-free photographic papers and significant improvements to the *powder 'dust on' and *photoceramic processes. He also worked on early colour photography. RL

Gebhardt, H., *Königlich bayerische Photographie, 1838–1918* (1978).

occultism and photography. For photographic historians, occult imagery is a new field of investigation. Formerly the concern of collectors and niche publications, it did not feature in historical research until the 1990s. But novelty is only one of the difficulties associated with it. Occultism being, by definition, hidden, its archives are hard to access; and photographs that render it visible, still more so. This practical problem is compounded by an epistemological one. Occultism is a vast field embracing widely divergent beliefs (contrasting, for example, powers of the living versus manifestations of the dead) and approaches (commercial versus experimental), often embodied in the same visual forms. Since a purely photographic approach to occult iconography is inadequate, it is necessary to proceed via the history of occultism itself. From this perspective three categories of occult photographs emerge.

Spirit photography
In the 1850s there were various descriptions of translucent likenesses of dead people appearing on photographs. But it was an American, William Mumler (d. 1884), who in 1869 turned spirit photography into a business. He offered to photograph his clients in the company of one or more ghosts, invisible when the exposure was made but discernible on the developed photograph. The contemporary spiritualism craze in the USA contributed to Mumler's success and the proliferation of photographic mediums. The first European ones, Frederick Hudson in London and Jean Buguet in Paris, appeared at the beginning of the 1870s. This first, essentially commercial, phase of spirit photography was accompanied by various processes which, according to their outcomes, either boosted or discredited the practice. But a strong revival was prompted by the millions of deaths in the First World War and families' desperation to make contact with their loved ones. It was especially strong in England, associated with mediums like William Hope (d. 1932)—leader of the 'Crewe circle'— and Emma Deane, and personalities such as Sir Arthur Conan Doyle (1859–1930), and was experimentally rather than commercially orientated. Remnants of it persist today. But although the aim is still to capture spirit images, modern media such as television and the Internet are favoured.

Effluviography
In the last decades of the 19th century, occultism was riven by conflict between supporters of spiritualism and those of animism. The former believed that the explanation for occult phenomena lay in the world beyond, while the latter attributed them to the power of mediums. This division favoured the development of effluviographical imaging: the cameraless capture, directly on a sensitized plate, of 'fluids' emanating from the medium: the soul, the vital force, but also thoughts and dreams. After preliminary work by Karl von Reichenbach (1788–1869) in 1861, this became prominent in the 1890s, benefiting from the respectability of research on radioactivity and X-rays. In France, Dr Hippolyte Baraduc (1850–1902) and Louis Darget attempted to photograph thoughts or psychic energy ('the light of the soul') simply by placing foreheads or fingers on a photographic plate. Despite refutations by experts, who argued that the results claimed by the 'effluvists' were merely technical accidents, these experiments continued throughout the 20th century. Semyon and Valentina *Kirlian in the 1940s, Ted Serios and Armando Salas Portugal twenty years later, revisited the field. 'Aura photography', practised commercially by many operators today, is its latest manifestation. In moving from the experimental to the commercial it has taken an opposite course to that of spirit photography.

Supernatural photography
The third category of occult photography is the largest and most diverse. It goes back to the beginnings of photography itself and covers images of various phenomena: hypnosis, levitation, telekinesis, poltergeists, ectoplasms, etc. It also includes 'fairy pictures' (as at *Cottingley), or images of legendary creatures (the Yeti, the Loch Ness monster), or UFOs. Fundamental to this type of photograph compared with the others is that it does not show 'the invisible', but more or less what an observer present during the exposure could have

seen. Supernatural photography is not an investigative tool that sees what the eye cannot, but a mere documentary record. CC

Baraduc, H., *L'Âme humaine* (1896).

Conan Doyle, A., *The Case for Spirit Photography* (1922).

Krauss, R. H., *Beyond Light and Shadow* (1995).

Fischer, A., and Loers, V. (eds.), *Im Reich der Phantome* (1997).

Le troisième oeil. La photographie et l'occulte (2004).

Oceania. Photography spread only gradually across this vast region. Samoans, Hawaiians, and Maori in New Zealand as well as European settlers, missionaries, and naval officers had been photographed in the late 1840s and early 1850s. The first photograph of a Papuan (taken in Sydney) was not until 1876. French expeditions probably carried equipment to the Pacific Islands in 1840, but photographs from this period are rare or unverified. Amateurs and professionals soon settled in port towns across the Pacific, but visiting expeditions, colonial officials, and later tourists provided most of the early images entering the public domain. An imagined 'South Seas' paradise, evoked by philosophy, literature, and the art of early European voyages, was made publicly accessible by photographs of palm-fringed beaches, partially clothed women, and lagoon sunsets. Costumed warriors with clubs, alleged cannibals, and mountain villages confirmed what was already familiar to European audiences: a paradise waiting to be possessed by trading companies, colonial empires, and missions; and by scientists seeking to classify everything from north Pacific Chamorro 'types' in the Marianas archipelago to stone *Moi* on Rapa Nui (Easter Island) in the south-east. Photographic studios such as those of *Dufty in Fiji, the Tattersalls in *Samoa, *Lindt in Melbourne, Kerry in Sydney, Gibson in Port Moresby, and Hughan in Noumea later supplied images that were widely disseminated.

Half-tone reproduction in the mid-1890s created a boom in photographically illustrated newspapers and magazines, and Pacific images were part of this. When the penny post was introduced, picture *postcards by the millions appeared. For instance, some 5,000 different postcards of Fiji were available between 1899 and 1930 and as many as 2,000 for the recently colonized territories of the New Hebrides (Vanuatu) and the Solomon Islands. German companies dominated the production of both black-and-white and colour cards for sale in the Pacific. German and Dutch publishers also produced lavishly illustrated books on their New Guinea colonies, such as A. B. Meyer and R. Parkinson's two-volume *Album von Papua Typen, Neu-Guinea und Bismarck-Archipel* (1894–1900). Mid-19th-century themes continued into the early 20th century, in addition to picturesque views of ports, wharves, and outrigger canoes bartering for curios alongside steamers. These were widespread in traveller's presentation albums, stereographs, tourist postcards, posters, and travel magazines. These photographs also featured in a number of theoretical debates on the origin of coral atolls, flora and fauna, Polynesian migration, nature-versus-nurture studies of culture, and the place of Oceanic peoples in the 'great chain of being'. To the general public they were doubtless as 'real' as the photographer-

authors claimed. At the turn of the century, illustrated books by visiting naturalists, geographers, anthropologists, private travellers, and resident colonial officials containing up to 100 photographs were common. After the First World War photographer-authors such as Thomas McMahon published illustrated magazine articles and thousands of photographs of the south-western Pacific. In the 1930s, Mick Leahy took 5,000 images in the New Guinea highlands, and in the 1950s and 1960s Jack and Dorothy Fields took 50,000 slides across the Pacific before publishing a benchmark coffee-table book, *South Pacific*, in 1972. Older images were rediscovered: for example the 300 glass-plate negatives made in the 1880s by the Hungarian ethnographer and collector Lajos Biro, which now form an invaluable historical resource on late 19th-century New Guinea.

Photojournalism arrived quite late, though the region soon had several illustrated news magazines covering the Tongan royal family, environmental issues, logging, corruption, tsunami, volcanic eruptions, and military coups. *Pacific Islands Monthly*, the best known, ran from 1930 to 2000. Other best-selling magazines like *National Geographic, Wide World Magazine*, and *Walkabout* relied heavily on photographs of 'natives', villages, and unusual customs. During the Second World War both the Allies and Japan photographed the region in great detail, but these images have only recently been critically studied. L. Lindstrom and G. M. White's *Island Encounters: Black and White Memories of the Pacific War* (1990) was the first to interrogate and challenge this propagandistically constructed wartime 'reality'. A new wave of analytical approaches regards these and other images as significant evidence in colonial and imperial histories, but there is much we still do not know about the history of photography in the Pacific. There are few big collections of Pacific photography, most of it being lost or scattered in small lots in repositories and institutions around the world. Although many Pacific Islanders now have cameras, historically there are no records of Pacific Islanders starting photography businesses, and little is known about those who helped travellers and resident photographers compile albums as they passed through Oceania. The history of photography in the Pacific is really only beginning. AMQ

Quanchi, M. (ed.), *Imaging, Representation and Photography of the Pacific Islands*, special issue of *Pacific Studies*, 20 (1997).

Young, M. W., and Clark, J., *Anthropologist in Papua: The Photography of FE Williams 1922–39* (2001).

Davis, L. A. (ed.), 'Photography in Hawaii', *History of Photography*, 25 (2001).

Tahiti: L'Éden à l'épreuve de la photographie (2003).

Oddner, Georg (b. 1923), Swedish photographer, active in Malmö. Leaving his job as drummer with the legendary jazz musician Putte Wickman, Oddner travelled to New York in 1950 to work as assistant to Richard *Avedon. In 1952, he opened a studio in Malmö. His output has embraced fashion, advertising (Volvo), and portraiture; books on Spain, and on sugar production in Sweden; illustrations for Pablo Neruda's poems; reportage from Vietnam, India, Russia, Japan, and Algeria; and allegorical still lifes. He is a founding member of the influential TIOFOTO group. J-EL

Office of War Information (OWI), USA. See DOCUMENTARY PHOTOGRAPHY.

Ohtsuji, Kiyoji (1923–2001), Japanese photographer and teacher. After serving in the Second World War, he opened a studio in Shinjuku, Tokyo, in 1947. He helped to boost photography's status in Japanese contemporary art with experimental and often surrealistic or constructivist images. A key member of the avant-garde, he was influenced by Shuzo Takiguchi, a student of Marcel *Duchamp. He co-founded the cross-disciplinary artists' groups Jikken Kobo (Experimental Workshop) and Graphic Shudan (Graphic Group) in 1953. As a teacher from the late 1960s he emphasized individual expression; his students included Naoya *Hatakeyama. OH

oil pigment print. Introduced by G. E. Rawlings (1904) from work by John Pouncy (1864), this process used a dichromated gelatinized paper, exposed under a negative, then soaked in water to produce a planographic surface. This was inked while wet, using lithographic ink and a brayer or brush. Robert *Demachy developed a transfer variant (1911), in which the inked paper was put through a press in contact with a clean sheet of paper. The original gelatin matrix could be re-inked to make multiple prints, or coloured inks could be printed in registration. Both versions were used by pictorial photographers into the 1930s. HWK

Olie (Jbz), Jacob (1834–1905), Dutch carpenter, architect, headmaster of the first Dutch technical school (1868–90), and prolific amateur photographer. He photographed in two periods, during the 1860s until c.1867, and between his retirement and death, in these latter years taking c.3,600 photographs. In both periods he used the same 9 × 12 cm (3^{1}/$_{2}$ × 4^{4}/$_{5}$ in) plate camera, but after 1890 with a better lens and dry instead of wet plates. Olie's photographs are enormously interesting and varied, including portraits and self-portraits, architecture, harbour and nautical subjects, rural views, and countless scenes from his native Amsterdam. They are held, with a large collection of personal documents, in the Amsterdam City Archive. RL

Bool, F., et al. (eds.), *Jacob Olie Jbz (1834–1905)* (2000).

OM series, Olympus, successful series of small 35 mm SLR cameras designed by Yoshihisa *Maitani, inaugurated with the mechanical OM-1 (initially M-1) in 1972. The semi-automatic OM-2 (1974) incorporated a sophisticated *through-the-lens metering system for both flash and ordinary photography that measured light reflected from the film surface during exposure; automatically timed slow shutter speeds exceeded 120 s. Both the OM-1 and OM-2 were subsequently improved, and further OM models were introduced, most notably the mechanical OM-3 (1985) and electronic OM-4 (1983), both with multi-spot metering. Ultimately the system comprised twenty bodies and nearly 80 lenses.

The OM-1 and OM-2 were small, light—the former with standard lens weighed only 700 g (24.7 oz)—and, with their Zuiko lenses, well balanced and comfortable to use. They became identified with glamorous professionals like David *Bailey and Patrick *Lichfield and, compared with their tanklike Canon and Nikon rivals, appeared more often at fashion shoots than on battlefields. However, the OM-1s supplied to Doug Scott's 1975 *Everest expedition performed well. Production of the last models, the titanium-clad OM-3Ti and OM-4Ti, ended in 2002. RL

Matanle, I., 'Classics to use', *Amateur Photographer* (19 Feb. 2005).

opalotype, a photograph, usually a portrait, made on glass having a translucent white tint. By 1859, opaline glass was used as a support for silver *collodion emulsions, and in 1884, *Marion & Co. introduced opaline glass coated with projection-speed gelatin silver bromide. Opalotypes could also be made with carbon transfer; both variants were popular in the 1890s and early 1900s as an upmarket novelty. Opalotypes should not be confused with 'opalines', which were gelatin silver chloride prints mounted face down on bevelled glass, like crystoleum photographs. From the 1950s, large black-and-white display transparencies were made on opaline plastic sheets coated with gelatin silver bromide. HWK

optical transfer function. At one time the only criterion for the performance of an optical system was its resolving power. In an ideal system (i.e. one without any aberrations) this bears a simple relation to its *f-number. In practice, camera lenses fall below this ideal, and resolving power is tested by imaging a chart of black and white bars, a so-called Sayce chart (see FOURIER OPTICS, Fig. 5a) or a Siemens star. As the pitch decreases the image contrast reduces, until at a certain point the bars can no longer be distinguished. This represents the limit of resolution, and it is specified as a *spatial frequency* in line pairs per millimetre (lp mm^{-1}). (A line pair is a black and a white bar.)

The difficulty is that this tells us only the point at which the optical system fails to produce an image. It gives no information as to the quality of what it *does* resolve. The nature of this defect became clear during the Second World War, when photo interpreters were examining reconnaissance photographs under high magnification, and saw that some types of camera lens produced more readily interpretable images than others of higher resolving power. Others performed less well than would be expected, and even produced misleading distortions in fine detail.

By careful ray tracing (nowadays done by computer programs) lens designers could predict the shape and size of the image of a point of light. However, this *point spread function* is somewhat difficult to relate to image quality.

The modern approach

In the early 1950s it was noticed that in the image of a Sayce chart, as the spatial frequency increased the image contrast fell steadily, and

the intensity profile became markedly sinusoidal (see FOURIER OPTICS, Fig. 5*b*). Further trials using a test chart with a sinusoidal profile instead of black and white bars showed that there was no change in the profile as the spatial frequency increased apart from a progressive decrease in contrast. Taking a leaf from the electronic engineering book, it became clear that any image (analogously to complex sound waveforms) could be analysed into a spectrum of sinusoidal gratings of various amplitudes (i.e. contrasts) and (spatial) frequencies, and, for two-dimensional images, orientations. If an optical system were to be tested using sinusoidal gratings it would be possible to plot the ratio of image contrast to subject contrast for the whole range of spatial frequencies, and thus obtain data on the performance of the system for every type of subject and at all levels of detail.

Modulation

Contrast is a subjective perception, and it is difficult to express as a measurable quantity. In photography it is traditionally defined as the logarithm of the highlight-to-shadow luminance ratio. This matches visual sensations fairly closely until the contrast becomes very high, and as it increases further the logarithmic figure continues to rise while the eye perceives little or no change. A closer fit to perceived contrast—again familiar to electronics engineers—is *modulation*. The modulation M of a scene is given by the expression

$$M = (L_{max} - L_{min})/(L_{max} + L_{min})$$

where L_{max} and L_{min} are the respective luminances of the brightest and darkest parts of the scene. Modulation cannot go higher than 1, corresponding to a black that is completely devoid of shadow detail ($L_{min} = 0$).

The optical transfer function

The *optical transfer function* (OTF) provides a full description of the imaging quality of an optical system. It is a combination of the *modulation transfer function* (MTF) and the *phase transfer function* (PTF). The MTF is a graph of image modulation ÷ object modulation plotted against image spatial frequency in cycles per millimetre (mm⁻¹). (With a sinusoidal test object the spatial frequency is counted in cycles per mm rather than line pairs.) The PTF is a graph of the displacement of the image compared with the geometrically correct position in radians (rad), plotted against image spatial frequency. A displacement of one whole cycle is ±2π radians or 360 degrees. Fig. 1 shows a typical OTF for a wide-aperture camera lens. The MTF shows how the system behaves at all levels of detail, and is an accurate predictor of image quality. The PTF is in general less useful, but it does predict whether image artefacts (such as doubled edges to details) are likely to occur at high spatial frequencies.

OTFs can be predicted by computer programs that design optical systems, and can be tested on existing lenses by a device that projects an image of a continuously variable grating on to the test system via a high-quality collimator. A collimator is an optical device that produces an accurately parallel (collimated) beam of light. Two sets of data are produced, one with the grating bars orientated radially from the optical

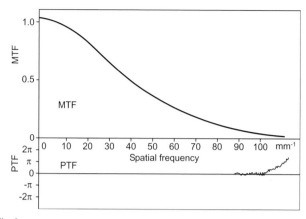

Fig. 1

centre, and the other tangentially to it. Readings are taken at intervals from the centre of the field to its periphery. The PTF for the radial OTF will be zero throughout unless the lens has become decentred; but it will depart from zero for the tangential readings if the lens suffers from coma or distortion (see LENS ABERRATIONS). A lens that is defocused will show an MTF that dips below zero, while the PTF switches between +π, 0, and −π. Examination of the image of the test object reveals spurious reversals of the image, with white bars appearing where dark bars belong and vice versa (Fig. 2). This is a consequence of the overlapping of spread functions distorted by the defocusing. It can also be caused by certain lens aberrations, and it was one of the more serious problems for photo interpreters involved in wartime reconnaissance photography.

The OTF of an 'ideal' lens can be calculated precisely using diffraction theory. Fig. 3 shows MTFs for several different f-numbers. In practice, any lens will have an MTF lower than this ideal, but once it reaches 'aperture limitation' its MTF will follow the 'ideal' curve for that aperture.

Cascading of OTFs

Most optical imaging systems have more than one component. A simple camera system has separate OTFs for the lens and the film. Multiplying all the MTFs and adding all the PTFs obtains the aggregate OTF. Some optical systems can have five or more components, each with its own OTF; they can all be combined in the same way to give a final OTF.

Historical note

The photographic division of the former Royal Aircraft Establishment at Farnborough, Hampshire, was responsible for the development of aerial cameras and processing systems during the Second World War, and treated the problem of image artefacts seriously. For reasons of secrecy, little was said in public then or later. But the concept of the OTF had already been evolved from the analogy with electronic audio amplification, and it had been realized that it was simply the Fourier transform of the point spread function, a concept familiar to audio engineers. The team built an analogue computer to perform Fourier

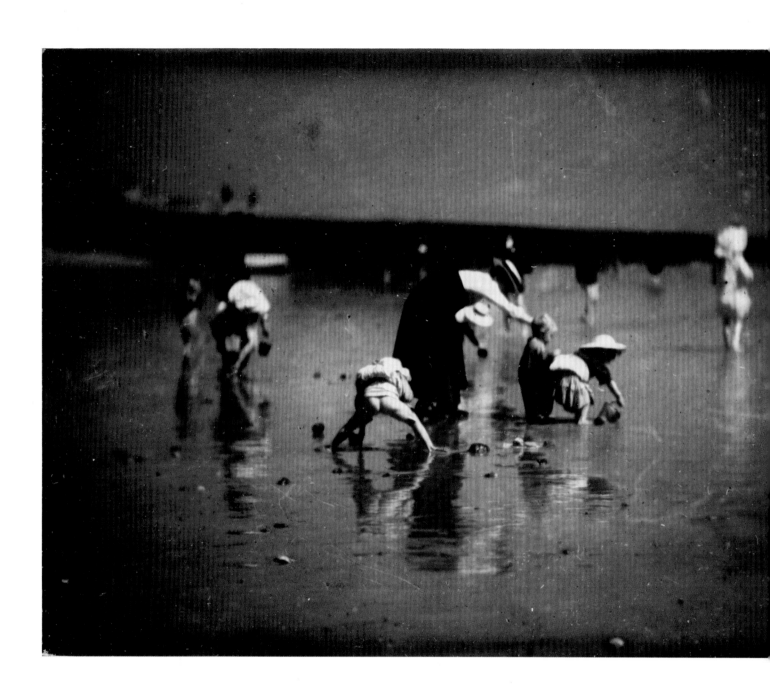

Otto Pfenninger Brighton beach, 16 June 1906. Tricolour carbon print

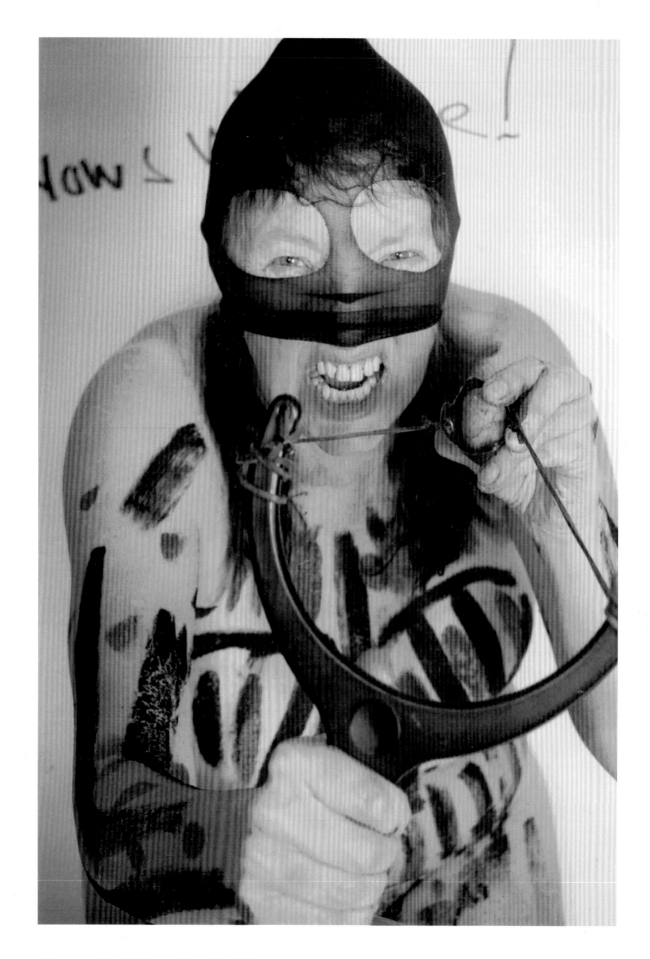

Jo Spence and David Robert *Cultural Sniper* (Jo Spence), 1990

Fig. 2a

Fig. 2b

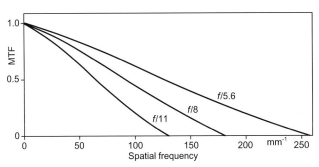

Fig. 3

transforms, to obtain the OTF from the PSF. The first OTF measuring system was designed and built at Farnborough in the early 1950s, and a company was set up to exploit the new insights, but without commercial success. In the meantime, Japanese manufacturers had eagerly accepted the principles of OTF theory, and had discovered that a slight defocusing of an existing camera lens from the optimum resolution point gave an OTF that had a more satisfactory shape for pictorial purposes. As a result, Japanese lenses acquired a reputation for image quality that resulted in their domination of the lens market for nearly 50 years. GS

Williams, T., *The Optical Transfer Function of Imaging Systems* (1999).
Jacobson, R. E. (ed.), *The Manual of Photography* (9th edn. 2000).
Ray, S., *Applied Photographic Optics* (3rd edn. 2003).

Orientalism. Between 1840 and *c*.1910 photographic production linked to the *Middle East and North Africa was considerable; indeed, it was the single most flourishing branch of commercial photography apart from studio portraiture. There were several reasons for this. The fashion for the Orient had been developing since the end of the 18th century, with numerous writers, painters, and archaeologists journeying to Egypt, Syria, Palestine, and Turkey. Travel books, novels and paintings, and objects brought back to Europe fed the public's taste for these fantasy zones. Colonization, the development of trade, *tourism, and the modernization of communications intensified contacts between East and West. The world exhibitions held in major European capitals also increased familiarity with these countries.

Photography advanced in step with these changes. In 70 years, images made with great difficulty by the pioneers—artists and archaeologists—gave way to commercial mass production and finally to a boom in amateur photography by ever more numerous tourists.

The first photographers in the Orient were *daguerreotypists, and in many cases little or nothing remains of their work. Frédéric Goupil-Fesquet (1817–?), nephew of the painter Horace Vernet, reached the foot of the Pyramids with a camera as early as October 1839. But the most remarkable expedition was that of the wealthy French art historian and painter Joseph Philibert Girault de Prangey (1804–92), who left for the East in the spring of 1842, travelled through it for three years, and returned with nearly 1,000 daguerreotypes that have miraculously survived.

The first traveller to use the paper-negative process was the writer Maxime *Du Camp, who set out in the autumn of 1849 accompanied by his friend Gustave Flaubert. He was soon followed by the German E. *Benecke, a talented amateur more interested in domestic scenes than monuments; and by Félix *Teynard, John B. *Greene, Théodule Devéria (1831–71), Auguste *Salzmann, Louis de Clercq (1836–1901), and many others. These *calotypists were concerned above all with *archaeology: photography enabled them to document the monuments that French, British, and German scholars were currently studying with a degree of precision for which sketches were inadequate. Their works had considerable impact in Europe, where they were disseminated in artistic and scientific circles in albums (Du Camp, Greene, Salzmann, de Clercq) or sold individually.

The Egyptologist Prisse d'Avesnes (1807–79), staying in Cairo between 1858 and 1860, took with him a young photographer, A. Jarrot, who took all the photographs of monuments of Islamic art that d'Avesnes intended to publish on his return.

From the mid-1850s onwards, accompanying the rise of tourism, professional photographers like Francis *Frith travelled to the Orient in order subsequently to sell their pictures in European cities. Others

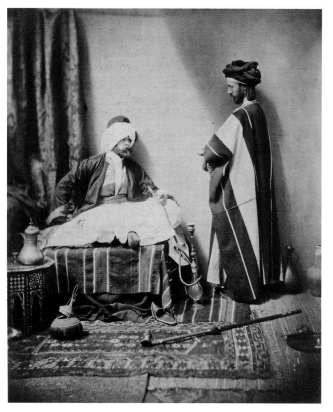

established themselves locally: James *Robertson in Constantinople from 1854, W. Hammerschmidt in Cairo *c.*1860, Gustave *Le Gray in Alexandria in 1861, Félix *Bonfils in Beirut in 1867. These professionals were predominantly English or French, although photographers of local origin, such as the Turks J. Pascal Sébah and the *Abdullah brothers, Armenians like G. Lékégian (*fl.* 1860s–1890s), and Greeks like Georgiladakis and Nicolas Koumianos, gradually emerged. Their output, aimed at Western travellers (who included numerous Orientalist painters), was extremely varied: famous monuments and sites, landscapes, picturesque scenes, local trades, and portraits of indigenous beauties. Although many of these images appear artificial, manufactured to recreate an 'Orient to order' comparable to what appears in many contemporary paintings, some are of outstanding quality. Robertson's prospects of Constantinople are remarkable for their artful composition, with groups of figures agreeably setting off the views of monuments. Among the vast numbers of items by Frith and Bonfils are works of undeniable aesthetic value. From the 1860s on, photographers based in the Middle East benefited from commissions by the Turkish and Egyptian governments, which used photography to document the great modernization projects taking shape in major cities.

At the same time, in cities like Paris or London, studio photographers were confecting Orientally inspired scenes: Roger *Fenton's fine set of odalisques, Julien Vallou de Villeneuve's series of female models in costumes reminiscent of the biblical East (1853–4), and many other examples. Portraits also reflected the fashion; and from Charles Nègre in his Algerian *burnous* to Pierre Loti, whose extravagant taste for disguise found expression in Oriental settings, by way of Julia Margaret *Cameron, Toulouse-Lautrec, and Robert de Montesquiou, a mythical Orient for wealthy Westerners or artists invaded studios and inspired amateurs.

At the end of the 19th century local commercial production faced competition from the appearance of the *postcard and the expansion of amateur photography (notably Loti's pictures of Turkey and Georges Maroniez's of Egypt and the Maghrib). Some studios, such as Lehnert & Landrock, Geiser, Arnoux, or Neurdein, shifted their business from original photographic prints to postcards and *heliogravures. But another type of original photograph was emerging: Gustave Lehnert in Tunis between 1904 and 1914, and other North African-based operators in these years, produced decidedly erotic scenes featuring smiling, half-naked girls and boys. SA

Perez, N., *Focus East: Early Photography in the Near East, 1839–1885* (1988).
Félix Teynard, Calotypes of Egypt: A Catalogue Raisonné, introd. K. S. Howe (1992).
Fleig, A., *Rêves de papier: la photographie orientaliste, 1860–1914* (1997).
Aubenas, S., *Voyage en Orient* (1999).

Orive, Maria Cristina (b. 1931), Guatemalan female photographer, arguably the first to establish a professional reputation. After studying in her birthplace, Antigua, France, and the USA, she worked in the press and broadcast media. She then documented religious festivals in

Guatemala. *Actos de fe en Guatemala* (1980) recounts the syncretism of animism and Catholicism, particularly in the Holy Week rituals. Shot in colour and first published in Argentina, it included a text by Nobel Prize-winning novelist Miguel Ángel Asturias. It is primarily for this social/anthropological documentation that Orive is known abroad. AH

Hopkinson, A. (ed.), *Desires and Disguises* (1992).

Orlan, Pierre Mac. See MAC ORLAN, PIERRE.

orthochromatic and panchromatic materials. The first silver halide emulsions were sensitive only to blue and ultraviolet radiation. In 1873 Hermann Wilhelm *Vogel discovered that the addition of dyes such as erythrosine to an emulsion extended its sensitivity well into the green region: he called this improved response *orthochromatic*. By 1890 other dyes had been found which extended the sensitivity throughout the visible spectrum: these emulsions were termed *panchromatic*. Orthochromatic emulsions remained popular for a long time, particularly among amateurs, as they could be processed under a red safe light. They are still used in the printing industry. GS

Ortiz-Echagüe, José (1886–1980), Spanish photographer, and for many years, due to his success in international salons, better known abroad than any other. Not until today, however, has his work begun to be properly understood in Spain.

He took his first photographs aged 12; he later trained as a military engineer and served as an aerial photographer in Morocco. Images of North African landscapes and people founded his early reputation. Ortiz-Echagüe's mature work is a natural reference point for understanding the history of Spanish art photography, and although his aesthetic principles are dated, the quality of his images, and his lengthy dominance of the Spanish photographic scene, explain his classic status. Although his work (mainly using the Fresson or *bromoil processes) was firmly rooted in *pictorialism, and he was not averse to staging in the interests of visual impact, he defended the documentary value of his images, aspiring both to create art and to register what he perceived to be the national 'reality' of his time. The critic Antonio Ollé Pinel said of him in 1944 that he was 'in love with his country, [and] became the singer (through photographic images) of the beauty of its places and of the character of its people, managing with all his work . . . to show the world the richness and variety of aspects that the country can offer to the sensitive observation of an artist'. His best-known images aimed to capture the variety and richness, the regional dress and mystic character of 'eternal Spain', a project realized in three widely distributed books published in the period straddling the Civil War (1936–9): *España: tipos y trajes* (*Spain: People and Costumes*; 1933), *España: pueblos y paisajes* (*Spain: Villages and Landscapes*; 1938), and *España mística* (*Mystic Spain*; 1943).

As with many post-Civil War Spanish artists, ideological concerns permeated his work. However, although his images of Spain are often viewed as propagandistic, they are in reality more complex, a blend of

patriotic hymn and anthropological record. Ortiz-Echagüe gave up photography in 1973. GFK

Martínez de Morentin, D., *Asunción. La fotografía de José Ortiz-Echagüe: técnica, estética y temática* (2000).

O'Sullivan, Timothy H. (1840–82), American photographer. Possibly born in Ireland (though he claimed Staten Island, New York, as his birthplace), O'Sullivan was one of the major photographers of the Civil War (1861–5) and the *American West. He began at a young age as an apprentice in the portrait studios of Mathew *Brady. With Brady, and later Alexander *Gardner, O'Sullivan photographed much of the Civil War including the battles of Antietam and Gettysburg. Following those grim years, he was an official photographer for several government expeditions mapping the still relatively unknown regions of the West. From 1867 to 1869, he accompanied Clarence King and his Geological Explorations of the Fortieth Parallel into the Great Basin. Later, 1871–4, he joined Lieutenant George Montague Wheeler, leader of the US Geographical Surveys West of the One Hundredth Meridian, on various journeys into the south-west. O'Sullivan's clear, often austere images constitute a curiously unromanticized record of the West, very different from, but no less important than, for example, the work of William Henry *Jackson and Carleton *Watkins. O'Sullivan died of tuberculosis aged 42. TT

Snyder, J., *American Frontiers: The Photographs of Timothy H. O'Sullivan, 1867–1874* (1981).

Otsup, Pyotr (1883–1963), Russian photojournalist whose long career spanned the last years of the tsarist regime, the revolution, and the consolidation of Soviet power. Apprenticed to a portrait photographer at the age of 9, he published his first picture in 1901. He contributed news pictures to numerous publications and worked as a war photographer in both the Russo-Japanese War (1904–5) and the First World War. In 1917 he covered the revolutionary events in Petrograd, including the storming of the Winter Palace; later the Civil War and the Kronstadt Rising (1921). An enthusiastic supporter of Bolshevism, Otsup became in effect Lenin's personal image maker, creating *c*.70 widely distributed reportages and portraits of him between 1918 and 1922. He remained active after 1945 and left an archive of *c*.40,000 images. RL

Morozov, S., and Lloyd, V. (eds.), *Soviet Photography 1917–40: The New Photo-Journalism* (1984).

Ottoman Empire. See MIDDLE EAST, EARLY PHOTOGRAPHY IN THE; TURKEY.

Outerbridge, Paul (1896–1958), American photographer who gained recognition as an early modernist *advertising photographer. After studying at New York's Art Students League (1915) and the Clarence H. White School of Photography (1921), he contributed regularly to *Vanity Fair*, *Harper's Bazaar*, and other periodicals. Outerbridge's 1920s advertising photographs combined close-up

examination of the product with severe reduction of form, creating elegant abstract compositions with a highly nuanced tonal range. From 1925 to 1929 he worked in Europe, making contact with modern artists in Paris, Berlin, and London. In the 1930s, he turned to colour photography, becoming expert in the *carbro process, and producing images for journals like *House Beautiful*. He also embarked on a series of brashly coloured, surrealistic erotic nudes, which constitute the major portion of his personal work after 1930. PJ

Outerbridge, P., *Photographing in Color* (1940).
Barryte, B., Howe, G., and Dines, E., *Paul Outerbridge, a Singular Aesthetic: Photographs and Drawings, 1921–1941. A Catalogue Raisonné* (1981).

Owens, Bill (b. 1938), American social realist photographer raised in rural California. Owens discovered photography while in Jamaica with the Peace Corps and subsequently studied visual anthropology; he later became staff photographer for the *Livermore Independent*. Alongside his photojournalism, he produced a body of work documenting friends and neighbours engaged in stereotypically suburban activities. Despite publishing three books and having numerous exhibitions, he failed to find financial stability, and so in 1982 sold his equipment to open a brewpub and publish *American Brewer Magazine*. Revived interest in his work later allowed him to return to photography. MR

Owens, B., *Suburbia* (1999).

oyaji ('old men'), Japanese colloquialism for the middle-aged enthusiast patrons of the numerous photographic galleries in the Ginza district of Tokyo. RL

ozobrome. See CARBRO; OZOTYPE.

ozotype. Patented by Thomas Manly (d. 1932) in 1898, this pigment process used sized paper sensitized with chromate and manganese salts and exposed under a negative. The exposed paper was washed, then squeegeed onto a carbon tissue treated with a reducing agent such as acidulated hydroquinone. Diffusion transfer of the chemicals selectively hardened the tissue, which was subsequently developed as a *carbon print. Another version, gum ozotype, coated treated gum arabic directly onto the sensitized and exposed paper. The process produced a carbon print without image reversal, and brush development allowed localized manipulation of detail and density. Used by *pictorialists such as Robert *Demachy, it was supplanted by Manly's ozobrome process (1905). An improved version of the ozobrome was marketed in 1919 as the *carbro process. HWK

pack (or product) **shot**, ubiquitous *advertising photograph of an inanimate object, usually studio made and intended for publication in a magazine or catalogue. Items depicted range from circuit boards and bottles of shampoo to sports cars and luxury watches. Their often mundane quality belies the skill and imagination needed to light and photograph them. The young Victor *Keppler took two days and nights to complete a deceptively simple test assignment for the Batten, Barten, Durstine, and Osborn (BBDO) agency: spinach in a white bowl on a white plate on a white cloth. Much theoretical writing has been devoted to the pack shot in relation to the 'manufacture of desire' in consumer society. However, the working photographer—who may range widely, or specialize in products such as *food or cars—is primarily concerned to please the client and art director, using large-format cameras and a battery of equipment to reflect, diffuse, and filter light and create convincing illusions of texture and space. 'Application' shots may require elaborate props and settings (or *digital simulation) to show the product in action. Samples of current work appear in annuals such as *European Photography* and *Contact Photographers*. Product shots by the masters, from *Steichen onwards, have become museum-worthy items of classic photography. RL

Salomon, A., *Advertising Photography* (1982).
Sturken, M., and Cartwright, L., *Practices of Looking: An Introduction to Visual Culture* (2001).

Paget process, British screen plate colour process, described by G. S. Whitfield of London in 1912 and first marketed in 1913. The screen was made up of a regular pattern of red, green, and blue squares, with two slightly smaller blue squares to each red and green one. Paget plates were more sensitive than contemporary *autochrome plates, allowing exposures of around 1/25 s. The colour had a delicate translucent quality but did not match the rich colours captured on autochromes. A paper-based Paget process was also briefly sold. Both processes were discontinued in the early 1920s. JPW

painting and photography. Photography arrived at a point in the history of European painting when Romanticism, as embodied in the turbulent fictions and exotic allegories of figures such as Eugène Delacroix (1798–1863), was widely admired and commercially successful; realism, the painting of immediate visual experience, was beginning to coalesce into an oppositional movement, championed by the brash young Gustave Courbet (1819–77). Neither of these painters saw photography as a threat to painting. They, and others later, quickly embraced it as a means of referencing such details as facial expression, ephemeral light effects, and motion. Delacroix even wrote in his journal that 'if a man of genius should use the *daguerreotype as it ought to be used, he will raise himself to heights unknown to us'. Some painters, notably Edgar *Degas, Pierre *Bonnard, Edvard *Munch, and Ernst Ludwig *Kirchner, themselves became accomplished photographers. It was rather the popular Salon painter Paul Delaroche (1797–1856), celebrated for the technical precision of his work, who reportedly declared, on seeing his first daguerreotype, 'From today, painting is dead.' The fear that photography would replace painting was felt primarily by those who, like Delaroche, understood painting's purpose within a fairly narrow concept of visual representation. It can hardly be coincidence that a number of the photographers who achieved prominence in photography's first decades were trained in Delaroche's studio (Gustave *Le Gray, Henri *Le Secq, Roger *Fenton, Charles *Nègre), nor that the painting–photography relationship eventually emerged as the paradigmatic instance of the broader reciprocal one between art and technology.

Some kinds of painting did disappear after 1839. Many portrait miniaturists, for example, made a successful transition to portrait photography (the less successful became retouchers). More complex and far reaching in its implications was the declining prestige of the ambitious, sometimes outsize representations of past events or recent news known as *history painting*. Photography can only partly explain the shift in interest from large, complex images drawing on biblical, mythological, or historical sources, to traditionally 'lesser', more immediately accessible modes such as genre, still life, and landscape. But the possibility of seeing a *photograph*, rather than a painting of, say, the queen of England, the Parthenon, or Niagara Falls, even if in engraved reproduction, inevitably undermined painting's claim to historical and documentary authority. Instead, painters and the public began to seek other qualities in painting, those that early photographs lacked: sensuous colour, spontaneity, and a reflection of what the poet and critic Charles Baudelaire called 'the heroism of modern life', a way of making 'modern' (increasingly big-city or leisure) experience—including trains, gaslight, department stores, and pervasive uncertainties about the identities of other people—seem significant, noble: in a word, worthy of painting. The list might serve to summarize the goals of Impressionist painting of the 1870s and 1880s.

Anon.

Walter Langley painting in Newlyn

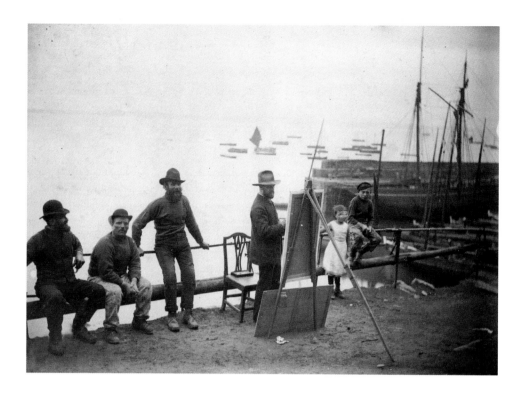

By the late 19th century, many painters were using the camera as a tool. Its most obvious application was in portraiture, and in extreme cases the artist would simply overpaint a photographic image faintly developed on sensitized canvas. Two successful Munich portraitists, Franz Lenbach (1836–1904) and Franz Stuck (1863–1928), used photography extensively to reduce sittings and speed production; Lenbach accumulated a photo archive of *c.*13,000 images, many of them taken by the Munich professional Karl Hahn. Today, Hahn's revealing preparatory photographs of celebrities like Bismarck and Field Marshal von Moltke seem considerably more interesting than Lenbach's portraits. Other artists closely linked with photography were the members of the enormously influential *plein-airiste* movement founded by Jules Bastien-Lepage (1848–84). Pascal-Adolphe-Jean Dagnan-Bouveret (1852–1929), Émile Friant (1863–1932), Alexis *Muenier, and the Hessian peasant painter Carl *Bantzer all used the camera to record details of costumes and settings, and to experiment with different groupings and poses. Especially in Germany, however, the widespread belief that art and 'the machine' were incompatible made artists reticent about their activities. When, for example, in 1897 the critic Karl Voll complained to his friend, the painter Max Slevogt, about the use of photographic studies, he had no idea that Slevogt was already well versed in the practice.

But photography had its most dramatic effect on painting as a technology of reproduction. From the beginning, numerous observers had suggested that by reproducing works accurately and inexpensively, photography could visually educate a wider public, and so build a larger, more appreciative audience for painting. Photographic reproductions, especially of well-known paintings, became a thriving business by mid-century. The difficulty and expense of reproducing text and image together on the same page, however, occasioned a succession of different experimental reproduction methods for books and periodicals, most still involving the slow and expensive hand labour of an engraver, trained to 'translate' the tonal and textural effects of painting into black-and-white. *Photomechanical processes only gradually displaced this. But photography eventually decisively influenced the historical study of painting, providing many more reproductions of study objects for comparative purposes, even though the camera rendered the subject matter of a given work more accurately than physical characteristics such as scale, surface quality, or colour. Through photographic reproduction (eventually including lantern slides), it became possible for paintings, especially those in private collections or still relatively remote museums like the Prado or Hermitage, to become familiar to a wider and more diverse public. Yet, ironically, that public could remain startlingly unfamiliar with the physical qualities of these works.

Photography did extend the audience for painting in the course of the 19th century. But it was more effective in habituating audiences to see photographs as art. Both photographic reproductions of paintings and photographs set up to look like paintings reinforced the idea that the making of artistic images need not be confined to a select few—predominantly males—with exceptional gifts and lengthy training. Amateur photography *clubs, an outstanding feature of photographic culture in Europe and the USA in the 19th and much of the 20th centuries, attracted many aspiring artists and consolidated

an audience for photography as art. Often these groups sought to articulate an aesthetic through which to evaluate their achievements and, in adopting the aesthetic values of contemporary painting, especially Symbolism or, more loosely, 'secessionism', around the turn of the century, they established the movement known as *pictorialism. This was the context in which Alfred *Stieglitz began to make photographs, and to assert the artistic parity of painting and photography through the medium of *Camera Work.

These were also the years of radical pictorial innovation led by painters, of Cubism and a range of *Futurist projects, the invention of collage, and the first experiments with pictorial abstraction. Futurist 'photodynamism', and the *Vortographs of Alvin Langdon *Coburn, followed this lead. Others, however, pursued the possibility of a specifically photographic aesthetic: Paul *Strand, most notably, whose crisply focused photographs of familiar objects and scenes, images that did not refer to any kind of painting, impressed Stieglitz. In Camera Work's final years and later, under the banner of *'straight' photography, Strand and Stieglitz articulated an idea of photography as modern art, a project with uniquely photographic goals distinct from, but equal to, those of painting. It was this broad conception of a parallel between the two that would eventually underpin the 1940 founding of the first department of photography in an art museum, MoMA in New York.

In the meantime, particularly in the inter-war years, the advent of small, light cameras, faster lenses, and offset photographic reproduction technologies cheap enough to use in newspapers and for posters etc. produced an inundation of photographs. This abruptly new, assertive photographic presence in the street, home, and workplace was experienced as one of a rapid succession of new technologies—phonograph/gramophone, telephone, film, radio, and fax—creating the sense of a changed world. In Germany, the Hungarian-born artist László *Moholy-Nagy proclaimed a *'New Vision', finding support for the idea in the wealth of contemporary photographic experimentation both in and outside the arts: high and low camera angles, *solarization, extreme close-ups, X-rays, *photomontage, and moving images. Approaching the centenary of its invention, photography also began to draw the attention of historians and critics, such as the Austrian Heinrich *Schwarz, with interests embracing both photography and painting. In this kind of discourse, painting began to be identified with tradition, photography with a new, contrasting set of values and effects. In his celebrated 1936 essay 'The Work of Art in the Age of Mechanical Reproduction', for example, Walter *Benjamin uses painting to exemplify a unique product of the human hand, against which the effects of 'mechanical reproduction'—photographs, film, and sound recording—are seen to have the potential to alter consciousness dramatically.

This contrast between the slow, exacting labour and calligraphic individuality of painting and the comparatively effortless flow of identical mass-media images remained at issue for many artists in the post-war period. Paintings that reproduced photographs, gathered under the name Photorealism (or Superrealism) in the 1960s, in some ways exactly reversed the 19th-century understanding of the relationship, and may seem, in hindsight, to substantiate Marshall McLuhan's (1911–80) contention, in Understanding Media (1964), that older media effectively 'criticize' newer ones. By painstakingly reproducing a photograph, often a very ordinary, 'throwaway' news image or family snapshot, such painters as Richard Estes (b. 1936) in the USA or Gerhard Richter (b. 1932) in Germany (in conjunction with his *Atlas archive) implied that photographs had become the environment, the 'nature' that traditionally constituted a painter's legitimate subject matter. Such work was also read as an assertion of the value and meaning of skilled hand labour, in contrast to instantly produced, ubiquitous photographs. In deliberately making surfaces that resist the possibility of 'good' or stable reproduction, e.g. by using unstable or translucent materials, artists like Sigmar Polke (b. 1941) have addressed the uniqueness of painting.

With the wide availability of video technology c.1965, and personal computing from c.1980, it became possible to conceive of a digitized 'flow' of information: images, texts, sounds, easy to manipulate, and to reproduce and transmit, instantly, along the same wire or wavelength. The long-term effect of this development remains unclear, but it has already eroded the disciplinary boundaries between modernist arts, including that between painting and photography. Digital photographs, encoded as patterns of magnetization rather than chemically on paper, have arguably become 'thinner' in terms of an authoritative connection with a specific past moment; painting, accordingly, less committed to asserting its difference. Although painting remains broadly associated with manual skill and human scale, the relationship between it and a range of image-making apparatus no longer seems acutely problematic. An example is the work of the American Chuck *Close, who achieved prominence in the 1960s with outsize portraits in which the screen pattern used for photographic enlargement was painted in. Later he made gestural loops of paint on separate, relatively small canvases. Arranged on a wall and viewed from a certain distance, these paintings become recognizable as a face, marking a kind of minimum level of information necessary for such legibility. Features of both painting and photography are deployed in a perceptual exercise.

Photography has not replaced painting. If anything, the ubiquity of photographs seems currently to reinforce the value of painting, its association with rarity and luxury, although the rising *market value of photographs is blurring this boundary. Rather, photographs mechanized a particular way of organizing visual information on a surface, of making two dimensions 'read' as three, and in so doing, to defining a single viewpoint. This much was familiar to European viewers of the first photographs. In separating this principle from dependence on a highly skilled hand, in making it infinitely mobile and reproducible, however, photography modelled a world in which infinitely many single points of view could exist at the same time, dispersed in space, but identical to one another. It was, further, a world visible beyond the capability of the human eye, recorded at speeds far greater than that of the draughtsman's hand. Those 19th-century painters who, like Delacroix, greeted photographs as a potential asset

to art understood their work not solely in terms of a technique, but as the project of making meaningful models of the world. Artists are still making such models, often real-time, interactive ones. Whether their work involves photography, painting, neither, or both, the world to model now is one in which photographic images deeply and continuously inform everyone's sense of space, time, and self. NRO

Moholy-Nagy, László, *Painting, Photography, Film* (1927; repr. 1969).

Scharf, A., *Art and Photography* (1968).

Galassi, P., *Before Photography: Painting and the Invention of Photography* (1981).

Vaizey, M., *The Artist as Photographer* (1982).

Crary, Jonathan, *Techniques of the Observer: On Vision and Modernity in the Nineteenth Century* (1992).

Franz von Stuck und die Photographie (1996).

Wood, P. (ed.), *The Challenge of the Avant-Garde* (1999).

Kosinski, D. (ed.), *The Artist and the Camera: Degas to Picasso* (2000).

Palestine. See MIDDLE EAST, EARLY PHOTOGRAPHY IN THE.

Palestine Exploration Fund (PEF), British organization established in 1865 to provide for long-term survey and scholarly investigation of the Holy Land. The impetus for its founding was the successful Ordnance Survey of Jerusalem and accompanying photographs completed by the *Royal Engineers (RE) and Colour Sergeant James McDonald (1822–85) in 1864–5. Another survey, of the Sinai Peninsula (1868–9), again photographed by McDonald, validated the PEF approach, which used private subscription, the RE's military resources, and the expertise of biblical scholars. A number of photographers, primarily drawn from the RE, produced a large body of images of the region. Photographs taken by Royal Engineers for the PEF include the series made in 1874 and 1877 by Lieutenant H. H. Kitchener (later Lord Kitchener of Khartoum). In the 1880s the PEF focused on the Transjordan (eastern Palestine), where surveys and photographic work were accomplished by Lieutenant Mantell, RE,

and Dr Gordon Hull. The last photographs made in the Holy Land before the First World War and under the auspices of the PEF were by another RE officer, T. E. Lawrence (Lawrence of Arabia). A complete listing of the PEF photographs taken in the Holy Land, 'Catalogue of Photographs and Slides for the Lantern', was published in the 1890s. The PEF's photographic work is primarily views of topography, archaeological sites, and locations matching biblical references; the archive is maintained today at the PEF's London offices. KSH

Perez, N. N., *Focus East: Early Photography in the Near East 1839–1885* (1988).

panchromatic materials. See ORTHOCHROMATIC AND PANCHROMATIC MATERIALS.

panoramic photography. A strong case can be made that the panoramic photograph in its broadest conceptions has been, since the invention of photography, a key element in 'modern' ways of looking, in particular because it has been used to visualize the major issues and concerns of modernity on the grandest scale.

Simple definition of a panoramic photograph is difficult, as so many ways have been used by photographers to achieve an image that goes beyond the conventional formats. Some sources insist on the image being made by a 360-degree rotational camera, but this would exclude many images described as 'panoramic' by their makers. Circular, *fisheye images are one example; the continuous strip images of the periphery camera another.

Indeed, the meanings given to the term 'panoramic' have always fluctuated, as artists, photographers, and scientists have sought a wider perspective on humanity and nature. Invented by the panorama painter George Barker in the 1790s, the term originally meant simply a distant, all-encompassing view from a vantage point. Later, it came to describe a circular painted image taking in all four points of the compass. But whether continuous or assembled, single-image, joiner, or collage, there has been a long fascination by photographers with the

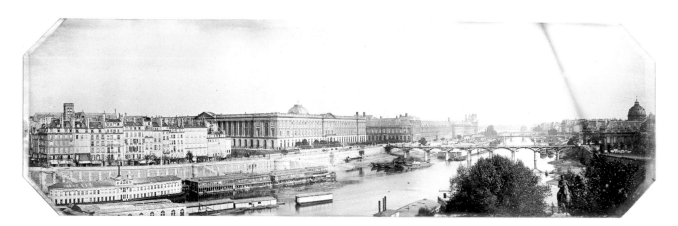

Charles Chevalier

Parisian panorama sent to Henry Talbot, *c.*1842. Daguerreotype

genre. The invention of photography itself is closely linked to the panorama, for J.-M. *Daguerre himself was a panorama painter, and his diorama has some clear links to the invention of the medium in the 1830s.

Since the beginning of photography, the 'wider' view has been embraced by its practitioners to make images that explore the limits of human vision—of what photography can enable us to 'see'. The richness of this vision is impressive. It runs from early *daguerreotype and *calotype views in the 1840s, through the golden age of French photography in the 1850s and 1860s (*Baldus, *Braun, the *Bisson brothers); the multiple-image tableaux of *Rejlander and Peach *Robinson of the same period; the experiments of *Muybridge and *Marey in the 1870s–1880s; the new vision of *pictorialists such as *Stieglitz, *Steichen, and *Puyo at the turn of the 20th century; then on through *modernism with *Brandt's wide-angle nudes and *Avedon's Vietnam-era joiner-style group portraits, and up to contemporary work by artists like *Hockney, *Wall, *Gursky, and Sam Taylor Wood. During each of these moments the panoramic genre has offered art and science new ways of visualizing big themes and big ideas about the natural world, the built environment, and human relationships. A commercial medium par excellence, the panoramic photograph was boosted by photographers who saw it as a means both to increase their profits and to make intriguing images.

Panoramic photography has been widely used since the 19th century to visualize the vast scale of human progress, but also as the best way to attempt to 'take in' or represent the devastation and tragedy of natural disaster and armed conflict. Events from the Crimean War to 11 September 2001, from the Rhône floods of 1851 to the San Francisco earthquake of 1906 and other 20th-century catastrophes, have all been captured by photographers who adopted the panoramic 'Big Picture' as the best method for visualizing their scale and impact.

The earliest panoramic photographs were made within two or three years of photography's invention in 1839, and the first known patent for a specialized panoramic camera, by an Austrian, dates from 1843. Many early panoramas were simple assemblages of two or more daguerreotypes placed alongside each other (such as the W. S. Porter (1822–89) and C. Fontayne views of Cincinnati waterfront, 1848), yet the fascination with this type of view ensured that by 1844–5 Friedrich von Martens (1806?–85?) and others in the circle around N. M. P. Lerebours were making wide-view daguerreotype panoramas of the Louvre and Seine on a specially designed swing-lens camera (also marketed by Lerebours) using a curved plate. Henry *Talbot and his circle were equally fascinated by the problems of making a wider view by joining a series of paper negatives (Calvert *Jones made several impressive images in the mid-1840s by this method), but it was with the widespread adoption of the negative-positive process that the genre really took off.

The panoramic photograph rapidly became a form of imagery symptomatic of modernity itself, being used in various ways from the mid-19th century to record wars, exploration, the creation of new cities and industrial enterprises, scientific and technical advances,

and the emergence of new forms of society and social relationships—the last expressed in carefully orchestrated scenes of mass celebration, from the private banquet to the military tournament. Until the 1860s and 1870s, groups of soldiers were mainly depicted by the great photographers of the time (*Fenton, *Disdéri, *Beato) in proto-panoramic views where the subjects are posed informally, but from the 1880s they increasingly appear in uniformly serried ranks, as modern warfare and its demands for discipline and industrial efficiency start to take over. The panoramic camera was seen from the 1850s onwards by many inventors and photographers as having *military uses (Camille *Silvy invented one for this purpose in the 1860s), and this accelerated development of the rotational camera capable of taking a 360-degree view. The *Lumière brothers' drum-shaped Periphote (1901), for example, seems ideal for taking pictures from a trench or fortress. The first widely sold professional variant, the clockwork-rotated, *roll-film Cirkut camera patented in 1904 and sold from 1907 by Eastman Kodak, was used for numerous purposes, from military reconnaissance to large-group photography, and was successful because the quality of its results made them easy to sell: to club members, college graduates, industrial and mining companies, and tourists. (The Cirkut No. 10 remained available until 1941.)

By the early 20th century whole armies, fleets, and air forces were being recorded by enormous photographs that offered emblematic evidence of military power. Cirkut photographers such as Eugene Goldbeck and Arthur S. Mole devised techniques for making orderly panoramic views of thousands of soldiers, battle squadrons, and formations of aircraft. Assemblages of the great and good, wedding parties, beauty contests, funerals, and a host of other social events were also favoured by photographers capable of using the technology of swinging lenses and gear-driven cameras to create images that conveyed social cohesion and institutional stability.

But the panoramic image has been used not only to encompass humanity en masse, but to explore individuality. Jacques-Henri *Lartigue's extremely personal panoramic images from the 1920s and 1930s of his wife Bibi and their life of leisure on the Côte d'Azur reveal how an artistic temperament can transform an instrument of documentation into an expressive tool. (In Lartigue's hands the format seems perfectly calibrated to take in a yacht's deck or the bonnet of an Hispano Suiza.) So do the aesthetically more modest efforts of Nicholas II of Russia, who had recorded both military reviews and family picnics with his Kodak Panoram in the 1900s.

Many contemporary artists who use the camera have created panoramic images to express current concerns. Photographers such as Josef *Koudelka, Mark Klett, Naoya *Hatakeyama, and Lois Connor have incorporated aspects of panoramic photography into their work, and it has become much more widely known as a genre. The availability of *digital imaging techniques such as Quicktime VR have made the panoramic view readily available via digital cameras and the *Internet. However, a wide range of equipment still exists to make silver-based panoramic images, from sophisticated and expensive medium-format cameras to humble APS (*Advanced Photographic

System) compacts using relatively simple methods of masking and selective enlargement. PH

Coe, B., *Cameras: From Daguerreotypes to Instant Pictures* (1978).

Meehan, J., *Panoramic Photography* (1990).

Watts, J. A., and Bohn-Spector, C., *The Great Wide Open: Panoramic Photographs of the American West* (2001).

Meers, N., *Stretch: The World of Panoramic Photography* (2003).

paparazzo, photojournalist specializing in intrusive, often compromising *celebrity photographs. The name derives from a minor character in Federico Fellini's film *La dolce vita* (1960), based on 1950s *fotografi d'assalto* like Felice Quinto and Tazio Secchiaroli (1925–98) who worked the then exclusive nightspots of Rome's Via Veneto and Piazza di Spagna. In the film, the *Rolleiflex-wielding Paparazzo cruises on a motor scooter, and pitilessly photographs a woman whose husband has just killed himself and their children. Top American *paparazzo* for 30 years was Ron Galella (b. 1931), whose greatest coup was to snatch nude photos of Jackie Kennedy Onassis on the island of Skorpios in 1973. Despite court battles over privacy, and the anti-*paparazzo* outcry following the death of Diana, princess of Wales, in 1997, the job continues to appeal. 'Hot' pictures of major stars command six-figure sums. In 2002, Galella had a retrospective at the Andy Warhol Museum in Pittsburgh. RL

Mormorio, D., *Tazio Secchiaroli: Greatest of the Paparazzi* (1998).

Bluttal, S., *The Photographs of Ron Galella 1960–1990* (2002).

papers, photographic. The unique look of many *vintage prints is due, in no small measure, to the wild profusion of paper types on which they were printed. Barnet Regal Rough and Verona De-Luxe; Dassonville Charcoal Black; Kosmos Vitegas; Buchet Stenox Gaslight; Criterion Vandyk; we shall not see their like again. For much of the 19th and 20th centuries, a bewildering variety of manufacturers offered a still more bewildering variety of papers in a range of weights (airmail, single, double, card), base colours (typically white, cream, and ivory), textures (from glossy through 'pearl' and matte to linen, silk, canvas, chamois, and more) and image tones (warm, cool, 'engraving black', red—the list went on).

Textures were varied by using additives (normally starch or silica) for matte effects or by impressing the paper or the emulsion or both with patterned rollers. Although *albumen papers (invented in 1850) were popular in the early days, the vast majority of commercial papers have always been silver gelatin; the only other ready-coated material that has commonly been available is platinum, though there have intermittently been others.

Particularly in the 1970s and 1980s, papers became more and more alike, though in the 1990s warm-tone and to a lesser extent cool-tone papers revived in popularity. *Image tones* are partly a matter of crystal size, and partly a matter of 'doping' the emulsion with various additives. Unfortunately for photographers, though fortunately for the environment, cadmium was dropped as an ingredient, and the best warm-tone papers (such as Forte Polywarmtone) were never

the same again. In some ways, those who bemoan the passing of the 'good old days' are, for once, right. On the other hand, there is much to praise in modern papers. Maximum blacks are for the most part much richer; development is much faster; and although the original variable-contrast (VC) papers were markedly inferior to single-contrast graded papers, in the 1980s the quality caught up and indeed surpassed the majority of graded papers. Ilford invented VC papers with Multigrade, though Du Pont was first to market with Varigam (using dyes supplied by Ilford) thanks to the Second World War.

There are also a few specialist papers that compare with the exotica of the past, for unusual surface textures and the like; leading manufacturers include Kentmere and Bergger. Many are graded rather than VC, sometimes for technical reasons (VC does not work well on canvas-textured papers, for example) and sometimes merely to pander to the prejudices of traditionalists.

The vast majority of modern papers are 'projection speed', i.e. suitable for enlargements, but there are still a few contact papers that are too slow for making enlargements; they can be handled under weak artificial light, hence their old name of *'gaslight' papers. For printing, they need strong UV sources, either a printing box or daylight. An even greater majority are 'developing-out' papers, in contradistinction to 'printing-out' papers where the paper darkens in direct proportion to the light falling on it. A typical printing-out paper takes anything from ten minutes to half an hour to form a usable image, which is then washed, toned, fixed, and washed again.

Historically, chloride papers were slow and cool toned, but gave the richest blacks; bromide papers were much faster and warmer, with lower maximum densities; and chlorobromides were predictably in between. Some also distinguished between chlorobromides (more chloride than bromide) and bromochlorides (more bromide than chloride). Today, the distinctions between bromide and chlorobromide/bromochloride no longer hold good: advances in crystal technology mean that chlorobromides can be warmer than bromides, and maximum densities are independent of halide type.

There is a popular myth that the more silver a paper has, the richer the tonality. This is not borne out in practice. Beyond a certain point, obviously, there can be no increase in maximum density, and there is no point in using more silver. Actual coating weights vary from under 1 gram per square metre (gsm) to over 2 gsm. Most manufacturers use 1.6 to 1.8 gsm for projection (enlarging) papers, but a contact paper can use as little as 0.9 gsm and still produce a better maximum black than a projection paper with twice the coating weight: the secret lies in the smaller crystal size of the slower paper.

There is also a widespread and substantially irrational prejudice against resin-coated (RC) papers. As with VC papers, early RC papers were markedly inferior to fibre base (FB), with poor maximum blacks, an unpleasant 'bloom', and a tendency to cracking and crazing; but today, if the print is behind glass, it is often impossible to distinguish between RC and FB. There is probably a small archival advantage in FB papers, however, and for 'fine-art' purposes (where the tactile advantages are also important) FB continues to rule the roost.

For reproduction, glossy prints should be the automatic choice—textured papers often reproduce very badly indeed—and there is little or no reason not to use RC paper. For exhibition, the photographer's taste must reign supreme, though matte and textured prints are easier to light and therefore often easier to see.

Although much can be quantified about papers, including their speed and contrast under specified conditions, the final results that they deliver in different photographers' hands argue strongly that printing is more akin to cookery or perhaps alchemy than to science. Developers play a very major part in both image tone (warm or cool) and *contrast (a developer can increase effective contrast by up to half a grade, or decrease it by a grade or more), but enlarger type, negative *characteristic curve, and more can mean that a paper which delivers superb results for one photographer can be a disaster for another, and of course vice versa.

A note on *formats*: papers were originally sold in large sheets, to be cut by the user, but by 1900 pre-cut paper was widely available in a huge range of sizes, as it is to this day; although, paradoxically, the 'halvable' DIN A-series, the most logical size of all, has never become popular. At least as curiously, the popular 20.3 × 25.4 cm (8 × 10 in) size is a poor match for 35 mm, but 20.3 × 30.5 cm (8 × 12 in) paper (which would be far more useful) has never been a standard size. RWH

Paraskeva, Mary (née Griparis; 1882–1951), Greek amateur photographer, born on the island of Mykonos and brought up on her millionaire father's estate at Baranovka in the Crimea. The lantern slides she created include landscapes, domestic scenes, and images of life in an important Greek mercantile colony on the Black Sea before the Russian Revolution. Her pictures were rediscovered in the late 1990s, together with work by her close friend Argine Salvago (1883–1972). RL

Karavia, M., *Odessa: The Forgotten Homeland* (1999).

Paris Commune (March–May 1871), a brief and bloodily suppressed takeover of the French capital by radical republicans accompanied by both rebel and government atrocities, and one of the first events in French history to be extensively covered by photographers. Nearly all the pictures (including *stereographs) were taken by professionals for commercial purposes. Most are spectacular urban views, showing Paris in ruins after the final 'Bloody Week' of reconquest and massacre in late May. Images actually taken during the uprising are scarcer, although there are examples by the Léautté brothers (*The Hôtel de Ville under the Commune*) and Bruno Braquehais (*Paris under the Commune*), the latter often described, without evidence, as pro-Communard.

Not surprisingly, no direct photographic record of 'Bloody Week' survives, apart from a famous image of twelve corpses in coffins inconclusively attributed to *Disdéri. Subsequently, however, the government made extensive use of photography for identifying suspected Communards, not only by seizing portrait photographs of rebels from shops but also by photographing those arrested.

Some portraits were used in widely distributed anti-Communard *photomontages, Eugène Appert's (1830–91) *Crimes of the Commune*, one of the first examples of the political use of this technique. A particularly sensational example recreated the shooting of the archbishop of Paris and other hostages in the rue Haxo on 24 May. Fearing that sales of such images, and portraits, would keep alive memories of the Commune, the Paris authorities decided in December 1871 to ban them. Only photographs of ruins, considered more artistic, were authorized for sale. QB

Bajac, Q. (ed.), *La Commune photographiée* (2000).

Paris Match, French weekly illustrated magazine, launched by Jean Prouvost on 25 March 1949. Its precursor was *Match* (1926–44). In 1962 it began incorporating 32 pages of colour pictures, but black-and-white remained important and revived strongly at the end of the 20th century. The magazine adapted successfully to television and the rise of the big French and international *agencies, but with far fewer than its original corps of c.25 staff photographers. Contributors have included most of the world's most celebrated fashion photographers and photojournalists. In 1999 its circulation stood at 900,000. RL

Thérond, R., *1949–1998: 50 ans Paris Match* (1999).

Parkinson, Norman (1913–90), English photographer and eccentric whose career saw *fashion photography transform itself from decorative depiction of aristocratic ladies to a more commercial and democratic medium. After apprenticeship to the court photographers Speaight & Sons of Bond Street, he set up his own studio at the age of 21. Like Cecil *Beaton, Parkinson was noted for taking his sitters out of the studio and encouraging them to move naturally, resulting in elegant portraits captured in contrastingly grimy or working-class environments. Sittings with contemporary figures including the Sitwells, Vaughan Williams, and Kathleen Ferrier for publications such as *The Bystander*, *Life*, and *Look* led to a close relationship with Condé Nast from the 1940s to the late 1970s. Parkinson pioneered the outdoor use of colour photography with then difficult to source early 35 mm stock, which he used for landmark fashion imagery for American *Vogue*. Many of his most celebrated images, such as a satin-clad model reclining against a Rolls-Royce Silver Ghost (1950), featured his wife Wenda Rogerson.

In 1963, Parkinson moved from Twickenham to Tobago, where he set up a pig farm and marketed his famous 'Porkinson's Bangers' sausages. One of the first fashion photographers to enjoy personal celebrity, he was latterly known as the unofficial royal portraitist. PM

Pepper, T., *Photographs by Norman Parkinson: Fifty Years of Portraits and Fashion* (1981).

Parks, Gordon (b. 1912), American photographer, born in Kansas. At 15, when already active as a writer and musician, he became interested in photography, doing freelance fashion work in Minneapolis 1937–42. As a promising young African-American he won a Julius Rosenwald Fellowship in 1942 to study *documentary photography in

Washington, DC, under Roy *Stryker at the 'Historical Section' of the Farm Security Administration, where he became a staff photographer. He stayed on when the agency became part of the Office of War Information in 1943–4, and worked for Stryker again in the *Standard Oil of New Jersey documentary project (1945–8). From 1948 to 1961 he was a staffer at *Life, and thereafter an independent photographer until he became editorial director of *Essence* magazine. From 1961 he worked increasingly in film as well as photography, directing *The Learning Tree* (1969), *Shaft* (1971), and *Leadbelly* (1976). He published *Camera Portraits: The Techniques and Principles of Documentary Photography* in 1948. He also produced remarkable portraits, most notably of Malcolm X, Muhammad Ali, and Duke Ellington. CBS

Buchsteiner, T., and Steinorth, K. (eds.), *Gordon Parks: 40 Jahre Photographie* (1989).

Parks, G., *Voices in the Mirror: An Autobiography* (1990).

Parr, Martin (b. 1952), English documentary photographer, brought up in a Surrey suburb. After graduating from the Manchester Polytechnic photography course in 1973 he worked in Hebden Bridge, Yorkshire, and in Ireland and produced a number of exhibitions and publications, before settling in Bristol in the 1980s. *Bad Weather* (1982) showed people grappling with the British climate. His seminal seaside monograph *The Last Resort* (1986) demonstrated that social documentary photography in colour could be effective both as a vehicle of self-expression and as a record: something previously assumed to be the province of black-and-white. He joined *Magnum in 1994. In 2002 a major retrospective of his work from 1970 to 2000 was held at the Barbican Gallery, London. An ongoing project is the compilation of a visual archive of everyday sights and objects, from vegetables to parking spaces. RSA

Williams, V., *Martin Parr* (2002).

Parsons, John Robert (c.1862–1909), Irish portrait painter and photographer. Parsons exhibited at the Royal Academy from 1850 to 1868, by which time he had taken up photography, and was employed by Dante Gabriel Rossetti to make copies of his paintings. His series of

Martin Parr

Woman and bus, York, November 1981, from *Bad Weather*

portrait photographs of Rossetti's lover Janey Morris, made under Rossetti's supervision in the garden of his Chelsea home, are among the most original and powerful of the 19th century. His more conventional portrait photographs include those of two Rossetti models, Elizabeth Siddal and Alexa Wilding, the *Pre-Raphaelite patron and shipowner Frederick Leyland, and Janey's husband William Morris. CF

Patterson, Freeman (b. 1937), Canadian photographer, writer, and teacher. After writing his master's dissertation, at Union Theological Seminary, Columbia University, on 'Still Photography as a Medium of Religious Expression', he taught religious studies for three years before taking up photography full time in 1965. Fifty-five of his pictures were included in the centennial exhibition at Expo 67 in Montreal and the accompanying volume, *Canada: A Year of the Land*, published by the National Film Board of Canada.

Patterson's quasi-mystical approach to photography as a path to self-discovery and oneness with the natural world is reflected in books such as *Photography for the Joy of It* (1972) and *Photography of Natural Things* (1982, 1989). Particularly memorable are his images of abandoned mining towns in Namibia from the mid-1990s. He has organized workshops at his home in Shamper's Bluff, New Brunswick (from 1973), and, since 1984, in Namaqualand in western South Africa. RL

Patterson, F., *Shadow Light: A Photographer's Life* (1996).

Pavie, Auguste (1847–1925), French naval officer, colonial administrator, explorer, and photographer. In Cambodia in 1875 he acquired an extensive knowledge of the people and customs and learned the language. From 1879 to 1895 he led a loose group of up to 40 men, ultimately known as 'la Mission Pavie', in explorations in Laos, Cambodia, Tonkin, Annam, and south China. They conducted cartographic surveys and ethnographic studies and investigated local resources. Pavie himself, the cartographer Pierre Cupet (1859–1907), the officer Joseph de Malglaive (1862–1914), and the doctor Alexandre Yersin (1863–1943) photographed the various expeditions. RT

Peabody, Henry Greenwood (1855–1951), American photographer, born in Missouri and educated at Dartmouth College (1876). After a year as an engineer, he joined Alexander Hesler in Chicago and made photography his lifelong profession. Following marriage to Dora Phelps the couple moved to Boston and Peabody specialized in *marine photography, publishing *The Coast of Maine* (1889) and *Representative American Yachts* (1891). The *Notman studio sent him to British Columbia via the Great Northern Railway in 1893 and he became photographer to the Boston and Maine Railroad in 1896. A successful 1899 trip to Mexico with Sylvester Baxter to record Spanish colonial architecture resulted in his joining the *Detroit Publishing Company in 1900. It placed Peabody in Pasadena, where he remained even after the firm's demise. Until his death he regularly photographed the National Parks and used his lantern-slide and filmstrip shows to promote the 'See America First' programme. JVJ

Penn, Irving (b. 1917), American photographer, active in New York. After studying design with Alexey *Brodovitch in Philadelphia, and spending a year (1940–1) painting in Mexico, he became assistant to Alexander *Liberman at *Vogue in 1943. Hired to help design covers, he was soon shooting them himself. He opened his own fashion and advertising studio in 1953 and became extremely successful. One of the most influential photographers of the 20th century, Penn's oeuvre spans over 60 years and includes many classic images. While fashion, portraiture, and still life (including product photography), almost exclusively created in the studio, is the foundation of his work, he has consistently expanded his range of subject matter and method. *Worlds in a Small Room* applied characteristically austere portraiture, done in a portable studio using available light, to 'ethnographic essays' for *Vogue*, while his famous photographs of cigarette ends rediscovered the platinum print and pushed the limits of the medium in conveying form and detail. Penn has been a master of reduction and refinement, working in a deliberate way with simple, controllable settings to create timeless images of an ephemeral world. Still highly productive in his late eighties, he explored new themes such as the self-portrait and dance, and returned to the nude. J-EL

Penn, I., *Moments Preserved* (1960).
Westerbeck, C. (ed.), *Irving Penn: A Career in Photography* (1997).
Still Life: Photographs 1938–2000 by Irving Penn, introd. J. Szarkowski (2001).

Peress, Gilles (b. 1946), French photojournalist, based in New York. He became a photographer in 1971, after studying politics and philosophy in Paris. He joined *Magnum in 1974, later becoming its president. From the beginning he was drawn to conflict, from early images of a French mining community at the end of a long strike, to coverage of the Iranian Revolution, the troubles in Northern Ireland (a twenty-year project), and ethnic strife in Bosnia and Rwanda. The 1960s left him with a distrust of verbalization; later he also came to distrust 'good photography', believing that crude realism, without captions or aesthetic frills, would best convey his message. Like others of his generation—for example, James *Nachtwey—he hoped that photography might raise awareness of violence and oppression. He has stated, 'I'm gathering evidence for history, so that we remember.' His books include *Telex Iran* (1983), *Farewell to Bosnia* (1994), and *The Silence: Rwanda* (1995). His work also appears on the *Internet. LAL

performing arts and photography. For obvious technical reasons, photography of dramatic, dance, or musical performances was impossible during the medium's early history. But demand for photographs of performers, along with those of royalty and other *celebrities, fuelled the mid- and late 19th-century *carte de visite* and *cabinet boom, and commercial photography generally into and beyond the *postcard era. Theatre specialists included firms like Reutlinger in Paris, *Sarony in New York, and London studios such as *Elliot & Fry, whose valuable images of Lily Langtry, Henry Irving, and Buffalo Bill were registered, sometimes in large batches, under

Erich Auerbach

Mstislav Rostropovich, 1965

the 1862 *Fine Art Copyright Act. In the inter-war years, *Manassé in Vienna and *Harcourt in Paris flourished on sales of glamour portraits of stage and screen stars in old and new formats, including cigarette cards.

The performance element of star portraits could be conveyed with relative ease in the studio, though never with more economy and grace than in *Nadar's famous series of the mime Jean-Charles Debureau as *Pierrot* in 1854–5. The cult of the Wagnerian music drama from the 1860s tended to produce less elegant results. Joseph *Albert's 1865 photograph of the principals of *Tristan und Isolde*, Ludwig and Malwine Schnorr von Carolsfeld, captured them in full costume on a creaking modern sofa. Later, Wagnerian scenes were often photographed on stage, with tanklike, helmeted performers posed amid the clutter of late 19th-century historicist decor. The Charlottenburg photographer Emil Schwalb used superimposition and retouching to convey the illusion of actual performance in his pictures, which appeared as postcards, prints, and illustrations in programmes and Wagner handbooks. The spread of *half-tone printing by 1900, and the proliferation of theatrical magazines like *Le Théâtre*, *Das Theater*, and *Bühne und Welt*, increased demand for stage pictures generally, but particularly for full-set photographs of the 'strong climaxes' of new plays. Specialists in this kind of work included firms like Foulsham & Danfield in London's West End, and White's Studio and *Byron in New York. The pictures were usually taken during dress rehearsals from a temporary platform in the stalls, and lit by carefully placed charges of magnesium flash.

In the 1920s the expanding illustrated press developed an appetite for pictures of performers of all kinds, from ballet dancers to clowns. A particularly versatile photojournalist was Felix H. *Man, who photographed weightlifters in Munich beer cellars, jazz musicians in Berlin, and modern plays in both Germany and England. But his speciality was orchestral music. Usually permitted to set up a tripod—sometimes mistaken for a new instrument—in the orchestra during rehearsals to photograph conductors and soloists, he also succeeded with more dramatic or surreptitious shots at first nights and other 'real' performances.

Influential in the increasingly popular field of expressive modern dance was Arnold *Genthe, who aspired, for technical reasons not always successfully, to liberate dance photography from the posed studio shot; his *Book of the Dance* appeared in 1916. Using more versatile equipment in the 1920s, though still based in the studio, Charlotte Rudolph in Dresden and Lotte *Jacobi in Berlin were better at conveying the illusion of dynamic action. Especially memorable were Rudolph's exuberant image of the dancer Gret Palucca in 1923, published in *Moholy-Nagy's *Malerei, Fotografie, Film*, and Jacobi's almost abstract study of Lieselotte Felger performing a spinning-top dance that almost eliminates her waist (1931). Jacobi continued to experiment with dance photography after emigrating to New York, and in 1950 montaged pictures of the dancer Pauline Koner with the cameraless images she called 'Photogenics'. The former abstract painter Barbara *Morgan, perhaps the most

important dance photographer of the mid-20th century, also used experimental methods, including double exposure, in her celebrated photographs of Martha Graham, Merce Cunningham, and other performers. Like Jacobi, she preferred the controlled conditions of the studio to the uncertainties of the theatre, and planned her pictures with extreme care. 'Previsualisation', she wrote, 'is the first essential of dance photography. The ecstatic gesture happens swiftly and is gone; unless the photographer previsions in order to fuse action, light and space simultaneously, there can be no significant dance picture.'

Some of the most famous photographs of the classical ballet had been taken before 1914 by Adolphe de *Meyer, whose shimmering studio images of Vaslav Nijinsky and other stars of the Ballets Russes have fixed them for ever in collective memory. Equally unforgettable were Alexey *Brodovitch's photographs published in *Ballet* in 1945. The book is a kind of visual anthology of ballets by different companies shot by Brodovitch in New York between 1935 and 1937. Using a 35 mm Contax without flash, he photographed both on and off stage, sometimes in among the performers, sometimes at a distance, using slow shutter speeds and often pointing his lens into the lights for flare and halo effects. The fantastic, often dreamlike results were further enhanced in the darkroom by bleaching, airbrushing, and other techniques. Another fearless rule breaker, using blur and blank backgrounds to convey the illusion of bodies liberated from gravity, was the post-war British ballet photographer Anthony *Crickmay.

In the second half of the 20th century, performance photography became an ever larger, more varied, and more competitive field. Photographers already famous in other fields, like Irving *Penn and Richard *Avedon, did important work in the theatre. *Cartier-Bresson, Guy Le Querrec, and others in France, and Dennis Stock (b. 1928) in the USA, were drawn to jazz. Roger Pic, working with the Renaud–Barrault company, and Brecht, broke away from the conventional 'strong climaxes' approach to photographing plays and tried to record the ebb and flow of performances in their totality. Longer, faster lenses, more sensitive films, and colour offered new creative possibilities, although fundamental problems remained. Dance photographers like Lois Greenfield, for example, continued to prefer the studio to the stage. Perhaps the most challenging new development since the 1950s was the rise of rock music, offering both performance and documentary opportunities. Its practitioners were soon legion. But a legend of its kind was Annie *Leibovitz's 1975 tour with the Rolling Stones, a journey of discovery that not only produced unrivalled concert images but a visual chronicle of life on the road, the fans, and the whole scene. RL

Morgan, B., *Martha Graham: Sixteen Dances in Photographs* (1941).
Beaton, C., and Buckland, G., *The Magic Image: The Genius of Photography from 1839 to the Present Day* (1975).
Ewing, W. A., *Fugitive Gestures: Masterpieces of Dance Photography* (1987).
Craske, O., *Rock Faces* (2004).

perp walk, American term for the passage of an arrested suspect (perpetrator) en route from a police station to court, past tabloid photographers shouting abuse in order to elicit an expression of criminal savagery for the front page. Direct flash and a low camera angle made the subject look still more menacing (and guilty). Such an ordeal, endured by the former 'master of the universe' Sherman McCoy, is described with brutal realism in Tom Wolfe's novel *Bonfire of the Vanities* (1987). In the 1990s courts increasingly frowned on the practice as an infringement of prisoners' rights. RL

Perscheid, Nicola (1864–1930), German photographer. He originally planned to be a painter, but in the 1880s served a photographic apprenticeship in Koblenz and in 1891 opened a studio in Görlitz, Saxony. In 1894 he moved to Leipzig and in 1905 opened a branch in Berlin. Both his landscapes and his portraits of famous people won international acclaim. Perscheid continued to flourish as a portraitist after the First World War, and also worked with colour photography. JJ

Kempe, F., and Appel-Heyne, O. M., *Nicola Perscheid—Arthur Benda—Madame d'Ora* (1980).

Persia. See IRAN, EARLY HISTORY.

perspective, a sense of depth in a flat image, may be conveyed in at least four ways: *aerial perspective*, *perspective of receding planes*, *perspective of scale*, and linear or '*vanishing point*' perspective.

Aerial perspective is conveyed by loss of contrast and detail in more distant subjects, and by increasing blueness. It is generally least in the morning of a clear, bright, cold day: the greater the departure from these criteria, the more apparent aerial perspective will be. In black-and-white photography it can be greatly reduced by using yellow, orange, red, and even infrared filtration (in increasing order of effect), or slightly increased by using blue filtration or films with reduced red sensitivity.

The *perspective of receding planes* is most clearly seen in Japanese and Chinese brush paintings of mountains: even with no other indicator of scale, if one thing is in front of another it creates an impression of depth.

Perspective of scale or size is clear when, for example, there are two human figures in a picture, one of which is twice the size of the other. Experience argues that in reality both are of similar height, so one must be further away.

'*Vanishing point*' *perspective* is, in a sense, merely a variation of perspective of scale, but the extent to which it is a convention is well demonstrated by a photograph of a street of tall buildings, from ground level. The 'vanishing point' is cheerfully accepted in the apparent narrowing of the street as it stretches into the distance, but if the camera is tilted upwards, the buildings look as if they are falling over backwards, even though exactly the same perspective considerations apply; hence the popularity of rising fronts on view cameras, and of shift lenses.

Tolerance of what used to be called 'violent' perspective seems to have increased with ever-greater use of *wide angles. In the 1950s, the perspective effects associated with 21 mm lenses (on 35 mm) were regarded as so extreme that the lenses were seen as of limited usefulness. Today, most people hardly notice. RWH

Kingslake, R., *Optics in Photography* (1992).

perspective control (shift) **lens**. When photographing *architectural subjects it is usually necessary to keep the camera film plane vertical in order to avoid keystoning (converging verticals) effects. To achieve this without cutting off part of the subject matter, field and studio cameras have a facility for shifting the lens panel so that the centres of the subject, the lens, and the film format are in a straight line. Since the 1980s, so-called perspective control (or 'shift') lenses have become available for 35 mm and medium-format cameras, the amount of shift being controlled by a setscrew. As the mechanism operates in only one direction, the entire lens mount is rotatable in steps. More recently, lenses that can also be rotated about their rear nodal point have become available. These permit the application of the *Scheimpflug rule to the photography of scenes in which the important planes of the subject and the image are not parallel. GS

Peru. Despite periods of economic and political instability, and occasional severe earthquakes, Peru's photographic history is well documented, with large collections of historic photographs held either privately or in institutions like the Fototeca Andina in Cuzco. A significant influence on photographic practice has been the country's rapid modernization, creating extremes of wealth and poverty and exacerbating tensions between the Hispanic and *mestizo* population of the cities and the indigenous rural poor. The growth of tourism has also been significant, especially since the discovery of the remains of Machu Picchu in 1911, and Inca ruins, Andean views, and indigenous genre scenes have long been a staple commercial product.

Peruvian photography can best be examined under two headings: as part of the sophisticated, cosmopolitan culture of the capital, Lima, birthplace of the *celebrity photographer Mario Testino (b. 1954); and in towns like the old Inca capital of Cuzco in the southern Andes, a centre of early 20th-century *Indigenismo* and the home of Martín *Chambi, since his death in 1978 Latin America's most famous photographer.

As in other Latin American countries, foreigners played a leading role. A Frenchman, Maximiliano Danti, and an American, Benjamin Franklin Pease, founded two of the earliest Lima studios, the latter offering paintings as well as *daguerreotypes. Another Frenchman, Eugenio Courret, established himself there in the early 1860s and created a thriving business, producing not only refined, rather Spanish-looking portraits of solid citizens, and rich little girls with their dolls, but urban views, architectural studies, and occasional scenes of political unrest. He maintained contact with European culture by exhibiting in numerous salons, and won a gold medal at the 1900 Paris Exhibition. When he finally returned to France the business passed to another Frenchman and survived until 1935.

In the culturally more mixed southern city of Arequipa, the Vargas brothers, Carlos (1885–1979) and Miguel (1886–1979), opened a studio in 1912. They created thousands of portraits of Hispanic and indigenous clients, as well as theatrical and topical scenes and nocturnes. Their studio also functioned as a gallery, showing *indigenista* art, and the photographs of Chambi and another Cuzco-based photographer (and painter), Juan Miguel Figueroa-Aznar (1878–1951). The latter played an important part in the contemporary revival of Peruvian indigenous culture, but also married a bishop's niece and became a regular portraitist of the Catholic clergy. Chambi was much more closely and constantly involved with pre-Hispanic culture, being of indigenous origin himself. In addition to portraits of all kinds of people, his output was enormously varied, ranging from the earliest photographs of Machu Picchu to landscapes, social gatherings, and a sustained documentation of rural life and the traces of Inca culture. Particularly moving is a 1934 photograph of a pyramidal group of seven peasants and a straw-hatted infant reclining proudly on a pyramid of potatoes. Such pictures showed indigenous people as autonomous human beings rather than as merely 'backward' or 'exotic'. In the same spirit was a late 20th-century initiative, *Talleres de Fotografia Social* (Social Photography Workshops), that supplied peasants with cameras and encouraged them to record their own lives.

Another important documentarist was Sebastián Rodríguez (1896–1968) who in 1923, after training in Lima, began working as an itinerant photographer in Peru's bleak mountain mining camps. In 1928 he settled in the town of Morococha, employed by the Cerro de Pasco mining company, and over 40 years created thousands of numbered identity photos, but also images of the miners' harsh working conditions, everyday lives, and funerals. RL

McElroy, K., *The History of Photography in Peru in the Nineteenth Century, 1839–1976* (2 vols., 1977).

Billeter, E., *Fotografie Lateinamerika von 1860 bis heute* (1981).

Poole, D., 'Figueroa Aznar and the Cuzco *Indigenistas*: Photography and Modernism in Early Twentieth Century Peru', *Representations*, 38 (1992).

Castro, F., *The Frayed Twine of Modernity: Photography in the Southern Andes of Peru, 1900–1939* (1992).

Watriss, W., and Zamora, L. P. (eds.), *Image and Memory: Photography from Latin America, 1866–1994* (1998).

Peterhans, Walter (1897–1960), German photographer and teacher. He studied mathematics, philosophy, and art history, then photographic reproduction at the Academy of Graphic Art and Book Design in Leipzig. He opened a studio in Berlin in 1927, but from 1929 to 1933 headed the newly established photography department at the *Bauhaus, where photography had previously played only a marginal role. His appointment established it at a professional level, in conjunction with typography, advertising, and exhibition design. Peterhans's work was strongly influenced by *Neue Sachlichkeit, and the syllabus emphasized the precise rendering of light effects, the structure of materials, and the texture of surfaces. In his own idiosyncratically composed still lifes, however, surreal and abstract tendencies appear, creating multiple levels of reality and meaning.

After the closure of the Bauhaus, Peterhans taught in Berlin, then, after emigrating to the USA, at the Illinois Institute of Technology in Chicago. He only worked in post-war Germany on an occasional visiting basis. UR

Bauhaus-Archiv Berlin, *Fotografie am Bauhaus* (1990).

Petersen, Anders (b. 1944), Swedish photographer, born and resident in Stockholm. A student of Christer *Strömholm at Fotoskolan, Petersen soon developed a personal approach for which extended fieldwork and total involvement by the photographer are key requirements. His brand of social photography has consistently represented social outcasts—prostitutes, prisoners, the elderly poor, mental patients. Influential and widely exhibited, Petersen's intimate and empathetic photography attempts to penetrate the psychic universe of his subjects. His debut publication *Café Lehmitz* (1974), depicting the socially marginal regulars of a Hamburg coffee shop, is a classic. J-EL

Anders Petersen: Photographs 1966–1996 (2002).

Petrussov, Georgi (1903–71), Ukrainian-born Russian photojournalist. In the mid-1920s he worked for Moscow-based trade union papers, then *Pravda*. As head of information on the site of the Magnitogorsk steelworks between 1928 and 1930, he created a photographic chronicle of the construction process. From 1930 to 1941 he worked on the prestigious *USSR in Construction*. Petrussov was influenced by avant-garde colleagues like *Rodchenko and Boris Ignatovich (1899–1976), and images like his contre-jour shot of the Dnieper Dam (1934) are magnificent examples of dynamic modernism. However, his propaganda pictures of happy collective-farm workers and optimistic fraternal delegations enabled him to survive under *Socialist Realism. He covered many episodes of the Second World War, including the fall of Berlin, and afterwards remained a photojournalist. RL

Morozov, S., and Lloyd, V. (eds.), *Soviet Photography 1917–1940: The New Photo-Journalism* (1984).

pets. By *c.*1840 the habit of pet keeping was spreading rapidly from the aristocracy to the middle class; dogs, cats, rabbits, guinea pigs, and the occasional monkey or parrot found homes in British households. Sentimental cat and dog paintings flooded the art market. However, early photography could only record very old or sleepy animals—like Minette the cat photographed by Auguste Vacquerie on Jersey in 1853, or the tabby-in-a-basket stereographed by William Mason in Brighton a few years later. In the 1870s, another Brighton photographer, Harry Pointer, published over 100 posed cat photographs ('Pointer's pets'), an achievement both extraordinary and profitable. By the 1900s, animals were appearing regularly in *snapshots and even studio portraits. True to form, Jacques-Henri *Lartigue captured astonishing pictures of leaping cats, and the family rabbits hurtling from an upstairs window down an improvised track. Albums increasingly included pets, on laps, chairs, lawns, or squirming in children's arms, recognizable though still often tiny and poorly exposed.

Harry Pointer

Kittens, 1870s. *Cartes de visite*

Like beaches and Christmas trees, pets have remained a staple of popular photography, often snapped to test a camera or finish a film. Children favour them; as Dave Kenyon has noted, 'Pets . . . are never "too busy" or "looking dreadful".' Animals themselves are generally indifferent to these scentless, static, and minuscule images, although cats may respond to life-size projected transparencies of themselves or a sibling taken at ground level. RL

Silverman, R. (ed.), *The Dog Observed: Photographs 1844–1984* (1984).
Eauclaire, S., *Le Chat en photographie* (1991).
Kenyon, D., *Inside Amateur Photography* (1992).

Petzval, Josef (1807–91), Hungarian mathematician who in 1840 became the first person to compute a lens design mathematically. His lens, designed specifically for cameras, used two achromatic pairs of elements, and with its then enormous aperture of f/3.6 reduced exposure times from minutes to seconds. Petzval's configuration is still the basis of some long-focus and projection lenses. He also worked out a formula (the *Petzval sum*) for the curvature of field of a lens in terms of the radii of curvature of the surfaces of its elements, thus enabling later lens designers to compute lenses with a completely flat field. GS

Pfahl, John (b. 1939), American photographer. From his native New York state to the American south-west, Pfahl has documented the American landscape since 1961. His observation of human interaction with the environment has resulted in colour series like *Altered Landscapes* (1974–7) and *Extreme Horticulture*. A frequent commentator on perceptions of landscape, Pfahl eventually incorporated *digital manipulation in his photographs (*Permutations on the Picturesque*, 1997). He taught at the Rochester Institute of Technology in Rochester, New York. KEW

Brutvan, C. (ed.), *A Distanced Land: The Photographs of John Pfahl* (1990).

pH. The pH of a solution is a measure of its acidity or alkalinity. It is important in photographic processing. For example, the pH of a developer determines its level of activity; and the final pH of a paper print has a profound effect on its longevity. A neutral solution has a pH of 7.0; higher figures are associated with alkalinity, lower figures with acidity. The acidity of a solution depends on its hydrogen-ion concentration, which is equal to the hydroxyl-ion concentration (10^{-7} moles per litre, hence the 7) in a neutral solution. The pH scale is logarithmic, so that a developer with a pH of 9.5 is ten times as alkaline as one with a pH of 8.5. The pH values found in photographic processing solutions vary from about 10.5 for the most vigorous developers to about 5.5 for acid fixing baths and 4.5 for acid bleach baths.

Laboratory pH meters are expensive and need frequent recalibration. For most purposes indicator papers, which change colour according to the pH of the solution, suffice. The colour is matched against a printed colour sheet.

The origin of the symbol 'pH' has puzzled generations of chemistry students, photographers, and gardeners. In fact, 'H' is the symbol for hydrogen, and the 'p' is a corruption of the Greek letter ρ (rho), which was formerly the symbol for concentration. GS

photoblogging, on-line photo publishing via a 'weblog' ('blog'), a journal-form, constantly updatable website. This type of *Internet publishing became widespread with the appearance from *c.*2000 of user-friendly site-design software. Typical weblog components may include a picture gallery, archive, photographer CV, and links to other sites. Photoblogging may be used to record everyday experiences, chronicle a journey, or exhibit and sell photographs. RL

Henry, M., 'Why the World Needs Photoblogs', *Digital Camera Shopper*, 12 (Mar. 2004).

Robinson & Thompson, Birkenhead

Man with dog, c.1890s. Cabinet print

photo booths. See INSTANT PHOTOGRAPHY; PRINT CLUB.

photoceramic processes. In the 1850s, the instability of silver photographs encouraged the invention of *alternative (non-silver) processes based on pigments suspended in organic colloids such as gelatin or gum arabic and sensitized with chromates like potassium dichromate. These were used to make photographs on paper, but the principles also applied to producing permanent photographic images on ceramic and enamel ware. The first successful method, called the 'dusting-on' or 'powder' process (H. Garnier and A. Salmon, 1859; F. Joubert, 1860), used a sticky coating of dichromated albumen and honey on a glass support. This coating was selectively hardened by exposure to sunlight under a photographic transparency. The surface was dusted with vitrifiable, powdered pigment, which adhered to the unexposed areas as a dense layer corresponding to the shadows of the image, and as progressively thinner layers in the middle tones. The excess powder was dusted off the highlights, and the pigmented image was secured with a temporary coating of *collodion for transfer on to the final ceramic support. A later variant used carbon transfer paper made with vitrifiable pigments. In both versions, the image was fixed by firing, and given a top coat of copal varnish, or fired again with a transparent glaze.

A different approach, called the 'substitution' process (Lafon de Camarsac, 1855), was inspired by an 18th-century method of decorating ceramics with metallic oxide pigments such as colloidal gold. A silver collodion photograph was produced on glass, and toned with gold, iridium, or platinum chloride, which partially plated and partially replaced the silver. The image was transferred on to ceramic ware. An initial firing fixed the pigment, which was then coated and refired with up to three layers of protective transparent glaze.

In the 1870s, the new *photomechanical processes of photolithography and *collotype were used to print in metallic oxide inks on to transfer paper. The inks and transfer papers were based on 'decalcomanie', an 18th-century method of decorating ceramics by intaglio transfer. A later method of collotype printing dispensed with the transfer paper and used a flexible matrix to print directly to flat ceramic ware, such as fireplace tiles. This reduced labour and brought down production costs.

All these methods were labour intensive, and manuals warned of failure and frustration. Nevertheless, the commercial market was substantial, especially in the 1890s, when portrait studios were looking for novelty alternatives to the ubiquitous paper photograph and, with the growth of *snapshot photography, wished to lure customers back from amateur portraiture. Photoceramics were made for everything from tea cups to tombstones: the *powder dust-on process suited individual commissions such as portrait plaques and medallions inset into jewellery, while lithographic or collotype transfers were used for mass-produced souvenir and commemorative ware. Modern photoceramics are still produced in some quantity, especially for gravestone plaques. HWK

Eder, J. M., *History of Photography*, trans. E. Epstean (1945).

Nadeau, L., *Encyclopedia of Printing, Photographic, and Photomechanical Processes* (1990).

Ceramic Stained Glass & Vitrified Photographic Co., London

Photoceramic centre decoration on Minton earthenware plate, 1882

Photo-Club de Paris. Founded in 1888, and from 1891, under the presidency of Maurice Bucquet (*c.*1860–1921), dedicated to the cultivation of photography as a fine art. It played a role in France similar to that of the *Photo-Secessionists in America or the *Linked Ring in Britain. Its members numbered some of the most accomplished French *pictorialists, like Robert *Demachy and Émile Constant *Puyo, who in 1903 founded *La Revue de photographie* to replace the *Bulletin du Photo-Club de Paris*. Bucquet organized a series of prestigious art photography salons between 1894 and 1914. In the 1920s, under Puyo's leadership, the society remained wedded to pictorialism, and closed in 1928. KEW

photodynamism. See FUTURISM AND PHOTOGRAPHY.

photo-essay. Occasionally, photographers have captured a single event in sequential form: for example, Paul *Nadar's photographs of the interview between the centenarian chemist Chevreul and Félix *Nadar (1886), *Brassaï's *A Man Dies in the Street, Boulevard de la Glacière* (1932), and Arthur Codfod's pictures of the *Hindenburg* disaster (1937). But the term photo-essay implies something more extended, structured, and multifaceted: the exploration by one (usually) or more photographers of an issue, place, or social situation in a more or less leisurely manner that reveals its character and dynamics. How and by whom the story is written up has varied, and often caused friction between photographer and editor.

The classic era of the photo-essay lasted from the 1920s to the 1960s, with the rise of the mass-circulation illustrated press. Subjects ranged from sport and travel to war, politics, and social documentary. Over the same period, layouts evolved from symmetrical arrangements of discretely captioned pictures to much more dynamic placement and sizing of photographs and combinations of image and text. Papers like the *Berliner illustrirte Zeitung*, the *Münchener illustrierte Presse*, *Vu*, *Regards*, *Life*, and *Picture Post* were in the forefront, although journals like the Russian *USSR in Construction*, the Japanese *Nippon*, and wartime German *Signal* also reflected the trend. After 1945 the photo-essay experienced an Indian summer, with outstanding examples in *Lilliput* (Bill *Brandt on Connemara, 1947), *Fortune* (Walker *Evans on Chicago, 1947), *Vogue* (Walker Evans on 'Faulkner's Mississippi', 1948), and *Paris Match* (George *Rodger on the Nuba, 1949; Henri *Cartier-Bresson on Moscow, 1955). But the master of the mature photo-essay was W. Eugene *Smith, whose essays *Country Doctor* (1948), *Spanish Village* (1951), and *Death-Flow from a Pipe* (on pollution at *Minamata, 1972) appeared in *Life*. His relations with *Life* were notoriously difficult, however, and led to his resignation in 1955. At issue were fundamental questions like length, but above all whether the story itself would be structured by the photographer or by editors.

The decline of the major news magazines removed the economic basis for what was, by its nature, a slow-paced, costly, and usually unsensational branch of photojournalism. Since the late 20th century, work in the genre has been relegated to books and exhibitions, for

which photographers usually have to find their own sponsorship. Although sponsorship from organizations like the Guggenheim and Hasselblad foundations may be available, usually few publishers and fewer galleries are prepared to put up serious funding (other than for certain members of famous-name agencies such as *Magnum), so that a photographer must earn the cost of travel and equipment before even embarking on a necessarily uncertain project. The rewards are in the satisfaction of producing a sustained piece of work, outside the inherently ephemeral format of news journalism, which may attract critical attention and become a classic of its kind. AH/RL

Willumson, G. G., *William Eugene Smith and the Photographic Essay* (1991).
Dewitz, B. v., and Lebeck, R., *Kiosk: A History of Photojournalism 1839–1973* (2001).

photo-finish camera. In order to avoid possible wrong decisions over the order in which racehorses, athletes, racing cars, etc. pass the finishing post when the result is very close, the finish of a race can be recorded by a special camera called a *photo-finish camera*. Until recently this has been a specially constructed or modified film camera, taking 70 mm or larger roll-film. Instead of a normal *focal-plane shutter this camera has only a capping shutter, and in the focal plane a fixed vertical slit centred on the optic axis of the lens. The camera is set up so that the image of the finishing post falls on the slit, with a high viewpoint so that the competitors do not mask one another. To record the finish of the race the lens is uncapped and the film is set in motion at a speed matched to the movement of the image of the participants. This is calculated according to the formula $v = f/D \times V$, where v is the required film movement speed, f the focal length of the lens used, D the average distance of the competitors from the camera, and V the average speed of the participants, all measurements being made in the same units.

In horse races it is usually the relative positions of the horses' noses as they pass the finishing post that decides the outcome of the race; in athletics it is the heads of the competitors (hence the practice of ducking forward at the finishing line); with cars, cycles, etc. it is the front of the machine. In each case this will be the part that is moving at more or less the average speed, and this part of the image will appear sharp and undistorted, whereas other parts such as legs will inevitably show some distortion. In particular, a hoof or foot that lands precisely on the finishing line will be imaged as a smear with a length corresponding to the time it was stationary. If the film movement has been accurately judged the spacing between the noses etc. will give the precise time margins between the competitors. The winning post may also bear a moving image with timing marks, date, and race number. This will record as a full image on the film.

Owing to the delay in processing, film cameras are rapidly becoming obsolete, and are being replaced by *digital recording cameras. These do not require a full frame of pixels, as a single vertical row of these suffices. There is no need for a slit, and the result can be displayed on a screen in near-real time, and printed out immediately in full colour. GS

Ray, S. (ed.), *High Speed Photography and Photonics* (1997).

photogenic drawing. In 1834, Henry *Talbot so named the first photographic process on paper. He immersed Whatman's writing paper in dilute salt solution, then after drying brushed it with concentrated silver nitrate solution, precipitating silver chloride within the surface fibres. This sensitized paper darkened in sunlight within a few minutes due to the formation of finely divided metallic silver, so could easily provide *photograms of botanical specimens and textiles. Treatment with strong solutions of salt, or potassium iodide, partially fixed the images. This low-sensitivity material required hour-long camera exposures, but yielded Talbot's first negatives in 1835. MJW

See also INVENTION OF PHOTOGRAPHY.
Schaaf, L. J., *Out of the Shadows* (1992).

photogenic quality cannot be precisely defined. It is partly a matter of fashion; partly a question of the eye of the photographer; and partly empirical.

For the first, the importance of genre should not be underestimated: the picturesque harbour scenes of the 1880s; the mannered portraits and shiny nudes of the 1930s; fishermen mending their nets in Spain in the 1950s; the 'swans and sunsets' of the camera club. Even when a genre sets out to subvert the picturesque, as did a section of Soviet photography in the 1920s and 1930s, or the gritty black-and-white reportage of the 1960s, or the American 'New Color' photography of the 1970s, it spawns its own unstated definition of 'photogenic'.

For the second, little need be said, except to repeat the importance of fashion: sharp focus versus soft focus, or the infighting between *'pictorialists' (under William *Mortensen) and 'naturalists' or 'realists' (under Ansel *Adams) in the 1930s.

For the third, it is a common experience that there are people and places that the camera seems to love and flatter; flattering, by extension, the photographer's talent. Often, this is a matter of how much the photographer cares about the subject, but there is something more than this: some subjects seem promising, but do not 'work', while others that seem fairly ordinary at the time are transmuted into magic in the photograph. Over the years, most photographers develop a feeling for those subjects that are likely to be most photogenic. But, even then, their intuition can deceive them. RWH

photoglyphic engraving, a term coined by Henry *Talbot (1858) to describe his photo-etching process (patented 1852 and 1858), using dichromated gelatin as an etching resist on a plain copper or steel-faced plate. Talbot experimented with a ferric chloride etching bath and later proposed an aquatint grain (*c*.1856), contributing to the subsequent development of *photogravure. He also patented the principle of a screen (initially of muslin, later of ruled lines on glass) through which the plate was exposed; this method of obtaining shadow density led to the *half-tone process. HWK

photoglypty. See WOODBURYTYPE.

photogram. Term used in the 19th century by photographers to denote any photograph made with artistic intent, but today to describe a photograph made by direct contact, i.e. without a camera. Historians often refer to the 'photograms' made by Henry *Talbot and Anna *Atkins in the first decade of photography, but these early specimens were not considered different from camera negatives made at that time, and 'photogram' should not be mistaken for *'photogenic drawing'. In the modern sense, that of the *contact print, 'photograms' were most famously made by *Man Ray in his 'Rayographs'. László *Moholy-Nagy and Christian *Schad also used the technique, the latter naming his pictures Schadographs. Since the late 20th century, the photogram as an art form has gained popularity, encouraged partly by market forces that value the unique image, as well as innovative work by contemporary artists like Adam Fuss, the first to make a photogram on a *daguerreotype plate, and Susan *Derges. Contact prints made for scientific purposes, and 19th-century renderings of spectra, are still widely considered to be 'photographs', as if 'photograms' only occur within the purview of the fine arts. KEW

photogrammetry, photography for measurement purposes. This covers measurement of anything, from the spaces between atoms in a crystal to the drift of continents or even the motion of stars. Early work on photogrammetric surveying (often for military purposes) was done by, among others, Aimé Laussedat in France, Eduard Déville in Canada, Albrecht Meydenbauer in Germany, and Ernst Mach, Eduard von Ortel, and Theodor *Scheimpflug in Austria-Hungary. An International Society for Photogrammetry was founded in Vienna in 1910. Photogrammetry's main application today is mapping by *aerial survey. GS

Photographers' Gallery, London. See GALLERIES OF PHOTOGRAPHY.

photographically illustrated publications, 19th-century. The term covers a form of 19th-century publishing frequently referred to as the photographically illustrated book. 'Publication', however, is more wide ranging, since it encompasses all the types of printed text that were photographically illustrated during the 19th century.

While making up a comparatively small component of the overall publishing market during the second half of the 19th century, the long-term significance of the photographically illustrated publication is difficult to overstate. The application of photographic illustration to accompany printed text is now such a fundamental and integral part of industrialized societies that it is a paradox that relatively little has been written on its history. Heidtmann and Gernsheim have been the two principal scholars to have published bibliographic information in this field. However, the scale, scope, and significance of the application of photography to the illustration of books and other publications containing printed text largely await discovery and interpretation.

The application of photography to book illustration was appreciated by Henry *Talbot. His six-part serial *The Pencil of Nature* (1844–6) may generally be considered the first photographically illustrated publication of any significance, although it only contained a total of 24 photographic plates. Few photographically illustrated publications appeared in the remainder of the 1840s, probably no more than a few dozen worldwide.

Talbot's photographically illustrated publications exemplified a standard that was used throughout the 19th century. Photographic prints were most often pasted on to one side of separate sheets of paper

The Queen's Bible. The Holy Bible … illustrated with Photographs by [Francis] Frith, William Mackenzie, Glasgow, Edinburgh & London, 2 vols., 1862–3, each with 57 albumen prints

of heavier stock than the text pages, and these were inserted amongst the signatures. Frequently these folios were unpaginated, although they might include letterpress captions and credits. Nevertheless, as early as 1850 there had been rare examples of photographically illustrated books in which photographs had been pasted into specifically created blank spaces on text pages, thus pointing to full integration of photographic image and text. However, this remained uncommon.

Another milestone was the creation of a special photographically illustrated presentation edition of the *Reports by the Juries* of the *Great Exhibition of 1851. Around 130 copies of this edition were produced, each containing more than 150 individual images that had to be pasted on to mounting cards and then bound into the volumes of text. The production of over 20,000 photographs was a massive undertaking. The contemporary impact of these volumes through their international distribution remains to be evaluated.

While *photomechanical processes were applied to book illustration as early as 1840, with Joseph Berres's (1796–1844) publication *Phototyp nach der Erfindung des Prof. Berres in Wien*, the vast majority of photographically illustrated books produced during the 19th century were created through the insertion of mounted original photographic prints into printed texts. Used initially was the *salted-paper print, where the image was formed in the chemical emulsion imbedded in the fibre structure of the paper and thus had a mattlike appearance. This was particularly suitable for purposes such as the reproduction of engravings, for example in *Notice sur la vie de Marc Antoine Raimondi* (1853). Similarly, in the 1870s the *heliographic photomechanical process of Amand Durand (1831–1905), a master engraver, was adopted for a number of facsimile reproductions of old-master prints. These continue to cause confusion amongst print collectors today.

From the second half of the 1850s the salted-paper print was replaced by the *albumen print. While this had a shiny appearance, it could render better linear detail since the photographic image was not affected by the structure of the paper. Its combination with the rise of the *wet-plate process proved to be decisive. The albumen process was to dominate the remainder of the 19th century.

Photographic illustration of books and other publications was also used to promote a number of other photographic print processes during the 19th century. By the 1860s the issues surrounding the fading of albumen prints were addressed by the introduction of the permanent *carbon process. An additional advantage of the carbon process was that the pigments that formed the photographic image could be tinted as a single colour. This was effectively exploited by some publishers, such as those who produced books on old-master drawings; Macmillan & Co.'s *Specimens of the Drawings of Ten Masters, from the Royal Collection at Windsor Castle* (1870) is a pertinent example.

Another photographic print process widely used for illustration was the *Woodburytype, a photo-relief process renowned for its deep and rich tonalities, first marketed in 1869. Although the Woodburytype was a photomechanical process, it, like the albumen and carbon print, required prints to be individually trimmed and mounted.

From the middle of the 1850s photomechanical illustrations were appearing in a range of publications. In some instances 'hybrid' processes were used to create full-colour illustration, such as the combination of *photolithography and chromolithography to produce illustrations accompanying Jules Labarte's *Histoire des arts industriels* (1864). *Collotype and photogravure were also used extensively during the last quarter of the 19th century.

From the mid-1850s books illustrated photographically with images including portraits from life, topographical views, architecture, paintings, engravings, drawings, manuscripts, sculpture, and the decorative and minor arts were appearing in modest but ever increasing numbers, primarily in Europe. The 1860s was a particularly rich and varied decade in the history of British publishing and illustration, and the photographically illustrated publication forms an integral part of it.

Nineteenth-century photographically illustrated publications were produced in a number of different forms. The portfolio of loose photographic prints was the simplest, frequently having nothing more than a printed title page and an index of the plates. In some instances a few pages of accompanying printed text might be loosely inserted. In others, loose prints with text captions and credits on each mount were sold as sets. Again, loose pages of text might also be available.

The physical size of photographic illustrations during the 19th century varied considerably. They ranged from almost 'thumbnail' size in some cases—for example, Henry *Taunt's *New Map of the Thames* (1872)—to large plates. A number of standard photographic print formats were also exploited for book illustration. The popularity of *carte de visite-format celebrity portraits spawned a number of book publications across Europe. One distinctive type is the biography—often of a religious figure—with a *carte de visite* portrait as frontispiece. From the late 1850s the stereoscopic view was used to illustrate books on diverse subjects ranging from topography and architecture to sculpture. The *Stereoscopic Magazine,* published from 1858 by Lovell Reeve (1814–65) as a serial, each monthly part costing two shillings and sixpence, and containing three stereo photos with descriptive letterpress, is a prominent example. The *cabinet format, introduced in the late 1860s, was also used for illustration.

The size of print runs varied considerably. Some titles were privately printed and only a handful of copies produced. Conversely, other titles may have had a run of several thousand. The British Library catalogue notes the number of copies printed for some 19th-century photographically illustrated titles. However, publishers sometimes significantly overestimated demand and the sale of 'remainder' copies through specialist auction houses is indicated by advertisements in contemporary journals such as the *Athenæum*.

Photographic publishers adopted a number of standard marketing strategies. One was the use of pre-publication subscription, particularly for deluxe titles. The part-work or serial was another. These devices were used both to attract a wide range of buyers and to limit financial exposure in a market affected by nascent mass-production techniques. Frequently, once a full year of a serial had been published the parts

were given a special title page, bound as individual volumes and sold to the Christmas market. Advertisements in periodicals like the *Athenæum* show that the 'illustrated gift book' was another sector targeted by photographic publishers.

The commercial success of photographically illustrated publications has yet to be fully evaluated. Photographically illustrated art serials that reproduced well-known paintings were popular. The results of effective advertising of such works were noted by the contemporary press, and in 1875 it was reported that the 'artisan classes' of northern manufacturing towns had flocked to obtain an issue of *The Picture Gallery* (published by Sampson Low, Marston, Low and Searle, of London) dedicated to Sir Joshua Reynolds. Curiously, the photographic illustrations were in fact almost exclusively taken from engravings after the paintings.

One feature of photographically illustrated publications was the rise of specialist publishers. *Blanquart-Évrard in Lille was a particularly successful photographic publisher in the early 1850s, thanks to his industrialization of photographic printing. In Paris Gide et Baudry and Goupil et Cie also published significant works. In the following decade many book publishers adopted photographic illustration, though a number were particularly prominent. In Great Britain these included Sampson Low, Bell & Daldy, A. W. Bennett, Day & Son, Seeley, Jackson & Halliday, and Bickers & Son. Specialist art societies, such as the Arundel Society, also played a key role, and in the late 1860s and early 1870s this society collaborated with the South Kensington Museum and the Department of Science and Art in a series of photographic publications entitled *Art Workmanship of Various Ages and Countries*.

Many journals of scholarly societies were beginning to include some form of photographic illustration by the 1860s. Professional journals exploited the opportunities far less frequently until the last decade of the 19th century, and newspapers such as the *Illustrated London News* did not make extensive use of photographic illustration until the early 20th century.

Assisted by the rise of printing technologies, photographically illustrated publications proliferated during the last decade of the 19th century to become a mainstream component of publishing. But, while the pasted-in albumen print was still in use, it was the photomechanical processes that were dominating illustration. AJH

Gernsheim, H., *Incunabula of British Photographic Literature 1839–1875* (1984).

Heidtmann, F., *Wie das Photo ins Buch Kam* (1984).

Wilson, J., *Photography and the Printed Page in the Nineteenth Century* (2001).

Kusnerz, P. A. (ed.), 'Photography and the Book', *History of Photography*, 26 (2002).

photographic amusements. The use of photography as a means of entertainment or play certainly goes back to the middle decades of the 19th century, and ranged from the elaborate collages made by Lady *Filmer and her well-to-do friends to the *stereoscopic craze in all its manifestations. However, photographic amusements in a narrower sense were closely associated with the *amateur photography movement in full swing by the 1890s. *Composite images, extreme high- and low-angle shots, and the deliberate use of optical distortions were its principal tools, used by photographers to caricature their friends and perhaps to lampoon current fads; Jacques-Henri *Lartigue, for example, was one of many enthusiasts who created spoof 'spirit' images with double exposures. The numerous articles and dozen or so books on the subject published in Europe and the USA between 1890 and 1910 attest to the popularity of this kind of image making. But it was the rise of the fantasy *postcard at the beginning of the 20th century that really gave it mass appeal. A few years later, it was the turn of members of avant-garde movements—*Futurism, Dada, *Surrealism, *New Vision—to adopt these techniques. Particularly celebrated was the combination by the one-time Futurist Wanda *Wulz of her own features with those of her cat (1932). Some artists, like Hannah *Hoech or Paul Éluard (1895–1952), actually collected fantasy cards. Others, like László *Moholy-Nagy, freely acknowledged the influence of photographic amusements on their artistic experiments. Yet their aims were different. Even if the desire to create caricatures was common to both amateurs and artists, its target had changed. Whereas the former had simply made fun of their subjects, the latter set out to challenge the medium itself, by calling in question its most basic rules. Their aim was not distortion but transformation. CC

Woodbury, W. E., *Photographic Amusements* (1896).

Smith, E., *All the Photo-Tricks* (1940).

photographic innovation, economic and social aspects of. Photography arrived at an economically inauspicious moment: in the autumn of 1839, the USA, Britain, and Europe suffered a sharp recession that lasted until 1843. In Britain and France, economic instability encouraged protectionism, as did political and commercial rivalry, inhibiting the circulation of photographic formulae and methodologies. High unemployment encouraged many in the USA to take up the *daguerreotype process; most were untrained, some were fraudsters, and the poor results obtained gave early photographers a bad name. By 1850, improved transportation increased output and lowered prices, producing a wave of prosperity lasting until the early 1860s. A growing consumer market demanded better-quality photographs, made more easily and cheaply, and technologies were adapted to enhance uniformity and affordability. New lenses improved image resolution and reduced exposure times, and glass-plate negatives and coated printing paper brought a new generation of inexpensive photographic artefacts. By 1861, *cartes de visite, *tintypes, and stereographs were being produced in their millions, and successful studios were structured like small factories, with standardized procedures and a clear division of labour. (Like other factories, they also employed large numbers of women.) Photographic art reproductions tapped into the growing middle-class interest in collecting, and this market boomed after 1865, when new pigment and *photomechanical processes such as *carbon and *Woodburytype facilitated stable and relatively inexpensive photographic reproductions.

Mass-produced photographs were finally so cheap that only the largest firms could profit from them, and as the market became saturated with each new product type, prices dropped. In the 1860s, overproduction and economic stagnation reduced prices for manufactured goods and competition was fierce: studios turned to larger formats such as *cabinet cards, tried unusual support materials like ivory, and promoted novelties, including photographs set into jewellery. The situation worsened in the 1870s, with a severe depression on both sides of the Atlantic, aggravated by war. In Paris, many studios went bankrupt during the Prussian siege, and the mayhem of the *Paris Commune drove wealthy clients out to the provinces, although it provided a commercial opportunity for photographs—sometimes faked—of atrocities and destruction.

The last 30 years of the 19th century were marked by economic fluctuation, with a decline in output between 1875 and 1884, and recessions in 1873 and 1893. The photographic market had been held back by the perishability of materials, inhibiting standardization and mass production, and the relative complexity of products had restricted the *amateur market. This changed with the commercial introduction of gelatin bromide *dry-plate negatives and printing papers in the 1880s. These products were fast and effective, but their increased sensitivity required more control during manufacture. Few photographers had the necessary time or skill, so commercial manufacturers took on the production of ready-sensitized materials, whose adoption was slowed by high prices, technical inconsistencies, and the need to light-proof apparatus and darkrooms. Exposures had to be timed more precisely, but effective exposure calculators and meters would not appear for another ten years. Bromide printing paper was also finicky, and taken up only after the wider acceptance of an intermediate technology in the form of ready-sensitized gelatin and *collodion printing-out papers. Bromide paper was adapted for small-format *roll-film negatives, which led to the introduction of small, light, hand-held cameras, most notably the Eastman Company's *Kodak series. Cameras became simpler and cheaper with the goal, for manufacturers, of boosting sales of materials: Eastman's core business was film and paper, and the cameras were essentially vehicles to increase demand; the company's processing and printing services cost up to 50 per cent of the initial outlay for a camera.

The amateur market grew steadily from 1880, as social mobility and disposable income increased, and bank holidays and a (gradual) reduction in working hours produced a boom in leisure activities. Existing photographic associations were reinvigorated and new amateur *clubs started; their numbers grew tenfold 1880–90. *Women became a notable constituency: as early as 1886, women's magazines carried photographic advertisements, and from 1889 Eastman publicity depicted women using Kodak cameras. By 1900, women accounted for 30 per cent of British amateur photographers, and the US census listed more than 3,500 female professionals. Many specialized in family portraiture, a relatively strong market at a time when birth rates were declining and parents were investing more time and money in their smaller families. Manufacturers targeted these

increasingly privileged children; the inexpensive *Kodak Brownie of 1900 was named after and promoted with popular cartoon characters.

Another key development was *tourism, boosted since the mid-19th century by rail and steamer transport, and later by the bicycle and motor car. The camera became indispensable, first for the well-off leisure traveller but later also for lower-middle-class vacationers as paid holidays became widespread between the wars. Another by-product of tourism was the picture *postcard, from c.1900 to a considerable extent based on photography, and superseding the larger-format albumen 'view scraps' that had earlier dominated the souvenir market.

The later 1890s were generally prosperous, but there remained few patentable mass-market inventions, so profit margins were low and manufacturers fought price wars. The professional portrait trade was saturated with cartes and cabinet cards, and now also competed with postcards and home *snapshot portraiture. High-street studios lured back customers with novelty photos on cloth, glass, metal, and ceramic ware: many of these were enlargements, achieved with new projection-speed emulsions and better artificial light sources. The popular press was one of the signal influences of this time, serving a more widely enfranchised and literate population. Inexpensive illustrated papers and periodicals were made possible by the new photomechanical processes, which afforded cheap, good-quality tonal reproductions. In turn, the growing corps of press and *documentary photographers experimented with magnesium *flash lighting, and inspired more advanced cameras like the Graflex single-lens reflex of 1898.

Photographic profits peaked in 1899, and the subsequent slump continued through the First World War. Censorship at the front restricted (but did not eliminate) photography, and production costs jumped due to cuts in the supply of imported raw materials. Yet lack of access to German sensitizing dyes induced British and American manufacturers to synthesize substitutes, producing better panchromatic emulsions and introducing new X-ray and *infrared materials. On both sides, demand for improved rangefinders and gun sights promoted optical research. *Aerial photography, used on an increasingly vast scale for reconnaissance, came of age in 1914–18.

Industrial and amateur photographic markets grew in the 1920s, as modernized production techniques supplied more sophisticated and standardized products at lower cost. The prices of snapshot cameras and film halved between 1900 and 1930. Cheap cameras were mass produced in metal or, from the 1930s, moulded plastic, and offered free for coupons on cigarettes and confectionery; in 1930 Kodak actually gave away 550,000 Hawkeye cameras to 12-year-olds in North America. (The company was also busy marketing cameras as fashion accessories, modernistically decorated and bundled with cosmetic outfits.) In Germany, Britain, Japan, and the USA, workers' photography clubs compensated for scarce resources; members clubbed together to buy cameras and pay for processing. Their photographs were published by the labour press and workers' magazines such as the *Arbeiter illustrierte Zeitung. New high-circulation photo magazines such as *Vu, *Life, and *Picture Post published reportage, sports, and travel photography, which encouraged the manufacture of higher-speed

lenses and film, and 'miniature' 35 mm cameras like the 1925 *Leica and 1932 Contax. The flashbulb technology developed by Paul Vierkötter (1925) and Johannes Ostermeier (1929) created a more reliable and user-friendly means of illumination. Meanwhile, the other mass medium of the time, cinema, stimulated research in colour materials, from assembly processes like Technicolor in 1933, to tripack colour transparency films such as Kodachrome in 1935.

Rationing curtailed civilian consumption of photographic goods during the Second World War. In Britain, sales dropped to less than 25 per cent of their 1938 levels, and manufacturers reduced their product range. Yet rationing encouraged innovation: Ilford introduced variable-contrast printing paper to save on paper stocks and miniaturized radiographic film to replace large-format plates. New fast films were developed for aerial and night photography, while higher image resolution improved microfilm; these materials later had atomic and astronomical applications.

After the war, companies like Kodak produced new colour negative and print processes at the expense of Agfa, whose research was documented in Allied government reports. Colour materials were complicated and expensive to manufacture, but in the 1960s more stable dyes and high-speed machinery reduced wastage and brought down costs. The post-war consumer boom and rise of mass tourism increased the demand for colour photography, and occasioned the one real innovation of the post-war years, the Polaroid *instant photography system, introduced for black-and-white imaging in 1948 and adapted to colour in 1963. However, although the Polaroid system found important commercial and industrial applications, and went on being refined for half a century, the uniqueness and high cost of each image limited its market potential. In general, economies of scale favoured large companies that could afford to manufacture inexpensive versions of advanced technologies.

From the 1960s onwards, against a background of increasing affluence and leisure in Western societies and Japan, innovation proceeded apace. New systems like the cassette-loading *Kodak Instamatics (1963) and Pocket Instamatics (1972), the *disc camera (1982), and high-street *minilabs (1980s) were designed to open up new segments of the mass market. *Automation of camera functions proceeded apace, and innovations aimed first at professionals soon became available to amateurs. Meanwhile, photography's increasingly wide acceptance as an art form, and as a means of self-expression for non-artists, went hand in hand with the proliferation of museums and galleries wholly or partly dedicated to it, and of exhibitions, books, and television programmes about star photographers. A large *market for art photographs and *classic cameras emerged. Demographic change (and environmental concerns) presented both challenges and opportunities. Although falling marriage and birth rates in late 20th-century developed societies weakened one of photography's traditional mainstays, there were growing numbers of affluent retirees for whom photography offered a hobby and an adjunct to other pursuits, such as gardening or travel. (Manufacturers' response to 'grey' needs, with lightweight materials and ever more automation, generated products more attractive to consumers generally.) By contrast, the growth of 'extreme' leisure pursuits—scuba diving, caving, mountaineering—boosted demand for both 'ruggedized' high-end gear and ultra-basic *single-use cameras, which reached the market at the end of the 1980s and generated useful profits for the industry.

The *Advanced Photographic System (APS) launched in 1996 was the last large-scale innovation in silver-based photography. Offering many clever refinements, it was an ambitious attempt, after five years of economic recession, to attack both ends of the market. However, it was soon overshadowed by *digital imaging.

The speed of the digital boom exceeded the most optimistic initial predictions. The first professional digital camera had a 1.3 megapixel sensor and a price of £15,400 when launched by Kodak in 1992. Just over a decade later, 5-megapixel sensors were appearing in compact cameras costing less than £1,000. Some 35 mm-equivalent professional models exceeded twice this capacity. There was a growing consensus to the effect that digital images could match the quality of silver-based ones. Digital cameras outsold film cameras in Japan in 2001 and the USA in 2003, and were predicted to do so worldwide by 2005. Much of this progress was due to convergence between digital cameras and other advanced consumer products, such as hand-held computers and mobile telephones, for which a huge global market had developed. It was a short step from exchanging technologies to combining them, and in 2002 already c.19 million *camera-phones were sold worldwide. Historically, major innovations have tended to create as well as satisfy needs, and it seems likely that digital photography, whether or not combined with mobile communications and data processing, will transform imaging culture: the role played by picture making in society and the ways in which images are distributed, stored, and displayed. One notable trend, with significant implications for the industry, is the low ratio—c.1 : 10 according to some estimates—of pictures printed to pictures taken, compared with silver-based photography. As yet unanticipated new uses for the instantly transmissible digital image, whether in industry, medicine, policing, or everyday life, will inevitably appear. HWK

Taft, R., *Photography and the American Scene: A Social History, 1839–1889* (1938).

Jenkins, R. W., *Images and Enterprise: Technology and the American Photographic Industry, 1839–1925* (1975).

Hercock, R. J., and Jones, G. A., *Silver by the Ton: The History of Ilford Limited, 1879–1979* (1979).

McCauley, E. A., *Industrial Madness: Commercial Photography in Paris, 1848–1871* (1994).

Brown, J. S., and Duguid, P., *The Social Life of Information* (2000).

photographic journalism. See JOURNALISM, PHOTOGRAPHIC.

Photographic Notes. An opinionated journal and the personal fiefdom of its editor Thomas Sutton (1819–75), *Photographic Notes* was published from 1 January 1856 until 1867, when it merged with the *Illustrated Photographer*. During the 1850s it was associated with, and

carried contributions by, Sutton's collaborator *Blanquart-Évrard, and was also at various times the house journal of the Manchester, Scottish, and Birmingham photographic societies. It openly voiced Sutton's views and antipathies, notably against the Photographic Society of London. But it only published original material and its frequency (monthly) gave it a topicality not enjoyed by its rivals. MP

photographic processes, black-and-white. These can be divided into those that produce camera originals, including negatives, and those that produce copies. The overwhelming dominance of silver halide in both areas can lead to unwarranted neglect of *alternative processes—though the familiar negative-positive process, established in its essentials by Henry *Talbot in the early 1830s, has more twists and turns than many realize.

By far the most common black-and-white process involves the formation, through the influence of light, of a *latent image* in a silver halide (chloride, bromide, or iodide) 'emulsion'. To be accurate, the 'emulsion' is a suspension of silver halide in gelatin, though the term 'emulsion' is too well entrenched to be overthrown. Instead of gelatin, *collodion can be used, and indeed was used in the past; but the disadvantage is that the material must be exposed while still wet, hence the term 'wet-plate' photography. It is also worth knowing that in photographic *papers, though far less in films, natural gelatin (derived from bones and hides) is supplemented by synthetic latexes: supplemented rather than supplanted, because organic constituents of gelatin (especially sulphur compounds) contribute greatly to the sensitivity of the 'emulsion'.

The latent image is then *developed* by a reducing agent that reduces silver halide to metallic silver in direct proportion to the intensity of the latent image. The very earliest processes obtained an image without development via *printing out*, where the influence of the light alone produced the image: a technique still used with 'printing-out paper' (*POP). The exposure required to give a 'printed-out' image is however several orders of magnitude greater than that required to give a latent image for development: up to about a million times greater. Unconverted silver halide is then dissolved out of the emulsion (*fixing*). A final *wash* removes anything in the emulsion that poses a threat to the stability of the image: by-products of processing, and the fixer itself. The result is the familiar negative, in which tones are reversed: the brightest parts of the original scene are the darkest parts of the negative.

A variant on the negative process is *chromogenic* development, so called because it works in a similar way to colour films. Dye precursors are incorporated in the emulsion, and are converted during processing to dyes in direct proportion to the intensity of the halide image. The halide image can then be bleached away, leaving an extremely fine-grained dye image which will not, however, be as sharp as a halide image.

In practice, a 'negative' can be made to appear 'positive' by at least two simple tricks. One is to make a conventional negative, but back it with black varnish or even black paper: this is the *'ambrotype' or

'melainotype' devised by Frederick Scott *Archer and Peter W. Fry in 1851. The other is to coat the sensitive medium on to a shiny black surface: traditionally, japanned sheet iron (hence 'ferrotype') or 'tinplate' (hence *'tintype'), a process invented by A. A. Martin in 1852. Both ambrotypes and tintypes were used for rapid, low-cost portraits, affordable by all but the poorest. Often poorly fixed, many are badly faded today, some even to invisibility.

The *daguerreotype (1835–7) is another direct-positive silver halide process. Here, the halide is formed directly on a thin sheet of polished silver, normally plated or affixed to a copper support. The 'developer' is mercury vapour, and the image is seen against the mirror-like background of the plate. The disadvantages of the daguerreotype are that it is slow and expensive; that each image is unique (and laterally reversed); that the mercury vapour used for processing is toxic; and that the image is very fragile indeed, and can be destroyed with a fingertip. This explains its rarity and appeal to collectors.

Other *direct-positive* processes are mostly clever adaptations of the halide negative-positive process. For direct reversal materials (normally black-and-white slides) the negative is formed in the usual way, then bleached out. This leaves unexposed silver halide in inverse proportion to the original negative. This is then re-exposed to light and developed (or it can be chemically fogged) to create a positive image. Traditional peel-apart Polaroid materials actually form a negative, which is then transferred by chemical diffusion to the positive, after which the negative is discarded or (in some films) recovered: 'integral' materials form transient images en route to the final negative, but again work essentially by dye diffusion.

Armed with a camera original negative, there are numerous ways to make copies. Overwhelmingly the most popular is a simple repetition of the silver halide process, so that the negative is again reversed and becomes a positive: this is the principle of what used to be called *developing-out* papers, though similar emulsions can be coated on glass to give positive lantern slides. Silver halide printing-out papers also have a small but loyal following: the extremely low sensitivity is far less of a disadvantage at the printing stage than at the camera stage. Most silver halide papers use a gelatin 'emulsion' that is similar in many ways to a film 'emulsion', though typically a couple of orders of magnitude slower (some are slower still), but other supports have been used: *salted-paper* printing papers are sensitized by forming silver halide on the surface of, and in the fibres of, good-quality writing paper, while *albumen* prints used egg white. This held more silver and therefore gave a more vigorous and contrasty image. Albumen papers were devised by L. D. *Blanquart-Évrard in 1850; in 1851 he started developing prints, instead of printing them out.

The paper 'emulsion' is normally coated on top of a stratum of whitener to increase the brightness of the highlights, and therefore the overall brightness range of the print. In traditional fibre-based papers the normal brightener layer is baryta (barium sulphate) but with resin-coated papers titanium oxide is used.

Both alternative and early silver-based processes like daguerreotypy enjoyed a considerable revival in the later 20th century. RWH

See also BROMOIL; POWDER 'DUST-ON' PROCESS; WOODBURYTYPE.

Crawford, W., *The Keepers of Light: A History and Working Guide to Early Photographic Processes* (1979).

Hicks, R., and Schultz, F., *The Black and White Handbook: The Ultimate Guide to Monochrome Techniques* (1997).

Jacobson, R. E. (ed.), *The Manual of Photography* (9th edn. 2000).

photographic processes, colour. One of the most fundamental points about colour processes is also one of the least immediately obvious. It is that with the exception of a few very obscure processes, the colours in a photograph are not an objective record of the colours in the original scene: they are a re-creation of those colours.

Even where the colours are an objective recording, as in the *Lippmann interference process (1891) or the Lancaster dispersion process (1895), they may well look less convincing than subjective re-creations, either because of technical shortcomings or because of personal or cultural preference. Also, the materials for objective processes were very slow, and viewing was often difficult. The importance of preference was well illustrated by the release of a particular ink-jet printer in 2002 which, instead of conventional colour profiling, offered 'US' and 'European' options. The former was contrastier, with higher saturation: 'garish' to its detractors. The latter was lower in contrast and saturation: 'dull' and 'flat' to its detractors. The advocates of either system doubtless perceived the colours as 'natural'.

Another point about subjectivity is demonstrated by the tendency of colours to 'shift' under different kinds of light. With an objective system, these shifts will be the same in the image as in the original; with a subjective one, there is almost certain to be some discrepancy, which can in some cases be unacceptable.

The basic distinction in subjective colour processes is between *additive* and *subtractive*. In additive processes, colours are made up by adding together three primaries. In subtractive processes, dyes are used to filter out the unwanted colours from white light. A colour television screen is an excellent example of an additive process: the image is made of huge numbers of tiny dots, each of which can only be red, green, or blue, though each dot can vary widely in brightness. Ink-jet printers (and, indeed, book illustrations) work in a similar way, except that the colours are cyan, magenta, and yellow, plus black for extra intensity in the dark areas. Variations in saturation of each colour are obtained by varying the size or frequency (or both) of the dots; a further refinement is the use of light and dark inks in each of the primaries.

Although the success of additive processes is well demonstrated by these examples, they are relatively little used in conventional silver halide photography. For prints, there are easier ways of doing things, and for *transparencies, additive processes are very dark as compared with subtractive. Nevertheless, additive processes were among the earliest types of colour photography, both experimentally and commercially. In 1861, James Clerk *Maxwell famously had Thomas

Sutton photograph a tartan ribbon successively on three plates through three filters, red, green, and violet, then 'reassembled' by projecting the three images in register through the appropriate coloured filters. (A fascinating aside is that he did this with plates that were sensitive only to blue, violet, and ultraviolet light: it was a matter of pure chance that the ribbon and the filters also reflected and transmitted light in the blue, violet, and ultraviolet ranges. This is as convincing a demonstration as can readily be imagined of the subjectivity of colour photography.)

The three-colour system of separation negatives was greatly simplified in 1892 with the arrival of the Ives one-shot colour camera, which made all three separation negatives simultaneously. Although this was of limited use for amateurs—and, indeed, of limited use overall until red sensitizing dyes were introduced by Koenig and Homolka in 1904—it paved the way for *photomechanical reproduction of colour: commercial *half-tone blocks for monochrome had been introduced by Meisenbach in 1882. There was even a 35 mm one-shot colour camera, the Czech Spektaretta, on the eve of the Second World War.

The first commercial colour process to use a single colour plate was the *Lumières' *autochrome of 1907, in which the filters consisted of grains of potato starch dyed variously red, green, and blue, embedded in a matrix of carbon black. Saturation was low, and because of clumping of the starch, grain was big; but even so, the results have considerable *pointilliste* charm. Finlaycolor (1908) and Dufaycolor (1930) used ruled grids instead of random grains, a process that was revived decades later (1983) for Polachrome instant movies and 35 mm slides. The disadvantages of all of them are twofold. First, the filter pattern is clearly visible when the images are much enlarged. Second, they are very dark, because at least two-thirds of the light is blocked by each individual filter, and the space between the filters is black.

Slightly related to these additive processes were lenticular processes from Kodak (Kodacolor cine-film, 1928) and Agfa (Agfacolor 35 mm, 1932): lenticles—small cylindrical convex lenses—were impressed on the emulsion itself. With a striped tri-colour filter (used with wide-aperture lenses), the image was broken into parallel bands, then projected through a similar filter. All were positive transparencies, not least because one step in colour photography is demanding enough: having to go through two steps, capture and printing, would have added unacceptably to both the expense and time involved for most people, although patents for colour printing date back to the 1860s.

In parallel with these materials, there was an evolutionary dead end of two-colour subtractive materials, beginning with the original Kodachrome movie film in 1914. This was based on patents taken out in 1912 by Siegrist and Fischer. Although two-colour materials may sound (and indeed are) very limiting, it is surprising how convincing the colours can seem.

In 1935–6, the first modern transparency material appeared: Kodachrome. At first it was issued only as movie film, but in 1936 it was made available for still cameras in 35 mm and Bantam (828) formats. It was an *integral tripack*, meaning that it had three emulsion layers (with inbuilt filter layers) on a single piece of film. During

processing, the three layers were dyed the appropriate colours, and the silver image was bleached out, leaving an all but grainless filter of continuously varying colour, a 'subtractive' transparency in which only the light not needed for a particular colour was filtered out. Kodachrome was a *non-substantive* film in which the dyes were added during a complex processing sequence: each emulsion layer was exposed to a different coloured light and developed with different colour couplers. In 1936, Agfacolor Neue had the dye precursors incorporated in the emulsion, again along the lines of the Siegrist and Fisher patents. This *substantive* construction greatly eased processing, though at the cost of bigger grain, poorer sharpness, less stable exposed film (especially when inappropriately stored), and much poorer dye permanence.

Despite the inferior quality of substantive films, Kodak in the 1940s adopted similar technology for Ektachrome, thereafter running the two processes (substantive and non-substantive) side by side: the E-series Ektachrome process, as distinct from the K-series Kodachrome process. By the end of the 20th century, E-6 (Ektachrome-compatible) processing had become the world standard, and the best E-6 films could compete on substantially equal terms with Kodachrome in all areas: the main reason for the survival of Kodachrome was that people liked the look of it, rather than any technical merit.

On the eve of the Second World War, the first subtractive negative film appeared (from Agfa, for cinematography), followed by unmasked Kodacolor in 1944. Integrally masked Kodacolor was launched in 1950, setting the trend for subsequent camera-original negative films.

When it came to colour *printing, various techniques using separation negatives have long existed, but they were scarcely convenient. One of the earliest commercial successes was Tri-chrome *Carbro (Farmer, 1919), although a single print took around $2\frac{1}{2}$ hours. *Dye-transfer prints (Kodak, 1935) are almost as time consuming.

Although Tri-chrome Carbro and dye transfer allow enormous control and far better print longevity than early alternatives, most practical colour print processes rely on similar technology to Agfacolor Neue, with dye couplers incorporated in the emulsion and developed at the same time as the silver image, which is subsequently bleached out. As with films, dye stability has improved enormously over the years, until the life of a dark-stored colour print can be measured in decades instead of years.

There are, however, other ways of doing things. One of the most noted is *dye destruction*, in which the dyes are destroyed by exposure to light. The initial patents date from 1918 (Christensen); the first commercial process was Gasparcolor *c.*1930; and Ilfochrome Classic, often better known by its former name of Cibachrome (from Ciba-Geigy, 1964), is the surviving process. Although slow, suitable only for reversal printing, and expensive, its permanence (even on display) and superb overall look mean that it has many devotees. An interesting point is that it is far better matched to some colour slide films than others: because the dyes are not the same as those used in conventional colour materials, there is considerable potential for mismatches.

Then there are Polaroids, the chemistry of which is exceedingly complex. In peel-apart Polacolor (1962), there are migratory dyes (arranged in a comparatively conventional integral tripack) which also function as developers. When activated, they start to develop the silver image. As they do, they are inactivated and immobilized (thereby creating the negative), but where they do not develop the film, they continue to migrate to the receiving sheet to create the final colour image. 'Integral' Polaroid films (1970) are even more complicated, with transitory opaque phases and more. Finally, the three-layer Fresson colour process, although expensive, continues to be favoured for exhibition prints.

If there is any lesson to be learned from the profusion of processes available, it is that convenience and speed are regarded by some, particularly art photographers, as secondary to archival permanence, which explains the survival and indeed revival of such media as dye transfer, officially discontinued by Kodak in the early 1990s but subsequently of intense interest among artists—a trend paralleled by the revival of *hand colouring, which seemed about to wither away altogether in the 1970s and 1980s. RJW

See also COLOUR REPRODUCTION PRINCIPLES; INSTANT PHOTOGRAPHY.

Coe, B., *Colour Photography: The First Hundred Years, 1840–1940* (1978).
Farbe im Photo: Die Geschichte der Farbphotographie von 1861 bis 1981 (1981).
Jacobson, R. E. (ed.), *The Manual of Photography* (9th edn. 2000).

Photographic Society of London. See ROYAL PHOTOGRAPHIC SOCIETY.

'photography', etymology of, from *photos* (φοτοσ), light, and *graphos* (γραφοσ), writing, delineation, or painting. Although 'heliography', 'photogeny', and 'daguerreotypy', were first used as alternatives, 'photography' eventually gained universal precedence as the preferred name. First published by the German astronomer Johann von Mädler in the *Vossische Zeitung*, the name appears to have occurred to Charles Wheatstone and Sir John *Herschel independently in England. (Hercules *Florence in Brazil had already used the term *photographie*—albeit to describe a cameraless process—in his experimental notebooks in 1833–4, but these were not discovered until much later.) Herschel had long been the authority on new nomenclature, and his use of the term in 'Note on the Art of Photography', 14 March 1839, was a catalyst for its adoption as a properly inclusive name for both 'photogenic drawing' and 'daguerreotypy'. KEW

Schaaf, L. J., 'Sir John Herschel's 1839 Paper on Photography', *History of Photography*, 3 (1979).

Photography 1839–1937 exhibition, at MoMA, New York, a seminal event, securing for photography a place within the art museum and the modern fine-arts tradition in the USA. Organized by curator Beaumont *Newhall, the 1937 exhibition survey of the medium's history arranged over 800 items according to technical processes (daguerreotypy, calotypy, etc.) and contemporary applications

(e.g. press, astronomical, creative photography). After its inauguration in New York, an abridged version travelled to ten American cities. MoMA's exhibition and catalogue—although guided by European avant-garde interest in photographic practices—established a decidedly American orientation and institutionalized the 'straight' photographic style as modern art. The catalogue (now in its 5th edition) codified what Newhall saw as the 'relationship of technique to visualization' and established a canon that has shaped the course of photographic history. WAG

Newhall, B., *The History of Photography* (1937; 1982).

photogravure. Also known as *'heliogravure', photogravure is a photomechanical etching process from work by Henry *Talbot in 1852, perfected by the Czech Karl Klič (Klietsch) in 1879. A copper plate is dusted with aquatint rosin and a dichromated gelatin-carbon tissue laid on top. Exposure to sunlight through a photographic transparency selectively hardens the photosensitive gelatin and forms a gradated etching resist, while the rosin gives a fine, random grain structure to the image. From the mid-1880s, gravure was used for high-quality art reproductions and adopted by photographers for portfolio and exhibition work, in which form it persists. HWK

photojournalism can be defined as photography intended, in conjunction with text, to convey information about a topical event or events. This demarcates it, albeit loosely, from *documentary photography, which trades immediacy for time spent examining an ongoing situation or process: AIDS in the Congo, for example, or the life of Hutterites in Montana, as opposed to a hostage-taking incident. As William Stapp has pointed out, several conditions had to be fulfilled before photojournalism became practicable: the *photographic process* had to be capable of capturing newsworthy events or their aftermath with sufficient realism and clarity; *transmission* had to be fast enough to bring pictures home while the subject matter was still topical; and a *reproduction process* was needed that could multiply images rapidly, on a large scale and preferably together with text. By 1914, all these conditions were on the way to being met. Cameras were efficient and relatively portable, and *dry plates and *roll-film (though photojournalists often preferred not to use it) were increasingly easy and quick to use. Trains, cars, and steamships offered rapid transport, and phototelegraphy was becoming a practical, if expensive, option. Finally, the *half-tone process had been widely in use since *c.*1900, and in 1904 the London *Daily Mirror* had become the world's first daily newspaper to be illustrated entirely with photographs.

There is, of course, more to the early history of photojournalism than this. Photographers had attempted to record the aftermath of battles and disasters since the 1840s (the Hamburg Fire of 1842, the US–Mexican War of 1846–8). Moreover, the burgeoning illustrated press on both sides of the Atlantic soon began to make considerable use of photographs, albeit in wood-engraved or lithographed form that gave considerable licence to the journals' in-house artists. As early as July 1848, L'*Illustration published pictures from specially

commissioned *daguerreotypes of revolutionary events in Paris. Joseph Cundall's photographs of Crimean veterans were used by the *Illustrated London News* in 1855, and pictures by *Le Gray of Garibaldi (1860) and *Nadar of visiting Japanese emissaries (1862) by *Le Monde illustré*. The trend increased during the American Civil War (1861–5), when photographers went out to capture events on a considerable and organized scale. However, people who wanted to see Civil War photographs in their original form still had to view them in galleries, or buy them as individual prints, or as tipped-in illustrations in expensive volumes.

Another problem, increasingly apparent when photographs began to appear in print from the 1880s onwards, was the camera's inability to capture the kind of violent, dramatic action that the public was accustomed to from battle paintings and graphic illustrations. It is interesting, for example, to compare Karl *Bulla's photograph of a terrorist incident in a St Petersburg street in 1910 with contemporary artists' impressions of bomb outrages—all panic, commotion, and flying debris. Bulla's picture shows an entirely static situation, with an empty carriage and a group of soldiers and policemen assuming studied poses (different according to rank) of confident authority for the camera. The only trace of the event is a horse lying dead on the cobbles in its harness.

In fact, Bulla's firm was one of the first major picture *agencies, supplying news photographs to the Russian and foreign press. It covered the Russo-Japanese War, the 1905 Revolution, the First World War, and many of the revolutionary events of 1917 in Petrograd (St Petersburg). By this time, however, the Russian press was in considerable disarray and communications were breaking down. The same cannot be said for Berlin, which also experienced revolutionary disturbances between November 1918 and the following spring, though with a different outcome. The German capital had at least ten picture agencies, linked to newspapers all over Central Europe, and many of the thousands of photographs of the German Revolution were taken by experienced agency photographers like Willy *Römer who went out day after day in search of pictures.

The German Revolution illustrates several features of photojournalism at this stage in its history. One relates to equipment. In addition, usually, to a 13 × 18 cm (5 × 7 in) plate camera weighing about 2 kg (4.5 lb), the photographer had to carry spare plates, a tripod, and often a step ladder. Emulsions and lenses were slow, and telephoto lenses were also heavy and hard to focus, so were rarely used. Flashpowder was awkward to use and liable to attract unwanted attention. Photographers were unlikely to use valuable plates unless conditions were good and the action really interesting. They were also loath to risk the confiscation of expensive equipment by flouting bans, and they had a healthy fear of bullets. Many events, therefore, went unrecorded. Moreover, the production cycle of contemporary newspapers was slow: pictures might take between a week and a fortnight to appear in the 'illustrateds', although the picture supplements of daily papers were faster: the Wednesday *Bilder vom Tage* supplement of the *Berliner Lokalanzeiger* might carry photographs from the previous weekend.

Anon.

Photograph of SS *Great Eastern*'s lifeboats, *c.*1859

Wood engraving, published in *Illustrated London News*, 17 September 1859

L'ILLUSTRATION

LE PRÉSIDENT DE LA RÉPUBLIQUE EN RUSSIE

Anon.

President Poincaré and Tsar Nicholas II inspect naval guardsmen during Poincaré's state visit to Russia, July 1914. *L'Illustration*, no. 3726, 25 July 1914

Finally, although most photojournalists seem to have approached their work in a fairly neutral way, the events of 1918–19 revealed some emerging issues about visual coverage. For example, Spartakists and other proletarian insurgents were unfamiliar with photography and had little idea how to exploit it. Generals and politicians, however, were learning how to manage events for photographic effect. In particular, left-wing atrocities were likely to be much more thoroughly recorded than those (often ghastlier) by government troops and auxiliaries. After the event, of course, photographs took on a life of their own, and many pictures of the German Revolution were used as *propaganda during the political struggles of the next ten years.

The 1920s and 1930s witnessed a large-scale expansion of photojournalism, driven by urbanization, consumerism, and the parallel growth of sports and mass entertainment. Established papers like the *Berliner illustrirte Zeitung*, the *Illustrated London News*, and *L'Illustration* modernized their appearance and used more photographs, while many newcomers entered the market: the *Zürcher illustrierte* (1925), *Match* (1926), *Vu* (1928), *Regards* (1931/32), *Weekly Illustrated* (1934), *Life* (1936), *Lilliput* (1937), *Look* (1937), *Picture Post* (1938), and countless others. *Advertising (which also increasingly used photography) became a major source of revenue, keeping cover prices down and boosting circulation. More agencies appeared on both sides of the Atlantic. Layouts became more imaginative and dynamic, and the concept of the *photo-essay emerged. The AP Wirephoto network was inaugurated in 1935, reducing transmission times (in optimum conditions) from days or hours to minutes. There was a constant broadening of content, from summit conferences to air shows and beauty contests. Sport became an integral part of all illustrated papers, and also spawned its own journals. Equipment also improved, with the 1924 *Ermanox followed by the *Leica, *Rolleiflex, and Contax: all eminently suitable for the roving photojournalist, though not themselves the cause of the new mass picture market. Photojournalists proliferated, from the urbane, bespectacled Erich *Salomon to the buccaneering Robert *Capa, who by 1939 had become identified with a new kind of celebrity. Female professionals included Margaret *Bourke-White, Lotte *Jacobi, and Gerda *Taro. However, photojournalism was not just a business for photographers: agency chiefs like Simon Guttmann of *Dephot, editors like Stefan *Lorant, publishers like Lucien *Vogel and Henry Luce (1898–1967), and businessman-experts like Kurt Korff and Kurt Safranski, first of Ullstein publishing, then of *Black Star, all helped to create the system that existed by the Second World War.

Photojournalism had political implications. Totalitarian movements increasingly recognized its importance for their own purposes, hence the founding of the Communist *Arbeiter illustrierte Zeitung and Nazi *Illustrierter Beobachter*, both in 1926, and *USSR in Construction in 1931. The late 1930s and 1940s saw the appearance of beautifully photographed and produced, but mendacious, propaganda magazines like the Japanese *Nippon* and *Front* and the German *Signal. Even in the democratic press, however, especially on controversial issues such as the Spanish Civil War (1936–9), the choice, layout, cropping, and

Werner Bischof

Press photographers in Korea, 1951

captioning of photographs radically affected the messages conveyed. Later, during the television era, such issues would arouse concern, especially the imbalance between photography's emotional impact and its power to explain.

After playing a major role in the reporting of the Second World War, photojournalism in its classic form experienced a kind of Indian summer, with a final efflorescence, in the USA, in the *civil rights campaigns of the late 1950s and 1960s. But an early sign of impending change was the foundation of the *Magnum agency in 1947, partly reflecting photographers' desire for more control of their work, both during publication and afterwards. In the second half of the century, the agency scene was to become ever more varied and complex, with the appearance by c.2000 of both giants like Corbis and *Getty Images and small elite groups like *VII. Photographers' working conditions still varied considerably, according to whether they were agency contract workers or members of a cooperative; but far fewer of them than in 1945 were likely to be staff employees of an individual newspaper or magazine.

In the background was the rise of television which, during the 1960s, became the first source of news for increasing numbers of people, especially in the USA. (John F. Kennedy's assassination in November 1963 is often cited as a turning point.) However, the effects of the new 'super-medium', to which all other media had to adapt, were neither simple nor immediate. One obvious casualty was the film newsreel, which was doubly undermined by shrinking cinema audiences. Television also threatened still photography by drawing advertising revenue away from the illustrated press. Nevertheless, mechanical 35 mm cameras like the Leica and *Nikon F continued for years to have important advantages over television equipment. The most remembered images of the 1960s and 1970s, from civil rights reportage to Eddie *Adams's *Execution in a Saigon Street* (1968) and Nick Ut's Vietnamese girl burned by napalm (1972), were made by photojournalists. Some photographs, like those of the *My Lai massacre, achieved even greater currency by being shown on television.

The 'landmark' significance of *Picture Post*'s (1957) and *Life*'s (1972) demise should not be exaggerated. Both papers had internal

Ian Bradshaw

Streaker, Twickenham, 1974

problems that might have been avoided. Magazines like *Stern and *Paris Match continued, and new picture outlets appeared, from the *colour supplements of the 1960s to photography-conscious newspapers like the British *Independent*. Eventually, most print media increased their earning power and extended their reach by acquiring websites. The upshot of all this was that, at the beginning of the 21st century, photojournalism's role in reporting breaking news remained strong.

From the 1960s, nevertheless, there was increasing awareness of the polysemic character of the image—its capacity to be read in different ways by different individuals and groups; its malleability (from the 1980s also by *digital means); and the ways in which the picture-gathering process could be manipulated. As already suggested, these were not new issues; indeed, British suffragettes had become adept at staging media events before 1914. But from the 1960s,

campaigns by civil rights, gay rights, and feminist activists brought them into sharp focus, as did the proliferation of film- and communications-studies courses in higher education. The long-term consequences have been, arguably, both greater sophistication and critical awareness on the part of both picture makers and viewers and the permanent weakening of earlier assumptions about the truthfulness of the photographic image. AH/RL

➲ See also The *Daily Herald* Archive *opposite*.

Life Library of Photography: Photojournalism (1972).
Evans, H., *Pictures on a Page: Photo-Journalism, Graphics and Picture Editing* (1978).
Fulton, M. (ed.), *Eyes of Time: Photojournalism in America* (1988).
Fotografía Pública/Photography in Print 1919–1939 (2000).
Amar, P.-J., *Le Photojournalisme* (2000).
Lebeck, R., and Dewitz, B. v., *Kiosk: A History of Photojournalism* (2001).

The *Daily Herald* Archive

The *Daily Herald* newspaper's photographic archive, housed at the National Museum of Photography, Film, and Television at Bradford, Yorkshire, contains approximately 3 million photographs and 100,000 glass negatives. Covering a period from 1911 to the mid-1960s it includes work by many well-known photographers such as James *Jarché and *agencies such as Associated Press, Reuters, and the Press Association. Coverage is particularly strong for the 1930s and 1940s, providing a fascinating view of this important period in British history. The archive gives an insight into the role of photography in newspapers at the time, containing much unpublished work and the diaries or Day Books detailing photographers' daily assignments for the newspaper between 1931 and 1946. Only a small proportion of any press photographer's work is ever used, and photographs rarely escape the layout artist's knife. Many show evidence of cropping and this tells a fascinating story in itself. The majority of the photographs have details of the stories they were used to illustrate on the back, giving a further insight into the editorial process. The archive remains as it was originally organized for use in the *Daily Herald*'s London offices, the filing cabinets and box files still grouped into three broad categories: place, subject, and person (which includes a 'Morgue' section for deceased personalities).

The *Daily Herald* originated in January 1911 as a strike sheet for the London printing unions and was so successful that in April 1912 it became the British Labour Party's official daily newspaper. In its early years, however, it staggered from one financial crisis to another, first under the direction of the socialist Lord George Lansbury (1859–1940) and then, from 1922, under the direction of the Trades Union Congress (TUC). The *Daily Herald* of this period avoided appealing to a broad public, preferring instead to rely on loyal Labour supporters. Its closely printed columns contained detailed political coverage, and its photographs tended to be static portrait shots of politicians and other worthies. In 1926 improvements in printing technology allowed the introduction of a page devoted to photographs, typically featuring a mix of news and sport, plus a pretty girl. However, politics remained the paper's pre-eminent concern with, for example, photographs of the coal-mining dispute of 1926 featuring heavily. But sales remained low and the paper continued to struggle.

Throughout the 1920s the paper was hampered by a lack of funds that was only solved in 1929 when a joint ownership deal was struck between the TUC and the publisher Odhams Press. Odhams held 51 per cent of shares in the newspaper, the TUC the rest. This

Anon.

Daily Herald reporter interviewing a Lyons Corner House waitress ('nippy'), 27 April 1931

partnership gave the paper a much-needed financial boost and for the first time the *Daily Herald* could truly expand. March 1930 saw the paper double in size from ten to twenty pages. Aggressive marketing schemes were introduced to boost sales, featuring insurance policies and cameras given away as free gifts. The journalistic style was broadened to appeal to a wider readership, and photography became more prominent in defining the look of the paper. Jarché, already an experienced and well-regarded photographer with the *Daily Sketch*, was hired as chief photographer. The Day Book for April 1931 records the variety of photographic subjects taken by him and his colleagues: women making hot cross buns for Easter and rehearsals for a West End show are balanced by the reporting of an armed robbery, extensive coverage of a National Union of Teachers conference, and the Woolwich by-election.

In 1934 Odhams launched the first British photo magazine, *Weekly Illustrated*, as a companion to the *Daily Herald*. Jarché began working on it with a number of Europeans, most notably Stefan *Lorant, who served briefly as editor. Through these links the ideas and techniques of European *photojournalism influenced photography on the *Daily Herald*. While the newspaper continued to use pictures of pretty showgirls it also strove to produce more socially aware photographic features. A sequence of pictures could be used to tell a story rather than simply illustrate one, as the series of photographs of British workers taken by one *Daily Herald* photographer, Roper, in 1940 demonstrates. The paper continued to feature an interesting mix of photographs throughout the war period, the 1946 Day Books revealing a diverse cross-section of subject matter: preparations for the upcoming victory parades, the National Union of Public Employees conference, a boxing match, a society wedding, and the *Daily Herald* brass band concert in Newcastle.

In 1933 certified net sales reached 2 million, making the *Daily Herald* the world's biggest-selling daily newspaper. However, circulation wars took their toll and the paper's sales never again reached this peak. The 1940s witnessed the beginnings of a slow decline, which brought to the fore long-standing tensions over the paper's political ties. Odhams felt that the paper's left-wing affiliations hampered its commercial prospects and, faced with downwardly spiralling sales, finally persuaded the TUC to relinquish its shares in 1960. But the paper had lost too much ground, chiefly due to the aggressive tabloid style of the *Daily Mirror*, which since the 1940s had taken an increasing share of the *Daily Herald*'s core working-class readership. Ironically it was to be Mirror Group Newspapers (MGN/IPC) that took over the ailing paper in 1961. Yet another relaunch followed in 1964 with the *Daily Herald* becoming the *Sun*, but sales remained unimpressive. In 1969 MGN/IPC closed the paper and sold the name *Sun* to Rupert Murdoch's News International. However, the *Daily Herald*'s legacy lives on in its photographic archive, an invaluable visual record of 20th-century British social history. SB

Jarché, J., *People I Have Shot* (1935).
Dutt, R. P., 'The Rise and Fall of the *Daily Herald*', *Labour Monthly/Daily Worker* (1964).
Richards, H., *Bloody Circus* (1997).

Photokina. See GRUBER, L. FRITZ; TRADE FAIRS, PHOTOGRAPHIC.

Photo League. See DOCUMENTARY PHOTOGRAPHY.

photolithography derived from the asphaltum process (Lemercier, Lerebours, Barreswil, and Davanne, 1852), itself based on experiments by *Niépce (1816), in which a grained lithographic stone was coated in photosensitive bitumen and exposed to harden the coating selectively. The coated stone was washed with turpentine, inked, and printed, producing coarse half-tone images. Alphonse *Poitevin (1855) substituted dichromated albumen, which was washed in water to produce a planographic surface. The process was the basis for photolithographic transfer (Asser, 1857) and chromolithography. It also led to photozincography (James, Osborne, 1861), using a zinc plate and later adapted for 'offset litho' (Harris, Rubel, 1906). HWK

photomacrography is the making of an image that is larger than the object, using conventional camera techniques. It is often miscalled 'macrophotography', which in fact describes techniques for making giant prints, quite another thing. Photomacrography is formally described as photography over a range of magnifications from ×1 to ×20. Many modern *zoom lenses claiming a 'macro' facility in fact operate at a maximum magnification of only ×0.5 or less. A true macro lens is fully corrected for ultra-close-up work, whereas normal lenses used in this manner may show noticeable aberrations. Ordinary camera lenses can be used (at a small aperture) for magnifications at around ×1 to ×2, using extension tubes or a bellows extension, but at higher magnifications the reversal of the usual conjugate distances requires the lens to be reversed in its mount. There is little depth of field, and it is usual to focus by adjusting the camera back rather than the lens, or with cameras with fixed backs by mounting the camera on a sliding platform.

The most important effect of high magnification is the increase in exposure that is required. The effective f-number is increased, as this is no longer simply focal length ÷ lens diameter, but extension ÷ lens diameter. The increase in f-number is equal to the marked f-number $\times (1 + m)$ where m is the magnification, and the required increase in exposure because of this is $(1 + m)^2$. So a magnification of ×1 (double extension) requires four times the indicated exposure, and a magnification of ×2 (triple extension) requires nine times the indicated exposure. *Through-the-lens (TTL) metering takes this increase into account, but high magnifications send the required exposure soaring, and this is aggravated by the

necessity for using a small aperture in order to secure adequate depth of field. Meters do not take account of the *reciprocity problems that go with very long exposures, such as underexposure, unduly high contrast, and incorrect colour balance (though film manufacturers provide lists of correction filters to use for long exposures). It is therefore advisable to bracket exposures upwards by several stops when shooting macro.

Because of the long exposures certain other precautions are necessary. The camera must be on a rigid support, and subjects such as flowers must be fully protected from any wind. Even in the studio, flowers and leaves can move towards the light during a long exposure, and because of this and the risk of overheating it is preferable to use flash (which also takes care of reciprocity problems).

Most beginners automatically choose their shortest focal length lens for macro work, as it produces the largest image with a given set of extension tubes. This is a mistake. Such a lens will be covering a much larger area than the format for which it is designed, and will thus not be operating at its best. In addition it is very close to the subject matter, which can result in perspective distortion. A longer focus lens (say, 100 mm for a 35 mm format) gives better proportions, puts the background well out of focus, and keeps the camera a reasonable distance from the subject, leaving plenty of room for flash illumination. *Depth of field depends only on magnification and f-number, and is independent of the focal length of the lens. It should be emphasized that, in photomacrography, image definition is not improved by using a small aperture. The depth of field will certainly be increased, but the resolution, even at apertures as large as (a nominal) f/4, will be governed by the laws of diffraction. GS

Meehan, J., *The Art of Close-up Photography* (1994).

photomacroscopy. See SCIENTIFIC PHOTOGRAPHY.

photomechanical processes. The photomechanical processes developed following the announcement of photography in 1839 perpetuated the principles of relief, intaglio, and planographic processes in new and innovatory combinations. They joined a plethora of reprographic processes, estimated in the middle of the century to number over 150. As markets and technologies developed in the later 19th century these processes underwent a degree of consolidation. During the first half of the 20th century a comparatively small set of processes began to dominate large-scale industrial photomechanical production. Later, the advent of xerography—invented in 1938—and a number of *digital technologies have introduced a range of photomechanical processes that have brought mechanical reproduction of photographic images to a wide-ranging consumer market.

One basic premiss of photomechanical processes is that ink or a toner is applied on to a support—usually paper based—to render, consistently, a wide tonal range with high levels of linear detail. Coupled to these attributes is the need to produce long and cost-effective print runs. During the 19th century these criteria provided

very significant challenges, and it was not until the early 20th century that photomechanical processes for a mass market truly came of age.

Two immediate challenges faced photography following the announcement of the photographic processes of *Daguerre and *Talbot in 1839. The first was to create reprographic processes suitable for industrialized mass production and, in the case of Talbot's paper-based process, to produce paper photographic prints that remained stable and did not fade.

As early as the 1840s, photomechanical processes based on the *daguerreotype were beginning to appear across Europe. In 1840 Dr Joseph Berres (1796–1844) of Vienna published the booklet *Phototyp nach der Erfindung des Prof. Berres in Wien*, illustrated with five 'photomechanical' plates created by the etching of daguerreotype plates with nitric acid. Berres distributed copies of this title, and sample prints, across Europe. However, only a print run of *c*.200 was possible from the silver-plated copper plates.

Others followed Berres's lead. In Paris, Dr Alfred Donné (1801–78) and Armand-Hippolyte-Louis Fizeau (1819–96) both developed *photogravure processes based on the daguerreotype. Fizeau's process was used to create illustrations for the serial publication *Excursions daguerriennes: vues et monuments les plus remarquables du globe* (1840–4). In 1841, in London, Sir William Grove (1811–96) announced his photogalvano-caustic etching process.

By the 1850s, such was the concern for the future of photographic paper prints that in both France and Britain competitions to find both solutions to the impermanence of photographic prints and industrial processes for mass production were created. In France, between 1856 and 1867, Albert, duc de Luynes (1802–67) sponsored a 'petit prix' for the creation of a permanent photographic print process and a 'grand prix' for the creation of a photomechanical process. The French chemical engineer Alphonse *Poitevin won both prizes.

During the 1850s and 1860s a significant number of photomechanical processes were introduced. However, they all achieved comparatively limited success.

In 1852 Talbot patented his steel etching process, and subsequently an improved photogravure process that he called *photoglyphic engraving (1858). Talbot also developed the principle of breaking up the image into lines and dots (a so-called 'screen'), which forms the basis of photogravure screened intaglio printing plates, to produce *half-tone printed images.

In the late 1850s there was significant research into photo-planographic processes. The first important experiments were undertaken in France by Joseph Lemercier (1803–87) together with Lerebours, Barreswil, and Davanne, and the results published in 1852. Poitevin patented a *photolithographic process in 1855 that could provide up to 700 impressions from one stone. This process was used for book illustration, such as the 44 plates in *Choix des terres cuites antiques du cabinet de M. le vicomte Hte. de Janzé* (1857). Poitevin's process was also used in combination with chromolithography to

produce colour illustrations included in two volumes of plates accompanying Jules Labarte's *Histoire des arts industriels* (1864). However, photolithography probably had its greatest impact in the 19th century on the reproduction of line drawings such as architects' drawings and plans.

In 1859 in England, Colonel Sir Henry James (1803–77) of the Ordnance Survey Office introduced his photo-planographic process called photozincography, in which zinc printing plates could be wrapped around the cylinder of rotary printing presses, thereby enabling mass production of prints. At the same time, in Australia, John Walter Osborne (1828–1902) announced a similar process and Eduard Asser (1809–94) in the Netherlands developed his process of 'indirect photolithography'. In Britain, the politics involved in its funding dictated that the primary application of James's process lay in its reproduction of maps, and the inventor regularly pointed out that photozincography reduced the cost of map-making by several thousand pounds a year. From 1865 the process was extensively used to reproduce historical and illuminated manuscripts in the national collections.

The 1850s also saw a number of failed attempts to commercialize photomechanical processes. In 1855 Paul Pretsch (1808–73), who had worked in the Imperial Printing Office in Vienna, founded the Photo-Galvanographic Company in Islington, London. This aimed to exploit Pretsch's photo-galvanographic process that used a copper intaglio plate produced by galvanoplasty. Although Roger *Fenton was appointed chief photographer and manager of the company's photographic department, the company had closed by 1858.

The *Woodburytype was extensively used for book and periodical illustration during the last quarter of the 19th century. While it gave rich images with a fine tonal range it was highly labour intensive to produce, each print needing to be trimmed and then pasted on to the page it illustrated. It was also unable to handle both image and text. One of its more esoteric uses was by Léon Vidal (1834–1906), who in 1875 perfected his *photochromie* colour printing system, which combined the Woodburytype and chromolithography.

Poitevin had recognized as early as 1855 the underlying principles of the continuous-tone *collotype process. In the late 1860s Joseph *Albert of Munich significantly improved it, introduced the rotary collotype in 1873, and in the following year made the first colour collotype. The collotype remained popular until the 1970s. However, as with the Woodburytype process, it could not print both image and text together.

The photogravure process introduced by Karel Klič (1841–1926) in 1879 is generally credited as one of the major milestones in modern photomechanical reproduction. In the 1890s he introduced rotogravure in which printing could be from cylinders on fast presses. Eduard Mertens (1860–1919) invented a rotogravure process in 1904 and in 1910 his presses produced a landmark, the first rotogravure images to appear in a newspaper, the *Freiburger Zeitung*. In 1912 the *Illustrated London News* adopted the process.

During the 20th century there was a consolidation of photomechanical processes. The use of the collotype and photogravure declined while, from the late 1950s, offset lithography came to dominate and now represents more than 50 per cent of all printing. AJH

Eder, J. M., *History of Photography* (1968).

Nadeau, L., *Encyclopedia of Printing, Photographic, and Photomechanical Processes* (2 vols., 1989–90).

Aubenas, S., *D'encre et de charbon: le concours photographique du duc de Luynes 1856–1867* (1994).

Grivel, C., et al. (eds.), *Die Eroberung der Bilder* (2003).

Wright, H. E., 'Photography in the Printing Press: The Photomechanical Revolution', in B. Finn (ed.), *Representing Pictures* (2004).

photometry is the measurement of light. It is important in photographic lighting set-ups, as it links the output of a luminous source to the exposure received by the photographic material. The units of luminous intensity are the *candela* (cd) and *lumen* (lm), 1 candela being 1 lumen per steradian. Candelas are measured in a specified direction, whereas lumens are averaged over a specified solid angle. These units are linked to the watt for one specific wavelength, namely 555 nanometres (mid-green, the maximum sensitivity of the human eye), where 1 watt corresponds to 683 lumens.

A uniform source of 1 candela would emit 1 lumen per square metre (lm m⁻¹). At 1 m distance this represents an *illuminance* of 1 lux (lx). Illuminance is directly proportional to intensity and inversely proportional to the square of the distance from the source (the *Inverse Square Law*). The *luminance* of a source is directly proportional to its power and inversely proportional to its area. The unit is the candela per square metre (cd m⁻²). This unit also applies to light reflected from a surface. Like the candela, it is measured from a specified direction.

Luminous energy applies to flash exposures. It is reckoned in lumen seconds (lm s), and is equal to the area under the time–intensity graph for the flash in question (Fig. 1).

Where *colour temperature is inapplicable, *spectral power distribution* is shown as a graph of power against wavelength (Fig. 2). GS

Coaton, J. R., and Marston, A. M. (eds.), *Lamps and Lighting* (4th edn. 1996).

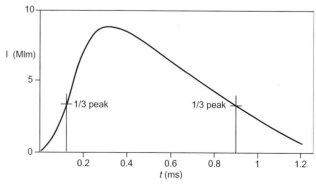

Fig. 1

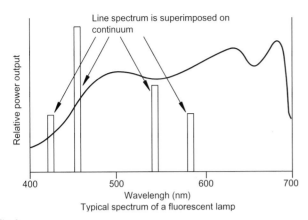

Fig. 2

photomicrography. See SCIENTIFIC PHOTOGRAPHY.

photomontage uses cut-up photographs, usually from newspapers, magazines, or other printed sources, which are severed from their original context and juxtaposed with other images, text, and graphic elements, leaving the joins visible. The technique at once references, disrupts, and moves beyond the realism of photographs. It may be done in the darkroom or directly on to the page, although some historians use the term photocollage for the latter. The term is historically associated with Berlin Dada artists, who after the First World War were developing their anti-art aesthetic by working with mass-produced imagery rather than painting. They chose the term photomontage for its non-artistic connotations. A *monteur* is a mechanic or engineer, and montage means fitting, assembling; it evokes something put together by rivets or solder, as part of an industrial process, rather than with glue, an old and artisan material. It distanced Dada works from Cubist collage, pioneered around 1912 by Picasso and Braque, which consisted of the inclusion of fragments of 'real' or simulacral (fake rather than representational) elements into their compositions; but also from 19th-century uses of combined photographs, such as combination prints (see COMPOSITE PHOTOGRAPHS) and amateur photocollages found in *albums. The term montage also relates to cinema, in particular the editing techniques of Dziga Vertov and Sergei Eisenstein, who spliced different takes with no attempt to construct the illusion of a seamless whole or to foster suspension of disbelief. Montage always foregrounds its nature as a re-presentation, a cultural construction.

Photomontage was used politically by the Berlin Dada artists John *Heartfield, Raoul *Hausmann, and Hannah *Hoech to question the claim of both photography and language, as used in the press, to represent reality in a truthful and authoritative manner. Photomontage came to be seen as both a product and a visualization of the fragmentation of modern life, its jolting movement, speed, and frenzied tempo. It commented on the accelerated and uneven transformation of personal lives and identities, now revolving around an industrialized economy and an urbanized culture.

John Heartfield

The Meaning of the Hitler Salute (Little Man Asks for Big Donations), 1932. Photomontage

For Dada artists, photomontage embodied an expanded vision, collapsing many viewpoints and replacing the image of a continuous life glimpsed through a window frame—the heritage of the fine arts since the Renaissance—with a discontinuous, fast-paced, multifaceted image. It gave artists the means to reflect critically on modern, urban lifestyles, but also to play with the fantasies and desires of a consumer age, by combining the sobriety of black-and-white, factual photographs with the strong imaginative effort needed to fragment and recombine them. Russian Constructivists such as El *Lissitsky and Alexander *Rodchenko were interested in visual strategies for 'making strange', jolting people into perceiving the ideological nature of realities taken for granted as natural, including representation itself. They used photomontage to reveal the ideological nature of signs, and in particular of photography. By juxtaposing apparently disparate images, they could show not just visible reality, but abstract relationships such as cause and effect, and expose links obscured by ideology. Surrealist publications also used montage logic by grouping disparate images to disrupt perception of reality and make the repressed or the unconscious visible. By the 1930s, photomontage featured regularly in *advertising, political *propaganda, and exhibition design, as a powerful signifier of modernity, but also in an attempt to anchor the meaning of individual images, paradoxically using the lessons learned from artistic strategies which aimed to open up meaning, to attempt to close it down again to an unambiguous political or commercial message.

Photomontage continued to be used throughout the 20th century, especially by artists committed to political activism, as a technique and as a conceptual approach to deconstruct mass-media images. Martha Rosler's series *Bringing Home the War* (1967–72) dropped photojournalistic images of the Vietnam conflict into advertising or editorial photographs from lifestyle magazines, suggesting that connections should be made between the political and the personal. Barbara Kruger's bold juxtaposition of simple photographs and confrontational text used strategies derived partly from Dada photomontage, partly from her experience as an advertising designer, to make deceptively simple statements about the role of women in commodity culture. Today, software such as *Adobe Photoshop has made the juxtaposition of lens-generated or virtual photographs more versatile, but the clean smoothness of the output seems to lack the visual vitality, rich tactility, and playfulness of scissors-and-paste techniques. PDB

Ades, D., *Photomontage* (1986).

Evans, D., *Photomontage: A Political Weapon* (1986).

Teitelbaum, M. (ed.), *Montage and Modern Life, 1919–1942* (1992).

Lavin, M., *Cut with the Kitchen Knife: The Weimar Photomontages of Hannah Höch* (1993).

Photorealism. See PAINTING AND PHOTOGRAPHY.

photoromance (or photo-novel), popular photographic picture story, published in individual or serial form, borrowing both comic-strip and cinematic conventions. Its precursor was the *cine-novel*, pioneered by William Selig in the *Chicago Tribune* in 1913. The *fotoromanzo* flourished in Italy in the 1940s and 1950s (*Grand Hotel*, 1946– ; *Bolero Film*, 1947–), and was satirized in Federico Fellini's first film, *Lo sceicco bianco* (*The White Sheikh*, 1952). *Fotoromanzi* were either cut-down versions of feature films or were shot specially, emphasizing the modishly dressed protagonists while settings were minimally rendered. Though essentially a pulp product, the *fotoromanzo* was briefly adopted by mainstream publishers like Mondadori, which in 1953 issued a photo version of Alessandro Manzoni's 19th-century classic *I promessi sposi*. But leading players in both Italy and France were the Del Duca brothers, whose productions, despite competition from television, continue to appear and are widely translated. In Britain, titles like *Oh Boy* and *Photo-Love Monthly* (both 1976–), and *My Guy*, *Jackie*, and *Blue Jeans*, are aimed at teenage girls; tabloid newspapers use the format to illustrate agony-aunt columns.

*Digital photography and the *Internet gave the genre a new lease of life. Teenage enthusiasts produced web-comic versions (sometimes ironically modified) of sci-fi classics like *Star Wars*. Schools used it as a tool for language teaching. In Quebec, photography was used to create interactive narratives that could be disseminated in print, on the Internet, and on CD-ROM. One such was the 'photoroman aléatoire' (random photoromance) *Liquidation* created by Michel Lefebvre and Eva *Quintas 1994–8. RL

Fotoromanzo: fascino e pregiudizio (1979).

Scott, C., *The Spoken Image: Photography and Language* (1999).

photosculpture, originally an ingenious method, patented in 1859 by the French painter, sculptor, and photographer François Willème (1830–1905), designed to make the production of portrait sculpture quicker, cheaper, and more accurate. The sitter was positioned in a rotunda, surrounded by an array of 24 cameras at fifteen-degree intervals which took simultaneous photographs. These were later projected on to a translucent screen, on the back of which an assistant traced each outline and transferred it by means of a pantograph to a cutting machine. The machine cut the outlines, every fifteen degrees, into a pillar of clay rotating on a turntable. The result was trimmed and touched up by the artist, then fired. However, the company founded by Willème in 1862 lasted only about six years. Despite considerable interest from artists and writers, and improvements devised by Antoine *Claudet ('photoplastigraphy', 1865) and others, the invention never took off. The reasons were both technical and cultural: photosculpture was too complicated and expensive; fashions in sculpture had moved from illusionistic smoothness to a rougher, more spontaneous-seeming *fa presto* style unsuitable for the machine; and, ironically, there was the increasing popularity of portrait photography, especially the *carte de visite*.

In the 20th century the term was used in a quite different sense to describe the combination of photographs or segments of photographs with other materials (wood, cardboard, plexiglass) or objects (boxes, cylinders) to create a three-dimensional work. The possibilities are

Leonid Andreyev *With Anna*. Andreyev and his wife at Vammelsuu, Russian Finland, after 1908. Autochrome

Jan Vetter Kite-ski Championship, Switzerland, 2003

almost endless. Notable practitioners included Douglas Prince (b. 1943), Lucas *Samaras, and Robert *Heinecken. RL

Bogart, M., 'Photosculpture', *Art History*, 4 (1981).

Sorel, P., 'Photosculpture: The Fortunes of a Sculptural Process Based on Photography', in F. Reynaud, C. Tambrun, and K. Timby (eds.), *Paris in 3D: From Stereoscopy to Virtual Reality* (2000).

Photo-Secession. Founded by the brilliant but domineering Alfred *Stieglitz in 1902, the Photo-Secession is perhaps unique in the history of world arts organizations for being both apparently open and uncompromisingly exclusive in its structure and stated aims. Stieglitz had fallen out with the Camera Club of New York, whose journal, *Camera Notes*, he had created and edited. He and his followers had been increasingly influenced by forward-looking photographic organizations abroad such as the *Linked Ring Brotherhood in England and secessionist movements in Austria and Germany. These groups sought to emancipate themselves from the constraints of existing photographic organizations that, they felt, inhibited individual expression and the recognition of photography as a fine art on a par with painting and sculpture. Key early figures in the Photo-Secession were Gertrude *Käsebier, Clarence H. *White, Joseph T. Keiley (1869–1914), Edward *Steichen, Frank *Eugene, and Alvin Langdon *Coburn. The full founding governing council consisted of thirteen 'founders', selected from a pool of elected 'fellows'. The ranks of lesser, associate members, initially numbering 28, would soon swell to well over 100.

In 1903 Stieglitz brought forth the first issue of *Camera Work*, in which the intentions of the Photo-Secession were more clearly articulated. The organization mounted significant shows of photography, most notably the International Exhibition of Pictorial Photography in Buffalo in 1910. But Stieglitz's autocratic ways and growing interest in the exhibiting of modern art generally—not just photography—began to alienate some of his followers. Although never formally disbanded, the Photo-Secession effectively ended with the closing of Stieglitz's *Gallery 291 and the cessation of *Camera Work* in 1917. TT

Doty, R., *Photo-Secession: Stieglitz and the Fine-Art Movement in Photography* (1960; repr. 1978).

Homer, W. I., *Alfred Stieglitz and the Photo-Secession* (1983).

phototherapy. The use of photographic representations in various therapeutic contexts to promote self-awareness and psychic healing. In the 1970s in the USA and Canada therapists started to use photographs as counselling tools. Working within a range of theoretical frameworks, they used the photographic image as a route to the unconscious, assuming that the meanings an individual finds in a photograph are the result of a projective process and mirror an unconscious 'inner map' he or she is using. A therapist, using a non-judgemental approach, may assist the client to articulate and reflect on his or her values and beliefs, using photographs as a catalyst for communication. Photographs taken by the client prior to therapy may offer insights into feelings and relationships of deep personal concern.

Family *albums can provide a resource for autobiographical storytelling and an exploration of family dynamics, and offer clues as to why certain early experiences continue to affect the individual.

However, an important element in phototherapy is often the photographic enactment of life events that were not or could not have been photographed before, e.g. because they involved conflict, abuse, or deprivation. *Re-enactment phototherapy* was developed by Rosy Martin and Jo *Spence from 1983. Issues linked to memories unearthed and explored through counselling would be made visual with the use of carefully selected clothes and props. Scenarios were staged with the client as protagonist in a variety of power situations— for example mother–daughter. (In some situations models might be used.) The photographer-therapist offered reassurance, support, and reflection. The goal was to enable the client to re-experience a previously repressed trauma in a secure setting, re-examine his or her perceptions and feelings, and achieve a degree of cathartic release.

Photographs are constructions, the product of a range of specific choices; yet are widely believed to represent 'truth'. Phototherapy provides opportunities to play with the notion of photographic truthfulness, using re-enactments of past scenes, or scenes that *might* have occurred in the past, to suggest alternative identities or life histories. Moving the photographs around and creating new narratives disrupts the sense of closure or inevitability. New stories may be told, new possibilities envisaged. Re-enactment phototherapy presents the self as process and, in theory, offers openings for change. RM/RL

Martin, R., and Spence, J., 'Phototherapy: Psychic Realism as a Healing Art?', *Ten8*, 30 (1988).

Weiser, J., *Phototherapeutic Techniques: Exploring the Secrets of Personal Snapshots and Family Albums* (1993).

Berman, L., *Beyond the Smile: The Therapeutic Use of the Photograph* (1993).

photowallahs. A term for local street photographers in *India. While early, city-based studio portraiture catered largely to the elite, popular photographic practices (also known as bazaar or street photography) in smaller towns met the demand for portraits among ordinary people. In opposition to the 'objective' realist discourse embedded in photography, this form was sometimes performative and coexisted from the 1920s with similar non-realist branches of popular visual culture, including cinema (especially that associated with the film-maker, theatrical painter, and conjuror D. G. Phalke) and film posters, theatre, chromolithography, and calendar art. In studios, the photographer's aesthetic and practical resources (*backdrops, props, sets, costumes) and technical input (*hand colouring, overpainting, or forms of trick photography), together with the agency of the subject, could turn the photograph into a space for transgression, or parody of existing identities.

For those who wanted cheap, instant images, there were travelling and street photographers who used wall hangings and backdrops (for example, cut-outs of film stars or cityscapes), often fixed to cycles or rickshaws, to set up fantasy locales and scenarios for the sitter. Many street photographers still use turn-of-the-century wooden box

cameras that combine two 19th-century technologies, the *calotype camera and the portable darkroom, to provide positives directly from the camera. Negative paper is exposed manually (there is no shutter) by removing the lens cap, then rephotographed on a further sheet of negative paper. With new technology in the 1980s making standardized colour prints available, this form of photography is becoming less common, but still practised at fairs like the *Pushkar mela*, and at holiday destinations.

In their 1992 film *Photowallahs*, David and Judith MacDougall showed how street photographers in the north Indian hill station of Mussoorie offered middle-class visitors an opportunity for fantasy and dressing-up as part of the tourist experience. SG

See also ITINERANT PHOTOGRAPHERS.

Pinney, C., *Camera Indica: The Social Life of Indian Photographs* (1997).

Piçarra, Mariano (b. 1960), Portuguese photographer, based in Lisbon. After initial work as a photojournalist he studied industrial design, and in 1986 joined the Lisbon Gulbenkian Foundation. Meanwhile he was trying to establish himself in Portugal's inhospitable art photography scene. Like other young photographers, he was encouraged by the critic and owner of the Ether Gallery, Lisbon, António Sena. He photographed wet streets and deserted urban spaces, working mainly in black-and-white. A visit to the former colony of Guinea-Bissau with his wife, an anthropologist, in 1996–7, transformed his vision and inspired many magical images. RL

Siza, M. T., and Weiermair, P. (eds.), *Livro de viagens: Portugiesische Photographie seit 1854* (1997).

pictorialism, as a term, characterized photography whose intention and expression derived from fine art, as opposed to that whose object was purely scientific, documentary, or commercial. Although pictorial photography was specifically identified in the late 19th and early 20th centuries, its principles were first established by H. P. *Robinson in *Pictorial Effect in Photography* (1869). Robinson asserted that photographic art should imitate the conventions of academic painting, and his own photographs showed a disposition of elements—figures, foreground interest, peripheral framing, and background closure— that marked such work as a purposefully constructed picture rather than a spontaneous or serendipitous transcription of nature. A photograph might be 'taken' from nature, but a picture had to be 'made', and differing perspectives on how this might be achieved enlivened debates between Robinson and P. H. *Emerson, who described photography as 'A Pictorial Art' in an 1886 lecture at the Camera Club, London. Emerson's ideas reflected an increasing interest in the possibility of personal expression in photography, while others, including George *Davison and A. *Horsley Hinton, took from theories of Impressionist painting an awareness of the power of individual temperament to affect what the artist sees and represents to the viewer. By the late 1890s, the Symbolist movement in literature, art, and music inspired an interest in allegorical and idealist subject matter, and expressive rather than mimetic representation.

In photography, as in the decorative arts, there was a reaction against mechanization and industrialization. The advent of *snapshot photography resurrected long-standing accusations that the photograph was the automatic product of a machine; now, more than ever, photographs were popularly seen as both instantaneous and unmediated. Photographers such as Alfred Maskell were intrigued by a notion of art as the unique consequence of additive effort, which suggested that it was the photographer, not the apparatus, who 'made' the picture. This, with a concurrent interest in a pre-industrial, artisanal tradition, encouraged the adoption of hand-made and home-made photographic papers, including *gum bichromate and brush-developed *platinotypes (platinum prints). The textured, inflected surfaces of such photographs were very different from the machine-made perfection of manufactured printing papers.

Many of these processes developed at a time when photographers were rather self-conscious about the role and status of their medium as an art form, both in its own right and in relation to, or even in competition with, the fine and graphic arts. There was dismay at the increasing industrial exploitation of photography, and at practices and institutions that pandered to a commercial and professional establishment. In the 1890s, this encouraged a secession from traditional photographic associations and the founding of groups dedicated to artistic practice, such as the Vienna Camera Club, the Brotherhood of the *Linked Ring (London), the Society for the Encouragement of Amateur Photography (Hamburg), the *Photo-Club de Paris, the Cercle d'Art Photographique (Brussels), the *Photo-Secession (New York), the Studio Club (Toronto), and the Sydney Camera Circle. Many groups had a multinational membership that organized or contributed to international exhibitions of art photography, including the Photographic Salon of the Linked Ring (from 1893), the exhibitions at the Hamburg Kunsthalle (1893–1903), the International Exhibitions at Glasgow (1901) and Turin (1900 and 1903), and the Albright Art Gallery (Buffalo, New York, 1910). Pictorial photography was promoted in the pages of periodicals such as *Amateur Photographer* and *Photograms of the Year* (London), *Photographic Review* (Lvov, Poland), *Die Künst in der Photographie* (Berlin), *Camera Work* (New York; Alfred Stieglitz, editor), *La fotografia artistica* (Italy), and *Vestnik fotografii* (Moscow; Nikolai Petrov, art director). *The Studio* (London) published two special issues on pictorial photography, edited by Charles Holme in 1905 and 1908.

When *Camera Work* ceased publication in 1917, the journal had outlasted most other expressions of pictorialism: Stieglitz showed modern sculpture and painting in the old Photo-Secession gallery at 291 Fifth Avenue, and progressive photographers increasingly looked towards formalism and abstraction. While pictorialism lost its currency as a movement, it persisted as an aesthetic diaspora, whose concern with craft, the constructed image, and personal expression have remained influential. As Paul L. Anderson argued in 1917, pictorial photography looked for a harmony of matter, mind, and spirit; the first was addressed through objective technique and

Frederick Evans

A Sea of Steps (Wells cathedral), 1903. Platinum print

process, the second in a considered application of the principles of composition and design, and the last by the development of a subjective and spiritual 'motive'. HWK

Anderson, P. L., *Pictorial Photography: Its Principles and Practice* (1917).

Bunnell, P. (ed.), *A Photographic Vision: Pictorial Photography 1889–1923* (1980).

Kopanski, K. W., and Philipp, C. G. (eds.), *Meisterwerke russischer und deutscher Kunstphotographie um 1900: Sergei Lobovikov und die Brüder Hofmeister* (1999).

picture formats. See FORMATS, PLATE AND FILM.

picture libraries, photographic. These contain collections of images that are usually available for commercial use. The size of a library may vary from a few thousand to millions of images. It may hold work by many photographers or just one, depending on the nature of the collection. While the larger general libraries contain photographs in hundreds of categories, others are more specialized.

Libraries charge a fee for the use of the picture on behalf of the photographer whom they represent. The advantage of using a library for the client is that he or she can source images quickly and easily (often online) and are usually provided with a selection of photographs to choose from. Guidebooks, holiday brochures, and magazines are just a few examples of publications that make heavy use of picture libraries, with or without additional commissioned photographs. Popular images can be used repeatedly by different clients at reasonable cost, although if a client wants exclusive rights to use a picture, a larger fee will be charged. The industry is represented in the UK by the British Association of Picture Libraries and Agencies (BAPLA).

Libraries are generally passive organizations, awaiting requests from clients rather than adopting a proactive sales approach. Whilst a library may contain material from a number of photographers (some famous) the images are not generally marketed as being by particular photographers. The author or source of the images tends to be anonymous to the client. Many photographers produce work specially for libraries, submitting batches of pictures of which only the most saleable are retained. Increasingly, however, libraries commission photographers to produce particular types of image, either to replenish popular subjects or to create additional categories. Generally, photographers will do this work at their own expense, as an investment in future sales, and retain copyright. But, given the global nature of photography and the media, there is a growing trend for libraries to purchase copyright too. This allows them to market the work in a number of ways. For example, a CD can be sold containing large numbers of copyright-free images. Here the profit is made not from the individual pictures, but from the sales of the CD.

Many non-commercial picture libraries hold images of cultural, historical, social, and scientific value. These are often found in museums, galleries, educational and charitable institutions, and professional societies where research and archival preservation takes precedence over commercial use. However, ever-increasing demand for specialized visual material of all kinds, from users ranging from the mass media to academic publishers, has made picture collections a significant source of income for many organizations. Finally, while most libraries hold images on traditional photographic materials, digitization and the use of digitally generated images is growing. DM

Picture Post, British illustrated paper, subtitled *Hulton's National Weekly*, started in October 1938 by the Hungarian émigré Stefan *Lorant, who imported a stable of the most salient continental photographers of the epoch, including Tim *Gidal, Felix H. *Man, Kurt Hutton (Hubschmann), and Gerti Deutsch, and revolutionized readers' ways of seeing. Within two years, *Picture Post* was selling 1.5 million copies at only 1*d.* a week. In 1941, after Lorant's departure for the USA, Tom *Hopkinson became editor; and remained until a dispute with the owner, Edward Hulton, over a story (by Bert *Hardy and James Cameron) critical of the Korean War, forced him out. Thereafter *Picture Post* changed editors annually, for periods monthly, and so lost direction and sales. It finally closed in June 1957.

Picture Post appeared at a time when, although it existed, television was neither a popular nor an accessible medium. Newspapers carried little analysis and no picture stories; many, most notably *The Times*, did not even carry a photograph on the front page. What reads now, through the back copies of *Picture Post*, as a social history of Britain over two decades was at the time the most exciting of weekly treats. Its founding philosophy was to place its faith in people rather than politicians and to give even the most serious subjects a lighter touch. Thus Chamberlain's appeasement policy was interpreted with a photocollage by John *Heartfield showing winged elephants in the English countryside under the rhetorical caption: 'The elephants are happy because they have got peace. But for how long have the elephants got peace?' AH

Hopkinson, T., *Picture Post 1938–50* (1970).

pigment processes. See ALTERNATIVE (NON-SILVER) PHOTOGRAPHIC PROCESSES.

Ping, Otto. See ITINERANT PHOTOGRAPHERS.

Pingyao Festival, annual international photographic festival, inaugurated in 2001 in the ancient Chinese town of Pingyao, 700 km (435 miles) south-west of Beijing in Shanxi province. The event has grown rapidly, and in 2004 *c*.4,000 works by 170 photographers from twenty countries were shown. Sponsors have included major Chinese and French organizations and firms, most notably the publisher of French *Photo* and *Elle*, Hachette Filipacchi, which founded a prize for fashion photography. RL

pinhole photography is the most basic optical system, using no lens, but a tiny 'pinhole' aperture punched in a metal plate fixed to the front of the camera. Its precursor was the camera obscura, dating

George Davison

The Onion Field (*The Old Farmstead*), 1889. Photogravure of a pinhole photograph

from the 10th century and adapted as an optical aid for artists in the 1540s. From the 1850s, pinhole apertures were used in experimental *photometry, assessing lens distortion and spectral absorption, but were rarely applied to photographic imaging until after 1880. The reasons for this concern the particular optical properties of a pinhole which, as compared with a lens, produces substantial diffusion and requires very long exposure times. Unlike a lens, an aperture cannot bend the rays of light to focus an image on the receiving plane, but instead simply allows a bundle of light rays to pass through it. Poor image resolution results, although it can be improved by radically restricting the size of the aperture. Yet this operates only to a degree, because a very small aperture produces diffraction, which itself undermines resolution. Furthermore, at a small aperture, fewer light rays will reach the receiving plane, necessitating long exposures, and pinholes were not practicable for imaging until photographic negatives were made more light sensitive.

A pinhole aperture dispensed with *lens aberrations, and was recommended for *architectural work, as no curvilinear distortion was produced. Depending on the distance from aperture to image plane, the pinhole camera also gave a wide *angle of view and nearly infinite *depth of field. Even the soft focus of the images was appreciated, for diffusion was an aesthetic championed since the 1840s as being akin to natural human vision. Indeed, the pinhole camera was thought to be a more direct means of imaging, and an early term for the device was the 'natural camera'. In the early 1890s, some photographers associated the pinhole's uniform diffusion with the principles of impressionism, arguing that this approximated the mind's synthetic analysis of optical sensation.

Pinhole cameras were manufactured in the USA from 1887 and in France from 1888. Though often dismissed as cheap amateur toys, they were also valued as a practical riposte—made by domestic craftsmen—to the elaborate devices of the photographic industry. Indeed, the long exposure times were welcomed as a contemplative antidote to instantaneous photography and the tumult of Victorian life. 'To get the largest amount of enjoyment out of pinhole photography', wrote H. H. O'Farrell in 1887, 'you must set your camera . . . at dewy morn before some old ruin that will keep still without a head-rest, and linger on till the lengthening shadows and the sinking sun warn you that night is at hand.'

Given the simplicity of lensless photography, there was little scope for technical improvement. In 1890, Sir William *Abney experimented with a diffraction grating, and in 1892, Alfred Watkins published a system of calibrating exposure to aperture size. More extreme diffusion was obtained through the use of a slit aperture, though the resulting astigmatism led dizzy viewers to dub this approach the 'nauseagraph'. At the beginning of the 21st century, pinhole imaging in its basic form is practised by enthusiasts; but it also has relevance to astronomy and nuclear physics, and is used in ever more innovative circumstances. HWK

See also ZONE PLATE.

Kraszna-Krausz, A. (ed.), *Focal Encyclopaedia of Photography* (rev. edn. 1960).
Renner, E., *Pinhole Photography* (2nd edn. 2000).

Pirelli Calendar. See CALENDAR PHOTOGRAPHY.

Pisarek, Abraham (1901–83), Jewish-German photographer, born in Russian Poland. He migrated to Germany in 1919, then to Palestine, but in 1928 established himself in Berlin as a press and stage photographer. His communist sympathies led to collaboration with John *Heartfield and the Workers' Photography movement. Though banned from professional activity in 1933, he was later allowed to work for the five Jewish newspapers still permitted to appear (until 1941), and recorded the twilight existence of Jews in Nazi Germany. He attempted unsuccessfully to emigrate to the USA, but escaped the *Holocaust. After 1945 he documented the Soviet occupation and the emergence of the German Democratic Republic. From the 1950s he concentrated on stage photography. Part of his archive is in the Deutsche Photothek, Dresden. RL

> Rosenstrauch, H. (ed.), *Aus Nachbarn wurden Juden: Ausgrenzung und Selbstbehauptung 1933–1942* (1991).

Pitseolak, Peter (1902–73), Canadian Inuit artist and photographer from Baffin Island. Active initially in the fur trade, he acquired a camera in 1942 or 1943, and with his wife Aggeok took pictures on hunting trips and developed them in an igloo. Later, he used his own and other people's photographs as templates for watercolours and prints of mythical scenes; for example, fellow Inuit at Keatuk camp near Cape Dorset were made to stage exploits by the legendary hero Taktillitak. Pitseolak's work has been widely exhibited, and his negatives are held at the McCord Museum of Canadian History, Montreal. RL

> Bellman, D. (ed.), *Peter Pitseolak (1902–1973), Inuit Historian of Seekooseelak: Photographs and Drawings from Cape Dorset, Baffin Island* (1980).

pixel. See DIGITAL IMAGING.

place, photography and the construction of. From the earliest *daguerreotypes engraved for N. M. P. Lerebours's *Excursions daguerriennes* (1841–2), to the series of stereoscopic views published by *Underwood & Underwood, to the images of earth from space disseminated by NASA, photographs have served as a means by which people have come to know the world and situate themselves in it. In the 19th century, in particular, photography offered a new way of seeing, one which extended the powers of human observation across space and time, carried the authority of visual truth from the realm of actual experience to the verisimilitude of photographic realism, and made it possible to gather, preserve, analyse, order, and disseminate all kinds of information, in visual, purportedly unmediated form, with unprecedented ease and accuracy. Increasingly part of the way people lived their lives and engaged with the physical and human world around them, photographs were enlisted as a way to confront, to comprehend, and, thereby, to gain a measure of control over what was strange or threatening in new surroundings. Produced to 'picture place' in the literal sense, they also served to 'picture place'

in the figurative sense, contributing to those processes by which knowledge was conceptualized, landscape meanings were inscribed, and the world was made a smaller, safer, more familiar place. In concert with other forms of representation—textual, visual, cartographic, statistical, artefactual—photographic images gave rise to new geographical imaginings.

Initial emphasis on the realism and truthfulness of photography, coupled with a prevailing belief in the legibility of appearances, gave rise to assumptions about the inherent ability of photographs to capture and project not only outward appearances but also inward meanings, in particular the spirit of a place and the character of its people. Embraced as the experiential equivalent of direct observation, photographs served not only as an incentive for, an accessory to, and a souvenir of *travel, but also as a surrogate for travel. Marcus Aurelius *Root, William Lake Price (1810–96), and others even suggested that the photograph was not only a substitute for first-hand observation, but that, in some instances, it permitted a 'completer and truer' understanding than direct experience. Indeed, in a celebrated essay, Oliver Wendell *Holmes wrote: 'Give us a few negatives of a thing worth seeing, taken from different points of view, and that is all we want of it. Pull it down or burn it up, if you please'—the world could be reduced to a gigantic picture library. Travel photographs introduced viewers to distant parts of nation and empire. Series of stereographs functioned as education and entertainment to fuel the geographical imagination. Photographs were purchased and collected into personal albums as surrogates for travel and devices of memory. Incorporated into the routine processes that linked people to place, included in government reports, sold in sets of stereo views, displayed at international exhibitions, compiled into tourist albums, and sent to family and friends at home. Through their inherent selectivity and subjectivity, they helped to constitute and sustain individual and collective notions of place and place-based identity on a variety of scales—individual and collective, local, regional, national, and imperial. Indeed, photographs were particularly important in the construction of place in those parts of the world—the white settler colonies of the British Empire, for example—where photography and nation came of age together. Widely adopted as a tool of fieldwork, geographical description, travel writing, and scientific documentation, photographs expressed and mediated the experience of land and life, privileging some aspects and marginalizing others, in the process helping to transform space on the ground into place in the mind. JMS

> Holmes, O. W., 'The Stereoscope and the Stereograph' (1859), in A. Trachtenberg (ed.), *Classic Essays on Photography* (1980).
> Schwartz, J. M., and Ryan, J. R., *Picturing Place: Photography and the Geographical Imagination* (2003).

platinotype. The acme of photographic process c.1900 was contact printing in platinum, invented by William *Willis in 1873, using potassium tetrachloroplatinate(II) and iron(III) oxalate sensitizer, with potassium oxalate developer. The permanent, grey tonality and matte surface of platinotypes so departed from the customary brown

gloss of albumen prints that Willis obligingly added 'sepia' and 'Japine' platinotype papers to his company's range. Platinotype became the favoured medium of *pictorialists, but the demand for platinum catalysts in explosives manufacture extinguished its photographic use in 1917. Since the 1970s it has enjoyed an elite revival, notable users including Irving *Penn and Robert *Mapplethorpe. MJW

Playboy, legendary men's magazine launched by Hugh Hefner (b. 1926) in November 1953, with Marilyn *Monroe (clothed) on the cover, and a 1948 nude photograph of her by Tom Kelley (b. 1914) as the first of its celebrated centrefolds. *Playboy* evolved an anti-repressive, hedonistic philosophy, its graphic and photographic images seeking to combine traditional erotic fantasy with girl-next-door wholesomeness. It backed its appeal to well-educated, affluent males with serious interviews (Castro, Martin Luther King, Malcolm X, Nabokov), articles by major writers (Amis, Mailer, Updike), and photographs by the likes of *Friedlander, *Newton, and *Ritts. Circulation topped 6 million in the early 1970s, but later sagged as competition from more blatantly pornographic rivals intensified. RL

Plossu, Bernard (b. 1945), French photographer, born in Indo-China. He began to photograph in the Sahara Desert, aged 13, and at 20 joined a two-year ethnological expedition to Mexico. He has travelled constantly ever since, working mainly in black-and-white, and treating the photograph as a means of self-reflection. Books like *Le Voyage mexicain* (1979) and *Jardin de poussière* (1993) offered subjective images of empty, skeletal landscapes that resonated strongly with the post-1960s generation. He has returned frequently to the American West. In 1988 he had a major retrospective at the Centre Pompidou, Paris. LAL

Mora, G. (ed.), *Bernard Plossu* (1994).

Poidebard, Antoine, SJ (1878–1955), French missionary, aviator, and aerial archaeologist. He entered the Society of Jesus in 1897, in 1911–14 worked as a missionary in Armenia, and in 1917–21 played a semi-diplomatic role during war in the Caucasus. Based in Beirut from 1924, he conducted, for the Société de Géographie de France, an aerial photographic survey of the roads and strong points constituting the former Roman frontier (*limes*) in Syria. Flying enabled him to scan the vast spaces of the Syrian desert and spot remains that would have been invisible or inaccessible from the ground. The results appeared in *La Trace de Rome dans le désert de Syrie* (1934). In the 1930s and 1940s Poidebard used both aerial photography and divers to explore the ancient ports of Tyre and Sidon, then Tripoli and Carthage. His photographic archive is located at St Joseph's University, Beirut. RL

Nordiguian, L., and Salles, J.-F., *Aux origines de l'archaeologie aérienne: A. Poidebard 1875 [sic]–1955* (2000).

Poignant, Axel (1906–86), Anglo-Swedish photographer, active for 30 years in Australia. Poignant was both a fine portraitist and a master of the photo-story. An old man kangaroo or the violinist Yehudi Menuhin equally yielded their essential selves to his camera. His formative years—the 1930s—were in Perth, Western Australia, where he adopted the 35 mm *Leica in the struggle to achieve a form of visual representation that would express his growing social awareness. It was on his first journey to the far outback, along the Canning Stock Route in 1942 (when he joined a work party to repair the wells), that sensibilities and skills coalesced in a singular directness of vision. Two Aboriginal portraits—a young mother and baby, and a young stockman—have been singled out for their humanity of vision. After the Second World War he worked first on Harry Watt's film *The Overlanders*, then as cinematographer on *Namatjira the Painter* for the Commonwealth Film Division. His most significant work was a self-generated assignment to photograph an Aboriginal community, Arnhem Land (1952). One outcome was a children's picture story (1956) republished in 1972 as *Bush Walkabout*, regarded as a path-breaking example of the genre. Not until 40 years later when his wife Roslyn returned to the same area with the photographs was a record of the experience published, as *Encounter at Nagalarramba* (1996). Other photographic books included *The Improbable Kangaroo and Other Australian Animals* (1965), and the children's picture stories *Kaleku* (1972), made in the Highlands of New Guinea, and *Children of Oropiru* (1976), in Raiatea, Polynesia. RPO

Axel Poignant: Photographs 1922–1980 (1982).

Point Lobos. A magnificent peninsula with cliffs, odd juxtapositions of rock types, remote coves, and tidal pools, Point Lobos is located just south of Monterey, California. Its scenery had attracted artists well before Edward *Weston relocated to the nearby village of Carmel from San Francisco in 1929. It was Weston, however, who until his death in 1958 focused his artistic and spiritual life on the peninsula with incomparable intensity. His thousands of images—close-up studies and broader seascapes—are unquestionably the work of genius. Scoffing at the attempts of tourists and 'pictorialists' to capture the famed cypress trees of Point Lobos, a young Weston exclaimed precociously: 'Poor abused cypress . . . But no one has done them—to my knowledge—as I have, and will. Details, fragments of the trunk, the root,—dazzling records, technically superb, intensely visioned.' TT

Travis, D., *Edward Weston: The Last Years in Carmel* (2001).

poisoning. See HAZARDS AND DIFFICULTIES OF EARLY PHOTOGRAPHY.

Poitevin, Louis Alphonse (1819–82), French photographer and photographic inventor. He encountered photography while studying engineering at the École Centrale des Arts et Manufactures in Paris (1838–43), and subsequently produced both *daguerreotypes and *calotypes. As early as 1842, however, he embarked on research relating to the dual problem hindering the dissemination of

505

photographic images: the instability of the silver salts that composed the photographic image, and the slowness and cost of reproducing it. A meeting with Edmond Becquerel (1820–91), who encouraged him and publicized his early work, was decisive. In 1855 Poitevin perfected the process of *photolithography by coating a lithographic stone with albumen (or, alternatively, gelatin) sensitized with potassium dichromate. In 1857, after attempting unsuccessfully to exploit the process himself, Poitevin sold the rights to the lithographic printer Lemercier. In 1860 Poitevin invented a process of permanent printing using carbon or coloured powder, and sold 30 licences worldwide. He also worked with Becquerel on colour photography, but without decisive results. His efforts were rewarded by two prizes offered by the duc de Luynes in 1862 and 1867, and by a special award at the 1878 Paris Exhibition. The importance of his discoveries has led to him being called 'photography's fourth inventor'. SA

Alphonse Poitevin: collections du Musée Niépce (1987).

Aubenas, S., *D'encre et de charbon: le concours photographique du duc de Luynes, 1856–1867* (1994).

Poland. Like the other arts, photography in Poland has often been influenced by politics, especially the passions aroused by desire for independence from powerful neighbours; in 1839, it should be recalled, there was no Polish state and the country was partitioned between Austria, Prussia, and Russia. Images directly inspired by, or documenting, political movements have been important, especially in the 20th century; but landscapes and ethnographic photographs have also carried strong patriotic undertones.

The announcements of 1839 evoked a rapid response in Poland. Photographs taken with *Talbot's process were made the same year by the engineer Maksymilian Strasz, as were *daguerreotypes by Andzej Radwanski. An important early photographer was Karol Beyer (1818–77), who worked in Warsaw (where the principal early studios appeared) until 1845. Noted especially for his portraits and landscapes, Beyer also recorded events leading to the January 1863 uprising against Russian rule. While Poland experienced much the same photographic fashions as other countries (e.g. the *carte de visite, *stereoscopy), an interesting Polish speciality from the 1870s—again with patriotic associations—was *mountain photography, linked with Awit Szubert, Stanislaw Bizanski, and others.

Polish *pictorialism was, as in other countries, centred on 'art photography' societies created by amateurs: in Lvov, for example, the Art Photography Club (later the Lvov Photographic Society), which in 1895 launched the *Photography Review*, photography's first monthly journal. The Warsaw Photographic Society was created in 1901. This activity was significant both photographically and politically, in that it encouraged discussion of ideas from abroad (especially France and Austria), and because leading pictorialists such as Jan Bulhak (1876–1950) consciously used their portraits, landscapes, and architectural images as patriotic metaphors. Before 1914, Polish photographers also participated vigorously in the international salons held in Vienna, Paris, Berlin, and elsewhere.

The creation of an independent, albeit tension-ridden, Polish Republic after the First World War strengthened the political and cultural ties to Western Europe, especially France. Although pictorialism remained the dominant photographic mode, and the *'New Vision' photography that flourished in Germany and Czechoslovakia was relatively uninfluential in Poland, avant-garde movements such as Dada, Constructivism, and Surrealism all had their adherents in major centres like Warsaw, Lvov, and Kraków. Individuals like Wladyslaw Strzeminski and Stefan and Franciszka Themerson, and groups like the Polish Avant-Garde Film Studio in Kraków, experimented with combinations of photography and film and with *photomontage and cameraless images. *Documentary work embraced Aleksander Minorski's photographs of poverty in Warsaw, Roman *Vishniac's, Mojzesz Worobieczk's and Stefan Kielsznia's documentation of Polish Jews, and Jozef Szymanczyk's coverage of the rural east. Notable also was the *First Workers' Photographic Exhibition* held in Lvov in 1936.

During the Second World War the German occupation massively inhibited all forms of cultural activity, including photography, although some illicit pictures were taken of conditions in the ghettoes by Jewish and anti-Nazi German photographers. During the 1944 Warsaw Rising, however, an extraordinary number of Polish photographers, despite the savagery of the fighting and all kinds of logistical problems, took pictures for record and propaganda purposes. Their heroic efforts were commemorated in Wladyslaw Jewsiewicki's extensively illustrated book *Powstanie Warszawskie 1944*, published in 1989.

With the post-war establishment of a communist regime, *Socialist Realism was imposed, with veterans like Bulhak adapting pictorialism to propaganda needs. On the other hand, although conformity was a precondition for access to the media and many other kinds of work, plenty of semi-clandestine experimentation went on, partly looking back to the pre-war avant-gardes, partly responding to Western movements such as *'Subjective Photography' and Pop art. Even in periods of intense repression such as the years of martial law between 1981 and 1984, this activity never entirely ceased. Moreover, coverage of the rise of the Solidarity movement in the 1980s, even by approved photojournalists and film-makers, arguably helped to undermine communism's grip on power.

Since the restoration of political and cultural pluralism in 1989, the Polish photographic scene has increasingly come to resemble that in other liberal societies, with the proliferation of avant-garde groups and the expansion of commercial opportunities in photojournalism, advertising, and fashion photography. Poland has also followed the same institutional path as other countries, with the formation of numerous photographic societies, galleries, and museum collections. Several photographic schools were founded in the 1990s, and degree courses in or including photography were established at a number of academies and universities. Regular events include the Photography Biennale in Poznań (since 1988), the Polish Landscape Biennale in Kielce (since 1963), and an International Photographic Trade Fair in Miedzyzdroje (since the early 1990s). LAL

polarized light. Understanding the complex physics of polarized light is fortunately unnecessary in practical photography. Outside the studio, it suffices to know that a polarizing screen reduces reflections from non-metallic surfaces and darkens blue skies. The extent to which it will suppress reflections depends on the angle of reflection (polarization is most complete at the Brewster angle, which is at an angle of incidence close to 56 degrees for almost all surfaces except water, for which it is 53 degrees). The extent to which it darkens blue skies depends on the angle of the line of sight to the camera–sun axis. It is a maximum at 90 degrees to this axis.

Two unexpected side effects are the way in which blue seas and lakes lose their colour—the blue is, after all, reflected skylight, and is filtered out like any other reflection—and an increase in saturation in almost any scene, whether foliage, rocks, or anything else. The latter is because the polarizer screens out scattered white-light reflections, revealing the colour of the subject more clearly.

In the studio, two polarizers can be used, one in front of the light source and one in front of the camera lens. Again, this allows the reduction of reflections. This can be particularly useful when photographing oil paintings, where 'flashback' from the impasto reduces saturation. Because polarization is maintained in reflections from metallic surfaces, polarized light can also be useful in photographing metallic objects such as coins.

High-quality polarizing screens introduce little or no colour shift; cheaper screens often introduce a green or purple cast. RWH

Saxby, G., *The Science of Imaging* (2002).

Polaroid system. See INSTANT PHOTOGRAPHY.

polar photography. See EXPLORATION PHOTOGRAPHY; EXTREME CONDITIONS, PHOTOGRAPHY IN.

police and forensic photography serves the purposes, respectively, of identifying and documenting individuals suspected or convicted of committing crimes, and of detecting and presenting evidence needed to solve crimes and obtain convictions. The former has involved the compilation of rogues' galleries and albums; the latter, scene-of-crime photography and a range of *scientific imaging techniques.

During the 19th and 20th centuries two developments were particularly important in relation to police and forensic photography. First, as state administrations became increasingly professionalized, more and more data about citizens were collected. Secondly, the organizational and technical modernization of criminal-justice systems brought science to bear on both police and judicial procedures. As far as identification and investigative photography were concerned, criminological, physiognomical, and anthropological theories were significant, but played little part in everyday practice. The main reason for eventual police and judicial adoption of photography, apart from the medium's increasing ubiquity, was the widespread belief in the unequivocal verisimilitude of the photographic portrait.

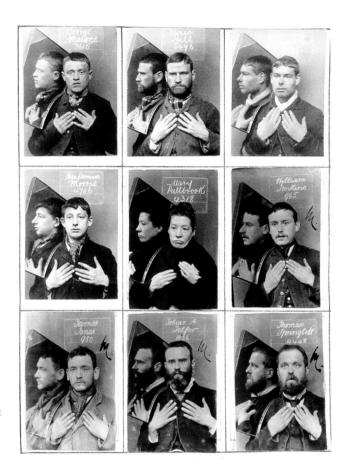

Anon.

Prisoners, Wormwood Scrubs, London, *c*.1880. Albumen prints with handwritten annotations

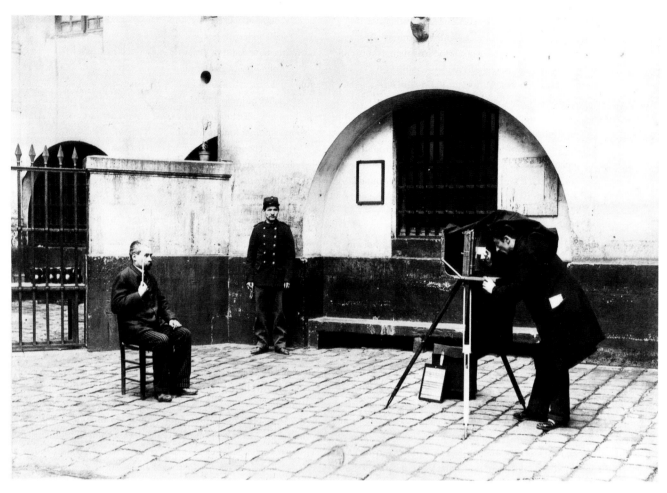

Alphonse Bertillon

Police photography studio, *c.*1880s

Police photography to 1890

Although photography was accepted from the beginning as the most precise method of depicting people and objects, its acceptance as a forensic instrument and means of identification took some time. The earliest evidence for the photographic recording of prison inmates comes from Belgium (1843–4) and Denmark (1851). Although in the 1850s the photography of detainees began in Switzerland (Prosecutor-General Jakob Amiet, 1854), the USA (San Francisco, 1854), and England (Bristol, 1852), and in the 1860s in many other states, including Germany, Spain, and Italy, it was on a purely experimental basis. It was not yet governed by any basic technical or legal principles, and there was no special training for photographers, policemen, or prison officials. Nor were there any sizeable portrait collections that could have facilitated systematic searches for suspects or escapees. The pictures were taken either by amateurs, such as prison governor Gardener in Bristol from 1852, or by commercial photographers like Carl Durheim in Bern, Switzerland

(1852), or Emil Rye in Odense, Denmark (1867–78). Efforts to make prisoner portraits in the 1850s were not only scattered, but sometimes failed to win approval from above. Although in 1850s France the journal *La *Lumière* several times discussed suggestions for prison photographs, there was no response until after 1871. (However, the Paris police took an early interest in photographic *pornography, as their *Dossier* BB3 demonstrates.)

In the 1870s, when the authorities in many countries increasingly had delinquents photographed, it was by professional photographers who produced conventionally posed portraits. Although poses were gradually adapted to police requirements, this practice remained widespread until the end of the 19th century; until 1900, for example, the Berlin police presidency used the firm of Zielsdorf & Adler. This period also saw the emergence of the still widely accepted convention that—subject to police discretion—only individuals convicted of fairly serious offences should have their pictures taken and archived.

In practice, police and, particularly, forensic photography remained for a long time limited to big cities. Only there did the scale of police organization and the existence of a scientific infrastructure make it feasible to use photographic methods to record clues at crime scenes and evaluate them in the laboratory. But urban criminal investigation departments had to keep track of ever-increasing numbers of suspects. With the 'rogues' gallery', a means was found to classify criminals and sort their portraits in albums or card indexes according to types of offence. The earliest precursors of such collections have been identified in Birmingham, England (1850s–1860s), Danzig (1864), Odense (1867), and Moscow (1867). But systematic picture archives were first assembled in London (1870), Paris (1874), and Berlin (1876), the responsibility for them shifting from prison services to the police. The first attempts were also made to standardize the pictures. But although the anthropological practice of using profile and full-face shots was suggested, it took nearly two decades to be universally accepted. Another challenge was the sorting and classification of the collections, which in a few years swelled to many thousands of images and therefore became practically unusable.

The problem was solved by Alphonse *Bertillon while he was employed in the Paris prefecture of police at the end of the 1870s. The Paris portrait collection was arranged according to sets of anthropometric data designed to guarantee reliable identification even when the name of an individual was unknown. In fact, the system was meant to replace the mug shot as a means of identification, but this did not happen, since photography was by this time too firmly established in police practice. Bertillon therefore worked out rules for a scientifically exact form of identification photography, which were published in Paris under the title *La Photographie judiciaire* (1890). For police purposes, an individual would be photographed full face and in profile, with the face well lit and, in the profile image, the ear clearly visible. Bertillon insisted that the conventions of commercial portraiture should be completely excluded from judicial photography. His physical measurement system and photographic rules gained acceptance and by the turn of the century had been introduced in nearly all states. While body measurements were replaced soon after 1900 by fingerprinting, the standardized method of making photographs endured, but was supplemented from the 1920s by the inclusion of a three-quarter portrait.

Since the early 20th century, identification data have been exchanged internationally, a practice that increased after the founding of Interpol in 1923. Whenever possible, lists of internationally wanted criminals have been accompanied by photographs.

Not only criminal investigation departments but special branch (political) sections made and used photographic portraits for identification and search purposes. As early as 1855, Berlin police president Karl Ludwig von Hinckeldey circulated photographs of 'revolutionaries' among his colleagues in other German states. In 1858 the Württemberg political police used photographs in hunting for the Italian republican nationalist Giuseppe Mazzini. Collections of political portraits also grew rapidly. The National Library of Ireland holds an album of 204 pictures of Fenian (Irish Republican) conspirators compiled by Samuel Lee Anderson, a government intelligence officer, between 1865 and 1871; many more Fenian portraits exist in the Irish National Archives. At international level, from 1898 to 1899, a secret album of hundreds of portraits of wanted anarchists assembled by the Berlin political police was regularly updated by pictures of new suspects. The survival of this 'anarchist album' in numerous European archives indicates how far reaching such cooperation was.

Research on 'criminal physiognomy'

Scientific examination of picture collections from an anthropological or physiognomical perspective was not actually done by the police themselves. Significantly, the two best-known users of criminal portraits, the Italian Cesare Lombroso (1836–1909) and the Englishman Francis *Galton, began their work before Bertillon's reform of police photography. Lombroso, a doctor and eventually professor of forensic medicine and hygiene in Turin, attempted in his book *L'uomo delinquente* (1876) to prove both that criminal tendencies were hereditary and that they could be identified from particular physical characteristics. To this end he had visited prisons, made body measurements of prisoners, and collected pictures of criminals. After the appearance of his book he continued to work on the subject, and by the turn of the century had a large collection of criminal portraits obtained from governments in Europe and overseas. Although his theory was heavily criticized, and was never accepted by experts, it became popular. So too with Galton, who began his research a few years after Lombroso. He too believed in the heritability of mental traits, grappled with the phenomenon of criminality, and used official pictures. His method was to make composite copies of portraits of different people in order to arrive at an 'average' deviant physiognomy. His major work, *Inquiries into Human Faculty*, containing papers written since 1869, appeared in 1883. But his theories also failed to convince his peers, and there were no further attempts to examine criminals or criminality on the basis of police portraits. Undeniably, however, a certain image of 'the' delinquent did emerge in the popular imagination, and persists as a visual code identifying certain characters as criminals in literature, comics, films, and tabloid newspapers.

Forensic photography

Alongside photography's role as a means of documenting individuals, it is an important tool in solving crimes. Narrowly defined, forensic photography serves to identify and document clues. Crime-scene photographs were made in Lausanne as early as 1867. Photographic exposure of forgery, and revelation of handwriting invisible to the eye, also took place before the end of the 1860s. But it took decades before such evidence became widely acceptable in court. Eventually in Germany, however, the forensic chemist Paul Jeserich from Olmütz and the Berlin court official Friedrich Paul formulated convincing procedures for photographic clue gathering; Paul's 1900 handbook, complete with gruesome images of murders and accidents, also

provided a fascinating history of the whole subject and a review of current practices. Rodolphe *Reiss, professor of judicial photography at Lausanne University from 1906, played an equally important role in Switzerland. After the turn of the century the celebrated Austrian criminologist Hans Gross (1847–1915) also lent his authority to the cause of forensic photography. In this more favourable climate an increasing number of police forces created their own studios or modernized existing ones, among them those in Vienna (1899), Berlin (1900), and London, where in 1901 Scotland Yard could finally give up using commercial photographers.

Such developments, reflecting the increasing professionalization and scientific sophistication of police work, have continued up to the present. Promising technical advances have been rapidly adopted by police specialists, while tasks unsuitable for police laboratories have been handled by outside institutes. At the beginning of the 21st century, conventional and *digital photography continues to play an important role in police work, ranging from long-established, technically straightforward activities such as surveillance and traffic monitoring to the use of sophisticated equipment to show minute objects and invisible substances. JJ

Paul, F., Handbuch der criminalistischen Photographie für Beamte der Gerichte, Staatsanwaltschaften und der Sicherheitsbehörden (1900).

Phéline, C., L'Image accusatrice (1985).

Regener, S., Fotografische Erfassung: Zur Geschichte medialer Konstruktionen des Kriminellen (1999).

Hamilton, P., and Hargreaves, R., The Beautiful and the Damned: The Creation of Identity in Nineteenth-Century Photography (2001).

Jaeger, J., 'Photography: A Means of Surveillance? Judicial Photography 1850 to 1900', in Crime, History and Society (2001).

polyfoto, a portrait service offered from the 1930s in many British department stores. For a standard fee the sitter would have 48 photographs taken in various head-and-shoulder poses in rapid succession. The impressively large camera actually used unperforated 35 mm film, producing small square images, which were available within a day or two as a *contact sheet from which enlargements could be ordered. The service continued throughout the Second World War, and later ventured into colour. But its operators were often poorly trained, and as photo booths became popular the system faded into oblivion. GS

Ponti, Carlo (1820/24–93), Swiss-born Italian inventor, photographer, and publisher. After six years in Paris perfecting his technique for making *albumen prints, he established himself in Venice c.1852. Here he exploited the growing market for photographic souvenirs, producing a *Ricordo di Venezia* album containing twenty views apparently chosen by the client. His shop on the Piazza San Marco also sold work by other Venetian photographers, often under Ponti's name. He invented new camera lenses and the Megalethoscope, a device for creating diorama-like 'day-for-night' effects. MR

Dewitz, B. v., et al., Italien sehen und sterben: Photographien der Zeit des Risorgimento (1994).

Ponting, Herbert (1870–1935), English photographer and film-maker noted for his documentation of Captain Robert Falcon Scott's ill-fated 1910–12 expedition to the South Pole. A celebrated travel photographer prior to his association with Scott, Ponting's place on the expedition was hailed as decidedly advantageous to scientific exploration. The first footage of the journey was exhibited by Gaumont just weeks before the bodies of Scott and two others were found. Ponting went on to devote himself to the publication and re-editing of his work in an effort to memorialize the dead explorers. MR

Ponting, H., The Great White South (1921).

POP (printing-out paper) was coined by Ilford (Britannia) in 1891. The term refers to printed-out gelatin silver chloride paper stabilized with citric acid, introduced by William *Abney in 1882, and manufactured with a baryta substrate by Emil Obernetter from 1884. A *collodion variant (J. B. Obernetter, 1868) was available from 1890 to the early 1920s. POP prints were usually gold toned to enhance stability and convert the harsh red-brown image colour to a more pleasing purple grey; later 'self-toning' papers incorporated gold chloride in the emulsion. POP was the most popular ready-sensitized paper of the 1890s, replacing *albumen for portraiture and amateur work. It was widely available until the 1920s, but made by Kodak until the late 1980s and by Guilleminot until 1997. The Chicago Albumen Company currently supplies specialist silver citrate paper. HWK

Pop art (1950s–1970s) was the first post-war art movement to embrace mass-media photographic imagery. Popular culture, consumer products, and photos of media stars provided the subject matter and the materials for artists who, no longer satisfied with abstract painting, were looking for a more playful and ironic strategy than the modernist insistence on heroic stances and deep spiritual references. Richard Hamilton's (b. 1922) *$he* (1958–61) was sourced from photographs found in American adverts, the epitome of desirability in post-war Britain. His *Swingeing London 67* (1968–9), based on a newspaper photograph of the singer Mick Jagger and Hamilton's dealer Robert Fraser being arrested on drug charges, was produced using photomechanical processes in a variety of different versions. For *Cosmetic Studies* (1969), fragments of fashion photographs were collaged to make a single facial image. Robert Rauschenberg's (b. 1925) *Combine Paintings* of the 1950s and 1960s mixed painted surfaces with various objects, including photographs, in a practice alluding to *Duchamp's use of 'ready-mades': everyday objects presented as art by being recontextualized in a gallery. Important shows for defining the movement were *This is Tomorrow*, organized by the Independent Group at the Institute of Contemporary Arts, London, in 1956; and *The New Realists*, held at New York's Sidney Janis Gallery in 1962, which included works by *Warhol. They articulated the claim that the hierarchy of high and low art was outmoded in a democratic society, and that the various arts should coexist as different but of equal value. PDB

Walker, J., Art in the Age of Mass Media (1983).

pornography (from the Greek *pornographos*, meaning writing about prostitutes) in modern parlance denotes writings or images primarily intended to cause sexual arousal. Controversy has raged, however, about more precise definitions, especially in relation to other kinds of sexually stimulating material. The terms 'erotica' or 'erotic art', for example, have suggested a degree of aesthetic value, often with implications of costliness, exclusiveness, and rarity. 'Pornography', on the other hand, has been used synonymously with 'smut', 'filth', and 'trash', and stigmatized as cheap and corrupting. In Western societies and Japan in the 20th century, definitions of and attitudes towards pornography changed dramatically, although often unevenly as between the provinces and the metropolis. Particularly fluid was the boundary between 'soft' pornography (pin-up nudes and, eventually, simulated sex acts) and the 'harder' variety, depicting unsimulated, 'deviant', and sometimes illegal activity. Changing levels of tolerance, influenced by extraneous factors such as affluence, feminism, safe-sex campaigns, and shifting attitudes towards the private sphere in relation to the state, have had legal, social, and commercial consequences. Although in the past few people referred to themselves as pornographers without apology, at the beginning of the 21st century 'porn stars' in some societies are celebrities. Well before 2000, moreover, photographers such as Nobuyoshi *Araki and Robert *Mapplethorpe acquired considerable reputations while also producing hard-core material; and fashion stars like Helmut *Newton and Guy *Bourdin could spice their commercial work with pornographic allusions and conceits.

Notwithstanding the existence of ancient sexual materials, pornography as understood today emerged during the 18th century, although the term did not come into widespread use until the mid-19th. Its purpose has varied significantly in different cultures and eras. Between 1500 and 1800, European artists and polemicists often used the shock value of sexual activity to attack the Church, the state, or prevailing conventions and ideologies. In pre-revolutionary France, pornographic pamphlets and flyers were deployed massively against the corruption of the court and the incompetence of the monarchy. However, pleasure was also important; although a distinction needs to be made between the crude materials peddled to the masses and the sumptuous books and prints available to elites.

Photography revolutionized access to and ownership of images. The desire to make photographic portraits prompted many technical improvements—especially shorter exposures and various forms of retouching—that facilitated the depiction of naked bodies and sexual scenarios. One of the earliest official records of the making and distribution of pornographic photographs, the celebrated *Dossier* BB3 (1855–68), originated in Paris, a long-established production centre for licentious materials. By 1841 photographers there were creating both nude studies for artists (*académies*) and, probably, pornographic images. While the former tended to feature figures in classical poses or settings, the latter often showed genitals and sexual acts, and/or simulated eye contact between subject and viewer. But for legal reasons the borderline was often blurred, and in the mid- and later 19th century both types of picture could be found for sale in cafés, dance halls, brothels, print shops, and photographic studios, along with printed pornography and sex aids. Documents like *Dossier* BB3, and the careers of photographers like Bruno Braquehais (1823–75), reveal a highly developed industry, with a complex distribution system, lucrative exports, and a model pool that included prostitutes, seamstresses, shop girls, actresses, and other entertainers. Across the Channel, a police raid on the premises of the London photographer Henry Hayler in 1874 yielded *c.*130,000 obscene photographs and 5,000 lantern slides. Pornography, like portraiture, kept in step with evolving photographic technology, and *microphotography, *stereographs, *cartes de visite, and eventually *postcards all rapidly found pornographic uses. Hand colouring made photographs more lifelike, and even dignified pornography with fashionable ideals of beauty, such as flushed cheeks or ruby lips. Together with popular *travel photographs during the second half of the 19th century came representations of exotic peoples, often nude or semi-nude. Viewing non-white, non-Western bodies, once exclusively an aristocratic privilege, became popular at world fairs, in souvenir photographs, and at peepshows like the *Kaiserpanorama. (Pornographic scenes in fake or semi-fake Oriental surroundings were already an established genre.)

It was in the decade or so before 1914 that the photo-pornography industry probably reached its peak. Morality campaigners identified numerous specialized firms active throughout Europe, and in more remote places like North Africa where models were cheap and regulations lax. Given the efficiency of international communications, bringing the product to market was straightforward. Exactly how much material was in circulation is impossible to estimate, given the perennial problems of definition: for some commentators, 'pornography' ranged from crudely explicit images to saucy postcards and reproductions of old-master nudes. But by the early 1900s most big-city police forces had mountains of banned material, and on 4 May 1910 the scope of the problem was acknowledged by the conclusion of an international treaty. On the 'demand' side of the equation was pervasive sexual repression (vividly recalled by memoirists like Stefan Zweig), minimal sexual education, and the criminal sanctions against certain sexual practices. In these circumstances, pornographic photographs could probably be found everywhere from schools and barracks to gentlemen's clubs and the smoking rooms of stately homes. (The upper end of the market continued to be partly served by graphic artists.) By 1914, photography was capable of capturing even the most frantic sexual callisthenics, and constructing fantasy scenarios from harem orgies to boarding-school flagellation. Doubtless the bulk of the trade was in relatively stereotyped, ready-made material. However, some commercial photographers had always been ready to produce bespoke images for clients arriving with their own partners and equipment, and the antecedents of late 20th-century boudoir photography go back at least to the *belle époque*. At the most exclusive level, finally, on the problematical borderline between pornography and *erotic photography, were gentleman-amateurs like the French

writer Pierre *Louÿs, who had the imagination, money, and technical skill to produce erotica at home.

Especially from the 1920s onwards, titillating images could be found in physical culture (or naturist) magazines, Hollywood films, 'pin-ups', and playing cards. Sexually stimulating writing could be found in literary works by acclaimed authors and playwrights as well as pulp fiction and advertising. More explicit photographs, often sold in packs, depended on sequencing to build a loose storyline. Alongside these images were photographs of sexy 1940s Hollywood stars, often featured in men's magazines like *Esquire* and forces publications like *Yank*. A post-1945 landmark was the launch of Hugh Hefner's *Playboy* in 1953, featuring nude photographs of Marilyn *Monroe and other voluptuous women and celebrating guilt-free sexual adventure. Helen Gurley Brown gave the same advice to single women in her book *Sex and the Single Girl* (1962) and *Cosmopolitan*. A new singles culture emerged during the prosperous and permissive 1960s. The pornographic magazine industry continued to flourish during the last quarter of the 20th century, with the proliferation of publications devoted to special areas of interest along with an explosion of hard-core material on film, video, and the *Internet.

In addition to these industrially produced and mass-circulated images, the second half of the 20th century was also the era of home-made pornography. First Polaroid *instant photography; then home video; finally *digital imaging eliminated the high-street laboratory. Couples could now make explicit images of themselves or friends without fear that they might be copied by strangers or, worse, alert the police. Home pornography also became an object of exchange, with journals like the Italian *Coppia moderna* in the 1970s and 1980s publishing samples, often of dire technical quality, of domestic pornography ('Polaroid wives') submitted by couples hoping to meet kindred spirits. By the year 2000, however, these transactions were increasingly being superseded by the webcam and the Internet.

Despite resistance in some quarters, sexuality and pornography now feature prominently in many academic disciplines. Early scholarly investigations focused on censorship, beauty, and the difference between pornography and erotica. Originally dealing primarily with the female body as an object, feminist scholarship has expanded to address the gaze, fragmentation, agency, pleasure, and power. Feminists opposed to both censorship and pornography have tended to view power as a central issue, articulated as the tension between male viewers and female subjects, or between opposing feminist camps. Some pro-censorship feminists, conservative Christian groups, and right-wing politicians have blamed pornography for violence against women in contemporary society, although the scientific evidence is, at best, inconclusive. Controversy about pornography was prominent in the American 'culture wars' of the 1990s, involving politics, law, religion, and art. Much of the conflict was played out through the National Endowment for the Arts (NEA). Photographers dealing with controversial subject matter, such as sexuality and religion, had their funding revoked. Work by Andres *Serrano and Robert Mapplethorpe became key examples, for anti-NEA right-wing politicians, of the type

of art that should not be supported by taxpayers. A tendency to conflate the representation of nude children with child pornography affected reputable artists, including Jock *Sturges and Mapplethorpe, and art administrators like Dennis Barrie who was prosecuted for exhibiting Mapplethorpe's work at Cincinnati's Contemporary Art Center. At the beginning of the 21st century, concern about paedophilia in both the USA and elsewhere has created a climate in which photographing children or adolescents (even by parents) may lead to conflict with the law. JPY/RL

See also EROTIC PHOTOGRAPHY; GAY AND LESBIAN PHOTOGRAPHY; KINSEY INSTITUTE FOR RESEARCH IN SEX, GENDER, AND REPRODUCTION; LAW AND PHOTOGRAPHY; NUDE PHOTOGRAPHY; VOYEURISM.

Mendes, P., and Ovenden, G., *Victorian Erotic Photography* (1973).
Dubin, S., *Arresting Images: Impolite Art and Uncivil Actions* (1992).
McCauley, E. A., *Industrial Madness: Commercial Photography in Paris 1848–1871* (1994).
Bright, D. (ed.), *The Passionate Camera: Photography and Bodies of Desire* (1998).
Childs, E., *Suspended License: Censorship and the Visual Arts* (1998).
Ault, J., and Yenawine, P. (eds.), *Art Matters: How the Culture Wars Changed America* (2000).
Gilardi, A., *Storia della fotografia pornografica* (2002).
Sigel, L., *Governing Pleasures: Pornography and Social Change in England, 1815–1914* (2002).
Willis, D., and Williams, C., *The Black Female Body: A Photographic History* (2002).

Porter, Eliot (1901–90), American photographer. Son of a Chicago architect and brother of the painter Fairfield Porter, he trained at Harvard, first in engineering, then in medicine, in which he graduated in 1929. Throughout his life Porter used the discipline of his scientific training in his photographic work; and had a lifelong interest in the natural world which he documented in countless articles and books, many in collaboration with people like the naturalist Joseph Wood Krutch and David Brower of the Sierra Club. He took up photography as a hobby in 1930 and soon succeeded, receiving support from many including Ansel *Adams and Alfred *Stieglitz. The latter showed his work at An *American Place in 1938. Noted particularly for his colour work, the technical complexities of which he understood exceptionally well, Porter exhibited widely, including at the Metropolitan Museum of Art in 1979. He travelled and photographed the very ends of the earth, from Antarctica and Iceland to the Adirondacks, the Maine coast, and Baja California. TT

Thoreau, H. D., and Porter, E., *In Wildness Is the Preservation of the World* (1962).

portraiture. As the very earliest *daguerreotypes required an exposure time of about eight to ten minutes, and no living person could possibly keep still for so long, there were at first no portraits. (In March 1839, however, L. J. M. *Daguerre had shown Samuel *Morse a view of the Boulevard du Temple in Paris that included a

man having his boots polished—probably the first human being to be recorded, albeit inadvertently, on a photograph.) But exposure times soon became shorter, and as many as 95 per cent of all surviving daguerreotypes seem to have been portraits.

Curiously, many daguerreotypes were reversed 'mirror' images, because the process made direct positives, requiring no negatives. Soon, however, daguerreotypists learned techniques for correcting this reversal. When, for instance, Alexander Wolcott opened the first photographic portrait *studio in the USA—in New York in 1840—he photographed his sitters reflected in a mirror.

The first professional portrait studios in Britain opened in the early summer of 1841. Richard Beard (1801–85), a coal merchant, built a 'glasshouse' on top of the Royal Polytechnic Institution in central London. He soon adopted all the devices that were to become familiar in 19th-century studio portraits: painted backcloths, rich draperies, pedestals, bookcases, heavy armchairs, and footstools, all conjuring up an atmosphere of money and possessions. (But the hundreds of *itinerant daguerreotypists who plied their trade in Europe and North America in the decade or so after 1839 made do with more primitive settings.) Among the most consistently fine daguerreotype portraits were those taken by two Americans, *Southworth and Hawes, who, in their Boston studio, turned the rigidity of the medium to their advantage, tightly controlling their light sources, the placement of furniture and accessories, and the artfully contrived, iconic poses of their sitters. Though photographers frequently asserted that they could make portraits to rival those made by painters, it was the Southworth and Hawes daguerreotypes which first began to live up to the claim. However, as the example of *Cromer's Amateur—an anonymous Frenchman—suggests, many other outstanding daguerreotype portraitists will probably never be identified.

Meanwhile, Henry *Talbot had recognized the suitability of his negative-positive process for portraiture almost as soon as he made his first 'photograph from nature' in 1835, but did not succeed in making a photographic portrait until October 1840. In the event, his *calotypes were never as popular for portraits as daguerreotypes, especially in the USA. Although not reversed, they were on fairly coarse-grained paper and could not show as much detail as Daguerre's fine-grained process. Nevertheless, outstanding results were sometimes achieved, for example in Scotland by Robert Adamson and the painter David Octavius *Hill between 1843 and Adamson's death in 1848. In 1843, Hill witnessed the foundation of the Free Church of Scotland in a ceremony in Edinburgh attended by over 500 church ministers and others. Determining to paint a picture commemorating the event, he joined Adamson in setting up a studio on a hill overlooking the city. The resulting studies for the painting (which took Hill twenty years to complete) owe much to the traditions of Scottish academic painting. They concentrate on the face rather than extraneous detail or background, and demonstrate a rigorous control of daylight (all were taken in the open air) as well as a flair for theatrical posing. With the unrivalled control of the chemical process by Adamson, these are the most accomplished calotype portraits to survive.

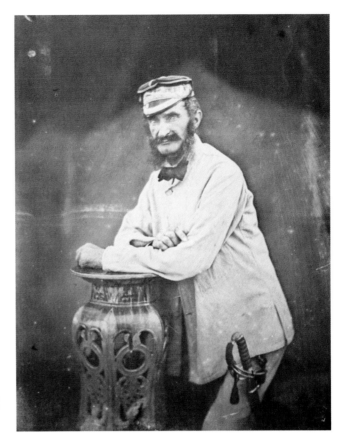

Felice Beato
Sir Hope Grant, India, 1859–60. Albumen print

If early Victorian portrait photographers soon learned to show their subjects the right way round, their results were still not very lifelike. The slowness of the processes available to them meant that their subjects had to remain motionless for up to a minute at a time. Often, a sitter's head was held still by a neck clamp; sometimes there was another at the waist. Like a victim of a firing squad, she or he grasps the arms of a chair or other piece of furniture tightly, and stares grimly at an intimidatingly large camera and brass-barrelled lens, while the photographer disappears under a dark cloth to adjust the focus. No wonder the men, women, and children portrayed usually look so miserable, and that we think of the Victorians as strait-laced and humourless.

In the 1850s, both calotypes and daguerreotypes were superseded by Frederick Scott *Archer's *wet-plate process. This changed the practice of photography everywhere, and opened the field of portraiture to amateurs who—because they had unlimited time, often knew their sitters well enough to make them relax, and were not concerned with profit—often outdid professionals in the artistry of their results. A prime example was Charles Lutwidge *Dodgson (Lewis Carroll), who started taking portraits at Oxford University in 1853. Although his early efforts showed little originality or skill, he soon learned to make his sitters look more relaxed and natural than most of his contemporaries, despite the fact that his shortest exposure time seems to have been 40 seconds. Like Hill and Adamson, Dodgson concentrated on the face, and took great care in placing his sitters' hands. Over a quarter of a century, he took hundreds of the most revealing portraits, particularly of the children—mostly girls—who were his favourite subjects.

An even more remarkable amateur was Julia Margaret *Cameron, who took up photography aged 48. Closely connected with the artistic and cultural world of the 1860s and 1870s, she photographed the most famous writers, artists, and scientists of the time, bringing her large-format camera close to their heads and shoulders. Using dramatic side lighting, and eliminating extraneous detail (often even covering her sitters' clothes in dark velvet), Cameron's depictions of heads at almost life size are the earliest examples of what we now call 'close-ups'. Her pioneering discovery of the power of indirect, dramatic lighting perhaps derived from the fact that her first studio may have been a greenhouse in her garden on the Isle of Wight, where direct sunlight would have made the wet-collodion process extremely difficult to control. Forced to cover most of the windows to reduce the light, she soon saw the dramatic results of illuminating her sitters from one direction only. An interest in the fashionable 'science' of phrenology, which purported to read character and intellect from the shape of a person's skull, may also have encouraged her use of raking side light to highlight every bump. The combination of Cameron's large-format camera, reduced lighting, and extreme close-up dictated exposure times of minutes rather than seconds. But the resultant slight movement, together with a frequent lack of focus and imperfections in her developing and printing technique, give her portraits a life and immediacy which has never quite been surpassed.

In France, meanwhile, one professional portraitist achieved something of Cameron's close-up impact. The head-and-shoulder portraits of *Nadar use light almost as dramatically as hers. In due course, he adopted electric lighting, which he could control more precisely than daylight, and his portraits are smoother and more technically proficient than Cameron's. However, they often lack the immediacy and dramatic impact of hers.

The *carte de visite format, patented by André *Disdéri in 1854, dramatically cut the cost of portraits and led to a surge in their popularity, especially when Disdéri sold thousands of his pictures of Napoleon III in 1859. The carte de visite was imported to Britain by a French company, *Marion & Co., and its most fashionable London practitioner was also a Frenchman, Camille *Silvy, who wore elegant clothes and white gloves in the expensively equipped studios he opened in 1859. The pictures he took there certainly stand out from the mass of tiny, flatly lit, stereotyped carte portraits which filled Victorian photograph albums for the next two decades. In England, too, the popularity of the royal family and the desire to collect photographs of them led to commercial success.

In the USA, meanwhile, Napoleon *Sarony photographed thousands of actors and celebrities in his New York studio (including Oscar Wilde, on his famous 1882 tour). Like Silvy, Sarony dressed the part. He wore a red fez in the studio, and signed his portraits with a red flourish, an idea surely borrowed from Nadar. Though it is true that, at the turn of the 20th century, it was in the USA that photographers became more and more enamoured of the *snapshot, partly because of Eastman Kodak's non-stop production of cheap *roll-film cameras, it was also here that professionals began to assert artistic control over the medium. (But key figures like Emil *Hoppé in England and Rudolph *Dührkoop and Hugo *Erfurth in Germany did so too.) An example of the trend was Gertrude *Käsebier, who opened a studio on Fifth Avenue, New York, in 1897. She soon became one of America's leading portraitists, bringing a new naturalness and life to what was often formulaic and stereotyped. Like many of her contemporaries, she mastered the rather painterly printing processes of the time, making *gum bichromate and platinum prints of her pictures. Another influential portraitist, Alvin Langdon *Coburn, who worked in Käsebier's studio 1902–3, did the same. He was an early member of the *Photo-Secession, which brought *pictorialism to its peak, and whose portraits shrouded their subjects in a romantic out-of-focus haze, giving them the texture and feel of paintings rather than photographs. The pictorialists used *soft-focus lenses, developed new printing techniques, and manipulated negatives and prints with brushes, pencils, and scalpels. Though their control of these effects, and their skill at composition, was remarkable, they often seemed to be showing off, reducing their subjects to mere design elements.

Among the photographers who stood out from this crowd were Edward *Steichen and Baron Adolphe de *Meyer. Steichen had followed in Sarony's footsteps, photographing celebrities, socialites, and artists (in Paris, he made famous studies of Rodin and his work), and remained active as a portraitist until 1938. De Meyer was a master

of pictorialist wizardry, and manipulated light to swathe the glamorous celebrities who visited his studio in what his disciple Cecil *Beaton called an 'aurora borealis'. As a final guarantee of idealized beauty, he employed skilful retouchers to remove any perceived imperfections of face and figure.

Beaton, who took up photography in England in the 1920s, decided that to prosper in this field it was essential to create a glamorous character for himself, as Nadar, Sarony, and de Meyer had done before him. Having succeeded at home, he crossed the Atlantic to work for *Vogue, *Harper's, and Vanity Fair, and went on to *Hollywood, where sleek and glossy glamour portraiture reached its height in the work of such men as Ernest Bachrach, Robert Coburn, and Eugene Richee. Returning to Britain just before the Second World War, Beaton took the first of a long series of royal portraits: romantic images of Queen Elizabeth that made her a fashionable icon. No other royal photographer, before or since, so effectively rivalled the flattering court painters of previous centuries.

In the meantime, both in the USA and Europe, a very different, *documentary approach to the depiction of people had been developing since the late 19th century. In New York Jacob *Riis captured the misery and deprivation of slum dwellers, and both he and Lewis *Hine, who photographed immigrant workers and children in appalling factory conditions, used their cameras as tools of propaganda. Later, Paul *Strand and Walker *Evans, artists more than propagandists, photographed people they encountered in the street or on farms, giving them a dignified nobility. In Germany, August *Sander took straightforward pictures of people from every background and walk of life for his monumental People of the Twentieth Century project. In Britain, a less accomplished photographer, Sir Benjamin *Stone, had similar ambitions. Sander in particular has continued to influence photographers until the present day, and the attempt to make 'objective' formal portraits of people who are asked not to alter their demeanour for the camera (an impossible task) is very much in fashion at the beginning of the 21st century. (Significantly, not only Evans and Sander but contemporaries like Boris *Mikhailov, Fazal *Sheikh, and Rineke *Dijkstra, who depict their subjects with often painful candour, were prominently represented in the huge *Cruel and Tender exhibition of documentary-realist photography held in London and Cologne in 2003.)

Well before 1914, gifted amateurs like Jacques-Henri *Lartigue had made 'candid' portraits, sometimes of people in violent motion. Paul *Martin used a disguised camera to snap excursionists and courting couples. After the First World War, cameras like the *Ermanox and the 35 mm *Leica made this kind of photography much easier. In Paris, André *Kertész and *Brassaï often photographed people unawares. Despite the spontaneous nature of these street pictures, the photographers developed an extraordinary ability to produce well-composed and penetrating images which seemed to capture an emotional reality about their subjects (who, as people on the move, could no longer be called sitters). The split-second instant when the disparate elements of a candid photograph lock together to convey meaning came to be called the *'decisive moment', a concept later defined by Kertész's and Brassaï's French contemporary, Henri *Cartier-Bresson.

One partial consequence of the development of the 35 mm camera was the proliferation of photographic news magazines, which flourished in the Weimar Republic and reached Britain in the shape of *Picture Post and the USA with *Life. They used photographic portraits in considerable numbers. The photojournalists who took them are too numerous to list here, but increasing editorial use of portraits—in newspapers as well as magazines—meant that eminent people became more familiar to the public than ever before, and often in less formal contexts and attire. Some of these photojournalists, and other 20th-century photographers, kept alive the icon-making ambitions of Julia Margaret Cameron, especially in North America. The American Arnold *Newman and the Canadian Yousuf *Karsh learned their trade as assistants to commercial portraitists in cities with moneyed clients—Newman in Philadelphia and Karsh in Boston. Starting their own studios, they specialized in heroic portraits of politicians, scientists, artists, and other successful people. Newman often included the tools of his subjects' trade to make 'environmental portraits'; Karsh's dramatically lit concentration on the face and exclusion of unnecessary detail more closely emulated Cameron's style.

One theme in the history of 20th-century portraiture, however, is the retreat from the Victorian cult of heroes and their historical role, and from the 'proper' (dressed-up, dignified) photographic pose. By the 1920s, swimwear, cigarettes, and informal or risqué poses were becoming common. (Ever the pioneer, Lartigue had captured friends and relations hurtling down steps or falling off go-karts or into ponds, and in 1920 his wife Bibi sitting on a lavatory.) Newman, too, with his careful pre-planning and skilled lighting, took a handful of overtly non-heroic portraits. His studies of the German arms manufacturer Krupp and the British politician Enoch Powell make both look like the villains he obviously thought them to be. Newman's younger countryman Richard *Avedon often placed his subjects head on in front of a plain light background and waited, silently, for them to strike a pose—which he then captured with a sudden flash. The edgy, uncomfortable, disorientated people who stare out from his photographs are anything but heroic, not just because of his harsh and uncompromising lighting, but because his silence was the opposite of the relaxing conversation with which portraitists often put sitters at ease. One powerful set of Avedon portraits documents the last four years of his own father's struggle with cancer. In some ways just as disturbing are the portraits of handicapped people and social misfits taken by Diane *Arbus. Contemporary photographers such as Nobuyoshi *Araki, Seiichi Furuya (b. 1950), Nan *Goldin, and Sally *Mann have variously captured their subjects—often friends, lovers, or family members—naked, angry, sick, or dying.

Another, contrasting kind of successor to photographers like Newman is perhaps Annie *Leibovitz, who began her career

photographing rock stars for *Rolling Stone* magazine, then *Vanity Fair*. Her portraits are witty, imaginative, and frequently very elaborate, if seldom intimate. One complex collage by the artist David *Hockney reveals how, for her portrait of him, Leibowitz arrived with an assemblage of people and equipment worthy of a Hollywood production. Such effects are difficult to achieve, and call for supreme self-confidence in the photographer. One cannot take images of great people unless one has a strong character oneself. Throughout the medium's history, the finest portraits of powerful subjects have been taken by powerful photographers.

By the end of the 20th century, such carefully worked portraiture had all but disappeared. Editorially, it has been replaced by *'celebrity' snapshots. Rather than attempting to capture the inner character of their sitters, these highly coloured, hard-edged images—often taken by photographers who started their careers as *paparazzi*, or who have adopted elements of the usually flash-lit *paparazzo* style—glory in actuality, fashion, and glamour. Among the best and most celebrated exponents of the style is Mario Testino (b. 1954), who leads the pack in the way that Camille Silvy led the 19th-century purveyors of *cartes de visite*.

In contrast to this strident cultivation of celebrity, the art world—which has increasingly embraced photography—has favoured the intense gaze of the apparently objective camera which, as already noted, owed much to the influence of August Sander. This began to reassert itself in Germany in the late 1970s and 1980s. An early practitioner of the style was Michael Schmidt, who first documented Berliners and their surroundings, then made an exhaustive study of his own face and body. Thomas *Ruff and Thomas *Struth, both based in Düsseldorf, were much influenced by their teachers Bernd and Hilla *Becher. Struth seeks to use his camera as a psychological tool, and is particularly interested in group and family dynamics. Ruff, in contrast to the attempts of generations of photographers who have striven to get beneath the surface contours of objects and people, believes that photographs can show no more than an outer likeness. It is clear, from the placement of the sitters in the frame and their frequent direct gaze at the camera, that they are willing participants. But, like the Bechers' photographs of buildings, their portraits delineate exteriors and reveal nothing interior. Ruff's larger than life-size colour head-and-shoulder prints resemble highly finished, outsize passport photographs, though they undoubtedly have a powerful—if impersonal—presence on gallery walls.

The work of these artists and their contemporaries (such as Nicholas *Nixon and Fazal Sheikh in the USA, and Rineke Dijkstra in the Netherlands) is mostly intended for museums rather than family albums, newspapers, or even books. In this, it is radically different from earlier photographic portraiture. If such portraits reveal less and less about what lies beneath the skin of the people in them, it is worth remembering that, in the 21st century, most men, women, and children own cameras. The snapshots we take of each other have been the most numerous photographic portraits since Eastman launched the *Kodak camera. Whatever direction photographic portraiture

takes next, we can be confident that our wish to preserve likenesses of our nearest and dearest will always sustain it. CF

See also FAMILY HISTORY AND PHOTOGRAPHY; GROUP PHOTOGRAPHS; POSING FOR THE CAMERA.

Maddow, B., *Faces: A Narrative History of the Portrait in Photography* (1977).
McCauley, E. A., *Likenesses: Portrait Photography in Europe 1850–1870* (1980).
Ford, C., *Portraits* (1983).
Clarke, G. (ed.), *The Portrait in Photography* (1992).
George, A. R., Heyman, A., and Hoffman, E. (eds.), *flesh & blood: Photographers' Images of their Own Families* (1992).
Linkman, A., *The Victorians: Photographic Portraits* (1993).
Hamilton, P., and Hargreaves, R., *The Beautiful and the Damned: The Creation of Identity in Nineteenth-Century Photography* (2001).

Portugal. The early history of photography in a backward country with a weak middle class was linked to the efforts of a relatively small number of individuals. The Scottish wine merchant Frederick *Flower made an important series of *calotypes in Oporto in the 1850s. Major Russell Gordon (a Portuguese aristocrat of Scottish descent) announced an effective dry-*collodion process in 1861, and was associated with Portugal's first significant photography show that year, part of the industrial exhibition organized by the Portuguese Industrial Association. (The year 1861 also saw the foundation of the elite Clube Photographico in Lisbon.) In the 1860s Carlos *Relvas, a wealthy amateur resident at Golegã, c.100 km (60 miles) from the capital, took up photography and joined the movement, in which the Englishman Charles Thurston Thompson (1816–68) and the French-born Spanish photographer Juan Laurent (1816–c.92) also participated, to record Portuguese historical monuments. Relvas subsequently became the first Portuguese photographer to achieve an international reputation, and in 1875 introduced the *collotype process into Portugal from Germany. He also worked closely with José Júlio Rodrigues, who founded the photography section of the Portuguese Directorate-General of Geographical Works (1872–9), and in 1875 organized the first national photographic exhibition. Further developments took place in the following decade: the appearance of an important amateur magazine, *A arte photographica*, in 1884, an international photography exhibition in Oporto in 1886, and the creation of two more amateur organizations that year and in 1890. Between 1882 and 1885 the German-born photographer and publisher Emilio Biel (1838–1915) produced a series of albums on railway construction in Portugal.

The accession of Carlos I in 1889 was followed by decades of upheaval, with political violence, financial crisis, the proclamation of a republic in 1910, ill-starred participation in the First World War, and periods of revolution and dictatorship. The regime (1932–70) of Antonio Salazar, a conservative-authoritarian dictatorship with fascist trimmings, achieved a degree of stability, especially economic, but at the cost of cultural stagnation. The use of cameras in public was restricted, and photography was dominated by a

romantic *pictorialism that celebrated timeless landscapes, historic monuments, and traditional ways of life. Particularly prominent was the veteran Domingos Alvão (1872–1946), with black-and-white images of merry grape pickers and solemn port refiners that symbolized the unchanging rhythms of rural life along the Douro. However, other kinds of work were possible: for example Orlando Ribeiro's (b. 1911) topographical and documentary work in Portugal and overseas; the surrealistic photographs and films of Carlos Calvet (b. 1928); and the contrasty street scenes caught by Manuel Costa Martins (1922–95) and Victor Palla (b. 1922) in Lisbon's formerly Arab quarter of Alfama: semi-clandestine portraits of people snatching conversations and running, head down, among pools of rain and light.

The Portuguese Revolution of 1974 brought an outpouring of activity in all the arts. Photography festivals were established in the university cities of Braga and Coimbra; the Grupo Iris established a major photo magazine, and a gallery to rival António Sena's Ether, the most avant-garde in Lisbon; and Sena followed in his father's footsteps to produce a comprehensive documentation of Portuguese photographic history. By the 1980s, colour workers such as Daniel Blaufuks, Luisa Ferreira, Fernando Namora, and Albano da Silva were joining the ranks of international photographers. Nevertheless, the sombre monochrome strain in Portuguese photography persists. The texture of Paulo *Nozolino's prints is so deep that effectively only he can print them dark enough. António Júlio Duarte (b. 1965), Jose Alfonso Furtado, Jorge Guerra, and Mariano *Piçarra produce hauntingly twilit works in the same vein. Lucia Vasconcelos has treated the great 19th-century royal spas in a book and exhibition of evocative images of bygone times.

Portugal only belatedly recognized and celebrated its photographic tradition. In 1989, the medium's 150th anniversary was fêted with a major exhibition hosted by the Ministry of Culture. In addition a National Archive of Photography was founded, as a repository for the estates and bequests of Portuguese photographers, with the assistance of the photographic historian Jorge Calado. Work began on renovating Carlos Relvas's still extant but dilapidated 'House of Photography' at Golegã. A decade later, when Oporto became a European City of Culture, the Centro Portugues de Fotografia (CPF) was established in a former prison, under the direction of the photography writer and curator Tereza Siza. AH/RL

Hopkinson, A. (ed.), *Reflections by Ten Portuguese Photographers* (1996).
Siza, M. T., and Weiermair, P. (eds.), *Livro de viagens: Portugiesische Photographie seit 1854* (1997).
Sena, A., *História da imagem fotográfica em Portugal, 1839–1997* (1998).
Carlos Relvas and the House of Photography (2003).

posing for the camera. Some Victorian sitters were persuaded to assume romantic fancy-dress postures before the lenses of amateur gentlefolk, but a stiffness of pose and expression was more commonly evident in the work of studio professionals. Though sometimes seen as the by-product of long exposures, this stiffness owed at least as much to prevailing taste. Photography echoed portrait painting in aiming to convey gravitas and respectability, and no great value was set on levity. Stereotypes were therefore the currency of the professional studio: men were serious figures of authority and women were calm and pensive. Nevertheless, long exposures did influence poses. It was often necessary to help sitters remain still: neck-rests were often used in the 1860s to assist steadiness, and the leaning poses popular in the 1870s exploited the support that furniture could provide. Another early posing principle sought to offset restricted depth of focus by keeping hands and face at the same distance from the camera. The popular female pose of hand raised to chin or cheek had, therefore, three advantages: it offered support, it kept features and fingers in the same plane, and it reinforced the air of demure thoughtfulness.

Outside the studio, poses were more relaxed, but still conventionalized and gendered. The narrator of Jerome K. Jerome's comic novel *Three Men in a Boat* (1889) thus described an encounter with a 'speculative photographer' on the Thames: 'All the girls were smiling. Oh, they did look so sweet! And all the fellows were frowning, and looking stern and noble. . . . I arranged my hair with a curl over the forehead, and threw an air of tender wistfulness into my expression, mingled with a touch of cynicism, which I am told suits me.'

Although 19th-century seaside pictures began to show signs of greater informality, it was the arrival of the snapshot camera, at the beginning of the 20th century, that introduced a whole new vocabulary of posing. Inspired amateurs like Jacques-Henri *Lartigue and Alice *Austen pounced on zany or extrovert behaviour. Suddenly people were being photographed in holiday mood, by someone they knew well. The camera's subjects were more at ease, and if they felt inclined to smile, they no longer had to hold the expression for any great length of time. Cheerfulness, even jokiness (perhaps as a defence mechanism), entered the repertoire and, as cameras improved, people were pictured in motion. The 1920s and 1930s in particular were the age of people caught striding towards the camera. Cigarettes, as signifiers of carefree sophistication, came and went. By this time, studio photographers were pursuing new directions. A romantic sense of photography as art, tempered by influences of fashion plates and *Hollywood, expressed itself in atmospheric lighting and sitters placed at an angle to the camera. (The Hollywood 'glamour' pose, in conjunction with more revealing swim- and leisurewear, appeared increasingly in beach scenes and holiday photography generally.) After 1945, the professional portrait had again become largely restricted to special occasions, though these might be commemorated by fairly relaxed and comfortable poses. By the century's end, thanks to the rise in higher education, a significant new stereotypical pose had arisen—the young person as academic achiever. RP

Pols, R., *Understanding Old Photographs* (1995).
Schroeder, F. E. H., 'Say Cheese! The Revolution in the Aesthetics of the Smile', *Journal of Popular Culture*, 32 (Fall 1998).
d'Astier, M., Bajac, Q., and Sayag, A. (eds.), *Lartigue: l'album d'une vie, 1894–1986* (2003).

postcards

Postcards provide the world's most complete visual inventory. Few things, people or places have not at some time or other ended up as the subject or an unwitting or unintentional component, of a postcard. (Tom Phillips, *The Postcard Century: 2000 Cards and their Messages*, 2000)

The types of image found on postcards have ranged from comic or saucy cartoons to art reproductions and chromolithographed views; but, since *c*.1896, photographs in one form or another have made up a large proportion of the total.

The first (non-pictorial) postcard was sent in Austria in 1869. The first illustrated card was published by a bookseller, A. Schwarz, in Oldenburg, Germany, on 16 July 1870, and in 1875 he produced the first series of 25 illustrated cards; in the 1870s picture cards also appeared in the USA. In Britain, pictorial cards could not be posted until 1894, and it was not until 1899 that the postal authorities stopped insisting on a squarish 'court' format (89 × 115 mm; 3^1/$_2$ × 4^1/$_2$ in) and allowed the 89 × 140 mm (3^1/$_2$ × 5^1/$_2$ in) format still most popular today. In 1902 (followed by France, Germany, and America by 1907), postcards in Britain could be produced, and more importantly posted, with the address and message on the same side, leaving the other side free for the image. From *c*.1905, individually printed 'real photograph' cards began to appear. Many *itinerant photographers, who had specialized in *ambrotypes, then *tintypes in the 19th century adopted the postcard format. Their images of working-class people at fairs, by the sea, at local beauty spots, or, occasionally, outside their homes constitute a vast source of social information. (Such pictures can sometimes be confused with postcard-format *snapshots produced with cameras like Kodak's popular Folding Pocket 3A.)

In the 'golden age' of the postcard (1907–*c*.1915) production supposedly doubled every six months, with sales averaging 860 million per year by 1910. Postcards were produced as advertising and trade cards, and even at this early stage as mass-produced publicity stills of entertainers. They also replaced the *cabinet card as the standard format for album portraits. View companies such as Frith, *Valentine, and *Wilson had begun issuing postcards by the turn of the century, and immediately faced stiff competition from German firms bidding for international supremacy. Commercially produced postcards depicting people and places at home and abroad are the best-known form of card, and as *tourism developed, sending 'wish you were here' cards became a ritual. However, the enormous popularity of postcard collecting created a market for images of every conceivable subject, from celebrities (soon including film stars) to ships, trains, exhibitions, street parties, political and military events, and the aftermath of storms and floods. Books and periodicals dedicated to the craze proliferated. The legendary 'dirty postcard', supposedly hawked to tourists at places like Port Said, represented a further democratization of *erotic photography. During the First World War milliards of cards were produced, supplementing the torrent of images in the press and other publications. (Often a 'topical' image of a conquest or occupation was faked by superimposing a stock shot of parading soldiers on to an existing view.) During the German Revolution of 1918–19, *c*.25 Berlin firms were producing and/or dealing in postcard-format news images which, as they were bought mainly to collect rather than send, often survived to supplement the visual record. Across Europe, thousands of images of ruin and destruction were produced to exploit the 'battlefield tourism' of the early 1920s.

The middle decades of the 20th century saw a restructuring of the commercial postcard industry, with the demise of many publishing firms in Germany and Britain and a narrowing of the range of subjects. Views and celebrities dominated the inter-war period. Since the 1950s, the use of cheap colour-printing technology and the huge expansion of tourism has kept the topographical postcard alive. Notwithstanding the battery of imaging equipment wielded by the modern traveller, the purchase and on-the-spot dispatch of postcards remains central to the tourist ritual. The postcard's garishness, formulaic composition, and anodyne subject matter continues, like the holiday brochure, to influence perceptions of alien places and cultures. LAL

➲ See also Early Postcards in East Asia and Indo-China *overleaf*.

Pryce, W. T. R., 'Photographs and Picture Postcards', in M. Drake and R. Finnegan (eds.), *Sources and Methods: A Handbook* (1994).
Pols, R., *Dating Old Photographs* (2nd edn. 1995).
We are the People: Postcards from the Collection of Tom Phillips (2004).

posterization, a popular term for tone separation, a method of reducing the tonal information in a photographed scene to a small number of discrete levels. The traditional method of achieving this is by making three to five separation negatives on high-contrast material, going from clear direct to opaque at various levels at equally spaced points on the original tone scale. These are then printed in succession on one sheet of paper. Especially in colour, the effect is achieved more easily with modern computer software. GS

postmodernism. See THEORIES OF PHOTOGRAPHIC MEANING.

post-mortem and memorial photography, although related as a form of remembrance of the dead, differ in focus. Post-mortem photographs record the corpse of the deceased, whereas memorial photographs are usually photographs of the remembered while still alive.

Photography has been used to record the 'last sleep' and memorialize the dead since its earliest days. It is no coincidence that much photographic theory, for instance that of Roland *Barthes, links photography to death.

It was not unusual for Victorian photographers to advertise their particular skills in this area of photography. Post-mortem *daguerreotypes, especially of children, survive in quite large numbers and are now sought-after collectors' items. Often the subject is carefully laid out as if asleep, perhaps in a crib or in the arms of bereaved parents, and beautifully dressed: a final presentation to the world. In a period of high mortality the deathbed photograph, frequently by an anonymous

(*continued on p. 521*)

(a)

(b)

(c)

(d)

(e)

W. Stander & Son, Geestemünde

(a) The German empress takes leave of officers departing to quell the
 Boxer Rebellion in China, Bremerhaven, 1901. Postcard

Anon.

(b) Riga: street scene after capture by German forces, 1918. Postcard
(c) The funeral of Empress Augusta Victoria, Berlin 1921
(d) Upper Elbe view, Saxony, c.1900s
(e) 'Good old Zillerthal!', September 1919

Early Postcards in East Asia and Indo-China

Early *postcards can be defined as a means of communication, a collector's item, or a 1900s fad. They were also, however, a new and effective means of spreading images of distant countries. They reached a broader audience than illustrated journals, exerting an influence comparable only with that of television much later. They appeared at a time significant for three neighbouring but culturally distinct eastern Asiatic areas: Indo-China, China, and Japan. The 1900 Boxer Rebellion in China unleashed the flood, hastening the proliferation of postcards of and in the area by providing both sustained interest abroad and a local market of foreign soldiers writing home.

Soon after photographic cards appeared c.1896, the market became global: pre-1900 postcards of China can be traced to publishers in Japan, Germany, France, Hong Kong, and Shanghai. Postcards were published everywhere, and sold everywhere. Markets were nevertheless distinct: for example, France and Britain would not always produce or buy the same images, and this diversity of provenance is reflected in surviving collections today. Still, because many postcards are unidentified, uncredited, and undated, we actually have no global conception of exactly what was produced, where, when, or, often, by whom. But it is clear that, even in the countries depicted (e.g. China or Japan), early postcards were for Western consumption. Also, the areas most frequented, or historically or politically most important, were the most widely photographed.

In contrast with photography generally, which was gradually moving towards a modern style, early postcards were a direct offshoot of 19th-century commercial photography, and although it sometimes treated standard subjects in new ways, postcard iconography generally stuck to well-established conventions. Often too, the photographs used for postcards, especially of Shanghai, Hong Kong, and, to a lesser degree, Japan, go back a surprisingly long way: while views of modern architecture were usually contemporary with the postcards, i.e. turn-of-the-century or later, genre scenes and portraits might be 30–40 years old. This was never indicated at the time, as photographic prints and postcards are normally undated (photographers probably tended deliberately to avoid showing datable features) and users doubtless believed they were 'current' images.

While Japan's and Indo-China's identities are clearly defined in postcards, China's is more blurred. The transition from empire to republic, and various foreign influences, impinged on images of the country. Yet postcards of China were unusually innovative compared with 19th-century photographs. Because, from 1900, foreigners were allowed to travel freely inland, the geographical scope of early cards rapidly extended beyond the treaty ports; in some cases, they were the earliest photographic images of a place. The 'typical scene' persisted, but also expanded to cover outdoor (non-studio) versions, or subjects that had been either inaccessible to non-portable cameras (village life, fairs, or candid street scenes) or effectively non-existent (Chinese army exercises, or the new development of territories leased to foreign powers). Postcards also covered current events, often

disasters: the 1911 Revolution, for example, was shown as very bloody. And a new genre of *missionary subjects appeared, useful for propaganda and fund-raising.

Japan was shown as possessing a dual identity: new were the trappings of modernity, a country with a developing industrial-age infrastructure, well on its way to becoming a major power. Old was the quaint Japan the West had fallen in love with decades earlier. Together, they yielded the image of a dynamic society, confident of its traditions without being held back by them.

Most of Indo-China was a French colony, where postcards followed the conventions of earlier photography—most of which was not very old in any case, especially for Laos. The market was dominated by the Hanoi publisher and photographer Pierre *Dieulefils to such an extent that a superficial glance would reveal a single style of images, with views of Tonkin very much in the majority.

Everywhere, publishers recycled studio portraits into 'typical' images (e.g. 'A Shanghai woman'), obscuring the question of who and what people really were. New stereotypes emerged, including, predictably, the archetypal postcard subject of pretty girls. The Japanese variant was the modest kimono-clad young woman described by all contemporary writers or, more rarely, the bare-breasted girl at her toilet popularized by Felice *Beato in the 1860s. Indo-China's was a country girl at work, also sometimes shown in bare-breasted innocence. This was innocuous enough, if simplistic. However, possibly because ordinary Chinese women were modestly attired and respectable looking, the Chinese version was based mostly on stock portraits of courtesans and other prostitutes from Shanghai and Tianjin. All three postcard-created female stereotypes were long lasting.

Captioning is a source of astonishment or frustration, both in spelling—the rendition of English on Japanese cards is fascinating— and for its identification of views or other subjects. It is clear that images of everywhere were produced everywhere, and, sometimes, anyhow. Some errors were deliberate and meant to boost sales, but many were not. Absurdities abound, like the location of the Great Wall of China in Hong Kong, or the caption 'Japanese Women Eating Makaroni [sic]'.

The postcard was also an effective political instrument. Its capacity to transmit colonial viewpoints was demonstrated by the French in Indo-China, and by the Japanese in Korea and Taiwan. German publishers carefully recorded all aspects of the transformation of Qingdao (Tsingtao in Shandong) into a model colony. In cases of territorial dispute, for example Manchuria before and after the Russo-Japanese War (1904–5), successive postcard issues showed the original owner ostentatiously in possession, then the new one installed with all the obligatory imperial symbolism of flags, soldiers, and warships. RT

Vincent, T., Pierre Dieulefils, photographe-éditeur de cartes postales en Indochine (1997).

Yu, J., and Chen, Z., Lao Mingxinpian: Fengsu Bian (Postcards of Old Shanghai; 1999).

local photographer, might be the only record of the deceased. Some images are of the highest aesthetic and technical quality, such as *Southworth & Hawes's full-plate daguerreotype of an unidentified child c.1850, while others are humble and barely competent *tintypes. Nonetheless they all fulfil the same *social function. In many cases they derive their iconography from earlier forms of memorial engraving and funeral art, or reflect the 19th-century taste for sentimental pictures (expressed photographically in images such as Henry Peach *Robinson's *Fading Away* (1858)).

Stylistic shifts reflect both changing social attitudes to death and developments in photographic technology. Photographs on memorials appeared in the mid-19th century and remain a common sight in Catholic countries—their faded and 'period' look is part of the narrative of community within graveyards and ossuaries. Graveside photographs, although always part of the genre (there are some graveside stereocards), had become more common by the end of the 19th century, and photographic attention was increasingly concentrated on the *material culture of death, the coffins, flowers, and tombstones.

The use of photography in mortuary practices and memorialization differs between cultures, reflecting specific attitudes to death. In many places photographs have been absorbed into funeral ritual. In Russia, they are carried in procession behind an open coffin. Elsewhere in Europe, they are incorporated into the *material culture of funerals, on urns or in floral tributes. By the late 19th century the Maori peoples of *New Zealand had absorbed photographs of the ancestors into *tangi* (funerary ritual). In Japan photographs of dead soldiers were hung over the entrances to temples and large photographs adorn coffins. In the West Indies, group photographs of the family at funerals are common; and in 1960s London, Brixton photographer Harry Jacobs took photographs of members of the West Indian community in their coffins for their families. In Ghana, photographs are often made of the family gathered around the deceased, laid out and decorated, not only as a final photograph but to show how well tended the body has been. In Java, it is normal to photograph family and friends looking down at the corpse. Many family albums include photographs of the dead, the final part of the narrative of human life usually missing in Western albums. If it does exist, the images tend to be hidden for private viewing, rather than being displayed in the album, although an important contemporary use of post-mortem photography is in the context of grief counselling and therapy in cases of stillborn and neonatal death.

Photography has also been used to document and explore the process and experience of death by anthropologists, documentary photographers, scientists, and artists. Some projects have been extremely controversial, for instance Andres *Serrano's large colour images from the New York morgue, and the exhibition *The Dead* at the National Museum of Photography, Film, and TV, Bradford, in 1995. Photographs of the dead, such as those of the corpses of Saddam Hussein's sons released in 2003, are frequently the subject of heated correspondence in newspapers. But levels of tolerance vary between cultures. For example, the 'nota roja' ('bloody news') pictures of murders and traffic accidents by the Mexican photojournalist Enrique *Metinides would probably not be publishable in most European countries.

Attitudes to photographs of the dead shift with attitudes to death itself and respect for the integrity of the individual. The post-mortem and memorializing functions of photographs are related to photography's inherent indexical qualities, its ability to secure the shadow as the substance fades, to cheat the finality of death. Alternatively they remind us of the fragility of life. EE

Danforth, L., and Tsiaras, A., *The Death Rituals of Greece* (1982).
Ruby, J., *Secure the Shadow: Death and Photography in America* (1995).
Williams, V., and Hobson, G., *The Dead* (1995).

powder 'dust-on' process. The moisture-induced tackiness of certain hygroscopic substances may be dried up by strong ultraviolet light. Such a treated surface, exposed under a photographic diapositive, then dusted over with a powdered pigment which adheres selectively to the still-tacky shadow regions, provides this positive-working printing process, invented by Garnier and Salmon in 1858, using ammonium iron(III) citrate or dichromates in honey and sugar. If refractory pigments are used to make photographs on porcelain surfaces, and kiln fired under a glaze, a true *photoceramic process results. MJW

pre-photographic imaging devices. Long before photography was invented in 1839, people had often attempted to capture beautiful scenery and the likenesses of loved ones. Indeed, this is a theme found in much of Western painting. Imaging devices provided half of the equation which formed the successful marriage between optics and chemistry that in the 1830s led to the production of the first successful photographic processes. The properties of the *pinhole image had been known since antiquity in both China and Greece, and this knowledge survived through the dark ages to re-emerge in the writings of the 10th-century Islamic scholar Alhazen. From his work, optical ideas were disseminated throughout Europe. By the end of the 13th century, the first practical advance in optical technology had been made: spectacles were contrived, probably in Pisa, by an unknown craftsman.

It was not, however, until after the invention of printing in the 15th century that the first record of the camera obscura (from the Latin, 'dark room'), used as an aid to drawing, is found, in the compilation by Giovanni Battista della Porta, *Magiae Naturalis* (1558). The first published illustration of the device was produced in a slightly earlier text by the mathematician Gemma Frisius, *De radio astronomico* (1545), where he illustrated the apparatus as a safe way to observe an eclipse of the sun. The image was improved by placing a convex lens in the pinhole from about 1550. The use of the camera obscura for astronomical observation proved to be of great importance: Christophe Scheiner used a telescopic form to study sunspots, and his contraption was illustrated in *Rose Ursina sive Sol* (1630), while the Englishman Jeremiah Horroxs was the first to observe the transit of Venus across the sun's disc in 1639 (a rare astronomical occurrence which allows the observer to calculate the size of the solar system), using a similar apparatus. Another Englishman, Robert Hooke,

Camera obscura in the form of a model eye, by George Adams, London, 1780

constructed a large conical camera obscura in 1681 to demonstrate to the fellowship of the Royal Society that the device operated on the same principles as the human eye.

Although it can now be seen as a 'scientific' instrument, the camera obscura was used as an artists' tool from the early 16th century—indeed, the artist David *Hockney has promoted the plausible idea that from about the time that the quality of optical glass produced effective lenses and mirrors, they had an immediate effect on European art, contributing to the mastery of perspective, and the 'natural' quality of painting, from which artists only moved away after the invention of photography. Hockney's theory that these techniques were so commonplace as to obviate comment contends that the knowledge of widespread use of these devices (of which the camera obscura is merely a single example) has been 'lost' to subsequent generations. It had been known that some specific artists used the camera obscura, among them, most famously, Johannes Vermeer, but also Joshua Reynolds, Thomas Sandby, and Allan Ramsay.

From the discovery of the laws of perspective by Filippo Brunelleschi in about 1413—perhaps derived from his knowledge of surveying techniques—various instruments were contrived to help other artists achieve these geometrical principles. Both Leonardo and Albrecht Dürer famously experimented with a perspective 'net' or grid and glass, and strings for plotting points. Various perspective machines had been invented in Italy by the end of the 15th century, and were being used by a presumably somewhat limited market. In 1631, Scheiner published

his invention for enlarging or reducing drawings, the pantograph; mounted vertically, it could also be used as a perspective machine. Other mechanical devices to help with perspective were produced over the years, including one by Christopher Wren, published in 1669. Gilles-Louis Chrétien invented his Physionotrace in 1786, and this was used extensively for profile portraits, sometimes for silhouettes. These instruments were also being made more portable, for use outside, clamped to a sketching board. One such was Ramsden's Optigraph, marketed by the London instrument maker Thomas Jones. Another, less portable, moved a bead over the subject to be traced using a system of cords and pulleys, patented in England in 1825 by Sir Francis Ronalds. A rival French design was the Diagraphé, produced by Adrien Gavard of Paris.

All of these perspective machines were, however, mechanical rather than optical devices. The camera obscura became the main optical imaging device, with various improvements as its growing numbers of customers demanded. By the late 18th century a vast range of sizes was on offer by London instrument retailers, and these were being used extensively by amateurs. A simpler device was the Claude glass, a tinted, curved piece of glass, usually in a small leather case, which reflected the scene in harmonious tones reminiscent of those found in the work of the great landscape painter Claude Lorraine (although he appears to have had nothing to do with it). In the early 19th century a number of new optical aids appeared, possibly prompted by increasing market demand.

Dwayne Senior English football fan celebrates England's World Cup victory over Denmark, 2002

Science Museum, London Thermal image of a person drinking, *c.*1980s

The 'camera lucida', patented by William Hyde Wollaston in 1806, used a special prism, through which both the scene and the drawing could be viewed simultaneously, and after some practice, an accurate sketch could be produced rapidly and in almost any light. This was extremely portable, and spawned a number of rival inventions, including Alexander's Graphic Mirror, which used a mirror rather than a prism. One competitor to the camera lucida was Cornelius Varley's Graphic Telescope patented in 1811. Perhaps the most complicated optical drawing aid produced, it was used by the watercolourist John Sell Cotman and other members of the Norwich school, but with uneven success. In fact, success with these drawing aids relied on some inherent skill of the amateur who used them; had Henry *Talbot possessed the artistic ability of his wife, Constance, or of John *Herschel, he might not have turned to fixing the images he could see through his drawing aids by chemistry, rather than by his own artistry. ADM-L

Kemp, M., *The Science of Art: Optical Themes in Western Art from Brunelleschi to Seurat* (1990).

Hockney, D., *Secret Knowledge: Rediscovering the Lost Techniques of the Old Masters* (2001).

Pre-Raphaelitism and photography. In the mid-19th century, certain aspects of photography were discussed in terms of a new phase in British art, initiated in 1848 by a group of English painters calling themselves the Pre-Raphaelite Brotherhood. They promoted a ruthless naturalism, aiming to rethink representation beyond the habits and conventions of academic painting. Inspired by what they saw as the simple, direct art pre-dating the Renaissance, they strove for a detailed, sharply focused representation of material reality, amplified by vivid colour and bright effects of light. These characteristics combined to produce a clarity and concentration that was identified, rarely felicitously, with the artificial eye of the camera lens. Pre-Raphaelite work was commonly believed to have been copied straight from nature—or from a photograph—without artistic mediation or interpretation. But while Pre-Raphaelite advocates such as John *Ruskin rejected the accusation that the painters imitated photographs, a few did use the medium for artists' studies, most notably Dante Gabriel Rossetti and John Everett Millais.

Photographers such as Julia Margaret *Cameron and H. P. *Robinson shared the cultural references of the Pre-Raphaelites, choosing equivalent subject matter from the Bible, Shakespeare, and Tennyson. Cameron's social network and sitters included many Pre-Raphaelite painters, whose works are sometimes echoed in her handling of pose and composition. Links between visual strategies are more tenuous: Cameron's broad treatment of focus and tone accorded most with the second generation of Pre-Raphaelite painting as represented by Rossetti and Watts, although her bold chiaroscuro was more commonly likened to the work of Rembrandt and Velasquez. For his part, Robinson defended the piecemeal appearance of his combination photographs (see COMPOSITE PHOTOGRAPHS) by comparing their distinct outlines and disparities of scale to

similar characteristics in paintings by Millais and William Holman Hunt, wherein backgrounds were painted *in situ* and the figures superimposed in the studio. Unfortunately, as Robinson made clear in 1860, the crudeness of these effects did not flatter either medium.

More generally, photographers' perception of Pre-Raphaelitism reflected the wider critical response to it as a phase of naturalism. Many who aspired to an artistic status for photography were wary of a style in painting whose seemingly prosaic accumulation of material facts was commonly condemned as inimical to the intellectual and emotional essence of art, a deficiency also ascribed to photography. Others welcomed Pre-Raphaelitism as a liberation from idealism, and recognized that photography was inherently naturalistic. Indeed, the most abiding connection between photography and Pre-Raphaelitism runs through Ruskin's call for artists to pay close attention to the particular and transient effects of nature. The corollary of this, a rejection of egregious invention, elaboration, and manipulation, was key to artistic and photographic debates on natural and pictorial truth well into the 20th century. HWK

Bartram, M., *The Pre-Raphaelite Camera* (1985).

Howard, J., and Roberts, P., *Whisper of the Muse: The World of Julia Margaret Cameron* (1990).

Prettejohn, E., *The Art of the Pre-Raphaelites* (2000).

Primoli, Count Giuseppe (1851–1927), Italian amateur photographer. A Roman descendant of Napoleon I, Primoli spent much of his time in Paris, leading the fashionable life of an aristocrat. He aspired to be an *homme de lettres*, and maintained long friendships with artistic personalities such as Théophile Gautier, Gabriele d'Annunzio, Edgar *Degas, Marcel Proust, and Sarah Bernhardt. By the late 1880s, Primoli's mania for photography had eclipsed other pastimes. His social position gained him access to the most exclusive events and personalities of his day. This, combined with an eye for the odd angle, significant instant, and incongruous detail, made him one of the most vivid chroniclers of his era. At his death he left more than 15,000 images, while another 17,000 were purportedly destroyed. What remains of the collection is now housed in the Primoli Foundation, Rome.

Primoli has been described as 'photography's missing link', bridging the gap between *Nadar and Henri *Cartier-Bresson. A photographer of considerable range, he recorded picturesque Roman street scenes, political events, and the leisure activities of Europe's *glitterati*, earning a posthumous reputation as a progenitor of action photography and the *photo-essay. Yet his specific interest in instantaneous photography marks him as a particular kind of amateur photographer. Serious amateurs, technically astute practitioners who flourished during the 1890s, were often men of fortune and leisure. Primoli's pursuit of the *instantané*, precursor to the snapshot, is typical of the interests of this little-studied group. KM

Vitali, L., *Un fotografo fin de siècle: il conte Primoli* (1981).

Richardson, J., *Portrait of a Bonaparte: The Life and Times of Joseph-Napoleon Primoli 1851–1927* (1987).

Print Club (*Puri-Kura*), Japanese coin-operated photo booth found in arcades and other venues, producing sheets of sixteen small-format (2.5 × 2 cm; 1 × ⁴/₅ in) portrait stickers. The image is superimposed on a coloured background chosen by the customer, with or without a caption. Launched in 1995, and used as a promotion gimmick by a teenage band, SMAP, the machines soon became wildly popular, and by early 1998 *c*.25,000 were in operation. The craze spread from teenage girls to other social groups, and to Japanese tourist destinations abroad. Attached to stationery, satchels, mobile phones, or bulletin boards, the stickers have found countless social, sexual, and commercial uses. RL

printing and enlarging, black-and-white. Until the widespread adoption of enlargers in the 1920s and 1930s, 'printing' meant *contact printing* (i.e. placing the developed negative in contact with paper of equal size, and exposing them to natural or artificial light). To this day, a *contact print can still put any enlargement to shame, and the reason is simple. Few lenses resolve fewer than 30 line pairs per millimetre (lp/mm), which corresponds to the maximum (vernier) resolution of the human eye at about 30 cm (12 in). The loss of sharpness when contact printing is negligible, so contact prints always look very sharp indeed.

With printing-out processes, a split-back contact printing frame allows the extent of printing out to be examined periodically under weak artificial light, so that the exposure can be stopped when the density is sufficient.

When contact printing with normal enlarging papers, dodging and burning (see below) can be done in much the same way as for projection prints, or for slower papers a sheet of glass can be set up a little way above the paper with pieces of cotton wool, torn tissue paper, and the like to shade the paper. Some purpose-made printing boxes have a grid of small bulbs that can be switched on and off independently. The great advantages of contact printing are simplicity and economy: very little equipment is needed, and it can be quite crude. But the negative (plate or film) must be the same size as the print, which means either small prints or bulky, slow-to-use cameras with high running costs: hence the popularity of *enlarging*.

An enlarger can produce much bigger prints, and the 30 lp/mm does not apply. Instead it is the angular resolution that matters: as a large print is viewed from a greater distance the resolution can be as low as 5 lp/mm on the print for a viewing distance of around 40 cm (16 in). The maximum resolution on the print can be calculated roughly by dividing the degree of enlargement into the maximum resolution on the negative, and knocking off 10 per cent to allow for the inevitable losses in the enlarging process: the losses are unlikely to be less than this, and can be considerably more. Thus a negative with 80 lp/mm should, when enlarged 10×, deliver a maximum of 8 lp/mm less 10 per cent: about 7 lp/mm. From this it might seem that a top-flight 35 mm negative should deliver a very sharp 10× enlargement (24 × 36 cm, almost 10 × 15 in) that can compete with results from larger formats. This is true in colour or with chromogenic films

(see PHOTOGRAPHIC PROCESSES, BLACK-AND-WHITE), but with conventional black-and-white films, tonality is likely to suffer.

The reason for this is the so-called half-tone effect. Up to a certain degree of enlargement, which differs with the film and the exposure and the developer used, the *grain of a conventional negative is invisible, and the tonality is creamy-smooth. At somewhere between 4× and 6× enlargement—sometimes more, rarely less—the grain starts to affect the tonality. With a conventional film, grain is greatest in the areas of greatest exposure, so the half-tone effect first becomes apparent in the lightest tones in the print; when it reaches into the mid-tones, the loss of tonality is the most obvious. At something beyond 6× to 10×, all the tones become half-tones, and the tonality reassembles itself. Tonality and *contrast are also affected by enlarger type: the more diffuse the light source, the lower the contrast and the greater the degree of enlargement before the onset of the half-tone effect.

The practicalities of making an enlargement are simple. Mechanical and optical quality are paramount: even a very old enlarger can deliver top-flight quality provided it is fitted with a first-class lens. Such refinements as variable-contrast heads are convenient, but not essential. One test strip at a series of different exposures is used to determine the optimum exposure; a second, at the optimum exposure but at a range of contrasts (assuming the use of VC paper), determines the optimum contrast grade.

Processing is the same for either an enlargement or a contact print. The chemicals and paper should be fresh—stale developer will never give a good black—and there must be no unsafe light in the darkroom: the slightest fogging can take the 'sparkle' off a print. The paper must be developed fully—if it develops too fast and too dark, it is overexposed and should be reprinted—and ideally it should be dried before evaluation: 'dry down' loses up to half a grade of contrast and adds up to ⅓ stop of density, resulting in a print that is flatter and darker than the wet test print. With a little experience of a particular paper/developer combination, it is easy to compensate for dry down by rule of thumb.

On the strength of the test strips, a 'work print' can be made, and this provides the basis for making the final print. It is quite normal to find that once the whole image has been printed, small adjustments are required to exposure or contrast or both. It is also common to have to give extra exposure locally to darken areas that are too light ('burning'), or to hold back the light for part of the exposure in areas that are too dark ('dodging'). Some photographers use only their hands; others use pieces of cardboard and 'dodging wands' consisting of a disc of card (or even a ball of cotton wool) on the end of a piece of wire. The important trick is to keep the dodging or burning tools moving, so as to avoid hard edges to the manipulated areas.

The biggest difference between a good printer and a bad one is often the number of prints they are willing to make on their way to the final image. A bad printer will be satisfied with the first attempt, or even with the work print; a good printer will, in the words of Bob

Carlos Clarke, 'go on printing until you make a print that isn't as good as the one before, at which point you realize you've made the best print you can'. RWH

Nocon, G., *Photographic Printing* (1987).

Hicks, R., *Successful Black-and-White Photography* (1992).

printing and enlarging, colour. Colour printing affords far less scope than monochrome for the photographer or printer to impose his or her particular vision on the final print. The whole process is vastly more standardized, and the demands on precision of working are significantly higher, so it is more demanding technically, with relatively fewer rewards artistically. This is why increasing numbers of photographers have switched to *digital colour output, even if they still shoot the original pictures on film, and even if they still cling to silver halide for their black-and-white printing.

This said, colour printing has been repeatedly simplified, and by the beginning of the 21st century it was possible to obtain excellent results without anything like the trouble that was normal for most of the 20th century. In particular, the chemistry was much quicker and easier to mix, and while ambient-temperature processing is slower than the old high-temperature methods, results are just as good. Also, any negative-positive process is far more forgiving than a reversal process: most devotees of digital output find it much easier to get good results by scanning *transparencies than by scanning negatives, and slide exposure is much more critical than negative exposure. And, of course, there are those who simply like the old 'wet' darkroom.

Even so, the lack of control as compared with monochrome begins at the negative stage. A monochrome negative can be (and often is) developed to suit the photographer's preferences: by developing his films himself, the photographer can exercise considerable control. Colour film processing, being more standardized, can safely be entrusted to a reliable lab with no real loss of control. Effectively all negative films go through one standardized process (C-41), and all but a very few reversal films go through another (E-6). These are named after the Kodak processes with which they are compatible. For 50 or so years after colour films were first introduced in the 1930s there were rival processes, notably from Agfa, but eventually all were standardized.

At the printing stage, the vast majority of colour enlargers are diffuser types, which still further limits the photographer's control: condenser-diffuser enlargers are little used any more, point-source enlargers are vanishingly rare, and cold cathode enlargers are unsuitable. Again, this limits the opportunity for a unique look, a 'flavour' that is imparted by the equipment. Dodging and burning are much more limited in scope. Small amounts of either are feasible, but colours can only be represented over a relatively limited range of tones, so lightening or darkening particular areas in a colour print looks unnatural far sooner than it does in a monochrome print. Also, excessive dodging and burning often introduces colour shifts, again resulting in locally unnatural images. The vast majority of prints are again made by a standardized process (generically described as RA-4,

again after Kodak's trade name), so there is not the scope for the variations in image colour and contrast that can be effected by developer choice in black-and-white. The print cannot be judged until it is dry—wet prints are bluish and slightly milky—so processing is time consuming. The print must be examined under an appropriate light source: a print that looks good under tungsten light may not be as acceptable under daylight or daylight-balance light, and vice versa. Nor, finally, is there any scope for the kind of toning or localized bleaching that is widely employed in monochrome.

All this is not to say that the photographer cannot impress his own personal vision on a colour print. Selection of materials is very important, and colour balance is very much a matter of personal preference, though most people greatly prefer warm, reddish or yellowish images to cool, bluish images. Nor should the cost of hand prints from a lab be ignored: the technical skill of the lab printer is not cheap, so printing oneself can save money as well as getting the best possible quality. This is particularly important to 'fine-art' printers. On the other hand, anyone who is shooting colour prints for commercial purposes will generally find it more cost effective to shoot negatives that will stand up to either machine printing or (which is only slightly more expensive) to 'graded' machine printing where the lab inspects the prints and remakes the ones that are not of the required standard. Exposure and colour casts are often readjusted to a level that is acceptable rather than the best that can be made, but from a commercial point of view, this may be all that is practical.

As well as the conventional negative-positive process, there are several other possibilities. Probably the most usual (apart from ink-jet printing) are R3 and Ilfochrome Classic positive-positive processes, the former (as ever) named after the Kodak standard, the latter often better known as Cibachrome after Ciba-Geigy who introduced it in 1964. Both deliver excellent quality but share three drawbacks. First, they require an optimally exposed transparency, which is much more difficult than getting an adequately exposed negative. Second, they take longer than negative-positive: about three times as long, per print. Third, they are more expensive. On the other hand, many photographers reckon that they produce superior prints to negative-positive: Ilfochrome Classic is widely regarded as the finest (reasonably) conventional colour printing process. A further advantage of positive-positive printing is that the print can be directly compared with the original.

Apart from these, the options are distinctly specialized. *Dye transfer survives, mostly with stockpiled Kodak materials (Kodak discontinued them in the 1990s). The Fresson process seemed still to exist at the time of writing, though it accounted for no more than a few hundred pictures a year; for this and *dye transfer see also PHOTOGRAPHIC PROCESSES, COLOUR. Multiple-colour *bromoil transfers are possible, though difficult. After this, it is as much a matter of photomechanical reproduction as of fine printmaking—even to the point of making silk-screen separations. RWH

Life Library of Photography: Colour (2nd edn., 1981).

printing-out paper. See POP.

privacy. See ETHICS AND PHOTOGRAPHY; LAW AND PHOTOGRAPHY.

process camera, an outsize camera, usually on horizontal rails, employed chiefly for making line copies, and *half-tone negatives from continuous-tone originals. The lens is a symmetrical design operating at a small aperture, usually with optional Waterhouse stops (see APERTURE CONTROL) of various shapes to allow variations in dot quality. Half-tone screens of various pitches can be inserted in front of the film; these are pre-set to different angles for colour separations, to avoid *moiré effects in the final print. More sophisticated models may use autofocus, and some have an optional device that moves the lens system in a square, to control line width in copies of line diagrams. The adoption of scanning systems by printing houses has made these monster cameras largely redundant. GS

product photography. See ADVERTISING PHOTOGRAPHY; FOOD PHOTOGRAPHY; PACK SHOT.

professional organizations, photographers'. Since the earliest days, photographers have formed groups to promote the art and craft of photography. Pioneering associations like the Photographic Society of London (later *Royal Photographic Society), founded in 1853, and the *Société Française de Photographie (1854) were not limited to professionals. However, the expansion of commercial photography in the second half of the 19th century led to the proliferation of professional groups. In Britain, there was pressure to create a national organization from the 1880s; and 1890 saw the formation of a photographic assistants' union, a Photographic Manufacturers' Association, and a National Association of Professional Photographers (NAPP). NAPP was succeeded in 1901 by the much more durable Professional Photographers' Association (PPA), founded to 'Improve the status of those who practise photography as a profession; to defend their interests; to assist its members by advice; to afford them opportunities of meeting and discussing matters pertaining to the craft; and to uphold the rights and dignities of the profession by all legitimate means'. Membership was open to studio proprietors and principals; assistants were excluded. The PPA concerned itself particularly with the copyright and royalty issues raised by the emergence of a national illustrated press, and contributed to the consultations leading to the 1911 Copyright Act. After several changes of name, it became the British Institute of Professional Photographers (BIPP) in 1983.

The legal status of professional bodies varies from country to country, as does the type of membership. Some organizations require only a subscription, while others stipulate a minimum level of competence within a given area of practice. The latter requirement allows the association to award qualifications to its members. The BIPP, for example, has three levels of corporate membership: Licentiate, Associate, and Fellow.

Most countries have organizations equivalent to the BIPP. In the USA, the Professional Photographers of America (PPA) represents many practising professionals. With over 14,000 members in 64 countries, it claims to be 'the world's leading certifying agency for imaging professionals. And the world's largest not-for-profit association for professional photographers.' In Germany, the Gesellschaft Deutscher Lichtbildner (1919) was overshadowed after the Second World War by the Deutsche Gesellschaft für Photographie (1951); Freelens was founded in 1995. Two major French groups are the Groupement National de la Photographie Professionnelle and the Organisation des Photographes de l'Édition et de Publicité. The *Japan Professional Photographers' Society (JPS; 1950) is the largest Japanese professional group; the *Japan Photographers' Association (JPA; 1989) includes both professionals and amateurs.

The diversity of professional photography is matched by the diversity of groups: in Britain, for example, the Association of Photographers (advertising, fashion, and editorial), the Guild of Wedding Photographers, the Association of High Speed Photography, the Association for Historical and Fine Art Photography, the British Association of Picture Libraries and Agencies, and so on. Similar variety prevails elsewhere. DM

See also AGENCIES, PHOTOGRAPHIC.

European Photography Guide (1982–).

Hannavy, J., *Images of a Century: The Centenary of the BIPP, 1901–2001* (2001).

progress book. See BABY BOOK.

projection of the photographic image began with experiments with *daguerreotypes which, although opaque, contained such precise detail that their enlargement on a projection screen was both desirable for individual or group viewing and an alternative to examining the plates with a hand magnifying lens. The American daguerreotypist John Adams Whipple in Boston in the late 1840s, and the *Langenheim brothers in Philadelphia in 1846, used megascope apparatus from Wilhelm *Voigtländer in Vienna for their projections, and the Langenheims marketed photographic slides for the magic lantern from 1850, using an *albumen on glass chemistry devised by Abel Niépce de Saint-Victor (1805–70) which they improved and patented under the name hyalotype. Their process, considered to have finer tonal range and better detail than prints on paper, was also used for stereo views, and in the stereoscope boom after the *Great Exhibition of 1851 photographic lantern slides were commonly produced by splitting stereo pairs. Although the French firm of Duboscq took up the Langenheim albumen process in 1853, during that decade production gradually switched to *collodion on glass, which was also amenable to the industrial manufacture of slides; by the 1890s large firms like York & Son in London were making over 100,000 slides annually.

At the end of the century, *celluloid was actively promoted as a substitute for the glass emulsion carrier in lantern slides due to both

its unbreakability and its lightness, but the highly flammable material was only used sporadically. The ubiquitous photography clubs of the late 19th century also promoted the making of lantern slides by their members, and invariably offered weekly or monthly meetings to view projected photographs. Projection was also used for making enlargements from negatives; if the negative was small, an ordinary magic lantern was usually recommended. For larger plates, adaptations were made to slide carriers, and fully rectilinear lenses were preferred; only towards the end of the century did the idea of projecting negatives to produce enlarged prints disappear as specialist vertical enlargers, which were still essentially projection apparatus, became commonly available outside professional studios. Many experiments with colour photographs, particularly the three-negative Kromoskop of Frederick Eugene Ives (1856–1937) that was viewed with red, green, and blue-violet filters, produced *transparencies which were typically viewed by projection. Stroboscopic projection of individual photographs representing the beating of the heart and the circulation of blood was used from 1861 by Jan *Purkinje, and Eadweard *Muybridge projected posed images of the skeleton of a horse at the gallop in some of his zoopraxiscope lectures in the 1880s. Amongst the chronophotographers producing images in series, only Ottomar *Anschütz projected before large audiences, using a two-disc Schnellseher with an intermittent movement that was seen in Berlin and Hamburg in 1894–5. Although the 1892 Phonoscope of Georges *Demeny was capable of projecting before small groups, there is no contemporary record of its use in this mode. Before moving pictures became an established new medium after c.1900, the introduction of projected images on long celluloid bands by Gray and Otway Latham in the USA (May 1895), by Max Skladanowsky in Germany (November 1895), and by Auguste and Louis *Lumière in France (December 1895) was firmly positioned within the culture of photography. Descriptions of pioneer moving-picture apparatus and exhibitions frequently made awed reference to the large number of individual photographs that were projected during the showing of a single film or programme.

Projected still images had been an important educational and entertainment medium since the late 19th century, used for numerous purposes from *missionary activity to the teaching of art history. Many view photographers, such as Henry *Taunt of Oxford, showed and sold lantern slides as a major part of their business. In the 20th century, projectors were marketed for a range of photographic formats, with the 35 mm transparency popular from the 1930s. From the 1960s, refinements such as the use of multiple projectors, dissolves, and the combination of images and sound—all anticipated in the 19th century, but now increasingly automated—became widespread, in lecture theatres, galleries, and homes. The era of the silver-based projected image finally faded in the 1990s with the rise of Powerpoint technology and the means to display *digital pictures on television and computer monitors. DR

Rossell, D., *Living Pictures: The Origins of the Movies* (1998).
Rossell, D., *Laterna Magica: A History of the Magic Lantern* (2003).

Prokudin-Gorskii, Sergei Mikhailovich (1863–1943), Russian chemist, photographer, and pioneer of colour photography, born in Murom, east of Moscow. After studying science at the Institute of Applied Technology, he worked in Berlin, then Paris, and encountered two leading photo-chemists, Adolf *Miethe and Edmé Jules Maumené, who significantly influenced his career. Back in Russia, he established courses on phototechnology, photographed episodes of the Russo-Japanese War (1904–5), and (1906–9) edited the journal *Fotograf-Liubitel* (*Amateur Photographer*). He also developed a practical three-colour system, using a modified camera designed by Miethe. Although more cumbersome than the contemporary *autochrome process, and initially limited to static subjects, it was capable of producing beautiful results, e.g. the portraits of Tolstoy taken at Yasnaya Polyana in May 1908. In 1909, after a successful lantern-slide presentation to the imperial family, Prokudin received an open-ended commission, with generous funding and travel facilities, to photograph throughout the empire, a task he pursued until 1915. After emigrating in 1918 he lived in Norway, England, and France, and worked on colour cinematography. The US Library of Congress holds *c.*2,000 of his colour plates of pre-revolutionary Russia. RL

Allshouse, R. H., *Photographs for the Tsar* (1980).

Promontory Point, Utah, meeting at, 10 May 1869. The historic 'joining of the rails' by the Union Pacific and Central Pacific railroad companies, celebrated by the hammering of a golden spike into a laurel sleeper. The event, which finally realized the dream of a transcontinental rail route, was recorded by three photographers: Andrew J. Russell (1830–1902) of Union Pacific, Alfred A. Hart (1816–1908) of Central Pacific, and Charles Roscoe Savage (1832–1909), a commercial photographer from Salt Lake City. Their wet-plate pictures, taken close together, show the chief engineers of the two companies, Grenville Dodge and Samuel Montague, shaking hands in front of two locomotives and a cheering crowd. However, none of the Central Pacific's large and heroic Chinese workforce appears. Russell's and Savage's photographs particularly became 'icons of empire', widely reproduced in books and periodicals. The scene was lovingly recreated, using the original locomotives, in John Ford's silent epic *The Iron Horse* (1924). RL

Sandweiss, M. A., *Print the Legend: Photography and the American West* (2002).

propaganda can be defined as any message intended to modify the attitudes and behaviour of people at whom it is directed, primarily by appealing to their emotions. Its use is not confined to dictatorships and authoritarian organizations. Democracies have employed it extensively in wartime. In peacetime it plays a significant role in electoral politics, and in public-service campaigns relating to social problems. Messages may range from simple verbal texts to elaborate combinations of aural and visual signals (e.g. television commercials). The media used have included print, graphic art, film, radio, television, and architecture, from baroque palaces to fascist monuments.

Photographs have also featured widely in modern propaganda, because of their reproducibility, manipulability, and, undoubtedly, because of the popular assumption that 'the camera never lies'.

The promotion of photography by Napoleon III and his government as a means of publicizing the achievements of the Second Empire (1852–70) can be described as propagandistic. But more explicitly so was use of the camera in France after the empire's collapse. Early examples related to the *Paris Commune, most notably the efforts of Eugène Appert (1830–91) to recreate Communard atrocities by means of elaborate *photomontages. Later, photographic propaganda was used on a large scale by right-wing opponents of the Third Republic, including Bonapartists, royalists, and the military demagogue General Boulanger, and, at the turn of the century, by both sides in the Dreyfus Affair.

In the First World War propaganda was used extensively by all belligerents. Although graphic art and, increasingly, motion pictures probably had greater impact, huge numbers of war photographs were exhibited and published. However, the war's greatest contribution to the history of propaganda was the emergence of large organizations with the task of bombarding soldiers, civilians, the enemy, and neutrals with carefully designed, emotive messages over long periods of time. Government-sponsored mass communication, using sophisticated methods, was to play a major role in left- and right-wing dictatorships, and the war efforts of democratic states, over the next several decades.

Visual communication was at a premium in Soviet *Russia, given the country's high level of illiteracy and multitude of linguistic groups. In the 1920s, before the consolidation of Stalin's dictatorship and the imposition of *Socialist Realism, the new regime mobilized many talented photographers and designers—including Max *Alpert, El *Lissitzky, Alexander *Rodchenko, Arkadi *Shaikhet, and Gyorgy *Zelma—who shared its utopian vision and created dynamic, modernistic images of industrialization and social renewal. Western imports like the *photo-essay, exemplified by A *Day in the Life of a Moscow Worker (1931) and Rodchenko's images of the *White Sea–Baltic Canal (1933), were adapted for Russia's urban public and sympathizers abroad. Even after the suppression of avant-garde styles as 'bourgeois deviationism' in the 1930s, photography continued to play a major role in the visual rhetoric of 'democratic centralism', collectivism, and 'Socialism in one country'.

Leadership imagery became increasingly important. Portraitist-in-chief to Lenin was Pyotr *Otsup, whose photographs were still circulating in their millions at the end of the 1920s. A range of photographers depicted Lenin's unphotogenic and camera-shy successor Stalin, who by the 1930s was shown with declining frequency alongside Vladimir Ilyich (or a bust or statue of him), and in monumental isolation from other Politburo members. Every medium and format was used to project his image, from *postcards to gigantic posters. On 1 May 1932 Sverdlov Square in Moscow was decorated with matching photo posters of Lenin and Stalin, each 25 m high by 9 wide (82 × 29½ ft), and copious information about the problems overcome and the quantities of materials used appeared in the press.

Other techniques included the conversion of photographs of Stalin into paintings, and the superimposition of his image on pictures of industrial or military subjects or, in 1949, of crowds celebrating his 70th birthday.

Long before Stalin's death in 1953 a comprehensive technical and iconographical repertoire had developed that continued to be used in other communist states, including China. There were variations from country to country. Whereas Stalin, for example, was rarely photographed interacting with ordinary people, Walter Ulbricht in the GDR was regularly depicted playing volleyball or eating in factory canteens. In general, however, photographers had to work with a palette of approved images: low-angle shots of Red Army soldiers, high-angle ones of applauding crowds, lyrical views of the homeland, and suitably impressive (but not avant-gardistic) pictures of mills, dams, power stations, and naval manoeuvres. Physical manipulation was used to rejuvenate geriatric leaders, eliminate bottles and cigarette butts from official meetings, and, as with Trotsky in the 1920s, weed 'unpersons' out of leadership photographs. Particularly sinister and surreal in this regard was a picture, c.1968, of the Czech reformer Alexander Dubček and President Svoboda surrounded by enthusiastic, camera-wielding youth. In a second version, Svoboda appears larger and more prominent, but Dubček has been eliminated (but not, presumably, from the onlookers' family albums).

The balance between official and grass-roots photography was more interesting in Nazi *Germany (1933–45), which had a richer photographic culture than other large totalitarian states. Germany in the 1920s had a major photographic industry, a mature illustrated press, and a large camera-owning population. By 1933 both Nazis and communists were adept at photographic propaganda, from photomontage to the recycling of historical images (e.g. of the German Revolution (1918–19)). During the Third Reich, notwithstanding the establishment of a Propaganda Ministry under Joseph Goebbels, Heinrich *Hoffmann, as Hitler's long-standing crony and personal photographer, remained the leading figure in the photographic firmament, and maintained a near-monopoly of Führer images until 1945. He helped to form the 'Hitler myth' that was one of the unequivocal successes of Nazi propaganda. Hitler pictures were distributed in saturation quantities as postage stamps, postcards, cigarette cards, posters, press illustrations, and in the albums published by Hoffmann. Two of the most successful of these, Hitler wie ihn keiner kennt (The Hitler Nobody Knows; 1932) and Hitler in seinen Bergen (Hitler in his Mountains; 1935), which presented their subject as reassuringly benign and ordinary, continued to sell well even after Hitler's official image, from c.1936, became that of an increasingly remote 'man of destiny'. Other branches of photographic propaganda were handled by the Propaganda Ministry. Like press coverage generally, photojournalism was 'tuned' and regulated according to political needs, with shifting emphases (e.g. on anti-Semitism, Soviet Russia) and predictable taboos (train crashes, indiscretions by Party bosses). Prestige photographic exhibitions such as Deutschland (1936) and Gebt uns vier Jahre Zeit (Give Us Four Years; 1937) were also

organized by the Ministry, as was coverage of propaganda events like the 1936 Olympics. In photography, as in other media, only those deemed politically and racially sound could belong to professional organizations and, therefore, work.

Amateur photography was another matter. Although all clubs were ideologically 'coordinated', individuals could generally be relied upon to convey a positive impression of life in the new Germany. Pets, babies, holidays, and landscapes continued to dominate exhibitions and family albums. Notable from this perspective were the photographic courses organized on the vacation cruises sponsored by the official leisure organization, Kraft durch Freude (Strength through Joy), which evidently aimed to spread the practice of self-generating photographic propaganda among the working class. Amateur activity continued to be encouraged in the first half of the war, but dwindled from 1943 as materials became scarce and wartime reality more grim.

Germany's democratic opponents made extensive use of photographic propaganda in the Second World War. Much more than in 1914–18, photography was the basis for posters, designed by advertising experts like the American Victor *Keppler. Accredited press photographers, subject to censorship and other pressures, fed the illustrated press, whose role was both to inform and encourage. Official photographers supplied vast numbers of images (some staged) for use in the innumerable publications of the US Office of War Information and British Ministry of Information, covering every aspect of the Allied war effort. Commercial publishers illustrated their books with pictures by civilian photographers—men like John *Hinde—whose wartime work can be described as propagandistic.

In peacetime democratic politics, management of photographic coverage is as important as the production of images. Politicians, whether in office or candidates for office, must not only disseminate photographs to convey a chosen message but endeavour to head off negative representation. (Frank Capra's 1939 comedy about a political ingénu on Capitol Hill, Mr Smith Goes to Washington, satirized the perils of photography.) Ulrich Keller and others have argued that photography became important in American politics during the successful presidential campaigns of William McKinley in 1896 and 1900, when large-scale process reproduction became a reality. It was subsequently used to good effect by Theodore Roosevelt and Woodrow Wilson. However, systematic image management came of age under Franklin D. Roosevelt (1933–45). Although by this time radio and newsreels were probably perceived as more important, Roosevelt's press secretary Stephen Early successfully imposed 'unwritten rules' on White House photographers in order to get favourable pictures (and, among other things, avoid depiction of the President's disability). This system was continually refined later on, so that by Ronald Reagan's presidency (1981–9) White House photo opportunities were governed, on pain of exclusion, by detailed rules about photographers' pecking order, the functional separation of photographers and reporters, and the kinds of pictures that could be taken. Yet even in this controlled environment embarrassing images were made, notably during the Iran-contra scandal in late 1986.

(Richard Nixon had suffered similar mishaps.) Outside the White House, and other controlled venues like Downing Street or the Élysée Palace, meticulous planning is needed to maximize positive coverage. An interesting 21st-century example was President George W. Bush's Iraq War victory speech aboard USS Abraham Lincoln on 1 May 2003. In fact the carrier was reachable from southern California by helicopter, from which Bush would have emerged in civilian clothes. However, he was flown in a fixed-wing aircraft, a decision that allowed him to appear before the cameras in a military flying suit, a warrior among warriors. Such calculations, using the media's known habits to generate suitable pictures, are fundamental to modern political management. RS/RL

English, D. E., *Political Uses of Photography in the Third French Republic, 1871–1914* (1984).

Jaubert, A., *Le Commissariat aux archives* (1986).

Winfield, B., *FDR and the News Media* (1990).

Squiers, C., 'Picturing Scandal: Iranscam, the Reagan White House, and the Photo Opportunity', in C. Squiers (ed.), *The Critical Image: Essays on Contemporary Photography* (1990).

Herz, R., Loiperdinger, M., and Pohlmann, U. (eds.), *Führerbilder: Hitler, Mussolini, Roosevelt, Stalin in Fotografie und Film* (1995).

King, D., *The Commissar Vanishes: The Falsification of Photographs and Art in Stalin's Russia* (1997).

Provoke, Japanese magazine and collective founded in November 1968 by a group of photographers and critics including Koji Taki, Takahiko Okada, and Takuma Nakahira (b. 1938), joined by Daido *Moriyama in the second issue. The magazine folded in August 1969 after only three issues. With a radical, leftist bent, it aimed to counter established viewpoints, publishing blurry, gritty photo-essays and critical new ideas. The history and demise of the magazine were discussed in the book *Mazu Tashikarashisa no Sekai o Sutero* (*First Discard the World of Pseudo-Certainty* (1970)), after which the collective disbanded. Its influence, however, persisted. MT

punctum, Latin term meaning puncture or wound, used by Roland *Barthes in *Camera Lucida* (1980), to describe how he feels touched by certain photographs, because of incidental details which trigger emotionally charged personal associations, unrelated to the meaning of photographs as culturally determined. In a portrait by James *Van Der Zee, for example, he is moved by a woman's necklace, which reminds him of one worn by his aunt, and since her death kept in a family box. It is questionable, however, how far these associations can be considered as uncoded. To be reminded of a family necklace by a historical photograph is consonant with an established language of jewellery as keepsakes and souvenirs. Influenced by phenomenology, *Camera Lucida* investigates the common factor (the essence) uniting not photographs but our encounters with them. The 'noeme' of photography, that which makes us experience photographs in a certain way, is their capacity to point to something 'that has been'. PDB

See also THEORIES OF PHOTOGRAPHIC MEANING.

Burgin, V., 'Re-reading Camera Lucida', in *The End of Art Theory* (1986).

Puranen, Jorma (b. 1951), Finnish photographer, resident in Helsinki. In the early 1970s, when still a student in Helsinki, Puranen encountered the Sami people in the Scandinavian north. His first book, *Maarf Leu'dd: Photographs of the Skolt Lapps* (1986), a poetic reportage, gives voice to the Skolt Sami group in north-east Finland. In concurrent projects—*Alpha et Omega* (1989) and *Imaginary Homecoming* (1999)—Puranen's work turns conceptual, staged, layered, while maintaining its focus on Sami culture. *Imaginary Homecoming* returns, as it were, photographs of the Sami from Roland Bonaparte's 1888 anthropological expedition to their source: a photographic memorial and act of empowerment, real and metaphorical, extending across a century and vast spaces. Subsequent works such as *Curiosus Naturae Spectator* explored histories of representation and the framing of nature by culture.　　J-EL

Puri-Kura. See PRINT CLUB.

Purkinje, Jan Evangelista (1787–1869), Czech physiologist. Working at the University of Breslau (from 1823), then Prague (from 1850), he made major contributions to understanding the physiology of the eye, discovered the Purkinje fibres in the wall of the heart that are used today to transmit the stimulus of a pacemaker, and worked on plant cells, muscles, and other topics. He pioneered the use of photomicrography to aid the examination of microscopic samples; improved the stroboscopic viewer of Simon Stampfer and J. A. F. Plateau with his Phorolyt of 1841, which was marketed in two sizes as a scientific toy; and produced in the 1850s a disc holding nine posed photographs of a simple movement intended for projection when his Kinesiskop viewer was attached to a magic lantern. With this apparatus, in 1861, he demonstrated the action of the human heart and the circulation of blood, using individual photographs of each sequence of the heart's movement. His Kinesiskop discs were used in his lectures throughout the decade; one survives at the Technical Museum, Prague.　　DR

push processing, colloquial term for a method of increasing effective emulsion speed by extending the development time. It is usually applied to colour reversal material; increasing the first development time by up to 50 per cent can increase the effective speed by up to two stops, with some loss in colour saturation and shadow density. Most modern professional colour transparency films are designed to give good results when processed for a variety of speeds.　　GS

Puyo, Émile Constant (1857–1933), French *pictorialist photographer. Born in Morlaix, Brittany, Puyo joined the army as a young man and began taking amateur photographs *c.*1889. He joined the Photo-Club de Paris in 1894, contributed to its annual exhibitions, and became linked to the prominent pictorialist Robert *Demachy. His *Notes sur la photographie artistique* (1896) began a long series of writings on techniques and equipment. In 1902 he left the army to concentrate on photography. Involvement with the *Photo-Secessionist movement led to his pictures appearing in *Stieglitz's *Camera Work*, and to participation in a group exhibition (1906). An extensive manipulator of the photographic image, he developed soft-focus lenses to give an impressionistic effect, and his figures and landscapes were often characterized by diffused light—illuminating gauzy fabrics, falling from one side, or reflected from water. He experimented (often with Demachy) with various pigment processes, including *gum bichromate, a method of low-relief printing that readily lent itself to tinting. Whilst the Photo-Club disbanded and Puyo rejoined the army in 1914, he did not abandon photography. He ran workshops, wrote copiously, and was paired with Demachy in a retrospective exhibition in Paris in 1931.　　RP

La Bretagne de Constant Puyo, photographe (1857–1933), maître de l'école pictorialiste (1992).

Quintas, Eva (b. 1964), Spanish photographer and transnational 'plurimedia' artist, born in Switzerland and active in Montreal. After studying literature and photography she exhibited in Europe and the Americas, became convenor of the Quebec photographers' collective Fovea, and in 1993 founded the Topo agency to promote cross-media projects. With the writer Michel Lefebvre, she developed the *photoromance *Liquidation* (1994–8), realized in print and on radio, the Internet, and CD-ROM (hence 'plurimedia'). From 1999, with Topo and other groups, she directed collaborative projects with West African photographers and digital artists. RL

Musée virtuel de la photographie québécoise (CD-ROM, 1998).

Rai, Raghu (b. 1942). Born in present-day Pakistan, but resident in India since Partition, Rai is one of the few contemporary Indian photographers to have established an international reputation as a photographer of his native land. After securing a job as a staff photographer with the *Hindustan Times* in 1965, his photographs soon began to appear in international publications. He turned freelance in 1976 and the following year joined *Magnum. Working in both colour and black-and-white, he has published much of his work in books, whose subjects have included Indira Gandhi (1974), the cities of Delhi (1983) and Calcutta (1989), the Sikhs (1984), Tibet in exile (1990), Mother Teresa (1996), and the Bhopal disaster (2002). Twenty-five of his photographs are held in the permanent collection of France's Bibliothèque Nationale and in 1997 the National Gallery of Modern Art in Delhi gave him the first retrospective exhibition dedicated to the work of a contemporary Indian photographer. JF

railways. The railway and the camera have been closely linked since the earliest days of photography. Perhaps the earliest surviving railway photograph is a *daguerreotype made in 1845 by David Octavius *Hill and Robert Adamson, which shows the new station at Linlithgow on the Edinburgh & Glasgow Railway. In the same year the Great Western Railway's Daniel Gooch was photographed alongside a model of the Firefly class locomotive he designed, and one of these engines, *Damon*, appears in a daguerreotype dating from the same period.

Photographers soon turned their attention to the massive railway construction projects that were transforming the natural landscape. In the USA in the mid-1850s the *Langenheim brothers photographed the building of the New York Central and Great Western Central Railroads. In England in the same decade photographs were made of the construction of Robert Stephenson's Britannia Bridge over the Menai Straits, and of Isambard Kingdom Brunel's bridges over the rivers Tamar and Wye.

In France in 1861 Hippolyte Auguste *Collard was commissioned by the Chemins de Fer du Bourbonnais to photograph its operations, producing memorable views of the engine shed and station at Nevers. In the same year Édouard Denis *Baldus's photographs for the Paris, Lyon et Mediterranée railway included images of its bridges over the Rhône, and of Toulon station.

During the American Civil War (1861–5) photographers recorded the railways' role in the war effort and documented the damage caused to the Confederate railway network by the advancing Union forces.

At the end of the conflict the opening of the West provided new opportunities for war photographers like Andrew Russell (1830–1902) and Alexander *Gardner, who were commissioned to photograph the building of the transcontinental railway. They were joined by Alfred A. Hart (1816–1908), William Henry *Jackson, Carleton *Watkins, and other photographers, who produced spectacular images of the building of the railway and the landscapes that it traversed.

British railway companies also commissioned photographs of railway construction. In the late 1860s, John Ward and J. B. Pyne photographed the building of the Midland Railway's extension to St Pancras station, while Henry Flather (*fl.* 1860–75) recorded the construction of the Metropolitan Railway in London, the world's first underground system. In the 1880s Frank Meadow *Sutcliffe recorded the construction of the North Eastern Railway's Whitby line, and a decade later S. W. A. Newton (1875–*c.*1960) produced remarkable images of navvies at work on the new Great Central Railway.

Railway vehicles were photographed too. In 1856 Beyer Peacock Ltd. of Manchester employed James Mudd (1821–*c.*1905) to photograph its new locomotives so that they could be advertised to overseas customers. This example was followed by the Midland Railway and the London & North Western Railway, and by the late 19th century most of the UK's major railway companies employed official photographers, briefed to photograph new locomotives and rolling stock, accidents, construction projects, and locations served by the railway. Production of scenic photographs to decorate railway carriages became a minor industry in its own right, and photography played an important role in the railway's emerging public relations and advertising departments. So that they could be photographed, new locomotives were specially painted in 'works grey', which showed up best on *orthochromatic emulsions, and the engines' final livery was only applied once the negatives had been successfully developed.

As official photography became commonplace, a growing band of private photographers began to produce railway images. For some photographers the railway has provided an occasional subject: Alfred *Stieglitz's 1902 image of the New York Central rail yards in the snow, and André *Kertész's street scene at Meudon in 1928, with the railway viaduct as an imposing backdrop, are examples. Railway enthusiasts, however, focused on little else. In Britain, early enthusiast photographers, like R. H. Bleasdale (1837–97) who began working in the 1850s, concentrated on static locomotives, sometimes conveniently

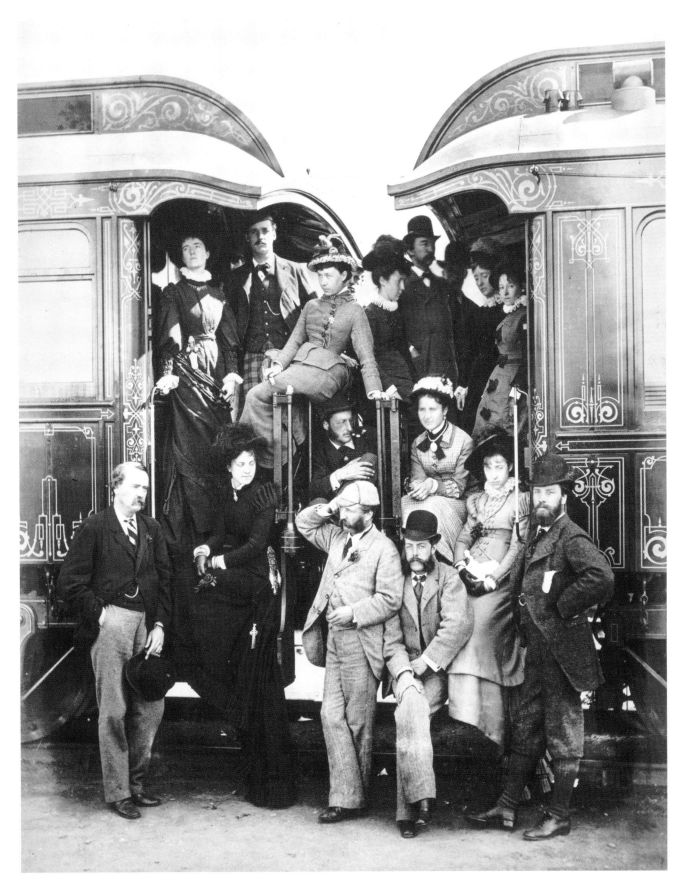

Anon.

British tourists posing in front of Pullman cars before embarking on a mystery tour, August 1876. Albumen print

Lala Deen Dayal

Indore State Railway, India, *c.*1880.
Albumen print

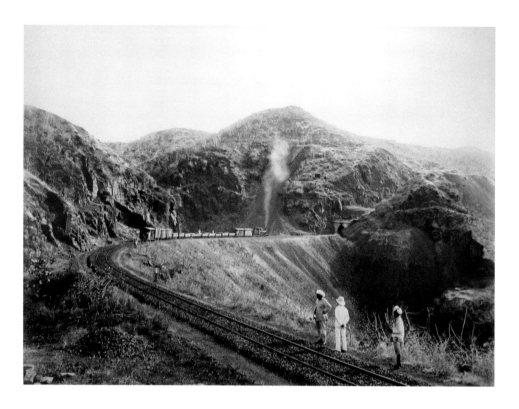

posed in sidings with the assistance of their crews. By the 1880s faster shutter speeds and more sensitive photographic emulsions allowed photographers like the Revd A. H. Malan (*fl.* 1875–95), Roger Langdon, and E. J. Bedford (*c.*1865–1953) to 'freeze' movement, and by the 1890s Dr Tice F. Budden (*c.*1870–*c.*1950) was experimenting with panning shots of passing trains.

In Britain, where railway enthusiasm was strongest, specialist photographers, many of them professional men with the time and money to indulge their hobby, were encouraged by a growing market for railway images. Some, like Henry Priestley (b. *c.*1910), travelled and photographed across the entire railway network, while others like Ivo Peters (1915–89) on the Somerset & Dorset, and Maurice Earley (*c.*1900–1982) on the Great Western Railway became associated with particular locations that they returned to again and again.

In 1922 the Railway Photographic Society was formed to improve the standard of railway images. Prints were circulated among members for criticism and, although this encouraged high-quality photography, it limited experimentation with camera angles or focus. Railway photography was also restricted by technology. Large-aperture lenses were extremely expensive, and conservative photographers proved reluctant to abandon their heavy, large-format glass plates for miniature or medium-format film negatives. Most railway photographers, whether official or private, produced monochrome images, and it was not until cheap processing and printing became available in the 1960s that they turned in any numbers to colour photography.

In the inter-war years railway publicity machines became increasingly sophisticated, and the production of press images became an important part of the work of official photographers, like Stan Micklewright of the Great Western Railway. The Canadian Pacific Railway employed Nicholas Morant (1910–99) as its 'special photographer' for more than 50 years from the 1920s to 1980s, and he provided them with striking scenic views of trains in the Rocky Mountains or amidst prairie skyscapes.

Security restrictions halted enthusiast photography during the Second World War, but it reached its peak in the following two decades, as steam locomotives began to be phased out in favour of diesel and electric traction. In the UK, for instance, Bishop Eric Treacy (1907–78) travelled across northern England and Scotland photographing passing steam trains in his favourite locations. In the USA between 1955 and 1960 O. Winston *Link documented the demise of steam on the Norfolk & Western Railway in intricately lit night shots. His images of locomotives thundering past the front porches, grocery stores, drive-in movies, and courting couples of small-town America are perhaps the most evocative of all railway photographs. Link's one-time assistant David Plowden (b. 1932) was also fascinated by America's disappearing industrial heritage and produced a series of images of steam locomotives.

In Britain during the final days of the steam railway in the 1960s a new 'progressive' railway photography emerged, typified by Colin Gifford, who saw the railway as an integral feature of the urban and industrial landscape. Unlike most enthusiast photographers he

produced many images in which locomotives barely featured. As steam engines disappeared in Europe and the USA many railway photographers either retired, or travelled further afield to countries like India or China, where steam locomotives continued to work. The British photographer Colin Garratt (b. 1940), for instance, has visited over 50 countries to produce his meticulously prepared images of surviving steam railways.

As the railway declined in economic importance, the role of official photographers declined too. Their units closed as works were shut and nationalized railways were privatized, and their work was contracted out to commercial photographers. In the early 21st century, much railway photography is driven by the demands of enthusiasts and magazine markets, with nostalgic images of steam locomotives at least as popular as photographs of the modern railway. In Europe and the USA many preserved lines run special photographic charters intended to recreate the 'golden age' of steam. Captivated by the railway's machinery and infrastructure, few railway photographers have devoted much time to its most important element, the passengers. It has been largely left to 'outsiders', like Walker *Evans and Bruce *Davidson, to photograph the railway from the users' point of view. EB

Link, O. Winston, *Steam, Steel and Stars* (1987).

Simmons, J., *Image of the Train* (1993).

Baker, Michael H. C., *Taking the Train: A Tribute to Britain's Greatest Railway Photographers* (1993).

Bartholomew, E., and Blakemore, M., *Railways in Focus* (1998).

Lyden, A. M., *Railroad Vision: Photography, Travel and Perception* (2003).

Ramsey, Lettice. See MUSPRATT, HELEN.

Rapho, *agency founded by the Hungarian Charles Rado, active in Paris 1933–40. It was vital in bringing such émigré photographers as *Brassaï, Nora Dumas (1890–1979), Ergy Landau (1896–1967), and Ylla (Kamilla Koffler; 1911–55) into contact with pre-war France's booming illustrated press and advertising industry. Rado, who had left Germany (where he had worked for Ullstein) in 1933, emigrated to the USA in 1940. But Rapho was restarted in 1946 by Raymond Grosset, who from modest beginnings, bicycling between editors, photographers, and an improvised office, restored it to prominence. Grosset sold his photographers' essentially humanistic output to both the communist and Catholic press and, a fluent English speaker, secured lucrative American assignments for *Doisneau (one of the refounded agency's leading members, with *Boubat, *Brihat, and *Dieuzaide) and others in the 1940s and 1950s when earnings in France were meagre. Later, Rapho diversified in the face of changing market conditions. In 1977 it acquired the TOP agency and in the 1990s (now run by Grosset's children Mark and Kathleen) branched out into medical and gastronomic photography and increasingly pursued institutional and corporate work. In 2000 it joined the Hachette Filipacchi magazine-publishing group. RL

Rapid Rectilinear lens. See LENSES, DEVELOPMENT OF.

Rau, William Herman (1855–1920), American photographer and stereograph publisher. Rau was official photographer for the Pennsylvania Railroad and Lehigh Valley Railroad in the 1890s, a time when both technologies were mature, tourism was expanding, and photography was a key tool for railway promoters. He made many *stereoscopic views along the routes, and sometimes used 45.7 × 56 cm (18 × 22 in) *mammoth plates for spectacular landscapes. He also photographed ships, architecture, and major installations like the 1904 St Louis exhibition. His company was bought by *Underwood & Underwood in 1901. LAL

Ray-Jones, Tony (1941–72), observer of English life. The youngest son of a painter and etcher, Ray-Jones learned about photography in London before travelling to the USA and studying at Yale. He worked for American advertising firms and magazines and regularly recorded New York street life. He won more commercial assignments on returning to Britain in 1965, and his touring show for the Institute of Contemporary Arts was the organization's first to feature a photographer. Recognition continued on both sides of the Atlantic, and in his last active year he was employed by both the San Francisco Art Institute and London's *Sunday Times*. From 1966 to 1971, between other assignments, he took photographs for a book, *A Day Off: An English Journal*. It explored the English leisure scene during a period of far-reaching social change and included coverage of seaside resorts, society events, and local festivals. The images combined affection and understanding with a sense of humour and an appreciation of the idiosyncratic. Ray-Jones died of leukaemia aged 30, but his book, published posthumously in 1974, was warmly received and influenced a new generation of *documentary photographers. RP

ready-made. See DUCHAMP, MARCEL.

realism. The term has complex meanings, partly because of the history of its use in philosophy and art. A strand of Western thought going back to Plato considers the visible word not reality, but mere appearances which tell us nothing of the reality of universal forms and ideas. These cannot be apprehended through our senses, but only via rational thought. Walter *Benjamin, for example, quoted Bertolt Brecht's antirealist argument: 'less than ever does the mere reflection of reality reveal anything about reality. A photograph of the Krupp works . . . tells us next to nothing about [it].'

The depiction of visible reality, however, had acquired an enhanced status by the 1840s, at the inception of the artistic and literary movement known as realism, as both artists and scientists had come to value the empirical study of nature. It was partly this interest in accurate visual records that led to the use of the camera obscura as an aid to drawing; and the development of photography as a way of fixing its image, bypassing the inaccuracies of the human hand. As an art movement, realism aimed to represent the visible world truthfully, by observing contemporary life and depicting ordinary people and situations, rather than idealized heroes and allegorical stories.

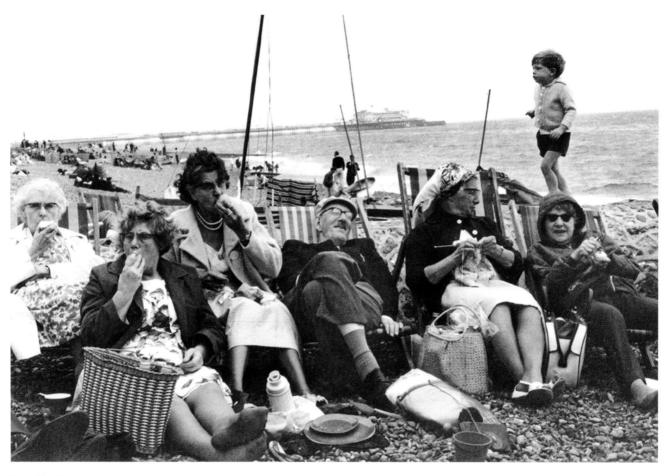

Tony Ray-Jones

On the beach at Brighton, 1967

The realist connotations of the photographic image have been enhanced by the significance of the camera obscura, which has been used, in a philosophical tradition going back to Descartes, as a metaphor for rational knowledge, detached from the subjective and inaccurate nature of sense perception. The idea of the camera as an instrument of knowledge is a powerful assumption underlying many photographic practices, from 19th-century studies of criminality and *mental illness to 20th-century documentarism; even if these are based on a subtler notion of correspondence between visual and social realities when mediated by the experience and integrity of the photographer. Recent histories and *theories of photographic meaning have emphasized the ideological nature of this model of vision.

In a different register, Jonathan Crary has argued that by the 19th century the camera was no longer understood as a model of objective knowledge, but had become part of a whole series of optical toys devised to stimulate subjective and embodied vision, now understood as an active and creative element of visual experience. Following Crary, Geoffrey Batchen argues that early photographers were motivated by romantic desires for traces of nature, as much as the need to know, classify, and possess it.

Photographs seem to mirror the world, or at least a fragment of it in space and time. But the photographer's choices—lens, viewpoint, framing, timing—intervene between the object and its image, even when these seem natural or unwittingly made, as in *snapshot photographs. Realist images are as much constructed as the most complex studio set; their illusion of transparency enhances their ability to construct and confirm conceptions of reality itself. PDB

Nochlin, L., *Realism* (1971).

Benjamin, W., *One Way Street and Other Writings* (1979).

Tagg, J., *The Burden of Representation* (1988).

Crary, J., *Techniques of the Observer* (1990).

Batchen, G., *Burning with Desire* (1997).

reciprocity failure. The Reciprocity Law states that photochemical effects depend solely on the light energy absorbed. It underlies the relation between exposure duration and f-number (e.g. that 1/30 s at f/11 gives the same result as 1/60 s at f/8). The law tends to break down

at low light levels when the indicated exposure duration exceeds a few seconds. If the law is followed rigidly the result will be underexposure, and possibly poor colour balance. Increasing the exposure duration corrects the underexposure, but often with increased contrast. Film manufacturers sometimes provide tables for exposure compensation and correction filters. GS

reconnaissance photography. See AERIAL PHOTOGRAPHY.

reflections exercise an enduring fascination for photographers; but they are harder to photograph than to resist. The most usual problem with reflections in water, apart from ripples destroying the resolution, is determining the ideal exposure: the reflection is almost always darker than the object reflected, though there are a few lighting conditions where this is not so. If the disparity is too great, a graduated grey filter can prove a useful remedy. If there is too great an expanse of smooth, featureless water in the foreground, tossing in a pebble or two to create ripples can be useful.

Reflections in other materials—glass, mirrors, chrome automobile trim, and more—are often let down by lack of *depth of field; this can sometimes be used creatively, throwing either the reflector or the reflected subject out of focus. For a plane surface, a reflection is at the same effective distance as the subject from the reflective surface. In other words, if the reflector is a metre from the camera, and the subject reflected is 3 metres (10 ft) from the reflector, then the effective

distance of the subject from the camera is $1 + 3 = 4$ metres. For curved reflectors, the effective distance may well vary. RWH

Régnault, Henri-Victor (1810–78), French physicist and a pioneer of French paper photography. Although he conducted experiments as early as 1841, it was not until 1847 that he used the process regularly. From then until the mid-1850s he devoted part of his time to photography, especially at and around the Sèvres porcelain works, of which he was, from 1851, director. His favourite subjects were landscapes, architectural studies, and portraits. He was the first president of the *Société Française de Photographie, which houses most of his work. QB

Jammes, A., and Parry-Janis, E., *The Art of the French Calotype* (1985).

Reiss, Rodolphe Archibald (1875–1929), forensic photographer, born in Frankfurt am Main. Between 1893 and 1898 he studied natural science in Lausanne, Switzerland, and in 1899 became head of the university's photographic laboratory. In 1903 he published *La Photographie judiciaire*, in 1906 became professor of judicial photography in Lausanne, and in 1909 founded the Institut de Police Scientifique, which he directed until 1919. He also did pioneering work in medical radiography. He published extensively and became a leading international authority in the field. In the First World War he went to Serbia as an expert and remained there until his death. JJ

See also POLICE AND FORENSIC PHOTOGRAPHY.

Matthyer, J., *Rodolphe A. Reiss, pionnier de la criminalistique* (2001).

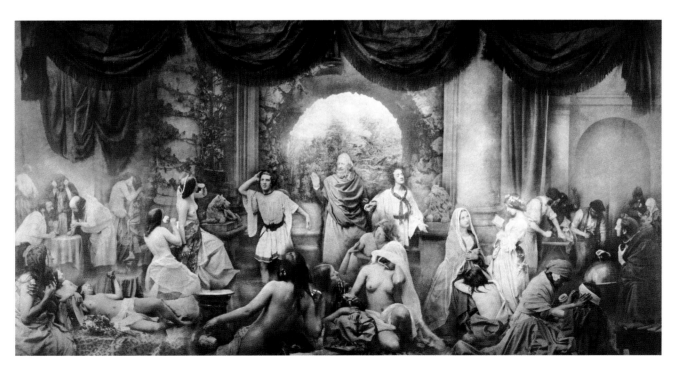

Oscar Rejlander

The Two Ways of Life, 1857. Albumen print

Rejlander, Oscar Gustav (1813–75), Swedish-born photographer, active in England and often known as 'the father of art photography', having pioneered practices such as combination printing and promoted photography's capacity to tackle subjects conventionally associated with painting. After studying lithography and painting in Rome, Rejlander arrived in England in the early 1840s and settled in Wolverhampton. A day's instruction with Nicolaas *Henneman was apparently his only training before he turned to photography in 1853. Throughout his professional career, Rejlander combined studio portrait work and other commissions with particular artistic projects, importing ideas and inspiration from such sources as Flemish and late Renaissance art, 18th-century English narrative works, or contemporary cartoons from papers like *Punch*. His famous moral allegory *The Two Ways of Life* (1857) combines sophisticated combination printing with elaborately *staged photographs. Although widely condemned as indecent—in Scotland only the 'virtuous' side of the picture could be shown—it was bought by Queen Victoria for Prince Albert. Rejlander vigorously defended photography's narrative capability, emphasizing artifice as a way to truth and creative expression, and works like *Hard Times* and *The Dream* (both 1860) convey unconscious states hauntingly and in a precociously modern way. In 1862 he left Wolverhampton for a London studio, where judiciously placed windows enabled him to create subtle lighting effects for portraiture. Charles *Dodgson (Lewis Carroll) and Alfred Tennyson were among his clients, as was Charles Darwin, for whose book *On the Expression of the Emotions in Man and Animals* (1872) he created illustrations, using himself and his wife as models. But Rejlander never achieved commercial success, and died in poverty.　　　J-EL

 Wigh, L., *Oscar Gustave Rejlander* (1998).

religion. See CHRISTIANITY AND PHOTOGRAPHY; MAGIC AND SUPERSTITION; POST-MORTEM AND MEMORIAL PHOTOGRAPHY.

Relvas, Carlos (1838–94), Portuguese landowner, wine grower, bullfighter, and amateur photographer. Born into a wealthy farming family at Golegã, *c.*100 km (60 miles) from Lisbon, Relvas had practically unlimited means to pursue photography when he took it up *c.*1861. He was admitted to the *Société Française de Photographie in 1869, and over the next couple of decades, thanks to success at major exhibitions (to some of which he submitted wine as well as photographs) in Europe and the USA, became internationally celebrated. In the 1870s he built a lavishly equipped studio on his estate and introduced the *collotype process into Portugal. Although many of his most important pictures were of historic buildings and monuments, his surviving photographs also include portraits and self-portraits, animals, Portuguese and foreign landscapes, 'popular types', and genre and fishing scenes. A particularly fascinating series documents the new self-righting lifeboat Relvas designed and personally demonstrated at Oporto in 1883. The previous year he had made 512 collotype prints of exhibits in the Lisbon Exhibition of Ornamental Art—a milestone in exhibition technology.

Although Relvas's death was treated as a national event, his achievements were soon forgotten. In 1988, however, initial steps were taken to restore both his photographs and the 'House of Photography' at Golegã, probably the only large-scale 19th-century photographic studio still in existence.　　　RL

 Carlos Relvas and the House of Photography (2003).

Rencontres Internationales de la Photographie, Arles. See ARLES FESTIVAL.

Renger-Patzsch, Albert (1897–1966), German photographer and, with *Sander and *Blossfeldt, leading exponent of German *Neue Sachlichkeit. Having practised photography since his teens, he took it up professionally after studying chemistry in Dresden (1919–21), and in the mid-1920s published books on animals and natural forms and medieval choir stalls. He became committed to a form of documentary realism that separated him decisively from both *pictorialism and the experimental 'art photography' of the avant-garde. Photography's supreme capability, he believed, was to capture the form and detail of organic and man-made objects with unequalled clarity and precision. Visual rhetoric and 'creative' distortion had no part in it. Tight, head-on composition, deep focus, diffused lighting, and close-ups were its tools. His approach was epitomized by his internationally acclaimed book *Die Welt ist schön* (*The World is Beautiful*, 1928), which contained images of leaves, animals, and industrial machinery and buildings. Interestingly, it was attacked by right-wingers like Erna *Lendvai-Dircksen for being denatured and rootless and by leftist critics like Walter *Benjamin for being dehumanized and in thrall to advertising. (Renger-Patzsch in fact created outstanding advertising photographs for the Jena Glass Works, and other important technical and industrial work.) In 1929 he participated in the *Film und Foto exhibition in Stuttgart and accepted a teaching post at the Folkwang School in Essen.

 During the Second World War Renger-Patzsch worked as a war photographer. In 1944 his entire archive was bombed. After the war he continued to do landscape, architectural, and industrial work, and received numerous awards. In the course of his career he published more than 35 books.　　　RL

 Wilde, A., *Albert Renger-Patzsch* (1997).
 Heckert, V. (ed.), 'Albert Renger-Patzsch', *History of Photography*, 21 (1997).

Rephotographic Survey Project. See AMERICAN WEST, PHOTOGRAPHY AND THE (FEATURE).

reproduction of photographs. See HALF-TONE PROCESS; LAW AND PHOTOGRAPHY; PHOTOMECHANICAL PROCESSES.

Resnick, Marcia (b. 1950), New York-based American photographer, noted for her inventive approach to image making. Her commercial work includes album-cover images for rock groups and musicians like UFO, Johnny Thunders, and Robert Quine.

Educated at Cooper Union and the California Institute of Arts, Resnick has created artist's books that examine gender, sexuality, the acts of seeing and remembering, and incorporate narratives with painted-upon photographic images and subtexts. They include *Landscape*, *See*, and *Tahitian Eve* (all 1975); *Landscape-Loftscape* (1977); *Re-Visions* (1978); and *Bad Boys: Punks, Poets, and Politicians*, an ongoing perusal of men. TT

resolution. See OPTICAL TRANSFER FUNCTION.

reticulation, orange-peel-like wrinkling of a photographic emulsion. In milder cases its surface goes matt, and prints look grainy. Reticulation is caused by large temperature differences between processing baths, especially between a cold pre-wash and a warm developer at high *pH. It was once a common occurrence with photographic plates, so emulsions were often prehardened in formaldehyde before development. The only treatment (in desperation) is quickly to rinse the emulsion in cold water and plunge it into a methanol bath before drying rapidly with a hairdryer set to 'cold'. Modern prehardened emulsions have made its appearance rare. GS

retouching. See FINISHING.

retrofocus lens, a reversed *telephoto lens in which the front element is negative, moving the rear nodal plane (from which the focal length is measured) behind the rear of the lens. It is the standard design for *wide-angle and *fisheye lenses in SLR and cine cameras where a conventional lens would foul the shutter mechanism. An extreme case of a retrofocus lens was the long-lens cine gun camera installed in RAF fighter aircraft during the Second World War to record aerial combats and for training sessions. To permit the mounting of the camera in thin wings the total length of the lens barrel was about 30 cm (12 in), though the focal length was only 50 mm (2 in). GS

See also GAUSSIAN OPTICS.

Reuters, British news agency created by Paul Julius Reuter in 1851 and soon one of the largest organizations of its kind. From the 1960s it invested heavily in computerization, and in 1985 founded its News Picture Service. Cumbersome transmission equipment was eventually replaced by digital technology, enabling images from the agency's worldwide network of photographers to reach newsdesks sometimes within minutes. AH/RL

Michel, U., *The Art of Seeing: The Best of Reuters Photography* (2000).

reversal process. See TRANSPARENCIES.

Rheims, Bettina (b. 1952), French photographer who began in 1978 after working as a model, journalist, and lab assistant. She is extremely versatile, succeeding in fashion, advertising, portraiture, and photojournalism; but made her name with stylish nudes and studies of disconcertingly unprepossessing teenagers (*Modern Lovers*,

1990), transsexuals (*Les Espionnes*, 1992) and women posing provocatively in hotel rooms (*Chambre Close*, 1992). In 1997 she made a controversial series, *I.N.R.I.*, of images recreating the life of Christ, published in 1998 with the writer Serge Bramly. She has received numerous awards. RL

Riboud, Marc (b. 1923), French photojournalist, born in Lyon. Trained as an engineer, he inherited a love of photography and, eventually, a *Leica from his father. Abandoning engineering, he came to Paris in 1950 to seek a career in photography, and became a member of *Magnum in 1952, very much under the wing of *Cartier-Bresson and Robert *Capa. His superb image of the painter of the Eiffel Tower (1953) was published in *Life* magazine, and defined his style: an elegant and simple composition, with the human figure at its heart. From 1955 he travelled the world, spending an increasing amount of time in the Far East, for whose people and landscapes he showed a great affinity. His work in China, to which he has returned many times, is an extraordinary record of change. But his best-known image was made elsewhere. In Washington for the anti-Vietnam War demonstrations of 1967, he made a picture of Jan Rose Kasmir offering a flower to the bayonets of National Guardsmen that has become an icon of pacifism. PH

Marc Riboud, photos choisies, 1953–1985 (1985).

Riefenstahl, Leni (1902–2003), German dancer, actress, film-maker, and photographer. She became famous in a series of spectacular mountain films by Arnold Fanck, and directed another, *The Blue Light*, in 1931. Admired by the film enthusiast Hitler, she made several propaganda documentaries for the Nazi regime, of which the most celebrated and influential were *Triumph of the Will* (1935) and *Olympia* (1938). After the *Berlin Olympics she also published a book of still photographs (republished as *Olympia* in 2002), and after the Second World War, when she found herself, because of her former Nazi associations, more or less excluded from film-making, she embarked on a second career as a photographer. Particularly notable was her study of the Nuba people of the Sudan, *Last of the Nuba* (1974). A woman of enormous energy and determination, she took up *underwater photography at the age of 71, published two books of underwater pictures, and was still diving at 98. An English translation of her autobiography (1987) appeared in 1992. The following year she was the subject of a revealing television documentary by Ray Müller. RL

Riis, Jacob Augustus (1849–1914), Danish-born American *documentary photographer. In 1870 he emigrated to New York, and for three years worked as a labourer, living in the streets and doss-houses he would later photograph. Hired in 1873 as a police reporter for the *New York Tribune* and later the *Evening Sun*, he was convinced that the poor were essentially victims of their unhealthy surroundings, and attempted to convey this reformist message to his readers. He knew little or nothing about photography; but in 1887, when he read

about *Miethe and Gaedicke's invention of flashpowder in Germany, he realized that the camera might do what his reporting had not been able to achieve. He persuaded two amateur photographer friends to help him photograph the lower East Side of New York by night, then bought a camera himself. His sensationalist lantern-slide lectures made his audience confront every detail of the squalor that his flashlit images revealed. Disappointed with the crude woodcuts of his photographs that the *New York Sun* published in 'Flashes from the Slums' in 1888, Riis published his best images and an accompanying text in *How the Other Half Lives* (1890). *Half-tone reproductions of his photographs changed the patterns of contemporary journalism. This and subsequent books helped promote legislation that changed some of the conditions he had documented. CBS

Martin, R. (ed.), *Floods of Light* (1982).
Trachtenberg, A., *Reading American Photographs* (1989).

ringl + pit. See AUERBACH, ELLEN.

Ritts, Herb (1952–2002), American fashion and celebrity photographer, born and active in Los Angeles. He took up photography, self-taught, at the end of the 1970s, achieving fame with a serendipitous portrait of the then rising young actor Richard Gere at a petrol station. In the 1980s he worked with magazines such as *Vogue, *Vanity Fair, and *Rolling Stone* and fashion houses like Armani and Versace. He became famous for his ultra-stylish black-and-white portraits, and directed music videos with superstars like Madonna and Michael Jackson. A major exhibition of his work at the Boston Museum of Fine Arts in 1996 attracted a quarter of a million visitors. RL

Herb Ritts: Work (1996).

Riwkin, Anna (1908–70), Russian-born Swedish photographer, initially trained as a dancer. Her first studio, specializing in portraiture and dance photography, opened in 1928. After succeeding as a portraitist she moved into reportage and book production. After *The Art of Dance in Sweden*, further books resulted from travel in Israel, Greece, Yugoslavia, and Korea, and among northern Sweden's Sami people. Her portrait of Elle Kari, a young Sami girl, being dressed by her father, and an image of an Israeli woman with upstretched arms, appeared in the *Family of Man* exhibition in 1954. J-EL

Wigh, L., *Anna Riwkin: Porträtt av en fotograf* (2004).

Robertson, Grace (b. 1930), English photographer. Robertson is unusual for having been a female photojournalist in a man's world. Disciplined by both her chosen medium and her situation, she wrote: 'I developed my working method in the belief that as a photojournalist, with strong leanings towards pure documentary, I should not let my feelings dictate the photographic process.' Nonetheless, as a woman she tended to be given the 'softer' stories, even during her time on *Picture Post* (1950–7). (One of her stories, on the birth of a baby, was killed for being 'too bloody'; wars, evidently, were not.) She also worked for Simon Guttmann's *Report* agency from 1949, and as a

Grace Robertson

From *Mothers' Day Off*, 1954

freelance for *Life in the 1950s. She continued to photograph while working as a teacher in the 1960s and 1970s, and began painting in the 1980s. AH

Grace Robertson, Photojournalist of the 1950s (1989).

Robertson, James (1813–82?), British photographer. Robertson was chief engraver and superintendent of the Imperial Mint in Constantinople, where his earliest dated photographs (1854) were made. In 1856 he photographed the Crimean War. He attracted notice when his photographs were exhibited in London with those of Roger *Fenton. In 1857 he was appointed official photographer to the British army in India and travelled with Felice, and perhaps Antonio, *Beato to photograph the aftermath of the Indian Rebellion. They photographed in Egypt and Palestine en route to India (confusion regarding which brothers participated is due to signatures on photographs which include 'Robertson and Beato' and 'Robertson Beato *et cie.*'). Initially, in Constantinople and the Crimea, Robertson worked with the paper-negative system, but later mastered the *wet-plate process to produce highly detailed albumen prints from large glass negatives. KSH

Perez, N. N., *Focus East: Early Photography in the Near East, 1839–1885* (1988).

Robinson, Henry Peach (1830–1901), English photographer, born in Ludlow, Shropshire. Apprenticed to a printer and bookseller, he took up photography after seeing the *Great Exhibition of 1851. From 1857 to 1864 he operated a portrait studio in Leamington Spa, but scaled back business due to ill health. Inspired by O. G. *Rejlander's *The Two Ways of Life* (1857), he exhibited elaborate combination prints of genre subjects such as the controversial deathbed scene, *Fading Away* (1858), and *Pre-Raphaelite narratives like *The Lady of Shalott* (1860–1). Robinson published extensively on photographic aesthetics, arguing for photography as a 'pictorial' art, transformed from mechanical transcription through the application of the conventions of academic painting. He believed that, like other art forms, the photograph could bear the marks of its maker, with its own visual qualities and expressive modes. In this, he was more in sympathy with the next generation of photographers, such as Alfred Maskell and George *Davison, with whom he founded the *Linked Ring Brotherhood in 1892. He exhibited at the Ring's Photographic Salon until 1900. HWK

Harker, M. F., *Henry Peach Robinson: Master of Photographic Art, 1830–1901* (1988).

Rodchenko, Alexander (1891–1956), Russian artist and photographer. Born in St Petersburg, Rodchenko pursued a career in painting and design, where his activities varied from teaching art theory in Moscow to winning competitions for the design of newspaper kiosks. His contributions to the Soviet pavilion at the 1925 Exposition Internationale des Arts Décoratifs in Paris, including the catalogue cover and designs for workers' clothing, attracted international interest. His first work with the camera, in the early 1920s, followed his increasing Constructivist focus on applied and socially responsible art. From 1923 to 1928 he produced photo-articles for the magazine *Novy Lef*, and included close-ups and low-angle shots in a varied repertoire of camera viewpoints. He also created *photomontages and wrote in praise of snapshot photography's ability to record a rapidly changing world. His style (particularly his camera angles) attracted hostility towards the end of the decade, and detractors denounced 'bourgeois' and foreign influences. Nevertheless, in the 1930s he was employed on documentary projects (including one on the notorious *White Sea Canal) for *USSR in Construction*, a large-format publication promoting Russian achievements. Criticism persisted, however, and Rodchenko's later years were spent in obscurity. In a post-war diary entry, he recognized that he had, in effect, become invisible. RP

See also SOCIALIST REALISM.

Lavrentiev, A., *Rodchenko: Photography, 1924–1954* (1996).

Rodger, George (1908–95), British photojournalist, formed in the photojournalistic tradition of the *Black Star agency and *Life magazine. He spent the Second World War as a correspondent covering Europe, Burma, and the North African campaigns. It was after he caught himself aesthetically 'framing' an image of the heaped corpses at Belsen that he decided to leave war and Europe behind him. A founder member of the *Magnum agency, he chose Africa as his section of the globe. His subsequent projects bore witness to his commitment. Looking back on his career, he cited the story of a secret circumcision ritual among Masai warriors as 'the first I've felt really happy about since I was living among the Nuba in the Upper Nile thirty years ago . . . I was much more at home with them than in any city in the world.' A reportage photographer without frills, he spent time and dedication on understanding his subjects. His most famous series of portraits will probably be the most original: the Sudanese wrestlers of the desert, who bear one another into battle on their shoulders and fight naked, their copper bracelets their only weapon. AH

Osman, C., *George Rodger, Magnum Opus: Fifty Years in Photojournalism* (1987).

Rodr´guez, Melitón (1875–1923), self-taught Columbian photographer, resident in the north-western town of Medellín. He did his best work c.1890–1920, as Medellín was developing rapidly into an industrial centre, with an ethnically diverse population of European entrepreneurs and indigenous workers. Conditions were rough; there was no electricity until 1912. Rodríguez did portraits, street and social scenes, and documentary photographs of mining and railway building. He won a gold medal in Paris in 1896 and socialized with the town's intelligentsia, but was apparently very poor. His photographs, though taken during the *pictorialist era, appeal because of their rawness and lack of pretension. His archive of c.80,000 negatives is held by the Biblioteca Pública Piloto de Medellín. RL

Watriss, W., and Zamora, L. P. (eds.), *Image and Memory: Photography from Latin America, 1866–1994* (1998).

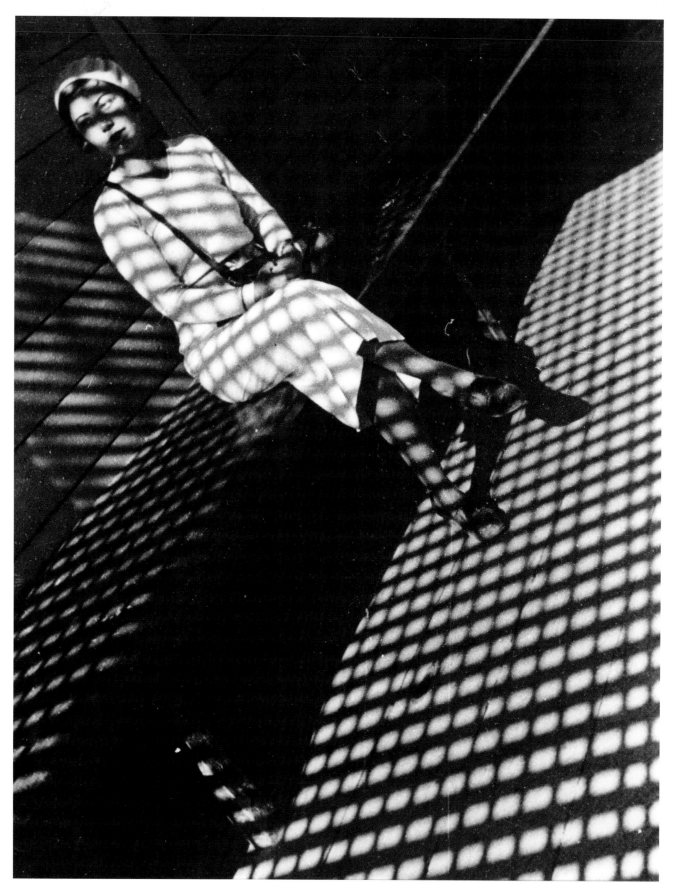

Alexander Rodchenko

Girl with Leica, 1934

Roh, Franz (1890–1965), German art historian, experimental photographer, and influential theorist and critic of avant-garde film and photography. After studying philosophy and art history (1908–18), and working as assistant to the art historian Heinrich Wölfflin, he became a freelance writer and critic. Between 1923 and 1933, however, encouraged by László *Moholy-Nagy, he also produced important experimental photographs, using techniques (often in combination) such as multiple and negative printing, collage, and *photograms to create fantastic, sometimes disturbing images. In 1929, with Jan Tschichold, he published a classic study of the subject, *foto-auge, 76 Fotos der Zeit*. After 'internal emigration' between 1933 and 1945, during which he continued to do some experimental work, he resumed his critical and academic career, only publicizing his photographs near the end of his life. LAL

See also ABSTRACT AND EXPERIMENTAL PHOTOGRAPHY.

Rotzler, W., *Photographie als künstlerisches Experiment: Von Fox Talbot zu Moholy-Nagy* (1974).
Franz Roh (1981).

Rolleiflex, a twin-lens reflex (TLR) camera, and *classic of photographic history. The basic design (incorporating two lenses, one for viewing and one for taking) dated from the 19th century, and by 1900 advertisements showed many commercial models. Yet in 1911 R. Child Bayley remarked that 'bulk and weight . . . have made twin lens cameras virtually obsolete'. However, the German manufacturers Franke & Heidecke brilliantly overcame these drawbacks. Benefiting from experience gained in making the Heidoscop and Rolleidoscop *stereoscopic cameras, the company designed an all-metal compact, TLR camera with a small—6 × 6 cm ($2^1/_4 \times 2^1/_4$ in)—*roll-film format, worlds apart from its clumsy predecessors. Called the Rolleiflex and introduced in 1928, it was conceived as a completely self-contained photographic system. No interchangeable lenses were offered and other accessories were limited. A British review of 1932 hailed it as 'one of the masterpieces of recent camera design'. A smaller-format—4 × 4 cm ($1^5/_8 \times 1^5/_8$ in)—alternative version was launched in 1931, and a simpler version of the main model, the Rolleicord, in 1933.

The Rolleiflex revived interest in TLR design and led to many imitations from other manufacturers. Several sold well, but from the 1930s until the 1960s, a succession of Rolleiflex models became the first choice of enormous numbers of professional and amateur photographers. Quality, compact size, and the ability to focus and compose up to and during exposure made it a particular favourite of press photographers and other professionals seeking action shots. The Rolleiflex disappeared in the 1970s, displaced by modern single-lens reflex cameras with instant-return mirrors and interchangeable lenses. However, two new models, incorporating *through-the-lens metering and other refinements, were launched in 2002. JPW

Mannheim, L. A., *The Rollei Way: The Rolleiflex and Rolleicord Photographer's Companion* (6th edn. 1959).

roll-film. In 1854, the English inventor Arthur James Melhuish (d. 1895) registered a patent for a roll-holder for *calotype paper. Although it remained impractical and little used, this patent signalled the beginning of the race to invent a flexible rolled film. In 1884 George *Eastman introduced a flexible gelatined-paper film, and in 1885 launched the Eastman-Walker roll-holder, taking a 24-exposure paper film and suitable for attachment to standard plate cameras. Eastman also became involved in a lawsuit with the Revd Hannibal Goodwin (1822–1900), who in May 1887 applied for a patent for a 'photographic pellicle and process of producing same'. However, his application was referred back for revision seven times by the Patent Office. It was finally issued in 1889, the year that Eastman obtained a patent for the improved form of *celluloid developed by Henry Reichenbach. With the *Kodak roll-film camera already dominating the market, Goodwin's contribution was eclipsed, even when the courts found in his favour in 1898. KEW

Coe, B., *The Birth of Photography: The Story of the Formative Years 1800–1900* (1976).

Römer, Willy (1887–1979), Berlin-based German photojournalist who covered numerous events of the German Revolution, including the Spartakist rising of January 1919. Berlin's status as a leading press centre, with numerous *agencies and newspaper offices, meant that Römer's images, captured despite the limitations of a heavy Deckrullo-Nettel plate camera, were widely disseminated. His picture agency, Photothek, prospered in the 1920s but closed in 1935, partly because of Nazi pressure. Its archive of *c*.50,000 negatives still existed at Römer's death. RL

Kerbs, D. (ed.), *Auf den Strassen von Berlin: Der Fotograf Willy Römer 1887–1979* (2004).

Ronis, Willy (b. 1910), French photographer, born in Paris and a leading figure in French humanism, active well into his nineties. A lifelong passion for music can be detected in many of his pictures, their careful and elegant composition evoking the tripartite structure of a Bach fugue. His fascination with the street, and with the muted tonality of Parisian light, also attests to an early encounter with Dutch painting of the 16th and 17th centuries, with Brueghel his acknowledged master.

Working freelance for the press from 1936, Ronis was briefly associated with his friend Robert *Capa's pre-war attempts to create a photo agency; his pictures were then credited to 'Roness'. He joined Emmanuel *Sougez's Groupe du Rectangle, a sort of *Group f.64 *à la française*, and belonged, with *Cartier-Bresson and others, to the communist Association d'Écrivains et Artistes Revolutionnaires. Much of his social reportage was informed by left-wing sympathies, reinforced after the Second World War by his marriage to the painter Marie-Anne Lansiaux (1910–91), a French Communist Party militant. Her son Vincent was the subject of many of Ronis's best-known pictures.

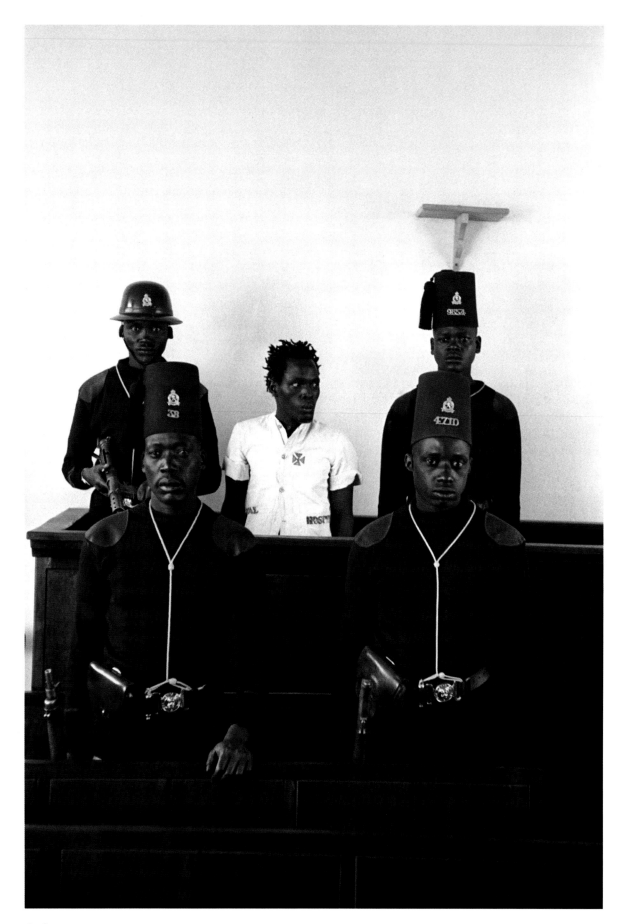

George Rodger

General China, Kenya, 1954

Exhibited with *Brassaï, Cartier-Bresson, *Doisneau, and *Izis at MoMA, New York, in 1951, Ronis had become an internationally recognized photographer, and a key member of the *Rapho agency and the Parisian Groupe du XV. His reputation was increased by the huge success of *Nu provençal* (1949), a portrait of his wife at her toilette on a hot day in the south. (Ronis was to live in Provence from the 1960s to the 1980s, and made an impressive body of work there.) Like so much of his work, it is a slice of everyday life, taken 'by chance' when the opportunity presented itself. His many nude studies share a delicacy and beauty that pay homage to the female form. Fashion work for *Jardin des modes* and *Vogue* displays this interest in a natural beauty, in which clothes are part of everyday life, rather than exotic plumage.

Ronis's strong character and personal integrity may have limited his opportunities in the press during the 1960s and 1970s. He resigned for political reasons from Rapho in 1955, after one of his pictures of a strike was used, without his knowledge, with an anti-communist caption in the *New York Times* (he rejoined in 1980).

The photographer of Paris par excellence, his work on the working-class area of Belleville-Ménilmontant (begun in 1947, first published as a book in 1954, but continued ever since) is among the great achievements of humanist photography. As Pierre *Mac Orlan told him, his work is a 'poetry of the street', brilliant and sympathetic evocations of a way of life. PH

Hamilton, P., *Willy Ronis: Photographs 1926–1995* (1995).

Röntgen, Wilhelm (1845–1923), German physicist, and in 1901 the first winner of the Nobel Prize for Physics. During his academic career in Germany he made major contributions to electrical theory. In 1895, while investigating cathode rays, he noticed luminescence in chemicals hidden behind a screen: this led him to the development of X-ray imagery. He retired in 1920, and died in poverty following Germany's runaway inflation. GS

Glasser, O., *Wilhelm Konrad Röntgen and the Early History of the Roentgen Rays* (1993).

Root, Marcus Aurelius (1808–88), American photographer who learned *daguerreotypy from Robert Cornelius c.1840. He ran a succession of photographic businesses, in Mobile, New Orleans, St Louis, and Philadelphia, where he bought the 140 Chestnut Street business of John Jabez Edwin *Mayall in 1846. He opened galleries in New York, 1849, managed by his brother Samuel, and in Washington, DC, in 1852. He wrote a celebrated early survey of the medium, *The Camera and the Pencil* (1864). LR

Finkel, K. E., *Nineteenth-Century Photography in Philadelphia: 250 Historic Prints from the Library Company of Philadelphia* (1980).

Rosenblum, Walter (b. 1919), American photographer, born in poverty on the Lower East Side of New York, who studied photography with Paul *Strand and Lewis *Hine at the Photo League (1937–40). He was closely associated with the League from 1938 until McCarthy-era blacklisting destroyed it in 1952. As a photographer with the US Army

Signal Corps during the Second World War (1943–5), he was the first photographer to enter Dachau. Although an accomplished *documentary photographer himself, he is best known as the cataloguer and preserver of the Lewis Hine collection, and as one of the first university-based teachers of photography. He joined the faculty of Brooklyn College, New York, in 1947, and taught there and for the Yale Summer School of Music and Art in Norfolk, Connecticut, until his retirement in 1977. His approach to photography, of social concern linked to aesthetic control, had a profound impact on the generations of students he taught. A 1979 Guggenheim Fellowship funded his *People of the South Bronx* exhibition, which exemplified the best of that tradition. CBS

Rössler, Jaroslav (1902–90), Czech avant-garde photographer whose 1920s work has been described by Vladimír Birgus as 'the most pronounced expression of Czech Constructivist photography'. Apprenticed to František *Drtikol in Prague at the age of 14, Rössler was producing cubo-futuristic montages and *photograms by the early 1920s, and became linked with various avant-garde groups and journals. He moved to Paris in 1927, but returned to Prague after being deported in 1935. In the 1930s, like many of his European modernist colleagues, he successfully applied experimental techniques to advertising. LAL

Birgus, V. (ed.), *Czech Photographic Avant-Garde, 1918–1948* (2002).

Rothstein, Arthur (1915–85), American *documentary photographer, born and educated in New York. While at Columbia University he worked with the agricultural economists Rexford Tugwell and Roy *Stryker to collect and copy photographs for their study of American agriculture. In 1935, when Tugwell founded the Resettlement Administration (later Farm Security Administration (FSA)) and hired Stryker to head the Historical Section's photographic project, Stryker chose Rothstein to establish the photographic laboratory. There he met and was influenced by Walker *Evans, and admired the work of Ben *Shahn and Dorothea *Lange, becoming eventually one of the FSA's key photographers, working for Stryker for the next five years. In 1940, he left to work as a photographer for *Look* magazine, returning briefly to work under Stryker in the Office of War Information in 1942, when he was drafted and served in India, Burma, and China with the US Army Signal Corps. From 1946 to 1971 he was director of photography for *Look*, then (1972–6) for *Parade*. The gentle charm of his FSA 'people' images illustrates the effectiveness of a photographic technique that became a staple of *photojournalism, the 'unobtrusive camera'. CBS

Rothstein, A., *The Depression Years as Photographed by Arthur Rothstein* (1978).

Royal Engineers (RE). While civil engineers were quick to realize the potential uses of photography as a recording tool in their profession, it was not until the mid-1850s, in Britain, that the medium was adopted by the *military. After largely unsuccessful attempts at photography during the Crimean War (1853–6), the

Anon.

Staff sergeants, Royal Engineers, with photographic and other equipment, Chatham, 1868. Albumen print

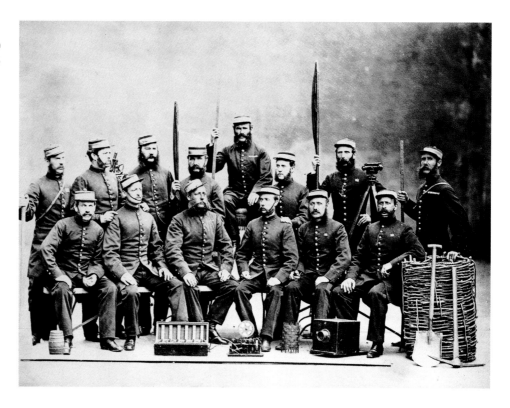

involvement of RE personnel in the construction of the South Kensington Museum was seen as a good opportunity to widen the photographic skills within the corps and led, in 1856, to a number of sappers receiving instruction in photography from the museum's photographer, Charles Thurston Thompson (1816–68). Shortly afterwards, courses in photography were officially established under Captain Henry Schaw at the RE Institution at Chatham, and henceforth until 1904, when it was absorbed into the Survey School, the Photographic School retained an independent status.

While the main purpose of this photographic work was to support the technical demands of the corps in both its day-to-day operations and on campaign, sappers were also officially encouraged to use the camera for more general photography. As a result, between the 1850s and 1870s, they produced some remarkable work, both in the course of their military duties and on secondment to other projects. The photographic influence of the Royal Engineers was thus felt well beyond the corps itself: in addition to producing photographers and photographic chemists of the international standing of Sir William de Wiveleslie *Abney, the Photographic School at Chatham was also involved in training photographers for expedition work (such as two members of the Nares Arctic Expedition of 1875–6); sappers with photographic training were routinely attached to survey parties (such as Corporal Lawson, who accompanied Charles Gordon on his Russo-Turkish border survey of 1857), while the photographic department of the *Archaeological Survey of India (ASI; f. 1870) was heavily reliant in its formative years on the expertise of the sappers

who undertook much of the technical work. Already by 1860, John Donnelly, writing on the military applications of photography, was able to enumerate RE photographs taken in places as varied as Panama, India, Singapore, China, and Russia. While Sergeant John Harrold (who was to spend his later years with the ASI) produced over 15,000 prints of maps for use during the Abyssinian Campaign of 1867–8, his photographic record of the progress of the campaign itself and the country through which it passed is of far greater historical interest. Arguably the most significant work of RE photographers was of a semi-military or civilian nature, where their skills were placed at the disposal of scholarship in a variety of fields: the two sappers (Corporals B. L. Spackman and J. McCartney) who accompanied Charles Thomas Newton's British Museum expedition to Halicarnassus and Cnidus in 1857–9 made one of the earliest detailed records of a major archaeological investigation, while in the survey field sappers produced an exhaustive record of the Canadian Boundary Commissions of 1858–62 and 1872–3, concentrating their photography as much on the people, landscapes, and daily life of the country as on their professional operations. Perhaps the most distinguished of the many photographers who received their training at Chatham was Colour Sergeant James McDonald (1822–85), who in the course of Ordnance Survey operations in Jerusalem (1864–5) and Sinai (1868–9) produced a magnificent series of technically assured and evocative views of the topography and architecture of the Holy Land, which remain a documentary resource of major importance. JF

Royal Geographical Society (RGS), London, founded in 1830 in order, as its royal charter states, 'to advance geographical science and improve geographical knowledge'. From the beginning, the society has actively collected books, maps, manuscripts, and photographs in the pursuit of this aim. It is interesting to consider that the RGS and photography became established in the same decade. The apparently empirical approach that photography offered was seized upon by geographers and scientists as a way of mapping and recording. Photographs became a tool of science and an important archival resource, and the society's Fellows were soon sending in prints and negatives from their travels and expeditions. The distinguished British photographer John *Thomson was appointed as 'Official Instructor of Photography' in 1886 and gave lessons to aspiring travellers. Today the RGS holds upwards of 500,000 images, and continues to promote the use of photography in its expeditions and research work and to accept donations from its fellowship. It has significant holdings on the polar regions, Mount Everest, Africa, and Arabia. JW

Hemming, J., *Royal Geographical Society Illustrated* (1997).

Royal Naval Photographic Branch. Founded in 1919, mainly for use in gunnery training, it developed into a body of specialists performing multifarious tasks for the navy, Fleet Air Arm, and Royal Marines, from documenting flight-deck accidents and weapons tests to intelligence work and combat photography and cinematography. (During the Second World War its activities were complemented by those of civilian professionals enlisted as Admiralty press photographers.) Public-relations needs, requiring positive images of the navy's role in a changing society, have significantly influenced the branch's capability since 1945. In 1997, dramatic pictures of relief operations during the Montserrat volcano eruption could be instantly transmitted to civilian news organizations. The Imperial War Museum, London, holds *c.*1 million official naval photographs; images of life aboard the royal yacht *Britannia* are in the Royal Collection at Windsor. RL

See also MILITARY PHOTOGRAPHY.

Mercer, N., *Camera at Sea: The History of the Royal Naval Photographic Branch 1919–98* (1998).

Royal Photographic Society (RPS). In January 1852, on the initiative of Roger *Fenton, a public meeting was held at the Society of Arts, London, in order to form a photographic society. Robert *Hunt and Henry *Talbot also supported the idea, based loosely on the already established Calotype Society (f. 1847) and the *Société Héliographique (f. 1851), but it was not until 20 January 1853 that the Photographic Society of London was founded. Its declared aim was 'the promotion of the Art and Science of Photography, by the interchange of thought and experience between Photographers'. Even in its embryonic form the group played a historic role, inducing Talbot, as he told William Parsons, Earl of Rosse, in a letter of 30 July 1852, to make his inventions freely available to the public. It also

precipitated the demise of Talbot's *calotype patent in 1854. No ill will existed, however, between the members of the new society and Talbot; in fact, he was offered the presidency. When he declined, Sir Charles Eastlake, president of the Royal Academy, was elected, with Fenton as secretary. Queen Victoria and Prince Albert became patrons. The prefix 'Royal' was granted in 1894.

Two records of photographic history, the *Journal of the Royal Photographic Society* and the RPS collection, continue to inform scholarship across a wide range of photographic subjects. Collecting began in 1892 at the suggestion of the photographer William Bedford, though the idea of a permanent collection had been previously mooted. But growth was slow, and when John Dudley Johnston (d. 1955) was appointed honorary curator in 1924, the collection comprised only *c.*100 photographs. By 1930, he had secured works by Henry Peach *Robinson, Frederick *Evans, and Julia Margaret *Cameron, as well as the private collections of Harold Holcroft and Alvin Langdon *Coburn. The RPS collection currently incorporates over 270,000 images: *daguerreotypes, calotypes, *salted-paper prints, *albumen prints, *ambrotypes, glass negatives, and examples of experimental colour processes. It includes over 6,000 items of photographic equipment, 13,000 books, 13,000 bound periodicals, and 5,000 other photography-related documents.

At the beginning of the 21st century, the RPS had over 10,000 members worldwide, practising all types of creative and technical photography, a degree of diversity reflected in the wide range of awards distributed by the society every year. In 2004 the RPS was granted a royal charter. JF/KEW

Roberts, P., *Photogenic: From the Collection of the Royal Photographic Society* (2000).

royalty and photography. Many monarchs who never touched a camera found uses for photography and, in the 20th century, had to adapt to the ubiquitous presence of photographers. Royal engagement with the medium has included photograph collecting; patronage of photographers and their associations; the initiation of major photographic projects; and strategies to manage the representation of royalty in modern societies.

In the background was the 19th-century concept of 'bourgeois monarchy'. In countries like the Netherlands and Great Britain this was paired with 'limited monarchy' and constitutionalism. But even in states such as Prussia and Russia, where monarchs had far greater powers, its moral and personal aspects were influential. These were exemplified, on the one hand, by expectations of gentlemanly conduct, dedication, and self-discipline and, on the other, by a distinction between office and person, and recognition that a monarch could have a private life separate from the ceremonial sphere. Railways and country residences facilitated this, with retreats like Balmoral, Livadia, and Hohenschwangau offering more privacy and comfort than hotel-like draughty piles such as Buckingham Palace, the Winter Palace, and the Munich *Residenz*. Royal yachts served the same purpose. With such amenities, even an autocrat

547

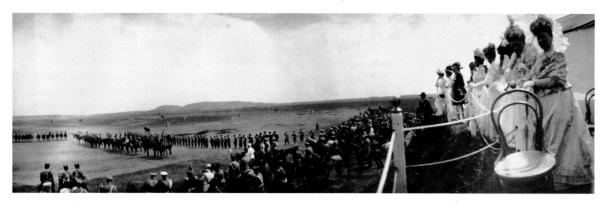

Anon.

Panoramic photographs from an album of the Russian imperial family, taken with a Kodak Panoram camera, 1903–12

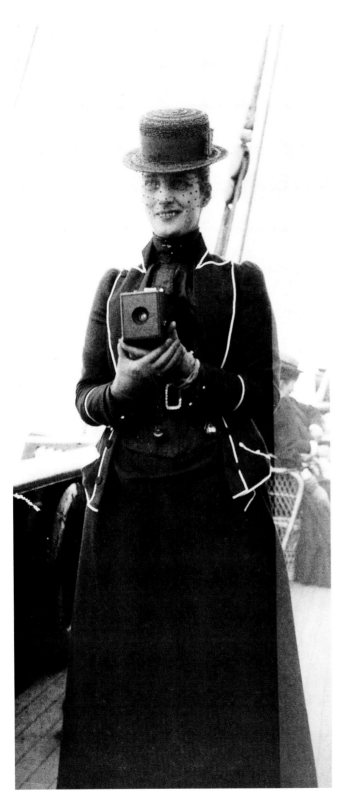

Anon.

Alexandra, princess of Wales, c.1889

like Tsar Nicholas II could spend time playing the paterfamilias, sportsman, and squire.

Photography, sometimes by professionals but increasingly by monarchs themselves or their families, was a means of demarcating this private sphere and chronicling its activities. Initially the pictures, assembled in family albums, remained strictly private. But eventually selected samples began to be made public, sometimes with the quasi-propagandistic aim of lending monarchies an appealingly 'ordinary' image as external events threatened their survival. Occasionally, if a home-made product did not exist, it was re-created. A classic British example was the 1936 series of informal portraits by Lisa Sheridan of George VI's young daughters, Elizabeth and Margaret, at play with their pets, which evoked a domestic idyll after the bruising abdication crisis. This was a stage in an ongoing process of negotiation, starting in Edward VII's reign (1901–10), between the monarchy and the media, in which the stakes were privacy for the royal family in exchange for glimpses of real or constructed intimacy for the press. The process reached its apogee in Elizabeth II's reign (1952–), but in an environment in which fascination with royalty merged with a global celebrity culture, and challenges to privacy increased.

A comprehensive history of monarchies' involvement with photography has yet to be written. But examples from German-speaking Central Europe, France, Russia, Turkey, and, again, Britain suggest key themes.

Central Europe

The region developed a rich photographic culture and, until 1918, also had a plethora of princely houses, ranging from the rulers of minute principalities to heavyweight dynasties like the Austrian Habsburgs and Prussian Hohenzollerns. In Vienna, Archduchess Maria Theresia, sister-in-law of Emperor Franz Joseph, was a keen amateur and patron of important photographic events in the city, and in the early 1860s Empress Elizabeth was one of many keen royal collectors of *celebrity portraits. In Berlin, although Friedrich Wilhelm IV had had his portrait taken as early as 1847, the first serious royal amateur was apparently Princess Victoria, daughter of Queen Victoria, who married Crown Prince (later, briefly, Emperor) Friedrich in 1858. Later, her granddaughter Viktoria Luise became a lifelong snapshooter. But the most interesting case was Victoria's son, Emperor Wilhelm II. Although Wilhelm probably took no photographs himself, his reign (1888–1918) coincided with the emergence of *photojournalism, and his histrionic public appearances and passion for dressing up fed an increasingly image-hungry mass press. Even cruises aboard the imperial yacht were accompanied by a photographer. (When Wilhelm visited Palestine in 1898, a French cartoonist depicted him, posing theatrically in uniform, surrounded by shutter-clicking hacks.) Wilhelm's craving for publicity, but inability to use it constructively, doubtless helped to convey an image of him—and, by extension, Germany—as a dynamic but unpredictable player on the international scene.

Alexandra, queen of England

Tsarevich Alexis Nicholaievich, Reval (Tallin), June 1908

Bavaria's art-loving king, Ludwig I (reg. 1825–48), was immediately captivated by the idea of photography; and in August 1839, after receiving three sample images from *Daguerre, had the Frenchman admitted to the Bavarian Academy of Sciences. The same month, the Munich pioneer Franz Kobell demonstrated the process to the court. Ludwig's son Maximilian II (reg. 1848–64) patronized the Munich photographers Franz *Hanfstaengl and, especially, Joseph *Albert, who became a regular visitor at the royal family's summer retreat at Hohenschwangau, and photographed Maximilian on his deathbed in March 1864. However, patronage of Albert increased exponentially under Ludwig II (reg. 1864–86), who commissioned innumerable portraits and lent him funds for a sumptuous new studio. From 1868 Albert also became a key figure in Ludwig's castle-building programme, not only documenting construction but photographing interiors and decorative details at Versailles and elsewhere to provide copy material for the craftsmen—commissions which often pushed his technical ingenuity to the limit. Although the king's death in June 1886 halted construction, Albert continued to profit from the buildings' tourist appeal.

France

Photography's efflorescence under the Second Empire (1852–70) owed much to imperial patronage, although the roles of Napoleon III and the state are not always precisely distinguishable. *Bisson, *Le Gray, Mayer & Pierson, *Nègre, and, above all, *Disdéri were among the best-known beneficiaries. Both Napoleon and Empress Eugénie were keenly interested in photography: the latter as a portrait collector, the former undoubtedly for propagandistic reasons. The regime's watchwords were modernization, social stability, and national revival. Court and public festivities, military exercises, railway building, Baron Haussmann's transformation of Paris, and pioneering institutions (e.g. the Imperial Asylum at Vincennes for disabled workmen, photographed by Nègre in 1859) were all recorded. The imperial family was constantly photographed, as were the court's activities at summer retreats like Saint-Cloud and Compiègne, although many of these more private pictures were later destroyed.

Russia

Particularly interesting, as Alia Barkovets has described it, was the reign of Tsar Nicholas II (1894–1917). He continued the practice of retaining a court photographer: initially the veteran Sergei *Levitsky, who had held the post since 1877, but then, until his death in 1916, A. K. Yagelsky, who worked under the commercial name of C. E. de Hahn. Ever in attendance, Yagelsky covered the imperial family's public and private activities—from c.1900 also with a cinematograph—travelled with them, and instructed the children; his thousands of pictures appeared both in official publications and in the Romanov albums. Despite his shyness, Nicholas was comfortable with this arrangement, and contemporary observers described him being photographed, both by 'Hahn' and others, wherever he went. Nicholas also dispensed important patronage, most notably to Sergei *Prokudin-Gorskii, whose ambitious scheme to create a

colour-photographic survey of the empire was supported with money and practical assistance. Finally, almost the entire imperial family were keen amateurs. Nicholas probably acquired the habit from his wife, Alexandra of Hesse-Darmstadt, although his mother was also interested. Eventually their daughters Olga, Tatiana, and Anastasia all acquired their own photographic outfits and albums, and Nicholas amused himself with a Kodak panoramic camera. Picnics, tennis matches, family get-togethers, cruises, and even Nicholas's dangerous illness in 1900 were recorded and the pictures pasted into albums, an activity that the tsar found therapeutic. 'After breakfast', he wrote in his diary on 12 December 1913, 'many people pestered me with intolerable questions which vexed and annoyed me! Had a good walk in between the showers. Glued photographs into the album.' This continued during the First World War and in the first months after Nicholas's abdication in February 1917, though not in the family's final period of captivity at Ekaterinburg. On 17 July 1918, by a grisly coincidence, the Romanovs' chief executioner was a former professional photographer. RL

Turkey

Ottoman sultans beginning with Abdul Aziz (1861–76) took an interest in photography. Court ceremonies were photographed, and official portraits were made of members of the royal family. During his long reign, Abdul Hamid (1876–1909) expanded the official uses of photography in various ways, employing numerous court photographers.

The Abdul Hamid albums, assembled at the behest of the sultan for presentation to the American and British governments in 1893 and 1894, conveyed a very particular view of the Ottoman Empire to those audiences. The two sets of albums are nearly identical, each consisting of 51 volumes containing about 1,820 photographs. These focus primarily on the most up-to-date aspects of the empire: the modern city or major architectural monuments; military installations, including training establishments, hospitals, and troops; schools and their students; and accoutrements of the palace. Hundreds of photographs depict people, including, for example, the sixth class of the Military Medical School, complete with cadaver (an important sign of modernity).

A second important royal Ottoman project was the Yildiz albums, now in the Istanbul University Library. Filled with images from all over the empire taken on Abdul Hamid's orders, the albums contain approximately 34,879 photographs. These include the same views as the two presentation sets discussed above, as well as subjects unsuitable for export, such as the new police stations built throughout the empire, and prisoners accused of various crimes. Thought to have served as a means for the sultan to keep abreast of events in his far-flung dominions and abroad, the albums show official ceremonies, new Ottoman factories, catalogues of goods, portraits of officials, and monuments and works of art from Europe and Japan. They seem to exemplify the use of photography as a means of official surveillance which was emerging in other states as well as the Ottoman Empire. NM

Great Britain

The longest involvement of a major dynasty with photography has been that of the British one. Already by 1910, its collection contained c.25,000 items. Queen Victoria's consort, Prince Albert, was an energetic patron of the new medium until his death in 1861. One of his major projects, involving many photographers, was the inventorization of royal buildings and works of art, including a huge collection of Raphael drawings which was systematically photographed and combined with reproductions of works in other collections. Individual photographers favoured by Victoria and Albert included Roger *Fenton, who took numerous family portraits and received royal assistance (though not funds) for his Crimean journey in 1855; and Francis *Bedford, who was sent by Victoria to Albert's native Coburg in 1857 to take surprise pictures for his birthday, then to the Middle East with the prince of Wales in 1862. Another association was with George Washington *Wilson, who recorded Princess Victoria's engagement to the Prussian crown prince in September 1855 and became 'Photographer to the Queen' in Scotland. Wilson's 1863 *carte de visite portrait of Victoria on her pony Fyvie, attended by John Brown—an important go-between for Wilson at court—sold spectacularly, and five years later the photographer published a set of Scottish views designed to be bound with Victoria's best-selling *Leaves from the Journal of our Life in the Highlands*. Finally, the royal couple were enthusiastic photograph collectors, their acquisitions ranging from 1850s exhibition pieces by figures like Fenton, O. G. *Rejlander (whose *Two Ways of Life* (1857) hung in Albert's dressing room), Gustave *Le Gray (*The English Fleet at Cherbourg*, 1858), and John Murray (Indian views) to portraits and topical images from across the empire. Particularly moving was an annotated album of Crimean veterans and invalids—some displaying the projectiles that had maimed them—photographed on Victoria's instructions by Joseph Cundall, Robert *Howlett, and John *Mayall in 1855–6.

Although Prince Albert understood photographic technology, no pictures by him appear to have survived. But other family members, from Queen Victoria's daughter Victoria to Elizabeth II's son Andrew, became keen amateurs. Particularly talented and prolific was the Danish-born Princess (later Queen) Alexandra, who married Edward, prince of Wales, in 1863. Especially after acquiring a Kodak No. 1 roll-film camera in 1889 she became an assiduous photographer of public occasions, cruises, and meetings with her own and her husband's far-flung network of relations. In 1897, with other family members, she contributed to an exhibition organized by Kodak, and in 1908 published 136 of her photographs in a successful charity volume, *Queen Alexandra's Christmas Gift Book*.

Prince Albert had himself *daguerreotyped by Richard Beard (1801–85) in 1842, and subsequently private family portraits were taken by Fenton, Wilson, household members, or employees like Dr Ernst Becker (1826–88) and William Bambridge (1819–79), and various commercial firms. But it was not until 1860 that royal portraits could be sold, opening the way to a hugely profitable business. Registers at the National Archives, Kew, list hundreds of portraits

submitted for protection under the *Fine Art Copyright Act of 1862. The prince and princess of Wales especially, society's most glamorous couple, became domestic icons whose images appear in countless family albums, and who were photographed by most of the leading firms. In the 20th century, the style of royal portraiture ranged from domesticity (Sheridan in the 1930s) to romantic, fairy-tale regality (Cecil *Beaton from July 1939 into the 1950s) and a more modern, sophisticated glamour (Patrick *Lichfield and Lord *Snowdon in the 1960s and 1970s). By the 1990s, however, the royal image had become increasingly contested and difficult to control. In particular, Diana, princess of Wales's dual status as royal personage and global icon created an unprecedented situation that ultimately contributed to her death in September 1997. In the 21st century pictures of the British royal family will doubtless continue to be extremely lucrative. They will also reflect, and have a bearing on, the position of the monarchy and the family's relationship with the wider society. RL

Ranke, W., *Joseph Albert: Hofphotograph der bayerischen Könige* (1977).

Dimond F., and Taylor, R., *Crown & Camera: The Royal Family and Photography 1842–1910* (1987).

Gavin, C. (ed.), *Imperial Self-Portrait: The Ottoman Empire as Revealed in the Sultan Abdul Hamid II's Photograph Albums* (1988).

Barkovets, A., 'Photographs in the State Archive of the Russian Federation of the Last Russian Emperor and his Family', in R. Timms (ed.), *Nicholas & Alexandra: The Last Imperial Family of Tsarist Russia* (1998).

Dimond, F., *Developing the Picture: Queen Alexandra and the Art of Photography* (2004).

Rübelt, Lothar (1901–90), Austrian sportsman, sports photographer, and photojournalist. After becoming an Olympic sprinter in 1920 his success at selling sports photographs to the press led him to become a professional. In 1924 he and his brother Ekkehard bought motorbikes and made a spectacular, highly successful improvised film about the Dolomites, *Mit dem Motorrad über die Wolken* (*Biking over the Clouds*). But Ekkehard's death in a crash in 1926 led Lothar back to still photography, which he pursued to growing international acclaim, using *Ermanoxes and then *Leicas. In 1936 he covered the *Berlin Olympics for the *Berliner illustrirte. In 1938–9 he worked as a photojournalist, covering the Sudeten Crisis, Austria's annexation by Germany, and the Polish campaign. During the last three years of the Second World War he did specialist photographic work in a military hospital in Vienna. After 1945 he returned to sports photography. RL

Jagschitz, G., *Lothar Rübelt: Österreich zwischen den Kriegen. Zeitdokumente eines Photopioniers der 20er und 30er Jahre* (1979).

Rudolph, Paul (1858–1935), German mathematician and lens designer who joined Carl *Zeiss, Jena, in 1886 and played a leading role, with Ernst *Abbe, in the firm's diversification into photographic lenses. Among the classic optics he designed were the first Anastigmat (1890; later renamed the Protar), the Planar (1896), and the relatively small, light, and cheap four-element Tessar (1902). He retired from Zeiss in 1911, but continued to do optical research in the First World War for the military. RL

Ruff, Thomas (b. 1958), German photographer. A student of Bernd and Hilla *Becher at the Staatliche Kunstakademie, Düsseldorf, Ruff applied the analysis of form and type at first to large colour portraits of his classmates. Working in series, he has also explored stars, buildings, interiors, newspaper photographs, and Internet pornography. His repetitious use of flat lighting and a uniform viewpoint mimics surveillance photography, from the historic images of *Duchenne and *Bertillon to modern crime-scene photographs. Each series, especially those embodying *digital manipulation, is a visual meditation on photographic authenticity. KEW

Winzen, M. (ed.), *Thomas Ruff, Photographien 1979–heute* (2001).

Ruge, Willi (1892–1961), German photojournalist and agency proprietor, specializing in sports and aviation. He started photography in 1910 and between the wars, working mainly for the Berlin illustrated press, typified the new breed of modern daredevil photojournalist, taking spectacularly composed pictures from parachutes, or from aircraft performing aerobatics or in combat. He was an official air force photographer in both world wars and after 1945 worked with magazines like *Weltbild* and *Quick*. His picture archive was destroyed in 1943. RL

rule of thirds. See COMPOSITION.

Ruohomaa, Kosti (1914–61), Finnish-American photographer. After studying at the Boston School of Practical Art he worked as a commercial artist, then as a Disney animator. In 1944, after turning to photography, he began a successful career as a photojournalist with the *Black Star agency. But his most celebrated photographs were of the people and landscapes of Maine, a selection of which, with texts by Lew Dietz, were published in *Night Train at Wiscasset Station* (1977; repr. 1998). RL

Ruskin, John (1819–1900), British art critic and author. Although Ruskin wrote that photography could never be art, and frequently denounced its mechanical nature in *The Stones of Venice* (1851–3), he had earlier been an advocate of the medium, and both made and collected *daguerreotypes. In *Modern Painters I* (1843), and in his correspondence from the mid-1840s, he praised the daguerreotype for its ability to record architectural detail, a trait he continued to appreciate. Ruskin's initial enthusiasm for photography can be seen as an extension of his advocacy of the painting of 'truth'. He praised both J. M. W. Turner and the *Pre-Raphaelites for just such realistic representation. KEW

Watson, R. N., 'Art, Photography and John Ruskin', *British Journal of Photography*, 91 (1944).

Cook, E. T., and Wedderburn, A., entry 'Photography', 'General Index', *The Works of John Ruskin* (1912).

Russia. The history of Russian photography, though rich, is unevenly documented, with much more literature on the pre-revolutionary

years and the 1920s than on the period between 'high' Stalinism and Gorbachev. At the end of the 1980s Y. V. Barchatova and others published a book, later translated as *A Portrait of Tsarist Russia*, that gave a fascinating overview of the photograph collections held in Russian museums. Yet, with exceptions such as the pictures taken by the last imperial family, most of them have barely been evaluated or written about. (Other major collections, like Leonid *Andreyev's *autochromes, and Sergei *Prokudin-Gorskii's pre-1915 colour photographs of the Russian Empire, exist abroad.) Future research will certainly bring more material to light. However, the break-up of the USSR and the appearance of many new states on the borders of today's Russian Federation will also make it harder to write the history of photography in the former Soviet and tsarist states.

To 1917

Russian photographers in this period were numerous, innovative, and alert to developments in other countries. Many of them travelled abroad; Sergei *Levitsky, one of St Petersburg's leading portraitists, learned daguerreotypy in Paris and Rome in the 1840s, won a gold medal in Paris for *daguerreotypes of the Caucasus in 1851, and spent the early 1860s running a studio in the French capital; Prokudin also worked in Paris, after studying in Berlin; and the *pictorialist Sergei *Lobovikov exhibited and won numerous awards at exhibitions in Europe before 1914. Under the last two tsars, Russian photographic societies and journals constantly discussed the latest technical advances, while the *Bulla agency in St Petersburg had many non-Russian clients. This international orientation reappeared, briefly, between the end of the Civil War (1918–20) and the establishment of Stalinism.

News of both *Daguerre's and *Talbot's inventions arrived and was discussed in Moscow and St Petersburg early in 1839. The Academy of Sciences in St Petersburg sent one of its members, I. Hammel, on an investigative mission to Paris and London, during which he met Daguerre and Isidore Niépce and obtained a daguerreotype outfit and numerous documents, which were discussed by the academy in September. Already nearly four months earlier, however, the chemist and botanist Julius Fritzsche had reported in detail on Talbot's process. There was considerable press interest, and two Russian photography handbooks appeared before the end of that year.

As in other countries, portraiture was the mainstay of early photography. Moscow's first commercial studio was opened in the summer of 1840 by Alexei Grekov (1779/80–mid-1850s), who reduced exposure times for the daguerreotype to about two minutes. By the middle of the decade, as knowledge increased and materials became easier to obtain, other establishments were proliferating in Moscow and other cities. As in other branches of Russian science and technology, many important early practitioners were of non-Russian extraction: for example, the semi-*itinerant daguerreotypist Alfred Davignon, the German or Austrian Karl August Bergner, who set up in Moscow in the early 1850s, and the St Petersburg painter and photographer André *Denier. But Russians included the aristocratic Levitsky, who opened his St Petersburg studio in 1849; and others entered the profession in the wake of the *carte de visite boom from c.1860. Particularly important in the 1860s, 1870s, and 1880s was Andrei *Karelin, who established himself in the important commercial centre of Nizhni Novgorod in the 1860s, and in addition to portraiture (in and outside the studio) made a name for himself in landscape and topographical photography and folkloric scenes.

The 1860s and 1870s, when the Russian Empire was expanding vigorously southwards and eastwards, witnessed a spate of ethnographic photography, created by military survey teams, professionals sponsored by the Imperial Russian Geographical Society, and photographers established in the new territories. Examples included a *Turkestan Album* (1872) by the Tashkent-based G. N. Nekhoroshev, and a three-volume compilation on the far-eastern Amur region by V. Lanin. Ethnographic pictures featured prominently in the Russia contribution to the 1875 Paris Exhibition. Both the ethnographic albums and the work of contemporary social-realist photographers combined posed studio photographs with others taken out of doors, with the latter becoming increasingly important for the realists. One example was the Scottish-born William *Carrick, whose radical sympathies led him to photograph peasants and Volga boatmen on location in the Simbirsk region in the 1870s. His work has much in common with the politically reformist painters of the realist 'Itinerant' school, such as Ilya Repin, whose celebrated *Volga Boatmen* was completed in 1873. Also interesting were the controversial open-air pictures of Don Cossacks by Ivan Boldyrev in the late 1870s. This radical strain in Russian photography persisted. Boldyrev later took pioneering *underground pictures of anthracite miners, which were among the earliest photographs of Russia's emerging working class, and Maxim Dimitriev recorded grim scenes from the 1891–2 famine.

The year 1858, meanwhile, had seen the founding of what seems to have been the first Russian photographic society, in Odessa, and of the journal *Svetopis* (*Light-Painting*). Not surprisingly, considering the artistic background and interests of many Russian photographers, debates about the relationship between photography and 'fine' art continued during the later decades of the century. It therefore seems odd that 'art photography' in the narrower sense of *pictorialism emerged in Russia much later than abroad. As late as 1900, when Alfred *Horsley Hinton submitted an article about it to the journal *Fotograf Liubitel* (*Amateur Photographer*) an editorial dismissed the movement as suitable for England because of the 'fog and smog' and Germany 'where short-sightedness is highly developed', but not Russia. The anti-pictorialists, such as Prokudin-Gorskii (soon to be editor of *Fotograf Liubitel*), included some of the most technically progressive members of the photographic establishment. In the event, Russian pictorialism became particularly associated with the Kiev-based Daguerre Society, and two Kiev photographers, Nikolai Petrov (1876–1940) and Lobovikov. The latter especially was a fervent advocate of *gum printing and other pigment processes

and, like pictorialists elsewhere—for example, the *Hofmeister brothers—regarded the making of the *negative as the beginning of a lengthy process that enabled the photographer to achieve truly painterly effects. His highly manipulated landscapes and peasant scenes won awards at major international salons in Dresden (1909), Budapest (1910), and Hamburg (1911). In 1911, a contingent of distinguished foreigners, including *Steichen, *Käsebier, *Puyo, and *Dubreuil, submitted to the International Salon of Artistic Photography in Kiev. The fact remained, however, that pictorialism abroad was well past its peak, although debates about it continued in Russia well into the First World War and it continued to flourish after the revolution.

From the 1880s onwards increasing numbers of salons were held, including an All-Russian Photographic Exhibition in Moscow in 1889, and photographic activity continued to expand under Nicholas II (1894–1917), who was himself a keen photographer. Societies and journals proliferated, and there was progress in fields such as *medical, *police, *aerial, and botanical photography, often involving Russian inventions. *Panoramic photography became something of a Russian speciality, from the tsar downwards. In 1909 Prokudin's ambitious project to document the empire using his own colour process received generous official support. Other forms of documentary photography also continued to flourish; there are anonymous photographs of the Moscow slums on the eve of the 1905 Revolution that would have done credit to *Riis or *Hine. Commercial enterprises included foreign firms like Boissonas & Eggler and (now) Russian ones such as C. E. de Hahn and *Bulla: a portrait and general photographer, but also one the world's earliest major picture *agencies. Karl Bulla and his sons Alexander and Viktor, together with more obscure figures like G. Fried, documented Russia's war effort in 1914–18, and in 1917 some of the most important revolutionary events in Petrograd (St Petersburg).

Since 1917

Notwithstanding the upheavals of 1917 and its aftermath, the full cultural impact of the revolution was not felt until the enunciation of *Socialist Realism in 1934, with a period of disputatious pluralism in between. From an early stage, however, the *propaganda value of both photography and film was recognized and, with Lenin's encouragement, photographic posters and displays were used both in cities and on the agitprop trains and steamers dispatched throughout Russia's still largely illiterate society; Pyotr *Otsup's Lenin portraits were disseminated in millions of copies. But probably the most important vehicle for photographic propaganda was the illustrated press—journals like *Pravda*, *Izvestia*, *Rabochaya Gazeta*, *Ogonyok*, and growing numbers of others, to which many Soviet photographers contributed. Also important was photography's use in propaganda abroad, for example in prestige events like the Russian Exhibition in Zurich in 1929 and the 1937 Paris World Exhibition. High-quality journals like *USSR in Construction* were aimed to a large extent at a foreign audience, and approved Soviet photographs appeared in

foreign communist papers like the *Arbeiter illustrierte Zeitung*, and were distributed via Willi Münzenberg's Unionbild agency. The question was, however, what kind of images would best represent Soviet aims and values.

As already noted, pictorialism remained popular in the 1920s, although it was increasingly attacked by communist ideologues as elitist, decadent, and remote from contemporary reality. In 1928 the formerly pro-pictorialist *Fotograf* asked: 'Are we acting correctly in allowing ourselves to be enticed by the sunsets and sunrises in artistic photography to the detriment of themes from Soviet life?' Finally it was officially anathematized by Socialist Realism, although—as would be the case with the avant-gardes— leading practitioners such as Abram Shterenberg (1894–1979) and Mosei Nappel'baum (1869–1958) trimmed their sails in order to survive; Alexander Grinberg (1885–1979), however, spent years in the Gulag.

More significant than late pictorialism was the experimental and *New Vision-inspired work that, especially after materials again became readily available in the mid-1920s, featured prominently in the 'cultural revolution' of the early Soviet era. For leading avant-garde figures like Alexander *Rodchenko and El *Lissitzky, photography's mission, in conjunction with graphic art, was to supplant painting as socialism's leading representational medium. However, an important influence on photography was cinema, especially the ideas of the documentary film-maker and theorist Dziga Vertov (1896–1943), and journals like *Kinofot* and *Sovetskoe Kino* hosted important discussions of both media. By the late 1920s, film and photography were the subject of complex debates; although the plethora of theoretical positions did not entirely correspond to actual practice.

Fundamental to the new Soviet photography as propagated by Rodchenko and his allies was rejection of pictorialism as elitist and individualistic, and the adoption of a New Vision aesthetic perceived as more in tune with an emerging socialist society. Machines, mass-produced objects, and industrial development would be its central themes, with individuals represented as components of a gleaming productivist mechanism. Further, the properties of film and lenses would be exploited to promote a literally new vision of the world. An influence here was *Moholy-Nagy's *Painting Photography Film* (1924). But another was Vertov, especially his concept of the 'cinematic eye' (*Kino-Glaz*), 'which, more comprehensively than any human eye, could investigate the chaos of visual phenomena'. For Vertov the camera's role was not to transcribe reality in an illusionistic, literal way, but to break it up into discrete elements and construct something radically new—just as Russian society was being broken up and reconstructed as socialism. Rodchenko wrote in 1928: 'The lens of the camera may record what it will be possible for the cultured person to see in a socialist society.' This meant ultra-high and -low viewpoints, soaring diagonals, reeling verticals, and the distortions created by wide-angle lenses and extreme close-ups. One other aspect of the radicals' anti-elitism was the notion of mass amateur photography, in which workers would record the reality of

their own lives and provide material for Soviet photojournalism. This clearly resembled the ideas of the worker-photographer movement in Germany, and was to prove equally unrealistic.

In the late 1920s Rodchenko was active in the *Futurist- and Constructivist-influenced Left Front of the Arts (LEF; f. 1925), as art director of the experimental journal *Foto i Film*, and in LEF's successor, the October group. With Boris Ignatovich (1899–1976), he also contributed photo-essays to another new magazine, *Dayesh* (f. 1929), on subjects ranging from the Moscow zoo and the Bolshoi Theatre (Rodchenko) to the battery farm run by the secret police (Ignatovich). Rodchenko also effectively led the photography section of yet another radical group, New October, which mounted summer photographic exhibitions in 1930 and 1931.

By this time, however, a strong backlash against avant-gardism—denounced as 'formalist deviationism', or 'leftism'—was developing. It was identified with journals like *Proletarskoe Foto*, the Russian Society of Proletarian Photographers (ROPF), and photojournalists such as Arkadi *Shaikhet and Max *Alpert, whose famous and (in general) much more conventional photo-essay *A *Day in the Life of a Moscow Worker* had appeared in 1931. Their central complaint was that the avant-garde's images were incomprehensible to the working masses and ugly to boot: hence, for example, the vitriolic attack on Rodchenko's famous low-angle *Pioneer Trumpeter* (1930). But there was also nationalistic resentment of the real or supposed indebtedness of Rodchenko and his friends to foreign, especially German, modernism. There were echoes here of the much larger contest between intellectual supporters of world revolution on the one hand and advocates of 'socialism in one country', which put the USSR's interests first, on the other. In the background was Stalin's increasing dominance, following the death of Lenin in 1924, the expulsion of Trotsky, the early completion of the first Five-Year Plan, and the beginning of agricultural collectivization.

Pressure on the radicals increased between c.1931 and the proclamation of Socialist Realism at the All-Union Congress of Soviet Writers in 1934. Rodchenko resigned from New October which, with other cultural groups, was dissolved in 1932. Socialist Realism essentially imposed a re-engineered version of late 19th-century Realism as the representational norm for artists, film-makers, and photographers in Stalin's Russia (and its later-acquired satellites). In practice, however, the distinction between it and 'formalism' was not absolute, or not initially. On the one hand, pictures from Rodchenko's modernistic *White Sea Canal photographs, published in *USSR in Construction* in 1933, were included in the 1935 *Masters of Soviet Photographic Art* exhibition in Moscow, together with images like *Girl with a Leica* (1934). On the other, *A Day in the Life* had included some New Vision-inspired shots, and the style continued to be used by photojournalists for inherently modernistic subjects like dams and steelworks. By November 1937, however, when the first All-Union Exhibition of Photographic Art opened in Moscow, the avant-garde as an entity had ceased to exist, its members forced to change tack or retreat from the public eye into laboratories or editorial offices.

Between 1941 and 1945, Russian photographers produced some of the Second World War's most powerful *war photography. They included *Alpert, *Baltermants, *Khaldei, Boris Kudoyarov (the siege of Leningrad), *Petrussov, Shaikhet, and many others, working for all the main papers, *Frontovaya Illustratiya*, and the TASS agency. They had to overcome the chaos of initial Russian defeats, changes in the propaganda line, and, occasionally, alarming interventions by Stalin.

After the war, Socialist Realism reigned supreme, at least officially: it would be premature to generalize about the total output of Russian photographers in the second half of the 20th century. But the USSR's thousands of professional photojournalists were expected to treat approved subjects in an upbeat, accessible way: enthusiastic congress delegates, the achievements of workers and *kolkhoz* farmers, Young Communists, military parades, and heroic cosmonauts. The yearbooks and national salons, with their obligatory Uzbek, Georgian, and Cossack scenes, projected the image of a multi-ethnic but unified Soviet society. Typical almost to the point of parody of 'high' Socialist Realism was Baltermants's *The Announcement of Stalin's Death* (1953), an impeccably lit and posed image of factory workers gathered round a radio that could have been adapted from a 19th-century painting. As in the 1930s, however, modernistic shots were acceptable when the occasion demanded: for example, Valery Gende-Rote's *Yury Gagarin* (1961), a dramatic overhead picture of the cosmonaut striding diagonally down a ceremonial carpet. Officially taboo, on the other hand, were images of dissidence, religious activity, pollution, alcoholism, sex, or (in general) nudity; although it remains to be seen how far Russia's army of amateurs, sustained by a considerable photographic industry, informally recorded these aspects of the Soviet scene.

Gorbachev's *glasnost* (openness) policy in the late 1980s permitted the increased visibility of a generation of 'new' (though not particularly young) documentary photographers, some of them brilliantly talented, who set out to capture the texture of everyday life without the formerly obligatory optimistic framing, and demonstrated a less inhibited approach to the anomic and dysfunctional aspects of Soviet society. Among them was Boris *Mikhailov, who was to become internationally the most celebrated Russian photographer of the post-Soviet era. However, the origins of this apparently new movement went back to the 1960s, and especially to developments in the Baltic republics. Lithuania in particular tacitly allowed photographers like Alexandras *Macijauskas to distance themselves from Socialist Realism, and several other leading 'new' documentarists of the Gorbachev period were Lithuanian (and soon, of course, to become citizens of an independent country).

Since the break-up of the Soviet Union in 1991, the Russian Federation has begun to acquire the features of a mature photographic culture, though hampered by economic crises and uncertainties about freedom of expression. The founding of the Moscow House of Photography, increased interest in Russia's early photographic history and collections, the rediscovery of forgotten figures—for example, Leonid *Andreyev and the documentarist Leonid Shokin

(1895–1962)—the proliferation of exhibitions and contacts with developments abroad, all seem to herald the country's integration into the international photographic scene. RL

Morozov, S., and Lloyd, V. (eds.), *Soviet Photography 1917–1940: The New Photo-Journalism* (1984).

Mražkova, D., and Remeš, V., *Another Russia: Through the Eyes of the New Soviet Photographers* (1986).

Barchatova, Y. V., et al., *A Portrait of Tsarist Russia: Unknown Photographs from the Soviet Archives*, trans. M. Robinson (1990).

Elliott, D. (ed.), *Photography in Russia 1840–1940* (1992).

Tupitsyn, M., *The Soviet Photograph* (1996).

Tihanov, G. (ed.), 'The Russian Avant-Garde', *History of Photography*, 24 (2000).

Ryko (Edward Reichenbach; 1892–1968), Australian photographer. In an Aboriginal rock art site in Arnhem Land, Northern Australia, a painting of Ryko's bicycle records a brief cross-cultural encounter (1914–17) with the young photographer. He reciprocated by recording aspects of Aboriginal history in a series of narrative genre photographs that at first sight seem only commercial in intent, but on analysis reveal Aboriginal re-enactments of actual events: one a murder of coastal Aborigines by 'Malay' fishermen (1916), the other a ritually restaged clash with the British on Melville Island in the 1820s. Thus the photographs join the chain of Aboriginal knowledge transmission. RPO

Poignant, R., 'Photographs of the "Fort Dundas Riot": The Story So Far', *Australian Aboriginal Studies*, 2 (1996).

Sabatier effect, the tone reversal of an image, partial or complete, produced when an exposed photographic emulsion is briefly re-exposed to white light during development. It has often, but incorrectly, been referred to as *solarization or pseudo-solarization.

The effect was first recorded in 1860 by Armand Sabatier (1834–1910), who observed the phenomenon when daylight fell on developing *wet collodion plates. Similarly, it may be seen in the modern darkroom following accidental re-exposure. However, using careful manipulation of exposure and development techniques, it has been dramatically exploited by photographers such as *Man Ray and Erwin *Blumenfeld.

The aim of most photographers seeking to exploit the effect is to produce a part positive, part negative image. The typical final result is a negative image produced by the original exposure and development, overlaid by the positive image produced by the re-exposure and development. Appearance depends on several factors, including the kind of original photographic material used, the relative length of first and second development times, and the timing and duration of the re-exposure. Under certain controlled conditions images can be formed where parts of the subject are outlined with delicate white lines, giving the appearance of an etching. Variations are possible, such as using positive and negative originals to give double white lines. The technique is difficult to master and may require much trial and error. To be most effective, sharp high-contrast originals are essential and simple subjects with strong linear elements are recommended. JPW

Life Library of Photography: The Print (1972).

Saché, John Edward (*fl.* 1860–82), German commercial photographer working in *India, believed to be Johann Edvart Zachert, born in 1824 in Prussian Poznań. Probably the same Saché who is recorded in Philadelphia in 1860, his first documented appearance in India was at an 1865 meeting of the Bengal Photographic Society, when his American work was displayed. The firm Saché & Westfield operated in Calcutta from 1865 to 1869, when Saché made a Himalayan tour. Subsequently a studio was opened in Nainital *c.*1870–1882, followed by further studios in Lucknow and Mussoorie. No records of Saché have been discovered after 1882. He produced topographical work covering major sites and towns in northern India, and studies of 'Indian trades'; and although his work has been unfavourably compared with other commercial photographers such as *Bourne, it displays a comprehensive understanding of the picturesque, and occasionally great originality. His sons Alfred and Edward were also photographers. SCG

safe lights. As many photographers are over-cautious about safe lights as are cavalier. A 'safe' light relies on two things: a colour to which the material in use is insensitive, or less sensitive, and an intensity that is insufficient to create a visible density during the normal length of time for which unprocessed material is likely to be exposed. 'Bounced' or indirect lighting is generally a great deal safer than direct lighting; light leaks from outside are often more important than unsafe darkroom lighting.

With the right colour, surprisingly bright lighting may be acceptable: most colour negative papers have a wavelength gap that allows the use of (low-pressure) sodium vapour lamps, or a fairly bright LED lamp. And most monochrome papers will never be fogged by a good red safe light—in other words, the light is totally safe, for any length of time—though many prefer to work under amber lighting which is less safe.

Although *orthochromatic and 'ordinary' (non-blue-sensitive) films may be handled under quite a bright red safe light, other films are normally handled in complete darkness or (very briefly) under very dim green lighting. Colour reversal papers likewise are handled in complete darkness or under extremely weak safe lighting. RWH

Salgado, Sebastião (b. 1944), Brazilian photographer. Trained as an economist, Salgado worked initially for the International Coffee Organization before taking up the camera in 1973. He became a photojournalist, a member successively of three leading *agencies— Sygma, *Gamma, and finally *Magnum, the latter from 1979 to 1994. He set up his own photo agency, Amazonas Images, in 1994. Although he had a distinguished career as a news photographer (including the attempted assassination of Ronald Reagan in 1981), he always preferred to work on large-scale thematic projects concerned with socio-economic change.

Salgado's photography might be termed pictorialist humanism: his photographs are expressively dramatic in their composition and tonality. Almost all in black-and-white, they have been used to create substantial pictorial monographs on macro-themes, intensively studied by Salgado. These have included a lengthy project on the threats to the indigenous peasant culture of South America

John Edward Saché

The Taj Mahal, Agra, India, 1860s.
Albumen print

(published as *Other Americas*, 1986), work on famine in North Africa (*Sahel: l'homme en détresse*, 1986); and a global project on the end of heavy industrial labour, published as *Workers* in 1993, that covered 26 countries. This was followed by a study of the plight of landless agricultural workers in Brazil, published as *Terra: Struggle of the Landless* (1997), and a further global study of population movements and their effects, *Migrations* and *The Children* (both 2000). Most recently he has photographed the polio eradication programme for UNICEF.

Throughout Salgado's work, characterized by its intensive exploration of the major socio-political issues of the world, there are two interesting threads. First is the sense of a universal humanism, which runs quite at odds with the anti-humanist trends present in much postmodern photography and its embrace by the art world. Salgado's photography is about basic human rights that apply everywhere: he is not a relativist, though he is interested in pictorial exploration of the widely different aspects of human life. Secondly, Salgado makes pictures that are often quite formal in their presentation of their subjects, who appear to represent human types or social categories rather than individuals in their own right. In this sense they recall certain images present in classical painting: the resting worker in the famous Serra Pelada mining series (1986) recalls a figure from an Italian Renaissance painting of a biblical scene.

Perhaps these two things account for the enormous appeal of Salgado's work, which is often widely distributed as multiple exhibitions that can be readily shown in different types of public space rather than art galleries alone, and as beautifully produced books that detail the major stages of his extraordinary output as a photographer.

PH

Salomon, Erich (1886–1944?), German photojournalist and 'father of candid photography'. Salomon was born into a bourgeois Berlin family that suffered heavily in the German hyper-inflation. After various jobs in the 1920s, he became publicity manager for Ullstein Verlag, publishers of the **Berliner illustrirte Zeitung* (*BIZ*). Having experimented with an *Ermanox camera, capable of taking pictures in low light, he took a chance on working as a photographer for the *BIZ*. Seeing himself as a kind of contemporary historian, and exploiting his social contacts, he captured unposed images of political and cultural celebrities. Typical was *Reception in Berlin* (1931), showing Albert Einstein engaged in animated conversation with Ramsay MacDonald, surrounded by a group of luminaries including the Nobel Prize-winner Max Planck, smoking cigars and sipping cognac.

Salomon would put his subjects at ease by his urbanity and ability to converse on almost any topic (and in any of seven languages). It was the London *Graphic* that coined the 'candid' epithet, following Aristide

Briand's 1930 quip that unless a ministerial meeting were documented by Salomon no one would believe it had happened. In the mid-1930s he took his family to Holland, where he worked for Dutch newspapers and magazines. Following the Occupation, they were deported to Theresienstadt, then Auschwitz, where Salomon perished with his wife (Maggy Schuler) and younger son (Dirk), probably in 1944. AH

Vries, H. de, *Erich Salomon: Portrait of an Age* (Eng. edn. 1966).
Erich Salomon, introd. Peter Hunter (1978).

Salon de l'Escalier, an exhibition of modern photography and its precursors in the stairway gallery of the Théâtre des Champs-Élysées, Paris, in May–June 1928. It was organized by the editor of *L'Art vivant*, Florent Fels, and the publisher Lucien *Vogel in protest against what they regarded as the conservatism of mainstream shows. The exhibits included work by *Man Ray, *Abbott, *Kertész, *Outerbridge, and *Hoyningen-Huene, but also *Nadar and *Atget. Vogel's participation ensured plentiful publicity, and the exhibition heralded further, regular exhibitions at venues such as the Galérie de la Pléiade. RL

salted-paper print. The first photographic positives were contact printed by sunlight from paper negatives on to *Talbot's photogenic drawing paper, but usually fixed with *Herschel's 'hypo' rather than Talbot's common salt solutions. These brown, plain-paper images had clear highlights, but if imperfectly washed out, residual thiosulphate promoted conversion to silver sulphide. The process was used from 1839 until *albumen printing was introduced in the 1850s; a significant example is Talbot's *Pencil of Nature*. The *'alternative process' revival includes salted-paper printing, but modern practitioners employ gold toning to improve image colour and stability. MJW

Ware, M., *Mechanisms of Image Deterioration in Early Photographs* (1994).

Salzmann, Auguste (1824–72), Alsatian painter, archaeologist, and photographer, who was the first to use photography systematically as an adjunct to archaeological work, and to provide evidence for his patron de Saulcy's earlier findings in the Holy Land. His paper-negative photographs consist primarily of architectural details and fragments from excavations, which he claimed were 'conclusive brute facts' in the continuing debate about the age of architectural remains in and around Jerusalem. After returning to France, he published *Jerusalem: études et réproductions photographiques de la Ville Sainte depuis l'époque judaïque jusqu'à nos jours* (2 vols., 1856), containing 150 photographs. The tightly cropped architectural detail he recorded was unusual in an age which prized the inclusive, middle-distance architectural view, and led in the 1980s to his classification as precociously modern. It is more accurate to see contemporary aesthetics, schooled in modernist strategies that emphasize surface over depth, as receptive to the formal elements of his work, although few modern viewers are able to read the archaeological argument embedded in his photographs. KSH

Heilbrunn, F., 'Photographies de la Terre Sainte par Auguste Salzmann', in *Félix de Saulcy (1807–1880) et la Terre Sainte* (1982).

Samaras, Lucas (b. 1936), Greek-American painter, sculptor, photographer, and performance and object artist. In the 1960s he took part in 'happenings' in the orbit of Allan Kaprow and the Fluxus movement. He also became known at this time for his *photosculptures. In 1973 he found that the wet dyes of Polaroid prints were easy to manipulate, leading to his 'Photo-Transformations', or distorted self-portraits. These images are usually more grotesque than flattering, the product of an ongoing process he calls 'professional self-investigation'. Samaras has taught and exhibited widely since the 1960s, and his career epitomizes the late 20th-century convergence between photography and 'fine' art. LAL

Lifson, B., *The Photographs of Lucas Samaras* (1987).

Sami, Ali (1866–1936), Turkish photographer. As photographic technology became more widespread in Istanbul following its introduction in the 1840s, Muslims joined the resident European, Greek, and Armenian practitioners, and Sami was one of the first. Trained as an artillery officer, he taught art and photography at the Imperial School of Engineers in Istanbul, and worked also as a military photographer for Sultan Abdul Hamid, recording the state visits of Emperor Wilhelm II. His work demonstrates a complex, accomplished presentation of his subjects, often departing from photographic conventions. In a 1908 picture, for example, family members are depicted informally at home, wearing everyday clothes, with four different newspapers spread about the room. Ali Sami's images, both court and privately commissioned, exemplify the sophistication with which Ottomans interacted with photography. NM

Çizgen, E., *Photographer/Fotoğrafçı Ali Sami 1866–1936* (1989).

Sammalahti, Pentti (b. 1950), Helsinki-based Finnish photographer and printer, known equally for his photographic narratives of Irish herdsmen or Hungarian gypsies, his Finnish and Russian landscapes, and his dedication to the photographic book and the development of quality printing methods. His photographic work is conceived on the wing, a traveller's vision encompassing landscapes, peoples, animals (e.g. his series of dogs in Russia). His photographic books, by contrast, are the product of painstaking craftsmanship. The *Opus* series, including his own and many other photographers' books, has transformed the art of the photographic book in Finland and elsewhere. J-EL

Samoa. As with other photographs of *Oceania, those of Samoa are characterized by their historical persistence, wide dissemination, variety of purposes, and multiplicity of uses. They are extremely numerous, though depicting a relatively unimportant place that few people have known directly, a factor contributing to the power and meaning of its paper representations.

Foreigners arrived with cameras as early as the 1860s. Traces of the first photographs remain in the engravings after R. P. Gator in T. H. Hood's *Notes of a Cruise in HMS Fawn* (1862). The English

missionary George Brown photographed in Samoa between 1876 and 1903. The famously itinerant New Zealander Alfred *Burton passed through in 1884 for *The Camera in the Coral Islands*, as did the American James Ricalton for *Underwood & Underwood stereos (1906). By the 1870s, as photography became simpler and its means of reproduction and distribution more established, Samoan pictures were widely available abroad. At least three professional photographers, the New Zealanders Thomas Andrew (1855–1939), John Davis (1850?–93) and A. J. Tattersall (1861–1951) spent most of their adult lives in Apia, producing images for local use, sale to visitors, and various forms of international consumption. In the 20th century, missionaries, artists, scientists, journalists and tourists continued to photograph Samoan subjects. Best known have been the anthropologist Margaret Mead, who published *Coming of Age in Samoa* in 1926, and the film-makers Frances and Robert *Flaherty.

Most photographs of Samoa show consistency and persistence of a few subjects, notably bare-breasted young women in elaborate headdresses, *kava* ceremonies, the traditional houses known as *fale*, sun-kissed palm-fringed beaches, and jungle waterfalls. The commonest images of cultural contact relate to the romanticized expatriate Robert Louis Stevenson. Not surprisingly, these images reinforce received ideas of Samoa as exotic and primitive in the countries that, through their political and cultural institutions, controlled both the Islands and their visual representation.

In the 19th century, photographs of Samoa were mass-produced as popular *cartes-de-visite*, cabinets, album-sized views and, then as now, postcards and illustrations in books and magazines. Images made as early as 1880 were regularly re-published as if current well into the 1930s, with changes of format, use, caption and meaning. A single 1890s image of a chief's daughter exists today at multiple sites as a named portrait, an ethnographic type, and a souvenir postcard. The use of such fixed, generic images to identify a place contributes to notions of a timeless, unchanging authenticity separate from the viewer's modern world. Today, in popular magazines, tourist snapshots, and Samoa's own tourist literature, the same markers appear. AN

Blanton, C. (ed.), *Picturing Paradise: Photography in Samoa 1875–1925* (n.d.).
Nordström, A., 'Paradise Recycled: Photographs of Samoa in Changing Contexts', *Journal of the Society for Photographic Education*, 28 (1991–2).
Nordström, A., 'Wood Nymphs and Patriots: Depictions of Samoans in *National Geographic*', *Visual Sociology*, 7 (1993).

sampler. See LOMOGRAPHY.

Sander, August (1876–1964), German *documentary photographer, introduced to the medium by a photographer depicting the iron-ore mine where he was working. After formal training he settled as a professional in Linz, Austria, working in the *pictorialist style. In 1910 he returned to Cologne, where he produced portraits, including those of peasants of his native Westerwald, landscapes, and architectural documentation. In the early 1920s, he met a group of Cologne artists who persuaded him to redefine his portraiture as

evidence of a vanishing rural society. In 1925 he embarked on a visual taxonomy of German social types, *People of the 20th Century*, originally planned around the idea of a photographic history of urbanization from village to metropolis. It was organized along a line drawn from the farmer and artisan, via the 'average citizen', to the 'economic leader' and 'intellectual aristocrat', and ending with marginal 'last people': the disabled, mentally ill, and dead. In 1929 he published a preliminary selection entitled *Face of our Time*. During the Third Reich Sander's activities were hindered and his son Erich imprisoned. Remarkably, *c.*1938, he took photographs that in 1947 he included in a portfolio 'Persecuted Jews' added to *Face of our Time*. In 1947 his architectural work *Cologne as it Was* was supplemented by the portfolio *Cologne Destroyed*. In the 1950s, Sander fought for recognition of his life's work. Although he died without having seen any of his complete portfolios published, he was eventually hailed as a major European documentarist. RS

August Sander 1876–1964 (1999).

Sarony, Napoleon (1821–96), Canadian-born American theatrical and portrait photographer. He founded a lithographic studio in New York in 1848, then travelled in Europe and practised portraiture in England before returning to open a portrait studio in New York in 1866. He became known for striking and unconventional poses and backdrops and, at a time when photography was becoming a key component of *celebrity image making, established mutually beneficial relationships with stars like Sarah Bernhardt and Lillie Langtry. His older brother Oliver (1820–79), after working as an itinerant *daguerreotypist, opened an enormously successful portrait studio in Scarborough, England, in 1858. LAL

Bassham, B. L., *The Theatrical Photographs of Napoleon Sarony* (1978).

Saudek, Jan (b. 1935), Czech photographer and painter, born in Prague, who studied at Prague School for Industrial Photography. From 1952 to 1980 he had farm and industrial jobs whilst developing his photography which, influenced by Steichen's *Family of Man*, aims to show the whole of human experience, even though created almost exclusively in his basement home/studio, with its peeling, graffiti-covered walls. Although he had his first international exhibition at the University of Indiana in 1969, and was shown at the *Arles Festival in 1977, he was not officially allowed to work as a photographer until 1984.

Saudek's photographic work, mainly hand-tinted black-and-white images, shows dreamlike experiences and grotesque allegories of human foibles and fantasies. Blending eroticism and sentiment, his theatrical scenarios, including himself, family members, and friends of all ages, are considered shocking, kitschy, or exploitative by some, but by others as addressing the core themes of human life—ageing, sexuality, and gender relations. Probably the best-known contemporary Czech photographer of nudes, his work has been widely published, including his book *Jan Saudek: Life, Love, Death and Other Such Trifles* (1991). RA

August Sander

Tramps, Germany, 1929–30

Saunders, William (d. 1892), British commercial photographer, and the longest-established Western operator in China. In January 1862 he opened one of Shanghai's first studios, and over a quarter of a century to 1887 produced innumerable images of current events and local scenery. He also photographed other ports in China and Japan (including an important visit to Yokohama in 1862), and contributed regularly to Western publications such as the *Far East* (Shanghai) and the *Illustrated London News*. Saunders's major achievement is his early series *Chinese Life and Character*. First advertised in 1871, the 50 scenes became instant classics and remain to this day extraordinarily evocative and successful. Most scenes are peaceful, and they cover many aspects of native life in Shanghai. They were all carefully staged, and everything is determinedly traditional, no details revealing the 'modernization' already under way in the foreign settlements. This was, and still is, Eternal China.　RT

Scandinavia. The Swedish chemist Carl Vilhelm von Scheele's (1742–86) work on the light sensitivity of silver salts and, in 1777, discovery of the unequal darkening effects of the different colours of the spectrum, brought Scandinavia into the annals of photographic history. Later, excited reports following the announcement of *Daguerre's process in Paris in January 1839 were published immediately in Scandinavian newspapers such as *Aftonbladet* (Stockholm) and *Åbo Underrättelser* (Turku). By September, the Dane Christian Tuxen Falbe (1791–1849), sponsored by Prince (later King) Christian Frederik, had produced *daguerreotypes in Paris. By December, Daguerre's manual, published in late August, had been translated into Swedish, and its publication, by Albert Bonnier, supported by importing daguerreotype kits. A Danish edition appeared in early 1840.

The pioneering Swedish daguerreotypist Lars Jesper Benzelstierna (1809–80) arranged for his own equipment to be brought from Paris in 1839 by the Swedish ambassador, Carl Gustaf Löwenhielm. Collaborating in early 1840 with two employees of the Stockholm Royal Opera, Georg Albert Müller (1803–64) and Ulrik Emanuel Mannerhjerta (1775–1849), Benzelstierna held a first exhibition in September with 'views of Stockholm . . . in which even the minutest details could be observed with a microscope', according to a contemporary newspaper. Similar shows were arranged the same year in Christiania (Oslo), Copenhagen, and Turku. An 1842 daguerreotype by a Finnish pioneer, the physician Henrik Cajander (1804–48), of the Nobel-house in Turku, may be the oldest surviving Scandinavian daguerreotype.

There were also Scandinavian inventions. Hans Thøger Winther (1786–1851), an enterprising Christiania publisher, invented a direct-positive method in June 1839. His 1845 handbook, presenting three paper processes, encouraged the development of amateur photography; Amund Larsen Gulden's (1823–1901) 1846 *calotype of his homestead is a fine example.

During the daguerreotype era, photographers were predominantly Scandinavian amateurs—scientists, officers, artists—or enterprising foreign *itinerants. The latter toured the region well into the 1870s, even after permanent studios were established in most cities. In 1842, the daguerreotypist Mads Alstrup (1809–76) opened Copenhagen's first photography studio. Johan Wilhelm Bergström (1812–81), perhaps the most aesthetically refined of Scandinavian daguerreotypists, ran the leading studio in Stockholm 1844–54. His portraits of the chemist Berzelius, and of his own wife at her spinning wheel, are among his masterpieces.

Photography now spread rapidly, with portrait studios established in Helsinki, Viborg, Odense, Bodö, Helsingborg, and other cities. In the 1850s, with the wet-plate process supplanting the daguerreotype and the appearance of the *carte de visite*, the process accelerated. By the mid-1860s, Stockholm counted over 60 permanent studios, Copenhagen over 80, although neither had more than c.100,000 inhabitants. Despite a recession in the 1870s, Stockholm continued to have c.40 studios for the rest of the century.

Axel Lindahl

Return from church, Hardanger, Norway, albumen print, 1884

Mark Webster Bicolour parrot fish eye, Red Sea, 2000

(*previous page*) **Judith Calford** Streamway, Ogof Ffynnondu, Wales, 2000

Many 19th-century studio photographers were female—*c*.30 per cent, for example, in Denmark. Bertha Valerius (1824–95) and Rosalie Sjöman (1833–19), active from 1860, were among Stockholm's photographic elite. Valerius rose to become a court photographer, well known for a 72-piece photo-mosaic of Parliament and popular composite-printed 'double' photographs. Smaller places also saw women joining the new profession: Conda Forssell (1899–1953) in Gumboda in the northern province of Västerbotten, Sweden, Hilda Sjölin (1835–1915) in Malmö, Marie Høeg (1866–1949) in Horten, Norway, Frederikke Federspiel (1839–1913) in Aalborg, Denmark, were locally renowned portraitists. The amateur Lotten von Düben (1828–1915) travelled widely and created early documents of Sami (Lapp) culture.

Photography remained an international enterprise throughout its first century. Of new entrepreneurs in Finland, for example, 40 per cent were outsiders. Similar figures are found across Scandinavia. In 1877, the young Norwegian Daniel Nyblin (1856–1933) opened a studio in the heart of Helsinki. Still in operation, it is Scandinavia's oldest. Itinerants from France, Germany, Russia, and Poland remained common into the late 19th century. While photographers' core clientele was dominated by the upper and middle classes, subject matter continuously expanded. In Aalborg Heinrich Tønnies (1856–1903) documented occupations in carefully staged group portraits; Victor Barsokevitsch (1863–1933) recorded a remarkable cross-section of citizens in Kuopio; and Norwegian-born Mathias Hansen (1823–1905) became Sweden's first court photographer. Johannes Jaeger (1832–1908), Carl de Shàrengrad, and many others exemplified the capable early entrepreneur producing and/or distributing photographs of royalty, actors, city views, or notable events, and expanding the market as they did so.

Scandinavian photographers also worked successfully abroad, including the father of documentary and reformist photography Jacob *Riis; John Andersson (1869–1948), who made intimate and powerful portraits of the Sioux in Rosebud, Montana, over a period of 50 years; and the Victorian art photographer Oscar *Rejlander. Guillaume *Berggren was a prominent photographer in Constantinople, Otto Wegener (1849–1922) in Paris.

Other genres besides portraiture developed. Into Konrad *Inha, prospecting for Karelian views, discovered photography as a means of representing Finnish culture. Knud *Knudsen's stark yet romantic photographic survey of Norway was matched by Axel Lindahl's (1832–1906) equally encyclopedic project to record the immense vistas of the north, and the vitalist landscape work of Anders Beer Wilse (1865–1949). In Sweden, the topographical work of Gösta Florman and, later, the photographers promoted by Svenska Turistföreningen (Swedish Tourism Association, f. 1895), such as Severin Nilsson (1846–1918) and the amateur Johan Emanuel Thorin (1863–1940), encompassed landscape studies, pastoral scenes, and folkloric and vernacular imagery. The next generation, especially the prolific Carl Gustaf Rosenberg (1883–1957) and the nature photographer Carl Fries (1895–1982), continued to explore the landscape and sites

of national significance; as, indeed, did many photographers in the wake of rapid modernization: for example, Axel Rydin (1837–1912) capturing images of Stockholm or Borg *Mesch tracing northern Sweden's evolving frontier. Nils *Thomasson and Marja Vuorelainen (1911–90) recorded Sami culture from the inside. On a different note, the Dane Mary Willumsen (1884–1961) founded her own *postcard genre with her playful seaside photographs of her circle of female friends.

Photography's relationship with the other arts was multi-faceted. Leading *fin de siècle* artists—Edvard *Munch, August *Strindberg, Anders Zorn (1860–1920), Hugo Simberg (1873–1917), Akseli Gallen-Kallela (1865–1931), and others—were all closely involved with photography, using photographs both as independent means of expression and as material for other works.

Amateur and professional organizations, and photographic periodicals, began appearing from the 1880s onwards, including Dansk Fotografisk Förening (1879), Fotografiska Föreningen (for amateurs, 1888), Svenska Fotografernas Förbund (1895); *Nordisk Tidskrift för Fotografi* (1888) and *Fotografisk Tidskrift* (1888).

*Dry plates and other late 19th-century innovations strengthened amateur photography. News photography expanded and photographs in the press, with the adoption of the *half-tone process, gradually proliferated in the 1890s. Older journals such as *Ny Illustrerad Tidning*, illustrated by engravings based on photographs, were supplanted by magazines such as the progressive *Hver 7 dag*. Carl Sandels (1845–1919) and Matti Pitkänen (b. 1930) were among the pioneers of Scandinavian *photojournalism.

*Pictorialism emerged as photographers aimed for artistic status, and remained dominant well into the 20th century, cultivated by skilled practitioners such as Ferdinand Flodin (1863–1935), Henry Buergel Goodwin (1878–1931), and Anna Marie Knudstrup (1884–1959). As late as 1930, the Danish society Danske Kamera Piktorialister was founded, crusading against modernist tendencies while promoting photography's status as an art form. Herman Hamnqvist (1865–1946) wrote and lectured tirelessly on behalf of the movement. Helmer *Bäckström, less involved in ideological causes, pioneered Nordic photographic history, penning numerous articles in *Nordisk Tidskrift för Fotografi*. Only in the post-war period was he followed by other major figures—Sven Hirn (b. 1925) in Finland, Björn Ochsner (1910–89) in Denmark, and Robert Meyer (b. 1945) in Norway.

Reactions against pictorialism nevertheless appeared in the 1930s and 1940s. Emil Heilborn's (1900–2003) industrial and advertising work in the 1930s transposed *Neue Sachlichkeit and Russian productivism/Constructivism into a Scandinavian context prepared by contemporary faith in technology. Eino Mäkinen (1908–87) introduced the soaring diagonal and the high-angle shot to Finland, as did Arne Wahlberg (1905–95) in Stockholm. Keld Helmer-Petersen (b. 1922), a *Bauhaus student and pioneer modernist, moved towards abstraction and minimalism in his influential portfolio *122 Colour Photographs* (1948).

Christer Strömholm

Boy with snails, Jura, France, 1948

Movements and opportunities elsewhere in Europe attracted many Scandinavian photographers in the post-war period. Christer *Strömholm and Kåre Kivijärvi (1938–91) were drawn to Otto Steinert's *fotoform in Saarbrücken, though without losing their own well-formed identities. Tore Johnsson (1928–80), the photojournalist and photohistorian Rune *Hassner, and others, chose Paris. In the 1950s and 1960s, New York replaced Paris as the magnet for upcoming photographers. In 1949 Stockholm's Young Photographers circle (Hassner, Johnsson, Sven Gillsäter (b. 1921), Hans Hammarskiöld (b. 1925)) saw themselves as speaking the new international language of photography. Lennart *Nilsson also began there, before turning to scientific photography. The Danish Delta Photos (Jesper Høm (1931–2000), Gregers Nielsen (1931–2002), and others), formed in 1950, defended the idea of a specifically photographic aesthetic.

The backbone of Scandinavian photography in this period was a strong, internationally orientated but personally inflected photojournalism: for example, the work of Georg Oddner (b. 1923), Caj Bremer (b. 1929), Ben Kaila (b. 1949), and Krass *Clement, the last uncompromisingly confrontational and emotive. A parallel, documentary strand included the writer Ivar Lo-Johansson (1901–90), who produced his 'social photobooks' with a group of photographers (Sven Järlås (1913–70), Gunnar Lundh (1896–1960), Tore Johnsson, Anna *Riwkin). In 1955 the Sju Fotografer group, led by Sune *Jonsson, ethnographer at Västerbottens regional museum, reformulated the very idea of documentary. Jonsson's vast, remarkable oeuvre offered a refined and suggestive documentary model that was inspired by independent image makers like Matti Saanio (b. 1925) or Ismo Hölttö (b. 1940). A more overtly politicized documentary,

especially in Sweden and Denmark, dominated the 1960s and 1970s: Jens S. Jensen (b. 1946), Jean Hermansson (b. 1938), Stig T. Karlsson (b. 1930), Pål-Nils Nilsson (b. 1929), Jefferik Stocklassa (b. 1948), and groups such as Ragnarok, 2 May, or Bildaktivisterna. 'Dig where you are', a contemporary motto, asserted the photographer's duty to capture the local and the everyday, in particular the workplace. In *American Pictures* (1977), Jacob Holdt (b. 1947) recapitulated Jacob A. *Riis's campaign for social justice. Anders Petersen's (b. 1944) *Café Lehmitz* (1978), photographed in 1968–9, offered an intimate, sometimes raw picture of life at the margins of society. Likewise, Krass Clement's work seemed to bring photographer and subject disconcertingly close together. Lars Tunbjörk (b. 1956) turned to the middle class and its ennui in his ironic *The Country beside Itself*. Anders Kristensson (b. 1958) produced large colour portraits of immigrants that undermined the official Swedish and Nordic self-image. Henrik Duncker (b. 1963) and Yrjö Tuunanen (b. 1964) staged documentary photographs of the new Finnish farmer. Jorma *Puranen adopted a multi-layered approach to Sami culture and the Arctic landscape.

Landscape photography has remained vital throughout the modern period, although from the 1970s a more topographical approach replaced the classical landscape and nature work of practitioners like Svante Lundgren (1913–88); examples include Gerry Johansson (b. 1945), Sven Westerlund (b. 1955), Per Berntsen (b. 1953), Johan Sandborg, Kirsten Klein (b. 1945), and Taneli Eskola's (b. 1958) photography of the Aulanko region, a Finnish national heritage site. Japo Knuutila (b. 1953) has reworked the landscape in his careful poetic arrangements. Nationalist romanticism has been interrogated by Torbjørn Rødland (b. 1970). Arno Rafael *Minkkinen, inserting his own body in the landscape, has evolved an aesthetic of his own. Pentti *Sammalahti, a road and landscape photographer inspired by the expanses of Russia, has renewed photographic print- and bookmaking.

Institutions developed slowly in the 20th century. Although discussion of a Swedish photography museum began in the 1940s, the department of photography at Moderna Museet in Stockholm did not materialize until the 1970s. Helmer Bäckström's collection, including his vast library, and the so-called Helmut Gernsheim Duplicate Collection, are the foundation of the museum's holdings. A Finnish museum of photography, Suomen Valokuva Taidemuseo, was founded in 1971, after a preliminary exhibition at the Kluuvi Gallery in 1969. The Norwegian Leif Preuss Fotomuseum was established as a private museum in 1976 and as a federal museum in 1999. The Danish Museet for Fotokunst in Odense opened in 1987. In 1999 the Royal Library of Copenhagen's collection of 10 million pictures became the Nationale Fotomuseum. The year 1975 brought the opening of the important Camera Obscura gallery in Stockholm, which became the venue for an imaginative and varied range of exhibitions and other events. Other galleries included the Fotograficentrum in Stockholm, focusing on documentary photography, Galleri Image in Århus (1977), Fotogalleriet in Oslo, and the Cable Factory Photography Gallery in Helsinki (2004).

The development of a photographic infrastructure has run parallel to photography's assimilation into the wider art scene. In the late 1970s, Gunnar Smoliansky (b. 1933) and *Dawid began to explore photographic materials and processes, reviving toning and other methods of enhancing the image, viewed first and foremost as a work of art. Dawid's *ROST* portfolio of 1983, a remarkable journey to the foundations of the medium, was a catalyst for a new generation: Tuija Lindström (b. 1950), manipulating portraits and landscapes, Timo Kelaranta (b. 1951), close-ups of nature, Per Bak Jensen (b. 1949), the archive photograph, Nanna Bisp Büchert (b. 1937), the family-based tableau. The exhibition *Nordisk Fotokunst* in Odense in 1985 was the first manifestation of a generation of photographic artists working from within the visual arts: Dag Alveng (b. 1953); Jim Bengston (b. 1953), master portraitist Hans Gedda (b. 1942); Ulla *Jokisalo; and Martti Kapanen (artist name: Kapa, b. 1949) were among the most influential.

In the 1990s, polarization between photography and 'fine' art was no longer an issue. The generation emerging in this decade was fully part of the world of the visual arts. Elina Brotherus (b. 1972), Miriam Bäckström (b. 1967), Annika von Hausswolff, Jan Kaila (b. 1957), Annica Karlsson-Rixon (b. 1962), Marjaana Kella (b. 1961), Maria Miesenberger (b. 1965), Esko *Männikkö and Martin Sjöberg (b. 1955) are leading visual artists, their output not limited to the photographic medium. Like their predecessors in the 1980s probing materials and techniques, they have expanded photographic practices: formally, via the outsize image or installation; thematically by addressing issues like gender, identity politics, and globalization. J-EL

See also ICELAND.

Ochsner, B., *Fotografiet i Danmark, 1840–1940: en kulturhistorisk billedbog* (1974).

The Frozen Image: Scandinavian Photography (1982).

Rittsel, P., and Söderberg, R., *Den Svenska Fotografins Historia, 1840–1940* (1983).

Kukkonen, J., and Vuorenmaa, T.-J. (eds.), *Valoa: Otteita Suomalaisen Valukovan Historiaan 1839–1999* (1999).

Erlandsen, R., *Pas nu paa! Nu tar jeg fra Hullet: Norsk fotohistorie, 1839–1940* (2003).

Sandbye, M. (ed.), *Dansk Fotografihistorie* (2004).

Schad, Christian (1894–1982), German experimental photographer and painter. He became interested in photography at school, before entering the Munich Academy in 1913. Between 1915 and 1920, after brief military service, he lived as a painter and graphic artist in Switzerland, where he cultivated contacts with Dada artists. In the course of experiments with 'found objects' he discovered cameraless photography and created *c.*30 works later known as Schadographs. In the 1920s, in Italy and then back in Germany, he concentrated on painting, becoming one of the leading exponents of *Neue Sachlichkeit and magic realism. But in 1960–3 he rediscovered the *photogram, creating a substantial body of late work in the medium. UR

Schad, N., and Auer, A. (eds.), *Schadographie: Die Kraft des Lichts* (1999).

Scheimpflug, Theodor (1865–1911), Austrian naval officer and photographic inventor. Although mainly identified with the *Scheimpflug rule governing *camera movements, he also made important contributions to aerial *photogrammetry and in 1903 patented a 'perspectograph' for correcting perspectively distorted aerial photographs for use in mapping. His work was continued after his death by the Scheimpflug Institute in Vienna. His method of photographing the anterior segment of the eye is still used in ophthalmology. RL

Scheimpflug, T., *Die Herstellung von Karten und Plänen auf photographischem Wege* (1907).

Radford, J., 'Theodor Scheimpflug', *British Journal of Photography*, 19 (1978).

Mayer, H., 'Theodor Scheimpflug', *Ophthalmic Research*, 26 (1994).

Scheimpflug rule. Formulated in 1904 by the Austrian Theodor *Scheimpflug (but acknowledged by him to have been anticipated by a Frenchman, Jules Carpentier), this applies to cameras with front and rear movements, when photographing a subject that lies largely in a plane that is not perpendicular to the lens axis. It states that for sharp overall focus the planes of the subject, film, and lens panel must all meet in a single line (the 'Scheimpflug line'). The proof is an extension of Newtonian lens laws. Principal applications are in *architectural and studio table-top (e.g. *pack shot) photography. GS

Jacobson, R. E., et al., *The Manual of Photography* (2000).

Schlieren photography. *Schlieren* is German for 'striations'. The term was coined by Albert Töpler, who developed the technique in 1906 from a related technique used to identify figuring errors in telescope mirrors. Schlieren photography is a way of visualizing density variations in a gas, and is useful in wind tunnel studies and investigations into heat flow. It employs a *shadowgraph principle. A collimated (i.e. parallel) beam of light passes through the test space and is brought to a focus at a knife edge; it then diverges on to a screen or a camera system. Any gas density gradient with a component perpendicular to the knife edge will deviate the light from the region, so that it either clears the edge, giving a bright area on the screen, or is intercepted by it, giving a dark area. The resolution can be improved by a further knife edge at the first focus of the system. Where large spaces are to be imaged, off-axis parabolic mirrors are used rather than lenses to collimate and focus the beam (Fig. 1). An alternative to the knife edge is a band of three colour filters, red above and blue below, with a narrow strip of green in between.

Schlieren photography is sensitive enough to record the pattern of warm air rising from a human hand, but a more sensitive test uses *interferometry, in a kind of hybrid of Schlieren photography and *holography. A laser beam replaces the white light beam, and a beamsplitter and beam combiner form a Mach–Zehnder interferometer set-up (Fig. 2). This shows density differences directly, rather than density gradients. GS

Settles, G. S., *Schlieren and Shadowgraph Techniques* (2001).

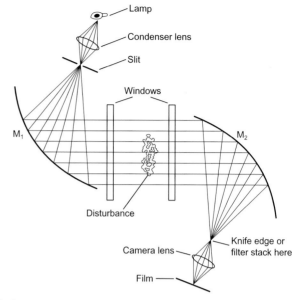

Fig. 1

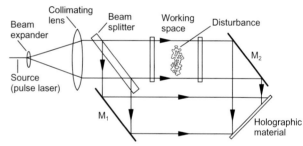

Fig. 2

Schneider, Trutpert (1804–99), German painter and daguerreotypist, based in Baden, who learned photography from the Frenchman Joseph Broglie and went into business in 1848, eventually in partnership with his sons Heinrich and Wilhelm. The firm began making *stereoscopic views in 1850, one of the earliest to do so. Between 1858 and 1862 the family travelled to Berlin, Silesia, Mecklenburg, and eventually Russia, photographing aristocratic and princely estates and monuments. (Count Dohna ordered over 50 views of his castle and gardens at Schlobitten, interiors, paintings, and family tombs.) The Schneiders' success quite late in the *daguerreotype's history was probably due both to the quality of their work, and to the medium's exclusivity compared with mass-produced stereocards and *cartes de visite. Their pictures, some hand tinted, are stamped 'W. T. Schneider' (until 1856) or 'Stereoscop von T. Schneider und Soehne'. RL

Geiges, T., *T. Schneider & Söhne 1847–1921* (1989).

Schollaert, Stéphane G. (b. 1929), Belgian doctor and photographer. The son of a keen amateur, Schollaert experienced as a boy the archetypal magic of the darkroom, but spent his career as a specialist in radiography and medical imaging, returning to personal photography only in 1986. His understated, intimate black-and-white images evoke the tranquillity of everyday things: evening sunshine glowing through a vase, the shadow of a walking stick on a wall, the texture of basketwork, wood, and skin. He has exhibited regularly since 1989. RL

Stéphane G. Schollaert: émotions et lumières, introd. B. Marcelis (1997).

schools. See EDUCATION, PHOTOGRAPHY IN.

Schuh, Gotthard (1897–1969), German-born Swiss painter and photojournalist, who took up photography in the mid-1920s and in the 1930s contributed to the *Berliner illustrirte Zeitung*, *Vu*, *Life*, *Paris Match*, and Swiss journals. However, his two best-known images, of a boy stretched out playing a game, and a temple dancer, were taken in Indonesia in 1938–9 and published in *Insel der Götter* (1940). In 1941–60 he was picture editor of the *Neue zürcher Zeitung*, and co-founded the Working Party of Swiss Photographers in 1951 with Werner *Bischof, Walter Läubli, Paul Senn, and Jakob *Tuggener. He returned to painting in 1960. LAL

Ein Zeitbild 1930–1950—Paul Senn, Hans Staub, Gotthard Schuh: 3 Schweizer Photoreporter (1986).

Schumann emulsion. See ULTRAVIOLET AND FLUORESCENCE PHOTOGRAPHY.

Schwarz, Heinrich (1894–1974), Austrian-born American art historian. He became interested in early photography while a curator at the Belvedere Gallery, Vienna, and in 1929 organized an exhibition of 180 *calotypes by D. O. *Hill and Robert Adamson. His book *David Octavius Hill, Meister der Photographie* (1931; Eng. 1931) was the first monograph on a photographer by an art historian. He held various curatorial and academic posts in the USA after settling there in 1940. His particular concerns were painters' use of *pre-photographic imaging devices; and what he perceived as a 'proto-photographic' vision (abandonment of classical compositional conventions, and fascination with the details of everyday things) developing among early 19th-century artists. RL

Galassi, P., *Before Photography: Painting and the Invention of Photography* (1981).

Parker, W. E. (ed.), *Art and Photography: Forerunners and Influences. Selected Essays by Heinrich Schwarz* (1985).

scientific photography. The scientific applications of photography and imaging as tools to assist visualization date from the earliest days of the introduction of photographic processes. J. W. Draper's celebrated image of the *moon, for example, was taken as early as 1840, and Sir John *Herschel had noted the presence and effects of *ultraviolet (UV) and *infrared (IR) radiation with Henry *Talbot's process in 1839. Today, however, by comparison with specialisms such as *advertising photography and *photojournalism, scientific photography has a low public profile, although its images have roles in many consumer products and health and civic matters.

Scope

Most scientific photographers work for governments or in research institutions, universities, or hospitals. A primary role is the production of images for recording, measurement, and interpretation purposes, principally in the fields of science, technology, and medicine, plus the communication of results in the form of audiovisual material and reports. The specialism is defined as 'photography and imaging used as scientific tools to provide records that cannot be made in any other way'. This includes cinematography, video, and *digital imaging, as these visual media have attributes individually of value, and the most appropriate medium is chosen to suit the recording task. Traditionally, 'imaging' refers to recording outside the visible spectrum.

Scientific imaging extends recording beyond the limits of human visual perception, producing permanent records for analysis and evaluation of the subject. Emphasis is on precision and accuracy, as in the micro-electronics industry from techniques such as photofabrication and micro-imaging. Objectivity and absence of ambiguity are necessary in images for clinical, forensic, and public inquiry work. Many scientific images may have little meaning except to specialists and lack general interest except in certain morbid or sensational—e.g. crime- or disaster-related—cases. However, suitable pictures are used in the editorial and advertising sections of popular and learned journals, where their normally non-visible or purely serendipitous nature, or beauty, attracts non-specialist attention. Additionally, compilations of such images are published in book form, on topics such as *astronomy, natural history, *aerial photography, and human physiology.

In addition to the techniques of studio and location photography, scientific photography uses specialist equipment to record subjects radiating outside the visible spectrum, or that may move too slowly or too fast for changes or events to be readily perceptible, or that may simply be too small or too far away to be examined visually in detail. Recording is possible in situations that are biologically hazardous, giving permanent images to provide accurate dimensional information about the subject without the need for physical contact.

Images may further be optically reduced to micro-images for storage purposes. Storage in digital form allows processing to enhance and emphasize parts of the image to aid interpretation and comprehension. The replacement of film-based recording by digital counterparts has not been a problem in scientific photography; the most appropriate system is chosen for a specific task. The scientific photographer is now involved less with actual recording and more in advising clients as to the most cost-effective method of obtaining results, and in creating the initial experimental design.

Spectral recording

Human visual perception and conventional photography are limited to the spectral band from 400 to 700 nanometres (nm). Information about the nature of a subject is obtained from its 'spectral signature' including patterns of emission and reflection outside the visible region, particularly in the 'near' UV at 300 to 400 nm and the 'near' IR from 700 to 1,300 nm. Both regions can be recorded with modifications to photographic techniques.

Silver halides are sensitive to all UV wavelengths, but modern optical glasses, the gelatin of emulsions and even the atmosphere may remove much of this actinic radiation. Lenses of fluorite and quartz and special film materials are needed for recording the shortest UV wavelengths. *Ultraviolet photography is used, for example, in dermatology (skin) and plant studies. *UV fluorescence photography* is used chiefly in non-destructive testing, for the detection of labelled molecular groups, and for forensic purposes. This technique employs conventional colour film.

For *infrared* recording, with extended sensitization, film materials can record to some 1,000 nm (1 μm). Most optical materials pass infrared but lenses may need a focus shift correction. Apochromatic lenses (i.e. those corrected for the three primary colours) may have the necessary properties. The striking results of infrared photography of landscapes are familiar and used in pictorial photography. The IR reflectance of foliage is indicative of plant types and diseases. The simultaneous recording of reflectance and emission of subjects in visible and IR spectral bands as selected by filters, usually called 'multi-spectral imaging', is a useful tool in agronomy, forensic work, and museum conservation.

Earth satellites use *multi-spectral imaging* to search for water and mineral resources by 'remote sensing'. Film may be replaced by a suitable solid-state sensor which may be 'non-imaging', giving only a single point response, so the subject field has to be 'scanned' by rocking or spinning mirrors to build up a full picture.

Thermal imaging (or *thermography) records the far IR at 3–5 μm and 8–14 μm, using two atmospheric transmission 'windows', and plays an important role in medicine, environmental studies, and *military applications. Such 'thermal cameras' use the emitted radiation from the subject to provide a 'heat map' and any local variations. Digital data can be displayed using designated colours to indicate specific temperatures so giving a 'false colour' image.

High energy particles and ionizing radiation such as X-rays and gamma rays have very short wavelengths. Various *radiographic* techniques use photographic, electronic, or digital imaging to give records of internal details of subjects suited to diagnostic and non-destructive testing purposes.

Optics and illumination

Use is made of various light sources, particularly lasers, and optical equipment such as filters, mirrors, lenses, and prisms, to illuminate subjects in ways that can provide forms of 'optical fingerprint'.

Back lighting and transillumination, especially using *polarized light, can show structure and flaws in simple cases while use of collimated (parallel) light between a pair of parabolic mirrors can show similar dynamic changes in solids, liquids, and gases from changes in refractive index of the subject. Such *Schlieren photography* can be used in aerodynamic studies and wind tunnel work to show air flows, vortices, and shock waves.

A laser provides an intense, shapable, highly monochromatic beam of light. This is used either to scan subjects, or to illuminate them by a motion-arresting pulse of light or show indirectly very small changes in properties by provision of motion-sensitive interference fringes. Interferometric experiments require a rare skill and patience in alignment and interpretation. The fringe patterns produced as topological 'maps' of the subject can be of great visual attraction. The technology of *holography provides images from the recording of interference patterns and is a routine technique for suitable subjects.

Special-purpose lenses can give views ranging from extremely wide to very narrow angle or detailed close-ups of a subject. They may have spectral correction for UV and IR use.

Photomacrography and photomicrography

The photography of small details in a subject is called *photomacrography, further extended to photomicroscopy. Specialized equipment is needed and, apart from their scientific uses, entrancing and beautiful images can result.

Photomacrography is the recording of an image whose size (magnification) is in the range from lifesize to about 20 times larger. To keep equipment manageable in terms of the considerable distance from lens to film needed (in contrast to the very short lens to subject distance), special 'macro' lenses with short focus and suitable aberration correction for a particular magnification or working distance are used. Large camera formats are still popular and camera movements can be used to manipulate the vanishingly small depth of field in the subject to best advantage. Lighting may be provided by ring-flash or fibre optic light guides, but transillumination may be the only way.

Photomicrography uses transillumination for subjects in the form of a prepared glass slide, but alternative reflected illumination is needed for opaque specimens such as in metallurgy and for microcircuit examination. The microscope uses a projection eyepiece to give a real image which can then be recorded using a camera body. No camera lens is needed. Conventional microscopy can give magnifications up to about ×1,000 and details of subjects down to sizes about the wavelength of light (say 500 nm). Thereafter, electronic imaging in the form of scanning and transmission electron microscopes are required, especially for the depth of field given by the former. The 'confocal' microscope uses a beam of laser light to scan the subject through the actual optical system. The image is effectively a record of a thin slice of the subject and can be suitably stored, manipulated, enhanced, colourized, or combined with others as need be. A variety of supplementary optical systems are used in microscopy to provide enhanced image contrast or detail.

The study of motion and flow

Many changes in subjects take a long time. The movement of a glacier, the growth of a plant or a person, the change in star patterns, and the onset of corrosion are imperceptible. To aid perception, elapsed time may be contracted by techniques of 'time-lapse' photography (or cine or video) whereby images are recorded at suitable intervals for playback at normal frequency. Intervalometer devices, often now built into cameras, aid this task and the typical 72-hour continuous recording capability of time-lapse video recorders is useful in surveillance applications. By contrast, an extended time exposure of a subject can reveal aspects of its intrinsic motion or behaviour hitherto unsuspected, for example the distribution pattern of an aerosol spray.

Other aspects of an aerosol, such as the droplet sizes and shapes, are captured by means of *high-speed photography*, where a very short exposure duration, usually provided by electronic flash, can freeze a moment in time. Applications such as aerodynamics, fluid flow, and ballistics use 'microflash' techniques or pulsed lasers to provide multiple images of phases of the action. Synchronization of the event with the flash can be problematic. The classic image of the corona splash pattern of a falling drop of milk is well known.

For a continuous record of an event, high-speed cine or video is used, where the usual framing rate of 25 pictures per second (pps) is increased to 500 pps (framing camera), 20,000 pps (rotating prism camera), 20 million pps (spinning mirror or Miller camera), or greater (image tube camera). A normal projection rate of 24 pps then gives a 'time expansion' to allow visual comprehension of events of very short duration. A pulsed laser gives suitably high repetition rates for illumination purposes. Much high-speed work is now done using video equipment. The long recording time available is useful, as is the rapid access to the image.

Photogrammetry and 3-D photography

An image contains photometric, positional, and dimensional information about the subject. Knowledge of the location and orientation of the lens axis and the photoplane relative to the subject and/or another camera position, followed by measurement of the image coordinates of chosen points and computer-assisted calculations, give three-dimensional data or contour maps of the subject. A stereo pair of images taken using techniques of *three-D photography* is a primary requirement to facilitate data extraction. Familiar applications include *aerial survey work and map-making, but terrestrial uses of *photogrammetry* by non-contact methods give precise measurement of subjects and changes otherwise difficult to achieve. SR

Darius, J., *Beyond Vision: One Hundred Historic Scientific Photographs* (1984).

Krook, H., et al., *Lennart Nilsson: Nature Magnified* (1984).

Jussim, E., and Kayafas, G., *Stopping Time: The Photographs of Harold Edgerton* (1987).

Ray, S. (ed.), *High Speed Photography and Photonics* (1997).

Thomas, A. (ed.), *Beauty of Another Order: Photography in Science* (1998).

Ray, S., *Scientific Photography and Applied Imaging* (1999).

Scotland. For a small nation, Scotland has made a quite disproportionate contribution to the art of photography. Even before David Octavius *Hill and Robert Adamson began their groundbreaking work in Edinburgh in the summer of 1843, Scotland had a significant role in the development of the medium. In the 18th century, Scotland was a European leader in the study of science, medicine, and philosophy. The Scottish Enlightenment had produced such significant figures as David Hume, Adam Smith, Robert Adam, James Hutton, Raeburn, and Burns, and an English visitor reported of Edinburgh's High Street that he could, 'in a few minutes, take 50 men of genius and learning by the hand'. One such was the great chemist Joseph Black FRS; and among those who came from all over Europe to study at Edinburgh University with him was Thomas *Wedgwood, who was there from 1786 to 1788, and who subsequently worked with Humphrey Davy on an idea of photography. The physicist David *Brewster, an expert in light and optics, reported their experiments in the *Edinburgh Magazine* of December 1802 and subsequently became a close friend of Henry *Talbot. By 1839, when Talbot announced his *photogenic drawing process, Brewster was principal of the United Colleges of St Leonard and St Salvator at St Andrews University, and it was through his agency that the *calotype came to Scotland.

Brewster's circle included Sir Hugh Lyon Playfair and Dr John *Adamson. With the assistance of the optical instrument maker Thomas Davidson, both *daguerreotypes and calotypes were made and Adamson's younger brother Robert was prompted into his remarkable but brief career. Robert Adamson set up his studio at Rock House on the Calton Hill in Edinburgh in May 1843, the month which saw the Disruption of the Church of Scotland, arguably the most significant event in Scotland in the 19th century, and it was this momentous occasion that prompted the Hill–Adamson partnership.

Photography had already taken Edinburgh, a city of numerous learned societies, by storm. James Bryson claimed to have taken a portrait daguerreotype in 1839 and Thomas Davidson was making daguerreotypes and improving cameras. As early as 17 April 1839, Dr Andrew Fyfe (1792–1861) delivered a lecture on 'The New Art' to the Society of Arts. In May, Mungo Ponton communicated his discovery of a system of photography using bichromate of potash rather than silver. By October, James Howie, 'Artist' at 64 Princes Street, was showing daguerreotypes he had made, and an exhibition in December included examples by *Daguerre himself. In the west of Scotland, Revd Dr John Smith Memes (1794–1858) made the first English translation of Daguerre's manual and in Glasgow in 1841 Robert Hunt published his 'Popular Treatise' *Art of Photography*, the first comprehensive account of the medium. In 1843, the Edinburgh Calotype Club became probably the world's first photographic society.

The achievement of Hill and Adamson is so dominant that it is easy to overlook the fact that they were surrounded by many other fine contemporary exponents. In 1844, George Skene Keith made daguerreotypes of Palestine; George Smith Cundell (1798–1882) published his own account of the calotype process. James Ross (d. 1878) and John Thomson (d. 1881) set up their own studio on

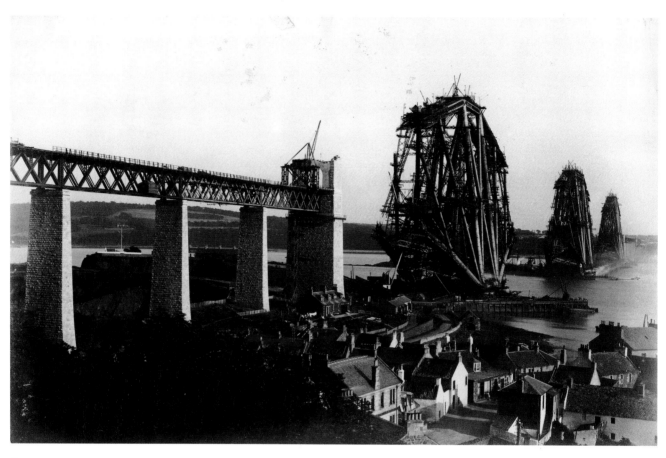

Anon.

Forth railway bridge under construction, late 1880s. Albumen print

the Calton Hill about 1846 and were among the first to use the *albumen process, winning a medal at the *Great Exhibition in 1851. John Muir *Wood, a musician and publisher, explored metals in photographic printing.

After Robert Adamson's death, his brother John encouraged Thomas Rodger to set up in business in St Andrews and he himself became an important portrait photographer. Jemima (Wedderburn) Blackburn (1823–1909) was one of the first to employ photography to reproduce her own drawings for publication; Charles Piazzi *Smyth, the Astronomer Royal in Scotland, used a *stereoscopic camera to take photographs at 2,730 m (9,000 ft) in Tenerife in 1856, and in 1865 inside the Great Pyramid at Giza.

Distinguished amateur photographers of the time included the physician Dr Thomas *Keith and his brother-in-law John Forbes White (1831–1904). Among the professionals were Thomas *Annan and others such as Archibald Burns (d. 1880), James Good Tunny (d. 1887), John Kibble (1815–94), Revd Dr Thomas Kerr Drummond (1799–1888), William Donaldson Clark (1816–73), John Moffat (1819–94), James Cox (1849–1901), Ronald Leslie Melville (1835–1906), and Horatio

Ross (1801–86). In the 1860s, James Clerk *Maxwell was the first to experiment with colour photography.

Scotland as a land of romance was largely the invention of Sir Walter Scott (1771–1832). His writings, the coming of the railways and tourism, and Queen Victoria's love affair with the *Scottish Highlands helped raise landscape photography to an industry through George Washington *Wilson and James *Valentine.

From the beginning, Scots photographers were to be found all over the world. Nearest to home, Lady Clementina *Hawarden, originally from Cumbernauld, produced her extraordinary evocative images in London and Ireland. John *Thomson travelled in Asia and also produced his Street Life of London. Among the many working in foreign fields, frequently the earliest and most successful photographers in their new countries, were William *Carrick in Russia, Alexander *Gardner in America, Alexander *Henderson and William *Notman in Canada, Sergeant James McDonald (1822–85) in the Holy Land, Robert *Macpherson in Rome, Dr John Murray in India, James *Robertson in Turkey, and George Valentine (1852–90) in New Zealand.

George Valentine, the son of James, indicates the professional and aesthetic continuity in the story. The Annan firm, established in 1855, has a special distinction. Thomas Annan's admiration for D. O. Hill, and his son James Craig *Annan's enthusiasm for the calotypes, which he introduced to the New York *Photo-Secession, ensured the impact of the Scottish tradition in America. It was this influence which brought Alvin Langdon *Coburn to Edinburgh at the beginning of the 20th century to illustrate Robert Louis Stevenson's *Edinburgh: Picturesque Notes* and helped persuade Paul *Strand to work in the Hebrides in 1954. Among others making important documentary photographs, often from an 'outsider' perspective, were Werner Kissling (1895–1988) on the island of Eriskay; Humphrey *Spender, Bert *Hardy, Bill *Brandt, and Oscar Marzaroli (1933–88) in Glasgow; Joseph McKenzie (b. 1929) and Wolfgang Suschitzky (b. 1912) in Dundee; Roger *Mayne in Edinburgh and Glasgow. The tradition has continued in the work of, for example, John Charity (b. 1946) and Chick Chalmers (1948–98).

Documentary photographers working outside Scotland include Leslie Hamilton Wilson (1883–1968) in India, George *Rodger, particularly in Africa, and Grace *Robertson (born of Scots parents in Manchester). Influential landscape photographers include Raymond *Moore, Fay *Godwin, and Murray Johnston (1949–90).

Scottish photography in the late 20th century was encouraged by exhibition and education. In 1977 Richard Hough (1945–85) established Stills Gallery in Edinburgh where he was succeeded by Murray Johnston, who became the first head of photography at the Edinburgh College of Art. The appointment of Thomas Joshua *Cooper at Glasgow School of Art was also crucial. Simultaneously, there was a growing awareness of the significance of the Scottish heritage in photography, manifested in 1983 by the founding of the Scottish Society for the History of Photography. In 1984 the National Galleries of Scotland set up the Scottish National Photography Collection, starting with the immensely important holdings of Hill–Adamson calotypes. In 1995, the National Galleries' crucial exhibition, *Light from the Dark Room*, publicly demonstrated Scotland's historical and contemporary wealth in photography. In 2001, the first moves were made to create a Scottish National Photography Centre in Edinburgh, and funding was obtained in 2004.

The key to progress is the current generation of photographers, many of whom work at international levels of excellence. Gunnie Moberg (b. 1941), Stephen Lawson (b. 1942), Patricia Macdonald (see AERIAL PHOTOGRAPHY (FEATURE)), John Charity (b. 1946), Ron O'Donnell, Robin Gillanders, David *Williams (all b. 1952), Pradip Malde, Ruth Stirling (both b. 1957), Andy Wiener (b. 1959), Maud Sulter, Jeremy Sutton-Hibbert (both b. 1960), Calum Colvin (b. 1961), Wendy McMurdo (b. 1962), Owen Logan, Mark Johnston (both b. 1963), Catriona Grant (b. 1964), Iain Stewart (b. 1967), and Jane Brettle (b. 1943) are only some of the significant names that future historians will need to take into account in surveying Scottish photography. DB

Brittain, D., and Stevenson, S., *New Scottish Photography* (1990).

Stevenson, S. (ed.), *Light from the Dark Room: A Celebration of Scottish Photography* (1995).

Scottish Highlands. The region was already established in the public's imagination in the pre-photographic era, thanks partly to Macpherson's *Ossian* forgeries, partly to Scott's romances: the publication of *The Lady of the Lake* (1810), for example, started an immediate rush to the Trossachs. Steamer routes developed from the 1830s, railways from the 1840s (Cook's first Scottish tour was in 1846), and Queen Victoria started building her retreat at Balmoral in 1853.

The 23 views in *Talbot's *Sun Pictures of Scotland* (1845) included famous, Scott-related locations such as Melrose Abbey, Abbotsford, and Loch Katrine. Tourist-photographers began appearing in the 1850s. Far more influential, however, were the Scottish landscapists of the *wet-plate era. The earliest and most outstanding was George Washington *Wilson of Aberdeen, beginning in the established tourist zones of Deeside, the Borders, and the Trossachs in the 1850s, then working north and west to Sutherland, Orkney, and the Hebrides; his assistants ultimately reached St Kilda. On his heroic early expeditions, Wilson sometimes travelled with his friend the bookseller George Walker, who wrote up their experiences in his journal, and in jaunty articles in the Aberdeen press. They give a vivid and rather moving account of a wet-plate photographer prospecting for pictures despite impassable roads, midges, bedbugs, horrible food, and days of unremitting rain. Formidable skills were needed; comparable to salmon fishing, Walker thought. On Staffa in 1860, as the day wore on, 'the wind rose, and small clouds ran races with each other across the heavens. Thus the light varied from time to time; sometimes Wilson would expose a plate for half a minute, and then it would require nearly three minutes, but so skilful was his sense of light, that out of two dozen negatives exposed by him, only one was a failure due to under exposing.'

From the 1860s, Wilson faced stiff competition from James *Valentine of Dundee; indeed it was jokingly claimed that Valentine pitched his camera in Wilson's tripod holes. Each firm created a huge inventory of 'view scraps' and stereographs, distributed throughout Britain and abroad, and eventually launched into *postcards. Their wet-plate views are finely executed, aesthetically pleasing, and usually devoid either of people—apart from the occasional figure to indicate scale—or any deliberate indication of poverty or social problems. (Walker's journals give a different impression.) After Wilson's business failed in 1908, Valentine dominated the field, continuing to purvey a conventionally filtered, tourist-orientated image of Scotland until the television era. RL

McKenzie, R., 'Problems of Representation in Early Scottish Landscape Photography', in M. Hallett (ed.), *Rewriting Photographic History* (1989).

Withers, C., 'Picturing Highland Landscapes: George Washington Wilson and the Photography of the Scottish Highlands', *Landscape Research*, 19 (1994).

seaside photography. If there is one genre of photography less esteemed by historians of photography than the snapshot, it is the seaside portrait. The beach portrait from *Coney Island, Brighton Beach, or Margate Sands is the lowest of the low. And yet, such pictures say a great deal about photography. People at the seaside are enjoying

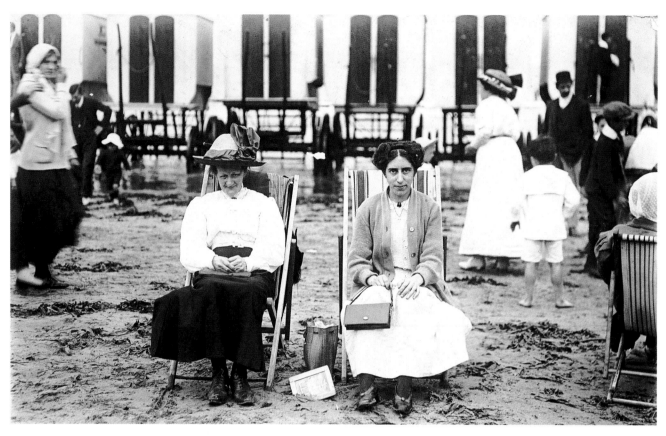

Anon.

Beach scene, England, 1910s. Postcard

themselves; they are ready to spend money; they want souvenirs. What better souvenir than a photograph of themselves? And to the historian, what better window into the way people perceive enjoying themselves? (Another is through the surreptitious pictures of beach fun taken at English resorts like Yarmouth and Ilfracombe by Paul *Martin with a disguised camera.)

Seaside portraits have historically fallen into three groups. The first group is a subset of the studio portrait. The second might be called the 'attraction' picture: the subject riding a donkey, or with his (or her) face inserted in a lifesize cut-out cartoon resembling a traditional seaside postcard. The third is the 'walkie' picture, in effect a snapshot of people on the beach that today would normally be taken by the holidaymaker himself or herself.

All three groups tended to have two things in common: speed and cheapness. Many beach-goers were day trippers, so the service had to be same day at the slowest. Ideally, it was 'while you wait'. Low prices were dictated by the combination of competition from other photographers and the limited funds of the sitters. Many photographers set up studios at the seaside, whether on permanent premises (which might well be manned only during the summer season) or in tents. The best were photographers who maintained studios elsewhere, and worked the

beaches only for the summer season. Others, less well established, had small booths or even handcarts containing all they needed to make a picture, including a miniature darkroom. A few did not even have that: a fraud that worked surprisingly often was to hand the victim a piece of blank paper with the assurance that the picture would appear a few hours later—by which time, of course, they would be back home, far from the 'photographer'.

*Itinerant photographers were already well established at leading beaches by the end of the 1850s. Initially, they used *ambrotypes, though the *tintype soon displaced the earlier process: quicker to make, cheaper, and more robust. The dry-*collodion process was another boost to ease and convenience. By the 1880s photographers were present by the dozen in many of the more popular beaches, so much so that disputes between rival photographers were commonplace, and they remained a familiar sight until the 1950s. Popular in the 1910s and 1920s was the *postcard-format photograph, distinguishable from the private snapshot by an order number (sometimes chalked on a slate stuck in the sand). Although the tintype survived for a very long time, after the Second World War the normal approach was either to use a 35 mm camera and an ultra-rapid 'd&p' (developing and printing) service, or a paper negative in a 'while you

wait' camera such as the Janos. The pressure for 'while you wait' pictures is one reason why so few beach portraits survive. Many were inadequately fixed, and of the few that were adequately fixed, many were inadequately washed. They might last for a few months, or even a few years, but by the time they were old enough to be fascinating historical records instead of commonplace souvenirs, many had faded to almost nothing or gone an almost uniform brown.

The favoured camera of the 35 mm 'walkie' photographer was the Leica, for the abuse it would take: collectors sometimes refer to a worn-out camera as 'a typical walkie Leica'. At the biggest beaches there would be a number of camera operators working from a single location, where the completed prints would be displayed on boards. Unlike the 'while you wait' photographer, who would not normally shoot unless a sale was certain, the 35 mm photographer would often shoot speculatively, relying on squeals of delight and subsequent sales when the holidaymakers saw themselves on display at the booth or shop. By the end of the 1950s, near-universal camera ownership had reduced beach photography to a shadow of its former self. A few photographers went over to Polaroid instant prints, but these were economically marginal because of a combination of high materials costs and ever-diminishing expectations on the part of the public as to what constituted a fair price. Today, there are very few beach photographers and the nearest equivalent to the photographers of yore are probably those studios that do 'fun' sepia portraits, typically with the holidaymakers dressed up in Victorian-style clothing—and even these were less popular by the beginning of the 21st century than they had been in the 1970s and 1980s. RWH

Linkman, A., *The Victorians: Photographic Portraits* (1993).

Garner, P., *A Seaside Album: Photographs and Memory* (2003).

Sébah, J. Pascal (d. 1890), Constantinople (Istanbul)-based commercial photographer whose genre scenes, views, and archaeological studies of the Middle East, especially Egypt, but also Palestine and Mesopotamia, were widely distributed from the 1870s. Made using the *wet-plate process, they appear in various formats, from *cartes de visite* to panoramas. At some stage he went into partnership with another photographer, Jollier (or Joaillier), and, as with many contemporaries, it is uncertain how many of the photographs issued by the firm were actually taken by Sébah. In 1899, the acquisition of *Abdullah Frères' stock compounded the problem of attribution.

In 1873 Sébah was commissioned by the Turkish painter Osman Hamdy Bey to make a series of studio costume studies of people from different regions and social classes for an Ottoman album to be shown at the Vienna International Exhibition. RL

Perez, N. N., *Focus East: Early Photography in the Near East, 1839–1885* (1988).

Sekula, Allan (b. 1951), American photographer, historian, and theorist of photography as a social practice. Sekula's writings explore the ways in which meanings generated by photography are continually shifting and are historically and culturally determined; in other words, the photographic sign is always in dialogue with the world. His work on the photographic archive, in which the dissociation of meaning and use is particularly evident, has been especially influential. In his own photographic practice he has investigated the economic and social conditions of late capitalism through series on work, war, and global commerce. Sekula the photographer seeks to address what is aggressively ignored; for him, the act of making photographs is above all a political act. Through his writings and photography, he has stimulated discussion on both sides of the dialogue described in his essays. MR

Sekula, A., *Photography against the Grain: Essays and Photo Works, 1973–1983* (1984).

semiotics and photography. Semiotics is the study of the social, cultural, and historical processes through which signs such as photographs acquire and circulate meaning. It is a useful critical approach with which to challenge simplistic beliefs in the *realism of the photographic image; and as a critique of humanist and modernist concepts of artistic expression which place the photographer in a central position; where the work's success is measured against the author's intentions, and understanding these intentions means understanding the work. In this view, meaning is created by individuals and communicated using a transparent language. By contrast, a semiotic approach emphasizes how in all signs the relationship between signified (the meaning or content) and signifier (the form of the message) is arbitrary, based on social and cultural consensus; and how all meaning is context determined. Meaning does not pre-exist language, as the author's ideas or feelings, but is created by and through it. Ferdinand de Saussure (1857–1913), who developed structural linguistics in the early 20th century, first proposed that meaning is generated by the difference between signs within a system, rather than by the correspondence between signs and a pre-existing reality. His ideas were then extended to the study of all types of sign systems, including visual ones, and refined by including psychoanalytical ideas and issues relating to reception. *Barthes analysed how realist sign systems, such as photography, disguise their own conventionality by presenting themselves as natural. This 'naturalness' is then used by dominant cultural groups to make their own values and ideologies appear natural, thereby imposing them as 'common sense' on marginalized or disempowered groups. He also argued that the meaning of any given work is not fixed, but a process only temporarily arrested by the reader. Different contexts and audiences bring to a work a different network of intertextualities (references to, or knowledge of, other texts, images, and ideas) and thereby change its meaning. Other writers, such as Rosalind Krauss, have re-evaluated the early model of semiotics proposed by the American philosopher Charles Sanders Peirce (1839–1914), who categorized signs as iconic, indexical, or symbolic, as being more useful to understanding visual signs. PDB

See also CONTEMPORARY ART AND PHOTOGRAPHY; THEORIES OF PHOTOGRAPHIC MEANING.

Storey, J., *An Introductory Guide to Cultural Theory and Popular Culture* (1993).

Cartwright L., and Sturken, M., *Practices of Looking: An Introduction to Visual Culture* (2001).

sensitometry and film speed. The basic work on sensitometry was carried out in Britain in the 1880s by Ferdinand Hurter (1844–98) and Vero C. Driffield (1848–1915), whose results were published in 1890. Their work is elegantly summarized by a graph that plots density D against the logarithm of the exposure, log H: this is variously known as the D/log H (formerly D/log E) curve, the H & D curve (from their initials), and the *characteristic curve.

Density is a logarithmic value. In a negative, if one area transmits twice as much light as another, the density difference is 0.30, the logarithm (to base 10) of 2. If it transmits ten times as much, the density difference is 1.0, the logarithm of 10. And so forth.

Negative density is measured from a baseline of *film base-plus-fog density* ($fb + f$). Film base has a density of about 0.03 for roll-film and sheet film, and 0.3 for 35 mm film, which has a grey dyed base to reduce halation and permit daylight loading of cassettes. 'Fog' refers to those silver halide crystals that develop anyway, whether or not they are exposed to light. It is (or should be) uniform throughout the emulsion, but varies according to the emulsion, the developer, and the development time.

For prints, reflection values are used. If one area reflects twice as much light as another, the density difference is again 0.30. Measurements are taken from a baseline of 'paper base white', the brightest white of which the material is capable.

Exposure is normally measured in lux seconds (formerly called metre-candle-seconds). The logarithm is taken because this gives a more convenient, compact, and easily comprehensible curve than plotting the actual (non-logarithmic) lux second values.

Characteristic curves vary widely in shape, but all follow the same basic form: the curve in Fig. 1 describes a typical black-and-white negative film in a typical developer. It may be divided into several sections:

- *Threshold*. Below a certain level of exposure, there is no density at all. This is a result of the 'inertia' of the material in question.
- *Toe*. At first, the increase in density with exposure is slow, and the slope of the curve is all but flat. By convention, the dark areas of the negative on the toe are called the shadows, though of course they may be any dark area: a black velvet dress in full

sun may be darker than anything in open shadow in the same scene.
- *Straight-line portion*. Sooner or later, the relationship between density and (log) exposure becomes more or less linear. This region is known as the straight-line portion of the curve, though it is seldom absolutely straight. The slope of this curve is known as 'gamma' and is an indication of the contrast of the material: a steep slope (higher gamma) means more contrast, a gentle slope, less.
- *Shoulder*. There is a limit to how much density a given emulsion can deliver, no matter how much exposure it receives. The absolute limit is normally abbreviated to Dmax (maximum density), but before this is reached, the slope of the curve slowly decreases, so that each subsequent lux second gives less and less density.
- *Region of solarization*. With some (not all) materials, with gross overexposure, the density may actually begin to fall again with increasing exposure: *more* exposure means *less* density. This was first seen when the sun recorded as a clear dot in the negative, instead of the black dot one would expect, hence the term *'solarization'. It is of little or no consequence in modern practical photography, and should not be confused with the *Sabatier effect or pseudo-solarization.

With reversal film, or any other direct positive, maximum density corresponds with complete lack of exposure, and minimum density results from maximum exposure. The curve therefore goes 'backwards' (see Fig. 2), the curve for a typical colour slide material.

Speed points

One of the most useful things about the H&D curve is that it can be used to establish film speed. The earliest criteria were based on the *threshold*: the minimum exposure required to give any density at all. For a given threshold speed, however, a short-toe film will be effectively faster than one with a long toe because there is more usable density at low exposures. Another possibility is to produce the slope of the straight-line portion of the curve downwards until it intersects the exposure axis, and use this as the speed point. This takes no account of toe speed and is greatly distorted by development time: the longer the development time, the steeper the curve, and the higher the speed.

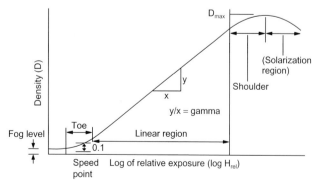

Fig. 1 (Idealized) D/logH curve for a B&W negative emulsion

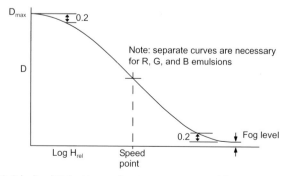

Fig. 2 (Idealized) D/logH curve for a transparency emulsion

The original DIN (Deutsche Industrie Norm) standard in the early 1930s addressed the latter problem by developing the film to the maximum possible contrast ('gamma infinity'). This was admirably standardized but bore little resemblance to real-life photography. The speed point on this curve was taken as a density of 0.10 above $fb + f$: a somewhat arbitrary figure, but a conveniently round number, easily measured adequately with a basic densitometer.

Later in the 1930s, L. A. Jones at Kodak determined a better speed point. He reasoned that the first useful density is when the slope of the curve (on the toe) becomes steep enough to provide useful differentiation of tone with increasing exposure. Empirically, he found that this occurred at 30 per cent of the average slope (gamma) of the straight-line portion, measured between the speed point and a point 1.5 log exposure units further along the curve (32× the exposure, or five stops more). This is the *fractional gradient speed point* criterion, and it is relatively little affected by development: the higher the overall gamma, the steeper the toe gradient needs to be in order to reach 30 per cent of it. This became the basis of the ASA (American Standards Association) film speed system until the late 1950s.

The disadvantage of the fractional gradient system is that the speed point is quite hard to find. In 1959, therefore, the ASA standard adopted the DIN criterion of 0.10 above $fb + f$, with a standard slope defined as one that gives a density of 0.80 above the speed point for an increase in exposure of 1.3 log units. The slope of this curve is therefore $0.80/1.30 = 0.61538$, normally rounded to 0.62. At the same time, the one-stop safety factor that had previously been built into black-and-white film speeds was dropped, so published film speeds doubled overnight, though of course actual film speeds remained constant.

The only significant change since then is that the old 'standard' ISO (International Standards Organization) developer has been dropped, and manufacturers can now use any developer they like. Most use 'middle of the road' developers such as Kodak D-76, though speed-increasing developers can deliver up to 2/3 stop extra speed while still adhering to ISO criteria of shadow density and contrast, and fine-grain developers typically wipe off up to one stop in speed, so an 'ISO 400' film may range from ISO 200 to ISO 650, depending on developer.

Speed points for colour negative films are similarly determined, though the speeds of each individual colour emulsion must be taken into account.

The speed points for transparency film are necessarily more complex. They are based on a *maximum exposure point*, which gives a density of 0.20 above $fb + f$, and a minimum exposure point, which is either where the shoulder of the curve begins or 2.0 above minimum density, whichever is lower. The speed point is the geometric mean of these two exposure points. RWH

Eggleston, J., *Sensitometry for Photographers* (1984).

Hicks R., and Schulz, F., *Perfect Exposure: From Theory to Practice* (1999).

Serrano, Andres (b. 1950), American photographer who became infamous in 1989 when Senator Alfonse D'Amato found *Piss Christ*

(1987) blasphemous. A photograph of a plastic crucifix immersed in urine, the image has a beautifully religious visual intensity: Christ surrounded by a golden reddish glow, its mass-produced details effaced by the bubbly fluid. Much of Serrano's work plays on and gets its strength from the contrast between rich visual qualities and disturbing subject matter: elegant abstractions made from *Semen and Blood* (1990); the chubby feet of a baby, revealed to be dead from *Fatal Meningitis* (1992). Sock elastic marks the ankles, a poignant tactile detail, but the desire to rub them better, as one would a baby, clashes with the thought of the clammy coldness of the corpse. PDB

Serrano, A., *Works 1983–1992*, texts by R. Hobbs, W. Steiner, and M. Tucker (1994).

Hooks, b., Ferguson, B., and Jones, A. (eds.), *Body and Soul* (1995).

Seth, Shetaki (b. 1957), Indian photographer who studied in India and the USA, and worked as a press photographer, before going freelance. She became known for black-and-white *documentary images of the ethnic, religious, and social melting pot of her native Mumbai (Bombay). She took part in the *Economy of Signs* exhibition of Indian photography at the Photographers' Gallery, London, in 1990. RL

Gupta, S. (ed.), *An Economy of Signs* (1990).

Seto, Masato (b. 1953), Japanese photographer of mixed Japanese and Thai-Vietnamese parentage, born in Thailand and resident in Japan since 1961. In 1987, after working as Masahisa *Fukase's assistant, he founded the 'PLACE M' photo gallery in Tokyo. He visited his birthplace for *Bangkok, Hanoi 1982–1987*, published in 1990. In 1994 he began *Silent Mode*, a series on women in the street. He is best known for his photographs of foreign residents at home in Tokyo: *Living Room, Tokyo*, exhibited in 1995 as printed, on a single roll of Photo paper, and published in 1996. MT

VII. Photographic *agency launched in 2001 by an international group of photographers: Gary Knight (London), Alexandra Boulat (Paris), Ron Haviv (Moscow), John Stanmeyer (Hong Kong), and Antonin Kratochvil, Christopher Morris, and James *Nachtwey (New York). It is loosely cooperative, with members free to manage relations with their primary clients and retaining their own copyright, while using the agency to negotiate subsidiary assignments and market their archive pictures online. VII was a response to difficult market conditions at the turn of the century and the unwieldiness of the larger agencies. RL

sex. See EROTIC PHOTOGRAPHY; KINSEY INSTITUTE FOR RESEARCH IN SEX, GENDER, AND REPRODUCTION; PORNOGRAPHY; STORYVILLE PORTRAITS.

Seymour, David 'Chim' (David Szymin; 1911–56), Polish-born American photographer. The son of a publisher of mainly Jewish writers, he embarked on a totally different career which, despite the differences in temperament between the two men, in many ways

mirrored that of his friend Robert *Capa. Both were key figures in the founding of the *Magnum agency.

Trained in book design and printing, Chim was a student at the Sorbonne when conditions in Poland obliged him to embark on photojournalism in 1933, at which he was immediately successful. The socialist and anti-fascist values of the Popular Front infused his work as a leading humanist photographer of the era. He was a brave and incisive reporter of the Spanish Civil War, and a member of the US army photo-reconnaissance division in the Second World War. However, he excelled at social projects. His pictures for UNICEF of children affected by the war are a lasting tribute to his skills. An owlish, scholarly figure who seemed the antithesis of the heroic war photographer, Chim was killed during the Suez invasion of 1956, during a supposed ceasefire. PH

Chim: The Photographs of David Seymour (1996).

shadowgraph, an image produced on photographic material without a camera; the subject matter is interposed between a point source (which can be *infrared, X-rays, or ultrasound, as well as visible light) and the material. Examples of shadowgraphs are *silhouettes of opaque objects, *photograms of transparent and translucent material, and radiographs. GS

Shahbazi, Shirana (b. 1974), Iranian-born photographer, trained and resident in Switzerland. Shahbazi's photography explores a society whose inhabitants' lives are constantly strung between tradition and change. In 2002 she won the internationally prestigious Citibank Group Photography Prize for her installation *Goftare Nik/Good Words*. She uses individual images of everyday people and occurrences, her own photographs as well as painted copies of them by Iranian street painters, presented in mosaic-like mural-size installations, to explore cultural stereotypes. These multiple images combine to create a multivalent portrait of Tehran, structurally complex but emotionally detached, evoking a fragmented and contradictory modern Iran. NM

Shahn, Ben (1898–1969), Lithuanian-born American painter, graphic artist, photographer, and political activist. After first working as a lithographer, he became an artist in the 1930s and in 1932 took up photography on the advice of his friend Walker *Evans, using it both then and later to provide studies for his leftist paintings and murals. He worked briefly for the Resettlement Administration under Roy *Stryker, who sent him south in 1935 to photograph the problems of the cotton industry. (Shahn also recorded his fascination with movie culture in the places he visited.) Later he made his own documentary studies of immigrant and working-class life in New York, continuing to use a 35 mm *Leica with a right-angle finder to capture his subjects unawares. The Fogg Art Museum holds many of his photographs. CBS

Kao, D. M., Katzman, L., and Webster, J., *Ben Shahn's New York: The Photography of Modern Times* (2000).

Shaikhet, Arkadi (1898–1959), Russian photojournalist. After service with the Red Army he worked as a photo retoucher in Moscow, then as a photographer with publications like *Rabochaya Gazeta* and *Ogonyok*. He celebrated the headlong modernization taking place under the banner of 'Socialism in One Country', and contributed to the celebrated photo-essay A *Day in the Life of a Moscow Worker* (1931). In 1930 he had participated in an exhibition of Soviet photography at the London Camera Club. During the Second World War he was decorated for powerful combat photographs published in *Frontovaya Illustratsiya*.

Even when *Socialist Realism was firmly in the saddle, some of Shaikhet's pictures, like the dynamically composed *Kiev Station, Moscow* (1936), have a remarkably avant-gardistic feel. However, he was one of the abler members of the Russian Society of Proletarian Photographers (ROPF) that had earlier attacked the 'formalism' and 'Western decadence' of *Rodchenko, Boris Ignatovich (1899–1976), and their foreign mentors, and favoured an essentially naturalistic, person-centred documentary approach. RL

Morozov, S., and Lloyd, V. (eds.), *Soviet Photography: The New Photo-Journalism 1917–1940* (1984).

Shaw, George Bernard (1856–1950), Anglo-Irish playwright, critic, and amateur photographer. In addition to literature, Shaw sustained abiding passions for music, humour, politics, art, vegetarianism, and also photography. In 1898 he began to photograph his friends, his wife Charlotte Frances Payne-Townshend, and street scenes. He was also a vociferous defender of photography's artistic value. In 1907 he wrote: 'I affirm the enormous superiority of photography to every other known method of graphic art that aims at depicting the aspects and moods of Nature in monochrome.' KEW

Jay, B., and Moore, M. (eds.), *Bernard Shaw on Photography* (1989).

Sheeler, Charles (1883–1965), American painter and photographer. Better known for his paintings, perhaps, Sheeler was nevertheless one of the most innovative photographers of the early 20th century. He studied at Philadelphia's School of Industrial Art, then with William Merritt Chase at the Pennsylvania Academy of the Fine Arts (1903–6). However, recognition of the importance of a kind of structural design and order in the work of the painters of the Italian Renaissance eventually led him away from the Chase school of representational painting. He learned photography initially to support himself and landed a commission to document the Ford Motor Company's River Rouge plant (1927–8). The resulting images, and his photographs of Shaker architecture, New York buildings, and Chartres cathedral are perhaps his best-known work. Charles Millard wrote in 1968: 'Sheeler's "straight", unsentimentalized, sharply focused pictures of urban and industrial life, so remarkable in an era steeped in pictorialism, helped shape the vision on which almost all the best contemporary photography is based.' Sheeler continued to use photography in support of his painting throughout his life. TT

Freedman, M., *Charles Sheeler* (1975).

Sheikh, Fazal Ilahi (b. 1965), American photographer, author, and activist, born in New York and resident in Zurich. A Princeton graduate, he has worked with refugees and displaced peoples from East Africa and Afghanistan. His books—*A Sense of Common Ground* (1996), *The Victor Weeps* (1998), *A Camel for the Son* (2001), and *Ramadan Moon* (2001), all exquisitely designed—are the result of extended and painstaking fieldwork in which the artist seeks trust and collaboration. The combination of Sheikh's elegant, austere portraits and detailed first-person stories by those portrayed establish them as subjects in their own lives, notwithstanding their plight. J-EL

Sherman, Cindy (b. 1954), American photographer and celebrated contemporary artist. Her *Untitled Film Stills* (1977–80), begun after her BA at State University College of Buffalo, New York, attracted instant attention. This was a series of black-and-white photographs inspired by 1950s film adverts in which, as in all her later work, she performed simultaneously as model, photographer, make-up artist, and designer. The images did not make reference to any particular movie or autobiographical narrative, but to stereotypes of female heroines in films. Moving to colour, she continued to point to the socially constructed nature of femininity by subverting culturally prevalent images. In her *Untitled* series of 1981, Sherman used the horizontal, looking-down format of the 'centrefolds' in pornographic magazines, but frustrated the expectations of the genre, using discordant and unsettling poses. In *Fashion Pictures* (1983–4; her images are untitled, and numbered in one continuous sequence) the smooth appeal of fashion photographs is disturbed by angry or inane poses, scarred faces, or the appearance of bodily fluids, as if the models were beginning to physically reject the masquerade of femininity. While 'the feminine struggle to conform to a facade of desirability' (Laura Mulvey) continued to haunt Sherman's iconography, her images from the later 1980s and 1990s seem to reveal the monstrous otherness behind the masquerade. Loosely based on myth, horror, and fairy tales, they feature characters of uncertain gender and species, enlarged glistening organs, oozing orifices, decomposing body parts, and foodstuff tainted by vomit and decay, all rendered vividly by her accomplished use of deeply saturated prints. Her amazing, almost painterly make-up, and costumes, prostheses, and lighting, are used to recreate generic old masters in a series, *History Portraits* (1988–90), that seems to investigate the art-historical dimension of the contradictions and anxieties explored in her previous work.

Returning to her preoccupation with female identity, her late work seems to reference the *'makeover' photographs advertised at the back of women's magazines (2000–2). We still wince at the fashion mistakes, bad skin, and excessive make-up of Sherman's protagonists as they struggle to fulfil familiar clichés of successful femininity, precariously balanced between the ridiculous and the poignant. In this respect, they are conceptually related to the *Clowns* included in a major retrospective at the Serpentine Gallery, London, in 2003.

Sherman's work has attracted much attention from feminist critics, who have seen it as a positive act of resistance to dominant constructions of femininity. PDB

Mulvey, L., 'A Phantasmagoria of the Female Body: The Work of Cindy Sherman', *New Left Review*, 188 (1991; repr. in L. Mulvey, *Fetishism and Curiosity* (1996)).
Krauss, R., *Bachelors* (1999).
Steiner, R., 'Cast of Characters', in *Cindy Sherman* (2003).

Shibata, Toshio (b. 1949), Japanese photographer, born in Tokyo. A graduate in painting and printing of the Tokyo National University of Fine Arts and Music, he changed to photography while studying in Belgium. Returning to Japan in 1979 he held his first exhibition, *Winter Europe*. He then focused his large-format camera on land use and containment in Japan, photographing concrete dams and embankments amid forests and rivers, coolly capturing the dynamism and lyricism in man-altered nature. These photographs became his internationally renowned series *Quintessence of Japan*, exhibited in Japan in 1989 (pub. 1992). OH

Shinoyama, Kishin (b. 1940), Japanese art and advertising photographer. While studying photography at Nihon University, he began his career at Light Publicity (1961–3). Freelance from 1968, he made his name with his second book, *Nude* (1970), which pioneered a new style of artistic nude photography. Although working on various subjects, including travel and body tattoos, he is best known for his celebrity portraits and nudes, the latter including *Gekisha* (*Agitated Shot*), a series using amateur models. His other books include *Hareta-hi* (*Sunny Day*; 1975), *Shinorama Nippon* (1989), *Tokyo Mirai Seiki* (1992), *BALTHUS* (1993), and *House of Mishima Yukio* (1995). MT

shipbuilding and photography. Robert Howlett's (1831–88) portrait of the engineer Isambard Kingdom Brunel (1806–59) posed against a checking drum for the launch of his steamship *Great Eastern* (still known as the *Leviathan*) is one of the icons of 19th-century photography. Taken in November 1857, it captured a moment near the end of one of the first large-scale engineering projects to be extensively recorded by the camera. (Precursors included the reconstruction of the Crystal Palace at Sydenham, photographed by *Delamotte.) Already between 1854 and 1856 a series of construction photographs had been taken by Howlett's sometime partner Joseph Cundall (1818–95). Both men's images were widely circulated either as stereographs or, in engraved form, in papers like the *Illustrated Times* and *Illustrated London News*.

Shipyard photography became widespread from the late 19th century onwards, both to document the progress of projects (in order to obtain payments from customers) and as publicity. As in other branches of *industrial photography, some big firms, such as J. & G. Thomson (later John Brown) of Clydebank and William Denny Bros. of Dumbarton, Scotland, and Ansaldo of Genoa, established special photographic

Reginald Silk

Launch of HMS *Orion*, 20 August 1910, Portsmouth Dockyard

Rick Wilking US Air Force Academy graduates celebrate in traditional fashion, 2 June 1999

(*previous page*) **NASA official** Apollo 11 astronaut Neil Armstrong in spacecraft prior to moon landing, July 1969

departments. Others used commercial firms. In the countless small ports where small-vessel building went on, sometimes on the beach, until 1914, recording the process was a routine aspect of many photographic practices, from the Gibsons at St Mary's, Isles of Scilly, to Wilhelm Hester at Puget Sound, Washington. Their images are often of both archaeological and social interest, showing not only materials and work methods but also the ceremonies accompanying keel laying and launch. At the other end of the scale, chief photographer Ornano and his team at the huge Ansaldo works recorded the whole production cycle from steel making to construction, fitting-out, completion, and trials, their pictures eventually supplying a patriotically inflected publicity campaign aimed at customers (Italian and foreign admiralties), shareholders, and the nation at large.

Britain offers many examples of shipbuilding photography in its halcyon period between *c.*1880 and 1914. The hull construction of the revolutionary battleship HMS *Dreadnought* at Portsmouth Dockyard (1905–6) was carefully recorded in 52 photographs—two a day in the first week, then at weekly intervals. Most images were taken from the bow area looking along the various emerging decks towards the stern, and rarely included workers. After the *Dreadnought*'s launch the Admiralty became reticent about having photographs taken of the fitting-out—only six appear to have survived—and few construction pictures were made of the other eight Portsmouth-built dreadnoughts. However, the Portsmouth-based photographers Cribb and Silk captured many dreadnought launches. Both sought to convey the imperial and navalist ethos of 'launch days': public spectacles dense with patriotic and imperialist meanings. (In Germany, Admiral von Tirpitz's Imperial Navy Office and the *Flottenverein* were using warship photographs to promote the idea of naval expansion and, by extension, world-power status; spies from both countries used photography to capture each other's dockyard secrets.)

The rich collection of photographs commissioned by John Brown, Clydebank, now at Glasgow University's Business Records Centre, includes over 1,000 pictures of the construction of the battleship HMS *Barham* and five battlecruisers; and of transatlantic liners like the *Lusitania*, launched in 1906, and *Aquitania* (1913). The firm's commemorative albums record every phase of warship construction. Its photographers tended to take pictures from three or four set positions, usually from mobile cranes at the berth or dockside. Some pictures emphasize the presence of shipyard workers, and reveal the number of work gangs on a particular ship and the patterns of labour practices. In the later phases of construction 'the ship' was frequently caught in profile in order to bring out her lines.

There are few biographical details of the photographers, whether company employees or independents. An exception is Robert Welch (1859–1936) in Belfast, official photographer of Harland & Wolff from the mid-1890s until the First World War. His images range across the shipyard and include the mould loft, the platers' shed, the foundry with moulds and castings, the engine shops including turbine assembly, brass finishing, and valves, the generating station, hydraulic rooms, and pattern makers' shops. The many liners built by the firm included White Star's *Olympic* (1910) and *Titanic* (1911), and Welch recorded the former's luxuriously appointed interior.

After the First World War, naval treaties and economic uncertainty depressed shipbuilding, and many firms axed their photographic departments. (John Brown, however, retained a photographer until its closure in 1971.) The launches of liners like the *Queen Mary* or *Normandie*, of course, were red-letter days for the popular and technical press, as well as design and fashion magazines. In the later 20th century, photography was still used on an ad hoc basis for purposes of record and publicity. The advent of *digital technology gave shipbuilders a highly flexible tool for monitoring their work. Art photographers continued to be captivated by the overpowering bulk and abstract forms of vast hulls under construction or repair. RDT/RL

Powell, R., *Brunel's Kingdom: Photography and the Making of History* (1985).
Dewerpe, A., 'Miroirs d'usines: photographie industrielle et organisation du travail à l'Ansaldo (1900–1920)', *Annales*, 42 (1987).
Moss, M., *The Clyde: A Portrait of a River* (1997).
Thomas, R. D., and Patterson, B., *Dreadnoughts in Camera* (1998).

shipwrecks. See MARINE AND NAUTICAL PHOTOGRAPHY.

Shiraoka, Jun (b. 1944), Japanese photographer who left a university post in physics after finishing his studies at Tokyo College of Photography in 1972. After travelling in Europe for a year, he settled in New York in 1973, where he participated in workshops with Lisette *Model, Nathan *Lyons, and George Tice. In Paris from 1979 to 2000, he exhibited frequently and made his name with monochrome photographs characterized by deep, nearly impenetrable blacks, ambiguous subject matter, and snapshot spontaneity. He currently teaches photography at Tokyo Zokei University of Art. OH

Shore, Stephen (b. 1947), influential American colour photographer who participated in the 1975 *New Topographics* exhibition. Aged 12 he sold work to MoMA, New York, and at 17 began photographing the activities of Andy *Warhol's Factory; Shore was the first living photographer to have a one-person exhibition at the Metropolitan Museum. Early success gave way to his mature work in 1972, when he left New York and photographed the anonymous back streets of small towns. His highly detailed and structured yet subtle colour prints epitomized the New Topographic sensibility of the 1970s. MR

Shore, S., *Uncommon Places* (1982).

Sidibé, Malick (b. 1936), Malian photographer, born in Soloba (then French Sudan), active in Bamako, Mali. After training as a goldsmith at the National School of Arts, he apprenticed himself to a French photographer, Gérard Guillat (Gégé), and in 1962 opened his own business, Studio Malick, in Bamako. Dividing his time between portraiture and reportage, he created a vibrant and original body of work on Bamako's youth scene in the early independence era. Exuberant, intimate, and direct, it is a document of Mali's post-colonial history and of modern African urban culture. In 1988,

Sidibé became president of the Malian Photographers' Union. Fame brought him international exhibitions and collaboration with magazines like *Vogue and *Cosmopolitan*. In 2003 he won the Hasselblad Photography Award. J-EL

Magnin, A., *Malick Sidibé* (1998).

Sieff, Jeanloup (1933–2000), French photographer who began as a photojournalist in the 1950s, belonging briefly to *Magnum. In 1959 he won the Prix Niépce and published his first book, *Borinage*, containing gritty images of a Belgian miners' strike. But he spent the early 1960s in New York working for leading fashion magazines, especially *Harper's Bazaar*. He made portraits—notably of Rudolf Nureyev (1960) and Charlotte Rampling (1967)—and landscapes (Scotland in 1972, Death Valley, California, in 1977). Most striking, however, was Sieff's continual output of stylish nudes and near-nudes, presented either in sculptural isolation, or in surreal settings like train compartments or, waiflike, in sparse interiors. Shadows or designer lingerie evoke mythical enchantment and bondage. For much of his nude and landscape work he favoured ultra-wide-angle lenses and grainy monochrome. RL

Jeanloup Sieff: 40 Years of Photography, trans. C. Daro and C. Miller (1996).

Signal (1940–5), German fortnightly *propaganda magazine published in twenty languages, for occupied and neutral countries, by the Foreign Bureau of the Wehrmacht. With a circulation of *c*.2.5 million (including 800,000 in France alone), it was notable for exceptionally high-quality monochrome and colour graphics and photographs. Editorial coverage included cultural topics as well as politics and the war, and German photographic firms were strongly represented in the advertisements. Leading contributors, including Harald Lechenperg (1904–94), Hilmar Pabel (1910–2000), and Hanns Hubmann (1910–96), later joined the West German journal *Quick*, and *Signal* itself was a significant influence on post-war magazine production. RL

silhouette, blacked-in profile portrait, named after Étienne de Silhouette (1709–67), Finance Minister under Louis XV, who enjoyed paper cutting as a hobby. As a popular art form the silhouette became widespread in the late 18th century, thanks partly to the Romantic cult of friendship and the physiognomical theories of J. K. Lavater. Although a variety of techniques and materials were used, paper cutting was the method of choice for the most famous silhouette artists, the Englishman John Miers and August Édouart, a Frenchman working in the USA who led a revival of interest in the early 19th century, before photography became the preferred form of affordable portraiture. Silhouette himself had been notorious for his penny-pinching financial policies, and the term was widely used to denote something cheap and common.

In photography, figures or objects can be silhouetted against a bright sky or background by exposing for the latter. MR

Jackson, E. R., *The History of Silhouettes* (1911).

Silvy, Camille (1835–1910). Silvy emerged as a major photographer of the Second Empire in France before repeating his success and enhancing his fame in high Victorian London. He excelled as an individual artistic talent and as the director of a portrait studio serving both an exclusive clientele and a mass market. He was born in Nogent-le-Rotrou, a market town in the Eure-et-Loir, where he photographed his first masterpiece: *River Scene, France* or *La Vallée de l'Huisne*. It was exhibited to acclaim in Edinburgh, London, and Paris in 1858 and 1859. The exquisite rendition of a stretch of river, surrounded by foliage and town houses, with two well-dressed members of the country bourgeoisie preparing for a boating trip on one bank and a larger, working-class group relaxing on the other, was crowned by a dramatic, clouded sky—for which Silvy used a second negative. He came to the attention of the imperial court, but moved to London in 1859 to set up what seems to have been the first *carte de visite studio in London. He established London's most fashionable studio at 38 Porchester Terrace, looking onto Hyde Park, with luxuriously appointed waiting rooms, fine tapestries, sculptures, and other *objets d'art*. His distinguished or at least wealthy sitters from 'the upper ten thousand', set off by choice accessories and painted backdrops, were personally posed by Silvy, who drew on a fresh pair of white gloves for each sitting. His *carte de visite* portraits, printed with Silvy's name and red facsimile signature, are also easy to spot today because of the elegance of the poses and the richness of the gold-toned *albumen prints. The studio was also a factory, with a staff of over 40 to print, trim, and mount the images. *Cartes*, taken six to a glass negative, were volume productions, and Silvy had 50 portraits printed from each negative, 40 for immediate sale to the client and ten for stock (for the client's friends to buy for their albums). One of his royal portraits would sell by the thousand or even by the hundred thousand. Silvy continued to make and exhibit extraordinary larger photographs, some of the best being views taken immediately outside the studio. One of these from 1859 or 1860 (now in the J. Paul Getty Museum) shows a man buying an evening paper from a boy who leans against a lighted gas lamp on a misty afternoon. A figure hurrying along the pavement is caught in a blur—probably used deliberately for the first time to suggest rapid movement. Silvy sold his business in 1868 and returned to France. He fought with distinction in the Franco-Prussian War but soon afterwards succumbed to illness, possibly contracted from the dangerous chemicals used in his profession. He was in hospital for the last 35 years of his life. MH-B

Haworth-Booth, M., *Camille Silvy: River Scene, France* (1992).

Simpson, Sir Benjamin (1831–1923), British amateur photographer who served in the Indian Medical Service (Bengal) from 1853 until retiring as Surgeon General in 1890. During the intervals of a busy career he established a reputation as one of the most distinguished amateur photographers in *India. In the early 1860s he made several journeys to north-east India to photograph racial types, and a series of 80 of these portraits received a gold medal at the London International Exhibition of 1862; the same year

he received the gold medal of the Bengal Photographic Society for portraits, and for 'the best single photograph taken in India'. A number of his unusually sensitive ethnographical studies were later published in *The People of India* (1868–75). A series of 76 views of Kandahar, taken while serving as Deputy Surgeon General with the South Afghanistan Field Force in 1881, was later marketed by *Bourne & Shepherd. JF

Falconer, J., *India: Pioneering Photographers 1850–1900* (2001).

Singh, Raghubir (1942–99), Indian photographer, born in Rajasthan, and a significant figure internationally. He became interested in photography at school. Abandoning his studies at Hindu College, Delhi, Singh moved to Calcutta in the 1960s to seek employment in the tea industry. Instead he met the film director Satyajit Ray, who was instrumental in his decision to become a photographer. He relocated to Paris in the 1970s but returned continually to India to execute a vast body of work on its land and everyday life, published as a series of books including *Rajasthan: India's Enchanted Land* (1981), *Kashmir: Garden of the Himalayas* (1983), *Banaras: Sacred City of India* (1987), and *The Grand Trunk Road* (1995). His work is represented in several museums in the West.

In contrast to many contemporary photographers, Singh was a master of colour, yet able to decentre its distracting and overwhelming presence in India by his natural sense of *mise-en-scène* and framing. Composed with a sharp eye for the arrangement and division of space, his images related multiple narratives that reflected the fractured nature of modernity in India. Influenced by Mughal and Rajasthani miniature painting, Singh also acknowledged a legacy of *photojournalism that began to alter with his work on Rajasthan. *Bombay* (1994), on contemporary urban India, marked a distinct shift in his photography. His last work (*A Way into India*, 2002) used India's Ambassador car to frame and compartmentalize his images. This was his fourteenth book, after his 1998 retrospective *River of Colour*. SG

single-use (disposable) **camera**, basic, usually 27-shot 35 mm camera, with a plastic housing and fixed-focus lens, designed to be used once by the purchaser, then recycled. It was introduced in the late 1980s by companies like Kodak, Fuji, and Agfa to boost film sales. Later versions permitted flash, panoramic, or underwater picture making. Kodak ultimately launched a *digital model, offering the consumer digital files on CD as well as prints.

The single-use concept was remarkably successful. British sales rose from 250,000 to *c*.4.5 million 1989–97. The average Kodak disposable is reused at least three times. Print quality, by high-street standards, is respectable. Disposable cameras are ideal for weddings, children's parties, and environments too crime ridden or otherwise hazardous for conventional equipment. In the early 21st century, significantly, sales of single-use film cameras held up strongly against digital inroads. RL

Uddin, K., 'The Disposable Camera in the Risk Society', *Leisure Futures*, 2 (1996).

Sinsabaugh, Art (1924–83), American photographer, known particularly for his photographs of the American Midwest. Between 1945 and 1959 he studied, then taught, at the Institute of Design in Chicago; afterwards he founded and led the photography department at the University of Illinois, Urbana. Sinsabaugh's wide, horizontally composed photographs were made with a camera producing a negative *c*.30 × 50 cm ($11^4/_5 \times 19^7/_{10}$ in), and his images of flat, often typically arable landscapes encouraged a widespread photographic interest in the Midwest. JG-P

The Photographer and the American Landscape (1963).

Sipa Press, French press *agency founded in 1973 by the Paris-based Turkish photojournalist Göksin Sipahioglu. It became a major institution, with an archive (2003) of *c*.30 million pictures. Sipahioglu left at the end of 2003, after the agency had been bought by the media group Sud Communication, and was replaced by Claude Thierset. RL

Siskind, Aaron (1903–91), American, born in New York, who became a photographer when he received a box camera as a honeymoon gift. From 1932 to 1941 a member of the Film and Photo League, he worked as a *documentary photographer, but after 1945 increasingly turned towards more abstract expressionism. One of the early photographic educators, he taught with Harry *Callahan in North Carolina; 1951–71 was head of the photography department at the Rhode Island School of Design; and in 1963 a founding member of the *Society for Photographic Education. CBS

Chiarenza, C., *Aaron Siskind: Pleasures and Terrors* (1982).

Skeen & Co. Commercial photographers in *Ceylon (Sri Lanka), 1860–*c*.1920. Trading as S. Slinn & Co. until 1868, the firm came to dominate the photographic scene in Ceylon. Under William Louis Henry Skeen (1847–1903), it produced a comprehensive stock of views of the island, including an important record of *railway construction from the 1860s. The firm's establishment coincided with the expansion of the island's plantation economy, and its output includes a particularly extensive record of every aspect of tea production and other agricultural activities. A successful Burmese branch, managed by William's brother Frederick, and trading as Watts & Skeen, was established in Rangoon in 1887. JF

sky. See CLOUDS; FILTERS.

slides. See TRANSPARENCIES.

Slovakia since 1990. Whereas before the separation of the *Czech and Slovak states many Slovak photographers studied at FAMU (the Film and Television Faculty) in Prague, Slovakia subsequently created its own training opportunities, most notably at the Academy of Fine Arts and Design in Bratislava (VŠVU). A key influence on Slovak photography has been the teacher, curator, and writer Vaclav Macek, who headed the FOTOFO organization formed in 1992. He is also a

photographic book and magazine publisher, and organizer of the annual Bratislava Month of Photography festival.

An important debate about the nature and boundaries of art photography was generated by the 1989 exhibition *Slovak Photography of the 1980s*, curated by Macek and Aurel Hrabušicky. Although Slovak documentary photography since the end of communism has been rooted in traditions that had evolved earlier in Czechoslovakia, it has developed a more empirical slant, based on examination of village life, social, and women's issues. Its progress was reviewed in Colin Jacobson's survey *Slovak Documentary Photography* (2002).　　RA

Smith, Edwin (1912–71), English photographer. As with a number of talented photographers of his generation, Smith saw himself more as a painter who had taken up the camera by chance. Trained as an architect, his first encounter with the medium came when he saw some of *Atget's photographs as a student, and bought a Box *Brownie with coupons from cornflake packets. It was soon replaced with a 1904 Ruby plate camera, used almost until his death. Highly successful as an architectural, landscape, and garden photographer, his studies for *English Paris Churches* (1952) are still in print. His work on the streets and people of Camden Town, and on the world of the fairground and *circus, deserves to be better known.　　PH

　　Edwin Smith: Photographs 1935–1971, introd. O. Cook (1984).

Smith, W. Eugene (1918–78), American photojournalist, born in Wichita, Kansas. He began selling pictures in 1933, studied with Helene Sanders in New York 1937–8, then joined the *Black Star agency and worked in fashion and portraiture. In the period 1939–45 he photographed for *Life*, *Parade*, and *Flying*, between 1942 and 1945, when he was badly wounded, producing powerful war reportage in the Pacific. After a slow recovery he rejoined *Life*, contributing numerous *photo-essays, of which the most famous were *Country Doctor* (1948), *Spanish Village* (1951), and *A Man of Mercy* (1954), about Albert Schweitzer. A charismatic, intense, and often difficult man, Smith fought for a conception of the photo-essay in which the pictures, taken, chosen, and arranged by the photographer, governed the narrative, a position that led to constant friction between him (and other photographers) and the text-orientated editors at *Life*. In general, however, his work was outgrowing the magazine format and becoming more suited to the photographic book. At all events, he finally resigned from *Life* in 1955 and joined *Magnum.

Important works were still to come, further demonstrating his intense commitment to projects that excited him or stirred his conscience. The famous *Pittsburgh* study, for example, which was intended to take three months, lasted for three years, and in 1955 alone he took *c.*11,000 photographs in and around the city. In 1971, after a period of architectural and industrial work, he moved to Japan with his wife Aileen and documented the pollution disaster at *Minamata (*Minamata*, 1975). In 1970 a retrospective exhibition, *Let Truth Be the Prejudice*, had been held at the Jewish Museum, New York. At the end of his life he was active as a teacher. His archive is held at the Center of Creative Photography, University of Arizona at Tucson, and managed commercially by Magnum.　　RL

Maddow, B., *Let Truth be the Prejudice. W. Eugene Smith: His Life and Photographs* (1985).
Willumson, G. G., *William Eugene Smith and the Photographic Essay* (1991).

Smyth, Charles Piazzi (1819–1900), Scottish astronomer, artist, and photographic pioneer. Smyth made *photogenic drawings at the Cape in 1839 and died whilst producing an extended series of cloud-form photographs (presaging *Stieglitz). He photographed his 1856 ascent up Tenerife, illustrating his official reports with enlargements produced by his wife Jessie and *photoglyphic engravings made from his negatives by Henry *Talbot. For his controversial 1865 expedition to document the Great Pyramid, Smyth devised a miniature negative camera, invented sealed developing tanks, and employed magnesium *flash lighting.　　LJS

Brück, H. A. and M. T., *The Peripatetic Astronomer: The Life of Charles Piazzi Smyth* (1988).

snapshot. Originally a shooting term, meaning a shot taken with little or no delay in aiming. It first acquired a photographic meaning as early as the 1850s, when the first 'instantaneous' exposures became possible. A writer in 1859 spoke of 'snapping' the camera shutter at the subject and, in 1860, Sir John *Herschel first used the word 'snapshot' when discussing the possibility of taking a rapid sequence of instantaneous photographs to analyse motion. However, it is only since the 1880s, with the emergence of popular photography, that it has assumed its more common photographic association and popular usage. Following the introduction of cheap, easy-to-use hand cameras around the end of the 19th century, a snapshot has progressively come to mean a photograph taken by an unsophisticated *amateur, using a simple camera.

Today, it is the intent of the photographer, rather than the exposure time, that best serves to define the snapshot. Whilst the majority of snapshots are taken with comparatively brief exposures, some are not. Moreover, whilst the word also implies a degree of spontaneity, many snapshots are the result of considerable preparation and arrangement of the subject. The fundamental characteristic of the snapshot is that it is a 'naive' document, motivated solely by a personal desire to create a photographic record of a person, place, or event and with no artistic pretensions or commercial considerations. Since snapshots are taken by people with little or no technical knowledge of photography or the rules of *composition—with often predictable and unfortunate results—the word has also acquired a pejorative association. The popularization of photography was seen as a threat by those who championed the status of the medium as Art. As early as 1899 Alfred *Stieglitz complained that 'The placing in the hands of the general public a means of making pictures . . . has of necessity been followed by the production of millions of photographs. It is due to this fatal facility that photography as a picture-making medium has fallen into disrepute.' Photographs considered to be without particular value or

Anon.

Three men in a car, 1920s

merit were dismissed as snapshots or, in the abbreviated and even more damning-sounding form of the word, as 'snaps'.

In a shoebox at the writer's parents' home there is a postcard addressed to his grandmother, dated August 1963. From her deckchair on the beach, with one eye on her 4-year-old son's sandcastle building, his mother writes: 'Dad gone for a walk on his own to see the camera shops (no interest to us). Thanks for sending the camera. It arrived safely. We have bought a colour film so hope it turns out OK. We should have some good ones.' His father did indeed get 'some good ones', still kept in the same shoebox as the postcard—children paddling or donkey riding, their mother asleep in her deckchair—together with hundreds of other snapshots, bundled together in this and other boxes. Snaps of family and friends, pets and possessions, holidays and weddings, achievements and embarrassments. Most families have a similar hoard, hidden away in wardrobes, cupboards and drawers, boxes or old handbags. Accumulated over several generations, they are a treasured part of the domestic clutter with which we surround ourselves. Familiar, comfortable, and often predictable images, they conform to a visual language that we can all 'read'. Together, they form a record of the complex relationships and social rituals that shape our lives. Each collection of family snapshots shares a common pattern, yet each is unique. Family snaps are an essentially private medium in which we invest all the weight of our personal experience and memory. No matter how technically poor they might be, snapshots are enriched by the many layers of meaning that we are able to bring to them. Remove this level of understanding and personal involvement and the photograph is inevitably diminished. As Hugo van *Wadenoyen wrote in *Wayside Snapshots* (1947), 'snaps . . . are nearly always dull, lifeless things. They are feeble ghosts of the occasions that have brought them forth, mildly evocative possibly to those immediately concerned in the events recorded but merely fatuous and boring to the outsider.' Snapshots may, of course, be viewed objectively, as it were from 'outside'. But the context then is that of social history, sociology, or the history of photography.

Snapshots are primarily personal records. Once removed from this context, their meaning inevitably changes. When the link between the snapshot and its creator or subject is severed, the 'anonymous' photograph is laid open to a vast range of potential readings. Lacking specific information, we rely on imagination to fill the gaps. As Doug Nickel, curator of the first major snapshot exhibition, held at the San Francisco Museum of Modern Art in 1998, has written, 'we enjoy anonymous images for their strangeness, their narrative indeterminacy, for the ambiguity that frequently compels us to ask, Why was this picture taken? What is going on here? What were they *thinking*? The voyeuristic pleasure obtained from examining another's private documents . . . operates here as well, kindling voluptuous speculation and vicarious sensation.' However, whilst diminishing its value, removing a snapshot from its contextual framework does not render it entirely worthless. The value of snapshots as historical documents has recently come to be recognized. Moreover, to the sociologist and cultural anthropologist snapshots are a potentially

Anon.

James Murray, editor-in-chief of the
Oxford English Dictionary, relaxes on
the beach at Borth, N. Wales, *c.*1900

rich resource for study and interpretation. There is a danger of snapshots, just like other vernacular evidence of material culture, being transformed into aesthetic objects through being exhibited in galleries in a traditional art context. However, this should not preclude a considered study of the aesthetics of snapshot photography. Occasionally, of course, snapshot photographers have created images of startling power and beauty. Given the countless millions of snapshots that have been taken, however, this is hardly surprising and should be viewed as serendipity rather than design. Of greater importance is the snapshot's seeming lack of artifice and unselfconscious directness of approach. From the 1970s, some photographers, seeing a stylistic virtue in this perceived lack of sophistication, created work that was grouped under the general label of 'the snapshot aesthetic'. Later, a similar approach may be identified in the work of photographers such as Martin *Parr and Richard *Billingham. A different form of 'snapshot art' is to be seen in the work of the German artist Joachim Schmid, who for twenty years worked with 'found' photographs picked up in the street, arranging them into fantastic visual archives.

The origins of popular photography can be traced back to George Eastman's introduction in 1888 of the *Kodak camera, pre-loaded with film and marketed with the slogan *'You press the button, we do the rest.' For the first time, the act of picture *taking* was separated from that of picture *making*. The Kodak was simple enough for anyone to use. Eastman claimed: 'We furnish anybody, man, woman or child, who has sufficient intelligence to point a box straight and press a button . . . with an instrument which altogether removes from the practice of photography the necessity for exceptional facilities, or in fact any special knowledge of the art.' As Frank Meadow *Sutcliffe put it, no longer did a photographer have to be 'an artist, chemist and mechanical engineer' rolled into one. With the rapid introduction of cheaper camera models, culminating in Eastman's introduction of the *Brownie in 1900,

the economic as well as the technical constraints which had delayed the popularization of photography were lifted. For the first time, photography became accessible to millions of people. By the 1930s it was estimated that over half the households in Britain owned a camera. Today, most families have several. The proliferation of cameras has been dynamically related to advances in photographic technology, especially since the 1970s. Colour film, electronic flash, automatic exposure, focusing, and loading made it easier than ever for anyone to produce sharp, correctly exposed photographs, indoors or out. From the late 1990s, home computer ownership, cheaper cameras, and direct printing technology brought *digital photography within reach of the 'point-and-shoot' amateur. However, whether in colour or black-and-white, silver based or digital, the subjects that people choose to photograph and the ways in which they photograph them have changed remarkably little. The syntax of the snapshot has remained consistent over generations. The 'typical' roll of film (or flash card) still has a Christmas tree at each end and a beach in the middle, and the birth of a child remains the prime incentive for buying a camera. CWH

Green, J. (ed.), 'The Snapshot', *Aperture*, 19 (1974).

Coe, B., and Gates, P., *The Snapshot Photograph: The Rise of Popular Photography, 1888–1939* (1977).

King, G., *Say 'Cheese': The Snapshot as Art and Social History* (1986).

Harding C., and Lewis, B., *Kept in a Shoebox: The Popular Experience of Photography* (1992).

Kenyon, D., *Inside Amateur Photography* (1992).

Starl, T., *Knipser: Die Bildgeschichte der privaten Fotografie in Deutschland und Österreich von 1880 bis 1980* (1995).

Nickel, D., *Snapshots: The Photography of Everyday Life, 1888 to the Present* (1998).

Batchen, G. (ed.), 'Vernacular Photographies', *History of Photography*, 24 (2000).

Smith, J., 'Roll Over: The Snapshot's Museum Afterlife', *Afterimage*, 29 (2001).

snow and frost. For those who do not dwell in the wilderness, the only way to capture pristine snow is to get up very early indeed; and because frost so often melts as the day warms up, the window of opportunity is often very slender there, too. It is worth reflecting on all this when admiring a photograph of snow or frost. Much depends on the old press photographer's adage, 'f/8, and be there': being there is what matters, regardless of the equipment or materials chosen.

Exposure for snow scenes can be a problem, because of their very high reflectivity: a through-lens or other broad-area reading may indicate an underexposure of two to three stops. Exposure for frost can also be a problem, because the best traceries of frost are often against dominant dark backgrounds: in this case, overexposure is the risk. In both cases, incident light readings are advisable. (Still, even without meters, Auguste Rosalie *Bisson made superbly exposed Alpine snowscapes in the 1860s, and Henry *Taunt exquisite frost scenes near Oxford in the 1870s.) Under arduous conditions, e.g. when snowshoeing, a heavy camera bag can overbalance the photographer in deep snow, while a reasonably fast film helps counteract camera shake caused by exertion. Batteries must be kept warm, or they will die. In very harsh conditions, cameras may need to be 'winterized' with special lubricants, and there is a risk that bare metal can freeze to the skin: tape can help. To stop tripods sinking into the snow, plastic discs are useful, preferably with holes to accept the leg spikes.

Low-contrast colour films, or reduced development in black-and-white, are likely to be necessary in order to hold texture both in the snow and in dark objects seen against it. RWH

Snowdon, Earl of (Anthony Armstrong-Jones; b. 1930), British editorial and portrait photographer. Snowdon took his first photographs while at school, making his own enlarger from soup cans. He first came to public attention in the 1950s with his grainy black-and-white pictures of London theatre productions (his uncle was the stage designer Oliver Messel). But, aged 20, Armstrong-Jones had for six months assisted the fashionable society photographer 'Baron', and it was as a portraitist that he became best known. His photographs of eminent and glamorous celebrities have appeared regularly in the *Telegraph* and *Sunday Times* magazines, as well as *Vanity Fair*, American *House and Garden*, *Life*, and many others. Many of these portraits show an unusual sense of humour, and he has persuaded sitters to pretend to be a table leg, stick their heads through lavatory seats, be made up as Dracula, and so on. Armstrong-Jones married HRH Princess Margaret in 1960 (they were divorced in 1978), and was created Earl of Snowdon in 1961. He has published nearly a score of books of his work, designed buildings and fashion, made television films and furniture, and worked with disabled and disadvantaged people. CF

Photographs by Snowdon: A Retrospective (2000).

Snyder, Ruth. See EXECUTION PHOTOGRAPHS.

social functions of photography. These are the main reasons why many photographs exist. Photographs are used by people to exert control over their own lives and memories and construct pasts, bursts of photographic activity marking major life events such as births, weddings, or retirements. Before the advent of cheap and accessible photographic technology, these were the occasions when studio photographers were called upon to make commemorative photographs. Indeed, professionals will still make images particularly dense with social significance: graduation portraits, for example, or formal engagement or *wedding photographs, with participants carefully positioned to reveal relationships and hierarchies.

While this might seem obvious, it reflects how people construct themselves through photography. Feminist writers such as Jo *Spence, Pat Holland, and Annette Kuhn have explored the way in which family *albums privilege certain, often gendered, relationships while suppressing others through the narratives they reproduce. For this reason, photographs are also used in therapy.

Photography also functions at a more collective level. This is evidenced by the strong interest in local visual history projects, such as the Totnes Image Bank or the Beaford Archive in Devon, England. Such initiatives constitute a form of collective memory making, promoting the identity and cohesion of a community. *Digital technologies have given them a new impetus, facilitating the recording and storage of images as a historical resource.

Photographs bind families or communities together, sometimes over great distances. Pictures of a wedding or bar mitzvah, for example, may be sent to distant kin to give them a kind of participatory role in the event. Late 19th-century migrants frequently had themselves photographed; both before departure, and later as a token of success for relatives back home. Eventually photographs may be shown to children and new family members to maintain the link with the 'old country'. The acts of giving, exchange, and sharing with which they are associated may be an important element in the evaluation of photographs.

While the technology of the medium is uniform, the social or cultural functions of photographs are profoundly culture specific. In India, for example, portrait photographs are not put on public view until after the subject has died, being garlanded every year on their birthday. Photographs and, more recently, videos of prospective brides and grooms are submitted to families. In Japan from the mid-1990s *Puri-Kura* stickers created by *Print Club photo booths became hugely popular as signifiers of group membership.

Many social uses of photographs are integrally associated with their *material forms. The size of prints, types of frames, and the design of albums are all related to the images' social functions. In the modern world, there is hardly an aspect of life or, in some cultures, death, to which photographs do not contribute. EE

Halle, D., *Inside Culture: Art and Class in the American Home* (1993).
Pink, S., *Doing Visual Ethnography* (2001).

Jean Rudinger

Snowballs, 1953

586

Socialist Realism. Aesthetic doctrine enunciated at the 1934 first All-Union Congress of Soviet Writers by Maxim Gorky and Communist Party Secretary Andrei Zhdanov, Stalin's son-in-law. Following the early completion of Russia's first Five-Year Plan (1928–32), it reflected Stalin's growing power and determination to subordinate cultural production to his ideological aims. (In 1932 all existing cultural associations had been dissolved, and the individual arts reorganized in centrally controlled unions.)

Socialist Realism in the visual arts harked back to late 19th-century realist painting, but with new improved optimism and political correctness: reality would be recognizable, but selected and idealized; Soviet achievements and heroes would be presented positively and in a form accessible to the masses. The anti-naturalistic avant-gardes that had flourished in the 1920s would be suppressed.

In photography, the principal targets were both the remnants of *pictorialism and *New Vision-influenced cosmopolitan photographers and photographer-designers such as Alexander *Rodchenko, Gustav *Klucis, and Abram Shterenberg (1894–1979). Since the late 1920s they had been criticized for 'formalism' and 'decadence' by journals such as *Proletarskoe Foto* and *Sovetskoe Foto* and members of the Russian Society of Proletarian Photographers (ROPF). Typical was an attack on Rodchenko's famous low-angle *Pioneer Trumpeter* (1930): 'Surely the issue of class lies like a thick, harmful shadow over [it] . . . in the crude bestial knot of muscle and clumsy shape of the face, surely one cannot recognise the lively, happy face of the younger generation of Communists.'

Although Socialist Realism officially put paid to avant-gardism in photography as in the other arts, it was notable that even ROPF stalwarts like Arkadi *Shaikhet, and younger photojournalists such as Georgi *Petrussov and Yakov Khalip (1908–80), continued to use 'New Vision' dynamic perspectives and tilting verticals when it suited them: usually in depicting inherently modernistic subjects like dams or steelworks. Nevertheless, the new orthodoxy persisted for decades, hindering experimentation and the treatment of 'difficult' (non-uplifting) topics. With local variations, it also spread to the USSR's East European satellites. RL

Art and Power: Europe under the Dictators 1930–1945 (1996).

Société Française de Photographie (SFP). In 1854 the SFP's founding group (O. *Aguado, Hippolyte *Bayard, E. Durieu, J.-B. Gros, Gustave *Le Gray, H.-V. *Régnault, et al.) left the *Société Héliographique, a body that was probably too loose, and disintegrated soon after its creation in 1851. Mindful of this failure, the SFP adopted a firm structure, modelled on the Academy of Sciences, including an established venue, regular sessions, commissioned papers, and a bulletin. For the rest of the 19th century it committed itself to the promotion of photography through regular exhibitions, technical competitions, training courses, and lectures. It functioned as both an academy and a repository of photography. Demonstration sessions were usually followed by the deposit of specimens in the SFP's archive, which was also constantly enriched by members' donations. In the

20th century the society has been active primarily in the historical and preservation field. Today it is a research centre, publishing the *Études photographiques* and making available its rich collections of equipment and images (10,000 prints and 50,000 negatives, including 5,000 *autochromes) and its library (8,000 books and over 650 periodicals). CC

Poivert, M., 'La SFP rejoint la BnF', *Revue de la Bibliothèque Nationale de France*, 2 (1994).

Société Héliographique. Founded in January 1851 as a society of artists, literati, and scientists 'to hasten the perfection of photography', it existed for less than a year. However, it served as a model for later associations (many of its members became founding members of the *Société Française de Photographie in 1854), just as its journal, La *Lumière*, inspired similar journals. It also pressed strongly for the government-funded *Mission Héliographique. Under the presidency of the daguerreotypist Jean-Baptiste Louis, Baron Gros (1793–1871), members included Hippolyte *Bayard, Edmond Becquerel (1820–91), Eugène Durieu (1800–74), *Niépce de Saint-Victor, Olympe *Aguado, Gustave *Le Gray, Édouard *Baldus, Henri *Le Secq, N. M. P. Lerebours (1807–73), the writers Francis *Wey, Henri-Victor Regnault (1810–78), and Ernest Lacan, the painter Eugène Delacroix (1798–1863), the engraver Augustin-François Lemaître (1797–1870), and the optician Charles-Louis Chevalier (1804–59). KEW

Rouillé, A., *La Photographie en France, textes & controverses: une anthologie 1816–1871* (1989).

societies, photographic. See CLUBS AND SOCIETIES, PHOTOGRAPHIC; PROFESSIONAL ORGANIZATIONS, PHOTOGRAPHERS'.

Society for Photographic Education (SPE). Prior to the 1960s, photography was taught primarily in departments of journalism at American universities. The SPE appeared as art departments were beginning to include photography in their curricula. Nathan *Lyons, then associate director at George Eastman House, recognized the emerging academic field and organized a conference in November 1962 in Rochester, New York, to address educators' concerns. Beaumont *Newhall, Walter *Rosenblum, Art *Sinsabaugh, Aaron *Siskind, Henry Holmes Smith, John *Szarkowski, Jerry *Uelsmann, and Minor *White were among the 30 attendees who, representing the intersection of fine-art practice, education, and history, aimed to formulate the goals of photographic education. The first annual conference was held in Chicago in 1963 and the articles of incorporation were signed in May 1964. Since its establishment, many noted photographers, curators, and critics have been involved with SPE, a national non-profit organization that seeks to promote a wider understanding of photography in all its aspects, and to foster teaching, scholarship, and critical analysis. The SPE's headquarters are at Miami University in Oxford, Ohio, and its archives are at the Center for Creative Photography in Tucson, Arizona. JPY

sociology and photography. Photography's early connection to sociology derived from the assumed ability of the photograph to document reality. Photographers such as Jacob *Riis photographed urban squalor, child labour, and related topics, as American sociologists explored similar social problems via field research. The *American Journal of Sociology* 1896–1904 and 1909–15 routinely included photographs in published field studies. (Especially notable were Bushnell's 1901 articles on the Chicago stockyards.) The early use of photography in sociology, however, was not tied to theorizing, and it seems not to have occurred to founding theorists of the discipline like Émile Durkheim to test or present concepts such as mechanical solidarity with photographic or other visual evidence.

The assumption that photos carried palpable traces of the world, however, had already been shown to be naive. Photographs by Eugène Appert (1830–91) that supposedly depicted atrocities committed during the *Paris Commune of 1871 were eventually found to be fabrications created by means of scissors and darkroom work. Today, software applications such as *Adobe Photoshop make image manipulation much simpler and more deceptive.

Sociology, however, did not reject photography because it could easily be made to lie. Rather, as sociology explained society more abstractly, photography's inevitable focus on the particular appeared to make it irrelevant. Only a handful of field studies completed during the heyday of the Chicago School in the 1920s and early 1930s included photographs, and they were not integrated into the theoretical arguments. The breakthrough in linking photos with social science theory was Gregory Bateson and Margaret Mead's *Balinese Character: A Photographic Analysis* (1942). For the first time in modern social science, photographs became more than records of field experiences; rather, Bateson and Mead used them to ground concepts in the observed world. But the impact of this study mainly began to be felt in the 1960s and 1970s, as separate fields of visual *anthropology and visual sociology took form.

Visual sociology began in the USA as an outgrowth of *documentary photography, itself revitalized by the *civil rights struggles, the anti-Vietnam War movement, and the growth of a counter-culture in America. Robert *Frank's biting documentation of 1950s America, *The Americans* (1959), fuelled the idea that sociologists could use images to explore sociological concepts. However, Howard Becker was the first modern sociologist systematically to elaborate the link, in a groundbreaking article in the first number of *Studies in the Anthropology of Visual Communication* (1974), 'Photography and Sociology'. Here he defined the relationship between the photographic image and sociological thinking; compared the approach of photographers like Frank and Larry *Clark with the theoretically informed work of sociologists; and considered how the explanatory value of photographs could be enhanced by interviews and accompanying texts. His own photographic work (for example, in field studies of counter-cultural medical emergency work) and subsequent articles and reviews can be credited with legitimizing photography in mainstream sociology.

So can other 1970s studies, such as Doug Harper's work on tramps, Phyllis Ewen's on beauty parlours, and Bill Aron's on Manhattan's Hasidic Jews.

In the 1980s, Christopher Musello and Richard Chalfen explored the sociology of photographic culture itself, pioneered in the 1960s by the French sociologist *Bourdieu. In 'Studying the Home Mode: An Exploration of Family Photography and Visual Communication', published in *Studies in Visual Communication*, 6 (1980), Musello proposed categories both for what appeared in *family photographs (poses, subject matter, etc.) and for the practices surrounding picture taking: e.g. the kinds of occasions that would and would not be recorded, conventions of editing and display, the use of pictures to bridge generations or integrate new family members, and the changing role of photography over the family life cycle. Chalfen explored these topics at greater length in *A Snapshot View of Life* (1987), which examined home movies as well as photographs, and devised a 'socio-vidistic grid' for classifying practices before, during, and after picture making. An important influence here was the work of the visual anthropologist Sol Worth, who had emphasized photography's status as a product of culture as well as a means of recording it.

The link between visual sociology and photography became more complex as visual sociology split between visual ethnography (which maintains a familial relationship to documentary photography) and *semiotics. The former has itself undergone a transformation from documentation (that is, an ethnographer taking photographs, as part of field research, that embody the ethnographer's own viewpoint) to elicitation. In photo-elicitation, images become the basis of dialogue between researcher and subject. Their meanings, rather than being assumed, are constructed in interviews, discussions, and reflections. The images may come from photographic fieldwork, personal records, or photographic archives. Harper's study *Changing Works: Visions of a Lost Agriculture* (2001), for example, used photos from the Second World War era to encourage elderly farmers to construct a critical history of an agricultural community. (A contrasting approach, more vivid but also more subjective, was Michael Lesy's interview-based study *Time Frames: The Meaning of Family Pictures* (1980).)

While cultural studies has resurrected semiotics, its relationship with the photographic image remains problematical. All visual traces of the world (many are photos, and many are recorded via photographs) are treated as texts embodying messages about politics and class relationships. While this represents a welcome infusion of theory into the study of images, it also reduces the image to a means by which ideas are communicated rather than a basis of discovery.

Interest in photography on the part of social scientists is increasing. Documentary photography refused to wither before the postmodern tempest. *Digital technology has invigorated rather than emasculated photography, now that the issue of *realism is settled. Critical examination of society, found in cultural studies, has come closer to

newly sophisticated visual ethnographies, which address the matter of the constructed image as well as the image as representation.　　DHA/RL

Wagner, J. (ed.), *Images of Information: Still Photography in the Social Sciences* (1979).

Halle, D., *Inside Culture: Art and Class in the American Home* (1993).

Prosser, J. (ed.), *Image-Based Research* (1998).

Pink, S., *Doing Visual Ethnography* (2001).

Banks, M., *Visual Methods in Social Research* (2001).

softcopy photogrammetry. See AERIAL SURVEY.

soft focus. In a soft-focus image, highlights are surrounded with an almost imperceptible glow that softens both contrast and fine detail—an effect quite different from out-of-focus images, or lack of sharpness resulting from camera shake. Soft focus has long been popular for portraits, especially for flattering the complexions of women who are no longer in the first flush of youth, but it has gone in and out of fashion for other subjects such as landscapes, still lifes, and flower studies.

The classical route to soft focus is via a specially computed lens, in which spherical aberration is deliberately under-corrected. The lens is used at a wide aperture, because stopping down reduces spherical aberration. The results obtainable with such lenses, especially on large-format cameras, cannot be equalled in any other way: *Hollywood portraits from the 1930s are perhaps the perfect example, shot on 20.3 × 25.4 cm (8 × 10 in) film with 400 to 600 mm (16 to 24 in) lenses as fast as f/3 to f/6.

With smaller formats, or with soft-focus screens instead of purpose-made *soft-focus lenses, the effects are less predictable and generally less successful. The most successful soft-focus screens, such as the Zeiss Softars, when used on a roll-film camera such as a Hasselblad, can give effects that are all but indistinguishable from true soft-focus effects on larger formats, at least in colour. Soft-focus monochrome with small cameras is the most difficult of all.　　RWH

Hicks, R. W., and Nisperos, C., *Hollywood Portraits: Classic Shots and How to Take Them* (2001).

Ullrich, W., *Die Geschichte der Unschärfe* (2002).

soft-focus lenses, early. Single lenses give a lower resolution because of *lens aberrations: they were reintroduced in the late 19th century for 'impressionistic' photography (Dehors Spectacle Lens Sets, 1895), as were simple uncorrected portrait lenses (Wollensak, Pinkham, and Smith) in the early 1900s. Combination lenses designed to produce diffusion included convertible triplets such as John Dallmeyer's 'Patent Portrait Lens' (1866; modified 1886, 1909), variable-focus lenses (Thomas Dallmeyer, Adolph Miethe, both 1891), and the uncorrected telephoto Dallmeyer-Bergheim portrait lens (1896–1937). All altered the focus by changing the distance between lens elements, and were popular with pictorial and portrait photographers. Adjustable diaphragms could also be used to control the effect of 'off-axis' image rays through the lens, responsible for soft focus.　　HWK

solar camera, a device that used sunlight, reflected by a mirror through an optical system into a darkroom, to make photographic enlargements from *negatives. The first one was described in 1854 and a well-designed example was patented in England in 1857. In 1860 Joseph *Albert in Munich acquired one, designed by Justus von Liebig with a mechanism capable of maintaining a constant angle with the sun, to produce lifesize portrait enlargements. It had a 3 × 0.9 m (10 × 3 ft) mirror and a gigantic lens, necessary to collect enough light for short printing exposures. Solar cameras had largely disappeared by the mid-1880s, when the increased sensitivity of silver bromide printing papers allowed artificial illuminants like gas and electricity to be used for enlarging.　　MP

solar eclipses. The apparent diameter of the moon is almost exactly the same as that of the sun, but the plane of its orbit is not the same as that of the earth round the sun, so it passes directly in front only rarely. When it does, there is an eclipse. However, if the moon is at its furthest from the earth it does not completely cover the sun, and the eclipse is annular.

Photography of solar eclipses is not easy. The contrast is high, and it is difficult to record the corona at the same time as solar prominences. If the sky is clear, an emulsion speed index of ISO 400 will demand an exposure of around 1/60 s at f/4 to record the corona, and 1/250–1/500 s for prominences. A lens of at least 200 mm focal length is recommended.

If clouds obscure the sun all is not lost. The black shadow flitting across the sky can be recorded by a wide-angle lens, and if taken at approximately one picture per ten seconds this can provide a dramatic series of images.　　GS

Pasachoff, J. M., and Covington, M. A., *The Cambridge Eclipse Photography Guide* (1993).

solarization, the tone reversal of an image on printout paper or negative materials caused by gross overexposure. The figure normally quoted is about 1,000 times the amount of light required to give a normal negative image following development. Studies of the phenomenon began in the 19th century, notably by the French astronomer P. J. C. Janssen (1824–1907) and by Sir William *Abney, but the chemistry remains imperfectly understood today. Many photographers use the term incorrectly. The so-called 'solarized' images of artists such as *Man Ray are produced by a different chemical mechanism known as the *Sabatier effect.　　JPW

Life Library of Photography: The Print (1972).

Sommer, Frederick (1905–99), Italian-born American artist, musician, poet, and photographer. He grew up in Brazil, then trained as a landscape architect at Cornell University in Ithaca, New York. After Cornell, he returned with his new wife Francis (née Watson) to Brazil to practise architecture until 1930. Tuberculosis forced his departure for Switzerland, then Arizona, where he remained until his death. Although he began to photograph in 1930, photography remained secondary to his painting and composing until 1938 when,

Carleton E. Watkins

Solar eclipse from Mount Santa Lucia, January 1880. Albumen print

having met Edward *Weston, Alfred *Stieglitz, and Georgia O'Keeffe, he bought and used a 20.3 × 25.4 cm (8 × 10 in) camera to photograph an amputated foot and decomposed animals. In 1941 he began his horizonless landscapes and met the Surrealists *Man Ray, Max Ernst, and André Breton. He continued to write, compose, and draw, but concentrated mainly on photography, both with a camera and without, making *clichés-verre and *photomontages, and photographs from manipulated negatives and paper cut-outs. In 1981 he had a retrospective exhibition at the Center for Creative Photography, Tucson, Arizona. KEW

Conkleton, S. (ed.), *Frederick Sommer: Selected Texts and Bibliography* (1995).

Sommer, Giorgio (1832–1914), German photographer, active in Italy. Born in Frankfurt, Sommer turned to photography after initial commercial training, and in 1856–7 co-owned a studio in Rome specializing in *stereo and *carte de visite views, and pictures of the Vatican treasures. Soon afterwards he established himself in Naples, by this time increasingly frequented by tourists, and eventually ran four studios there. His growing output of *albumen prints of Naples, Sicily, and other Italian locations gave him a strong position in the market, as did the vertical integration of his business, from picture taking to retail and mail-order distribution. In the early 1860s he captured topical images of Garibaldi and the aftermath of the Unification campaign around Naples. RL

Miraglia, M. (ed.), *Giorgio Sommer in Italien: Fotografien 1857–1888* (1992).

Sontag, Susan (1933–2004), American critic and novelist, the author of *On Photography* (1982), a collection of essays first published in 1977, much quoted and reprinted since. The book critically examines the *realism of the photographic image; the variety of its uses in our culture; and how the camera operates as an addictive 'fantasy machine'. Sontag was particularly exercised by photography's ethical dimension; how the photographer, especially the photojournalist, is in a position of power characterized as predatory by the very language used to talk about 'shooting', and marked by unbalanced gender relationships (the camera as gun, as penis). Photography, she argued, with its inherent tendency to aestheticize tragedy and distress, transforms 'history into spectacle', removing people's instinct to want to experience the world first hand, where changes can be effected, and turning them into passive spectators of an endlessly recyclable 'image world'. In *Regarding the Pain of Others* (2003), however, Sontag seemed to want to reconsider the *ethics of photography, and re-evaluate its power to bear witness to traumatic historical events, even in a culture dominated by spectacle. PDB

Sougez, Emmanuel (1889–1972), French photographer, born in Bordeaux. In 1911 he abandoned art training to travel in Europe. After the First World War he started as a freelance photographer in Paris, eventually becoming a leading exponent of post-*pictorialist *photographie pure*, a movement similar to *Neue Sachlichkeit. In 1926

he founded the photographic department of *L'*Illustration*, and encouraged the formerly staid paper to use colour photography. In 1933 his photographs of Rodin sculptures earned considerable acclaim. But he also excelled at rigorously composed, large-format still lifes, Paris street scenes, and nudes that combined voluptuousness with classical elegance. He illustrated numerous publications on art and artefacts from around the world, and after the Second World War wrote extensively on photographic history and theory. Many of his negatives were bequeathed to the Bibliothèque Nationale de France. RL

Sougez, M.-L., and Rochard, S., *Emmanuel Sougez: l'éminence grise* (1993). *Figures parfaites: hommage à Emmanuel Sougez* (2001).

Southam, Jem (b. 1950), British photographer, best known for *Rocks, Rivermouths, Ponds: The Shape of Time* (2000), colour landscapes that investigate the changing physical environment of the south and south-west of Britain. He regularly revisits sites, which range from a single pond or cliff face to long stretches of river, making use of even light to create a systematic visual barometer of nature. The method is archaeological; the implications existential. Pictures are aesthetically harmonious, but detail unsettles. He has exhibited widely; other publications include *The Red River* (1987) and *Raft of Carrots* (1992). LW

Southworth, Albert Sands (1811–94), and **Hawes, Josiah Johnson** (1808–1901), New England studio photographers who took up photography separately after attending demonstration lectures by *Daguerre's disciple François Gouraud in 1840. Southworth, a drugstore owner, opened his first *daguerreotype gallery in Chicopee, Massachusetts, with Joseph Pennell in 1840; the early experience of Hawes, a self-taught painter and former apprentice carpenter, probably included a partnership with Fred Somerby in Boston. But by 1843 the two men were principals of a business that was to last until the beginning of the 1860s. (Southworth temporarily joined the Gold Rush in 1849–51, and made daguerreotypes of San Francisco.) Their Boston studio flourished: they specialized in simple, high-quality daguerreotype portraits, capturing gravity and dignity without the stiffness and tension evident in the work of the average practitioner, and they firmly refused to adopt the increasingly common practice of hand tinting. They habitually used larger plates than their competitors, and boasted that they never needed to charge less than $5 for a picture. They also patented various items (including *stereoscopic equipment), manufactured cameras, and sold photographic supplies. After the partnership was dissolved, Southworth lectured on photography for a number of years, and Hawes continued to photograph at least until the end of the century. RP

space photography. See ASTRONOMICAL AND SPACE PHOTOGRAPHY.

Spain. As in most European countries *c.*1839, progressive circles in Spain looked to Paris as the source of innovation and enlightenment.

Southworth & Hawes

Two Hawaiian princes, May 1850. Daguerreotype

The announcement of *Daguerre's invention was therefore extensively covered, with a predictably optimistic gloss, in the liberal press. In early 1839, however, the prestigious Academy of Arts and Sciences of Barcelona was also getting direct information about Daguerre's process from its agent in Paris, the doctor and writer Pedro Felipe Monlau y Roca (1808–71), whose reports led it to acquire a daguerreotype outfit, brought to Barcelona by the engraver Ramón Alabern. The academy then organized a public demonstration of the process. On the morning of 10 November 1839, to the accompaniment of a band, and explanations for the spectators of what was going on, Alabern made a successful exposure of a building. The resulting daguerreotype was exhibited, and publicly raffled four days later. Thus did photography become a practical reality in Spain.

In 1839–40 up to four different translations of Daguerre's manual were published—an unprecedented event for a technical work in Spain. However, photographic activity remained limited, given the narrow basis of science and technology in Spanish society, and because the country was just emerging from civil war (1833–9). But by 1850, cities like Madrid, Barcelona, Seville, and Cadiz had portrait studios, and shops where daguerreotype equipment could be obtained. The advent of the *wet-plate process and the spread of the *carte de visite subsequently boosted the portrait business, so that by c.1860 practically every provincial capital had a least a couple of permanent studios. By 1900, their numbers had increased dramatically. As elsewhere, the competence of commercial operators was variable, although the average quality of Spanish portraiture seems to have been high.

Many professionals also moved into the celebrity portrait and art reproduction markets. Much late 19th-century non-portrait work was related to the latter, and to illustrated book publishing. Particularly spectacular was the output of the Madrid-based French photographer Jean Laurent (1816–c.1892). After an initial catalogue of 1863 containing a few hundred photographs of works of art in Spain (mainly painting, architecture, and monumental or urban views), Laurent assembled a large archive of negatives, and by the 1890s had thousands of items on offer. His firm, J. Laurent y Cia, had a shop in Paris and a European-wide distribution network. (Under subsequent owners, the Laurent archive remained active until around the mid-1970s.) On a smaller scale, several Spanish photographers followed in Laurent's footsteps: for example, Casiano Alguacil Blázquez (1832–1914) in Toledo, A. Esplugas in Barcelona, the Beauchy family in Seville, and Eusebio Juliá (1826–c.1890) in Madrid. Such enterprises contributed significantly to knowledge of classic Spanish art in the late 19th and early 20th centuries.

Spain's history, topography, and cultural heritage increasingly attracted visitors from all over the world. Commercial and amateur photographers toured the country to record the main cities and art treasures; Burgos, Madrid, El Escorial, Granada, and Seville were featured in the core itineraries. Of cities, Seville probably attracted the most photographers; the Alhambra in Granada was Spain's most-photographed individual monument. Prominent among 19th-century

visitors, lured by the fabulous—and, it was feared, disappearing—remnants of a glorious past, were Eugène Piot (1812–91), who arrived in 1840 with the writer Théophile Gautier; Edmond Jomard, who contributed a few Spanish views to N. M. P. Lerebours's *Excursions daguerriennes* (1840–4); the Irish photographer Edward King Tenison, who produced a set of extraordinary *calotypes c.1851–2; Gustave de Beaucorps in 1858 and Louis de Clercq in 1863, en route to Africa and beyond. For commercial purposes, Francis *Frith, James *Valentine (both using hired operators), and Jules Levi obtained large numbers of Spanish views. Of resident foreigners, other than Laurent, the key figure was the Welshman Charles Clifford (1819–63), whose output between 1850 and 1862 at least equalled in quality anything else produced there in the 19th century.

By the turn of the 20th century, alongside industrial and social modernization, the availability of *dry plates, *roll-film, and hand-held cameras facilitated the growth of amateur photography. Salons and photographic magazines became popular in the larger cities and even outside them. But most materials were imported, and the local photographic industry never captured a significant share of the market. Photographic practice remained rather exclusive, which kept costs high and gave the medium an elitist, aesthetically conservative aura. The debates surrounding *pictorialism—mainly as to whether or how far the negative should be manipulated—centred on the newly formed photographic societies. The most important was Madrid's Photographic Society, which from 1904 produced an influential bulletin, edited by Antonio Cánovas del Castillo (*Kâulak*).

Some modernist movements, and many talented individuals, worked their way round 'official' artistic trends. Artistic movements in early 20th-century Spain mainly followed European and American trends. However, in different regional and social contexts, their impact varied considerably. The movements imbued with the spirit of the *Generación del 98* first and the *Novecentistas* later (especially in Catalonia) substantially influenced Spain's otherwise not very dynamic art photography. In the 1920s Catalonia's highly developed graphic tradition certainly impacted on the region's photographic scene. Many Catalan *Nouvecentistes* sought to renew prevailing intellectual and aesthetic conventions, and to launch a new era of Spanish art, one that would be dramatically interrupted by the coming of civil war in 1936. Until then, many Spanish photographers would be involved in the *Nouvecentistes* movements, and between 1927 and 1930, when Joaquin Pla Janini (1879–1970) was president of the Agrupación Fotográfica de Catalunya, some, including Rafael Areñas Tonà, Antoni Arissa, and Claudi Carbonel, would achieve international exposure and recognition.

But between 1936 and 1939 the Civil War drove talent into either the propaganda machines or exile. The conflict was covered on an unprecedented scale in the international illustrated press, although both at the time and later a disproportionate amount of glory went to foreigners like *Capa rather than to Spanish photographers, who took most of the casualties. In the war's immediate aftermath the economy could hardly sustain even minimal photographic activity, commercial

or creative, and it was not until the mid-1950s that recovery began. As autarky was dismantled, the photographic scene revived; some strong local photographic industries emerged (but would disappear in the late 1980s); and, *c.*1960, photography became popular with both ordinary consumers and a new generation of aspiring 'authorial' photographers. Key events of the 1970s included the founding of the magazine *Nueva lente* (1971); the opening of the Spectrum Gallery in Barcelona (1973), followed by similar initiatives; and the inauguration, in 1974, of the Photocentro in Madrid. May 1980 brought the first Week of Spanish Photography in Barcelona, a festival that was repeated every 2–3 years thereafter. By this time, against the background of political democratization and Spain's entry into the EEC (1984), photographic culture had come to conform to general Western trends.

In the 21st century, photography in Spain is a major visual medium, fully accepted as a means of expression. Exhibitions and festivals are numerous and popular, especially with the young. However, the development of an art photography market has been limited, and only a few institutions promote the study of photographic history or photography as an art form. *Digital photography has had a seismic impact on the Spanish photographic scene, and become central to photographic creation and debate. GFK

Fontanella, L., *Historia de la fotografía en España, desde sus orígenes hasta 1900* (1981).

López Mondéjar, P., *Fotografía y sociedad en la España del siglo XIX* (1989).

Cuatro direcciones: fotografía contemporánea española, 1970–1990 (2 vols., 1991).

López Mondéjar, P., *Fotografía y sociedad en España, 1900–1939* (1992).

López Mondéjar, P., *Fotografía y sociedad en la España de Franco,* trans. Watson, L., *Photography in Franco's Spain* (1996).

López Mondéjar, P., *Historia de la fotografía en España* (*c.*1997).

Fontcuberta, J., *De la posguerra al siglo XXI* (2001).

Spence, Jo (1934–92), British photographer. After running a high-street business between 1967 and 1974, she reinvented herself as a radical teacher and writer, belonged to the *Hackney Flashers, and taught at the Polytechnic of Central London (1979–82). In *Beyond the Family Album* (1979) she deconstructed and analysed her own photograph collection, prompting a re-evaluation of images hitherto trivialized and ignored. In collaboration (1983–92) with Rosy Martin, she developed *phototherapy, making visible complex narratives of the self: the social, cultural, and psychic formation of identities.

Spence challenged the boundaries between private and public, personal and political. She used her subjectivity as a focus for issues of class, gender, health, disease, and the body, contesting taboos relating to representation. Always questioning, intellectually curious, and generous with her ideas, she combined theory and practice, critical analysis, and cultural intervention in telling her story, of a self-in-process, from her own point of view. In *Picture of Health* (1985) and *Narratives of Disease* (1989) she confronted the complexities of living with cancer. RM

Spence, J., *Putting Myself in the Picture* (1986).

Spence, J., *Cultural Sniping: The Art of Transgression* (1995).

Spencer, D. A. (*fl.* 1920s–1950s), British chemist and inventor. In 1929, with Frank Coppin, a colleague at Colour Photographs Ltd. of Willesden, London, he inaugurated the *Vivex process, a version of tricolour *carbro using cellophane as a temporary support. This produced outstanding prints and was successfully used by professionals including Mme *Yevonde. In 1938 Spencer wrote the classic *Colour Photography in Practice,* which survives today in updated editions. In 1939 he joined the research department of Eastman Kodak, eventually becoming managing director. GS

Spender, Humphrey (1910–2005), London-born English photographer, educated at Freiburg University, Germany, the Architectural Association School, London, and the London School of Economics, where he studied anthropology. Self-taught as a photographer, he had access to the latest photographic technology through his brother Michael, who worked for the *Leitz Company. In the 1930s and 1940s he became one of Britain's leading proponents of *documentary photography as a tool for understanding society by portraying ordinary people. Strongly influenced by the German *New Objectivity movement, he worked as a staff photographer for the *Daily Mirror* (1936–8) and *Picture Post* (1938–41 and 1946–9). He became official photographer for the group of poets, documentary film-makers, photographers, painters, and social scientists who formed Mass-Observation in 1937 as a means of promoting social democracy by recording in detail the lives of ordinary people. His books *Britain in the '30s* (1977) and *Worktown People: Photographs from Northern England 1937–38* (1981) illustrate his technique of using a concealed camera to capture his subjects unawares. Spender joined the army in 1941 and served as a War Office photographer, then a photo interpreter, Theatre Intelligence Service (1942–6). After the war, he moved into textile design and painting, becoming a tutor in textile design at the Royal College of Art (1953–75), and a visiting lecturer at various design schools in and around London (1960–75). CBS

Frizzell, D., *Humphrey Spender's Humanist Landscapes: Photo-Documents, 1932–1942* (1997).

spirit photography. See OCCULTISM AND PHOTOGRAPHY.

sports photography emerged as the result of technological developments in photography, the expansion of the illustrated press, and the concomitant proliferation of mass sport during the late 19th and early 20th centuries. The term is generally understood to refer to photographic coverage of organized sporting events geared toward mass-media distribution, but has also been used to include photography of all forms of athletic and leisure activities—travel, ice skating, motor racing, picnicking—made by professional photographers as well as amateurs for public and personal use.

Sport has long been a central theme in the visual arts. From the springing figures in prehistoric cave paintings, to the idealized athletes in classical Greek and Roman art, to brawling footballers of the present day, artists have been fascinated with action, grace,

Anon.

Penny-farthing riders at Herne Hill,
London, 4 September 1933

and competition. In photography, studio portraits of athletes were common from the invention of the *daguerreotype, as were hunting still lifes and rustic genre scenes produced by photographers sensitive to traditions in painting. However, with the advent of faster shutters and the *dry-plate process, widespread by the 1880s, instantaneity was added to photography's bag of tricks, and suddenly bodies arrested in mid-trajectory came to define a prominent feature of the sports photograph.

The first appearance of such images came by way of science. Almost simultaneously, Eadweard *Muybridge in the USA, Étienne-Jules *Marey in France, and Ottomar *Anschütz in Germany produced rapid-fire sequences of photographs that analysed distinctive movements of men and animals. Although many of these featured athletes performing carefully choreographed sports movements, the purpose of the pictures was wholly scientific; all three inventors envisaged medical or military applications as the end product of their effort.

As instantaneity became a full-blown fad during the 1890s, images of leaping figures became a common sight in amateur photography journals, but these images, too, were defined by other contexts—*amateur photographic culture, in this case, which remained enthralled by technological questions into the 1910s. Not until the appearance of the first photographically illustrated sports magazines, which achieved large circulation *c.*1900, did sports photography garner the context it needed to become a clearly defined genre within a rapidly expanding and diversifying sphere of photographic activity.

Early sports magazines, like other photographically illustrated periodicals, were made possible by new developments in reproduction and printing technologies. Their variety and breadth of coverage was impressive. There were general sports magazines like *La Vie au grand air* (Paris), *Outing* (New York), *Amateur Athlete* (New York), and *Illustrated Sporting and Dramatic News* (London); sport-specific magazines, such as *Vélo* (Paris), *Lawn Tennis and Badminton* (London), and *L'Auto* (Paris); and special-occasion sports magazines, like *Sport im Bild* (Berlin), published to cover the first Olympic Games in 1896. Moreover, general-interest publications like *Tatler* (London), *The Standard* (New York), and *Je sais tout* (Paris) regularly included sports coverage, while the *New York Journal* had established the institution of 'the sports page' by 1897.

The popularity of sports magazines signified sweeping changes in social demographics. With the expansion of the middle and working classes came increased involvement in mass sport. Throughout the 19th century, sports had been mainly the province of elites, with hunting in its various forms the most prevalent. As more people were able to afford leisure, however, sport became a more democratic pastime. It offered relief from industrial tedium, and could be approached through both participation and observation. Importantly, the diversity of sports reflected significant class divisions. Animal fighting, shooting, football, and spectacle sports like bicycle racing were available to the middle and lower classes; while fencing, hunting, rowing, tennis, and sports that required prohibitively expensive equipment, like motoring or even aviation, appealed to the rich. Sports like horse racing and gymnastics, whose appeal ran across class lines, relied upon imposed restrictions—private clubs and special boxes—to maintain distinctions. This was also true for photography, which was

commonly considered a sport in its own right; cost and qualitative differences in equipment erected significant social barriers.

With the sports magazine came the sports photographer, a new breed of professional who worked in a documentary mode, but made particular use of new, faster, lightweight cameras capable of seizing movement in the field. A popular model was the Nettel, advertised as the 'sports camera', as it came equipped with a special viewfinder called the 'sports finder', and had a shutter speed of 1/1,000 s. Though mostly unknown today, important early sports photographers included E. P. Hahn, Neudin, and Albert Meyer in Germany; Comerio in Italy; Laking, McNeill, *Beken, and Holliday in England; Jean and Georges Delton, Jules Beau, and Simons frères in France; Arthur Hewitt, William Jennings, and Louis Alman in America (many more went uncredited). But there were also obvious overlaps with social photography, with some photographers as much (or more) interested in goings-on around the track as in the sports themselves. The British freelance Horace *Nicholls, for example, prosperously supplied images of the fashionable crowd at Cowes (yachting), Henley (rowing), and the great horse-racing events at Aintree, Ascot, and Epsom.

Early sports photographers adapted the technological and aesthetic innovations of the 1890s to sports reportage. Besides instantaneity, they explored the expressive potential of the blurred form, the streaked background, and the floating figure, which became a kind of symbol of poetic athleticism in its own right, a distilled vision of human vigour detached from time, space, or the context of a specific event. In this sense, the sports photograph should be seen as the direct legacy of the scientific motion studies conducted by Muybridge et al., but adapted to satisfy the capricious desires of an expanding mass readership. Moreover, sports photographs served as inspiration during the 1910s, 1920s, and 1930s for avant-garde artists, who discovered in their dynamism and fresh perspectives a visual vocabulary for modernity. This in turn was readily adapted by some photographers, like the football ace Martin *Munkácsi, to *fashion and *advertising.

Amateurs also pursued sports photography. *Lartigue in France and *Austen in the USA are two famous names in a crowd of thousands worldwide. Crocquet, cricket, and eventually tennis were staples of *country-house photography and, as technology permitted, beach sports invaded the holiday album. Amateur photography and amateur sport were often conflated, with amateur photographers classified as a kind of amateur sportsman. Indeed, the amateur movement in photography had its counterpart in the contemporary amateur sports movement; Baron Pierre de Coubertin's reinstitution of the Olympic Games in 1896 was its fullest expression. But links between sport and photography were particularly notable in travel-based activities like bicycling, motoring, and hiking, for which a camera soon became standard equipment. For example, the activities of Marseille's large Sunday hiking club—the so-called buveurs d'air—included photographic lantern lectures, the creation of a photographic archive, and informal training of photographers. Aesthetically, amateur sports photographs tended to express another side of modernism in their approach to depicting movement. Where professionals sought perfect

form—muscular athletes demonstrating their skill in a single pose or gesture, often consciously mimicking Greek sculpture—amateurs like Lartigue celebrated the camera's ability to capture awkward, improper, or humorous movements. This reflected changing attitudes toward bodily propriety, and fostered a more casual idea of personal comportment generally.

After the First World War, sports photography continued to proliferate as both public interest in sport and the mass media expanded. The association between sportiness, body culture, and modernity became more pronounced. New sports emerged, or became photographable. Thanks to wartime advances in aviation technology, for example, aerobatics and air races attracted a still larger public than before 1914. Pictures were supplied by daredevils like Willi *Ruge, whose career exemplified the overlap, on the one hand, between sports and *war photography and, on the other, between the stardom enjoyed by photographers and international sportsmen. In 1930s Germany and Russia, sports became equated with utopian notions of an ideal social order. Gymnastics demonstrations in those countries became symbolic exhibitions of political strength. For spectators, the vision of thousands of limbs moving in precisely choreographed unison created an overwhelming impression of order, unity, and national strength. Photography, with its power to document and abstract, played a central role in the creation and distribution of political *propaganda centred around the image of the 'new man', a human specimen of perfect physique poised to transform society after the model of rational industry. Indeed, the human body and machinery were commonly conflated, and photography, because of its nature as a mechanical mode of representation, served as the logical mediator. The period's supreme example of the sporting 'event for photography' (with strong propaganda undertones) was the 1936 *Berlin Olympics, recorded by champions of the genre like Leni *Riefenstahl, Lothar *Rübelt, and Paul *Wolff.

After the Second World War, increasing leisure and affluence in rich countries, and the global spread of television from the 1950s, vastly enlarged the audience for sports. More new activities, like skydiving or windsurfing, appeared, or were practised for the first time in an organized, competitive way. Many others, from ocean racing to bowling—again, mainly thanks to television—attracted unprecedented popular interest and large sums of money from sponsors. The result was a greatly expanded market for sports photographers, since television failed to outdo the still camera's ability to freeze the dramatic moment. New mass-circulation journals like the American Sports Illustrated (1954), weekly supplements, and the sports pages of daily newspapers developed an insatiable demand for images, which for sports like soccer, rugby, golf, and athletics were also saleable worldwide.

Technology continued to exert much greater influence than on most other branches of the medium. The 35 mm SLR established its supremacy for most applications. Colour dominated increasingly from the 1970s. Improved film emulsions, lenses, film-transport mechanisms, and shutter speeds (upwards of 1/8,000 s by c.2000) made it possible to obtain shots that would earlier have been unthinkable.

595

So did *underwater housings and remote-control devices. In some sports, such as surfing, skydiving or dinghy racing, photography is possible only in the thick of the action, requiring equipment that is both rugged and highly automated. As with the first autofocus systems, early *digital cameras were too slow for most sports. But within less than a decade they were practically ubiquitous.

Technology apart, the basic requirements for a sports photographer have remained constant: concentration, patience, stamina, rapid reflexes, and intimate knowledge of the sport. In the emotion-hungry environment of the modern media, however, an eye for pain and exultation, for players and spectators 'gutted' or 'over the moon' (preferably with the moon visible in the picture) is also essential. Certain sports, like Formula One racing or ocean yachting, favour specialization, although some late 20th-century masters—the veteran George Silk (b. 1916), Walter Looss Jr., Co Rentmeester, Neil Leifer—captured astounding pictures across a wide range of activities. Other individuals, such as Larry *Fink and James Fox in relation to boxing, have concentrated on documentary coverage of a sporting subculture as much as on the sport itself.

Sports photography is extremely demanding and competitive. The number of full-time jobs—e.g. as newspaper staff photographers—is tiny relative to the market's size. The cost of equipment, insurance, travel, and the hire of facilities (e.g. helicopters) is high. Access to many major events is restricted by security considerations and, often, sponsorship arrangements. All this puts the resources and leverage of big *agencies and other groups at a premium, and makes life hard for the freelance and beginner. Finally, the sporting world is not just the domain of the sports photographer. Late 20th-century sporting contests all too often became occasions for other kinds of event: hooliganism, terrorism, or sensational accidents. Meanwhile, activities 'around the track', today involving celebrity sportsmen as much as celebrity spectators, attract photojournalists and *paparazzi. KM/RL

See also MARINE AND NAUTICAL PHOTOGRAPHY.

Lattes, J., *Sportphotographie, 1860–1960* (1977).
Dugan, E. (ed.), *This Sporting Life, 1878–1991* (1992).
'Body/Sport/Image', *Photogeschichte*, 62 (1996).
Fink, L., *Boxing* (1997).
Tomlinson, R., *Shooting H₂O* (2000).
Wombell, P., *Sportscape: The Evolution of Sports Photography* (2000).

spotting. See FINISHING.

Sri Lanka. See CEYLON.

staged photography involves a performance enacted before the camera, akin to the arrested dramas of *tableaux vivants* and *poses plastiques*. It embraces studio portraiture and other more or less elaborate, peopled scenarios directed or manipulated by the photographer. In the 19th century, the intention was often allegorical. One of the earliest-known dramas staged for the camera was Hippolyte *Bayard's *Le Noyé* (*The Drowned Man*, 1840), a self-portrait intended as a protest against the French government's apparent indifference to his development of a paper-based photographic process in 1839. An early example of staged *photojournalism was Gioacchino Altobelli's (1814–78) image of Italian troops 'storming' Rome's Porto Pia on 21 September 1870, the day after the actual event.

Though the fictional and artistic impulses of staged photography have persisted throughout the medium's history, two major periods of staged photography can be identified: mid-Victorian narrative photography, and a late 20th-century critique of representation informed by conceptualism and postmodern theory.

Nineteenth-century staged photographs sometimes involved techniques such as multiple exposure or combination printing. Oscar Gustave *Rejlander's controversial *The Two Ways of Life* (1857), for example, created from 32 *wet-plate negatives, is an ambitious example of the latter. The discrete elements are staged in the studio, while the overall composition is manipulated in the darkroom. Henry Peach *Robinson, who learned from Rejlander, won acclaim with painstakingly assembled pictures such as *Fading Away* (1858). The narrative intention of his imagery was frequently reinforced by the transcription of lines of verse on the mount, as with *The Lady of Shalott* (1861).

Many Victorian photographers, however, created narrative scenes using a single negative. In the 1850s–1860s, Lady *Hawarden photographed her daughters in elaborate costumes and dramatic poses, to suggest and inspire stories. Charles *Dodgson (Lewis Carroll) photographed young girls in a variety of roles, and choreographed images that made reference to dreams and myths. Julia Margaret *Cameron conflated the 'real' with the 'ideal' in a series of photographic personifications, e.g. by portraying her maid as the Madonna. In 1874–5, she directed scenes from Lord Tennyson's *Idylls of the King* for use as photographic illustrations. The famous collaboration between Countess *Castiglione and Pierre-Louis Pierson between 1856 and 1898 produced over 400 staged scenes based on contemporary fiction and events from Castiglione's life.

But by far the largest number of 19th-century staged photographs were either by anonymous individuals, or by others whose names alone have survived. They were among the thousands of 'operators' who fed the boom in *stereoscopic photography between the 1850s and the 1900s. In addition to countless views and architectural studies, stereo publishers issued narrative series on religious, historical, fairy-tale, and erotic subjects. Most used live models, costumed or not, while some incorporated figurines or cardboard cut-outs. Examples from the prolific London Stereoscopic Company included titles like *A Ghostly Warning*, a hand-coloured scene by James Elliott showing two men terrified by a female apparition, *The Death of Thomas a'Becket*, also by Elliott, and a *Hamlet* series by 'Phiz'. These and thousands of other picture stories produced by hundreds of companies around the world anticipated both the cinema and other mass-market products like the *photoromance.

In the 20th century, portraiture and self-portraiture continued to incorporate staged manipulations of the self, from de *Meyer,

*Beaton, and *Yevonde to *Cahun and *Leibovitz. Fantasies of glamour and consumption, often involving elaborate sets or exotic locations, became central to *fashion and *advertising photography. Likewise with *erotic photography, both in its most sophisticated (commercial and private) manifestations and at the high-street level of *makeover and boudoir images.

In the late 20th century, staged photography became overtly theorized and politicized. Artifice was accentuated in a bid to question narrative authenticity and undermine belief in 'documentary truth'. Quotation and parody were deployed as critical tools. *Digital technology offered new ways to combine disparate moments and interrogate accepted meanings. From the 1970s, Jeff *Wall problematized the relationship between photography, documentary, and art in his dramatizations of apparently ordinary street scenes and social encounters. As with much 19th-century staged photography, his constructed realities regularly quote from the history of painting, although his purpose is different. Depicting the photographer and his camera reflected in a large mirror, *Picture for Women* (1979) takes Manet's *A Bar at the Folies-Bergères* (1881–2) as its referent. Joel-Peter *Witkin has constructed photographs that refer directly or indirectly to well-known paintings, in order to subvert stereotypes and transgress notions of taste; *Las Meninas, New Mexico* (1987) is a provocative appropriation of Velázquez's famous group portrait of King Philip IV of Spain's family (1656). Often adopting fancy dress and prosthetics, Cindy *Sherman has emphasized artifice to question the representation of femininity, and the existence of an essential, unified subjecthood. The parodic intent of her black-and-white *Untitled Film Stills* (1970s–1980s) increasingly gave way, in later works, to images of the abject and macabre. Other authors of staged series from the 1980s and early 1990s include the American Duane *Michals (*Christ in New York*, 1981), the Australians Farrell & Parkin (Rose Farrell and George Parkin, both b. 1949; *Repentance*, 1988; *A Passion for Maladies*, 1990–1), and the British photographer Colin Gray (b. 1956; *The Parents*, 1985).

In *Twilight* (1998–9), Gregory Crewdson (b. 1962) borrows familiar tropes from American cinema, and 'makes them strange'. His images of suburbia are ambiguous, surreal, and unnerving, suggesting a narrative that resists resolution. Tina Barney (b. 1945) and Hannah Starkey (b. 1968) dramatize seemingly everyday situations. Their aim, however, is to suggest hidden psychological states. Members of Barney's family appear before the camera stilted, self-conscious, and tense. Starkey's tableaux, featuring teenage girls, articulate the apparent ennui of growing up in late capitalist society. In *Spirit West* (2001), Justine Kurland (b. 1969) directed a cast of adolescent girls who enact enigmatic dramas in the landscape. JLF

See also CHRISTIANITY AND PHOTOGRAPHY.

Dérision et raison (1997).
Henry, P., *Fabula* (2003).
Jeff Wall: Photographs (2003).
Kismaric, S., and Respini, E., *Fashioning Fiction in Photography since 1990* (2004).

stage photography. See PERFORMING ARTS AND PHOTOGRAPHY.

standard lens. A photographic print is usually viewed most comfortably from a distance roughly equal to its diagonal. Therefore, for the perspective to appear correct the camera lens needs a focal length equal to the diagonal of the camera format (provided the whole area is to be printed). This gives an *angle of view of around 52 degrees, corresponding to a *focal length of 160 mm (6 in) for a 4 × 5 in format, 110 mm (4^1/$_3$ in) for 6 × 9 cm (2^1/$_4$ × 3^1/$_2$ in), 85 mm (3^1/$_3$ in) for 6 × 6 cm (2^1/$_4$ × 2^1/$_4$ in), and 43 mm (1^2/$_3$ in) for 24 × 36 mm (35 mm format). In cameras supplied complete with lens these indications are usually followed fairly closely except for 35 mm cameras, which have traditionally been supplied fitted with a 50 mm (2 in) lens. However, the lenses in modern *single-use and fixed-lens compact cameras are usually of focal length 40–5 mm (1^1/$_2$ – 1^3/$_4$ in). Because of the different viewing conditions, the standard lens for cine and video cameras has a longer focal length, usually twice the diagonal of the format. GS

Standard Oil Company of New Jersey. In 1943 the company hired Roy *Stryker to set up a photographic unit to document the lives of oil workers. The project, which was broadly interpreted by Stryker, lasted until 1950 and involved several ex-Farm Security Administration *documentary photographers, including Gordon *Parks, Russell *Lee, John *Vachon, and Esther *Bubley. RL

Plattner, S., *Roy Stryker: USA, 1943–1950* (1983).

stanhope, item of photographic jewellery incorporating a magnifying lens (invented by Charles, earl of Stanhope (1753–1816)) and a *microphotographic *albumen or *collodion positive transparency. Image and lens were assembled in a small tube that could be mounted in a locket or other decorative object. Queen Victoria made them fashionable in the 1860s. Pornographic versions may also have been available. RL

Henisch, H. H. and B. A., *The Photographic Experience 1839–1914: Images and Attitudes* (1994).

Steichen, Edward (1879–1973), American photographer, born in Luxembourg, who in 1881 immigrated to the American Midwest. He trained with a Milwaukee firm specializing in commercial lithography; and in 1900–2 and 1906–14 worked in France, where he took portraits, painted Symbolist landscapes, made *pictorialist photographs, and supplied Alfred *Stieglitz with exhibition ideas for his *Gallery 291. He gained an international reputation as an art photographer and became a master printer whose manipulation of the *gum bichromate process incorporated painterly brush strokes and subtle layers of colour to produce elegant, romantic studies.

Steichen returned to the USA in 1914. He enlisted in 1917 and eventually, thanks to his administrative skills, headed the Army Air Service's photographic section. After the war he returned to the French village of Voulangis, where he explored the formal and

technical problems of modernist photography, a direction already evident in his pre-war work but further energized by the military emphasis on practicality and communication. In 1923 he became chief New York photographer for Condé Nast Publications, and his fashion photographs for *Vogue and celebrity portraits for Vanity Fair appeared regularly for the next two decades. Employing carefully controlled studio lighting, Steichen developed an elegant, dramatic signature style that profoundly influenced commercial photography.

He also joined the *advertising industry. When he started with the J. Walter Thompson agency in 1923, fewer than 15 per cent of illustrated advertisements employed photography. Within a decade, however, it appeared in nearly 80 per cent of illustrated advertisements in national magazines. This change owed much to Steichen, who showed art directors how photography could be used for both realism and romance and convinced them of the persuasive advantages of mass-market advertising with photography. His approach followed industry strategies. His earliest advertising photographs exploited the descriptive 'realism' of photography, probably because art directors clung to ideas about photography as a vehicle of information. But Steichen soon mastered the paradox by which precise detail conveyed suggestions of luxury, sophistication, and wealth. As the Depression worsened, and advertisers required more dramatic and emotive images, Steichen crafted images of romance and class in which consumption promised social mobility and rewarded women for conformity to traditional roles.

In the Second World War, Steichen commanded the Naval Aviation Photographic Unit, which documented aircraft carriers in action. He also organized several popular exhibitions, including Road to Victory and Power in the Pacific, that drew on his commercial experience: he acted as a picture editor, selecting images for human interest and editing through scale and cropping to maximize dramatic power.

In 1947 Steichen succeeded Beaumont *Newhall as director of the department of photography at MoMA, New York—controversially, since some at MoMA would have preferred a director who promoted photography solely as a fine art; Steichen, however, emphasized the populist. His best-known exhibition, The *Family of Man (1955), which aimed to illustrate the 'essential oneness of mankind throughout the world', toured internationally for years and sold millions of catalogues. Steichen retired in 1962 and pursued his interest in landscape photography. PJ

Steichen, E., A Life in Photography (1963; repr. 1985).

Johnston, P., Real Fantasies: Edward Steichen's Advertising Photography (1997).

Niven, P., Steichen: A Biography (1997).

Steiner, Ralph (1899–1986), American photographer and film-maker. After his 1921 graduation from Dartmouth College, where he learned photography, Steiner moved to New York and studied at the Clarence H. *White School of Photography. Though he subsequently criticized its curriculum as too reliant on 'design, design, design',

Steiner's 1920s commercial photography echoed its emphasis on clean modernist composition. Increasingly socially engaged, Steiner turned to a more realist documentary style. The shift is particularly apparent in his films: his early abstract study of water and light, H_2O (1929), scored by Aaron Copland, was followed by documentaries in the 1930s. With Paul *Strand and Pare Lorenz, he collaborated on The Plow that Broke the Plains (1936), and with Willard Van Dyke co-directed The City (1939). He joined a series of progressive, anti-fascist organizations for independent film-makers in the 1930s. After wartime military service and five years working for MGM in Hollywood, Steiner returned to art and *advertising photography in New York. He always insisted that successful photography required deeply personal interpretations. In later years, in Vermont, he pursued expressive cloud photography. PJ

Steiner, R., A Point of View (1978).

Payne, C., 'Interactions of Photography and the Mass Media, 1920–1941: The Early Career of Ralph Steiner', Boston University Ph.D. dissertation (1999).

Steinert, Otto (1915–78), German photographer, theorist, and teacher. Trained as a doctor and self-taught as a photographer, Steinert became highly influential in the 1950s as leader of the West German *fotoform group and the *'Subjective Photography' movement. He looked back particularly to the *New Vision photographers of the inter-war years, especially *Man Ray, *Moholy-Nagy, and *Bayer, and, in rejecting the neo-*pictorialist blandness of the post-war club and salon scene in favour of maximum exploration of creative techniques such as cameraless images, negative printing, and *solarization, prepared the way for late 20th-century acceptance of the photographer as an autonomous artist. These ideas were influential as far afield as Japan. Steinert also gained an international reputation as a teacher, first at the Art and Craft School in Saarbrücken, then from 1959 at the Folkwang School in Essen. He developed the Folkwang Museum's photographic collection, organized frequent exhibitions, and wrote prolifically on photography. RL

Eskildsen, U. (ed.), Der Fotograf Otto Steinert (1999).

Steinheil, Carl August von (1801–70), German astronomer and mathematician, professor of physics and mathematics in Munich (1832–49), and inventor of optical, electrical, and telegraphic apparatus. It is uncertain exactly when Steinheil began to experiment with photographic processes. But early in 1839, encouraged by reports on the work of *Daguerre and *Talbot, he collaborated with the mineralogist Franz von Kobell (1803–82), and by April they had created several paper negatives; later that year, Steinheil built a small camera that could take circular *daguerreotypes. Experiments with photographs through a microscope are also documented. By 1840 Steinheil had increased the sensitivity of his plates enough to make portrait exposures possible. In 1854, after several years' preoccupation with telegraphy, he founded an optical works in Munich that rapidly prospered. Its success owed much to Steinheil's son Hugo Adolph (1832–93), who refined the calculation of lens designs, and constructed

the first wide-angle lens in 1865 and the first aplanat in 1866. Hugo's son Rudolf (1865–1930) followed in his footsteps. JJ

> Franz, H., *Steinheil: Münchner Optik mit Tradition: 1826–1939* (1995).

Stelzner, Carl Ferdinand (1805–94), German miniaturist, portrait painter, and photographer from Hamburg. Stelzner took up photography in 1842 and worked briefly with Hermann *Biow. He became known well beyond Hamburg for his portraits and group pictures, which he began to colour in 1843. In 1844 he also photographed the construction of the Hamburg–Altona railway. After going blind in 1854 he employed other photographers to carry on his studio. JJ

> Kaufhold, E., 'Hermann Biow (1804–1850) und Carl Ferdinand Stelzner (1805–1894) in Hamburg', in B. Dewitz and R. Matz (eds.), *Silber und Salz: Zur Frühzeit der Photographie im deutschen Sprachraum, 1839–60* (1989).

Stéréo-Club Français (SCF), Paris-based society founded by Benjamin Lihou (d. 1909) in 1903, at a time of vigorous innovation in *stereoscopic photography. In many ways it epitomized the *belle époque* amateur club, organizing competitions, regular meetings, and photographic excursions and, from 1904, issuing a monthly newsletter. Of the many French photographic societies founded in this period, only the SCF survived, with wartime interruptions, throughout the 20th century. RL

> Chéroux, C., 'Amateur Stereoscopic Photography: The Example of the Stéréo-Club Français', in F. Reynaud, C. Tambrun, and K. Timby (eds.), *Paris in 3D: From Stereoscopy to Virtual Reality 1850–2000* (2000).

stereopticon, American term for a magic lantern; but coined apparently by the *Langenheim brothers in the 1860s to describe a twin-projector system permitting dissolves between two sets of (non-stereoscopic) photographic or painted slides. RL

stereoscopic photography. Together with the magic-lantern craze of the 18th and 19th centuries, the rise of this branch of *three-dimensional photography in the 1850s was the most important development in visual mass culture before the coming of the cinema. Initial research on practical stereoscopy was done by Charles Wheatstone (1802–75) and published by him, with an illustration of a reflecting stereoscope for viewing simple drawings, in 1838. After the announcement of *Daguerre's and *Talbot's photographic processes in 1839, Wheatstone commissioned Antoine *Claudet, Richard Beard, and Henry Collen to make stereo *daguerreotypes and *calotypes. Later research by Sir David *Brewster resulted in the creation of a lenticular stereoscope suitable for viewing daguerreotypes in 1849. A luxury version made by the Paris optician Louis-Jules Duboscq, with a set of stereo daguerreotypes, was presented to Queen Victoria after she had admired the invention at the *Great Exhibition in 1851.

This precipitated a craze for the medium, almost immediately boosted by the rise of the *wet-plate process. Early suppliers in London included *Negretti & Zambra, who began with a series on the exhibition itself. Claudet, who remained loyal to the daguerreotype,

sent a set of exhibition stereos to the tsar of Russia in 1852, and subsequently improved Brewster's stereoscope. In 1854 George Swan Nottage founded the London Stereoscopic Company (LSC), with the slogan 'No Home without a Stereoscope'; within two years it had sold half a million viewers, and by 1858 had 100,000 subjects in stock. There was a similar boom, after initial patent wars, in Paris, where Duboscq and Claude-Marie Ferrier led the field, and viewers were even installed at the annual Salon, where in 1859 Charles Baudelaire noted 'thousands of avid eyes' peering 'into the holes of the stereoscope, which were like skylights into infinity'. Important in the USA were the *Langenheim brothers, *Southworth & Hawes (who invented an elaborate 'grand parlor stereoscope' for viewing whole-plate daguerreotypes in their Boston showroom), and E. & H. T. *Anthony, which adopted the typical practice of both commissioning pictures and publishing foreign imports. Important in promoting stereoscopy in America was Oliver Wendell *Holmes who, after initial scepticism, hailed it as a valuable educational and democratic medium and called for the creation of stereo libraries. He also coined the term 'stereograph', and designed a successful hand-held viewer for stereocards, manufactured by Joseph Bates from 1861.

The earliest stereoscopic image pairs were taken in quick succession by moving the plate, the lens, or the whole camera a precisely calculated distance between exposures, and various refinements of this system were introduced during the 19th century. In 1854, however, Achille Quinet patented the first 'binocular' (twin-lens) camera, the Quinetoscope, and in 1856 the Manchester inventor J. B. *Dancer launched an improved version of his own binocular design, usable with either wet or dry plates. This succeeded commercially, and the twin-lens principle subsequently dominated stereo camera development.

The range of stereo images produced was enormous. Landscapes and architectural studies, including thousands of views of the Crystal Palace, predominated at first and remained popular, with new scenes added from throughout the world. But they were soon supplemented by a huge variety of *staged images (usually with live subjects, but sometimes figurines or cut-outs), from costumed period pieces, play scenes, and re-creations of celebrated paintings like Henry Wallis's *Death of Chatterton* or W. P. Frith's *Derby Day*, to genre series like the LSC's *Happy Homes of England*, 'sentimentals' with titles like *Broken Vows* and *In the Bitter Cold*, and humorous scenes. Another important staged genre was erotic, ranging from suggestive series like *La Vie de Bohème* to downright pornography. Many of these images were hand coloured; others, mostly produced in France from the 1860s, were 'tissues'—photographs printed on thin paper coloured on the back and designed to be viewed against the light. The high point of stereoscopy's 'first age' was probably the year 1858, when the astronomer Charles Piazzi *Smyth published the first stereo-illustrated book, *Teneriffe: An Astronomer's Experiment*, Warren de la Rue (1815–89) made stereographs of the moon, and Mayer & Pierson took a stereo portrait of Napoleon III on his 50th birthday. Stereographs of the *American West were also on sale by this time, and the great American survey

photographers, *Hillers, *Jackson, *O'Sullivan, *Watkins, and *Weed, made them in their thousands through the 1860s and 1870s. In 1869, finally, the British War Office published a set of 36 stereocards taken by the *Royal Engineers during survey work in Sinai.

The mid-1860s saw the launch of the multiple-viewing apparatus eventually known as the *Kaiserpanorama. In 1880 one of the leading names of the 'second age' of commercial stereoscopy, *Underwood & Underwood, was founded, and continued to publish series on a wide range of topical, educational, and religious subjects until 1921. However, the fashion had declined during the 1860s, perhaps partly because of the newer *carte de visite craze, and in the 1870s and 1880s the registration of stereoscopy-related patents in France plummeted. But interest revived in the 1890s, especially on the part of amateurs. The Stereoscopic Society was founded in England in 1893, and the *Stéréo-Club Français in 1903; and photo enthusiasts like the young Jacques-Henri *Lartigue naturally added stereoscopy to their repertoires, sometimes combining it with the *autochrome process. However, *Ducos Du Hauron had patented a method for making colour stereo images in 1897, and other innovations ranged from the ingenious *Taxiphote viewer to the stereo *postcard. There were also new cameras from French, German, and American manufacturers, competing in terms of portability, versatility (plates and *roll-film, sometimes also a *panoramic facility), and user-friendliness. Particularly successful was the Richard *Verascope, launched in 1893, which in its numerous versions remained a favourite of wealthy amateurs until well after the Second World War. New arrivals in the 1920s included Franke & Heidecke's Heidoscop (1921) and Rolleidoscop (1926), triple-lens cameras with waist-level viewfinders that in certain respects anticipated the *Rolleiflex (1928), and devices like Leitz's prismatic Stereoly that enabled conventional cameras to take stereoscopic pictures.

In the 1930s, judging by the equipment available, stereo photography remained popular among a minority of keen amateurs. In the meantime, two other long-heralded forms of three-dimensional imaging, the *anaglyph* and the *lenticular screen system*, seemed to be coming of age, and to a degree overshadowed the classic stereograph. The French photographer Léon Gimpel (1878–1948) published a sensational anaglyphic picture of the moon in *L'*Illustration in 1924, and the technique found applications in advertising and other fields into the 1930s. The technically more daunting lenticular stereogram was espoused by Maurice Bonnet (1907–94), who founded the Relièphographie company in 1937, and in the Second World War ran a 3-D portrait studio in the Champs-Élysées.

After 1945, new stereoscopic cameras were launched in both the USA and the USSR, while late versions of classics like the Verascope remained available. Commercial stereographs continued to be marketed to tourists until at least the 1970s, for use with simple plastic viewers like the Romo, made by the French firm La Stéréochromie. There was yet another stereoscopic revival in the 1990s, associated, at one extreme, with fun snapshots from the 35 mm Loreo camera (1995) made in Hong Kong, and at the other with the work of contemporary fine artists such as Síocháin Hughes (b. 1961), Martha Laugs (b. 1935), and Bruce McKaig (b. 1959). An exhibition at the Musée Carnavalet, Paris, in 2000, *Paris en 3D*, reviewed the whole history of the medium in one of its major centres. RL

Jones, J., *Wonders of the Stereoscope* (1976).
Darrah, W. C., *The World of Stereographs* (1977).
Coe, B., *Cameras: From Daguerreotypes to Instant Pictures* (1978).
Pellerin, D., *La photographie stéréoscopique sous le Second Empire* (1995).
Reynaud, F., Tambrun, C., and Timby, K. (eds.), *Paris in 3D: From Stereoscopy to Virtual Reality* (2000).

Stern, Bert (b. 1929), self-taught American photographer who in the 1960s epitomized the photographer as media star. His career began with *Look* magazine, where he was an assistant art director 1946–8, but he later rapidly made a reputation in *advertising. In the 1960s he ran a large factory-style studio in New York, specializing in fashion, advertising, and *celebrity portraits. Stern's 'last sitting' photographs of Marilyn *Monroe, taken six weeks before her death, are among his best-known images. MR

Stern, B., *The Last Sitting* (1982).

Stern, Der, German news magazine, founded in Hamburg in 1948, and one of the leading examples of its kind in post-war Europe. Its motto, 'Capture the moment', reflected a journalistic philosophy similar to that of *Life* and other journals attempting world coverage. But its interest in high fashion and celebrity culture positioned it somewhere between *Vogue* and the grittier tabloids. *Stern*'s *Portfolio Library* series has featured the work of fashion photographers like Horst P. *Horst and Peter Lindbergh, portraitists Peggy Sirota and Annie *Leibovitz, and photojournalists from Peter Beard to Henri *Cartier-Bresson. TT

50 Jahre Stern: Die Besten Fotos (1999).

Stern, Grete (1904–99), German-born photographer who studied graphic design at the Kunstgewerbeschule Weisenhof, Stuttgart, 1923–5, then photography with Walter *Peterhans in Berlin 1927–9. With Ellen *Auerbach she did innovative *advertising and portrait work as 'foto ringl + pit', but continued working with Peterhans at the *Bauhaus until her emigration to London in 1933. She married another Bauhaus student, Horacio Coppola, in 1935 and moved with him to Buenos Aires in 1937. She published Surrealist photomontages in various Argentinian journals, and documented aboriginal cultures in Argentina. AL

Wingler, H. M., *Begegnungen mit Menschen: Das Fotografische Werk von Grete Stern* (1975).

Stieglitz, Alfred (1864–1946), American photographer and writer, and a seminal figure in American art and culture in the early years of the 20th century. Born in Hoboken, New Jersey, he was the eldest son of successful German immigrants, Edward and Hedwig Stieglitz. After attending schools in New York, he was sent to Berlin in 1880

Alfred Stieglitz
The Hand of Man, 1902

to study mechanical engineering. In 1884 he took a course with the renowned photo-chemist Hermann Wilhelm *Vogel, and discovered a passionate calling that inspired him for the rest of his life. On his return to the USA in 1890 he dedicated himself to proving the artistic merit of the medium: by publishing articles, widely exhibiting his own photographs made in both Europe and New York, and founding and editing periodicals such as *Camera Notes* (1897–1902) and *Camera Work*. In 1902 Stieglitz founded an elite group of photographers called the *Photo-Secession, including Edward *Steichen, Clarence *White, and others whose work he believed exemplified the highest accomplishments of the art of photography. In 1905, eager to have a place in New York to show their work, Stieglitz founded the Little Galleries of the Photo-Secession, which quickly became known as *291 from its address on Fifth Avenue. Because Stieglitz was fascinated with the relationship between photography and the other arts, he began to exhibit works by leading European and American modern artists, including Paul Cézanne, Henri Matisse, Pablo Picasso, Constantin Brancusi, as well as Marius de Zayas, Arthur Dove, Marsden Hartley, John Marin, and Georgia O'Keeffe, often giving them either their first shows in the USA or their first ever exhibitions. Gallery 291 quickly became the centre for avant-garde art in America, attracting not only painters, sculptors, and photographers, but also writers, poets, critics, and musicians. He actively engaged the art of these contemporary painters and sculptors in his own photographs, exploring issues of abstraction in both his portraits and studies of New York made at this time.

After 291 closed in 1917, a victim of both the war and Stieglitz's declining finances, he turned his attention to his own photographs, making one of his most celebrated bodies of work, his portraits of Georgia O'Keeffe, whom he married in 1924. In 1925 he opened the Intimate Gallery, where he exhibited work by Dove, Hartley, Marin, Charles Demuth, and Paul *Strand, as well as O'Keeffe. In 1929, he opened his last gallery, An *American Place, where, until his death, he continued to show these artists as well as such younger photographers as Ansel *Adams and Eliot *Porter. Throughout the 1920s and early 1930s Stieglitz made some of his most accomplished photographs, including a series of photographs of clouds, which he called *Equivalents*, as well as studies of New York and his family's summer home at Lake George, New York, which celebrate the camera's unique ability to capture a fragment of reality and infuse it with personal meaning. Ill health forced him to stop photographing in 1937. SGR

Frank, W., et al. (eds.), *America and Alfred Stieglitz: A Collective Portrait* (1934; rev. edn. 1979).

Greenough, S., and Hamilton, J., *Alfred Stieglitz: Photographs & Writings* (1983).

Whelan, R., *Alfred Stieglitz: A Biography* (1995).

Stillfried-Ratenicz, Baron Raimund von (1839–1911), Austrian nobleman who pursued varied careers as artist, soldier, and diplomat before establishing himself in Yokohama in 1871 as a photographer. In 1872, he caused a stir by taking an illicit portrait of the Meiji emperor that was immediately suppressed by the authorities. Nevertheless,

the Japanese government later employed him as a photographer and adviser at the Hokkaido Development Office (Kaitakushi) and the Finance Ministry's Printing Bureau (Shiheikyoku). Stillfried prospered as a commercial photographer, catering to a mixed clientele of Western residents and globe-trotters. In 1876, he formed a partnership with Hermann Andersen, known as the Japan Photographic Association, and the following year purchased the studio and stock of Felice *Beato. In 1878, the Stillfried–Andersen partnership was dissolved, with the latter retaining the company name of Stillfried & Andersen, while the former operated as Baron Stillfried, creating confusion both for contemporaries and for later photohistorians. Stillfried left Japan permanently in 1881 and undertook various photographic commissions in Siam (Thailand) and Hong Kong before finally returning to Vienna in 1883. SD

Gartlan, L., 'A Chronology of Baron Raimund von Stillfried-Ratenicz (1839–1911)', in J. Clark (ed.), *Japanese Exchanges in Art, 1850s–1930s* (2001).

still life, or, in French, *nature morte*, is one of the staples of photography. In the earliest days, when exposures ran to many minutes, still life was easier to photograph than people, and it remains often easier to assemble the elements of a still life than to find a model for a portrait or nude study. Most importantly of all, a photograph of a still life can be a thing of beauty in its own right.

In the earliest days of photography, even photographers such as Henry *Talbot who were often merely researching technical processes made superb still-life images, and Roger *Fenton's still-life photographs of the 1840s are among the finest ever shot. One of the greatest decades in non-advertising still-life photography was the 1920s, when 'abstract' pictures enjoyed a great vogue: objects such as folded paper, light bulbs, cutlery, and much else were photographed as studies in line and form, without 'content' in the conventional sense. And one of the worst decades was the 1950s, with its craze for saccharine 'table-top' pictures of glass ornaments like dancing fauns. In the 1960s, still life all but disappeared, only to reappear in the late 20th century with the latest super-saturated colour films.

Overall, however, still life for its own sake has often been surprisingly neglected by amateurs and even by art photographers: by far the greatest numbers of still-life images that one sees are advertisements. The main reason is probably the belief that still-life photographs are time consuming and difficult, and require a lot of space and equipment. But, as an examination of photo magazines reveals, this belief is wrong: those who shoot still life often use simple equipment, yet produce striking images.

For basic black-and-white work, a single desk lamp can be all the light that is needed. With the camera on a tripod—exposures are likely to be long—an extraordinary range of things can be grist to the mill of the still-life photographer, from an eye-catching everyday object to something chosen for its intrinsic beauty, whether a figurine or a piece of driftwood. And the composition can be anything from a study of a single object to the most elaborate assembly: even that Victorian staple, the dead pheasant surrounded with other foodstuffs.

Even at the highest level, in *advertising photography, demands on lighting and equipment are modest. Camera movements are often used to hold focus via the *Scheimpflug rule, or (more rarely) to restrict planes of focus or create distortions, so large-format cameras (increasingly used with roll-film backs) are popular. Lenses are usually of a great enough focal length to allow a good working distance between camera and subject. Lights are rarely either powerful or numerous. Flash is generally preferred for still-life work involving natural subjects such as *food or flowers, because of the heat from tungsten lights. But some photographers prefer the effects of tungsten; its disadvantages can be overstated.

Often amateurs treat still life as a branch of record photography. Very few indulge in fancy lenses, unusual film-stocks, and processing techniques, though their effects can be worthwhile. *Soft-focus lenses, extremely grainy film-stocks, and post-production techniques in *Adobe Photoshop or other image manipulation programs all deserve to be experimented with, though the last can easily be overdone.

Professionals often shoot still-life pictures, partly for recreation but arguably more as a means of exploring their craft, learning more about how to use light and shade, line and tone, and even exposure. The relevance to advertising work is obvious, but professionals in other spheres still seem to be disproportionately fond of them, often citing private still-life photographs among their favourite images. RWH

See also PACK SHOT.

Keppler, V., *Man + Camera* (1970).

Stone, Sir Benjamin (1838–1914), English industrialist and parliamentarian, a keen, even obsessive amateur photographer and collector of photographs. Although appointed by King George V as official photographer of the 1911 coronation, Stone's major contribution was to the Survey movement, especially the establishment of the *National Photographic Record Association (1897–1910). He was president of the Birmingham Photographic Society and closely involved with the Warwickshire Photographic Survey, from which the national vision emerged. Soon known as 'Mr Snapshot', he contributed many photographs to the Survey himself, travelling tirelessly to photograph ancient customs, architecture, and townscapes, sometimes aided by other photographers. His political connections gave him unparalleled access. Perhaps his most famous picture is of sailor-suited Mbuti 'pygmies' on the steps of the House of Commons. A fervent advocate of systematic photography as a historical record, he gave lantern lectures to camera clubs, working men's clubs, and charities, and published an affordable two-volume book, *Sir Benjamin Stone's Pictures: Records of National Life and History* (1905–6). He photographed extensively abroad, including Japan, the West Indies, and South Africa. His 37,000 photographs and 50 volumes of collected images are in Birmingham Central Library. EE

Jay, B., *Customs and Faces: Photographs by Sir Benjamin Stone* (1972).

Noel Griggs

Canvas shoes, 1940

604

stop. See APERTURE CONTROL.

stopbath. A stopbath has two functions in photographic processing: it arrests development, allowing leisurely inspection of a print; and it prevents the fixing bath from becoming contaminated with developer. It is useful where a number of prints have to be precisely matched for tone, as in *aerial mosaic making. Prints can be left in the stopbath and compared, and if necessary put back in the developer, before fixing the whole set. The standard stopbath is a 1 per cent solution of ethanoic (acetic) acid. Proprietary stopbaths include an indicator that turns green when the bath is exhausted. GS

Storyville portraits. In 1970 an obscure New Orleans commercial photographer, E. J. Bellocq (1873–1949), won posthumous cult status when his pictures of nude and clothed women, supposedly prostitutes from the Storyville red-light district, were exhibited at MoMA, New York. Taken c.1912, they had been printed by Lee *Friedlander from 89 battered plates acquired from a New Orleans dealer. Relaxed poses and expressions, suggesting friendly familiarity with the photographer, differentiate most of them from either *pornography or conventional portraiture. The nudity seems casual, unselfconscious, and mostly unalluring; one woman displays a conspicuous Caesarean scar. But various extraneous factors have given the pictures an exaggerated aura of strangeness and mystery.

Some of the faces have been roughly obliterated. Blemishes on the plates, and Friedlander's soft, archaic printing method, convey a haunting, romantic quality. (Prints on modern paper look more prosaic.) Some of the backgrounds, settings, and poses seem incongruous, even 'surreal'; there are naughty slogans, but also Christmas cards. But the images were evidently intended to be cropped. Finally, although tradition had described Bellocq as personally odd—in John *Szarkowski's words, 'a hydrocephalic semi-dwarf'—he was probably fairly ordinary. Not surprisingly, however, given their enigmatic origin, the photographs have prompted endless speculation and a novel, Peter Everett's *Bellocq's Women* (2000). RL

E. J. Bellocq: Storyville Portraits. Photographs from the New Orleans Red-Light District, circa 1912 (2nd edn. 1996).
Malcolm, J., *Diana & Nikon: Essays on Photography* (2nd edn. 1997).

Strache, Wolf (1910–2001), German photographer and publisher who became attracted to photography working in the publisher Ullstein's advertising department after receiving a doctorate in political science in 1934. He soon went freelance, doing reportage for various sports magazines and journals such as *Die Woche* and *Die neue Linie*, and publishing his own, *New Vision-influenced photo books by 1936. Strache ran a picture archive at the German Foreign Office 1940–2, and was a war correspondent for the Luftwaffe

E. J. Bellocq

Storyville nude, c.1912

1942–5. His 1942 photograph of a gasmasked woman pushing a pram through Berlin's ruins has become an *iconic image of the war. Strache settled in Stuttgart in 1945 as a freelance photojournalist and founded his company DSB (Die Schönen Bücher) in 1950, publishing over 100 popular books on natural forms, landscapes, cities, art, and architecture, and combining photographs with writing; and, 1955–79 (from 1960 with Otto *Steinert), the annual *Das neue deutsche Lichtbild*, to showcase German photography. Between 1971 and 1985 he was the secretary and lobbyist of the Association of Freelance Photo-Designers.　　　　　　　　　　　　　AL

Strache, W., *Fotografische Stationen: Bilder aus den Jahren 1934–1980* (1981).

straight photography. The term emerged in the 1880s to mean simply an unmanipulated photographic print, in opposition to the composite prints of Henry Peach *Robinson or the soft-focus painterly images of some *pictorialist photographers. At first, straight photography was a viable choice within pictorialism, as, for example, the work of Henry Frederick *Evans. Paul *Strand's 1917 characterization of his work as 'absolute unqualified objectivity' described a change in the meaning of the term. It came to imply a specific aesthetic typified by higher contrast, sharper focus, aversion to cropping, and emphasis on the underlying abstract geometric structure of subjects. Some photographers began to identify these formal elements as a language for translating metaphysical or spiritual dimensions into visual terms. This emphasis on the unmanipulated silver print dominated modernist photographic aesthetics into the 1970s.　　　　　　　　PJ

Strand, Paul (1890–1976), American photographer and film-maker, and a key figure in the development of *modernism. He attended the Ethical Culture School in New York, a progressive institution where the teachers included Charles Caffin, an art historian and critic who had written the path-breaking *Photography as a Fine Art* (1901), and Lewis *Hine. Later Strand remembered it was Hine who introduced him to the world of artistic photography through a field trip to Alfred *Stieglitz's *Gallery 291. After graduating in 1909, Strand worked, travelled, and built a porfolio of photographs that he eventually showed to Stieglitz, who gave him a one-man exhibition in March 1916. Strand's vision reflected the vibrant interest in modernism in the New York art world. The Cubist principles of Cézanne and Picasso had greatest influence on him at this point, and in the summer of 1916 he embarked on a series of compositional studies of cups, bowls, and fruit, and another of chairs and porch rails that resulted in abstract photographs of shapes—solids and voids, lights and shadows. He then produced images of everyday life in New York: forceful, astute studies of pedestrians, vendors, workers, and architecture that Stieglitz praised as 'the direct expression of today'. Stieglitz devoted his last issue of *Camera Work* (1917) to Strand's work, and reprinted the photographer's statement from the short-lived periodical *Seven Arts*, which now appears almost as a manifesto of modernist, *straight photography. Photography's 'complete uniqueness of means', Strand wrote, was in its 'absolute

unqualified objectivity'. He prescribed, for a photographer with 'honesty, no less than intensity of vision [that t]his means a real respect for the thing in front of him, expressed in terms of chiaroscuro . . . through a range of almost infinite tonal values'.

Strand's work in the 1920s was characterized by sharp, close-up compositions based on nature and machines, but he turned increasingly to film-making. *New York the Magnificent* (1921, later retitled *Mannahatta*), with Charles *Sheeler, was a seven-minute observation of the city in motion. Films from the 1930s were more political. *Redes* (1934, released in the USA as *The Wave* in 1937), filmed in Mexico, examined the economic conditions of fishermen in a village near Vera Cruz. After returning to New York in 1934, Strand affiliated with Harold Clurman's Group Theater and the radical film-making association Nykino. Through the USDA's Resettlement Administration, he worked on Pare Lorenz's Dust Bowl documentary *The Plow that Broke the Plains* (1936). With Leo Hurwitz, Ralph *Steiner, and others, he founded the progressive Frontier Films (1937–42). His primary project of this period, *Native Land* (1941), reported on the persecution of 1930s labour activists.

After the Second World War, Strand worked with several writers to produce books interpreting various locales, completing the first one, *Time in New England*, with Nancy Newhall (1950), and the others after moving to France in 1950 to avoid McCarthyism. Strand's papers are at the Center for Creative Photography, Tucson, Arizona; negatives at the Paul Strand Archive, Aperture Foundation, New York.　　PJ

Greenough, S., *Paul Strand: An American Vision* (1990).
Stange, M. (ed.), *Paul Strand: Essays on his Life and Work* (1990).
Hambourg, M. M., *Paul Strand: Circa 1916* (1998).

Strelow, Liselotte (1908–81), German photographer, who trained at the Berlin *Lette-Verein (1930–2), assisted the photographer Sys Byk, and worked for Kodak in Berlin before opening a studio in 1938 and starting freelance photojournalism. After the Second World War she moved into theatre photography, achieving fame with her studies of Gustaf Gründgens at the Düsseldorf Schauspielhaus. Subsequently she became one of post-war Germany's most celebrated stage and portrait photographers. Her high-contrast style, and concentration on hands and faces against a usually plain background, set a trend for the 1950s and 1960s.　　　　　　　　　　　　　UR

Vielhaber, G., *Gründgens: Sieben Jahre Düsseldorf. Aufnahmen von Liselotte Strelow* (1954).

Strindberg, August (1849–1912), Swedish writer, insatiably curious about art and science, whose experimental interest in photography between 1886 and 1907 was mainly an extension of his literary concerns. Thus his 1886 photographs of the French countryside (sometimes from train windows), and his family scenes and self-portraits, were intended to illustrate books he was writing. He was one of the first writers to join the fruitful dialogue between photography and literature. Ever the innovator and experimenter,

Strindberg in the 1890s did research on the recording of colour; tried *pinhole photography; and made *photograms by placing a sensitized surface against a frost-covered window pane. In the same spirit of technical minimalism, he tried to photograph the stars by exposing a sensitized plate immersed in a developing bath to the sky; convinced that he had revolutionized astrophotography, he failed to realize that the 'star clouds' in the image were simply white patches produced by clumsy manipulation. Fascinated by *occultism, Strindberg also attempted to photograph the soul, then gravitated towards 'psychological portraits'. Unfortunately, although his writings indicate a wide variety of photographic experiments, only *c.*60 images survive. CC

Hedström, P., *Strindberg, Painter and Photographer* (2001).

Strömholm, Christer (1918–2002), Swedish photographer and teacher, born in Stockholm. From 1937 he studied art in Dresden, then Prague, Paris, and Stockholm. After fighting as a volunteer in Finland during the Second World War, he resumed his studies in Paris and discovered photography. In the early 1950s he belonged to the *fotoform group and participated in its 'subjective photography' exhibitions. From 1962 to 1974 he headed Stockholm's influential Fotoskolan, educating many Scandinavian photographers. In the 1960s and 1970s he travelled extensively worldwide, with intervals in Paris. His stature as a major European photographer was recognized late in life. His oeuvre ranges from portraits of artists and writers to street scenes and studies of Paris transsexuals. His contrasty monochrome images, dominated by deep blacks, reveal a bleak outlook influenced by post-war existentialism. J-EL

Strömholm, C., *Poste Restante* (1967).

'struggle photography', black-and-white *documentary and activist photography that emerged during the political mobilizations of the 1980s in South Africa, when the camera was seen as a cultural weapon of struggle against apartheid. An important landmark was the 1982 Culture and Resistance Festival held in Gaberone, Botswana, soon followed by the formation of the Afrapix Collective (later Agency).

The 1980s work built on important precedents from previous decades. Ernest Cole (1940–90) had documented the working and living conditions of the 1960s in his remarkable *House of Bondage* (1967); Peter *Magubane and others had photographed political events from Sharpeville onwards in the 1960s. The Soweto Uprising of 1976 produced a spate of protest images by press photographers. Sam Nzima's published photograph of Hector Peterson, the first child to die from a police bullet in the student protests of June 1976, became *the* icon of the South African struggle. It attained the status of a South African *pietà*, signifying state brutality and the sacrifice of the innocents. Nzima himself was never properly credited for this photograph. Security police seized his negatives and drove him into hiding for many years. Nzima's case points to the dual condition of opportunity and shutdown which the period 1976–94 offered to

photographers, and how black photographers often experienced this in more extreme ways than their white counterparts.

Afrapix founder members such as Omar Badsha (b. 1945), Paul Weinberg, Cedric Nunn, and Peter Mackenzie argued that photographers needed to go beyond the 1970s and provide in-depth views of ordinary lives. But as the United Democratic Front formed, with massive consequences, in the mid-1980s, many new photographers took up positions on the barricades. Funerals, marches, and political meetings, with youths and labour unions doing the *toyi-toyi*, became familiar genres, especially in the quest to portray positive struggle as opposed to negative victimization. Amongst the new generation of photographers to emerge within Afrapix were Lesley Lawson, Rafik Mayet, Jeeya Rajgopaul, Paul Alberts, Chris Ledochowski (b. 1956), Paul Grendon, Rashid Lombard, Santu Mofokeng (b. 1956), Guy Tillim (b. 1962), Gideon Mendel, Anna Zieminski, Eric Miller, and others. Afrapix was behind two important exhibitions and books, *South Africa: The Cordoned Heart* (1986) and *Beyond the Barricades: Popular Resistance in South Africa* (1989), as well as contributions to *Staffrider* magazine. While political and market pressure to represent resistance, repression, and near-civil war in the cities was a fact of life and gave rise to the so-called Bang-Bang Club of the early 1990s, the documentary work of several key Afrapix photographers goes beyond straight 'struggle' paradigms. Badsha's work in Kwazulu-Natal, Ledochowski's on the Cape Flats, Nunn's on family bloodlines, Mofokeng's on township and spiritual life, all indicate sustained social and cultural projects that reflect on their own aesthetic.

Afrapix foundered in the early 1990s as South Africa's international isolation ended, heralded by the worldwide photographic feeding frenzy when Nelson Mandela was released in February 1990. But the legacy of 'struggle photography' is apparent in the continued practice of politicized documentary. This now attempts a more dialogic approach, strikingly apparent in the recent HIV/AIDS photography of Gideon Mendel (*Broken Landscape*) and others such as Fanie Jason. PHA

Anthology of African and Indian Ocean Photography (Eng. edn. 1999).
Marinovich, G., and Silva, J., *The Bang-Bang Club: Snapshots from a Hidden War* (2000).

Struss, Karl (1886–1981), American photographer and cinematographer. Born in New York, Struss became a pioneering photographer at an early age. He was elected a member of *Stieglitz's *Photo-Secession group in 1912. In 1916 he was one of the founders of the Pictorial Photographers with Clarence *White. Struss also developed innovative lenses. After the First World War he moved to *Hollywood, where his talents were recognized by key personalities including Cecil B. DeMille. He was the cinematographer for numerous films, notably Rouben Mamoulian's *Dr Jekyll and Mr. Hyde* (1931) and Chaplin's *Great Dictator* (1940). TT

McCandless, B., Yochelson, B., and Koszarski, R., *New York to Hollywood: Photographs by Karl Struss* (1994).

Struth, Thomas (b. 1954), German photographer, important in establishing photography as a major medium in *contemporary art, especially with his large-format colour prints. Struth studied under Gerhard Richter and Bernd *Becher at the Kunstakademie Düsseldorf (1973–80), moving from painting to photography and thus becoming part of a new generation of photographers known as the 'Becher School'. After beginning in 1976 with black-and-white studies of deserted streets, and bird's-eye views of cities such as Düsseldorf, Berlin, Paris, London, and New York, he turned to colour, including peopled street scenes in the Far East. In these cityscapes, with clarity and formal precision, Struth investigates the relationship of individuals with public spaces as sites of a collective unconscious and daily urban existence. This interest in exploring social interaction also informs his ongoing portraits of friends and their families in their private environments. His series of visitors contemplating works of art in museums and religious sites reflect the acts of seeing and representation, and the way we relate to the past and position ourselves in the present. Since the 1990s Struth has also photographed flowers, deserts, and primeval forests. AL

Thomas Struth, 1977–2002 (2002).

Stryker, Roy Emerson (1893–1975), one of the most influential contributors to American *documentary photography, who never took a photograph. Raised in Colorado, and a veteran of the First World War, Stryker studied agricultural economics at Columbia University, 1924–30, where he became a photo researcher. Invited in 1935 to create the 'Historical Section' of what became the Farm Security Administration (FSA), and Office of War Information (OWI), Stryker administered the creation of a massive 'file' of photographs. He later created a similar worldwide file of images for *Standard Oil of New Jersey (1943–50). He briefly headed the Pittsburgh Photographic Library (1950–1). CBS

Hurley, F. J., Portrait of a Decade: Roy Stryker and the Development of Documentary Photography in the Thirties (1972).

Anderson, J. C., Roy Stryker: The Humane Propagandist (1977).

studio backdrops. See BACKDROPS, STUDIO.

studio photography. Although many early *itinerants made portraits in courtyards or hotel rooms, a studio was essential for most 19th-century commercial practitioners, and their numbers grew rapidly. There were already 86 in New York City alone by 1853; in London they increased from about a dozen to over 150 between 1851 and 1857. Top photographers in major cities boasted sumptuous establishments that might include, in addition to the studio itself, a front-of-house sales and reception area, dressing and waiting rooms, and processing laboratories. Gustave *Le Gray's studio in the Boulevard des Capucines between 1855 and 1859 boasted old-master paintings and statues and fabulously expensive carpets and furniture, was depicted in the illustrated press, and became a magnet for the fashionable elite. Such premises consciously vied with the studios of leading portrait painters; in 1913, indeed, the London portraitist Emil *Hoppé took over John Everett Millais's 27-room studio/mansion. By the 1930s the rise of *advertising photography had put versatility and flexibility at a premium. The New York premises occupied by Victor *Keppler in 1933, for example, or Bert *Stern in the 1960s incorporated state-of-the-art lighting and processing equipment, and facilities for creating everything from table-top *pack shots to Hollywood-like fashion sets and interiors.

At the most basic, the advantage of working in the studio instead of in the open is that the studio can be warm and dry: it also provides a fixed address, which is handy for commercial photographers. A second advantage, greater today than in the first decades of photography's history, is that the light in the studio is more controllable.

In the earliest days, artificial light sources were weak, and materials were slow, so daylight was essential. The ideal studio had huge north-facing windows, and glazed roofs on the north side: north lights never admit direct sunlight, but are always lit by diffused skylight. The further south the studio, the steeper the roof must be: in the tropics roof-lights must always be diffused. In the southern hemisphere, south lights replace north lights. Complex systems of opaque and diffusing blinds allow considerable control of the light.

Despite an inevitable reliance on the vagaries of the weather, many excellent pictures were taken in daylight studios. Most were portraits, though (for example) Roger *Fenton's *still lifes from the 1840s are still very impressive today. Not until the rise of photographically illustrated books and magazines in the early 20th century was there much call for advertising and editorial photography as we now know it. And although advertising photography was well established by the Second World War, it was only after 1945 that advertising budgets became really large. The late 1960s and early 1970s were in many ways the heyday of the industry, with plenty of money changing hands.

For obvious reasons, photographic studios adopted artificial *lighting, especially electric lighting, as soon as it was feasible: most were so equipped by the end of the 19th century. When cool-running, powerful studio flash units became available, from the 1950s onwards, many studios switched to these from continuous or 'hot' lights, though plenty to this day prefer the effects obtainable with tungsten lighting.

Apart from light, the other thing that a photographic studio needs is space: far more than most people realize, except for 'table-top' photography which can be accomplished in the corner of any room with a reasonably high ceiling. For comfortable working with portraiture, for example, the camera typically needs to be up to 3 m (10 ft) from the subject; there must be at least one metre (3 ft), and preferably a couple of metres (6 ft), behind the subject if shadows are not to be thrown on the background; and the photographer needs at least a metre behind the camera. This translates to a minimum of 5 m (16 ft) and preferably 6 or 7 m (19 to 22 ft).

Then there must be room either side of the subject to set the lights, ideally at least a couple of metres (6 ft) each way: with a subject plus a bit of background only a metre wide, this means the studio must be

5 m wide (16 ft). Finally, if any sort of lighting from above is required, a ceiling of much less than 3 m (10 ft) is likely to prove inconvenient, as many have found when they try to convert their garages into studios. Walls are normally painted white; black is arguably better, but oppressive, and coloured walls affect the colour of the light. Of course it is possible to take excellent portraits in significantly smaller spaces, with walls of other colours, but it will be harder work than if a large studio is available.

Quite apart from shooting space, a studio requires a great deal of storage space. Lights and light stands take up a lot of room; so do 'bounces' or 'flats', large sheets of plywood or expanded polystyrene, painted white on one side to reflect light back on to the subject, and black on the other to absorb unwanted light. In a commercial studio, these are normally 120 × 240 cm (4 × 8 ft). Many studios rely on seamless background paper, normally supplied in rolls 2.75 m (9 ft) wide, and these have to be supported as well as stored. Other studios use fabric backdrops up to c.3.5 m (12 ft) square. And this is before you start to consider props, or indeed (with inanimate subjects) storage space for the things to be photographed.

General advertising work makes the greatest demands on a studio. One client may want a motor car photographed; another, a tiger lying on a sofa; a third, a model trying on lingerie. These examples illustrate further requirements: access, so that the car can be driven in, the possibility of building a cage to contain the tiger, a changing room for the model. The expense of maintaining such a studio explains the popularity of hire studios, as found in most major commercial centres: the photographer hires not only the space but also (as needed, whether from the studio or from other sources) cameras, lights, and even assistants.

At the other extreme, some sorts of 'high-street' portraiture are simple, formulaic, and can be set up with the lights, backdrops, etc. all but nailed down. In 1950s portrait studios it was not unusual for three or four set lighting plots to be marked on the floor of the studio with brass studs: the photographer or his assistant just set the lights for whichever one was needed.

Instead of tripods, many studios are equipped with pillar-type stands, which allow the camera to be lowered to floor level, or raised 2 m or more above the ground (a popular height is 2.4 m (8 ft)) in a few seconds: much faster and more convenient than a tripod, though heavy (typically around 50 kg (1 cwt)) and, again, bulky.

The fact that a discussion of camera equipment can be left until last shows just how unimportant it is, relative to all the other considerations involved in setting up a studio. The history is one of continually diminishing *formats. Before the Second World War, 18 × 24 cm (7 × 9$\frac{1}{2}$ in), whole-plate (16.5 × 21.6 cm; 6$\frac{1}{2}$ × 8$\frac{1}{2}$ in), and 20.3 × 25.4 cm (8 × 10 in) were the smallest that would be used for high-end work. Portraits were often shot on half-plate (12 × 16.5 cm; 4$\frac{3}{4}$ × 6$\frac{1}{2}$ in) or 12.7 × 17.8 cm (5 × 7 in) or 13 × 18 cm (5 × 7 in); anything smaller was regarded as an economy job, though quarter-plate (8.3 × 10.8 cm; 3$\frac{1}{4}$ × 4$\frac{1}{4}$ in) and even smaller sizes were popular in the 19th century and up to 1914.

By the end of the 1960s, 8 × 10 in was generally reserved only for top-flight advertising work, and 4 × 5 in was the norm for still lifes, though portraiture had shifted to a considerable extent to roll-film. By the end of the 20th century, roll-film (especially 6 × 7 cm; 2$\frac{1}{3}$ × 2$\frac{3}{4}$ in) was pretty much the standard for everything, and the second-hand market was glutted with 4 × 5 in monorail cameras, the staple of the business for three or four decades.

When *digital cameras started to come in at the very end of the 20th century, they were employed for two sorts of work. At the low end, for high-volume jobs such as catalogue photography, they allowed significant savings in shooting time and materials, though quality was inferior to film. At the high end, where budgets could stand the high cost of scanning backs and the like, the gains in quality as against film were often less important than faster time to press, and there was the immediate certainty, without having to wait for processing, that the shot was 'in the bag'. RWH

See also BACKDROPS, STUDIO; FOOD PHOTOGRAPHY; MAKEOVER PHOTOGRAPHY.

Pritchard, H. Baden, *The Photographic Studios of Europe* (1882).
Keppler, V., *Man + Camera* (1970).
Life Library of Photography: The Studio (rev. edn. 1982).
Sagne, J., *L'Atelier du photographe* (1992).

Sturges, Jock (b. 1947), American photographer. A student of the photographer and printer Richard Benson, Sturges worked and studied at Marlboro College in Vermont before gaining his MFA from the San Francisco Art Institute in 1985. His published work consists almost entirely of studies of pre-pubescent and adolescent girls (sometimes posed with their mothers) photographed in French and East and West Coast American naturist resorts. Stunning in their clarity and straight-on simplicity, the large-format nude images—in no way pornographic—have, nonetheless, generated an enormous body of discussion while making Sturges, married and now living in Washington state, financially very successful. TT

style, photographic. Briefly, style may be defined as the distinctive treatment of a given subject that is characteristic of a particular photographer, movement, or period. However, it took some time for a range of peculiarly photographic styles to emerge. As studio portraiture initially took its lead from painting, so another genre—landscape—was dominated by formulaic conventions adopted from easel artists. The branches of trees were used as framing devices, the rectangular picture plane was divided into thirds with the golden mean positioned with scientific accuracy. These stilted devices are still used by most 'weekend' painters and amateur landscape photographers, as is the studio portrait pose in which the sitter looks over his or her left shoulder at the camera lens.

But technical developments since the late 19th century enabled photographers to capture things on the wing. This candid, instantaneous style is unique to the medium and gives the impression of a moment frozen in time and captured for ever. Its suggestion of

naturalistic realism could be invalidated if the subject looked at the camera, because the photographer was considered to be an 'invisible' witness to the unfolding events, not their orchestrator. Henri *Cartier-Bresson is the most celebrated exponent of this *'decisive moment' style, although he always maintained that his approach was more surrealistic than reportorial.

In the late 20th century, when photography became popular with fine artists, its various styles and genres *became* the subject matter of innumerable works. For example, the postmodernist Jeff *Wall artificially recreates the candid-realist style in his *staged pieces by using actors and digital montaging, thus pointedly undermining its *raison d'être* despite the authentic 'look' of his tableaux. In the 1970s the Conceptual artist and theoretician Victor *Burgin used the styles of *advertising and *documentary photography to articulate critiques of capitalism. Twenty years later, Oliviero *Toscani did the reverse and put social realism in his advertisements for Benetton. Cindy *Sherman took the familiar style of film publicity photos and created fictitious scenarios where she played the 'star', though often introducing disturbing or incongruous elements at odds with the bland conventions of the genre.

Advertisers use pastiches of styles from the history of photography and film, knowing that they are part of a subconsciously assimilated, common visual vocabulary. This lexicon is continuously being enlarged; and it does not take long for the challenging works of the avant-garde (whose members, like the *New Vision photographers of the 1920s and 1930s, may create both gallery and commercial work) to become sufficiently mainstream to be appropriated by opportunistic practitioners and enterprising agencies alike.

All work has its antecedents, but its 'signature' must appear original if it is to be memorable, and bear its author into the pantheon. Bill *Brandt's high-contrast, wide-angle images were influenced by the film *Citizen Kane*, but their distinctiveness and lasting qualities are beyond question, as is Diane *Arbus's uncompromisingly direct use of flash in her portraiture, William *Eggleston's obsessive preoccupation with the colour of the unregarded, Nancy Rexroth's optically aberrated ethereal snapshots, Martin *Parr's humorously sarcastic vignettes from his travels, Mari *Mahr's meticulously montaged fragments from her personal history, Ralph *Gibson's formalist close-ups, Duane *Michals's psychologically charged narratives, and Richard *Billingham's revealing portraits of his dysfunctional family.

Style acts like a magnet to the eye. Stylists make 'showstoppers' through their command or subversion of conventional techniques that exposes us to unique ways of seeing. Their personal 'signatures' are more compelling than subject matter alone. Julia Margaret *Cameron's theatrical Victorian portraits, *Man Ray's playful *photograms, Alvin Langdon *Coburn's bird's-eye abstractions from the urban landscape, or O. Winston *Link's dramatically illuminated steam trains linger in the memory. In the late 20th century the humble colour *snapshot style was elevated to an art form despite its seeming artlessness. However, the makers are not naive primitives

but ironic decontextualizers. Gallery walls and glossy monographs have replaced the mantelpiece and the family album, and a type of work derided by professionals as 'bad' photography is now bought by museums, at appropriate prices. The style has become subsumed into the postmodern aesthetic and has, as a consequence, lost its 'innocence'. But the debates surrounding this process of reappraisal have underlined photography's pervasive role in contemporary art and culture. PHI

See also CONTEMPORARY ART, PHOTOGRAPHY AND.

Campbell, B., *Exploring Photography* (1978).
Life Library of Photography: The Art of Photography (1981).
Knapp, P., et al., *Dix ans d'enseignement: cours de photographie* (c.1998).

subjective photography, broadly, photography undertaken for purposes of self-expression rather than to record the appearance of the external world. The distinction was classically formulated by John *Szarkowski in his introduction to the catalogue of the *Mirrors and Windows* exhibition at MoMA, New York, in 1978. Celebrated examples of subjective photography are the cloud pictures, or *Equivalents*, of Alfred *Stieglitz, who wrote 'All art is but a picture of certain basic relationships; an *equivalent* of the artist's most profound experience of life'; and Minor *White's work, influenced by Oriental philosophy.

However, the term *Subjektive Photographie*, coined by Otto *Steinert at the end of the 1940s and associated with the German *fotoform group, signified a protest against the anodyne salon and yearbook photography of the post-war period and a more experimental approach harking back to the *New Vision of the 1920s and 1930s. In this context, 'subjective' implied a willingness to ignore the technical and aesthetic conventions of the 'good photograph'. Three large *Subjektive Photographie* exhibitions were held between 1951 and 1958. RL

'Subjektive Fotografie': Der deutsche Beitrag 1948 bis 1963 (1989).

sub-miniature photography. Although something of a pleonasm, the term 'sub-miniature' has, since the 1930s, been widely taken to include still cameras using film less than 35 mm wide, or taking unusually small images on 35 mm. The inclusion of 18×24 mm ($^7/_{10} \times 1$ in) single frame (or half-frame) is a matter of personal preference. Sub-miniature cameras appeal to four main groups: clandestine photographers; those who want an extremely compact camera; those who enjoy a technical challenge; and collectors.

The classic 'spy' camera is Walter *Zapp's Minox (1938) with its 8×11 mm ($^3/_{10} \times ^2/_5$ in) images on imperforate 9.5 mm film. The Kodak Match Box (MB), designed for espionage in occupied Europe, took a 30-exposure cassette of 16 mm film; c.1,000 were made 1944–5. A camera that enjoyed widespread popularity among Cold War intelligence services was the Tessina (1961), offering 14×21 mm ($^1/_2 \times ^4/_5$ in) on specially loaded 35 mm film: the bigger format could hold much more information. The Minox has been through several

iterations and was used in 1977, for example, to take clandestine pictures of Elvis Presley in his coffin. The Minox cassette has become a standard, used in most of the few new sub-miniatures that have been introduced from time to time.

Compactness without clandestine appeal has spawned countless cameras, many using 16 mm film, whether imperforate, single perforated, or double perforated. These were very popular in the 1950s and 1960s: leading manufacturers of 'serious' cameras (as distinct from novelties) included Mamiya, Minolta, and even Franke & Heidecke (Rollei 16, 1963). Others deserving mention include the Czech Meopta, the Russian Narziss SLR, and the Italian Gami. Many of these cameras are masterpieces of precision engineering: the Goerz Minicord twin-lens reflex (1951) is one of the most sought after.

Image sizes on 16 mm have ranged from 10×10 mm ($^2/_5 \times ^2/_5$ in) to 14×17 mm ($^1/_2 \times ^2/_3$ in), and there have been numerous mutually incompatible cassette types: the availability of these is the biggest barrier to using old sub-miniatures today. What really killed this aspect of the sub-miniature market (along with single frame) was the Rollei 35 (1966): tiny, but a full 24×36 mm ($1 \times 1^2/_5$ in), and with universal film availability and processing. Later cameras such as the Minox 35 EL (1974) followed this trend.

Devotees of a technical challenge delight in getting the maximum possible quality out of tiny negatives, concerning which there are only two things to say. One is that they often succeed: a postcard-sized print from a Minox is about a ×13 enlargement. The other is that, all too often, the pictures are mere snapshots that have absorbed an altogether disproportionate amount of time and effort. The full Minox system, in particular, has incorporated tripods the size of a fountain pen, tiny developing tanks using minute amounts of chemicals, and miniature enlargers.

Finally, collectors recognize both high-quality cameras, such as those mentioned above, and novelties, which are effectively fully functioning toy cameras. Some, such as miniature 'replica' Leicas or Contaxes, were very expensive when new; others, such as the Coronet Midget (1934), with a unique film size, cost very little when new and are only popular today because they are rare and cute. Very early 'sub-miniatures' (before the term really came in) also command collector attention: the Ticka 'pocket-watch' camera (1906) is one of the few quite often encountered. RWH

Coe, B., *Cameras: From Daguerreotypes to Instant Pictures* (1978).
Pritchard, M., and St Denny, D., *Spy Camera: A Century of Detective and Subminiature Cameras* (1993).

Sudek, Josef (1896–1976), Czech photographer, born in Kolin. Sudek was apprenticed to a bookbinder, but learned photography, probably from his sister Bozena Sudkova. He lost his right arm in the First World War and spent three years in hospitals, making portraits of patients. He studied photography at the School of Graphic Arts, Prague, and was a founder of the Czech Photographic Society. In 1928 he became a magazine editor and photographer for Druzstevni prace, who published his first portfolio on St Vitus cathedral. Included in the 1936 Prague Manes International Art Exhibition, his first solo exhibition was not until 1958. From 1936 he lived and worked in his small and chaotic Prague studio.

Atmospheric and romantic, but in keeping with Czech photography's inter-war modernism, Sudek's work included still life, portraits, architecture, and landscape. Preferring older cameras, using natural light, from 1940 he only made contact prints. His stunning panoramas of Prague, made with an 1899 Kodak Panoram camera, were published as *Praha Panoramaticka* (1959). Although poor and isolated for much of his life, Sudek became the best-known Czech photographer; his *Josef Sudek Fofografie* (1956) is regarded as one of the finest photographic books. RA

Farova, A., *Josef Sudek* (1999).

Sugimoto, Hiroshi (b. 1948), Japanese photographer. Born and raised in Tokyo, he studied photography in southern California and became enamoured of large format and black-and-white photography. He moved to New York in 1974, and began a series of photographs of dioramas at the Museum of Natural History. From 1978, in cinemas across the USA, he photographed *Theatres*, screen images each made with a single exposure lasting for the duration of a film. He began photographing *Seascapes* in the 1980s and 1990s. The earliest images divide the image at the horizon between a calm sea and a cloudless sky, the moment chosen to elide any particularity of time or season. The latest of the series are seascapes by night. His first book, *Sugimoto*, appeared in 1988. Recent work includes the series *Sanjusangendo, Hall of Thirty-Three Bays* (1995) of Buddhist statues, and portraits of the historical figures at Madame Tussaud's Museum (*Wax Museums*, since 1994). MHV

Sugimoto, H., *Architecture of Time* (2001).

Surrealism and photography. It may at first seem odd that Surrealism, with its emphasis on the poetry of the unconscious, should have had any interest in the all too physical processes of photography. But the Surrealists were not interested in escaping from reality; rather they sought a deeper, more heightened form of it. If photography could be turned away from the mere depiction of surfaces, its apparent objectivity could be powerfully put to Surrealist ends, producing evidence of this 'sur-reality'.

In fact, photography was found everywhere in Surrealist publications. Magazines such as *La Révolution surréaliste* (1924–9), *Documents* (1929–30), and *Le *Minotaure* (1933–9) featured *anonymous photographs, often with their meaning crucially changed in this new context, alongside images made by photographers such as *Man Ray, Jacques-André *Boiffard, and *Brassaï. The leader of the Surrealist group, André Breton, used photographs by Boiffard and Brassaï to illustrate the places visited in his two books *Nadja* (1928) and *L'Amour fou* (1937).

Several Surrealist books juxtaposed poetry and photography. In *Facile* (1935), Paul Éluard's poems for his wife Nusch were interwoven with Man Ray's photographs of her nude body. Roland Penrose's *The Road is Wider than Long* (1938) was the product of a journey

Hiroshi Sugimoto

Byrd, Richmond, 1993

through the Balkans with Lee *Miller, and brought together his photographs and poetry in a shifting page layout. *On the Needles of These Days*, published in Prague in 1942, juxtaposed photographs of found objects by Jindrich Styrsky (1899–1942) with unrelated fragments of text by Jindrich Heisler.

Surrealist photography itself took several forms. There was a great use of techniques of manipulation. Many artists used *photomontage —the early work of Max Ernst stands out here—but equally it was pursued by Surrealist writers such as Breton and Éluard. The foremost inventor of Surrealist photography was Man Ray—born in America but living in Paris from 1921. He developed a poetic form of the *photogram, which he called the 'Rayograph'. Later, he explored the technique of *solarization with great delicacy, especially in his portraits and nudes. In the 1930s, the Belgian Raoul *Ubac mixed solarization with photomontage to make more multi-layered, 'convulsive' images.

*Staged photography was also important for a number of Surrealist artists, often prefiguring its role in later art practice. On one level, this took the form of highly sophisticated snapshots, like the witty, ironic images made by René *Magritte and the rest of the Belgian group. More serious and indeed controversial are the photographs that Hans *Bellmer took of his 'Poupée'—the female doll he made in the 1930s. Variously seen as liberatory or misogynistic, the images of the doll twisted this way and that remain deeply disturbing. Recently, the work of two lesser-known figures, Pierre Molinier (1900–76) and Claude

*Cahun, has been much discussed for the way they crossed gender boundaries, Molinier dressing in corset and black stockings while Cahun often rendered herself neuter, almost alien.

Finally, and in quite different ways, the conventions of *documentary photography were exploited by Surrealism for its own ends. Among the images used anonymously in *La Révolution surréaliste* were four photographs by Eugène *Atget, made for quite different ends but 'discovered' as examples of unconscious Surrealism by Atget's neighbour, Man Ray. Very soon, though, the Surrealists came more broadly to view Atget's deserted cityscapes as images of a haunted urban environment pregnant with possibilities. Brassaï's later photographs of Paris by night can be seen as a nocturnal parallel to Atget's work; he was one of a generation of photographers in Paris in the early 1930s who were influenced by Surrealism. Using the new 35 mm camera, André *Kertész and the young Henri *Cartier-Bresson pictured a city full of coincidences and connections, caught in a fraction of a second before they disperse.

The influences of Surrealism within photography have been far reaching. Simply in this latter area of 'surrealist documentary', one would have to go on to consider the work of Bill *Brandt and Lee Miller in Britain, Vilém Reichmann (1908–91) and Emila Medková in Czechoslovakia, Manuel *Álvarez Bravo in Mexico, Frederick *Sommer in the Arizona desert, and Clarence John *Laughlin in New Orleans. All these photographers were interested in how the camera

can simultaneously record everyday reality and probe beneath its surface to reveal new possibilities of meaning. IW

Krauss, R., and Livingston, J. (eds.), *L'Amour fou: Photography and Surrealism* (1985).

Walker, I., *City Gorged with Dreams: Surrealism and Documentary Photography in Interwar Paris* (2002).

Bate, D., *Photography and Surrealism: Sexuality, Colonialism and Social Dissent* (2003).

Sutcliffe, Frank Meadow (1853–1941), English photographer based in Whitby, North Yorkshire. The son of a watercolour painter, he took up photography in the late 1860s. In 1876, after failing to establish himself in fashionable Tunbridge Wells, he opened a studio in Whitby, a fishing and seafaring town gradually developing into a resort. For decades he scraped a living from commercial portraiture, earning little from the work that eventually made him famous: subtly observed, atmospheric views of Whitby and the surrounding countryside, and studies of fisherfolk and rustics. Particularly celebrated was *Water Rats* (1886), of naked urchins disporting themselves in the harbour. In 1888 Sutcliffe had a large one-man show at the London Camera Club, and by 1905 he had won 62 British and foreign awards. Despite Whitby's remoteness, he kept abreast of technical developments and aesthetic debates, especially about photographic *realism. His lack of interest in pictorial anecdote, willingness to flout convention, and eye for pattern and form now seem proto-modern. Although he worked for years with cumbersome glass-plate equipment, he enjoyed using portable cameras lent to him by Kodak *c.*1900. A shrewd, sometimes acerbic commentator on the photographic scene, he contributed to numerous journals and wrote a column for the *Yorkshire Weekly Post* for 22 years. After selling his business in 1922 he became curator of a Whitby museum. RL

Hiley, M., *Frank Meadow Sutcliffe, Photographer of Whitby* (1974).

Suzuki, Shinichi (1835–1918), Japanese photographer. Born in Izu, Suzuki moved to Yokohama *c.*1854, initially working as a silkworm farmer before apprenticing himself to the photographer Shimooka Renjo in 1866. In 1873 he established his own studio, and soon became celebrated amongst foreign residents in Yokohama. In the following decade, Suzuki gradually withdrew from photography, handing over the running of a newly opened branch studio in Tokyo to his adopted son, and retiring in 1892. The Suzuki studio continued to operate until 1896. SD

Švol´k, Miro (b. 1960), Slovakian-born photographer, resident in Prague. Švolík studied at the School of Applied Arts, Bratislava, and FAMU (Film and Television Faculty), Prague. In the early 1980s he rejected state-sanctioned practice and became one of the leading exponents of *staged photography. In his work objects and people are placed in or on the landscape in arrangements sometimes enhanced by large-scale drawing, then photographed. Švolík has developed a

Frank Meadow Sutcliffe

Water Rats, 1886. Albumen print

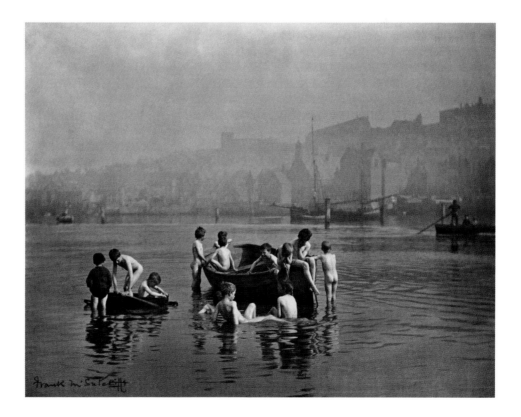

distinctive style which draws upon human relationships and nature for its subject matter. Many of his images are redolent of fragments of folk tales. By 1990 Švolík had won considerable international acclaim; and that year also helped to found the Prague House of Photography, the post-communist Czech photographers' professional body. ML

Macek, V., *Miro Švolík: Jedno tělo jedna duša* (*Miro Švolík: One Body One Soul*) (1992).

Sweden. See SCANDINAVIA.

Switzerland. In 1836 the veterinary professor Andreas Friedrich Gerber (1797–1872) produced microscopic images using paper treated with silver chloride; and, according to the *Journal of the Society of Art* (Jan. 1852), exhibited an album of photographs in London in 1840. So, in Switzerland, photographic research had been under way since before the official announcement of *Daguerre's invention in January 1839 (to which Gerber responded by asserting his own primacy). The fact that Johann Baptist *Isenring and a man called Compar were already organizing photography exhibitions in Zurich in 1840 underlines the extent to which Swiss society was receptive to the new picture-making process. Compar, who also showed *daguerreotypes in Lausanne that year, remains a shadowy figure. But Isenring, from St Gall, is known to have rapidly mastered photography, and to have developed a method of colouring photographs.

However, although Isenring was probably the first professional, he was not the only player on the Swiss photographic scene. After 1840 the number of daguerreotypists multiplied. The Geneva banker Jean-Gabriel Eynard (1775–1863) made portraits of his family and friends. In Bern, Carl Durheim (1810–90) opened a studio and in 1852, nearly 40 years before *Bertillon, made pioneering *police photographs. (In the 20th century, Rodolphe Archibald *Reiss in Lausanne was to make major advances in this field.) Franziska Möllinger (1817–80) published Swiss views lithographed from daguerreotypes, while in Basel the optician Emil Wick (1816–94) switched to photography in order to meet demand from rich and fashionable customers. But developments were not restricted to daguerreotypy. Also in Basel, the watchmaker Jakob Höflinger (1819–92) specialized in *cartes de visite, while in Lausanne from 1850 Constant Delessert (1806–76), initially a keen supporter of the daguerreotype, turned his efforts to negative-positive processes. As time went on, the number of both techniques and applications of photography increased. Switzerland's scenic attractions and the growth of tourism created major opportunities, and there was lively competition between studios—such as Charnaux frères (since 1870) and Jullien frères (since 1880) in Geneva—that published Alpine views.

At the beginning of the 20th century, the Swiss photographic scene was dominated by Fred Boissonnas (1858–1946), from an established Geneva photographic dynasty, who not only expanded the family business far beyond Switzerland but created internationally acclaimed studies of the monuments and people of Greece and, in the 1920s,

Egypt. By this time, the rise of the illustrated press in neighbouring Germany and France was in full swing, and Walter Bosshard's (1892–1975) collaboration with the *Münchener illustrierte* and the *Dephot agency, and his reportages from the Far East, dated from the end of the 1920s. From 1929, on the initiative of its editor, Arnold Kübler (1890–1983), just back from Germany, the *Zürcher illustrierte* began to transform itself into a modern magazine capable of presenting visual information as a medium in its own right. It attracted Hans Staub (1894–1990), Ernst Mettler (1903–33), Paul Senn (1901–53), Gotthard *Schuh, Theo Frey (1908–97), and, occasionally, Jakob *Tuggener. They have been called the Swiss equivalent of the US Farm Security Administration, a parallel that seems justified given the need to refocus on the fundamental realities of the country that was forced upon photographers by the Depression.

In the same period, photography teaching received a strong impulse, first from Hans *Finsler in Zurich, then also from Gertrud Fehr (1895–1996) in Lausanne; with Finsler's 'object photography' becoming influential beyond the fields of graphics and advertising. In 1941, Kübler co-founded *Du, a cultural magazine, directed by him, that was to provide a platform for a new, more international generation of photographers than the previous one. The examples of Werner *Bischof, co-founder of *Magnum, and Robert *Frank illustrate this trend, and the emergence of a 'Swiss school': Frank's 'anti-photography', after all, was the major development of the post-war period. The tradition of international reportage in the grand manner—also associated with René Burri (b. 1933)—has continued up till the present.

From the 1970s, however, with the help of the art market, and with museums opening their collections to photography, other players began to make their presence felt. With the successful promotion of the medium by institutions like the Fotostiftung Schweiz, the Musée de l'Élysée, and the Fotomuseum Winterthur, it was artists—figures as varied as Urs Lüthi (b. 1947), Balthasar Burkhard (b. 1944), Fischli/Weiss (Peter Fischli (b. 1952) and David Weiss (b. 1946)), and Markus Raetz (b. 1941)—who occupied centre stage in Swiss photography at the end of the 20th century. JCB

Breguet, E., *100 ans de photographie chez les Vaudois* (1981).
Frey, S. (ed.), *Mit erweitertem Auge: Berner Künstler und die Photographie* (1986).
La Photographie en Suisse: 1840 à nos jours (1992).
Gasser, M. (ed.), 'Photography in Switzerland', *History of Photography*, 22 (1998).
'Fotografie in der Schweiz', *Fotogeschichte*, 90 (2003).

Sygma. See AGENCIES, PHOTOGRAPHIC.

synchronization, flash. The means of firing a light while the camera shutter is open. This was originally accomplished by manually opening a shutter and igniting flashpowder or magnesium ribbon and allowing it to burn for a set time before closing the shutter. With the development of flashbulbs producing an intense light of short

duration, more precise mechanical, and later electro-mechanical, means were devised to make the period of maximum illumination coincide with the maximum shutter opening. Electronic flash, introduced in the 1940s, and *focal-plane shutters, require different methods to achieve the same result. MP

Szarkowski, John. See CURATORSHIP (FEATURE).

Székessy, Karin (b. 1939), German photographer, brought up in England. She studied at the Institute of Photojournalism in Munich (1957–9), then worked for the magazine *Kristall* as a photo-reporter (1960–6). She went freelance in 1966 and established her own studio in 1974. She is most admired for her unique style of nude photography, which she took up in 1963 (*Les Filles dans l'atelier*, 1969). Using only daylight in dark interiors, long exposure times, or extreme wide-angle lenses, she carefully arranges her models in often surrealistic tableaux. Originally working in black-and-white, she later revived the old *heliographic printing process. In the early 1970s Székessy met her future husband, the artist Paul Wunderlich, who frequently used her photographs to spark his fantastic and erotic paintings, and in

turn also inspired her work—a creative exchange which culminated in their collaborative book *Correspondenzen/Transpositions* (1977). She had also photographed a portrait series of fellow artists entitled *Zeitgenossen* (*Contemporaries*; 1962–7), and taught fashion photography at the Hamburg Werkkunstschule (1967–9). She has photographed Mediterranean landscapes, and in 1984–7 shot covers for a series of detective novels published by Ullstein. AL

Karin Székessy, *Fotografien, Gips, Gypsum, Gypse* (1997).

Sze Yuen Ming, Shanghai photographic business run by Yao Hua, first established as such in the Nanking Road in 1892. In addition to news pictures and topographical views, it produced portraits for both the Western and Chinese communities, the photographer's daughter dealing with female customers. The studio thrived in the important and purely local culture of the high-class Shanghai courtesan world, for whom photographs were both a status symbol and a tool of trade. The delicately hand-tinted portraits of elegant beauties were sold as photographic cards, or printed on the *postcards that the ever-enterprising managers eventually added to their business. The studio lasted into the 1920s. RT

Tabard, Maurice (1897–1984), French avant-garde photographer. Much of his early life was spent in the USA, and in 1922–8 he worked at the Bachrach Studio, New York, as a portraitist. On his return to Paris in 1928 Tabard worked freelance in fashion, portrait, and advertising photography, and associated with *Man Ray and *Magritte. He also experimented with multiple exposure (see COMPOSITE PHOTOGRAPHS), *solarization, and *photomontage to produce portraits and still lifes in a complex style influenced by Dada, *Surrealism, *Futurism, and the abstract work of *Moholy-Nagy. Returning briefly to America in 1948, he worked with *Brodovitch at *Harper's Bazaar. His last years were spent grappling with formal aesthetic problems. LAL

Baqué, D., *Maurice Tabard* (1991).

Taber, Isaiah West (1830–1912), American photographer and publisher. Born in Massachusetts, he did various jobs before practising *daguerreotypy in Syracuse, New York. He moved to San Francisco in 1864, opened his own studio in 1871, and ran a tourist-orientated portrait and view business. In 1875 he introduced the 8.2 × 17.8 cm (3³/₄ × 7 in) 'Promenade Card', a panoramic view format. From 1876 he published images by Carleton *Watkins acquired after the latter's bankruptcy. By the 1890s Taber had an international reputation and studios in Europe, but his negatives were destroyed in the 1906 San Francisco earthquake, ending his career. LAL

Tahara, Keiichi (b. 1951), Japanese photographer and installation artist. Born in Kyoto, he moved to France in 1972 to work as lighting designer and photographer for the Red Buddha theatrical group. In 1973 he moved to Paris. In his early series *Window, Cities*, and *Éclats* he explored the infinite possibilities of light and luminosity. *Homo Loquence*, portraits of and interviews with artists including Joseph Beuys and Pierre Klossowski, appeared in 1983. Later he returned to light-installation and environmental monuments. MT

Talbot, William Henry Fox (1800–77), English scientist and photographic pioneer. By the time photography was announced to the public in 1839, Henry Talbot (he disliked 'Fox Talbot') had been a Member of Parliament, had published two books and more than 30 scientific papers, and had been awarded two gold medals by the Royal Society in the previous four years. But throughout 1839 his own invention of *photogenic drawing was merely a sad reflection of the polished metal plates of his rival, Louis *Daguerre. In October 1833, goaded by his lack of success with drawing by the aid of the camera lucida whilst in Italy, Talbot conceived the idea of photography. In spring 1834, working at his Wiltshire home, *Lacock Abbey, he invented a means to produce images using silver compounds, fixing them initially with table salt. Although the term did not yet exist, these were *negatives, and Talbot first called them 'sciagraphs' (representing objects through their shadows). These first images were *photograms, but by the summer of 1835 he had increased the sensitivity to the point where they could be taken in a camera. Pressed by other activities, Talbot set this aside until shocked into publication by Daguerre's announcement. It was some time before the negative was seen as a crucial advantage, rather than an impediment, but the future was to lie in multiple prints. In 1840, his photographs began to speak to him. Immediately observing the depiction of nature as soon as he withdrew it from his camera, Talbot developed an aesthetic sense previously denied him in drawing. He became the first artist to be trained by photography and the first photographic artist. Later that year, he discovered the *calotype, a developed negative of exquisite sensitivity. Talbot's mastery of the art was so complete by 1844 that he began issuing the photographically illustrated *Pencil of Nature*. This lovely project backfired, for the silver-based prints proved to be no match for the smoke-laden air of Britain. As the prints began to fade, confidence in the art collapsed. By 1845, Talbot ceased taking photographs; the death of his mother in 1846 then removed his most effective supporter. *The Pencil of Nature* was discontinued and Talbot largely abandoned photography. He continued to make significant contributions in many areas, especially Assyriology. One in particular, however, has been a pervasive and largely hidden influence on our lives. Starting in 1852, he began perfecting the application of photography to making plates for the printing press. Known in his own day as *photoglyphic engraving, and later as *photogravure, this combination of light and ink for publication consumed the last 25 years of Talbot's life and was close to commercialization when he died (it was soon put into practice by Karel Klič). Photomechanical reproductions remain the primary way in which to see photographs to this day. LJS

Arnold, H. J. P., *William Henry Fox Talbot: Pioneer of Photography and Man of Science* (1977).
Buckland, G., *Fox Talbot and the Invention of Photography* (1980).
Schaaf, L. J., *The Photographic Art of William Henry Fox Talbot* (2000).

Henry Talbot
Table set for tea, *c.*1843. Salted-paper print

Talbot Correspondence. The correspondence of Henry *Talbot, located at www.foxtalbot.arts.gla.ac.uk, is a calendar and searchable database of the surviving letters written and received by Talbot between 1807 and 1877. Having commanded his stepfather at the age of 8 to 'tell Mama & everybody I write to to keep my letters & not burn them' (27 May 1808), he proceeded to compile a vast collection of documents, many of which are held at the Fox Talbot Museum, *Lacock, England. Assembled under the directorship of Larry J. Schaaf, with the support of the Burnett-Brown family of Lacock, and funded by the Arts and Humanities Research Council and the University of Glasgow, this database presents fully searchable transcriptions of letters that constitute primary sources for Victorian and photographic history,

as well as for the 19th-century histories of physics, mathematics, botany, politics, and cuneiform studies. A member of the Linnean, Astronomical, and Royal Societies, Talbot corresponded not only with photographic inventors and aspiring photographers, but also with some of the most influential British and European politicians, industrialists, linguists, and scientists. KEW

Taraporevala, Sooni (b. 1957), Indian photographer who grew up in Bombay (Mumbai) and studied at Harvard (1975–80), where she also learned photography. After gaining an MA in Cinema Studies at New York University, she returned to Bombay (1982) to freelance as a photographer. She also became known as the scriptwriter

Henry Talbot

Lace, *c.*1842. Calotype

for Mira Nair's *Salaam Bombay!* (1986) and *Mississipi Masala* (1991), among other films. Her twenty-year project, emerging from a nostalgic documentation of her own family, on the threatened Parsi community in Bombay was published as *The Parsis of India: A Photographic Journey* (2000). SG

Taro, Gerda (Gerda Pohorylles; 1911–37), German photojournalist. She took up photography after emigrating to Paris in 1933, became the lover and partner of Robert *Capa (to whom some of her published photographs were probably credited), and worked courageously in Spain during the Civil War. On 26 July 1937, after photographing the intense fighting around Brunete, near Madrid, she was fatally injured in an accident. Her leftist sympathies earned her an anti-fascist martyr's funeral in Paris. *Life* described her as 'probably the first woman photographer ever killed in action [*sic*]'. RL

Schaber, I., *Gerta Taro, Fotoreporterin im spanischen Bürgerkrieg: Eine Biographie* (1994).

Taunt, Henry (1842–1922), Oxford-based English photographer and postcard publisher. The son of a plumber, Taunt took his first photograph *c.*1858 and went into business as a general photographer in 1868. His *wet-plate views of Oxford and the Thames (taken on expeditions in a specially equipped boat) soon attracted praise and

many were included in his book *A New Map of the River Thames* (1872). Together with Taunt's celebrated lantern lectures, this doubtless contributed to the growth of tourism along the Thames at a time when communications were improving and the river itself was becoming cleaner and better regulated. Taunt also had a successful practice as a photographer of the Oxford social and sporting scene, and in 1889 leased extensive new premises in the Cowley Road. From the mid-1890s onwards, however, the firm faced increasing competition— for example, from German postcard companies—and other problems, and declined during the First World War. The manuscripts of Taunt's many publications, and some of his photographs, are held at the Centre for Oxfordshire Studies, Oxford. MG

Graham, M., *Henry Taunt of Oxford: Victorian Photographer* (1973).

Taxiphote (or Stéréo-classeur), a cabinet stereoscopic viewer patented in 1899 by Jules Richard (1848–1930) in Paris for use with 45×105 mm ($1^3/_4 \times 4^1/_4$ in) glass stereographs taken with the Richard *Verascope camera. An elegant, luxurious object, made of mahogany with brass and ivory fittings, the Taxiphote incorporated various clever devices. By depressing a lever, plates could be lifted one by one from a movable, slotted magazine into view between the eyepiece and a ground-glass screen. Captions written on the plates were viewable with a separate, movable lens. The eyepiece was finely adjustable, and

twelve magazines could be stored in trays in the base of the machine. The effect of viewing well-exposed, intact plates is quite magical. Refinements were added over the years and a smaller model appeared in 1908. The system remained on the market into the 1930s. RL

Teague, Walter Dorwin (1883–1960), American industrial designer, celebrated for art deco petrol stations and radio sets, and for a series of camera designs for Eastman Kodak 1928–*c*.1938. The earliest were essentially fashion products: the 1928 Kodak Vanity Ensemble, for example, which repackaged a Model B Vest Pocket Kodak for sale with a lipstick holder, compact, and purse. The 1930 Beau Brownie was a box design with a modernistically decorated face-plate available in six colours, and the 1934 Baby Brownie was the first plastic-moulded camera. Teague also styled the successful Bantam Special (1936) and the very advanced, semi-automatic Super Kodak Six-20 (1938). RL

technology and aesthetics in 19th-century art photography

. From the earliest years of photography, its means and materials were judged on more than their technical efficiencies. They were discussed in terms of taste and sensibility, and formal, aesthetic, and even moral values were ascribed to characteristics such as surface finish and focus. The photograph's striking resemblance to visible reality, as in the *daguerreotype, was a source of wonder and pleasure, and, for the most part, apparatus and materials were made to enhance that veracity. Lens optics were improved, *collodion-coated glass plates supplanted the daguerreotype and rough paper negatives, and plain printing paper was coated with *albumen for a smoother finish. If photography's only aim was to represent the world as accurately as possible, then these means and materials should have been sufficient and welcomed as such. But the smooth precision of glass-plate negatives and albumen paper was criticized as embodying a harsh and inartistic sensibility, while the rough, broad tones of *salt prints were likened to the work of Rembrandt, and the neutral hues and plain matt surface of *calotype positive prints were compared with etchings.

Albumen paper was often condemned as vulgar, a view that gathered force in the 1860s, when the paper was double coated and burnished for a higher gloss, and base papers were tinted to camouflage the yellowed deterioration of the silver albumen coating. In art, colour depended on truth to nature, and there was nothing natural about the pinks and mauves of tinted albumen prints. Furthermore, synthetic dyes and shiny surfaces were increasingly equated with cheap, mass-produced commodities, and in fine art, heavily worked and varnished canvases were giving way to paintings showing lightness and flatness in treatment and finish. This aesthetic was apparent in works by Camille Corot and James McNeill Whistler, and over the next 30 years would be taken up by French and British Impressionist painters. In the 1880s it contributed to the appreciation of the neutral grey-black image colour and matt surface of platinum prints, attributes seen as elegant and imitated in new developed-out silver papers.

Aesthetic issues also influenced lens design. While a transcription of the visible world demanded the most precise resolution, it was recognized that human vision was circumscribed by distance, field of view, atmosphere, and luminance. Such 'natural' limitations suggested that distinctness might not be the most artistically appropriate or truthful optical mode. From the late 1850s to the 1890s, photographic debates on optics incorporated this and related artistic concerns, such as the validity of verisimilitude as opposed to more subjective or expressive modes of representation, and the use of breadth of effect to subordinate detail in favour of tonal and compositional harmony. Photographers employed diffused focus to similar purpose, and in the 1860s *soft-focus lenses were manufactured with adjustable elements that controlled the degree of unsharpness. Most of these aimed for a slight and general diffusion, but in the late 1880s P. H. *Emerson made a case for selective focus, maintaining that this addressed pictorial unity and accorded with natural vision. Others produced more extreme diffusion with single meniscus lenses and *pinhole apertures. The latter were now practicable with new, fast *dry-plate negatives, whose subsidiary benefits included reasonable exposure times in conditions of lower luminance, which suited the *'naturalistic' taste for subdued light effects.

Some suggested that diffused focus was equivalent to the summary brushwork practised by Impressionist painters. Yet while the artist might argue that rapid execution was required to seize the fleeting impression, the photographer could hardly defend this necessity, for the camera could instantaneously capture a scene in all its detail and precision. There was some ambivalence about the notion of *instantaneity*; while it was broadly welcomed in Impressionist art and photography as an antidote to conventionalism, it also connoted facile quickness, and effects achieved by accident rather than through thought and training. Indeed, the Impressionist 'instant' was more a matter of philosophy; as Émile Zola noted, it depended on both the apparent objectivity of the quick impression and the more subjective 'sensation' that developed over a period of time. In 1889, H. P. *Robinson addressed this point with regard to photographic instantaneity, marshalling current theory on the persistence of vision to argue that the impression was perceived and experienced as an interval, not as a single moment. He also distinguished between images that might be optically correct, and those which the viewer accepted as artistically or conventionally truthful. This incorporated contemporaneous debate on the discrepancy between the customary depiction of a running horse and the different sequence of movement recorded in Eadweard *Muybridge's instantaneous photographs.

New hand-held cameras offered increasing mobility and compositional flexibility and, by the mid-1890s, photography was mooted as contributing to novel visual structures in art: asymmetric framing, spatial compression, and the presentation of foreground objects as dynamic compositional elements. But the simplicity of *snapshot photography also fed the perception that photographic art required little skill or training, its subtle pictorial effects captured by a happy combination of luck and timing. Dismayed by the

increasing popularization and standardization of their medium, art photographers essayed new strategies to reaffirm the seriousness of their practice. (Another factor was the perceived mediocrity of contemporary commercial photography.) There was a revival of single lenses and hand-coated silver papers, whose material and moral virtues included breadth of effect as well as authenticity and sincerity. New manipulative processes such as *gum bichromate printing aimed to replace the uniform, uninflected surfaces of manufactured papers with the tactile qualities of hand-made artefacts bearing the marks of artistic intervention. Yet, debates on art were by now less concerned with process or medium, and more with the individual temperament of the practitioner. And as amateur and professional technologies converged towards the end of the century, photographic art was also defined less by material issues and more by artistic intention. HWK

See also AMATEUR PHOTOGRAPHY, HISTORY.

Crawford, W., *The Keepers of Light* (1979).

Seiberling, G., and Bloore, C., *Amateurs, Photography and the Mid-Victorian Imagination* (1986).

Weaver, M. (ed.), *British Photography in the Nineteenth Century: The Fine Art Tradition* (1989).

Varnedoe, K., *A Fine Disregard: What Makes Modern Art Modern* (1989).

Ullrich, W., *Die Geschichte der Unschärfe* (2002).

telecentric lens. This consists of two lenses mounted so that the rear focal plane of the first coincides with the front focal plane of the second. The stop is positioned at the common focal plane. The depth of field is very small, and thus the stop has to be small; but as it is effectively a field stop, so that in general the angle of field is only a few degrees, this type of lens is used chiefly in scanning devices and confocal microscopy. Its importance lies in the fact that the magnification of the image is constant, regardless of its distance from the lens. GS

telephoto lens, a lens in which the focal length is greater than the dimensions of the lens itself. This is achieved by designing the lens to have a negative rear element, which increases the focal length by moving the rear nodal plane (from which the focal length is measured) forward to a position in front of the lens itself. The earliest telephoto lenses were simple small Galilean telescopes with the eyepiece racked out far enough to produce a real image. The first fully designed telephoto lens was produced by *Zeiss in 1898. It had a variable power of ×2–×3, and was thus an early example of a varifocal lens.

An important characteristic of telephoto lenses is their shallow *depth of field, especially at wide apertures. Before the arrival of high-performance autofocusing systems, this made focusing difficult, particularly in low light. But shallow depth of field enables the photographer to place a sharply focused subject against a pleasingly out-of-focus background. Short—80–85 mm—telephoto lenses are often used in 35 mm portraiture. GS

See also GAUSSIAN OPTICS.

Ten-8 (1979–92), British photographic journal launched with the backing of the newly formed West Midlands Arts photography panel, and intended to support independent photographers working in the region without the benefit of a photographic gallery in Birmingham. *Ten-8*'s approach was eclectic, and the first five issues dealt with community documentary work, landscape, self-portraiture, and the work of young Midlands photographers. Inadequate funding was a constant problem, and one of the main reasons for the journal's demise. The final issue, entitled *The Critical Decade*, appeared in spring 1992. RSA

Tenneson, Joyce (b. 1945), American photographer. Her first book, *In-Sights: Self-Portraits by Women* (1978), portended a move toward visual self-exploration by women artists. She became particularly well known for her abstracted nudes and semi-nudes, and her descriptions of her emotional states while photographing are reminiscent of the mystical writings of Teresa of Ávila. Recent work, however, consists of more classically framed portraits of men and women. Tenneson holds a Ph.D. from Antioch College, but is self-educated as a photographer. She taught at the Corcoran School of Art and has worked for magazines including *Italian Vogue*. TT

Tenneson, J., *Wise Women* (2002).

Terracina, Sal (c.1901–1995), Italian-American pianist, mask maker, mind reader, and photographer. His multiple talents gave him access to an extraordinary range of subjects, from gangsters and speakeasies in the 1930s, and midgets and other performers in a burlesque troupe, World of Mirth, in the late 1940s, to Key West's gay scene. He also took theatrical photographs, and travelled and photographed worldwide for the Seafarers' International Union. He worked in black-and-white in a straight-on documentary style, mostly with a 4 × 5 in Speed Graphic. He left c.80,000 negatives. RL

Hart, R., 'The Amazing Terracina', *American Photo* (July/Aug. 2004).

Teynard, Félix (1817–92), French photographer, creator of over 160 *calotypes made during his 1851–2 Nile voyage. They were published, in instalments, as *Égypte et Nubie* (1853–8). The publication, subtitled 'a photographic atlas complementing the great work of Napoleonic scholarship, *Description de l'Egypte*', represents a systematic recapitulation of one of the monuments of descriptive Egyptology. Teynard's gift lay in his use of the calotype process to evoke the gritty surface of desert ruins rendered in masses of light and shadow. The cost of the beautifully printed volumes—over 1,000 francs—and their publication after the novelty of Maxime *Du Camp's book of Egyptian views—the first photographically illustrated travel book—undoubtedly told against the work's commercial success. Fewer than twenty copies are known to exist. KSH

Howe, K. S., *Felix Teynard: Calotypes of Egypt. A Catalogue Raisonné* (1992).

theatre. See PERFORMING ARTS AND PHOTOGRAPHY.

theories of photographic meaning. A variety of theories to explain the meaning of the photographic image have developed, especially since the 1970s, in association with critiques of *realism as an unproblematic reflection of reality, and of the concept of the photograph as an unmediated copy of the world. On the whole, they treat photography as a language, acquiring meaning through cultural and social conventions, and conscious and unconscious processes, which cannot be reduced to subject matter, visual style, and authorial intentions, as modernist writers on the medium have tended to do. They are part of a more general academic tendency, defined as postmodern, rupturing or rejecting *modernism. (Postmodernity is characterized by the collapse of overarching narratives, in favour of interdisciplinary approaches concerned with analysing meaning-producing processes which are not necessarily medium specific.)

Thinking Photography (1982), edited by Victor *Burgin, argues for a variety of critical methodologies based on a plurality of practices—*advertising, *documentary, artistic, *amateur, and so forth. The book reflects many of the interests of postmodern theory, for example the visual *semiotics of Umberto Eco (b. 1932) and Roland *Barthes, or Jacques Lacan's (1901–81) post-structuralist rereadings of Sigmund Freud, used to analyse how images mobilize desires, and enable and control visual pleasures. Lacan's theorization of the unconscious as being structured like a language is a point of contact between earlier semiotics and the more open approach of semiology, which includes psychoanalytical theories to interpret images as symptoms of the unconscious workings and disturbances of a culture. The collection includes 'The Author as Producer' (1934) by Walter *Benjamin, attesting to the important contemporary influence of his writings on photography and visual culture. It is also part of a renewed interest in the political engagement of early avant-garde groups, which had been downplayed by post-war modernism. Overall, the book emphasizes how photographic meaning is not natural, universal, or intrinsic to the image, but socially produced. It argues for the need to focus on the ideological, cultural, and economic contexts in which meanings are created, not only at the point of production, but also of reception. In his contribution, Allan *Sekula argues that all photographic meanings are the result of traffic between subjectivism: the photograph as a magical, emotional, or aesthetic experience; and objectivism: the photograph as science, document, or information. Photographs cannot be separated from the representational tasks assigned to them by the institutions producing, circulating, and using them. His call for a historical investigation of the production of photographic meaning has remained too often unheard, and *Thinking Photography* can also be considered symptomatic of the dangers of overemphasizing theory. Images can become 'theorized' in the abstract, rather than investigated as part of a historically and geographically specific material culture. The book's attempt to differentiate photographic theories from *criticism is problematic; singling out images for discussion is in itself a critical judgement, even if this is unacknowledged. Moreover, while it is important to investigate how all images signify, it must be acknowledged that some do so more elegantly than others, in ways that are sensually or intellectually more satisfying, even if there is no final interpretation or consensus about them. The book has also been criticized for its lack of feminist perspectives.

It is important to remember that photography has been theorized about since its inception. As a new technology, its uses, status, and values were open to debate. A recurrent theme in 19th-century writings was the radical difference between photography and previous methods for obtaining images: at no stage is the quality of the result connected to the ability of the image maker to draw or otherwise make marks by hand. For most of the 19th century, this militated against the acceptance of photography as a form of art.

In his 1843 *Edinburgh Review* article on 'Photogenic Drawing, or Drawing by the Agency of Light' David *Brewster was the first to make explicit how the nature of photography, an image directly caused by the light reflected off historical actions, and the features of important people or loved ones, gave it a special value. 'The image is connected with its prototype by sensibilities peculiarly touching. It was the very light which radiated from his brow . . . that pencilled the cherished image, and fixed [itself] for ever there.' This relationship between a photograph and its object was further theorized by Charles Sanders Peirce (1839–1914) in his writings on logic and semiotics. Peirce divided the relationships between signs and their meaning into three fundamental types: the *index*, a sign that, like a footprint or a shadow, denotes an object by being physically caused by that object; the *icon*, a sign which looks the same as the object signified, for example a portrait; and the *symbol*, a sign related to its meaning only by social conventions, as in language. In the photograph, iconic and indexical features often come together. Its indexicality seems to guarantee its iconic content, its realism, but the two are not the same. Moreover, iconic or indexical signs also acquire or are given symbolic significance. In the 20th century this quality of photography has had its most enduring formulation in *Camera Lucida* (1980) by Barthes. His reflections are framed as a search for the source of his, and by extension his culture's, fascination with photography, its *punctum. He finds it in its power as an 'emanation' of the referent: 'from a real body, which was there, proceed radiations which ultimately touch me, who am here.' This becomes apparent to him only when he looks at a photograph of his own mother: she was there, and the light reflected off her beloved body has been captured and immortalized into precious silver by the photographic process, creating an image that is a relic of both the presence and the absence of the mother.

In the early 20th century, the development of illustrated magazines gave photographs a new importance as instruments of mass communication. The photographic image, seen as a code-free visual language because of its indexicality, was considered at once able to express the individuality of the photographer, and to give documentary authority to humanist values constructed as universal. In artistic circles, debates shifted from photography's pictorial qualities to more modernist concerns. As Benjamin wrote in his seminal essay 'The Work of Art in the Age of Mechanical Reproduction' (1936), 'photography freed the hand of the most important artistic function

which henceforth devolved only upon the eye looking into the lens'. Photographers and artists debated whether this mechanized vision was best exploited through *straight photography, or *experimental and abstract images.

John Tagg, in *The Burden of Representation* (1988), argues that the indexical nature of the photograph does not explain its meanings. 'What makes the link between the pre-photographic referent and the sign is a discriminatory technical, cultural and historical process in which particular optical and chemical devices are set to work to organise experience and desire and produce a new reality—the paper image which, through further processes, may become meaningful in all sorts of ways.' Rather than being a guarantor of realism, the camera is itself an ideological construct, producing an all-seeing spectator and effacing the means of its production. Analyses of who has possessed the means to represent and who has been represented reveal that photography has been profoundly implicated in issues of political, cultural, and sexual domination. This area of investigation has especially drawn upon Michel Foucault's (1926–84) reflections on the emergence of forms of knowledge; on the modern notion of the subject; and on practices of power which produce subjects actively participating in the dominant disciplinary order. Particularly influential have been his rejection of the notion of a pre-given self or human nature, and his insistence that every system of power and knowledge also creates possibilities of resistance. The role of critics then becomes the deconstruction of dominant assumptions within and about representations, to identify works embodying the possibility of resistance.

Feminist analyses have emphasized the active role of representation in the construction of gender differences, in themselves a matter of representation, of the meaning given by culture to biological differences. They have used psychoanalytical theory as a patriarchal tool with which to deconstruct patriarchy itself. In a 1973 essay, Laura Mulvey argued that the misogynistic images of women as sex objects so common in popular culture were not actually representing women, but male anxieties about castration, allayed by fetishizing the female body. In her essays on classical Hollywood cinema (1975, 1981) Mulvey endeavoured to show how the active gaze of the spectator is masculinized by the cinematic apparatus, while the female protagonist is constructed as its seductive object. The pleasures of the gaze are, in psychoanalytical terms, related to unconscious fantasies of control and power, and its active and passive forms, *voyeurism and exhibitionism, are connected. The desire to look always implies, at least unconsciously, a desire to be looked at. Dominant cultural forms, however, have traditionally arranged the pleasures of looking in an asymmetrical gender balance. Voyeurism, as an active form, is associated with masculinity; exhibitionism with passivity and femininity: 'woman as image, man as bearer of the look'. Her work on the gaze has generated wide debate, but, however criticized or modified, it remains an important landmark in understanding the gendered implications of the pleasures and anxieties of looking. Part of the attraction of photographs derives from their capacity

to allow the viewer to disavow distinctions between reality and representation from the safe position of the hidden voyeur.

The hold of the index on our culture has been analysed symptomatically by Christian Metz (b. 1931) in 'Photography and Fetish' (1985), combining Freud's concept of 'fetishism' with the processes identified in his study of 'Mourning and Melancholia'. Metz discusses the fetishistic qualities of photographs: they are small and can be touched and kept in private containers; make the spectator master of the gaze, allowing the possibility of a lingering look; are closer to the pure index, stubbornly pointing to the traces left by what was but no longer is. His concept of fetishism is less gender specific than that used by Mulvey. What is being disavowed by looking at and emoting over photographs, whatever their subject, is the trauma of loss and separation, and the fundamental gap between an unobtainable unmediated experience, and the means to represent it.

More recently, feminist critics have used concepts of masquerade and abjection to understand the multi-layered plays of and with identity permitted by the photographic medium. Julia Kristeva's (b. 1941) notion of the abject, that which must be expelled to establish the clean and proper self, yet can never be totally expelled as it is part of being alive (saliva, faeces, menstrual blood), has been used to analyse our cultural fascination with images of bodily horrors, made at once disturbingly close and pleasurably contained by the photographic process.

As photography's indexicality has been undermined by *digital techniques, and by convergence between still and moving images, theories of photographic meaning face dispersion into the expanded field of digital culture, or further self-definition through a reappraisal of the material specificities of photographs, in particular historical instances. PDB

Connor, S., *Postmodernist Culture* (1989).
Mulvey, L., *Visual and Other Pleasures* (1989).
Squires, C. (ed.), *The Critical Image* (1990).
Solomon-Godeau, A., *Photography at the Dock* (1991).
Wells, L. (ed.), *Photography: A Critical Introduction* (3rd edn. 2004).

thermography. *Infrared photography with a conventional camera is limited to the region 650–950 nm with silver halide emulsions, and up to about 1,500 nm in *digital cameras with specially formulated lenses. Thermography is a scanning process that uses the far infrared up to 20 μm. In one system two orthogonally pivoted mirrors oscillate to provide a scan of the scene on a single detector. The recording can be played in real time on a video screen. The alternative is a conventional vidicon TV camera with a germanium lens and a sensitive surface of pyroelectric material such as lithium tantalate. This is slower than a scanner, but is cheap and light and does not require special cooling.

Thermographic images resemble grainy monochrome TV pictures, but are often enhanced so that different temperatures appear as different colours.

The uses of thermography include the detection of buried survivors of earthquakes or of troops and mobile equipment in wartime, the diagnosis of tumours and other *medical problems, the identification of 'hot spots' in machinery and electronics components, the prediction of volcanic eruptions, and even the paths of warm ocean currents. GS

Burney, B., Williams, T., and Jones, C. (eds.), *Applications of Thermal Imaging* (1988).

Thomasson, Nils (1880–1975), Swedish photographer of Sami parentage, a pioneering photographer of the Sami people, whose life in the vast northern region of Jämtland he documented over five decades. Sent in 1900 by his father to the city of Gävle to work as a photographer's apprentice, he soon returned to his native Svedje and by 1902 had established an elegant but simple daylight studio at his family's homestead. After initially making portraits and documenting village life, Thomasson later looked beyond it to the region as a whole, at a time when the nation-state was rapidly encroaching on Sami culture and traditions. His oeuvre extends to over 30,000 glass plates, recording in detail not only Sami life but also early *tourism and the practices of farmers and forest workers. J-EL

Thomson, John (1837–1921), Scottish photographer and writer, active in Asia, Cyprus, and England. Born in Edinburgh, Thomson was apprenticed to an optician and instrument maker before moving to Singapore to set up a photographic studio in 1862. From this base he travelled and photographed widely in the South-East Asian archipelago. In 1865 he visited Thailand (where he photographed King Mongkut) and in early 1866 spent four months in Cambodia, where he took the first photographs of the great temple complex at Angkor. On his return to Europe the same year, sixteen of these views were published as original prints in his *The Antiquities of Cambodia: A Series of Photographs Taken on the Spot* (1867). Thomson went east again in late 1867, and in early 1868 transferred his studio from Singapore to the more flourishing photographic scene of Hong Kong. By now more professionally secure, he was commissioned in 1869 to photograph the royal visit, which led to the publication of seven of his photographs in William Beach's *Visit of His Royal Highness the Duke of Edinburgh . . . to Hong Kong in 1869* (1869). This period also saw the creation of Thomson's most celebrated body of work, the result of several extended and often hazardous forays, 1870–2, into mainland *China and Taiwan. The first published result, the fourteen albumen prints of his *Views on the North River*, appeared in Hong Kong in 1870.

Disposing of his Hong Kong studio, Thomson returned to Britain in 1872 and devoted himself to the publication of his China photographs. The first of these, *Foochow and the River Min*, containing 80 carbon prints, appeared in a limited edition in 1873 and is one of the most beautiful of 19th-century *photographically illustrated books. His next work, aimed at a broader market, was the four folio volumes of *Illustrations of China and its People*, which appeared in 1873–4. Illustrated with 200 *collotypes and with a descriptive text by the photographer, it was hailed as the most thorough visual record to date of the human and physical diversity of the Chinese Empire. In 1877–8, in collaboration with Adolphe Smith, Thomson published *Street Life in London*, issued in twelve monthly parts and containing a total of 36 *Woodburytypes. These images of working-class Londoners, though posed, are masterpieces of early social *documentary photography. A journey to the newly acquired colony of Cyprus resulted in his last major photographic publication, the two-volume *Through Cyprus with the Camera in the Autumn of 1878* (1879), illustrated with 59 Woodburytypes and *autotypes. A busy schedule of writing, translating, lecturing, and the maintenance of a fashionable London studio evidently precluded further major travels, although from 1886 he maintained his links with the world of exploration, as instructor in photography to the *Royal Geographical Society. In addition to consummate photographic skill and determination, Thomson was an able writer who, perhaps more than any of his contemporaries, successfully realized the marriage of text and photograph in the production of illustrated travel books. A major collection of his negatives is held by the Wellcome Institute, London. JF

Thomson, J., *The Straits of Malacca, Indo-China and China: Or, Ten Years' Travel, Adventures, and Residence Abroad* (1875).
Ovenden, R., *John Thomson (1837–1921) Photographer* (1997).

three-dimensional photography. In any scene there are clues to its three-dimensionality, such as variation in apparent size between near and distant objects, overlapping of distant by near objects, and aerial *perspective, but the most powerful clue is parallax—the positional changes in the scene as the viewpoint is changed. The left and right eyes are on average some 65 mm (2½ in) apart, and receive slightly different images of a scene as a result of the differing viewpoints. This is interpreted by the brain as 'depth'. In real-life situations the sensation is not strong, as it is swamped by the much greater dynamic parallax resulting from physical movement. A conventional photograph is static, and has no parallax, as it has a fixed viewpoint. But if two photographs are taken from positions 65 mm apart, and the resulting prints are examined via an optical device that presents each image separately to the two eyes, normal static parallax is introduced, and the image appears to have depth. The principle is known as *stereoscopy* and the photographs are called a *stereoscopic (or simply 'stereo') pair. Accommodation (visually focusing), a further clue to depth, is not involved, and ocular convergence for different distances (another clue) does not usually match that which would have been involved in viewing the original scene. Nevertheless, to people with normal binocular vision the sensation of three-dimensionality in the image is powerful.

Hand-drawn stereoscopic pairs appear to have existed before the invention of photography. The first stereoscopic viewer for photographs was designed by Charles Wheatstone (1802–75), and subsequently improved by David *Brewster. The stereoscope was a popular toy in late Victorian times, and many stereoscopic image pairs still exist.

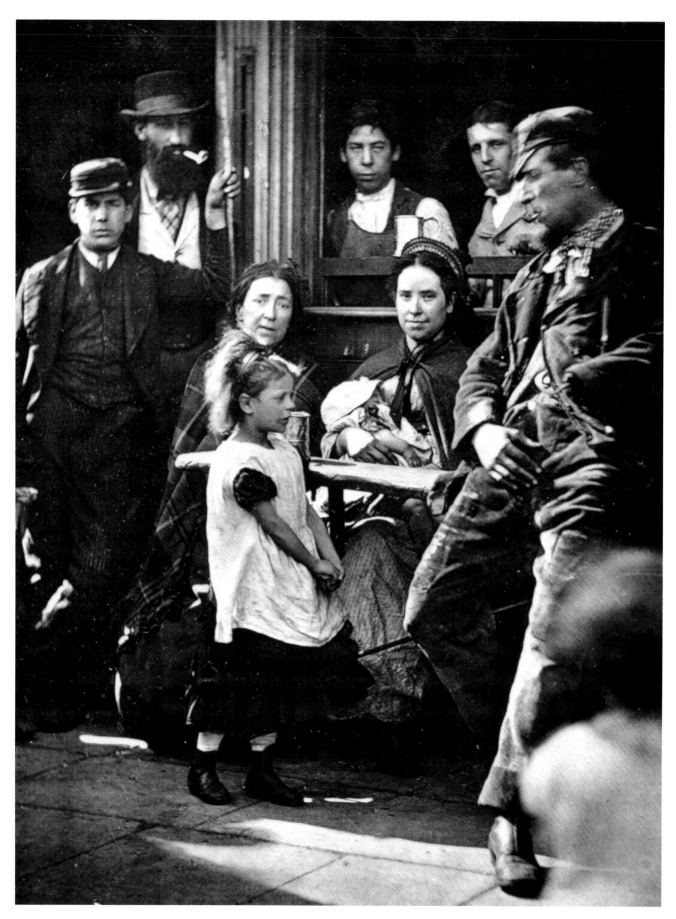

John Thomson

'Hookey Alf' of Whitechapel, London, 1877. Woodburytype

Stereoscopic camera formats

It is possible to produce stereo pairs with a conventional camera by using a platform on a tripod, with a guide to slide the camera along between exposures, but this confines the technique to static subjects. Stereoscopic cameras with twin lenses have been around since the early days of photography, and several versions are available. At least one specialist in Britain produces Siamese-twin modifications of professional SLR and digital cameras, and several camera manufacturers offer dual-prism conversion sets for the production of stereo pairs in portrait format with conventional 35 mm cameras. The Nimslo camera of the 1980s employed four lenses to produce a somewhat crude lenticular stereogram, and was initially popular, but its optical limitations, and logistic problems related to processing, eventually led to its falling out of favour.

Hyper- and hypostereoscopy

When the subject matter is distant it is often beneficial to lengthen the stereo base, to enhance the impression of depth slightly. This is called *hyperstereoscopy*. An extreme example of this occurs in aerial survey photography, which utilizes a series of overlapping vertical photographs made during straight and level flight, with a spatial separation of up to 500 m (1,640 ft). When pairs of images are viewed stereoscopically through appropriate optics, objects on the ground appear small, but heights appear exaggerated because of the excessive parallax angle. While aesthetically unpleasing, this is a positive advantage in map-making as it allows greater precision in contour plotting.

In contrast, some stereo adaptors for hand cameras give a base less than the average interocular distance, so that the images of objects at normal distances appear somewhat flattened (sometimes called 'cardboarding'). However, a short base (*hypostereoscopy*) is mandatory in *photomacrography, as the parallax angle should not exceed about 7 degrees for a realistic 3-D effect. In microscopy the camera is usually fixed, so instead the specimen is rotated between exposures through 5–7 degrees. The result is an apparently large image some distance away, but this is usually acceptable in this type of image.

The Brewster stereoscope, one of the oldest viewing devices, uses prints of a suitable size set up side by side, with a pair of simple convex lenses to put the two images at infinity. For larger prints there are more sophisticated designs using pairs of mirrors or rhomboidal prisms to cope with the increased distance between the print centres. With practice it is possible to view a small stereo pair without optical aid, by training the eyes to focus without convergence. A more modern technique dissects and interlaces the images, allowing the viewing of much larger images in a similar way. Stereo images that do not require optical aids are called *autostereograms*.

A type of stereo image needing less personal effort in the viewing is the *anaglyph*. The left and right images are printed superposed in respectively blue (or cyan) and red, and are viewed through spectacles coloured respectively red and cyan. It is possible to use this technique for images in natural colour, the left eye receiving the red image and the right the green and blue, but not all viewers find the result satisfactory. A better method involves two full-colour images polarized at plus and minus 45 degrees and viewed through similarly crossed polarizing spectacles. Both systems are suitable for projected images, and have been used for 3-D movies, but the latter technique demands a special metallized screen.

Full parallax systems

The ultimate in three-dimensional imaging is *holography. The *lenticular stereogram* is a full-parallax photographic imaging system. This initially employs a moving camera (or a multi-lens camera) to record a whole series of images; these are dissected and printed as interlaced strips, displayed behind a lenticular screen—a grid of retroreflecting cylindrical lenses that operate like a catseye reflector. The result is that each eye sees only the view recorded from that particular viewpoint. Dynamic parallax thus augments the stereoscopic imagery, and depth is perceptible even with one eye closed—albeit over only a fairly small angle. Unlike holograms, photographic stereograms do not need special illumination; they can be made in full colour and any size, and several people can view the image at the same time. But they still lack some of the requirements for the full 3-D experience, for example, ocular accommodation.

Further developments

There are a number of current developments involving computer programs that change the perspective of an image as the viewer moves around, as well as others that exploit visual illusions. There are also systems that produce genuine three-dimensional images ('integral imaging') using complicated arrays of microlenses. But for the present, lenticular stereograms present the most convincing form of 3-D photographic image. GS

Okoshi, T., *Three-Dimensional Imaging Techniques* (1976).
'Three-Dimensional Image Capture', *SPIE Proceedings*, 3023 (1997).
Ray, S., *Scientific Photography and Applied Imaging* (1999).
Reynaud, F., Tambrun, C., and Timby, K. (eds.), *Paris in 3D: From Stereoscopy to Virtual Reality* (2000).
Saxby, G., *The Science of Imaging: An Introduction* (2002).

through-the-lens (TTL) **metering**. Cameras with built-in light meters date from *c*.1900, and cameras with meters to control the shutter or aperture from 1938. The first with TTL metering was Feinwerk Technik GmbH's Mec-16 camera of 1960. Although the Asahi Optical Co. (Pentax) had shown a prototype in 1960, the first production SLR camera with TTL metering was Tokyo Kogaku's Topcon RE Super (1963). The CdS cells on the back of the mirror made averaged readings at full aperture from *c*.7 per cent of the total light. Film speed, shutter, and aperture were all coupled. TTL metering—also for dedicated flash—is standard on most modern cameras. MP

thumbnail, the computer equivalent of the 35 mm *contact sheet. It displays the entire contents of a chosen picture folder in very small format, from which examples may be chosen for display, manipulation, and printout. GS

Tibet. Western fascination with the remote and inhospitable landscape of Tibet can be traced back to the writings of Herodotus. Well before it could be mapped or visually documented, the country occupied a key position in the Western imagination as a source of rare commodities such as gold and as the homeland of esoteric religious practices. By the 18th century a handful of Europeans had managed to assail the Himalayan peaks and produce accounts of their experiences, some of them illustrated. Prince Henri d'Orléans was probably the first to photograph the country, en route to Indo-China in 1889–90. As in so many other regions during this period, the photographer began to eclipse the draughtsman in creating a visual record of spaces and places. However, the camera could still not easily encompass the immense plains of the Tibetan plateau or the towering peaks of the Himalayas, so that travellers to Tibet in the next century concentrated on its inhabitants and their built environment.

The 1903–4 Younghusband Expedition to Tibet began the process by which a particularly British way of seeing Tibet emerged. Younghusband battled his way to the Tibetan capital, Lhasa, and several members of his force carried cameras. The surgeon and 'Antiquarian to the Force', Lieutenant-Colonel L. A. Waddell, took hundreds of photographs and published some of them in his book *Lhasa and its Mysteries* (1905). A pattern was established by which the construction of ideas about Tibet was determined by political and aesthetic criteria and communicated to the British public through publications, lantern shows, and (later) films. In the early 20th century, British scholar-officials such as Waddell and his successors Charles Bell, Basil Gould, and Hugh Richardson saw photography as crucial to their attempts to define Tibet as an independent nation with distinctive religio-cultural traditions but a need for British protection. The images they produced or commissioned also responded to the demands of a public keenly interested in Tibetan Buddhism. British photographs made in Tibet between 1903 and 1947 thus present us with evidence of the evolution of present-day 'Shangri-La-ist' constructions of Tibet. They allow us to trace the development of key Western tropes (such as particular ways of viewing the Dalai Lama's palace—the Potala) and the invention of visual traditions including the repeated photo-documentation of religious ceremonies such as the Palden Lhamo procession and monastic masked dance, described by many British commentators as 'Devil Dances'. The density of the photographic record for certain subjects suggests that British photography of Tibet became embedded in *colonial practices, with officers literally standing in their forebears' footsteps to rerecord the same subjects. Their photographic engagement with Tibet stimulated the British public's imagination and created a demand for more of the same. Having learned to 'see' Tibet through the aesthetic and ideological framing devices adopted by a powerful British elite, many contemporary views (and viewers) of Tibet unwittingly absorbed the influence of this colonial gaze.　　　　CHA

d'Orléans, H., *De Paris au Tonkin à travers le Thibet inconnu* (1892).

Till, Emmett. See CIVIL RIGHTS MOVEMENT, AMERICAN.

Tillot, René (*fl.* early 20th century), French*postcard publisher and photographer, based in Shanghai. He started publishing views of the treaty port areas soon after 1900. In addition to topography, his collection includes many everyday scenes shot live in the Beijing streets, including barbers, open-air restaurants, and other small trades. Similar scenes from Shanghai illustrate the substantial cultural gap between the old-fashioned imperial capital and the leading international port. Well photographed and printed, Tillot's collection was very successful. It was soon reprinted (uncredited) by both the steamer company Messageries Maritimes and a third, anonymous contemporary.　　RT

tilt. See CAMERA MOVEMENTS.

time and space, held in the photographic frame, is one of the defining characteristics of photographs. Photography creates fragments of time by freezing the moment of exposure, and space by extracting physical experience from the flow of life. The control of time and space within the frame is tied to historically specific ideas of reality within photographs. For instance, the *British Journal of Photography* argued in 1889 that instantaneous photographs were actually unrealistic because their ability to capture moving figures completely frozen and unblurred was a denial of time.

Technical development in photography has to a large extent endeavoured to manipulate and expand photography's relationship with time and space, from faster films to microscopy. Photographs have also been used to explore invisible divisions of time and space—from recording the firing of a bullet or a splash of milk to the work of *Marey and *Muybridge that turned the temporal and spatial flow of *movement into discrete images.

The temporal and spatial dislocations embodied in photographs have made them potent metaphors for the passing of time and the fleeting comprehension of the moment. Writers like Marcel Proust and theorists such as *Barthes, *Kracauer, and *Benjamin have all focused their reflections on photography on the way photographs intervene in time and space. Barthes famously summarized it thus: 'The there then becoming here now.' More prosaically, advertising photographers often strive to convey the 'before' and 'after' of using the product.　　EE

time-lapse photography. See MOVEMENT, PHOTOGRAPHY OF; SCIENTIFIC PHOTOGRAPHY.

tintype. This is a *collodion positive (see also AMBROTYPE) produced on a thin metal plate first coated with black or brown enamel or varnish. A tintype image appears rather dark with grey highlights; the pale beige silver collodion image does not show up well on the black or brown surface, and unlike ambrotypes, tintypes were not chemically treated to intensify the collodion layer (in 1887, mercury chloride was suggested as a whitener for gelatin bromide tintypes, but

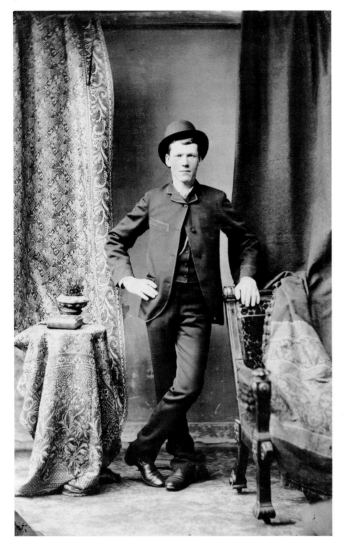

Anon.

Portrait, late 19th century. Hand-coloured American tintype

little used). The process was adapted from F. Scott *Archer's collodion glass plates by Adolphe Martin (France) in 1852, as 'ferrotype'. That term persisted in 1856 patents for the enamelled plates, most notably marketed by Hamilton Smith and J. W. Griswold in the USA. Another American manufacturer, Peter Neff, coined the term 'melainotype', but tintype is the common name, and distinguishes this process from 'ferrotype', Robert Hunt's developed-out silver paper of c.1851, and from 'ferrotyping', a method of producing a high gloss on a photographic print.

Tintypes were quick to make: their small format allowed relatively short exposure times, and experienced operators could complete the whole procedure in minutes, making this the first *'instant' system of photography. Such fast results were often crude; the exposed plates had but a cursory acquaintance with processing chemicals. Unscrupulous operators would seal up failures and warn the customer not to open the envelope for 48 hours: few could resist the temptation, but blamed their own impatience, not the photographer. The circumstances were equally unprepossessing: many tintypists were *itinerant, and one 1880s travelling studio was compared unfavourably with a third-class railway carriage. However disappointing the results, tintypes were cheap: a photo the size of a *carte de visite cost less than a shilling, and smaller formats were but a few pence or cents, making photographic portraits finally affordable to the working class. Tintypes were tremendously popular during the American Civil War; they were easier and cheaper to produce than paper prints from glass negatives, lighter and more durable than ambrotypes, and their robust metal support could survive even the military post.

While tintype plates are unique photographs, multiple images were made with the same sort of multi-lens and repeating-back cameras used for carte de visite photographs. By 1860, tintype portraits were being mass produced in the USA for campaign buttons and brooches. The disorder of the Civil War put paid to this craze, but the buttons inspired the 'Little Gem' format. A dozen exposures—each the size of a postage stamp—fitted on one plate, and, once processed, were snipped apart with metal shears and mounted in brooches, lockets, or simple 'medallion' cards with oval windows. Twelve 'Gem' portraits cost less than a shilling, and the format belatedly popularized the tintype in Britain.

By 1887, gelatin bromide coatings were adapted for ready-sensitized dry ferrotype plates. The most successful of these were 'photo buttons': small, circular tintypes introduced in 1905. This format prompted the design of compact, mobile cameras that carried a ribbon of the sensitized discs. The emphasis was on speed and the camera bodies were shaped like telescopes or guns; one German design, the Talbot Räderkanone, resembled a field artillery piece, complete with wheels. Dedicated processing cameras were marketed from 1893, based on earlier models for *glass-plate photography, whose integral processing baths allowed the plates to be prepared, exposed, and processed in situ. The first fully automated camera was exhibited by M. Enjalbert in 1889; operated by coins, the machine produced a finished tintype

in five minutes. While liable to mechanical breakdown and customer error and inattention, this apparatus—complete with a blinding magnesium or electric flashlight—was the prototype for the photo booth. Partly automated cameras were more reliable and suited itinerant photographers, who continued to produce souvenir portraits on beaches and at fairgrounds through the 1930s; one tintype photographer was still working on Westminster Bridge, London, as late as 1953. Today, specialist photographic dealers supply kits of the processing chemicals and plates for hobbyists.

Unlike other vernacular photographs, tintypes never exceeded their original, rather lowly status; their dim tones, mundane imagery, and rock-bottom cost kept them beyond the aesthetic pale. Yet they were appreciated in their own time for encouraging a more natural and casual type of portraiture, and today they provide an informal, sometimes irreverent view of the 19th century, approximating the spontaneity of *snapshot photography decades before its advent. HWK

Jones, B. E. (ed.), *The Cyclopedia of Photography* (1911).
Taft, R., *Photography and the American Scene: A Social History, 1839–1889* (1938).
Rinhardt, F. and M., and Wagner, R. W., *The American Tintype* (1999).

Titzenthaler, Waldemar (1869–1937), German photographer. The son and brother of photographers, Titzenthaler learned his trade in Hanover but settled in Berlin in 1896, where he specialized successfully in architectural photography, landscapes, and reportage. He became celebrated both for his views of the dynamic new imperial capital and for glimpses of the quainter, poorer quarters of *Alt-Berlin*. In 1918 he published *Berlin und die Mark*, depicting both the city and its rural hinterland. Titzenthaler's extensive archive is preserved in the Landesbildstelle Berlin. RL

Kampen, W. v., and Kirchner, R. (eds.), *Berlin: Photographien von Waldemar Titzenthaler* (1987).

Tomatsu, Shomei (b. 1930), Japanese photographer, resident in Nagasaki. Born in Aichi, he began photographing in 1950. Freelance since 1956, he became prominent in the late 1950s and early 1960s as a member of *VIVO with *Hosoe, *Kawada, *Narahara, and others. With his concentration on Japanese post-war society and strong figurative style, exemplified by *The Occupation* and *Houses* of 1960, he became very influential. The reputation established with these series was consolidated by his 1961 documentary project on Nagasaki and its A-bomb victims sixteen years on. His many books include *Nagasaki 11:02* (1966) and *Japan* (1967); *The Pencil of the Sun* (1975) resulted from an extended stay in Okinawa, base of the US fleet. His late 1980s work includes found still lifes on dark beaches littered with coloured plastic. In the 1990s he assembled silicon chips with other found objects and leaves. He has received numerous awards and exhibited worldwide, including a one-man show at the Metropolitan Museum of Art, New York (1992). MHV

Shomei Tomatsu, Traces: 50 Years of Tomatsu's Works (1999).

Tomishige Photographic Studio. Located in Kumamoto City on the Japanese island of Kyushu, and in continuous operation since 1872, it is the oldest photographic studio in Asia. Started by Rihei Tomishige (1837–1922), who learned his craft from Japan's photographic pioneer Hikoma *Ueno, it has been handed down from father to son—Rihei to Tokuji to Kiyoshi to Seiji—remaining in the Tomishiges' possession to this day. The family has preserved a repository of photographic materials from the incunabula of Japanese photography: old negatives, prints (including rare documents of the ancient Kumamoto Castle before it burned down), cameras, *wet-plate darkroom apparatus and materials, and other studio equipment. Many items were originally imported from Europe via Dutch traders in Nagasaki by Ueno and provide important evidence for the history of trade between East and West, as well as insights into the spread of photography in the non-European world. OH

toning, a means of enhancing, modifying, or changing the overall colour of a photographic image by chemical treatment. Also a key element of some obsolete subtractive *colour processes.

Toning has been a common feature of photographic practice since the earliest days of photography. Most *daguerreotypes were gold toned, a process that served to strengthen and protect the fragile image. During the 19th century, *albumen prints and early printing-out papers (see POP) were commonly toned in gold chloride baths, giving the rich sepia colour characteristic of images of the period. In the 20th century, sulphide or selenium toners were favoured for producing sepia prints, but black-and-white bromide prints were now being toned in a variety of hues using metal toners containing salts of elements such as uranium, cobalt, and vanadium. Mordant dye toning, which expanded the colour possibilities even further, was effectively introduced early in the 20th century and is now widely practised. JPW

Worobiec, T., *Toning and Handcolouring Photographs* (2002).

Toscani, Oliviero (b. 1942), Italian photographer and art director, trained at the Dada- and *Bauhaus-influenced Zurich Design School, and friendly with contemporary culture heroes like Andy *Warhol and Federico Fellini. He entered advertising in 1973 with a provocative campaign for Jesus Jeans, but achieved fame and notoriety during a long association (1984–2000) with the Italian clothing firm Benetton. Abandoning the bland pseudo-realism of conventional *advertising photography, he used his own and others' photographs to flout taboos associated with race, war, sex, religion, death, and bodily functions (*vide* his book *Cacas*, 1998). He chose Thérèse Frare's *pietà*-like image of a young American, David Kirby, dying of AIDS for Benetton's 1992 campaign. His increasingly strained relationship with Benetton was finally ended by images of Missouri death-row prisoners that allegedly cost the company a major contract with Sears. Toscani, who has described himself as a 'total anarchist', has been vilified and acclaimed in roughly equal measure, and his motivation variously attributed to moral fervour, exhibitionism, or cynical calculation. But his iconoclastic

approach has probably been effective in reaching youthful, affluent consumers in an increasingly global market place. RL

Salvemini, L. P., *Benetton-Toscani: storia di un avventura 1984–2000* (2002).

To the Attack (*Birmingham Protest*), 3 May 1963. In April and May 1963, at the height of the American *Civil Rights campaign, photographers converged on Birmingham, Alabama, where peaceful marchers faced police using truncheons, dogs, and fire hoses, led by the segregationist Sheriff 'Bull' Connor. Bill Hudson of AP captured the moment when an unresisting 15-year-old youth, Walter Gadsden, was seized by a policeman and savaged by his dog; a Coca-Cola sign appears in the background. Published next day in the *New York Times*, the picture caused a sensation; President Kennedy remarked that it made him 'sick to his stomach'. It subsequently appeared in newspapers worldwide, was used in fund-raising propaganda, and eventually inspired a statue in Birmingham. Similar, even more dramatic images taken by Charles Moore (b. 1931) on 4 May formed the basis for works by Andy *Warhol. RL

Goldberg, V., *The Power of Photography: How Photographs Changed our Lives* (1991).

tourism and photography. Tourism pre-dates photography; but it is striking that the rise of Thomas Cook, the 'father of modern tourism' who led his first 'Tartan Tour' to Scotland in 1846, should have coincided with the first decade of the new medium. Today, the

two practices are closely intertwined, each shaping and stimulating the other, with photography serving tourism as advertisement, commodity, instruction, and memento; and tourism serving photography as subvention, vehicle, justification, and structuring activity. Each of these complex undertakings influences each of the others, and the meaning and intention of each shifts constantly.

Photographs promote tourism when they appear in newspaper and magazine advertisements, in brochures, on billboards, railway stations, websites, and in television commercials. They often serve the same purpose in feature stories, informational travelogues, calendars, coffee-table books, museum exhibitions, and the like. They are usually idealized, and reduced to a few widely recognized signifiers, such as a palm-fringed beach, Big Ben, the Taj Mahal, a gondola, or a sombrero. In the past, mass-produced images of places were widely disseminated as collectable albumen-print views available in various formats either at or far from the places they depicted, and as *postcards, stereographs, and (in the 19th century mostly in engraved form) as illustrations in books and periodicals. Often, as in the cases of Niagara Falls, *Yellowstone, the *Scottish Highlands, the English Lake District, and the Alps, these images drew on pre-photographic visual conventions to identify, define, and legitimize new tourist destinations. In the USA as early as 1872 the New York firm of E. & H. T. *Anthony offered prints of the *American West made for government surveys by William Henry *Jackson, Carleton *Watkins, and others. When sightseeing in wheeled vehicles became possible at Yosemite in 1874, views of the

Platt D. Babbitt

Tourists viewing Niagara Falls from Prospect Point, *c.*1855. Daguerreotype

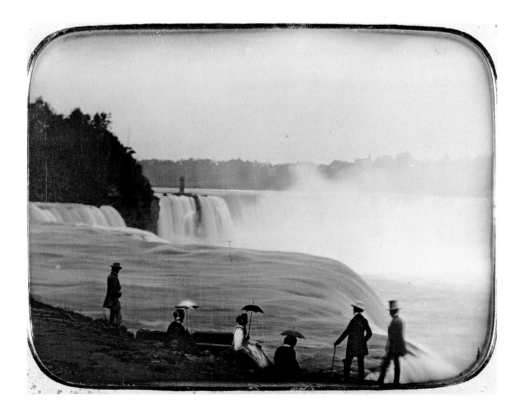

Francis Bedford

The prince of Wales (centre) and his party at Capernaum, April 1862. Albumen print

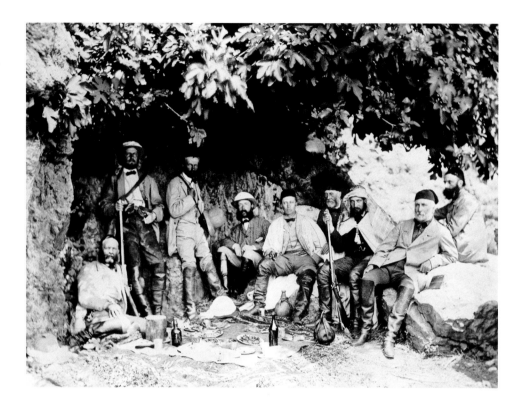

principal features were already on sale, and the region's leading hotelier popularized them on the American lecture circuit. In Scotland from the 1860s both George Washington *Wilson and James *Valentine began purveying views of tourist sites to the British middle and upper classes, then expanded their operations overseas; Valentine eventually became one of the world's largest manufacturers of postcards, with an important sideline in tourist guidebooks. In Italy, the *Alinari brothers in Florence and *Naya in Venice distinguished themselves among the country's countless 19th-century view specialists.

Tourists buy photographs before, during, and after their travels. Differing in use from advertisements and brochures, these images are commodities in their own right, functioning as means of instruction, gifts, or complex mementoes and validations. As early as the 1850s tourists could buy individual prints or albums depicting popular sites from hotels, stationers, booksellers, and street vendors. Today, postcards, posters, souvenir publications (including videos and DVDs), and photo-decorated T-shirts, plates, and ashtrays are on sale wherever tourists gather. Some images offer tips on local codes of behaviour, or incorporate brief information on the sites or monuments they depict. In general, images marketed to tourists are limited to a repertoire of instantly recognizable iconic subjects. A sub-trope of this category of tourist photographs is that in which tourist and icon are combined, ranging in its commercial form from early 20th-century images of camel-borne tourists in front of the Pyramids to modern Polaroids of visitors in Red Square against the backdrop of Lenin's tomb.

Amateurs travelled with cameras long before photography was easy or accepted, but the advent of *roll-film made it much simpler, cheaper (by middle-class standards), and more commonplace. It also came just in time for the bicycle boom of the 1890s, and by c.1900 bicycle (and, more gradually, automobile) tours were featuring in many a snapshot album. Hotels responded to the surge of self-propelled amateurs by offering darkroom facilities. Early tourist snapshots often resembled the professional 'view scraps' long available for sale, but the shift from buying photographs to making them gradually made photography a major component of the tourist day, both as a pastime and a means to infiltrate, occupy, understand, and control alien space. Flirting and larking about also became a recordable aspect of the holiday or honeymoon experience. In the early 21st century, against the background of mass tourism's vast expansion since 1945, photographers are often given signposts to the best vantage point for a successful picture; 'Hula shows' and similar performances are structured for photography (and may even be sponsored by camera manufacturers); film cartons litter popular sites; and organizers of 'camera safaris' and photographic workshops in scenic locations advertise photograph taking as the rationale for the trip.

When tourists return home, their photographs become complex mementoes, evidence of a journey that condenses a multifaceted experience into sets of discrete rectangles to be sorted, shared, and organized into an idealized narrative. As in the 19th century, some narratives may take the form of carefully edited and captioned holiday

albums. Many more pictures will remain structureless and loose in shoeboxes or envelopes or, unprinted, on CD-Rs, doomed to be forgotten or discarded. The social or sharing aspect of tourist photography remains significant, with the slide show or office hand-round giving way to the digital video display or the *Internet website or weblog. But considerations of status, and of various kinds of social transaction, still apply. And, like the unwritten rules of tourist picture taking, those of the 'return' phase have tended to remain remarkably stable. Airport delays, medical emergencies, or arguments with teenage children, if recorded at all, are unlikely to be shared with colleagues and friends. The conventions of tourist seeing are thus deeply established in society, replicated, and passed on as expectations to future vacationers. AN

See also CRUISE-SHIP PHOTOGRAPHY; TRAVEL PHOTOGRAPHY.

Löfgren, O., 'Wish You Were Here! Holiday Images and Picture Postcards', *Ethnologia Scandinavica*, 15 (1985).

Geary, C. M., and Webb, V.-L. (eds.), *Delivering Views: Distant Cultures in Early Postcards* (1998).

Osborne, P. D., *Travelling Light: Photography, Travel and Visual Culture* (2000).

Crouch, D., and Lübbren, N. (eds.), *Visual Culture and Tourism* (2003).

Tournachon, Gaspard Félix. See NADAR.

Tournier, Michel (b. 1924), French novelist and promoter of photography, which also appears frequently in his fiction. In *Le Roi des aulnes* (*The Erl King*; 1970), for example, a mythical tale set in the Second World War which won the Prix Goncourt, he pursues a disturbing analogy between the photography and abduction of children. Between 1960 and 1965 he made *c*.50 television programmes on photography in a series entitled *Chambre noire*. In 1970 he co-founded the *Arles Festival. RL

Townshend, Chauncy Hare (1798–1868), English clergyman, poet, dilettante, and creator of an important photograph collection, bequeathed to the South Kensington (later Victoria & Albert) Museum, London. Assembled mainly between 1855 and 1860, it included Crimean pictures by *Fenton, *Le Gray's *Sea and Sky* (1856), *Silvy's *River Scene* (1858), P. H. *Delamotte's photographic anthology *The Sunbeam* (1859; with illustrations by *Llewelyn, G. W. *Wilson, *Bedford, and others), and a sizeable collection of *stereographs. With the prince consort, Townshend was probably the most important photography collector of his day. RL

Haworth-Booth, M. (ed.), *The Golden Age of British Photography, 1839–1900* (1984).

trade fairs, photographic. Because photography is a business for some and a hobby for many, 'pure' trade fairs to which the public is not admitted are rare. Photokina, the biennial trade show in Cologne which has dominated the industry since the 1950s, sees countless amateurs, students, and spouses and children wandering among the stands of manufacturers and dealers; and L. Fritz *Gruber, a decisive influence on Photokina from its launch in 1950 until his retirement in 1980, ensured that it would offer a rich variety of photographic exhibitions as well as product displays.

The second most important contemporary show is that of the American Photo Marketing Association (PMA), which leads a peripatetic existence in the USA and is somewhat more trade orientated. Few other events make even the pretence of being only for the trade. Photo East and Photo West in the USA and Focus in Britain are long-running shows that attract a good professional attendance, partly international, and a very large but mainly domestic amateur turnout. There are comparable events in other major cities: Moscow and Delhi are two of the most important, but neither is as long established or prestigious as the older shows.

Few manufacturers now save up their announcements of new products for trade shows, which has led to the disappearance or truncation of some major fairs such as the SATIS/SIPI show in Paris, successor to the Biennale. There are, however, more and more one- or two-day 'mini-shows' at conference hotels, for professional and amateur photographers. Many announcements in *digital photography are made at electronics shows rather than photographic ones. RWH

transit of Venus. See ASTRONOMICAL AND SPACE PHOTOGRAPHY; PRE-PHOTOGRAPHIC IMAGING DEVICES.

transmission of photographs. In some fields, the ability to send photographs may be as important as the ability to take them. One example is *astronomical and space photography, where space exploration from the 1960s progressed hand in hand with the capacity to transmit remotely captured imaging data over vast distances. Another is *photojournalism.

In the early years of news photography, photographs were transported from the scene of action to the press by the best physical means available, from fast camels to steamships and eventually aeroplanes. In 1904 the *Daily Mirror* used a specially equipped railway van to make *half-tone process blocks of photographs from the north of England en route to London. But that year successful attempts were made to send images electrically by photo- or picturetelegraphy (or 'facsimile telegraphy'), a method first described by Alexander Bain in a patent of 1843. Now the German physicist Arthur Korn (1870–1945) transmitted a still photograph over telephone lines between Munich and Nuremberg, using an array of selenium cells to convert the image into electrical signals. In 1907 pictures were sent from Berlin to newspapers in Paris and London, and two years later the *Daily Mirror* was using Korn's apparatus to send horse-racing pictures from Manchester to London. Over the next three decades, further improvements were invented by Édouard Belin (1876–1963) in France and AT&T and Bell in the USA. Korn also pioneered the transmission of images by radio (1922).

All the early systems incorporated a revolving scanning drum at one end and a synchronized receiving one at the other, and much other cumbersome and complex equipment. Sending pictures was slow, mainly because of delays in getting a line, and many transmissions failed; picture quality was poor and costs were high, especially compared with air transport. Doubtless this explains why newspapers other than the exceptionally technology-minded *Mirror* did not leap to adopt phototelegraphy. However, it was increasingly widely used in Britain by 1928, and on 1 January 1935 the Associated Press (AP) news agency, which had already occasionally used the AT&T wire-transmission system, inaugurated the AP Wirephoto network. The first picture sent was of a plane crash in the Adirondacks. However, a more dramatic demonstration of the system's usefulness was the rapid distribution of pictures of the *Hindenburg disaster in May 1937. It also proved its worth in the Second World War, especially in the vast expanses of the Pacific where photographers often operated thousands of kilometres from base. Joe Rosenthal's historic photographs of the raising of the American flag on *Iwo Jima, for example, taken on 23 February 1945, were dispatched by plane and naval radio to San Francisco, where they were distributed on the Wirephoto network only 17.5 hours after the event.

After 1945, further improvements were made to the analogue system, producing simpler equipment, more automation, shorter transmission times, and a larger and more flexible network. However, increasing volume of traffic and growing use of colour necessitated more fundamental changes. Satellites were increasingly in use by the 1970s, and in 1978 AP introduced an integrated system of *digital picture handling ('Electronic Darkroom'). This was superseded in 1989–90 by the even more sophisticated and automated Leaf Picture Desk. By this time, colour pictures could be transmitted in 15 seconds, compared with 40 minutes previously. Rival organizations such as Agence-France Presse, United Press International (UPI), and Reuters introduced their own systems. Next came the digitization of picture taking itself, and further enhancement of the individual photographer's autonomy. By 2000, digital cameras were becoming universal in photojournalism, backed up by portable computing and transmission equipment. Photographers in the field during the Iraq War of 2003, for example, used a combination of digital cameras, laptops, and high-speed satellite modems to take and transmit images, their effectiveness limited only by their ability to replenish the batteries for all this equipment. RL

Fulton, M. (ed.), *Eyes of Time: Photojournalism in America* (1988).

Mitchell, W. J., *The Reconfigured Eye: Visual Truth in the Post-photographic Era* (1994).

Coopersmith, J., 'The Changing Picture of Fax', in B. Finn (ed.), *Presenting Pictures* (2004).

transparencies (or diapositives) have up to five advantages over prints or katapositives. All can be projected for viewing by a large audience, and those produced as 'camera originals' are in most cases both cheaper and more 'objective' than prints. They can also be quicker to produce, and are sharper because they are 'first-generation' images.

They are cheaper (for a given level of quality) because no additional processes are required beyond developing the film; and more 'objective' (i.e. with less scope for individual interpretation) because they are processed according to a standardized regime which allows little or no adjustment.

On the other hand, there is almost no exposure latitude, and they are unique. Whereas a negative can normally be used to make good or excellent prints despite overexposure (the latitude for underexposure is much smaller), exposure variations of half a stop can have considerable impact in transparencies. Also, whereas a lost print can be remade from a negative, a lost camera-original transparency is lost for ever.

Speed, economy, quality, and 'what you see is what you get' make the transparency supreme in some areas such as *advertising, while the latitude of colour print materials gives negatives the edge in others such as *wedding photography and, increasingly, *photojournalism, where negative films are often scanned directly without ever being conventionally printed. In the late 20th and early 21st centuries, amateur use of slide films declined rapidly in the face of constantly improving (and ever cheaper) prints, together with the opportunity of scanning directly from negatives.

The arcane *Lippmann interference process (1891) promises objective colour recording, forming all colours in direct proportion to the wavelength of the image-forming light, but most processes are subjective: the colours of the transparency look like the colours of the original, but are formed by dyes which do not reproduce the actual wavelengths.

Kodachrome (1935) was the first modern subtractive *integral tripack*, so named because all three of the layers required to give the final image are coated one atop the other on the film base. Almost all subsequent integral tripacks have, however, differed from Kodachrome by being 'substantive', with dye precursors incorporated in the emulsion layers; Kodachrome is 'non-substantive' because the couplers are added during processing, and the film is effectively black-and-white until it is processed.

Almost all modern transparency films are *subtractive*: white light is filtered by the transparency so that only a representation of the original colours is transmitted. Many older processes, together with Polaroid transparency films, were *additive*: the image is made up of numerous tiny dots of red, green, and blue, in much the same way as a television image. Early additive processes included Lumière *autochrome (1907); Finlaycolor (1908); Omnicolor (1910), later commercialized as Dufaycolor; and lenticular colour processes from both Agfa and Kodak, used in conjunction with wide-aperture lenses and striped filters, and based on patents dating to 1908. Subtractive images are much brighter than additive, and sharper. RWH

See also COLOUR REPRODUCTION PRINCIPLES; PHOTOGRAPHIC PROCESSES, COLOUR.

travel photography

Accepted by them, I was able to take photographs of these striking people [in Afghanistan] who, knowing nothing about photography, adopted no self-conscious poses; this is not easy to achieve in more sophisticated areas. When I first went to northern Kenya I took many photographs of relaxed and graceful tribesmen. Now, with the influx of tourists, all anxious to get photos, they have learnt to pose and demand money. Some, however, resent this intrusion and I have heard them protest: 'We are not wild animals to be photographed'. I have increasingly refrained from taking photographs, except from a distance, in places where I am not known and accepted. (Wilfred Thesiger, *Visions of a Nomad*, 1987)

These words, by one of the great travellers of modern times, underline the difference between travel and *tourist photography. Since the 19th century, tourism has relied on an ever more complex and pervasive infrastructure embracing hotels, transport, amenities, and cuisine; and developed a perceptual framework incorporating the 'Baedeker viewpoint', brochures, *postcards, and Kodak-sponsored ethnic dances. Most tourist photographs either conform to the resulting set of visual expectations or react against them in predictable ways.

Travel, both in the 19th century and since, has been a more individualistic and adventurous undertaking. The regions favoured by Thesiger (1910–2003) 'had to present a serious challenge of hardship and danger, and had if possible to be unexplored'. His first journey as an adult, in 1933, was into the Danakil country of Ethiopia, where 'three previous expeditions had been exterminated . . . by these tribesmen, who judged each other according to the number of men they had killed and castrated'. If not always quite so hazardous, difficult conditions were routine for the pioneering photographers of the 19th century, whose purposes were scientific, commercial, recreational, or a mixture of all three. Between the 1840s and 1914, scores of photographers on both sides of the Atlantic went to extreme lengths, in the early decades using heavy and cumbersome equipment, to capture images of exotic landscapes, people, and buildings. One of the most prolific was the English Quaker Francis *Frith, who between 1856 and 1860 made three trips to Palestine and *Egypt to photograph the monuments, and thereby, as Doug Nickel has argued, to fortify his contemporaries' belief in the reality of biblical events. Francis *Bedford was hired to accompany the prince of Wales to the Holy Land in 1862. A select sample of other Europeans might include Sergei *Levitsky in the Caucasus as early as 1843; the British clergymen George Bridges (*fl.* 1840s–1850s) and Calvert Richard *Jones in the Mediterranean in the late 1840s; Maxime *Du Camp in the Middle East in 1849–51; Samuel *Bourne in the Himalayas in the 1860s; John *Thomson in Cambodia and China in the 1860s and 1870s; and Georges Maroniez (*fl.* 1890–1910) in Egypt, the Maghrib, and elsewhere (also using *autochrome) around the turn of the century. (Although closer to home, George Washington *Wilson's photographic expeditions in the *Scottish Highlands in the 1850s and 1860s were hardly less adventurous in terms of the privations and technical challenges they involved.)

From the end of the 19th century onwards, the availability of *roll-film and increasingly portable cameras eased the travel photographer's problems. Indeed, one of the most interesting things about 20th-century travel photography is how much of it was done with rather basic equipment. The Australian *marine photographer Alan Villiers (1903–82) in the 1920s and 1930s recorded his vast sailing-ship voyages with folding Kodaks costing a few shillings. Other adventurers, from Eric Newby (b. 1919) to Bruce Chatwin (1940–89), seem to have cared little for fancy equipment, preferring simplicity and lightness to sophistication. Thesiger began photographing in Ethiopia in 1930 with his father's decrepit Kodak. Not long afterwards he bought a Leica II, and relied on it until 1959, never using flash, a tripod, or colour film and usually working with a 50 mm standard lens. Thesiger in fact was not only a great traveller but a great travel photographer, in both activities despising the refinements of modern civilization. (Apart from the Acropolis, he never photographed any subject—or person—in Europe.) Though little interested in photographic technology he had a natural instinct for composition and lighting, demonstrated by the superb landscapes and portraits he made in Africa, Afghanistan, and Arabia. His selection of favourite images came to fill 65 albums. MR/RL

Fabian, R., and Adam, H.-C., *Masters of Early Travel Photography* (1983).
Cortal, M., 'Georges Maroniez, peintre et photographe', *Bononia*, 27 (1995).
Winding Paths: Photographs by Bruce Chatwin, introd. R. Calasso (1998).
Osborne, P., *Travelling Light: Photography, Travel and Visual Culture* (2000).
Nickel, D. R., *Francis Frith in Egypt and Palestine: A Victorian Photographer Abroad* (2004).

Tress, Arthur (b. 1940), American photographer. Beginning with haunting documentary photographs of deserted *Coney Island in the late 1950s, and progressing through surrealistic imagery in *The Dream Collector* (1970), Tress has explored the role of fantasy, nightmare, and imagination in a variety of contexts. He is perhaps best known for his gay male fantasy pictures composed along New York's docks and piers during the late 1970s and published in *Facing up* (1980). Subsequently Tress turned to colour photography of 'found object' collages. *Fantastic Voyage*, a career retrospective, was exhibited in 2001. PC

Tress, A., *Fantastic Voyage: Photographs 1956–2000* (2001).

Tripe, Linnaeus (1822–1902), English photographer employed in the Madras Native Infantry 1839–75. Tripe's earliest photographs were made on leave in Devonport, England, *c.*1851–4. Returning to India in 1854, he photographed Halebid, Belur, and Sravana Belagola, later exhibiting views at the Madras Exhibition of 1855. From August to November 1855, Tripe was sent to *Burma as official photographer with the mission to Ava, a commission which produced a portfolio of 120 topographical and architectural studies. Following this success, he was appointed government photographer to the Madras presidency in October 1856. He toured south India between December 1857 and July 1858, publishing the results in 1858 as *Photographic Views in Ryacottah, . . . Seringham, . . . Trichinopoly, . . . Madura*

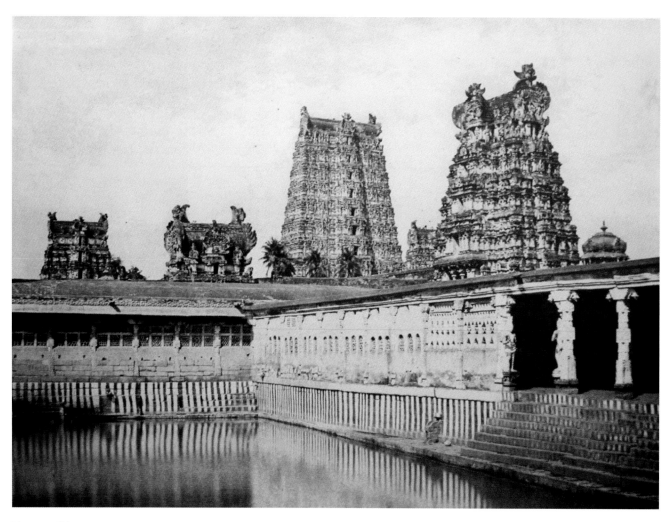

Linnaeus Tripe

The Tank, Sri Minakshi Temple, Madurai, India, 1858. Albumen print

(in four parts), . . . *Poodoocottah*, and . . . *Tanjore*. During this period he also made a 21-part panorama of an inscription in Tanjore, two volumes of stereographic views, and *Photographs of the Elliot Marbles* (1859). He was helped with the printing by the Indian photographer C. Iyahsawmy. The post of official photographer was abolished in 1860, whereupon Tripe returned to England until 1863. While stationed at Tonghoo, Burma, in 1870, he made views of Kasur-do Hill. Many of his original paper negatives survive in the collection of the *Royal Photographic Society, Bradford. SCG

Dewan, J., *By Thee I Draw: Catalogue Raisonné of Linnaeus Tripe* (2002).

tripods. See CAMERA SUPPORTS.

Tuggener, Jakob (1904–88), Swiss photographer and film-maker. He moved into photography while studying graphic design, typography, and film at the Reimann School in Berlin in 1930–2.

Back in Switzerland, he published *MFO—Maschinenfabrik Oerlikon* (1934), about work in an armaments factory, the first of many books. Subsequently he photographed both society events and Swiss rural life. He contributed to the 1955 *Family of Man* exhibition. Stylistically, he was inspired by the 'poetic realism' of the film director Jean Renoir. His own cinematic output was considerable, totalling 25 silent films. JCB

Gasser, M., *Jakob Tuggener, Photographs* (2000).

Turin Shroud. See CHRISTIANITY AND PHOTOGRAPHY.

Turkey. News of photography's invention reached Istanbul within months of its announcement in Paris in 1839, and soon afterwards photographers arrived from Europe to set up businesses there. In 1845, for example, the Italian Carlo *Naya advertised his inexpensive photographic portraits in an Ottoman newspaper. The Crimean

Abdullah Frères

Students and teachers with skeletons and a cadaver, Civil Medical School, Constantinople (Istanbul), c.1880–93. Albumen print

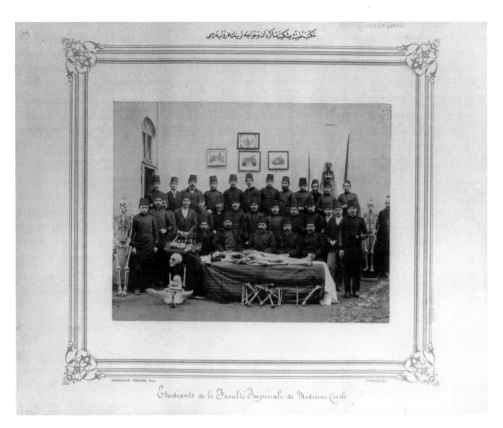

War brought Robert *Fenton to the Ottoman Empire and focused increased attention on the work of James *Robertson, chief engraver at the Ottoman Mint, who also opened a photographic studio in Pera in the mid-1850s.

The burgeoning tourist market was the primary driving force behind the numbers of photographers who established themselves in the major cities of the empire. (Photography reached rural areas much more slowly, and this account relates mostly to the urban scene.) Before the advent of *roll-film cameras, most tourists documented their travels by purchasing the work of commercial photographers, either as single images or in albums. Guidebooks directed travellers to the best shops for different kinds of photograph, and by 1900 Istanbul commercial directories listed 65 photographers active in the city, mostly in Pera, the district where many European-owned businesses were located. While some of these operators were Europeans, others were local residents who had established successful studios, for example, *Sébah & Jollier (or Joaillier) and *Abdullah Frères, which catered for local inhabitants as well as tourists. Commercial images produced for the tourist market included views of important architectural monuments, both ancient and contemporary, street scenes, landscapes, and photographs of local residents, often categorized by occupation or ethnicity. This body of images, from Turkey and elsewhere, has been the subject of intense scrutiny in recent years by scholars interested in using the photographs to understand the complex political, economic,

and cultural relationships between the European powers and other regions in this period.

Istanbul, as the imperial capital and a popular tourist destination, had a large population of resident and more transient Europeans, with a well-developed commercial network to serve their needs and to provide goods and services for the increasing number of Ottoman subjects who desired them. As a result, Istanbul residents had easy access to information about photography, to photographers, and to the technology itself. Ottomans quickly became conversant with the new medium, with training in photography provided at the Imperial School of Engineers, the military forerunner of the present-day Istanbul Technical University, and the Academy of Fine Arts. Amateur Ottoman photographers began taking their own pictures, and in so doing took control of the manner in which they were represented photographically.

Ottoman consumers of photographs were primarily interested in portraits of themselves and their families. Photographic portraiture of a kind very similar to what was being done by commercial studios in 19th-century London, Paris, or Boston found a ready market. Popular formats included the *cartes de visite and *cabinet portraits popular elsewhere, as well as larger ones; and pictures were often arranged in albums. The accessibility of studios and cheapness of portraits opened the medium to those who could not have afforded paintings. These new opportunities for self-presentation are particularly striking with

regard to women's portraits. Before the advent of photography, representations of women were not common; however, in the last decades of the 19th century Ottoman women from various classes appeared in photographic and painted portraits, signalling significant changes in their social roles. Yet although 19th-century Ottoman portraits often look identical to portraits of the same period from Europe or North America, formal similarities tend to belie great differences in the social circumstances of subjects and the nature of relationships: wedding photographs, whose conventions of setting and posture closely resembled European ones, are a notable example.

Well established by the turn of the century, photography continued to be important in 20th-century Turkey, gradually entering the curriculum at art schools, technical institutes, and universities throughout the country. *Photojournalism came of age at mid-century with the founding of the first photo press agency, Basın-Foto, the appearance of the first newspaper with staff photographers, *Yeni Istanbul*, and the launch of *Hayat* (*Life*) magazine. The Association of Turkish Photojournalists was established in 1957. Well-known Turkish journalists include Cemal Işıksel, called the 'Atatürk Photographer' because of his extensive documentation of Atatürk's activities, Ara *Güler, and Sami Güner. Photojournalism in Turkey has remained significant; Turkish newspaper readers were accustomed to seeing full-colour photographs in their papers a full decade before they began to be used sparingly in the North American press. Photography as an art form has been slower to gain widespread acceptance. However, there are numerous galleries in the larger cities which frequently exhibit the work of Turkish photographers, and photographers, among them Gültekin Çizgen and Mehmet Bayhan, have worked hard to encourage contemporary photography. Younger Turkish photographers, Cemil Ağacıkoğlu, Coşkun Aral, Ahmet Öner Gezgin, and Tahir Ün, to name only a few, working in a range of styles and techniques, have achieved international reputations through their participation in the international art world and its publications.

NM

Çizgen, E., *Photography in the Ottoman Empire 1839–1919* (1987).
Beauge, G., et al., *Images d'empire: aux origines de la photographie en Turquie/Türkiye'de fotoğrafın öncüleri* (1993).
Micklewright, N., 'Personal, Public and Political (Re)Constructions: Photographs and Consumption', in D. Quataert (ed.), *Consumption Studies and the History of the Ottoman Empire, 1550–1922* (2000).

Turner, Benjamin Brecknell (1815–94), English photographer. In 1849, Turner mastered the *calotype and, using it throughout his career, made celebrated views of the English countryside. Although he operated a commercial portrait studio from atop the family

Benjamin Brecknell Turner

Walter Chamberlain hiding behind Bredicot pump, mid-1850s. Salt print from paper negative

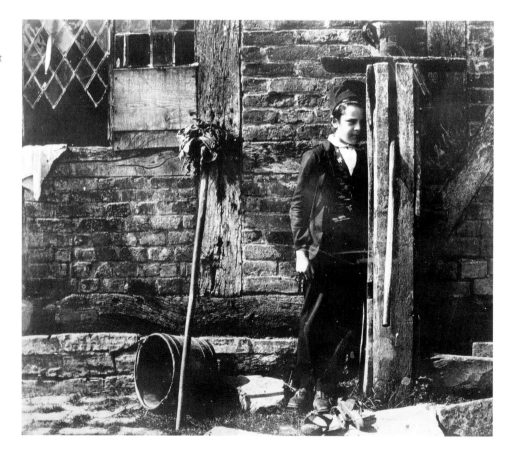

tallow-chandling business in London's Haymarket, he is best known for his strikingly modern series of the Crystal Palace in 1851, and his large (30 × 40 cm; 11⁴/₅ × 15⁷/₁₀ in) landscapes in the British topographical tradition. Many of these were taken near London, and others in the Worcester–Hereford area, home to his wife Agnes (née Chamberlain) of the Worcester china family. The detail and precision of Turner's images is a trait he strove for, often to the extent of retouching his images. He became a master of the paper-negative process, even when many of his contemporaries had begun to use *collodion on glass. By the mid-1850s, Turner was well known and widely collected, for he exhibited frequently at various societies, including the Society of Arts. Although he was widely rumoured to have helped Henry *Talbot to produce images for *The Pencil of Nature*, there is no evidence to support this claim, which was never made by Turner himself. KEW

Barnes, M., *Benjamin Brecknell Turner: Rural England through a Victorian Lens* (2001).

twilight. As well as being evocative in its own right, twilight is the key to many of the best so-called *'night' shots. Subjects are differentiated against the sky, whereas in true night they often merge into blackness, except in cities where light pollution means that not even the night is ever fully dark. It is often possible, by looking closely at a picture, to determine whether it was a true night shot or a dusk shot.

As soon as the sun has set, *contrast falls and the light becomes very blue, which is obvious in colour; but in black-and-white the result of a generous exposure looks like an overcast day. Reducing exposure creates a much more nightlike effect. Light levels change rapidly, so the exposure required to create a particular effect can change very quickly, especially in southern climes where twilight is shorter than in the north.

Dusk can also be faked, in the style of the movie maker's *nuit americaine*. This is achieved by a combination of heavy filtration (blue for colour, red for black-and-white) and underexposure. Done properly, *nuit americaine* can be quite convincing, as long as it is not let down by heavy shadows which seldom look like genuine moonlight. An overcast day, when street lights and car headlights stand out brightly, is often the most convincing. In the heyday of pictorial photography, combination prints of lowering skies and heavy overexposure often created much the same effect. RWH

Hicks, R., *Low Light and Night Photography: A Practical Handbook* (1989).
'Fotografie und Daemmerung', *Fotogeschichte*, 89 (2003).

291. See GALLERY 291.

Ubac, Raoul (1910–85), Belgian artist who dropped the study of forestry in response to André Breton's first *Manifeste du Surréalisme* in 1929. The following year he moved to Paris, and under *Man Ray's influence dedicated himself to photography. Through such techniques as *brûlage*, *solarization, and petrification Ubac sought to reveal the poetic significance of objects, but conceded late in life that perhaps photography was not capable of doing this. In 1945 he abandoned it in favour of drawing and painting; by then his interest in *Surrealism had also lapsed.

MR

Ueda, Shoji (1913–2001), Japanese modernist photographer, noted for his sense of play and jousts with *Surrealism. Ueda was born and lived most of his life far to the west of Tokyo in the seaside village of Yonago in Tottori prefecture. A member of the amateur club Yonago Shayu Kai from 1931, he opened a portrait studio in Tottori in 1932 and helped to establish several photography groups, including Ginreisha with Yoichi *Midorikawa in 1947. A frequent winner of amateur magazine competitions with his modern and figurative images, Ueda mainly photographed around his home town, especially at the Tottori Dunes where he took his best-known series of playful and carefully arranged family portraits and humorous still lifes. Numerous volumes of his work have appeared in Japan. He received many Japanese and foreign awards, and the Shoji Ueda Museum of Photography, devoted to his work, opened in 1995.

MHV

Uelsmann, Jerry (b. 1934), American photographer who studied at the Rochester Institute of Technology. Later, at Indiana University, he came under the influence of Henry Holmes Smith, who encouraged him to develop what would become an elaborate and uniquely individual style also heavily influenced by the *Surrealism of *Man Ray and Herbert *Bayer, and by his own notions of reality, space, and time. The essayist Roxanne Ramos has said of Uelsmann's inventive, layered images: 'It's easy [now] to overlook the initial audacity of Uelsmann's approach. . . . He challenged Weston's purist notion of "pre-visualization".' Instead, Uelsmann allows his work to evolve over a lengthy creative period, and has described that process as 'post-visualization'. Using up to seven negatives in separate enlargers, he achieves a layered black-and-white image incorporating, typically, a landscape, a seascape, sky, a human hand, a nude figure, a leaf, and feather plumes in surreally suspended arrangements that often bring to mind Zen gardens with their quiet expectation that the viewer will attain, possibly, some level of enlightenment.

TT

Jerry Uelsmann: Approaching the Shadow (2000).

Ueno, Hikoma (1838–1904), pioneering Japanese commercial photographer. Born in Nagasaki, Ueno opened the first Japanese-owned portrait studio there in 1862, the year he published the manual *Seimikyoku Hikkei* (*Chemical Laboratory Handbook*). He had learned chemistry from a Dutchman, Dr Pompe van Meerdervoort, at the Naval Medical College of Nagasaki in 1858, and the *wet-plate process from a French photographer, Rossier, in 1859. Continuing the photographic-materials business begun by his father, Shunojo Ueno, he also trained several talented photographers, including Kuichi Uchida and Rihei *Tomishige, who later opened studios. He was one of the first official photographers to document public enterprises (and also, in 1877, civil war), and portrayed many clan officials and retainers of the shogun. These unsentimental, clearly lit portraits often feature Western wooden banisters, parquet floors, and classical columns.

MHV

Ulmann, Doris (1882–1934), American photographer who grew up in New York, attended the School of Ethical Culture and Columbia University, and studied photography with Clarence H. *White. Working with large-view cameras, and before the advent of the Farm Security Administration, Ulman documented the crafts and people of Appalachia. Seasonally between 1928 and 1934, often accompanied by the balladeer and folklorist John Jacob Niles, Ulmann roamed the rural South, Niles in his Chevy, she in her outsized Lincoln driven by a German chauffeur. Her powerful portraits of South Carolina blacks illustrated Julia Peterkin's *Roll, Jordan, Roll* (1933).

TT

Niles, J. J., and Williams, J., *The Appalachian Photographs of Doris Ulmann* (1971).

ultraviolet and fluorescence photography. The invisible ultraviolet (UV) region of the spectrum extends from *c*.380 nm (nanometres) to less than 100 nm. It is conventionally partitioned into regions corresponding to its biological effects. UV-A (315–400 nm) is the region that produces suntan, and is transmitted by ordinary glass and Wood's glass ('black') filters. Using this filter it is possible to take UV photographs on general-purpose film with an ordinary camera, but as modern lenses transmit these wavelengths only weakly, and some

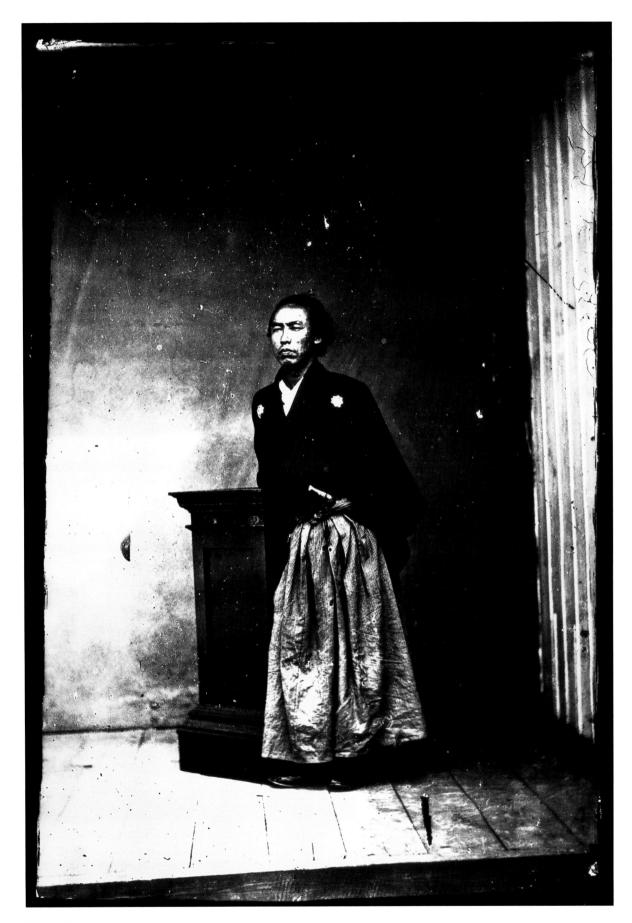

Hikoma Ueno

Portrait of Ryoma Sakamoto, 1866

films have an anti-UV coating, it is advisable to use a pre-1950 camera lens and an old-established film such as FP4, and to downrate the film speed in direct sunlight by a factor of 10. Indoors the only method is trial and error. UV-B (280–315 nm) causes serious sunburn and possible eye damage. It requires much longer exposures and refocusing of lenses. UV-C (100–280 nm) is lethal to life forms. Although radiated by the sun, it does not penetrate the atmosphere. Photography in this region demands special lenses made from quartz and/or fluorite, and special *Schumann emulsions* that have the silver halide crystals projecting through the surface, as gelatin is opaque to UV-C radiation. The best light sources for UV imaging are high-pressure mercury-xenon lamps, with appropriate filtration.

Another type of UV imaging is *fluorescence photography*. When stimulated by UV radiation at 280–350 nm many chemical substances and body fluids emit visible light and can be photographed using an ordinary camera and film, with a Wood's glass filter over the UV source and a UV-absorbing filter over the lens.

UV and fluorescence photography are used in medical diagnosis, forensic investigation (detection of document forgeries, body-fluid stains, etc.), military reconnaissance (camouflage detection), non-destructive materials testing, and the examination of works of art. GS

Ray, S. F., *Scientific Photography and Applied Imaging* (1999).

Umbo (Otto Umbehr; 1902–80), German photographer. Although he had intended to study painting in Düsseldorf, in 1921 Umbo instead became Johannes *Itten's student at the *Bauhaus. He later cited this contact as a key influence on his development as a photographer. In 1924, he moved to Berlin, where he opened a studio and joined the capital's dynamic arts scene. He also became involved with film, working with Walter Ruttmann on *Berlin, Symphony of a Great City* (1927). *Dephot, the Berlin picture agency, employed Umbo until its closure in 1932. During the Second World War, his studio and archive were destroyed. Only in the 1970s was his early work rediscovered, leading to a reassessment of his role in the German avant-garde. The *photograms, *photomontages, and surreal images from Berlin's 1920s theatre district are in stark contrast to his later photojournalism. In 1948, Umbo returned to professional photography, teaching at the Werkkunstschule, Hanover, until 1974. KEW

Molderings, H., *Umbo: Otto Umbehr* (1995).

underground photography. Photographing in caves, mines, and other structures beyond the penetration of daylight is closely tied to the development of artificial light and *flash, some of which was designed specifically for underground use.

In December 1861 Félix *Nadar experimented with battery-powered arc lights in the Paris catacombs. His *collodion plates were prepared and developed underground, where exposures of eighteen minutes were required to record mannequins with the bones. His pictures proved an astounding success, but the cumbersome, dangerous lights were far from ideal.

Charles Waldack

Magnesium fumes in deserted chamber, Mammoth Cave, Kentucky, 1866, stereocard

Then and later, limelight, Bengal light, and other chemicals were tried without success, but once magnesium was commercially available photographers found a new means of challenging darkness. On 27 January 1865, with a five-minute exposure, Alfred Brothers (1826–1912) produced a stereo view in the Blue John Caverns in Derbyshire, England; it was imperfect, and a second exposure was prevented by the choking clouds of fumes, but the experiment was clearly a success. Henry Jackson was the first to create an underground photograph in a mine when he worked in Bradford Colliery in March 1865, and in April that year Charles Piazzi *Smyth, the Astronomer Royal for Scotland, used great bundles of magnesium wire to photograph the interior of the Great Pyramid at Giza, Egypt.

Although ruinously expensive, magnesium was the only practicable light source for underground use, and in 1866 the Belgian-born immigrant Charles Waldack (c.1831–1882) photographed in Mammoth Cave, Kentucky, employing up to 120 tapers to generate each of about 80 negatives. Forty of these were marketed as stereo views and drew universal acclaim. Waldack set a benchmark for underground photography, overcoming the same problems that daunted both his predecessors and later workers, and developing techniques that remain guiding tenets today. He placed lights to the side of the camera, both to create relief and to avoid light bouncing directly back into the lens from the humid, dust-laden air. Typically, a tripod-mounted camera was used with a wide-angle lens, which was uncapped while the magnesium burned.

In subsequent decades most underground photographers were driven by commercial motives, such as advertising or producing pictures for sale, though in Australia government cave protection promoted underground photography for documentation. Even so, cave photography did not flourish until the invention of flashpowder in 1887. Underground photography was generally conducted in tourist caves, not least because the sale of pictures was assured. The move to recording caves during their exploration only came with the 1890s, and the efforts of the Frenchman Édouard Alfred Martel (1859–1938; but notable also were Charles Kerry (1857–1928) in Australia, Ben Hains in the USA, and J. Charles Burrow (1852–1914) working in Cornish tin mines). Henceforth, cave exploration generally demanded a photographer's presence, one of the best being James Henry ('Harry') Savory (1889–1962) in the UK.

Caves, by their nature, are fascinating and mysterious; not surprisingly, therefore, such photographs are avidly devoured by an awed public. In the USA Ray V. Davis (1894–1980) extensively photographed in what was later named Carlsbad Caverns in New Mexico, where he used a mortar-like device to fire magnesium powder; the pictures of vast chambers led directly to the cave's designation as a National Park in 1923.

Magnesium, with its billowing clouds of smoke, went into decline after the introduction of flashbulbs, though publicity was required to aid their acceptance. In 1952 Ennis Creed ('Tex') Helm (1903–82), a newspaper photographer, was sponsored by Sylvania to demonstrate the worth of their bulbs. Helm used 2,400 flashbulbs connected by 5 km (3 miles) of cable to expose a single picture in the Big Room, Carlsbad Caverns; *National Geographic* noted that this was the most vivid flash since the atomic bomb was fired in 1945.

While photography has today turned almost exclusively to electronic flash, cave photographers often combine this source with stockpiled flashbulbs (which ceased to be manufactured in the 1980s) for their characteristics of high power and wide spread from large reflectors. Photographers also take advantage of their slower speed of illumination for depicting fluid motion in water, and of their ability to fire *underwater.

Modern cave photography still uses many 19th-century techniques, with one major exception. Slave units detect a pulse of light from a flash and trigger a second flashgun at a remote location, thus enabling synchronized multiple-flash photography without the requirement for connecting cables. Since the 1970s cavers have developed highly sensitive infrared slaves specifically calibrated for total darkness, generally fired by a pulse from the camera position to avoid foreground lighting. This has removed the need for a cumbersome tripod and made multiple flash photographs easy to set up, creating unparalleled possibilities. CH

Howes, C., *To Photograph Darkness* (1989).
Howes, C., *Images Below* (1997).

underwater photography is one of the most challenging of all photographic activities. In addition to the technicalities of producing a proficient image, the camera must be kept dry and the photographer must ensure his or her survival in an alien environment. Underwater photography is for some enthusiasts merely a means of recording marine life encountered, but for others it can become a passion, and diving only the means of transport to the underwater studio. Whichever level is aspired to, underwater photography can appear to be a daunting challenge; but with a logical approach to equipment and techniques respectable results can be achieved very quickly.

History

Notwithstanding the problems involved, attempts to take photographs underwater began as early as the middle of the 19th century. In 1856 William Thompson obtained a murky picture of damage to a bridge on the Wey estuary in southern England, about 6 m (20 ft) below the surface. In subsequent decades further efforts were made on both sides of the Atlantic, including an experiment by Eadweard *Muybridge in San Francisco Bay in 1875. Contemporary advances in engineering, e.g. bridge building; the development of submersible vehicles; and, perhaps above all, the laying of submarine cables, created a demand for reliable ways of recording objects underwater. (A century later, the offshore oil boom would give a comparable stimulus.) But the earliest sustained progress was achieved by Louis *Boutan in the 1890s. Between 1893 and 1899, using a succession of cameras and both natural and artificial lighting, he captured some remarkable images off the Mediterranean coast. In 1899 he obtained clear photographs of underwater vegetation at night, and of a plaque at a

depth of 50 m (164 ft), using battery-powered arc lamps in watertight housings. Although Boutan's interests shifted elsewhere, his book, *La Photographie sous-marine* (1900), and the projection of some of his pictures at the 1900 Paris Exhibition, encouraged further experiments. By 1920, in addition to developments in underwater cinematography, still cameras were being used for a range of applications, from salvage work to the Allied investigation of mines flooded and booby-trapped by the German army. In 1926 the American ichthyologist W. H. Longley and the *National Geographic* photographer Charles Martin took underwater *autochromes in the Caribbean, publishing them in the magazine in January 1927.

In the 1930s, 1940s, and 1950s important developments took place in three main areas: exploration of the deep oceans; the invention of aqualung equipment that vastly increased the mobility of divers and photographers at depths down to *c.*40 m (130 ft); and the creation of stroboscopic lighting systems. A key figure was Jacques-Yves Cousteau (1910–97), whose books and films kindled public awareness of the underwater environment. He had a long association with Harold *Edgerton, who contributed cameras, lighting equipment, and sonar positioning apparatus for expeditions to locations as diverse as the Mediterranean and Lake Titicaca in the Andes. (In 1976 Edgerton took part in a vain attempt to locate the Loch Ness monster; in 1986, an Edgerton–Benthos camera took some of the first still photographs of the rediscovered *Titanic*.) Cousteau also collaborated with the Belgian Jean de Wouters in developing an underwater 35 mm camera, the Calypsophot, the design for which was bought by Nippon Kogaku and launched in 1963 as the Nikonos.

In the late 20th century, ever-improving equipment, oil exploration, and the growing popularity of leisure diving strongly encouraged underwater photography by both amateurs and professionals. Notable among many outstanding practitioners was Leni *Riefenstahl, who learned diving in her seventies and produced two books of tropical underwater photographs, *Korallengärten* (*Coral Gardens*; 1978) and *Wunder unter Wasser* (*Underwater Miracle*; 1990).

Equipment

Today's would-be underwater photographer must first choose a camera system. This can range from spending a few pounds on a disposable camera for depths of 3–5 m (10–15 ft), or investing £1,000 or more in a housing for an autofocus SLR system. Between these options are amphibious semi-compact systems produced by Nikon (the Nikonos—though production ceased in 2001) and Sea & Sea (the Motormarine), which offer various lens options for total flexibility. As these cameras do not have reflex viewing, camera-to-subject distance must be estimated and the lens focused accordingly. However, framers and prods can be used to measure subject distance in close-up or macro work, when using accessory lenses and *extension tubes; and wide-angle lenses have the advantage of considerable depth of field. SLR systems are bulkier and heavier, but considerably more flexible, offering both a wide choice of lenses and autofocus. From the turn of the 21st century a growing range of underwater *digital equipment became available.

Most underwater photographs are lit at least partly by artificial light. This is both to ensure adequate exposure in the sometimes gloomy depths (allowing the use of smaller apertures), and to restore colours largely absorbed by water as distance from the surface increases. Amphibious flashguns are available for either compact cameras or housed SLRs which are compatible with the camera's TTL flash exposure control. A housed camera may be combined with an appropriate (housed) dedicated flashgun to ensure total exposure control and compatibility with *matrix metering systems. Amphibious flashguns are available in a variety of power options and with differing beam angles: lower power, narrow beam for close-up and macro, and high power, wide beam for wide-angle photography. Finally, a flexible or jointed arm is needed to attach the flash to the camera system and allow changes of lighting position and angle, dependent on the subject.

To produce successful underwater photographs it is essential to appreciate the physical constraints that working underwater imposes.

Colour absorption

White light or daylight is made up of several colours ranging from the warm end of the spectrum (reds and oranges) to the cool end (blue and green), and water is an efficient filter of light (Fig. 1). It is more efficient at the warm end of the spectrum, and noticeably soaks up red light by a depth of *c.*10 m (30 ft). Absorption intensifies with increasing depth until very little colour remains. The human brain is able to compensate in part for this colour loss and allow continued recognition of the suppressed colours even if they are less vivid. Colour film, however, is balanced for use in daylight only and cannot compensate; it therefore records only what it 'sees'. This rule applies not only to increasing depth but also to distance. So, even in only a few feet of water, too great a distance from the subject will result in loss of colour by absorption. To overcome this, the photographer must get as close to the subject as possible; stay shallow if shooting with natural light; or use a flashgun to restore the lost colours. Colour-correcting filters can be used in shallow water, but as these also affect exposure values, flash is the most efficient choice.

Reflection and scatter

Even in a flat calm up to 25 per cent of the sun's light is reflected by the water's surface and this figure increases as conditions become rougher and waves present a variety of angles to reflect the light. Light underwater is also scattered by particles of matter suspended in it. Even the clearest tropical water contains countless minute suspended particles that reflect light from their own surfaces and degrade definition of the image as subject distance increases. An above-surface subject photographed on a misty day would lack definition. Owing to suspended matter these conditions exist permanently underwater, so that the photographer must approach as near to the subject as possible, using a wide-angle or close-up lens to minimize the scatter effect.

Refraction

Light rays are refracted (bent) as they pass from the water through the face-plate of the diver's mask or the flat port of the camera; this has the

Larry Burrows On a mission over Cambodia, 1966

(*overleaf*) **Kudo Studio** Japanese wedding photograph, *c.*1980s

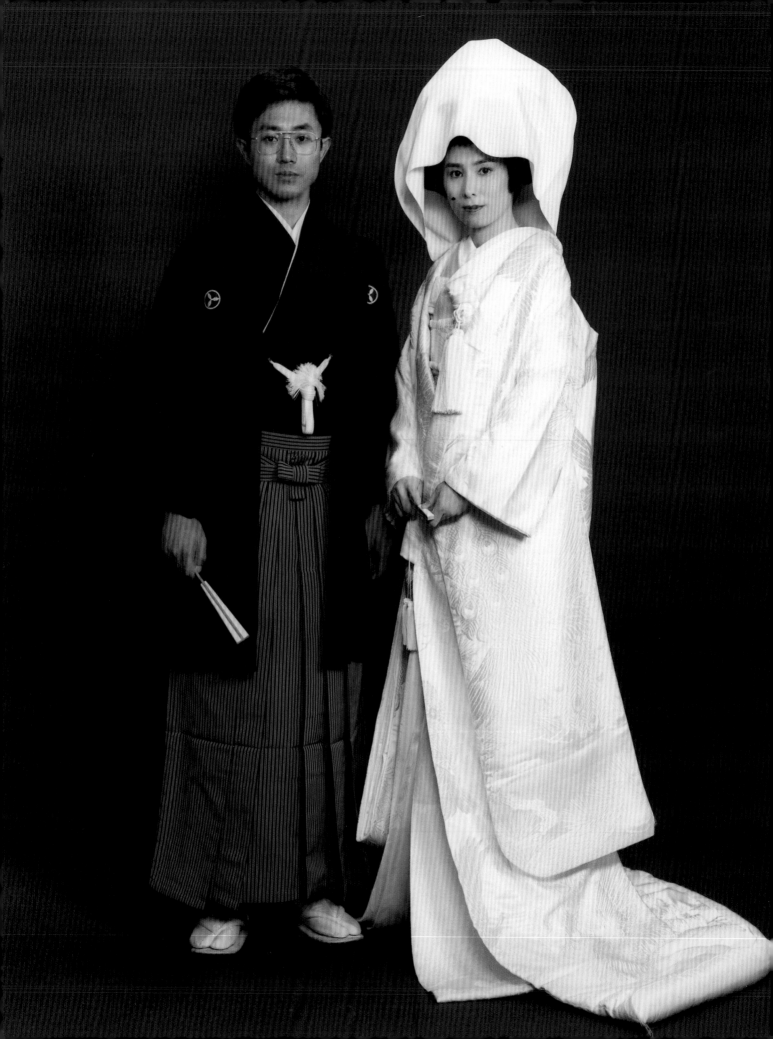

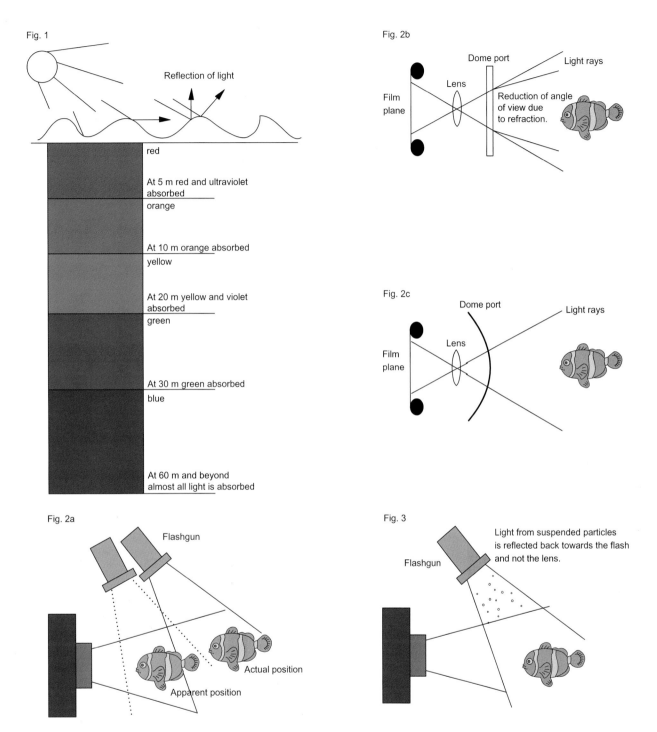

Fig. 1

Reflection of light

red

At 5 m red and ultraviolet absorbed

orange

At 10 m orange absorbed

yellow

At 20 m yellow and violet absorbed

green

At 30 m green absorbed

blue

At 60 m and beyond almost all light is absorbed

Fig. 2b

Dome port

Light rays

Lens

Film plane

Reduction of angle of view due to refraction.

Fig. 2c

Dome port

Light rays

Lens

Film plane

Fig. 2a

Flashgun

Actual position

Apparent position

Fig. 3

Light from suspended particles is reflected back towards the flash and not the lens.

Flashgun

Fig. 1. Colour absorption and reflection.

Fig. 2a. Refraction makes it difficult to aim the flash correctly.

Fig. 2b. Flat port underwater. When light rays pass from one medium to another, in this case from air to water, rays are refracted or bent. As a result objects appear to be about 25% bigger and closer, and the angle of view of the lens is decreased by approximately the same percentage.

Fig. 2c. Dome port underwater. A dome port corrects refraction and maintains the angle of view of the lens.

Fig. 3. Backscatter. By keeping the flash above the lens and aiming it at the subject at 45° backscatter (light reflected from suspended particles) will be minimized.

effect of magnifying what is in vision by about 25 per cent, thus making an object appear to be both larger and closer (Fig. 2*a*). The magnification also reduces the angle of view that the lens has on land (i.e. there will be less in the picture under water); and with wide-angle lenses refraction will also cause a variety of optical distortions at the edge of the picture. With longer focal length lenses this can be an advantage, particularly when using close-up and macro lenses, as magnification is enhanced. However, wide-angle lenses must be corrected for underwater use by means of a dome port, which restores the correct angle of view and removes the optical distortions (though not the magnification) (Figs 2*b* and *c*).

Backscatter

This term refers to reflection of light from the particles suspended in the water between camera and subject (Fig. 3). If the flashgun is positioned close to the camera lens and pointed straight at the subject, much of the light will be reflected back at the lens by these particles, producing a 'snowstorm' effect in the final image. The remedy is to position the flashgun above the subject and at an oblique angle, approximately 45 degrees, thus ensuring that any backscatter from the particles is directed at the flash and not the lens. When pointing the flashgun, the photographer must also be aware of the effects of refraction, particularly when working at a distance from the subject. It is important not to aim at the 'apparent distance' of the subject, which appears to be closer than it actually is, but about 50 per cent beyond it.

'O' rings

Cameras, whether amphibious or housed, require 'O' rings as a seal to keep the water out. Part of general camera maintenance and dive preparation is the cleaning and lubrication of the 'O' rings in the camera, housing, and flash body. It is often assumed that more silicone grease on the 'O' ring will produce a better seal, but this will attract more dirt and debris; the 'O' ring should only be lubricated lightly until it shines. As some manufacturers now use silicone-based 'O' rings which require more regular greasing to prevent them drying out and shrinking, it is essential to check in the instruction manual whether the material used is silicone or neoprene rubber. When equipment is left unused for long periods the main 'O' rings should be removed and stored in plastic bags to prevent them becoming deformed by long-term compression.

Safety

For any dive, safety must be the prime consideration, and it is important to have a reasonable level of experience and proficiency before taking the plunge. Just as in land photography, improving results will come with patience and attention to detail, and perfecting each technique before moving on to the next. MW

Cousteau, J.-Y., *The Silent World* (1953).

Howes, C., *Images Below* (1996).

Webster, M., *Art and Technique of Underwater Photography* (1998).

Edge, M., *The Underwater Photographer* (1999).

Underwood & Underwood, American stereographic company. In 1880, the brothers Elmer (1860–1947) and Bert (1862–1943) Underwood founded a firm in Ottowa, Kansas, to distribute stereos by Charles Bierstadt, the Littleton View Co., and J. F. Jarvis. The head office moved to New York in 1891, and the firm began buying and making as well as distributing pictures; by 1901 it was producing 25,000 stereos a day and 300,000 stereoscopes a year. It also began to market boxed sets of pictures on religious, educational, and travel themes. From 1896 news photographs became an increasingly important part of the business, with *war, from the Graeco-Turkish conflict (1897) to the First World War, a particular speciality. Manufacture of stereos and lantern slides ceased in 1921, and the brothers retired in 1925. The stereo negatives and rights were sold to *Keystone, which published them with a 'V' prefix. In 1931 the firm was split into four separate entities. RL

Darrah, W. C., *The World of Stereographs* (1977).

United States of America

To 1920

The first four decades, 1839–80, of American photography are generally, if perhaps unfairly, seen as relatively insignificant when compared to the same period in Europe, when major developments were occurring. It is true that Americans, many, in fact, immigrants from abroad, emulated the medium's growth in England and France, but a closer examination of the American scene reveals dozens of key figures in the advancement of photography. These men (seldom women) were often chemists, engineers, and businessmen, and the emphasis therefore was on improving processes and equipment rather than on the development of a new art form.

*Portraiture predominated in the early years, and portrait studios sprang up in the major cities, New York, Boston, Philadelphia, and Cincinnati in particular. *Itinerant daguerreotypists roamed the back roads of rural America, and people generally marvelled at the idea of photographic likenesses, however uncomfortable long-sitting subjects might appear. Most of these photographers' names remain obscure or have been forgotten, their output scattered or lost. Fires were commonplace, and in 1852, for example, the *Anthony brothers' 'National Daguerrean Gallery' in New York was completely destroyed. Mergers, bankruptcies, and other commercial vicissitudes also often led to the destruction of stock. However, much has survived in private collections and in library and museum archives both large and small.

Recognizable names had begun to emerge as early as the 1840s. Mathew *Brady, for example, established a successful studio in New York, as did Jeremiah Gurney (1812–post-1886), Edward White, Alexander Beckers, Samuel *Morse, and John W. Draper (1811–82). In Boston, Albert *Southworth and Josiah Hawes began their celebrated firm in 1843. Edward Anthony with J. M. Edwards (1831–1900) established a successful daguerreotype business in Washington, DC, as did the *Langenheim brothers in Philadelphia. Early explorers of the Yucatán in Mexico, and John Charles Frémont

Arnold Genthe

Ruins of earthquake and fire,
San Francisco, 1906

on his various expeditions to the *American West, carried bulky photographic equipment. In 1849 Henry Hunt Snelling published *The History and Practice of the Art of Photography* and became the dominant spokesperson for photography in its first American decades. He launched *The Photographic & Fine Arts Journal* in 1851 and was general manager of E. & H. T. Anthony & Co., a major photographic supplier.

Westward expansion, beginning in earnest with the discovery of gold in California in 1849, resulted in the establishment of studios in San Francisco and scattered mining towns in the Sierra Nevada foothills. Key names of photographers in California such as Isaiah West *Taber, Robert Vance, and J. Wesley Jones survive, although most of their work has not. In 1850 the important *Daguerreian Journal* (later renamed *Humphrey's Journal*) was begun in New York by Samuel D. Humphrey, and Americans won a number of awards in 1851 at London's Great Exhibition. The 1850s saw the arrival of the *wet-plate process, the invention of the *ambrotype and *tintype, and the beginning of stereo-mania. (In 1853, however, the *New York Herald Tribune* estimated that an annual 3 million daguerreotypes were being made nationwide.) In 1855 Charles A. Seely, ultimately a holder of many photographic patents, founded the *American Journal of Photography*, and in 1858 George B. Coale published what was essentially the first how-to book for the growing numbers of amateur photographers, called simply *A Manual of Photography*. The same year saw the foundation of the American Photographic Society, mainly an association for amateurs. The Cooper Institute of New York City and the Franklin Institute of Philadelphia became centres of photographic activity.

The years 1859–60 saw the introduction of the *carte de visite* from Europe, which within months, with various kinds of patent *albums, became the object of an immense craze. Brady alone sold tens of

thousands of *cartes* through his various studios, and Oliver Wendell *Holmes described them as 'the social currency, the sentimental "greenbacks" of civilisation'. Besides giving a huge fillip to commercial photography, the *carte* revolution ended the long heyday of the American daguerreotype and consolidated the ascendancy of the wet-plate process. The Civil War (1861–5) marked a significant stage in the emergence of *photojournalism, *war photography, and, often in response to military needs, *documentary and survey work. Brady is the best known of many photographers covering the conflict, though he fielded many employees to do much of the actual work. Another war photographer, Alexander *Gardner, was initially an employee of Brady's. Later he founded his own business and gallery, and photographed Lincoln, Supreme Court justices and other dignitaries, and Native Americans visiting Washington.

Continuing fascination with the West resulted in a broadening of the concept of *landscape photography. One of its best-known early practitioners was Carlton E. *Watkins, one of the first to photograph in the now fabled Yosemite region, using a *'mammoth-plate' camera. Timothy *O'Sullivan, who had worked for both Brady and Gardner, furthered the development of western landscape photography as a member of the King and Wheeler US Geological and Geographical Surveys (See AMERICAN WEST, PHOTOGRAPHY AND THE (FEATURE)). Other celebrated survey photographers were E. O. Beaman, Jack *Hillers, and William Henry *Jackson. In 1871 Jackson photographed what were to become—in large part owing to his influential pictures—the *Yellowstone and Grand Teton National Parks. Also in the post-Civil War years, Gardner, Andrew J. Russell (1830–1902), Alfred A. Hart (1816–1908), the English-born John Carbutt, and others inaugurated the first great era of American *railway photography.

American photographers were quick to assimilate developments in Europe. Men such as John A. Whipple (1822–91) of Boston

competed for patents, and there were frequent debates between Americans and Europeans over who created or perfected a method first. As new techniques were developed, fierce legal battles sometimes ensued. One of the most notorious and protracted of these involved James Cutting of Boston, who held patents to the ambrotype, photolithographic, and bromide processes. Especially his bromide patent, covering a method of considerably accelerating the wet-plate process, became the bane of most practising photographers' and photographic businesses' existences for nearly twenty years from 1854 to Cutting's death in 1867. Rallying at the National Photographic Convention in 1868 in New York, prominent photographers and businessmen fought the renewal of Cutting's patent and ultimately won. From this fraternal effort emerged the National Photographic Association (succeeded later by the National Photographers' Association and, in 1880, by the Photographers' Association of America). Its secretary was Edward L. Wilson (1838–1903), who emerged in the 1870s as the key spokesman for photography in the USA. In 1864 he had launched the journal *Philadelphia Photographer* (which became *Wilson's Photographic Magazine* in 1889 and the *Photographic Journal of America* in 1915). In 1876, with his friend William *Notman, Wilson organized photography's successful showing at the Philadelphia Centennial Exposition.

The 1870s and 1880s saw a proliferation of new and improved methods and equipment, new business groupings, and new markets (for example, the college graduation photograph). By 1875 the magic lantern had become widespread in entertainment and education. In 1877–8 Eadweard *Muybridge developed a practical method of photographing horses in motion. Electric lighting in studios became prevalent in the early 1880s, and as *dry plates with shorter exposure times boosted amateur photography, George *Eastman launched his *Kodak camera in 1888 and *celluloid *roll-film in 1889 (the famed *Brownie would arrive in 1900). By October of that year, Eastman Kodak was getting back 60–75 Kodaks a day, and processing 6,000–7,000 negatives. The company's monopoly became so great that other notable makers of small cameras have been forgotten. William Schmid, for example, patented the first American hand-held camera in 1883, and the Boston Camera Company, *c.*1888, offered the Hawkeye. The advent of celluloid film in the 1880s occasioned yet another legal marathon. Settled finally in 1914, the key contenders for patent rights to celluloid included—among many—George Eastman, the heirs of the Revd Hannibal Goodwin, and the Ansco Company (formed in a merger of E. & H. T. Anthony and Scovill & Adams). Also emerging in the late 1880s were a number of new journals, among them *American Amateur Photographer*, *Photo-American*, and *Photo-Beacon*. Finally, one other significant event in this period was the publication, on 4 March 1880, of a small picture of Manhattan's Shantytown by means of the *half-tone process. It appeared in the *New York Daily Graphic* on the initiative of Stephen Horgan (1854–1941). Although the process did not become a regular feature of newspapers until 1897, it then became the mainspring of the modern photographically illustrated press.

As the Gay Nineties gathered momentum, and tremendous wealth became commonplace in big cities, posh galleries were opened by men like Benjamin J. Falk in New York and J. C. Strauss in St Louis. Amateurs proliferated, many of them, like Francis Cooper (1874–1944) of Philadelphia, combining their hobby with another *fin de siècle* craze, cycling. But at the other end of the urban spectrum Jacob *Riis and the equally effective Frances B. *Johnston and Lewis W. *Hine were engaged in documenting the condition of workers in New York's sweatshops and Pennsylvania's mines. Especially Riis's *How the Other Half Lives* (1890) had a tremendous impact on thinking Americans. In the meantime, *pictorialism emerged as the predominant aesthetic style in the 1890s, and the turn of the century saw the emergence of 'New Schools' of photography with Alfred *Stieglitz as the chief American exponent of the doctrine of photography as a fine art. Discouraged by the conservative amateurism of organizations like the New York Camera Club, Stieglitz broke free to establish the celebrated *Photo-Secession in 1902. His *Camera Notes* and, later, *Camera Work* (1903–17) effectively dominated the art photography world for nearly two decades. Although key exhibitions were held in other cities like Philadelphia and Buffalo, New York, largely thanks to Stieglitz, became the principal centre of art photography.

Especially after the celebrated International Exhibition of Pictorial Photography at the Albright Museum, Buffalo, in 1910, leading photographic artists began to break with Stieglitz over his growing inflexibility and emphasis on a *'straight' approach in photography. Gertrude *Käsebier, Clarence H. *White, Karl *Struss, Alvin Langdon *Coburn, and F. Holland *Day pursued a more soft-focused emphasis and *Platinum Print*, a journal reflecting their views, started in 1913.

Taft, R. M., *Photography and the American Scene: A Social History, 1839–1889* (1938; repr. 1964).

Jenkins, R., *Images and Enterprise: Technology and the American Photographic Industry, 1939–1925* (1975).

Welling, W., *Photography in America: The Formative Years, 1839–1900* (1978).

Sandweiss, M. A. (ed.), *Photography in Nineteenth-Century America* (1991).

Wood, J. (ed.), *America and the Daguerreotype* (1991).

Ruby, J., *The World of Francis Cooper, Nineteenth-Century Pennsylvania Photographer* (1999).

Sternberger, P. S., *Between Amateur and Aesthete: The Legitimization of Photography as Art in America 1880–1900* (2001).

Since 1920

While few photographers were actually given shows within its confines, Stieglitz's An *American Place (1929–46) was, during its lifetime, arguably the single most important determining force in American art and photography. It and Stieglitz were the focus of great attention, whether admitted by all concerned or not. All three of Stieglitz's venues, *Gallery 291, the Intimate Gallery, and An American Place, were used to introduce European *modernism into the American consciousness. Politics and personalities inevitably clashed, and the painter Max Weber, and a number of photographers, as already noted,

broke from the brilliant but domineering Stieglitz to go their own way, some to form the Pictorial Photographers of America in 1916. Nevertheless, the prevalent direction in American photography through the first four decades of the century—if not beyond—was provided by Stieglitz.

Edward *Steichen, a young and close associate of Stieglitz at the founding of 291 and *Camera Work*, became in particular something of a bridge from the early Stieglitz era into the 1930s and the war years, and Paul *Strand, to whom the last issue of *Camera Work* was devoted, carried much of Stieglitz's formal and aesthetic sense into the middle of the century as he roamed the world, the American abroad. The Stieglitz charisma extended to the West Coast where in 1931 the *Group f.64 , in protest over the persistence of soft-focus pictorialism, sought to celebrate 'straight photography'—the idea that the defining attributes of the other fine arts, painting in particular, need not be applied to a photograph to render it an acceptable *objet d'art*. Ansel *Adams travelled east to meet with the revered Stieglitz. The latter granted him a one-man show in 1936. Like Stieglitz, but with perhaps a more amiable personality, Adams exercised a guru-like charisma; his disciples appeared first on the West Coast but were soon everywhere. The *Friends of Photography, of which Adams was a primary founder, existed until 2001. Via Adams and, to a certain extent, in the photographs of Edward *Weston on the West Coast (and into the south-west through the paintings of his wife Georgia O'Keeffe), much of Stieglitz's thinking, including his philosophy of 'equivalents', would span the continent. However, it was Adams who brought to light the writings of the conservationist John Muir (1838–1914) and the sense of the American West. As Strand had reflected the visionary humanism of Walt Whitman, so Adams celebrated the wilderness of Muir.

The Great Depression, following the stock market crash of 1929, fostered, interestingly, some of the greatest *documentary photography of all time. The Farm Security Administration, beginning in 1937, sponsored the work of Walker *Evans, Dorothea *Lange, Russell *Lee, Carl *Mydans, Arthur *Rothstein, Ben *Shahn, and others.

Steichen went on to great success in *celebrity portraiture and *fashion photography, something Stieglitz could not fully understand. Louise *Dahl-Wolfe and Lee *Miller were two others of many who pioneered in the fashion genre, the latter even combining fashion and photojournalism as a war correspondent for *Vogue*. Steichen, acclaimed for his wartime photography, returned and wrested control of the new department of photography at MoMA, New York, from its first curator, Beaumont *Newhall, who in 1937 had mounted the first-ever survey of the history of photography in an American museum. A forgiving man and undaunted, Newhall went on to Rochester to direct the *International Museum of Photography, George Eastman House.

It was Steichen, too, as a dominant personality in photography through the middle of the century, who mounted perhaps the most talked about photography exhibition in history, *The *Family of Man*, which opened at MoMA in 1955. In its all-embracing style, the show was seen by many as something less than a celebration of the fine art of photography. Nonetheless, it capped Steichen's career and his vision for the world and, notwithstanding the inclusion of a huge transparency of an H-bomb test (the only colour image), embodied for millions of its viewers a sense of hope. It was in large part a reflection of the photojournalistic world. From Riis's *How the Other Half Lives* (1890) had been born a sociological use of photography that came to fruition in the journalistic magazines of the 1930s and 1940s. Margaret *Bourke-White, Robert *Capa, and, perhaps most prominently, W. Eugene *Smith figured in the public's mind as the pre-eminent photojournalists. The consciousness-raising attributes of the *photo-essay pervaded American thinking and seeing through the post-war years, and on into the tumult of the 1960s and 1970s when television helped to kill off magazines like *Life, Look, and the *Saturday Evening Post*.

In 1952, Minor *White founded *Aperture*, which became the pre-eminent journal of American art photography. It and the proliferation of fine-arts photography courses in colleges and universities after 1945 were instrumental in assuring that photography as a fine art thrived. The Aperture Foundation went on to publish innumerable important monographs on individual photographers.

Steichen's successor at MoMA in 1962 was John *Szarkowski, and through his writing and exhibitions it was he who attempted the most penetrating explanations of developments in American photography into the 1980s. His 1967 exhibition *New Documents* noted an objectivity in the photography of people which moved beyond the optimism all but demanded of viewers by Steichen in *The Family of Man*. Lee *Friedlander, Garry *Winogrand, and Diane *Arbus, the featured photographers of the Szarkowski show, observed human beings, but reform is not suggested, and we are never lectured or told how to respond. Szarkowski went on to analyse what he perceived to be an emergent dichotomization in American photography in his 1978 exhibition *Mirrors and Windows*. He noted that artists like Jerry *Uelsmann and Paul *Caponigro, two of dozens he cited, saw photography as a means of self-expression (a continuation, in a way, of the Stieglitz introspective approach via 'equivalents'), while others like Friedlander and Ken Josephson looked beyond themselves to explore and know the world. Robert *Frank's *The Americans*, published in the USA in 1959 with an introduction by Jack Kerouac, invited viewers to go on the road and challenged them to see America as it had really become. Winogrand accepted the challenge with a vengeance, as did Danny *Lyon and many artists. Szarkowski's bifurcating analysis is still useful as an approach to American photography, though, as Szarkowski himself pointed out, many artists can be seen moving back and forth along an imaginary axis between the 'mirror' and the 'window'. Szarkowski's point was that, while 'straight' photography was alive and well, many of the great photography teachers and mentors of the mid-century, notably Harry *Callahan, Minor White, Aaron *Siskind, and Frederick *Sommer, had moved into new creative realms and encouraged their students to follow.

Szarkowski's attempt to track photographic trends became increasingly problematic after the Vietnam years. While the war and related protests were covered in much the same way photojournalists had always covered conflict, the emergence of a questioning postmodernism in the arts and arts criticism in the 1970s and 1980s caused an explosion of styles that defied easy analysis. American photography also broke loose and, to mention only a few manifestations and artists, ranged widely from defiant image appropriation and manipulation (Sherrie Levine (b. 1947), Robert Heinecken (b. 1931)) to inventive artists' books (Ed Ruscha (b. 1937), Clarissa Sligh (b. 1939)). Text, sometimes polemical, was coupled with images (Duane *Michals, Allan *Sekula, Barbara Kruger (b. 1945)), and artists like Robert Rauschenberg, John Baldessari, and Bruce Nauman, primarily identified as creators in other media, incorporated photographs into their work in much the way Andy *Warhol had done in the Pop art era of the 1960s. Questions of individual and sexual identity were explored in new forms of portraiture (Cindy *Sherman, John Coplands, Robert *Mapplethorpe). Photographs were created in unique formats (Susan Rankaitis (b. 1949), Louise Lawler (b. 1947), Meridel Rubenstein), two-dimensional exhibitions gave way to sometimes controversial installations (Andres *Serrano, William *Christenberry), and venerable techniques such as pinhole imaging were resurrected and used in ways never imagined by 19th-century practitioners (Naomi Savage, Bea Nettles (b. 1946)). Groundbreaking journals were launched (*Afterimage*, *Artforum*), and theorists and critics (Susan *Sontag, A. D. Coleman) questioned long-held assumptions about photography and its intent and function in American society. Finally, the earlier explorations of Harold *Edgerton, Winston O. *Link, and others in high-speed photography and elaborate lighting portended the emergence of exploratory *digital photography. Meanwhile, as in other developed countries since the 1960s, picture taking became a near-universal activity by amateurs of all ages and social classes. By the 1970s, sociologists, historians, and others were trying to make sense of this torrent of images, photographic collections were being increasingly valued and made available, and the *market for classic (or just interesting) images was beginning to boom.

Following the *Civil Rights movement, but more evidently in the 1990s, young artists from African-American (Debbie Fleming Caffery (b. 1948), Carrie Mae Weems (b. 1953)), Native American (Carm Little Turtle (b. 1952), Jolene Rickard (b. 1956)), Asian American (Albert Chong (b. 1958), Dinh Q. Le (b. 1968)), Hispanic American (Louis Carlos Bernal (1941–93), Joseph Rodriguez (b. 1951)), and other minority communities, who had only occasionally been represented in mainstream American photography over the years (James *Van Der Zee, Gordon *Parks, Lee Marmon (1949–99)), began to be heard and seen. Those who had been the sought-after subjects—particularly Native Americans—were, in effect, claiming the right to take the pictures themselves.

Finally, the exploration of the fabled American West continued. There were rephotographic projects (Mark Klett (b. 1952), Gordon Bushaw, Rick Dingus) that attempted to locate and photograph from the exact positions of 19th-century survey photographers. The photographers included in the *New Topographics* show of 1975 coolly observed the impact of Americans on America, and John *Pfahl and Richard *Misrach photographed the impact of the human enterprise on the West in colour. By the early 1990s David Levinthal (b. 1949) was photographing toy cowboys and Indians using a giant Polaroid 20 × 24 cm ($7^9/_{10} \times 9^1/_2$ in) Land Camera. The American creative spirit was alive and well as it entered the new century. TT

See also NATIVE PEOPLES, PHOTOGRAPHY AND.

⮕ See also Photography and Slavery *overleaf*.

Smith, J., *The Photography of Invention: American Pictures of the 1980s* (1989).
Livingston, J., *The New York School: Photographs 1936–1963* (1992).
Alison, J., et al., *Native Nations: Journeys in American Photography* (1998).
Goldberg, V., and Silberman, R., *American Photography: A Century of Images* (1999).
Davis, K. F., *An American Century of Photography: From Dry-Plate to Digital: The Hallmark Photographic Collection* (2nd edn. 1999).
Willis, D., *Reflections in Black: A History of Black Photographers, 1840 to the Present* (2000).
Orvell, M., *American Photography* (2003).

unsharp masking. The idea of sharpening an image by adding an unsharp image to it seems like an oxymoron, but in fact it underlies almost all the methods of achieving this. In almost any optical image, the contrast falls off as the detail gets finer (see OPTICAL TRANSFER FUNCTION). Unsharp masking couples a negative with a positive transparency made from it, using a diffuse exposing light and a spacer between the two emulsions. The positive is developed to a low contrast, and printed in register with the negative (Fig. 1*a* and *b*). The negative contrast is effectively reduced everywhere but in the fine detail, which is unaffected. When the combination is printed on a more contrasty grade of print material, the overall contrast is as originally seen, and the contrast of the fine detail is enhanced (Fig.1*c* and *d*). The unsharp masking principle has carried over into scanning printers, which use a finite size spot and feedback contrast control of the spot intensity. More recently it has been extended to *digital scanners and printers, where it is now universally available. (See Fig. 1 on page 650.) GS

unsharpness. See FAULTS IN NEGATIVES, TRANSPARENCIES, AND PRINTS; SOFT FOCUS.

Ur-Leica (original Leica). Made by Oskar *Barnack *c.*1912–13, it was constructed of metal and used 35 mm cine-film in the double cine format of 24 × 36 mm ($1 \times 1^2/_5$ in). The supply and take-up spools were 25 mm in diameter and the shutter was a cloth roller blind type. Though intended for Barnack's personal use it attracted the attention of Ernst Leitz Jr., who on 12 June 1914 applied unsuccessfully for a patent. The *Ur-Leica* was the precursor of two further developmental models and the null-series Leicas of 1923–4 before the first production *Leica I (or Model A) camera appeared in 1925. MP

Photography and Slavery

In 1976 a group of remarkable early photographs was discovered in the attic of the Peabody Museum of Archaeology and Ethnology in Cambridge, Massachusetts. The fifteen *daguerreotypes depict five black men of African birth and two young African-American women, daughters of two of the men. The photographs had been hidden away for more than 100 years.

At first glance they appear to be conventional daguerrean portraits, of which millions were made in America during the 19th century. The presence of photographic furniture and a decorative carpet in some of the images indicates they were taken in a professional studio, while the leather and velvet-lined cases that were used to display and protect early photographs reinforce the impression that the pictures are conventional portraits. Yet there is evidence to suggest otherwise: the masklike expressions and stiff frontal and profile poses of those depicted are not at all typical of the genre; but, more strikingly, the subjects of the daguerreotypes were photographed with their clothing partially or in some cases fully removed, a clear sign that these photographs were not intended as family keepsakes. The men and women in the Peabody's daguerreotypes were not middle-class Americans seeking images of themselves or their loved ones, but slaves on Southern plantations. Discovered with the photographs were handwritten labels that make their status clear. Each label gives the name of the person photographed, the African tribe to which he or she was affiliated, and the name of his or her 'owner'. This information makes these the earliest known photographs of identifiable slaves.

The daguerreotypes were made in South Carolina in 1850 by J. T. Zealy (1812–93), a respected photographer in the state capital of Columbia. He catered to an elite clientele, including military officers and fashionable ladies, more than one of whom was moved to praise his skill with poetry. Zealy's client for the slave daguerreotypes was Dr Robert Wilson Gibbes, a physician and palaeontologist of national reputation who also collected daguerreotypes of famous people. It was Gibbes who wrote the labels, his role as physician to some of Columbia's leading citizens and their slave populations providing him with detailed knowledge of the slaves' identities. The photographs, however, were not for his own use, but commissioned on behalf of America's most famous natural historian of the time, Louis Agassiz (1807–73).

Arriving from Europe in 1846, Agassiz had captivated both the scientific community and the general public with his ability to describe and elucidate the most complex mysteries of nature. Seemingly an expert on all things, there was one area that was new to Agassiz, the so-called 'problem of the races'. Almost from the moment he arrived, Agassiz was caught up in the scientific debate about the origin of man and the cause of human diversity that took place in the decades before Darwin published his *Origin of Species* (1859), and

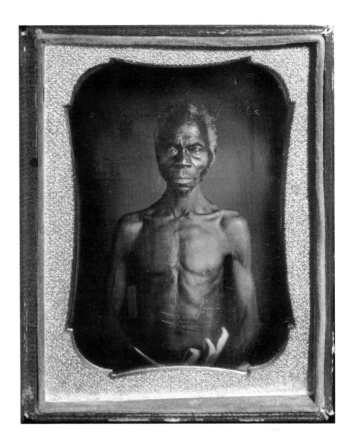

J. T. Zealy

Renty, a slave farmhand on B. R. Taylor's plantation at Edgehill, South Carolina, 1850. Daguerreotype

was of particular interest in racially mixed America. One theory, associated with the new discipline of ethnology, proposed that racial difference was the result of multiple acts of creation, or polygenesis. Although considered by many to be heretical and by others to be nonsense—the black abolitionist Frederick Douglass called ethnology 'scientific moonshine'—it was an idea that proved especially useful to Southern slaveholders and politicians, who in response to the rise of abolitionism sought an irrefutable defence of slavery. In 1850, at a conference in Charleston, South Carolina, Agassiz announced his support for polygenesis, and by virtue of his fame propelled the debate into the public arena.

Following the conference and his controversial announcement, Agassiz travelled to Columbia as the guest of Dr Gibbes to examine a number of slaves from nearby plantations in search of evidence to support his ideas on race. He was looking for proof that 'the Negro type' was essentially different from other races and, according to Gibbes, found what he was after.

It is uncertain how the idea of photographing the slaves came about, but it may well have been during another session in Zealy's studio. Gibbes persuaded Agassiz to sit for his daguerreotype so that he might add the great naturalist to his collection, and perhaps that experience led to the idea of photographing the slaves. Gibbes used his own collection to remind him of people he admired, and similarly

the slave photographs made by Zealy would have been useful reminders to Agassiz of the men and women he examined while in Columbia. The fifteen slave daguerreotypes were not intended to record the public face of individuals; they are not in fact portraits. Rather, their purpose as scientific documents was to contribute to a typology of human beings, a project that reduced the sitters to bodies representative of racial types. And yet the images fall short of this function as well. Dodging both the conventions of portraiture and the requirements of scientific evidence, Zealy's daguerreotypes manage to capture something more than the appearance of specific men and women by documenting aspects of the power relationship that characterized American slavery. In the event, the photographs seem never to have been used: Agassiz did not reproduce them for publication, nor did he keep them with other images of racial types that he collected later in his career. They were instead placed in a cabinet and forgotten. Perhaps, contrary to his expectations, and with great immediacy and intensity, the men and women in the daguerreotypes appeared all too human. MR

Reichlin, E., 'Faces of Slavery', *American Heritage*, 28 (1977).
Wallis, B., 'Black Bodies, White Science: Louis Agassiz's Slave Daguerreotypes', *American Art*, 9 (1995).
Banta, M., *A Curious and Ingenious Art: Reflections on Daguerreotypes at Harvard* (2000).

Fig. 1a, b

Fig. 1c, d

USSR in Construction (*SSSR na Stroike*), prestige Russian journal, published in Moscow 1931–41 and, with French, German, English, and Spanish editions, mainly directed at foreign readers. Usually each issue was devoted to a particular propaganda theme, e.g. *Rodchenko's December 1933 photo-essay on the *White Sea Canal, or Georgi *Petrussov's on the Red Fleet in January 1937. Rodchenko and *Lissitzky were among the designers, and photographers included Max *Alpert, Boris Ignatovich, Arkadi *Shaikhet, and Gyorgy *Zelma. RL

U-2 aircraft. See MILITARY PHOTOGRAPHY.

Uzzle, Burk (b. 1938). A self-taught American news photographer from North Carolina, Uzzle worked for the *Black Star news agency and *Life in the 1960s and 1970s. His increasingly recognized genius as an observer of American life began to give him independence, and in 1975 he received a grant from the National Endowment for the Arts. Moving beyond Robert *Frank, Uzzle observes ordinary people in innocent but quirky juxtaposition with each other and their surroundings. The resulting black-and-white images are often witty. In other work, reminiscent of Abstract Expressionist painting, shapes and patterns emerge in wondrous balance with actual people and places being photographed. TT

Uzzle, B., *All American* (1984).

Vachon, John (1914–75), American *documentary photographer, becoming so by accident. A student at Catholic University in Washington, DC, he joined the Farm Security Administration (FSA) in 1936 as a messenger and file clerk; when he showed interest in photography, Walker *Evans, Arthur *Rothstein, and Ben *Shahn taught him their skills. Vachon organized the FSA's extensive files, then officially became an agency photographer in 1940. Drafted into the army, he worked briefly for Roy *Stryker at *Standard Oil of New Jersey, and from 1948 was a staff photographer for *Life* and *Look* magazines. CBS

 O'Neal, H., *A Vision Shared: A Classic Portrait of America and its People, 1935–1943* (1976).

Valentine, James, & Sons, view- and *postcard-publishing firm of Dundee, Scotland. In 1851, James Valentine (1815–79) added a portrait studio to his engraving and stationery business, then in the 1860s started publishing *wet-plate Scottish views rivalling those of G. W. *Wilson. Identified with the initials J.V., they are usually of fine quality. Later, like Wilson, Valentine extended his reach throughout Britain. The business was continued by his son William (1844–1907), and in 1897, when it had 1,000 employees, began publishing postcards. After mixed fortunes in the 20th century, it was bought by Hallmark Cards Inc. in 1980, and the Dundee works closed in 1994. Valentine's view archive is at St Andrews University. RL

 Smart, R., 'James Valentine 1859–79', in M. Kemp (ed.), *Mood of the Moment: Masterworks of Photography from the University of St Andrews* (1996).

Van Der Zee, James (1886–1983), African-American photographer. He survived the post-Second World War collapse of studio portraiture by turning to photographic conservation, preserving an extraordinary archive of his own photographs that records the residents, customs, and key events of pre-war Harlem. Especially important are images of businesses, religious organizations, and social institutions such as Marcus Garvey's Universal Negro Improvement Association. Rediscovered in 1969 during research for the Metropolitan Museum of Art's exhibition *Harlem on my Mind*, Van Der Zee's legacy was assured through the establishment of an archive at Harlem's Studio Museum. CDH

 Willis, D., *Van Der Zee, Photographer* (1993).

Verascope. Hand-held *stereoscopic camera patented (1891) and manufactured by Jules Richard (1848–1930), Paris. The first model, launched in 1893, had twin f/8/55 mm lenses and used 45 × 105 mm

($1^{3}/_4 \times 4^{1}/_{10}$ in) glass plates in a twelve-plate cassette. The design was so successful that 78 regular models, plus seven larger-format (60×130 mm ($2^{1}/_4 \times 5$ in), 70×130 mm ($2^{3}/_4 \times 5$ in)) ones, were issued over 60 years. In all, 52,000 were made. The last, top-of-the-range F40 rangefinder (1939, introd. *c*.1946), of which 5,000 were manufactured, took 21 image pairs on a standard cassette of 35 mm film, with f/3.5/40 mm lenses and a shutter speed of 1/250 s. It had a matching stereoscopic viewer, and sold in the USA as the Busch Verascope F40. RL

 See also TAXIPHOTE; THREE-DIMENSIONAL PHOTOGRAPHY.

 Perrin, J., *Jules Richard et la magie du relief* (2 vols., 1993, 1997).

Verger, Pierre (1902–96), French photographer and ethnographer, sensitive observer of and authority on Afro-Brazilian culture, especially the Macumba sect Candomblé. Born into an upper-middle-class family in Paris, he travelled extensively from 1932, to the USSR, Haiti, West Africa, and Polynesia. He published his first works in conjunction with the Paris Musée d'Ethnographie in the 1930s, but also published travel reportages in *Paris Soir*, *Match*, and the *Daily Mirror*. In 1937 his photographs were included in the *Photography 1839–1937* exhibition at MoMA, New York. In 1946, in Salvador de Bahia, he first encountered Candomblé, encouraged by Roger Bastide and Jorge Amado. Both there and among the Yoruba in Benin, he was made a Candomblé priest. His first major work, *Deux Afriques*, appeared in Paris in 1954. In 1979 he became an honorary professor at Salvador University. His house and collection—comprising over 65,000 pictures and documents—now belong to a foundation. JB

 Verger, P., *Notes sur le culte des Orishá et Vodun à Bahia, la Baie de Tous les Saints au Brésil, et sur l'ancienne Côte des Esclaves en Afrique* (1957).

 Andrade, R. de, *Fotografia e antropologia* (2002).

Vienna Camera Club. See VIENNA TRIFOLIUM.

Vienna Trifolium. An offshoot of the *pictorialist Vienna Camera Club that had been founded (as the Club der Amateur-Photographen in Wien) in 1887. The Trifolium's members were Hugo *Henneberg, the Innsbruck-based Heinrich *Kühn, and Hans Watzek (1848–1903), and began to be designated as such in 1898. (They also started signing their work with a three-leaved clover.) Specializing in variants of the complex *gum bichromate process, they travelled together to various European countries between 1897 and 1903 and cultivated relations

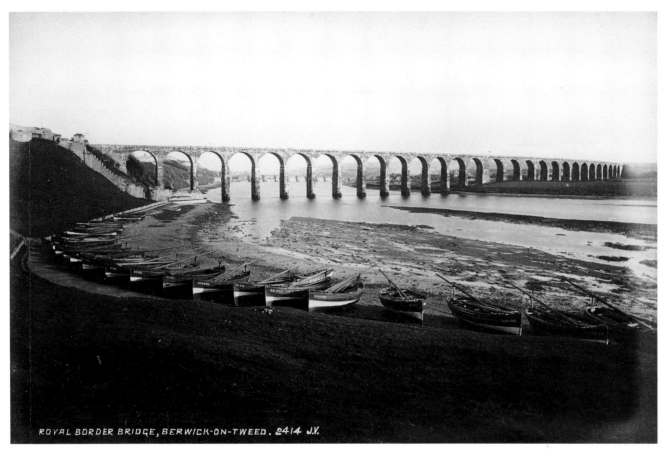

James Valentine & Co

Royal Border Bridge, Berwick-on-Tweed, late 19th century. Albumen print

with the *Linked Ring in London, James Craig *Annan in Glasgow, and *Stieglitz in New York. They also exhibited with the Vienna Secession and published work in *Ver Sacrum* (Dec. 1902). The group's existence effectively ended with Watzek's death in May 1903. Although relatively short-lived, it was remarkable both for the quality of its members' work and for its range of international contacts. RL

 Auer, A., 'The Wiener Trifolium: Hans Watzek, Heinrich Kühn and Hugo
 Henneberg', in J. Lawson, R. McKenzie, and A. D. Morrison-Low (eds.),
 Photography 1900: The Edinburgh Symposium (1992).

view camera. See FIELD CAMERA.

View from the Study Window (*Point de vue du Gras à Saint-Loup de Varennes*), by Joseph Nicéphore *Niépce. Niépce had attempted since 1816, using various materials, to capture images with a home-made camera obscura pointed out of his study window. But in the summer of 1827 he was able to use a more advanced instrument with a double convex lens that he had bought in Paris the previous February. In it he exposed a pewter plate thinly coated with bitumen of Judea

apparently for *c*.2–3 days, after which the dark portions of the image where the bitumen had remained soft were rinsed away with a mixture of turpentine and lavender oil. The result was a laterally reversed image measuring 16.5 × 19.7 cm (6¹/₂ × 7³/₄ in) that appeared positive when viewed obliquely.

 At the end of his unsuccessful visit to London in 1827–8, Niépce gave this and other examples of his work to the botanist Francis Bauer, who noted on the back of the plate, 'Monsieur Niépce's first successful experiment of fixing permanently the Image of Nature.' After Bauer's death in 1841 it passed through various hands, eventually reaching Henry Baden Pritchard, the editor of *Photographic News*. On 15 February 1952, after over half a century of obscurity, it was rediscovered in a trunk owned by Pritchard's son by Helmut and Alison *Gernsheim. Helmut wrote afterwards, 'I had reached the goal of my research and held the foundation stone of photography in my hand.' However, the plate was so hard to read that P. B. Watt of the Kodak Research Laboratory, Harrow, was asked to photograph it. He did so with great difficulty, and produced what Gernsheim described as 'a travesty of the truth'. Gernsheim himself then

Joseph Nicéphore Niépce

View from the Study Window, 1827.
Copy by Ken Philips, 1987

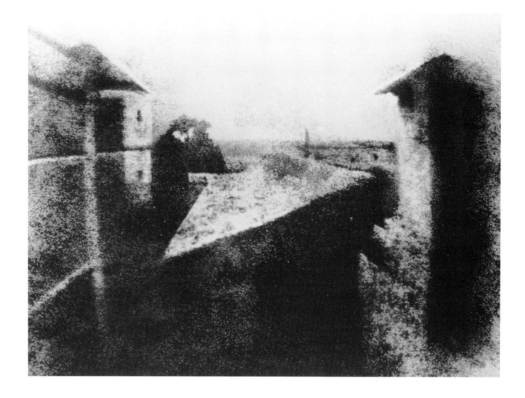

laboriously touched up a print with watercolour, publishing it in his *Origins of Photography* (1952) as 'the world's first photograph'; as such, it subsequently reappeared in countless other publications. In 1964 Niépce's original plate went with the rest of the Gernsheim Collection to the Harry Ransom Humanities Research Center, University of Texas, Austin.

Although Niépce's other surviving 'heliographic' works, his contact-printed copies of engravings, were probably earlier than *View from the Study Window*, the latter may well be the first surviving *camera* image. Another, *Table Set for a Meal*, on glass and known only from reproductions, was destroyed in 1909. Whether it either pre-dated *View from the Study Window* or was made by Niépce is unascertainable. RL

See also INVENTION OF PHOTOGRAPHY.

Batchen, G., *Burning with Desire: The Conception of Photography* (1997).
Koetzle, H.-M., *Photo Icons: The Story behind the Pictures*, 1 (2002).

vignetting. See FALL-OFF AND VIGNETTING.

vintage print, a *market term, current since the 1970s, denoting a photographic print made by or under the supervision of the photographer within about five years of the negative's creation. It is much more valuable than *later* or *modern* prints done later in the photographer's life, or *estate* prints executed posthumously. The vintage print's special aura among dealers and collectors derives partly from its greater rarity (except, usually, in the case of contemporary work); partly from the sense that it encapsulates the photographer's original vision, and results from technical choices available when the picture was taken. Moreover, in the case of the 'old masters' of 19th- and 20th-century photography, silver-rich older papers produced greater tonal depth than modern materials can achieve.

However, although the term is useful for demarcating a finite number of items within a photographer's oeuvre, it masks various complexities. Not all photographers have been dedicated darkroom workers. Early *advertising photographers and *photojournalists—before their work became collectable—often left printing to others; and their prints were frequently defaced, cropped, and ultimately discarded by magazines and agencies. In other cases too—for example Bellocq's *Storyville portraits—only negatives may have survived. By contrast, some photographers have honed their skills and changed their approach to printing over a long career; Bill *Brandt and Ansel *Adams are classic examples.

In the late 20th century it became increasingly common for photographers, like printmakers, to produce limited editions of their prints. At the beginning of the 21st, the art trade faces the need to devise criteria of value suited to the conditions created by *digital imaging. RL

Badger, G., *Collecting Photography* (2003).

Visa pour l'Image. See EXHIBITIONS AND FESTIVALS OF PHOTOGRAPHY.

Vishniac, Roman (1897–1990), Russian-born American photographer. A biologist, photomicrographer, and art historian, Vishniac left Russia for Berlin in 1920, and pursued a career in *photojournalism. From 1934 to 1939 he photographed the Jewish shtetls of Eastern Europe, a project that he later depicted as a conscious act of resistance against Nazism and attempt to memorialize his people in the face of genocide. He took over 5,000 pictures, often coming into conflict with the authorities. He emigrated to the USA in 1940 with negatives sewn into his coat, and in New York worked in photomicrography, portraiture, and teaching. MR

See also HOLOCAUST, PHOTOGRAPHY AND THE (FEATURE).

Vishniac, R., *A Vanished World* (1983).

Visible Human Dataset. See MEDICAL PHOTOGRAPHY.

visual literacy. See EDUCATION, PHOTOGRAPHY IN.

Vivex process, the only process to become commercially available for producing full-colour *carbro prints. The Vivex company was founded *c.*1930 by D. A. *Spencer, who had patented a number of modifications to the process, including a simplified chemical procedure, and the temporary support of the cyan, magenta, and yellow images on cellophane, the flexibility of which simplified the registration of portraits made with three successive exposures using the cumbersome repeating-back system. Vivex later marketed a one-shot camera using dichroic beamsplitters, and colour portraitists such as Mme *Yevonde used this with great success until the company's Willesden processing plant closed on the outbreak of the Second World War. In *Madame Yevonde: Colour, Fantasy and Myth* (1990), Pam Roberts describes both the complexities of the original process and the creation of modern *dye transfer prints from Yevonde's negatives. GS

Coote, J., *The History of Colour Photography* (1990).

VIVO agency (July 1959–June 1961), Japanese photographer-managed agency, based in the Ginza district of Tokyo, created by Shomei *Tomatsu, Eikoh *Hosoe, Ikko *Narahara, Kikuji *Kawada, Akira Sato, and Akira Tanno, who had participated in Tatsuo Fukushima's *Eyes of Ten* exhibition. They shared studio space and pushed forward the boundaries of art and *documentary photography, developing a modern, uniquely Japanese style. Deep blacks, high-contrast images, and unusual camera angles typified their work. At a highly charged moment in Japanese history their subject matter—whether nudes, political rallies, or the city of Nagasaki—reflected their conflicting feelings towards the Western influences pouring into the country; each photographer in his own way conveyed his political and personal defiance. Although VIVO was short-lived, its influence was extensive and drew Daido *Moriyama to Tokyo, amongst others. MHV

Vogel, Hermann Wilhelm (1834–98), German photo-chemist. In 1860, after earlier studies in Frankfurt an der Oder and Berlin, he became interested in photo-chemistry and in 1862, after visiting the World Exhibition in London, published a report on the current state of photography. In 1863 he obtained a doctorate in photo-chemistry and founded the Photographic Association in Berlin. (A breakaway group, the German Photographers' Association, was formed in 1867.) In 1864 he founded the technical journal *Photographische Mitteilungen*, and edited it for many years. Vogel passed on his encyclopedic knowledge in lectures at the Berlin Polytechnic, numerous articles, and the four-volume *Text-Book of Photography* (*Lehrbuch der Photographie*, 1867–70). His research led to the development of the *orthochromatic plate (1873), and in 1884 to the panchromatic plate, equally sensitive to all the colours of the spectrum. He travelled widely and served on the juries of many photographic exhibitions. In the 1890s he published a four-part *Handbook of Photography*. JJ

Herneck, F., *Hermann Wilhelm Vogel* (1984).

Vogel, Lucien (1886–1954), French magazine publisher, editor, and photographer. He began as art director of various publications before becoming editor of *Art et décoration*, then in 1911 founded the luxury lifestyle magazine *La Gazette du bon ton* and became associated with Condé Nast, the publisher of *Vogue. When French *Vogue* appeared in 1920, Vogel's wife Cosette de Brunhoff became editor, and Vogel served as art director from 1922 to 1925. In 1928 he founded the magazine *Vu, but was eventually forced out by its conservative backers. After emigrating to the USA he worked for *Free World*, but in 1945 returned to France and ran *Jardin des modes*. RL

Travis, D., and Phillips, S. S., *André Kertész* (1985).

Vogt, Christian (b. 1946), Swiss photographer, trained at the Basel Design School, who assisted the American photographer Will McBride in Munich before launching himself in Basel in 1970. He has done advertising, editorial, and experimental work, playing with the idea of the picture-within-a-picture (*Without Title*, 1975), and reacting against the conventions of mass-market glamour photography. For *In Camera* (1982) he invited 52 women to realize their own erotic self-images in a bare space with a packing case as sole prop. 'For me', he wrote, 'being erotic did not necessarily mean being naked—no-one had to undress.' RL

Vogue. The stature of *Vogue* as primary fashion reporter for the world of haute couture, its elite readership, and the willingness of its editors to commission high-style commercial art made it a leader in the development of *fashion photography. Condé Nast bought the society weekly in 1909 with the aim of turning it into an influential fashion magazine. In 1913 Nast hired the *pictorialist glamour portraitist Adolphe de *Meyer as his first fashion photographer, and his work appeared next to established fashion illustrators. Edward *Steichen's appointment as chief photographer for Nast Publications in 1923 inaugurated a more modernist trend. The following two decades were dominated by photographers who blended a sophisticated modern approach with dramatic *Hollywood glamour (Steichen, Cecil *Beaton,

George *Hoyningen-Huene, Horst P. *Horst) and others influenced by *Surrealism (Erwin *Blumenfeld, André Durst, George Platt *Lynes, and *Man Ray). After 1945, some photographers continued to make spare, elegant modernist images (Irving *Penn); others strove for a more natural look, following the style pioneered by Martin *Munkácsi at *Harper's Bazaar, Vogue's chief rival. John Rawlings, for example, used daylight, and Richard *Avedon incorporated a sense of motion. The 1960s were marked by a variety of new directions, from street photography (James Moore), to urban grittiness (William *Klein), to the casual (Jeanloup *Sieff), to sharply outlined colour and geometry (*Hiro). Moodiness and psychological complexity arrived in the 1970s with the soft, grainy images of Deborah Turbeville and Sarah *Moon, and more overtly suggestive or sexualized tableaux by Guy *Bourdin and Helmut *Newton, particularly in the European editions of the magazine. The fashion photographers worked closely with the many high-profile art directors and editors who shaped Vogue's direction, from Edna Woolman Chase and M. F. Agha in the 1920s to Alexander *Liberman, Diana Vreeland, Grace Mirabella, and Anna Wintour later. Almost from its beginnings, Condé Nast Publications expanded continually by publishing many international editions of Vogue and adding other titles to its line. Despite strong competition, Vogue remains the foremost reporter of the high-fashion world and patron of cutting-edge fashion photography. PJ

Vogue Book of Fashion Photography, 1919–1979, text by P. Devlin, introd. A. Liberman (1979).

Seebohm, C., The Man who was 'Vogue': The Life and Times of Condé Nast (1982).

Voigtländer, Peter Wilhelm Friedrich von (1812–78), German optical manufacturer. The Voigtländer firm was founded in Austria in 1756 by Johann Christoph Voigtländer (1732–97), originally to make scientific instruments. It was continued by his son Johann Friedrich (1779–1859), who started lens manufacture in 1808, and, in 1837, by his grandson Peter Wilhelm Friedrich. He saw photography as a new market for optics and agreed to produce Josef *Petzval's newly computed photographic portrait lens in 1840. The Petzval lens was an immediate success, being up to twenty times as fast as its contemporaries, and by 1850 some 8,000 had been produced. The f/3.6 Petzval lens with a focal length of 150 mm was fitted by Voigtländer to a metal *daguerreotype camera in 1841, of which c.670 were made.

Voigtländer and Petzval quarrelled in 1845 over finance and, partly to avoid litigation, Voigtländer opened a branch optical works in Brunswick in 1849. Some 60,000 Petzval-type lenses were produced over the next twenty years. The Vienna branch was closed in 1866, and Voigtländer was ennobled by the Austrian emperor. He retired from the business in 1876 and it was carried on by his son, Friedrich Ritter von Voigtländer (1846–1924). The company continued to manufacture photographic optics and cameras and was taken over by Zeiss Ikon in 1965. The rights to the name were subsequently sold to Japan. MP

Vortograph, *abstract photograph made by Alvin Langdon *Coburn using a device incorporating three mirrors placed between camera and subject. Eighteen of these kaleidoscopic images were shown at the London Camera Club in February 1917, causing a furore. The show also created a rift between Coburn and his former ally Frederick *Evans. But Coburn had been moving towards abstraction since c.1910; the dizzyingly modern pictures he took from New York skyscrapers in 1912 were influenced by Cubism. In the First World War he encountered the volatile, Cubist- and Futurist-influenced Vorticist movement, and in 1916 made a portrait of one of its leaders, Wyndham Lewis. In a programmatic essay in Photograms of the Year (1916), 'The Future of Pictorial Photography', Coburn proposed an exhibition of entirely abstract photographs.

The term 'Vortograph' was coined by the poet Ezra Pound. In the catalogue introduction for Coburn's show, he proclaimed: 'the camera is freed from reality'. RL

Steinorth, K. (ed.), Alvin Langdon Coburn, Photographien 1900–1924 (1998).

Christie's, London, Catalogue 6717: Photographs (21 May 2003).

voyeurism, particularly in film and cultural studies, has attracted much debate since the 1970s, often invoking psychoanalytical theories (see THEORIES OF PHOTOGRAPHIC MEANING). However, it can be straightforwardly defined as the pleasurable, illicit observation of someone else's intimate acts, usually but not necessarily sexual. The unguardedness of the person(s) observed is key to the observer's thrill. The use of a camera—for example by a *paparazzo—exposes it to a potentially unlimited number of others. Stereographs and the apparatus needed to view them enhance the sense of intrusiveness still further: in the words of one collector, 'You can collect photography only if you are a Peeping Tom . . . With stereo you really dig in.' Much *erotic photography and *pornography has sought to create the illusion that its subjects' nudity and/or sexual abandon are being captured unawares. An example of the real thing is Merry Alpern's Dirty Windows (1995): grainy images of business in a Manhattan brothel taken surreptitiously from an adjacent building. Two Hollywood films, Manhunter (Michael Mann, 1986) and One Hour Photo (Mark Romanek, 2002), explore their protagonists' voyeuristic obsession with families whose lives they have entered—as lab technicians—through the medium of private photographs. RL

Sturken, M., and Cartwright, L., Practices of Looking: An Introduction to Visual Culture (2001).

'Das geoffnete Kleid: Scham und Voyeurism in der Fotografie', Fotogeschichte, 92 (2004).

Vu. Left-of-centre French illustrated weekly launched on 21 March 1928 by Lucien *Vogel. In its first year alone, it published 3,324 photographs. Estimates of its peak circulation range from 300,000 to 450,000. In the 1930s Vu supported the French Popular Front and the Spanish Republic, and on 23 September 1936 published Robert

Alvin Langdon Coburn

Vortograph, 1917

*Capa's celebrated *Falling Soldier*. Other contributors included James *Abbe, *Brassaï, *Cartier-Bresson, *Krull, *Kertész, and *Man Ray, and the writers Colette and Pierre *Mac Orlan. Art director from 1933 to 1936 was Alexander *Liberman, who transformed *Vu*'s appearance with dynamic, Soviet-influenced photomontages. After he left, and Vogel sold the paper (1936), it lapsed into conservatism, and closed after France's defeat in 1940. RL

Aubry, Y., 'Magazines et photographie, 1928–1940', *Zoom*, 88 (1981).

Osman, C., and Phillips, S. S., 'European Visions: Magazine Photography in Europe between the Wars', in M. Fulton (ed.), *The Eyes of Time: Photojournalism in America* (1988).

Vuillard, Édouard (1868–1940), French painter. Like other artists of his generation, including *Bonnard and Vallotton, Vuillard became an amateur photographer during the 1890s. Using a hand-held *Kodak, he recorded the activities of his domestic circle. The technical challenge of photographing interiors using natural light demanded that subjects engaged in routine leisure pursuits 'pause' during exposure of the negative. As a result, Vuillard's photographs retain the studied spontaneity of his decorative, *intimiste* canvases. For Vuillard, photography served a dual purpose: it was both a means of documenting family life and an artistic exercise. KM

Salomon, J., *Vuillard et son Kodak* (1964).

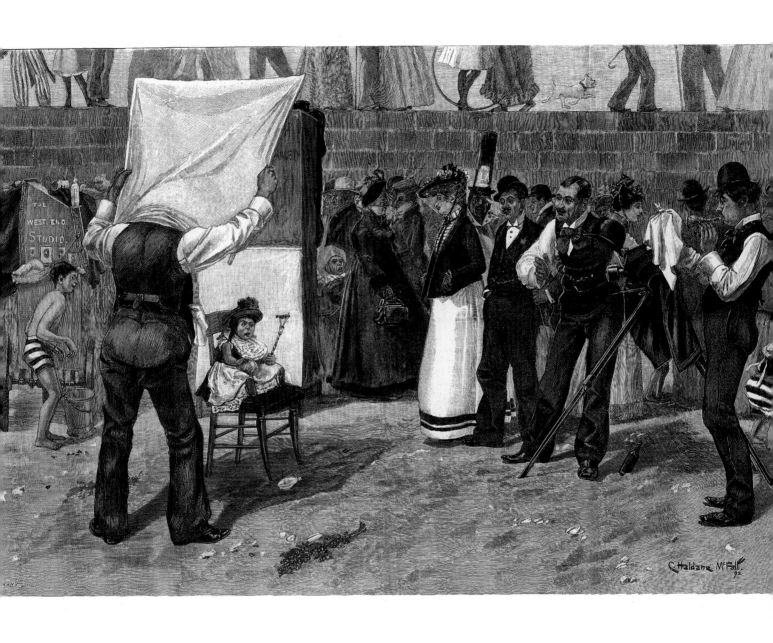

C. H. McFall British bank holiday scene, from *Illustrated London News*, 6 August 1892

Heather Angel Emperor penguins in Antarctica, 1994

Wadenoyen, Hugo van (1892–1959), Dutch-born British photographer, and author of numerous books on portraiture, lighting, and general photography. He belonged to the *Royal Photographic Society, but in the 1950s broke away from mainstream neo-*pictorialist conventions in favour of a more informal, candid approach. As a prominent figure in the photography club scene he favoured inviting outsiders to judge competitions, and influenced young British photographers of the 1950s, notably Roger *Mayne. His *Wayside Snapshots* (1947) included a brilliant essay on the pleasures of spontaneous picture-making. KEW

Wall, Jeff (b. 1946), Canadian artist, born and resident in Vancouver. Working with photography since the late 1970s, Wall's modus operandi is akin to that of the conductor or film director, enabling actors, props, landscapes, and light to work in unison. His work consists of painstakingly *staged and composed photographs, sometimes involving *digital manipulation, realized as large-scale colour transparencies and displayed on lightboxes like those used in advertising. They explore contemporary social and political realities—poverty, class and gender conflicts, racist violence, urban living conditions. In constant dialogue with historical art forms, genre painting in particular, and with cinema, Wall creates complex, often enigmatic visual narratives of modern life. Often 'documentary'-seeming at first sight, they frequently cross the borders between the real and the fictive, the journalistic and the phantasmagoric. *Mimic* (1982) is a constructed 'street photograph' of a racist encounter; *Dead Troops Talk* (1992) a panoramic after-death fantasy retelling the ambush of a Red Army unit in Afghanistan. Often using locations in multicultural Vancouver, Wall's oeuvre renders his perception of the contemporary human condition with disturbing precision: the isolated, lonely individual, unfree, enmeshed in conflicts and contradictions. J-EL

Ammann, J.-C. (ed.), *Jeff Wall the Storyteller* (1992).
Duve, T. de, et al., *Jeff Wall* (1996).

Wandering Jew exhibition. In January and February 1941, hundreds of Jewish refugees, mostly from Poland, began arriving in Japan. They had crossed the USSR on the Trans-Siberian Railway after obtaining visas from a Japanese diplomat in Lithuania, Chiune Sugihara. Most stayed in Kobe, funded by the American Jewish Joint Distribution Committee. In April, they were the subject of a documentary project by members of neighbouring Osaka's Tanpei Shashin Club, including Nakaji *Yasui, Osamu Shiihara, Kametaro Kawasaki, Yutaka Yezuka, Tetsu Kono, and Kaneyoshi Tabuchi. Twenty-two of the pictures were included in the club's regular show at Osaka's Asahi Kaikan Museum in May.

About half of the refugees were later deported to China, where many of them survived the war. The episode was commemorated by an exhibition, *Flight and Rescue*, at the Holocaust Memorial Museum in Washington, DC, in 2000–1. RL

Tucker, A. W., et al., *The History of Japanese Photography* (2003).

Warhol, Andy (1928–87), American *Pop artist who began working with photographs in the 1960s, using existing portraits of media icons (*Twenty-Five Marilyns*, 1962) and news photographs (*Thirteen Most Wanted Men*, 1964) to create hand-produced silk-screen prints. He also used both still and movie cameras to portray friends and personal heroes as well as himself. His work demonstrates the enduring *iconic potential of photographs beyond their topicality, and highlights the inter-medial possibilities of art made using mechanical means of reproduction. His *Screen Tests* of the 1960s, close-ups of people asked to stay still, are close to the moving image as used by many contemporary photographers. PDB

McShine, K., *Andy Warhol: A Retrospective* (1989).

war photography

Introduction

Perhaps no event susceptible to being photographed has received more attention than war. Many groups have been interested in the camera's precise visual documentation of the people, places, and activities of warfare: military officers and decision makers in the field; political decision makers at home; opponents of war seeking visual proof of its horrors and inhumanity; ordinary citizens trying to visualize the places in which armies confront each other, and loved ones are fighting or have fought; and ex-combatants seeking mementoes of their comrades-in-arms, camps and equipment, and the people and landscapes encountered on campaigns far from home. When wars are over, societies seek visual means of commemorating the sites of heroic turning points or tragic loss.

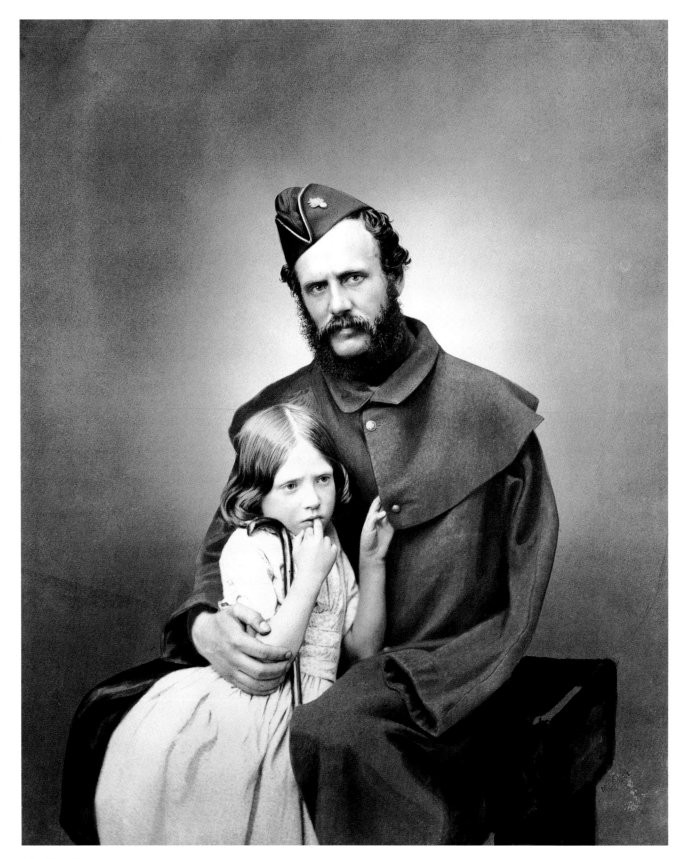

John Mayall

Sergeant Dawson and his daughter, 1855

John Reekie

Remains of Union soldiers killed at Cold Harbor, Virginia, June 1862. Albumen print

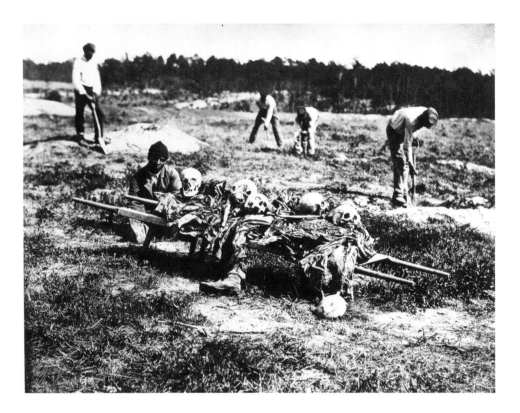

Artists fulfilled these needs entirely before 1839. Photography first supplemented, then in the 20th century largely replaced the artist as visual recorder of the preparations preceding combat, the fighting itself, and its horrific consequences for humans and their environment. From photography's beginnings, even when the bulky and cumbersome equipment needed for *daguerreotypes, *calotypes, and *wet-plate photographs narrowly restricted photographers' movements in the field, photographic entrepreneurs were quick to seize opportunities to act either as independent operators or as official observers of military operations.

War photography went through several stages before 1920, corresponding roughly to advances in photographic technology. Before the wet-plate process was announced by Frederick Scott *Archer in 1851, the earliest war photographs were daguerreotypes or calotypes which, with their long exposures, produced relatively static, staged photographs of men in uniform, landscapes, and buildings (whole or ruined). Although it cut exposure times, the wet-plate process obliged photographers to carry both a darkroom or dark-tent and supplies of water and chemicals with them into the field. This meant in practice that subjects were still limited to static personnel, fortifications and other installations, and the human and material debris of battle. Notwithstanding the assumption that photography (unlike art) produced true images of reality, for aesthetic, practical, or *propaganda reasons photographers could and did frame or stage the images they captured. Even after the advent of *dry-plate technology c.1880 freed photographers from the need to process their pictures immediately,

large-format cameras continued to make the best-quality negatives, requiring photographers to carry bulky tripods. Throughout the 19th century, therefore, the camera remained a 'distant witness'.

The majority of war photographs taken before c.1900 did not reach broad audiences through publication, although many served as the basis for engravings published in popular journals such as *Harpers Illustrated Weekly* or the *Illustrated London News*. By the end of the 19th century, photographs could be reproduced in daily newspapers, and photographers began to function as war correspondents. War photographers attempted to support themselves by exhibiting in galleries, or publishing books of their photographs: commercial enterprises which ensured that the most repulsive images of carnage tended to be avoided.

Lewinski, J., *The Camera at War: War Photography from 1848 to the Present Day* (1978).

'La Guerre', *La Recherche photographique*, 6 (1989).

Voir ne pas voir la guerre: histoire des représentations historiques de la guerre (2001).

'Krieg und Fotografie', *Fotogeschichte*, 85–6 (2002).

Bolloch, J., *War Photography* (2004).

Early conflicts

Susan *Sontag noted that while modern sentiment assumes that the absence of war is normal, in fact normality is the presence of war, a 'normality' that has so far prevailed throughout photography's history. In the medium's first two decades, despite the technical limitations already mentioned, skilled amateurs and experienced professionals

Roger Fenton

'The Valley of the Shadow of Death', 1855

produced a significant record of military activity in the war between Mexico and the United States (1846–8); in small uprisings in the British Empire (the Punjab, 1848–9; Burma, 1852), and larger conflicts like the Crimean War (1853–6); the *Indian Rebellion (1857–8); and the Second Opium War in China (1858–60). The small group of photographers who preceded the large-scale documentation of the American Civil War (1861–5) began to define the earliest subjects of war photography: posed portraiture of officers and men; panoramas of camps, supplies and transport arrangements; records of the destruction of buildings and landscape; and propaganda for governments and causes.

The Mexican War began in the spring of 1846 when General Zachary Taylor invaded disputed territory after the American annexation of Texas, ending with the capture of Mexico City (late 1847) and the 1848 treaty by which the USA 'purchased' part of northern Mexico. Although several American daguerreotypists were active in Mexico from the early 1840s, it is difficult to identify the photographers responsible for the first war photographs. More than 50 images in the Amon Carter Museum at Fort Worth, Texas, and at Yale, depict a variety of military scenes: soldiers in Saltillo, occupied after the American victory at Buena Vista in February 1847; an artillery battalion in a mountain pass; graves of the dead; portraits of officers. Little contemporary attention was paid to these daguerreotypes, the public evidently preferring the more heroic renderings in widely distributed coloured engravings.

John *McCosh, the first identified war photographer, was an amateur. A surgeon in the Bengal Infantry, he first created calotypes in 1844 while stationed in the Himalayas, and later took additional views during the Sikh War in 1848 and the Second Burma War in 1852. His images are primarily portraits of friends, although those from 1852 include scenes of ruined buildings, and artillery and troops posed in the foreground of a grand pagoda in Prome (Burma).

James Robertson and/or Felice Beato

Interior of the Redan battery, Sebastopol, September 1855. Albumen print

Roger *Fenton is the first photographer to bequeath images of a major conflict. The Crimean War, in which Russia fought Britain, France, Turkey, and eventually Sardinia, centred on Russia's Black Sea naval base at Sevastopol. Fenton was preceded in the Crimea by Karl von Szathmary, who followed the Russian army in 1854, and exhibited photographs (now lost) in Paris in 1855. The British military authorities commissioned Richard Nicklin to record coastal installations, but he and his photographs vanished in a Black Sea hurricane in 1854. Fenton, funded by the publishers Thomas Agnew & Sons and with letters of introduction from Prince Albert, arrived in late March 1855 and in the following weeks, using the new wet-plate process, created 360 Crimean images. However, although his carefully posed photographs have been criticized for ignoring the harsh realities of war that he described so eloquently in his correspondence, long-held assumptions that he was on a propaganda mission to counter reports of military mismanagement seem unsupported by the evidence. The last stages of the conflict were documented by the French panorama painter and photographer Jean-Charles Langlois (1789–1870) and the Scotsman James *Robertson and his Italian-born brother-in-law Felice A. *Beato. They were the first to photograph corpses on a battlefield.

James, L., *Crimea 1854–56: The War with Russia from Contemporary Photographs* (1981).

Robichon, F., and Rouillé, A., *Jean-Charles Langlois: la photographie, la peinture, la guerre* (1992).

Keller, U., *The Ultimate Spectacle: A Visual History of the Crimean War* (2001).

India and China

Beato and Robertson went from the Crimea to India, where in 1857–8 the Indian Rebellion broke out and was eventually suppressed in the northern province of Bengal, with savagery on both sides. Shortly after its beginning, Harriet (1827–1907) and Robert Tytler (1819–72) took nearly 500 large-format calotypes of events in Delhi. Beato was sent by the War Office to Lucknow, after the capture of the city in April 1858, and made 60 glass-plate negatives, primarily of damage to buildings in the city.

From India, Beato travelled to China in 1858 with a British army sent to enforce trade concessions wrested from the Chinese after the First Opium War (1839–42). During the autumn of 1860 he accompanied the Anglo-French forces attacking Peking (Beijing), returning to England with 102 images, including the first known photographs of that city. Presented in albums and sold commercially to a Victorian public, Beato's photographs mostly but not entirely avoided the gruesome details of destruction and death, concentrating on panoramas that showed the beauty of the landscape and the power of the victorious British army.

Harris, D., *Of Battle and Beauty: Felice Beato's Photographs of China* (1999).

The American Civil War

From the bombardment of Fort Sumter in Charleston, South Carolina, on 12 April 1861 until the Confederate surrender at Appomattox Courthouse, Virginia, on 9 April 1865, photographers were present at almost every major event, created a comprehensive record of the people and places affected by conflict, and left a visual legacy that changed the way in which the war was remembered both by those who fought in it and those who did not. The limitations of wet-plate technology still prevented them from photographing action, although unlike most of their predecessors, they did not flinch from recording the ghastly aftermath of battle. In *America's Bloodiest Day: The Battle of Antietam 1862* (1978), William Frassanito brilliantly analysed one of the single most gruesome collections of battlefield photographs in relation to the action. The bulk of Civil War photography, however, records not battles but less dramatic images of the men and armies that fought them. In Alan Trachtenberg's words, 'without the means to idealize persons and actions, photographers in the Civil War focused on the mundane, on camp life, on drills and picket lines and artillery batteries. They saw the war essentially . . . as a unique form of everyday life.' That life was experienced by some 3 million men who served in the Union and Confederate armies, of whom 360,000 Federal and 250,000 Confederate soldiers died, while another 500,000 were wounded.

Unlike earlier small-scale war photography by individuals or partners, during the American Civil War a successful photographic business model emerged of substantial investment in equipment and supplies, trained photographer-employees, and sustained marketing efforts through widespread distribution; herein lay the origins of wartime *photojournalism. Photographers in the field followed Fenton's practice of working from well-equipped and -supplied mobile

Mathew Brady

Self-portrait after his return from Bull Run, 22 July 1861. Albumen print

Anon

Chaplain, Royal Munster Fusiliers,
after conducting a field burial,
Western Front, 1916

darkrooms. Mathew *Brady has become synonymous with Civil War photography, but his system of sending photographic teams into the field, though extensive, was only one of many. By August 1862, 35 photographic operations were producing war-related images. By 1865 the Federal military authorities had authorized more than 300 photographers to enter encampments and other military zones. In the Confederacy, photographers were hampered by the Federal blockade, which cut off their supplies, but another *c.*100 photographers worked similarly throughout the South. In camp, daguerreotypists, tintypists, and photographers set up photographic tents to provide soldiers with portraits and memorabilia of army life. The New York photographic firm E. & H. T. *Anthony made a fortune supplying both sides with equipment and chemicals. The Anthony brothers also systematically purchased negatives, and published and sold thousands of stereographs and *cartes de visite. In addition to Brady, their photographers included Thomas C. Roche, George N. *Barnard, Alexander *Gardner, and Timothy *O'Sullivan.

The US government employed photographers systematically throughout the war: the Treasury Department, Army Medical Museum, the Ordnance Department, the Department of Engineers, the Quartermaster-General, and the Bureau of Military Railroads all maintained a photographic staff. Andrew J. Russell (1830–1902), working under General Hermann Haupt, extensively documented the construction and destruction of railroads and bridges. Barnard

worked for the Topographical Branch of Engineers in the Armies of the Potomac and the Cumberland, making photographic copies of maps used by officers in the field. Assigned to the west in 1863, he documented the massive logistical build-up in Tennessee, the siege of Atlanta, Georgia, and General William Sherman's march to the sea. In addition to military photographers, the army also employed civilians such as Samuel A. Cooley, who operated a studio in Beaufort, South Carolina, documenting the invasion of the southern coast in the autumn of 1862, selling images both to the public and to Quartermaster-General Montgomery Meigs.

Supply shortages made it harder for the Confederacy to create comparable documentation. Studios such as that of George S. Cook in Charleston, George W. Minnis in Richmond, Virginia, and Andrew D. Lytle in Baton Rouge, Louisiana, did a steady business in portraits of Confederate civilian and military leaders and pictures of camp life, as long as chemicals and other necessities from the Anthony brothers could be smuggled through to them. Lytle even managed to photograph Union fortifications secretly and signal the location of Union forces to nearby Confederate troops.

Sold as individual images and in numbered series such as *Brady's Photographic Views of the War* (1862) during hostilities, Civil War photographs also appeared in several major publishing efforts. They formed the basis for wood engravings in mass-circulation illustrated papers like *Harper's Weekly* and *Leslie's Illustrated News.*

After the war, some photographers published memorial albums of mounted photographs, notably *Gardner's Photographic Sketch Book of the War* (1866), and Barnard's *Photographic Views of Sherman's Campaign* (1866). In 1911–12, Francis Miller edited a ten-volume *Photographic History of the Civil War*, capitalizing on fading and sentimentalized memories of the conflict.

Major collections of Civil War photographs include those at the National Archives, and the Civil War Collection of the Library of Congress, whose 7,000 images are digitized and available online. Thousands more are held by museums and historical societies across the USA; many were used by Ken Burns in his 1990 television epic *The American Civil War*. CBS

Fulton, M. (ed.), *Eyes of Time: Photojournalism in America* (1988).
Davis, K. F., ' "A Terrible Distinctness": Photography of the Civil War Era', in M. A. Sandweiss (ed.), *Photography in Nineteenth-Century America* (1991).
Panzer, M., *Mathew Brady and the Image of History* (1997).

Other wars to 1914

Outside the USA, between the 1860s and 1914, photography was used on an increasing scale to record conflict. (Functional *military photography also continued to develop.) Among relatively few surviving images of the Wars of Italian Unification (1859–70) were pictures by Gustave *Le Gray of Palermo in June 1860, just after its capture by Garibaldi. A classic of early *staged photography was Gioacchino Altobelli's (1814–78) image of Italian troops 'storming' Rome's Porto Pia on 21 September 1870, the day after the actual event. More photographers were involved in the Wars of German Unification (1864–71), culminating in the Franco-Prussian conflict (1870–1). Friedrich Brandt photographed captured Danish fortifications at Düppel (1864), and Paul Sinner and Karl Schwier the—by 19th-century standards—enormous devastation of Strasbourg after the Prussian siege (1870). Thousands of miles away in South America, the Uruguayan photographer Esteban Garcia recorded the War of the Triple Alliance (Paraguay versus Brazil, Uruguay, and Argentina, 1865–70) for an American company, and the Chilean Eduardo Spencer recorded episodes of the war between Chile and Peru in 1879–83. But photographers still faced major obstacles: cumbersome equipment, long exposures, and the impossibility of large-scale publication of campaign photographs except in engraved form; the biggest market was for contact-printed *carte* portraits of military and political leaders.

By *c.*1900 this situation was being transformed, thanks to portable dry-plate or *roll-film cameras, 'instantaneous' shutter speeds, and the *half-tone printing process. These innovations shaped photographic coverage of the Spanish-American (1898), Boer (1899–1902), and Russo-Japanese (1904–5) wars. All three created massive demand for images, and news organizations and firms like Biograph and *Underwood & Underwood spent heavily on obtaining them. A leading Boer War photographer was Horace *Nicholls, who in 1899 and 1900 made his reputation with scenes from Ladysmith and other newsworthy places. Many other press photographs, and snapshots taken by participants, appeared in newspapers, and in illustrated books like the British journalist H. W. Wilson's *With the Flag to Pretoria* (2 vols., 1900–1). The same was true of the Russo-Japanese War, which involved the allies of two major European powers (respectively, France and Britain) and took place in a region of growing interest to the USA. It was recorded by the Japanese Army Photographic Unit, foreign military observers, participants, and photojournalists—on the Russian side most notably by Viktor *Bulla and, with the Japanese, many individual professionals, and 'operators' for firms like Underwood & Underwood and *Collier's Weekly*. Protracted episodes like the siege of Port Arthur were extensively photographed. Not only American, Russian, and European newspapers but also Japanese ones like *Hochi Shimbun* printed countless photographs. Much action, of course, remained unphotographable, and continued to be depicted by graphic artists, some of whom, like J. Matania, would perform the same function in 1914–18.

The First World War

The immense conflict that began in August 1914 generated more photographs than all previous wars put together. They can be roughly categorized under four headings: *functional* pictures made for operational or administrative purposes; *official* informational, propaganda, or historical photographs; *press* pictures; and *private* images taken by ordinary civilians and service personnel.

Functional photographs were quantitatively the most important. One example was the millions of *aerial reconnaissance photographs taken by all the belligerents. Another was military medical photography, which recorded the construction and running of hospitals and the transportation, treatment, and rehabilitation of casualties. A third was identity photography, especially in occupied countries. In October 1915, for example, the German authorities in formerly Russian Poland set out to produce 2 million identity photographs, using 60 photographers and 250 clerks who sometimes achieved an output of 30,000 pictures a day.

All the major belligerents sponsored *official* photographs of various aspects of the war, many of which survive in instititutions like Britain's Imperial War Museum (IWM) and France's Bibliothèque de Documentation Internationale Contemporaine (BDIC; formerly Bibliothèque-Musée de la Guerre). Although the organization of official photography varied from country to country, the key objectives everywhere were supplying images to the press, producing propaganda for domestic, neutral, Allied, and enemy consumption, and creating an historical record (especially important, for example, in Australia and Canada). The Germans took energetic action from the beginning, and redoubled their efforts with the creation of the Bild- und Filmamt (BUFA) in 1916. The French Section Photographique de l'Armée was not formed until April 1915, while the British created a succession of bureaucratic bodies, beginning with the Press Bureau and the Propaganda Bureau (Wellington House), which continued to evolve until they were absorbed into the Ministry of Information in February 1918.

Official photographers were generally recruited from the ranks of professionals (nearly half the British ones were from the *Daily Mirror*), were subject to military supervision in the field, and had their work vetted and censored before distribution to the press and other agencies. Britain devoted a smaller effort to photography than either Germany or France, and coverage was uneven. Of a total of *c*.30,000 British photographs, *c*.20,000 were taken on the Western Front. The Royal Navy kept official photographers at bay for most of the war, and coverage of other theatres was patchy. Even on the Western Front, apart from the prelude to the Battle of the Somme, which was photographed by Ernest Brooks and three teams from the *Royal Engineers, coverage was thin, with never more than a dozen British and Dominion photographers active there 1916–18. Nevertheless, many memorable pictures were taken. Notable also were the series of home front photographs taken by Horace Nicholls and G. P. Lewis in 1917–18.

The illustrated *press* of belligerent and neutral countries was awash with photographs throughout the war, and initial demand for pictures nearly overwhelmed the official bodies supplying them. Commercial firms like Underwood & Underwood continued to find war pictures to sell to the public; and countless photographs were issued as *postcards. However, neither of the world wars, in contrast to many post-1945 conflicts, was covered to any significant extent by free-ranging photojournalists. All major war zones were controlled by the military, and all the photographers working in them—although mostly pressmen—were carefully selected and, as already mentioned, subject to strict supervision. (A possible exception was the American cinematographer Harry Chase, who documented some of T. E. Lawrence's activities in the Middle East; but even he had official approval.) Especially in the early stages of the war, many publications probably used recaptioned—and/or doctored—photographs of peacetime exercises for want of the genuine article. Later, as with the sensational picture of the sinking SMS *Blücher* (1915), editors paid handsomely for amateur snapshots.

Although many personnel had carried cameras in the Russo-Japanese and Boer wars, the First World War was the first conflict in which private photography took place on a huge scale. Tens of thousands of portable roll-film cameras like the Vest Pocket Kodak were owned and used by servicemen, and the German photographic industry reported increasing demand for materials and cameras until the last year of the war. Despite official prohibitions on both sides, soldiers continued to take pictures, both as souvenirs and, probably, to sell; as a French soldier, André Kahn, wrote in May 1916 about his spectacular front-line pictures, the authorities 'are hardly going to catch us red-handed here'. (In fact, before the introduction of official photography, the French subverted their own rules by buying up private pictures.) As the war progressed, jaunty images of still-smart soldiers with their comrades and pets gave way to pictures of grim-faced, shabby veterans—looking, in Paul Klee's words, 'more like slaves than soldiers'—ruins, devastation, and, breaking the ultimate taboo, piles of corpses. Notable among the thousands of surviving private collections are the meticulously annotated albums of a German cavalry officer, Gustav Lachmann, on the Eastern Front in 1915 (IWM), Georges Salles's photographs of the heavily contested village of Soupir in the Aisne, 1915, and M. Boudinhou's photographs of life in the internment camp at Holzminden in 1916–17 (Musée d'Orsay). Finally, there are Käthe Buchler's home front photos of hospitals, war work, and everyday life in Brunswick. RL

Carmichael, J., *First World War Photographers* (1989).
Rother, R. (ed.), *Die letzten Tage der Menschheit: Bilder des Ersten Weltkrieges* (1994).
Huss, M.-M., *Histoires de famille, 1914–1918: cartes postales et culture de guerre* (2000).

Between the wars

The Russo-Polish War of 1920, the Irish Civil War (1922), the Italian invasion of Abyssinia (1935–6), and the Sino-Japanese War (from 1937) were all recorded by the camera, some by leading photojournalists (for example, *Eisenstaedt in Abyssinia, Robert *Capa in China); others, like the Irish conflict, by a mixture of amateurs and professionals.

Photographically most significant, however, was the Spanish Civil War (1936–9). Spain was easily accessible from the main European press centres, and the conflict fitted into the larger confrontation between fascism and democracy, with worrying implications especially for France. But there were other reasons for Spain's importance. The first was technical: the availability of small and 'miniature' (35 mm) cameras and more sensitive films, and new *transmission technology used by organizations like the Associated Press (AP) Wirephoto network inaugurated in January 1935. Secondly, *agencies more generally, like AP, Agence Espagne, Alliance Photo, and Trampus, facilitated coverage. Thirdly, the 1930s saw magazine journalism come to full maturity, with venerable papers like the *Illustrated London News* and L'*Illustration* rivalled by newer, more dynamically designed and photo-hungry ones like *Vu, Regards,* and *Match* in France, *Weekly Illustrated* in Britain, and *Life* (1936) and *Look* (1937) in the USA. Newspapers like *Paris-Soir, L'Intransigeant,* the *Daily Mail,* and the *Berliner illustrirte Zeitung* (BIZ) also boosted their photo-coverage. There was already a buoyant market for illustrated journalism and, as *Life*'s founder, Henry Luce, had predicted in 1935, 'A war, any sort of war, is going to be a natural promotion for a picture magazine.'

Certain aspects of Spanish Civil War coverage are particularly notable. In the first place, as Caroline Brothers has argued, editors tended to use photographs in ways that matched their preconceptions about the conflict (and the world in general), with issues like the mobilization of women, the bombing of cities, anticlericalism, and the use of North African troops by the Nationalists particularly susceptible to visual bias. The misleading use of archive photos was also common when first-hand images were lacking and, in general, picture editors often used cropping and selective blow-ups to convey the illusion of close-ups and to skew the impact of pictures. Photojournalists themselves were sometimes cavalier about the dating

and captioning of their pictures, and occasionally staged them. Capa was guilty of the first, if not the second, and he was doubtless not the only culprit; the issue of staging persisted into the Second World War. At the same time, legendary figures like Capa—famously described by *Picture Post in 1938 as 'The Greatest War-Photographer in the World'—and Gerda *Taro have probably been over-glamorized compared with men like 'Chim' *Seymour and Hans Namuth, not to mention Spanish photographers (for example, the three Mayo brothers), who took the largest number of photographs and suffered most of the casualties.

This aside, the Spanish Civil War further enhanced the cult, already building in the 1920s, of the daredevil photojournalist, honed the techniques and challenged the ethics of the new illustrated magazines, and thus prepared the ground for the much vaster tasks of 1939–45. It also produced 20th-century war photography's ultimate icon, Capa's controversial *Falling Soldier (1936).

Whelan, R., *Robert Capa: A Biography* (1985).
Brothers, C., *War and Photography: A Cultural History* (1997).
Fontaine, F., 'La Guerre d'Espagne: une guerre d'images', in *Voir et ne pas voir la guerre: histoire des représentations photographiques de la guerre* (2001).

The Second World War

As in the previous world conflict, all records were broken. British official photographs alone numbered *c.*2 million, compared with the 30,000 of 1914–18. The numbers of still photographs taken by all belligerents for all purposes probably ran into milliards. But information about the organization of all this picture making is patchy, with particularly large gaps in relation to Japan and the USSR. Once again, rough categorization of picture types is useful. First and most numerous were the millions of *functional* pictures taken by military, naval, and other photographers for purposes ranging from aerial reconnaissance and weapons testing to the illustration of official publications and armed-forces periodicals like the British *Parade* and American *Yank* and *Leatherneck*. Second was the work of *photojournalists* and other photographers accredited to the armed forces and other official agencies like the British Ministry of Information and the US Office of War Information (OWI). Although their pictures were quantitatively least important, they were crucial in defining the 'look' of the war, especially after it was over. The third category comprised pictures taken by amateurs in and out of uniform, and again for reasons that ranged widely, from the purely personal to the illicit and subversive: for example, records of atrocities made by German anti-Nazis, and by resisters and others in occupied countries.

The boundaries between these categories were sometimes fluid, all the more so as, in a war involving mass conscription, many official photographers had been civilian professionals. Many of them also took private pictures, as did some print journalists: for example, the German art historian and naval war correspondent Lothar-Günther Buchheim, who took dramatic U-boat photographs. As in the First World War, some amateur photographs were published in the press.

Others, like the snapshots of European locations that the British Admiralty, from June 1941, collected for its Ground Photographic Information library, contributed directly to the war effort. Finally, microphotographed letters (*airgraphs)—and, from 1943, photographs—between servicemen and home probably did more for Allied morale than many a propaganda image.

Press photography was differently organized in the democracies than in either the USSR or the Axis countries, although on both sides of the conflict handsomely produced illustrated magazines— *Life and *Look* in the USA, *Picture Post* in Britain, *Signal* in occupied Europe, and *Nippon*, *Shashin Shuho* (*Photo Weekly*), and *Front* in Japan—supplied by top photojournalists were the main vehicles of photographic *propaganda. Notwithstanding certain differences in practice between Britain and the USA, including the ranking of American photojournalists as officers and British ones as NCOs, their two systems were broadly similar. Photojournalists of the main magazines, newspapers, and agencies had to be officially accredited, were paid by their civilian employers, housed, transported, and subjected to various controls by the military, and their pictures and captions comprehensively censored. In the USA, all visual material had to be submitted to a pool, although key publications like *Life* negotiated the right to prevent its own photographers' work being published first in another journal. Washington, London, and Cairo became the main nodal points for Allied war photography, and the bureaucracies that developed there to vet and distribute the flood of incoming pictures often caused rigidities and delays. In theatres like the Pacific, photographers might be thousands of miles from base, communications were tenuous, and it was sometimes weeks or months before pictures appeared in print. Nevertheless, much superb work was done by Western Allied photojournalists, who included some of the most famous names in the business: Margaret *Bourke-White, Robert Capa, Lee *Miller, Carl *Mydans, George *Rodger, Joe Rosenthal (b. 1911), 'Chim' Seymour, W. Eugene *Smith, and many others. Russian photographers like Dmitri *Baltermants, Yevgeny *Khaldei, and Gyorgy *Zelma, working in more oppressive conditions, produced equally powerful images.

The total numbers of military and other official photographers deployed were considerable, with combat photographers the tip of a much larger iceberg. Photographic tasks were, as already indicated, multifarious, and their organization a microcosm of the larger military and political cultures of which they were a part. Particularly short-lived and ineffective was the French system, crippled by red tape, lack of resources, and military obsession with security. As all photographs that showed unit numbers on uniforms were banned, the Commissariat of Information's lack of retouching facilities meant that countless pictures were wasted. Administrative delays encouraged neutral papers to fill their pages with German photographs. When, finally, the experienced Jean Prouvost of *Paris-Soir* took charge in March 1940, he found only seven French military photographers available between Narvik and Beirut. Britain, too, was slow off the mark and plagued by comparable obstacles, although a nucleus of 40 photographers and

Julien Bryan

Kazimiera Kosewicz, aged 12, grieves for her sister Anna, 14, killed by German bombs at Kolo, Warsaw, 14 September 1939

cinematographers was soon assembled and trained, the advance guard of much larger numbers later on. The small *Royal Naval Photographic Branch was supplemented by Admiralty press officers, usually recruited from the ranks of civilian professionals. Official naval and military photographers, and others assigned to home front duties, supplied pictures (uncredited) for a long series of publications issued by the Ministry of Information on military campaigns, armaments production, civil defence, the women's services, and other subjects. The flexibility of the British system—at least where celebrities were concerned—is illustrated by the wartime career of Cecil *Beaton, who did home front assignments for the Ministry of Information and worked as an official RAF photographer in the Middle East, India, and China, but also continued to produce private portraits, pictures for *Vogue, and an impressive tally of books.

Of all the Allies, the USA was probably best prepared for the conflict. Army photographers, mostly incorporated in the Signal Corps, even received some training from civilian photojournalists. A typical Signals Company had 75 men, of whom 30 were cinematographers and 20 still photographers. Their work was used for a predictably wide range of purposes, from training and intelligence to public relations and the documentation of enemy atrocities. Photographers' numbers increased rapidly during the war, and 100 covered the D-Day landings alone in June 1944. Other military units included the Naval Aviation Photographic Unit famously headed by Edward *Steichen, and those of the Marine Corps (including David Douglas *Duncan) and USAF. But, again, military operations were only one branch of wartime activity involving photography. Others included shipbuilding and aircraft production, rail transport (documented by Jack *Delano and others), medical and rehabilitation services, and the top-secret work of the Manhattan Project. Meanwhile, advertising specialists like Victor *Keppler were employed to design war bond posters for the US Treasury.

The best-documented Axis power was Germany, where considerable effort and advance preparation was devoted to visual propaganda. At its centre were the propaganda companies (PKs) set up in 1938, under the operational control of the armed forces (which also used photography for their own functional purposes), but whose output was handled by Goebbels's Propaganda Ministry. Many PK photographers were established photojournalists and the more prominent of them, including Artur Grimm (b. 1909), Hanns Hubmann (1910–96), Walter Frentz (b. 1907), and Hilmar Pabel (1910–2000), continued to make credited contributions to papers like the BIZ. During the war the PKs produced 2–3.5 million photographs, many of exceptional quality and some of exceptional horror, like PK 689's coverage of the liquidation of the Warsaw and Łódź ghettoes.

Censorship was strict in all belligerent countries. On the Axis side, and in Stalin's Russia, it was an extension of already authoritarian political systems. In the democracies, however, it was a more complex issue. As in 1914–18, security was a vital consideration, although there continued to be differences of emphasis as between politicians and the military. Another was morale, especially in relation to casualties and setbacks. As the war progressed, a degree of consensus developed between photographers, censors, and editors about the kinds of images that might be acceptable. (Some unacceptable ones were taken anyway, doubtless in the hope that they would be published eventually.) A perennial problem was the depiction of dead Allied servicemen. Dead Americans had been taboo in 1917–18, and remained so until the middle of 1943, when both the head of OWI, Elmer Davis, and President Roosevelt became increasingly concerned about complacency and war-weariness. They also believed, correctly, that the public would accept more hard-hitting pictures. On 2 August 1943, Life was allowed to publish a picture of a soldier killed during the invasion of Sicily, albeit muffled in a blanket. On 20 September George Strock's more explicit *Buna Beach photographs appeared, and thenceforth selections of gruesome images from OWI's 'chamber of horrors' were released to the press. But taboos about identifiable corpses, serious wounds, and shell-shock remained, and the first published photograph to include a pool of American blood seems to have been Capa's picture of a sniped corporal in Leipzig on 18 April 1945. There were far fewer inhibitions about images of enemy soldiers or civilians, especially Japanese, dead or being killed.

Especially in the early years of the war, amateur photography continued on a considerable scale in Germany and Britain, and throughout the conflict in the USA. British magazines like *Amateur Photographer and annuals such as Photograms of the Year continued to appear, and salons and club competitions went on being held, their subject matter (babies, dogs, landscapes, and decorous nudes) indicating an obvious escapist function. More interesting was the activity of German amateurs. In 1939, c.10 per cent of the population owned cameras, and a probably similar proportion of German servicemen took them to war. Materials, including Agfa colour film, were initially plentiful and photography was encouraged as a bridge between soldiers and their families. Albums were manufactured with 'In Memory of my Military Service' on the covers and sometimes a Hitler portrait as frontispiece. As in the First World War, surviving collections underline the fact that for many ordinary Germans war was the first opportunity for foreign travel: hence the countless snaps of the Eiffel Tower and the Acropolis. There are also cheery shots of soldiers quaffing local vintages or socializing with friendly civilians. Later, after the invasions of the Balkans and Russia, such images were increasingly replaced by pictures of wrecked equipment, graves, snowdrifts, and, prohibitions notwithstanding, atrocities.

Illicit and resistance photography has increasingly come to light. A selection of underground Dutch photographs, taken between the invasion of Holland and the Liberation, was published in 1995 by Flip Bool and Veronica Hekking. Other collections originated from German servicemen—for example the PK member and anti-Nazi Joe *Heydecker—who either systematically recorded the horrors of German occupation policy or at least snapped glimpses of camps like Treblinka from passing troop trains. In Germany itself, clearly for a variety of motives, amateurs in cities like Cologne and Hamburg managed to record the increasingly grim reality of bombing, queues, and deportations. Although regulations about civilian photography

were often unclear, the presence of the Gestapo and its informers certainly made taking and processing such pictures seem a risky undertaking. Nevertheless, many have survived. On the home front too, however, practical difficulties were becoming insuperable by 1943; by 1945 photographers were burying their Leicas and Contaxes in the garden in the hope of better times. RL

See also HOLOCAUST, PHOTOGRAPHY AND THE.

Mrázková, D., and Remeš, V. (eds.), *The Russian War, 1914–1945* (1978).

Keller, U. (ed.), *The Warsaw Ghetto in Photographs* (1984).

Moeller, S., *Shooting War: Photography and the American Experience of Combat* (1988).

Roeder, G. H., Jr., *The Censored War: American Visual Experiences during World War Two* (1993).

Bool, F., and Hekking, V., *Die illegale Camera 1940–1945: Nederlandse fotografie tijdens de Duitse bezetting* (1995).

Deres, T., and Rüther, M. (eds.), *Fotografieren verboten! Heimliche Aufnahmen von der Zerstörung Kölns* (1995).

Jahn, P., and Schmiegelt, U. (eds.), *Fotofeldpost: Geknipste Kriegserlebnisse 1939–1945* (2000).

Korea

Soon after the war began on 25 June 1950, experienced American and British photojournalists headed for the combat zone; within two months nineteen nations had 270 correspondents and photographers in place. Most notable among the latter were the Americans David Douglas Duncan, Carl Mydans, and Margaret Bourke-White, all on assignment for *Life*, and the British photographer Bert *Hardy sent by *Picture Post*. Where Second World War photography had been characterized by close military control and strict censorship, Korean War photographers initially enjoyed more freedom. Living and working closely with small military units, they pioneered a new, more intimate style that captured the emotional as well as physical experience of combatants. Hardy's damning photographs of South Korean troops mistreating North Korean prisoners, suppressed just before publication by the owner of *Picture Post*, did not become publicly known until the 1970s. In contrast, Duncan's close identification with the marines with whom he travelled led to the publication of *This is War* (1951), a close-up, personal vision of the face of battle. Many Korean War photographers took this new style of war photography into the killing fields of Vietnam.

Vietnam

The Vietnam War (1954–75) was preceded by the unsuccessful war waged by the French in Indo-China between 1946 and 1954. Although of less widespread media interest than Korea, it was heavily photographed by both the French army and photojournalists. Two of the latter, the French photographer Jean Peraud (1923–54) and the American Robert Capa, were killed in 1954. (A year later, the French became embroiled in another colonial conflict, in Algeria (1955–62); among relatively few prominent photographers on the French side were Marc Flament (1929–91), effectively personal photographer of the paratroop leader Colonel Bigeard, and Marc Garanger (b. 1935).)

In Vietnam, more perhaps than in any other war before or since, still photography played a crucial role in documenting the impact of the fighting and informing audiences around the world about it. The conflict coincided with a conjunction of events crucial for war photography: the circulation heyday, then decline, of documentary news magazines such as *Life* and *Look* in the USA and *Picture Post* in Britain; the increasing importance to photojournalism of agencies such as *Magnum, *Black Star, the AP Wirephoto Service and United Press International (UPI); and the growth of television and its live coverage of news events. Western news photography paralleled the slow escalation (1961–70) and subsequent diminution (1970–3) of US military involvement in Vietnam, described by the historian George C. Herring as 'America's longest war'.

Television news coverage, which made this a 'living-room war' in the USA and Europe, created an enormous parallel commercial demand for still images. In its systematic coverage between 1961 and 1972, *Life* alone published over 1,200 photographs from the war zone and another 600 of the American home front, filling more than 1,000 photo pages, including 38 cover-story photo-essays. *Life* relied heavily on its lead staff photographers, London-born Larry *Burrows and (after 1967) David Douglas Duncan and Co Rentmeester, but also featured the work of wire-service photographers such as Horst Faas and Akihiko Okamura. Photographers from South Vietnam and Cambodia joined photojournalists from the USA, Europe, and Japan, often as freelances hired by the wire services; AP, UPI, and another half-dozen agencies maintained permanent offices in Saigon. Limited by supply shortages, a smaller number of skilled North Vietnamese photographers also covered the war, many for the Vietnam News Agency, often travelling with troops and developing film in makeshift darkrooms in the field. Photographers from both sides sought to influence public opinion; much North Vietnamese photography, for obvious reasons, presents an uncritically supportive view of the country's fight for independence.

In depicting military operations and civilian scenes in Vietnam, Western photojournalists enjoyed unprecedented freedom from censorship. (As in previous conflicts, many US military photographers were also active, working for operational purposes or supplying service journals like *Leatherneck*.) This freedom, combined with extensive use of colour film and the intimate approach pioneered in Korea, produced a photographic record that was often shockingly immediate and graphic. In a war without front lines, fought in rice fields, mountain jungles, and villages, civilians including women and children were among the casualties depicted with a realism that seemed increasingly horrifying. Photographs of a Saigon monk immolating himself in protest (Malcolm Browne, 1963), of the execution of a Vietcong prisoner in a Saigon street (Eddie *Adams, 1968), of the massacre of villagers at *My Lai (Ronald Haeberle, 1968), and of a naked Vietnamese girl fleeing burning napalm (Nick Ut, 1972) became iconic images. Arguably they had a more profound impact than television footage of the same or similar events. Claims that such coverage turned Americans against the war have been countered by recent scholarship, which suggests that the representation of war's reality articulated the growing opposition

rather than causing it. A particularly moving anti-war essay was *Vietnam Inc.* (1971), by the British photographer Philip *Jones Griffiths, which documented four years of the devastation affecting the people and land of Vietnam and got him banned from the country (he later returned to photograph in Cambodia for Magnum).

A few Western photojournalists photographed life in North Vietnam; the British photographer James Cameron (1911–85) and the Italian Romano Cagnoni were the first non-communists admitted to the north in 1965. The American Lee Lockwood did an extended photo-essay on Hanoi for *Life* in 1967, and the French photographer Marc *Riboud was invited to North Vietnam in 1968. Although in a minority on both sides, women photographers worked with distinction in Vietnam. The French photographer Catherine *Leroy stayed 1966–8 and survived to cover equally harrowing struggles in the Lebanon in the 1970s. The American Dickey Chapelle (1918–65), whose career had begun in the Second World War, won awards for her Vietnam coverage before being killed. In total, more than 135 photographers went missing or died in Vietnam, of whom perhaps the most famous was Larry Burrows. CBS

Bigeard, M., and Flament, M., *Aucune bête au monde* (1959).

Mills, N. B., *The Vietnam Experience: Combat Photographer* (1983).

Graffenried, M. v., *Algérie, photographies d'une guerre sans images* (1990).

Jones Griffiths, P., *Dark Odyssey* (1996).

Requiem: By the Photographers Who Died in Vietnam and Indochina (1997).

After Vietnam

Since the 1970s, photographers have covered many conflicts, in widely varying conditions. (A fundamental precondition is the degree of media interest in a given theatre: Iraq, for example, compared with the Sudan or Mauritania; photojournalists do not risk their lives for unsaleable pictures.) Examples have included wars fought by regular forces (the Falklands, 1982; Iraq, 1991 and 2003); civil wars involving government forces, guerrillas, and militias (the Lebanon and Nicaragua in the 1970s; Sri Lanka since 1983; Chechnya, the Congo, Rwanda, Sierra Leone, and Côte d'Ivoire in the 1990s); the disintegration of states (Yugoslavia since 1991); and localized but often ultra-violent communal conflicts within states (Northern Ireland since the 1970s, South Africa in the early 1990s, Indonesia since 1998). In a category by themselves, finally, though related to many of these struggles, have been the 21st-century terror campaigns triggered by the events of 11 September 2001. A leading member of the post-Vietnam generation, James *Nachtwey, who nearly died in the collapse of the *World Trade Center, was by this time a veteran of Croatia, Guatemala, Indonesia, Kosovo, Northern Ireland, the Palestine intifada, Rwanda, South African township violence, and Sri Lanka.

On every assignment the photographer needs shelter, sustenance, transportation, support for complex equipment, opportunities to take pictures, and the means to get them home. In different theatres, however, he or she may have more or less freedom of movement and access to the fighting, and security, back-up, and information may be abundant or scarce. In the Falklands, for example, the media faced a situation reminiscent of the First World War: a tightly controlled war zone, with access granted to only a handful of 'acceptable' journalists, and rigorous censorship. (The Royal Navy's traditional distrust of the press was compounded by post-Vietnam anxiety about the effect of 'negative' images.) Unsurprisingly, most British pictures were by military and naval photographers. In the 1991 Gulf War, photographers were subjected to rigorous pooling and censorship arrangements, and their numbers—in theory—also strictly controlled. But at the opposite extreme, in conditions of anarchy and civil war, a free-for-all may prevail, with photographers enjoying considerable liberty but dependent on their own resources and often dangerously exposed. The exploits of Don *McCullin, Catherine Leroy, and Raymond *Depardon in the Lebanon, Susan *Meiselas in Nicaragua, and Nachtwey in Sri Lanka are paradigmatic; as are those of the 'Bang-Bang Club' photographers (Kevin Carter, Greg Marinovich, Ken Oosterbroeck, and Joao Silva) in South African townships like Thokoza, Soweto, and Sebokeng. In such situations the photographer must capture strong and meaningful pictures, avoid being intimidated or manipulated into creating propaganda, and stay alive.

War photography is, obviously, a high-risk occupation. Mines, snipers, 'friendly fire', road and helicopter accidents, abduction, and torture are among the physical hazards. The psychological ones range from burn-out to long-term depression. Of the Bang-Bang Club four, Oosterbroeck was killed in action, Marinovich was seriously wounded, and Carter committed suicide. McCullin has spoken frequently of the stress caused by recording unimaginably harrowing scenes. Of a picture of a dead Vietcong and his scattered possessions, he has said: 'I have a conscience about photographing these people [dead soldiers and their families], intruding on their grief, walking away with images of their grief. Don't think it's been easy to live with that, because it hasn't.' Yet recruits keep coming. The French photographer Patrick Chauvel's (b. 1949) description of his baptism of fire in the Six-Day War (1967) speaks volumes:

I saw lots of things, but I couldn't translate. I just knew I felt incredibly good when I was there. The action was very quick and very big. The heavier the fighting, the more I could feel—even why I had fingers. Everything came into place. My eyes could see what I needed them to see; I could hear, and I needed to hear fast; I could run fast, walk fast; I wasn't tired, hungry, or thirsty. I felt so alive. Everything existed. (P. Howe, *Shooting under Fire*, 2002)

Ever since *Picture Post*'s 1938 tribute to Capa the job has been heavily glamorized. A 1985 French magazine article on war photographers carried the strap-line 'Twenty years old; the most gorgeous babes; danger, the world's strongest drug; pals. And they even want to pay you.' Two years earlier, the Hollywood feature film *Under Fire*, set in Central America, had built a thrilling and romantic story around Nick Nolte as a go-anywhere, relationship-hopping, Nikon-toting lensman. More significantly, perhaps, Christian Frei's 2002 documentary about Nachtwey, *War Photographer*, constructed a heroically focused and disciplined, almost monastic figure dedicated to exploring the world's dark places.

The 21st century will inevitably bring further advances in both automated military technology and the ability to capture images with remote-controlled devices. Computer-generated pictures will probably play an increasing part in the reporting and analysis of conflict. However, there is no sign that the public's appetite for graphic, up-close images of war and its consequences, obtained by photographers at ground level, will abate. RL

McCullin, D., *Unreasonable Behaviour: An Autobiography* (1990).

Peress, G., *The Silence* (1994).

Ristelhueber, S., *Beyrouth photographies* (1994).

Marinovich, G., and Silva, J., *The Bang-Bang Club: Snapshots from a Hidden War* (2000).

Howe, P., *Shooting under Fire: The World of the War Photographer* (2002).

Warsaw Rising, 1944. See POLAND.

Warworks: Women, Photography, and the Iconography of War exhibition, held in London in 1994. Curated by Val Williams, it aimed to question the nature of reportage and explore how war affects the contemporary imagination. The twelve participants were Barbara Alper, Ania Bien, Deborah Bright, Hannah Collins, Anna Fox, Masumi Hayashi, Moira McIver, Anne Noggle, Sophie Ristelhueber, Martha Rosler, Judith Joy Ross, and Elizabeth Williams. RM

Williams, V., *Warworks* (1994).

Waterhouse, James (1842–1922), Indian army officer and Assistant Surveyor-General in charge of the Photo-Litho Office of the Survey of India. Waterhouse took up photography soon after arriving in India in 1859, and in 1861–2 was sent to photograph the tribes of central India; many of these portraits were later to appear in *The People of India* (1868–75). In 1866 he became head of the photographic department of the Survey of India and over the next three decades, until his retirement in 1897, established himself as an international authority on the photomechanical applications of photography, particularly in the field of *cartography. His contributions to scientific photographic research were recognized by the award of the *Royal Photographic Society's Progress Medal in 1890 and the Vienna Photographic Society's Voigtländer Medal in 1895. He was president of the Royal Photographic Society in 1905–6. JF

Watkins, Carleton E. (1829–1916), American photographer of the far western landscape. Born in New York, he joined the California Gold Rush, and learned photography from the daguerreotypist Robert Vance (1825–76); by 1857 he had a studio in San Francisco. With an enormous custom-built camera, glass-plate negatives weighing 1.8 kg (4 lb) each, a stereoscopic camera, and tripods, he travelled on horseback to the Yosemite Valley in 1861, and in 1870 climbed Mount Shasta with Clarence King's geological survey. Though a recipient of numerous awards and internationally renowned, he earned a meagre living, and lost his negatives and his Yosemite Art Gallery in an 1875 bankruptcy to his former employee Isaiah W. *Taber (1830–1915).

Beginning anew, Watkins practised field photography until his eyesight failed in 1892. In the great earthquake of 1906, fire consumed his studio and its contents. From the majestic Yosemite and *Yellowstone to the craggy coastal Farallon Islands, and from Canada to Mexico, Watkins's aesthetic might be called 'commercial sublime': exceptionally clear and highly detailed *mammoth-plate and panoramic photographs for residents, tourists, railway and mining companies. DRI

Nickel, D., *Carleton Watkins: The Art of Perception* (2001).

waxing negatives. Wax was applied to paper negatives to increase translucence, thus shortening the printing time and improving image resolution (*Talbot, 1841). Waxing the paper before sensitization (*Le Gray, 1850) improved resilience and keeping properties: once waxed and prepared with potassium iodide and a casein or rice water binder (which prevented oxidation of the image-forming chemicals), the paper could be stored indefinitely. It could remain stable for two to three weeks after sensitization with acidified silver nitrate, and did not have to be developed immediately after exposure. These advantages recommended such negatives to the travelling photographer. HWK

Weber–Fechner law. This is in fact two laws. Ernst Heinrich Weber (1793–1878) postulated that 'just noticeable stimuli' are proportional to the magnitudes of the stimuli. Gustav Theodor Fechner (1801–87) quantified this, stating that subjective sensation is proportional to the logarithm of the stimulus intensity. Arcane though this formal definition may seem, the Weber–Fechner law is a crucial link between the physical and perceptual worlds. It implies that what we *perceive* as a linear scale of tones, say, 1, 2, 3, 4, 5 in perceived degrees of lightness, is represented in the physical world by luminances of 1, 2, 4, 8, 16 units of measurement. This is known as a *logarithmic relationship, and is the reason we use logarithmic scales for photographic *density and sound intensity. GS

wedding photographs. Although the camera did not record the wedding of Queen Victoria and Prince Albert in 1840, Roger *Fenton was commissioned to commemorate the event fourteen years later with photographs of the couple in their wedding clothes. Subsequently, royal betrothal and wedding photographs were widely disseminated, doubtless with an influence on society at large. But for a long time wedding pictures were usually limited to a studio portrait of the bride or bridal couple in formal attire, with the bride often identified as such by a bouquet rather than a wedding dress. The studio portrait remained popular until the Second World War, but with the group often enlarged, from the 1920s onwards, to include the best man and bridesmaids. By the 1900s, in England, outdoor group photographs had begun to appear, including members of the extended family. Church-door pictures proliferated from the 1920s, especially when the groom was in the forces, entitling him to an avenue of comrades making an archway of swords, bayonets, or even police truncheons. There might also be a picture of the bridal couple leaving for their honeymoon. But for most ordinary town dwellers until at least the

Anon.

Wedding group, Morton Hall, Norfolk, June 1887. Albumen print

1950s, as images by photographers like Robert *Doisneau suggest, weddings were unpretentious affairs in which photography played a modest part. (Doisneau's parents and their families, however, had treated themselves to a rather grand studio portrait in 1909.) What pictures there were tended to be formal and static, with the photographer making the exposure by removing the lens cap of a large plate camera.

After the Second World War, wedding photography (and eventually videography) became increasingly elaborate, to the point, sometimes, of hijacking the proceedings. From being the record of an event it became a major lifestyle statement, at a cost to match: in the early 21st century, photography may absorb 10 to 15 per cent of an American wedding budget. Growing affluence made weddings key success indicators and occasions for conspicuous consumption, to be documented as lavishly as possible. Demographic mobility (even between continents) enhanced the significance of family gatherings. Paradoxically, rising divorce rates made the bridal photograph into a kind of pledge of permanence, and the wedding album—in marketing parlance—a 'precious and lasting keepsake' or 'treasured heirloom filled with emotion'.

Also paradoxical was the fact that wedding photography developed into a lucrative and heavily marketed industry as private camera ownership became almost universal in rich countries, with weddings among the most popular photographic occasions. (Since *c*.1990 the *single-use camera has swelled the image torrent.) But amateurs take on the main task at their peril. The cost of the modern wedding, and the social and emotional freight it carries, has put the professional's assets at a premium. These include, in addition to equipment (usually medium-format film and/or high-end digital cameras, and often in-house processing facilities), essential technical skills (e.g. an ability to get good pictures in bad weather), experience, stamina, tact, and a talent for self-promotion. On the other hand, the business is highly competitive, while its seasonal structure, except in locations like Hawaii or the Bahamas, where wedding photography has links with the travel industry, keeps prices high. The market is divided between a few big studios employing many photographers and a much larger number of small firms. Awards and celebrity connections create important advantages. Advertising is done via wedding magazines, regional wedding fairs, and the *Internet. For both large and small firms, however, word-of-mouth recommendation plays a major role.

The wedding photographer's task falls into three stages:

Preparation. The scope and cost of the assignment are negotiated as precisely as possible, usually months in advance, and a relationship established between photographer and client.

Shooting. This requires its own groundwork. The photographer will check equipment and locations. The bride may undergo elaborate hairdressing and cosmetic preparations. On the day (or, in some cultures, over several days), the photographer must get the key shots specified by the client, sidestep the difficulties created by family feuds and snapshooting guests, stay cool in the face of cloudbursts or the appearance of ex-spouses or estranged parents, and maintain the flow of events. Sometimes he may find himself in the role of an unofficial master of ceremonies. Shooting styles have become increasingly varied. At the centre of mainstream Western wedding

Anon.

British wedding photograph, early 20th century

photography is a series of 'essential' shots, traditionally taken in medium format: the bride's arrival at the church or register office, the signing of the register, group pictures of family, friends, and bridesmaids, the cutting of the cake, and the couple's departure. (How much photography is permitted during the actual ceremony varies considerably.) But since the 1970s, young, affluent, and socially competitive couples have favoured a more fluid, 'photojournalistic' approach, in which the photographer's task is less to record an event than to direct—or observe—a narrative, sometimes shooting in black-and-white. Photographers like Dennis Reggie, Bambi Cantrell, and John Solano in the USA and Anna Henly and Annabel Williams in Britain emphasize picturesque details, unplanned incidents, and spontaneous interactions. The format of choice is 35 mm and, increasingly, digital. The end product will be 'arty, hip and elegant',

influenced by contemporary trends in *fashion, *celebrity photography, and cinema. Finally, multiculturalism, and the combination in many societies, for example Japan and the Chinese communities of the Pacific Rim, of traditional and Western ceremonies and costumes, has added further subjects for the camera.

Follow-up. In this phase, the photographer will endeavour to produce prints as soon as possible, so that guests can order reprints in person. In immigrant communities, pictures may be required for display at further celebrations in the country of origin. The bridal couple will expect printed or digital proofs on returning from their honeymoon. A final selection of images may be arranged (sometimes with the help of special layout software) in a presentation album, or in a 'wedding book' of pictures digitally printed in conjunction with graphic designs and text. These extras, together with reprints, may

add substantially to the photographer's earnings from the original package (shooting, and a stipulated number of pictures).

The afterlife of wedding photographs deserves to be better studied. Many pictures will be displayed around the house or distributed among friends and relations. The expensive tooled-leather albums and packets of prints will probably be relegated to quiet obscurity, to be viewed on anniversaries, or perhaps with children on the threshold of marriage. But in Western societies their existence is uncertain. Marital breakdown may cause them to be banished to attics, or destroyed, or—the unkindest cut of all—pushed back through the letter box at the moment of departure. RL

Halle, D., *Inside Culture: Art and Class in the American Home* (1993).
Cantrell, B., and Cohen, S., *The Art of Wedding Photography* (2001).
Pols, R., *Family Photographs, 1860–1945* (2002).
The Annabel Williams Book of Wedding and Portrait Photography (2004).

Wedgwood, Thomas (1771–1805), English inventor and amateur scientist, son of the famous potter Josiah Wedgwood. It is likely that he was educated at home prior to attending Edinburgh University (1786–88), where chronic ill health prevented him completing his studies. The relationship between light and heat interested him in connection with the search for a technique to form images on china or glass. To this end he enlisted the help of his friend Humphry Davy (1778–1829), and in 1802 they published a joint paper in the *Journal of the Royal Institution*. They had observed that white paper or leather, when moistened with a solution of silver nitrate, blackened on exposure to sunlight; and were able to produce images of insects' wings or leaves laid on the paper. However, neither Wedgwood nor Davy discovered a means of fixing the images. CR

Litchfield, R. B., *Tom Wedgwood: The First Photographer* (1903; repr. 1973).

Weed, Charles Leander (1824–1903), American portraitist and landscape photographer who took views in the USA, Asia, and Hawaii. But he is famous as the first person to photograph the Yosemite Valley in California, where he made large-format *wet-plate photographs, and stereographs, in June 1859. He moved there in 1863, and his *mammoth-plate views, many of them reproduced as engravings, contributed to the developing tourism industry. LAL

Adam, H. C., 'Go West! Die Photographen Charles Leander Weed und Carleton E. Watkins im Yosemite-Valley', in B. v. Dewitz and R. Scotti (eds.), *Alles Wahrheit! Alles Lüge! Photographie und Wirklichkeit im 19. Jahrhundert* (1997).

Weegee (Arthur Fellig; 1899–1968), Austrian-born American photographer who made his reputation as a police-beat photographer and gangster chaser in the crime-ridden slums of New York. He followed this up, for good measure, with portraits of Hollywood stars, including those taken with a kaleidoscopic lens to produce caricatures of the likes of Marilyn *Monroe, Marlene Dietrich, Gregory Peck, Leslie Caron, and Liberace. From his beginnings as a freelance news photographer to his later glamorous successes, Weegee also took on *advertising, *fashion, and society photography. In addition he worked

as actor and cameraman on numerous films and lectured on spot-news photography in general and his work in particular.

Weegee's hallmarks were his 'Weegeescope' trick lens and his love of flash to capture dark crime in a spotlit glare akin to O. Winston *Link's night pictures of trains. His primary motivations were love of dramatic intensity; a taste for both humour and catastrophe; and an unexpected affinity with the afflicted, perhaps partly due to his own impoverished origins. Certainly, he had the gift of getting on with everyone: he appeared as much at home in Sammy's on the Bowery (having spent long years in doss-houses himself), or among the homeless beggars of post-war Europe, as in 'high society' enjoying high culture at establishment institutions such as MoMA, New York, where his work found a permanent place.

Naked is the one adjective that appears in his book titles. *Naked City* (1945) and *Naked Hollywood* (1953) have nothing to do with other passing interests (nudist holiday camps and Parisian strip clubs), and everything to do with his desire to focus the harsh light of his flashbulbs on stripping away pretensions. In a roughly written but racy (and glamorized) account of his life, Weegee explained his vocation: 'I think about my camera all the time . . . There are photographic fanatics, just as there are religious fanatics. They buy a so-called candid camera . . . there is no such thing: it's the photographer who has to be candid, not the camera.' His dedication was avowedly absolute: 'People are always asking me when I am going to reform, settle down, get married, etc. I am married to my camera. I belong to the world. And I work only for kicks and for money.' AH

Weegee's People (1946).
Weegee by Weegee: An Autobiography (1961).
Barth, M., *Weegee's World* (1997).

Weems, Carrie Mae (b. 1953), American photographer, daughter of Mississippi sharecroppers who relocated to America's Pacific Northwest. She received her first camera as a 21st-birthday present, and later studied fine art and folklore. Weems works primarily in series and installations, often combining images with text. Her photography explores the experience and culture of African-Americans throughout history. Early work focused on her family and other people she encountered, while later series examine the status of blacks in America historically. Increasingly her work has addressed broader issues relating to gender and personal identity. MR

Wegman, William (b. 1943), American photographer. Best known for his whimsical photographic work and books featuring his pet Weimaraners, most notably Man Ray and Fay Ray, Wegman has had a career spanning many media and styles, from drawing and video to performance art. He studied at the Massachusetts College of Art, where his explorations included Dada and *Surrealism, and has also been strongly influenced by Conceptual art. Widely published, he continues to pursue his eclectic and quixotic interests. TT

Kunz, M. (ed.), *William Wegman, Malerei, Zeichnung, Fotografie, Video* (1990).

Weegee (Arthur Fellig)

Billie Dauscha and Mabel Sidney, entertainers at Sammy's on the Bowery, 1944–5

Wehrmacht atrocities exhibition (*War of Extermination: Crimes of the Wehrmacht 1941–1944*). Launched in March 1995 by the privately funded Hamburg Institute for Social Research, it toured widely in Germany and Austria, attracting nearly a million visitors. Its aim, using both photographs and written documents, was to refute the myth of a 'blameless' wartime army and prove the Wehrmacht's thoroughgoing complicity in Nazi crimes in Russia and the Balkans. Though this contention was not new, the images magnified its impact and the exhibition provoked furious protests from veterans' organizations and right-wing politicians, riots in Munich, and wrangles in the media and the courts. (Controversy about the film *Schindler's List* and Daniel Goldhagen's Holocaust book *Hitler's Willing Executioners*, and parliamentary debates on other wartime issues, heightened the furore.) While some critics dwelt on the organizers' leftist antecedents, historians attacked their methodology, and in October 1999 the heavyweight *Vierteljahreshefte für Zeitgeschichte* published an article by the Polish scholar Bogdan Musial claiming that some photographs revealed Russian, not German atrocities, and raising larger questions about barbarism in Eastern Europe in 1941. Subsequently the exhibition was withdrawn, and replaced by a revamped (though still controversial) version which opened in Berlin in December 2001. The episode demonstrated both the explosiveness of Germany's recent past and the pitfalls of photographic evidence, and academics' and journalists' inexperience in using it.　　RL

Heer, H., and Naumann, K. (eds.), *War of Extermination: The German Military in World War II, 1941–1944* (2000).

Weimar, Wilhelm (1857–1917), German museum official. In the 1900s, as a curator at the Hamburg Museum of Art and Design under Justus Brinckmann, he acquired numerous Hamburg *daguerreotypes, then cheaply and plentifully available, thus forming one of Germany's earliest public photographic collections. His monograph *Die Daguerrotypie in Hamburg, 1839–1860* (1915) was a path-breaking study. Before Weimar's death part of the important *Juhl collection was also acquired; both are now in the Landesbildstelle Hamburg.　　RL

Kempe, F., *Vor der Kamera: Zur Geschichte der Photographie in Hamburg* (1976).

Weston, Brett (1911–93), American photographer, and second son of Edward *Weston, whose pupil he became in 1925. Twenty nature and landscape photographs by him were shown at the *Film und Foto* (*FiFo*) exhibition in Stuttgart in 1929. In 1932 the M. H. de Young Museum in San Francisco mounted his first major one-man show. In conjunction with great technical precision, Weston favoured a severe vocabulary of containing lines and monochrome contrasts that transforms his images of landscapes and natural objects into abstract compositions. A lifelong interest in surfaces and textures also governs his abstract-leaning close-ups, which turn everyday objects into pure form.　　JG-P

Theodore Brett Weston: A Personal Selection (1986).

Weston, Edward (1886–1958), American photographer who, after early success as a *pictorialist, became a leading exponent of *straight photography.

Weston was given his first camera by his father in 1902, and later studied at the Illinois College of Photography in Chicago. After marriage to Flora Chandler in 1909, he moved to California, working as a portraitist in the Mojonier studio in Los Angeles before opening his own studio in the suburb of Tropico (now Glendale) in 1911. The following decade saw the creation of many masterly images, mostly portraits or genre scenes, in which he fashioned the classic pictorialist style into a means of personal expression. Experiments with light and shadow, soft focus, and deliberate over- and underexposure enabled him to wrap his studio set-ups in a magically artistic atmosphere. However, a visit to his sister in Ohio in 1922 led him to change direction, finding methods adequate to the industrial structures he saw there (e.g. *Armco Steel*, 1922). Photography now became a medium for direct vision and the analysis of (primarily natural) forms. This new course was confirmed by meetings with *Stieglitz, *Sheeler, and *Strand in New York the same year, and Weston became the spokesman for a photographic movement that strove to capture the details of reality with extreme precision.

In 1923, with his pupil and lover Tina *Modotti, he travelled to Mexico, where he encountered intellectuals and artists such as Diego Rivera and José Clemente Orozco. Along with portraits, he concentrated on nudes and still lifes (e.g. *Washbowl*, 1925), using extreme close-ups and isolating segments of bodies and things. His quest for elemental form continued after his return to the American West Coast in 1926. The years 1927–30 produced his celebrated images of peppers, cabbage heads, and shells, 'more real and comprehensible than the actual object'. In 1929 he left San Francisco, where he briefly ran a studio with his son Brett *Weston, for Carmel, California, and embarked on a long series of views and close-up studies around nearby *Point Lobos. Also in 1929, with *Steichen, he organized the American section of the Werkbund's *Film und Foto* exhibition in Stuttgart. In 1932, with Ansel *Adams, Imogen *Cunningham, and others, he founded the *Group f.64 in direct opposition to residual pictorialism. Late in 1933 Weston met Charis Wilson, who became his second wife in 1938 and inspired the wonderful series of nudes created at the height of his powers in the mid- and late 1930s; the relationship lasted until the end of the Second World War.

In 1937–8, meanwhile, the first Guggenheim Fellowship for Photography had enabled the couple to travel throughout the American West. In 1946 a Weston retrospective was held at MoMA, New York. But Parkinson's disease was already crippling Weston, and eventually forced him to abandon photography. His last decade was spent supervising the printing of his work by his sons Cole and Brett.　　JG-P

Maddow, B., *Edward Weston: His Life* (1973).
Conger, A., *Edward Weston: Photographs from the Center for Creative Photography* (1992).
Gilles, M. (ed.), *Edward Weston: Forms of Passion* (1995).

Edward Weston

Two shells, 1927

wet-plate process (or wet-collodion negative). In 1851, F. Scott *Archer described a *collodion binder to hold silver iodide on a glass support plate (potassium bromide was later added to improve photosensitivity). Archer's 'wet-plate' process was cumbersome, but produced inexpensive, high-quality negatives, and was the standard plate technology from 1855 until about 1881, when it was superseded by gelatin silver bromide *dry plates. In the 1850s and 1860s, various formulae were proposed for 'dry'-collodion negatives incorporating tannin or acidic sugar preservatives such as raspberry syrup, but the poor keeping properties and slow speed of these plates limited their use. HWK

Wey, Francis (1812–82), French writer, art and pioneering photography critic, and friend of the painter Gustave Courbet. He praised the expressive qualities of the *calotype and argued in favour of photographers' authorial rights. Wey also belonged to the *Société Héliographique, contributed frequently to its journal, La *Lumière, and on 9 February 1851 published 'De l'influence de l'héliographie sur les beaux-arts', proclaiming the value of *architectural photography and the usefulness of the camera in recording historical monuments. Thus he vigorously supported the *Mission Héliographique. RL

 Mondenard, A. de, *La Mission Héliographique: cinq photographes parcourent la France en 1851* (2002).

White, Clarence (1871–1925), American *pictorialist, and founder of two influential schools of photography. He achieved early recognition for his soft-focus photographs, often depicting women and children in domestic or natural settings. Founder of the Newark Camera Club in 1898, White was intimately involved in photographic politics 1898–1910. A member of the *Linked Ring and founding member of the *Photo-Secession, he was also co-founder of the Pictorial Photographers of America in 1916. Always in need of money to support his family, he took professorial jobs and founded the Seguinland School of Photography in rural Maine, to which Fred Holland *Day and Gertrude *Käsebier, both lifelong friends, contributed their teaching services. With students ranging from Dorothea *Lange to Paul *Outerbridge at New York's Clarence H. White School of Photography, which he started in 1914, White helped bridge the gap between pictorialist and modernist styles. His 1925 trip to Mexico with students resulted in a fatal heart attack, but not before White's own photography, which he had long neglected, was revitalized with a portfolio of pictures emphasizing geometric forms. PC

 Yochelson, B., *Pictorialism into Modernism: The Clarence H. White School of Photography* (1996).

White, John Claude (1853–1918), British amateur photographer, who served in the Indian Public Works Department from 1876 and as political agent for Sikkim, Bhutan, and Tibetan affairs 1905–8. White accompanied the Younghusband Mission to *Tibet in 1903–4 and during the campaign made a series of mainly landscape photographs, including a number of impressive panoramas. A selection of these was later issued in two photogravure volumes by the Calcutta photographers *Johnston & Hoffmann as *Tibet and Lhasa* (1906). Owing to political sensitivities regarding the accompanying text, they were subsequently withdrawn, and are now extremely rare. A memoir, *Sikhim and Bhutan: Experiences of Twenty Years on the North-Eastern Frontier of India*, appeared in 1909, and many of White's photographs accompany the articles on Sikkim and Bhutan which he later wrote for the *National Geographic Magazine*. JF

White, Minor (1908–76), American, born in Minneapolis, Minnesota, and between the 1940s and the 1970s an influential photographer and teacher, developing innovative ideas of abstraction and spirituality in photography. His interest in photographing the natural world stemmed from photomicrographic work in botany at the University of Minnesota, where he received an English BA in 1934. In 1937, he moved to Portland, Oregon, and over the next three years set up a photography club, ran exhibitions, and taught classes. In 1940, he began publishing articles and exhibited more widely; his photographs were included in the MoMA, New York, 1941 exhibition *Image of Freedom*. Drafted in 1942, he took few photographs but wrote poetry and began to codify his teaching practice. He also converted to Catholicism, the first of many faiths and practices including Christian mysticism and Zen Buddhism.

 Upon discharge in 1945, White studied at Columbia University, where the art historian Meyer Schapiro's psychological approach to aesthetics helped White evolve a methodology for analysing photographs. Working as a photographer at MoMA, he was befriended by Beaumont and Nancy *Newhall, who introduced him to Edward *Weston and Alfred *Stieglitz. Stieglitz's ideas of pictorial sequencing and his theory of 'equivalents'—whereby the literal subject is a metaphorical gateway to deeper meaning—had a profound impact on White. He also met Ansel *Adams, who in 1946 asked him to teach at the California School of Fine Arts (CSFA). White's photography course extended Adams's *Zone System and method of previsualization to embrace psychological considerations, and incorporated the Abstract Expressionist influences of fellow faculty members such as Clyfford Still. For White, abstraction might free photography from the 'tyranny of the visual facts', linking poetry's metaphorical and expressive language with photography's formalist vocabulary, the latter inspired by Weston.

 In 1952, White became editor of *Aperture*. When CSFA cut its photography programme, Beaumont Newhall invited him to the *International Museum of Photography at George Eastman House, where he curated exhibitions 1953–6. In 1956, White joined the Rochester Institute of Technology, inaugurating his famous photography workshops, whose ethos of personal growth included exercises in awareness derived from G. I. Gurdjieff, and Jungian and Gestalt psychology. He expanded this work at the Massachusetts Institute of Technology (MIT) from 1965, and in 1970 received a

Guggenheim Fellowship for 'Consciousness in Photography and the Creative Audience', a manuscript on universalizing photographic expression. In 1970, the Philadelphia Museum of Art mounted a national tour of his photographs. White's own exhibitions attracted controversy; he was accused of mystical obfuscation in *Octave of Prayer* (MIT, 1972), which suggested that photographs of the external world might correspond to spiritual inwardness. Ill health brought White's retirement from MIT in 1974, and he gave up editing *Aperture* in 1975, though he continued to photograph until his death. His archives are at Princeton University, and his book *Mirrors Messages Manifestations* (1969) is key to his extraordinary synthesis of art, science, religion, and psychology. HWK

Bunnell, P., *Minor White: The Eye That Shapes* (1989).

White Sea–Baltic Canal (originally Stalin Canal). A 227-km (141-mile) system of rivers, lakes, and man-made waterways constructed 1930–3 using convict labour, probably at a cost of *c*.25,000 lives. Alexander *Rodchenko visited the works three times 1931–3, taking over 2,000 photographs. (Other photographers were covering similarly huge but more useful projects like the Turksib railway and the Dnieper dam at Magnitogorsk.) Although apparently aware of the workers' privations he was forbidden to speak to them, and censorship restricted what he could photograph. A 50-page selection appeared in a special edition (December 1933) of *USSR in Construction* designed by Rodchenko and his wife. Ironically, Rodchenko's modernistic epic appeared after his style had been denounced as 'formalist deviationism', and as *Socialist Realism was about to be imposed on the arts. RL

Gassner, H., *Rodchenko Fotografien* (1982).

wide-angle distortion. True wide-angle distortion describes the way in which three-dimensional objects near the edges of the field of view appear 'stretched' out of shape because of the angle of view of the lens: a round ball is distorted into an ellipse, and a human head can look quite unpleasant. It is not so much a defect as an inherent property of extreme wide-angle lenses: it cannot be 'designed out' and has been used to powerful creative effect, most notably in the nudes of Bill *Brandt. It should not be confused with another kind of distortion sometimes seen in cheaper *retrofocus lenses, namely, 'barrel distortion' or the bowing outwards of straight lines near the edge of the image area. RWH

wide-angle lens, loosely defined, any lens that has a focal length markedly less than the length of the diagonal of the format it is being used with, i.e. giving an angle of view greater than about 60 degrees. The principle of eliminating distortion by making the lens elements symmetrical about the stop was discovered in the 1860s, but early wide-angle lenses showed severe fall-off in image illuminance towards the edges of the format, and various devices were adopted to minimize this. The problem has been largely solved by introducing highly curved negative meniscus elements at the front and rear of the lens so that the

peripheral rays pass more nearly perpendicularly through the stop (the Slussarev effect). The introduction of the *fisheye lens, with its severe barrel distortion, has made it necessary to distinguish this from the orthoscopic (or 'rectilinear') wide-angle lens with correct perspective drawing. Modern designs of the latter can cover up to 120 degrees with zero distortion and little fall-off. GS

See also LENSES, DEVELOPMENT OF; WIDE-ANGLE DISTORTION.

wildlife photography is by no means confined to taking big game on safari, but is a vast genre that embraces mammals, birds, reptiles, amphibians, and fish, as well as insects, spiders, and marine and freshwater life. Nevertheless, it is interesting behaviour displayed by the larger animals that tends to produce the most eye-catching and memorable pictures. A wildlife photograph succeeds if it entices the viewer to give it more than a cursory glance.

Just as the sizes, habits, and mobility of animals vary greatly, so do the techniques required to photograph them, and the approach adopted can be either scientific or artistic, or a combination of both. Identification books prefer high-definition pictures of individual animals showing their characteristic features; whereas a more aesthetic approach can stand on its own in an exhibition or a photographic book. But achieving scientific accuracy or an artistic composition need not be mutually exclusive. An example that successfully bridges the gulf between science and art was produced by Eadweard *Muybridge in the 1870s, with his pioneering work recording animal locomotion frame by frame. At the time, this was a scientific breakthrough, and many of his images still exhibit a classic beauty.

Shortly after the invention of the *wet-plate process in 1851, dedicated field photographers transported not only cumbersome cameras, but also portable darkrooms in wagons or tents out on location. Almost a decade later, the elephant hunter James Chapman used two unwieldy cameras in his attempt to photograph living African wildlife. One camera was wrecked when it blew down in the wind; the other disintegrated in the heat. Resourcefully, Chapman rebuilt a new camera from the parts he salvaged, but luck was against him when chemical containers ruptured and his porters inadvertently scared the game. In the end, therefore, he had to resort to photographing animals he had shot.

Slow emulsions limited the choice of subjects; relatively static portraits, notably of birds at the nest, were therefore popular. The nest was a fixed place to which the birds would return, so a hide could be erected at fairly close quarters for working with not particularly long lenses.

At the end of the 19th century, when photographing breeding birds at close range, Richard and Cherry Kearton devised many ingenious ways for camouflaging themselves, including using artificial rocks, tree stumps, and even a dummy bullock. Once when Richard was working inside the bullock, he became dizzy from peering through the small opening and lost his balance, so the hide tipped over, with all six legs, four of the bullock plus Richard's, sticking incongruously into the air.

The year 1895 saw the publication of the first book of wildlife photographs, entitled *British Birds' Nests*, by the Keartons. Just two years later, their book *With Nature and a Camera* included pictures of birds in flight, one of which was a barn owl taken with magnesium *flashlight. Some of the techniques used by pioneering wildlife photographers would raise more than an eyebrow today. Sometimes so much magnesium powder was ignited for a single picture that it set fire to the surrounding vegetation. The explosion frightened the animals so much that, not surprisingly, they failed to return after the first frame was exposed. When working with seabirds, the Keartons would fire a revolver to disturb the adults, so that the position of a nest could be located before they descended from the clifftop with camera and tripod.

The introduction of the *dry plate and smaller-format cameras aided field photographers, but for the first half of the 20th century the weight of equipment still remained problematical. Herbert *Ponting, the photographer on Scott's 1910–12 British Antarctic Expedition, transported 180 kg (400 lb) of photographic and camping gear over the ice on a one-man sledge. His half-plate negatives still produce superb prints.

The brisk evolution of cameras and film transformed the techniques of wildlife photography in the latter part of the 20th century. The reduction in size and weight of cameras and lenses was a boon to the wildlife photographer and, with the advent of the 35 mm or medium-format single-lens reflex camera, plates were discarded for film. Long-focus lenses increased the working distance between photographer and subject, giving greater freedom to capture the natural behaviour of birds and mammals.

Without a hide, the wildlife photographer had to learn how to stalk subjects with acute vision out in the open. Wearing appropriately coloured clothing became essential and learning how to keep a low profile by zigzagging forward using rocks or trees as cover, or even belly crawling, became second nature.

The next great advance was the production of colour film that allowed wildlife photographers to capture the glorious hues of some subjects. However, original Kodachrome had a film speed of only 10 ASA, much slower than the monochrome films used at the time; so that the photographer was limited to either using a 'fast' lens or waiting until the light was bright enough to expose the slow colour film. Colour plays a key role in the ecology of the natural world; for example, camouflage colours enable an animal to blend in with the background and escape predation, while bright colours may advertise an animal to a possible mate or threaten a potential predator. Clearly, a monochrome photograph cannot convey the same messages.

Timing is crucial to success in many aspects of wildlife photography; the prime location and way of life of an animal needs to be thoroughly researched via websites and by getting local advice from rangers. Animals have distinct biological clocks that ensure optimum times to migrate, to mate, and ultimately to breed, which allows a narrow window of opportunity for the wildlife photographer. Determining

Anon.

A. R. Dugmore using a reflex camera to photograph African wildlife, 1909

Bill Biggart World Trade Center, New York, 11 September 2001. The photographer was killed shortly afterwards

Eiko Yamazawa *What I'm Doing*, no. 77, 1986

Anon.

Cherry Kearton standing on Richard Kearton's shoulders to photograph a bird's nest, 1900

the prime time is therefore crucial. For instance, pregnant female harp seals haul out on pack ice off the Îles de la Madeleine in the Gulf of St Lawrence, Canada, to pup within a few days of each other. The time-span for achieving the most photogenic pictures is thus only a few days long, and since the speediest way to reach the ice is by helicopter, bad visibility reduces the 'window' for photography still further. Success comes to the wildlife photographer who plans carefully and has a lot of patience, and luck.

Working on location varies between taking meticulously planned shots depicting some aspect of animal behaviour, to being able to exploit unexpected opportunities that arise from ephemeral moments when a shaft of light backlights hairy coats or prickly spines. A wildlife photographer is constantly on the lookout for a combination of elements that transform a picture from a simple record into an image that communicates. Lighting alone can turn a wildlife picture into something that makes people look twice. Birds and mammals that display fascinating behaviour are a great boon to wildlife photographers, who can choose the technique they wish to depict the event. Today, fast motordrives, *through-the-lens metering, and near-instantaneous autofocus allow sequences to be taken of high-speed action, such as a cheetah chase or an osprey lifting off with a fish in its talons.

A slow shutter speed can also be used to convey movement as the camera is panned in the same direction as a bird is flying or a mammal running, or the motion of a few individuals in an otherwise static group. For much of the time king penguins are on land they are relatively inactive, but as a bird begins to weave through the colony, the adjacent birds lunge towards it. In fading light, the film may have to be pushed one or more stops to get any picture at all; alternatively, instead of using a faster film to gain a fast shutter speed to freeze all action, a slow shutter speed can be used to blur the moving birds in contrast to the stationary ones.

Each wildlife photographer will adopt an individual approach. In an African game park, some may prefer to photograph as many different species as possible; while others prefer to concentrate on a single species, such as the elephant. By focusing on just one species the rewards can be greater because time can be spent observing, and then anticipating behaviour. Using a selection of lenses at different times of day, in variable weather conditions, will provide an insight into the way of life of African elephants.

When the action is fast, long-focus *zoom lenses are a boon to wildlife photographers, since they allow precise cropping of a subject, in a horizontal or vertical format. But longer zooms (up to 400 mm) are slow lenses, which means faster films will have to be used at dawn and dusk when many mammals are active. This is the reason why a fast prime lens in the 400 mm–600 mm range is an essential tool for the serious wildlife photographer. Shorter zooms are useful for depicting animals in their habitat. Macro zoom lenses allow speedy and tight framing of smaller wary animals in the field; whether they be insects, amphibians, reptiles, or life in rock pools accessible only for a limited time between tides.

Photographing nocturnal animals is a real challenge, since their senses at night are infinitely sharper than those of any human moving around in the dark. Since mammals have an acute sense of smell, they need to be approached from downwind, to avoid human scent reaching them. Nocturnal mammals are often creatures of habit that utilize favourite tracks, on which a camera can be set up to be triggered by an animal breaking an infrared trip beam. Flash units need to be moved off the camera axis to avoid the problem of red-eye, whereby the flash reflects back off the retina.

There are few habitats where wildlife photographers have not ventured with their cameras. Caves require a continuous light source to locate animals and flash to photograph them. Working in polar regions requires special clothing to function and dedication to keep cameras working. In extreme cold, batteries cease to function, rendering electronic cameras without a remote battery pack, or a chemical hand warmer taped to the outside of the battery pack, useless. Manual models are therefore more reliable in sub-zero temperatures, when it is safer to rewind 35 mm film by hand, because the film becomes brittle and sprocket holes easily tear.

The ever-improving facility of *digital enhancement now adds an extra dimension to the question of *ethics. Digital manipulation can be a highly creative tool, but it can result in the production of misleading—or even biologically untruthful—pictures. Images of wall-to-wall zebras, achieved by the replication of individual animals to fill grassy spaces, may be impressive but are unrealistic and misleading. However, the removal of an out-of-focus leaf or branch can help to produce a more arresting picture which can convey the conservation message in a more convincing way.

In their quest for more striking photographs, some wildlife photographers favour a technique adopted by certain television cameramen: namely, working at very close quarters with a wide-angle lens. This is not only potentially dangerous for the photographer, but disturbing for the animal. Alternatively, the camera can be placed where animals congregate, such as a waterhole, and triggered remotely by radio control. As the human population expands and wilderness areas shrink, so pressure on many wildlife populations increases. Wildlife photographers must not allow their own activities to have a negative impact on the subjects they are trying to photograph. To this end, some countries have introduced legislation controlling the photography of rare and endangered species, notably birds at or near their nest; as well as more general guidelines for photographers. HA

◷ See also Pandas in China *opposite*.

Guggisberg, C. A. W., *Early Wildlife Photographers* (1977).
Life Library of Photography: Photographing Nature (2nd edn., 1981).
Angel, H., *Photographing the Natural World* (1994).
Lanting, F., *Eye to Eye: Intimate Encounters with the Animal World* (1997).
Hicks, N., *Professional Nature Photography* (1999).
Hope, T., *Wildlife: The World's Top Photographers and the Stories behind their Greatest Images* (2002).

Williams, David (b. 1952), Scottish photographer and teacher. Born in Edinburgh, he studied at Stirling University and worked as a musician and composer before becoming a photographer. His early interest in *documentary work is typified by *Pictures from No Man's Land* (1984), an exhibition and book based on a six-month residency at an Edinburgh private girls' school. Later exhibitions, such as '*Is*': *Ecstasies I–XII* (1989), use monochrome abstract forms to explore a range of existential concerns, while *Source* (1995), a sequence of colour images of a vibrating string, proposes a correspondence between visual art and music. RMCK

Willis, William (1841–1923), born at St Austell, Cornwall, the elder son of William Willis Senior of Penzance, the landscape engraver and inventor of the aniline copying process. He found employment in practical engineering and banking in Birmingham, before devoting himself to the problem of photographic impermanence. He made the first platinum print in 1873, but the process was imperfect, attracting little interest; by 1879 he had improved it sufficiently to justify founding the Platinotype Company to market his papers. Years of laboratory research led, via five British patents, to a perfected, but secret, process by 1892. Universally acclaimed and commercially successful by 1900, Willis's *platinotype was the predominant choice of photographers for permanent, exhibition prints. During the platinum famine of the First World War, Willis substituted his satista (1913) and palladiotype (1917) processes. The *Royal Photographic Society awarded Willis its Progress Medal in 1881, and Honorary Fellowship in 1905. His company won a gold medal at the International Inventions Exhibition in 1885. A modest, cultured, and sociable bachelor-scientist, Willis died at Brasted Chart, Kent, survived by countless platinotypes worldwide—the enduring testimony to his invention. MJW

Nadeau, L., *History and Practice of Platinum Printing* (1994).

Wilson, George Washington (1823–93), Scottish photographer, originally trained as a miniature painter. By the mid-19th century tourism was flourishing, and Wilson's business, established in Aberdeen in 1852, met a huge demand for *wet-plate views of Scotland. In the early phase of his career he undertook lengthy photographic tours, laden with equipment and sometimes accompanied by his friend the bookseller George Walker. The resulting pictures, trademarked GWW, soon established Wilson's reputation and did much to publicize regions like the *Scottish Highlands. Later he extended his reach to England. Finally, his staff photographers reached Australia. The firm eventually held 45,000 negatives and advertised 25,000 views of Scotland and England and produced portraits, stereograms, *cartes de visite*, *postcards, and albums. Commissions, from 1854 onwards, to photograph Balmoral Castle and members of the royal family brought Wilson the prestigious and lucrative title of 'Photographer to the Queen'.

Wilson published a guide to the wet-collodion process in 1855. In 1859 he made prints of sky and sea from a single negative and froze, photographically, movement in Edinburgh's Princes Street. By 1880 (continued on p. 686)

Pandas in China

A few practised strokes by an ink-brush artist are enough to convey the clownlike face, complete with black eye patches, of the monochromatic giant panda. Monochrome films are also a good medium for taking panda portraits, but they cannot convey the subtle nuances of the variety of plants in an ecosystem. Colour transparency film has the edge here. However, because it has more limited latitude than monochrome film, achieving the correct exposure at both extremes of the tonal range with black-and-white animals like pandas may prove tricky when working in conditions of contrasty light and shadow.

Nowadays wild pandas are confined to western China; but fossil remains indicate that they once extended as far south as Burma and North Vietnam, as far north as Beijing, and as far east as Shanghai and Hong Kong. Satellite photographs prove that between 1974 and 1989 half of the panda's natural forest habitat was destroyed to provide land for agriculture. Pandas now live in small pockets within mountainous areas in three provinces—Sichuan, Gansu, and Shaanxi—along the eastern flank of the Tibetan plateau at altitudes ranging from 2,300 to 3,300 m (7,216–9,840 ft). During the summer, pandas move up to higher and cooler elevations and descend again during the winter months.

The mountainous terrain makes it difficult to count the giant panda population accurately, but it is estimated at *c.*1,000 individuals in the wild. Even biologists spend long periods attempting to track down individual pandas, so that the odds of finding and photographing a panda at large are remote. It is, however, possible to photograph captive-bred pandas within huge natural forested enclosures at Wolong in Sichuan province. But irrespective of

Heather Angel
Giant panda rolling down a slope, Wolong Reserve, China, 1997

location, the panda is a classic example of a creature whose behaviour and habitat must be understood as a precondition for successful photography.

The forest is a mix of evergreen conifers and deciduous trees, which cast shade for most of the year. Beneath the tree canopy are the bamboo stands so essential for the panda's survival. The panda has a virtually exclusive diet of bamboo leaves, which it consumes for more than half of every 24-hour day, just to stay alive. This makes it relatively easy to photograph a panda feeding, but more difficult to record any other behaviour.

Although pandas sit or even lie down to feed, because their jaws move incessantly to munch the bamboo a shutter speed of at least 1/125 s is needed to freeze the action. Unless a fast f/2.8 lens is used, the shutter speed in poor light will make a 100–200 ISO film obligatory, especially if the lens is stopped down to gain necessary depth of field. Creatures that have a black eye surrounded by black fur or feathers need to have a highlight in the eye to make them appear alive. Sometimes a skylight reflection is sufficient, but when working in forests a fill-flash is often necessary to gain a little sparkle. However, during rain or snowfall, fill-flash adds myriad highlights to the wet fur, with most unnatural results.

Once a panda starts to feed, it is possible to take a series of pictures illustrating the process. The hands have a sixth digit or pseudo-thumb, to manipulate the bamboo stems towards the mouth. Each side branch is neatly bitten off the stem until a sizeable bunch appears at one side of the mouth. This is then removed so that the bamboo can be eaten from the hand. After feeding, pandas may rest or walk to a stream or river to drink. These times present rare opportunities to get pictures of a panda reflected in the water. Play is an important stage in the development of any young animal, and young pandas will spend time frolicking with other youngsters, or playing with plants or bark

shed from a tree. Both youngsters and more active adults will climb trees, using their strong claws to grip the trunk. They climb above the shrub layer until they find a suitable fork or horizontal branch on which to rest and survey their forest environment. The descent is even speedier than the ascent, often with the animal sliding down the trunk like a fireman down a pole. Sometimes it misjudges the distance and crashes unceremoniously to the ground, but its thick pelt helps to cushion the fall.

Unlike brown bears, pandas do not hibernate during the winter, but remain active throughout the year and feed daily regardless of the weather. In the open, a panda looks conspicuous against the green vegetation, but when bathed in dappled light it merges with sunlit and shady patches on the forest floor. After a winter snowfall the black-and-white fur is barely distinguishable from the dark trunks and white snow. Although the winter sun is at a low angle, more light penetrates the canopy during this season in areas where deciduous trees are reduced to winter skeletons, thereby aiding photography with slower, fine-grain emulsions. After a recent snowfall is a good time to search for panda paw prints for photography.

The more time spent with any animal in the field increases the chance of getting a grab shot of unexpected action; such as two young pandas locked in an embrace tumbling in the snow, or a panda that loses its footing on a slippery slope and ends up sliding down on its back with all four feet in the air.

Photography helps both to increase public awareness of endangered species such as the giant panda and to raise funds to assist the conservation of this charismatic animal. However, the use of *digital manipulation to 'drop' a panda into a more attractive but totally false habitat is not only misleading but also a biological untruth. HA

Angel, H., *Pandas* (1998).

G. W. Wilson & Co. was probably the largest producer of views in Britain, with a network of outlets in shops and railway stations, and its Aberdeen premises were a substantial industrial enterprise. After Wilson's death—hastened perhaps by long-term exposure to chemicals—it failed to adapt to changing commercial conditions and foundered in 1908. The firm's surviving negatives are held at Aberdeen University. WB

Taylor, R., *George Washington Wilson* (1981).

Winogrand, Garry (1928–84), American photographer whose street photographs capture the oddness and alienation of post-war America. Winogrand became interested in photography in 1948 while studying painting at Columbia University under the GI Bill. Alexey *Brodovitch's classes on photography at the New School for Social Research, which Winogrand attended in 1949, completed his formal training. During the 1950s, he worked professionally for magazines such as *Collier's* and *Sports Illustrated*. Dissatisfied by the limitations imposed by picture editors, and inspired by Walker *Evans's *American Photographs*, Winogrand set off on a cross-country trip in 1955.

In 1964 Winogrand received his first Guggenheim grant, allowing him 'to make photographic studies of American life', a project that consumed him until his untimely death in 1984.

Winogrand's style, characterized by grainy textures, tilted horizons, and seemingly random compositions, became a hallmark of the photographic formalism popular during the 1960s and 1970s. John *Szarkowski described Winogrand as 'the central photographer of his generation', and promoted him through exhibitions at MoMA, New York, notably *Five Unrelated Photographers* (1963) and *New Documents* (1967). MoMA also published a series of Winogrand monographs—*The Animals* (1969), *Women are Beautiful* (1975), *Public Relations* (1977), and *Stock Photographs* (1980)—variations on sundry public spaces and events, such as zoos, city streets, political demonstrations, press conferences, airports, and rodeos. Winogrand bequeathed his vast, enigmatic oeuvre to the Center for Creative Photography, Tucson, Arizona. KM

Chiarenza, C., 'Standing on the Corner . . . Reflections upon Winogrand's Photographic Gaze', *Image*, 34–5 (1991–2).

George Washington Wilson

Fingal's Cave, Staffa, 1860s. Albumen print

Witkin, Joel-Peter (b. 1939), American photographer who trained in sculpture at Cooper Union. He holds degrees from the University of New Mexico and taught there for several years. His shrouded and etched black-and-white images, bedlams of nude and ghoulish figures apparently engaged in sexual and inhumane acts, were markedly popular in the 1980s and 1990s. Not the first artistic works to illustrate the torment of our species, they emanate from their creator's mind and hands rather than being 'objective' photojournalistic images of human strife. In that sense, Witkin remains very much a sculptor. TT

 Celant, G., *Witkin* (1995).

Wolcott, Marion Post (1910–90), American *documentary photographer, raised in New Jersey by her progressive reformer mother, and educated at New York's New School for Social Research. She studied photography in Europe and worked freelance for the *Philadelphia Evening Bulletin*. In 1938 Roy *Stryker hired her as one of the few women photographers of the Farm Security Administration (FSA). She travelled extensively for the FSA, and is noted particularly for her photographs in Florida showing the harsh contrasts between wealthy racegoers and abjectly poor migrant workers; and for exuberant portraits of African-American sharecroppers dancing at 'Juke Joints' in the rural South. Soon after she married the diplomat Leon Wolcott in 1941, following a whirlwind courtship, she left the FSA; her husband required the agency to change the credit lines on all her file photographs to her new name. For the next 30 years her photography was private, limited to her growing family and her worldwide travels with her husband. Her reputation grew with that of the other FSA photographers, and when she retired to California in 1974 she returned to public exhibition of her work. CBS

 Hurley, F. J., *Marion Post Wolcott: A Photographic Journey* (1989).

Wolff, Paul (1887–1951), German photographer who studied medicine in Strasbourg, served in the First World War, and settled in 1920 in Frankfurt am Main. Instead of practising medicine, however, he opened a photographic agency. This concentrated initially on urban images for book illustration, but expanded into

public relations for motor companies, fashion houses, and the photographic industry. In 1933, Wolff published *Meine Erfahrungen mit der Leica* (*My Experiences with the Leica*), the first of several best-selling manuals which secured him a special relationship with *Leitz and a reputation as a moderate modernist. The agency, which included capable photographers like Alfred Tritschler (who, with Wolff, covered the 1936 *Berlin Olympics), Elisabeth Hase, and Willy Klar, prospered during the Third Reich. As a promoter of colour photography, Wolff was enlisted for an ambitious programme to record wall paintings in colour during the Second World War. In 1944 his premises and archives were bombed, a loss from which he never recovered. RS

Wolff, P., *Meine Erfahrungen—farbig* (1942).

Wols (Alfred Otto Wolfgang Schulze; 1913–51), German painter, graphic artist, and photographer, who through family connections had early contact with artists (Oskar Kokoschka, Otto Dix, Hugo *Erfurth) in his native Dresden. In 1932 he began an apprenticeship with the Berlin photographer Genja Jonas, but left the same year for Paris, where he cultivated the *Surrealist avant-garde. In addition to serial portraits, he was primarily interested in impersonally photographed everyday subjects—tramps, empty streets, and details like railings or fragments of posters. He had a first success with photographs shown at the fashion pavilion at the 1937 Paris World Exhibition, and adopted the pseudonym Wols. After wartime internment, mostly in the south of France, he returned to Paris and did still lifes of found objects. Later he concentrated on painting and printmaking. He was rediscovered in the late 1970s. UR

Glozer, L., *Wols Photograph* (1978).

women and photography. Women have been active in photography from its inception, although earlier histories did not fully acknowledge this. In Britain, Anna *Atkins was the first to use *photograms for illustrations of flora and fauna. Lady *Eastlake was prominent among Victorian critics debating the nature of photography. Numerous Victorian women made photographs destined for the family album and some, such as Lady *Hawarden, became renowned for the quality of their work. Julia Margaret *Cameron was among the first to stage mythological scenes for photographs, as well as making portraits of eminent Victorians she knew. Many other outstanding English and Irish *country house photographers were women. In Germany from 1890, increasing numbers of women were trained at the Berlin *Lette-Verein's photographic school, one of the best such establishments in Europe. In North America, women such as Alice *Austen, Frances Benjamin *Johnston, and Jessie Tarbox *Beals used the camera to explore their local communities. Others, such as Gertrude *Käsebier (or, in Britain, Agnes Warburg (1872–1953)), belonged to *pictorialist groups. Many early female photographers, like their male counterparts, were amateurs in the sense that their work was not made for sale. But countless other women worked in commercial studios, usually as

administrators but often as stand-in photographers or specialists in child portraiture. (As photography became increasingly industrialized by the 1870s, armies of women were employed in processing.) Some, however, like Sophia Goudstikker in Munich and Madame *Yevonde in London, operated their own successful businesses. Other opportunities were also emerging. The British photojournalist Christina (Mrs Albert) Broom (1863–1939), self-styled as a press photographer, included suffragette rallies in her portfolio. The American ethnographer Mary Schaeffer (1861–1939) travelled extensively on foot and horseback documenting First Nation peoples in the Canadian Rockies. Claude *Cahun, Hannah *Hoech, Lotte *Jacobi, and Lucia *Moholy were involved in the aesthetic and political experimentation of the 1920s, and the expansion of magazine journalism and advertising in the Weimar Republic (1919–33) created many openings for women. Gisèle *Freund and Germaine *Krull worked in portraiture and documentary; Moholy and Freund also wrote important books on photography. Gerda *Taro became a war photographer (the first of many women), and Margaret *Bourke-White created the first cover picture for *Life* magazine. By the second half of the century, in Western societies, few if any branches of the medium remained closed to women. In Japan, too, more and more women became photographers. By the turn of the 21st century, finally, the market value of works by celebrities like Nan *Goldin and Cindy *Sherman was fully comparable to that of men.

The feminist movement of the 1970s and 1980s brought questions of gender and culture into focus. Photography histories and practices were not excepted. Broadly, three sets of concerns emerged: first, given the numbers of women photographers, questions were asked about their relative absence from the principal histories of the field. Second, in countries as far apart as North America, Britain, Germany, and Australia, there was concern to give women equal access to training and work. Third, and in a different register, questions of gender and representation were addressed, and ways in which women had been pictured came up for scrutiny. Later, attention shifted to critical analysis of imagery, and the visual imagination, in terms of gender and difference.

Absence from his-story

In 1971, the American art historian Linda Nochlin famously asked why there were no great women artists. She was one of many academics then scouring museums and archives for evidence of women's creativity. In photography, numerous exhibitions, articles, catalogues, histories, and monographs demonstrated women's participation across a range of genres. The exhibition and book *Women Photographers: The Other Observers 1900 to the Present*, by Val Williams (1986; reissued in 1991 as *The Other Observers*), surveyed the British scene. Williams emphasized the diversity of women's contribution, from documentary and reportage to experimental (art) practices; and from portraiture and *family photography to the celebration and satire characteristic of feminist

photography from the 1970s and 1980s. She postulated a distinctively feminine eye for detail, and a tendency to blur the boundaries between public and personal. Her study reflected a British emphasis on cultural contexts. By contrast, North American modernism influenced Constance Sullivan's more aesthetically orientated, text-centred *Women Photographers* (1990), which claimed enhanced status for women within the artistic canon. Identification and investigation of work by women subsequently became a burgeoning research field, especially in American universities and museums. Most comprehensively, Naomi Rosenblum's *A History of Women Photographers* (2nd edn. 2000) surveys and discusses women's participation in photography up till 2000, albeit with a North American emphasis. Publications and exhibitions accumulated examples of work by women and interrogated relations between subject matter, aesthetics, and gender. Uncovering histories of women's activity was intended not only to do justice to photographers previously overlooked, but also to encourage contemporary women's photography.

Putting women in the picture

The phrase 'woman photographer' now seems outmoded, but in the 1970s and 1980s, certainly in Britain and North America, there seemed a need to emphasize women's participation. While the term was resisted by some as belittling, for others its use was political, drawing attention to female activity while also implying distinctive styles and subject matter. A number of women-only organizations, including archives, were established as spaces for women photographers and for stories told from women's perspectives. For instance, women-only agencies not only gave some priority to women's lives in their coverage but also aimed to support female photojournalists' efforts to retain influence over the use of their pictures. Likewise, community-based photo workshops offered opportunities for women to work together to explore themes outside the dominant modes of formalist aesthetics and decisive-moment documentary. A preoccupation with the domestic, with family relations—both 'normal' and dysfunctional—and sexuality, typified much of the work. In the USA, for example, Donna *Ferrato devoted a decade of her career to the study of domestic violence, and founded an organization dedicated to combating it. In Britain, Jo *Spence worked with others at the Half Moon Photography Workshop in east London on re-interrogating the family *album. (Since the advent of roll-film technology in the 1880s, middle-class women had been heavily involved in the making, preservation, and presentation of family photographs.) Emphasis was upon documenting the social and political world as experienced from a female perspective. Broader issues of class and ethnicity as related to gender and biography began to be articulated. On both sides of the Atlantic, *gay and lesbian concerns were also broached. From the perspective of the 21st century it is hard to convey how radical this felt at the time. Women's lives were brought into focus in ways previously unknown, and women's work was centrally framed rather than marginalized.

Gender and representation

As John Berger remarked, in a classic formulation (in *Ways of Seeing*, 1972), men look at women and women conceptualize themselves as objects of the male gaze. Questions of gender and representation became central to feminist analysis and debate. The stereotyping of women in visual culture was a primary focus of attention. It was argued that women were over-commonly portrayed as mothers, as sex objects, as secretaries, as participants in activities traditionally associated with the feminine; and that this limited range of representation tended, ideologically and politically, to promote negative role modelling, limiting female ambitions and horizons and reinforcing the patriarchal status quo. For those involved in community workshops, the possibility of portraying women in more diverse and positive ways seemed all important. One method of achieving this was to run women's photography groups, to see what women would do with cameras if given the opportunity to record and comment on their own lives.

Photographic education also came up for discussion. Where traditionally theory had been concerned with the aesthetic (the specifics of photographic seeing) and the scientific (chemical processes), questions of politics and culture entered the frame. Debates related not only to subject matter, but also to modes of picturing. Psychoanalytical interpretations of patriarchy have placed the male I/eye at the centre of discourse, with woman as 'other': simultaneously object of desire and source of fears and insecurities for the male spectator. In a celebrated essay on cinema, 'Visual Pleasure and Narrative Cinema' (1975), Laura Mulvey argued that the objectification of women was reinforced through the framing look of the camera, and through identification with the viewpoint of male characters within the narrative. Victor *Burgin drew upon this to analyse 'the look' in photography and the possibilities opened up by using psychoanalytical categories and perceptions. While others have questioned the empirical validity of these approaches (and of the theories underlying them), the resulting debates have fostered more complex understandings of image, identity, sexuality, the erotic, and the power of the gaze, especially in relation to questions of gender, class, and ethnicity.

Issues of economic relations also became involved. For instance, in 19th-century colonialism, Middle Eastern women were commonly pictured by (male) European photographers as exotic objects of fascination. Here, an interweaving of imperial mastery and the tourist gaze associated with *Orientalism, coupled with women's position within Arab cultures, effected a double otherness.

What, then, shifts when women become authors of the gaze? In some genres, perhaps rather little: for example, the visual codes of documentary concede little to the maker. Elsewhere, for instance in advertising, or in gallery photography, parameters are less fixed. Women artists have variously explored new subject matter, experimented with materials, and with the effects of different methods of putting content into the picture. As the French feminist Luce Irigaray has commented (in relation to women's writing), creativity is not neutral in terms of gender and cultural experience. Likewise,

there is no neutral viewing position. Post-structuralist theory called attention to the interactive nature of the act of looking; the spectator engages not passively with the picture as art object but actively with the image as a means of visual communication.

Reappraisals of women's contribution to photography postulate ways in which gender influences form, style, and subject matter; and, indeed, methods of working, including approaches to research. By the 1990s, although feminism in its classical manifestation was outmoded, many more women were active in the public sphere as photographers, artists, academics, curators, and archivists.　　LW

Burgin, V., 'Looking at Photographs', in *Thinking Photography* (1982).

Graham-Brown, S., *Images of Women* (1988).

Solomon, J., and Spence, J., *What Can a Woman Do with a Camera?* (1995).

Heron, L., and Williams, V., *Illuminations: Women Writing on Photography* (1996).

Sturken, M., and Cartwright, L., *Practices of Looking: An Introduction to Visual Culture* (2001).

Wood, John Muir (1805–92), Scottish amateur photographer who worked in the family music business as a pianist, musicologist, publisher, and impresario. He lived in Edinburgh until 1848, then in Glasgow. Wood started photography some time in the 1840s, and his first dated photographs were recorded on a tour in 1847, starting at York and visiting towns in Belgium. He also took views in Germany and France, perhaps on the same tour. He continued to photograph in the 1850s, principally in the Scottish landscape. His collection, which includes work by Joseph Cundell (b. 1802), brother of George Smith Cundell (1798–1882), and Hugh Owen (1808–97), indicates that he exchanged information and pictures with other amateurs. His sophisticated knowledge of chemistry suggests contact with the prolific photographic experimenter Charles John Burnett (1820–1907).

Wood's photographs explore portraiture, groups, and sculpture, but mostly landscape. His approach was appropriately lyrical and often mysterious. He apparently regarded the prints as a variable idea, like different performances of music, and experimented with various printing methods from the paper *calotype negative. He is particularly remarkable for his use of metals in toning, working with the chrysotype (gold and uranium), tin, and copper.　　SS

Stevenson, S., Lawson, J., and Gray, M., *The Photography of John Muir Wood* (1988).

Woodbury, Walter Bentley (1834–85), British photographer and inventor, and a colourful character who deserves to be remembered for more than the photomechanical process that bears his name. Born in Manchester, he was brought up by his maternal grandfather. Following a scientific education and apprenticeship in a patent office, he suddenly left England for the Australian goldfields. After various mundane jobs, he took up a post at the Melbourne waterworks which allowed him to practise *wet-collodion photography and become a professional photographer. He moved to Java in 1858, where he opened a studio and sent many fine views back to England.

Ill health forced him to return permanently to England in the early 1860s. In 1864–5 he devised and developed the *Woodburytype photomechanical process that could produce large numbers of grainless prints almost indistinguishable from *carbon prints, and which for a time were widely favoured for high-quality book illustrations. Unfortunately, Woodbury was a poor businessman and made little money from his invention. His other photographic interests included *photoceramics, stereoscopic photography, stereoscopic projection, balloon photography, and electromagnetic shutters. He died in Margate following an overdose of laudanum.　　JPW

Woodburytype. Also known as 'photoglypty', this photomechanical process was based on work with chromate relief images (Auer, 1852; Pretsch, 1854), and patented by W. B. *Woodbury in 1866. The process produced a bichromated gelatin relief, which was used to emboss a soft lead plate; this intaglio held a liquid gelatin ink whose varying thicknesses produced the fine, continuous-tone gradations of the pigmented gelatin image. Woodburytypes resemble *carbon prints in colour and surface finish, but show a more obvious relief. Woodburytype was employed from the mid-1870s until the early 1890s, primarily for art reproductions. It was succeeded by less labour-intensive gravure processes suited to longer print runs at a lower cost.　　HWK

Woodman, Francesca (1958–81), American photographer. Brought up in Boulder, Colorado, the daughter of a painter and a potter, she studied at the Rhode Island School of Design and in Italy. She committed suicide just after the appearance of her only publication, *Some Disordered Interior Geometry*. Her oeuvre consists largely of monochrome figure studies, mainly of herself, often nude and faceless, sometimes in surreal settings. Since her death her photographs have been widely exhibited and written about, evoking mixed responses.　　RL

Chandes, H. (ed.), *Francesca Woodman* (1998).

works of art, photography of. The graphic reproduction of works of art has a long and diverse history. Photography followed a tradition in which the depiction of the fine and decorative arts bestows some kudos on the reprographic processes used. At the time of photography's invention a plethora of reprographic processes were available and these were being exploited to meet the rising demand for loose graphic reproductions and the business opportunities offered by rapidly expanding and diversifying commercial markets. Both *Daguerre and *Talbot appreciated the importance of reproducing works of art (including paintings, drawings, engravings, sculpture, and decorative art), not only to demonstrate their respective photographic processes but also for commercial reasons. Subsequently during the 19th century, art reproduction was to form a key and commercially very significant part of the photographic market.

Anon., Italian

Michelangelo's *Last Judgment* in the Sistine Chapel, Rome, late 19th century. Albumen print

While most 19th-century commercial photographers marketed themselves as generalists covering the general requirements of their customers, across Europe and beyond some created significant reputations for art reproduction. These included Fratelli *Alinari of Florence, Adolphe *Braun of Dornach, Robert Macpherson and James Anderson (1813–77) in Rome, Leonida Caldesi (*fl.* 1850s–1870s), an Italian working in London, the Parisian-domiciled Englishman Robert Bingham (1825–70), Franz and Edgar *Hanfstaengl in Munich, and Juan Laurent (1816–c.1890) and Charles Clifford (1819–63) in Madrid. At the end of the century Frederick Hollyer (1837–1933) was renowned for his reproduction of paintings. In the 20th century Walter Hege (1893–1955) and Wim Swaan (1927–95) were also highly acclaimed.

By the 1850s all aspects of the commercial art world, including painters, sculptors, architects, engravers, art dealers, and auction houses, had adopted photography. The public sector in the form of museums also did so, and appointed photographers. Charles Thurston Thompson (1816–68) was one of the earliest of these and his career at the South Kensington (now Victoria & Albert) Museum during the 1850s and 1860s created a benchmark as he recorded the permanent collections and temporary loan exhibitions, and ventured abroad to photograph in France, Spain, and Portugal. By 1880 the museum held a collection of some 50,000 photographs acquired from all over the world.

Photography was beset by numerous technical problems during much of the 19th century. The angle of view of lenses and the 'movementa' of plate cameras restricted architectural views. A major challenge was the limited spectral sensitivity of black-and-white photographic emulsions that could not reproduce the full colour spectrum. This was particularly apparent in the reproduction of paintings. It is significant that it was the specialist photographic art reproduction company of Adolphe *Braun that introduced improved *orthochromatic (or isochromatic) emulsions in 1878, fully panchromatic film being introduced in 1905. However, colour photographic processes were developed as early as the late 1860s and paintings by Édouard Manet reproduced at this time.

Photographs of works of art were disseminated through a number of print dealers such as the London firms of Colnaghi, Agnew, and W. A. Mansell & Co. Goupil & Cie, founded in 1827, had offices in Paris, Brussels, The Hague, London, Berlin, New York, and Australia. Hanfstaengl of Munich and Giraudon of Paris are other examples. In the 20th century firms such as Scala of Florence continued this specialism.

A wide variety of photographic print formats were exploited for art reproduction during the 19th century. These ranged from thumbnail-sized prints, used as border decoration in photo albums, to the 'elephant'-format images of paintings in major European galleries published in portfolios by Adolphe Braun et Cie. In some instances a variety of different loose print sizes were available of the same image. Stereographs, *cartes de visite* from the 1850s, and *cabinet prints from the 1860s were all used to document a wide

variety of works of art. The glass photographic lantern slide, a cornerstone of art history teaching, was invented in the late 1840s and was beginning to have a significant impact in Germany by the end of the 1870s, promoted by celebrated lecturers like Hermann Grimm (1828–1901). It was not until the 1960s that it was abandoned in favour of the 35 mm slide.

The use of photography to illustrate art books began in the 1840s and has become one of the most significant applications of photographs of works of art. Publishers such as Sampson Low, Bell & Daldy, A. W. Bennett, Day & Son, Seeley, Jackson & Halliday, and Bickers & Son were prominent in the 19th century, while Phaidon, Albert Skira, and Thames & Hudson were notable 20th-century examples.

AJH

Hamber, A. J., 'A Higher Branch of the Art': Photographing the Fine Arts in England 1839–1880 (1996).

Bergstein, M., and O'Brien, M. C. (eds.), Image and Enterprise: The Photographs of Adolphe Braun (2000).

World Trade Center, New York, destruction of. Catastrophe photographs have usually been aftermath pictures. Exceptions were either of prolonged disasters like the San Francisco earthquake and fire of April 1906, or of accidents at well-covered news or sporting events, such as the *Hindenburg explosion in May 1937. Conditions in New York on 11 September 2001 were ideal for photography, with perfect weather and a conspicuous, protracted event occurring in a global media and tourist centre. Newspapers like the New York Times and the Newark Star-Ledger provided saturation photo-coverage. The photojournalist Bill Biggart perished; James *Nachtwey narrowly escaped. Thousands of pictures were taken during the attacks and countless more in the months that followed. The Museum of the City of New York created a special archive overseen by Joel *Meyerowitz, who also had privileged access to the site during the clearing operations. Working with the museum and the State Department, Meyerowitz assembled an exhibition of 27 Ground Zero images shown worldwide as part of America's post-11 September

diplomatic offensive; it opened at the Museum of London in March 2002. Meanwhile, books poured from the presses, agencies compiled selections of their members' work, and photographic magazines produced '9/11' issues. In September 2002, the *International Museum of Photography at George Eastman House launched an exhibition entitled Picturing What Matters comprising photographic *icons that, according to director Anthony Bannon, 'captured or expressed in some way what could be identified as core American values'.

RL

George, A. R., Peress, G., Schulan, M., Traub, C., Here is New York: A Democracy of Photographs (2002).

Wulz, Wanda (1903–84), Italian photographer, from a family of portrait photographers in Trieste; her grandfather Giuseppe had founded the Studio Fotografico Wulz in 1868. Taught by her father Carlo, she photographed Trieste's cultural notables. In 1931 she met Filippo Marinetti and subsequently joined the *Futurist movement, participating in their exhibitions. Her experiments with photodynamism employed superimposition and rhythmic scansion to create studies of bodies in motion, multiple portraits, and Futurist still lifes. Wulz's self-portrait Io+gatto (I+cat; 1932) is one of the best-known Futurist photographic images. But by the late 1930s she was focusing again on commercial work.

AL

Guagnini, E., and Zannier, I. (eds.), La Trieste dei Wulz: volti di una storia. Fotografie 1860–1980 (1989).

Wynfield, David (1837–87), English portrait photographer, born in India of unknown parentage. A founder member of the St John's Wood Clique of painters, he regularly exhibited at the Royal Academy, and briefly practised photography in the early 1860s, making costumed portraits of his fellow artists. He is best remembered because his famous contemporary Julia Margaret *Cameron took one lesson from him, wrote to seek his help with technical difficulties, and was clearly indebted to his close-up style.

CF

Hacking, J., Princes of Victorian Bohemia (2000).

X-ray photography. See MEDICAL PHOTOGRAPHY (FEATURE); RÖNTGEN, WILHELM.

Xun Ling (*c.*1880–1943), Chinese court photographer. The son of an envoy to Japan and France, Xun Ling was largely educated abroad, where he learned photography. Returning to Beijing and the Manchu court in his early twenties, he created in 1903–4 a series of photographs of the Dowager Empress Cixi and her court which remains a unique record of a forceful ruler, a closed world, and a dying era. Together with exquisite portraits of the dowager empress in stately dress, or views with her ladies and eunuchs, are well-known, extraordinary tableaux showing her in the guise of Guanyin, the Buddhist goddess of mercy. RT

 Gugong zhenzang renwu zhaopian huicui (*Exquisite Figure Pictures from the Palace Museum*) (1994).

Xu Xiaobing (b. 1916) and **Hou Bo** (b. 1924), husband-and-wife team of Chinese photographers, propagandists for Mao Zedong and Chinese communism. Xu had joined the Maoist forces in the 1930s, and both photographers witnessed the proclamation of the People's Republic in Tiananmen Square, Beijing, on 1 October 1949. Hou took many of the ubiquitous official Mao portraits, but also informal pictures of the chairman relaxing with his daughters or, more controversially, swimming in the Yangtze River (1966). In 2004 the couple's work was shown at the Photographers' Gallery, London, simultaneously with very different images by their compatriot *Li Zhensheng. RL

Yamazawa, Eiko (1899–1995), Japanese photographer. Born in Osaka, she moved to the USA to continue her painting studies at California University, where she worked with Consuela Kanaga. After returning home in 1929, she opened a portrait studio in Osaka in 1931. She established the Yamazawa Institute of Photography in Osaka in 1950 and the Yamazawa Studio of Commercial Photography in 1952. Her first book was *En-Kin* (*Near and Far*; 1962). She moved to abstraction in 1960, stating that the time for realist expression was over. Her abstract work has been widely exhibited and published.　　MT

Yampolsky, Mariana (1925–2002), American-born Mexican photographer who moved to Mexico City in the 1940s and joined the Popular Graphics Workshop, where she worked as a designer and illustrator. In the 1960s, after travels in Europe and the Middle East, and influenced by Lola *Álvarez Bravo, she turned to photography, becoming celebrated both for portraits and for documentary work on the indigenous and mestizo inhabitants (especially women) of places such as Mayahua and Magüey. Her publications included *La casa che canta* (1982) and *Estancias del olvido* (1987).　　LAL

Billeter, E., and Poniatowska, E., *Mariana Yampolsky: Nachdenken über Mexiko* (1993).

Yasui, Nakaji (1903–42), Japanese photographer. Born in Osaka, he was a leader of the New Photography movement in the Kansai area. Sensitive to trends from abroad, he participated in the Naniwa Shashin Club in 1922 and in the Tanpei Shashin Club in 1930, through both of which he influenced his peers. His photographs show a mastery of technique and a stylistic range from avant-gardism to realism. He worked both as a fine artist and in *photojournalism, maintaining his liberal point of view and independence during the war when others worked for propaganda magazines. Amongst his photo series, *The *Wandering Jew* and *Travel-Weariness* highlight his engagement with society as both artist and photographer.　　MHV

Yavno, Max (1911–85), American photographer. Born in New York, he studied business administration and worked on the Stock Exchange before becoming a social worker in 1935. He did *documentary social photography for the Works Progress Administration from 1936 to 1942, in the meantime joining the Photo League in New York and serving as its president in 1938–9, and rooming with Aaron *Siskind 1939–42. He served in the US air force 1942–5. After the war he moved to San Francisco, where he worked with a view camera (see FIELD CAMERA) as an urban landscape photographer, producing for Houghton Mifflin *The San Francisco Book* (1948) with Herb Caen and *The Los Angeles Book* (1950) with Lee Shippey. For financial reasons he worked as a commercial *advertising photographer for the next twenty years (1954–75), creating finely crafted *still lifes that appeared in *Vogue* and *Harper's Bazaar*. He returned to artistic landscape photography in the 1970s, when his introspective approach found a more appreciative audience. Funding from the National Endowment for the Arts enabled him to travel to Egypt and Israel in 1979.　　CBS

The Photography of Max Yavno, introd. B. Maddow (1981).

Yellowstone and Yosemite National Parks. The *Yellowstone* region, 890,700 ha (2.2 million acres) of volcanic wilderness located in the north-west corner of Wyoming and extending into Montana and Idaho, was designated America's first National Park in 1872, thanks partly to the photographs of William Henry *Jackson. Well known to Native Americans long before the 19th century, it was during the age of westward exploration that this region of extraordinary natural beauty came to the attention of white Americans. Although at first stories of a fantastic landscape were met with disbelief, the testimony of trappers, Jesuits, and prospectors eventually proved too intriguing to ignore, and an official survey was organized in 1871. Led by Ferdinand V. Hayden, director of the government's newly formed Geological Survey of the Territories, the party included the painter Thomas Moran and two photographers, J. Crissman and Jackson. The latter was engaged after Hayden saw his photographs of the Union Pacific Railroad under construction. In return for food, shelter, and travel expenses, he was offered a congenial lifestyle and the chance to make spectacular photographs. Following his first expedition with the team, Jackson was made a full member, which provided a salary as well as ensuring the association of his work with the early exploration of Yellowstone. Jackson used the *wet-plate process to make his pictures, requiring him to carry up to 55 kg (*c.*120 lb) of equipment to each vantage point. This included two or three cameras, 100 glass plates, a darkroom-tent, and several jugs of chemicals; melted snow and river water were used to wash the plates. Working in the Romantic landscape tradition, Jackson composed his images for maximum effect, capturing the feel of Yellowstone's grandeur as much as its appearance. When Hayden eventually presented the pictures to Congress, their impact

William Henry Jackson

Tower Falls, Yellowstone National Park, *c.*1892. Albumen print

was immediate. Together with Hayden's scientific narrative of the expedition, and lobbying from banking and railroad interests and others who staked a claim in the development of the area, the images of Yellowstone's bizarre geology helped to convince Congress that such a landscape was worth preserving, and exploiting for tourism. On 1 March 1872, President Ulysses S. Grant signed into law a bill designating Yellowstone as a National Park, the country's first. A number of Jackson's photographs were later used to lobby Congress to fund further expeditions to the west, and some were published as stereo views, bringing 'America's wonderland' to public attention and advertising it to potential vacationers.

Following thousands of years of habitation by the Miwok Indians, and then miners seeking gold, word of *Yosemite Valley*'s beauty spread, leading to a conflict between advocates of tourism and conservationists that continues today. President Lincoln signed the Yosemite Grant in 1864, which deeded the valley and adjacent Mariposa Grove to the state of California, the first federal assignation of land for preservation. The surrounding area, however, soon suffered from the effects of tourism. Conservationists like John Muir (1838–1914) campaigned to have the area designated a National Park, following the example of Yellowstone. On 1 October 1890 Congress officially created Yosemite National Park, and sixteen years later California ceded Yosemite Valley and Mariposa Grove to the National Park System, ending dual control of the region. The first man to photograph Yosemite had been Charles L. *Weed, but it was Carleton *Watkins who best captured the towering peaks of El Capitan, Half Dome, and Cathedral Rock. Made between 1861 and 1866, Watkins's stereographic and *mammoth-plate views helped to raise awareness of the site. Eadweard *Muybridge also photographed Yosemite, preferring unusual vantage points and often capturing views in the reflection of the Merced River. In the 20th century, Ansel *Adams became closely associated with the park due to the popularity of posters, calendars, and other items made using his black-and-white photographs. Adams's work further promoted the site as a tourist attraction. MR

Hales, P. B., *William Henry Jackson and the Transformation of the American Landscape* (1988).

Schullery, P., and Whittlesey, L., *Myth and History in the Creation of Yellowstone National Park* (2003).

Yevonde, Madame (Yevonde Cumbers; 1893–1975), English portrait photographer, born in London into a well-to-do middle-class family and expensively educated. From 1911 to 1914 she apprenticed with the London portraitist Lallie Charles and then opened her own studio, with a brief interruption during the First World War. She specialized in society portraiture, on which she sought to put her own creative stamp. One series, for which she had costumed her well-known sitters as mythical goddesses, was exhibited in 1935 to considerable acclaim. Her business was highly successful, with images appearing frequently in *Sketch* and *Tatler*. She belonged to the Professional Photographers' Association and the *Royal Photographic Society (RPS), with which she exhibited during the 1920s.

Yevonde was a confirmed suffragist, researching the role of women photographers in England and abroad and actively urging women to take up the profession. In the 1920s she began to work in advertising, using colour materials—in particular the *Vivex process—and props to create elaborate compositions. A large retrospective of her portrait work was held at the RPS in 1973. NR

Gibson, R., and Roberts, P., *Madame Yevonde* (1990).

Yosemite National Park. See YELLOWSTONE AND YOSEMITE NATIONAL PARKS.

'you press the button, we do the rest', celebrated advertising slogan devised by George *Eastman in 1888 for his revolutionary *roll-film *Kodak camera. The Kodak was loaded with enough film for 100 exposures. When the last exposure had been made, the camera was sent to Eastman's factory for the film to be processed. The camera, reloaded with a fresh film, was then returned to its owner together with a set of prints. Thus began the modern developing and processing industry. CWH

Zapp, Walter (1905–2003). Born in Riga, Latvia, of German parents, Zapp invented the Minox *sub-miniature ('spy') camera, patented in England on 22 December 1936. The first production version, manufactured in Riga from 1938, had a 15 mm f/3.5 lens and produced 8 × 11 mm ($^1\!/_3$ × $^1\!/_2$ in) negatives. The cassette-loaded film was advanced by a push-pull action. Zapp moved to Germany in 1941, and in 1945 founded the Minox GmbH, based in Wetzlar then, from 1948, Heuchelheim, where it eventually also made 110 and 35 mm-format cameras. (It was bought by Leica Camera AG in 1996.) Zapp, who did not make a fortune from his invention, left the firm and settled in Switzerland in the 1950s. RL

 Young, D. S., *Minox: Marvel in Miniature* (2000).

Zeiss, Carl (1816–88), German manufacturer of microscopes and other precision optical and mechanical instruments, who founded his firm in Jena in 1846. Zeiss was amongst the first optical firms to establish a research and computational department and employed Ernst *Abbe, who became a partner in 1875. Abbe designed a series of optics based on mathematical modelling and from 1881 collaborated with Otto Schott (1851–1935) in the scientific manufacture of optical glass for the Zeiss works. Another key figure was the lens designer Paul *Rudolph. After Zeiss's death Abbe took over the firm, but in 1896 transferred ownership to a foundation, the Carl-Zeiss-Stiftung. This later became the majority shareholder in the optical conglomerate Zeiss Ikon AG, founded in 1926.

 The firm developed a number of classic photographic optics including the Planar (1896), Tessar (1902), and Sonnar (1932) lenses, and many cameras incorporated Zeiss optics, including models by Zeiss Ikon, Hasselblad, Kodak, and Franke & Heidecke (Rollei). From an early stage, Zeiss lenses were also made under licence. The company's T lens coating patented in 1936 helped reduce reflections on glass surfaces.

 Zeiss remained relatively unscathed during the Second World War, but in 1945 all the factories except those in Stuttgart fell under Russian control, and US forces evacuated plant, machinery, and 126 staff from Jena to Stuttgart. The Zeiss optical works resumed production in Oberkochen from 1946 while the Zeiss and Schott works in Jena became state owned under the VEB prefix. In 1995 the two entities were finally reunited under the Carl-Zeiss-Stiftung. Today Zeiss continues to manufacture professional photographic optics and a range of scientific and specialized optical equipment. MP

 Rohr, M. v., *Zur Geschichte der Zeissischen Werkstätte* (1936).

Zelma, Gyorgy (1906–84), Russian photojournalist, born in Tashkent, Uzbekistan. In Moscow from 1921, he worked at the Proletkino film studio, then for Russfoto, an agency supplying the foreign market. He was sent back to Uzbekistan in 1924, and worked extensively in Central Asia. Whether recording balloon ascents or citizens at play, Zelma's pictures are dynamic and eye catching; those of Uzbek encounters with modernity are brilliant as both reportage and *propaganda. He joined *Izvestia* in 1936, and in the Second World War took pictures at Stalingrad. RL

 Morozov, S., and Lloyd, V. (eds.), *Soviet Photography 1917–40: The New Photojournalism* (1984).

zenana studio. 'Zenana', a term commonly used in South Asia, refers to that part of an establishment reserved exclusively for women. In 19th-century India, a number of women-only photographic studios were established, the best known being Deen *Dayal's zenana studio in Hyderabad. It opened in 1892, run by an Englishwoman, Mrs Levick, wife of the editor of the *Deccan Times*. One of the earliest examples was Mrs Mayer's studio, based in Calcutta 1863–6. Occasionally a photographer's wife—such as Mrs Garrick in Calcutta in 1878–9—would run a zenana studio as part of her husband's business. SCG

Zille, Heinrich (1858–1929), German craft lithographer and graphic artist who, between 1882 and *c*.1906, also took photographs in and around Berlin and Charlottenburg. Made, probably, with borrowed cameras, they are thematically and compositionally idiosyncratic and differ markedly from both salon *pictorialism and commercial view photography. Nor were they simply adjuncts to Zille's celebrated illustrations of Berlin popular life. They range from family portraits and images of artist friends—mostly sculptors associated with the Berlin Secession—and their models (some nude) to unpicturesquely recorded corners of old Berlin, and amusement parks, bathing spots and rubbish tips on the city's shifting outskirts. Fairground idlers, passers-by, women dragging carts of firewood are often captured unawares in middle distance, moving away from the camera; horizons tilt; the photographer is revealed by his shadow. Interiors and family scenes, lit by magnesium *flash, document Zille's lifestyle and his rise in status, *c*.1900, from artisan to artist. His non-domestic pictures are a form of primitive reportage, material perhaps for a project lost or never quite defined. Over 400 negative plates discovered in 1966, probably most of his photographic output, are in the Berlin Gallery. RL

 Kaufhold, E. (ed.), *Heinrich Zille, Photograph der Moderne* (1995).

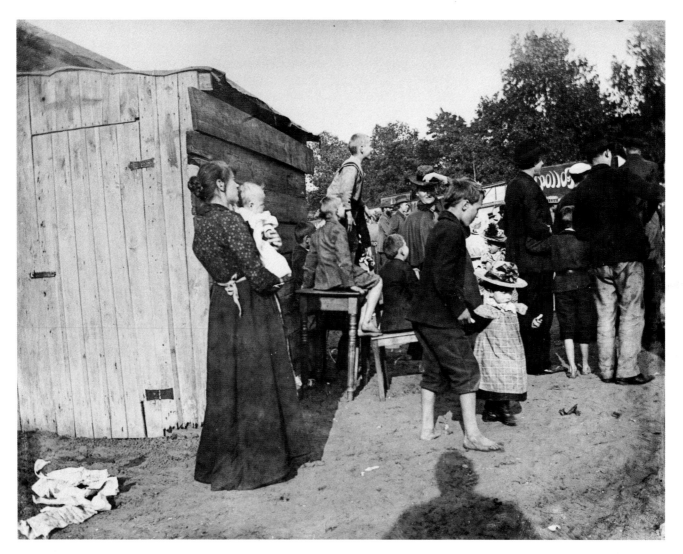

Heinrich Zille

Woman and infant beside a fairground lavatory, Berlin, August 1900

zone plate, a device (properly called a *Fresnel zone plate*) behaving like a lens but operating by diffraction. It is a transparent disc bearing alternate transparent and opaque bands. The diameters of successive band pairs are proportional to the square roots of 1, 2, 3, 4, etc. The focal length $f = r^2/\lambda$, where r is the innermost radius and λ the wavelength of light. A central disc of 0.2 mm diameter gives a focal length of approximately 80 mm (3 in) for green light.

A zone plate is a useful addition to a *pinhole (enlarged), as, for a given pinhole diameter, it (paradoxically) allows twice as much light to arrive at each point on the image. Zone plates are usually made for this purpose by drawing them on a large scale, then photographing them down to the correct size on fine-grain film.　　　GS

Renner, E., *Pinhole Photography* (2nd edn. 2000).

Zone System, a system of *exposure determination and development control for black-and-white. It was devised by Ansel *Adams in the late 1940s. It is partly a system of visualization, and partly a form of simplified *sensitometry.

The visualization is based on print zones, originally nine in number, symmetrical about Zone V:

- Zone I—the maximum black the paper can deliver;
- Zone II—the first tone distinguishable from Zone I;
- Zone III—darkest tone with texture: one stop lighter than Zone II, one stop darker than Zone IV;
- Zone IV—dark mid-tones: one stop lighter than Zone III, one stop darker than Zone V;

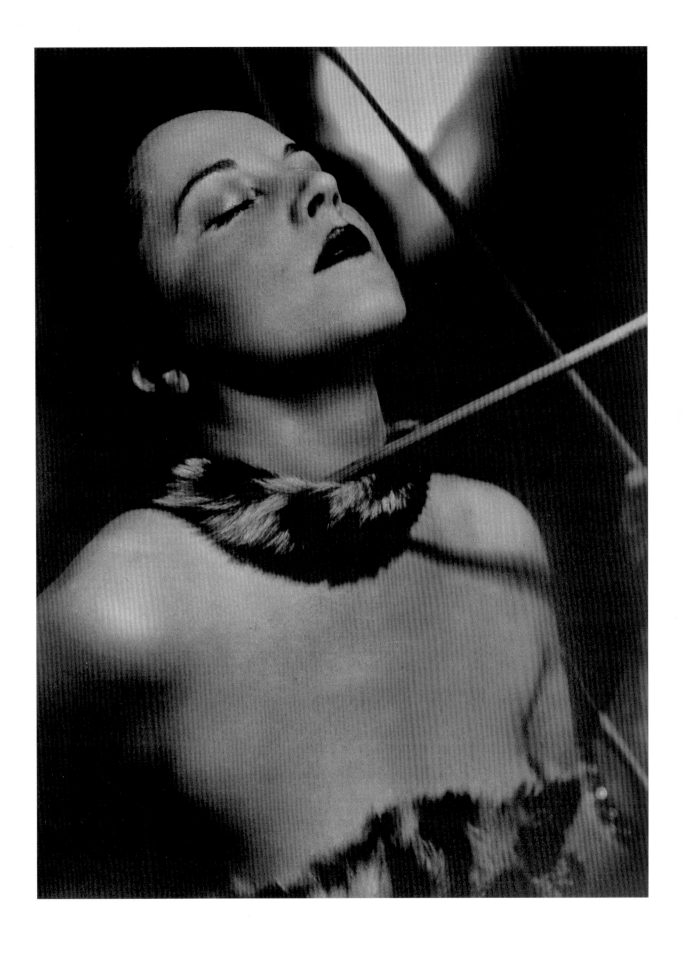

Madame Yevonde Lady Milbanke as *Queen of the Amazons* (Penthesilea), from the *Goddesses* series, 1935. Vivex print

David Miller Venus and Jupiter rise over water

- Zone V—the mid-tone: an 18 per cent grey, one stop lighter than Zone IV, one stop darker than Zone VI;
- Zone VI—light mid-tones: one stop lighter than Zone V, one stop darker than Zone VII;
- Zone VII—lightest tone with texture: one stop lighter than Zone VI, one stop darker than Zone VIII;
- Zone VIII—lightest tone distinguishable from paper-base white;
- Zone IX—pure, paper-base white.

Subsequent versions, taking account of improvements in materials, were extended first to ten zones and then to eleven (0 to X). The earlier system is more memorable and demonstrates the principles rather more clearly. The idea is that a particular subject tone is metered and 'placed' on a particular zone; other tones are then metered to see where they 'fall'. For example, if one tone is metered and 'placed' on Zone IV, then another tone that is three stops lighter will 'fall' on Zone VII.

The sensitometric side of the system is concerned with metering; with establishing a personal exposure index or EI; and with establishing personal development times, centred around 'N' (normal), so that every exposure can be printed on grade 2 paper. Contrasty subjects are given shortened or 'N–' development: N – 1, N – 2, even up to N – 6. Flat subjects are given longer or 'N+' development: this rarely exceeds N + 3.

To get the full benefit of this part of the Zone System, every image must be developed individually, or at least, in batches requiring the same N–, N, or N+ development, so it is of limited use for roll-film and 35 mm. Also, with variable-contrast papers, grade 2 is less important than it used to be. Although Zone System aficionados display almost religious zeal, there are at least as many great black-and-white photographers outside their ranks as inside, so the Zone System is hardly a sine qua non of great photography.

Those who find the system appealing may find that it helps them get better results. Those who do not should enjoy at least as much success via a simple iterative system of adjusting film speed until they are happy with the amount of shadow detail in their negatives, and adjusting development times until the majority of their negatives print on their preferred grade of paper.　RWH

Adams, A., *The Negative* (1981).

zoom and varifocal lenses. The first lens with continuously variable *focal length appears to have been a somewhat primitive *telephoto produced by *Zeiss in 1898. There were further tentative designs in the 1930s, but the first commercially available zoom lens was F. G. Back's eponymous Zoomar lens of 1945, designed for 16 mm cine-cameras. After the introduction of the Kodak Carousel 35 mm projector in the 1950s, slide projectors began to be fitted as standard

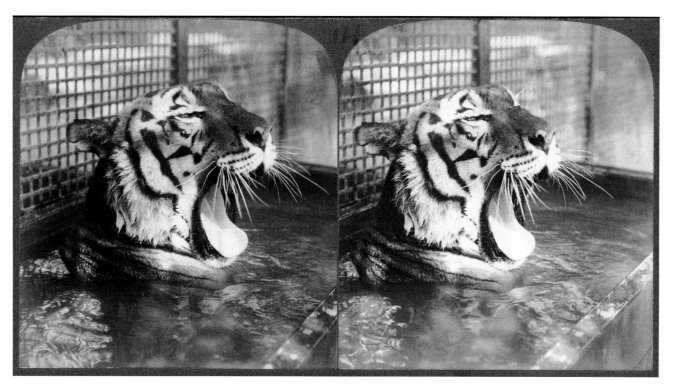

Underwood & Underwood

Tiger, 1902. Stereoscopic pair

with varifocal lenses, but these were not true zooms as they had to be refocused when the focal length was changed.

Zoom lenses contain components (usually two groups) that move as the focal length is shifted, the effect being to move the rear nodal plane (from which the focal length is measured) smoothly from in front of the lens (telephoto configuration) back towards the film plane, and even behind it (retrofocus configuration), the focal plane remaining at the film. Zoom lenses are classified according to the ratio of maximum to minimum magnification: most high-quality zooms are around 3 : 1, though 8 : 1 is becoming more common. Some TV camera lenses have a ratio as high as 18 : 1. Most zoom lenses show a measure of barrel distortion at the shortest focus setting and some pincushion distortion at the longest, but the latter is less noticeable owing to the small *angle of view. GS

See also GAUSSIAN OPTICS.

zoo photography has flourished since the proliferation of zoological gardens in the mid-19th century. Manuals and encyclopedias were soon offering advice on technique, and approaches have ranged from the documentary-taxonomic efforts of figures like the comte de Montizon (1822–87) and Francis George Schreiber (1803–92) to the animal portraiture of Wolfgang Suschitzky (b. 1912) and other modern photographers.

Changes in zoo photography have mirrored changes in zoo design. Early photographs almost invariably show animals against concrete backgrounds, sometimes with fences or bars. Today's pictures normally have naturalistic backgrounds, mimicking photography in the wild; or neutral backgrounds, making it hard to tell exactly where the picture was shot; or anthropomorphic 'play' backgrounds, as though (for example) a tiger had retired, or made a lot of money and bought a quiet retreat with a pool, ledges for taking the sun, and trees for shade.

Changes in photographic equipment and materials have also had considerable effect. In the days of quarter-plate reflexes, long, fast, quick-handling lenses were unthinkable. On quarter-plate (83×108 mm; $3^1/_4 \times 4^1/_4$ inches), the equivalent of a 200 mm lens on 35 mm is roughly 600 mm. Such a lens could scarcely be handy, and f/6.3 would justly have been regarded as fast. Combined with sensitized materials at maybe one-tenth of today's sensitivity, slow lenses of moderate focal length limited the photographer's options.

Today, most zoo photographers use moderately long to very long lenses: 135 mm to 300 mm and beyond on 35 mm, 150 mm to 500 mm on medium format. These allow attention to be focused on the animal itself, with the added advantage of cropping out unwanted areas. Fast lenses also allow differential focus, to the same end. Depending on lens speed and subject matter, films as slow as ISO 100 may be entirely suitable; there is rarely much need for anything faster than ISO 400, except indoors (in reptile houses, for example). RWH

Life Library of Photography: Photographing Nature (rev. edn. 1981).

Chronology

The following general chronology is provided for reference. The history of photography has been traced thematically in many of the longer entries. But this 'backbone' of dates offers a general overview of key technical, institutional, and artistic events in a wide range of countries. Usually, for each year cited, technical innovations appear first, followed by institutional events, and with publications (italicized) and significant photographs (italicized and bold) last.

Listing dates is not always a straightforward matter, especially in the case of new processes or items of equipment. In some cases—the year 1839 is an extreme example—similar discoveries were claimed by several people in different places. Preparing the list sometimes revealed inconsistencies between entries in the book, which were difficult to resolve. But we have done our best, using a wide range of sources. The most useful included Gail Buckland, *Fox Talbot and the Invention of Photography* (1980); *Farbe im Foto: Die Geschichte der Farbphotographie von 1861 bis 1981* (1981); Willfried Baatz, *Geschichte der Fotografie* (1997); Quentin Bajac, *L'Image révélée: l'invention de la photographie* (2001; Eng. *The Invention of Photography*, 2002); A. W. Tucker et al., *The History of Japanese Photography* (2003); and, much the most detailed and wide ranging, Christian Sixou, *Les Grandes Dates de la photographie* (2000). There is an admirably clear and well-illustrated short chapter on the history of photographic processes in Brian Coe (ed.), *Techniques of the World's Great Photographers* (1981).

1558 Giovanni Battista della Porta's *Magiae Naturalis* includes a description of a camera obscura

1725 The German chemist Johann Heinrich Schulze discovers that light can darken a solution of chalk moistened with silver nitrate

1777 The Swedish chemist Carl Vilhelm Scheele compares the darkening effect on silver compounds of the different colours of the spectrum

1801 The English doctor Thomas Young elucidates the principles of human colour perception

1802 Thomas Wedgwood and Humphry Davy contact-print silhouettes of leaves and other objects on paper and leather sensitized with silver nitrate, but cannot fix them

1816 The French inventor Joseph Nicéphore Niépce, working at his Burgundian estate near Saint-Loup-de-Varennes, embarks on

photographic experimentation, using a variety of supports and light-sensitive materials. His objective is to create multiple reproductions of engravings and of images formed in the camera obscura

1822 Niépce makes a permanent copy of an engraving contact printed onto a glass plate sensitized with bitumen of Judaea, a substance that hardens when exposed to light

1824 At about this time, Niépce succeeds in making camera obscura images from his study window (*points de vue*), using a direct-positive process involving bitumen-coated metal plates. He names the process 'heliography'

In Paris, the diorama proprietor Louis Jacques Mandé Daguerre also begins photographic experiments

1826 Daguerre learns from the Paris optician Chevalier of Niépce's work and conducts an inconclusive correspondence with him

1827 Probably in this summer Niépce creates ***View from the Study Window (Point de vue du Gras à Saint-Loup de Varennes)***. Niépce meets Daguerre in Paris while en route to visit his brother in London, where he fails to interest the scientific establishment in his heliographic process

1829 Niépce and Daguerre sign a formal partnership contract (14 December), prior to which Niépce writes a description of his process, *Notice sur l'héliographie*. Subsequently Niépce starts using silver iodide as a means of sensitizing silver-plated copper plates

1833 In rural Brazil, Hercules Florence succeeds in contact printing and fixing on paper drawings and script created on glass with a burin; he also uses the term *photographie*

Following Niépce's premature death (5 July), and building on his work, Daguerre continues to experiment, from 1836 assisted by the architect Eugène Hubert. The priority is now the speed of the process and the clarity and permanence of the image, rather than its reproducibility

1834 In England, William Henry Fox Talbot begins photographic experiments (January) and eventually succeeds in making and partially fixing silhouetted cameraless negative images of

botanical specimens on paper, a process he describes as 'photogenic drawing'

1835 On 28 February Talbot first notes the possibility of making 'positive' from 'negative' images

That summer Talbot creates photogenic negative images on his estate at Lacock, using small wooden cameras ('mousetraps'). The earliest surviving example is the *c.*1-inch square *Lacock Oriel Window* (*Latticed Window*) (August). Most significantly for the future, however, he also makes positive prints from his original negatives

Some time between *c.*1835 and 1837, Daguerre begins to use mercury vapour to develop the latent image and salt to fix the result: a unique, positive, and finely detailed picture which becomes known as the *daguerreotype*

1838 In the autumn, after unsuccessful attempts to fund his invention by public subscription, Daguerre approaches the physicist and parliamentarian François Arago with a view to obtaining government support

Daguerre, *Boulevard du Temple Paris*, probably the first surviving photograph of a human being, a man having his shoes polished in the street

Charles Wheatstone invents a reflecting stereoscope

1839 Arago and the physicist Jean Baptiste Biot announce Daguerre's discovery—but not its practical details—to the Academy of Science in Paris (7 January)

The first public showing of Talbot's photogenic drawings takes place at the Royal Institution, London (25 January)

Talbot reveals the working details of his process to the Royal Society, London (21 February)

Talbot's friend Sir John Herschel reveals his own, rapidly devised photographic process to the Royal Society (14 March). Herschel also proposes the use of sodium thiosulphate ('hypo') as a means of fixing photographic images

The French civil servant Hippolyte Bayard produces his first direct-positive images on paper (20 March)

In Munich, Carl August von Steinheil and Franz von Kobell make circular paper negatives of local views, and describe their process to the Bavarian Academy of Sciences (13 April)

In June and July it is arranged that Daguerre should cede the rights to his invention to the French state in return for an annual pension of 6,000 francs

Arago reveals the details of Daguerre's process at a joint meeting of the Academies of Science and Fine Arts (19 August)

Daguerre's manual *Historique et description du procédé du daguerréotype et du diorama* is published (21 August). A daguerreotype craze follows, with kits on sale from entrepreneurs like Chevalier, Lerebours, and Daguerre himself for *c.*300 francs

The first public demonstration of the daguerreotype in London (11 September)

In Barcelona, Ramón Alabern makes Spain's first daguerreotype (10 November)

The details of Daguerre's process rapidly circulate throughout Europe and the eastern United States, and many translations of the *Historique et description* appear

1840 The Hungarian mathematician Josef Petzval designs a fast (f/3.6) 'portrait' lens that, in conjunction with chemical improvements by John Goddard, Franz Kratochwilla, and Antoine Claudet, greatly reduces daguerreotype exposure times; Hippolyte Fizeau introduces gold toning to improve the contrast of the final image and make it less fragile

The American dentist Alexander S. Wolcott opens the world's first photographic (daguerreotype) portrait studio (Wolcott & Johnson) in New York (4 March)

The first lunar daguerreotype is taken by the American chemistry professor John W. Draper

Talbot discovers a method of speeding the formation and development of the latent (negative) image (September). It becomes easier to use the negative-positive process for living subjects, and Talbot creates a portrait of his wife Constance on 10 October. Talbot's improved process, patented in 1841, is called the *calotype* (or, by some, the *Talbotype*)

The Abbé Louis Compte, visiting South America aboard a French vessel, makes daguerreotypes at Rio de Janeiro (January); the young Emperor of Brazil, Pedro II, buys a camera and subsequently becomes a patron of photography

Hippolyte Bayard, *Self-Portrait as a Drowned Man* (*Le Noyé*)

During the next decade, a variety of optical, chemical, and manipulative advances improve the efficacy of both Daguerre's and Talbot's processes, until both are superseded by the wet-plate process during the 1850s

1841 Richard Beard opens what is reputed to be Europe's first daguerreotype portrait studio, in Regent Street, London (March); Hermann Biow opens a studio in Hamburg

1842 Herschel invents the cyanotype printing process

Appearance of the *Illustrated London News* (14 May)

Biow photographs the aftermath of the catastrophic Hamburg fire (May)

Mads Alstrup opens the first portrait studio in Copenhagen

1843 The Austrian Joseph Puchberger patents a panoramic camera capable of making 48.3 × 61 cm (19 × 24 in) daguerreotypes

Robert Adamson opens a studio at Rock House, Calton Hill, Edinburgh (May), and goes into partnership with the painter David Octavius Hill; that year they begin making calotypes at the fishing village of Newhaven (until 1847)

Founding of the Edinburgh Calotype Club

Appearance of the *Illustrirte Zeitung* in Leipzig, Saxony

Anna Atkins begins publication of *Photographs of British Algae: Cyanotype Impressions* (October; it is completed a decade later)

Sergei Levitsky makes daguerreotype views in the Caucasus

The firm of Southworth & Hawes is founded in Boston

1844 Henry Talbot opens the Reading Establishment for commercial production of photographic prints and publications

Talbot, *The Pencil of Nature* (6 parts, 1844–6)

Talbot, **The Haystack**

1845 Talbot, *Sun Pictures of Scotland*

1847 C. F. A. Niépce de Saint-Victor introduces a practical method for making negatives on glass, using a coating of egg white (albumen) and potassium iodide

Calotype Society founded in London

L. D. Blanquart-Évrard announces significant improvements to Talbot's calotype process

The African-American Glenalvin Goodridge founds a daguerreotype studio in York, Pennsylvania; by 1865, after an interval, his brothers Wallace and William have restarted the business in Saginaw, Michigan

1848 *L'Illustration* publishes wood engravings of revolutionary events in Paris from daguerreotypes by Thibault (July)

1849 Sir David Brewster perfects a lenticular stereoscope for viewing stereo daguerreotypes

In the autumn Maxime Du Camp and Gustave Flaubert embark on a photographic expedition to the Middle East which lasts until the spring of 1851

1850 The Imperial Printing Office in Vienna opens a photographic department under Paul Pretsch which produces calotype architectural studies and views

L. D. Blanquart-Évrard introduces albumen paper for printing positives from negatives

The *Daguerreian Journal* (later *Humphrey's Journal*) is founded in New York

J. T. Zealy makes daguerreotypes of South Carolina slaves (rediscovered in 1976)

1851 Gustave Le Gray's *waxed negative* technique further improves the calotype process, enabling sensitive materials to be prepared and stored before use

Frederick Scott Archer publishes a description of the wet-collodion process in *The Chemist* (March). Although cumbersome and difficult to use, especially out of doors, this *wet-plate process*, especially in conjunction with albumenized paper, is capable of producing extremely fine images. It dominates photographic practice for over two decades

The Great Exhibition in the Crystal Palace, London, includes over 700 entries from both sides of the Atlantic, including Jules Duboscq's stereo-daguerreotypes and John Whipple's daguerreotype of the moon, but also boosts the wet-plate process

Société Héliographique founded in Paris (January)

Appearance of *La Lumière*, edited by Ernest Lacan (9 February)

The French Mission Héliographique, the first state-sponsored photographic survey of historical monuments, produces *c*.300 paper prints, made by Baldus, Bayard, Le Gray, Le Secq, and Mestral

L. D. Blanquart-Évrard opens his Imprimerie Photographique at Loos-lès-Lille, and by the time the establishment closes in 1855 has produced the salt prints for several important archaeological and other works, including Du Camp's *Égypte, Nubie, Palestine et Syrie* (1852), Greene's *Le Nil* (1854), and Salzmann's *Jérusalem* (1856)

1852 Henry Talbot begins experimenting with a photomechanical etching process ('photoglyphic engraving'), later known as photogravure, which is eventually brought to fruition by Karl Klič in 1879

George Washington Wilson establishes his firm in Aberdeen, Scotland

1853 Adolphe Martin invents a rapid direct-positive process later known as the tintype, which becomes particular popular with itinerant photographers

The Photographic Society of London is founded (20 January; it becomes the Royal Photographic Society of Great Britain (RPS) in 1894)

Félix Teynard, *Égypte et Nubie* (part-work completed in 1858)

1854 Achille Quinet patents the first 'binocular' (twin-lens) stereoscopic camera, the Quinetoscope

First description of a solar camera, using reflected sunlight to make enlargements from negatives (ordinary contact printing created images the same size as the original negative)

Société Française de Photographie (SFP) founded in Paris

London Stereoscopic Company founded

The *Liverpool Journal of Photography* is launched, becoming in 1860 the *British Journal of Photography*

André Disdéri patents the *carte de visite* format (November)

The firm of Fratelli Alinari is founded in Florence

Nadar, *The Mime Charles Debureau as Pierrot* (1854–5)

US Acting Master's Mate Eliphalet Brown Jr., *Portrait of Tanaka Mitsuyoshi* and other daguerreotypes of people and scenes in Yokohama and elsewhere (the Mitsuyoshi portrait is rediscovered in 1983); other Japanese scenes are photographed by a Russian naval officer, Alexander Fyodorovich Mozhaisky

1855 Roger Fenton takes *c.*360 wet-plate photographs of views and military scenes in the Crimea (March–June)

Édouard-Denis Baldus creates an album of photographs of the railway between Paris and Boulogne-sur-Mer

Gustave Le Gray opens a lavish studio on the Boulevard des Capucines, Paris

The Exposition Universelle in Paris includes a large photographic exhibition organized by the SFP

A photographic school is established at Elphinstone College, Bombay

John Mayall, *Sergeant Dawson and his Daughter*

1856 William Thompson makes primitive underwater photographs in the Wey estuary, southern England

Photographic instruction is included in the training of the British Royal Engineers

Countess Castiglione begins her photographic association with Pierre-Louis Pierson of the Paris studio Mayer & Pierson

Gustave Le Gray, *The Brig*

1857 Felice Beato photographs Lucknow after its recapture from rebels by the British

Carlo Naya opens a studio in Venice

The Bonfils photographic company is founded in Beirut

Camille Silvy, *La Vallée de l'Huisne (River Scene, France)*

Oscar Gustav Rejlander, *The Two Ways of Life*

Robert Howlett, *Isambard Kingdom Brunel before the Launch of the Leviathan [Great Eastern]* (November)

Shiro Ichiki, *Portrait of Nariakira Shimazu*, the oldest surviving daguerreotype by a Japanese (rediscovered in 1975)

1858 The South Kensington Museum, London (later the Victoria & Albert Museum) holds an international photography

exhibition jointly organized by the Photographic Society and the SFP

Nadar makes wet-plate aerial photographs from a balloon

Warren de la Rue makes stereographs of the moon

The American Society of Photographers is founded

Désiré Charnay makes the first of several visits to the Yucatán, Mexico, where he photographs pre-Columbian ruins

Founding of the Odessa Photographic Society and the Russian journal *Svetopis (Light-Painting)*

Egypt and Palestine Photographed and Described by Francis Frith

Henry Peach Robinson, *Fading Away*

1859 Camille Silvy opens a successful *carte de visite* studio in Bayswater, London

Charles Leander Weed takes the first photographs of the Yosemite Valley (June)

1860 Permission for the sale of royal photographic portraits in Britain gives a major impetus to celebrity photography

Personal and financial difficulties force Le Gray to leave France; later he photographs Palermo shortly after its capture by Garibaldi (June)

Disdéri launches his subscription celebrity series *Galérie des contemporains*

1861 The English photographer Thomas Sutton invents and patents (August) a single-lens reflex (SLR) camera, but few are actually made

The Scottish physicist James Clerk Maxwell makes the first (projected) colour photograph, using three colour separations, but the photographic establishment takes little notice

Auguste Rosalie Bisson takes wet-plate views from the summit of Mont Blanc (24 July)

Nadar uses battery-powered lights to photograph the Paris catacombs (December)

A photographic department is founded by the Krupp steelworks, Essen

1862 The British Fine Art Copyright Act extends copyright protection to photographs registered at Stationers' Hall, London (it remains in force until 1912)

Hikoma Ueno opens the first Japanese-owned studio, in Nagasaki

Guillaume Duchenne de Boulogne, *Mécanisme de la physionomie humaine*

1863 The studio of Howard, Bourne & Shepherd (from 1865, Bourne & Shepherd) is established in Simla, north-western India; Samuel Bourne makes the first of three photographic expeditions into the Himalayas

Felice Beato arrives in Japan, and opens a studio in Yokohama

1864 John Wilson Swan introduces important improvements to the carbon process, described by Adolphe Louis Poitevin in 1855; the resulting prints are both subtle and permanent, and become widely used in commercial photography

The journal *Photographische Mitteilungen* is founded by Hermann Wilhelm Vogel

Central Europe's first exhibition devoted exclusively to photography is organized in Vienna by the Photographische Gesellschaft (f. 1861)

1865 Charles Piazzi Smyth uses magnesium combustion to photograph inside the Great Pyramid at Giza, Egypt

Foundation of the Palestine Exploration Fund

William Mervyn Lawrence opens a portrait and view business in Dublin; a British intelligence officer, Samuel Lee Anderson, based in Dublin Castle, creates an album of Irish nationalists, inscribed *Members of the Fenian Brotherhood*

The Uruguayan Esteban Garcia photographs the war between Paraguay and Argentina, Brazil, and Uruguay (1865–70) for an American company

Alexander Gardner, *Execution of the Lincoln Conspirators at Washington Arsenal* (7 July)

1866 W. B. Woodbury patents the photomechanical Woodburytype process

The Rapid Rectilinear distortion-free lens is introduced independently by J. H. Dallmeyer and H. A. Steinheil

Ernst Abbe of Zeiss collaborates with the Schott glass company to develop new glasses suitable for the manufacture of more advanced lenses

Introduction of the cabinet format studio photograph

Émile Gsell photographs of the ruins of Angkor in Cambodia

George Barnard, *Photographic Views of Sherman's Campaign*

1867 Commencement of the first of four US Geological and Geographical Surveys of the Western Territories, a programme lasting until 1879 and producing thousands of photographs of the American West

Julia Margaret Cameron, *Sir John Herschel* (April)

1868 An eight-volume official work, *The People of India*, begins to appear, and is completed in 1875

1869 The 'joining of the rails' at Promontory Point, Utah, is recorded by A. J. Russell, Alfred Hart, and Charles R. Savage (10 May)

Launch of the specialist *Revue photographique des hôpitaux de Paris*, illustrated with tipped-in, hand-coloured photographs (it lasts until 1876)

1870 During the Franco-Prussian War (1870–1), microphotography is used to create micro-documents transportable by pigeon to and from besieged French cities

Eugène Appert's *Crimes of the Commune* use photomontage to fake images of atrocities committed by the Paris Communards

Foundation of the Archaeological Survey of India, which in 1871 acquires a photographic branch

Launch in Yokohama of the journal *Far East* (30 May), regularly illustrated with albumen prints

Andrei Karelin, *Nizhni Novgorod*

1871 Richard Leach Maddox describes a prototype gelatin *dry plate*; improved versions are increasingly used in the course of the decade, and eventually revolutionize photographic practice. In particular, dry emulsions make the creation of *roll-film* possible, and standardized manufacturing procedures encourage the development of practical sensitometry

William Henry Jackson photographs in Yellowstone

1872 Tomishige Studio founded by Rihei Tomishige in Kumamoto City, Kyushu, Japan

Henry Taunt, *A New Map of the River Thames*

Charles Darwin, *On the Expression of the Emotions in Man and Animals*, partly illustrated with photographs by Oscar Rejlander

1873 William Willis introduces the platinum print (platinotype)

Timothy H. O'Sullivan, *Ancient Ruins in the Canyon de Chelly, New Mexico*

1877 John Thomson, *Street Life in London* (12 parts completed in 1878)

1878 Eadweard Muybridge devises a battery-of-cameras system to capture photographs of horses in motion

1879 Photogravure, a photomechanical process for creating high-quality reproductions, is perfected by Karl Klič

1880 The *New York Daily Graphic* uses the half-tone process to print a small-scale reproduction of a photograph of Manhattan's Shantytown (4 March)

The Underwood & Underwood stereographic company is founded in Ottowa, Kansas (it moves to New York in 1891)

1881 George Eastman founds the Eastman Dry Plate Company at Rochester, NY, with six employees

1884 Photomechanical reproductions of photographs of military manoeuvres by Ottomar Anschütz appear in the Leipzig *Illustrirte Zeitung* (15 March)

Launch of *Amateur Photographer* magazine (10 October)

Lala Deen Dayal becomes court photographer to the Nizam of Hyderabad

The first edition of Josef Maria Eder's multi-volume *Ausführliches Handbuch der Fotografie* (*Comprehensive Handbook of Photography*) begins to appear

1885 Launch of the Eastman-Walker roll holder, taking a 24-exposure paper film and suitable for attachment to standard plate cameras

Gaston Tissandier, *La Photographie en ballon*

1886 John Thomson is appointed 'Official Instructor of Photography' at the Royal Geographical Society, London

Nadar's interview of the centenarian chemist Michel Chevreul is photographed by Paul Nadar, and thirteen of the pictures are photomechanically reproduced in *Le Journal illustré* (5 September)

An international photography exhibition is held in Oporto, Portugal

Frank Meadow Sutcliffe, **Water Rats**

Josef Maria Eder, *Die Moment-Photographie* (*Instantaneous Photography*)

1887 Patenting of the Kinetoscope motion-picture viewer

Peter Henry Emerson, *Life and Landscape on the Norfolk Broads*

Eadweard Muybridge, *Animal Locomotion*

1888 Launch of the Kodak roll-film box camera (June), with the marketing slogan 'you press the button, we do the rest'

As a by-product of their pioneering research on sensitometry, Ferdinand Hurter and Vero Driffield patent an exposure calculator (14 April), later marketed as the Actinograph

Founding of the Photo-Club de Paris

Appearance of *National Geographic Magazine* (October)

1889 Opening of the *Graphische Lehr- und Versuchsanstalt* (Graphic Art Institute) in Vienna, providing important facilities for photographic training

P. H. Emerson, *Naturalistic Photography for Students of the Art*

1890 Paul Rudolph of Zeiss designs the Protar, the first anastigmat lens

Inauguration of the Berlin Lette-Verein's photography school for women

Berliner illustrirte Zeitung founded

Jacob Riis, *How the Other Half Lives*

Alphonse Bertillon, *La Photographie judiciaire*

1892 Foundation of the Brotherhood of the Linked Ring (April)

Foundation of the Keystone View Company in Meadville, Pa., by Benjamin L. Singley

1893 Verascope stereoscopic camera launched by Jules Richard, Paris

1894 Invention of the Mutoscope, a device using series of still photographs to create the illusion of movement

Creation of the Japanese Army Photographic Unit

Alfred Lichtwark, *Die Bedeutung der Amateur-Photographie* (*The Significance of Amateur Photography*)

1895 The German physicist Wilhelm Röntgen takes the first X-ray photographs (November–December)

The pictorialist Society for the Encouragement of Amateur Photography is founded in Hamburg

George Ewing, *A Handbook of Photography for Amateurs in India*

1896 Paul Martin receives the RPS's Gold Medal for his series of night photographs *London by Gaslight*

1897 Foundation of the National Photographic Record Association by Sir Benjamin Stone and others, active until 1910

Richard and Cherry Kearton, *With Nature and a Camera*

1898 The Folmer & Schwing Manufacturing Co. launches the Graflex camera, the first of a long line of best-selling SLR cameras

Secondo Pia takes controversial photographs of the Turin Shroud

Clarence H. White, **Girl with a Mirror**

1899 Louis Boutan makes an artificially lit underwater photograph 50 m (164 ft) down in the open Mediterranean

1900 Eastman Kodak launches the Brownie camera

By this time, *c*.30 per cent of British amateurs are women, and more than 3,500 female professionals are working in the USA

George R. Lawrence of Chicago uses a purpose-built Mammoth camera to photograph an entire train

The Munich Photo School is founded, a joint venture between the city, the Bavarian state, and the South German Photographers' Association

Louis Boutan, *La Photographie sous-marine et les progrès de la photographie*

1901 The Professional Photographers' Association is founded, and later (1983) becomes the British Institute of Professional Photographers

Charles Caffin, *Photography as a Fine Art*

1902 Paul Rudolph designs the Tessar lens

Alfred Stieglitz founds the Photo-Secession in New York

1903 Stieglitz launches the journal *Camera Work*

Rodolphe Archibald Reiss, *La Photographie judiciaire*

Frederick Evans, *A Sea of Steps* (**Wells Cathedral**)

1904 The German physicist Arthur Korn transmits photographic images over telephone lines from Munich to Nuremberg

The autochrome colour process is announced by the Lumière brothers of Lyon, France

Edward S. Curtis, **The Vanishing Race—Navaho**

1905 The Little Galleries of the Photo-Secession—later known as Gallery 291—open at 291 Fifth Avenue, New York, and continue until 1917

Sir Benjamin Stone's Pictures: Records of National Life and History (2 vols., 1905–6)

1906 Marketing of the first commercial panchromatic plates, sensitive to all the colours of the spectrum

1907 The autochrome process is introduced commercially, becomes popular with amateurs, and remains available for *c*.30 years

The first volume of Edward S. Curtis's twenty-volume *The North American Indian* appears (the last volume is published in 1930)

Alfred Stieglitz, **The Steerage**

1908 Karl Karlovich Bulla and his son Victor photograph Leo Tolstoy and his family at Yasnaya Polyana on the occasion of the writer's 80th birthday (July)

1909 Sergei Prokudin-Gorskii embarks on an official photographic survey of Russia, using his own three-colour system

1910 Herbert Ponting makes still and motion pictures of Scott's ill-fated expedition to the Antarctic (1910–12)

International Exhibition of Pictorial Photography at the Albright Museum, Buffalo, NY

The 'Kodak Girl' becomes a central feature of Kodak advertising

1911 *International Salon of Artistic Photography* in Kiev

1912 Jacques-Henri Lartigue, **Grand Prix of the Automobile Club de France**

1913 Alvin Langdon Coburn, *New York from its Pinnacles*

Anton Giulio and Arturo Bragaglia, *Fotodinamismo futurista*

Paul Strand, **Abstraction, Shadows of a Veranda, Connecticut**

1914 The Australian Frank Hurley joins Shackleton's expedition to Antarctica and takes spectacular photographs in extreme conditions

1915 British troops attacking at Neuve Chapelle on the Western Front use maps based entirely on aerial reconnaissance; in general, the First World War produces major advances in aerial photography

Wilhelm Weimar, *Die Daguerreotypie in Hamburg, 1839–1860*

1916 Arnold Genthe, *The Book of the Dance*

1917 Alvin Langdon Coburn's Vortographs exhibited at the London Camera Club (February)

The final, double issue (49/50) of *Camera Work* appears, with modern work by Paul Strand (June)

Elsie Wright and Frances Griffiths take their first 'fairy' photographs at Cottingley, Yorkshire (July)

Foundation of the Imperial War Museum, London

Victor Bulla records the revolutionary events in Petrograd (St Petersburg) (February–October)

1919 The Photographic Bureau of the British Ministry of Information becomes the Imperial War Museum's Department of Photographs (1 January)

1922 Arthur Korn transmits photographs by radio

Edward Weston, **Armco Steel**

1923 Edward Steichen becomes chief photographer for Nast Publications, publishers of *Vogue*

Alfred Stieglitz embarks on a long series of cloud studies that he describes as *Equivalents*

Edward Weston travels to Mexico with Tina Modotti

1924 *L'Illustration* (26 January) publishes a three-dimensional anaglyph of the moon produced by Léon Gimpel from two earlier (1902, 1904) astronomical photographs

László Moholy-Nagy, *Malerei Fotografie Film* (*Painting Photography Film*)

Man Ray, **Kiki: le violon d'Ingres**

1925 Launch of Leitz's Leica I(a) 35 mm camera

Arbeiter illustrierte Zeitung founded

1926 The German Ica, Goerz, Ernemann, and Contessa-Nettel companies merge to create the Zeiss Ikon photographic conglomerate

Meeting of Eugène Atget and Margaret Bourke-White, who acquires many of his negatives after his death the following year; later she sells them to MoMA, New York

Japanese magazine *Asahi Camera* launched

Rudolf Koppitz, **Movement Study**

1927 Germaine Krull, *Metall*

1928 Franke & Heidecke introduce the Rolleiflex twin-lens reflex

Dephot agency founded in Berlin

Appearance of the French illustrated weekly *Vu* (21 March)

Salon de l'Escalier exhibition of modern photography in Paris (May–June)

Karl Blossfeldt, *Urformen der Kunst* (*Archetypes of Art*)

Albert Renger-Patzsch, *Die Welt ist Schön* (*The World is Beautiful*)

August Sander, **Pastry-Cook, Cologne**

1929 Alfred Stieglitz opens the gallery An American Place in New York, which lasts until 1946

Walter Peterhans is appointed to teach photography at the Bauhaus in Dessau, Germany

Film and Foto (*Fifo*) exhibition in Stuttgart

An exhibition of Hill and Adamson calotypes is held at the Belvedere, Vienna, curated by Heinrich Schwarz

August Sander, *Antlitz der Zeit* (*Face of our Time*)

Tina Modotti, **Woman of Tehuantapec** (*c*.1929)

1930 Lewis Hine is commissioned to document the construction of the Empire State Building, New York, eventually creating hundreds of images, a selection of which are published in *Men at Work* (1932)

Atget: photographe de Paris, introduced by Pierre Mac Orlan

At about this time, Man Ray creates his celebrated **Glass Tears**

1931 The Soviet photo-essay *A Day in the Life of a Moscow Worker* (Alpert, Shaikhet, Tules) appears in the *Arbeiter illustrierte Zeitung*

Julien Levy opens his first gallery, at 602 Madison Avenue, New York, with a retrospective exibition of American photography

1932 Launch of Zeiss Ikon's Contax I 35 mm camera

Group f/64 exhibition at the M. H. de Young Museum, San Francisco (November–December)

Edward Weston, *The Art of Edward Weston*

Launch of Japanese journal *Koga* (*Light Picture*)

Henri Cartier-Bresson, **Place de l'Europe**

Wanda Wulz, **I+Cat**

1933 Founding of the Rapho agency in Paris

A team led by Col. L. V. S. Blacker overflies Mount Everest for the first time and takes photographs (3 April)

Brassaï: *Paris de nuit: 60 photos inédites*

José Ortiz-Echagüe inaugurates a three-part series (completed in 1943) of photographic studies of Spain with *España: tipos y trajes* (*Spain: People and Costumes*)

1934 Founding of Alliance Photo in Paris, and opening of the Harcourt Studio

Edward Weston begins a relationship with Charis Wilson (April), who inspires a series of celebrated nudes in the mid- and late 1930s

Alexey Brodovitch becomes art director of *Harper's Bazaar*

Doctrine of Socialist Realism proclaimed in the USSR

Antoine Poidebard, *La Trace de Rome dans le désert de Syrie*, based on aerial photographs

Alexander Rodchenko, **Girl with a Leica**

1935 Launch of the AP WirePhoto network (1 January)

Kodachrome colour transparency film is introduced for cinematographic use (in 1936 for still cameras)

Roy Stryker creates and heads the Historical Section of the US Resettlement Administration (in 1937 renamed the Farm Security Administration [FSA])

Madame Yevonde, **Lady Milbanke as 'Queen of the Amazons'**

1936 Launch of Ihagee Kamerawerk's 35 mm Kine Exakta SLR, and of Agfacolor transparency film

T* lens coating patented by Zeiss

In Japan, the Seiki Optical Co. designs a Leica-type 35 mm camera called the Kwannon (marketed in Europe from 1937 as the Hansa Canon)

Walter Benjamin's essay 'The Work of Art in the Age of Mechanical Reproduction'

Appearance of *Life* magazine (23 November)

Founding of the Black Star agency in New York

The Photo League, a group of New York-based documentary still photographers, emerges from the earlier (1928) Film and Photo League

Bill Brandt, *The English at Home*

Bill Brandt, **The Lambeth Walk**

Dorothea Lange, **Migrant Mother, Nipomo, California** (**Prairie Mother**) (March)

Robert Capa, **The Falling Soldier** (**Death in Spain**) (23 September)

1937 Founding of Mass-Observation in England by Tom Harrison, Humphrey Jennings, and Charles Madge

Edwin Land founds the Polaroid Corporation

The *Hindenburg* disaster at Lakehurst, NJ (6 May), is recorded by numerous photographers; many of the pictures are distributed by WirePhoto and published next day

Photography 1839–1937 exhibition at MoMA, New York, curated by Beaumont Newhall, and the first survey of photography to be held at an American museum. It is accompanied by Newhall's *The History of Photography*

Edward Weston receives the first fellowship awarded to a photographer by the Guggenheim Foundation, for travel in the western states of the USA

Maurice Bonnet founds the Relièphographie company in Paris for production of lenticular stereograms

Man Ray, Max Ernst, Lee Miller, and other Surrealists gather at Lambe Creek near Truro, Cornwall (June)

Herbert List, *Goldfish Bowl, Santorini*

1938 Kodak Super Six-20 camera with automatic exposure control, styled by Walter Dorwin Teague

The Minox sub-miniature camera goes into production in Riga

Andor Kraszna-Krausz founds the Focal Press in London

Appearance of the British weekly illustrated paper *Picture Post* (1 October), edited by Stefan Lorant

D. A. Spencer, *Colour Photography in Practice*

R. M. Taft, *Photography and the American Scene: A Social History, 1839–1889*

Henri Cartier-Bresson, **Sunday on the Banks of the Marne**

1939 Horst P. Horst, **Mainbocher Corset, Paris**

1940 Foundation of the Department of Photography at MoMA, New York, the first of its kind in an art museum, directed by Beaumont Newhall

Edward Weston, **Tide Pool, Point Lobos**

1941 Victor Hasselblad founds his own manufacturing company in Gothenburg, Sweden

The German serviceman Joe Heydecker takes illicit photographs of the Warsaw Ghetto (February)

Launch of the Zurich monthly magazine *Du* (March)

John Grierson founds the National Film Board in Canada

The Wandering Jew exhibition held by Tanpei Shashin Club, Osaka, Japan (May)

Walker Evans (with James Agee), *Let Us Now Praise Famous Men*

Ansel Adams, **Moonrise, Hernandez, New Mexico**

1942 Introduction of the Kodacolor process for making colour prints from colour negatives

Gregory Bateson and Margaret Mead, *Balinese Character: A Photographic Analysis*

Jindrich Styrsky (with Jindrich Heisler), *On the needles of these days*

Launch of the Japanese propaganda magazine *Front* in sixteen languages (January), its first edition dedicated to the Japanese navy

Gordon Parks, **Ella Watson** (**American Gothic**)

1943 George Strock, **Three American Soldiers Ambushed on Buna Beach, New Guinea** (February; published in *Life*, 20 September)

Weegee, **The Critic**

1944 Robert Capa photographs the D-Day landings on Omaha Beach, but most of the pictures are ruined in processing (6 June)

1945 Atomic bomb test at Alamogordo, N. Mex.; the only surviving colour photograph of the explosion is taken by Jack Aeby of the Special Engineer Detachment (16 July)

The atomic attack on Hiroshima is photographed from the bomber *Enola Gay* by George R. Caron, and on the ground by Yoshito Matsushige (6 August)

Alexey Brodovitch, *Ballet*

Weegee, *Naked City*

Joe Rosenthal, **Raising of the Stars and Stripes at Iwo Jima** (23 February)

1946 Refounding of Rapho by Raymond Grosset

1947 Edwin Land's 'peel-apart' instant picture process is demonstrated at the American Optical Society (21 February), heralding the launch of Polaroid 95 instant cameras the following year

Magnum agency founded at meetings in Paris and New York

Edward Steichen succeeds Beaumont Newhall as director of the Department of Photography at MoMA, New York, and stays until 1962

Incorporation of the Kinsey Institute for Research in Sex, Gender, and Reproduction (Indiana University, Bloomington), which eventually acquires a large photographic archive

Hugo van Wadenoyen, *Wayside Snapshots*

1948 Holography described and named by Denis Gabor

W. Eugene Smith's photo-essay *Country Doctor* appears in *Life*

Philippe Halsmann, **Dali Atomicus**

Eric Hosking, **Barn Owl with Vole**

1949 Opening of the International Museum of Photography at George Eastman House, Rochester, NY

German fotoform group founded

Launch of *Paris Match* (25 March)

Robert Doisneau (with Blaise Cendrars), *La Banlieue de Paris*

Willy Ronis, **Provençal Nude**

1950 First Photokina photographic trade fair, Cologne

Drum magazine founded in South Africa, lasting until 1985

Japan Professional Photographers' Society founded

Izis (Israëlis Bidermanas), *Paris des rêves*

Robert Doisneau, **The Kiss at the Hôtel de Ville** (**Les Amants de l'Hôtel de Ville**) (March)

1951 Partly as the result of official harassment, the Photo League disbands

Light Publicity, one of the most important post-war Japanese advertising agencies, is created, and employs many leading photographers

The Photographic Society of Japan is founded (December)

David Douglas Duncan, *This Is War*

1952 Helmut and Alison Gernsheim rediscover Niépce's **View from the Study Window** (**Point de vue du Gras à Saint-Loup de Varennes**) of 1827 (15 February)

Launch of the journal *Aperture*

Henri Cartier-Bresson, *Images à la sauvette, photographies* (Paris)/*The Decisive Moment: Photography by Henri Cartier-Bresson* (New York)

1953 Launch of *Playboy* magazine (November)

Dmitri Baltermants, **The Announcement of Stalin's Death**

1954 Ernst Leitz GmbH launches the Leica M series with the M3 rangefinder camera

Pierre Bourdin begins working for French *Vogue*

Pierre Verger, *Deux Afriques*

1955 *The Family of Man* exhibition opens at MoMA, New York (January)

Henri Cartier-Bresson, *Les Européens*

1956 *The Family of Man* exhibition is held at the Takashimaya department store in Tokyo, and attracts large crowds (March–April); later the first *International Subjective Photography* exhibition takes place at the same location (December)

William Klein, *New York* (*Life is Good and Good for You in New York*)

Josef Sudek Fofografie

O. Winston Link, **Hot Shot Eastbound at Iaeger Drive-In, West Virginia**

1957 *Picture Post* closes (1 June)

Lucien Clergue, *Corps mémorables*

1958 Robert Frank, *Les Américains: photographies de Robert Frank* (Paris)/*The Americans* (New York, 1959)

Ansel Adams, **Aspens, Northern New Mexico**

1959 Launch of 35 mm Nikon F SLR by Nippon Kogaku (later Nikon)

The Family of Man exhibition reaches Moscow

VIVO agency launched in Tokyo (July), and lasts until 1961

Bernd Becher and Hilla Wobeser (later Becher) begin collaborating on images of industrial structures in western Germany

A selection of W. Eugene Smith's Pittsburgh photographs appears in *Photography Annual*

Richard Avedon, *Observations*

Jeanloup Sieff, *Borinage*

1960 Federico Fellini's film *La dolce vita* gives currency to the term *paparazzo* for intrusive celebrity photographers

Irving Penn, *Moments Preserved*

Alberto Korda, **Il guerillero heroico** (**Che Guevara**) (5 March)

1961 Creation of the first successful holograms

Bill Brandt, *Perspective of Nudes*

1962 John Szarkowski succeeds Edward Steichen as director of the department of photography at MoMA, New York

Bert Stern photographs Marilyn Monroe (July), shortly before her death

American aerial reconnaissance photographs identify Russian missiles positioned in western Cuba (October)

Malick Sidibé opens Studio Malick in Bamako, Mali

Eliot Porter, with texts by H. D. Thoreau, *In Wildness is the Preservation of the World*

1963 Kodak Instamatic series launched (February)

First production 35 mm SLR camera with through-the-lens (TTL) metering, Tokyo Kogaku's Topcon RE Super

Nippon Kogaku launches the Nikonos underwater camera

An acclaimed exhibition of Jacques-Henri Lartigue's early photographs is held at MoMA, New York

Publication of the first Pirelli Calendar

1964 The young Chinese photographer Li Zhensheng joins the *Heilongjiang Daily* in Harbin in north-eastern China (October); later he photographs events of the Cultural Revolution (1966–76)

Edwin Smith (with Edward Hyams), *The English Garden*

1965 Pierre Bourdieu, *Un art moyen: essais sur les usages sociaux de la photographie* (Paris)/*Photography: A Middlebrow Art* (New York, 1996)

Lennart Nilsson, *A Child is Born*

1966 *The Photographer's Eye* exhibition at MoMA, New York

Michelangelo Antonioni's film *Blowup*

Hou Bo, **Mao Zedong Swimming in the Yangtze River**

1967 *New Documents* exhibition at MoMA, New York

Founding of the Friends of Photography at Carmel, California

Ernest Cole, *House of Bondage*

1968 The radical Japanese journal and collective *Provoke* is founded (November) by Daido Moriyama and others

Laura Gilpin, *The Enduring Navaho*

Eddie Adams, **General Nguyen Ngoc Loan Executes a Vietcong Prisoner in a Saigon Street** (1 February)

Ronald L. Haeberle, **Massacre of Villagers at My Lai 4, South Vietnam** (16 March; the pictures are not published until November 1969)

1969 Ralph Gibson founds Lustrum Press in New York

The Lee Witkin photographic gallery opens in New York

Harlem on my Mind exhibition, Metropolitan Museum of Art, New York

MoMA, New York, acquires the Eugène Atget archive

Neil Armstrong, **Buzz Aldrin on the Moon** (20 July), taken with a Hasselblad 500SL camera

1970 E. J. Bellocq's rediscovered **Storyville Portraits** of New Orleans prostitutes, taken *c.*1912 and newly printed by Lee Friedlaender, are exhibited at MoMA, New York

The French Law of 17 July 1970 severely restricts the photographic invasion of privacy

Inauguration of the Arles Festival

Ralph Gibson, *The Somnambulist*

Bernd and Hilla Becher, *Anonymous Sculptures*

Jacques-Henri Lartigue, *Diary of a Century*

Kishin Shinoyama, *Nude*

1971 The Photographers' Gallery opens in London

Sotheby's, London, holds its first photographic auction, organized by Philippe Garner

Appearance of the Spanish journal *Nueva lente*

Philip Jones Griffiths, *Vietnam Inc.*

Nobuyoshi Araki, *Sentimental Journey*

Larry Clark, *Tulsa*

1972 Launch of Olympus's OM SLR system with the mechanical OM-1

Bell Systems USA announces the use of charge-coupled devices (CCDs) for a solid-state camera

Polaroid SX-70 Deluxe instant-picture camera, with ultrasonic autofocus system

The Musée Niépce opens at Châlon-sur-Saône

Diane Arbus becomes (posthumously) the first photographer to be represented at the Venice Biennale

Publication of *Life* magazine suspended (December)

The publishing house La Azotea is founded in Argentina; in general, book publishing becomes an increasingly important activity for photographers

The first of W. Eugene Smith's photographs of pollution in Minamata, Japan, appear in *Life* (2 June); they are exhibited in Japan and elsewhere from 1973 and are published as a book in 1975

Daido Moriyama, *Bye Bye Photography*

Nick Ut, **Napalm Attack, Trang Bang, South Vietnam** (8 June)

1973 Sygma agency founded in Paris

Harold E. Edgerton, **Bullet Passing through a Candle Flame**

1974 *The Camera and Dr Barnardo* exhibition at the National Portrait Gallery, London includes images of Victorian child prostitutes by 'Francis Hetling' shown later (1978) to be fakes: a symptom of the rising value of the market in historic photographs

International Center of Photography founded in New York

New Japanese Photography exhibition at MoMA, New York, curated by John Szarkowski and Shoji Yamagishi

Tony Ray-Jones (d. 1971), *A Day Off: An English Journal*

Bernd and Hilla Becher, **Water-Towers, 1**

1975 The Fox Talbot Museum opens at Lacock Abbey, Wiltshire

New Topographics: Photographs of a Man-Altered Landscape, organized by William Jenkins, at the International Museum of Photography, George Eastman House

The Camera Obscura gallery opens in Stockholm

Mervyn Bishop, **Prime Minister Gough Whitlam Pours Soil into the Hand of Traditional Gurindji Landowner Vincent Lingiari, Northern Territory, [Australia]**

Josef Koudelka, *Gypsies*

1976 Introduction of ASA 400-rated colour negative film (Fujicolor FII 400), 11 million times more sensitive than the bitumen-coated plates used by Niépce in the 1820s

Founding of Contact Press Images

William Eggleston's Guide exhibition of colour photographs at MoMA, New York

Susan Meiselas, *Carnival Strippers*

1977 Konica C35A autofocusing compact camera, using infrared sensing

The Hackney Flashers, a socialist and feminist collective, is founded in east London

Stills Gallery opens in Edinburgh

Cindy Sherman begins the series *Untitled Film Stills* (1977–80)

Kosti Ruohamaa, *Night Train at Wiscasset Station*

Humphrey Spender, *Britain in the '30s*

Thomas Nelson, *A Practical Introduction to the Art of Daguerrotypy in the 20th Century*

1978 Ian Berry, *The English*

Mirrors and Windows exhibition at MoMA, New York

1979 Founding of the Consejo Argentina de Fotografía

Jo Spence, *Beyond the Family Album*

1980 First Week of Spanish Photography in Barcelona (May)

The Imaginary Photo Museum exhibition at Photokina, Cologne

David Bailey's Trouble and Strife

Martine Franck, *Le Temps de vieillir*

Roland Barthes, *La Chambre claire (Camera Lucida: Reflections on Photography)*

Annie Leibovitz, **John Lennon and Yoko Ono**

1981 Cindy Sherman's *Untitled Film Stills* exhibited at Metro Pictures, New York

Tee A. Corinne's series *Yantras of Womanlove*

Susan Meiselas, *Nicaragua*

Helmut Newton, **Self-Portrait with Wife and Model**

1982 Demonstration of Sony's 'still-video' Mavica camera, recording up to 50 analogue images on a magnetic disc

Launch of Kodak disc camera. Production continues until 1988

A survey estimates that *c.*20 million working cameras exist in France, and that 62 per cent of households own at least one

Susan Sontag, *On Photography*

Bert Stern, *The Last Sitting*

Stephen Shore, *Uncommon Places*

1983 The National Museum of Photography, Film, and Television opens in Bradford, an outstation of the Science Museum in London

Scottish Society for the History of Photography founded

The Ken Domon Museum, Japan's first museum dedicated exclusively to photography, opens in Sakata

Sirkka-Liisa Konttinen, *Byker*

Robert Mapplethorpe, *Lady: Lisa Lyon*

Roman Vishniac, *A Vanished World*

Michael Hiley, *Seeing through Photographs*

1984 Launch of the fully automated Minolta Dynax 7000 (Maxxum 7000) 35 mm SLR

The National Galleries of Scotland create the Scottish National Photography Collection

The J. Paul Getty Museum in Malibu, California, founds a department of photography, of which Weston Naef becomes director

Oliviero Toscani begins his association with the Benetton clothing firm (until 2000)

The Picture Photo Space gallery opens in Osaka, Japan

David Williams, *Pictures from No Man's Land*

1985 Richard Avedon, *In the American West*

Takeshi Ozawa et al. (eds.), *The Complete History of Japanese Photography* (12 vols., completed in 1988)

Black Sun: The Eyes of Four exhibition (Eikoh Hosoe, Masahisa Fukase, Daido Moriyama, Shomei Tomatsu) at the Museum of Modern Art, Oxford, then in London and Philadelphia

1986 Nan Goldin, *The Ballad of Sexual Dependency*

André de Dienes, *Marilyn mon amour*

South Africa: The Cordoned Heart, book and exhibition sponsored by the anti-apartheid agency Afrapix

1987 Controversial *Corps à corps* exhibition held by the French group Noir Limite

Andres Serrano, **Piss Christ**

1988 Foundation of the Daguerrian Society in the USA

1989 Canon and Fuji launch consumer electronic cameras, recording analogue images on, respectively, floppy disks and memory cards

The 150th 'official' anniversary of photography is celebrated with exhibitions including *The Art of Photography, 1939–1989* at the Royal Academy, London, and *On the Art of Fixing a Shadow* at the National Gallery of Art, Washington, DC, and the Art Institute of Chicago

The exhibition *Robert Mapplethorpe: The Perfect Moment* arouses major controversy

The Ansel Adams Center for Photography opens in San Francisco

David Goldblatt founds the Market Photography Workshop in Johannesburg

Japan Photographers' Association founded, for both professionals and amateurs

1990 The Hubble Space Telescope, using a CCD array to capture astronomical images, is launched into orbit by the US space shuttle *Discovery*

The first edition of Adobe Photoshop image manipulation software is launched

Photography Until Now exhibition at MoMA, New York, followed by the retirement of John Szarkowski as director of the photography department

Ken Burns makes extensive use of historic photographs in his television documentary series *The American Civil War*

Fay Godwin, *Our Forbidden Land*

Pierre Mac Orlan and Marcel Bovis, *Fêtes foraines*

1991 Kodak and Philips launch the Photo CD system

The beginning of a spate of censorship scandals in Japan, involving the work of photographers such as Nobuyoshi Araki and Kishin Shinoyama

Foundation of the research-orientated Japan Society for the Arts and History of Photography

Alexandras Macijauskas, *My Lithuania*

Donna Ferrato, *Living with the Enemy*

1992 Launch of the Canon EOS-5, the first camera with eye-controlled autofocus

Launch of Kodak DCS digital SLR cameras

In their film *Photowallahs*, David and Judith MacDougall explore the culture of street photography in the north Indian town of Mussoorie

Toshio Shibata, *Quintessence of Japan*

Jeff Wall, **Dead Troops Talk**

1993 Sebastião Salgado, *Workers*

1994 The US *Clementine* spacecraft maps the entire surface of the moon and takes *c*.1.8 million photographs

Sally Mann, *Still Time*

Nouvelle Histoire de la photographie, edited by Michel Frizot

1995 *Light from the Dark Room* exhibition, National Galleries of Scotland

Freelens professional photographers' association founded in Hamburg

Tokyo Metropolitan Museum of Photography opens fully, and hosts the first Tokyo International Photo-Biennale (June–July)

Launch of Print Club (*Puri-Kura*) photo-booths in Japan

1 June becomes an annual Day of Photography in Japan

1996 Launch of the Advanced Photographic System (APS) by a consortium of manufacturers

First Tokyo Month of Photography (May)

1997 The Helene Anderson collection of avant-garde photographs of the 1920s and 1930s is auctioned at Sotheby's, London (May), fetching high prices

Founding of Getty Images Inc.

Opening of Tokyo Photographic Cultural Centre

1998 *Native Nations: Journeys in American Photography* exhibition at the Barbican Gallery, London

David Goldblatt, *South Africa: The Structure of Things Then*

Raghubir Singh, *River of Colour*

1999 The Royal Library of Copenhagen's collection of 10 million pictures becomes the Nationale Fotomuseum

A large part of the Jammes collection of 19th-century and modernist photography is auctioned at Sotheby's, London, achieving record prices and a total of over £6 million; Gustave Le Gray's *La Grande Vague, Sète* fetches £507,000 (*c.* $800,000)

The New York collector John Pritzker pays over $1 million for a print of Man Ray's **Glass Tears**

Online sales of photography are boosted by the creation of **www.eyestorm.com**

Daido Moriyama et al., *Stray Dog*

Patricia Macdonald (with John Berger), *Once in Europa*

Annie Leibovitz, *Women*

2000 Photojournalists and other professionals adopt digital photography in ever larger numbers; Canon launches its last film-based professional SLR, the EOS-1V

Paris en 3D exhibition at the Musée Carnavalet, Paris

How You Look at It exhibition, an overview of 20th-century photography, at the Sprengel Museum, Hanover

Inauguration of an annual Documentary Photo Festival at Miyazaki, Japan. However, economic depression leads to the closure of many photographic galleries and periodicals

Naoya Hatekeyama, *Underground*

Sooni Taraporevala, *The Parsis of India: A Photographic Journey*

2001 Digital cameras outsell film cameras in Japan (and in the USA in 2003)

Founding of VII photographic agency by James Nachtwey and others

Andreas Gursky retrospective at MoMA, New York, curated by Peter Galassi; a print of his **Montparnasse** (1994) sets a record for contemporary photography by fetching *c.* $600,000

Wolfgang Tillmans wins the Turner Prize at Tate Britain, London

Closure of the Friends of Photography (October)

Hiroshi Sugimoto, *Architecture of Time*

Jean Gaumy, *Men at Sea*

2002 Production of Olympus OM film cameras ceases

The first consumer-level camera phones are launched

The exhibition *Ansel Adams at 100* tours the USA and Europe

2003 Launch of the Canon EOS 300D 6.3 megapixel digital SLR for under £1,000

Launch of the Olympus E-1 digital SLR, incorporating the Four Thirds sensor system and using lenses designed exclusively for digital imaging

The Japanese manufacturing giants Konica and Minolta merge to become Konica-Minolta (October)

Guy Bourdin exhibition at the Victoria & Albert Museum, London

Transfer of the RPS photographic collection to the National Museum of Photography, Film, and Television, Bradford

Cruel and Tender exhibition at Tate Modern, London, its first exclusively photographic show

Lartigue: l'album d'une vie exhibition at the Pompidou Centre, Paris (and the Hayward Gallery, London, in 2004); another major Paris show, *Le Daguerréotype français: un objet photographique* celebrates pioneering French photography

Susan Sontag, *Regarding the Pain of Others*

Li Zhensheng, *Red-Color News Soldier*

2004 Kodak ends production of APS cameras and embarks on a restructuring of its business worldwide

Launch of the Nikon F6, predicted in some quarters to be the company's last professional film-based SLR

Launch of the Canon EOS 1Ds Mk II digital SLR, with 16.7 million pixels

Samsung launches a 5-megapixel camera phone. A *Fonetography* exhibition is held at the AOP Gallery, London

Ilford Ltd., specialists in black-and-white film materials, go into administration

Two NASA exploration vehicles soft-land on Mars and begin transmitting stereoscopic digital images of the terrain

Opening of the Smithsonian National Museum of the American Indian, Washington, DC, incorporating a major photographic archive (21 October)

The Cable Factory Photography Gallery opens in Helsinki

At its annual award ceremony in November, the RPS honours the lifetime achievements of the portraitist Arnold Newman and documentary photographer Humphrey Spender. Other awards illustrate the many-sidedness of the medium in the early 21st century. Those honoured include the

photojournalists Terry O'Neill and Simon Norfolk; the picture editor Aidan Sullivan; the nature photographer Andy Callow; the cinematographer Seamus McGarvey; Eric Fossum and Peter Burns for research on digital image processing, and Efthimia Bilissi for work on image reproduction via the Internet; the collector and auctioneer Philippe Garner; the hologram collector Jonathan Ross; the photographic publisher

Dewi Lewis; and Anne McCauley, Colin Harding, Val Williams, and Mark Holborn for curatorship and historical scholarship

2005 The Japanese firm Kyocera, maker of Contax and Yashica cameras, announces its withdrawal from camera production and concentration on camera phones

Select Bibliography

The following bibliography is restricted to books in English and European languages, with emphasis on recent scholarship. The list is intended to complement rather than duplicate the literature cited elsewhere in the book. For works on individual photographers, the reader is referred to the relevant entries.

I

1. Reference Works
2. General Histories and Background Studies
3. General Technical Works
4. Classic and Specialized Manuals
5. Source Material: Memoirs, Letters, and Interviews
6. Source Material: Collections of Writings on Photography
7. Critical Approaches
8. Collections
9. Conservation and Materials
10. The Market

II

1. Early Photography
2. Amateur, Family, and Private Photography
3. Nude and Erotic Photography
4. Landscape Photography
5. Portraiture
6. Photojournalism and War Photography
7. Documentary Photography
8. Advertising and Fashion
9. Travel and Tourism
10. Art and Architecture
11. Medical and Scientific
12. Social Science
13. Colonialism and Native Peoples
14. Miscellaneous Topics

III

1. Regional and National Studies: Great Britain and Ireland
2. Continental Europe and Russia
3. North America
4. Latin America
5. The Middle East and Africa
6. Australasia, Antarctica, and Oceania
7. Indian Subcontinent
8. China, Japan, and South-East Asia

I.1. General Reference

Auer, M., and M., *Encyclopédie internationale des photographes de 1839 à nos jours* (2 vols., 1985).

Badge, P., and Birgus, V. (eds.), *European Photography Guide* (1982–).

Beaton, C., and Buckland, G., *The Magic Image: The Genius of Photography from 1839 to the Present Day* (1975).

Boni, A. (ed.), *Photographic Literature: An International Photographic Guide to General and Specialized Literature on Photographic Processes* (1963).

—— *Photographic Literature 1960–1970* (1972).

Browne, T., and Partnow, E. (eds.), *Macmillan Biographical Encyclopaedia of Photographic Artists and Innovators* (1983).

Dixon, P., *Photographers of the Farm Security Administration: An Annotated Bibliography, 1930–1980* (1983).

Edwards, G., *International Guide to Nineteenth-Century Photographers and their Works, Based on Catalogues of Auction Houses and Dealers* (1988).

Eskind, A. H., and Drake, G. (eds.), *Index to American Photographic Collections* (3rd rev. edn. 1995).

Gernsheim, H., *Incunabula of British Photographic Literature: A Bibliography of English Books Illustrated with Original Photographs* (1984).

Glenn, J. R., *Guide to the National Anthropological Archives* (1996).

Goldschmidt, L., and Naef, W., *The Truthful Lens: A Survey of the Photographically Illustrated Book, 1844–1914* (1980).

Guillemot, M., and Chiesa, P. (eds.), *Dictionnaire de la photo* (1996).

Heidtmann, F., *Bibliographie der Photographie: Deutschsprachige Publikationen der Jahre 1839–1984* (2nd edn., 2 vols., 1989).

The International Center of Photography Encyclopaedia of Photography (1984).

Johnson, W. S., *Nineteenth-Century Photography: An Annotated Bibliography 1839–1879* (1990).

Kelbaugh, R. J., *Directory of Civil War Photographers*, i: *Maryland, Delaware, Washington DC, Northern Virginia, West Virginia* (1990).

—— *Directory of Civil War Photographers*, ii: *Pennsylvania, New Jersey* (1991).

Kreisel, M., *American Women Photographers: A Selected and Annotated Bibliography* (1999).

Lambrechts, E., and Salu, L., *Photography and Literature: An International Bibliography of Monographs* (2 vols., 1992, 2000).

Lewinski, J., *Photography: A Dictionary of Photographers, Terms and Techniques* (1977).

Marchesi, J. J., *Handbuch der Photographie* (3 vols., 1993–8).

Melville, A., *Special Collections in the Library of Congress: A Selective Guide* (1980).

Misselbeck, R. (ed.), *Prestel-Lexikon der Fotografen: Von den Anfängen 1839 bis zur Gegenwart* (2002).

Nadeau, L., *Encyclopedia of Printing, Photographic and Photomechanical Processes* (1989).

Nauman, A. K., *Handbook of Latin American and Caribbean National Archives* (1984).

Palmquist, P. E. (ed.), *Photographers: A Sourcebook for Historical Research* (1991).

Photohistorica: Literature Index of the European Society for the History of Photography (1977–).

Public Archives of Canada, *Guide to Canadian Photographic Archives* (1984).

Roosens, L., and Salu, L. (eds.), *History of Photography: A Bibliography of Books* (1989–).

Scottish Visual Arts Group, *Report on Photographic Literature Collections in Scotland* (1996).

Sennett, R., *Photography and Photographers to 1900: An Annotated Bibliography* (1985).
—— *The Nineteenth-Century Photographic Press: A Study Guide* (1987).
Stevenson, S., and Morrison-Low, A. D., *Scottish Photography: A Bibliography* (1990).
Stroebel, L., and Zakia, R. (eds.), *The Focal Encyclopaedia of Photography* (3rd edn. 1993).
Vanderbilt, P., *Guide to the Special Collections of Prints and Photographs in the Library of Congress* (1955).
Voignier, J. M., *Répertoire des photographes de France au dix-neuvième siècle* (1993).
Wall, J., *Directory of British Photographic Collections* (1977).

I.2. General Histories and Background Studies

Ades, D., *Photomontage* (1986).
Amar, P. J., *La Photographie: histoire d'un art* (1993).
Amelunxen, H. v., et al. (eds.), *Photography after Photography: Memory and Representation in the Digital Age* (1996).
Anniger, A., and Melby, J. (eds.), *Six Exposures: Essays in Celebration of the Opening of the Harrison D. Horblit Collection of Early Photography* (1999).
Baier, W., *Quellendarstellung zur Geschichte der Fotografie* (2nd edn. 1980).
Bauret, G., *Approches de la photographie* (1992).
Braive, M., *The Photograph: A Social History* (1966).
Brauchitsch, B. v., *Kleine Geschichte der Photographie* (2002).
Briggs, A., *Victorian Things* (1988).
Buddemeier, H., *Panorama, Diorama, Photographie: Entstehung und Wirkung neuer Medien im 19. Jahrhundert* (1970).
—— *Das Foto: Geschichte und Theorie der Fotografie als Grundlage eines neuen Urteils* (1981).
Busch, B., *Belichtete Welt: Eine Wahrnehmungsgeschichte der Fotografie* (1989).
Campbell, B., *Exploring Photography* (1978).
Coe, B., Allison, D., et al., *Techniques of the World's Great Photographers* (1981).
Clarke, G., *The Photograph* (1997).
Coke, Van Deren (ed.), *One Hundred Years of Photographic History: Essays in Honor of Beaumont Newhall* (1975).
Crary, J., *Techniques of the Observer: On Vision and Modernity in the Nineteenth Century* (1990).
Davis, D. (ed.), *Photography as Fine Art* (1983).
Delpire, R., and Frizot, M., *Histoire de voir: une histoire de la photographie* (3 vols., 1989).
Druckrey, T. (ed.), *Iterations: The New Image* (1993).
—— **(ed.),** *Electronic Culture: Technology and Visual Representation* (1996).
Eder, J. M., *The History of Photography*, 4th German edn., trans. E. Epstean (1932; repr. 1978).
Frizot, M. (ed.), *A New History of Photography* (1998).
Gassen, A., *A Chronology of Photography: A Critical Survey of the History of Photography as a Medium of Art* (1972).
Gernsheim, H., *A Concise History of Photography* (1965).
Gilardi, A., *Storia sociale della fotografia* (1976).
Greenough, S., Snyder, J., Travis, D., and Westerbrook, C., *On the Art of Fixing a Shadow* (1989).
Gruber, R., and L. F., *The Imaginary Photo Museum*, trans. M. Rollof (1982).
Hein, D., and Schulz, A. (eds.), *Bürgerkultur im 19. Jahrhundert: Bildung, Kunst und Lebenswelt* (1996).
Henisch, H. K., and B. A., *The Photographic Experience 1839–1914: Images and Attitudes* (1993).
Hick, U., *Geschichte der optischen Medien* (1999).
Hirsch, R., *Seizing the Light: A History of Photography* (2000).
Hoffmann, D., and Junker, A., *Laterna magica: Lichtbilder aus Menschenwelt und Götterwelt* (1982).

Hyde, R., *Panoramania! The Art and Entertainment of the 'All-Embracing View'* (1988).
Ivins, W. M., *Prints and Visual Communication* (1969).
Jaeger, J., *Photographie: Bilder der Neuzeit. Einführung in die historische Bildforschung* (2000).
Jeffrey, I., *A Concise History of Photography* (1981).
—— *Revisions: An Alternative History of Photography* (1999).
Jussim, E., *Visual Communication and the Graphic Arts: Photographic Technologies in the Nineteenth Century* (1974).
Kern, S., *The Culture of Time and Space 1880–1918* (1983).
Koetzle, H. M., *Photo Icons: The Story behind the Pictures, 1827–1926* (2002).
—— *Photo Icons: The Story behind the Pictures, 1928–1991* (2002).
Koschatzky, W., *Die Kunst der Photographie* (1984).
Lamb, T., and Bourriau, J. (eds.), *Colour: Art & Science* (1995).
Lecuyer, R., *Histoire de la photographie* (1945).
Lemagny, J.-C., and Rouillé, A. (eds.), *A History of Photography: Social and Cultural Perspectives*, trans. J. Lloyd (1987).
Life Library of Photography: The Art of Photography (2nd edn. 1981).
Life Library of Photography: The Great Photographers (2nd edn. 1981).
Life Library of Photography: The Great Themes (2nd edn. 1981).
Marien, M. W., *Photography: A Cultural History* (2002).
Mayor, A. H., *Prints and People* (1971).
Mitchell, W. J., *The Reconfigured Eye: Visual Truth in the Post-Photographic Era* (1992).
Mrázkova, D., *Masters of Photography: A Thematic History* (1987).
Newhall, B., *The History of Photography from 1839 to the Present Day* (rev. edn. 1982).
Oettermann, S., *The Panorama: History of a Mass Medium*, trans. D. L. Schneider (1997).
Pritchard, H. B., *The Photographic Studios of Europe* (1882; repr. 1973).
Ritchin, F., *In our Own Image: The Coming Revolution in Photography. How Computer Technology is Changing our View of the World* (1999).
Roberts, J., *The Art of Interruption: Realism, Photography and the Everyday* (1998).
Rosenblum, N., *A World History of Photography* (rev. edn. 1989).
—— *A History of Women Photographers* (1994).
Scheurer, H., *Zur Kultur- und Mediengeschichte der Fotografie: Die Industrialisierung des Blicks* (1987).
Sixou, C., *Les grandes dates de la photographie* (2000).
Sobieszek, R., *Color as Form: A History of Color Photography* (1982).
Stenger, E., *Die Photographie in Kultur und Technik* (1938).
Stepan, P. (ed.), *Icons of Photography: The 20th Century* (1999).
Szarkowski, J., *Photography until Now* (1989).
Tausk, P., *Photography in the 20th Century* (1980).
Teitelbaum, M. (ed.), *Montage and Modern Life, 1919–1942* (1992).
Thomas, A., *The Expanding Eye: Photography and the Nineteenth-Century Mind* (1978).
Wall, E. J., *The History of Three-Color Photography* (1970).
Weaver, M., *The Photographic Art: Pictorial Traditions in Britain and America* (1986).
—— **(ed.),** *The Art of Photography, 1839–1989* (1989).
Westerbeck, C., and Meyerowitz, J., *Bystander: A History of Street Photography* (1994).

I.3. General Technical Works

Abramson, N., *The Making and Evaluation of Holograms* (1981).
Adams, A., *The Camera* (1980).
Adams, U. M., *Printing Technology* (1996).
Bellone, R., and Fellot, L., *Histoire mondiale de la photographie en couleurs* (1981).

Boutan, L., *La Photographie sous-marine et les progrès de la photographie* (1900).

Cahen, O., *L'Image en relief, de la stéréoscopique à la vidéo* (1989).

Coe, B., *Cameras: From Daguerreotypes to Instant Pictures* (1978).

—— *Colour Photography: The First Hundred Years, 1840–1940* (1978).

—— *Kodak Cameras: The First Hundred Years* (1988).

Collins, D., *The Story of Kodak* (1990).

Coote, J., *The History of Colour Photography* (1997).

Cope, P., *The Digital Photographer's A–Z* (2002).

Current, I., Compton, J., Stroebel, L., and Zakia, R., *Basic Photographic Materials and Processes* (2nd edn. 2000).

Daly, T., *Encyclopaedia of Digital Photography: The Complete Guide to Digital Imaging and Artistry* (2003).

Darrah, W. C., *Stereo-Views: A History of Stereographs in America and their Collection* (1964).

—— *The World of Stereographs* (1977).

Eder, J. M., *Die Moment-Photographie in ihrer Anwendung auf Kunst und Wissenschaft* (2nd edn. 1886).

—— *Die photographische Camera* (1892).

Edgerton, H., *Flash! Seeing the Unseen by Ultra-High-Speed Photography* (2nd edn. 1954).

—— *Moments of Vision: The Stroboscopic Revolution in Photography* (1979).

Finn, B. (ed.), *Presenting Pictures* (2004).

Fuller, P. G., *Alternative Image: An Aesthetic and Technical Exploration of Non-Conventional Photographic Printing Processes* (1983).

Gascoigne, B., *Milestones of Colour Printing* (1997).

Gauthier, S., *Traité et méthodes modernes de stéréoscopie* (1991).

Glassman, E., and Symmes, M. F., *Cliché-Verre: Hand-Drawn, Light-Printed. A Survey of the Medium from 1839 to the Present* (1980).

Graham, R., *Digital Imaging* (1998).

Gregory, R. L., *Eye and Brain* (5th edn. 1998).

Hariharan, P., *Optical Holography* (1996).

Henney, K., and Dudley, B., *Handbook of Photography* (1937).

Hicks, R., *A History of the 35 mm Still Camera* (1984).

Höfel, K. op ten, et al., *Farbe im Photo: Die Geschichte von der Farbphotographie von 1861 bis 1981* (1981).

Hunt, R. W. G., *The Reproduction of Colour* (5th edn. 1995).

Jacobson, R. E., et al., *The Manual of Photography* (9th edn. 2000).

Jensen, N., *Optical and Photographic Reconnaissance Systems* (1968).

Kingslake, R., *Optics in Photography* (1992).

Life Library of Photography: The Camera (2nd edn. 1981).

Life Library of Photography: Color (2nd edn. 1981).

Life Library of Photography: Frontiers of Photography (2nd edn. 1981).

Life Library of Photography: Light and Film (2nd edn. 1981).

Life Library of Photography: Photography as a Tool (2nd edn. 1981).

Life Library of Photography: Special Problems (2nd edn. 1981).

Martin, R. (ed.), *Floods of Light: Flash Photography 1851–1981* (1982).

Mees, C. E. K., and James, T. H., *The Theory of the Photographic Process* (1966).

Neusüss, F., *Das Fotogramm in der Kunst des 20. Jahrhunderts: Die andere Seite der Bilder—Fotografie ohne Kamera* (1990).

Okoshi, T., *Three-Dimensional Imaging Techniques* (1976).

Ostroff, E. (ed.), *Pioneers of Photography: Their Achievements in Science and Technology* (1987).

Pellerin, D., *La Photographie stéréoscopique* (1995).

Ray, S. (ed.), *Photographic Data* (1994).

—— **(ed.),** *Photographic Imaging and Electronic Photography* (1994).

—— **(ed.),** *Photographic Chemistry and Processing* (1994).

—— **(ed.),** *Photographic Technology and Imaging Science* (1994).

—— **(ed.),** *Photographic Lenses and Optics* (1994).

—— **(ed.),** *High Speed Photography and Photonics* (1997).

—— *Scientific Photography and Digital Imaging* (2001).

Rexer, L., *Photography's Antiquarian Avant-Garde: The New Wave in Old Processes* (2002).

Reynaud, F., Tambrun, C., and Timby, K. (eds.), *Paris in 3D: From Stereoscopy to Virtual Reality* (2000).

Reynolds, C., *Lenses* (1984).

Rijper, E., *Kodachrome 1939–1959: The American Invention of our World* (2002).

Rock, J., *Perception* (1984).

Rossell, D., *Laterna Magica: The History of the Magic Lantern* (2003).

—— *Living Pictures: The Origins of the Movies* (1998).

Saxby, G., *Manual of Practical Holography* (1991).

—— *The Science of Imaging: An Introduction* (2002).

—— *Practical Holography* (3rd edn. 2004).

Sobel, M., *Light* (1989).

Spira, S. F., et al., *The History of Photography as Seen through the Spira Collection* (2001).

Valyus, N., *Stereoscopy* (1966).

Van Keulen, W., *3-D Past and Present* (1986).

—— *3-D Imagics: A Stereoscopic Guide to the 3-D Past and its Magic Images* (1990).

Williams, T., *The Optical Transfer Function of Imaging Systems* (1999).

Wing, P., *Stereoscopes: The First One Hundred Years* (1996).

I.4. Classic and Specialized Manuals

Abbott, B., *A Guide to Better Photography* (1941).

Abney, W. de W., et al., *The Barnet Book of Photography: A Collection of Practical Articles* (3rd edn. 1898).

Adams, A., *Making a Photograph: An Introduction to Photography* (rev. edn. 1939).

—— *The Print* (1950).

—— *Natural-Light Photography* (1952).

—— *Examples: The Making of 40 Photographs* (1983).

—— **and Baker, R.,** *The Negative* (2nd edn. 1981).

Ang, T., *Silver Pixels: An Introduction to the Digital Darkroom* (1999).

Angel, H., *Nature Photography: Its Art and Techniques* (1972).

—— *Photographing the Natural World: A Practical Guide to the Art and Techniques* (1994).

Boubat, E., *La Photographie* (1974).

Buchanan, T., *Photographing Historic Buildings for the Record* (1983).

Davis, P., *Beyond the Zone System* (4th edn. 1998).

Dickinson, T., and Newton, J., *Splendors of the Universe: A Practical Guide to Photographing the Night Sky* (1997).

Edge, M., *The Underwater Photographer* (2nd edn, 1999).

Eggleston, J., *Sensitometry for Photographers* (1984).

Eisenstaedt, A., *Eisenstaedt's Guide to Photography* (1978).

Ensor, A., *Advanced Processing and Printing* (2001).

Feininger, A., *A Manual of Advanced Photography* (1962).

—— *The Complete Photographer* (1966).

—— *The Complete Colour Photographer* (1969).

—— *Total Photography: Learning to 'See' and Express Yourself through Technique* (1982).

Graham, R., and Read, R., *Manual of Aerial Photography* (1986).

Haas, R., *Special Effects in Photography* (1985).

Hepworth, T. C., *Photography for Amateurs* (1884).

Heyman, K., and Durniak, J., *The Right Picture* (1986).

Hicks, R., and Schultz, F., *The Black and White Handbook: The Ultimate Guide to Monochrome Techniques* (1997).

—— —— *Perfect Exposure: From Theory to Practice* (1999).

Hill, P., *Approaching Photography* (2nd edn. 2004).

Hosking, E., *The Art of Bird Photography* (rev. edn. 1948).

Howes, C., *Images Below* (1996).

Johnson, R., *The Art of Retouching and Improving Negatives and Prints*, rev. A. Hammond (14th edn. 1944).

Kelly, J. (ed.), *Darkroom 2* (1979).

Knapp, P., et al., *Cours de photographie: dix ans d'enseignement* (n.d.).

Lewis, E. (ed.), *Darkroom* (1977).

Life Library of Photography: The Techniques of Photography (1976).

Meehan, J., *Panoramic Photography* (1990).

—— *The Art of Close-up Photography* (1994).

—— *The Photographer's Guide to Using Filters* (1998).

Morgan, W. D., and Lester, H. M. (eds.), *Graphic Graflex Photography: The Master Book for the Larger Camera* (1940).

Mortensen, W., *The Model: A Book on the Problems of Posing* (1937).

—— *The New Projection Control* (1942).

Natkin, M., *Photography and the Art of Seeing* (1935).

—— *Fascinating Fakes in Photography* (1939).

Nurnberg, W., *Lighting for Photography: Means and Methods* (1940).

—— *Pocket Wisdom of Photography* (n.d.).

Paduano, J., *The Art of Infrared Photography* (4th edn. 1998).

Patterson, F., *Photography for the Joy of It* (1978).

Renner, E., *Pinhole Photography* (2nd edn. 1999).

Rockeach, B., *The Kodak Guide to Aerial Photography* (1996).

Smith, E., *All the Photo-Tricks* (1940).

Stroebel, L., *View Camera Technique* (7th edn. 1999).

Tarrant, J., *Digital Camera Techniques* (2003).

Warner, W. S., Graham, R. W., and Read, R. L., *Small Format Aerial Photography* (1996).

Webster, M., *Art and Technique of Underwater Photography* (1998).

White, L., *Infrared Photography Handbook* (1996).

White, M., *Zone System Manual* (1968).

Worobiec, T., *Toning and Handcolouring Photographs* (2002).

Zoete, J. de, *A Manual of Photogravure: A Comprehensive Working-Guide to the Fox Talbot/Klič Dustgrain Method* (1988).

I.5. Source Material: Memoirs, Letters, and Interviews

Adams, A., *An Autobiography* (1985).

Arnold, E., *In Retrospect* (1995).

Beaton, C., *Photobiography* (1951).

Blumenfeld, E., *Eye to I: The Autobiography of a Photographer*, trans. M. Mitchell and B. Murdoch (1999).

Borhan, P., *Voyons voir* (1980).

Brassaï, *Letters to my Parents*, trans. P. Laki and B. Kantor (1997).

Capa, R., *Slightly out of Focus* (1947).

Cooper, T., and Hill, P. (eds.), *Dialogue with Photography* (1979).

Diamonstein, B. (ed.), *Visions and Images: Photographers on Photography* (1982).

Doisneau, R., *Un certain Robert Doisneau: la très véridique histoire d'un photographe racontée par lui-même* (1986).

Duncan, D. D., *Photo Nomad* (2003).

Hockney, D., *Hockney on Photography: Conversations with Paul Joyce* (1988).

Hoppé, E. O., *Hundred Thousand Exposures: The Success of a Photographer* (1945).

Horvat, F., *Entre vues* (1990).

Hosking, E., and Lane, F. W., *An Eye for a Bird: The Autobiography of a Bird Photographer* (1970).

Kar, I., *Life as a Photographer* (1999).

Keppler, V., *Man + Camera: A Photographic Autobiography* (1970).

Langlois, J.-C., *La Photographie, la peinture, la guerre: correspondance inédite de Crimée (1855–1856)*, ed. F. Robichon and A. Rouillé (1992).

Light, K., *Witness in our Time: Working Lives of Documentary Photographers* (2000).

Lyons, N. (ed.), *Photographers on Photography* (1966).

McCullin, D., *Unreasonable Behaviour: An Autobiography* (1990).

Marinovich, G., and Silva, J., *The Bang-Bang Club: Snapshots from a Hidden War* (2000).

Martin, P., *Victorian Snapshots* (1939).

Mauro, A. (ed.), *Il mestiero di fotografo: lo sguardo de sud* (2004).

Meijer, E., and Swart, J. (eds.), *The Photographic Memory: Press Photography—Twelve Insights* (1987).

Nadar, *Nadar. I: Photographies*; *II: Dessins et écrits*, ed. P. Néagu and J.-J. Poulet-Allamagny (1979).

—— *Quand j'étais photographe*, ed. J.-F. Bory (1994).

Newton, H., *Autobiography* (2003).

Niépce, Claude, *Lettres de Claude Niépce à Nicéphore, 1818 à 1825*, ed. J. Paul (1995).

Roegier, P., *Écoutez voir: neuf entretiens (1984–1989)* (1989).

Spence, J., *Putting Myself in the Picture* (1986).

Steichen, E., *A Life in Photography* (1963).

Talbot, W. H. F., *Henry Fox Talbot: Selected Texts and Bibliography*, ed. M. Weaver (1992).

—— *The Correspondence of W. H. F. Talbot: A Draft Calendar, 31 Oct. 1995 Revision*, ed. L. J. Schaaf (1995).

—— *Records of the Dawn of Photography: Talbot's Notebooks P and Q*, ed. L. J. Schaaf (1996).

Tomkins, C. (ed.), *Paul Strand: Sixty Years of Photographs. Excerpts from Correspondence, Interviews and Other Documents* (1976).

Weston, E., *The Daybooks of Edward Weston*, ed. N. Newhall (2nd edn. 1990).

Whelan, R. (ed.), *Stieglitz on Photography: His Selected Essays and Notes* (2000).

I.6. Source Materials: Collections of Writings on Photography

Baqué, D. (ed.), *Les Documents de la modernité: anthologie de textes sur la photographie de 1919 à 1939* (1993).

Brittain, D. (ed.), *Creative Camera: Thirty Years of Writing* (1999).

Goldberg, V. (ed.), *Photography in Print: Writings from 1816 to the Present* (1981).

Greene, J., *Camera Work: A Critical Anthology* (1973).

Lugon, O. (ed.), *La Photographie en Allemagne: une anthologie de textes (1919–1939)* (1997).

Newhall, B. (ed.), *Photography: Essays and Images. Illustrated Readings in the History of Photography* (1980).

Petruck, P. R. (ed.), *The Camera Viewed: Writings on Twentieth-Century Photography* (2 vols., 1979).

Rouillé, A., *La Photographie en France. Textes et controverses: une anthologie 1816–1871* (1989).

Trachtenberg, A. (ed.), *Classic Essays on Photography* (1980).

Wells, L. (ed.), *The Photography Reader* (2003).

I.7. Critical Approaches

Adams, R., *Why People Photograph: Selected Essays and Reviews* (1994).

—— *Beauty in Photography: Essays in Defense of Traditional Values* (1996).

Amelunxen, H. v. (ed.), *Theorie der Fotografie, iv: 1980–1995* (2000).

Barnouw, D., *Critical Realism: History, Photography and the Work of Siegfried Kracauer* (1994).

Barrett, T., *Criticizing Photographs: An Introduction to Understanding Images* (2nd edn. 1996).

Barthes, R., *Mythologies*, trans. A. Lavers (1972).

—— *Camera Lucida: Reflections on Photography*, trans. R. Howard (1981).

Batchen, G., *Each Wild Idea: Writing Photography History* (2001).

Benjamin, W., *Illuminations: Essays and Reflections*, ed. H. Arendt, trans. H. Zohn (1968).

Berger, J., *Ways of Seeing* (1972).

Bolton, R. (ed.), *The Contest of Meaning: Critical Histories of Photography* (1989).

Brennan, B., and Hardt, H. (eds.), *Picturing the Past: Media, History and Photography* (1999).

Burgin, V. (ed.), *Thinking Photography* (1981).

Coleman, A. D., *Light Readings: A Photography Critic's Writings, 1968–1978* (1979).

—— *Depth of Field: Essays on Photography, Mass Media, and Lens Culture* (1998).

Dubois, P., *L'Acte photographique et autres essais* (1990).

Eisinger, J., *Trace and Transformation: American Criticism of Photography in the Modernist Period* (1995).

Freund, G., *Photographie et société* (1974).

Goldberg, V., *Light Matters: Writings on Photography* (2005).

Grundberg, A., *Crisis of the Real: Writings on Photography since 1974* (1999).

Hallett, M. (ed.), *Rewriting Photographic History* (1989).

Hartmann, S., *The Valiant Knights of Daguerre*, ed. H. W. Lawson and G. Knox (1978).

Hiley, M., *Seeing through Photographs* (1983).

Jenkins, W., *The Extended Document: An Investigation of Information and Evidence in Photographs* (1975).

Jussim, E., *The Eternal Moment: Essays on the Photographic Image* (1989).

Kemp, W., *Foto-Essays: Zur Geschichte und Theorie der Fotografie* (1978).

—— **(ed.),** *Theorie der Fotografie*, i: *1839–1912* (1980).

—— **(ed.),** *Theorie der Fotografie*, ii: *1912–1945* (1979).

—— **(ed.),** *Theorie der Fotografie*, iii: *1945–1980* (1983).

Kozloff, M., *Lone Visions, Crowded Frames: Essays on Photography* (1994).

Kruger, B., *Remote Control: Power, Cultures and the World of Appearances* (1993).

Lemagny, J.-C., *L'Ombre et le temps* (1992).

—— *La Matière, l'ombre, la fiction* (1994).

Malcolm, J., *Diana & Nikon: Essays on Photography* (2nd edn. 1997).

Marien, M. W., *Photography and its Critics: A Cultural History 1839–1900* (1997).

Mitchell, W. J. T. (ed.), *The Language of Images* (1980).

Newhall, N., *From Adams to Stieglitz: Pioneers of Modern Photography* (1999).

Nichols, B., *Ideology and the Image* (1981).

Pieroni, A., *Leggere la fotografia: osservazione e analisi delle immagini fotografiche* (2003).

Scott, C., *The Spoken Image: Photography and Language* (1999).

Sekula, A., *Photography against the Grain: Essays and Photo Works 1973–1983* (1983).

Shaw, B., *Bernard Shaw on Photography*, ed. B. Jay and M. Moore (1989).

Solomon-Godeau, A., *Photography at the Dock: Essays on Photographic Histories, Institutions and Practices* (1991).

Sontag, S., *On Photography* (1978).

Squiers, C. (ed.), *The Critical Image: Essays on Contemporary Photography* (1990).

—— **(ed.),** *Over-Exposed: Essays on Contemporary Photography* (1999).

Sturken, M., and Cartwright, L., *Practices of Looking: An Introduction to Visual Culture* (2001).

Tagg, J., *The Burden of Representation: Essays on Photographies and Histories* (1988).

Younger, D. P. (ed.), *Multiple Views: Logan Grant Essays on Photography, 1983–1989* (1991).

Zannier, I., *Leggere la fotografia* (1993).

I.8. Photographic Collections

Alinari, Fratelli, *Fratelli Alinari: The Archives. The Photographic Files. The New Photographic Campaigns. The Art Printworks. The Publishing House. The Museum* (1991).

Apraxine, P., *Photographs from the Collection of the Gilman Paper Company* (1985).

—— *Une passion française: photographies de la collection Roger Thérond* (1999).

Bastianelli, M. (ed.), *Archivi fotografici italiani: 600 fondi e raccolte di immagini* (1997).

Biblioteca Nacional, Madrid, *150 años de fotografía en la Biblioteca Nacional* (1989).

Boast, R., Guha, S., and Herle, A., *Collected Sights: Photographic Collections of the [Cambridge] Museum of Archaeology and Anthropology, 1860s–1930s* (2001).

Bonnett, W., *A Pacific Legacy: A Century of Maritime Photography 1850–1950. Photographs from the Museum Archives of the San Francisco Maritime National Historical Park* (1991).

Boom, M., and Rooseboom, H. (eds.), *A New Art: Photography in the 19th Century. The Photo Collection of the Rijksmuseum, Amsterdam* (1996).

Borcoman, J., *Magiciens de la lumière: photographies de la collection du Musée des Beaux Arts du Canada* (1993).

Bruce, C., and Grundberg, A., *After Art: Rethinking 150 Years of Photography; Selections from the Joseph and Elaine Monsen Collection* (1984).

Burger, B. L., *Guide to the Holdings of the Still Picture Branch of the National Archives* (1990).

Cartier-Bresson, A., et al., *Éclats d'histoire: les collections photographiques de l'Institut de France, 1839–1918* (2003).

Coming to Light: Birmingham's Photographic Collections (1998).

Davis, K. F., *An American Century of Photography, from Dry Plate to Digital: The Hallmark Photographic Collection* (2nd edn. 1999).

Dewitz, B. v., *Das Agfa Foto-Historama im Wallraff-Richartz-Museum/Museum Ludwig der Stadt Köln/Eine Auswahl von Photographien des 19. und des frühen 20. Jahrhunderts* (1986).

—— **and Scotti, R.,** *Alles Wahrheit! Alles Lüge! Photographie und Wirklichkeit im 19. Jahrhundert: Die Sammlung Robert Lebeck* (1996).

—— **et al.,** *Agfa Foto-Historama Köln* (1988).

Dimond, F., and Taylor, R., *Crown and Camera: The Royal Family and Photography, 1842–1910* (1987).

Enyeart, J. (ed.), *Decade by Decade: Twentieth-Century American Photography from the Collection of the Center for Creative Photography* (1989).

Eskind, A. H., and Drake, G. (eds.), *Index to American Photographic Collections* (3rd rev edn. 1995).

Faber, M., and Schröder, K. A. (eds.), *Das Auge und der Apparat: Eine Geschichte der Fotografie aus den Sammlungen der Albertina* (2003).

Folkwang Museum, Essen, *Die Fotografische Sammlung* (1983).

Forbes, D., and Stevenson, S., *A Companion Guide to Photography in the National Galleries of Scotland* (2001).

Fotomuseum im Münchner Stadtmuseum 1961–1991 (1991).

Fournié, P., and Gervereau, L., *Regards sur le monde: trésors photographiques du Quai d'Orsay, 1860–1914* (2000).

Galassi, P., *American Photography 1890–1965 from the Museum of Modern Art, New York* (1995).

Goetzman, W. H., *The First Americans: Photographs from the Library of Congress* (1991).

Graeve, I. (ed.), *Mechanismus und Ausdruck: Die Sammlung Ann und Jürgen Wilde. Fotografien aus dem 20. Jahrhundert* (1999).

Greenhill, B. (ed.), *A Victorian Maritime Album: 100 Photographs from the Francis Frith Collection at the National Maritime Museum [Greenwich]* (1974).

Guida alle raccolte fotografiche di Roma (1980).

Hambourg, M. M., and Phillips, C., *The New Vision: Photography between the Two World Wars. The Ford Motor Company Collection at the Metropolitan Museum of Art, New York* (1989).

—— **et al.,** *The Waking Dream: Photography's First Century. Selections from the Gilman Paper Company Collection* (1993).

Hathaway, N., *Native American Portraits, 1862–1918: Photographs from the Collection of Kurt Koegler* (1990).

Haworth-Booth, M., *Photography: An Independent Art. Photographs from the Victoria and Albert Museum 1839–1996* (1997).

—— **and McCauley, A.,** *The Museum and the Photography: Collecting Photography at the Victoria and Albert Museum, 1853–1900* (c.1998).

Heilbrun, F., and Bajac, Q., *Orsay Photography*, trans. C. Uranga (2003).

—— **and Néagu, P.,** *Musée d'Orsay: chefs-d'œuvre de la collection photographique* (1986).

Historic Photographs at the National Maritime Museum: An Illustrated Guide (1995).

Hitchcock, B., et al., *Innovation/Imagination: 50 Years of Polaroid Photography* (1999).

Ins Innere des Bilderbergs: Fotografien aus den Bibliotheken der Hochschule der Künste und der Technischen Universität Berlin (1988).

Jammes, A., and M.-T., *The First Century of Photography: Niépce to Atget. From the Collection of André Jammes* (1997).

Janda, J., *Camera Obscuras. Photographic Cameras 1840–1940. National Museum of Technology, Prague: Camera Collection Catalogue* (1982).

Kirstein, L., *The Latin American Collection of the Museum of Modern Art* (1943).

Kunstphotographie um 1900: Die Sammlung Ernst Juhl (1989).

Lange, S., *Degrees of Stillness: Photographs from the Manfred Heiting Collection* (1998).

Marbot, B. (ed.), *After Daguerre: Masterworks of French Photography, 1848–1920, from the Bibliothèque Nationale de France* (1980).

Mathon, C., and Garcia, A.-M., *Les Chefs-d'oeuvre de la photographie dans les collections de l'École des Beaux-Arts* (1991).

Mulligan, T., and Wooters, D., *1000 Photo Icons: George Eastman House* (2002).

Musée de la Photographie Charleroi, Centre d'Art Contemporain de la Communauté Française de Belgique (1996).

Naef, W., *The Collection of Alfred Stieglitz: Fifty Pioneers of Modern Photography* (1978).

—— *The J. Paul Getty Museum Handbook of the Photographs Collection* (1995).

—— *Photographers of Genius at the Getty* (2004).

National Film Board of Canada, Still Photography Division, *Contemporary Canadian Photography from the Collection of the National Film Board* (1984).

National Museum of Modern Art, Kyoto, Japan, *Modern Photography and Beyond: Photographs in the Collection of the Museum* (1987).

Parallels & Contrasts: Photographs from the Stephen White Collection (1988).

Photographies/histoires parallèles: collection du Musée Nicéphore Niépce (2000).

Photography from 1839 to Today: George Eastman House, Rochester, NY (2000).

Roark, C. E., Stewart, P. A., and McCabe, M. K., *Catalogue of the Amon Carter Photography Collections* (1993).

Roberts, P., *The Royal Photographic Society Collection* (1994).

—— *Photogenic: From the Collection of the Royal Photographic Society* (2001).

Roganti, G. (ed.), *Das Jahrhundert der Photographie: Die Sammlung der Galleria Civica Modena und Fondo Franco Fontana* (1999).

Rouse, S., *Into the Light: An Illustrated Guide to the Photographic Collections in the National Library of Ireland* (1998).

Royal Commission on the Historical Monuments of England, *The National Monuments Record: A Guide to the Archive* (1991).

Rule, A., and Solomon, N., *Original Sources: Art and Archives at the Center for Creative Photography* (2002).

Sammlung Gruber: Photografie des 20. Jahrhunderts (1984).

Sandweiss, M. A., *Masterworks of American Photography: The Amon Carter Museum Collection* (1982).

Schaaf, L. J., *Sun Pictures Catalogue 8: The Rubell Collection* (1997).

Scherer, J. C., *Indian Images: Photographs of North American Indians 1847–1928, from the Smithsonian Institution, National Anthropological Archives* (1970).

—— *Indians: The Great Photographs that Reveal North American Indian Life, 1847–1929, from the Unique Collection of the Smithsonian Institution* (1973).

Sobieszek, R. A., *Masterpieces of Photography from the George Eastman House Collection* (1985).

Spanenberg, K. L., *Photographic Treasures from the Cincinnati Art Museum* (1989).

Squiers, C., and Pearson Yamashiro, J., *Peek: Pictures from the Kinsey Institute* (2000).

Szarkowski, J., *Looking at Photographs: 100 Pictures from the Collection of the Museum of Modern Art* (1973).

—— *A Personal View: Photography in the Collection of Paul F. Walter* (1985).

Tenfelde, K. (ed.), *Bilder von Krupp: Fotografie und Geschichte im Industriezeitalter* (1994).

Thomas, D. B., *The Science Museum Photography Collection* (1969).

Travis, D., *Photographs from the Julien Levy Collection Starting with Atget* (1976).

Twentieth Century Photography: Museum Ludwig Cologne (1996).

Viola, H. J., *North American Indians: Photographs from the National Anthropological Archives, Smithsonian Institution* (microfilm, 1974).

Wagstaff, S., *A Book of Photographs from the Collection of Sam Wagstaff* (1978).

Wick, R. (ed.), *Die Pioniere der Photographie 1840–1900: Die Sammlung Robert Lebeck* (1989).

Zuckriegl, M., *Österreichische Fotografie seit 1945: Aus den Beständen der Österreichischen Fotogalerie im Rahmen der Salzburger Landessammlungen Rupertinum Salzburg* (1989).

I.9. Conservation and Materials

Baldwin, G., *Looking at Photographs: A Guide to Technical Terms* (1991).

Clark, S., *Photographic Conservation* (1988).

Coe, B., and Haworth-Booth, M., *A Guide to Early Photographic Processes* (1983).

Eastman Kodak, *Preservation of Photographs* (1979).

Haller, M., *Collecting Old Photographs* (1978).

International Federation of Library Associations and Institutions (IFLA), *Care, Handling and Storage of Photographs* (1992).

Keefe, L. E., and Inch, D., *The Life of a Photograph: Archival Processing, Matting, Framing, Storage* (1984).

Lavedrine, B., *La Conservation des photographies* (1990).

Life Library of Photography: Caring for Photographs (1979).

Marincola, P., *The Hand-Colored Photograph* (1980).

Martin, E., *Collecting and Preserving Old Photographs* (1988).

Moore, I. L., and A., *Conserving Photographs: The Care and Preservation of Photographic Images* (1986).

Ostroff, E., *Conserving and Restoring Photographic Collections* (1976).

Rathje, U. (ed.), *Das Auge des Zyklopen: Photographien—ihre Verfahren, Identifizierung, Bewahrung* (1989).

Reilly, J. M., *The Albumen and Salted Paper Book: The History and Practice of Photographic Printing 1840–1895* (1980).

—— *Care and Identification of 19th-Century Photographic Prints* (1986).

Rempel, S., *The Care of Photographs* (1987).

Weinstein, R. A., and Booth, I., *Collection, Use and Care of Historical Photographs* (1977).

Wilhelm, H., and Brower, C., *The Permanence and Care of Color Photographs: Traditional and Digital Color Prints, Color Negatives, Slides and Motion Pictures* (1993).

Zannier, I., and Tartaglia, D., *La fotografia in archivio* (2000).

I.10. The Market

Badger, G., *Collecting Photography* (2003).

Bennett, S., *How to Buy Photographs* (1987).

Blodgett, R., *Photographs: A Collector's Guide. A Complete Handbook for Buying Fine Photographs* (1979).

Gilbert, G., *Collecting Photographica: The Images and Equipment of the First Hundred Years* (1976).

Koetzle, M., *Das Foto: Kunst- und Sammelobjekt* (1997).

Scheid, U., *Photographica sammeln* (1977).

Wetling, W., *Collector's Guide to Nineteenth Century Photographs* (1976).

Witkin, L., and London, B., *The Photograph Collector's Guide* (1979).

II.1. Early Photography

Bajac, Q., *The Invention of Photography: The First Fifty Years*, trans. R. Taylor (2002).

—— **and Font-Réaulx, D. de,** *Le Daguerréotype français: un objet photographique* (2003).

Barger, M. S., and White, W. B., *The Daguerreotype: Nineteenth-Century Technology and Modern Science* (1991).

Batchen, G., *Burning with Desire: The Conception of Photography* (1997).

Beausoleil, J., et al., *Les Frères Lumière et les premières photographies en couleurs* (1989).

Brettell, R., Flukinger, R., Keeler, N., and Kilgor, S., *Paper and Light: The Calotype Process in France and Britain 1839–1870* (1984).

Bruce, D., *Sun Pictures: The Hill–Adamson Calotypes* (1973).

Brunet, F., *La Naissance de l'idée de photographie* (2000).

Buchwald, J. Z., *The Rise of the Wave Theory of Light: Optical Theory and Experiment in the Early Nineteenth Century* (1989).

Buerger, J. E., *French Daguerreotypes* (1989).

Coe, B., and Haworth-Booth, M., *A Guide to Early Photographic Processes* (1983).

Colnaghi, P., and D., Ltd., *Photography: The First Eighty Years* (1976).

Crawford, W., *The Keepers of Light: A History and Working Guide to Early Photographic Processes* (1979).

Dewitz, B. v., and Matz, R. (eds.), *Silber und Salz: Zur Frühzeit der Photographie im deutschen Sprachraum 1839–1860* (1989).

Feldvebel, T., *The Ambrotype, Old and New* (1980).

Foresta, M., and Wood, J., *Secrets of the Dark Chamber: The Art of the American Daguerreotype* (1995).

'From Today Painting is Dead': The Beginnings of Photography (1976).

Gernsheim, H., *The Origins of Photography* (1982).

—— *The Rise of Photography 1850–1880: The Age of Collodion* (rev. 3rd edn. 1988).

Haberkorn, H., *Anfänge der Photographie: Entstehungsbedingungen eines neuen Mediums* (1985).

Jammes, A., and Janis, E. Parry, *The Art of French Calotype* (1983).

Jay, P., *Les Conserves de Nicéphore* (1992).

Kempe, F., *Daguerreotypie in Deutschland: Vom Charme der frühen Photographie* (1979).

—— **and Dewitz, B. v.,** *Daguerreotypien, Ambrotypien, und Bilder anderer Verfahren aus der Frühzeit der Photographie* (1983).

Marignier, J.-L., *Niépce, l'invention de la photographie* (1999).

Morand, S., and Kempf, C., *Le Temps suspendu: la daguérreotype en Alsace au XIX. siècle* (1989).

Les multiples inventions de la photographie (1989).

Newhall, B., *The Daguerreotype in America* (rev. edn. 1968).

Pfister, H. F., *Facing the Light: Historic American Portrait Daguerreotypes* (1978).

Photography: Discovery and Invention. Papers Delivered at a Symposium Celebrating the Invention of Photography Organised by the Department of Photographs and Held at the J. Paul Getty Museum, 30 January 1989 (1990).

Pritchard, M. (ed.), *Technology and Art: The Birth and Early Years of Photography* (1990).

Rinhard, F. and M., *The American Daguerreotype* (1980).

Schaaf, L. J., *Out of the Shadows: Herschel, Talbot and the Invention of Photography* (1992).

Séguy, F., *Le Sens et l'origine du vocabulaire technique en photographie* (1998).

Sun Pictures: Images from the Dawn of Photography. Photographs by John Dillwyn Llewelyn and his Circle (1982).

Thomas, D. B., *The First Negatives: An Account of the Discovery and Early Use of the Negative-Positive Photographic Process* (1964).

Une invention du XIXe siècle: la photographie (1976).

Ward, J., and Stevenson, S., *Printed Light: The Scientific Art of William Henry Fox Talbot and David Octavius Hill with Robert Adamson* (1986).

Weimar, W., *Die Daguerreotypie in Hamburg 1839–1960* (1915).

Wood, J. (ed.), *The Daguerreotype: A Sesquicentennial Celebration* (1989).

—— *The Art of Autochrome: The Birth of Color Photography* (1993).

—— *The Scenic Daguerreotype: Romanticism and Early Photography* (1995).

II.2. Amateur, Family, and Private Photography

Adams, T. D., *Light Writing and Life Writing: Photography in Autobiography* (2000).

Chalfen, R., *Snapshot Versions of Life* (1987).

Coe, B., and Gates, P., *The Snapshot Photograph: The Rise of Popular Photography, 1888–1939* (1977).

Dewitz, B. v., *'So wird bei uns der Krieg geführt': Amateurfotografie im Ersten Weltkrieg* (1989).

Dufour, B., *La Pierre et le seigle: histoire des habitants de Villefranche-de-Rouergue racontée par les photographies d'amateurs et les albums de famille, 1860–1950* (1977).

Fehily, C., Fletcher, J., and Newton, K. (eds.), *I Spy: Representations of Childhood* (2000).

Fenoyl, P. de, and Laurent, J., *Chefs d'œuvre des photographes anonymes au XIX. siècle* (1982).

Ford, C. (ed.), *The Story of Popular Photography* (1989).

Harding, C., and Lewis, B., *Kept in a Shoebox: The Popular Experience of Photography* (1992).

Hirsch, J., *Family Photographs: Content, Meaning and Effect* (1981).

Hirsch, M., *Family Frames: Photography, Narrative, and Postmemory* (1997).

—— **(ed.),** *The Familial Gaze* (1999).

Holland, P., and Spence, J. (eds.), *Family Snaps: The Meanings of Domestic Photography* (1991).

Jahn, P., and Schmiegelt, U. (eds.), *Foto-Feldpost: Geknipste Kriegserlebnisse 1939–1945* (2000).

Johnson, R. F., *Anonymous: Enigmatic Images from Unknown Photographers* (2004).

Kenyon, D., *Inside Amateur Photography* (1992).

King, G., *Snaps as Art: A Brief Study of the Photographic Snap, its Role in Influencing our Perception of Reality, and its Aesthetic Potential* (1978).

—— *Say 'Cheese'! The Snapshot as Art and Social History* (1986).

Koltun, L. (ed.), *Private Realms of Light: Amateur Photography in Canada 1839–1940* (1984).

Kuhn, A., *Family Secrets* (1995).

Lesy, M., *Time Frames: The Meaning of Family Pictures* (1980).

Loetscher, H., *Photographie in der Schweiz von 1840 bis heute* (2nd edn. 1992).

Maas, E., *Die Goldenen Jahren der Photo-alben: Fundgrube und Spiegel von gestern* (1977).

Nickel, D. R., *Snapshots: The Photography of Everyday Life, 1888 to the Present* (1998).

Das Photo-Album 1858–1918: Eine Dokumentation zur Kultur- und Sozialgeschichte (1975).

Other Pictures: Anonymous Photographs from the Thomas Walther Collection, introd. M. Fineman (2000).

Pols, R., *Looking at Old Photographs* (1998).

—— *Family Photographs, 1860–1945* (2002).

Ravache, M., and Leblanc, B., *L'Album photo des Français, 1914 à nos jours* (2004).

Spence, J., and Holland, P. (eds.), *Family Snaps: The Meanings of Domestic Photography* (1991).

—— **and Solomon, J. (eds.),** *What Can a Woman Do with a Camera? Photography for Women* (1995).

Starl, T., *Knipser: Die Bildgeschichte der privaten Fotografie in Deutschland und Österreich von 1880 bis 1980* (1995).

Tucker, A. (ed.), *The Woman's Eye* (1973).

West, N. M., *Kodak and the Lens of Nostalgia* (2000).

II.3. Nude and Erotic Photography

Aubenas, S., et al., *L'Art du nu au XIXe siècle: le photographe et son modèle* (1997).

Bajac, Q., *Tableaux vivants: fantaisies photographiques victoriennes* (1999).

Callahan, S., and Olschewski, P., *Nudes* (1995).

Cooper, E., *Fully Exposed: The Male Nude in Photography* (1996).

—— *Male Bodies: A Photographic History of the Nude* (2004).

Le Corps regardé (2 vols., 1981).

Davis, M. D., *The Male Nude in Contemporary Photography* (1996).

Gilardi, A., *Storia della fotografia pornografica* (2002).

Herbert, D., *Le Nu* (1985).

Jay, B., *Views on Nudes* (1971).

Kelly, J. (ed.), *Nude Theory* (1979).

Köhler, M., and Barche, G. (eds.), *Das Aktfoto: Ansichten vom Körper im fotografischen Zeitalter* (1985).

Lacey, P., *Nude Photography: The Art and Technique of Nine Modern Masters* (1985).

Lewinski, J., *The Naked and the Nude: A History of Nude Photography* (1987).

Masclet, D., *Nus* (1933).

Nazarieff, S., *Le Nu stéréoscopique* (1985).

—— *Early Erotic Photography* (1993).

Nead, L., *The Female Body: Art, Obscenity and Sexuality* (1992).

Noël, B., *The Nude* (1990).

Ovenden, G., and Mendes, P., *Victorian Erotic Photography* (1973).

Pellerin, M. (ed.), *Masterpieces of Erotic Photography* (1977).

Pohlmann, U., et al., *The Nude. Ideal and Reality: From the Invention of Photography to Today* (2004).

Pultz, J., *Photography and the Body* (1995).

Richter, P.-C., *Nude Photography: Masterpieces from the Past 150 Years* (1998).

Romer, G. B., *Die erotische Daguerreotypie: Sammlung Scheid* (1989).

Sullivan, C., *Nude Photographs, 1850–1980* (1980).

Weiermair, P., *Das verborgene Bild: Geschichte des männlichen Akts in der Fotografie des 19. und 20. Jahrhunderts* (1987).

Wick, R. (ed.), *Die erotische Daguerreotypie: Sammlung Uwe Scheid* (1989).

II.4. Landscape Photography

Andrews, M., *Landscape and Western Art* (1999).

Brettell, R., et al., *A Day in the Country: Impressionism and the French Landscape* (1984).

Cahn, R., and Ketchum, R., *American Photographers and the National Parks* (1981).

Challe, D., and Marbot, B., *Les Photographes de Barbizon: la Forêt de Fontainebleau* (1972).

Cornish, J., *First Light: A Landscape Photographer's Art* (2002).

Dabrowski, M., *French Landscape: The Modern Vision, 1880–1920* (1999).

Daniels, S., *Fields of Vision: Landscape, Imagery and National Identity in England and the United States* (1993).

DATAR, *Paysages photographies: en France dans les années quatre-vingt* (1989).

Di Grappa, C. (ed.), *Landscape: Theory* (1980).

Foresta, M., *Between Home and Heaven: Contemporary American Landscape Photography* (1992).

Fryxell, F., *The Tetons: Interpretations of a Mountain Landscape* (1938).

Grad, B. L., and Riggs, T. A., *Visions of City and Country: Prints and Photographs of Nineteenth-Century France* (1980).

Heilbrun, F., *Landscapes and Nature* (2004).

Heilman, C., Clarke, M., and Sillevis, J. (eds.), *Corot, Courbet und die Maler von Barbizon: les amis de la nature* (1996).

Hemingway, A., *Landscape Imagery and Urban Culture in Early Nineteenth-Century Britain* (1992).

Hope, T., *The World's Top Photographers: Landscape* (2003).

Jenkins, W., *New Topographics: Photographs of a Man-Altered Landscape* (1975).

Johnson, B., *Nineteenth-Century Mammoth Plates of the American West* (1979).

Jussim, E., and Lindquist-Cock, E., *Landscape as Photograph* (1985).

Klett, M., et al., *Second View: The Rephotographic Survey Project* (1984).

Lindquist-Cock, E., *The Influence of Photography on American Landscape Painting, 1839–1880* (1977).

Naef, W., and Wood, J. N. (eds.), *Era of Exploration: The Rise of Landscape Photography in the American West, 1860–1885* (1974).

Szarkowski, J., *The Photographer and the American Landscape* (1963).

—— *American Landscapes* (1981).

Walther, S. D. (ed.), *The Railroad in the American Landscape 1850–1950* (1981).

Wells, L., Newton, K., and Fehily, C. (eds.), *Shifting Horizons: Women's Landscape Photography Now* (2000).

Wilmerding, J., *American Light: The Luminist Movement 1850–1875. Paintings, Drawings, Photographs* (1989).

Wolf, D. (ed.), *The American Space: Meaning in Nineteenth-Century Landscape Photography* (1983).

Yates, S. (ed.), *Poetics of Space: A Critical Photographic Anthology* (1995).

II.5. Portraiture

Abel, M. H. (ed.), *An Empirical Reflection on the Smile* (2002).

Akeret, R. U., *Photoanalysis: How to Interpret the Hidden Psychological Meaning of Personal and Public Photographs* (1975).

Arba¨zar, P. (ed.), *Portraits, singulier pluriel, 1980–1990: la photographie et son modèle* (1997).

Billeter, E. (ed.), *Self-Portrait in the Age of Photography: Photographers Reflecting their Own Image* (1985).

Clarke, G. (ed.), *The Portrait in Photography* (1992).

Darwin, C., *The Expression of the Emotions in Man and Animals* (3rd edn. ed. P. Ekman, 1998).

Dölle, S., et al., *Katse kameraan: Valokuvamuotokuvia Museoviraston Kokoelmista [Look at the Camera: Portraits from the Finnish National Board of Antiquities]* (2004).

Encantados de conocerse: fotografía, retrato y distinción en el siglo XIX. Fondos de la Colección Juan José Diaz Prósper (2002).

Ewing, W. A., *The Body: Photographs of the Human Form* (1994).

Fahey, D., and Rich, L., *Masters of Starlight: Photographers in Hollywood* (1987).

Ford, C. (ed.), *Portraits* (1983).

Hamilton, P., and Hargreaves, R., *The Beautiful and the Damned: The Creation of Identity in Nineteenth-Century Photography* (2001).

Heathcote, B., and P., *A Faithful Likeness: The First Photographic Portrait Studios in the British Isles, 1841 to 1855* (2002).

Hicks, R. W., and Nisperos, C., *Hollywood Portraits: Classic Shots and How to Take Them* (2001).

Honnef, K. (ed.), *Lichtbildnisse: Das Porträt in der Fotografie* (1982).

Identités: De Disdéri au photomaton (1985).

Kobal, J., *The Art of the Great Hollywood Portrait Photographers 1925–1940* (1980).

Krygier, I. (ed.), *The Unreal Person: Portraiture in the Digital Age* (1998).

Life Library of Photography: Photographing Children (2nd edn. 1981).

Life Library of Photography: The Studio (2nd edn. 1981).

Linkman, A., *The Victorians: Photographic Portraits* (1993).

McCauley, E. A., *A. A. E. Disdéri and the Carte de Visite Portrait Photograph* (1985).

Maddow, B., *Faces: A Narrative History of the Portrait in Photography* (1979).

Mathews, O., *The Album of Carte-de-Visite and Cabinet Portrait Photographs, 1854–1914* (1974).

Pepper, T., *High Society Photographs 1897–1914* (1998).

Philipp, C. G., *Porträtfotografie in Deutschland 1850–1918* (1991).

Pick, D., *Faces of Degeneration: A European Disorder c.1848–c.1918* (1989).

Pultz, J., *The Body and the Lens: Photography 1839 to the Present* (1995).

Rinhart, F. and M., and Wagner, R. W., *The American Tintype* (1999).

Rouillé, A. and Marbot, B., *Le Corps et son image: photographies du dix-neuvième siècle* (1986).

Sagne, J., *L'Atelier du photographe* (1992).

Sobieszek, R. A., *Ghost in the Shell: Photography and the Human Soul 1850–2000* (1999).

Truble, A., *A Brief History of the Smile* (2004).

Wichard, R. and C., *Victorian Cartes-de-Visite* (1999).

Williams, S. S., *Confounding Images: Photography and Portraiture in Antebellum American Fiction* (1997).

Younger, D. (ed.), *Photography with a New Face: The Advent of the Carte de Visite in American Culture* (1980).

II.6. Photojournalism and War Photography

Agence France Presse, *Facing the World: Great Moments in Photojournalism* (2001).

Almasy, P., et al., *Le Photojournalisme: informer en écrivant des photos* (2nd edn. 1993).

Amar, P.-J., *Le Photojournalisme* (2000).

Baughman, J. R., *Henry R. Luce and the Rise of the American News Media* (rev. edn. 2001).

Baynes, K., et al., *Scoop, Scandal and Strife: A Study of Photography in Newspapers* (1971).

Blecher, H., *Fotojournalismus* (2001).

Brown, J., *Beyond the Lines: Pictorial Reporting, Everyday Life and the Crisis of Gilded Age America* (2002).

Brothers, C., *War and Photography: A Cultural History* (1997).

Buchheim, L.-G., *U-Boot-Krieg* (1976), trans. as *U-Boat War* (1978).

Callahan, S., *The Private Experience: Elliott Erwitt* (1974).

Carmichael, J., *First World War Photographers* (1989).

Carlebach, M. L., *The Origins of Photojournalism in America* (1992).

—— *American Photojournalism Comes of Age* (1997).

Chantal, G., *Les Journalistes* (1986).

Chapnick, H., *Truth Needs No Ally: Inside Photojournalism* (1994).

Crimée 1854–1856: premiers reportages de guerre (1994).

Doss, E. (ed.), *Looking at 'Life' Magazine* (2001).

Dower, J., *War without Mercy: Race and Power in the Pacific War* (1986).

Eisermann, T., *Pressephotographie und Informationskontrolle im Ersten Weltkrieg: Deutschland und Frankreich im Vergleich* (2000).

Eskildsen, U. (ed.), *Fotografie in deutschen Zeitschriften 1924–1933* (1982).

—— **(ed.),** *Fotografie in deutschen Zeitschriften 1946–1984* (1985).

Fabian, R., and Adam, H. C., *Images of War: 130 Years of War Photography* (1985).

Fralin, F. (ed.), *The Indelible Image: Photographs of War, 1846 to the Present* (1985).

Frassanito, W. A., *Gettysburg: A Journey in Time* (1975).

—— *Antietam: The Photographic Legacy of America's Bloodiest Day* (1978).

Fulton, M., et al., *Eyes of Time: Photojournalism in America* (1988).

Galassi, P., and Kismaric, S. (eds.), *Pictures of the Times: A Century of Photography from the New York Times* (1996).

Germer, S., and Zimmermann, M. F. (eds.), *Bilder der Macht, Macht der Bilder: Zeitgeschichte in Darstellungen des 19. Jahrhunderts* (1997).

Gidal, T. N., *Modern Photojournalism: Origins and Evolution, 1910–1933* (1973).

Guerrin, M., *Profession photoreporter* (1988).

Hannigan, W., *New York Noir: Crime Photos from the 'Daily News' Archive* (1999).

Harrison, M., *Young Meteors: British Photojournalism, 1957–1965* (1998).

Hassner, R., *Bilder för miljoner: Pressefotografier och bildreportage under 100 är* (1977).

Heer, H., and Naumann, K. (eds.), *Vernichtungskrieg: Verbrechen der Wehrmacht 1941–1944* (1995).

Heller, J. (ed.), *War and Conflict: Selected Images from the National Archives, 1765–1990* (1990).

Hicks, W., *Words and Pictures: An Introduction to Photojournalism* (1952).

Howe, P., *Shooting under Fire* (2002).

Humbert, J.-M., Dumarche, L., and Pierron, M., *Photographies anciennes, 1848–1918: regard sur le soldat et la société* (1985).

James, L., *Crimea 1854–56: The War with Russia from Contemporary Photographs* (1981).

Kelbaugh, R. J., *Introduction to Civil War Photography* (1991).

Keller, U., *The Ultimate Spectacle: A Visual History of the Crimean War* (2001).

Kerbs, D., Uka, W., and Walz-Richter, B. (eds.), *Die Gleichschaltung der Bilder: Pressefotografie 1930–36* (1983).

Kozol, W., *'Life's America': Family and Nation in Postwar Photojournalism* (1994).

Lebeck, R., and Dewitz, B. v., *Kiosk: A History of Photojournalism* (2001).

Lewinski, J., *The Camera at War: A History of War Photography from 1848 to the Present Day* (1978).

Life Library of Photography: Photojournalism (2nd edn. 1981).

Loengard, J., *'Life' Photographers: What They Saw* (1998).

—— *The Great 'Life' Photographers* (2004).

Marcus, A., *The Photojournalist: Mary Ellen Mark and Annie Leibovitz* (1974).

Moeller, S. D., *Shooting War: Photography and the American Experience of Combat* (1989).

Neubauer, H., *Black Star: 60 Years of Photojournalism* (1997).

Pohlert, C.-M. (ed.), *Bilder in der Zeitung: Journalistische Fotografie 1949–1999* (1999).

Reed, D., *The Popular Magazine in Britain and the United States 1880–1960* (1997).

Roeder, G. H., *The Censored War: American Visual Experience During World War 2* (1993).

Sandweiss, M. A., Stewart, R., and Huseman, B. W., *Eyewitness to War: Prints and Daguerreotypes of the Mexican War, 1846–1848* (1989).

Sontag, S., *Regarding the Pain of Others* (2003).

Stahel, U., and Gasser, M. (eds.), *Weltenblicke—Reportagefotografie und ihre Medien* (1997).

Taylor, J., *War Photography: Realism in the British Press* (1991).

—— *Body Horror: Photojournalism, Catastrophe and War* (1998).

Voir ne pas voir la guerre: histoire des représentations photographiques de la guerre (2001).

Voss, F. S., *Reporting the War: the Journalistic Coverage of World War 2* (1994).

II.7. Documentary Photography

Buckland, G., *Reality Recorded: Early Documentary Photography* (1974).

Curtis, J., *Mind's Eye, Mind's Truth: FSA Photography Reconsidered* (1989).

Daniel, P., Foresta, M., Stange, M., and Stein, S., *Official Images: New Deal Photography* (1987).

Dixon, P., *Photographers of the Farm Security Administration: An Annotated Bibliography, 1930–1980* (1983).

Featherstone, D. (ed.), *Observations: Essays on Documentary Photography* (1984).

Finnegan, C. A., *Picturing Poverty: Print Culture and FSA Photographs* (2003).

Fleischhauer, C., and Brannan, B. W. (eds.), *Documenting America, 1935–1943* (1988).

Hurley, F. J., *Portrait of a Decade: Roy Stryker and the Development of Documentary Photography in the Thirties* (1972).

Life Library of Photography: Documentary Photography (2nd edn. 1981).

McEuen, M. A., *Seeing America: Women Photographers between the Wars* (2000).

Meltzer, M., and Cole, B., *The Eye of Conscience: Photographers and Social Change* (1974).

Natanson, N., *The Black Image in the New Deal* (1992).

Puckett, J. R., *Five Photo-Textual Documentaries from the Great Depression* (1984).

Rothstein, A., *Documentary Photography* (1986).

Stange, M., '*Symbols of Ideal Life*': *Social Documentary Photography in America, 1890–1950* (1989).

Stott, W., *Documentary Expression and Thirties America* (1973).

Stryker, R., and Wood, N., *In This Proud Land: America 1935–1943 as Seen in the FSA Photographs* (1973).

Thézy, M. de, *La Photographie humaniste, 1930–1960: histoire d'un mouvement en France* (1992).

Tucker, A., *Photographic Cross: The Photo League* (1978).

Twelve Photographers of the American Social Landscape (1967).

II.8. Advertising and Fashion

Cornfield, J., *The Photo Illustration: Bert Stern* (1974).

Cotton, C., *Imperfect Beauty: The Making of Contemporary Fashion Photographs* (2000).

Craig, J., *The Face of Fashion* (1994).

Devlin, P., *The Vogue Book of Fashion Photography* (1979).

Dyer, G., *Advertising as Communication* (1982).

Eskildsen, U. (ed.), *Werbefotografie in Deutschland seit den Zwanziger Jahren* (1989).

Gilbert, G., *Photographic Advertising from A to Z: From the Kodak to the Leica* (1970).

Hall-Duncan, N., *The History of Fashion Photography* (1979).

Harrison, M., *Appearances: Fashion Photography Since 1945* (1991).

Johnston, P., *Real Fantasies: Edward Steichen's Advertising Photography* (1997).

Lears, J., *Fables of Abundance: A Cultural History of Advertising in America* (1994).

Marchand, R., *Advertising the American Dream: Making Way for Modernity, 1920–1940* (1985).

Nye, D. E., *Image Worlds: Corporate Identities at General Electric 1890–1930* (1985).

Poppy, J., *The Persuasive Image: Art Kane* (1975).

Severa, J., *Dressed for the Photographer: Ordinary Americans and Fashion, 1840–1900* (1995).

Sobieszek, R. A., *The Art of Persuasion: A History of Advertising Photography* (1988).

Vanités: photographies de mode des XIXe. et XXe. siècles (1993).

Williamson, J., *Decoding Advertisements: Ideology and Meaning in Advertising* (1978).

Winship, J., *Inside Women's Magazines* (1987).

II.9. Travel and Tourism

An den süssen Ufern Asiens: Ägypten, Palästina, Osmanisches Reich. Reiseziele des 19. Jahrhunderts in frühen Photographien (1988).

Beelden van de Oriënt: Fotografie en Toerisme, 1860–1900/Images of the Orient: Photography and Tourism, 1860–1900 (1986).

Bouqueret, C., and Livi, F., *Le Voyage en Italie: les photographes français en Italie, 1840–1920* (1989).

Crouch, D., and Lübbren, N. (eds.), *Visual Culture and Tourism* (2003).

Fabian, R., and Adam, H.-C., *Masters of Early Travel Photography* (1983).

Geary, C. M., and Webb, V.-L. (eds.), *Delivering Views: Distant Cultures in Early Postcards* (1998).

Hershkowitz, R., *The British Photographer Abroad: The First Thirty Years* (1980).

Life Library of Photography: Travel Photography (2nd edn. 1981).

Löfgren, O., *On Holiday: A History of Vacationing* (1999).

Nickel, D. R., *Francis Frith in Egypt and Palestine: A Victorian Photographer Abroad* (2004).

Osborne, P. D., *Travelling Light: Photography, Travel and Visual Culture* (2000).

Pemble, J., *The Mediterranean Passion: Victorians and Edwardians in the South* (1988).

Pohl, K., *Ansichten der Ferne: Reisephotographie 1850-heute* (1983).

Rojek, C., and Urry, J. (eds.), *Touring Cultures* (1997).

Selwyn, T. (ed.), *The Tourist Image: Myths and Myth-Making in Modern Tourism* (1996).

Taylor, J., *A Dream of England: Landscape, Photography and the Tourist's Imagination* (1994).

Urry, J., *The Tourist Gaze: Leisure and Travel in Contemporary Societies* (1990).

Zannier, I., *Le Grand Tour in the Photographs of Travellers of [the] 19th century* (1997).

II.10. Art and Architecture

Ansichten. Standpunkte zur Architekturfotografie: 21 Fotografen zeigen Arbeiten über historische und zeitgenössische Architektur (1994).

Billeter, E., *Malerei und Photographie im Dialog. 1840 bis heute* (1979).

Building Images: 75 Years of Photography at Hedrich Blessing (2001).

Campany, D. (ed.), *Art and Photography* (2003).

Chadwick, W. (ed.), *Mirror Images: Women, Surrealism and Self-Presentation* (1998).

Coke, Van Deren, *The Painter and the Photograph: From Delacroix to Warhol* (1972).

Cross References: Sculpture into Photography (1987).

Desmarais, C., *Proof: Los Angeles Art and the Photograph, 1960–1980* (1992).

Freeland, C., *But is it Art? An Introduction to Art Theory* (2001).

Galassi, P., *Before Photography: Painting and the Invention of Photography* (1981).

Goldstein, A., and Rorimer, A., *Reconsidering the Object of Art: 1965–1975* (1995).

Grundberg, A., and Gauss, K. M., *Photography and Art: Interactions since 1946* (1987).

Haenlein, C.-A., *Künstlerphotographien im XX. Jahrhundert* (1977).

—— **(ed.),** *Dada: Photographie und Photocollage* (1979).

—— *Momentbild: Künstlerphotographie* (1982).

Hamber, A., '*A Higher Branch of the Art*': *Photographing the Fine Arts in England, 1839–1880* (1995).

Hochreiter, O., *Im Zeichen des Janus: Portale, Türen und Tore in der Architekturfotografie, 1840–1980* (1986).

Jacobson, K., et al., *Étude d'après nature: Nineteenth-Century Photographs in Relationship to Art* (1996).

The Kiss of Apollo: Photography and Sculture, 1845 to the Present (1991).

Kosinski, D. (ed.), *The Artist and the Camera: Degas to Picasso* (2000).

Kunst und Photographie: Italienische Kunst von 1960 bis 1980 (1989).

Krauss, R., and Livingston, J., *L'Amour fou: Photography and Surrealism* (1986).

Lista, G., *Futurism and Photography* (2001).

Lost Paradise: Symbolist Europe (1995).

Maas, J., *The Victorian Art World in Photographs* (1984).

Mason, R. M., and Pinet, H., *Pygmalion photographe: la sculpture devant la caméra, 1844–1936* (1985).

Misselbeck, R. (ed.), *Photographie in der deutschen Gegenwartskunst* (1993).

Neusüss, F. M., *Fotografie als Kunst—Kunst als Fotografie: Das Medium Fotografie in der bildenden Kunst Europas ab 1968* (1979).

Nochlin, L., *Realism* (1971).

Orvell, M. (ed.), *After the Machine: Visual Arts and the Erasing of Cultural Boundaries* (1995).

Pare, R., *Photography and Architecture, 1839–1939* (1982).

Photographie/Sculture (1991).

Pultz, J., and Scallen, C. B., *Cubism and American Photography, 1910–1930* (1981).

Roberts, J. (ed.), *The Impossible Document: Photography and Conceptual Art in Britain, 1966–1976* (1997).

Robinson, C., and Herschman, J., *Architecture Transformed: A History of the Photography of Buildings from 1839 to the Present* (1987).

Sachsse, R., *Photographie als Medium der Architekturinterpretation: Studien zur Geschichte der deutschen Architekturphotographie im 20. Jahrhundert* (1984).

Scharf, A., *Art and Photography* (2nd edn. 1974).

Schmoll, J. A., *Malerei nach Fotografie: Von der camera obscura bis zur Pop Art. Eine Dokumentation* (1970).

Schulman, J., *Architecture and its Photography,* ed. P. Gössel (1998).

Schwarz, H., *Art and Photography: Forerunners and Influences,* ed W. E. Parker (1985).

Skulptur im Licht der Fotografie: Von Bayard bis Mapplethorpe (1997).

Thomas, A., *Fact and Fiction: Canadian Painting and Photography, 1860–1900* (1979).

Turkle, S., *Life on the Screen: Identity in the Age of the Internet* (1997).

Ungern-Sternberg, M. C., 'Fotografie-Sponsoring als Einflussgrösse zeitgenössische Kunstgeschichte: Firmenkonzepte zur Förderung der Fotografie' (Cologne dissertation, 2000).

Vaizey, M., *The Artist as Photographer* (1982).

Varnedoe, K., *A Fine Disregard: What Makes Modern Art Modern* (1990).

Venetië, R. van, and Zondervan, A., *Geschiedenis van de Nederlandse architectuurfotografie* (1989).

Vigneau, A., *Une brève histoire de l'art de Niépce à nos jours* (1963).

Wallis, B. (ed.), *Art after Modernism: Rethinking Representation* (1984).

Walther, I. F. (ed.), *Art of the 20th Century* (2000).

Wood, P., *Conceptual Art* (2002).

II.11. Medical and Scientific

Bourély, F., *Hidden Beauty: Microworlds Revealed* (2002).

Burns, S. B., *Early Medical Photography in America, 1839–1883* (1983).

Cagnetta, F. (ed.), *Nascita della fotografia psichiatrica* (1981).

Cartwright, L., *Screening the Body: Tracing Medicine's Visual Culture* (1995).

Darius, J., *Beyond Vision: One Hundred Historic Scientific Photographs* (1984).

Didi-Hubermann, G., *Invention de l'hystérie: Charcot et l'iconographie photographique de la Salpêtrière* (1982).

Drury, S., *Images of the Earth: A Guide to Remote Sensing* (1998).

Ewing, W. A., *Inside Information: Imaging the Human Body* (1996).

Fox, D. M., and Lawrence, C., *Photographing Medicine: Images and Power in Britain and America since 1840* (1988).

Gasser, J., and Burns, S., *Photographie et médicine* (1991).

Gilardi, A., *Wanted! Storia, technica e estetica della fotografia criminale, segneletica e giudiziaria* (1978).

Gilman, S. L. (ed.), *The Face of Madness: Hugh W. Diamond and the Origin of Psychiatric Photography* (1976).

—— *Seeing the Insane* (1982).

—— *Health and Illness: Images of Difference* (1995).

Hope, T., *Extreme Photography: The Hottest, Coldest, Fastest, Slowest, Nearest, Farthest, Brightest, Darkest, Largest, Smallest, Weirdest Images in the Universe . . . And How They Were Taken* (2004).

Kevles, B. H., *Naked to the Bone: Medical Imaging in the Twentieth Century* (1997).

Malin, D., *A View of the Universe* (1993).

La Mésure du ciel: de la plaque photographique aux techniques spatiales (1987).

Morton, R. (ed.), *Photography for the Scientist* (1984).

Otto, L., and Martin, H., *150 Jahre Mikrophotographie* (1989).

Pasachoff, J. M., and Covington, M. A., *The Cambridge Eclipse Photography Guide* (1993).

Phillips, S. S., Haworth-Booth, M., and Squiers, C., *Police Pictures: The Photograph as Evidence* (1997).

Practical Applications of Infrared Thermal Sensing and Imaging Equipment (1999).

Ray, S. (ed.), *High Speed Photography and Photonics* (1997).

—— *Scientific Photography and Digital Imaging* (2001).

Regener, R., *Fotografische Erfassung: Zur Geschichte medialer Konstruktionen des Kriminellen* (1999).

Schuller, M., Reiche, C., and Schmidt, G. (eds.), *BildKörper: Verwandlungen des Menschen zwischen Medium und Medizin* (1998).

Rhodes, H. T. F., *Alphonse Bertillon: Father of Modern Scientific Detection* (1956).

Settles, G. S., *Schlieren and Shadowgraph Techniques* (2001).

Sicard, M., Pujade, R., and Wallach, D., *À corps et à raison: photographies médicales, 1840–1920* (1995).

Thomas, A. (ed.), *Beauty of Another Order: Photography in Science* (1997).

Walter, I. (ed.), *Biomedical Photography* (1992).

Witkin, J.-P., *Masterpieces of Medical Photography: Selections from the Burns Archive* (1887).

II.12. Photography and Social Science

Appadurai, A. (ed.), *The Social Life of Things: Commodities in Cultural Perspective* (1986).

Banks, M., *Visual Methods in Social Research* (2001).

—— **and Morphy, H. (eds.),** *Rethinking Visual Anthropology* (1997).

Banta, M., and Hinsley, C., *From Site to Sight: Anthropology, Photography and the Power of Images* (1986).

Bateson, G., and Mead, M., *Balinese Character: A Photographic Analysis* (1942).

Becker, H., *Exploring Society Photographically* (1981).

Bourdieu, P., *Un art moyen: essai sur les usages sociaux de la photographie* (1965), trans. S. Whiteside, *Photography: A Middlebrow Art* (1996).

Chalfen, R., *A Snapshot View of Life* (1987).

Collier, J., and Collier, M., *Visual Anthropology: Photography as a Research Method* (2nd edn. 1986).

Edwards, E. (ed.), *Anthropology and Photography 1860–1920* (1992).

—— *Raw Histories: Photographs, Anthropology and Museums* (2001).

Georges, R. A., and Jones, M. O., *People Studying People: The Human Element in Fieldwork* (1980).

Gross, L. (ed.), *Studying Visual Communication* (1981).

Halle, D., *Inside Culture: Art and Class in the American Home* (1993).

Hitchcock, M., and Norris, L., *Bali: The Imaginary Museum. The Photographs of Walter Spies and Beryl de Zoete* (1995).

Hoskins, J., *Biographical Objects: How Things Tell Stories about People's Lives* (1998).

Isherwood, B., *The World of Goods: Towards an Anthropology of Consumption* (1978).

King, J. C. H., and Lidchi, H. (eds.), *Imaging the Arctic* (1998).

McQuire, S., *Visions of Modernity: Representation, Memory, Time and Space in the Age of the Camera* (1998).

Maresca, S., *La Photographie: un miroir des sciences sociales* (1996).

Morgan, D. M., and Promey, S. M. (eds.), *The Visual Culture of American Religions* (2001).

Peterson, N., and Pinney, C. (eds.), *Photography's Other Histories* (2003).

Pink, S., *Doing Visual Ethnography* (2001).

Prosser, J. (ed.), *Image-Based Research* (1998).

Rochberg-Halton, E., *The Meaning of Things: Domestic Symbols and the Self* (1981).

Rosenblum, B., *Photographers at Work: A Sociology of Photographic Style* (1978).

Smith, V. (ed.), *Hosts and Guests: The Anthropology of Tourism* (2nd edn. 1989).

Sullivan, G., *Margaret Mead, Gregory Bateson and Highland Bali: Fieldwork Photographs of Bayung Gedé, 1936–1939* (1999).

Theye, T. (ed.), *Wir und die Wilden: Einblicke in eine kannibalische Beziehung* (1985).

—— *Der geraubte Schatten: Eine Weltreise im Spiegel der ethnographischen Photographie* (1989).

Tillema, H. F., *A Journey among the Peoples of Central Borneo in Word and Picture,* ed. V. T. King (1938, 1989).

Wagner, J. (ed.), *Images of Information: Still Photography in the Social Sciences* (1979).

II.13. Colonialism and Native Peoples

Alison, J. (ed.), *Native Nations: Journeys in American Photography.*

Baker, W., *Backward: An Essay on Indians, Time and Photography* (1983).

Bush, A. L., and Mitchell, L. C., *The Photograph and the American Indian* (1994).

Curtis, E., *The North American Indian: Being a Series of Volumes Picturing and Describing the Indians of the United States and Alaska,* ed. F. W. Hodge (20 vols., 1907–1930; repr. 1970).

Fleming, P. R., and Luskey, J. L., *The North American Indians in Early Photographs* (1986).

—— —— *Grand Endeavors of American Indian Photography* (1993).

Geertz, C., *The Interpretation of Cultures* (1973).

Hight, E., and Sampson, G. (eds.), *Colonialist Photography* (2002).

Hiesinger, U., *Indian Lives: A Photographic Record from the Civil War to Wounded Knee* (1994).

Keegan, M. K., *Enduring Culture: A Century of Photography of the Southwest Indians* (1990).

Kerr, J., and Holder, J. (eds.), *Past Present: The National Women's Art Anthology* (1999).

Kleinert, S., and Neale, M. (eds.), *The Oxford Companion to Aboriginal Art and Culture* (2000).

Landau, P., and Kaspin, D. (eds.), *Images and Empire* (2003).

Lippard, L. (ed.), *Partial Recall: Photography and Native North Americans* (1992).

Lyman, C., *The Vanishing Race and Other Illusions: Photographs of Indians by Edward S. Curtis* (1982).

Mackenzie, J., *Propaganda and Empire* (1984).

—— **(ed.),** *Imperialism and Popular Culture* (1986).

McLuhan, T. C., *Dream Tracks: The Railroad and the American Indian 1890–1930* (1985).

Maxwell, A., *Colonial Photography and Exhibitions: Representations of the 'Native' and the Making of European Identities* (1999).

Poole, D., *Vision, Race and Modernity: A Visual Economy of the Andean Image World* (1997).

Public Archives of Canada, *Arctic Images: The Frontier Photographed, 1860–1911* (1911).

Ryan, J. R., *Picturing Empire: Photography and the Visualisation of the British Empire* (1997).

Scherer, J., *Indians: Contemporary Photographs of North American Indian Life, 1847–1929* (1974).

Silversides, B. V., *The Face Pullers: Photographing Native Canadians 1871–1939* (1994).

Smith, B., *European Vision and the South Pacific, 1768–1850* (1960).

Strong Hearts: Native American Visions and Voices (1995).

Taylor, P., *After 200 Years* (1988).

II.14. Miscellaneous Topics

Amelunxen, H. v., Iglhaut, S., and Rötzer, F., *Photography after Photography: Memory and Representation in the Digital Age* (1996).

Botanica: Photographies de végétaux aux XIXe. et XXe. siècles (1987).

Buckland, G., *The Photographer and the City* (1977).

—— *First Photographs: People, Places and Phenomena Captured for the First Time by the Camera* (1980).

Burns, S., *Sleeping Beauties: Memorial Photography in America* (1990).

Cavallo, R. M., and Kahan, S., *Photography: What's the Law?* (2nd edn. 1979).

Eauclaire, S., *Le Chat en photographie* (1991).

Ewing, W. A., *Danse: chefs d'œuvre de la photographie* (1987).

—— *Flora Photographica* (1991).

Fischer, A., and Loers, V., *Im Reich der Phantome: Fotografie des Unsichtbaren* (1997).

Ford, C. (ed.), *Happy and Glorious: 130 Years of Royal Photography* (1977).

Fotografía Pública: Photography in Print 1919–1939 (2000).

Frosh, P., *The Image Factory. Consumer Culture, Photography and the Visual Content Industry* (2003).

Gérôme, N. (ed.), *Archives sensibles: Images et objets du monde industriel et ouvrier* (1995).

Gross, L., Katz, J. S., and Ruby, J. (eds.), *Image Ethics: The Moral Rights of Subjects in Photographs, Film and Television* (1988).

Hevey, D., *The Creatures Time Forgot: Photography and Disability Imagery* (1992).

Howe, K. S. (ed.), *Intersections: Lithography, Photography and the Traditions of Printmaking* (1998).

Hoy, A. H., *Fabrications: Staged, Altered and Appropriated Photographs* (1988).

Hülsewig-Johnen, J. (ed.), *Das Foto als autonomes Bild: Experimentelle Gestaltung 1839–1989* (1989).

Hunter, J., *Image and Word: The Interactions of Twentieth-Century Photographs and Texts* (1987).

Hurley, F. J., *Industry and the Photographic Image: 153 Great Prints from 1850 to the Present* (1980).

Iles, C., and Roberts, R., (eds.), *In Visible Light: Photography and Classification in Art, Science and the Everyday* (1997).

Koppen, E., *Literatur und Photographie: Über Geschichte und Thematik einer Medienentdeckung* (1987).

Krauss, R. H., *Photographie und Literatur: Zur photographischen Wahrnehmung in deutschsprachigen Literatur des 19. Jahrhunderts* (2000).

Lalvani, S., *Photography, Vision and the Production of Modern Bodies* (1996).

Lesser, W., *Pictures at an Execution: An Inquiry into the Subject of Murder* (1995).

Lesy, M., *Wisconsin Death Trip* (1973).

Matz, R., *Industriephotographie: Aus Firmenarchiven des Ruhrgebiets* (1987).

Meinwald, D., *Memento Mori: Death in Nineteenth Century Photography* (1990).

Padon, T., et al., *Deceits and Fantasies: Contemporary Photography and the Garden* (2004).

Parr, M., and Stasiak, J., '*The Actual Boot*': *The Photographic Post Card Boom 1900–1920* (1986).

Phéline, C., *L'Image accusatrice* (1985).

Photographieren im Bergwerk um 1900 (1998).

Photography and the Printed Page in the Nineteenth Century (2000).

'*Punch' in Camera-Land* (1948).

Rabb, J., *Literature and Photography: Interactions 1840–1990* (1995).

Rozenberg, J., *Privacy and the Press* (2004).

Ruby, J., *Secure the Shadow: Death and Photography in America* (1995).

Schwartz, J. M., and Ryan, J. R., (eds.), *Picturing Place: Photography and the Geographical Imagination* (2003).

Silverman, R. (ed.), *The Dog Observed: Photographs 1844–1988* (1984).

Stafford, B. M., *Good Looking: Essays on the Virtue of Images* (1996).

Taken: Photography and Death (1989).

Tenfelde, K. (ed.), *Bilder von Krupp: Fotografie und Geschichte im Industriezeitalter* (1994).

Ullrich, W., *Die Geschichte der Unschärfe* (2002).

Visual Paradox: Truth and Fiction in the Photographic Image (1988).

Webster, F., *The New Photography: Responsibility in Visual Communication* (1980).

Weiser, J., *Photo Therapy Techniques: Exploring the Secrets of Personal Snapshots and Family Albums* (1993).

Wildlife Photographer of the Year (1991–).

Williams, V., and Hobson, G., *The Dead* (1996).

III.1. Great Britain and Ireland

Badger, G., and Benton-Harris, J., *Through the Looking-Glass: Photographic Art in Britain, 1945–1989* (1989).

Bartram, M., *The Pre-Raphaelite Camera: Aspects of Victorian Photography* (1985).

Brittain, D., and Stevenson, S., *New Scottish Photography* (1990).

Chandler, E. C., *Photography in Dublin during the Victorian Era* (1982).

—— *Through the Brass-Lidded Eye: Ireland and the Irish 1839–1859: The Earliest Images* (1989).

Flukinger, R., *The Formative Decades: Photography in Great Britain 1839–1920* (1985).

Ford, C., and Harrison, B., *A Hundred Years Ago: Britain in the 1880s in Words and Photographs* (1983).

Garner, P., *A Seaside Album: Photographs and Memory* (2003).

Green-Lewis, J., *Framing the Victorians: Photography and the Culture of Realism* (1996).

Hannavy, J., *The Victorian Professional Photographer* (1980).

—— *A Moment in Time: Scottish Contributions to Photography, 1840–1920* (1983).

Harker, M., *The Linked Ring: The Secession Movement in Photography in Britain, 1892–1910* (1979).

Haworth-Booth, M. (ed.), *The Golden Age of British Photography, 1839–1900* (1984).

Kelly, S. F., *Victorian Lakeland Photographers* (1991).

Liebenaus, J. (ed.), *The Challenge of New Technology: Innovation in British Business since 1850* (1988).

Macdonald, G., *Camera: A Victorian Eyewitness* (1979).

Pohlmann, U., (ed.), *Viktorianische Photographie 1840–1890* (1993).

—— **(ed.),** *Zeitgenössische Photographie aus Schottland* (1994).

Pritchard, M., *A Directory of London Photographers 1841–1908* (2nd edn. 1994).

The Real Thing: An Anthology of British Photographs 1840–1950 (1975).

Seiberling, G., *Amateurs, Photography and the Mid-Victorian Imagination* (1986).

Stevenson, S., et al., *Light from the Dark Room: A Celebration of Scottish Photography. A Scottish-Canadian Collaboration* (1995).

Thomas, C., *Views and Likenesses: Early Photographers and their Work in Cornwall and the Isles of Scilly* (1988).

Weaver, M. (ed.), *British Photography in the Nineteenth Century: The Fine Art Tradition* (1989).

Williams, V., *The Other Observers: Women Photographers in Britain, 1900 to the Present* (1986).

III.2. Continental Europe and Russia

Abeels, G., *Les Pionniers de la photographie à Bruxelles* (1977).

Alle origine della fotografia: un itinerario toscano, 1839–1880 (1989).

Allshouse, R. H., *Photographs for the Tsar: The Pioneering Color Photography of Sergei Mikhailovich Prokudin-Gorskii Commissioned by Tsar Nicholas II* (1980).

Aspetti della fotografia toscana dell'Ottocento (1976).

Barchatova, Y., et al., *A Portrait of Tsarist Russia: Unknown Photographs from the Soviet Archives* (1990).

Beaugé, G., *La Photographie en Provence, 1839–1895* (1995).

Becchetti, P., *Fotografi e fotografia in Italia, 1839–1880* (1978).

—— *La fotografia a Roma dalle origini al 1915* (1983).

Beke, L., Szilágyi, G., and Töry, K., *The Hungarian Connection: The Roots of Photojournalism,* ed. C. Ford (1987).

Bertonati, E., *Das experimentelle Photo in Deutschland 1918–1940* (1978).

Birgus, V. (ed.), *Czech Photographic Avant-Garde 1918–1948* (2002).

Bouqueret, C., *Des années folles aux années noires: la Nouvelle Vision photographique en France, 1920–1940* (1997).

—— *Les Femmes photographes de la Nouvelle Vision en France 1920–1940* (1998).

Les 'Buveurs d'air': photographies des excursionnistes marseillais 1897–1937 (1998).

Castro, F. Di, *Nel raggio dell'utopia: l'esperienza fotografica ungherese tra le due guerre* (1987).

Coke, Van Deren, *Avant-Garde Photography in Germany, 1919–1939* (1980).

Coppens, J., *Een camera vol stilte: Nederland in het begin van de fotografie, 1839–1875* (1976).

—— *et al., Introductie en integratie van de Fotografie in België en Nederland, 1839–1869* (1989).

Costantini, P., and Zannier, I., *Venezia nella fotografia dell'ottocento* (1986).

Couderc, J.-M., et al., *A Village in France: Louis Clergeau's Photographic Portrait of Daily Life in Pontlevoy, 1910–1936,* trans. W. Wood (1996).

Cuatro direcciones: fotografía contemporánea española, 1970–1990 (2 vols., 1991).

Denhez-Apélian, D., *La Photographie à Montpellier au XIXe siècle* (1983).

Derenthal, L., *Bilder der Trümmer- und Aufbaujahren: Fotografie im sich teilenden Deutschland* (1999).

Dewitz, B. v., Siegert, D., and Schuller-Procopovici, K. (eds.), *Italien sehen und sterben: Photographien der Zeit des Risorgimento (1845–1870)* (1994).

Draussen vor der Tür: Fotografien zum Kriegsende (1995).

Elliott, D. (ed.), *Photography in Russia 1840–1940* (1992).

English, D. E., *Political Uses of Photography in the Third French Republic: 1871–1914* (1984).

Erlandsen, R., *Pas nu paa! Nu tar jeg fra Hullet: Norsk fotohistorie, 1839–1940* (2003).

Eskildsen, U. (ed.), *Fotografieren hiess teilnehmen: Fotografinnen der Weimarer Republik* (1994).

—— and Horak, J.-C. (eds.), *Film und Foto der zwanziger Jahre: Eine Betrachtung der internationalen Werkbundausstellung 'Film und Foto' 1929* (1979).

Faber, M., and Kroutvor, J., *Photographie der Moderne in Prag* (1991).

Fotografie in Nederland, 1839–1920 (1978).

Fiedler, J. (ed.), *Fotografie am Bauhaus* (1990).

Fontanella, L., *Historia de la fotografía en España, desde sus orígenes hasta 1900* (1981).

Fontcuberta, J., and Zelich, C., *Photographies catalanes des années trente* (1982).

Fotografia pittorica, 1889–1911 (1979).

The Frozen Image: Scandinavian Photography (1982).

Gebhardt, H., *Königlich bayerische Photographie, 1838–1918* (1978).

Gesichter einer verlorenen Welt: Fotos aus dem Leben des polnischen Judentums (1982).

Haenlein, C. (ed.), *Photographie und Bauhaus* (1986).

Helsted, D. (ed.), *Rome in Early Photographs: The Age of Pius IX, Photographs 1846–1878 from Roman and Danish Collections* (1977).

Herz, R., and Bruns, B. (eds.), *Hof-Atelier Elvira 1887–1928: Ästheten, Emanzen, Aristokraten* (1985).

—— **and Halfbrodt, D.,** *Fotografie und Revolution: München 1918/19* (1988).

Hoerner, L., *Das photographische Gewerbe in Deutschland, 1839–1914* (1989).

Höfel, K. op ten, and Neite, W., *In unnachahmlicher Treue: Photographie im 19. Jahrhundert, ihre Geschichte in den deutschsprachigen Ländern* (1979).

Hoffman, D., and Thiele, J. (eds.), *Lichtbilder Lichtspiele: Anfänge der Fotografie und des Kinos in Ostfriesland* (1989).

Honnef, K., and Breymayer, U. (eds.), *Ende und Anfang: Photographen in Deutschland um 1945* (1995).

—— **Sachsse, R., and Thomas, K. (eds.),** *German Photography 1870–1970: Power of a Medium* (1997).

Hopkinson, A. (ed.), *Reflections by Ten Portuguese Photographers* (1996).

Images inventées: la photographie créative belge dans les années quatre-vingt (1990).

Internationale Ausstellung des Deutschen Werkbundes: Film und Foto Stuttgart 1929, introd. K. Steinorth (1979).

Jaeger, J., *Gesellschaft und Photographie: Formen und Funktionen der Photographie in Deutschland und England 1839–1960* (1996).

Jammes, A., and Sobieszek, R., *French Primitive Photography* (1970).

Kaufhold, E., *Bilder des Übergangs: Zur Mediengeschichte von Fotografie und Malerei in Deutschland um 1900* (1986).

Kemp, W., and Neusüss, F. (eds.), *Kassel 1850 bis heute: Fotografie in Kassel—Kassel in Fotografien* (1981).

Kempe, F., *Vor der Kamera: Zur Geschichte der Fotografie in Hamburg* (1976).

—— *Kunstfotografie um 1900 in Deutschland* (1982).

King, D., *The Commissar Vanishes: The Falsification of Photographs and Art in Stalinist Russia* (1997).

Klemz, W., *Photokina: Gründung, Entwicklung, Erfolg. Eine Dokumentation* (1980).

Kopanski, K. W., and Philipp, C. G. (eds.), *Meisterwerke russischer und deutscher Kunstphotographie um 1900: Sergei Lobovikov und die Brüder Hofmeister* (1999).

Kuehn, K. G., *Caught: The Art of Photography in the German Democratic Republic* (1997).

Kühn, W., *Die photographische Industrie Deutschlands, wirtschaftsgeschichtlich gesehen* (1929).

Kukkonen, J., and Vuorenmaa, T.-J. (eds.), *Valoa: Otteita suomalaisen valokuvan historiaan 1839–1999* (1999).

Kunstfotografie um 1900 in Deutschland.

Loetscher, H., *Photographie in der Schweiz von 1840 bis heute* (2nd edn. 1992).

López Mondéjar, P., *Fotografía y sociedad en la España del siglo XIX* (1989).

—— *Fotografía y sociedad en España, 1900–1939* (1992).

—— *Fotografía y sociedad en la España de Franco*, trans. L. Watson, *Photography in Franco's Spain* (1996).

—— *Historia de la fotografía en España* (c.1997).

McCauley, E. A., *Industrial Madness: Commercial Photography in Paris 1848–1871* (1994).

Magelhaes, C., and Roosens, L., *De fotokunst in Belgie 1839–1940* (1970).

Matz, R., *Industriephotographie: Aus Firmenarchiven des Ruhrgebiets* (1987).

Mellor, D. (ed.), *Germany: The New Photography, 1927–33* (1978).

Meyer, A. (ed.), *Der Blick des Besatzers: Propagandaphotographie der Wehrmacht aus Marseilles 1942–1944* (1999).

Milde, H., *Dresdner Atelier-Fotografie zwischen 1860 und 1914* (1991).

Molderings, H., *Fotografie in der Weimarer Republik* (1988).

Mondenard, A. de, *La Mission Héliographique: cinq photographes parcourent la France en 1851* (2002).

Morozov, S., and Lloyd, V., *Soviet Photography 1917–1940: The New Photojournalism* (1984).

Mražkova, D., and Remeš, V., *Tschechoslowakische Fotografen, 1900–1940* (1983).

—— —— *Another Russia: Through the Eyes of the New Soviet Photographers*, introd. I. Jeffrey (1986).

Nori, C., *La Photographie française des origines à nos jours* (2nd edn. 1988).

Ochsner, B., *Fotografiet i Danmark, 1840–1940: en kulturhistorisk billedbog* (1974).

—— *Fotografer i og fra Danmark til og med år 1920/ Les Photographes au et du Danemark jusqu'an 1920* (1986).

Pellerin, D., *La Photographie stéréoscopique sous le second Empire* (1995).

Peters, O., *Neue Sachlichkeit und Nationalsozialismus: Affirmation und Kritik 1931–1947* (1998).

Peters, U., *Stilgeschichte der Fotografie in Deutschland 1839–1900* (1979).

Photographies hongroises des romantismes aux avant-gardes (2001).

Poivert, M., *Le Pictorialisme en France* (1992).

Regards sur la photographie en France au XIXe siècle (1980).

Revolution und Fotografie: Berlin 1918/19 (1989).

Reynaud, F., Tambrun, C., and Timby, K., *Paris in 3D: From Stereoscopy to Virtual Reality, 1850–2000* (2000).

Ritter, D., *Venise: Photographies anciennes, 1841–1920*, trans. A.-M. Mourot (1994).

Rouillé, A., *L'Empire de la photographie, 1839–1870* (1982).

—— **(ed.),** *La Photographie en France: anthologie de la critique photographique 1839–1880* (1989).

Sandbye, M. (ed.), *Dansk Fotografihistorie* (2004).

Savulescu, C., *Cronologia ilustrata a fotografiei din Romania, 1834–1916* (1985).

Scheufler, P., *Praha, 1848–1914: Essays on the History of Photography* (1986).

Schiller, A., *Das Photographengewerbe in Deutschland* (1923).

Schuller-Procopovici, K. (ed.), *Das Land der Griechen mit der Seele suchen: Photographien des 19. und 20. Jahhunderts* (1990).

Siza, M. T., and Weiermair, P. (eds.), *Livro de viagens: Portugiesische Photographie seit 1854* (1997).

Söderberg, R., *Den Svenska Fotografins Historia, 1840–1940* (1983).

Stathatos, J., *The Invention of Landscape: Greek Landscape & Greek Photography, 1870–1995* (1996).

—— *Image and Icon: The New Greek Photography 1975–1995* (1997).

Starl, T. (ed.), *Geschichte der Fotografie in Österreich* (2 vols., 1983).

Tory, C., *La Photographie hongroise, 1900–1945/ Hungarian Photography between 1900 and 1945* (1985).

Tupitsyn, M., *The Soviet Photograph* (1996).

Vercheval, G. (ed.), *Pour une histoire de la photographie en Belgique* (1993).

Waibl, G., 'Photographie und Geschichte. Sozialgeschichte der Photographie in Südtirol 1919–1945' (Vienna D.Phil. diss., 2 vols., 1985).

Walker, I., *City Gorged with Dreams: Surrealism and Documentary Photography in Interwar Paris* (2002).

Winkler, S., *Blickfänge einer Reise nach Wien: Fotografien 1860–1910 aus den Sammlungen des Historischen Museums der Stadt Wien* (2000).

Wolter, B.-M., et al. (eds.), *Die grosse Utopie: Die russische Avantgarde 1915–1932* (1992).

Xanthakis, A., *History of Greek Photography* (1988).

Zannier, I., *70 anni di fotografia in Italia* (1978).

—— **and Costantini, P.,** *Cultura fotografica in Italia* (1985).

Zelizer, B., *Remembering to Forget: Holocaust Memory through the Camera's Eye* (1998).

Zuckriegl, M., *Laterna Magica: Einblicke in eine Tschechische Fotografie der Zwischenkriegszeit* (2001).

III.3. North America

Andrews, R. W., *Photographers of the Frontier West: Their Lives and Works 1875–1915* (1965).

Banta, A., *A Curious and Ingenious Art: Reflections on Daguerreotypes at Harvard* (2000).

Bezner, L. C., *Photography and Politics in America: From the New Deal into the Cold War* (1999).

Brey, W. and M., *Philadelphia Photographers 1840–1900* (1992).

Buerger, J. E., *The Last Decade: The Emergence of Art Photography in the 1890s* (1984).

Bunnell, P. C., *Degrees of Guidance: Essays on Twentieth-Century American Photography* (1993).

—— **(ed.),** *A Photographic Vision: Pictorial Photography 1889–1923* (1980).

—— **(ed.),** *The Art of Pictorial Photography, 1890–1925* (1992).

Castleberry, M. (ed.), *Perpetual Mirage: Photographic Narratives of the Desert West* (1996).

Cavell, E., *Sometimes a Great Nation: A Photo Album of Canada, 1850–1925* (1984).

Coke, Van Deren, *Photography in New Mexico from the Daguerreotype to the Present* (1979).

Collins, K. (ed.), *Shadow and Substance: Essays on the History of Photography in Honor of Heinz K. Henisch* (1990).

Cousineau-Levine, P., *Faking Death: Canadian Art Photography and the Canadian Imagination* (2003).

Current, K. and W., *Photography and the Old West* (1978).

Cutcliffe, S. H., and Reynolds, T. S. (eds.), *Technology and American History* (1997).

Davidov, J. F., *Women's Camera Work: Self/Body/Other in American Visual Culture* (1998).

Doty, R., *Photo-Secession: Stieglitz and the Fine-Art Movement in Photography* (1960).

—— *Photography in America* (1974).

Earle, E. W. (ed.), *Points of View: The Stereograph in America—a Cultural History* (1979).

Eauclaire, S., *The New Color Photography* (1981).

Finkel, K., *Nineteenth-Century Photography in Philadelphia: 250 Historic Prints from the Library Company of Philadelphia* (1980).

Foresta, M., *American Photographs: The First Century* (1996).

Gee, H., *Photography of the Fifties: An American Perspective* (1980).

Gover, C. J., *The Positive Image: Women Photographers in Turn of the Century America* (1988).

Greenhill, R., *Early Photography in Canada* (1965).

—— **and Birrell, A.,** *Canadian Photography, 1839–1920* (1979).

Guimond, J., *American Photography and the American Dream* (1991).

Hales, P., *Silver Cities: The Photographs of American Urbanization, 1839–1915* (1984).

Homer, W. I. (ed.), *Pictorial Photography in Philadelphia: The Pennsylvania Academy's Salons 1898–1901* (1984).

Jenkins, R. V., *Images and Enterprise: Technology and the American Photographic Industry, 1839–1925* (1975).

Kasher, S., *The Civil Rights Movement: A Photographic History, 1954–68* (1996).

Koja, S. (ed.), *America: The New World in Nineteenth-Century Painting* (1999).

Koltun, L. (ed.), *Private Realms of Light: Amateur Photography in Canada, 1839–1940* (1984).

Livingston, J., *The New York School: Photographs 1936–1963* (1992).

Mangan, T. W., *California Photographers 1852–1920* (1977).

Mattison, D., *Camera Workers: The British Columbia Photographers Directory 1858–1900* (1984).

Natanson, N., *The Black Image in the New Deal: The Politics of FSA Photography* (1992).

Neumaier, D. (ed.), *Reframings: New American Feminist Photographies* (1995).

Orvell, M., *The Real Thing: Imitation and Authenticity in American Culture, 1880–1940* (1989).

Palmquist, P. (ed.), *Camera Fiends and Kodak Girls: Fifty Selections by and about Women in Photography, 1840–1930* (1989).

Panzer, M., *Philadelphia Naturalistic Photography, 1865–1906* (1982).

Peeler, D., *The Illuminating Mind in American Photography: Stieglitz, Strand, Weston, Adams* (2001).

Peterson, C. A., *After the Photo-Secession: American Pictorial Photography, 1910–1955* (1997).

Pitts, T., *Photography in the American Grain: Discovering a Native American Aesthetic, 1923–1941* (1988).

Read, D., *Japanese Photography in America, 1920–1940* (1985).

Rudisell, R., *The Mirror Image: The Influence of the Daguerreotype on American Society* (1971).

Sandeen, E. J., *Picturing an Exhibition: 'The Family of Man' and 1950s America* (1995).

Sandler, M. W., *Against the Odds: Women Pioneers in the First Hundred Years of Photography* (2002).

Sandweiss, M. A. (ed.), *Photography in Nineteenth-Century America* (1991).

—— *Print the Legend: Photography and the American West* (2002).

Schloss, C., *In Visible Light: Photography and the American Writer, 1840–1940* (1987).

Smith, J. P., and Foresta, M. A., *The Photography of Invention: American Pictures of the 1980s* (1989).

Smith, S. M., *American Archives: Gender, Race and Class in Visual Culture* (1999).

Snyder, J., and Munson, D., *The Documentary Photograph as a Work of Art: American Photographs, 1860–1976* (1976).

Sternberger, P. S., *Between Amateur and Aesthete: The Legitimization of Photography as Art in America, 1880–1900* (2001).

Stryker, R., and Wood, N., *In This Proud Land: America 1935–1943 as Seen in the FSA Photographs* (1975).

Szarkowski, J., *Mirrors and Windows: American Photography since 1960* (1978).

Taft, R., *Photography and the American Scene* (1938).

Trachtenberg, A., *Reading American Photographs: Images as History from Mathew Brady to Walker Evans* (1989).

Traub, C., and Grimes, J., *The New Vision: Forty Years of Photography at the Institute of Design* (1981).

Travis, D., *Photography Rediscovered: American Photographs, 1900–1930* (1979).

—— **and Siegel, E. (eds.),** *Taken by Design: Photographs from the Institute of Design, 1937–1971* (2002).

Turner, P., *American Images: Photography 1945–1980* (1985).

Welling, W. B., *Photography in America: The Formative Years, 1839–1900* (1978).

Wexler, L., *Tender Violence: Domestic Visions in an Age of US Imperialism* (2000).

Willis, D. (ed.), *Picturing Us: African American Identity in Photography* (1994).

—— *Reflections in Black: A History of Black Photographers 1840 to the Present* (2000).

Winkler, A. M., *The Politics of Propaganda: The Office of War Information, 1942–1945* (1978).

Without Sanctuary: Lynching Photography in America (2000).

Wood, J. (ed.), *America and the Daguerreotype* (1991).

III.4. Latin America

Alexander, A., *Las primeras exposiciones de daguerreotipos en Argentina* (1989).

Arboleda, C. P., *Latin America: Photographs* (1993).

Barroso, M., *Historia documentada de la fotografía en Venezuela* (1995).

Billeter, E., *Fotografie lateinamerika, 1860–1993: canto a la realidad* (1994).

Camargo, M. J. de, *Fotografia: cultura e fotografia paulista no século XX* (1992).

Carvalho, M. L., *Novas travessias: Contemporary Photography in Brazil* (1995).

Castellote, A., et al., *Memoria visual de los andes peruanos: fotografias 1900–1950* (1994).

Castro, F., and Viera, R., *Broken Vessel: Eleven Contemporary Peruvian Photographers* (1995).

Center for Cuban Studies, New York, *Cuban Photography, 1959–1982* (1983).

Conger, A., and Poniatowski, E., *Compañeras de México: Women Photograph Women* (1990).

Covington, P. (ed.), *Latin American and Caribbean Studies: A Critical Guide to Research Resources* (1991).

Davidson, M., et al., *Picture Collections. Mexico: A Guide to Picture Sources in the United Mexican States* (1988).

Eder, R., et al., *Imagen histórica de la fotografía en México* (1978).

Facio, S., *La fotografía en la Argentina* (1985).

—— *La fotografía, 1840–1930: historia general del arte en la Argentina* (1988).

—— *La fotografía en la Argentina: desde 1840 a nuestros dias* (1995).

Ferrer, E., *A Shadow Born of Earth: New Photography in Mexico* (1993).

Ferrez, G., *Photography in Brazil, 1840–1900* (1984).

—— **and Naef, W. J.,** *Pioneer Photographers of Brazil, 1840–1920* (1976).

Garc´a, O., *Fotografias para la historia de Puerto Rico, 1844–1952* (1989).

Gesualdo, V., *Historia de la fotografía in América* (1990).

Gómez, J., *La fotografía en la Argentina: su historia y evolución en el siglo XIX, 1840–1899* (1986).

Granesse Philips, J. L., *Fotografía chilena contempóranea* (1985).

Guzmán, F., and Sequera, A. J., *Orígenes de la fotografía en Venezuela* (1978).

Hassner, R., et al., *Mexikansk fotografi* (1983).

Haya, M. E., *Cuba: la fotografía de los años 60* (1988).

—— *et al.,* *Obra gráfica: historia de la fotografía cubana* (1979).

Kossoy, B., *Origens e expansão da fotografia no Brasil, seculo XIX* (1980).

—— *Fotografia e história* (1989).

Levine, R. M. (ed.), *Windows on Latin America: Understanding Society through Photographs* (1987).

—— *Images of History: Nineteenth- and Early Twentieth-Century Latin American Photographs as Documents* (1989).

McElroy, K., *The History of Photography in Peru in the Nineteenth Century, 1839–1876* (2 vols., 1977).

—— *Early Peruvian Photography: A Critical Case Study* (1985).

McNeil, R. A. (ed.), *Latin American Studies: A Basic Guide to Sources* (1990).

Merewether, C., *Portrait of a Distant Land: Aspects of Contemporary Latin American Photography* (1984).

—— *A Marginal Body: The Photographic Image in Latin America* (1987).

Meyer, E., et al., *Imagen histórica da la fotografía en México* (1978).

Molina, J. A., *Siete fotógrafos cubanos/Seven Cuban Photographers* (1996).

Mraz, J., *México, 1910–1960: Brehme, Casasola, Kahlo, López, Modotti* (1992).

—— *La mirada inquieta: el nuevo fotoperiodismos mexicano, 1976–1996* (1996).

Naggar, C., and Ritchin, F., *México through Foreign Eyes/Visto por ojos extranjeros, 1850–1990* (1993).

Ollman, A., *Other Images, Other Realities: Mexican Photography since 1930* (1990).

Orive, M. C., *Libros fotográficos de autores latinoamericanos* (1981).

La Photographie contemporaine en Amérique Latine (1982).

Poole, D., *Vision, Race and Modernity: A Visual Economy of the Andean Image World* (1997).

Priamo, L., *Archivo fotográfico del ferrocaril de Santa Fe, 1891–1948* (1991).

—— *Los años del daguerrotipo: primeras fotografías argentinas, 1843–1870* (1995).

Rodr´guez, B., *Images of Silence: Photography from Latin America and the Caribbean in the 80s* (1989).

Rubiano, R., La Huella, T., et al., *Crónica de la fotografía en Colombia, 1841–1948* (1983).

Ruiz, D., *Fotografía colombiana* (1978).

Salcedo-Mitrani, L., *Africa's Legacy: Photographs in Brazil and Peru* (1995).

Schulz, R., *Cuba 1959–1992: Fotografien* (1992).

Serrano, E., *Historia de la fotografía en Colombia* (1983).

Szankay, L., et al., *Nicht nur Tango: Argentinische Fotografie 1985–1995* (1996).

Vasquez, P., *Dom Pedro II e a fotografia no Brasil* (1985).

—— *Brazilian Photography in the Nineteenth Century* (1988).

—— *Mestres da fotografia no Brasil: Coleção Gilberto Ferrez* (1995).

Watriss, W., and Zamora, L. P. (eds.), *Image and Memory: Photography from Latin America, 1866–1994* (1998).

Ziff, T. (ed.), *Between Worlds: Contemporary Mexican Photography* (1990).

III.5. The Middle East and Africa

Anthology of African and Indian Ocean Photography (Eng. edn. 1999).

Aubenas, S., *Voyage en Orient* (1999).

Behrend, H., and Wendl, T., *Snap Me One! Studio Photographers in Africa* (1998).

Bensusan, A. D., *Silver Images: History of Photography in Africa* (1966).

Bull, M., and Denfield, J., *Secure the Shadow: The Story of Cape Photography from its Beginnings to the End of 1870* (1970).

—— **and Lorimer, D.,** *Up the Nile: A Photographic Excursion. Egypt 1839–1898* (1979).

Çizgen, E., *Photography in the Ottoman Empire, 1839–1919* (1987).

Graham-Brown, S., *Images of Women: The Portrayal of Women in Photography of the Middle East, 1860–1950* (1988).

Hartmann, W., Hayes, P., and Silvester, J. (eds.), *The Colonialising Camera: Photographs in the Making of Namibian History* (1998).

Howe, K. S., *Excursions along the Nile: The Photographic Discovery of Ancient Egypt* (1993).

—— *Revealing the Holy Land: The Photographic Exploration of Palestine* (1997).

Lundstrom, J.-E. (ed.), *Democracy's Images: Photography and Visual Art after Apartheid* (1998).

Monti, N. (ed.), *Africa Then: Photographs, 1840–1918* (1987).

Nimis, E., *Photographes de Bamako de 1935 à nos jours* (1998).

Nir, Yeshayahu, *The Bible and the Image: The History of Photography in the Holy Land, 1839–1899* (1985).

Onne, E., *Photographic Heritage of the Holy Land, 1839–1914* (1980).

Pankhurst, R., and Gérard, D., *Ethiopia Photographed: Historic Photographs of the Country and its People Taken between 1867 and 1935* (1996).

Perez, N. N., *Focus East: Early Photography in the Near East, 1839–1885* (1988).

Vaczek, L. C., and Buckland, G., *Travellers in Ancient Lands: A Portrait of the Middle East, 1839–1919* (1981).

Wilson, F. (ed.), *South Africa, the Cordoned Heart: Essays by 20 South African Photographers* (1986).

III.6. Australasia, Antarctica, and Oceania

Abramson, J., *Photographers of Old Hawai* (3rd edn. 1981).

Annear, J. (ed.), *Portraits of Oceania* (1997).

Blanton, C. (ed.), *Picturing Paradise: Colonial Photography of Samoa, 1875–1925* (1995).

Cato, J., *The Story of the Camera in Australia* (3rd edn, 1979).

Davies, A., and Stanbury, P., *The Mechanical Eye in Australia: Photography 1841–1900* (1985).

Davis, L., *Na Pa'i Ki'i: The Photographers in the Hawaiian Islands 1845–1900* (1980).

Engelhard, J., and Mesenhöller, P. (eds.), *Bilder aus dem Paradies: Koloniale Fotografie aus Samoa 1875–1925* (1995).

Holden, R., *Photography in Colonial Australia: The Mechanical Eye and the Illustrated Book* (1988).

Kakou, S., *Découverte photographique de la Nouvelle-Calédonie 1848–1900* (1998).

Kleinert, S., and Neale, M. (eds.), *The Oxford Companion to Aboriginal Art and Culture* (2000).

Knight, H., *Photography in New Zealand: A Social and Technical History* (1971).

Main, W., and Turner, J. B., *New Zealand Photographers from the 1840s to the Present* (1993).

Meyer, A. B., and Parkinson, R. (eds.), *Album von Papua Typen, Neu Guinea und dem Bismarck-Archipel* (2 vols., 1894, 1900).

Murphy, S., Newton, G., and Gray, M., *South with Endurance: Shackleton's Antarctic Expedition 1914–1917. The Photographs of Frank Hurley* (2001).

Newton, G., *Silver and Grey: Fifty Years of Australian Photography 1900–1950* (1980).

O'Reilly, P., *Les Photographes à Tahiti et Leurs œuvres, 1842–1962* (1981).

Stephen, A., *Pirating the Pacific: Images of Travel, Trade and Tourism* (1994).

Stephenson, E., *Fiji's Past on Picture Postcards* (1994).

III.7. Indian Subcontinent

Dehejiya, V., et al., *India through the Lens: Photography 1840–1911* (2000).

Desmond, R., *Victorian India in Focus: A Selection of Early Photographs from the India Office Library and Records* (1982).

Embree, A., and Worswick, C., *The Last Empire: Photography in British India, 1855–1911* (1976).

Falconer, J., *India: Pioneering Photographers, 1850–1900* (2002).

Gutman, J. M., *Through Indian Eyes: 19th- and Early 20th-Century Photography from India* (1982).

Pelizzari, M. A. (ed.), *Traces of India: Photography, Architecture and the Politics of Representation, 1850–1900* (2003).

Pinney, C., *Camera Indica: The Social Life of Indian Photographs* (1997).

Thomas, G., *History of Photography: India 1840–1980* (1981).

Worswick, C., *Princely India: Photographs by Raja Deen Dayal, 1884–1910* (1980).

III.8. China, Japan, and South-East Asia

Banta, M., and Taylor, S. (eds.), *A Timely Encounter: Nineteenth-Century Photographs of Japan* (1988).

Borhan, P., and Iizawa, K., *La Photographie japonaise de l'entre deux guerres: du pictorialisme au modernisme* (1990).

Capa, C., *Behind the Great Wall of China: Photographs from 1870 to the Present* (1972).

De la Mer de Chine au Tonkin, photographies 1886–1904 (1996).

Fuku, N., *An Incomplete History: Women Photographers from Japan, 1864–1997* (1998).

Iizawa, K., *Japanese Contemporary Photography: Twelve Viewpoints* (1990).

Japan Photographers Association, *A Century of Japanese Photography,* introd. J. W. Dower (1980).

Kaneko, R., *Japanische Photographie, 1860–1929* (1993).

—— *Modern Photography in Japan, 1915–1940,* ed. D. Klochko (2001).

Kohmoto, S. (ed.), *Images in Transition: Photographic Representation in the Eighties* (1990).

Nawigamune, A., *Early Photography in Thailand* (1988).

Phillips, C., and Hung, W., *Between Past and Future: New Photography and Video from China* (2004).

Reed, J. L. (ed.), *Toward Independence: A Century of Indonesia Photographed* (1991).

Ryuichi, K., *Innovation in Japanese Photography in the 1960s* (1991).

Spielmann, H. (ed.), *Die japanische Photographie: Geschichte, Themen, Strukturen* (1984).

Stearns, R. (ed.), *Photography and Beyond in Japan: Space, Time and Memory* (1994).

Szarkowski, J., and Yamagishi, S. (eds.), *New Japanese Photography* (1974).

Thiriez, R., *Barbarian Lens: Western Photographers of the Qianlong Emperor's European Palaces* (1998).

Tucker, A. W., et al., *The History of Japanese Photography* (2003).

Worswick, C., *Imperial China: Photographs 1850–1912* (1978).

Yamamoto, K. (ed.), *Photographic Aspect of Japanese Art Today* (1987).

Yokoe, F., *Japanese Photography in the 1970s* (1991).

Websites

By the turn of the 21st century the Internet had become a vast resource for information gathering on virtually any subject. Photography was no exception, and today tens of thousands of museums, galleries, manufacturers, societies, journals, and individuals have websites which can be rapidly located by powerful search engines. Practically every application of photography past and present, and innumerable personalities, events, and items of equipment, have sites dedicated to them, although these vary greatly in quality and usefulness. Hundreds of new ones appear every month.

The following selection therefore represents only a tiny proportion of what is available. It would have been easy, if time consuming, to have made a list of useful items many times longer. The emphasis in the first section is on public and private institutional sites, which were chosen for their user friendliness, probable longevity, and frequency of revision; many include links to other related sites. The second section gives a varied but selective guide to the proliferating photography festivals being held in various parts of the world. The more general final section includes sites such as Photolinks, the International Directory of Photographic Historians, and the Open Directory Project, which offer large numbers of systematically organized links. However, anyone interested in creating a database of sites is also referred to regularly updated publications like *European Photography Guide*, *USA Photography Guide*, and *Japanese Photography Guide*, and the numerous yearbooks aimed mainly at imaging professionals.

Organizations and Journals

Australia

Art Gallery of New South Wales, Sydney
www.artgallery.nsw.gov.au

Australian Centre for Photography, Sydney
www.acp.au.com

Centre for Contemporary Photography, Fitzroy, Victoria
www.ccp.org.au

Museum of Contemporary Art, Sydney
www.mca.com.au

National Gallery of Australia, Canberra
www.nga.gov.au

Stills Gallery, Sydney
www.stillsgallery.com.au

Austria

Albertina Collection
www.albertina.at

Buchhandlung Lia Wolf, Vienna
www.lia.wolf.at

Camera Austria
www.camera-austria.at

Eikon
www.eikon.or.at/eikon/

Fotogalerie Wien
www.fotogalerie-wien.at

Kunsthalle Wien im Museumsquartier
www.kunsthallewien.at

Österreichische Fotogalerie im Rupertinum, Salzburg
www.fotonet.at/rupertinum/rupinfo.html

Verband Österreichischer Amateur-fotografenvereine
www.voeav.org

Vienna Secession
www.secession.at

Belgium

Musée de la Photographie, Charleroi
www.museephoto.be
www.arkham.be

Museeum voor Fotografie, Antwerp
www.provant.be/fotomuseum
www.fotomuseum.be

Brazil

Biblioteca Nacional, Rio de Janeiro
info.lncc.br/dimas/bibl_nac.htm

Pinacoteca do Estado, São Paulo
www.uol.com.br/pinasp

Canada

Archives of Ontario
www.archives.gov.on.ca/

Canadian Centre for Architecture, Montreal
cca.qc.ca

Canadian Museum of Contemporary Photography, Ottawa
cmcp.gallery.ca

Library and Archives, Canada, Ottawa
www.collectionscanada.ca/art-photography

McCord Museum of Canadian History, Montreal
www.mccord-museum.qc.ca/

Photographic Historical Society of Canada
www.phsc.ca

Czech Republic

Film and TV School of the Academy of Performing Arts (FAMU), Dept. of Still Photography, Prague
foto.famu.cz

Institute of Creative Photography, The Silesian University, Opava
www.foto.sk

Prague House of Photography
www.php-gallery.cz

Denmark

Danmarks Fotomuseum, Herning
www.fotomuseum.dk

Fotografisk Center, Copenhagen
www.photography.dk

Galleri Image, Århus
www.galleriimage.dk

Museet for Fotokunst, Brandts Klaede-fabrik, Odense
www.brandts.dk

National Museum of Photography Copenhagen
www.kb.dk./kb/dept/nbo/kob/fot-mus_en/dafot.htm

Estonia

Town Prison Museum of Photography, Tallinn
www.linnamuuseum.ee/fotomuuseum

Finland

Finnish Museum of Photography, Cable Factory,
Helsinki
www.fmp.fi/fmp_fi/muvieras/english/general.htm

Laterna Magica (gallery)
www.laterna.net

Pohjoinen valokuvakeskus (Northern
Photographic Centre), Hallituskatu
www.ouka.fi/pvk

France

Agence France Presse
www.afp.com

Bibliothèque Nationale de France, Paris
www.bnf.fr

Centre National d'Art et de Culture, Centre
Georges Pompidou, Paris
www.cnac-gp.fr

Centre National de la Photographie Paris
www.cnp-photographie.com

Documentation Française
www.ladocfrancaise.gouv.fr

École Nationale des Ponts et Chaussées
www.enpc.fr/fr/documentation/

École Nationale Supérieure de la Photographie,
Arles
www.enp-arles.com

Études photographiques
etudesphotographiques.revues.org

Fondation Henri Cartier-Bresson, Paris
www.henricartierbresson.org

Gamma Presse
www.gamma-presse.com

Guide Internet des Photographes et de la
Photographie en France
www.itisphoto.com

Maison Européenne de la Photographie, Paris
www.mep-fr.org/us

Musée d'Orsay, Paris
www.musee-orsay.fr

Musée Nicéphore Niépce, Chalon-sur-Saône
www.museeniepce.com

Patrimoine Photographique, Hôtel de Sully, Paris
www.patrimoine-photo.org

Photographie (Internet journal)
www.photographie.com

Rapho
www.rapho.com

La Recherche photographique
www.pictime.fr/maison-europeenne/lrp/

Réunion des Musées Nationaux
www.photo.rmn.fr

Revue noire
www.revuenoire.com

Salon International Européen de la Photographie,
Paris
www.parisphoto.photographie.com

Sipa Press
www.sipa.com

Société Française de la Photographie, Paris
www.sfp.photographie.com

Germany

Agfa Photo-Historama, Cologne
www.museenkoeln.de/agfa-photo-historama

Berlinische Galerie
www.germangalleries.com/Berlinische_Galerie/

Deutsche Gesellschaft für Photographie
www.dgph.de

Deutsches Historisches Museum, Berlin
www.dhm.de

Fotogeschichte
www.fotogeschichte.info

Kunstakademie Düsseldorf
www.kunstakademie-duesseldorf.de

Kunstakademie Düsseldorf, Fotostudium
www.fotoinfo.de

Leica Galerie, Solms
www.fotopunkt.de

Münchener Stadtmuseum/Fotomuseum
www.stadtmuseum-online.de
www.muenchen.de/stadtmuseum

Museum Folkwang, Essen
www.museum-folkwang.de

Museum für Kunst und Gewerbe, Hamburg
www.mkg-hamburg.de

Photographische Sammlung/SK Stiftung Kultur,
Cologne
www.sk.kultur.de

Sprengel Museum, Hannover
www.sprengel-museum.de

Greece

General Greek photography site
www.fotoart.gr/photography/internet

Benaki Museum, Athens, Photography Archive
www.benaki.gr/archives/photographic/gr/

Thessaloniki Museum of Photography
www.thmphoto.gr/english

Thessaloniki Photography Centre
www.fkth.gr

Hungary

Hungarian Museum of Photography, Kecskemét
www.fotomuzeum.hu

India

Centre for Photography, National Centre for the
Performing Arts Mumbai/Bombay
www.charm.net/~nayak/cpa.html

Ireland

Dublin Photographic Centre
www.dublincameraclub.ie

Gallery of Photography, Dublin
www.irish-photography.com/

National Library of Ireland, Photographic
Archive, Dublin
www.nli.ie/a_coll.htm

Photographic Society of Ireland, Dublin
www.psa-photo.org

Italy

Archivio Fotografico Toscano, Prato
www.aft.it

Fondazione Italiana per la Fotografia, Turin.
Museo della Fotografia Storica e Contemporanea
www.fif.arte2000.net/

Fratelli Alinari Educational, Florence
www.edu.alinari.it

Fratelli Alinari Museum of Photography,
Florence
www.alinari.it

Galleria Civica, Modena
www.comune.modena.it/galleria

Museo Nazionale della Fotografia, Brescia
www.bresciainvetrina.it/bresciaarte/
museonazionalefotografia.htm

Scuole di Fotografia in Italia
www.fotoscuola.it/elenco_generale_.htm

Japan

Canon Camera Museum
www.canon.com/camera-museum

Japan Professional Photography Society
www.jps.gr.jp

Nara City Museum of Photography
www.dnp.co.jp/museum/nara/nara-e.html

National Museum of Modern Art, Tokyo
www.momat.go.jp

Photo Gallery International, Tokyo
www.pgi.ac/aboutus/yamazaki-e.html

Third Gallery Aya, Osaka
www.threeweb.ad.jp/~aya/exhibitions

Tokyo Metropolitan Museum of Photography
www.tokyo-photo-museum.or.jp

Latvia

Latvian Museum of Photography, Riga
www.culture.lv/photomuseum

Lithuania

Union of Lithuanian Art Photographers
www.photography.lt

Mexico

INAH Photographic Archives, Hidalgo
www.mexicodesconocido.com.mx/english/

Netherlands

Contemporary Dutch Photography
www.paradox.nl

Gerrit Rietveld Academie, Amsterdam
www.gerritrietveldacademie.nl

Musea (ethnographic museums in Holland and
Belgium)
www.africaserver.nl/kunstcultuur/musea.htm

Nederlands Fotoinstitut, Rotterdam
www.nfi.nl

Nederlands Fotomuseum, Rotterdam
www.nederlandsfotomuseum.nl

Netherlands Photo-Archive
www.nfa.nl

Rijksmuseum, Amsterdam
www.rijksmuseum.nl/

Rijksmuseum, Amsterdam, etc.: Early
Photography 1839–1860
www.earlyphotography.nl/

New Zealand

NZ Centre for Photography, Wellington
nzcp.wellington.net.nz

Photoforum
www.photospace.co.nz

Norway

Norsk Museum for fotografi-Preusfotomuseum,
Horten
www.foto-museum.no/
www.museumsnett.no/fotografimuseum

Peru

Talleres de Fotografía Social
www.gci275.com/peru/tafos01.shtml

Poland

Fotopolis (Internet magazine)
www.fotopolis.pl

Galeria FF— Forum Fotografii, Łódź
www.galeriaff.infocentrum.com/off.html

Mala Galeria ZPAK-CSW (Small Gallery of the
Union of Polish Art Photographers and Centre for
Contemporary Art), Warsaw
fototapeta.art.pl/malagaleria.php

Museum of the History of Photography, Kraków
www.mhf.krakow.pl

Portugal

Casa Museu de José Relvas, Golegã
www.eps-jose-relvas.rcts.pt/museu.htm

Russian Federation

Agency of Professional Photography
www.photoweb.ru/prophoto

Moscow House of Photography
www.mdf.ru

Photographer.Ru
www.photographer.ru/galleries

Russian Photo Museum, Nizhny Novgorod
www.sci-nnov.ru/culture/museums/photo/

South Africa

South Africa History Online
www.sahistory.org.za

South African Museum: Encounters with
Photography
www.museums.org.za/sam/conf/enc/

Spain

Fundación Foto Colectania, Barcelona
www.colectania.es

Sweden

Hasselblad Centre, Gothenburg
www.hasselbladcenter.se

Hasselblad Foundation, Gothenburg
www.hasselbladfoundation.org/index_en.html

Modern Museum and Photography Museum,
Stockholm
www.modernamuseet.se

Nordic Museum, Stockholm (ethnographic
collections)
www.nordiskamuseet.se/

Photomuseum, Osby
www.fotmuseetiosby.nu/frameseng.html

Switzerland

Fotomuseum Winterthur
www.fotomuseum.ch

Hochschule für Gestaltung und Kunst, Zürich
www.hgkz.ch

Kunsthaus Zürich
www.kunsthaus.ch

Kunstmuseum Bern
www.kunstmuseumbern.ch

Musée Suisse de l'Appareil Photographique, Vevey
www.swiss-riviera.com/musee-photo/

United Kingdom

Amateur Photographer
www.amateurphotographer.com

Amphot UK (club listings)
www.amphot.co.uk

Autograph: The Association of Black
Photographers
www.autograph-abp.co.uk

Birmingham Museum and Art Gallery
www.birminghamheritage.org.uk/museum.htm

British Association of Picture Libraries and
Agencies (BAPLA)
www.bapla.org.uk

British Institute of Professional Photographers
(BIPP)
www.bipp.com

British Journal of Photography
www.bjp-online.co.uk

British Press Photographers' Association (BPPA)
www.britishpressphoto.org

Camera Clubs.co.uk
www.cameraclubs.co.uk

Disabled Photographers' Society
www.dps-uk.org.uk

ffotogallery, Cardiff
www.ffotogallery.org

History of Photography
www.tandf.co.uk/journals

Ikon Gallery, Birmingham
www.birminghamheritage.org.uk/ikon.htm

Imperial War Museum, London
collections.iwm.org.uk

Mass-Observation Archive
www.sussex.ac.uk/library/massobs

National Maritime Museum, Greenwich
www.nmm.ac.uk

National Museum of Photography, Film and
Television, Bradford
www.nmpft.org.uk

Photographers' Gallery, London
www.photonet.org.uk

Photographic Exhibitions in Britain 1839–1865
(listings)
www.peib.org.uk

Photo Imaging Council
www.pic.uk.net

Pitt Rivers Museum, Oxford
www.prm.ox.ac.uk/

Royal Anthropological Institute, London
www.therai.org.uk

Royal Geographical Society, London
www.rgs.org/

Royal Photographic Society (RPS), Bath
www.rps.org

RPS Digital Imaging Group
www.digit.org.uk

Scottish National Galleries
www.nationalgalleries.org

Scottish Photographers
www.scottish-photographers.com

Side Gallery, Newcastle upon Tyne
www.amber-online.com/gallery/index.html

Stereoscopic Association
www.stereoscopicsociety.org.uk

Stills Gallery, Edinburgh
www.stills.org

Sutcliffe Gallery, Whitby
www.sutcliffe-gallery.co.uk

Tate Modern, London
www.tate.org.uk

Victoria & Albert Museum, London
www.vam.ac.uk

USA

Afterimage Gallery, Dallas, Texas (articles, links)
www.afterimage.com

American Institute for the Conservation of
Historic and Artistic Works
www.aic.stanford.edu

American Museum of Photography (virtual)
www.photographymuseum.com

Aperture Inc.
www.aperture.org

Associated Press
www.ap.org

California Council for the Humanities
Documentary Project
www.calhum.org/programs/doc_intro.htm

California Museum of Photography
photo.ucr.edu

Center for Creative Photography, University of
Arizona
www.library.arizona.edu/branches/ccp/

Contact Press Images
www.contactpressimages.com

Daguerrian Society
www.daguerre.org

Digital Imaging Forum
www.art.uh.edu/DIF/

Eastman Kodak
www.kodak.com/

Getty Images
www.gettyimages.com

International Center of Photography, New York
www.icp.org

International Museum of Photography at George
Eastman House, Rochester, NY
www.eastman.org/home.htm

J. Paul Getty Museum, Los Angeles
www.getty.edu

Kinsey Institute, Indiana University
www.indiana.edu/~kinsey/
www.kinseyinstitute.org/resources/sexlinks.html

Latin American Photographic Archive, Tulane
University
www.tulane.ed/ latinlib/lalphoto.html

Metropolitan Museum of Art, New York
www.metmuseum.org

Museum of Contemporary Photography
www.mocp.org

Museum of Modern Art, New York
www.moma.org

Smithsonian Institution, Washington, DC
www.si.edu/resource/faq/nmah/photography

Smithsonian National Museum of the American
Indian, Washington, DC
americanindian.si.edu/

Society for Photographic Education
www.spenational.org/

Southeast Museum of Photography, Daytona
Beach, Fla.
www.smponline.org

Stanford University Conservation Site
palimpsest.stanford.edu

Third View (Rephotography Project)
www.thirdview.asu.edu

US Holocaust Memorial Museum Washington,
DC
www.ushmm.org

US Library of Congress, Washington, DC
www.loc.gov/resdev/browse/a.html

Events

AIPAD—New York (February)
www.photoshow.com

Arles Festival (Rencontres Internationales de la
Photographie), France
www.rip.arles.org

Bienal International de Fotografia Curitiba, Brazil
curitiba.pr.gov.br

Bratislava Mesiac Fotografie, Slovakia
fotofo.sk

Contact, Toronto, Canada
contactphoto

Encontros da Imagem, Braga, Portugal
eimagem.bragatel.pt

Encuentros Abiertos de Fotografia Buenos Aires,
Argentina
encuentrosabiertos.com

exposure: Hereford Photography Festival, UK
www.photofest.org

FotoBiennale Rotterdam, Netherlands
fbr.nl

FotoFest, Inc., Houston, Texas, USA
FotoFest.org

Fotoseptiembre, Mexico City
www.cnca.gob.mx/in.htm

Modena per la fotografia, Italy
www.comune.modena.it

Mois de la Photo à Montréal, Canada
moisdelaphoto.com

Mois Européen de la Photographie, Paris (from
2004 linked to events in Berlin and Vienna),
France
www.2005.photographie.com
mep-fr.org

NAFOTO, São Paulo, Brazil
www.fotosite.com.br/mes

Odense Foto-Triennial, Denmark
brandts.dk
photography.dk

Paris Photo annual photography fair
www.parisphoto-online.com

PhotoEspaña, Madrid, Spain
www.phedigital.com
www.photoes.com

Photo LA—Los Angeles (January), USA
www.stephencohengallery.com

Photo San Francisco (July), USA
www.stephencohengallery.com

Photosynkyria Festival, Thessaloniki, Greece
www.photosynkyria.gr

Pingyao Festival, China
www.pipfestival.com

Primavera Fotográfica, Barcelona, Spain
cultura.gencat.es

Skopelos Photography Festival, Greece
www.skopelos.gr
www.skopelos.net/culture/photocentre.htm

Visa pour l'Image (photojournalism festival),
Perpignan, France
www.visapourlimage.com

General

Aites, Edwardo (alternative processes)
www.geocities.com/edwardaites/index.html

Amateur Photographer equipment tests
www.testreports.co.uk/photography/ap

Art in Holography
www.art-in-holography.org

Artmag (links to galleries, events)
www.artmag.com

Berman Graphics (interviews)
bermangraphics.com/press

Children as Photographers Project
www.cap.ac.uk

Christie's
www.christies.com

Digital Camera Resource Page (tests of new
equipment)
www.dcresource.com/reviews/

European Society for the History of Photography
www.donau-uni.ac.at/eshph

International Directory of Photography Historians
www.rit.edu/~andpph/hpg.html

Leggat, Robert, on photographic history
www.rleggat.com/photohistory

Lomography
lomography.com

Magnum Photos
www.magnumphotos.com

Malin, David (astronomical photography)
www.davidmalin.com

Man Ray Trust
www.manraytrust.com

Masters of Photography (articles, biographies, links)
www.masters-of-photography.com

Media History Project
www.mediahistory.umn.edu/photo.html

Nadeau, Luis (conservation)
www.photoconservation.com

Open Directory Project: Photography
dmoz.org/Reference/Museums/Arts_and_ Entertainment/Photography

Photography dealers' guide
www.photography-guide.com

The Photography School Directory
PhotographySchools.com

Photolinks (links to numerous countries and organizations)
www.photolinks.com

Poidebard, Antoine (virtual gallery)
www.usj.edu.lb/poidebard/bibl.htm

Sight: Fine Photography Online
www.sightphoto.com

Sotheby's
www.sothebys.com

SPress (virtual photography museum)
www.spress.de/foto/history

Sub Club (sub-miniature)
www.subclub.org

Talbot, William Henry Fox (correspondence)
www.foxtalbot.arts.gla.ac.uk/letters

Women in Photography Archive
www.sla.purdue.ed/WAAW/Palmquist

Index of People and Companies

Picture Acknowledgements

The publishers are grateful to the following for their permission to reproduce the illustrations. Although every effort has been made to contact copyright holders, it has not been possible to do so in every case and we apologise for any that may have been omitted. Should the copyright holders wish to contact us after publication, we would be happy to include an acknowledgement in subsequent reprints.

Colour plates

facing page

42	Patricia Macdonald
43	Patricia Macdonald
58	Reproduced with permission of The Rothschild Archive
59	Alan Weintraub/arcaid.co.uk
98	National Museum of Photography, Film & Television/Science & Society Picture Library
99	National Museum of Photography, Film & Television/Science & Society Picture Library
122	Anglo-Australian Observatory/David Malin Images
123	Richard Bryant/arcaid.co.uk
162	www.mikegreenslade.com
163	© Christie's, London • www. christies.com • leading specialist international auctions of vintage and collectible photographs and photographic equipment
178	National Museum of Photography, Film & Television/Science & Society Picture Library
179	National Museum of Photography, Film & Television/Science & Society Picture Library
202	Photo © National Gallery of Canada, Ottawa. Gift of the Harold and Esther Edgerton Family Foundation, Santa Fe, New Mexico, 1997/© Kim Vandiver & Harold Edgerton 1973, courtesy of Palm Press, Inc.
203	By courtesy of Cecil Beaton Studio Archive, Sotheby's
218	Photo RMN/Herve Lewandowski
219	Andrew Lawson
258	Naoya Hatakeyama *Underground/River (Tunnel Series)* 1999 (Courtesy of Taka Ishii Gallery, Tokyo)
259	David Miller/David Malin Images
282	National Museum of Photography, Film & Television/Science & Society Picture Library
283	Photograph by Warrant Officer Giles Penfound; Crown Copyright, image from www.photos.mod.uk. Reproduced with the permission of the Controller of her Majesty's Stationery Office
322	Ronald S Haeberle/Time Life Pictures/Getty Images
323	James Nachtwey/VII
338	Photo Lennart Nilsson/Albert Bonniers Förlag AB, *A Child Is Born*
339	British Library
378	Reuters/Ulli Michel
379	Freeman Patterson, *SHADOWLight*, Harper Collins
402	© Annie Leibovitz/Contact/nbpictures
403	© Nick Cornish
442	Library of Congress, Prints & Photographs Division, Prokudin-Gorskii Collection [LC-DIG-ppmsc 03948]
443	National Museum of Photography, Film & Television/Science & Society Picture Library
443	National Museum of Photography, Film & Television/Science & Society Picture Library
458	National Museum of Photography, Film & Television/Science & Society Picture Library
459	Jo Spence/David Roberts, 1990/Jo Spence Archive, London
498	Leeds Russian Archive, University of Leeds
499	fotoworx.de/Jan Vetter
522	Dwayne Senior
523	National Museum of Photography, Film & Television/Science & Society Picture Library
562	Chris Howes/Wild places
563	Mark Webster/www.photec.co.uk
578	National Museum of Photography, Film & Television/Science & Society Picture Library
579	Reuters/Ulli Michel
642	© Larry Burrows/Time Life Pictures/Getty Images
643	Private Collection
658	Private Collection
659	Heather Angel/Natural Visions
682	Photo: © 2001 Bill Biggart
683	Eiko Yamazawa, *What I'm Doing No.77*, 1986
698	© Yevonde Portrait Archive
699	David Miller/David Malin Images

Black and white illustrations

7	Courtesy of the Royal Photographic Society Collection at National Museum of Photography, Film & Television/Science & Society Picture Library
12	Collection Heike Behrend
14	Collection Heike Behrend
15	Collection Heike Behrend
16	Library of Congress, Prints & Photographs Division, FSA/OWI Collection [LC-USF34-T01-013407-C]
18	Courtesy of the Royal Photographic Society Collection at National Museum of Photography, Film & Television/Science & Society Picture Library
22	Private Collection
26	Branwell Collection, Penlee House Gallery & Museum, Penzance
30	Library of Congress, Prints & Photographs Division [LC-USZ64-129906]
32	Library of Congress, Prints & Photographs Division [LC-USZ62-64704]
35	Scottish National Photography Collection, Scottish National Portrait Gallery
37	Private Collection
37	Private Collection
38	© Pitt Rivers Museum, University of Oxford
41	© Nobuyoshi Araki
48	National Museum of Photography, Film & Television/Science & Society Picture Library
49	© Christie's, London • www. christies.com • leading specialist international auctions of vintage and collectible photographs and photographic equipment
52	Bibliotheque nationale de France
54	Photograph by Peter Dombrovskis, copyright Liz Dombrovskis
60	Private Collection
61	Private Collection
63	The Royal Archives © 2005. Her Majesty Queen Elizabeth II
64	The J. Paul Getty Museum, Los Angeles/Copyright Michael P. Mattis Collection
67	Aperture Foundation/© Letizia Battaglia
70	The Royal Archives © 2005. Her Majesty Queen Elizabeth II
71	Photo Beken of Cowes
77	Imperial War Museum, London
79	Photo R.M.N./P. Schmidt/© ADAGP, Paris and DACS, London 2005
81	The Alkazi Collection of Photography
82	The Royal Archives © 2005. Her Majesty Queen Elizabeth II
84	Bill Brandt © Bill Brandt Archive
86	Courtesy of ESTATE BRASSAÏ/R.M.N./National Museum of Photography, Film & Television/Science & Society Picture Library
94	National Museum of Photography, Film & Television/Science & Society Picture Library